ITALIAN PAINTINGS
1250–1450

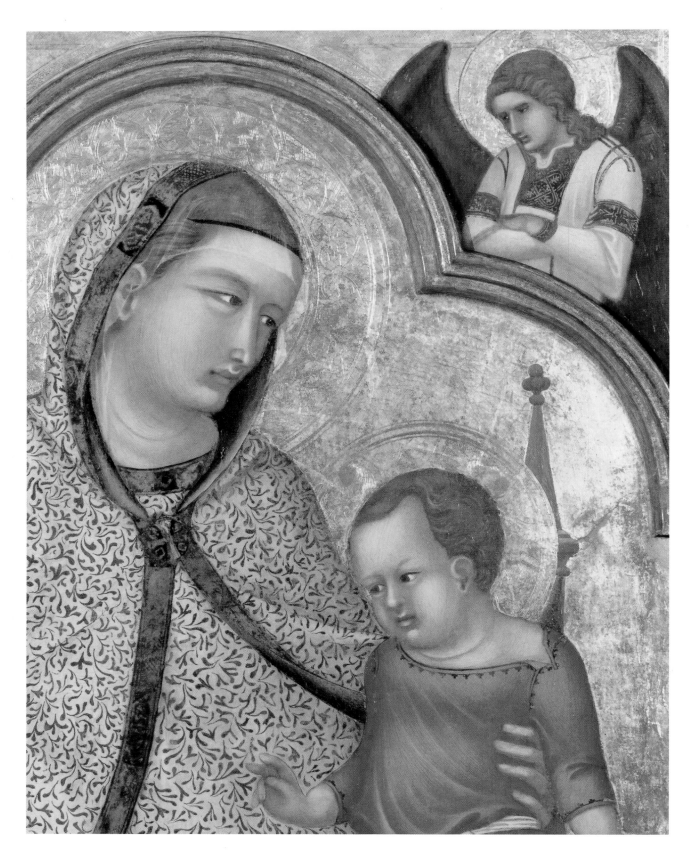

Published with the assistance of the GETTY GRANT PROGRAM,
and with an endowment for scholarly publications
established at the Philadelphia Museum of Art in 2002 by
THE ANDREW W. MELLON FOUNDATION and matched by generous donors.

ITALIAN PAINTINGS
1250–1450

In the JOHN G. JOHNSON COLLECTION
AND THE PHILADELPHIA MUSEUM OF ART

Carl Brandon Strehlke

PHILADELPHIA MUSEUM OF ART

Produced by the Publishing Department
Philadelphia Museum of Art
2525 Pennsylvania Avenue
Philadelphia, PA 19130
USA
www.philamuseum.org

COVER/JACKET: FRONT Masaccio and Masolino, detail of *Saints Paul and Peter* (plate 44A [JC inv. 408]); BACK Zanobi Strozzi, detail of the *Annunciation* (plate 77 [JC cat. 22])
FRONTISPIECE: Pietro Lorenzetti, detail of *Virgin and Child Enthroned with Donor and Angels* (plate 39A [JC cat. 91], plate 39C [PMA EW1985-21-2])
PAGES 20–21: Attributed to Benedetto di Bindo, *Virgin of Humility and Saint Jerome Translating the Gospel of John* (plate 13 [JC cat. 153])

Edited by Sherry Babbitt and Nicole Amoroso
Production by Richard Bonk
Designed by Bessas & Ackerman, Guilford, Connecticut
Index by Frances Bowles
Color separations, printing, and binding by Nissha Printing Co., Ltd.,
Kyoto, Japan

LIBRARY OF CONGRESS CATALOGING-IN-PUBLICATION DATA
Philadelphia Museum of Art.
Italian paintings, 1250–1450, in the John G. Johnson Collection and the
Philadelphia Museum of Art / Carl Brandon Strehlke.
 p. cm.
 Museum catalog.
 Includes bibliographical references and index.
 ISBN 0-87633-183-5 (cloth) – ISBN 0-87633-184-3 (paper) –
 ISBN 0-271-02537-9 (Penn State)
1. Painting, Italian–Catalogs. 2. Painting, Renaissance–Italy–Catalogs.
3. Painting, Medieval–Italy–Catalogs. 4. John G. Johnson Collection
(Philadelphia, Pa.)–Catalogs. 5. Philadelphia Museum of Art–Catalogs.
6. Painting–Pennsylvania–Philadelphia–Catalogs. I. Strehlke, Carl Brandon.
II. John G. Johnson Collection (Philadelphia, Pa.) III. Title.
 ND615.P468 2004
 759.5'09'0207474811–dc22 2004050517

Contents

FOREWORD

When Carl Strehlke joined the Philadelphia Museum of Art in 1983 as Assistant Curator of the John G. Johnson Collection, he was already an established scholar of Italian Renaissance art. He was then completing his dissertation for Columbia University on the wall paintings by Domenico di Bartolo in the hospital of Siena, and he had finished compiling a survey catalogue of the Italian painting holdings of the Brooklyn Museum of Art. During the past twenty-one years, he has embraced with loving and intelligent attention the old master collections of this Museum, and of the John G. Johnson Collection in particular. He has become a crucial part of the creative life of the entire Museum, just as his reputation as a scholar and connoisseur has grown to international proportions.

This volume is the result of a superb scholar's passionate focus on an important group of objects, conjoined with his broad and cultured perspective about works of art, their purpose and meaning. Its publication is an achievement to be widely celebrated for the insights and new information brought to bear on these 121 paintings as well as for the window it widens onto still larger and delightful understandings of Renaissance Italy. We are thrilled that Carl's remarkable and deeply considered research, informed by his many collaborations with scholars and conservators here and abroad, has taken such handsome and articulate shape in this book.

Elsewhere in these pages, Carl expresses his profound gratitude to a multitude of colleagues both outside and inside the Museum for their assistance, which is here most warmly seconded. Danielle Rice, Associate Director for Program, joins us in a special salute to the high standards and dedication of the Museum's indefatigable Publishing Department: its Director, Sherry Babbitt; Production Manager, Richard Bonk; and especially Nicole Amoroso, Associate Editor, who has seen this complex manuscript into print. Jo Ellen Ackerman has given the book its intelligent and elegant design.

Begun in 1986 with the appearance of Richard Dorment's authoritative *British Painting in the Philadelphia Museum of Art*, the Museum's ongoing endeavor not only to document and publish its distinguished holdings but also to set them in broader context has reached another important milestone with this volume. Without crucial endowments for scholarly publications established by two challenge grants from The Andrew W. Mellon Foundation and matched by corporate and private contributions, this book could not have been published. Without a timely and handsome grant from the J. Paul Getty Trust, which funded essential research and travel, the project could not have begun. We are also indebted to the John G. Johnson Trust for support of the study of the legendary collector, and to the Samuel H. Kress Foundation for funding research into the masterpieces by Masaccio and Masolino

(plates 44A–B), which was the subject of another volume and has also enriched this book.

Extensive examination and analysis, as well as years of painstaking treatment conducted in the Museum's Conservation Laboratory under the direction of Mark S. Tucker, Senior Conservator of Paintings, not only inform the research published herein but also render many of the paintings more readily accessible to public understanding and delight. We thank the Lila Wallace–Reader's Digest Fund for its support of much crucial conservation treatment of the Italian paintings collection, undertaken during the vast project to renovate and reinstall the European galleries, which concluded in 1995.

John Graver Johnson, the most distinguished corporate lawyer of his era, was not only a great collector but also a notable civic leader, a strong advocate for art museums, and a believer in their role in the creation of an educated and well-rounded society. He played a formative role in the early history of this Museum and in 1896 encouraged its first major purchase of an Italian painting, by Vittore Crivelli, with income from a newly endowed acquisition fund. Johnson wanted the benefit of authoritative scholarship for his collection, and this book, in which so many of his pictures are documented, would have pleased him no end. The Museum's strength in the arts of Italy continues to this day, and it is a source of extra satisfaction that the appearance of this catalogue raisonné of thirteenth- to fifteenth-century Italian paintings coincides with a very focused publication and exhibition (also created by Carl Strehlke) inspired by two later Renaissance masterpieces from Florence in the Museum: Medici portraits by Jacopo Pontormo and Agnolo Bronzino. Completing a trio of concurrent projects devoted to Italian art is a book and exhibition, prepared by Ann Percy, the Museum's Curator of Drawings, that presents a selection of Italian drawings in the collection from the sixteenth century to the present.

Writing to his close friend John G. Johnson in 1909, the English art critic Roger Fry singled out the "imaginative intensity and intimacy which I find to be the real note of your collection," a collection that Fry declared to be "itself a work of art." We join Carl Strehlke in the hope that readers of this book will find themselves caught up in the same "intensity and intimacy" conveyed through deeper familiarity with the paintings herein described.

Anne d'Harnoncourt
The George D. Widener
Director and Chief Executive
Officer

Joseph J. Rishel
The Gisela and Dennis Alter
Senior Curator of European Painting
before 1900, and Senior Curator
of the John G. Johnson Collection
and the Rodin Museum

ACKNOWLEDGMENTS

This catalogue has taken many years to research, write, and produce—so many, in fact, that I began writing it on a Smith Corona typewriter, and that in the editing, references to museums in former East Berlin and Leningrad had to be updated. Completing a project of this size and breadth has also required a great deal of assistance from colleagues and friends alike.

The support of my colleagues at the Philadelphia Museum of Art was exemplary. With the sustained encouragement of Anne d'Harnoncourt and Joseph J. Rishel, I was able to spend much of my time working on this project in Florence, where I had essential access to the libraries of the Kunsthistorisches Institut, The Harvard University Center for Italian Renaissance Studies at Villa I Tatti, and the Biblioteca Nazionale Centrale, as well as the help of their kind staffs. I also worked in the Archivio di Stato in Florence and in many other Florentine and Italian archives. Any art historian knows that entering an archive to look for particular information on a specific work of art is often an exercise in folly, rather like searching for the proverbial needle in a haystack. But in a number of cases, the information I culled from these documents, ranging from artists' tax records to papal bulls, has rendered new insights about the paintings themselves. For making this possible, I wish to thank the staffs of all of these archives as well as Rolf Bagemihl, who helped with the transcription of several documents.

Margaret Quigley and then for many years Jennifer Vanim acted as bridges between the European Painting Department in Philadelphia and my home in Florence. Jennifer performed countless tasks, both large and small, with endless patience and great skill.

I also wish to thank Moreno Bucci, who helped me every step of the way in Florence.

A crucial section of this catalogue is devoted to the technical analysis and condition history of the pictures, which took place in the Conservation Laboratory of the Philadelphia Museum of Art. Mark S. Tucker and I examined every painting under the microscope and with X-radiography and infrared reflectography. The most pleasurable and useful aspects of these sessions were our conversations about the pictures. And, as questions arose during my research, we often reexamined the paintings in the laboratory. In addition to this work with Mark, a particularly useful period in this dialogue between conservators and curators took place before the reinstallation of the John G. Johnson Collection in 1994, when many of the Italian paintings passed through the laboratories for examination and restoration, and the conservation staff was increased to include Stephen Gritt, Teresa Lignelli, Roberta Rosi, and the late David Skipsey, all of whom contributed to the examinations and elucidations of the works they were treating. Joe Mikuliak completed all of the technical photography. He also patiently photographed the many punch marks that are illustrated in Appendix II, and organized and printed many of the glass negatives that John G. Johnson had made for Bernhard Berenson's 1913 catalogue. Many of those photographs are invaluable records of the condition of the pictures before they were restored in the 1940s. Joe was assisted by Steven Crossot, Laura Voight, and Tony Wychunis, and interns Kate Cuffari, Alison Gilchrest, Megan Halsband, and Rana Sindhikara.

A book of this length requires not only careful but inspired editing, for which Sherry Babbitt and Nicole Amoroso are responsible. They worked on it tirelessly for many years, seeing the texts through numerous versions. Nicole brought the book into production, collaborating closely with Richard Bonk and the designer Jo Ellen Ackerman of Bessas & Ackerman. Jessica Murphy and Thomas Loughman provided valuable assistance with fact-checking the text and bibliography. Morgen Cheshire, Mary Christian, Patricia Day, Lucía Vázquez García, Jean Harvey, Fronia Simpson, Deborah Stuart Smith, and Eileen Wolfberg proofread the text. Frances Bowles compiled the index. And without the efforts of Josephine Chen, Gina Kaiser, Lilah Mittelstaedt, and Jesse Trbovich in the Museum's library, none of us could have done our work. I wish also to thank Heather Grossman, Jessica Jewell, Jay Massey, and Kitty Plummer for their help with preparing the manuscript.

Graydon Wood, assisted by Lynn Rosenthal, photographed many of the color plates for this catalogue. Terry Murphy and Jason Wierzbicki arranged for the photography. And William Rudolph ordered countless comparative photographs.

In writing the entries I have consulted with many of my curatorial colleagues working on Italian art in both American and European museums. I would like to thank in particular Dillian Gordon of the National Gallery, London; Michel Laclotte and Dominique Thiébaut of the Musée du Louvre, Paris; Keith Christiansen, Everett Fahy, and Laurence B. Kanter of The Metropolitan Museum of Art, New York; Alessandro Cecchi of the Galleria degli Uffizi, Florence; Alessandro Bagnoli of the Soprintendenza in Siena; and Miklós Boskovits, author of catalogues of Italian painting for the Gemäldegalerie of the Staatliche Museen, Berlin, and the National Gallery of Art, Washington, D.C., as well as many other studies of early Italian painting. Cecilia Frosinini and Roberto Bellucci of the Opificio delle Pietre Dure in Florence collaborated closely with Mark Tucker and me on the Masaccio and Masolino entries.

I should also like to thank Lisa Ackerman, Giovanni Agosti, Alexandra Q. Aldridge, Magda and Silvia Barsotti, Luciano Bellosi, the late Lorenzo Bonechi, Paola Bracco, Duncan Bull, Marigene Butler, Fausto Calderai, Clarisse Carnell, Laura Cavazzini, Filippo and Giorgiana Corsini, Elizabeth Cropper, Andrea De Marchi, Charles Dempsey,

Caroline Elam, Aldo Galli, Alison Goodyear, Priscilla Grace, Linda R. Jacobs, Michael Mallon, George H. Marcus, Deborah Marrow, Kirstin Mattson, Lucia Meoni, Nicolò Orsi Battaglini, Serena Padovani, Ann Percy, Marilyn Perry, Antonio Pettena, the late John Pope-Hennessy, the late Dorothee Puccini, Francesco and Charlotte Ricasoli, Eliot W. Rowlands, Angelica Rudenstine, Piero Scapecchi, Max Seidel, Barbara Sevy, Marla K. Shoemaker, and Anchise Tempestini. I particularly wish to remember my Florentine friend Camilla Mazzei, who died prematurely as this book was about to be published.

In closing, several family members need to be remembered. My grandparents Ruth Milliken and Albert LaPool Strehlke, and my great-uncle and great-aunt T. Roosevelt and Louise Brandon Allen were particularly interested in my study of early Italian painting. Aunt Louise bought me my first computer, which replaced the Smith Corona. I am sorry she did not live to see this book finished. My mother, Rose Barocco Strehlke, who long ago stopped asking when it would be completed, will now have something to show her friends. I am particularly pleased that it will be published in the month of her eighty-fourth birthday.

Notes to the Use of the Catalogue

In addition to the plate numbers assigned herein, the paintings' John G. Johnson Collection (JC) numbers and Philadelphia Museum of Art (PMA) numbers are used throughout this book. Paintings in the Johnson Collection are identified by their catalogue (cat.) or inventory (inv.) numbers. The catalogue numbers are those given by Bernhard Berenson in 1913 and by Wilhelm Valentiner in 1914 (for these sources, see Berenson 1913 and Valentiner 1914). Inventory numbers were assigned to the paintings in Johnson's estate when it was inventoried in 1917. Paintings in the collection of the Philadelphia Museum of Art are identified by their accession numbers.

The paintings were measured in centimeters and then converted to inches (height precedes width precedes depth).

Many color plates and comparative photographs illustrate the paintings with their original edges as they appear outside their frames.

Reconfigurations of the surviving pieces of the disassembled altarpieces are approximations only. There has been no attempt to reconstruct the missing parts of the complexes or the frames.

X-radiography was carried out with a Picker Company portable industrial unit with a model 603 head and T40-36 x-ray tube.

Infrared reflectography was carried out with a Hamamatsu infrared vidicon, model C1000-03, with an N2606 tube.

Many of the X-radiographs and infrared reflectograms are composites that have been assembled digitally.

In most cases, the panels of the paintings have the characteristic general appearance of poplar wood, and the paint medium that of egg tempera. However, neither the wood nor the medium received technical analysis, except for the medium of the paintings by Masaccio and Masolino (plates 44A–B [invs. 408–9]), in which there was found to be some oil content.

The bibliographies provided with the artists' biographies list only selected references, whereas the goal has been to give a complete bibliography for the works of art (although this cannot be guaranteed). When a cited reference contains an attribution that differs from those put forth in this catalogue, the former attribution is noted (in parentheses) in the following cases: if the reference predates Berenson's 1913 catalogue; if the publication was issued by the John G. Johnson Collection or the Philadelphia Museum of Art; or if the work appears in Burton Fredericksen and Federico Zeri's standard list of Italian paintings in North American collections (see Fredericksen and Zeri 1972).

All dates correspond to the modern style of dating. However, the beginning of the year was celebrated at different times in various Italian cities (for example, in cities such as Florence and Siena, it was on March 25); therefore, it has been noted where dates have been converted to the modern style.

The Bible is cited according to the Douay-Rheims version.

Before 1938 the Philadelphia Museum of Art was called the Pennsylvania Museum.

In this catalogue, Bernhard Berenson's first name is not spelled "Bernard," as is now common, because he signed his correspondence with Johnson using "Bernhard." Only later did he change the spelling.

Johnson's letters to Berenson are held at The Harvard University Center for Italian Renaissance Studies at Villa I Tatti, Florence. All other quoted letters are housed in the John G. Johnson Collection Archives at the Philadelphia Museum of Art unless noted.

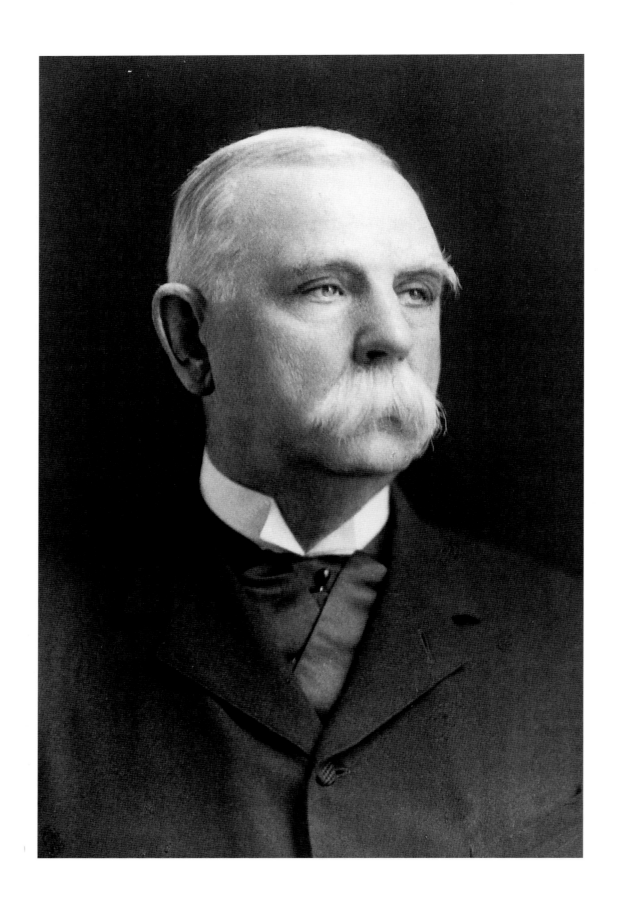

JOHN G. JOHNSON
AND THE ITALIAN PAINTING COLLECTIONS
AT THE PHILADELPHIA MUSEUM OF ART

John G. Johnson's Collecting of Italian Art

There are 469 Italian paintings dating before 1800 in the Philadelphia Museum of Art; 457 of them belonged to the renowned lawyer John Graver Johnson, who bequeathed his art collection of 1,279 objects to the citizens of Philadelphia in 1917.[1] Johnson (fig. 1) was a prodigious collector of paintings. In 1885, after less than a decade of activity, he was able to exhibit his collection of 41 works at the Union League in Philadelphia; in 1892 he printed a catalogue of 292 of his pictures; in 1913 and 1914 he published Bernhard Berenson's and Wilhelm R. Valentiner's three-volume catalogue of his 1,180 works of art; and by the time of his death three years later he had added about a hundred objects. A notable difference between 1885 and 1917 was the transformation of Johnson's collection from a gathering of modern paintings into a fine holding of old masters.

When Johnson turned his sights to older art in the 1890s, collecting Italian pictures was problematic, owing to difficulties with authentication and attribution. He entered the field with great enthusiasm, obviously enjoying the challenge of vetting purchases himself, and made his first acquisitions in bulk from the Parisian dealer Ludovico (or Louis) de Spiridon in 1903, but they proved disappointing. A year later, after meeting the American art historian Bernhard Berenson (fig. 2), Johnson became convinced of the need for expertise; soon he was collecting scholars. In addition to his relationship with Berenson, he developed professional ties with the art critic Roger Fry as well as other established dealers and connoisseurs of Italian painting, such as Osvald Sirén, Langton Douglas, F. Mason Perkins, and Herbert Horne.

Johnson's formation as a collector merits note. An interest in art would have been encouraged as early as his secondary school days at Central High, from which several other future collectors, including William Lukens Elkins, Charles Tyson Yerkes, and Peter A. B. Widener (fig. 3), also graduated.[2] A municipal school in Philadelphia with an entrance exam, Central High guaranteed boys of modest circumstances—such as Johnson (his father was a blacksmith)—opportunities then only afforded to college graduates. Students were required to master draftsmanship in art classes that met for four hours weekly.[3] Probably at school, Johnson became good friends with Widener. After establishing themselves as leading citizens of Philadelphia, Johnson as a lawyer[4] and Widener as a financier, the two men traveled to Europe together annually on buying sprees. At the start their collecting patterns ran along the same lines: first with modern pictures, then tentatively foraging in the realm of old masters, especially Dutch seventeenth-century landscape and genre paintings. They both soon branched out into other fields, and it was Johnson's more modest resources that probably dictated his interest in the then relatively economical field of early Italian paintings.

Although Johnson earned a fine living, making as much as $100,000 in 1880, he was not in the same league financially as the really big American collectors. Sometime in the 1910s, when he dined at the

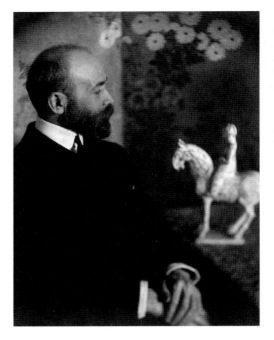

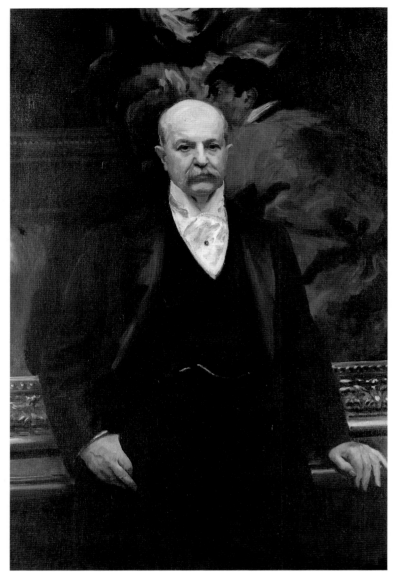

FIG. 2 (*left*) Sarah Choate Sears (American, 1858–1935). *Bernhard Berenson*, 1903. Boston, Isabella Stewart Gardner Museum, Archives

FIG. 3 (*right*) John Singer Sargent (American, 1856–1925). *Peter A. B. Widener*, 1905. Oil on canvas, 50 × 40″ (127 × 101.6 cm). Private collection

mansion of steel magnate and collector Henry Clay Frick in New York, he jokingly wrote to Berenson about how the "squillionaires" lived.[5] The luxury and refinement of homes like Frick's were in direct contrast to the disorganized atmosphere of Johnson's house (fig. 4), where the walls could not contain the overflow of paintings. During a visit to Philadelphia in the early 1900s the Swedish painter Fritz Thaulow "was amused at the intrusion of Mr. Johnson's pictures into his toilet, his row of shoes, his clothes presses and hooks, his bed, his bath."[6]

In his early days of collecting Johnson would not have had many opportunities to see Italian art in Philadelphia. Although a smattering of works by such seventeenth- and eighteenth-century Italian artists as Salvatore Rosa, Giovanni Paolo Pannini, and Andrea Locatelli could be viewed, there were no Italian paintings from the fourteenth and fifteenth centuries in any of the city's public collections.[7] Johnson's first serious contact with Italian culture probably occurred at the 1876 Centennial Exhibition held at Memorial Hall in Fairmount Park, the Museum's former location. The Italian section (fig. 5) boasted 518 works of art and included a tapestry lent by Pope Pius IX, mosaics, and some significant modern paintings by Amos Cassioli (fig. 6), Giovanni Fattori, and Telemaco Signorini. There was, however, little display of older art.[8] Only one dealer, a certain Giuseppe Abati from Bergamo, sent paintings ambitiously attributed to Francesco Bassano, Vincenzo Catena, and Giorgione.[9] But his objects were listed much like the olive oil and wine at the fair that came from Brolio, the Tuscan castle of the Italian prime minister Bettino Ricasoli. While Johnson does not seem to have bought any works of art at the exhibition, he began to build an art history library. The French publisher Goupil had a stand of its own in Memorial Hall, and Johnson purchased Charles Blanc's fourteen-

volume *Histoire des peintres*, which was highly touted as an important art history manual.

By 1892 Johnson had collected enough art to print a catalogue of his collection, but at that point one would have been hard pressed to predict his future as a collector of Italian masters. There were few older pictures in his holdings; of the Italians he owned an unidentified Madonna and some Venetian views, none of which were very good. Furthermore, Johnson's personal relationship with Italy was limited to a few visits. Although a dedicated traveler, he more willingly roamed Amsterdam, Berlin, London, and Paris, or spent August in Saint-Moritz rather than cross the Alps with a copy of Crowe and Cavalcaselle's standard histories of Italian art. In the summer of 1909, after already establishing himself as a collector of Italian paintings, he made a brief tour of northern Italy, with Herbert Horne as his guide in Florence. Back in the cool air of Switzerland, Johnson wrote Berenson a few disappointingly

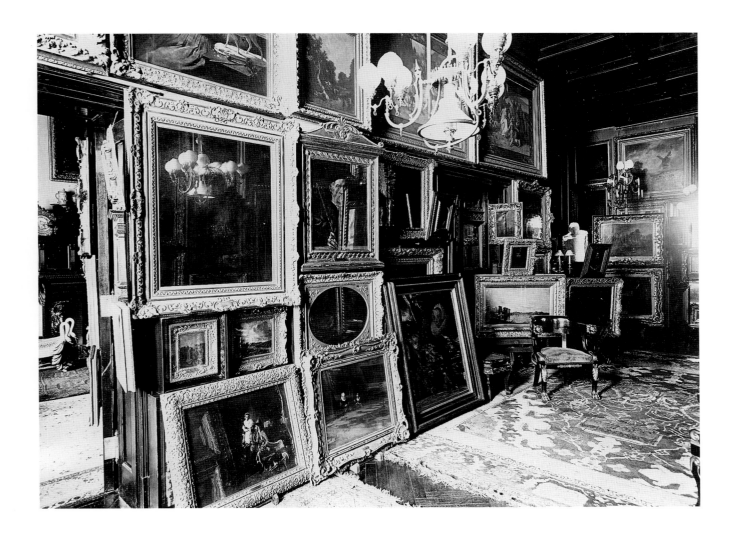

FIG. 4 (*above*) Frederick Gutekunst (American, 1831–1917). John G. Johnson's parlor, c. 1884. Philadelphia Museum of Art, John G. Johnson Collection Archives

FIG. 5 (*right*) The Art Annex, Memorial Hall, Centennial Exhibition, Philadelphia, 1876. Centennial Photographic Co. Print and Picture Collection, The Free Library of Philadelphia

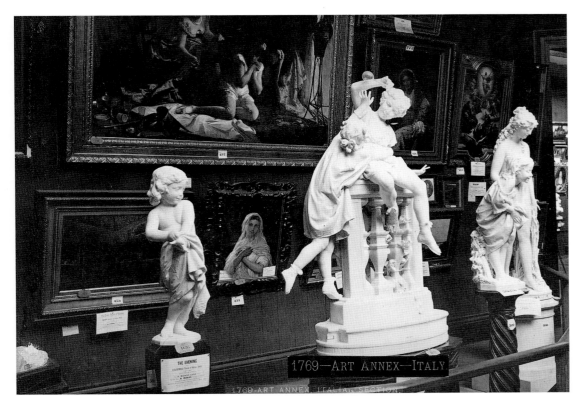

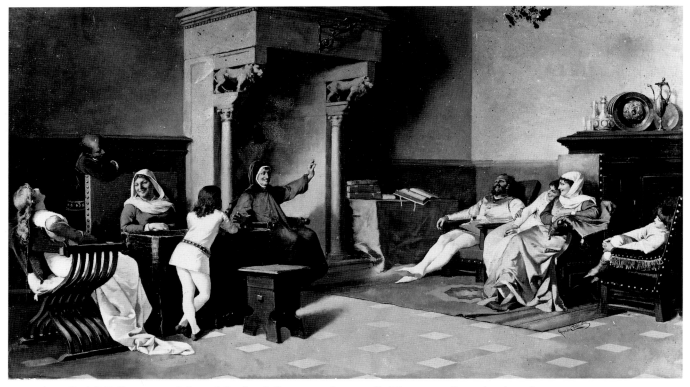

FIG. 6 Amos Cassioli (Italian, 1832–1891). *Boccaccio Reading the Decammeron*, late 1860s(?). Oil on canvas. Present location unknown

general but enthusiastic comments about the trip: "I had no conception of what Italian Art is; of the God-like altitude many Painters reached. What has gotten into other countries saving 3 or 4 museums are but drippings. I am beyond all form of expression—delighted at what I was able to see . . . Giotto, Simone Martini, Masaccio, Correggio, Mantegna, [Piero della] Francesca, Botticelli, Bellini, Lippi, Titian, Tintoretto, Carpaccio, Cimabue, Angelico etc. etc, I found infinitely greater than I had known."[10]

Johnson must have visited Italy at least twice before his trip in 1909, because a youthful photograph of him from about 1875 was taken in Venice by the professional photographer Antonio Sorgato (fig. 7). There is also a marked copy (fig. 8) of his catalogue of the 1884 Turin international exposition, in which he assiduously noted the pictures by contemporary Italian artists he liked as well as those purchased by galleries in Turin and Rome and by the king of Italy. He seemed most interested in modern artists who are hardly remembered today: Angelo Dall'Oca Bianca, Pietro Morgari, Carlo Pittara, Gian Battista Quadrone, Rubens Santoro, and Giuseppe Zannoni.[11] By the early 1890s Johnson's taste in modern Italian art had become more sophisticated. In 1891, at the international contemporary art exhibition in Berlin, he purchased Francesco Paolo Michetti's *Serenade* (fig. 9), which he discussed in an article sent to a Philadelphia newspaper: "It is so rendered the clear atmosphere, the blue water, the sunshine and the cloudless sky of Italy, that we forgot we were in prosaic Berlin."[12] But in the same piece, he singled out for harsh criticism the Symbolist Giovanni Segantini, now considered one of the most interesting Italian artists of the period.

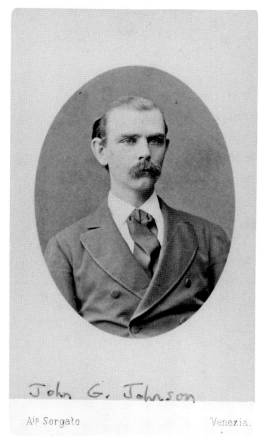

FIG. 7 Antonio Sorgato (Italian, active nineteenth century). *John G. Johnson*, c. 1875. Philadelphia Museum of Art, John G. Johnson Collection Archives

FIG. 8 Official catalogue of the 1884 *Esposizione generale italiana* of Turin, marked in John G. Johnson's hand. Philadelphia Museum of Art, John G. Johnson Collection Library

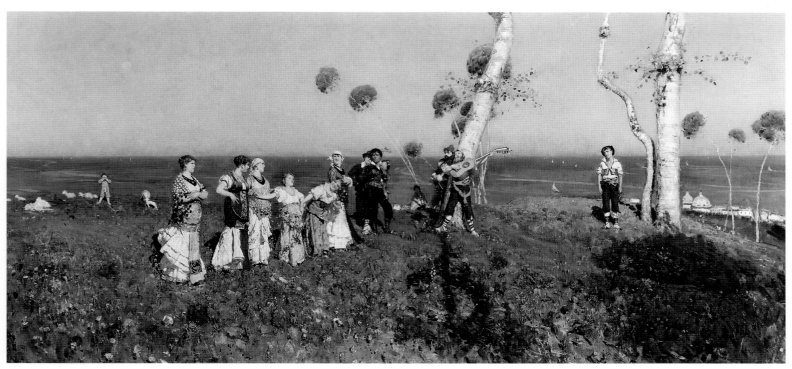

FIG. 9 Francesco Paolo Michetti (Italian, 1852–1924). *Serenade*, 1878. Oil on canvas, 40 × 87″ (101.6 × 221 cm). Private collection

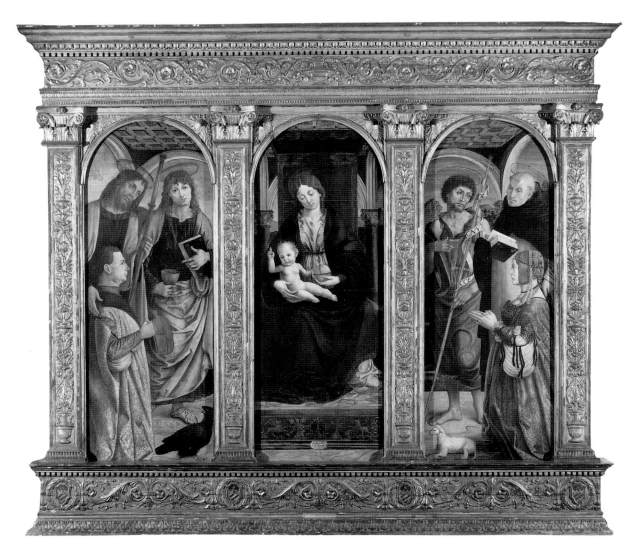

FIG. 10 Macrino d'Alba
(Italian, active by 1495; died 1528).
Altarpiece: *Virgin and Child
Enthroned with Saints and Donors*,
1494. Oil on panel, 79⅛ × 89⅜″
(201 × 227 cm). Turin, Museo
Civico, inv. 42

By the end of the nineteenth century, wealthy American collectors had become increasingly interested in early Italian pictures. It was only at that time that James Jackson Jarves's remarkable collection of such art, property of Yale University since 1872, began to receive any attention (Johnson himself owned the 1879 edition of Jarves's manual for American collectors, entitled *Art Hints*). In 1895 William Rankin, an American art critic who knew Johnson and wrote about his collection, published an article on the Jarves pictures in the *American Archaeological Review,* and in 1896 Bernhard Berenson did the same in the *Gazette des beaux-arts.* The same year marked the publication of Berenson's influential *Florentine Painters of the Renaissance with an Index to Their Works,* the first comprehensive study of the subject in English, which would be followed by volumes on the other Italian schools. Jarves's collection and Berenson's article and book must have taken root in Johnson's mind. He developed an interest in the primitives. The problem was where and how to buy them.

Some of Johnson's first purchases of early Italian paintings were for the Philadelphia Museum of Art. While serving on a committee that managed funds bequeathed by Anna Wilstach for the purchase of works of art, Johnson oversaw the acquisition of two large Italian altarpieces, one by Vittore Crivelli[13] and the other by Macrino d'Alba (fig. 10),[14] acquired in 1896 and 1900, respectively. Over the next few years the line between his purchases for the Wilstach Collection and for himself blurred. For some he relied on Ludovico de Spiridon, who had come to Philadelphia to help install the Wilstach Collection as well as to restore and frame paintings.[15] In the summer of 1903 Spiridon returned to Rome to purchase a single large collection that he knew about through his family. Johnson reserved twenty-one paintings for himself and had seventy-nine sent to the Museum. Unfortunately, Spiridon's list and set of photographs do not survive, and only a few of the pictures, such as a portrait by Moretto da Brescia (fig. 11), are still in the collection today. Many of the attributions were questionable, and there seemed to be many copies, leading Johnson to scold Spiridon: "Purchasing pictures for a Public Gallery exposes those who purchase them, as I wrote you, to attacks from every side. The discovery of the fact that a painting was a copy, not an original, would inflict mortification which nothing on earth could atone for."[16]

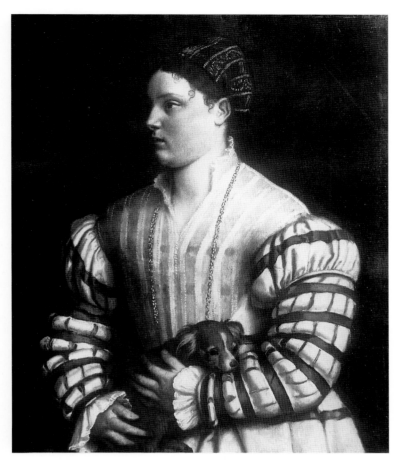

FIG. 11 Moretto da Brescia (Italian, c. 1498–1554). *Portrait of a Lady,* c. 1530. Oil on canvas, 33½ × 27⅛″ (82.6 × 68.9 cm). Philadelphia Museum of Art, John G. Johnson Collection, cat. 1172

Johnson enjoyed doing research on his acquisitions; his art library abounded in old sales catalogues, and he often questioned Spiridon on provenance. In the same 1903 letter he wrote: "You might make some little inquiry about the Poussin. I am sure it could not have been in the Fesch sale." Concerning a work supposedly by Leonardo da Vinci,[17] which Johnson attributed to Sodoma, he wrote lengthy letters about various versions of the composition and the preparatory drawings, citing scholarship by such art historians as Giovanni Morelli, Jean Paul Richter, and J. A. Crowe.[18] About another picture he wrote: "I am surprised to hear you suggest that no. 6, the *Pilgrims at Table,* stated to be of the 'Venetian School' is by Carlo Crivelli. To my mind it carries with it no characteristics of that artist. He is freer in line, softer and warmer, than the great but angular work of Crivelli. To my mind no. 6 is by a pupil of Bellini."[19] Seven days later Spiridon responded that it was by Marco Marziale, indeed a follower of Giovanni Bellini.

In early 1904 Bernhard and Mary Berenson—who were in Philadelphia to see Mary's cousin Carey Thomas, president of Bryn Mawr College—visited Johnson. Afterward Mary wrote to their friend the Boston collector Isabella Stewart Gardner describing the place:

> We have seen Mr. Johnson's pictures, and B.B. lunches there today. We found only three forgeries, an unusually small proportion. He has some good things though no masterpieces . . . Most of his Italian pictures, though, are badly repainted. . . . The perfectly awful thing is the way his pictures are placed—all over the walls and doors, on easels and morningstands, you can hardly move about. I needn't tell *you* how fatal this is for works of art!
>
> The naming of his pictures is very funny, as if it were done by someone who meant to lead you off the track and mix you up completely by the use of that much misleading of cues, the à peu près . . . but we can't tell who has been Mr. Johnson's blind guide. Whoever he is, he has done better for Mr. Johnson than we expected, but not *well,* oh not at all well considering what he *might* have done![20]

Berenson requested photographs from Johnson: "I am much obliged to you for the photographs that you send me. But I beg for more, more & more . . . in fact photographs of anything I can get hold of."[21] Their first letters show that the collection already possessed some notable works, including Paolo Veronese's *Diana and Actaeon,*[22] Vittore Carpaccio's *Metamorphosis of Alcyone,*[23] Antonello da Messina's *Portrait of a Man,*[24] Crivelli's *Pietà,*[25] Zanobi Strozzi's *Annunciation* (plate 77 [JC cat. 22]), and Fra Angelico's *Dormition of the Virgin* (plate 7 [JC cat. 15]). But Berenson also told Johnson that "there are always a certain number of pictures that won't go into the witness-box to be cross-examined."[26] After settling in Saint-Moritz for the summer, the critic sent a long letter that was nothing less than a corrigendum of the collection's labels, and he could be quite brutal in his assessments: "'Perugino.' Madonna, child, Jerome & Baptist. Not Perugino, but Umbrian whom I know. I dare say when I return to Florence I can tell you his name. He is quite *third rate.* 'Macrino d'Alba.' Madonna & Child with infant John. Almost certainly not work by that master, & rather dubious looking. 'Botticelli' Madonna & child. Never in the world. Landscape suggests Sellajo."[27] After this initial meeting Johnson continued to privilege the opinion of Berenson, but he did not depend on him exclusively.

The idea that Berenson would catalogue Johnson's pictures developed soon after the two men met, possibly as early as 1904. Berenson mentioned the project in 1908, when he stated that he particularly liked the fact that Johnson's holding was a "representative historical collection."[28] The plan gave a certain urgency to Johnson's acquisitions; many of his most important Italian paintings were purchased after 1908. Pesellino's *Virgin and Child Enthroned with Saints Jerome and John the Baptist* (plate 65 [JC cat. 35]) was bought as late as April 1913 and duly catalogued by Berenson for the book that came out later that year.

After the acquisition of a new work, Berenson would vet a photograph of it and give Johnson his opinion, which often differed from that

of the seller. One of Johnson's sources for pictures was the English dealer and scholar Langton Douglas, who wrote a still-useful book on the history and art of Siena. In 1908 Douglas sold Johnson the *Virgin and Child Enthroned and Donor* (plate 39A [JC cat. 91]) as a work by Ambrogio Lorenzetti. But Berenson, through his wife, Mary, assured Johnson that it was not by Ambrogio but by his brother Pietro, whose work was then deemed less valuable. In that same year Berenson and Johnson's friendship underwent a serious testing over the attribution of a predella said to be by Sandro Botticelli. Johnson had purchased the work from Herbert Horne, and Berenson contested Horne's attribution, believing the painting to be by another painter he called "Amico di Sandro," later identified as Filippino Lippi.[29] In another case, Berenson wrote to tell Johnson that he had misunderstood Osvald Sirén's ascription of the predella panel, now given to Agnolo Gaddi, as by Giotto. Sirén had said Giottino, but Berenson disputed even that attribution, saying the work was painted at least fifty years after the artist was active.

Berenson also recommended pictures to Johnson, sometimes stating his own financial interest. For example, in 1909 he wrote to Johnson from Paris that the dealer Kleinberger, in an effort to get Berenson's business, was willing to reduce the price of two Sienese predella panels showing the *Marriage of the Virgin* and the *Virgin Returning to the House of Her Parents*, now attributed to Giovanni di Pietro (plates 34A–B [JC cats. 107–8]). He further enticed Johnson by mentioning that the Louvre was interested in buying them. Berenson also secured for him the *Purification of the Virgin* by Benozzo Gozzoli (plate 36 [JC cat. 38]). It had been offered to him by the dealer Otto Gutekunst, whom the critic described as "a much less rapacious animal than my more recent dealer acquaintances."[30]

In his recommendations, Berenson satisfied Johnson's interest in small pictures, particularly narrative scenes (usually predella panels). He frequently commented on the jewellike qualities of a picture. About the predella panels by Giovanni di Pietro, Berenson said that he "never saw in their kind more delicious feeling, & more gorgeous jewel-like colouring."[31] In offering a Sienese diptych, now attributed to Benedetto di Bindo, Berenson wrote: "The third picture is one I am very much in love with. It is a little Sienese diptych representing the Madonna on one wing & St. Jerome on the other. The back shows a good deal of its original painting. Of that too I send a photograph. The painter is unknown to me, but it is very close to Bartolo di Fredi. It is one of those delicious Sienese 14th century things which are even more *bibelots* than pictures."[32]

Berenson appealed to Johnson's scholarly interests and was not adverse to presenting pictures that he was still trying to attribute. Berenson was perplexed by Paolo Schiavo's predella panels. He recognized them to be stylistically close to Fra Angelico, but he did not know the painter. He wrote: "I am hot on his traces and hope to be able to make him give up his name."[33] Johnson enjoyed this scholarly pursuit. His interest in pictures was almost totally that of a connoisseur who wished to know the artist or to discover the underlying aesthetic values of a work of art. One of the few comments Johnson wrote about a

painting concerned Fra Angelico's *Saint Francis of Assisi* (plate 8 [JC cat. 14]): "The Angelico is a most vital figure, intense and most attractive. I had no idea that Fra Angelico could put so much power into his expression."[34] Alternatively, Johnson had little patience for iconography, which he seems to have thought a rather childish pursuit. Writing to E. A. Shunk, the secretary of Memorial Hall, Johnson disparaged her need to identify the saints in the altarpiece by Macrino d'Alba (see fig. 10): "To me the attribution to the mythical Saints is absolutely meaningless and without interest."[35]

Even after Berenson's catalogue came out in late 1913, Johnson continued to buy more paintings. Two of his most important acquisitions were made after that date: Masaccio and Masolino's *Saints Paul and Peter* and *Saints John the Evangelist(?) and Martin of Tours* (plates 44A–B [JC invs. 408–9]) and Vitale da Bologna's *Crucifixion* (plate 85 [JC cat. 1164]. The problem of the attribution of the Masolino panels fascinated Berenson. He had trouble believing that the pictures were by that master:

> Well, I wish I could be as nearly sure of Hughes' election as I can that Sirén is nearly right in attributing them to Masolino. They obviously and conspicuously are worthy of him and very close to him. . . . In the photos I find certain things which I do not recall elsewhere in Masolino. That may prove all the more interesting if the panels turn out to be his. They would reveal him in a relatively new phase and thereby advance our knowledge of the master. . . . After all whether actually Masolino or not makes no great difference, for these pictures are immensely interesting and very impressive and if not by Masolino they must be by another painter his equal whom we must place as high and study as lovingly.[36]

The war soon preempted the art talk in Johnson's letters, and it also separated him from Europe and his sources for pictures. He had one last disastrous trip in 1915 during which travel proved cumbersome and difficult. In Paris the Ritz Hotel, his habitual haunt, was uncomfortable, and he could not get into the overcrowded Ritz in London. The next summer he had to take an American holiday, spending part of it in Bar Harbor, Maine.

During his last years Johnson planned what would become of his collection. In his will of 1914 he bequeathed it to the people of Philadelphia with the obligation that the city construct a gallery. However, in February 1917 Johnson changed his mind and wrote a codicil asking the city to maintain it in his own home on South Broad Street. After Johnson died in April of that year and the paintings became the property of the city, an exhibition was planned to show part of the collection to the public, with the Italian paintings meriting special prominence. From March 10 to June 6, 1920, the Museum (then called the Pennsylvania Museum) exhibited sixty-two fourteenth- and fifteenth-century Italian works at Memorial Hall. The exhibition drew 137,852 visitors, and an accompanying catalogue was published to commemorate the event.[37]

During that exhibition, the city began plans to build a separate museum for the Johnson Collection. The architect Horace Trumbauer

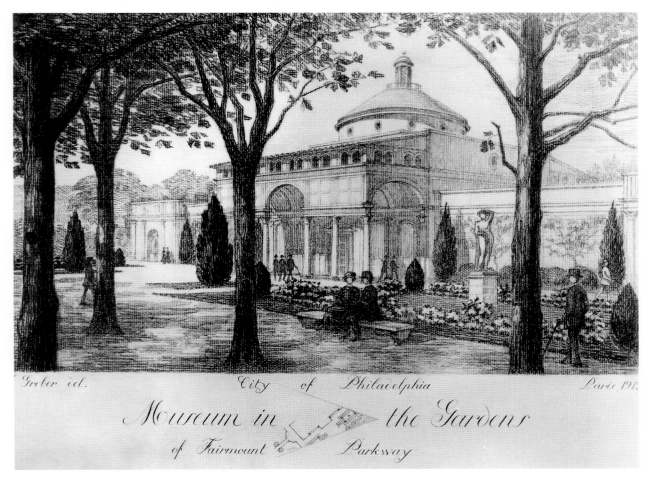

proposed a design with a façade based on Filippo Brunelleschi's Pazzi chapel in Florence (fig. 12).[38] However, that project soon fizzled, and, as Johnson's will had directed, his home was opened as a gallery in 1923. Restrictions of space meant that the collection had to be rotated; thus, the Italian paintings were not always on view.

Johnson's house proved impractical as a public space, but the Museum's new building on the Benjamin Franklin Parkway was soon ready to open its doors. Hamilton Bell (fig. 13),[39] the first curator of the Johnson Collection, concurrently held the position of assistant director of the Museum. Consequently, a number of Johnson's Italian works (fig. 14) were included in the Museum's Inaugural Exhibition, which opened in March of 1928. Many more Italian and Netherlandish pictures from the Johnson Collection went on view in 1931, when the Museum opened the medieval period rooms and galleries, brilliantly installed by director Fiske Kimball, who combined historical architectural settings with works of art (fig. 15). A complementary exhibition, organized by the pioneering museum educator Philip N. Yourtz, was held in December of that year at the Museum's Sixty-ninth Street branch (fig. 16). Yourtz, a master at mounting unusual and challenging exhibitions, wrote to Henri Marceau (Bell's successor as Johnson curator) that it was the branch's most successful show to date.[40] Finally, in 1933, after Johnson's house was deemed unsafe, the entire collection

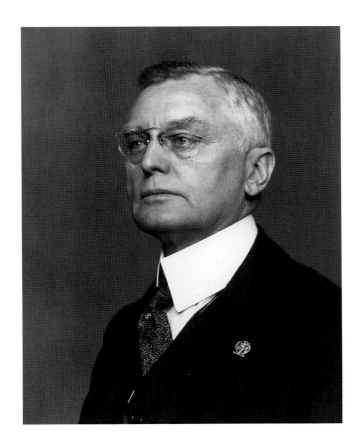

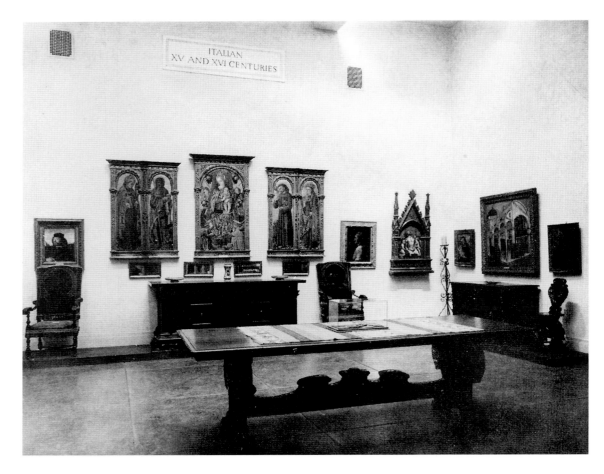

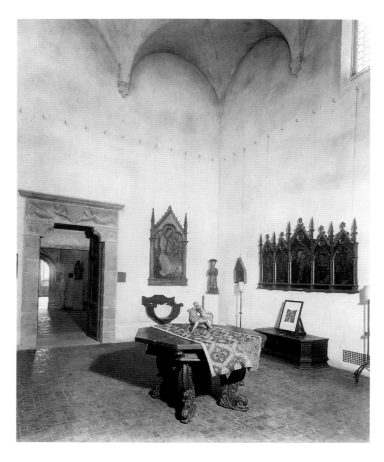

was transferred to the Museum's building on Fairmount. But even there, the various schools of painting had to be rotated. Two hundred and nineteen paintings constituted the first group of Johnson pictures to be shown en bloc, and as in the 1920 exhibition at Memorial Hall, the Italian works were accorded prominence. A two-volume picture book was published in conjunction with the show.

In 1939 the Johnson Collection was assigned separate spaces in the Museum, and in 1941 all of the pictures were reinstalled. The galleries were again rearranged in 1976. The most recent reinstallation of the early European paintings of the collection occurred in 1993 (fig. 17), when they were brought into the galleries adjacent to the medieval and early Renaissance period rooms, much as Fiske Kimball had envisioned the collection when he put together these very same spaces in 1931. Johnson's desire that the collection remain intact and Berenson's wish that it be an art-historical survey were finally both fulfilled.

Catalogues

Bernhard Berenson's catalogue of the Italian paintings in the Johnson Collection was published in 1913. During the nineteenth and early twentieth centuries experts had often authored sales catalogues of individual collections, but this was the first professional catalogue of a collection that was not intended as a commercial promotion. Berenson's entries

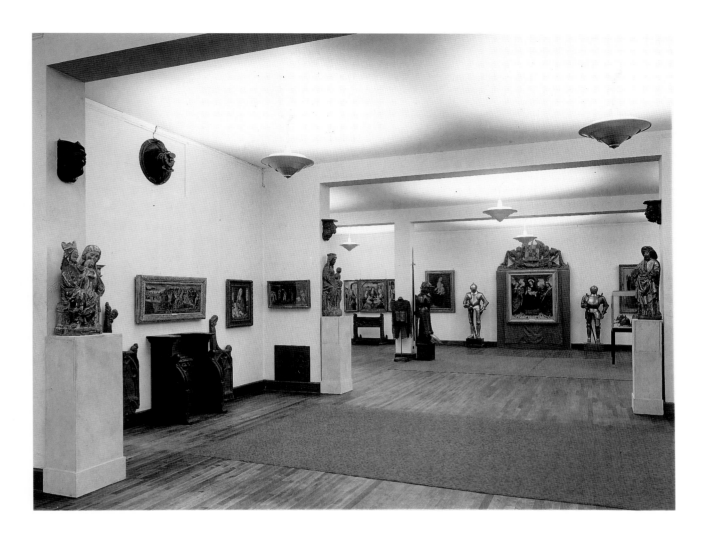

FIG. 16 Installation of *Religious Art of Gothic and Renaissance Europe* at the Sixty-ninth Street branch of the Philadelphia Museum of Art, 1931

FIG. 17 Installation of the Johnson Galleries showing Masaccio and Masolino's *Saints Paul and Peter* (see plate 44A [JC cat. 408]), as installed in 1993

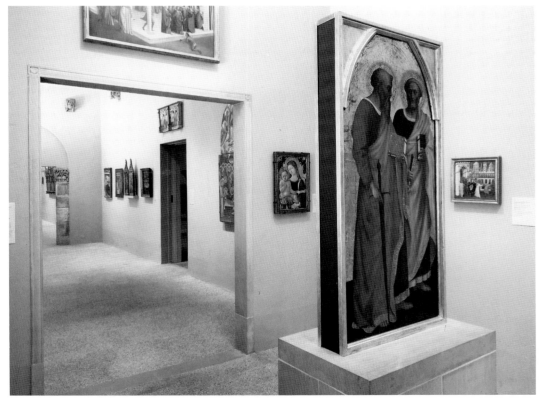

not only described the pictures but also became statements of his methods in determining attributions. The Johnson catalogue spawned imitators, and shortly after its publication Berenson contributed to a much more summary catalogue of Philadelphia's other important collection, belonging to Peter A. B. Widener. In 1916 a catalogue by Osvald Sirén documenting the Jarves Collection at Yale University appeared, and in 1919 the Fogg Art Museum at Harvard University issued an exemplary catalogue of their medieval and Renaissance paintings.[41]

In 1926 and 1927 Richard Offner gave a series of seminars about the Johnson Collection at Johnson's house. His lectures were essentially critiques of Berenson's catalogue, but Offner never prepared his own book about the collection. The lectures sound as if they were similar to Offner's near-contemporaneous volume about the Jarves Collection, which was essentially a rereading of Sirén's earlier catalogue. Although the texts of the Johnson talks do not survive, Daphne M. Hoffman, a reference worker for the Frick Art Reference Library in New York, took notes that are preserved there. Offner also annotated some of the photographs of the Johnson Collection that the Frick library owns. In 1929 director Fiske Kimball appointed Offner as the Museum's adviser for Italian art.[42] In this capacity he reviewed all the attributions of the Johnson paintings that were displayed at the Museum's 1928 Inaugural Exhibition.[43]

In 1941 Henri Marceau, Bell's successor as curator of the Johnson Collection, and Barbara Sweeny, the collection's secretary since the late 1920s, issued a summary catalogue of the holding. This publication included some of the pictures that had not appeared in Berenson's 1913 volume and also offered some new attributions. Many of the modifications reflected Berenson's own rethinking and mirrored the opinions he published in a series of articles titled "Homeless Pictures" in *International Studio* and *Dedalo*, as well as his book of lists, *Italian Pictures of the Renaissance*, issued in 1932 by Claredon Press at Oxford.

In the following years Sweeny maintained the files on the collection. While she kept up with the bibliography, some of the most judicious opinions to appear in her own 1966 catalogue of the Italian pictures came out of her correspondence with scholars around the world. Evelyn Sanberg-Vavalà and Federico Zeri were the most important of her contacts. She also had a soft spot for anything that Ellis Waterhouse told her, and he was helpful in tracking down provenances.

In 1994 a summary catalogue of the paintings in the Philadelphia Museum of Art illustrated each picture for the first time and also reflected current opinion about the attributions.

Loans

The first time that any of the Johnson Collection's paintings were sent outside of Philadelphia was in 1930 when Sandro Botticelli's predella showing the legend of Saint Mary Magdalene[44] traveled to the grand exhibition of Italian art held at the Burlington House in London. The show carried considerable prestige because the Fascist government of Italy had loaned some of the country's greatest artistic treasures.[45] In Philadelphia the occasion was deemed so noteworthy that Roger Fry's enthusiastic description of the painting in a review of the show was reprinted in the Museum's *Bulletin*.[46] As a result, more Italian paintings from the Johnson Collection appeared in other loan exhibitions. In 1935 a group was sent to Paris to take part in the ambitiously titled *De Cimabue à Tiepolo*—another exhibition staged by Benito Mussolini's government as a celebration of Italian artistic genius. These loans included the panels from Masaccio and Masolino's Santa Maria Maggiore altarpiece (plates 44A–B [JC invs. 408–9]) and Domenico di Bartolo's *Virgin and Child* (plate 21 [JC cat. 102]). In 1939 the Johnson Collection loaned to the two art exhibitions that were part of the San Francisco World's Fair. While there were other loans in the early years of the collection, none can match the élan of including Giovanni di Paolo's *Saint Nicholas of Tolentino Saving a Shipwreck* (plate 33 [JC inv. 723]) in the 1936 show *Fantastic Art, Dada, Surrealism* (fig. 18) at the Museum of Modern Art, New York.

Since the Second World War, early Italian works have been lent far less frequently, owing to their fragile wood panels. However, a few pictures were sent to two separate exhibitions of Sienese and Florentine Renaissance art held at the Metropolitan Museum of Art, New York, in 1988 and 1994. The Johnson pictures were essential for the reconstructions of two predellas—the first by the Master of Osservanza and the second by Fra Angelico—each of which had long been dispersed in collections around the world. In 2002 Benozzo Gozzoli's *Purification of the Virgin* (plate 36 [JC cat. 38]) went to an exhibition about the artist in Montefalco, Italy, where it was reunited with other sections of the predella. And in 2003–4 Duccio's *Angel* (plate 23 [JC cat. 88]) went to the monographic exhibition of Duccio in Siena, where it was displayed with the panels of the artist's *Maestà*, from which the Johnson work most likely originated. The most-traveled picture is Francesco d'Antonio's *Christ Healing a Lunatic and Judas Receiving Thirty Pieces of Silver* (plate 24 [JC cat. 17]), a painting not on panel but on its original linen support. In 1987 it appeared in an exhibition about Western pictorial space held at the National Museum of Western Art in Tokyo. In 1990 it went to Florence for an exhibition about Masaccio, and then in 1994 and 1995 it was shown at exhibitions about Renaissance architecture held in Venice and Washington, D.C.

Conservation

John G. Johnson was not careful about investigating the condition of paintings before purchasing them. Although he was aware that many of the early Italian works were fragments of altarpieces and other larger complexes, early picture dealers often sought to disguise this by making panels conform to a false rectangular format. The collection's most dramatic example of this practice is Fra Angelico's *Saint Francis of Assisi* (plate 8 [JC cat. 14]), which was transformed from a silhouetted panel to an easel painting by adding a background. Unusual shapes were not

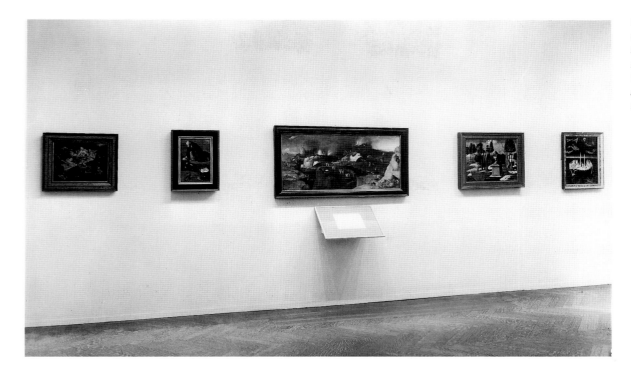

appreciated during Johnson's time; for example, the trefoil forms of the panels by Lorenzo Veneziano and attributed to Martino da Verona were masked to make them appear rectangular, and the gold borders of small predella panels by Fra Angelico (plate 7 [JC cat. 15]), Neri di Bicci (plates 60A–F [JC cats. 28–33]), and the Master of the Castello Nativity (plates 47A–B [JC cats. 24–25]) were painted over to make them appear to be regularly shaped objects. Even large works did not escape such alterations. The well-preserved gilded backgrounds of Masaccio and Masolino's *Saints Paul and Peter* (plate 44A [JC inv. 408]) and *Saints John the Evangelist(?) and Martin of Tours* (plate 44B [JC inv. 409]) were regilded sometime before 1760, making the panels shine but also hiding the arched tops and any bare wood that was revealed when the engaged frame was removed.

Sometimes early restorations were much more apparent, but they were still considered an acceptable consequence of centuries of age. Johnson could not have been deluded about the state of Pietro Lorenzetti's *Virgin and Child Enthroned and Donor* (plate 39A [JC cat. 91]), which in the lower half had a large area of loss that had been filled and repainted. In 1912 Mason Perkins wrote that the picture had been badly restored, but it is not clear whether the treatment happened before Johnson bought it in 1910 or after. The former is more likely, since Perkins had known the picture in Siena, where a veritable industry of restorers and falsifiers thrived.

In 1904 Bernhard Berenson identified only three fakes in the Johnson Collection.[47] These were weeded out before the publication of the 1913 catalogue, but he and Johnson did not recognize some deceptive repainting in two others. The fraudulent restoration of a modest little *Nativity* (plate 93 [JC cat. 16]) by a Marchigian artist of

the early 1400s made it look like a more expensive work by a follower of Fra Angelico, stumping both Berenson and Offner when they tried to discover the artist. In addition, the *Crucifixion* (plate 89 [JC cat. 93]) long maintained an attribution to the great trecento painter Barna da Siena in Berenson's catalogue, even though it was badly damaged and overpainted.

During the present cataloguing some instances of very early restorations have been observed. The faces of the figures in Niccolò di Pietro Gerini's *Christ in the Tomb and the Virgin* (plate 27 [JC cat. 8]) were cleverly restored in the early sixteenth century, while around the same time the Florentine trecento *Crucifixion* (plate 90 [PMA F1938-1-51]) was also completely repainted. Some damaged areas in Martino di Bartolomeo's predella (plates 43A–D [PMA 1945-25-120a–d]) were restored in the seventeenth century. And in the early 1800s the Anglo-Florentine painter and collector Ignazio Hugford reconstructed the top part of Fra Angelico's *Dormition of the Virgin* (plate 7 [JC cat. 15]).

Johnson made only a few isolated comments on the subject of restoration. He was quite adamant that it might ruin modern pictures, and he was also reluctant to restore older works.[48] In 1912 Johnson wrote that Fra Angelico's *Saint Francis of Assisi* was "a little dirty, and the color, in its subtlety would be more apparent with a little cleaning, but I do not dare to have it touched."[49] He is said to have liked the paintings to look old, then a common sentiment.[50] However, despite hesitations, he did send pictures out for treatment, and the *Saint Francis* did not escape "a little cleaning."

In the early years of the century Johnson favored Ludovico de Spiridon as a restorer, but Johnson also had Roger Fry treat some pictures. Fry was briefly the curator of paintings at the Metropolitan

Museum of Art and one of Johnson's good friends. The most famous of Fry's restorations for Johnson were Jan van Eyck's *Stigmatization of Saint Francis*[51] and Giovanni Bellini's *Virgin and Child*.[52] Johnson also noted that Fry restored some of his other Italian pictures "skillfully and very successfully"; one of these was the Sano di Pietro (plate 73 [JC cat. 106]).[53]

Spiridon and Fry could not be relied on as full-time restorers. Around 1905 Pasquale Farina (fig. 20), an Italian immigrant to Philadelphia, won Johnson's favor with his restoration work. A graduate of the Accademia di Belle Arti in Naples, Farina founded his own female drawing academy in Tucuman, Argentina, before coming to North America to work in Philadelphia. He later said that Johnson had employed him for fourteen years. Copies of bills exist from 1909 to 1916, but Farina probably started as early as 1905, succeeding Spiridon in the Wilstach Collection.[54] Although Farina wrote detailed descriptions of his treatments, including a lot of unreliable technical information, no report survives for any of his restorations of the early Italian pictures in the Johnson Collection, and only Fra Angelico's *Saint Francis of Assisi* and Apollonio di Giovanni and Marco del Buono's *Virgin and Child Enthroned with Saint Benedict and a Bishop Saint* (plate 10 [JC cat. 26]) can be documented. However, he did write a report about the altarpiece by Neri di Bicci (plate 57 [PMA 1899-1108]). Compared to other conservation records of the period, this is a comprehensive examination of the picture's condition before treatment began.

Farina was later quoted as supporting the establishment of a scientific art laboratory in the United States similar to the center being set up at the Fogg Art Museum by director Edward W. Forbes. Farina, however, was firm that conservators should also be artists: "I think it will be possible to train an artist, not a layman, but an artist."[55] This remark was probably directed at the administrations of both the Museum and the Johnson Collection. It was Hamilton Bell who, as acting director of the Philadelphia Museum of Art from December 1917 to January 1919, had hired Farina to treat the Neri di Bicci. But in 1920, when Bell became curator of the Johnson Collection, he no longer employed Farina. Complaints about Farina seem to have been brewing; his flamboyant personality, while amusing to Johnson, certainly did not bode well with institutional art administrators like Bell and Eli Kirk Price, the Museum's president.[56] Embittered by his dismissal, over the next few years Farina instigated a flurry of unflattering articles in Philadelphia newspapers about the state of some of the Museum's pictures and restoration in general. He also wrote several books on conservation issues.[57]

Although Farina never names him, many of his more acerbic comments were directed toward Joseph Widener, a discerning collector who had inherited the holdings of his father, Peter A. B. Widener (see fig. 3). Joseph had been appointed to replace Johnson as president of the Wilstach Collection. He sent his own pictures to the New York dealer, Knoedler's, to be cleaned and framed, and soon he was doing the same with the works from the Wilstach Collection.

Widener tried to secure municipal funds for restoring the Johnson pictures.[58] He clashed with Mayor J. Hampton Moore over the

issue but ultimately won. In the summer of 1919 Bell surveyed all the paintings and made condition notes. According to the report submitted to the mayor, "many of the pictures were not in good condition when received by the City and required immediate care, repair and restoration."[59] A new conservator was appointed, Carel de Wild, who was, conveniently enough, the same man Widener used in New York. De Wild had come to the United States from Holland in 1911 as an employee of Knoedler's. He also worked privately for Henry Clay Frick. Although de Wild's studio was located at 753 Fifth Avenue in Manhattan, his work on the Johnson Collection was carried out in the Penn Mutual Insurance Company in Philadelphia. He worked on the paintings from 1919 to 1922 and received $2,800 a month for his labors, an astonishing sum for the time. By November 23, 1920, three hundred pictures had been restored and about two hundred more were thought to need restoration. Few notes exist about de Wild's work, but those that do mainly record the laying down of flaking paint and the cradling of cracked and warped panels.[60] De Wild's treatments were done in preparation for the exhibition of sixty-two Italian paintings at Memorial Hall in 1920 and the opening of Johnson's home as a public gallery in 1923. After his death in 1922,[61] a local restorer, T. H. Stevenson, was briefly employed to complete de Wild's survey of the collection.

During the 1930s not much restoration was done. Bell was succeeded as curator of the Johnson Collection by Henri Marceau (fig. 19), who held the position for forty-three years. Early on, Marceau sent a few panels to the conservator Herbert Thompson of the Museum of Fine Arts, Boston.[62] Marceau conscientiously stayed in Massachusetts to oversee Thompson's work. By that time conservation had become a matter of professional interest to connoisseurs and museum men like Marceau. The new scientific conservation laboratory at the Fogg Art Museum was the most concrete manifestation of this trend. In 1936, when two predella panels by Cenni di Francesco in the Johnson Collection needed restoration, they were sent to George Stout, the director of the laboratory.

Shortly afterward, probably on the recommendation of Stout, David Rosen (fig. 19) was hired to work on the Johnson Collection in preparation for a new installation scheduled to open in 1941. Rosen worked closely with Marceau to clean whole sections of the collection, as Carel de Wild had done. Rosen was on contract and did not spend a full year in Philadelphia. It is difficult to be dispassionate about his period of activity because of the number of paintings that suffered from his attentions. Under the perceived pressure of the 1941 deadline, dozens of old master paintings were cleaned in haste. Although there is little documentation or record photography, a comparison of the illustrations from the 1913 catalogue and the 1933 picture books issued in 1941, 1948, and 1953 chronicles the changed state of many pictures he is known to have treated.

Deeply suspicious of the motives and ethics of earlier restorers, Rosen felt that the principal threat to the aesthetic integrity of paintings was the distortion created by the varnishes and repaints added to

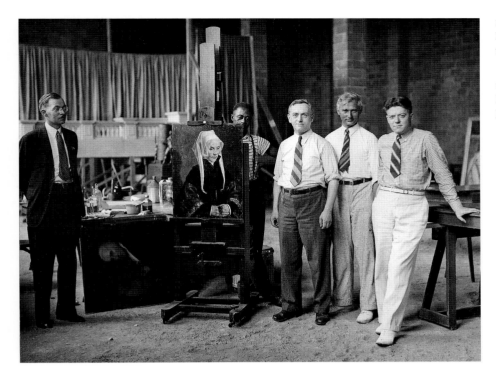

FIG. 19 (*left*) Philadelphia Museum of Art conservation laboratory, 1936. David Rosen is pictured third from the left; Henri Marceau is fifth from the left. The other men have not been identified.

FIG. 20 (*below*) Pasquale Farina in his studio on Arch Street in Philadelphia, early twentieth century. Philadelphia Museum of Art, John G. Johnson Collection Archives

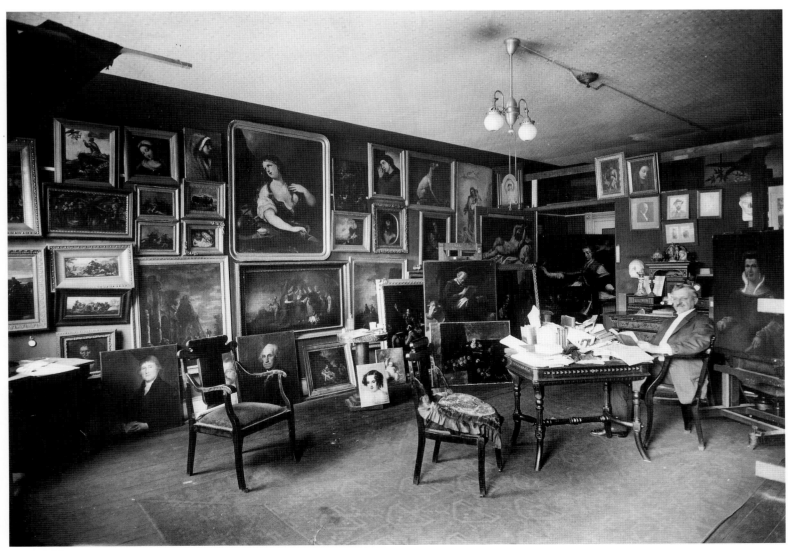

FIG. 21 David Rosen's metal cradle on the back of the Master of the Pomegranate's *Virgin and Child Enthroned* (plate 54 [JC cat. 36]), 1947

own versions of panel stabilization (often the complete immersion in molten wax) and restraint (the attachment of materials such as plywood or aluminum bars [fig. 21]).

Rosen was kept on a retainer at the Museum as technical adviser until 1955. In that year Theodor Siegl was hired as the Museum's conservator, a position he held until his death in 1976. He never undertook a comprehensive restoration of the Italian paintings. Although he cleaned a few panels, most of his work with the Italian pictures was restricted to maintenance and the setting down of flakes.

In 1978 Marigene H. Butler became the Museum's new chief conservator. She instituted modern standards of professionalism, not only in the treatment, documentation, and technical study of individual works of art but also in raising awareness of the need for preservation. The Museum's in-house capability for the analytical study and documentation of a painting's technique and condition increased throughout the 1980s and 1990s, and during this time conservation scientists Beth Price and Ken Sutherland joined the staff.

Mark Tucker, senior conservator of paintings, treated a sampling of individual Italian works by Cosmè Tura,[65] Agnolo Bronzino,[66] Paris Bordone,[67] Michele Marieschi,[68] Francesco Guardi,[69] and others, but it was not until 1987 that a whole group of related paintings was treated. The occasion was the Metropolitan Museum of Art's exhibition *Painting in Renaissance Siena, 1420–1500,* held in 1988–89. Conservators Suzanne Penn and Mark Aronson restored predella panels by the Master of Osservanza (plate 52 [JC inv. 1295]), Giovanni di Pietro (plates 34A–B [JC cats. 107–8]), and Giovanni di Paolo (plate 31 [JC cat. 105]). This treatment and the context of the exhibition prompted a rethinking of the fragmentary nature of so many of the early Italian panels in the collection. At the same time, it opened up a discussion of the ways the paintings might be presented so as to suggest more clearly their origin as interrelated objects.

In late 1989 the most significant reconsideration of the individual and collective appearance of the paintings in the Johnson Collection was occasioned by the Museum's plan to reinstall all of its European art from before 1900. The comprehensive project required removing large portions of the holdings from public view, affording an extraordinary opportunity to address the restoration of key works. Over time the collection had acquired an inconsistent appearance. Many paintings had not been cleaned in decades or at all since their purchase by Johnson, while others carried restorations that had discolored and were excessive or misleading. Moreover, the appearance of the paintings often did not reflect the most current information about preservation or the works' aesthetic potential.

The curators and conservators selected a number of key objects whose conservation would benefit the collection as a whole. The treatments and the need for ample time to research each problem that might arise led to hiring three more staff members, Teresa Lignelli, David Skipsey, and Stephen Gritt. In addition, Roberta Rosi, a conservator from Italy and an expert in Italian inpainting techniques, joined the team for

their surfaces; he seems never to have acknowledged the far greater potential for permanent alteration by removing the original paint in the cleanings he undertook. He poorly judged where restorations stopped and original paint began, and his treatments left many works aesthetically weakened. In a number of cases, after his cleanings Rosen did little inpainting, or retouching, of the damages, adhering to what he perceived as a more honest presentation of the surviving original. The works that were most dramatically altered by this method were Jacopo di Cione's *Saint Peter Liberated from Prison* (plate 37 [JC cat. 4]) and the Master of the Castello Nativity's *Adoration of the Christ Child* (plate 46 [JC cat. 23]), which were left in a stripped state. Rosen elucidated his philosophy in a 1941 article, "Preservation Versus Restoration," published in the *Magazine of Art.*[63] Marceau later defended this practice at a discussion session of the Twentieth International Congress of the History of Art at Princeton University.[64]

Like many curators, collectors, and conservators of his generation, Rosen wanted the wooden panels to be flat. He was rightly critical of the damage often caused by the attachment of traditional cradles to the backs of panels, and so he experimented rather freely with his

eight months, and the panel-painting specialist George Bisacca of the Metropolitan Museum of Art generously contributed time and expertise to the structural treatment of the two spandrel panels with angels that were reunited with Pietro Lorenzetti's *Virgin and Child Enthroned and Donor* (plate 39A [JC cat. 91]).

This intense period of conservation considerably advanced knowledge about a number of Italian paintings in the Museum, and the findings are included in the entries that follow. Three treatments reported in this catalogue were the focus of special research and study: Pietro Lorenzetti's *Virgin and Child Enthroned and Donor*; Fra Angelico's *Saint Francis of Assisi* (plate 8 [JC cat. 14]); and Masaccio and Masolino's *Saints Paul and Peter* and *Saints John the Evangelist(?) and Martin of Tours* (plates 44A–B [JC invs. 408–9])

Teresa Lignelli's restoration of the large losses on the Pietro Lorenzetti panel depended on firsthand comparisons with the artist's other works in Tuscany. She carefully reconstructed the losses in a manner that visually integrated the image but on close examination was easily distinguished from original areas of paint. Her method was a modification of an Italian technique known as *tratteggio,* meaning that losses are chromatically filled in with small vertical brushstrokes (fig. 22). This same technique was used to improve the appearance of many other early Italian panels, particularly enhancing the legibility of four pictures: Dalmasio's *Virgin and Child with Dog* (plate 19 [JC cat. 3]), Jacopo di Cione's *Saint Peter Liberated from Prison* (plate 37 [JC cat. 4]), Domenico di Bartolo's *Virgin and Child* (plate 21 [JC cat. 102]), and Benozzo Gozzoli's *Purification of the Virgin* (plate 36 [JC cat. 38]).

In the nineteenth century Fra Angelico's *Saint Francis of Assisi* was removed from the freestanding Crucifixion group in the confraternity of San Niccolò del Ceppo in Florence. The painting was then modified to look like an easel painting, completely disguising its original shape. After cleaning revealed the fine preservation of its original surface, the false addition seemed even more unnecessary and dishonest to the object. However, the decision to liberate the work and exhibit it as an independent fragment was not easy. While the actual operation proved straightforward, it was at first difficult to envision the picture as anything but a framed painting.

Investigation into the nature of Masaccio and Masolino's collaboration in the two panels with saints had begun in the 1980s.[70] In his treatment, David Skipsey pursued technical questions raised by the earlier study (confirming, with analytical assistance from the National Gallery of Art in London, Masolino's unusual use of oil paint in the late 1420s). The Johnson paintings were once opposite sides of the same panel (and had been cut in two sometime in the 1600s). They have now been framed together and placed in the middle of the gallery as an indication of their original format (see fig. 17). Skipsey's conservation was documented in a video about the panels that he co-authored.[71] Study of this altarpiece and the two artists has continued among a collaborative team comprised of conservators and curators from the National Gallery of Art in London, the Opificio delle Pietre Dure in Florence,

FIG. 22 Detail of Teresa Lignelli's inpainting on Pietro Lorenzetti's *Virgin and Child Enthroned and Donor* (plate 39A [JC cat. 91])

and the Philadelphia Museum of Art. A book reporting the results of this research was published in 2002.[72]

By October 1992 a remarkable number of early Italian paintings had been conserved, including Fra Angelico's *Dormition of the Virgin* (plate 7 [JC cat. 15]), Giovanni di Paolo's *Saint Nicholas of Tolentino Saving a Shipwreck* (plate 33 [JC inv. 723]), and those mentioned above. In addition, such minor treatments as the removal of surface grime, the adjustment of mismatched older retouching, and revarnishing were carried out on almost every other painting on view. The appearance of the collection as a whole has never been more unified.

Framing

Many of the early Italian paintings in the Museum are small fragments of much larger paintings or complexes that were disassembled and

dispersed in the eighteenth and early nineteenth centuries. Disassembly usually resulted in the removal and destruction of original frame elements, from simple moldings to elaborate tracery and spires. Of the larger paintings, only Bernardo Daddi's altarpiece preserves significant parts of its original frame. While Niccolò di Pietro Gerini's *Christ in the Tomb and the Virgin* (plate 27 [JC cat. 8]) is not in its original frame, the present one predates 1400; its edges still carry residues of lime mortar from when the picture was plastered into a niche in a wall. Medium-sized paintings by Tommaso del Mazza (plate 80 [PMA 1945-25-119]) and by the Master of Carmignano (plate 45 [PMA 1950-134-527]) retain their original engaged frames. The latter is a tabernacle whose columns, base, and some of the other carpentry survive because the piece was once of minor importance. The same accounts for the preservation of the frames on pictures by the so-called Pseudo–Pier Francesco Fiorentino (plates 69–71 [JC cats. 39–41]).

Very few of the frames on the smaller paintings in the collection have remained completely intact. The engaged frames of a diptych attributed to Benedetto di Bindo (plate 13 [JC cat. 153]) and the *Virgin and Child* (plate 21 [JC cat. 102]) by Domenico di Bartolo are notable exceptions. The Domenico di Bartolo also has a hole where a hanging hook would have been attached, but the hardware is gone. The hinges of Benedetto di Bindo's diptych and of the triptych by the Master of the Johnson Tabernacle (plate 49 [JC inv. 2034]) also seem to be original. While the two valves of Allegretto di Nuzio's diptych (plate 4 [JC cat. 118]) were fastened together to make them a stationary wall painting, the moldings are original and, in fact, the diptych is one of the better preserved trecento paintings in the collection. Bits of original molding survive in other pictures, although in examining them Mark Tucker and I have repeatedly marveled at how often and how cleverly past restorers have imitated or added to older moldings.

One of the pleasures of examining the collection closely was the frequent discovery of original painted surfaces on the backs and side edges of the paintings. The most dramatic examples are the geometric patterns on the backs of the *Virgin and Child with Dog* (plate 19 [JC cat. 3]) by Dalmasio and of the diptych attributed to Benedetto di Bindo. Barely visible drawings of frame profiles and mathematic calculations on the bare wood of Arrigo di Niccolò's *Saints Benedict, Sebastian, Stephen, and John the Evangelist* (see fig. 11.1) yielded an interesting view of old workshop and carpenters' practices. The most interesting of all the reverses, however, was the back of Niccolò di Pietro Gerini's *Scourging of the Four Crowned Martyrs* (plate 28 [JC inv. 1163]), which was partially painted blue with a pattern of gilded stars. This clue allowed for the identification of the original location of the panel on a pilaster in the Florentine church of Orsanmichele.

Over the past decade, the examination, conservation, and installation of the Italian paintings in the John G. Johnson Collection and Philadelphia Museum of Art have contributed considerably to our knowledge of these pictures and have subsequently informed all of the entries in this catalogue.

1. Only a few Italian pictures came from other sources. Clara Bloomfield Moore's (1824–1899) bequest in 1899 included a painting by Neri di Bicci. (On Moore, who sold her house at 510 South Broad to John G. Johnson, see a manuscript biography [1965–66] by Susan T. Mueller in the Office of the Registrar of the Philadelphia Museum of Art.) Isaac Lea (1792–1884), another Philadelphia collector, purchased a late trecento crucifixion in Florence in 1849, but it did not come to the Museum until 1938. (Most of Lea's Italian paintings date after the chronological parameters of this catalogue, and will be treated in another volume.) One of the former presidents of the Museum, John D. McIlhenny (1866–1925), owned two early Italian pictures—*Saint Cecilia of Rome and Her Husband, Valerian, Being Crowned by an Angel* by the Master of the Pesaro Crucifix (plate 53 [PMA 1943-40-51]) and the *Virgin and Child* by Giovanni Toscani (plate 81 [PMA 1943-40-45]); both came to the Museum some years after McIlhenny's death. The *Virgin of Humility and Eight Angels* by Tommaso del Mazza (plate 80 [PMA 1945-25-119]), the predella by Martino di Bartolomeo (plates 43A–D [PMA 1945-25-12a–d]), two small panels by Giovanni di Paolo (plates 32A–B [PMA 1945-25-121, 122]), and a ruined mural fragment (plate 92 [PMA 1945-25-118]) were part of the 1945 purchase of George Grey Barnard's cache of medieval art. In 1950 the great modern art collectors Louise (1878–1954) and Walter (1879–1953) Arensberg gave three minor Italian pictures (plates 11, 45, 88 [PMA 1950-134-528, 1950-134-527, 1950-134-195]). Only two paintings were direct Museum purchases: in 1952 the *Crucifix* by the Master of Montelabate (plate 50 [PMA 1952-1-1]) was acquired in Florence by the curator Henry Clifford, and in 1985 two spandrel panels with angels (plates 39B–C [PMA EW1985-21-1, 2]) by Pietro Lorenzetti were reunited with the Johnson Collection's *Virgin and Child Enthroned and Donor* (plate 39A [JC cat. 91]).
2. In the following decades the artists John Sloan and William Glackens, as well as the collector Dr. Albert C. Barnes, also graduated from there.
3. Through the painter Thomas Eakins, who enrolled in Central High the year Johnson graduated, we know that the art professor, Alexander Jay MacNeill, taught mechanical and perspective drawings and the copying of prints. See Foster 1995, pp. 19–23.
4. After graduating from Central High, Johnson clerked in a law firm and briefly attended the University of Pennsylvania Law School before being admitted to the bar in 1868. In 1870, at the age of twenty-nine, he was named counsel of the Pennsylvania Company, Philadelphia's largest bank. Later in life he declined appointments to the Supreme Court offered by Presidents Garfield and Cleveland, and he also refused an offer to serve as President McKinley's attorney general. On Johnson's career, see Winkelman 1942.
5. Strehlke 1990, p. 428.
6. Morris 1930, p. 108.
7. The situation would have been different if in the 1850s the city had accepted the collection of Thomas Jefferson Bryan, which contained many early Italian paintings. When Philadelphia declined, Bryan moved to New York, and the works went to the New-York Historical Society. Most of these pictures have since been sold.
8. Philadelphia 1876, pp. 110–20.
9. Philadelphia 1876a, p. 34.
10. John G. Johnson to Bernhard Berenson, Hotel Engadiner Kulm, Saint-Moritz, August 8, 1909. Florence, Villa I Tatti Archive.
11. Slipped into the pages of this catalogue is a card from M. Guggenheim, purveyors of furniture and antiques in the Palazzo Balbi in Venice, suggesting that Johnson also visited that city.
12. Johnson 1892, p. 10.
13. PMA W1896-1-11a-c. Philadelphia 1994, repro. p. 189.
14. This was sold in 1954 and is now in the Museo Civico of Turin.
15. Spiridon was raised in Rome by his father, Georges, a dealer and painter. Georges bought heavily at the sale of Cardinal Fesch's pictures in 1841.
16. Johnson to Spiridon, Philadelphia, September 17, 1903.
17. JC cat. 393, now thought to be by an Italian or Spanish follower. Philadelphia 1994, repro. p. 246.
18. Johnson to Spiridon, Philadelphia, September 21, 1903. Quoted by Henri Marceau in Sweny 1966, p. ix.
19. Johnson to Spiridon, Philadelphia, November 2, 1903. This work was sold from the Wilstach Collection in 1954. Its present location is unknown.
20. Hadley 1987, pp. 330–31.
21. Berenson to Johnson, the Deanery, Bryn Mawr, February 2, 1904.
22. JC cat. 225. Philadelphia 1994, repro. p. 236.
23. JC cat. 173. Philadelphia 1994, repro. p. 186.
24. JC cat. 159. Philadelphia 1994, repro. p. 176.
25. JC cat. 158. Philadelphia 1994, repro. p. 189.

26. Berenson to Johnson, the Deanery, Bryn Mawr, February 2, 1904.

27. Berenson to Johnson, Saint-Moritz, August 18, 1904.

28. Berenson to Johnson, Boston, November 13, 1908. For other scholarly views of Johnson's collection, see Gennari Santori 2003.

29. JC cats. 44–47. Philadelphia 1987, repro. p. 182. On this purchase, see Strehlke 1990.

30. Berenson to Johnson, May 27, 1911.

31. Berenson to Johnson, Paris, April 27, 1909.

32. Berenson to Johnson, Boston, November 11, 1908.

33. Berenson to Johnson, London, July 20, 1911.

34. Johnson to Berenson, Philadelphia, April 23, 1912. Florence, Villa I Tatti Archive.

35. Johnson to Shunk, Philadelphia, September 29, 1900.

36. Berenson to Johnson, Settignano, September 10, 1916.

37. Bell 1920, p. 4. It was followed by an exhibition of modern, largely French, paintings from the collection.

38. Brownlee 1989, pp. 74–77.

39. Edward Hamilton Bell (1857–1929) studied at the Slade School of Art in London and with his uncle Sir Edward Poynter, who in 1876 had succeeded John Millais as president of the Royal Academy of Arts. Bell came to America in 1885 and established himself as a building and landscape architect. He also worked as a decorative painter and stage and costume designer. In 1895 he decorated the tapestry gallery of Biltmore, the Vanderbilts' estate in Asheville, North Carolina, and in the early twentieth century he was the art director of the New Theater in New York. In 1916 he arranged and catalogued the inaugural collection of the Cleveland Museum of Art (*Catalogue of the Inaugural Exhibition of the Cleveland Museum of Art,* June 6–September 20, 1916 [Cleveland 1916]). The following year he came to Philadelphia to take over for the director Langdon Warner, who had been given leave to go to Japan for research. Although Bell was curator of the Johnson Collection until the end of his life, he principally devoted himself to Asian art and to the preparation of an illustrated book (unpublished) about private collections in Japan and Europe. His own interest in Italian art seems to have been minimal. In the 1916 Cleveland catalogue, not he but Stella Rubenstein wrote the entries about the early Italian collection of Liberty E. Holden. On Bell, see "Announcement," *Bulletin of the Pennsylvania Museum* (Philadelphia), vol. 16, no. 60 (January 1918), pp. 1–3; "Necrology," *The Pennsylvania Museum Bulletin* (Philadelphia), vol. 24, no. 127 (April 1929), p. 31; "Edward Hamilton Bell, 1857–1929," *Eastern Art: An Annual* (Philadelphia), vol. 2 (1930), p. 3. For his family connections, see the obituary of his brother Charles Francis Bell (1871–1966) by Francis J. B. Watson in *The Walpole Society* (London), vol. 41 (1968), p. ix.

40. Like Hamilton Bell, Marceau also served as assistant director of the Museum.

41. The Fogg catalogue was edited by the director, Edward W. Forbes, who also wrote the section on Byzantine painting. The sections on Florentine, northern Italian, and Venetian painting were written by Arthur Pope, and George Harold Edgell wrote the one on Sienese painting.

42. Other advisers included Marcel Aubert for Gothic art, Nicola D'Ascenzo for stained glass, Ananda Coomaraswamy for Indian art, and Samuel Yellin for metalwork.

43. Handbook 1931, p. 3.

44. JC cats. 44–47. Philadelphia 1994, repro. p. 182.

45. Haskell 1999.

46. Fry 1930.

47. See Mrs. Berenson's letter to Mrs. Gardner, quoted in Hadley 1987, pp. 330–31.

48. On October 29, 1912, he wrote to Miss E. A. Shunk, the secretary of the Wilstach Gallery at Memorial Hall, concerning *Peasant Boy* by Jules Bastien-Lepage (Philadelphia Museum of Art Archives): "The blister at the top may be removed. The cracks and horizontal lines over the upper part of the painting cannot do much harm and may remain unattended to for the present. Better leave it coated with varnish, because it is not well to do much to modern pictures in the way of change or restoration."

49. Johnson to Berenson, Philadelphia, May 16, 1912. Florence, Villa I Tatti Archive.

50. An undated memorandum filed with letters of 1912–14 (Philadelphia Museum of Art Archives, Wilstach, Reports . . . , 1912–14) mentions how the Art Jury does not want pictures "'restored,' if by that is to be meant bringing them back into the original condition they were in after they left the brush of the artist. They want the pictures to look like old pictures, as they really are."

51. JC cat. 314. Philadelphia 1994, repro. p. 55.

52. JC cat. 165. Philadelphia 1994, repro. p. 180. He also cleaned *The Finding of Moses* (JC cat. 474) then attributed to Rembrandt; Philadelphia 1994, repro. p. 89.

53. Fry had a troubled career in the United States, and Johnson was asked by Robert W. De Forest, the president of the Metropolitan Museum of Art, to defend Fry's restoration work on Johnson's pictures. De Forest thought Johnson might be able to counter the criticism of Charles Kurtz of the Albright Gallery in Buffalo, New York. Kurtz had publicly censured Fry for the overcleaning of a painting by Peter Paul Rubens. Fry seems to have used a somewhat controversial technique called the Pettenkofer method, named after the German chemist Max von Pettenkofer. As restorer for the Munich galleries, Pettenkofer developed a procedure for clarifying degraded varnish layers in part by exposing a picture to alcohol fumes over a period of time. Pettenkofer taught a course on this method at the Uffizi in Florence. And while the technique was well received by Italian art historians and administrators, such as G. B. Cavalcaselle, as a scientifically proved method of art restoration, it remained subject to debate and criticism (on Pettenkofer, see Gavin Townsend in *Dictionary of Art,* vol. 24 [1996], pp. 568–69). Johnson's reply to De Forest briefly acknowledged Fry's use of the controversial method, but he also opined that Fry was "most thoroughly informed as to all matters connected with what I may call the physique of a painting" (New York, The Metropolitan Museum of Art, archive P1662; Johnson to Mr. Robert W. De Forest, May 1, 1906; De Forest to Johnson, April 30, 1906).

54. A letter dated October 14, 1905, from Johnson to Shunk speaks of asking Justice Samuel Gustine Thompson's permission to turn over the Wilstach Collection's *Portrait of a Lady* (PMA w1896-1-6), then attributed to Bronzino, to Farina because of blistering. The painting is now attributed to Giulio Campi; Philadelphia 1994, repro. p. 184.

55. Newspaper clipping in the John G. Johnson Collection Archives entitled "Expert Here Fears Decay of Pictures," *Evening Bulletin* (Philadelphia), July 1, 1920(?).

56. On February 25, 1918, Eli Kirk Price wrote to Hamilton Bell about the need to supervise Farina carefully. Philadelphia Museum of Art Archives, Wilstach Collection [Sully gift . . .], 1918–1922.

57. See Farina 1929, Farina 1930, and clippings file, John G. Johnson Collection Archives. He later moved to New York and exhibited as a painter.

58. Brownlee 1989, pp. 76–77; and an article in the *Public Ledger* (Philadelphia), February 28, 1920.

59. *The John G. Johnson Collection of Paintings and Works of Art: Report of Committee apppointed by Hon. J. Hampton Moore Mayor,* November 23, 1920, p. 9.

60. Warped panels and flaking paint were ongoing problems, with many pictures suffering from the extreme seasonal fluctuations of humidity in the Museum before the installation of climate control in 1976.

61. His son C. F. Louis de Wild, whose studio was on 57th Street in New York, continued his father's practice.

62. One of them was Lorenzetti's *Virgin and Child Enthroned and Donor* (plate 39A [JC cat. 91]), which Thompson cradled.

63. Rosen 1941.

64. Marceau 1963. Marceau also wrote a Museum *Bulletin* on conservation and technical research in 1940, when Rosen was beginning his work in Philadelphia (Marceau 1940). See also Tucker 1997, p. 680 n. 17.

65. JC cat. 241a, b. Philadelphia 1994, repro. p. 235.

66. PMA 1950-86-1. Philadelphia 1994, repro. p. 183.

67. JC cat. 206. Philadelphia 1994, repro. p. 182.

68. JC cat. 209. Philadelphia 1994, repro. p. 214.

69. JC cat. 303. Philadelphia 1994, repro. p. 197.

70. See Strehlke and Tucker 1987.

71. "Understanding a Renaissance Masterpiece," 16-minute video, produced by the Philadelphia Museum of Art (1994).

72. Strehlke 2002.

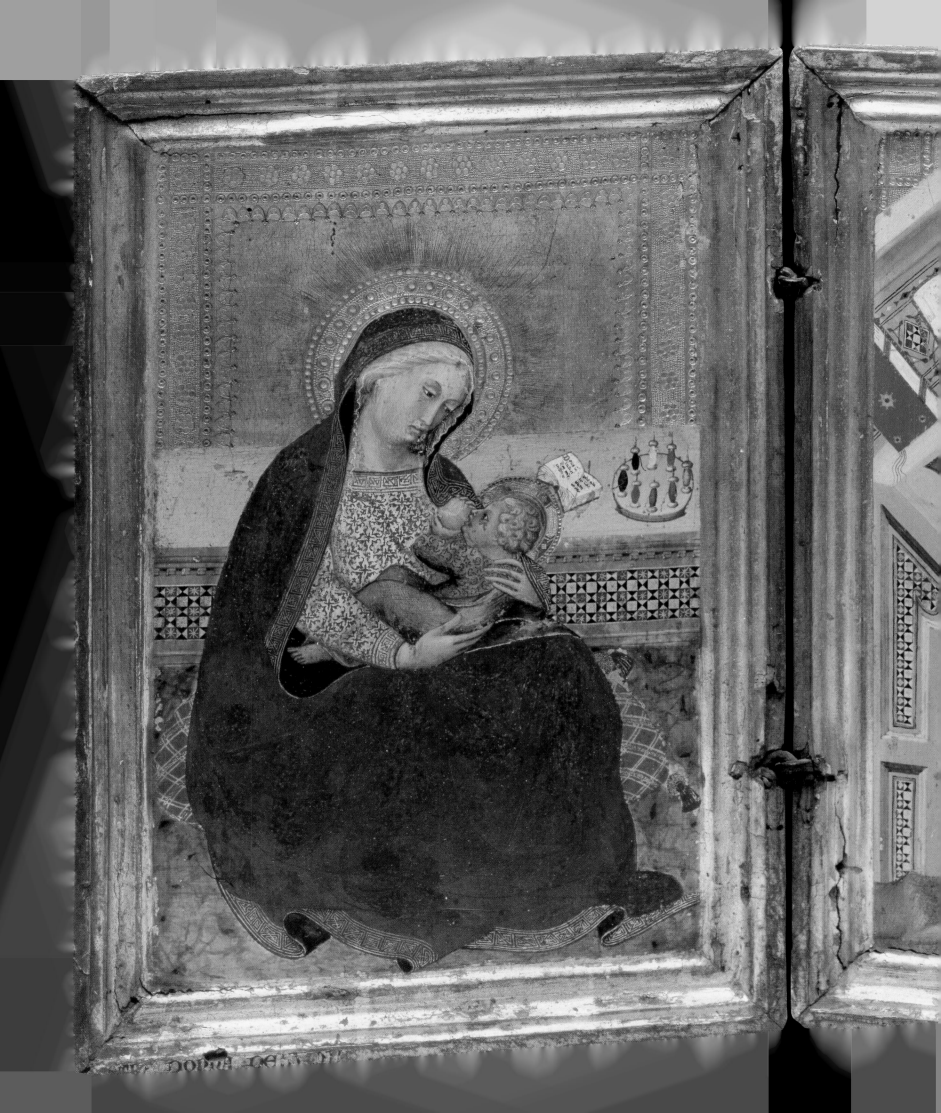

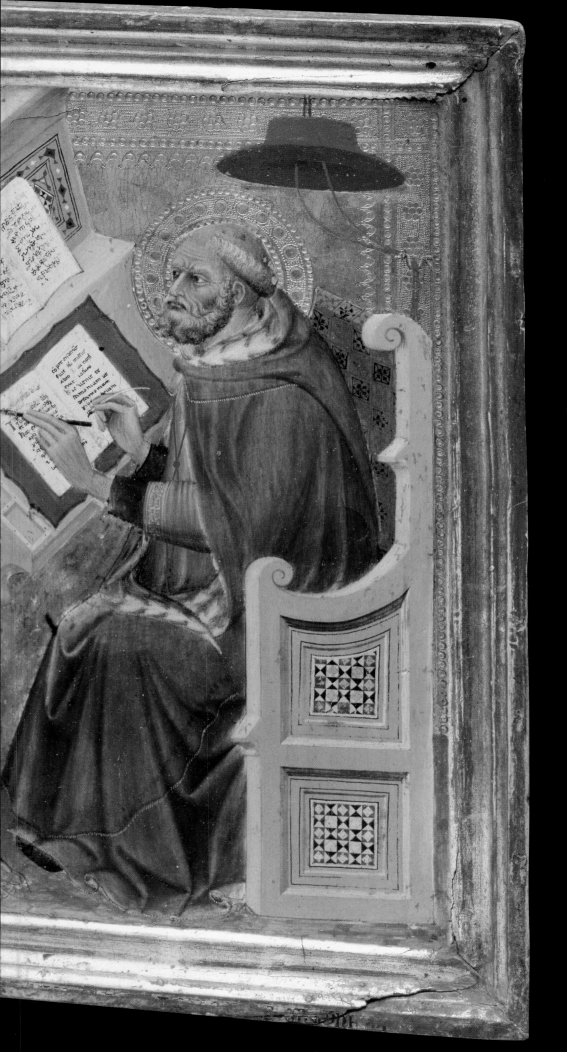

CA

ALLEGRETTO DI NUZIO

(also called *Allegretto Nuzi*)

FABRIANO, FIRST DOCUMENTED 1345;
DIED 1373, FABRIANO

Knowledge of Allegretto di Nuzio's early activity comes from documents related to his enrollment in 1346 as a foreign artist in the company of San Luca, the local painters' brotherhood. For unknown reasons, his place of origin is recorded not as his native Fabriano, but as Siena. Although no works by Allegretto can be traced to the latter city, the Museo dell'Opera del Duomo in Orvieto, where many Sienese artists worked, owns a panel that must have come from an altarpiece once in a local church.[1] Allegretto's first dated work, the *Virgin and Child Enthroned with Angels* of 1345,[2] also shows the influence of the Sienese painter Ambrogio Lorenzetti.

The Johnson Collection's polyptych (plates 1A–E [JC cat. 5]) probably dates to Allegretto's 1346 sojourn in Florence. It is a transitional painting that shows him taking up a more Florentine style. The artist is next recorded in Fabriano in 1348.[3] His two murals in the Saint Lawrence chapel of that city's cathedral must date around this time.[4] Both are the fruit of his Florentine experiences, demonstrating a close study of Maso di Banco's Bardi di Vernio chapel (c. 1332–35) in the basilica of Santa Croce.[5]

In the next decade Allegretto di Nuzio's style became flatter and more decorative, as seen in the *Coronation of the Virgin and Saints,* originally from San Francesco in Fabriano, now in Southampton, England.[6] Federico Zeri (1975) proposed that Allegretto executed this work in collaboration with Francesco di Cecco Ghissi (or Cicchi), known as Francescuccio Ghissi.[7] While the provincial taste of Fabriano and a continuing collaboration with Ghissi might account for the shift in style, Allegretto would also have been aware that in Florence taste was moving in the same direction. The artist was able to keep in touch with these developments through his connections to Puccio di Simone, a follower of Bernardo Daddi (q.v.), who painted an altarpiece for Sant'Antonio fuori Porta Pisana in Fabriano in 1353.[8] The next year, on commission from an otherwise unidentified Fra Giovanni, Puccio worked on a triptych for the same church,[9] the left wing of which Allegretto later repaired.[10]

Allegretto's most important work in the 1360s was the decoration of the Saint Ursula chapel in Santa Lucia Novella in Fabriano for the De Santi family. He painted the murals as well as the altarpiece, dated 1365, now in the Pinacoteca Vaticana.[11] The following year he signed a large altarpiece (fig. 4.8) for the Franciscan church of Apiro, near Macerata, and

the *Virgin of Humility* now in the Pinacoteca Civica in San Severino Marche.[12] The triptych that he painted in 1369 (fig. 3.1) was commissioned by a Fra Giovanni, who may be the same Fra Giovanni who had commissioned Puccio di Simone's triptych of 1354.[13] Allegretto's last-dated work is the 1372 *Virgin and Child,* now in the Galleria Nazionale delle Marche in Urbino.[14]

The artist enjoyed a certain fame as the founder of the Fabriano school of painters. However, already in 1493 a large altarpiece by Carlo Crivelli had replaced his *Coronation of the Virgin* on the high altar of San Francesco in Fabriano.[15] But local traditions would ensure that Allegretto's name did not die out. A sonnet by Silvio Gilio (died 1584) called him the father of the Fabriano school and the master of Gentile da Fabriano.[16]

In the 1630s, Allegretto's 1365 altarpiece now in the Vatican was brought to Rome, and, later in the century, a member of the Altieri family (possibly Pope Clement X) is recorded as owning one of his altarpieces.[17] Examples of signed works by Allegretto appear as engravings in histories of Italian painting by Jean-Baptiste Séroux d'Agincourt (1823, plate cxxviii) and Giovanni Rosini (1848–52, vol. 2, 1848, plate 150), but the painter was not truly "rediscovered" until Amico Ricci (1834) published his extensive research on the art of the Marches. Following earlier cinquecento sources such as Gilio and a manuscript history of Fabriano by Vincenzo Lori, Ricci argued that Allegretto was Gentile's master. This is largely discounted in Gaetano Milanesi's notes to Vasari (1568, Milanesi ed., vol. 3, 1878, p. 16 n. 5).

In the twentieth century, research on Allegretto di Nuzio was mainly focused on the attribution of the altarpiece in Washington, D.C. Bernhard Berenson (1922) assigned it to Allegretto, whereas Richard Offner (1947) argued that Allegretto painted only the left wing and that the rest was by another master whom Roberto Longhi (1959, pp. 9–11; 1965, pp. 10–13) subsequently identified as Puccio di Simone. Zeri (1949; 1975) explored the relationship between Allegretto and Ghissi. Miklós Boskovits (1973) suggested that Allegretto's activity encompassed work in Perugia, and Filippo Todini (1977) was able to identify the original location of the Vatican altarpiece. More recently, Erling Skaug (1994) has worked out a chronology for Allegretto based on a study of his punch marks. In addition to these specific studies, Bruno Molajoli's 1968 guidebook to Fabriano contains valuable observations, as do a number of exhibition catalogues of restored works from the Marches (Urbino 1968, 1969, 1973; Macerata 1971; Fabriano 1993).

1. Garzelli 1972, fig. 10 (color).
2. Present location unknown; formerly London, Viscountess D'Abernon Collection; Berenson 1968, plate 206. It may come from the Dominican church of Santa Lucia Novella in Fabriano, where local sources record altarpieces dated 1345 and 1349; the 1349 work is lost.
3. He is listed as present at a meeting of the confraternity of Santa Maria in that year (Zonghi 1908, p. 4).
4. Molajoli 1968, color plates VIII–IX, figs. 20–23.
5. Acidini Luchinat and Neri Lusanna 1998, postrestoration color repros.; see also fig. 26.2 of this catalogue. On the date of the Bardi di Vernio murals, see Bartalini 1995, pp. 16–22. These similarities make it unlikely that the murals in the Saint Lawrence chapel in Fabriano cathedral were done after 1365, a date that has been proposed on the basis of payments for masonry work in that part of the cathedral (Molajoli 1968, pp. 102, 109).
6. Art Gallery, no. s-1403. Side panels are also in Houston, The Museum of Fine Arts, nos. 48.568–9; Wilson 1996, pp. 53–66, repros. pp. 54–55, fig. 4.7 (color) and photomontage fig. 4.6. Zeri showed that this work was from San Francesco. Allegretto di Nuzio may have painted the altarpiece around the same time he painted the now-ruined tabernacle of 1354 on the church's exterior.
7. An altarpiece of Saint John the Evangelist, now divided between several American museums, is probably another such joint project. A reconstruction by Federico Zeri and Keith Christiansen can be found in Lloyd 1993, p. 109, fig. 1. This altarpiece, usually dated to the 1370s, was more likely executed in the late 1350s.
 Ghissi's 1359 *Virgin of Humility* in Fabriano, Pinacoteca Civica (Donnini 1973, fig. 2) for Santa Lucia Novella in Fabriano may well be based on an earlier painting of the same subject by Allegretto. Two other paintings of the Virgin of Humility, often attributed to Ghissi, are assigned by Zeri (1975, p. 5) to Allegretto. They are in the Pinacoteca Vaticana (no. 192 [inv. 40211]; Rossi 1994, figs. 41–44) and the church of Sant'Agostino in Ascoli Piceno (Donnini 1973, fig. 5). It is also possible that the *Virgin of Humility* in the Pinacoteca Civica in Fermo (originally San Domenico; Donnini 1973, fig. 7) is also by Allegretto or was produced by Ghissi in Allegretto's workshop.
8. Fabriano, Pinacoteca Civica, no. 16 (Offner 1947, plate xxxvi). Before his identity became known, Puccio di Simone was called the Master of the Fabriano Altarpiece, after this painting.
9. Washington, D.C., National Gallery of Art, no. 6 (Shapley 1979, plate 276).
10. Shapley (1979, pp. 384–85) noted that there is evidence that the figure of Saint Anthony Abbot executed by Allegretto is a repair of a damaged or unfinished figure.
11. No. 187 (inv. 40204); Rossi 1994, figs. 46–49. The murals are not fully illustrated. One scene is reproduced in Molajoli 1968, fig. 32.
12. Originally from Sant'Antonio in nearby Montecassiano. Macerata 1971, postrestoration repro. p. 58.
13. The Macerata painting counterfeits elements of the earlier painting and both were originally for churches of the Antonine order.
14. Postrestoration repro. in Urbino 1968, p. 23.

15. Now Milan, Brera, no. 202; Bovero 1974, color plate LIX.
16. "L'un perché Allegretto, il gran pittore,/ Di Nuzio, qual fu al mondo si eccellente,/ E d'ogni altro oscurò la fama altiera,/ Di Gentil mastro fu" (One, because Allegretto, the great painter,/ son of Nuzio, who was so excellent in the world/ and who obscured the other's fame/ was Gentile's master); Sassi 1923–24, p. 276.
17. This is the Saint John the Evangelist altarpiece. See n. 7.

Select Bibliography
Ricci 1834, vol. 1, pp. 81–90; Anselmi 1906; Walter Bombe in Thieme-Becker, vol. 1, 1907, pp. 306–7; Berenson 1922; Van Marle, vol. 5, 1925, pp. 130–69; Romagnoli 1927; Offner 1947, pp. 141–237; Zeri 1949, pp. 21–22; Marabottini Marabotti 1951–52; Longhi 1959, p. 6; Alessandro Marabottini in *DBI*, vol. 2, 1960, pp. 476–77; Procacci 1961, p. 65; Vertova 1967, pp. 671–72; Berenson 1968, pp. 302–5; Molajoli 1968, pp. 29–30; Boskovits 1969, pp. 18–19 n. 19; Vita-lini Sacconi 1969; *Bolaffi*, vol. 1, 1972, pp. 80–82; Boskovits 1973, pp. 18–19; Donnini 1975; Zeri 1975; Todini 1977; Giampiero Donnini in *Allgemeines Künstlerlexikon,* vol. 2, 1986, pp. 180–82; Enrica Neri Lusanna in *Pittura* 1986, pp. 418–20; Valerio Terraroli in *Pittura* 1986, p. 644; Zampetti 1988, pp. 119–21; Giampiero Donnini in *Saur,* vol. 2, 1992, pp. 460–62; Skaug 1994, esp. pp. 142–46; Joan Isobel Friedman in *Dictionary of Art* 1996, vol. 23, pp. 322–24

PLATES IA–E (JC CAT. 5)

Altarpiece: *Virgin and Child with Saints Mary Magdalene, James Major, Stephen, and a Bishop Saint*

1346(?)

Tempera, silver, and tooled gold on panels with vertical grain; *Virgin and Child:* 28⅞ × 16⅝ × 1¼″ (73.2 × 42 × 3 cm) (without additions); extra strips of wood on the sides, each 18⅛ × ⅛″ (46 × 0.3 cm), and added wood on the top, height 2″ (5 cm); *Saint Mary Magdalene:* 24⅜ × 12 × 1¼″ (61.7 × 30.5 × 3 cm) (without additions); extra strips of wood on the sides, each 17⅜ × ⅜″ (44 × 0.7 cm), and added wood on the top, height 1⅜″ (3.5 cm); *Saint James Major:* 24 × 12⅛ × 1¼″ (61 × 30.7 × 3 cm) (without additions); extra strips of wood on the sides, each 18½ × ⅜″ (47 × 0.7 cm), and added wood on the top, height 1½″ (3.7 cm); *Saint Stephen:* 24⅜ × 12 × 1¼″ (61.7 × 30.3 × 3 cm) (without additions); extra strips of wood on the sides, left 18 × ¼″ (45.5 × .5 cm) and right 18⅛ × ¼″ (46 × 0.6 cm), and added wood on the top, height ⅞″ (2 cm); *Bishop Saint:* 24¼ × 12 × 1¼″ (61.5 × 30.5 × 3 cm) (without additions); extra strip of wood on the left, 17½ × ⅛″ (44.5 × 0.2 cm), and added wood on the top, height 1″ (2.3 cm)

John G. Johnson Collection, cat. 5

INSCRIBED ON THE REVERSE: *CITY OF PHILADELPHIA/ JOHNSON COLLECTION* (stamped many times on each panel in black ink); *5/ IN 1858* (in ink on each panel); various dimensions and other numbers indicating the panels' placement in the frame

PUNCH MARKS: See Appendix II

TECHNICAL NOTES

The *Virgin and Child* panel from the center of this polyptych consists of two members joined at 1⅝″ (4 cm) from the left. Each of the other four panels is a single plank. While the backs of the five panels have been planed toward the edges, they all retain their original thickness. When, at an unknown date, the altarpiece was disassembled and the applied moldings of the frame were removed, the exposed wood on the front was gessoed and gilded, and new wood was added to the top and sides. The panels were originally spanned by a transverse batten, as indicated by a pair of nail holes on the back of each panel at a height of about 19¾″ (50 cm). Some of the nails are still present. The five panels were placed in a neo-Gothic frame in the early twentieth century.

A linen layer applied to each panel before it was gessoed can be seen at the bottom edges, except the *Saint Mary Magdalene* and *Saint James Major* panels.

In its original state the altarpiece may have been similar to Allegretto's polyptych from Cancelli near Fabriano (fig. 1.1). Like that painting, the Johnson work may have had pinnacles. Its scheme may likewise have been similar to the Cancelli altarpiece, but the central pinnacle may have been inset with a roundel similar to the Blessing Redeemer above the

enthroned Virgin and Child on another panel in Fabriano (fig. 1.2).[1]

The outlines of all the figures are incised in the gesso, whereas the details of the inner forms, such as the drapery, hands, and attributes, are drawn. Some drawing is visible to the naked eye. In addition, infrared reflectography revealed delicate brushed lines in all the panels, being most pronounced in the *Virgin and Child* (fig. 1.3) and *Saint Stephen.* The Virgin's right hand and the tail of the bird in Christ's hand show minor changes.

Overall the gold background is in good condition, while the brown mordant is all that survives on much of the silver and gilt embellishments of the costumes. Most of the mordant gilding on the two stars of the Virgin's mantle is missing; their shape, for example, is now indicated only by shallow depressions in the surface of the paint. On the border of her mantle rests what may be a low-karat gold that has corroded.[2] A similar material appears to have been employed for other details, including the decoration of James's and Stephen's books, the borders of Stephen's robe, Mary Magdalene's pyx, and the bishop's orphrey and glove. Silver alone was used for some of the decoration of Stephen's robe as well as the staff of the bishop's crozier and the ornamentation of his miter. The bishop's crozier was modeled with paint before being decorated with a sgraffito vine pattern.

All the panels have general wear and localized losses. Those that show the most wear from cleaning are the *Virgin and Child* and *Saint James.* In addition, the lower third of the left side of the Virgin's blue mantle is repainted.

Hamilton Bell wrote in August 1919 that the altarpiece needed attention. Unspecified repairs by Carel de Wild began in December 1920. He noted that the picture was in generally poor condition and had been much restored. In 1942 David Rosen cleaned all the panels of old repaint and varnish. He filled and retouched the cracks and losses, and said that he had "repaired" the gold ground.

PROVENANCE

The picture may have been made for the female Augustinian convent of San Cajo e Santa Caterina, known as San Gaggio, outside Porta Romana in Florence. The altarpiece was recorded by Raimond van Marle (vol. 3, 1924) as having been in the Corsini Collection in Florence, from which it was presumably sold to the dealer Aranaldo Corsi, from whom Johnson had acquired it by 1911. Nada Bacic, archivist of the Corsini family, remembered seeing an old photograph of the polyptych among the papers of Principe Tommaso Corsini (1835–1919), but it cannot at present be located. As the Corsini Collection contains few fourteenth- or early fifteenth-century pictures, the altarpiece would probably have come to them for special reasons;[3] it may have been returned to them from an altar patronized by a member of the family after one of

PLATE IA *Saint Mary Magdalene*
PLATE IB *Saint James Major*
PLATE IC *Virgin and Child*
PLATE ID *Saint Stephen*
PLATE IE *Bishop Saint*

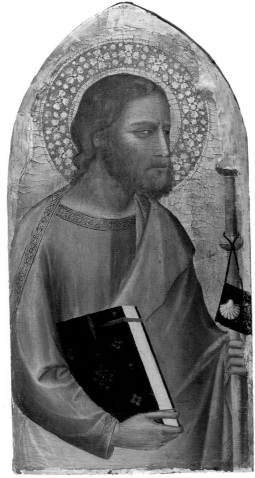

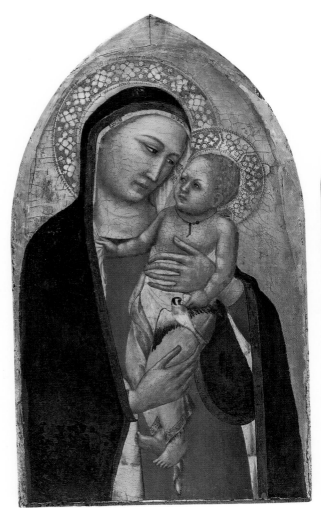
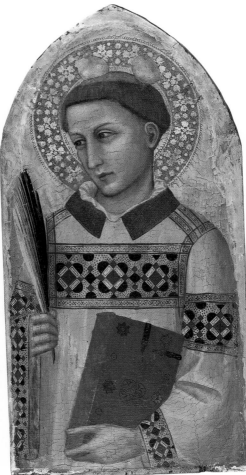
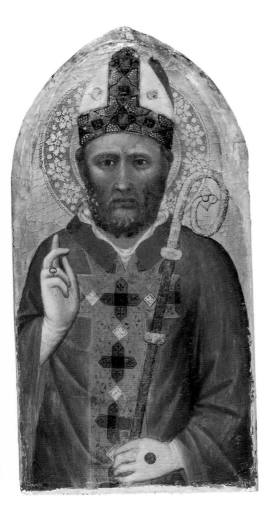

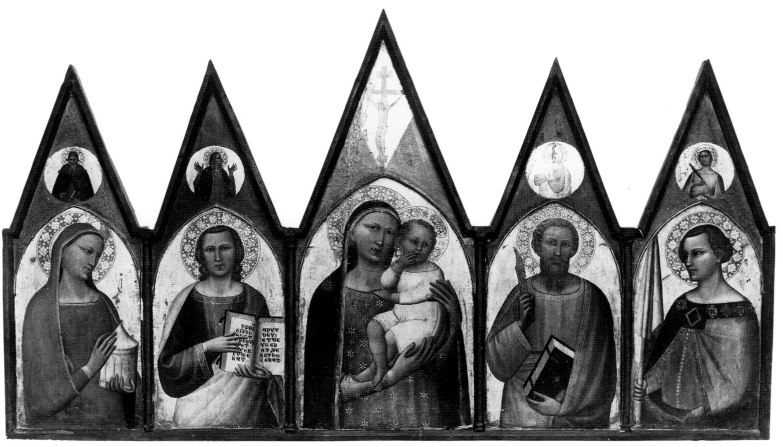

FIG. 1.1 Allegretto di Nuzio. Altarpiece: *Virgin and Child with Saints Mary Magdalene, John the Evangelist, Bartholomew, and Venanzo*, late 1340s(?). Tempera and gold on panel; 44½ × 79⅝″ (113 × 202 cm). From Cancelli, abbey of Santa Maria d'Appennino. Fabriano, Pinacoteca Civica "Bruno Molajoli"

the periodic suppressions of religious institutions.[4] Restitutions of works of art to patron families were rare, but the prominent position of the Corsini was cause enough for an exception.[5] Alternatively, Tommaso Corsini was a known patron of the arts and may have acquired the altarpiece by other means. A 1902 photograph of the four lateral panels, now in the archives of Wildenstein's in New York, has an inscription identifying the owner as one Conte C. Alberti of Florence. Unfortunately, nothing is known of him and it cannot be determined whether he acquired them from Corsini and if he also owned the central panel of the Virgin and Child. In the photograph the four lateral panels are each framed separately. They and the Virgin and Child were placed in a neo-Gothic frame by 1911, when Johnson purchased the altarpiece from Aranaldo Corsi.

COMMENTS

In the center of the polyptych are the Virgin and Child, who plays with her veil and holds, by the wing, a goldfinch—symbol of Christ's suffering on the cross,[6] as is the red coral on his necklace. In the other panels, from left, are: Mary Magdalene with the pyx of unguents she used to perfume Christ's feet (Matthew 26:6-13; Mark 14:3; John 11:2, 12:3); James Major grasping a staff with a tag-bearing cockle shell—a symbol of Santiago de Compostela in Spain, the pilgrimage site where he was buried;

the deacon Stephen with rocks on his head commemorating his martyrdom by stoning (Acts 8:57–59); and a blessing bishop or abbot saint with a crozier. The inscription on the modern frame identifies him as Nicholas of Bari, but considering the likely Florentine provenance of the polyptych, he could be Saint Zenobius, the first bishop of Florence.

The early twentieth-century attribution of this panel was wrapped up with the then-tentative and confused identifications of the artists Giotto di Maestro Stefano, known as Giottino, and Maso di Banco. Osvald Sirén (1908) first attributed it to Giottino, later to Maso di Banco (1917), and then to a so-called Master of the Johnson Polyptych (1927–28). Bernhard Berenson (1913) called Sirén's attribution to Giottino "quasi-historical" but kept it, and put the name in quotation marks. He argued that the altarpiece was by a Florentine artist who was much influenced by the Lorenzetti of Siena.[7] Raimond van Marle (vol. 3, 1924) identified the artist as Pseudo-Giottino in the caption to the illustration in his publication, but in an appendix noted that the qualifier "Pseudo" should be eliminated. Berenson (1931–32, 1932, 1936, 1963, 1969) later identified the Johnson painting as an early work of Jacopo di Cione (q.v.), although he noted its similarities to Maso di Banco. In the catalogues of the Johnson Collection (1941, Sweeny 1966), it was classified as close to Maso di Banco, whereas Burton Fredericksen and Federico Zeri (1972) simply called it fourteenth-century Florentine. In 1971 Millard Meiss

suggested that it was close to the mid-fourteenth-century Pratese painter Alesso d'Andrea. In a letter dated June 30, 1983, Angelo Tartuferi was the first to argue that the altarpiece was by Allegretto di Nuzio, noting that Miklós Boskovits agreed that it must be an early work.

The attribution to Allegretto di Nuzio was first published in Dillian Gordon's new edition of Martin Davies's catalogue of the early Italian paintings in the National Gallery of London (Davies and Gordon 1988). She reported the research of Erling Skaug, who attributed *Saints Catherine and Bartholomew* in London[8] to Allegretto based on the similarities between that picture's punch marks and those of this polyptych and a diptych (plate 4 [JC cat. 118]) in the Johnson Collection, as well as a number of other pictures.[9] In his letter to Gordon dated April 22, 1987, and subsequent publication (1994), Skaug stated that the complex clusters of punch marks in the halos of the Johnson altarpiece closely resemble the punches used by Pietro Lorenzetti (q.v.) in his 1340 altarpiece from San Francesco in Pistoia.[10] He also noted that the elaborate punch marks of the *Virgin and Child and Angels* in Avignon (fig. 1.4) are very similar to those in the Johnson polyptych. The Christ Child in both pictures is also almost identical. Although the Avignon painting is frequently considered to be a late Allegretto (Laclotte and Mognetti 1987, p. 39) because of the elaborate brocades, its composition is much closer to Florentine painting

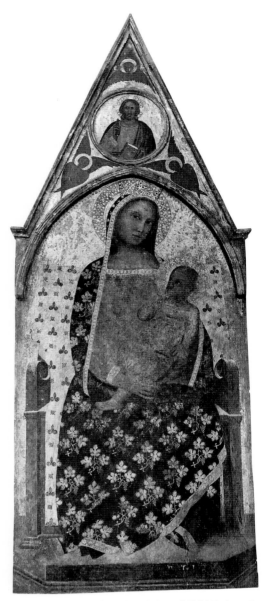

FIG. 1.2 Allegretto di Nuzio. *Virgin and Child Enthroned and the Blessing Redeemer*, late 1360s. Tempera and tooled gold on panel; 65 × 26⅜″ (165 × 67 cm). Fabriano, Pinacoteca Civica "Bruno Molajoli"

of the early fourteenth century, which suggests that it may be an early Allegretto. The similarities of the Johnson altarpiece to Florentine painting of the 1340s and, in particular, to the work of Maso di Banco, would suggest that it dates to Allegretto's Florentine period in the mid-1340s.

The fact that in the early twentieth century the Johnson painting seems to have been in the possession of the Corsini, one of Florence's most prominent families, suggests that it was originally made for a Florentine church. If a Corsini had commissioned the altarpiece, it may have been made for the convent of San Gaggio. It had been founded on March 29, 1345, by Tommaso Corsini and his son Cardinal Pietro;[11] Tommaso's daughter Caterina was among the first nuns. Partial support for such a provenance

is the fact that the Corsini family once owned choir-books from San Gaggio.[12] The Johnson picture, however, is not listed among the works of art from the convent that were taken from San Gaggio after it was suppressed in 1810 by the Napoleonic government.[13] Furthermore, there are no specific iconographic reasons to relate the painting to San Gaggio.[14]

A provenance from Florence, if not specifically from San Gaggio, can be argued on chronological grounds. In 1346 Allegretto di Nuzio enrolled as a foreign artist in the painters' guild and brother-hood. Receiving the commission of an important altarpiece may have prompted Allegretto's matriculation in these associations. This painting certainly is the most Florentine of his known works. Its previous attributions to Giottino and Maso, or comparisons with works by Nardo di Cione, are likewise understandable once it is recognized that the polyptych is one of Allegretto's earliest paintings. If this dating is accepted, an often-cited comparison with Maso di Banco's altarpiece (fig. 1.5) of about 1340 in the Vettori chapel of Santo Spirito in Florence is also reasonable.

Few early paintings by Allegretto di Nuzio have been identified. If the Johnson polyptych dates around 1346, it was made at least a year after the altarpiece formerly in the D'Abernon Collection in London,[15] whose style is still derivative of Sienese art, suggesting that Allegretto had been in Siena in the earlier part of the decade. The Allegretto *Crucifixion* in the Metropolitan Museum of Art is based upon the Lorenzetti of Siena and thus must also represent his earlier period.[16] Closer to the more Florentine style of the Johnson altarpiece are Allegretto's Crucifixions in the Virginia Museum of Fine Arts[17] and the Birmingham Museum of Art in Alabama.[18]

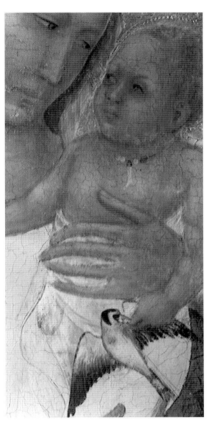

FIG. 1.3 Infrared reflectographic detail of plate 1C, showing the underdrawing of the Virgin and Child

1. Although the date and dimensions of Allegretto's *Blessing Redeemer* (Brunswick, Maine, Bowdoin College Museum of Art, no. 1961.100.4; Shapley 1966, fig. 205) from the Kress Collection would make it a likely candidate for the central pinnacle of the Johnson Collection's altarpiece, structural reasons indicate that this was not the case. An X-radiograph indicates that the Kress panel has a join up the center, whereas the join on the center panel of the Johnson altarpiece is 1⅝″ (4 cm) from the left.

2. At the time Allegretto worked it was known that alloyed gold might tarnish. See Cennino Cennini (c. 1390, Thompson ed. 1932–33, vol. 1, p. 59; vol. 2, p. 60), who in chapter 95 states, "anchora ti ghuarda d'oro di meta, che di subito vien negro" (beware of alloyed gold, for it soon turns black).

3. The Metropolitan Museum of Art in New York owns a small tabernacle by Bicci di Lorenzo (no. 41.100.16) that is also said to have come from the Corsini in Florence. The other early Italian paintings of the collection, which was catalogued by Ulderigo Medici (1886), are few. There was a predella of the legend of Saint Andrea Corsini, then catalogued as Pesellino (q.v.), from their chapel in the Carmine in Florence, which Tommaso

Corsini brought from the church in 1875 (Medici 1886, pp. 94–96, no. 341; Kaftal 1952, figs. 50, 51); and a mural attributed to Gaddo Gaddi from Santa Maria del Prato, which the prince had detached and made part of his collection in 1878 (Medici 1886).

4. In Tuscany the suppressions occurred in 1778 under Grand Duke Pietro Leopoldo, in 1810 under Napoleon, and in 1866–67 under the unified Italian government. At these times many churches and monasteries were deprived of their artistic treasures.

5. Likewise, another prominent Florentine family, the Rucellai, came into possession of several works of art from their family church of San Pancrazio. See Strehlke 1992, p. 38 n. 78.

6. See Battista di Gerio, plate 12 (JC cat. 12).

7. He proposed that this artist had painted the Strozzi chapel in Santa Maria Novella and the refectory of Santo Spirito in Florence (Offner 1960, plates IX–XIII [as the Master of the Pentecost]; 1962, plate V [as the Master of the Santo Spirito Refectory]). The artist is now recognized to be Nardo di Cione.

8. National Gallery, no. 5930; Davies and Gordon 1988, plate 1.

9. Skaug's list included the following: *Sixteen Saints and Four Angels*, Houston, The Museum of Fine Arts (nos. 44.568–9; Wilson 1996, repro. pp. 54–55 [color]); the *Virgin and Child and Angels*, Avignon, Musée du Petit Palais (fig. 1.4); the *Virgin and Child and the Dead Christ*, and the *Virgin and Child with Donors and Saints Michael Archangel and Ursula* (signed and dated 1365), both Vatican City, Pinacoteca Vaticana (invs. 40208

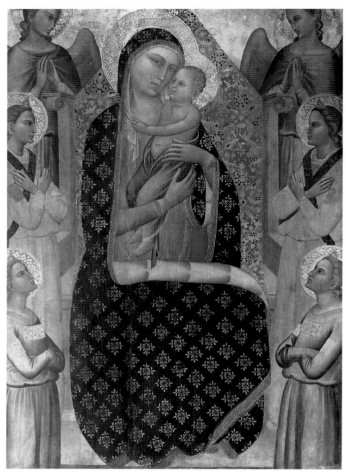

FIG. 1.4 Allegretto di Nuzio. *Virgin and Child and Angels*, c. 1365–70. Tempera and tooled gold on panel; 54⅜ × 39″ (138 × 99 cm). Avignon, Musée du Petit Palais (formerly on deposit in Agen, Musée Municipal), no. 5

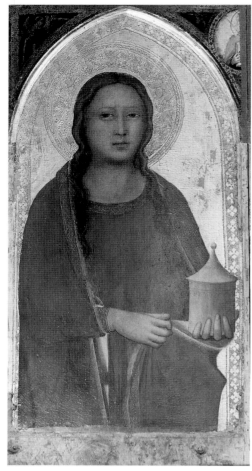

FIG. 1.5 Maso di Banco (Florence, first documented 1338/42; died 1349). Panel of an altarpiece: *Mary Magdalene*, c. 1340. Tempera and tooled gold on panel. Florence, church of Santo Spirito, Vettori chapel

and 40210, nos. 188–89; inv. 40204, no. 187; Rossi 1994, figs. 46–57); and the *Crucifixion*, New York, The Metropolitan Museum of Art (1975.1.106; Pope-Hennessy 1987, plate 28). Skaug wrongly identified the Metropolitan work as being in a private collection.

10. Florence, Uffizi, no. 445; Volpe 1989, figs. 135, 135a.

11. On the church, see Moreni, vol. 2, 1972, pp. 81–99; on Tommaso Corsini, see Anna Benvenuti Papi in *DBI*, vol. 29, 1983, pp. 673–76; and on the cardinal, see Jacques Chiffoleau in *DBI*, vol. 29, 1983, pp. 671–73.

12. Florence, Museo Nazionale di San Marco, inv. 1890, n. 10074–10075; Scudieri and Rasario 2003, illustrated pp. 91–104 (color).

13. Florence, Accademia di Belle Arti, *Inventario degli oggetti di belle arti estratti dalle chiese e conventi soppressi nel 1808–1810*, 1813, no. 17, cc. 111–12; and *Rapporti della Commissione sugli oggetti di arti e scienze esistenti nei conventi del Dipartimento dell'Arno*, 1808–11, no. 25, folder 84, cc. 223–24.

14. On October 23, 1810, the commissioners in charge of selecting works to be removed from San Gaggio made the unusual note that the Corsini family needed to be consulted about their family's tombs in the church. An earlier description of the church by Domenico Moreni (vol. 2, 1792, pp. 92–93) notes that near the ciborium,

which was under Corsini patronage, there was "una tavola antichissima, chiamata da antiquari, *Ancona*, che nei primi tempi era all'Altar maggiore" (a very old painting, called by antiquarians, an *ancona*, which had been on the high altar). An 1863 inventory of the church, drawn up by Carlo Pini, does not record this painting or any other that would correspond to the Johnson altarpiece (Florence, Soprintendenza, Archivio Storico, 2./4, no. 323). An inscription in San Gaggio records that in 1899 Tommaso Corsini had his ancestors' tombs removed from the church. They are now in the cloister of Santo Spirito in Florence (Florence, Soprintendenza, Gabinetto Fotografico, neg. 264124). It is he who seems to have sold the Johnson picture.

15. Berenson 1968, plate 206. The recorded signature and date of 1345 are no longer visible.

16. No. 1975.106. Pope-Hennessy 1987, plate 28.

17. At some point it was transformed into a triptych with wings by an anonymous Florentine artist of the mid-fifteenth century. The additions, which were removed before 1935 (see Minneapolis 1935, repro. p. 159), appear in a photograph of the painting when it was on the Florentine art market sometime before 1925 (Reali neg. 673).

18. No. 61.113 (K1197); Shapley 1966, fig. 204.

Bibliography

Sirén 1908, p. 27, plate 12 (Giottino); Mather 1911, p. 61 (Giottino); Berenson 1913, p. 5, repro. p. 227 ("Giottino"); Sirén 1917, pp. 209, 274, detail plate 183; Van Marle, vol. 3, 1924, pp. 423–24, fig. 242; Sirén 1927, p. 22, fig. 12; Sirén 1927–28, pp. 396–400, repro. opp. p. 398; Handbook 1931, p. 41 (Florentine school, about 1350); Kimball 1931, n.p., repro.; Berenson 1931–32, repro. p. 1042; Berenson 1932, p. 275; Berenson 1936, p. 236; Callisen 1937, p. 458 n. 67; Johnson 1941, p. 10 (close to Maso di Banco); Friedmann 1946, p. 147, detail plate 88; Berenson 1963, p. 105; Sweeny 1966, p. 48, repro. p. 87 (close to Maso di Banco); Berenson 1969, pp. 96, 98, fig. 146; Meiss 1971, p. 418, fig. 59; Fredericksen and Zeri 1972, p. 219 (Florence, fourteenth century); Davies and Gordon 1988, p. 2; Frinta 1993, pp. 23–24, fig. 9; and color detail p. 18; Philadelphia 1994, repro. p. 175; Skaug 1994, vol. 1, pp. 143, 145 n. 59; vol. 2, chart 6.2; Frinta 1998, pp. 79, 236, 285 repro., 295, 306, 347, 352, 358 repro., 373, 495, 499, 504–5, 540

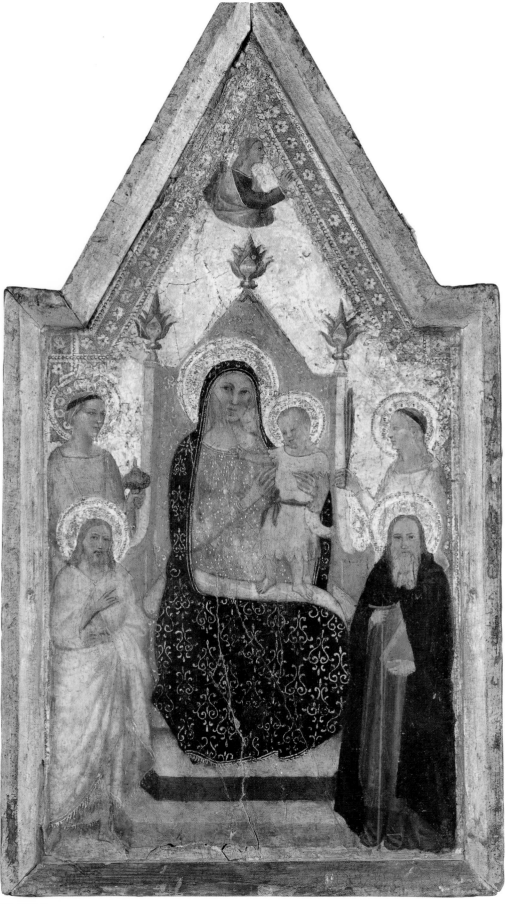

PLATE 2

PLATE 2 (JC CAT. 2)

Valve of a diptych: *Virgin and Child Enthroned with Saints Lucy, John the Baptist, and Anthony Abbot, a Female Martyr, and the Annunciate Angel*

c. 1350

Tempera and tooled gold on panel with vertical grain; 17⅛ × 9⅝ × 1″ (43.5 × 24.2 × 2.4 cm), painted surface 16 × 7¾″ (40.5 × 19.5 cm)

John G. Johnson Collection, cat. 2

INSCRIBED ON THE REVERSE: *Dodge* (in ink on a sticker); *JOHNSON COLLECTION/ PHILA.* (stamped in black)

PUNCH MARKS: See Appendix II

EXHIBITED: Philadelphia Museum of Art, Sixty-ninth Street Branch, *Religious Art of Gothic and Renaissance Europe* (December 1, 1931–January 2, 1932), no catalogue

TECHNICAL NOTES

The panel retains its original thickness and seemingly original red paint on the back (fig. 2.1). A complex split runs the length of the panel left of center. The applied moldings are original except for the left strip on the gable and the bottom strip. The sides of the panel are repainted, but where this repaint has chipped away, some of the apparently original red can be seen. Nail holes are visible on the right edge, where a hinge or hinges were once attached. A hanging hook was most likely once inserted into the top of the panel, where a gouged-out area is now covered with an irregular scrap of canvas. In an early restoration a strip of wood was attached to the bottom of the back.

The gilding is largely new. Traces of the original gilding are visible in the engaged frame, in the punched border, and in the gable of the picture surface. Some of the gold fringe is restoration and does not follow the original contours. The mordant gilding on the Virgin's costume is finely preserved and has little restoration. The mordant itself is white.

Though generally worn, the paint surface has no real losses. The figure of Saint Lucy is in the best condition, and the gold of her halo is intact. In 1964, however, Theodor Siegl noted that the panel was "quite fragile."

PROVENANCE

Langton Douglas billed John G. Johnson 300 pounds sterling on February 25, 1911.

COMMENTS

The enthroned Virgin balances the Christ Child on her lap. To the left stand Saint John the Baptist wearing a hair shirt and Saint Lucy holding a pyx. To the right a female saint carries a palm of martyrdom,¹ and Saint Anthony Abbot holds a tau-shaped cane. Gabriel, the Annunciate Angel, appears as a bust-length figure at the top.

FIG. 2.1 Reverse of plate 2, showing the probably original paint

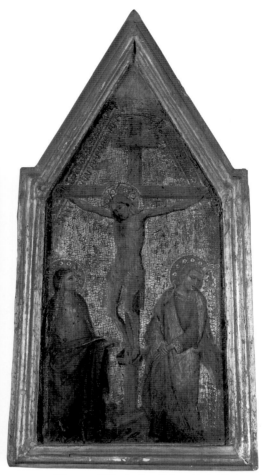

FIG. 2.2 Allegretto di Nuzio. *Crucifixion with the Virgin and Saint John the Evangelist,* c. 1350. Tempera and tooled gold on panel; 15⅜ × 7½″ (39 × 19 cm). Esztergom, Hungary, Keresztény Múzeum, no. 55.149. See Companion Panel

COMPANION PANEL for PLATE 2

Valve of a diptych: *Crucifixion with the Virgin and Saint John the Evangelist.* See fig. 2.2

C. 1350

Tempera and tooled gold on panel; 15⅜ × 7½″ (39 × 19 cm). Esztergom, Hungary, Keresztény Múzeum, no. 55.149

PROVENANCE: Unknown

SELECT BIBLIOGRAPHY: Boskovits, Mojzer, and Musci 1965, p. 181, plate 1/6; Boskovits 1966, no. 27 (color)

PLATE 3 (JC CAT. 119)
Virgin and Child

1360s

Tempera, silver, and tooled gold on panel with horizontal grain; with modern frame 17 × 13⅞″ (43 × 35.2 cm); panel measured from the back 14¾ × 11⅞ × 1¼″ (37.3 × 30 × 3 cm); painted surface 13⅝ × 10⅝″ (34.5 × 27 cm)

John G. Johnson Collection, cat. 119

INSCRIBED ON THE REVERSE: *Si visiterà divotamente que/ sta Sagra Immagine detta del/ Nome SSmo di Mᵃ le recete/ rà qualunque orazione acqui=/ sterà 100 giorni d'In-gul·ᵃ:/ e recitandosi le litanie ne ac=/ quisterà 50 giorni di conces=/ sione detta S.M. di Papa Pio VI.* (Who will come devotedly to see this sacred image of the Most Holy Name of Mary and will recite there any prayer will gain 100 days of indulgence and reciting the litanies will acquire 50 days of concession called the "S.M." of Pope Pius VI); *119 IN 159* (in pencil on a piece of glued paper); *CITY OF PHILADELPHIA/ JOHNSON COLLECTION* (stamped in black ink); two pieces of fabric (attached by nails), each ¾″ (2 cm) square

EXHIBITED: Philadelphia Museum of Art, Sixty-ninth Street Branch, *Religious Art of Gothic and Renaissance Europe* (December 1, 1931–January 4, 1932), no catalogue

TECHNICAL NOTES

The applied moldings are new. Original gesso barbes are visible on the sides, but none are seen at the top and bottom, which may indicate that the panel has been slightly cropped. The palmettes in the corners are old, if not original: they were executed in a silver leaf on a transparent mordant. Those at the top are largely lost and have been restored. The panel has not been thinned, and original gesso can be seen on the back. At the top center of the back there is an old hole for a hanging hook.

The Virgin's undergarment and Christ's drapery were executed in elaborate sgraffito. Well-preserved mordant gilt striations decorate the Virgin's mantle. The mordant is a dark buff color.

On March 13, 1920, Hamilton Bell and Carel de Wild noted old retouches throughout. De Wild subsequently treated the painting. In 1926 F. Mason Perkins wrote on the mount of the photograph of this panel in the Frick Art Reference Library in New York that the painting was darkened and damaged.

Bernhard Berenson (1913) attributed this panel to Bernardo Daddi (q.v.). Osvald Sirén, in a letter to Johnson dated New York, January 5, 1916, correctly ascribed it to Allegretto di Nuzio and dated it early in the artist's career. Evelyn Sandberg Vavalà, speaking to Barbara Sweeny in 1939, agreed with this attribution. In 1978, during a visit to the Philadelphia Museum of Art, Miklós Boskovits recognized that this panel was the left valve of a diptych, and that the other valve is a *Crucifixion* (fig. 2.2) in Esztergom, Hungary. The measurements of the two pieces correspond; the Esztergom painting is cut at the top and is therefore missing the Virgin Annunciate. The tooling of the borders and the halos of the two panels are similar but not exactly the same, although these are not reasons enough to doubt that they once formed a diptych.

The Philadelphia-Esztergom diptych can be compared with Allegretto's signed diptych in the Staatliche Museen in Berlin.[2] The pose of the Virgin in that *Crucifixion* is the same as the one in the Esztergom panel. Both diptychs probably date shortly

after Allegretto's Florentine period of 1346 because of their similarity to small-scale works produced by Florentine artists such as Bernardo Daddi and his many followers in the previous decade. This date is further supported by the shape of the finials of the throne in the Johnson painting, which is the same as that on the throne of Allegretto's mural of the enthroned Virgin in the Saint Lawrence chapel of Fabriano cathedral, also dating around the late 1340s.[3]

1. Berenson (1932) tentatively identified her as Ursula.
2. Nos. 1076, 1078; Boskovits 1988, plates 1–2.
3. Molajoli 1968, fig. 20.

Bibliography
Berenson 1913, pp. 4–5 (Bernardo Daddi); Sirén 1914a, p. 264; Comstock 1928, p. 26; Offner 1930, p. 11; Berenson 1932, p. 400; Berenson 1936, p. 344; Johnson 1941, p. 12; Sweeny 1966, p. 59, plate 88; Kermer 1967, pp. 60–61, no. 58A, fig. 74a; Berenson 1968, p. 304; Fredericksen and Zeri 1972, p. 4; Giampiero Donnini in *Allgemeines Künstlerlexikon,* vol. 2, 1986, p. 181; Boskovits 1988, p. 3; Giampiero Donnini in *Saur,* vol. 2, 1992, p. 461; Philadelphia 1994, repro. p. 175

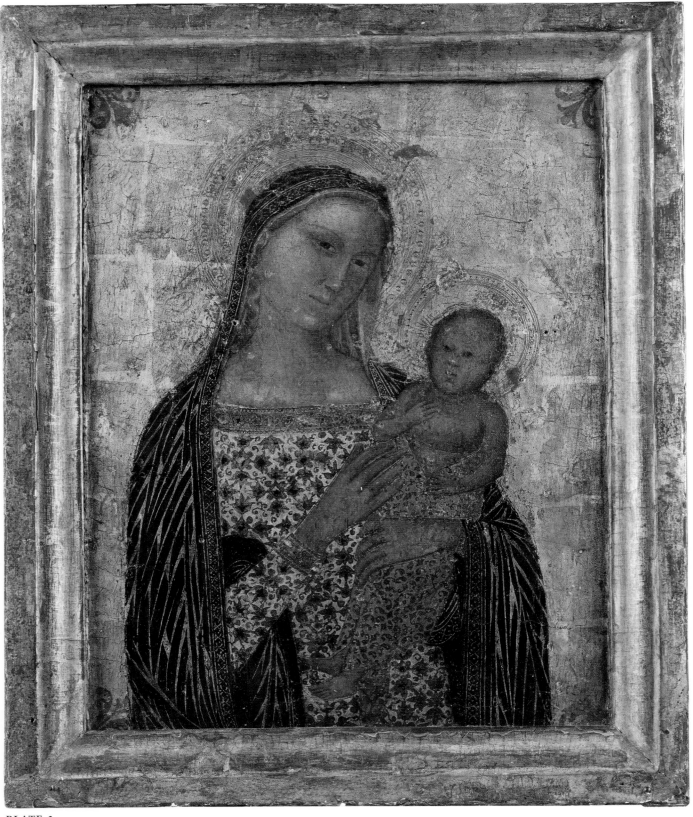

PLATE 3

And, in fact, the surface still carries a heavy layer of discolored varnish. There is evidence that metal crowns were once attached to the heads of the Virgin and the Child for devotional reasons.

PROVENANCE

According to Perkins's 1926 note on the photograph in the Frick Library, this painting was sold to John G. Johnson by Herbert Horne. However, the Johnson-Horne correspondence makes no reference to the picture. The inscription on the back of the panel suggests that it was highly revered in the late eighteenth century, when Pope Pius VI Braschi granted indulgences for prayers said in front of the image.

COMMENTS

The Virgin, depicted in half-length, presents the Christ Child to the viewer in a simple image that is enhanced by their elaborate dress. Richly patterned costumes appear in many other works by Allegretto. The taste for portraying such luxurious textiles was popularized in Florentine painting in the workshop of the Cioni, who also juxtaposed different patterns within the same picture, as is done here. Such motifs were apparently introduced into Allegretto's work through the influence of the Florentine Puccio di Simone. Allegretto restored one of the saints for the altarpiece that a certain friar Giovanni had commissioned Puccio to paint in 1354 for Sant'Antonio fuori Porta Pisana in Fabriano,[1] and in 1369 Allegretto

executed a free copy of this altarpiece (fig. 3.1), which the Johnson *Virgin and Child* resembles quite closely in style.

1. Shapley 1979, plate 276.

Bibliography
Berenson 1913, p. 68 (school of Allegretto di Nuzio); Van Marle, vol. 5, 1925, pp. 153–54, fig. 93; Berenson 1932, p. 400; Berenson 1936, p. 344; Callisen 1937, p. 458 n. 54; Johnson 1941, p. 12; Sweeny 1966, p. 59, repro. p. 89; Berenson 1968, p. 304; Fredericksen and Zeri 1972, p. 4; Donnini 1975, p. 536 n. 13; Giampiero Donnini in *Allgemeines Künstlerlexikon*, vol. 2, 1986, p. 181; Giampiero Donnini in *Saur*, vol. 2, 1992, p. 461; Philadelphia 1994, repro. p. 175 (Allegretto di Nuzio); Frinta 1998, p. 194

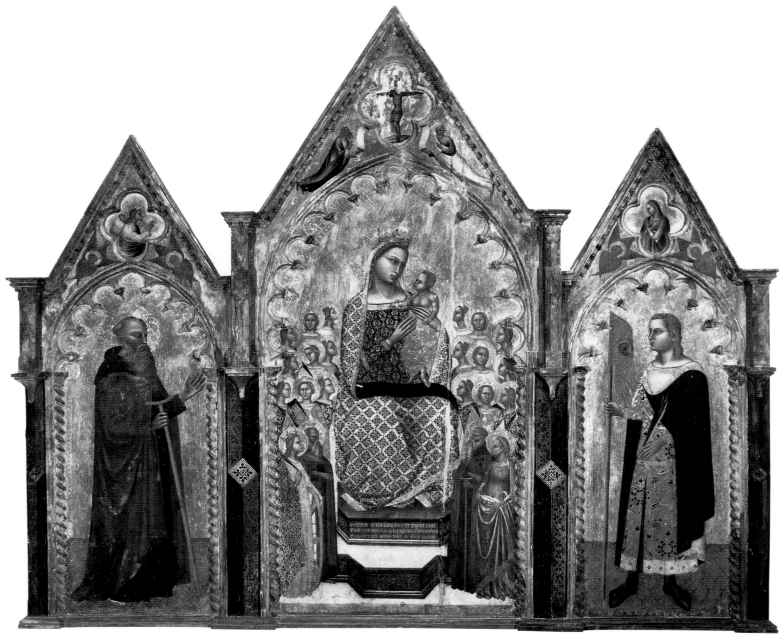

FIG. 3.1 Allegretto di Nuzio. Altarpiece: *Virgin and Child with Saints*, 1369. Tempera and gold on panel; 59⅞ × 69¾″ (152 × 177 cm). From Montecassiano, church of Sant'Antonio. Macerata, cathedral

PLATE 4 (JC CAT. 118)

Diptych: (left valve) *Virgin and Child;* (right valve) *Man of Sorrows*

c. 1366

Tempera and tooled gold on panel with vertical grain; overall 15⅜ × ½″ (39 × 1.2 cm); left valve 15⅜ × 10⅛ × 1¼″ (39 × 25.5 × 3.2 cm), painted surface 13¾ × 8½″ (34.7 × 21.5 cm); right valve 15⅜ × 9⅞ × 1¼″ (39 × 25 × 3.2 cm), painted surface 13⅞ × 8⅜″ (35 × 21.3 cm)

John G. Johnson Collection, cat. 118

INSCRIBED ON THE REVERSE: *Royal Academy Winter Exhibition—1904/ Sienese School/ Diptych Madonna & Child and Pietà/ Arthur E. Street Esq./ 24ª Bryanston Sq. W.* (on a label); *S004/ 118* (on a sticker); *S003* (on a sticker); *118.IN1515* (in pencil)

PUNCH MARKS: See Appendix II

EXHIBITED: London 1904, cat. no. 19 (Sienese School)

TECHNICAL NOTES

The two panels are now glued together and attached with iron straps at the top and bottom; it is not clear how they were originally joined. The X-radiograph (fig. 4.1) shows numerous paired nail holes along the common edge, but no indication of hinges or other hardware. The panels retain their original thickness and are painted a dark, mottled reddish brown on their backs and side (fig. 4.2). The applied moldings are original, but they have been regessoed and regilt. Under microscopic examination, some of the original gold is evident.

The gilding and paint surface are in an exceptionally good state. Extremely fine brushstrokes can be seen on details like the hairs and specks of blood on Christ's body. The Virgin's now-darkened blue mantle was glazed with a red lake pigment, which would have originally given it a more violet tonality. The gilt decoration on the costumes is applied on a colorless mordant. The outlines of the figures were incised in the gesso, and after gilding the background a white paint was applied where the figures would have overlapped the gold to improve adhesion of the colors. This method, for which Cennino Cennini (Cennini c. 1390, Thompson ed. 1932–33, vol. 1, pp. 85–86; vol. 2, pp. 83–84) recommended a paint size made of white lead and glue, is known as *ritagliare* and is here clearly visible in the X-radiograph (fig. 4.1).

In March 1920 Hamilton Bell and Carel de Wild both noted the good condition of this painting.

PROVENANCE

The label on the back indicates that the painting was owned in 1904 by Arthur E. Street of London.

COMMENTS

In the left valve the half-length Virgin carries the Christ Child. The star on her right shoulder is the symbol of the *stella maris.* Jesus clutches a

FIG. 4.1 X-radiographic detail of plate 4, showing the paint size that outlines the figures

FIG. 4.2 Reverse of plate 4, showing the original paint

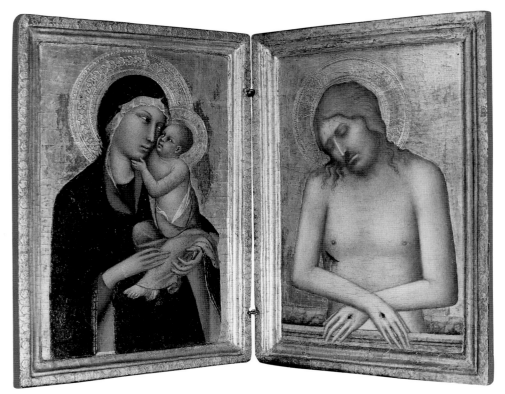

FIG. 4.3 Attributed to Simone Martini (Siena, c. 1284; died 1344) or a close follower. Diptych, c. 1325–30: LEFT VALVE *Virgin and Child;* RIGHT VALVE *Man of Sorrows.* Tempera and tooled gold on panel; each 11⅛ × 9⅞″ (28 × 25 cm). Florence, Museo Horne, nos. 55–56

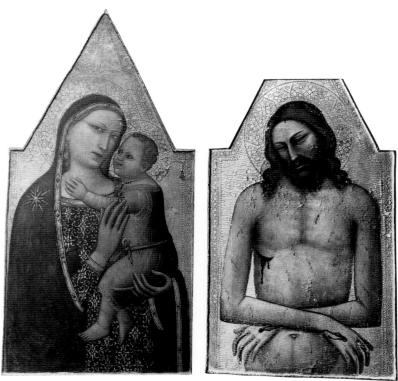

FIGS. 4.4 and 4.5 Allegretto di Nuzio. Diptych, 1345. LEFT VALVE *Virgin and Child.* Tempera and tooled gold on panel. Last recorded Frankfurt, Georg Hartman Collection. Present location unknown. RIGHT VALVE *Man of Sorrows.* Tempera and tooled gold on panel; cropped at the top. Genoa, private collection

goldfinch, a prescient symbol of his suffering on the cross.[1] In the right wing, the dead and naked Christ as the Man of Sorrows stands in a pinkish sarcophagus with his arms crossed.

The pairing of the Virgin and Child with the Dead Christ in diptychs seems to have first occurred in Italian art in the third decade of the fourteenth century.[2] A diptych (fig. 4.3) of about 1325–30, attributed to Simone Martini or a close follower, is one of the first surviving examples.[3] Before that time the Crucifixion was more common in diptychs with the Virgin and Child.[4] The subsequent substitution of the more intimate Man of Sorrows combined two popular devotional images that could be depicted on the same scale. Artists such as Pietro Lorenzetti (q.v.) followed Martini's lead and popularized such paintings,[5] which were invariably made for private patrons.[6] Although the type was not unknown in Florence,[7] Allegretto probably saw examples in Siena before his Florentine sojourn of about 1346.

Two other diptychs by Allegretto di Nuzio and his workshop also combine the Virgin and Child with the Man of Sorrows (figs. 4.4–4.7).[8] The rectangular format of the Vatican and Johnson diptychs may indicate a late date, as Allegretto's small panels with gabled tops tend to date early. Support for a later date for the Johnson diptych might be found in Allegretto's altarpiece of 1366 (fig. 4.8), for San Francesco in Apiro, for as Berenson noted, the Virgin and Child in both paintings are very similar.

1. On both the goldfinch and the *stella maris,* see Battista di Gerio, plate 12 (JC cat. 12).
2. On the Man of Sorrows, see Niccolò di Pietro Gerini, plate 27 (JC cat. 8), and Taddeo di Bartolo, plate 78 (JC cat. 95). The origin of the diptych with the Virgin and Child and Man of Sorrows can be traced to twelfth-century Byzantine examples. See, for example, the icon in Kastoria, Greece (Belting 1981, figs. 49, 50).
3. Occasionally the Man of Sorrows was an independent subject. See Naddo Ceccarelli's *Man of Sorrows* of c. 1337–40 in the Liechtenstein Collection in Vaduz (Lugano 1991, color plate p. 49).
4. For example, see the Sienese thirteenth-century diptych of the Virgin and Child in London, National Gallery (no. 4741); and *Christ on the Cross* in Budapest, Szépmüvészeti Múzeum (no. 18c); Davies and Gordon 1988, plates 67–68, fig. 21.
5. See the diptych in Altenburg, Germany, Lindenau-Museum (nos. 47–48); Volpe 1989, plates 172–73.
6. Simone's diptych in the Museo Horne in Florence has a contemporary inscription indicating it was owned by "Misser Giorgio di Tommaso."
7. An anonymous Florentine example of c. 1330–40 is in New York, The Metropolitan Museum of Art (1975.1.3,4; Pope-Hennessy 1987, repro. p. 47).
8. In addition, a *Virgin and Child* in Altenburg, Germany, Lindenau-Museum (no. 52; Oertel 1961, plate 78a) may have been a left valve of a similar diptych.

(text continues on page 36)

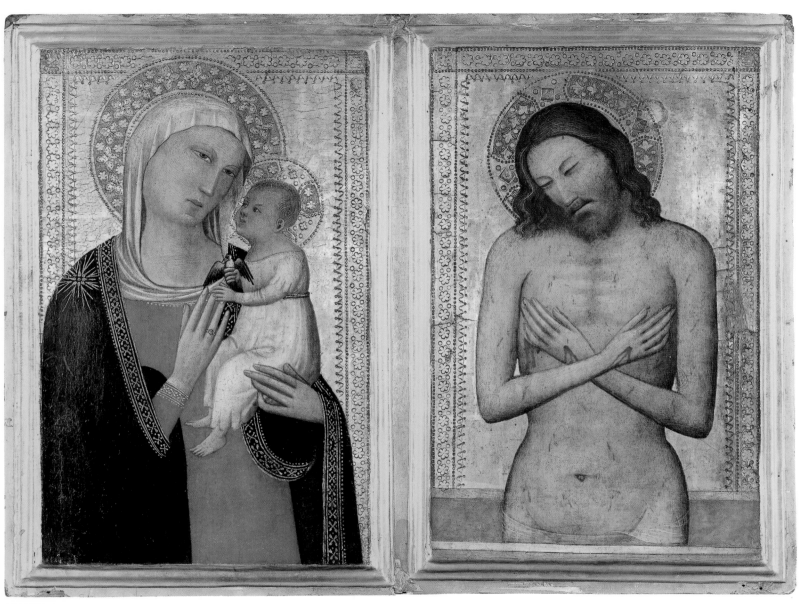

PLATE 4

Bibliography
London 1904a, p. 9, no. 19 (Sienese School); Berenson
1913, p. 68 (Allegretto di Nuzio); Post 1915, p. 214; Van
Marle, vol. 5, 1925, p. 161 n. 1; Comstock 1927, p. 22; Offner
1927, p. 94; Serra 1929, p. 296 n. 8; Berenson 1932, p. 400;
Berenson 1936, p. 344; Johnson 1941, p. 12; Friedmann
1946, p. 160, plate 113; Sweeny 1966, p. 59, repro. p. 89;
Kermer 1967, pp. 61–62, no. 59, fig. 75; Vertova 1967, p. 671;
Berenson 1968, p. 304; Fredericksen and Zeri 1972, p. 4;
Philadelphia 1994, repro. p. 175; Rossi 1994, pp. 67–68;
Skaug 1994, vol. 1, p. 143, vol. 2, chart 6.2; Frinta 1998, pp.
79, 209, 295, 346 repro., 358, 499 repro., 504

 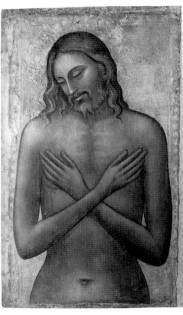

FIGS. 4.6 and 4.7 Allegretto di Nuzio and workshop. Diptych, c. 1366. LEFT VALVE *Virgin and Child.* Tempera and tooled gold on panel; 12 × 8⅛″ (30.5 × 20.5 cm). Vatican City, Pinacoteca Vaticana, no. 180 (210). RIGHT VALVE *Man of Sorrows.* Tempera and tooled gold on panel; 13⅞ × 8¼″ (35 × 21 cm). Vatican City, Pinacoteca Vaticana, no. 189 (208)

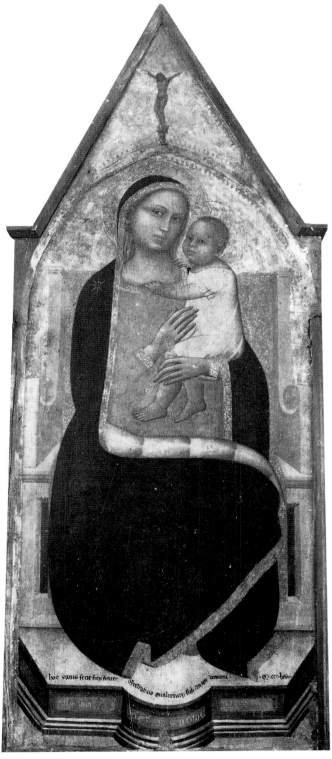

FIG. 4.8 Allegretto di Nuzio. Detail of an altarpiece: *Virgin and Child,* 1366. Tempera and tooled gold on panel; overall 64⅝ × 90⅝″ (164 × 230 cm). From Apiro (near Fabriano), church of San Francesco. Apiro, Palazzo Muncipale

Andrea di Bartolo

SIENA, FIRST DOCUMENTED 1389;
DIED BEFORE JUNE 3, 1428, SIENA

Son of the painter Bartolo di Fredi and Bartolomea di Cecco, Andrea enrolled in the Sienese painters' guild in 1389. That same year he collaborated with his father and Luca di Tommè on a now-lost altarpiece for a chapel in the cathedral of Siena; his hand may be seen in some of his father's other surviving paintings as well.[1] In what must be Andrea's first independent work, the *Coronation of the Virgin* in the Virginia Museum of Fine Arts in Richmond, he signed himself "the son of Bartolo," and, in fact, the picture depends on his father's models.[2] It seems that this altarpiece came from Venice, where Andrea di Bartolo found employment in the 1390s. This may be the altarpiece that the sixteenth-century Venetian historian Francesco Sansovino (1604, p. 175) described in the Camaldolese convent of San Michele in Isola in Murano.[3]

Creighton E. Gilbert (1984a) and Gaudenz Freuler (1987) have conjectured that a number of Andrea's small-scale devotional paintings were made for the cells of the Dominican Observant nunnery of the Corpus Domini in Venice, which was the original location of his altarpiece *Saint Catherine of Siena and Four Mantellate of the Third Dominican Order*.[4] This convent was consecrated by the influential Florentine friar Giovanni Dominici in 1394. The Sienese Dominican Observant Tommaso Caffarini was also in Venice in the 1390s. Both of these friars had close contacts with the convent of San Domenico in Siena, and it is likely that Andrea secured work in Venice through such connections.[5]

The artist was back in Siena by 1397, when he signed a now-fragmentary polyptych of the Annunciation, probably for the church of San Domenico.[6] The painting demonstrates that the artist's style no longer reflected the influence of his father but rather the more solid manner of his contemporaries Taddeo di Bartolo and Martino di Bartolomeo (qq.v.).

While many documents attest to Andrea di Bartolo's political activity in Siena in the following years, little information exists about his artistic career.[7] His only employment that is securely documented is his work in the cathedral of Siena, where he painted murals in the chapel of San Vittore in 1405 and restored Ambrogio Lorenzetti's *Presentation in the Temple* in the chapel of San Crescenzio in 1406–7.[8] In 1409 he also polychromed two of Francesco di Valdambrino's statues of Siena's patron saints and provided designs for stained glass; of these, only one of the statues survives.[9] His only dated later works are four panels of saints from a polyptych of 1413, now in the Osservanza in Siena.[10] Andrea's son Giorgio may have executed, or at least collaborated on, a group of altarpieces from the

Marches and northern Lazio that are usually attributed to Andrea himself.[11] It also seems likely that in later years Andrea returned to northern Italy and painted a chapel in San Francesco in Treviso.[12] On June 3, 1428, the artist was given an honorable burial in the convent of San Domenico in Siena.

1. These include the Cacciati altarpiece of c. 1380 from San Francesco in Montepulciano and the Circumcision altarpiece of 1388 from Sant'Agostino in San Gimignano (see reconstructions in Freuler 1994, figs. 136, 240). For the latter, Andrea painted the panel of the Massacre of the Innocents (Baltimore, The Walters Art Museum, inv. 37.1018; Freuler 1994, fig. 239 [color]). See also Freuler 1985, p. 162; 1987, p. 578; Kanter 1983.
2. No. 54-11-3; Berenson 1968, plate 423.
3. His observations were first noted by Gilbert 1984a, p. 113. This painting is described in other guides as a Nativity. See Freuler 1987, pp. 577–78 esp. n. 48, 580. Freuler (1987, pp. 570 n. 1, 584) argues convincingly for the San Michele in Isola provenance for the painting in Richmond.
4. See Gaudenz Freuler in Lucco 1992, pp. 486–94. The altarpiece is on deposit from the Gallerie dell'Accademia of Venice (inv. 658 [cat. 7]), in the Museo Vetrario in Murano; Lucco 1992, figs. 649–51 (color).
5. Gilbert 1984a; Freuler 1987.
6. Now in the museum in Buonconvento, near Siena; see Serena Padovani in Padovani and Santi 1981, pp. 23–25, fig. 5 (color); and Giulietta Chelazzi Dini, cited by Alessandro Cecchi in Siena 1982, p. 313.
7. Milanesi 1854–56, vol. 1, 1854, p. 41.
8. Florence, Uffizi, no. 8346; Chelazzi Dini, Angelini, and Sani 1997, postrestoration color repro. p. 173.
9. *Saint Crescentius*; Siena, Museo dell'Opera della Metropolitana; Siena 1987a, color repro. p. 141.
10. Osservanza 1984, color plates 71–73.
11. Kanter 1986. Freuler (1987, p. 571 n. 1) disagrees with this view.
12. See Meiss 1955; Freuler 1987; Gaudenz Freuler in Lucco 1992, pp. 494–501. Reproduced in Meiss 1955, p. 145, fig. 28; Freuler 1987, figs. 10–12; Lucco 1992, figs. 657–58 (color).

Select Bibliography
Milanesi 1854–56, vol. 1, 1854, pp. 41–42; vol. 2, 1854, pp. 26, 36, 383; Crowe and Cavalcaselle 1903–14, vol. 3, edited by Langton Douglas, 1908, pp. 85, 121, 125 n., 126, 129, 134–37; Giacomo De Nicola in Thieme-Becker, vol. 1, 1907, pp. 449–50; De Nicola 1921; Van Marle, vol. 2, 1924, pp. 572–82; Bacci 1936, pp. 163, 169, 255; Bacci 1944, p. 209; Brandi 1949, pp. 28, 173–74 n. 6, 243; Meiss 1955, p. 145; Ornella Francisci Osti in *DBI*, vol. 3, 1971, pp. 74–75; *Bolaffi*, vol. 1, 1972, pp. 133–35; Alessandro Cecchi in Siena 1982, p. 313; Kanter 1983; Gilbert 1984a; Freuler 1985; Kanter 1986; Eberhard Kasten in *Allgemeines Künstlerlexikon*, vol. 2, 1986, pp. 973–77; Monica Leonici in *Pittura* 1986, pp. 551–52; Freuler 1987; Charlotte Weithoff in Van Os et al. 1989, p. 29; Gaudenz Freuler in Lucco 1992, pp. 486–501; Eberhard Kasten in *Saur*, vol. 3, 1992, pp. 511–15; Freuler 1994; Gaudenz Freuler in *Dictionary of Art* 1996, vol. 7, pp. 330–31

PLATE 5 (JC CAT. 99)

Center panel of a triptych: *Virgin and Child Enthroned with Saints John the Baptist and James Major*

c. 1394

Tempera and tooled gold on panel with vertical grain; 11⅛ × 7⅞ × ¾" (28.2 × 20 × 1.9 cm)

John G. Johnson Collection, cat. 99

INSCRIBED ON THE BAPTIST'S SCROLL: *E* [in red] *CCE ANGUS* [*sic*] *DEI* [*ECCE*] *QUI* [*TOLLIT PECCATA MUNDI*] (John 1:29: "Behold the Lamb of God, behold him who [taketh away the sin of the world"]); ON THE REVERSE: *99/ in. 350* (in pencil on a label); *CITY OF PHILADELPHIA/ JOHNSON COLLECTION* (stamped in black ink)

PUNCH MARKS: See Appendix II

EXHIBITED: Philadelphia Museum of Art, John G. Johnson Special Exhibition Gallery, *From the Collections: Paintings from Siena* (December 3, 1983–May 6, 1984), no catalogue

Technical Notes

When this panel was disassembled from a triptych, the applied moldings and pinnacle were removed, and the back was planed except for a patch of the original gesso layer near the top. On the front a strip of the gilt pastiglia was removed from the top when at some point the painting was fitted with a separate frame. Remnants of gesso barbes are present along the sides and bottom.

Incised lines were used to indicate the limits of the gilding and the folds in the Virgin's blue mantle. Infrared reflectography revealed drawing throughout the panel (figs. 5.1–5.3).[1] In the Virgin's robe the drawing and incised lines coincide. A grainy freehand drawing executed with a dry medium can be seen in all the major areas of folded drapery on Christ and the two saints, and in the pedestal. Changes can be seen in the position of Christ's right shoulder and the bird he holds as well as in the angle of the corners of the pedestal. The drawing in the Baptist's drapery near the scroll also shows changes, and his robe overlaps with that of the Virgin.

The gilding and paint surface are in good condition, with little abrasion and only fairly minor losses. Typical color changes have occurred: red lakes have faded throughout; the throne's vermilion hanging and the Virgin's blue mantle have darkened; and the green glazes in Christ's garment and in the pedestal have turned brown. The throne's hanging is decorated in sgraffito with vermilion glazed with a red lake, and mordant gilding was used for details

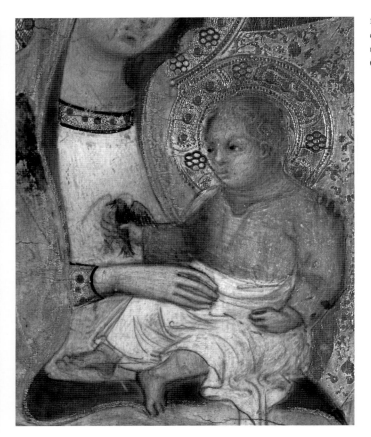

FIG. 5.2 Infrared reflectographic detail of plate 5, showing the underdrawing of the Virgin and Christ Child

FIG. 5.3 Infrared reflectographic detail of plate 5, showing the underdrawing of the base of the throne

FIG. 5.1 Infrared reflectographic detail of plate 5, showing the underdrawing of Saint John the Baptist

in the costumes. The floor was painted to imitate blue-and-red-veined marble. The edge of the floor closest to the picture plane was lightened with strokes of white paint, a typical late trecento spatial device that is also seen in the diptych attributed to Benedetto di Bindo (see plate 13 [JC cat. 153]).

There is no record of restoration.

PROVENANCE

Johnson owned the painting in 1905. It is likely that he purchased it through F. Mason Perkins, who had published it that year.

COMMENTS

Saints John the Baptist and James Major stand on either side of the enthroned Virgin and Child. Jesus grasps a goldfinch, a symbol of his future suffering on the cross.

The picture was the center of a portable triptych by Andrea di Bartolo; the other sections are not

known.² However, four very similar triptychs, in which the tooling of the gold and the treatment of the pastiglia are nearly or almost identical, help reconstruct the original appearance. They are in the Lindenau-Museum in Altenburg, Germany (fig. 5.4); the Staatliche Museen in Berlin;³ the Národní Galerie in Prague;⁴ and the Pinacoteca Nazionale in Siena.⁵ The Philadelphia triptych probably had a scene in the center gable, possibly the Crucifixion (as in Berlin) or the Resurrection (as in Siena). The wings would have contained either a single saint or a pair of saints, and the pinnacles would have shown the Annunciate Angel and the Virgin Annunciate.

The identity, pose, and dimensions of the figures in the Johnson panel are closely related to those in the center section of the Altenburg triptych (fig. 5.4), which suggests that the artist used a similar cartoon for both.⁶ Although the Philadelphia painting shows much freehand drawing and several changes in composition, it is unclear that it is the

first version. The figure of James Major in a triptych in the Brooklyn Museum (fig. 5.5) is similar in both its painting and underdrawing to the Johnson panel (fig. 5.6), although they were not necessarily based on the same cartoon.

Repetition is not unusual in Andrea di Bartolo's small-scale work. For example, Henk van Os (1974a; 1969, esp. pp. 119–23) has documented its frequent occurrence in the artist's compositions of the Virgin of Humility. This working method might have been employed in executing a series of paintings, such as those for the cells of a convent. In fact, Creighton Gilbert (1984a) has suggested that Andrea di Bartolo painted a group of documented *ancone*, or small-scale paintings such as triptychs, for the Venetian Dominican Observant nunnery of Corpus Domini, which was consecrated in 1394. Although the Corpus Domini pictures have not been securely identified as his work,⁷ both the Johnson panel as well as the above-mentioned triptychs could have been made

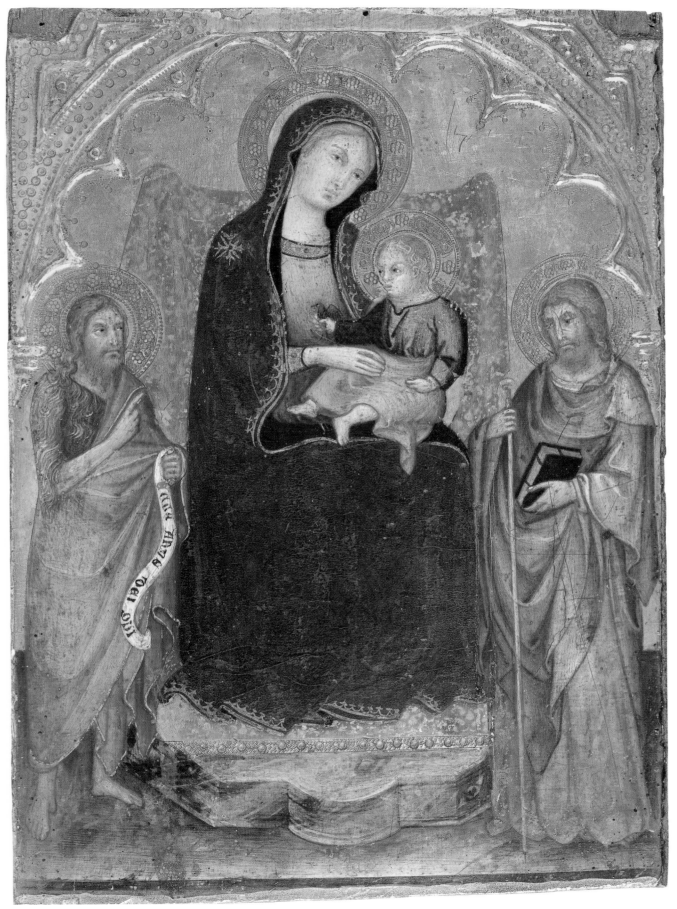

PLATE 5

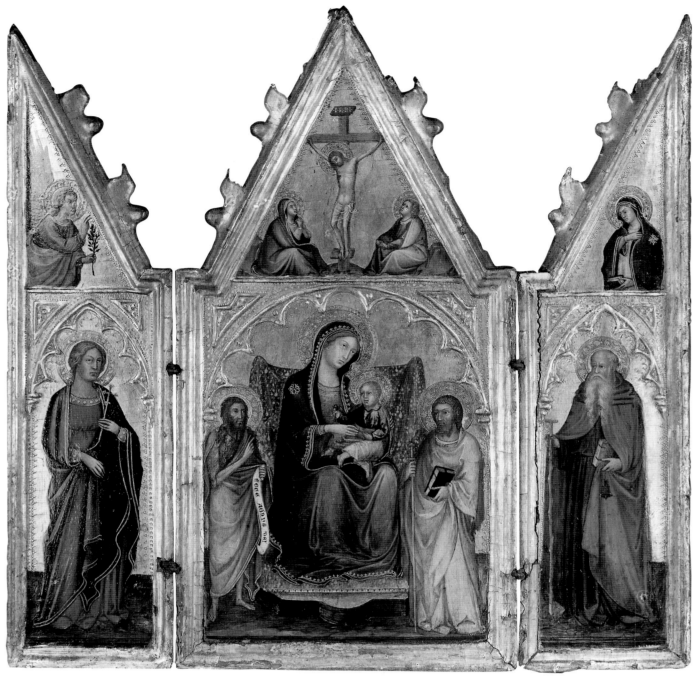

FIG. 5.4 Andrea di Bartolo. Triptych: (center) *Virgin and Child with Saints John the Baptist and James Major with the Crucifixion;* (left wing) *Saint Margaret with the Annunciate Angel;* (right wing) *Saint Anthony Abbot with the Virgin Annunciate,* c. 1395–1400. Tempera and tooled gold on panel; overall 20½ × 21⅛″ (52 × 53.5 cm). Altenburg, Germany, Lindenau-Museum, no. 58

for such cells of a convent or monastery. While it is impossible to say if the Johnson painting was part of the Venetian project, a date around 1394 or shortly after fits well in our present understanding of Andrea di Bartolo's stylistic development.

1. Strehlke 1991, p. 200, figs. 63–65.
2. In the Museo Stefaniano in Bologna there are two panels, each with a saint and each missing its pinnacles (photograph Edizioni Croci, neg. 4617). The tooling

and pastiglia decoration are identical to those in the Johnson panel, but since one of the saints is James Major, who appears here, they must be excluded from consideration as possible companion pieces from the same altarpiece. Other candidates might be two wings (each 23⅝ × 11⅝″ [60 × 29.5 cm]; sold London, Sotheby's, December 12, 1979, lot 78, as Andrea di Bartolo) that were published in 1982 as being in a private collection in Florence (Siena 1982, p. 314, cat. 113). They date c. 1400–1405. Each contains pairs of saints and the Annunciation in the pinnacles, but because one of the

saints is the Baptist, these wings must also be excluded.
3. No. 1095; overall 20⅞ × 16½″ (53 × 41.8 cm); Boskovits 1988, plate 6.
4. Nos. 011.919–011.921; overall 20⅛ × 19¾″ (51 × 50 cm); Pujmanová 1984, color plate 20.
5. No. 133; overall 21¾ × 20⅞″ (55 × 53 cm); Torriti 1977, fig. 231 (color).
6. Without its gable, the triptych measures 11⅛ × 8¾″ (28 × 22 cm). The figures measure as follows: the Virgin, 8⅜ × 4″ (21.2 × 10.1 cm); the Baptist, 7⅛ × 1⅝″ (18 × 4 cm); James Major, 7½ × 2⅝″ (19.1 × 6.7 cm). The

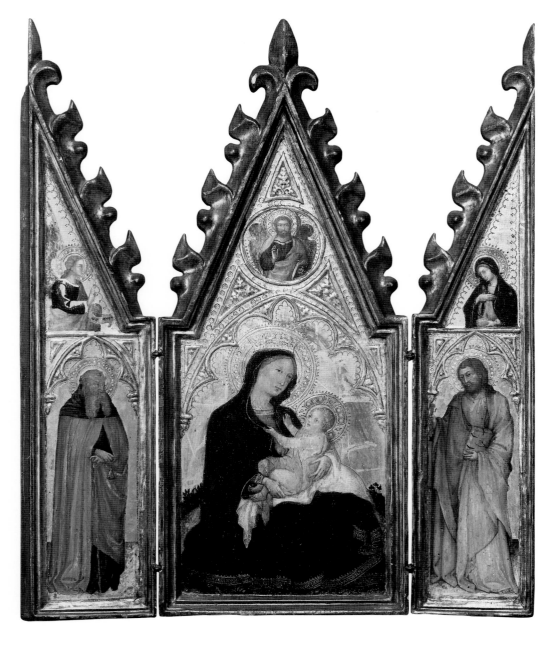

corresponding figures in Philadelphia are: the Virgin, 7½ × 3¾″ (19 × 9.5 cm); the Baptist, 6¼ × 2″ (16 × 5 cm); James Major, 6¾ × 2⅜″ (17 × 6 cm). I thank Jutta Penndorf of the Lindenau-Museum for her help in obtaining this information.

7. Gilbert (1984a) associated Andrea's *Virgin of Humility* and *Crucifixion* in the National Gallery of Art, Washington, D.C. (no. 131 [Kress 1014]; 11½ × 7⅛″ [29 × 18 cm]; Shapley 1979, plates 1, 1a), with the Corpus Domini series. The Berlin triptych also depicts a kneeling Dominican nun as donor, which may connect it to the same program.

Bibliography

Perkins 1905, p. 120 (previously attributed to Guido da Siena; follower of Andrea Vanni); Berenson 1909, p. 257 (Taddeo di Bartolo); Rankin 1909, p. lxxx; Berenson 1913, p. 55; Fogg 1919, p. 114; Van Marle, vol. 2, 1924, p. 268 n. 2; Berenson 1932, p. 552; Berenson 1936, p. 475; Johnson 1941, p. 16 (Taddeo di Bartolo); Symeonides 1965, p. 249; Sweeny 1966, p. 74, repro. p. 101 (Taddeo di Bartolo); Berenson 1968, p. 421; Fredericksen and Zeri 1972, p. 6; Eberhard Kasten in *Allgemeines Künstlerlexikon*, vol. 2, 1986, p. 975; Eberhard Kasten in *Saur,* vol. 3, 1992, p. 513; Strehlke 1991, p. 200, figs. 63–65; Philadelphia 1994, repro. p. 17

FIG. 5.5 (*above*) Andrea di Bartolo. Triptych: (center) *Virgin of Humility with the Redeemer;* (left wing) *Saint Anthony Abbot with the Annunciate Angel;* (right wing) *Saint James Major with the Virgin Annunciate,* c. 1400. Tempera and tooled gold on panel; overall 17¾ × 21¾″ (45.1 × 55.2 cm). Brooklyn Museum of Art; Gift of Mrs. Mary Babbott Ladd, Mrs. Lydia Babbott Stokes, Mrs. Helen Babbott MacDonald, and Dr. Frank L. Babbott, Jr., in memory of their father, Frank L. Babbott, no. 34.839

FIG. 5.6 (*left*) Infrared reflectographic detail showing the underdrawing of Saint James Major in fig. 5.5

Pilaster panel of an altarpiece:
Blessed Ambrogio Sansedoni

After 1413

Tempera, silver, and tooled gold on panel with vertical grain; 15⅛ × 6¾ × ¾″ (38.2 × 17 × 1.9 cm), painted surface 14⅞ × 6¾″ (37.8 × 17 cm)

John G. Johnson Collection, cat. 96

INSCRIBED ON THE REVERSE: *96/ i.n. 1377* (in pencil); *CITY OF PHILADELPHIA/ JOHNSON COLLECTION* (stamped in black ink); *JOHNSON COLLECTION/ PHILA.* (stamped in black ink)

PUNCH MARKS: See Appendix II

TECHNICAL NOTES

The silver leaf in the pastiglia decoration in the arched frame is tarnished and quite abraded, but some untarnished metal is visible under magnification. In the upper left a large loss of the pastiglia exposes the wood of the panel. The punching in the pastiglia is erratically executed. Except for the lower edge (particularly on the right), the paint is in good condition beneath the discolored varnish.

In 1919 Hamilton Bell remarked on the panel's bad state. He and Carel de Wild later noted the absence of ornament in the top left corner as well as some flaking and overcleaning in the paint. De Wild repaired the picture in March 1920. For further comments, see plate 6B (JC cat. 97).

PROVENANCE

See plate 6B (JC cat. 97)

COMMENTS

Starting with Bernhard Berenson's 1913 catalogue this portly Dominican was described as Thomas Aquinas; however, Burton Fredericksen (letter to Barbara Sweeny, dated Malibu, October 10, 1967) noted that the figure's stocky physique and the dove whispering in his left ear argue for an identification with the Blessed Ambrogio Sansedoni (1220–1286). Sansedoni, a Sienese friar, was said to have been such an inspiring preacher that audiences testified to seeing the dove of the Holy Spirit at his ear. While preaching a Lenten sermon against usury, the friar suffered a burst artery and died; he was buried in San Domenico in Siena. His cult quickly became so popular locally that, two years after his death, the Sienese government declared an official annual celebration in his honor and financed the building of his sepulchral chapel.[1] Taddeo di Bartolo's (q.v.) mural of Sansedoni in the Palazzo Pubblico in Siena, executed between 1406 and 1407, depicts the holy man with the same physical characteristics, dress, and dove seen here, although in the mural he also holds a model of the city.[2] For further comments, see plate 6B (JC cat. 97).

1. Sadoc M. Bertucci in *Bibliotheca sanctorum*, vol. 2, 1968, cols. 629–33.
2. Kaftal 1952, fig. 32.

Bibliography
See plate 6B (JC cat. 97)

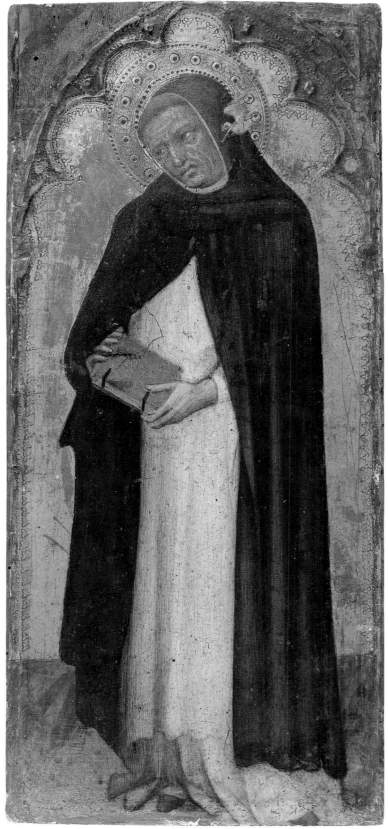

PLATE 6A

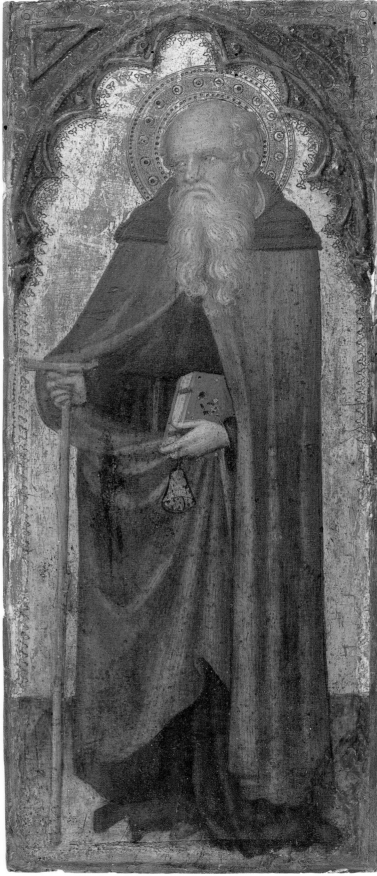

PLATE 6B (JC CAT. 97)

Pilaster panel of an altarpiece: *Saint Anthony Abbot*

After 1413

Tempera, silver, and tooled gold on panel with vertical grain; 16⅛ × 6¾ × ¾″ (40.7 × 17 × 1.8 cm), painted surface 15½ × 6¾″ (39.2 × 17 cm)

John G. Johnson Collection, cat. 97

INSCRIBED ON THE REVERSE: *97/ i.n. 1378* (in pencil); *CITY OF PHILADELPHIA/ JOHNSON COLLECTION* (stamped in black ink); *JOHNSON COLLECTION/ PHILA.* (stamped twice in black ink)

TECHNICAL NOTES

This and plate 6A (JC cat. 96) are on a single panel that has been planed on the edges and back. Bare wood is visible at the sides of the panels where frame moldings were once attached. The pastiglia decoration in the arched frames is covered with worn and tarnished silver. The background gilding is locally abraded, but the punch marks in both are well preserved. Mordant gilding is present on the saints' books. The bell was originally silver, most of which is missing. The paint in plate 6B is in generally good condition beneath the discolored varnish. In April 1920 Carel de Wild wrote: "Fair condition. Local retouches."

PROVENANCE

Johnson purchased this painting and the *Blessed Ambrogio Sansedoni* (plate 6A [JC cat. 96]) from Herbert Horne in 1912.[1] The panels were said to have come from the collection of Contessa Bourturline, whose family lived in the Palazzo Niccolini on the via dei Servi in Florence.[2] At the same time Johnson purchased a painting by Andrea Brescianino (JC cat. 114)[3] and paid a total of 7,000 lire for all three.

COMMENTS

Saint Anthony Abbot stands on marbleized pavement. He wears monastic garb and holds a book, bell, and T-shaped staff, the symbol of the hospital order dedicated to him. The bell was hung on the pigs that this order tended, and also was rung when its members arrived in a town.[4]

In a letter to Johnson dated Florence, December 15, 1911, Herbert Horne described the artist of this panel and plate 6A (JC cat. 96) as an "unknown Master who stands midway between Bartolo di Fredi and Taddeo di Bartolo on the one hand and has much in common with Paolo di Giovanni Fei, on the other, but is more naturalistic than any of these masters, except Taddeo." Bernhard Berenson (1913) first published the panels as Bartolo di Fredi but expressed some doubt: "Nevertheless, there is something about these two panels which does not quite fit into the present writer's notion of Bartolo." He later (1932) listed them as the work of Andrea di Bartolo. The two saints seem to be late works and posterior to Andrea's only dated work, the panels of 1413 in the church of the Osservanza in Siena.[5] Francesco Santi (1969) dated them about 1410, based on what he considered the probable date of Andrea's two paintings with Saints Dorothy and Anthony Abbot in the Galleria Nazionale dell'Umbria in Perugia.[6]

This panel and plate 6A (JC cat. 96) come from the same work. As both saints are oriented to the left, they were probably part of the right pilaster of an altarpiece. The distance from which they would have been seen might account for some of the carelessness of the punch work in the pastiglia in plate 6A (JC cat. 96). Several pilaster fragments by Andrea di Bartolo with single standing saints exist, but none are sufficiently similar in size and detail to be associated with the Johnson works.[7]

1. Horne to Johnson, Florence, December 15, 1911; February 28 and March 17, 1912.
2. On this family, see Ginori Lisci 1972, vol. 1, no. 65, pp. 443–50.
3. Philadelphia 1994, repro. p. 183.
4. Kaftal 1952, cols. 73 n. 4, 76 nn. 5–6.
5. Osservanza 1984, color plates pp. 71–73.
6. Nos. 975–76; F. Santi 1969, figs. 87a, b.
7. Kauffmann (1973) has shown that a panel with Saint Stephen in the Victoria and Albert Museum in London (no. 371-1876; Kauffmann 1973, repro. p. 7) did not come from the same complex as the Johnson panels, as Berenson (1968) had proposed. Martin Davies (in Worcester 1974, pp. 309–10) proved the same concern-ing two pilaster panels with female saints in the Worcester Art Museum (nos. 1940-31 a, b; Worcester 1974, repro. p. 609).

Bibliography
Berenson 1913, p. 55 (Bartolo di Fredi); Van Marle 1920, p. 155; Berenson 1932, p. 9; Rigatuso 1934, p. 267; Berenson 1936, p. 8; Johnson 1941, p. 1; Sweeny 1966, p. 1, repro. p. 100; Berenson 1968, p. 7; F. Santi 1969, p. 107; Fredericksen and Zeri 1972, p. 6; Kauffmann 1973, p. 7; Martin Davies in Worcester 1974, pp. 309–10; Eberhard Kasten in *Allgemeines Künstlerlexikon*, vol. 2, 1986, p. 975; Eberhard Kasten in *Saur*, vol. 3, 1992, p. 513; Philadelphia 1994, repro. p. 176; Frinta 1998, pp. 260, 475

Fra Angelico
(*Guido di Pietro,* also called *Fra Giovanni da Fiesole*)

FLORENCE, FIRST SECURELY DOCUMENTED
1417; DIED FEBRUARY 18, 1455, ROME

Guido di Pietro, universally known as Fra Angelico,[1] trained and worked as a painter in Florence before he professed as a friar in the Dominican Observant convent of San Domenico in nearby Fiesole sometime between 1417 and 1424. Little is known of his early painting, but his first altarpiece[2] for his new convent reflects the manner of Lorenzo Monaco (q.v.). Angelico's subsequent works, however, show the more modern influence of Masaccio (q.v.). The triptych[3] he painted for the nunnery of San Pier Martire in Florence in about 1424 demonstrates his awareness of Masaccio's early style, whereas the *Annunciation*[4] from San Domenico, done a year or two later, shows that Angelico had been studying Masaccio's murals in the Brancacci chapel of the Carmine in Florence.

The early *Last Judgment*[5] from Santa Maria degli Angeli in Florence is a masterful example of Angelico's use of perspective to give drama to a religious subject that traditionally had been presented in an hieratic and two-dimensional manner. His later *Coronation of the Virgin* in the Louvre[6] shows an even more sophisticated conception of pictorial space used to stage a heavenly scene in a rationally measured, three-dimensional environment. It and three nearly contemporary masterpieces—the tabernacle for the guild of the textile merchants (Arte degli Linaioli e Rigattieri)[7] the Strozzi *Deposition* from Santa Trinita, Florence[8] and the *Annunciation* from San Domenico in Cortona[9]—established Angelico as Florence's leading painter.

Despite Angelico's status as a friar, he was a full-fledged member of the Florence artistic community. In the Linaioli tabernacle, for example, he collaborated with the sculptor Lorenzo Ghiberti. In the Annalena[10] and San Marco[11] altarpieces he created works that were tailored to the classicizing vocabulary that Filippo Brunelleschi had introduced into Florentine church architecture. With all Gothic paraphernalia now abandoned, the paintings are square in shape and have frames composed of pilasters, lintels, and tympana.

Angelico's accomplishments as an artist-theoretician cannot be separated from those he achieved as an artist-theologian and Dominican Observant friar. His murals[12] in the cloister, chapter house, and cells of the convent of San Marco in Florence, undertaken in the late 1430s and early 1440s, represent the Observant Dominicans' willingness to incorporate art in all aspects of their religious life. Angelico himself probably encouraged the friars to use painting as a catalyst for prayer and meditation.

Fra Angelico had moved to Rome by 1447, when he is recorded as painting in Saint Peter's; in the same year he also painted in the San Brizio chapel in the cathedral of Orvieto.[13] In 1448 he frescoed a chapel and study in the Vatican Palace for Pope Nicholas V Parentucelli.[14]

The artist's last great undertaking was a series of thirty-five paintings of the Gospel stories for the silver cupboard of Santissima Annunziata in Florence.[15] Commissioned by Piero de' Medici in 1448, they were executed by Angelico with his assistants in the early 1450s.

1. The name was first applied in Fra Domenico di Giovanni Corella's *Theotocon* of 1468 in reference to the theological content of the artist's silver cupboard of Santissima Annunziata in Florence (see n. 15).
2. The main panel is still in San Domenico, Fiesole. The predella is in the National Gallery, London (no. 663). There are also related pilaster panels in various collections; Gordon 2003, pp. 2–25.
3. Florence, Museo Nazionale di San Marco; Spike 1997, color repro. pp. 88–89. The final payment, made to Angelico's convent of San Domenico in 1429, is the only documentation of this painting, but stylistically it must date much earlier.
4. Madrid, Prado, no. 15; Strehlke 1998, plate 23.
5. Museo Nazionale di San Marco; Spike 1997, color repro. p. 104–5. The picture's date is not known, but it must be around 1425 rather than the early 1430s, as is often claimed.
6. No. 1210; Spike 1997, color repro. p. 117.
7. Museo Nazionale di San Marco, no. Uffizi 879; Spike 1997, color repros. pp. 114–15.
8. Museo Nazionale di San Marco; Spike 1997, color repro. p. 107.
9. Cortona, Museo Diocesano; Hood 1993, color plate 87.
10. Museo Nazionale di San Marco; Hood 1993, color plate 88.
11. Museo Nazionale di San Marco; Hood 1993, reproduced in color and black-and-white plates 85, 96, and 100–107. The predella is divided between museums in Washington, D.C., Munich, Dublin, Paris, and Florence.
12. Amply reproduced in color in Hood 1993.
13. Spike 1997, color repros. pp. 171–75.
14. The chapel survives. Reproduced after its restoration in Buranelli 2001.
15. Pope-Hennessy 1974, plates 130–38, figs. 43–44.

Select Bibliography
The literature on Fra Angelico is vast. An annotated bibliography can be found in Strehlke 1998. See also Garibaldi 1998; Kanter 2000; Buranelli 2001; Laurence B. Kanter in Kanter, Strehlke, and Dean 2001, pp. 17–39; Luciano Bellosi in Bellosi 2002, pp. 46–47; Giorgio Bonsanti in Bellosi 2002, pp. 172–76; Miklós Boskovits in Toscano and Capitelli 2002, pp. 41–55, 156–59; Guido Cornini in Toscano and Capitelli 2002, pp. 162–69; Scudieri and Rasario 2003

PLATE 7 (JC CAT. 15)

Predella panel of an altarpiece: *Dormition of the Virgin*

c. 1425

Tempera, silver, and tooled gold on panel with horizontal grain; 10⅜ × 20⅝ × ½″ (26.2 × 52.2 × 1 cm), painted surface 9¾ × 19″ (24.5 × 48.2 cm)

John G. Johnson Collection, cat. 15

INSCRIBED ON CHRIST'S BOOK: *A Ω* (Greek letters alpha and omega, from the Apocalypse 1:8: "I am Alpha and Omega, the beginning and the end"); ON THE REVERSE: LEFT *Questa pittura [——] era del Etruria pittrice come si può vedere in [——] con dispiacere di molti specialmente professori [——] a poi medioevo e perde molto in confronto del Originale essendo quest'opera ricca prova incontrasta del risorgimento di arte in Cimabue e Giotto, così hanno dovuto accordare diversi professori e dilettanti che [——] s'innanzi erano stati sopra ciò [——] proprio a di.* (on three pasted pieces of faded paper; see fig. 7.1);[1] CENTER: *Questa Pittura è di mano del rinomato Giotto di Bondone restauratore con Cimabue della Pittura e de la più Celebre opera che egli abbia lavorato. Leggasi la sua Vita scritta da Giorgio Vasari, dove la descrive esistente allora nella Chiesa di Ogni Santi colle maggiori esspressioni di Lode e della stima universale, ma quel che illustra maggiormente è il rispetto che ne mostrava il Divino Michelangiolo Bonarroti. Questa Tavoletta fu poi comprata con segretezza da Persona allora potente, finalmente ne' nostri moderni tempi esinta quella famiglia fu aquistata con gran consolazione del Celebre pittor Fiorentino Ignazio Hugford che la gode negl'ultimi suoi anni come opera de singular merito e la collocò nella sua tanto rinomata Collezione di pitture sculture disegni. Questa pittura non è goduta meno la stima in questi ultimi tempi di quello fosse nel antico tra i professori in particolare l'ammirò il Cavagliere Raffaello Mengs Pittor primario del Re di Spagna abbenché poco portato a lodare pure stupito a sapere che ci trovava del bello di Raffaello, e di Andrea, ad presente [——] da me Lamberto Cristiano Gori discepolo del Maestro illustre Ignazio Hugford questo dì 3 Novembre 1786;[2]* RIGHT *Questa tavoletta [——] da Personaggi mi è stata da richiesta per com[pra]re ma specialmente [——] anno 1786 fui di ciò p[——]pato da personaggio non convito a con al[——] e specialmente una di [ma]no di Cimabue ma non ebbi coraggio di p[ro]vami e la parvia di G[iot]to pregio, mi aspiccavo il prezzo non accrebbe guastato e seppi che l'ebbe stata comprato d'Imperatric[e] covia.*[3] 31 (on a paper sticker); JOHNSON COLLECTION/ PHILA (stamped in black ink)

ENGRAVED: By Carlo Lasinio for Lastri 1791–95, vol. 1, 1791 (as Giotto [see fig. 7.8]) (reproductions of this engraving appeared in Séroux d'Agincourt 1823, vol. 6, plate CXIV, no. 6 [see fig. 7.9], and Séroux d'Agincourt 1826–29, vol. 6, 1829, plate CXIV, no. 6); and by Giuseppe Rossi for Rosini 1839–47, plate vol. 1, 1840 (as Giotto [see fig. 7.10]) (a detail of the same appeared in Rosini 1848–52, vol. 1, 1848, repro. opposite p. 173)

EXHIBITED: New York, The Metropolitan Museum of Art, The Cloisters, *Seven Joys of Our Lady* (December 20, 1944–January 21, 1945), no catalogue; New York 1994, no. 47c

The panel consists of a single piece of poplar to which a ½″ (1 cm) strip of poplar has been added at the top. The addition is of considerable age, and the tops of the other identified panels from the same predella (see figs. 7.4–7.7) all have similar damage or additions. A band up to ¾″ (1.7 cm) wide along the top edge is repainted, including the heads of Christ and two music-making angels as well as the top of the Virgin's head. This repainted area, which is common to all the other panels, was probably painted by either Ignazio Hugford or his student Lamberto Gori.[4] Hugford was a well-known painter who collected early Italian art and also sold paintings to the Uffizi. After his death in 1778, the Uffizi acquired other pictures from his heirs. Gori bought other works from the estate including this painting. Hugford is thought to have painted at least one forgery after Filippino Lippi and is likely to have made deceptive restorations of early Italian panels, many of which were from disassembled altarpieces. A number of his restorations were probably intended to repair damage that occurred during the disassembly of the altarpieces[5] as well as to mask the fragmentary state of the paintings as seen in plate 9 (JC cat. 1166).

Two battens are present on the reverse; the one on the right is old but covers the addition. It is glued in place, whereas the other is screwed in place and probably more recent. In the X-radiograph two nail holes are visible in the center of the panel. They probably secured a now-lost vertical wood batten or internal partition of the predella.

The panel was prepared with a linen canvas and a thick layer of gesso. Infrared reflectography revealed no underdrawing. However, the lack of changes suggests that a detailed drawing was executed on the ground layer before painting. The outlines of the heads and halos, as well as the straight edges of the tomb, were incised into the ground. The robes of the disciples were painted before the background and flesh. The gold trim of the draperies and the silver leaf in the torches were applied over a reddish orange mordant.

Except for the repainted area at the top, the picture's surface is in good condition. The Johnson Collection's files record repairs made by Carel de Wild in December 1920 and the laying down of flaking and retouching of small losses done by Theodor Siegl on May 14, 1956, and March 2, 1966.

In 1992 David Skipsey cleaned the picture. His restoration included removal of some regilding on the halos and of the brown overpaint covering the gilded strips on the panel's edges. The cleaning revealed a sharper disparity in color between the original and the repaint along the top edge. Skipsey corrected these inconsistencies in his restoration and reconstructed the heads of the figures in this area. The angels in Fra Angelico's illumination of the *Glorification of Saint Dominic*[6] were used as models for the angels' heads.

Florence, Ignazio Hugford (died August 16, 1778); Florence and Pisa, Lamberto Gori, 1786; William Young Ottley; London, Colonel William Young Ottley, 1836; unsuccessful sale, London, Foster's, June 30, 1847, lot 30 (as school of Angelico); Essex, Stansted Hall, W. Maitland Fuller, c. 1854; purchased, London, Agnew's, June 3, 1899, and sold, July 8, 1900, John G. Johnson.

On the basis of the subject of a companion panel in a private collection (see fig. 7.6), Laurence Kanter (2000) has suggested that the predella panel came from an altarpiece in a Florentine church or chapel dedicated to Saint Lucy.

The scene is set in a rocky landscape meant to be the valley of Josaphat in Jerusalem. Four apostles are

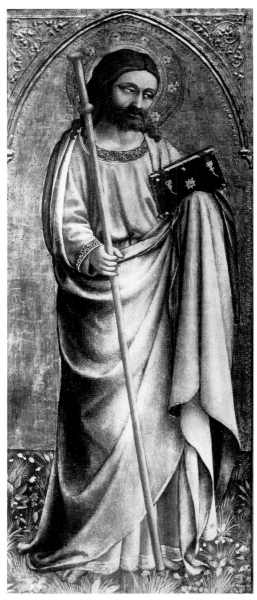

FIG. 7.2 Fra Angelico. *Saint James Major*, c. 1425. Tempera and tooled gold on panel; 35⅛ × 17″ (89 × 43 cm). Present location unknown. See Possible Companion Panel A

lowering the shrouded Virgin into the tomb; four others hold tall funeral torches, one blows on a censer, and another holds an aspergillum, used for sprinkling holy water. In the center, the apostle Peter, wearing a papal stole, presides over the service. The apostle Paul is probably the balding man with a dark, pointed beard seen behind the Virgin's head. John the Evangelist holds a golden palm, whose fronds have sprouted stars.[7] He turns to a haloed and bearded man wearing a long blue mantle and a black hat typical of a Florentine patrician. This costume can be compared with those worn by the contemporary figures in Masaccio's and Masolino's (qq.v.) murals in the Brancacci chapel in the Carmine in Florence.[8] Another figure in the left background,

FIG. 7.1 Reverse of plate 7, showing the applied inscriptions

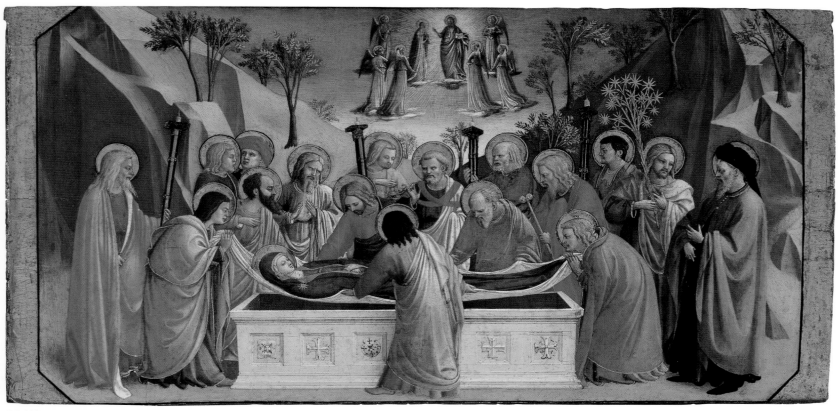

PLATE 7

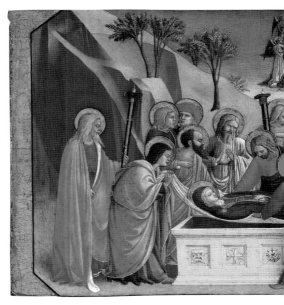

FIG. 7.3 Original sequence of Fra Angelico's predella, c. 1425. Left to right: FIG. 7.4 *Saint James Major Freeing Hermogenes.* Tempera and tooled gold on panel; 10 × 8⅞″ (25.4 × 22.5 cm). Fort Worth, Kimbell Art Museum, no. AP 1986.03. See Companion Panel A; FIG. 7.5 *Naming of Saint John the Baptist.* Tempera and tooled gold on panel; 10¾ × 9⅞″ (27.3 × 24.9 cm). Florence, Museo Nazionale di San Marco, no. Uffizi 1499. See Companion Panel B; PLATE 7; FIG. 7.6 *Saint Agatha Arising from Her Tomb and Appearing to Saint Lucy and Her Mother, Eustachia.* Tempera and tooled gold on panel; 9¾ × 8½″ (24.9 × 21.6 cm). New York, Feigen Collection. See Companion Panel C; FIG. 7.7 *The Meeting of Saints Dominic and Francis of Assisi.* Tempera and tooled gold on panel; 10½ × 10⅛″ (26.7 × 25.7 cm). M. H. de Young Memorial Museum, Fine Arts Museums of San Francisco, Gift of the Samuel H. Kress Foundation, no. 61.44.7. See Companion Panel D

facing the blond-haired saint in profile, wears a red hat that also reflects current Florentine fashion. Above there is an unusual heavenly vision in blue monochrome in which the Virgin prays before the Blessing Christ, who emanates golden rays.

In other versions Fra Angelico followed traditional iconography by showing Christ beside the tomb, with the Virgin's soul in his arms,[9] an episode that is conspicuously absent here. The reason in this one case may be the influence of Antonino Pierozzi. He and Angelico both were Dominican Observant friars, and Antonino had been a prior of Fra Angelico's convent in Fiesole. Antonino questioned apocryphal tales about Mary's funeral, and complained in particular about the uncertainty of the angelic host's participation. He emphasized the humility of Mary's obsequies, and personally did not acknowledge that Christ had come to collect her soul, preferring only to cite other church authorities in that regard.[10]

When this painting was engraved by Carlo Lasinio in 1791 (fig. 7.8), it was identified as Giotto's lost altarpiece of the Dormition of the Virgin from the Florentine church of the Ognissanti, which was then only known from a description by Giorgio Vasari (1550 and 1568, Bettarini and Barocchi eds., text vol. 2, 1967, pp. 113–14). The latter painting, however, is actually now in the Staatliche Museen in Berlin.[11] The attribution to Giotto subsequently appeared with engravings (figs. 7.9, 7.10) in histories of Italian art by Jean-Baptiste Séroux d'Agincourt (1823, 1826–29) and Giovanni Rosini (1839–47, 1848–52). Giuseppe Montani and Giovanni Masselli,

in the first volume of the 1832 edition of Vasari's *Lives,* recognized the impossibility of this attribution. Gustav Friedrich Waagen (1837–39), when he saw the painting in the London collection of William Young Ottley, was the first to attribute it to Fra Angelico. In September 1857 P. & D. Colnaghi & Co. and T. Agnew & Sons published a photograph of it (fig. 7.11) as by Fra Angelico. It appeared as such in art historical literature until Frida Schottmüller's 1911 *Klassiker der Kunst* monograph of Angelico, in which she attributed it to his studio. Her opinion was followed by subsequent writers, except for Raimond van Marle (1928), who assigned it to Zanobi Strozzi (q.v.). The painting did not appear in either edition of John Pope-Hennessy's important Phaidon monograph of the painter (1952, 1974). In 1987 Everett Fahy reevaluated the painting's importance, recognizing it to be the centerpiece of an important predella by Angelico.

The predella (fig. 7.3) comprised, from left to right: *Saint James Major Freeing Hermogenes* (fig. 7.4); the *Naming of Saint John the Baptist* (fig. 7.5); the Johnson *Dormition of the Virgin* (plate 7); *Saint Agatha Arising from Her Tomb and Appearing to Saint Lucy and Her Mother, Eustachia* (fig. 7.6); and *The Meeting of Saints Dominic and Francis of Assisi* (fig. 7.7). X-radiographs that map the wood grain confirm that the panels were painted on the same plank and indicate that this was probably the original sequence. That the existing panels belong together is clear because of their similar style, dimensions, and gold borders with angled edges. Each panel was also cut across the top. In addition,

the architecture connects the two left-hand scenes, as the green building at the right in *Saint James Major* is the same as that at the left in the *Naming of Saint John the Baptist.* The two buildings also share the same molding. A comparison for the scenes' original polygonal format, soon abandoned by Angelico in favor of rectangular fields, is the predella of the *Annunciation* altarpiece of about 1425 from the convent of San Domenico in Fiesole.[12]

The panels date to a period just after Masaccio had cast his spell over Angelico. The inventive narrative, the studied relationship of the figures, and the clear representation of architectural space are all lessons that Angelico learned from Masaccio's murals in the Carmine. The man on the far right in the *Dormition* specifically corresponds to a figure from a lost mural by Masaccio known as the *Sagra,* which depicted the consecration of the Carmine. It was destroyed in 1598–1600, but drawings after it attest to its impact. One, made by the young Michelangelo (fig. 7.12), shows the very same figure that enchanted Angelico.

The rest of the altarpiece has not been identified. It has been suggested that a panel showing the apostle James Major (fig. 7.2) in an unknown location was one of the pieces, but this is by no means certain. The other saints and the Virgin, who would have been in the center, are either lost or unidentified.[13]

1. The many lacunae make a precise translation impossible. The inscription speaks about an engraving of this painting in *Etruria pittrice* (see fig. 7.8), which it says is hardly satisfying when compared to the original, not-

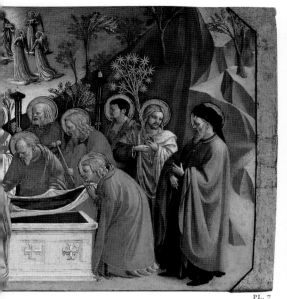

PL. 7 7.6 7.7

ing that the painting is indeed proof of how art was renewed under Cimabue and Giotto.

2. "This picture is by the renowned hand of Giotto di Bondone, restorer, with Cimabue, of painting, and is the most celebrated work that he made. Reading his life by Giorgio Vasari, the picture is described as then in the church of the Ognissanti [in Florence] with the greatest expressions of praise and universal esteem, but that which proves it the most is the respect that the Divine Michelangelo Buonarroti showed it. This painting was then bought in secret by a once very powerful person. When in modern times his family died out, it was acquired with great consolation by the famous Florentine painter Ignazio Hugford, who enjoyed it to the end of his days as a work of unique merit and who placed it in his very renowned collection of paintings, sculpture, and drawings. This picture attracted no less esteem in recent times than of old. It was in particular admired by the Cavaliere Raphael Mengs, painter to the king of Spain; although hardly inclined to praise [it], he was astounded to find there something of the beauty of Raphael and Andrea [del Sarto], now [owned?] by me, Lamberto Cristiano Gori, disciple of the illustrious Master Ignazio Hugford, this day, the 3rd of November 1786."

3. The right side of the paper is torn, making translation almost impossible. It seems that the inscription describes a dispute over the painting's purchase and particularly over its attribution to either Cimabue or Giotto and the corresponding price.

4. On Hugford, see Fleming 1955; Previtali 1964, pp. 222–23; Cole and Middeldorf 1971; Borroni Salvadori 1983. On Gori, see Serenella Rolfi in *DBI*, vol. 58, 2002, pp. 36–39.

5. On the disassembly of altarpieces, see Carl Brandon Strehlke in Kanter, Strehlke, and Dean 2001, pp. 41–58.

6. Florence, Museo Nazionale di San Marco, missal, no. 558, folio 67 verso; New York 1994, color repro. p. 336.

7. According to the story told in *The Golden Legend* by Jacopo da Varazze (c. 1267–77, Ryan and Ripperger ed. 1941, pp. 449–50, 452), when the archangel Gabriel announced to Mary her imminent death, he brought her a branch of the Palm of Paradise that "shone with a great brightness, and for its greenness was like to a new branch, but its leaves gleamed like the morning star." Mary later told John that this palm was to be carried before her funeral bier. After her death, John asked Peter to bear it, but Peter refused, saying that John, who himself was a virgin, should carry the palm.

8. Postrestoration color repros. in Baldini and Casazza 1990, plates 77–104, 107–8.

9. They are the predella scenes in the Annunciation altarpieces in Madrid (Strehlke 1998, plate 23), San Giovanni Valdarno (Pope-Hennessy 1974, fig. 11), and Cortona (Hood 1993, color plate 87); the reliquary in Boston (New York 1994, color repro. p. 343); and a panel in Florence (Pope-Hennessy 1974, fig. 14).

10. Antonino 1581, chaps. 43–45; Antonino 1587, p. 388.

11. No. 1884; Boskovits 1988, color plate I.

12. Strehlke 1998, plate 23.

13. Laurence B. Kanter (quoted in New York 1994, p. 327 n. 2) proposed that the fragments of *Christ Blessing* in Hampton Court (no. 1208; Pope-Hennessy 1974, fig. 103) may have been among the central elements, but this cannot be confirmed.

Bibliography

Lastri 1791–95, vol. 1, 1791, plate IX (Giotto); Séroux d'Agincourt 1823, vol. 3, p. 130; vol. 6, plate CXIV, no. 6 (Giotto); Séroux d'Agincourt 1826–29, vol. 6, 1829, p. 368; plate CXIV, no. 6 (Giotto); Giuseppe Montani in Vasari 1550–73, Masselli ed., vol. 1, 1832, p. 129 n. 70 (not Giotto); Waagen 1837–39, vol. 1, 1837, pp. 396–97 (Angelico); Rosini 1839–47, vol. 1, 1839, pp. 241–42, 246 n. 32; plate vol. 1, 1840, plate XIV (Giotto); Vasari 1568, Le Monnier ed., vol. 1, 1846, pp. 331–32 n. 3 (Angelico); Rosini 1848–52, vol. 1, 1848, pp. 173, 177 n. 32, engraving opposite p. 173 (Giotto, suggesting it may be in England or Germany); Waagen 1854–57, vol. 3, 1854, p. 2 (Angelico); Blanc 1857, p. 46; Vasari 1568, Milanesi ed., vol. 2, 1878, p. 513 n. 2; Hoeber 1902, p. 4; Perkins 1905, p. 114, fig. 1; Grant 1908 (July), pp. 144–45, repro. p. 146 (Angelico); Crowe and Cavalcaselle 1908–9, vol. 2; Edward Hutton 1909, p. 283 n. 2; Rankin 1909, p. lxxxiii; Crowe and Cavalcaselle 1903–14, vol. 4, edited by Langton Douglas assisted by G. de Nicola, 1911, pp. 94–95 n. 2 (Angelico); Schottmüller 1911, p. 243, repro. p. 213 (studio of Angelico); Berenson 1913, p. 11, repro. p. 237 (studio of Angelico); Perkins 1914, p. 195; Suida 1923, pp. 129 n. 4, 131; Schottmüller 1924, p. 277; Ciraolo and Arbib 1924, p. 61; Van Marle, vol. 10, 1928, p. 182 (Zanobi Strozzi); Johnson 1941, p. 1 (studio of Angelico); Salmi 1958, p. 92; Previtali 1964, p. 223, fig. 32, plate VI.5; Sweeny 1966, p. 3, repro. p. 109 (studio of Angelico); Baldini 1970, p. 116, repro. no. 121; Fredericksen and Zeri 1972, p. 9 (studio of Angelico); Fahy 1987, fig. 5; Strehlke 1993, fig. 1 (color); Philadelphia 1994, repro. p. 176; Carl Brandon Strehlke in Kanter et al. 1994, pp. 326–32, repro. p. 330 (color); Kanter 2000; Laurence B. Kanter in Kanter, Strehlke, and Dean 2001, pp. 30, 39 n. 23, fig. 11; Giorgio Bonsanti in Bellosi 2002, p. 176

COMPANION PANELS for PLATE 7

A. Predella panel of an altarpiece: *Saint James Major Freeing Hermogenes.* See fig. 7.4

c. 1425

Tempera and tooled gold on panel; 10 × 8⅞″ (25.4 × 22.5 cm), painted surface 10 × 8⅝″ (25.4 × 21.9 cm). Fort Worth, Kimbell Art Museum, no. AP 1986.03

PROVENANCE: Paris, Comte Lafond, c. 1865–79; by descent to François, duc des Cars, Paris, 1932; New York, Wildenstein; purchased, Fort Worth, Kimbell Art Museum, 1986

ENGRAVED: Chromolithograph by Fraillery, Paris, c. 1865–79

EXHIBITED: New York 1994, no. 47a

SELECT BIBLIOGRAPHY: Boskovits 1976, pp. 39–40; Fahy 1987; Henderson and Joannides 1991, pp. 4, 6 n. 11; Strehlke 1993, pp. 5–6; Carl Brandon Strehlke in Kanter et al. 1994, p. 327; Kanter 2000

B. Predella panel of an altarpiece: *Naming of Saint John the Baptist.* See fig. 7.5

c. 1425

Tempera and tooled gold on panel; 10¾ × 9⅞″ (27.3 × 24.9 cm). Florence, Museo Nazionale di San Marco, no. Uffizi 1499

PROVENANCE: Acquired from Vincenzo Prati for the Uffizi, Florence, 1778; Florence, Museo Nazionale di San Marco, since 1924

EXHIBITED: Vatican City 1955, no. 15; Florence 1955, no. 16; Florence 1990, no. 84; New York 1994, no. 47b; San Giovanni Valdarno 2002

SELECT BIBLIOGRAPHY: Boskovits 1976, pp. 39–40; Fahy 1987; Maria Cecilia Fabbri in Florence 1990a, p. 228; Strehlke 1993, p. 6; Carl Brandon Strehlke in Kanter et al. 1994, p. 327; Kanter 2000; Giorgio Bonsanti in Bellosi 2002, p. 176

C. Predella panel of an altarpiece: *Saint Agatha Arising from Her Tomb and Appearing to Saint Lucy and Her Mother, Eustachia.* See fig. 7.6

c. 1425

Tempera and tooled gold on panel; 9¾ × 8½″ (24.9 × 21.6 cm). New York, Feigen Collection

PROVENANCE: Germany, Freiburg im Breisgau, King Johann of Saxony (died 1873); by descent to Prince Johann Georg of Saxony (died 1938); sold, London, Sotheby's, July 9, 1998, lot 121 (as Zanobi Strozzi)

INSCRIBED ON THE REVERSE: *P.J./ No. 189;* label with the inventory no. IX-65; mark of Prince Johann Georg of Saxony and inventory no. 193

SELECT BIBLIOGRAPHY: Kaftal 1952, p. 646; Kanter 2000

D. Predella panel of an altarpiece: *The Meeting of Saints Dominic and Francis of Assisi.* See fig. 7.7

c. 1425

Tempera and tooled gold on panel; 10½ × 10⅛″ (26.7 × 25.7 cm), painted surface 10⅛ × 9¼″ (25.5 × 23.5 cm). M. H. de Young Memorial Museum, Fine Arts Museums of San Francisco, Gift of the Samuel H. Kress Foundation, no. 61.44.7

PROVENANCE: Paris, Alexis-François Artaud de Montor, 1808–43; sold, Paris, Hôtel des Ventes Mobilières, January 17–18, 1854, lot 129 (as Alesso Baldovinetti); Lyons and Paris, Georges Chalandon; London, Langton Douglas, 1924; London, Mrs. Walter Burns; Florence, Contini Bonacossi; New York, Kress Collection; exhibited, Washington, D.C., National Gallery of Art, 1941–50; gift of the Samuel H. Kress Foundation

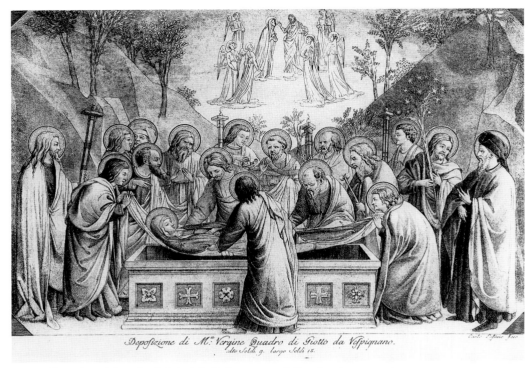

FIG. 7.8 Engraving of plate 7 by Carlo Lasinio (Italian, 1759–1838), from Lastri 1791–95, vol. I, 1791

FIG. 7.9 Engraving of plate 7 from Séroux d'Agincourt 1823

ENGRAVED: By Pierre-Eugène Aubert for Artaud de Montor 1843, plate 50

EXHIBITED: Vatican City 1955, no. 37; Florence 1955, no. 41; New York 1994, no. 47d

SELECT BIBLIOGRAPHY: Boskovits 1976, pp. 39–40; Fahy 1987; Strehlke 1993, p. 6; Carl Brandon Strehlke in Kanter et al. 1994, p. 332; Kanter 2000

POSSIBLE COMPANION PANEL for PLATE 7

A. Lateral panel of an altarpiece: *Saint James Major.*
See fig. 7.2

c. 1425

Tempera and tooled gold on panel; 35⅛ × 17″ (89 × 43 cm). Present location unknown

PROVENANCE: Florence, Landor Collection; sold, Florence, Impresa C. Galardelli, April 13–14, 1920, lot 141 (as anonymous fourteenth century); The Minneapolis Institute of Arts, 1922–56; sold, 1956

SELECT BIBLIOGRAPHY: Boskovits 1976, pp. 39–40; Fahy 1987; Strehlke 1993, p. 6; Carl Brandon Strehlke in Kanter et al. 1994, p. 327; Kanter 2000

FIG. 7.10 Engraving of plate 7 from Rosini 1839–47, plate vol. 1, 1840

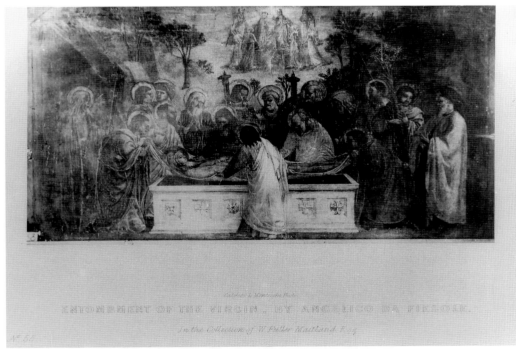

FIG. 7.11 Photograph of plate 7 by Caldesi & Montecchi, 1857

FIG. 7.12 Michelangelo Buonarroti (Florence, 1475–1564). Figure from Masaccio's lost *Sagra,* c. 1495. Ink on paper; 11½ × 7¾″ (29 × 19.7 cm). Vienna, Graphische Sammlung Albertina, inv. 116 R 129 recto

PLATE 8 (JC CAT. 14)
Fragment: *Saint Francis of Assisi*

c. 1427

Tempera and tooled gold on panel with vertical grain; 24 × 14¼″ (61 × 36.2 cm)

John G. Johnson Collection, cat. 14

INSCRIBED ON THE REVERSE: *9-1928-1* (in ink on a label); *C 7456* (in ink on a label); *Exhibition of Italian Art* (torn label from the Royal Academy, London); *139* (in chalk) *# 3. Lorenzo di Credi* (typewritten on a label)

PUNCH MARKS: See Appendix II

EXHIBITED: London, 1930, no. 139; Philadelphia Museum of Art, John G. Johnson Special Exhibition Gallery, *A Closer Look at Paintings from the Johnson Collection: Related Works and Reconstructions* (March 29–August 3, 1980), no catalogue

TECHNICAL NOTES

The painting is a fragment from the freestanding *Crucifixion with Saints Nicholas of Bari and Francis of Assisi* in the confraternity of San Niccolò del Ceppo in Florence. In the late nineteenth or early twentieth century Saint Francis's head, torso, and part of his outstretched proper right arm were removed from this complex by sawing through about one-half the original thickness of the wood to remove the section. A copy of the removed fragment was then attached to the remaining support, where it remains.

The excised panel, which is about ¼″ (0.4 cm) thick, underwent an artful transformation when it was mounted on a vertically grained and rectangular poplar panel, and two repairs were made to the support in the area of the halo. The composition was then falsified by painting Francis before a low brick wall with his hands folded in prayer (fig. 8.1). Where the new hand was added, original paint was scraped away, thereby removing part of the saint's habit and the lower half of the wound in his side. However, as the photograph of the fragment in its unrestored state shows (fig. 8.2), despite some small losses scattered throughout and some abrasion on the cheek and chin, the paint surface is extremely well preserved.

In 1992 David Skipsey cleaned the painting (fig. 8.2) and liberated the figure from the false background to better suggest its original form (Skipsey 1993). The additions were removed, although a margin of later wood was left to make up for the black contour that had been lost when the figure was excised from the group in Florence (see fig. 8.4).[1] In addition, a triangular piece of added wood was left at the proper right shoulder to compensate for a missing portion that had been cut away to create the praying arm. The edges of the Johnson fragment were then built up and painted black to imitate those in the original. Minor losses on the surface were also filled and inpainted.

An X-radiograph shows that, in the original panel, there is a nail hole under the right elbow and

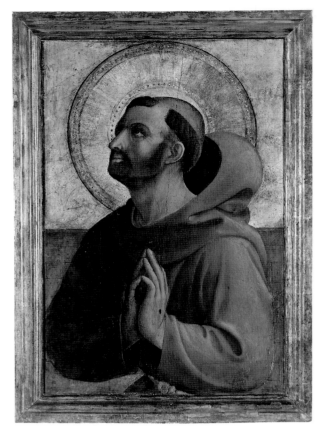

FIG. 8.1 Plate 8 before conservation

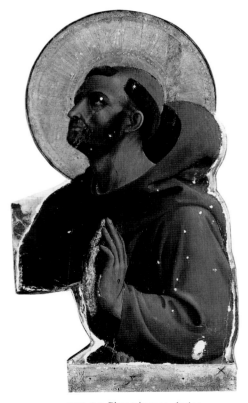

FIG. 8.2 Plate 8 in 1992, during conservation treatment

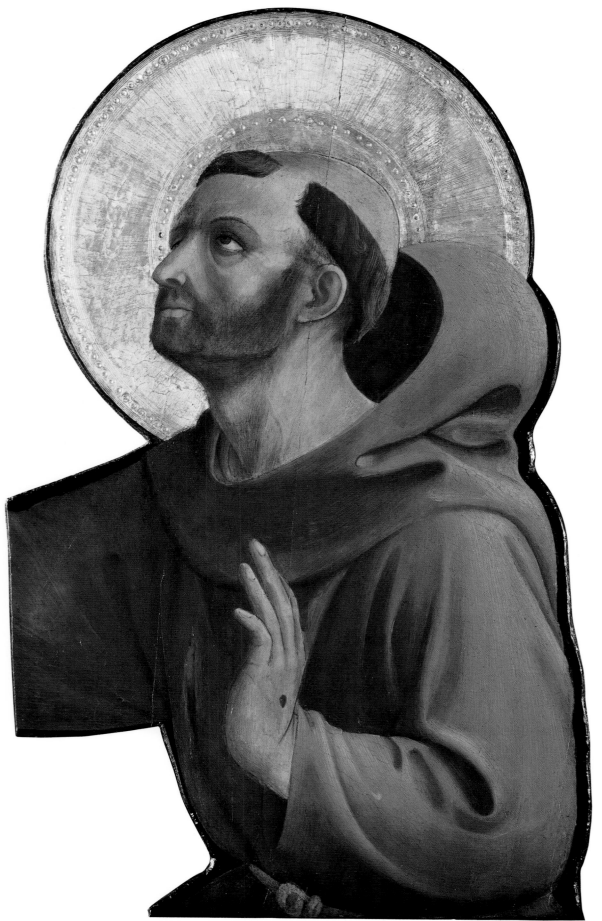

PLATE 8

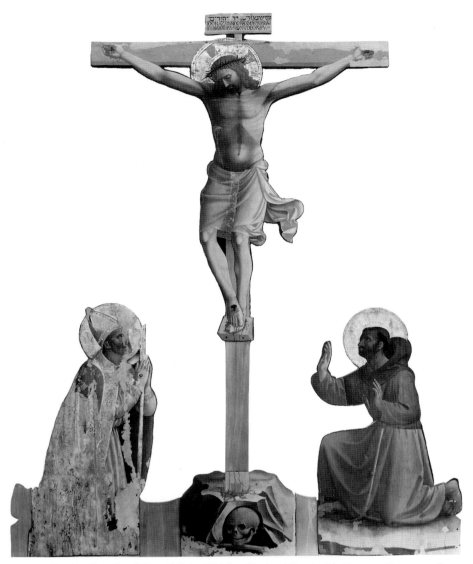

FIG. 8.3 Detail of the reverse of fig. 8.4, showing the back of Saint Francis of Assisi

FIG. 8.4 Fra Angelico. *Crucifixion with Saints Nicholas of Bari and Francis of Assisi*, c. 1427. Tempera and tooled gold on panel; 82¾ × 57⅛″ (210 × 145 cm). Florence, confraternity of San Niccolò del Ceppo. See Companion Panel

another under the heel of the hand. These correspond to nail holes visible on the reverse of the full figure of the saint in the Crucifixion group (fig. 8.3) and indicate where a batten had run across the back of the figure to support the outstretched arm, which was painted on a separate piece of wood. In order to smooth the surface, canvas strips were placed over the heads of the nails and on the left side of the panel before it was gessoed.

The design was scored in the ground before the painting was begun, but infrared reflectography did not reveal any other type of underdrawing. Infrared examination did show, however, that the drapery was first broadly executed in dark brushstrokes in the shadows and then modeled with fine strokes. The flesh was built up with a green earth and malachite underlayer and finished with pink highlights.

A thin red paint was used to outline the hand and features of the face. The beard and shadows are painted in a translucent brown over the green underlayer. The flesh paint overlaps the gold of the halo; its center is marked by an indentation in the saint's temple.

Describing the painting in a letter to Bernhard Berenson, dated Philadelphia, May 16, 1912, John G. Johnson wrote, "It is a little dirty, and the color, in its subtlety, would be much more apparent with a little cleaning, but I do not dare to have it touched." Yet despite his concerns, in March 1913 the picture was taken to the restorer Pasquale Farina; there is, however, no record of his work on the painting. In August 1919 Hamilton Bell observed that it was in fair condition, although the gesso under the halo was moving a little. In April 1920 he noted the

extensive repainting, and in May Carel de Wild treated it. In October 1937 David Rosen varnished and waxed the panel, and replaced the top of the frame. A new split necessitated reattachment of flaking paint and minor inpainting, which was executed by Theodor Siegl in 1962 and 1963.

PROVENANCE

The painting was originally part of the *Crucifixion with Saints Nicholas of Bari and Francis of Assisi* (fig. 8.4) in the confraternity of San Niccolò del Ceppo in Florence. There is no record of when the Johnson fragment was removed and replaced by a copy, but it is likely to have occurred in the later nineteenth or early twentieth century. The complex was originally made around 1427 for the confraternity's first headquarters near the hospital of the Ceppo delle

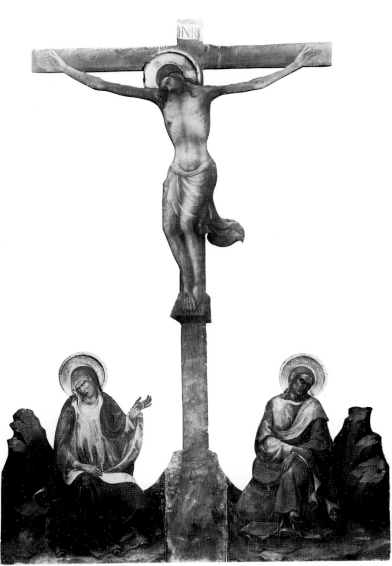

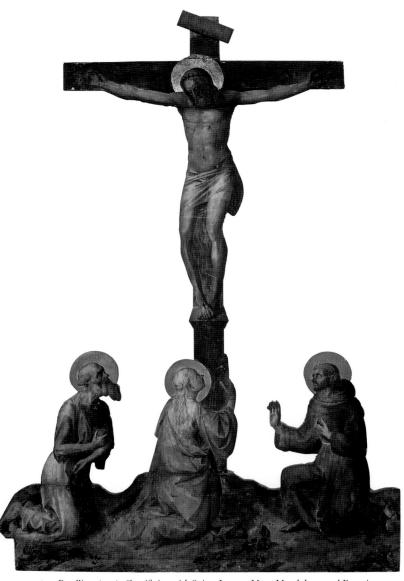

FIG. 8.5 Lorenzo Monaco (q.v.). *Crucifix with the Mourning Virgin and Saint John the Evangelist*, c. 1415. Tempera and tooled gold on panel; 163⅞ × 87″ (416 × 221 cm). Florence, church of San Giovanni dei Cavalieri di Malta

FIG. 8.6 Pesellino (q.v.). *Crucifixion with Saints Jerome, Mary Magdalene, and Francis*, 1440s. Tempera and tooled gold on panel. Florence, church of San Gaetano, oratory of the Antinori

Sette Opere di Misericordia. In 1530 the confraternity was transferred to the church of Santa Maria del Tempio. Construction on the present oratory, on the via Pandolfini, began in 1561. While the oratory was still being built, the flood of 1567 severely damaged the painting, which was restored the next year by Giovambattista Del Verrocchio and again in 1594 by Stefano Orlandi.[2] The painting seems to have been on the oratory's high altar until 1611, when it was replaced by a painting of the same subject by Francesco Curradi[3] and removed to the sacristy. In order to make the work fit its new location, the carpenter Giovanni Sassi had to cut the saints at the base and shorten the cross. He then reassembled the pieces, and the painter Giovanni di Zanobi painted over the repairs. In 1820 the painting was transferred to the choir.[4] It is recorded in an inven-

tory of 1798 as the work of Paolo Uccello,[5] and then, without an attribution, in inventories of 1820, 1825, 1835, and 1856.[6] After the flood of 1966 it was taken to the Fortezza da Basso in Florence for restoration. It was briefly exhibited at the Museo Nazionale di San Marco and is now in the sacristy of San Niccolò del Ceppo.

In 1911 Bernhard Berenson offered this fragment from the Crucifixion group to John G. Johnson as an independent painting. Its sale can be partially reconstructed in their surviving correspondence. A letter from Berenson to Johnson, dated I Tatti, Settignano (Florence), February 10, 1912, reads: "I received a cable from you beginning with the word YELICO, but ending unintelligibly. Doubtless it means you will take the Fra Angelico St. Francis, but I have been waiting for a letter to confirm this.

If you have not written such a letter in the meanwhile will you kindly cable the word YELICO again." Johnson wrote back from Philadelphia on February 24: "The unintelligible cable was: 'Yelico cabled heretofore Yesarto.' This was meant to state that I never heard anything further about the Del Sarto. The cable was followed by a letter, in which I confirmed the purchase of the Fra Angelico and alluded to the Del Sarto, expressing a fear, which I take for granted is very well founded now, that I had lost it." Other letters from Johnson to Berenson followed. On April 10 the former wrote to say that he had been notified that the Angelico was on its way. On April 23 Johnson said: "Last night the Fra Angelico and the Basaiti portrait came. With these I am more than delighted. The Angelico is a most vital figure, intense and most attractive. I had no idea that Fra

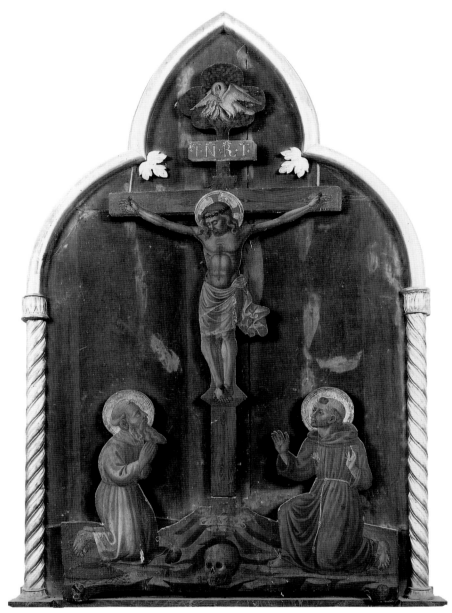

FIG. 8.7 Florentine School. *Crucifixion with Saints Jerome and Francis of Assisi*, c. 1430–40. Tempera and tooled gold on panel. Florence, convent of Santa Trinita

him and painted by somebody else, or it may have been much changed by repainting in recent times. Fra Angelico has lately been so commercialized that everything that comes near him is attributed to him." The broad manner noted by both Berenson and Offner reflects the fact that they knew the panel as a small easel painting, whereas Angelico had actually painted it this way because of the scale and function of the original complex.

Umberto Baldini and Luciano Berti (in Florence 1955) were the first to realize that the Johnson painting was not an independent image but rather a disguised fragment of the group in San Niccolò del Ceppo.[9] The confraternity, established in the late fourteenth century, comprised two groups. One, devoted to Saint Nicholas of Bari, enrolled young boys, and the other, for adults, was dedicated to Saint Jerome. In 1417 they built an oratory near the hospital of the Ceppo delle Sette Opere di Misericordia in Florence.[10]

In the thirteenth and fourteenth centuries, large, shaped crucifixes could be found on the rood screens of many Italian churches. A silhouetted crucifix of the sort in San Niccolò del Ceppo, in which the panel is cut along the contours of the body to simulate painted sculpture, is rarer. While several smaller, late trecento silhouetted crucifixes belonged to various adult religious confraternities,[11] it was Lorenzo Monaco who developed a large-scale version for use in monasteries. One of these, his crucifix with the mourning Virgin and Saint John the Evangelist of about 1415 (fig. 8.5), was the specific model for Fra Angelico's group.

The selection of a silhouetted crucifix for San Niccolò del Ceppo lies in the nature of the club's activities. In 1435 Ambrogio Traversari, who was the abbot of Santa Maria degli Angeli (Lorenzo Monaco's convent) as well as a patron of Angelico and Lorenzo Ghiberti, explained to Pope Eugenius IV Condulmer that Florentine boys' clubs met to recite and sing psalms and lauds, and to participate in "worthwhile colloquies."[12] Like their modern counterparts, the clubs channeled the youths' energy into a variety of endeavors. The boys marched in municipally sponsored religious processions, for which they often created special floats. And, from at least the late 1420s, the youngsters were recruited as actors in religious plays. Although records are scarce, the confraternities soon staged their own all-boy productions, with San Niccolò del Ceppo's Christmas pageant gaining particular renown late in the century. Angelico undoubtedly co-opted the silhouetted crucifix from its use in adult brotherhoods and monastic settings in the hope that the form's dramaturgic potential would facilitate the boys' orations. By breaking the confines of the frame, the cutout achieves a tangibility that personalizes a worshiper's experience of sacred events.

Stylistically, the group can be placed about 1427. The treatment of the contours, head, and musculature of Christ is similar to the Christ in Masaccio's

Angelico could put so much power into his expression."[7] And on May 16 he elaborated: "The Fra Angelico continues to be an infinite pleaser. It is a wonderful work."

COMMENTS

Saint Francis of Assisi is shown in three-quarter view, looking up. Tonsured and bearded, he wears a brownish gray hooded habit bound at the waist with a white cord. His arms are positioned as if in the act of the receiving the stigmata, or the signs of Christ's wounds, which can be seen on his hand and side. The figure is outlined in black.

In the early literature, the painting was only known in its falsified state (fig. 8.1), which in 1913 Berenson called one of "the most vital of Fra Angelico's creations." He dated it to the artist's late Roman period, saying "the execution is of a breadth and freedom to be expected from the relaxed hand of an old man." He compared the Johnson work with the Crucifixion group in San Niccolò del Ceppo (fig. 8.4), which he considered to be by a follower of Fra Angelico, and to the Saint Francis in Antoniazzo Romano's altarpiece of 1464 in Rieti.[8] In a lecture given at the Johnson Collection on May 17, 1926, Richard Offner was critical of Berenson's opinion: "In my opinion [it is] not by Fra Angelico. It is far too coarse. It may have been designed by

mural of the *Trinity* executed about 1425–26.[13] But perhaps more than to Masaccio, Angelico may have looked to the sculptor Ghiberti, who reminisced in his autobiography that he made wax and clay models for painters and that "to those who had to make figures larger than life size, I have given the rules for executing them on perfect scale."[14] Angelico is documented as having collaborated with the sculptor in 1433. The *Saint Francis* suggests an even earlier association, for the deep folds of the tunic and the three-dimensionality of his head recall Ghiberti's bronzes for Orsanmichele in Florence and in particular the *Saint Stephen,* which was completed in 1429 but begun as early as 1425.[15]

Two derivations of Angelico's *Crucifixion* exist (figs. 8.6, 8.7). Saint Jerome's presence in both suggests that they were made for the Ceppo's adult confraternity devoted to that saint.

1. The word "bottom" was found on the back of the lower framing element, possibly indicating that the forgery had been executed in England.
2. Sebregondi Fiorentini 1985, pp. 47–48.
3. Sebregondi Fiorentini 1985, fig. 16.
4. Sebregondi Fiorentini 1985, p. 48.
5. Poggi and Bucciardini 1998.
6. Sebregondi Fiorentini 1985, pp. 47–49.
7. On May 5 Berenson responded, "Needless to tell you how glad I am that both the Angelico and Basaiti have pleased you." For the portrait by Marco Basaiti, see Philadelphia 1994, repro. p. 178.
8. Rieti, Museo Civico; Paolucci 1992, repro. pp. 62, 64 (color).
9. Licia Collobi Ragghianti (1950a) thought that the picture was the wing of an altarpiece. She proposed as the central section the *Virgin and Child* in the Prepositura di San Michele Arcangelo in Pontassieve, near Florence (on deposit at the Museo Nazionale di San Marco; Pope-Hennessy 1974, fig. 59).
10. The name "Ceppo" continued to be used even after the boys moved to Santa Maria del Tempio in 1530. *Ceppo,* or "tree trunk," was the common name for charities that had traditionally collected donations in hollow trunks.
11. The earliest is Pietro Lorenzetti's (q.v.) crucifix in the Museo Diocesano in Cortona (Volpe 1989, fig. 117). Mariotto di Nardo's crucifix of c. 1385–90 in San Firenze in Florence once belonged to the oratory of the company of the Neri (Offner 1933, repro. p. 167). A cross of about 1380–85 by Pietro Nelli in San Pietro a Ripoli near Florence was cut from a painting of the Crucifixion for ceremonial use by a company of the Bianchi, a lay penitential group that carried crosses through Florence in the year 1400 (Boskovits 1975, plate 101). The Florentine Niccolò di Tommaso's (q.v.) silhouetted crucifix of c. 1371, on deposit in the Museo e Gallerie Nazionali di Capodimonte in Naples, comes from a Neapolitan confraternity, the Disciplina della Croce (Boskovits 1975, fig. 67).
12. Quoted in Trexler 1974, pp. 209–10.
13. Florence, Santa Maria Novella; Danti 2001, post-restoration color plate I.
14. Ghiberti 1447–55, Bartoli ed. 1998, p. 97. The translation is by Krautheimer 1982, p. 15.
15. Krautheimer 1982, plate 14.

Bibliography
Berenson 1913, pp. 10–11, repro. p. 236; Schottmüller 1924, p. 277, repro. p. 203; Inaugural 1928, p. 9; Van Marle, vol. 10, 1928, pp. 116–17; London 1930, p. 98, no. 139; Balniel, Clark, and Modigliani 1931, p. 30, no. 84 (139); Berenson 1932, p. 23; Berenson 1936, p. 20; Johnson 1941, p. 1; Collobi Ragghianti 1950a, p. 467 n. 7; Pope-Hennessy 1952, p. 178, fig. XVII; Luciano Berti in Florence 1955, pp. 36 n. 21, 45–46 n. 25; Salmi 1958, p. 86; Berenson 1963, p. 15; Sweeny 1966, p. 3, repro. p. 106; Baldini 1970, repro. p. 96 nn. 48, 48a; Baldini and Dal Pogetto 1972, pp. 32–33; Fredericksen and Zeri 1972, p. 9; Pope-Hennessy 1974, pp. 226, 231, fig. 63; Boskovits 1976a, p. 31; D. Cole 1977, pp. 380–82, 446; Sebregondi Fiorentini 1985, esp. pp. 47–49; Maria Cristina Improta in San Marco 1990, p. 71; Skipsey 1993, figs. A–B; Strehlke 1993, cover (color detail), figs. 11 (color), 12–13; Philadelphia 1994, repro. p. 176; Spike 1997, p. 234, fig. 76A; Carl Brandon Strehlke in Kanter, Strehlke, and Dean 2001, p. 54, figs. 25–26

COMPANION PANEL for PLATE 8

Crucifixion with Saints Nicholas of Bari and Francis of Assisi. See fig. 8.4

c. 1427

Tempera and tooled gold on panel; 82¾ × 57⅛" (210 × 145 cm). Florence, confraternity of San Niccolò del Ceppo

INSCRIBED ON THE TABLET ABOVE THE CROSS: *IHS. NAZARENUS REX IUDEORUM* (John 19:19: "JESUS OF NAZARETH, THE KING OF THE JEWS")

EXHIBITED: Florence 1955, no. 25; Florence 1972, Room VIII, no. 3

SELECT BIBLIOGRAPHY: Luciano Berti in Florence 1955, pp. 45–46 n. 25; Salmi 1958, p. 101; Baldini and Dal Poggetto 1972, pp. 32–33; Pope-Hennessy 1974, pp. 226, 231; Boskovits 1976a, p. 31; D. Cole 1977, pp. 380–82, 446; Sebregondi Fiorentini 1985, esp. pp. 47–49; Baldini 1986, p. 244; Maria Cristina Improta in San Marco 1990, p. 71; Strehlke 1993, p. 9; Spike 1997, p. 234

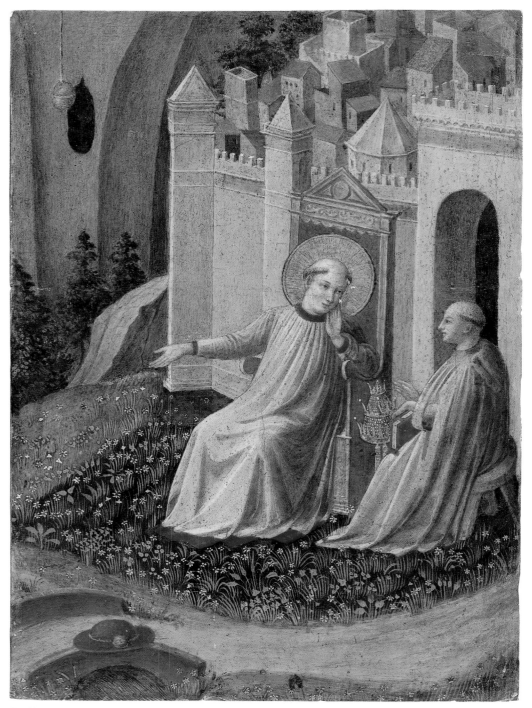

PLATE 9

PLATE 9 (JC CAT. 1166)

WORKSHOP OF FRA ANGELICO

Fragment: *An Episode in the Life of Saint Celestine V or Saint Gregory the Great*

c. 1430–35

Tempera and tooled gold on panel with horizontal grain; 11 × 7⅞ × ⅛″ (28 × 20 × 0.4 cm)

John G. Johnson Collection, cat. 1166

INSCRIBED ON THE REVERSE: *1166* (in pencil)

TECHNICAL NOTES

The panel is thinned and cradled; strips of new wood are attached on all four sides. A crack runs horizontally through the wood about 6¾″ (17 cm) from the bottom edge. The panel has numerous small losses and has been extensively repainted in the flesh areas, the hat on the bridge, the architecture, the trees and rock on the left, and the breadbasket in the background. The restorer even painted his own cracks in the retouching. It would seem that this restoration was done before John G. Johnson purchased the panel in 1913, as no restoration work has been recorded after that date. There is some possibility that it was executed by Ignazio Hugford (1703–1778) or Lamberto Gori (1730–1801) when the panel was sawn apart, in order to make the picture appear as an independent work. All the other paintings in this complex save the one in a private collection (see fig. 9.4) underwent similarly radical restorations.

Infrared reflectograms revealed an artist's pentimento that indicates there was originally a plan to place an arch in the wall to the left, between the two towers, and a cornice above it. In addition, the city walls were to have overlapped the knee of the saint. Flake loss on the city walls shows that the artist had first made them a bright pink that he later painted over with a buff gray.

The saint's halo is water gilded and the lower half reconstructed. The decoration on the tiara is mordant gilded. The mordant is an ocher color. There is some evidence of nonoriginal silver decoration in the tiara.

PROVENANCE

The panel was purchased by John G. Johnson from Ludovico de Spiridon in 1913 (see letter from Spiridon dated Paris, September 2, 1913) as a work by the school of Fra Angelico.

COMMENTS

In a flowering meadow outside city walls, a tonsured saint is seated on a throne. He gestures toward the left while conversing with a tonsured man seated on a stool and holding a book. A three-crowned papal tiara is placed between them. A path in the

foreground crosses a small bridge, on which there is the red hat of a cardinal. At the left is a rocky precipice with a cave, toward which a basket is being lowered.

Wilhelm R. Valentiner (1914) identified this scene as Saint Gregory the Great (reigned 590–604) being offered the papacy. George Kaftal (1952) accepted this opinion, citing as the literary source a passage in John Deacon's ninth-century life of the saint that describes how the Roman populace went to Gregory's monastery in the country to acclaim him pope, an honor that he was at first reluctant to accept. However, even though the cropping of the panel on the left precludes a view of the complete, original composition, the absence of a crowd coming from the city would seem to argue against associating the scene with this episode in Gregory's life. Since the gesture of the principal figure's right arm does apparently indicate his preference for a hermit's life in the wilderness over the honors represented by the tiara, an alternative identification may be Pope Celestine V (reigned 1294) either first reluctantly accepting or then abdicating the papacy. Before the humble monk Pietro del Morrone was proclaimed pope and given the name Celestine on July 5, 1294, he had headed his own monastic order and lived as a hermit in a grotto on Monte Morrone, above Sulmona. He abdicated the papacy a few months after accepting it, however, on December 13, 1294, and died in May 1296. He was proclaimed a confessor saint in 1313. His order, later known as the Celestines, followed the rule of Saint Benedict.

John Pope-Hennessy (1974, pp. 220, 222–23, 227) and Miklós Boskovits (1976, pp. 42–43, 52–53 n. 27) proposed that a number of other pictures showing episodes from the lives of monastic saints were possibly from the same complex, which they suggested was a predella: *Apparition of Saint Romualdo to Otto III* (fig. 9.1) in Antwerp; *Saint Benedict in Ecstasy* (fig. 9.2) in Chantilly; *Conversion of Saint Augustine(?)* (sometimes entitled the *Penitence of Saint Julian the Hospitaller*) (fig. 9.3) in Cherbourg; and *Temptation of Saint Anthony Abbot* (fig. 9.5) in Houston. Keith Christiansen added to the list the *Adoration of the Christ Child* in New York.[1] Boskovits also suggested that a panel of Saint Anthony Abbot was one of the main sections of the altarpiece.[2] Because the panels present varying sizes, Diane Cole (1977, pp. 475–77, 499–504, 530–32) and Elisabeth de Boissard (in De Boissard and Lavergne-Durey 1988, pp. 46–47) have rejected Pope-Hennessy's and Boskovits's proposals for its composition. Carolyn C. Wilson (1995, p. 738 n. 3) has more specifically rejected the inclusion of the *Temptation of Saint Anthony Abbot*.

None of these authors mentioned the Johnson panel. Like the other panels, it no longer has its original dimensions, but it does have a horizontal crack, which is a distinguishing feature of all the other panels except for the *Temptation*. While the evidence may well suggest that the Johnson panel was part of the complex, the Houston panel,

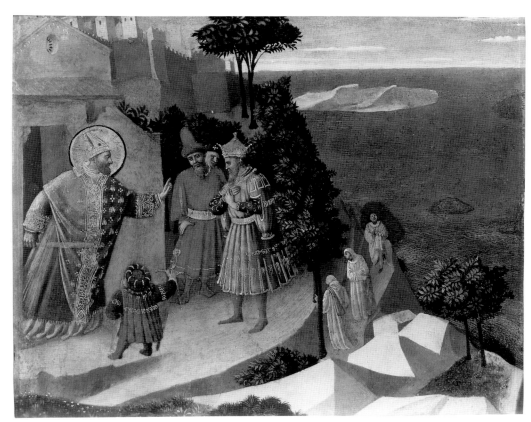

FIG. 9.1 Workshop of Fra Angelico. *Apparition of Saint Romualdo to Otto III*, c. 1430–35. Tempera and tooled gold on panel; 8¾ × 10¾″ (22.3 × 27.3 cm). Antwerp, Koninklijk Museum voor Schone Kunsten, no. 117. See Companion Panel A

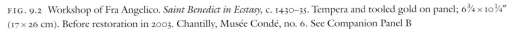

FIG. 9.2 Workshop of Fra Angelico. *Saint Benedict in Ecstasy*, c. 1430–35. Tempera and tooled gold on panel; 6¾ × 10¼″ (17 × 26 cm). Before restoration in 2003. Chantilly, Musée Condé, no. 6. See Companion Panel B

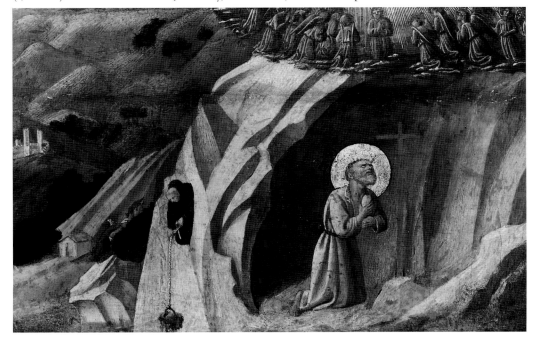

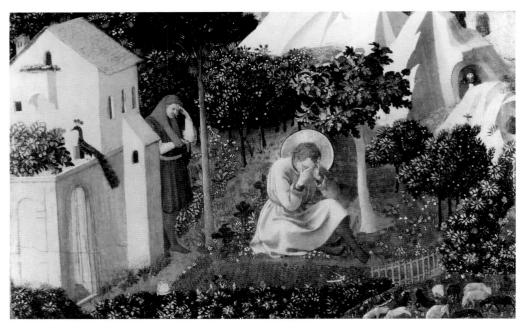

FIG. 9.3 Workshop of Fra Angelico. *Conversion of Saint Augustine(?)*, c. 1430–35. Tempera and tooled gold on panel; 7⅞ × 12⅝″ (20 × 32 cm). Cherbourg, Musée d'Art Thomas Henry, no. 8. See Companion Panel C

FIG. 9.4 Workshop of Fra Angelico. *Hermit Monks in a Landscape*, c. 1430–35. Tempera on panel; 10⅛ × 15⅛″ (27.5 × 38.5 cm). France, private collection. See Companion Panel D

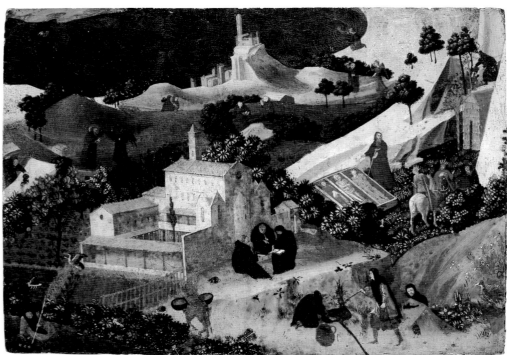

although seemingly by the same artist, most likely was not.

In July 1999 Anne Leader suggested that the panels, because of their varying sizes, were not part of a predella, but possibly were fragments of a rectangular panel showing the thebaid, a depiction of hermetic monks. She noted that, in the recent cleaning of the panel in Cherbourg, a figure of a monk appeared in a grotto in the background. This figure does not have any role in the scene, which probably represents the conversion of Saint Augustine. All the other panels have similar overpaintings that might mask other incidental figures. Leader also noted that in *Saint Benedict in Ecstasy* the monk on the mountainside holding a rope might actually have been connected to the pail of bread on a rope in the upper left of the Johnson panel. In the landscape of *Saint Benedict* there is also a monk feeding a wolf, which is a common episode in fourteenth- and fifteenth-century representations of thebaids. In 2001 Michel Laclotte was able to confirm this thesis by discovering the central fragment of the complex, which showed episodes of hermits. X-radiographs of all the panels were compared and Laclotte is now preparing a reconstruction. In addition, the panel in Chantilly underwent conservation (2003). It was found that the heavenly host in the upper part was a restoration, very much in the style of the repainting on the top part of the panel of Fra Angelico's *Dormition of the Virgin* in the Johnson Collection (plate 7 [JC cat. 15]), which must have been undertaken by Ignazio Hugford or Lamberto Gori who had successively owned that painting. Hugford is known to have restored early Italian paintings.[3] Furthermore, he owned Fra Angelico's *Thebaid,* which was bought for the Uffizi in 1789–80 after his death.[4] It is possible that he or Gori sawed apart this second picture and repainted the fragments to make them look like individual pictures.

The panel was sold by Spiridon as a work of a follower of Fra Angelico and was published as such by Valentiner in 1914 in the third volume of the catalogue of Johnson's collection. Bernhard Berenson apparently agreed with this attribution, as in a letter written to Johnson from Settignano, dated January 28, 1917, he said, "I like the charming school of Fra Angelico where a youth presents the papal tiara to a youthful cardinal." The attentive treatment of the landscape, in which the flowers, grass, and leaves are individually rendered, suggests a date close to Fra Angelico's altarpieces of the Annunciation of the mid-1420s in Madrid[5] and the early 1430s in Cortona.[6] Furthermore, the view of the descending hills and seashore in the panel in Antwerp (fig. 9.1) recalls the scene of the Visitation in the predella of the Cortona altarpiece.[7]

It would seem that the painting represented a series of episodes of saints associated with the history of monasticism interspersed with representations of

hermit monks in a rocky landscape. Anthony Abbot was regarded as the founder of monasticism; Benedict established monasticism in Italy; Augustine lived a communal life and in the later Middle Ages was credited with writing a monastic rule; and Celestine V founded his own monastic order. Saint Romualdo, who much revered the desert fathers and the ideals of monastic hermitism, founded the monastery of Camaldoli in the Apennines outside Florence. His presence in the predella suggests that it came from an altarpiece from one of the several Camaldolese churches in the Florentine countryside. Santa Maria degli Angeli, where Sanguigni rented a workshop, was the order's major monastery in the city of Florence itself. Paintings of this subject enjoyed a certain popularity in early fifteenth-century Florence, and a number of them were produced by Fra Angelico and his workshop and followers.[8]

1. Keith Christiansen in New York 1984a, pp. 61–62, color repro. p. 62.
2. San Francisco, private collection; 35 × 13″ (89 × 33 cm); Boskovits 1976, plate 13 (as location unknown).
3. On Hugford's fakes, see Fra Angelico, plate 7 (JC cat. 15).
4. No. 447; Bellosi 2002, color repro. p. 167. Hugford may well have obtained a picture like the thebaid from his brother Don Enrico (see Fleming 1955, pp. 106–10), who was the prior of Vallombrosa, a remote Tuscan monastery where the ideals of hermit monks would have been a relevant theme. At least one other fifteenth-century thebaid has a Vallombrosan provenance and was executed by a Vallombrosan monk-painter, Don Giuliano Amidei. His thebaid was also broken apart and is in a fragmentary state; see Gaudenz Freuler in Lugano 1991, pp. 250–52 (with earlier bibliography), color repro. p. 250; and reconstruction from Ellen Callmann, p. 252, fig. 1.
5. Strehlke 1998, plate 23.
6. Hood 1993, color plate 87.
7. Pope-Hennessy 1974, plate 22b.
8. Strehlke 1998, pp. 14–16, 68 nn. 8–9, figs. 13–16; Miklós Boskovits in Bellosi 2002, pp. 162–71, color and black-and-white repros.

Bibliography
Valentiner 1914, p. 198, repro. p. 394 (follower of Fra Angelico); Johnson 1941, p. 1 (immediate follower of Fra Angelico); Kaftal 1952, col. 462, fig. 542; Sweeny 1966, p. 3 (immediate follower of Fra Angelico); Fredericksen and Zeri 1972, p. 9 (follower of Fra Angelico); Strehlke 1993, p. 21, fig. 27 (follower of Fra Angelico, possibly Sanguigni); Laurence B. Kanter in Kanter et al. 1994, p. 287; Philadelphia 1994, repro. p. 176 (follower of Fra Angelico)

COMPANION PANELS for PLATE 9

A. Fragment: *Apparition of Saint Romualdo to Otto III.*
See fig. 9.1

c. 1430–35

Tempera and tooled gold on panel; 8¾ × 10¾″ (22.3 × 27.3 cm). Antwerp, Koninklijk Museum voor Schone Kunsten, no. 117

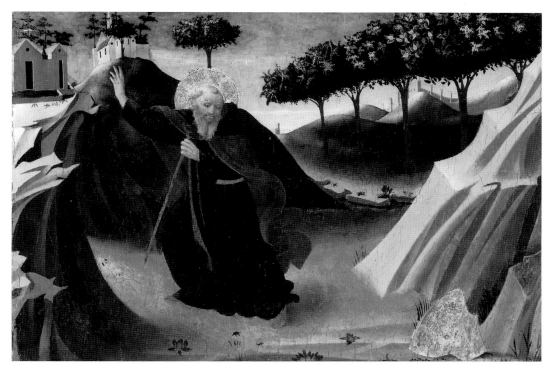

FIG. 9.5 Workshop of Fra Angelico. Predella panel of an altarpiece: *Temptation of Saint Anthony Abbot*, 1430s. Tempera and tooled gold on panel; 7¾ × 11″ (19.7 × 28 cm). Houston, The Museum of Fine Arts; The Edith A. and Percy S. Straus Collection, no. 44.550

PROVENANCE: Florence, comtesse de Lozz; Antwerp, van Ertborn, 1825

SELECT BIBLIOGRAPHY: Salmi 1958, p. 65; Berenson 1963, p. 11; Baldini 1970, p. 116, no. 117; Pope-Hennessey 1974, p. 220; Boskovits 1976, pp. 42–43, 52–53 n. 27; D. Cole 1977, pp. 475–77

B. Fragment: *Saint Benedict in Ecstasy.*
See fig. 9.2

c. 1430–35

Tempera and tooled gold on panel; 6¾ × 10¼″ (17 × 26 cm). Chantilly, Musée Condé, no. 6

PROVENANCE: Paris, Frédéric Reiset; sold Paris, Hôtel Drouot, April 28, 1879, lot 3 (as Angelico); acquired by the duc d'Aumale (died 1879); bequeathed to the Musée Condé

SELECT BIBLIOGRAPHY: Collobi Ragghianti 1950a, pp. 454, 457; Collobi Ragghianti 1955, pp. 22, 47 n. 5; Salmi 1958, p. 105; Berenson 1963, p. 11; Baldini 1970, p. 116, no. 120; Pope-Hennessy 1974, p. 222; Boskovits 1976, p. 43; D. Cole 1977, pp. 499–501; Elisabeth de Boissard in De Boissard and Lavergne-Durey 1988, pp. 46–47

C. Fragment: *Conversion of Saint Augustine(?).*
See fig. 9.3

c. 1430–35

Tempera and tooled gold on panel; 7⅞ × 12⅝″ (20 × 32 cm). Cherbourg, Musée d'Art Thomas Henry, no. 8

PROVENANCE: Thomas Henry Collection; in the Cherbourg museum since 1835

EXHIBITED: Paris 1956, no. 44 (as Angelico)

SELECT BIBLIOGRAPHY: Longhi 1940, p. 175; Salmi 1958, p. 92; Berenson 1963, p. 142; Baldini 1970, p. 98, no. 52; Pope-Hennessy 1974, pp. 222–23; Boskovits 1976, pp. 42–43, 52–53 n. 27; D. Cole 1977, pp. 502–4

D. Fragment: *Hermit Monks in a Landscape.*
See fig. 9.4

c. 1430–35

Tempera on panel; 10⅛ × 15⅛″ (27.5 × 38.5 cm). France, private collection

PROVENANCE: Unknown

SELECT BIBLIOGRAPHY: Michel Laclotte, forthcoming

APOLLONIO DI GIOVANNI
(*Apollonio di Giovanni di Tommaso*)

FLORENCE, 1415/17–1465

MARCO DEL BUONO
(*Marco del Buono di Marco Giamberti*)

FLORENCE, 1402–1489

In 1442 Apollonio di Giovanni became a member of the Florentine Guild of Physicians and Apothecaries (Arte dei Medici e Speziali), which included painters, and the next year joined the painters' fraternity, the company of San Luca. By 1446 he was in partnership with Marco del Buono in a workshop that specialized in painting panels for *cassoni*, or marriage chests, and other decorations for private residences. The partnership was dissolved by the time Apollonio dictated his last will and testament in August 1465. The *Libro di bottega,* a seventeenth-century copy of the register of works executed during their partnership, from 1446 to 1463,[1] unfortunately contains many lacunae.[2] The copyist seems to have been primarily interested in genealogical information, for he mainly recorded works such as *cassoni,* which were commissioned for marriages. Further insight into how the workshop operated is found in the account book of Bernardo di Stoldo Rinieri, who ordered suites of furniture in preparation for his wedding.

In 1944 Wolfgang Stechow recognized that a *cassone* (fig. 10.3) depicting Xerxes' invasion of Greece, in the Allen Memorial Art Museum in Oberlin, Ohio, and another showing the triumph of the victorious Greeks, now lost,[3] had been commissioned from the two artists in 1461 for the wedding of a daughter of

Giovanni Rucellai to Francesco di Pagolo Vettori. This in turn permitted identification of a large number of previously unattributed works as the product of their enterprise. An illuminated manuscript of Dante's *Commedia* and Petrarch's *Trionfi*[4] of 1442; the *cassone* panel in Oberlin and its lost companion, ordered in 1461; and the front of another *cassone* made for a Pazzi Borromei wedding in 1461 are their only securely dated works.[5] However, a *cassone* front in the Fondazione Longhi in Florence showing putti and the arms of the Del Bene family may be identified with one ordered in 1450.[6]

Differences in painting style suggests that the workshop employed various artists. There has been no successful attempt to distinguish the hand of Apollonio from that of his partner, about whom little is known. Apollonio was the more famous of the two and is generally thought to have been the dominant personality. Between 1458 and 1464, the poet Ugolino Verino wrote Latin verses in praise of Apollonio. In *Flametta* Verino describes a painting of episodes from the *Aeneid,* which Ernst Gombrich (1955) argued might be represented in two *cassone* panels at the Yale University Art Gallery.[7] The poem suggests that the artist's interpretations of ancient history had gained a certain currency in humanist Florence. *Flametta* was dedicated to Giovanni Rucellai, patron of Leon Bat-

tista Alberti. Apollonio's own association with Rucellai testifies to the appeal of the artist's paintings of ancient history to sophisticated and humanistically inclined upper-middle-class Florentines.

Six surviving small-scale paintings of the Virgin and Child represent another aspect of the partnership's production.

1. Florence, Biblioteca Nazionale Centrale, Ms. Magliabecchiano XXXVII, 305; see Schubring 1915, vol. 1, pp. 432–37; Callmann 1974, Appendix I, pp. 75–81.
2. Callmann 1988, p. 5.
3. Formerly Bath, Ermö Wittmann Collection, destroyed World War II; Callmann 1974, plate 53.
4. Florence, Biblioteca Mediceo-Laurenziana, Ms. Med. Pal. 72; Callmann 1974, plates 11–13, 16–17, 21–23.
5. Bloomington, Indiana University Art Museum, no. 75.37; Callmann 1988, fig. 18.
6. Callmann 1974, plate 20. Callmann, however, denies the attribution.
7. Nos. 1871.34, 1871.35; Callmann 1974, plates 43–44.

Select Bibliography
Logan 1901; Aby Warburg in Thieme-Becker, vol. 2, 1908, p. 33; Schubring 1915, vol. 1, pp. 432–37; Offner 1927, pp. 27–30; Van Marle, vol. 10, 1928, pp. 547–75; Berenson 1932, pp. 346–47; Stechow 1944; Gombrich 1955; Callmann 1974; Callmann 1977; Watson 1979–80; Francesca Petrucci in *Pittura* 1987, p. 565; Callmann 1988; Ellen Callmann in *Saur,* vol. 4, 1992, p. 525

PLATE 10 (JC CAT. 26)

WORKSHOP OF
APOLLONIO DI GIOVANNI
AND MARCO DEL BUONO

Virgin and Child Enthroned with Saint Benedict and a Bishop Saint

c. 1460

Tempera and tooled gold on panel with vertical grain; 29⅜ × 19¾ × ⅝″ (74.5 × 50 × 1.5 cm), painted surface 28⅝ × 18¾″ (72.5 × 47.5 cm)

John G. Johnson Collection, cat. 26

INSCRIBED ON THE REVERSE: *CITY OF PHILADELPHIA/ JOHNSON COLLECTION* (stamped several times); *in 2098 26* (in pencil)

TECHNICAL NOTES

The panel, which is thinned and cradled, consists of two planks joined approximately 11½″ (29 cm) from the left. Visible at the top is a piece of linen that appears to have been applied along the join. There is a barbe on all four sides, indicating that there originally were applied frame moldings.

The areas where the gold was to be applied are marked by stylus incisions, as are the folds in the baby's blanket and the Virgin's mantle. The arches of the apse were incised with a compass. Infrared reflectography revealed some faint evidence of dotted lines, which may suggest the use of a *spolvero*, or pounced drawing. These lines are mainly visible in the hands of the Virgin and on the Christ Child, most particularly in the hand holding the pomegranate. The reflectography also showed that Christ's other hand was drawn over an existing drawing of his jaw.

Mordant gilt details on the Virgin's mantle, Christ's blanket, the bishop's miter and gloves, and Saint Benedict's book are quite worn. Most of the tooling of the gold is incised. The only punching is a dot and a tiny crescent used to indicate highlights on the arms of the throne and the bishop's staff.

While the surface shows some wear, the painting is generally in good condition, except for scattered losses in the Virgin's blue mantle, which is dark and flat in appearance.

Pasquale Farina cleaned and cradled the picture in 1916. He wrote to Johnson about its condition in a letter dated July 21, 1916: "The last was cradled and revealed to its pristine exceptionally well preserved charming coloring. . . . I beg to call your attention to the beautiful rich variety of violet and turnsole shade, seen in the capitals and cornices of the architectural background of the Florentine picture. I consider those tones quite a rare note of coloring, used for such a purpose."

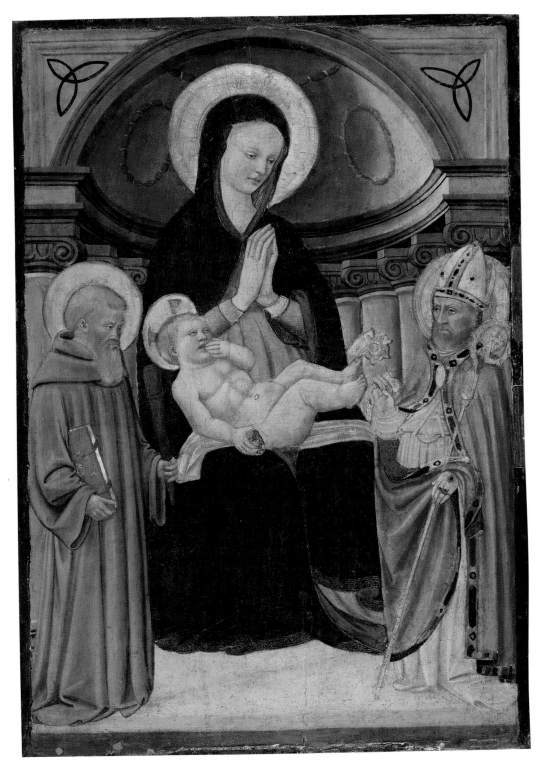

PLATE 10

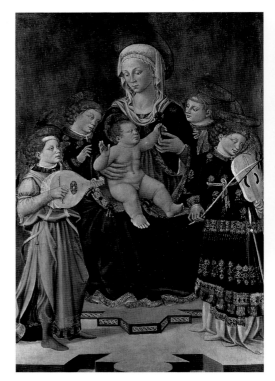

FIG. 10.1 Workshop of Apollonio di Giovanni and Marco del Buono. *Virgin and Child with Four Angels,* c. 1450. Tempera and tooled gold on panel; 27⅞ × 18⅜″ (70.8 × 46.7 cm). Berea, Kentucky, Berea College, Art Department, Special Collections, no. 140.11 (K528)

FIG. 10.2 Workshop of Apollonio di Giovanni and Marco del Buono. Birth salver (reverse): *Two Nude Boys with Poppy Capsules,* c. 1450–60. Tempera on panel; 23 × 23¼″ (58.4 × 59.1 cm). Raleigh, North Carolina Museum of Art, Gift of the Samuel H. Kress Foundation, no. GL. 60.17.23

FIG. 10.3 Workshop of Apollonio di Giovanni and Marco del Buono. Detail of a *cassone* panel: *Xerxes' Invasion of Greece,* c. 1461. Tempera and tooled gold on panel; 16¼ × 60⅞″ (41.2 × 154.5 cm). Oberlin, Ohio, Oberlin College, Allen Memorial Art Museum, R. T. Miller, Jr. Fund, 1943, no. 43.293

In August 1919 Hamilton Bell described the picture as blistered and cracked. On December 10, 1920, he and Carel de Wild noted that the flesh was much overcleaned and that the rest was much repainted; de Wild later repaired the picture. In 1956 and 1963 Theodor Siegl had to face the surface with wax due to a split at the center of the bottom edge and flaking over the entire surface. This wax was removed in 1969, and the picture's condition is now stable.

PROVENANCE
Unknown

COMMENTS
The Virgin sits enthroned in an exedra consisting of a semicircle of columns with Ionic capitals. The Christ Child lies on her lap holding an open pomegranate, an emblem of the Passion. To the left is Saint Benedict with a book and a scourge, the latter a reference to the discipline of his monastic rule. The saint on the right is a bishop, but there is no attribute to identify him specifically.

Bernhard Berenson (1913) assigned the picture to "some Florentine journeyman in contact with the followers of Fra Filippo and Domenico Veneziano." During a visit to the Johnson Collection in 1938, Evelyn Sandberg Vavalà attributed the painting to the Virgil Master, who was subsequently identified as Apollonio di Giovanni by Wolfgang Stechow (1944) and Ernst Gombrich (1955). Richard Offner (1927, pp. 28–30) had recognized four paintings of the Virgin and Child with angels by the same hand in the Fogg Art Museum in Cambridge;[1] the Berenson Collection at Villa I Tatti in Florence;[2] the former Toscanelli Collection in Pisa;[3] and the Murray Collection in Los Angeles.[4] In 1929 Mario Salmi added another (fig. 10.1).

In a monograph on the painter, Ellen Callmann (1974) rejected these attributions to Apollonio, arguing that he and Marco del Buono produced little besides panels for *cassoni* and illuminations. Later (1988), however, she revised her opinion, and now believes that their workshop painted the group identified by Offner and Salmi as well as a *Virgin and Child with Angels,* formerly in Bergamo, and a *Virgin and Child with Saint John the Baptist,* in a private collection.[5] However, in her 1974 monograph Callmann rejected an attribution to Apollonio for the Johnson Collection's painting, and in her 1988 article she did not mention the work.

The facial features of the Virgin and saints, the baby, and the ambitious architectural setting accord well with the workshop's other paintings of the Virgin as well as with its many *cassone* pictures and images of baby boys (fig. 10.2). The saints, with their prominent eyebrows, closely resemble figures found in the partnership's *cassone* (fig. 10.3) of about 1461, showing Xerxes invading Greece. The architectural setting argues that the picture probably dates very late in the workshop's production, and the clumsy positioning of the baby suggests that an assistant was involved in its execution.

1. Bowron 1990, p. 303, fig. 564.
2. Callmann 1988, fig. 157; Russoli 1962, color plate XXXV.
3. Callmann 1988, fig. 160.
4. Offner 1927, fig. 220.
5. Offner 1927, figs. 17, 22.

Bibliography
Berenson 1913, p. 20 (Florentine, c. 1450); Johnson 1941, p. 17 (Virgil Master); Sweeny 1966, pp. 79–80 (Virgil Master); Fredericksen and Zeri 1972, p. 12 (Apollonio di Giovanni); Callmann 1974, p. 87; Philadelphia 1994, repro. p. 177 (workshop of Apollonio di Giovanni di Tommaso and Marco del Buono)

ARRIGO DI NICCOLÒ
(*Master of the Manassei Chapel*)

PRATO, C. 1374–C. 1446

The Master of the Manassei Chapel is the name given to the artist who painted the mural cycle of the legends of Saints James Major and Margaret in a chapel of the *collegiata* (later the cathedral) in Prato.[1] This chapel was under the patronage of the Manassei family, but a document of 1396 mentions that Prato's leading citizen, Francesco di Marco Datini, was overseeing its decoration.[2] The lack of any further mention of the chapel in Datini's vast papers suggests that it may not have been finished until after his death in 1410.

Luciano Bellosi (1983–84) proposed that the artist was Arrigo di Niccolò, a local painter whose activity is well chronicled in the Datini papers. He, in fact, is recorded in 1391 as working with Niccolò di Pietro Gerini (q.v.), the original candidate for the Manassei chapel commission, in Datini's house.[3] A tabernacle of the Crucifixion executed in 1409 for the Palco, Datini's country home near Prato,[4] is the only picture that can be documented to Arrigo, who had to make a claim against Datini's estate for payment. Because the style of the tabernacle closely resembles the murals in the Manassei chapel, it is likely that the artists are one and the same.[5]

In 1397 Arrigo di Niccolò received his first important commission: the murals (now lost) for a chapel in San Domenico in Prato. That same year he was working in the church of San Salvatore in Bologna, but was injured when he fell off the scaffolding. After the accident he seems to have stopped painting for a while, as in 1404 he is documented as procuring wine for Datini, telling the merchant that "I would like to earn my keep with you by the brush and not with wine."[6] Although Arrigo lived until about 1446, little else is known about his life.

1. Cherubini 1991, fig. 191; Fremantle 1975, fig. 560 (as Agnolo Gaddi [q.v.]); Boskovits 1975, fig. 421.
2. Piattoli 1929–30, pp. 103–5.
3. Piattoli 1929–30, p. 548.
4. Boskovits 1983, fig. 9.
5. Miklós Boskovits (1975) tentatively proposed that the artist was one Neri d'Antonio. The name is recorded as among those who worked with Agnolo Gaddi in the chapel of the Virgin's Belt, or the *Cingolo*, in the *collegiata* of Prato in 1392–94. In 1398 Neri was among those who appraised a statue made by Piero di Giovanni Tedesco for Florence cathedral, and in 1399 he received a commission for mural paintings for the choir of Santa Felicita in Florence. It seems, however, that he died before finishing these projects. No works by Neri survive, but the late dating of the murals in the Manassei chapel would exclude him as their artist.
6. "Vorrei con voi guadagnare del pennello e non del vino" (Petri 1962, p. 48).

Select Bibliography
Piattoli 1929–30, vol. 1, pp. 247 n. 3, 410, 548–49; vol. 2, pp. 98, 106–13, 140–43; Petri 1962; Boskovits 1975, p. 241 nn. 183–84; Bellosi 1983–84, pp. 47–49; Andrea De Marchi in Turin 1987, no. 6; Luciano Bellosi in Cherubini 1991, pp. 922–23; W. Jacobsen in *Saur*, vol. 5, 1992, p. 289

PLATE II (PMA 1950-134-528)
Right lateral panel of an altarpiece: *Saints Benedict, Sebastian, Stephen, and John the Evangelist*

C. 1399–1410

Tempera and tooled gold on panel with vertical grain; $58\frac{1}{8} \times 32\frac{3}{8} \times 1\frac{1}{4}''$ (147.5 × 82 × 3 cm)

Philadelphia Museum of Art. The Louise and Walter Arensberg Collection. 1950-134-528

INSCRIBED ON THE EVANGELIST'S BOOK: *FILIO/ LI. M[EI]./ DILI/GAM[US]/ VE[R]BO/ NEQUE/ LING/UA. SET. O/P[ER]E [E]T/ VERI/ TATE.* (John 3:18: "My little children, let us not love in word, nor in tongue, but in deed, and in truth"); ON THE LOWER EDGE: *MRE MMN GRATII ME FECIT MEEI* (spurious Latin); ON THE REVERSE: *#450* (in pencil) *Grande Velocità/ da/ Bologna/ 99* [High Speed/ from/ Bologna] (on a sticker); *[s]cuola gaddi* (school [of] Gaddi) (in ink); charcoal drawings of arch configurations; profile of molding, and a series of mathematical calculations (fig. 11.1)

PUNCH MARKS: See Appendix II

EXHIBITED: Philadelphia Museum of Art, *Louise and Walter Arensberg Collection* (Fall 1954), no catalogue

TECHNICAL NOTES
The panel, which has been sawed at the top and along the edges of the arch, is made up of two planks joined $9\frac{3}{8}''$ (23.6 cm) from the left edge. On the right there is a thin strip, $\frac{5}{8}''$ (1.5 cm) wide, that has been glued and nailed in place. A large crack running the length of the panel to the right of center has been repaired by butterfly keys. An area where there was once a horizontal batten is visible on the reverse (fig. 11.1). The batten's location is marked by incisions, and it was attached by four square nails driven from the front, which were later cut flush with the reverse. In addition, there are nail holes on both sides as well as remnants of wood that have been glued to the left side. This wood may have been part of the original framing or a later arrangement.

The gold and tooling extend to the unplaned original edges. The barbe, now seen on the surface, seems to have been formed at a late date when the painting was put into another frame. The gaps between adjacent panels of the altarpiece would have been covered by colonnettes. The only indication of an original engaged frame that survives is the central element at the top and the corbel that divides the picture surface into two arches. Incisions in the gold ground show that this corbel was originally meant to be longer.

Charcoal marks on the reverse, including the area that the batten later covered, can be read in an infrared reflectogram (fig. 11.1). The marks, which were made before the altarpiece was put together, show calculations working out the shape of the arch and the profile of the frame as well as other seemingly mathematical formulas. A scribed line down the middle of the reverse of the panel marks the division between the two arches. Another horizontally scribed line indicates the springing of the arch.

The figures in the painting are fairly well preserved. The modeling in Saint Stephen's flesh and costume as well as most of the mordant gilding on this figure are in a particularly fine state. The flesh of Saint John the Evangelist is noticeably abraded, as are the faces of Saints Benedict and Sebastian.

The gold background, which is enriched by fine graining, is very abraded. The saints stand on a textile patterned in sgraffito with pomegranates, picked out in a now-darkened green glaze, on a red background decorated with rabbits. The same pattern is used on Saint Sebastian's costume.

The inscription on the bottom, which is painted over the sgraffito and is largely illegible, would seem to be fake. At best it may imitate one that had originally been in the frame, but it was poorly understood and several of the Gothic letters do not make sense.

PROVENANCE
Sold by Raoul Tolentino at New York, American Art Association, April 26, 1920, lot 831 (as Orcagna); purchased by Dr. Siegfried Aram, New York, at the sale of the collection of Mrs. Charles Wimpfheimer, New York, American Art Association, November 1, 1935, lot 109 (as Orcagna); purchased from Aram by Walter Arensberg, 1937

COMMENTS
Saint Benedict, in the upper left, wears a white habit and holds a bunch of sticks, a symbol of the discipline imposed by his monastic rule. The white habit suggests that this panel came from an altarpiece in a church of either the Camaldolese, Certosian,

FIG. 11.1 Infrared reflectogram of the reverse of plate 11, showing drawings, frame profiles, and calculations

FIG. 11.2 Arrigo di Niccolò. *Saints John the Baptist, Lawrence, James Major, and Peter,* c. 1399–1410. Tempera and tooled gold on panel; without modern frame 59⅛ × 31½″ (150 × 80 cm). Present location unknown. See Companion Panel

Olivetan, or Vallombrosan orders, as these offshoots of the Benedictine order all wore white rather than the usual black habit. At the upper right the young Saint Sebastian, a late third-century Roman soldier and Christian convert, clutches two arrows, which recall his survival of having been shot at by archers. The deacon Saint Stephen, at the lower right, holds a book and a palm of martyrdom. The stones on his bloodied head evoke his lapidation. Saint John the

Evangelist is the bearded man with a pen and an open book at the lower left.

This painting was the right lateral panel of an altarpiece. The left lateral panel depicts Saints John the Baptist, Lawrence, James Major, and Peter (fig. 11.2). The central panel has not been identified, but it may have been the Coronation of the Virgin. The double arch in both panels can be found in an important model for a Florentine altarpiece of this

period, the *Coronation of the Virgin* (fig. 11.3) executed between 1399 and 1401 for Santa Felicita in Florence.

The lettering on the Philadelphia panel may be a faulty transcription of the original. It is probably a continuation of an inscription that was on the lost central panel and would seem to refer to the person who had commissioned the altarpiece. The other lateral panel bears the fragmentary date MCCC XXXXX

(1350), which is much too early for the panels' style. In 1937 Walter Arensberg, who had bought both paintings, decided to return the left panel to the former owner, Siegfried Aram, because of its bad condition. Arensberg had received a report from the restorer Stan Pociecha on May 7 of that year describing its deteriorated state and former restorations.[1] Although the correspondence does not mention it, the inscription may have been tampered with in an earlier restoration. If, however, a now-missing *C* followed the five *X*s, this could be an unorthodox way of writing "1399," the possible date of the commission.

When the Museum's picture was sold in 1920, it was assigned to Andrea di Cione, called Orcagna. A letter in the Museum's files from Klara Steinweg (dated Florence, May 15, 1967) indicates that in the *Corpus of Florentine Painting*, Richard Offner had planned to publish it as by the Master of the Louvre Coronation.[2] In 1975 Miklós Boskovits attributed the panel to the Master of the Manassei Chapel—now identified as Arrigo di Niccolò—which a simple comparison of the head of Saint James Major in the companion work (fig. 11.2) with its counterpart in the cycle of his life in that chapel verifies. While Luciano Bellosi (1983–84, p. 54 n. 18, and in Cherubini 1991, p. 956 n. 85) generically questioned some of Boskovits's attributions to the master, he did not specify his opinion on this panel and its companion.

The Philadelphia picture is one of the earliest known works by Arrigo di Niccolò, probably dating to the first years of the fifteenth century, when he was still under the influence of his erstwhile collaborator Niccolò di Pietro Gerini.

1. Box 1, folder 16; and Box 10, folder 6, Arensberg Archives, Department of Modern and Contemporary Art, Philadelphia Museum of Art.
2. This painter was later identified as the Master of Santa Verdiana, who was subsequently shown to be Tommaso del Mazza (q.v.).

Bibliography
Philadelphia 1965, p. 35; Boskovits 1967, p. 58; Boskovits 1975, p. 241 n. 183; Offner 1981, p. 46; Philadelphia 1994, repro. p. 177; Barbara Deimling in Pasquinucci and Deimling 2000, p. 368

COMPANION PANEL for PLATE 11

Left lateral panel of an altarpiece: *Saints John the Baptist, Lawrence, James Major, and Peter.* See fig. 11.2

c. 1399–1410

Tempera and tooled gold on panel; without modern frame 59⅛ × 31½″ (150 × 80 cm). Present location unknown

INSCRIBED ON THE BAPTIST'S SCROLL: *ECCE A/ GNUS DEI/ ECCE QUI/ TOL/ LIT PECCATA/ MUNDI* (John 1:29: "Behold the Lamb of God, behold him who taketh away the sin of the world"); IN PETER'S HALO: *SANCTUS*

PLATE 11

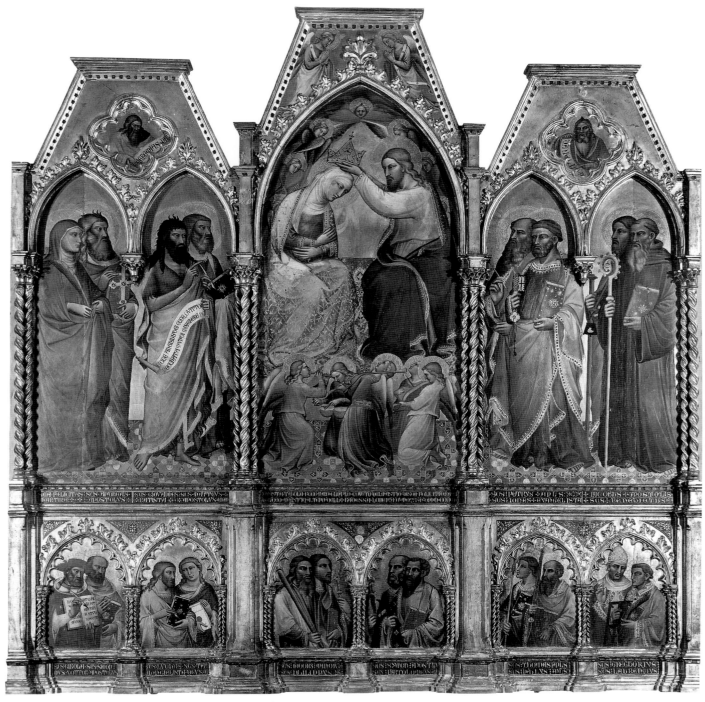

FIG. II.3 Spinello Aretino (Arezzo, first documented 1373; died 1410/11), Niccolò di Pietro Gerini (q.v.), and Lorenzo di Niccolò (Florence, documented 1392–1411). Altarpiece: *Coronation of the Virgin with Angels, Saints, and Prophets,* 1399–1401. Tempera and tooled gold on panel; 108⅜ × 85⅞″ (275 × 218 cm). From Florence, church of Santa Felicita. Florence, Galleria dell'Accademia, no. 8468

PETRUS APOSTOLUS (Saint Peter Apostle); ON THE LOWER EDGE: *MCCC XXXXX* (1350)

PROVENANCE: Walter Arensberg purchased this panel and its companion now in the Museum from Dr. Siegfried Aram of New York in 1937. In a letter dated Hollywood, May 27, 1937, he wrote to Aram explaining that he was returning this painting because it "is in very bad condition, and [because] the work you had done to strengthen and preserve it was

completely inadequate" (Box 1, folder 16, Arensberg Archives). The panel was later sold by F. Schnittjer & Son at New York, Parke-Bernet, January 14, 1943, lot 61 (as Niccolò di Pietro Gerini). The catalogue for that sale cites a letter from Osvald Sirén, dated November 27, 1935, in which he describes it as an early work by Lorenzo di Niccolò. In 1966 the painting was with the dealer Luzzetti in Milan. It was sold in Florence, Franco Semenzato, April 20, 1989, lot 100 (as Master of the Manassei Chapel).

EXHIBITED: Florence, Palazzo Strozzi, *Biennale, mostra mercato internazionale dell'antiquariato,* 1966, with Antichità Luzzetti of Milan (as Aretine School)

SELECT BIBLIOGRAPHY: *Antichità viva,* vol. 5, no. 6 (November–December 1966), p. v; Boskovits 1975, p. 241 n. 183; Andrea De Marchi in Turin 1987, no. 6; Barbara Deimling in Pasquinucci and Deimling 2000, p. 368

BATTISTA DI GERIO

PISA, DOCUMENTED PISA AND LUCCA
1414–18

Battista, son of the stoneworker Gerio di Giovanni from Pisa, finished his apprenticeship in Pisa with the Sienese painter Vittorio di Domenico on April 5, 1414. Their relationship was such that Vittorio provided the painter's sister with a dowry and named Battista his legal representative.

Battista's activity in his native city included work in the Camposanto and the Opera Primaziale Pisana,[1] for which he was paid on January 22, 1418. By April he had moved to Lucca, where on the fourth of the month he drew up a four-year partnership agreement with the local painter Francesco di Jacopo. Francesco was to do all the preparatory work, including gessoing, gilding, and burnishing the panels, whereas Battista would design and paint the images,[2] for which he was to receive a larger share of the profits. That same year Battista alone signed an altarpiece now in the *pieve* of Santi Giovanni Battista e Stefano at Camaiore near Pisa,[3] but probably originally in Santi Giovanni e Reparata in Lucca. No other documents or dated works are known, but Maria Teresa Filieri (1998) has recently shown that the altarpiece that included the Johnson picture was painted for a Lucchese church before the year 1423.

The Camaiore altarpiece and two other works attributed to him by Federico Zeri (1973), including the Johnson Collection's picture, comprise his known oeuvre, although Luciano Bellosi has suggested that an important illuminated parchment, the *Vacchetta pisana,* often thought to date to the mid-fourteenth century, is by Battista.[4] There was also some discussion as to whether he painted the predella panels showing stories of Saints Quirico and Giulitta in the Courtauld Institute Galleries in London[5] as well as a number of other related works, until Filieri (1995) identified this artist as the Lucchese painter Borghese di Pietro.

1. The former was a minor restoration. His mural of the Virgin and Child, probably dating 1417–18, is still in the Opera. Filieri 1998, fig. 176.
2. Concioni, Ferri, and Ghilarducci 1994, pp. 370–71.
3. Sometimes erroneously published as 1433 or 1444. Filieri 1998, color repro. p. 323.
4. Ente Comunale di Assistenza di Pisa; Bellosi 1974, p. 107. See Dalli Regoli (1970, figs. 1–8 [color and black-and-white]), who proposes an attribution to the trecento painter Francesco Traini.
5. Volpe 1973, figs. 15a–c.

Select Bibliography
H. V. in Thieme-Becker, vol. 3, 1909, pp. 46–47; Bacci 1913; Moriondo 1952 (with an incorrect date for the altarpiece of Camaiore); Carli 1961, p. 97; Longhi 1965b; *Bolaffi*, vol. 1, 1972, p. 422; Volpe 1973; Zeri 1973; Zeri 1976, p. 140, cat. 93; Zeri 1976a; Pietro Torriti in San Miniato 1979, pp. 66–67;

Padoa Rizzo 1981a; Maurizia Tazartes in *Pittura* 1987, p. 575; Fanucci Lovitch 1991, pp. 46–47; Claudio Casini in *Saur,* vol. 7, 1993, p. 492; Concioni, Ferri, and Ghilarducci 1994, pp. 370–71; Filieri 1995; Maria Teresa Filieri, Andrea De Marchi, Linda Pisani, Luciano Bellosi, and Everett Fahy in Filieri 1998, pp. 312–26.

PLATE 12 (JC CAT. 12)
Center panel of an altarpiece: *Virgin and Child Enthroned*

1423

Tempera and tooled gold on panel with vertical grain; 46¾ × 25⅜ × ¾″ (118.7 × 64.5 × 1.8 cm)

John G. Johnson Collection, cat. 12

INSCRIBED ON THE REVERSE: *IN 158/12* (in pencil on a label)

PUNCH MARKS: See Appendix II

EXHIBITED: Philadelphia Museum of Art, Sixty-ninth Street Branch, *Religious Art of Gothic and Renaissance Europe* (December 1, 1931–January 4, 1932), no catalogue

TECHNICAL NOTES
The thinned and cradled panel consists of three members, with the one in the center measuring 44″ (111.7 cm) wide and two strips on each side measuring 1¼″ (3 cm) wide on the left and 1⅝″ (4 cm) wide on the right. On the right side there are regularly spaced old nail holes, some with remnants of nails, which may indicate that this strip was an addition. On the left side, which is original, there are no such nail holes, although there is evidence of a dowel in the center, and two other dowel holes are present 10⅛″ (25.5 cm) and 11⅞″ (30 cm) below the springing of the original arched top.

The original applied moldings have been removed. The picture surface originally had an arched top that began at about the height of the lower molding at the top of the throne (fig. 12.1). There is also a faint indication that the frame included capitals. After the panel was disassembled from the frame, wood inserts, ⅝″ (1.5 cm) wide, were placed in the upper corners. The top and bottom of the painting have been cropped, and the linen layer is visible along the bottom edge.

Nails and nail holes that probably once held transverse battens can be seen at the back of the panel at 1⅝″ (4 cm), 22⅛″ (56 cm), and 22⅝″ (65 cm) from the top (fig. 12.1).

The gold background and halos are completely redone in oil gilding, probably to hide evidence of the removal of the original frame moldings. The mordant gilding on the Virgin's costume and

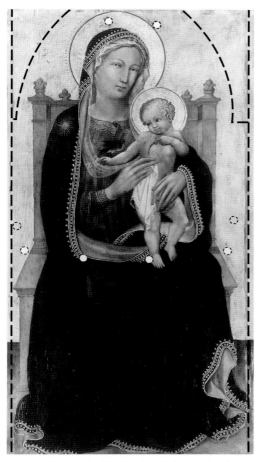

FIG. 12.1 Diagram by Mark Tucker of plate 12, showing the location of the nail holes of the transverse battens and dotted lines to indicate the original configuration of the picture surface

Christ's blanket is also almost completely restoration. The Virgin's blue mantle is entirely overpainted, possibly to mask a candle burn in the lower left that is visible with infrared reflectography. In raking light a brocade pattern can be seen. Infrared reflectography showed that the pattern consisted of interlocking circles with a six-petaled flower. The brocade did not follow the pattern of the folds, which were probably executed with glazes. A small cleaning test indicated that the brocade was made up of a mordant gilding over azurite.

Infrared reflectography (figs. 12.2, 12.3) further demonstrates that the artist used innovative drawing techniques that show concern for the development of volume, as in the unusual, circular hatching in the torso of the Christ Child. Much of the drawing was first done in a wash with a brush,

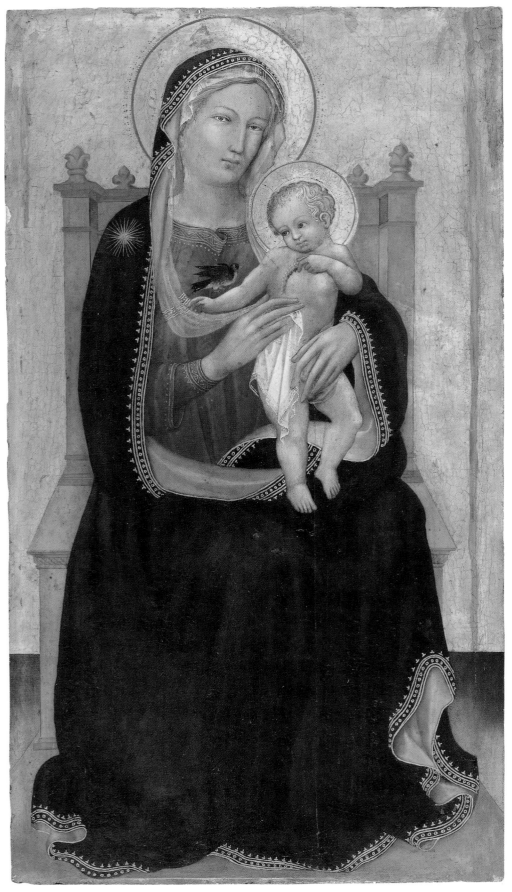

PLATE 12

with precise outlines added in a second stage. In the Virgin's face, for example, long, broad lines define the large shaded areas, and there is detailed drawing on the Virgin's proper right eye.

The paint in the flesh is quite abraded, and in some areas the green underpainting is visible.

In August 1919 Hamilton Bell stated that the condition of the picture had not changed since it had been cleated to take care of warps. However, the following April he inspected the panel with Carel de Wild, who noted that it needed cradling. At this point it was also found to be flaking, and while the flesh and the red robe were said to be in sound shape, Bell and de Wild observed that the blue mantle and all the gold were modern. The cradling was done in March 1921. In 1956 Theodor Siegl made minor repairs.

PROVENANCE

The picture was originally part of an altarpiece in San Quirico all'Olivo in Lucca. Its subsequent history is not known until Osvald Sirén published it as in the Johnson Collection in 1908. However, the following year Bernhard Berenson (1909a) mistakenly reported that it was in the collection of Admiral Charles Whiteside Rae in Washington, D.C. He reproduced it as possibly by the Sienese artist Pietro di Domenico and as having been in the Fornari Collection in Fabriano, but this seems to have been a mistake as it contradicts his text.

COMMENTS

The Christ Child stands on the Virgin's lap as he teases, with an unidentified flower or piece of grain, a goldfinch, a symbol of the Passion because it was reputed to live among thorns. The gold stars on the Virgin's right shoulder and head are symbols of the *stella maris,* or "star of the sea," a medieval attribute of the Virgin Mary that comes from the ninth-century hymn *Ave maris stella* (Hail, Star of the Sea) sung at vespers and religious feasts honoring her.[1]

This painting was attributed to the Master of the Bambino Vispo, now identified as Starnina (q.v.).[2] Although in 1940 Roberto Longhi recognized that it was not by him, the attribution persisted in the literature until 1973, when Federico Zeri correctly associated it with the only known signed work of Battista di Gerio: the Camaiore altarpiece of 1418.[3] Zeri also noted the Johnson painting's similarities with a mural of the Virgin and Child in the Opera Primaziale Pisana,[4] also attributed to Battista, which he dated to about the same year as the Camaiore altarpiece. The mural may, in fact, be a little earlier, because it demonstrates the influence of Taddeo di Bartolo (q.v.), who worked in Pisa intermittently from about 1389 to 1397/98.[5] By contrast, the altarpiece seems inspired by International Gothic painters such as Starnina and Àlvaro Pires (Alvaro Pirez), who were active in or near Pisa in the first decades of the century. The fact that there

FIG. 12.2 Infrared reflectographic detail of plate 12, showing the underdrawing of the Virgin's head

with the one by Battista di Gerio. The location and patronage of the altarpiece account for the presence of Saint Quirico, patron of the church, as well as Saints Sixtus and Luke, since another altar in the church was dedicated to Saint Sixtus, and the patron, Luca di Jacopo, is shown kneeling before his own name-saint, the apostle Luke.

The church, also known as San Quirico in Pelleria, was closed in 1808, and its property sold.[9] Remains of the building still exist on the via Fatinelli behind the church of Sant'Andrea. Two detached fourteenth- and fifteenth-century murals and fifteenth-century tombstones of the Parensi family that come from the church are now in the Museo Nazionale di Villa Guinigi in Lucca.[10]

1. See Heinrich Lausberg in Höfer and Rahner, vol. 1, 1957, cols. 1141–42.
2. The attribution was made by Osvald Sirén (1908). Bernhard Berenson (1932a) later proposed it as the central panel of an altarpiece that was then thought to

be dated to 1422 and to have come from the Corsini chapel in the cathedral of Florence.
3. Filieri 1998, color repro. p. 323.
4. Filieri 1998, fig. 176.
5. Documents record Battista as working in the Opera in 1417/18, but the mural could date earlier. Fanucci Lovitch 1991, p. 47; Filieri 1998, p. 313.
6. The saints had been erroneously identified as Crescentia and Vitus, who are much revered in Pisa.
7. The Avignon panel has nail holes in the same position as those in the Johnson panel, further confirming that they belong to the same complex.
8. Filieri 1998, pp. 317–18.
9. Barsotti 1923, p. 142.
10. Belli Barsali 1988, pp. 194–95, cats. 464/1, 464/2, and p. 215.

Bibliography
Sirén 1908, p. 325 (Master of the Bambino Vispo); Berenson 1909a, pp. 4, 6, repro. p. 6 (Pietro di Domenico[?]); A. Venturi, vol. 7, pt. 1, 1911, p. 26 (Master of the Bambino Vispo); Berenson 1913, pp. 9–10, repro. p. 234 (Master of the Bambino Vispo); Sirén 1914, p. 329, repro. p. 328; Henniker-Heaton 1924, pp. 211–15; Van Marle, vol. 9, 1927, p. 192; Berenson 1932, p. 340; Berenson 1936, p. 277;

is less gothicizing and more solid modeling in the Johnson painting suggests that it is later than the Camaiore altarpiece.

The Johnson painting was the center of an altarpiece (fig. 12.4) whose lateral panels were, on the left, *Saints Julian the Hospitaller and Luke with the Donor Luca di Jacopo* in Avignon (fig. 12.5), and, on the right, *Saints Giulitta, Quirico, and Sixtus* in Lucca (fig. 12.6).[6] However, whereas Carlo Volpe (1973) and Zeri (1973, 1976a) identified Battista di Gerio as the artist of these panels, Maria Teresa Filieri (1998) was the first to publish them all as parts of the same altarpiece. The cusped top of the panel in Avignon reflects the original shape of all three elements, although the Johnson *Virgin and Child* was slightly taller than the other two.[7]

Filieri[8] proposed that the altarpiece was the one mentioned in a document of February 17, 1423, in which a priest named Luca di Jacopo outlines his intended gifts for the altar of Saint Lucy in the Lucchese church of San Giovanni Maggiore, called "degli Spiafame" (Appendix I, plate 12, document 1). Luca di Jacopo also records what he had already done for the Lucchese church of San Quirico all'Olivo, where he was the rector. Stating that the floor, ceiling, and decoration of that church had been in bad condition, he claims to have spent more than his own earnings from the church on its restoration. Not only did he pay for structural improvements but he also provided the high altar with a "sumptuous painted panel with images of saints," a new missal, and a silver chalice. Based on a document, dated December 10, 1651, that describes the painting, which was then still on the high altar, as showing the Virgin and Saint Quirico with other, unidentified saints (Appendix I, plate 12, document 2), Filieri identified the altarpiece

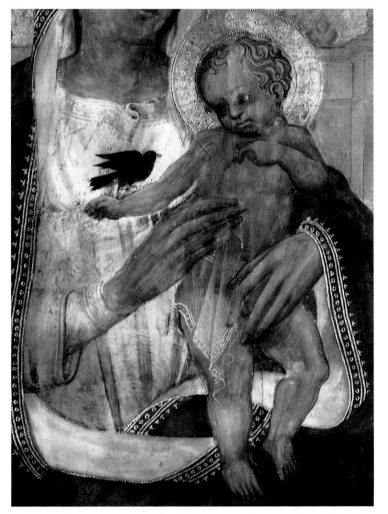

FIG. 12.3 Infrared reflectographic detail of plate 12, showing the underdrawing of the Virgin and Christ Child

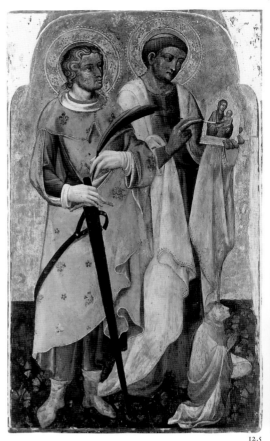

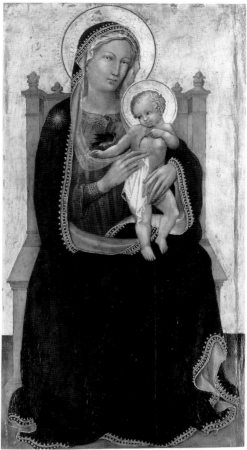

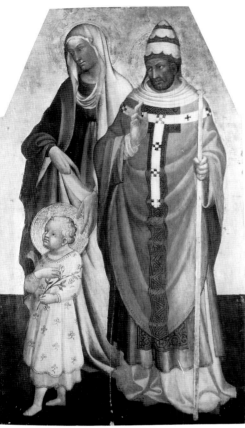

12.5

PL. 12

12.6

FIG. 12.4 Original configuration of the known extant panels of Battista di Gerio's altarpiece, 1423. Left to right: FIG. 12.5 *Saints Julian the Hospitaller and Luke with the Donor Luca di Jacopo.* Tempera and tooled gold on panel; 44⅞ × 26″ (114 × 66 cm). Avignon, Musée du Petit Palais, no. 26 bis. See Companion Panel A; PLATE 12; FIG. 12.6 *Saints Giulitta, Quirico, and Sixtus.* Tempera and tooled gold on panel; 38⅝ × 30⅜″ (98 × 77 cm). Lucca, Museo Nazionale di Villa Guinigi. See Companion Panel B

Pudelko 1938, p. 53; Longhi 1940, p. 183 n. 20; Johnson 1941, p. 10 (Master of the Bambino Vispo); Friedmann 1946, p. 147, detail repro. fig. 49; Hans Vollmer in Thieme-Becker, vol. 37, 1950, p. 32; Berenson 1963, vol. 1, p. 140; Sweeny 1966, pp. 50–51, repro. p. 103 (Master of the Bambino Vispo); Fredericksen and Zeri 1972, p. 125 (attributed to Master of the Bambino Vispo); Zeri 1973, p. 15, fig. 12; Zeri 1976a, pp. 36–38; Philadelphia 1994, repro. p. 179; Maria Teresa Filieri in Filieri 1998, pp. 316–18, fig. 179b

COMPANION PANELS for PLATE 12

A. Lateral panel of an altarpiece: *Saints Julian the Hospitaller and Luke with the Donor Luca di Jacopo.* See fig. 12.5

1423

Tempera and tooled gold on panel; 44⅞ × 26″ (114 × 66 cm). Avignon, Musée du Petit Palais, no. 26 bis

PROVENANCE: Paris; acquired by the Musée du Petit Palais from Gallerie Bailly, 1980

SELECT BIBLIOGRAPHY: Zeri 1976a; Laclotte and Mognetti 1987, p. 57; Maurizia Tazartes in *Pittura* 1987, p. 575; Filieri 1998, pp. 314–19

B. Lateral panel of an altarpiece: *Saints Giulitta, Quirico, and Sixtus.* See fig. 12.6

1423

Tempera and tooled gold on panel; 38⅝ × 30⅜″ (98 × 77 cm). Lucca, Museo Nazionale di Villa Guinigi

PROVENANCE: Rome, Paolo Paolini, c. 1920–25; Paris, Gallerie d'Atri; Milan, Manusardi Collection, 1973; purchased from the Manusardi heirs, 2001

SELECT BIBLIOGRAPHY: Volpe 1973, pp. 17–18; Zeri 1973, pp. 15–16; Zeri 1976a; Laclotte and Mognetti 1987, p. 57; Maurizia Tazartes in *Pittura* 1987, p. 575; Filieri 1998, pp. 314–19

BENEDETTO DI BINDO
(also called *Benedetto di Bindo Zoppo*)

SIENA, FIRST SECURELY DOCUMENTED 1409; DIED 1417, PERUGIA

Benedetto di Bindo is first documented on November 20, 1409, when he and Andrea di Bartolo (q.v.) received payment for painting Francesco di Valdambrino's wood statues of the patron saints of Siena for the city's cathedral; Benedetto painted Saints Savino and Vittore.[1] The following year he was commissioned to paint murals in three chapels of the cathedral's sacristy,[2] which serve as the basis for the reconstruction of the artist's oeuvre. After completing the sacristy project in 1412, Benedetto painted angels and stories of the Finding of the True Cross on its reliquary,[3] whose precious contents included the statues of the patron saints that he had helped to polychrome in 1409.

Benedetto's altarpiece for San Donato[4] and a series of projects for the Vallombrosan convent of Santa Marta, both in Siena, predate the sacristy's wall paintings. His work for Santa Marta included an altarpiece for the church (see fig. 13.6) as well as monochrome murals of the Desert Fathers in the cloister and of saints on a pilaster of the nave.[5] Benedetto may have also painted four murals in the church choir, the most interesting being *Saint Jerome Hearing the Trumpet of the Last Judgment,*[6] which an inscription dates 1392–93.

In 1414, the year he was registered in the Sienese painters' guild,[7] Benedetto was commissioned to paint a now-lost mural of the Virgin on Siena's city gate, known as the Porta Camollia. Shortly afterward he moved to Perugia, where he painted a chapel in San Domenico.[8] During this period he also painted altarpieces for the same church (or possibly the Dominican church of nearby Bevagna),[9] for the convent of the Sepolte Vive in Assisi,[10] and for the church of Santa Maria Maggiore in Bettona.[11] In 1417 Benedetto di Bindo died in Perugia, where he was buried in San Domenico.

1. Siena, Museo dell'Opera della Metropolitana; Siena 1987a, color repro. p. 141.
2. Brandi 1949, plates 16–18, 22–27, 35–39. These murals have also been attributed to Gualtieri di Giovanni and Giovanni di Bindino, whose names appear in the payment documents. But the observations of Miklós Boskovits (1980) and an attentive examination of the archival documents by Jacqueline Mongellaz (1985) have shown that Benedetto di Bindo was responsible for the whole cycle and that the other two artists worked there as assistants.
3. Brandi 1949, plates 11–15.
4. The *Virgin and Child* is still there. The other sections might include the panels with Saints Anthony and Margaret (present location unknown); parts of the predella in Berlin, Staatliche Museen (no. 1069), and Budapest, Szépművészeti Múzeum (no. 18); and two sections of the pilasters in Utrecht, Rijksmuseum Het

Catharijneconvent; see Boskovits 1980, figs. 16–20. However, in his catalogue of the Berlin museum's Italian paintings, Boskovits (1988, fig. 21) did not include the *Virgin and Child* in his reconstruction of the San Donato altarpiece.
5. For the murals in the cloister, see Callmann 1975, figs. 3–7, 9. The saints have not been illustrated. They are attributed to Benedetto by Roberto Bartalini in Gurrieri 1988, p. 288.
6. Kaftal 1952, fig. 614. The other scenes showed the *Martyrdom of Saint James Intercisus* (Kaftal 1952, fig. 600), *Saint Augustine Giving His Rule to Vallombrosan Nuns and Monks* (Kaftal 1952, fig. 99), the *Stigmata of Saint Francis,* and *Saint Augustine in His Study.* Piero Torriti (1988, p. 219) attributed all of them to a painter close to Martino di Bartolomeo, Taddeo di Bartolo, and Andrea di Bartolo (qq.v.).
7. On the guild lists in Siena, see Fehm 1972.
8. Van Marle, vol. 5, 1925, figs. 33–38 (as Umbrian, second half of the fourteenth century).
9. A triptych formed by *Saint Dominic* and the *Blessed Giacomo da Bevagna(?),* both in the collection of Monte dei Paschi (nos. 5866–67) in Siena, and *Virgin and Child with a Donor,* formerly in the Samuel S. Fleisher Art Memorial in Philadelphia (sold New York, Christie's, January 16, 1992, lot 50), may have come from San Domenico in either Perugia or Bevagna; see Gurrieri 1988, color and black-and-white repros. pp. 285–87.
10. A *Virgin and Child* from the otherwise lost altarpiece once in Assisi is in the University of Notre Dame Study Collection (no. 61.47.3); Shapley 1966, fig. 172.
11. For the *Assumption* in Bettona, see Brandi 1949, plate 19. Boskovits (1980) attributed it to Gregorio di Cecco, an identification rejected by Luciano Bellosi in Siena 1982, p. 346.

Select Bibliography
Romagnoli before 1835, vol. 3, pp. 813–16; Milanesi, vol. 1, 1854, pp. 45–46; vol. 2, 1854, p. 22; Borghesi and Banchi 1898, pp. 78–79, no. 43; Bacci 1944, pp. 195–229; Brandi 1949, pp. 29–33, 175–80 nn. 8–12, 243–48; Volpe 1958; *Bolaffi,* vol. 2, 1972, p. 32; Boskovits 1983a, p. 267; Mongellaz 1985; Strehlke 1985a, pp. 6–8; Roberto Bartalini in Gurrieri 1988, pp. 284–88; Gemma Landolfi in *Saur,* vol. 9, 1994, pp. 12–13

PLATE 13 (JC CAT. 153)

ATTRIBUTED TO BENEDETTO DI BINDO

Diptych: (left valve) *Virgin of Humility;* (right valve) *Saint Jerome Translating the Gospel of John*

c. 1400–1405

Tempera, silver, and tooled gold on panel with vertical grain; left valve 12 × 8⅜ × ⅞″ (30.3 × 21.1 × 2 cm), right valve 11⅞ × 8⅜ × ⅞″ (30.2 × 21.1 × 2 cm); painted surface: left valve 10 × 6½″ (25.2 × 16.5 cm), right valve 10⅛ × 6½″ (25.5 × 16.5 cm)

John G. Johnson Collection, cat. 153

INSCRIBED ON THE BOOK BEHIND THE VIRGIN AT LEFT: *D*[in red]*eus i*[n] *a/* [*d*]*iutori/ um me*[um] *intende;* AT RIGHT: *D*[*omin*]*ne* [*ad*] *ad/ iuvan/dum/* [*me*] *fe*[*stina*] (Psalms 69:2: "O God, come to my assistance; O Lord, make haste to help me" [from the versicle and response from the incipit intoned at lauds for the canonical hours, except at Compline, recited in honor of the Virgin, the Cross, and the Holy Spirit]); ON THE PAGE ON WHICH JEROME IS WRITING: *In pr*[*incipio*] *erat Verbum, et Verbum* [*erat*] *apud Deum, et De*[*us erat*] *Verbum. Hoc er*[*at in princi*]*pio apud* [*Deum Omnia*] *per i*[*psum facta sunt,*] *et s*[*ine ipso factum est nihil,*] *quod* [*factum est. In ipso vita erat,*] *et v*[*ita erat lux hominum. Et Lux in tenebris*] *lu*[*cet, et tenebrae eum*] *non comprehenderunt. Fuit homo missus a Deo, cui nomen erat Joannes. Hic venit* [*in*] *testimonium, ut testimonium perhiberet de lumine* [*ut omnes crederunt per illum*] (John 1:1–7: "In the beginning was the Word, and the Word was with God, and the Word was God. The same was in the beginning with God. All things were made by him: and without him was made nothing that was made. In him was life, and the life was the light of men. And the light shineth in darkness, and the darkness did not comprehend it. There was a man sent from God, whose name was John. This man came for a witness, to give testimony of the light, that all men might believe through him"); ON THE LOWER FRAME OF THE LEFT WING: [*NO*]*STRA DONNA DE HUMIL*[*ITATE*] [5⅛″ (13 cm) missing] (Our Lady of Humility); ON THE LOWER FRAME OF THE RIGHT WING: [5⅛″ (13 cm) missing] *A ST* [?] [illegible fragments of what appear to be two letters]*DNA* [illegible fragments of two letters] [1⅝″ (4 cm) missing]; ON THE REVERSE OF THE RIGHT WING: *Fira/ Fiera* (in black ink)

PUNCH MARKS: See Appendix II

EXHIBITED: Philadelphia Museum of Art, John G. Johnson Collection Special Exhibition Gallery, *From the Collections: Paintings from Siena* (December 3, 1983–May 6, 1984), no catalogue (as unknown Sienese painter, 1375–1410)

TECHNICAL NOTES
Each panel is a single piece of wood to which strips of poplar, 1½″ (1 cm) wide, have been nailed and

FIG. 13.1 Reverse of plate 13, showing the original paint

glued across the grain at top and bottom; these strips are original. The back and sides of the panels are covered with gesso and finished in a pale green paint. A pattern of six reddish squares containing lozenges in pale green is seen on the reverse of each panel (fig. 13.1). The panels retain their original applied frame moldings and hinges. The moldings have split and pulled up due to the warping of the panels.

Infrared reflectography (fig. 13.2) revealed that the artist painted out an earlier red-and-white pattern, a diamond inscribed in a circle, and small six-pointed stars on the surface of the bench behind the Virgin. Other drawing, such as the lines on Saint Jerome's desk, is easily visible with the naked eye. The inlaid geometric patterns on the furniture were all incised in the gesso, as were the pages of the books on Jerome's desk. Incised lines also define the folds of the Virgin's mantle and Jerome's beard.

The gilding and paint surface are in generally good states, although there is some light abrasion in the Virgin's face and the shaded portion of the desk under the writing surface is also abraded. Color that

was applied over the gold ground has flaked away in some areas, such as the Christ Child's blue robe. There is considerable flaking and retouching in the Virgin's ultramarine mantle. Her light-colored dress was decorated in sgraffito. In general, the mordant gilding is in good condition, although Saint Jerome's scraper, which was executed with both silver and gold, is abraded. Gilding was applied on a clear mordant on the inlaid geometric designs, the border of the Virgin's mantle, the pillow tassels, and the book straps. In addition, it was used as highlighting on the spool of white thread.

A particularly pleasing effect is the way the artist has suggested the translucency of the parchment on Jerome's desk with faint gray letters that indicate text on the reverse of the pages. The painter has represented the recession of the bench behind the Virgin by lighting the front edge and darkening the back edge.

In August 1919 Hamilton Bell noted that the molding was breaking away. In May of the next year he and Carel de Wild thought that, except for

the molding (which they decided not to repair), the painting was in good condition.

PROVENANCE
In 1908 F. Mason Perkins recorded this panel in the collection of the painter and dealer Chevalier Attilio Simonetti (1843–1925), who had a studio in the Palazzo Altemps in Rome. Very few earlier provenances for his collection are known. Solomon Reinach stated in 1918 that it had been with the Böhler gallery in Munich, where it was attributed to Lippo Memmi. In November 1908, when Bernhard Berenson, writing from Boston, offered the diptych to John G. Johnson, it was with the Parisian dealer Steinmeyer & Stephen Bourgeois, who charged Johnson 20,000 francs for the work.

COMMENTS
The left valve of the diptych shows the Virgin of Humility, as she is identified by the inscription on the frame, suckling the Christ Child.[1] She is seated on a pillow on the floor in front of a low bench on

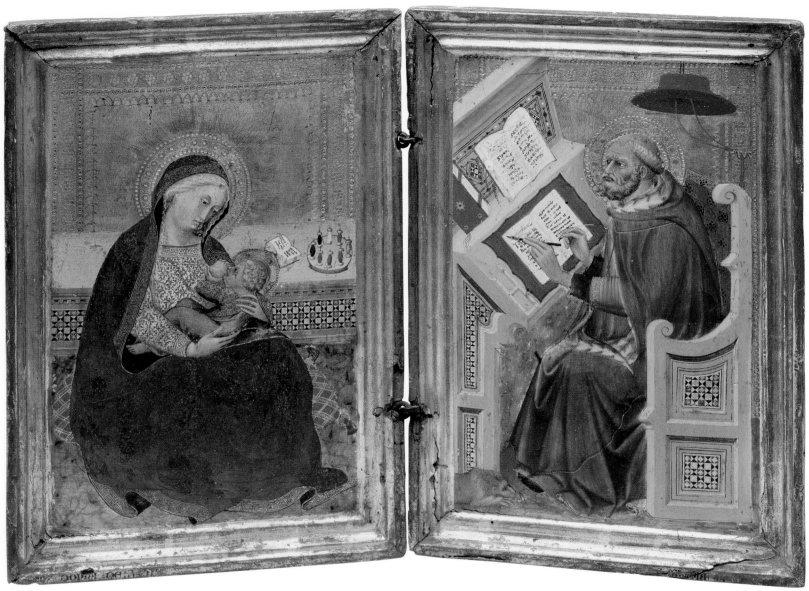

PLATE 13

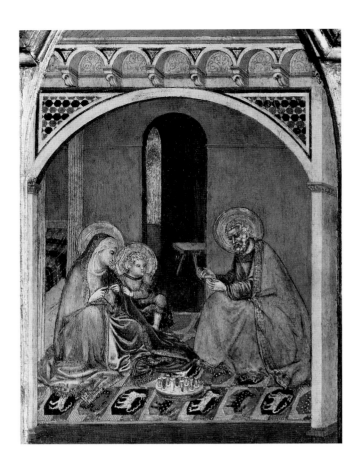

FIG. 13.2 (*above*) Infrared reflectographic detail of plate 13, showing the pattern on the bench behind the Virgin

FIG. 13.3 (*right*) Attributed to Pietro Lorenzetti (q.v.). Valve of a diptych: *Holy Family in an Interior,* c. 1340–45. Tempera and gold on panel; overall 21½ × 10⅛″ (54.4 × 25.6 cm). Riggisberg, Switzerland, Abegg-Stiftung, no. 14-21-66

which lie an open prayer book and spools of thread.

On the right is Saint Jerome in a cardinal's red robes; the cardinal's hat, called a *galerus ruber,* hangs above him. The lion whom he befriended in the wilderness reposes at his feet. Holding a quill pen in one hand and a scraper in the other, Jerome sits at a desk writing on an unbound sheet of parchment that rests on a blotting cloth nailed to the shelf. The text indicates that the saint is translating the incipit of the Gospel of John into Latin from the original Greek or Hebrew, which is represented by pseudo-characters on the open book above. The saint's translation of the Bible, known as the Vulgate, was the standard edition throughout the Middle Ages and Renaissance.

Perkins (1908) and Berenson (1909) both thought the diptych was Sienese. Perkins assigned it to Pellegrino di Mariano and Berenson to Bartolo di Fredi. Berenson, however, was troubled by his attribution, and in his 1913 catalogue of the Johnson Collection reassigned the panel to the Emilian painter Tomaso da Modena on the basis of the "substantial" execution, color, and comparison with Tomaso's murals in the church and convent of San Nicolò in Treviso.[2] Berenson also noted that the motif of the bobbins and of the Virgin sewing appeared in Bohemian and north Italian painting. However, the attribution to Tomaso did not satisfy him, nor did it gain currency. In 1930 he reattributed

the diptych, this time to the circle of the Sienese painter Niccolò di Buonaccorso, saying that it was "by some little Sienese painter between our Niccolò and the better known Taddeo [di Bartolo], and indeed close to Andrea di Bartolo, although not by him." Berenson's view is still the best—and essentially correct—analysis of the style of the picture.

A certain uniformity of style in late fourteenth- and very early fifteenth-century Sienese painting makes attributions to individual artists still a matter of some difficulty. In 1985 the present author suggested that this diptych was by Benedetto di Bindo. While this attribution was rejected by Roberto Bartalini (in Gurrieri 1988, p. 287) in an illuminating survey of Benedetto's career, a telling comparison can still be made between Saint Jerome and the old saints in the lateral panels of Benedetto's altarpiece in the Pinacoteca Nazionale of Siena (see fig. 13.6), or the images of the doctors of the church in their studies in the sacristy murals of the Siena cathedral,[3] executed in 1410–12. The distinctively pursed lips of the Virgin also appear on various female figures of the sacristy cycle[4] as well as on the Virgin of the altarpiece in the Pinacoteca Nazionale. The diptych probably dates in the decade before the cathedral murals, if not earlier. Some of the iconography is dependent on images by mid-fourteenth-century Sienese artists, and the Virgin recalls the delicate manner of Bartolomeo Bulgarini (q.v.), who died in

1378, which suggests that the painting belongs to Benedetto's early period.

The origins of the image of the Virgin and Child in a domestic setting can be traced to paintings by Simone Martini and by the brothers Pietro (q.v.) and Ambrogio Lorenzetti and their school. A work by a follower of Martini,[5] for example, shows the Virgin of Humility seated on a pillow on the floor in front of a low bench. The larger number of small-scale pictures by followers of the Lorenzetti depicting the Virgin in more specifically domestic settings indicates that the brothers probably invented the type. Pietro was certainly the first to understand that locating a sacred story in a contemporary domestic setting would help viewers identify with mystical religious events. In his large altarpiece[6] of 1342 from the cathedral of Siena, for example, he transformed the place of the Virgin's birth into a Sienese burgher's house. The popularity of this work probably induced the artist and his brother to create small-scale paintings that showed the Holy Family at home (fig. 13.3).[7] The theme was in turn taken up by other Sienese artists in the second half of the fourteenth century, with works by Bulgarini (q.v.)[8] and Niccolò di Buonaccorso (fig. 13.4) being the most immediate precedents for the painting in the Johnson Collection.

The spools of thread in Benedetto's diptych are not simply a domestic detail but a metaphor for the

Holy Family's life. The *Meditations on the Life of Christ,* written by a Franciscan friar from or near Siena in the late thirteenth or early fourteenth century,[9] describes how the Virgin earned the family's keep by needle and thread:

> We read that she provided the necessities for herself and the Son with spindle and needle; the Lady of the world sewed and spun for money, for love of poverty. . . . Did she not go from house to house asking for cloth or spinning-work? . . . When the child Jesus was five, did He not become His mother's messenger, asking whether there was any more she could do? . . . It was necessary for her to earn food by the work of her hands.

The author of the *Meditations* urged his readers to imitate this life of humility: "Do not disdain humble things. . . . Nurture the vigor of humility and poverty."[10] The spools may also be interpreted as a symbol of the Passion in that they might allude to the seamless garment, made by the Virgin, that Christ wore on the way to Calvary: "Now the coat was without seam, woven from the top throughout" (John 19:23).[11]

The Book of Hours on the bench is a prayer book intended primarily for use by laypersons. It is open to the versicle and response in the incipit of the Hours of the Virgin, the Cross, and the Holy Spirit,[12] which is the very text that the original owner of this panel would have recited in front of it each day. The same passage is inscribed on the book in the painting by Bulgarini in Amsterdam.[13]

The bench behind the Virgin was probably part of one of the beds, known as *letti a cassoni detti soppiedani,* which during this period were typically placed on platforms and had either built-in or movable bench-length chests in front that became all-purpose surfaces.[14] The bench is decorated with colored geometric patterns and a dentil motif. This type of decoration, called *alla certosina* because of its association with woodworkers of the Certosan order, was common in Tuscany and Lombardy, and became popular after the 1320s. Few domestic examples survive, however, except for small-scale boxes and chests. Similarly decorated furniture can be seen in Pietro Lorenzetti's *Birth of the Virgin*[15] as well as his earlier *Virgin and Child* (plate 39A [JC cat. 91]) in the Johnson Collection. Other Sienese examples include those in Benedetto di Bindo's murals in the sacristy of the cathedral.

The origins of the image of Saint Jerome in his study can be traced to Giovanni d'Andrea, a canon law professor from Bologna who, around 1342, wrote the tract *Hieronymianus* to promote the saint's cult in Italy. Recognizing that pictures played an important role in his mission, he wrote: "I have dictated the way of representing him, according to which he is now depicted, sitting in his seat, with the hat, nowadays worn by cardinals, taken off, and with the tame lion."[16]

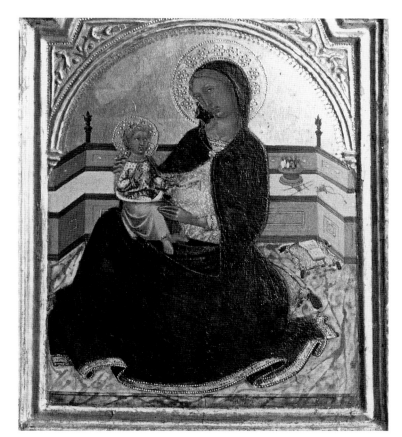

FIG. 13.4 Niccolò di Buonaccorso (Siena, documented 1355–88). Detail of a triptych: *Virgin and Child,* c. 1380s. Tempera and tooled gold on panel; overall (open) 25⅞ × 21½″ (65.6 × 54.6 cm). San Diego, The Putnam Foundation, Timken Museum of Art, no. 1967.02

The first images of Jerome with the cardinal's hat and robes appear to date around this period. Although Jerome had never been a cardinal, he was considered a doctor of the church.[17] In early Italian depictions, he is shown as a bishop.[18] He appears as a monk in other mid-fourteenth-century representations, including those by such Bolognese artists as Vitale and the Pseudo–Jacopino di Francesco, who presumably would have been familiar with Giovanni d'Andrea's ideas.[19]

Daniel Russo (1987, pp. 56–62) has argued that the growing importance of the college of cardinals during the first half of the fourteenth century caused a reevaluation of Jerome, so that by the end of the century he was commonly shown as a cardinal. The first surviving picture of him as a cardinal in his study is a mural of about 1352–55 by Tomaso da Modena in San Nicolò of Treviso.[20]

Jerome in the Johnson Collection's diptych also follows the illuminated manuscript tradition of representing an author writing at his desk. An illumination by Niccolò di Giacomo of 1353 illustrating Giovanni d'Andrea's *Novella super Decretalium,* for example, depicts a typical fourteenth-century professor's study with its built-in furniture.[21] A book stand is also a principal feature of Cenni di

Francesco's *Saint Jerome in His Study* of 1411.[22] Jerome's study in the Johnson diptych is, however, slightly different in that the book stand has been replaced by a desk with two tiers. This is more specifically the type of furniture one would encounter in a monastic scriptorium, where the copying of manuscripts was the primary activity and monks would need the original directly in front of their eyes at all times. Jerome's scriptorium is similar to those of the doctors of the church in Benedetto di Bindo's cycle in Siena cathedral.

The combination of Jerome with a scene from Christ's infancy is unusual for diptychs, which typically show the Virgin and Child on one side and a scene from the Passion on the other (see, for example, Allegretto di Nuzio, plate 4 [JC cat. 118]). However, Jerome and the infant Christ are clearly associated, because the saint was buried with the precious relic of Jesus' crib when his body was brought from Bethlehem to the basilica of Santa Maria Maggiore in Rome in the late thirteenth century.[23] By the middle of the fourteenth century, Jerome had become the object of much veneration in Italy, in part due to Giovanni d'Andrea's writing about the saint. New monastic orders were also established in his honor, including the Gesuati,

which was founded in 1355 in Siena by the Blessed Giovanni Colombini.

During the same period Jerome was also much revered by nuns, who saw themselves as successors of the Roman noblewoman Eustochium and her mother, Paola, who, at Jerome's urging, had founded a convent dedicated to the Virgin Mary in the Holy Land. In several paintings (fig. 13.5) nuns are shown kneeling in devotion to the saint.[24] A diptych combining the Virgin of Humility in a domestic setting with Jerome in his study thus would have been particularly appealing to a female monastic community. The Blessed Giovanni Colombini, Siena's greatest advocate for the worship of Jerome, had particularly close contacts with two female convents in the city. He kept a lively correspondence with the abbess of Santa Bonda, for example, and in 1359 made a donation to the Vallombrosan convent of Santa Marta,[25] where, probably because of Colombini, Jerome was much venerated. In the choir of its church is a mural of 1392–93—possibly an early work by Benedetto di Bindo—showing Jerome in the wilderness, hearing the trumpet of the Last Judgment. Benedetto also painted an altarpiece (fig. 13.6) as well as other murals for Santa Marta. Given these connections, the Johnson Collection's diptych may have come from Santa Marta. Evidence that the diptych was in Siena and was known to Sienese artists is provided by Giovanni di Paolo's copy of about 1425–30 of the Saint Jerome in a small panel now in the Pinacoteca Nazionale in Siena (fig. 13.7).

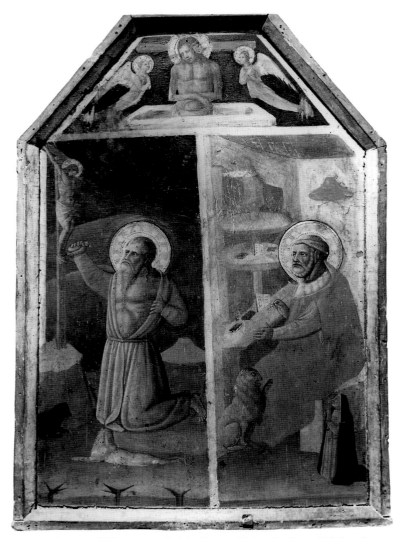

FIG. 13.5 Borghese di Pietro, also called the Master of Saints Quirico and Giulitta (Lucca, born 1397; last documented 1463). *Saint Jerome as a Penitent and in His Study with a Kneeling Dominican Nun; Man of Sorrows and Two Angels,* c. 1425. Tempera and gold on panel; 29⅝ × 20¾″ (75 × 52.5 cm). From Pisa, convent of San Domenico. Pisa, Museo Nazionale di San Matteo, no. 34

1. On the Virgin of Humility, see Lorenzo Monaco, plate 40 (JC cat. 10).
2. Gibbs 1989, plates 12–44, color plate A.
3. Brandi 1949, plates 16–18, 22–27, 35–39.
4. See, for example, Strehlke 1985, fig. 10.
5. Van Os 1969, plate 9.
6. Volpe 1989, fig. 123 (color).
7. Besides the painting illustrated in fig. 13.3, there is a much-damaged painting also showing the Holy Family "at home," attributed to Pietro Lorenzetti, in a private collection in Ancona. It is a valve of a diptych of which the other half, representing the Crucifixion, is in Avignon, Musée du Petit Palais (no. 299 bis; Avignon 1983, pp. 122–23). Giovanni Previtali (in Siena 1985, p. 30) disagreed with the traditional attribution to Pietro Lorenzetti, giving it to a collaborator of Simone Martini.
8. Amsterdam, Rijksmuseum, no. A4002; Van Os 1969, plate 9.
9. The text had been traditionally attributed to Saint Bonaventura. Evidence that the author comes from Siena is contained in the passage describing Mary and Joseph's search for the young Jesus, who had remained behind in the temple in Jerusalem, in which the writer says that their route was similar to that taken by a traveler "who returns from Siena to Pisa . . . by way of Poggibonsi or Colle or other places" (Ragusa and Green 1961, p. 89).
10. Ragusa and Green 1961, pp. 69–72.
11. Although the Johnson diptych has been compared (D'Amico 1986; Gibbs 1989) with mid-trecento depictions of the Virgin sewing by Stefano Fiorentino, Vitale da Bologna (q.v.), and Tomaso da Modena, here the Virgin in fact is *not* sewing, and the domestic setting in general is more important than any individual activity. The Stefano Fiorentino is lost. It is described in Vasari (1568, Milanesi ed., vol. 1, 1878, pp. 451–52 n. 2) as a painting in a tabernacle between the house of the Gianfigliazzi and the Ponte della Carraia on the north bank of the Arno in Florence (see D'Amico 1986, pp. 54–55). Significantly, Vasari says that Stefano painted this tabernacle after returning from Milan. The subject matter seems to have appealed mostly to north Italian artists. Besides Vitale's *Virgin* of c. 1350–55 in Milan (Museo Poldi Pezzoli, no. 1574; Gnudi 1962, color plate CIX), there is a detached mural of c. 1340 showing the Virgin sewing. Now in a private collection, it probably comes from the church of San Francesco in Bologna (Bologna 1990, color repro. p. 32). Tomaso da Modena's knitting Virgin of c. 1348–50 is part of the center panel of a triptych in Bologna, Pinacoteca Nazionale (no. 289; Gibbs 1989, detail plate 6a). Rosalba D'Amico (1986, p. 53) has related these images to the flourishing silk-weaving industry in Bologna.
12. See Wieck 1988, pp. 159–63.
13. See n. 8 above. Bulgarini's *Virgin and Child,* at the Harvard University Center for Italian Renaissance Studies at Villa I Tatti in Florence, also contains the same text (Van Os et al. 1989, fig. 8; Russoli 1962, color plate xviii [as Barna]).
14. For an example of a bed with a movable chest, see a painting by Giovanni del Biondo in the Museo dell'Opera del Duomo in Florence (Becherucci and Brunetti 1969–70, vol. 2, fig. 262). A mid-fifteenth-century predella by Giovanni di Francesco also shows how these beds were constructed. For a surviving fifteenth-century bed that belonged to the Serristori family, see Del Puglia and Steiner 1963, fig. 80. On beds in the fourteenth and fifteenth centuries, see Ellen Callmann in Allentown 1980–81, pp. 66–67 (with additional bibliography).
15. Siena, Museo dell'Opera della Metropolitana; Volpe 1989, fig. 123 (color).
16. Quoted in Ridderbos 1984, p. 19.
17. The cult of the doctors of the church had been made official by a papal bull issued by Boniface VIII Caetani in

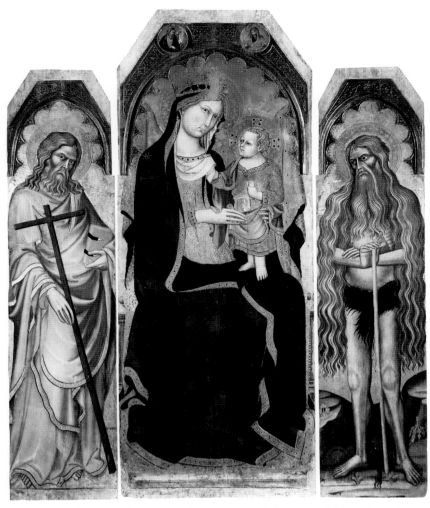

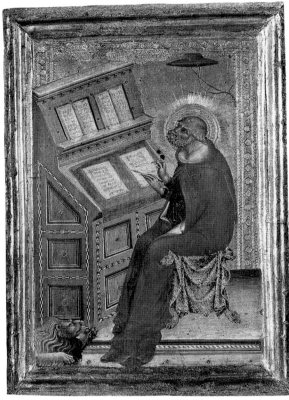

FIG. 13.6 Benedetto di Bindo. Altarpiece: *Virgin and Child Enthroned with Saints Andrew and Honophrius and the Prophets Isaiah and Jeremiah*, c. 1410–15. Tempera and tooled gold on panel; 69⅜ × 56″ (176 × 142 cm). From Siena, church of Santa Marta. Siena, Pinacoteca Nazionale, no. 140

FIG. 13.7 Giovanni di Paolo (q.v.). *Saint Jerome in His Study*, c. 1425–30. Tempera and tooled gold on panel; 12⅝ × 8¾″ (32 × 22 cm). Siena, Pinacoteca Nazionale, no. 180

1293. The other fathers were Ambrose, Augustine, and Gregory. The first two had been ordained bishops, and Gregory had been pope. Jerome's status was not clear.

18. This is the case, for example, in a roundel of Duccio's (q.v.) *Maestà* of 1285 from Santa Maria Novella in Florence (on deposit in the Uffizi; Uffizi 1990, p. 41, fig. 7); the mural by Giotto and Memmo di Filippuccio of c. 1292 in the vault of the Upper Church of San Francesco in Assisi (Previtali 1993, color plate v); and Pietro da Rimini's detached mural of the first quarter of the fourteenth century, showing Saints Jerome and Mark in their studies, from the convent of Santa Chiara in Ravenna (on deposit in the Museo Nazionale; Volpe 1965, plate 112).

19. See Vitale's mural of 1358 in the cathedral of Udine (Bologna 1990, fig. 69), and the *Altarpiece of the Presentation* of c. 1330 by the Pseudo–Jacopino di Francesco in the Pinacoteca Nazionale of Bologna (no. 217; *Pittura* 1986, fig. 334 [color]). In a pinnacle of Giusto de' Menabuoi's altarpiece of c. 1378 in the baptistery of Padua, showing Jerome as a monk in his study, a cardinal's hat was painted in at a seemingly later date (see Spiazzi 1989, fig. 154).

20. Gibbs 1989, plate c.

21. Vatican City, Biblioteca Apostolica Vaticana, Ms. Vat. lat. 145b, folio 1; Hermanin 1908, fig. 1.

22. Berti and Paolucci 1990, color repro. p. 91. Inscribed in Latin, "To the noble and generous man Lord Jerome, one of the cardinals by God's grace," this painting was commissioned by Jacopo and Girolamo di Giovanni in honor of their father in time for a meeting of the provincial chapter of the Dominicans held in San Miniato al Tedesco.

23. Rice 1985, pp. 55–64.

24. See also Giovanni del Biondo's *Saint Jerome and the Lion with Three Poor Clares* of c. 1360–65 in Altenburg, Germany, Lindenau-Museum (no. 22; Offner and Steinweg 1967, plate XIII).

25. See Strehlke in New York 1988, p. 54; Dufner 1975.

Bibliography
Perkins 1908, pp. 5–6 (Pellegrino di Mariano); Berenson 1909, p. 141 (Bartolo di Maestro Fredi); Berenson 1913, pp. 92–94, repro. p. 339 (Tomaso da Modena); Reinach, vol. 4, 1918, p. 361, fig. 2, engraving; Van Marle, vol. 4, 1924, p. 367 n. 1; Berenson 1930c, repro. p. 341; Berenson 1931, p. 29, fig. 1; E. King 1936, p. 233 n. 35; Meiss 1936, p. 447, fig. 21; Pope-Hennessy 1938, p. 29 n. 73; Johnson 1941, p. 16 (Tomaso da Modena); Brandi 1947, pp. 11, 70 n. 19, fig. 13; Meiss 1951, pp. 134 nn. 7, 138, 143, fig. 143; Panofsky 1953, vol. 1, p. 128 n. 6; Shorr 1954, p. 73, repro. type 10 Siena 6; Baltimore 1962, p. 28; Coletti 1963, p. 125; St. John Gore in London 1965, p. 17, no. 29; Sweeny 1966, pp. 71–72, repro. p. 93 (Siena, late fourteenth century); Kermer 1967, pp. 41–42, no. 34, fig. 45; Berenson 1969, p. 38, fig. 46; Henk van Os in Groningen 1969, cat. 27; Van Os 1969, p. 112 n. 116, p. 117 n. 127, fig. 53; Fredericksen and Zeri 1972, p. 149 (follower of Niccolò di Buonaccorso); Van Buren 1975, p. 44 n. 16; Torriti 1977, p. 304; Giulietta Chelazzi Dini in Siena 1982, p. 362; D'Amico 1982, pp. 179–80; Anne-Marie Doré in Avignon 1983, p. 262; Strehlke 1985a, pp. 6–8, fig. 8; D'Amico 1986, p. 55, fig. 54; Roberto Bartalini in Gurrieri 1988, p. 287; Gibbs 1989, p. 44; Michiel Franken in Van Os et al. 1989, p. 39; De Marchi 1992, p. 216 n. 124; Gage 1993, p. 122, fig. 89 (color); D'Amico 1994, p. 193; Philadelphia 1994, repro. p. 180; Philadelphia 1995, color repro. p. 162; Frinta 1998, pp. 48, 50, 224, 226, 479

BICCI DI LORENZO

FLORENCE, 1373–MAY 6, 1452, AREZZO

When Bicci di Lorenzo, the son of the painter Lorenzo di Bicci and the father of the painter Neri di Bicci (q.v.), took over his father's workshop in about 1404, the family business thrived because of a steady stream of commissions in Florence and the surrounding countryside. Rural priests and rich farmers who came to his workshop on the via San Salvatore (the present-day via della Chiesa) in Florence would have felt comfortable with Bicci's traditional taste. Only superficially taking note of how Masaccio (q.v.) had changed painting in Florence in the 1420s, Bicci basically remained faithful to the successful style established by his father.

Among Bicci's many prestigious commissions was a remarkable mural for the hospital of Santa Maria Nuova in Florence, showing Pope Martin V Colonna visiting its church of Sant'Egidio in 1420.[1] In 1421–22 the Florentine patrician Ilarione de' Bardi hired him to paint a mural cycle (now lost) in a chapel in the parish of Santa Lucia dei Magnoli in Florence; several years later Bicci executed murals for the same church's choir for Niccolò da Uzzano. Between 1429 and 1434 the artist worked on both the altarpiece[2] and the mural decoration of the Compagni chapel in Santa Trinita in Florence; other Florentine commissions included various projects for the cathedral of Santa Maria del Fiore. In the late 1430s and early 1440s he served as a gilding consultant for Domenico Veneziano, then at work on the murals of the choir of Sant'Egidio. In 1445 Francesco Bacci employed Bicci to paint the choir of San Francesco in Arezzo. Before the artist's death in that city in May 1452, he completed the vaults and part of the façade of the triumphal arch;[3] Piero della Francesca later took over the commission.

The names of Bicci's numerous assistants appear in documents dating from at least 1419.[4] On specific projects it has been possible to identify the hands of Stefano di Antonio Vanni,[5] Bonaiuto di Giovanni,[6] and the Master of Signa.[7]

1. Berenson 1963, plate 510 (as after 1424). For a summary about the dating of this mural, which included many contemporary portraits, see Frosinini 1984b, p. 6 n. 10. See also Beck 1971, pp. 181, 186–87. The mural is sometimes erroneously dated to the 1440s.
2. London, Westminster Abbey; Lynes 1983, fig. 2; and Frosinini 1984, fig. 1.
3. Lavin 1994, color plates 1a, 1b.
4. Frosinini 1987, p. 5 and notes; Frosinini 1990a, pp. 19–20 and notes.
5. Padoa Rizzo and Frosinini 1984.
6. Frosinini 1984a, 1984b.
7. Frosinini 1990a.

Select Bibliography
Billi c. 1506–30, Frey ed. 1892, pp. 14, 16; Magliabechiano 1536–46, Frey ed. 1892, pp. 91–92; Vasari 1568, Milanesi ed., vol. 2, 1878, p. 58; Gaetano Milanesi in Vasari 1568, Milanesi ed., vol. 2, 1878, pp. 63–69; Georg Gronau in Thieme-Becker, vol. 3, 1909, pp. 605–6; Van Marle, vol. 9, 1927, pp. 1–38; Colnaghi 1928, pp. 42–43; Berenson 1932, pp. 82–86; Zeri 1958a; Berenson 1963, plate 510; Emma Micheletti in *DBI*, vol. 10, 1968, pp. 327–30 (with earlier bibliography); *Bolaffi*, vol. 2, 1972, pp. 122–24; Fremantle 1975, pp. 471–82; Procacci 1976; Walsh 1979; Walsh 1981; Proto Pisani 1982, pp. 101–3; Lynes 1983; Sframeli 1983; Frosinini 1984; Frosinini 1984a; Frosinini 1984b; Padoa Rizzo and Frosinini 1984; Frosinini 1986; Frosinini 1987; Francesca Petrucci in *Pittura* 1987, pp. 584–85; Emanuela Andreatta in Berti and Paolucci 1990, pp. 250–51; Frosinini 1990; Frosinini 1990a; Werner Jacobsen in *Saur*, vol. 10, 1995, pp. 486–88; Bruno Santi in *Dictionary of Art* 1996, vol. 4, pp. 30–33

PLATE 14 (JC CAT. 7)

WORKSHOP OF BICCI DI LORENZO
Predella panel of an altarpiece: *Annunciation*

c. 1415–30

Tempera, silver, and tooled gold on panel with horizontal grain; $9\frac{3}{4} \times 13\frac{7}{8} \times \frac{5}{8}''$ (24.5 × 35.2 × 1.5 cm)

John G. Johnson Collection, cat. 7

INSCRIBED ON THE REVERSE: *JOHNSON COLLECTION/ PHILA.* (stamped twice in black ink)

PUNCH MARKS: See Appendix II

EXHIBITED: Philadelphia Museum of Art, *The Nativity* (November 23, 1935–January 7, 1936), no catalogue

TECHNICAL NOTES

The panel consists of a single member that has been thinned and flattened; three oak bars were glued across the grain on the back. When the piece was removed from a predella, where it was most likely part of one continuous plank, more wood was taken off on the right edge of the scene than on the left. About ½ to 1¼" (1 to 3 cm) of the composition was also lost at the top. The linen layer can be seen along the left edge. At the bottom there are remnants

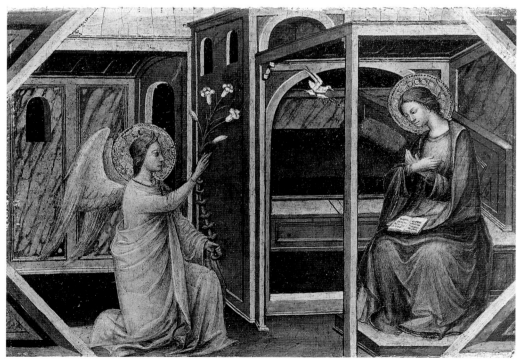

FIG. 14.1 Photograph of plate 14 as it appeared in 1913

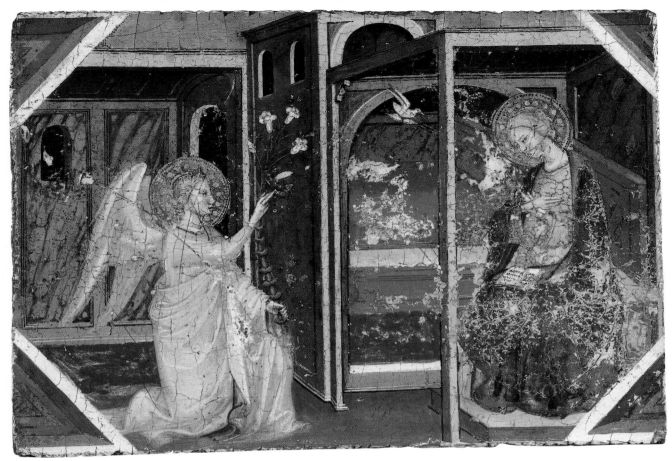

PLATE 14

of gold from the engaged frame and some evidence of a barbe.

There is a painted fictive frame consisting of strips of white and gray paint and chamfered corners with silver leaf in them. The gray strips are shaded to give the illusion of depth. A green foliate pattern was executed in sgraffito over the silver in the innermost triangle of each corner. The silver is mostly abraded, and the red bole is visible.

Mordant gilding was used for details in the angel and the Virgin's costume and for the rays of the dove of the Holy Spirit, but the gold is much abraded and often only the ocher-colored mordant is visible. The Virgin's mantle is a good example of a technique described by Cennino Cennini around 1390,[1] in which the area was first underpainted in gray and then glazed in azurite. Horizontal planes were made darker as they recede. For example, the floor was painted in a deep red and then highlighted in the foreground with a pink tone to indicate a sense of space.

In August 1919 Hamilton Bell noted that the faces had been restored. In 1941 David Rosen cleaned the panel, leaving it in an unrestored state, except for some older retouching in the Virgin's mantle that was not removed. Its condition before the cleaning is documented in fig. 14.1.

PROVENANCE
As indicated in a letter dated Paris, August 15, 1905, from Ludovico de Spiridon to Johnson, Spiridon sold this painting as a work of Taddeo Gaddi (first documented 1330; died 1366).

COMMENTS
In a courtyard off a loggia with marbleized walls, the Angel Gabriel greets the Virgin Mary, who is seated in an enclosed space before a bedchamber. Her arms are folded as a sign of humility and an open prayer book lies on her knees. The dove of the Holy Spirit descends on golden rays.

The painting was undoubtedly part of the predella of an altarpiece, but no other sections have been identified. The predella most likely represented scenes from the life of Mary, in which case the main panel of the altarpiece may have shown a narrative such as the Nativity of Christ. This suggests it may have been similar to Bicci di Lorenzo's altarpiece of the Nativity, dated 1435, in San Giovanni dei Cavalieri di Malta in Florence.[2] However, the absence of gold borders on the Johnson predella panel suggests that its altarpiece was rather modest.

The *Annunciation* was sold to Johnson as a work by Taddeo Gaddi. Frank Jewett Mather (1906) seems to have accepted this attribution, although he compared it with an *Annunciation* in the Gardner Collection in Boston then assigned to Agnolo Gaddi (q.v.).[3] Both Bernhard Berenson, in a letter to Johnson dated Settignano, January 16, 1906, and Osvald Sirén, in a letter dated Stockholm, February 5, 1908, rejected this attribution. Sirén called it school of Agnolo Gaddi, and Berenson (1913) also catalogued it as that. In a visit to the Johnson Collection on November 1, 1978, Miklós Boskovits was the first to suggest that it was possibly by Bicci di Lorenzo.

The *Annunciation* is of a type that Bicci di Lorenzo developed early in his career, as is seen in his first dated altarpiece, of 1414, in the *prepositura* of Santa Maria Assunta in Stia (fig. 14.2), which also shows marbleized panels in the architecture. An *Annunciation* in the wings of Bicci's diptych[4] in Berlin of about the same date compares with the Johnson

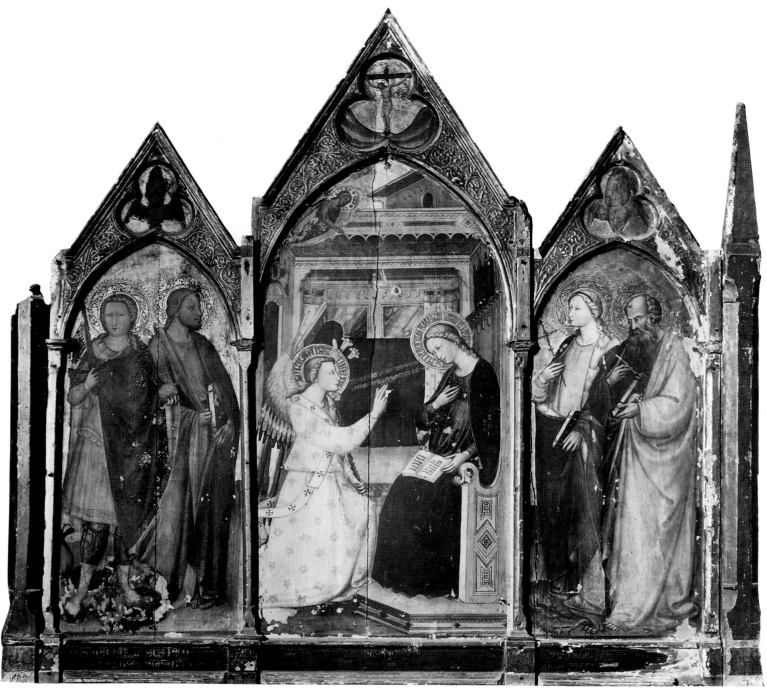

FIG. 14.2 Bicci di Lorenzo. Altarpiece: *Annunciation with Saints*, 1414. Tempera and tooled gold on panel; overall 74⅞ × 70⅞″ (190 × 180 cm). Illustrated here in an old photograph before restoration. From Porciano, church of San Lorenzo. Stia (near Arezzo), *prepositura* of Santa Maria Assunta

panel in quality and the tooling of the gold halos. However, the figures in the Johnson painting also relate to those in the artist's later works, such as the *Annunciation* in the church of San Martinone a Gangalandi at Lastra a Signa, near Florence, which is documented 1433.[5] The same type can likewise be found in his *Annunciation* in the spandrels of an altarpiece for the *pieve* of Santi Ippolito e Donato in Bibbiena, which is dated 1435.[6] Finally, although thoroughly consistent with Bicci di Lorenzo's style, the Johnson *Annunciation* may not be by his hand, for his workshop was large, and Bicci frequently hired collaborators.

1. Cennini c. 1390, Thompson ed. 1932–33, vol. 1, p. 53, chap. 83; vol. 2, pp. 54–55, chap. 83.
2. Berenson 1963, plate 509.
3. Boston, Isabella Stewart Gardner Museum; no. P15s2; Hendy 1974, repro. p. 89.
4. Staatliche Museen; nos. 1527–28; Boskovits 1988, pp. 20–21, cat. 10, plates 23–26.
5. Proto Pisani 1992, figs. 7–8 (color). On the documentation, see Procacci 1976, p. 9 n. 36. The Master of Signa (Frosinini 1990a, pp. 20–21) assisted on this project.
6. Berenson 1963, plate 511.

Bibliography
Mather 1906, p. 351, repro. p. 229 (Taddeo Gaddi); Sirén 1908a, p. 194 (close to Agnolo Gaddi); Rankin 1909, p. lxxxi (Florentine, Gaddesque); Berenson 1913, p. 7 (school of Agnolo Gaddi); Johnson 1941, p. 7; Sweeny 1966, p. 30; Fredericksen and Zeri 1972, p. 219 (Florence, fourteenth century); Philadelphia 1994, repro. p. 181

BARTOLOMEO BULGARINI

SIENA, FIRST DOCUMENTED 1338;
DIED SEPTEMBER 4, 1378, SIENA

Born to a noble Sienese family, Bartolomeo Bulgarini is documented as a painter starting in 1338, even though he was not recorded as having been registered in the local painters' guild until 1363. During his early career he took on many official commissions, including the covers for the account books of the Biccherna, the administrative offices of Siena, in 1338, 1340,[1] 1341, 1342, and 1353 (see fig. 15.8); a commission for the Palazzo Pubblico in 1341;[2] and a mural for the city gate, the Porta Camollia, in 1349. Sometime between 1348 and 1351 Bulgarini also worked on an altarpiece for the chapel of San Vittore in the cathedral of Siena.[3] In about 1348–49 he was described as one of Siena's best painters in a list drawn up for officials in Pistoia who wanted to commission an altarpiece for their city's church of San Giovanni Fuorcivitas. Although Bulgarini did not execute this altarpiece, he did work outside Siena and its territories: in the 1340s, for example, he painted an altarpiece that in 1669 was found in the Cistercian nunnery of San Cerbone in Lucca;[4] Giorgio Vasari (1550, 1568), who called Bulgarini a disciple of Pietro Lorenzetti (q.v.), described an altarpiece by Bulgarini in Santa Croce in Florence;[5] and between September 22 and October 2, 1369, he was painting murals for the Vatican, probably in preparation for the return of Pope Urban V Grimoard to Rome. The Vatican work would have brought him in direct contact with artists such as Giovanni da Milano, the brothers Agnolo (q.v.) and Giovanni Gaddi, and Giottino.[6]

According to Fabio Chigi's (later Pope Alexander VII) guide of Siena,[7] there was an altarpiece by Bulgarini in the hospital church of Santa Maria della Scala that bore the date 1350.[8] The hospital would play an important part in Bulgarini's life. In 1366 he and his wife, Bartolomea, and a sister-in-law became oblates there. In 1370 he became a brother, which meant donating his own house to and moving into the hospital. Three years later Bulgarini signed and dated another altarpiece for its church.[9] At the time of his death on September 4, 1378, he was working on a third, which another artist finished the following year. In addition, the 1388 will of one Giovanni d'Ambrogio Beringhieri stated that in the hospital's church there was a beautiful altarpiece ("pulcra tabula") by Bulgarini in the chapel of Saint John, next to the chapel of the reliquaries. However, it is not clear whether this was one of the altarpieces listed above or a fourth one.[10]

While Bulgarini's name appears in many records, the only work of art that can be almost securely documented to him is the 1353 book cover (see fig. 15.8) showing Siena's treasurer Buonaven-

tura di Messer Manfredi and his scribe at work on the city's accounts. Millard Meiss (1931, 1936a) used it as evidence that Bulgarini was the artist of two groups of paintings that Bernhard Berenson (1917, 1918) and Ernest DeWald (1923) had respectively listed under the names "Ugolino Lorenzetti" and the Master of Ovile. Berenson created the first name out of the names of Ugolino di Nerio and Pietro Lorenzetti (qq.v.) to indicate the styles that the anonymous master combined. The second name, first used by DeWald, referred to the provenance of one of the artist's paintings in the parish of San Pietro a Ovile in Siena.[11]

One work by "Ugolino Lorenzetti" that can be assuredly identified with Bulgarini is the *Assumption of the Virgin* in the Pinacoteca Nazionale in Siena.[12] It comes from the church of Santa Maria della Scala and may be the altarpiece that he signed and dated in 1373.[13] Another painting from a disassembled altarpiece, a *Virgin and Child* also in the Pinacoteca Nazionale,[14] comes from the hospital as well and can most likely be identified with Bulgarini's 1350 work. In addition, another *Virgin and Child*[15] that belonged to the hospital may be part of the altarpiece that Bulgarini was working on at the time of his death. There is also a Bulgarini altarpiece from Santa Croce in Florence, but it is unclear if it is the one that Vasari saw there, or another work that the artist painted for the church.[16]

Erling Skaug (1983, 1994) has shown that a number of the punches that Bulgarini employed in the tooling of gold were also used by such other Sienese artists as Naddo Ceccarelli, Jacopo del Pellicciaio, Niccolò di Ser Sozzo, and Luca di Tommè. Skaug proposed that they were part of a professional group that he called the "post-1350 *Compagnia*." However, their collaboration seems to have been limited to sharing punch tools. More interestingly, Skaug also noted that Giovanni da Milano, a Lombard artist largely active in Florence, also came into possession of many of Bulgarini's punches. Although Skaug suggested that this may have occurred in Siena, his theory was disputed by the present author (1995a), who noted that Giovanni may have obtained Bulgarini's punches in Florence. Another point of contact between the two artists was their collaboration in the Vatican in the autumn of 1369.

1. Paris, Bibliothèque Nationale de France, Mss. ital. 1669; Avignon 1983, p. 199, cat. 69 (color).
2. The artist was paid 9 florins for *pictura unius tovaglie*; it is not clear what this was. For various opinions, see Steinhoff-Morrison 1990, pp. 24–25.
3. On the identification of this altarpiece, see Beatson, Muller, and Steinhoff 1986, as well as Christiansen 1987.
4. This altarpiece is dispersed. It consisted of: the *Virgin and Child and Saint John the Evangelist* (Lucca, Museo Nazionale di Villa Guinigi, nos. 160, 162; Martinelli and Arata 1968, figs. 61–62); *Saint Bartholomew and Saint Mary Magdalene* (Rome, Pinacoteca Capitolina, nos. 345–46; Bruno 1978, figs. 9 [color], 10); and *Saint Catherine of Alexandria* (Washington, D.C., National Gallery of Art, no. 1943.4.20; Shapley 1979, plate 186).
5. The altarpiece Vasari mentioned was in the chapel of Saint Silvester, belonging to the Bardi di Vernio, which was decorated by Maso di Banco between 1332 and 1335. Vasari's attribution of the altarpiece to Bulgarini was probably based on a signature. He dated Bulgarini's activity to around 1350, which may have been the actual date of the painting.
6. For the full documents and lists of artists then working in the Vatican, see Cavalcaselle and Crowe 1883–1908, vol. 2, 1886, pp. 102–3 n. 2.
7. Chigi 1625–26, Bacci ed. 1939, p. 302.
8. On the problems with this date, see Steinhoff-Morrison 1990, pp. 48–51.
9. This is mentioned in several contemporary sources. See Cecilia Alessi in Siena 1982, p. 250.
10. On this problem, see Steinhoff-Morrison 1990, pp. 34–38. For a transcription of the will, see Steinhoff-Morrison 1990, p. 278, Appendix A, no. 21.
11. Siena, Museo d'Arte Sacra del Seminario Regionale Pio XII; Berenson 1968, plate 75.
12. No. 61; Torriti 1977, fig. 143 (color).
13. For a different opinion, see Steinhoff-Morrison (1990, pp. 48–51, 603–13), who dates it to the 1360s in conjunction with the hospital's purchase of relics, including one of the belt of the Virgin. However, the reliquary chapel was being built in 1368, and its murals, by Cristoforo di Bindoccio and Meo di Pero, are signed 1370 (see Gallavotti Cavallero 1985, figs. 68–71 [color]). It seems logical that the altarpiece would date around the same time as the wall paintings.
14. No. 76; Torriti 1977, fig. 132; Gallavotti Cavallero 1985, fig. 75 (color). Millard Meiss (1931, p. 376) reconstructed the altarpiece. The side panels are probably *Saint Gregory the Great* (Siena, Pinacoteca Nazionale, no. 59; Torriti 1977, fig. 134), and *Saints John the Baptist and Paul* and *Saint Peter and Unidentified Saint* (Florence, Gallerie Fiorentine, nos. 6136–37; Florence 1986a, p. 291, fig. 5). A predella panel may be *Saint John the Evangelist* (Siena, Pinacoteca Nazionale, no. 75; Torriti 1977, fig. 133 [color]). For a reconstruction, see Florence 1986a, p. 292, fig. 6.
15. Siena, Pinacoteca Nazionale, no. 79; Torriti 1977, fig. 144 (color).
16. The altarpiece belongs to the Museo dell'Opera di Santa Croce in Florence (no. 8). Since the flood of 1966 it has been at the restoration laboratories of the Opificio delle Pietre Dure in Florence. For a pre-flood illustration, see Péter 1931, fig. 1 (Brogi neg. 22077). It has the arms of the Covoni family, who had a chapel in the rood screen of the church. Steinhoff-Morrison (1990, p. 345) has reasonably proposed that the patron of this altarpiece might have been Giovanni di Guasco Covoni. See also n. 5.

Select Bibliography
Vasari 1550, Bellosi and Rossi ed. 1986, p. 137; Vasari 1550 and 1568, Bettarini and Barrochi eds., text vol. 2, 1967, p. 147; Vasari 1568, Milanesi ed., vol. 1, 1878, pp. 477–79; Ugurgieri

Azzolini 1649, vol. 2, p. 340; Baldinucci 1681–1728, Ranalli ed., vol. 1, 1845, p. 272; Romagnoli before 1835, vol. 2, 1976, pp. 505–11; Milanesi, vol. 1, 1854, pp. 49–50 n. 4; Giacomo De Nicola in Thieme-Becker, vol. 2, 1908, p. 567; Berenson 1917; DeWald 1923; Meiss 1931; Berenson 1932, pp. 294–95; Meiss 1936a; Hans Vollmer in Thieme-Becker, vol. 37, 1950, p. 260; Berenson 1968, pp. 435–37; Millard Meiss in *DBI*, vol. 15, 1972, pp. 38–40; Cecilia Alessi in Siena 1982, pp. 250–51; Skaug 1983; Gallavotti Cavallero 1985, pp. 111–14; Steinhoff-Morrison 1990; Skaug 1994, vol. 1, pp. 249–56; vol. 2, chart 7.12; Strehlke 1995a, p. 754; Judith Steinhoff-Morrison in *Dictionary of Art* 1996, vol. 5, pp. 164–65; Ada Labriola in *Saur*, vol. 15, 1997, pp. 109–10; Francesco Mori and Luciano Bellosi in Bagnoli et al. 2003, pp. 378–87

PLATE 15 (JC CAT. 92)

Wings of a tabernacle: (left) *Annunciate Angel, the Apostle Andrew, a Bishop Saint (Savinus?), and Saints Dominic and Francis of Assisi;* (right) *Virgin Annunciate and Saints Bartholomew, Lawrence, Lucy, and Agatha*

c. 1355–60

Tempera and tooled gold on enframed panels with vertical grain; 25 × 17 × ¾″ (63.5 × 43 × 1.8 cm), each wing approximately 24⅞ × 8⅛″ (63 × 20.5 cm)

John G. Johnson Collection, cat. 92

INSCRIBED ON THE ANGEL'S SCROLL: *AVE GRATIA PLENA* (Luke 1:28: "Hail [Mary], full [of grace]"); ON THE REVERSE: torn remains of a paper label on which only the word *Rue* (street) can be read; a crushed red wax customs seal showing the arms of the Italian state of Savoy

PUNCH MARKS: See Appendix II

EXHIBITED: Philadelphia Museum of Art, John G. Johnson Collection Special Exhibition Gallery, *From the Collections: Paintings from Siena* (December 3, 1983–May 6, 1984), no catalogue

TECHNICAL NOTES

These two wings from a tabernacle have been framed together to look like a single painting. This was done in the late nineteenth or early twentieth century, because a drawing used for the catalogue of the 1883 sale of the Toscanelli Collection (fig. 15.1) as well as an old Alinari photograph (fig. 15.2) show the wings before they were joined. The piece at top center with the papal keys has been added, and there are new strips of wood on the sides. An X-radiograph (fig. 15.3) shows not only that the lower part of the panel was damaged but also that the paint surface was reconstructed from about 5⅛″ (13 cm) from the bottom of the right wing and from

about 3⅜″ (8.5 cm) from the bottom of the left wing. The inner moldings that separate the figures into discrete fields are old, except for some modern repairs toward the bottom edge. In the left wing the linen layer continues to the bottom, whereas in the right wing it stops approximately 4⅜″ (11 cm) from the bottom edge.

Despite the considerable reconfiguration the wings have undergone, their backs were never thinned, and the decorative pattern on the reverse (fig. 15.4), which was visible when the wings were closed, has survived. It consists of four quatrefoils (in ocher, white, brown, green, and red) edged in filigree. Traces of the filigree following the original arched tops of the panels are also visible; otherwise the decoration in these areas is modern. The top transverse battens and the lower left batten are original; the center and lower right battens have been added.

The artist used a variety of techniques to embellish the painting with gold details, but some of the finer mordant gilding has suffered. The light pattern on Lawrence's blue garment, for example, is the result of the exposure of the paint surface caused by the loss of the mordant. Although the design on the bishop saint's violet costume appears to be similar, it never had mordant gilding; the pattern is instead painted in white shading to blue. However, his red and blue mantle has traces of small mordant gilt diamonds, which have mostly flaked away. A delicately wrought yet well-preserved sgraffito was used for the Annunciate Angel's wings and dress, the Virgin's dress, and parts of the costume of the bishop, Bartholomew, and Lawrence.

The paint is in fair condition. Some rather refined effects survive, such as those seen in the modeling of the robes of Andrew, Bartholomew, and Lawrence (except for the gilt decoration of the latter). The faces are generally intact. The Annunciation scene is in somewhat poorer condition than the rest of the painting.

Hamilton Bell and T. H. Stevenson inspected the painting on April 15, 1922, noting that it was much retouched and that there was flaking along the right side and at the lower left; Stevenson treated this. In 1956 Theodor Siegl also noted the extensive repaintings. While he repaired the flaking and cleaned part of the surface dirt and discolored varnish, he left the old retouchings. In 1976 the panel was cleaned by Louis Sloan, who filled and inpainted the losses at the bottom.

PROVENANCE

The panel, which had belonged to Giuseppe Toscanelli in Pisa, was sold in Florence at the Galerie Sambon on April 13, 1883, lot 42 (as anonymous fifteenth century). It later entered the collection of Charles Butler of London and Warren Wood, Hatfield. When Langton Douglas sold it to John G. Johnson in 1910, he wrote from London on July 19, 1910: "The price of the Lorenzetti panel is £150 ster-

ling. [Wilhelm] Valentiner and [Bryson] Burroughs—who both admired the little picture very much—seemed to think that was a reasonable price." On the back of the photograph Douglas included with the letter he wrote:

> Pietro Lorenzetti or his school./ Panel. 25 × 27 in./ From the Toscanelli and Chas. Butler Colls. See Crowe & Cavalcaselle vol. III, pp. 234–5 give this picture to "a Sienese follower of the Lorenzetti." But I now believe the panel to be an early work of Pietro Lorenzetti himself. As Dr. [Max] Friedländer and Valentiner and Burroughs have remarked, it is unusually fine in colour. This the photograph does not show. All these critics admire the panel very much.

COMMENTS

In each wing, below the scenes of the Annunciation, there are four saints in separate compartments, each standing on a marbleized floor. On the left, the apostle Andrew carries the cross of his martyrdom.[1] The bishop to his right has no specific attributes, but the embroidered S on his miter and closed Gothic S on the orphrey of his cloak may indicate that he is Savinus (or Sabinus), a patron saint of Siena.[2] Below, Saint Dominic holds a book and a lily, respective symbols of his learning and purity. Next to him, Saint Francis of Assisi is receiving the stigmata from a vision of the crucified Christ as a seraph.

On the far right, Saint Lawrence is shown as a deacon of the church, holding a book. To his left, the apostle Bartholomew holds the knife with which he was martyred. His elaborately embroidered costume, common in depictions of him, refers to his martyrdom in India, which was renowned for its riches. Below, Saint Lucy holds a pyx of fire and the knife of her martyrdom. To the right, Saint Agnes's breasts rest on a salver, and she holds the pliers that were used to remove them.

The Annunciation is shown in the pinnacles of the wings. To the left, the angel Gabriel kneels, holding an inscribed scroll. The image to the right, of the Virgin seated on the ground in front of a bench, is a rare example of the Virgin Annunciate in the attitude of a Virgin of Humility.[3] The angel's fluttering wings and flowing cape and the gold vase with lilies, symbol of the Virgin's purity, are copied from Simone Martini's altarpiece of the Annunciation of 1333, then in the cathedral of Siena.[4]

As first shown by Judith de Botton (1980), these two wings enclosed a tabernacle of the Virgin and Child with saints, angels, and the Redeemer (fig. 15.5), now in the Isabella Stewart Gardner Museum in Boston.

Few works of art from the late trecento are so spatially sophisticated. The saints in each tier of the wings in the Johnson panel and of the reveals of the Boston tabernacle stand on contiguous floors that unite the three sections of the complex (fig. 15.6).

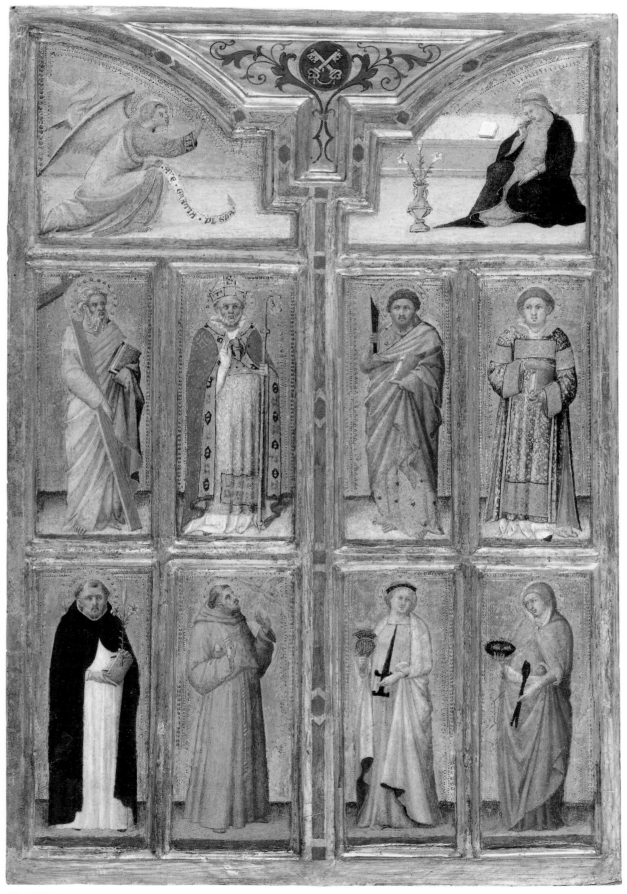

PLATE 15

FIG. 15.1 Drawing of plate 15 before 1883, when it was owned by Giuseppe Toscanelli, Pisa. London, Witt Library, Courtauld Institute of Art

FIG. 15.2 Late nineteenth-century Alinari photograph of plate 15. London, Witt Library, Courtauld Institute of Art

FIG. 15.3 X-radiograph of plate 15, showing damage in the lower part of the panel

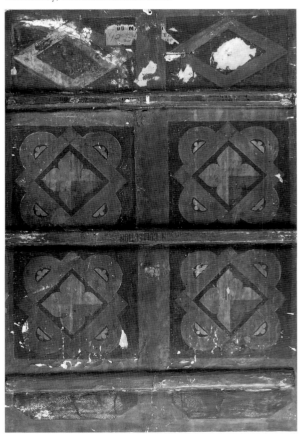

FIG. 15.4 Reverse of plate 15, showing the original painted decorative pattern

On the tabernacle, the Virgin's throne is set back on an inverted U-shaped platform, and the expanse of floor in front has a diamond-shaped pattern that recedes into the distance. The diamond closest to the edge is cut off as if to suggest that the floor continues into the viewer's domain.

Not many fourteenth-century Sienese painted tabernacles survive. The wings of two early trecento examples by Duccio (q.v.) and another by a close follower fold over the central panel to leave the central gable visible,[5] but even they are not as architecturally advanced as the work by Bulgarini, which de Botton (1980, p. 27) has justly compared to Parisian ivory tabernacles of the thirteenth and fourteenth centuries,[6] which were collected throughout Italy. An especially telling comparison can be made with a French ivory tabernacle in the Sienese church of San Pellegrino alla Sapienza (fig. 15.7).

Early opinions about the Johnson picture assigned it to Pietro Lorenzetti or his school. Frank Jewett Mather, writing to Johnson from Princeton on February 19, 1914, thought that it was by Pietro Lorenzetti with question, although the papal coat of arms in the frame misled him to suggest that the wings were from a panel by Lorenzetti in the Vatican.[7] In 1913 Bernhard Berenson wrote:

> these are among the most spirited, brilliant and attractive creations of the Sienese School. One is at a loss as to their exact authorship. They do not perfectly coincide with any unquestioned work of Pietro's, being more radiantly clear and golden in colour, and of a blither, gayer spirit. Nevertheless they are too close to him in every way to be by anyone but a very near follower, and among these there is none who attains to a quality so worthy of the master himself. It is thus better to assume that they are by him until more precise acquaintance with Sienese art proves or disproves the attribution.

The problem continued to intrigue Berenson, and he thought he had found the solution by developing the designation "Ugolino Lorenzetti" to refer to the artist (Berenson 1917). His opinion has been accepted by most subsequent authors, regardless of whether they called the artist "Ugolino Lorenzetti" or Bartolomeo Bulgarini.

The style of the figures is quite close to Bulgarini's dated book cover of 1353 (fig. 15.8). The saints are also similar to his series of figures (fig. 15.9) in the Museo Nazionale di San Matteo in Pisa, which come from a disassembled polyptych. The images of Saints Lucy and Bartholomew in Pisa were probably the models for the small-scale figures in the Johnson wings.[8] Steinhoff-Morrison (1990, p. 548) compared the Virgin and Child of the central panel of the Boston tabernacle with the *Virgin and Child* now in the Museo d'Arte Sacra in Grosseto (and once in the cathedral).[9] Stylistically the Grosseto *Virgin and Child* is very similar to Bulgarini's *Virgin and Child* in the Pinacoteca Nazionale in Siena;[10]

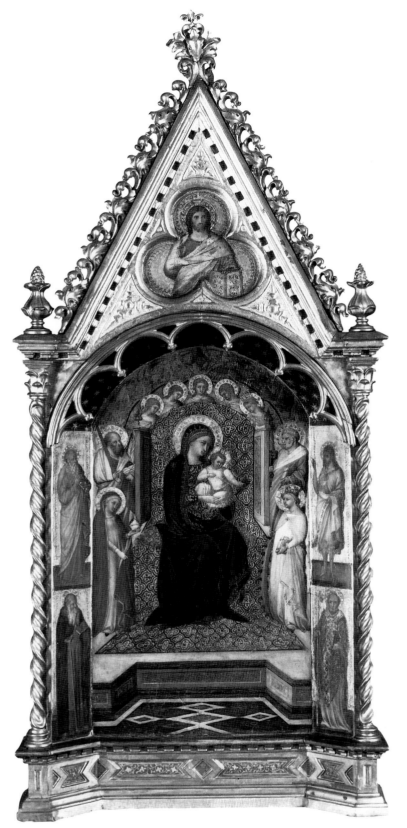

FIG. 15.5 Bartolomeo Bulgarini. *Virgin and Child Enthroned with Saints Paul, Mary Magdalene, Peter, and Catherine of Alexandria; in the reveals of the arch: Saints John the Evangelist, Anthony Abbot, John the Baptist, and Nicholas of Bari(?); in the trefoil: The Redeemer;* c. 1355–60. Tempera and tooled gold on panel; overall 25⅝ × 18⅛ × 4⅛″ (65 × 46 × 10.5 cm). Boston, Isabella Stewart Gardner Museum, no. P15n8. See Companion Panel

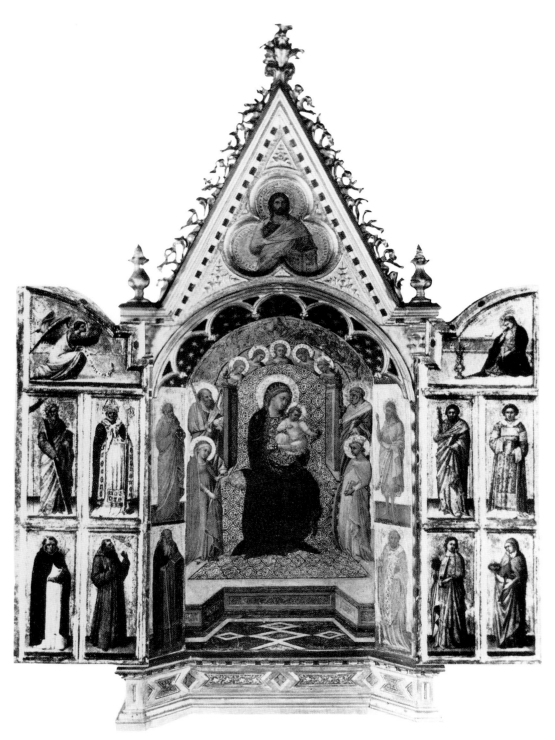

FIG. 15.6 Photographic reconstruction of the tabernacle by Bartolomeo Bulgarini, showing the center section in the Isabella Stewart Gardner Museum and the wings in the Johnson Collection (from De Botton 1980)

the latter may be the center panel of his altarpiece from Santa Maria della Scala, which presumably was dated 1350.[11] The Virgin in Grosseto and the Johnson-Gardner tabernacle probably date to the mid- to late 1350s.

1. Although Andrew was crucified on a X-shaped cross, he is often shown with a Latin cross in Tuscan painting of this period; Kaftal 1952, cols. 36–45; Henk van Os in Groningen 1969, no. 7.

2. Judith Steinhoff-Morrison (1990, p. 552) has suggested that the saint is Augustine.

3. See Lorenzo Monaco, plate 40 (JC cat. 10); and Benedetto di Bindo, plate 13 (JC cat. 153). See also Offner 1947, p. 154 n. 2; Meiss 1951, p. 149 n. 71; Van Os 1969, p. 112.

 The Virgin is more often shown standing or seated on a stool or chair, with her modesty conveyed by a gesture. The Virgin of Humility, showing the Virgin and Child seated on the floor, had become a popular subject in Sienese painting in c. 1340 (see the discussion for

Lorenzo Monaco, plate 40 [JC cat. 10]). Examples of the Virgin of Humility in depictions of the Annunciation occur about the same time in Florentine and Sienese painting. Taddeo Gaddi used it in a mural of the 1330s for the Baroncelli chapel in Santa Croce in Florence (Ladis 1982, plate 46-6). However, the theme appears mostly in small-scale works. Bulgarini would have known such examples by Pietro Lorenzetti and his circle such as those in triptychs in Dijon (Musée des Beaux-Arts, no. G.1; Volpe 1989, color repro. p. 172) and Siena (Pinacoteca Nazionale, nos. 292a, b; Torriti 1977, fig. 156).

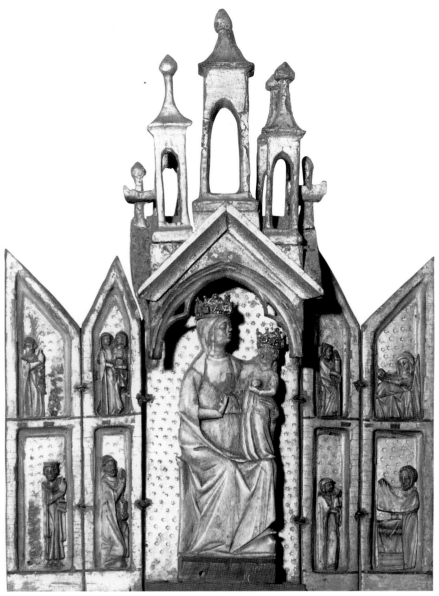

FIG. 15.7 Unknown artist (French). Tabernacle: *Virgin and Child Enthroned*, mid-1300s. Ivory. Siena, church of San Pellegrino alla Sapienza

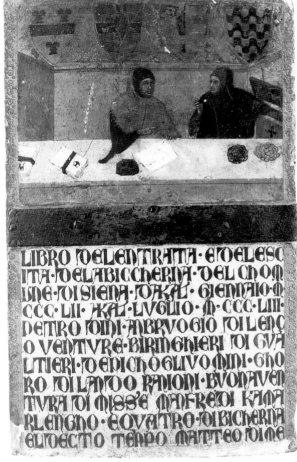

FIG. 15.8 Bartolomeo Bulgarini. *Biccherna* cover: *The City Treasurer Buonaventura di Messer Manfredi and His Scribe*, 1353. Tempera on panel; 16⅝″ × 9⅞ (42 × 25 cm). Siena, Archivio di Stato, no. 17

4. Florence, Uffizi, nos. 451–53; postrestoration color repros. in Cecchi 2001.

5. London, National Gallery, no. 566; Boston, Museum of Fine Arts, no. 45.880; and Siena, Pinacoteca Nazionale, no. 35 (Stubblebine 1979, vol. 2, plates 128–30, 145–49, 240–47). For a postrestoration color reproduction of the Siena picture, see Bagnoli et al. 2003, p. 327.

6. On these and similar tabernacles, see also Frinta 1967.

7. Mather wrote: "No. 92. Pietro Lorenzetti? A pair of wings from a central panel which still remains in the Vatican Gallery. The panels' arms on your piece tell the story and so do the measurements. I should be glad to reassemble the little triptych photographically for *Art in America*. There is nothing more delicate in the Sienese School." It is not exactly clear to which panel in the Pinacoteca Vaticana he is referring. It may be the *Crucifixion* (no. 154) from Pietro Lorenzetti's

workshop (Volbach 1987, fig. 109). See also Giulietta Chelazzi Dini in Siena 1982, pp. 253–54, who gives it to "Ugolino Lorenzetti."

8. Charles Seymour (1970, p. 87) proposed that a *Virgin and Child* at the Yale University Art Gallery (no. 1943.244; Seymour 1970, fig. 61) was the center of this altarpiece.

9. Grosseto 1964, plate XVII.

10. No. 76; Torriti 1977, fig. 132; Gallavotti Cavallero 1985, fig. 75 (color).

11. The date is based on Fabio Chigi's (1625–26, Bacci ed. 1939, p. 302) statement that there was an altarpiece dated 1350 in the church. Chigi, however, often misread dates. His information could well have been based on Vasari's (1550 and 1568, Bettarini and Barocchi eds., text vol. 2, 1967, p. 147) statement that Bulga-rini was active around 1350. However, it is likely that he did see the date 1350 or, if some of the final numerals were

missing, a date somewhere in the 1350s. For a different opinion and a later dating of c. 1355 for the *Virgin and Child* in Siena, see Steinhoff-Morrison 1990, esp. pp. 472–73.

Bibliography

Cavalcaselle and Crowe, 1883–1908, vol. 3, 1885, p. 235 (Sienese follower of the Lorenzetti); Berenson 1909 (Pietro Lorenzetti); Gielly 1912, p. 454 (Pietro Lorenzetti); F. Mason Perkins in Vasari 1568, Perkins ed. 1912, p. 41 (Pietro Lorenzetti); Berenson 1913, pp. 52–53, repro. p. 289 (Pietro Lorenzetti); Berenson 1917, pp. 42, 47–48, fig. 10; Berenson 1918, p. 29, fig. 15; Fogg 1919, p. 108; Offner 1919, pp. 194–95; DeWald 1923, p. 52; Van Marle, vol. 2, 1924, pp. 117–18; Van Marle, vol. 5, 1925, p. 458; Gielly 1926, p. 114; Péter 1927, p. 93; Hendy 1929, p. 232; Giulia Sinibaldi in Thieme-Becker, vol. 23, 1929; DeWald 1930, p. 35; Hendy 1931, p. 206; Kimball 1931, repro. p. 25; Meiss 1931, p. 376 n. 1; Péter 1931a, p. 5;

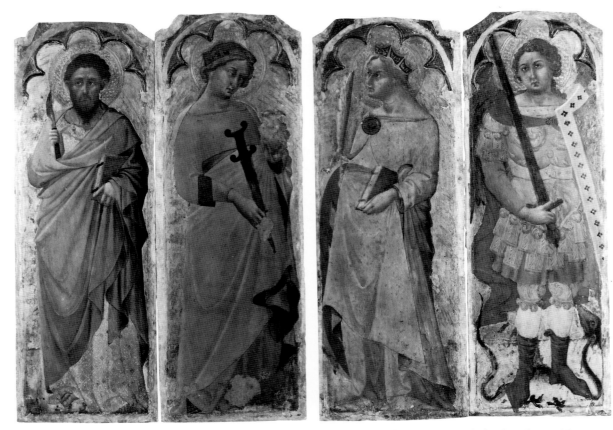

FIG. 15.9 Bartolomeo Bulgarini. *Saint Bartholomew, Saint Lucy, Saint Catherine of Alexandria,* and *Saint Michael Archangel,* c. 1355. Tempera and tooled gold on panel; 42⅜ × 14¼″ (107.5 × 36 cm); 43⅛ × 15″ (109.3 × 38 cm); 42⅝ × 14¼″ (108.3 × 36 cm); 43 × 14⅝″ (109.1 × 37 cm). Pisa, Museo Nazionale di San Matteo, nos. 1612–15

Berenson 1932, p. 295; Edgell 1932, p. 147, fig. 179; Sinibaldi 1933, p. 182; Berenson 1936, p. 254; Meiss 1936, p. 456 n. 75; Johnson 1941, p. 9 ("Ugolino Lorenzetti"); Offner 1947, p. 154 n. 3; Hans Vollmer in Thieme-Becker, vol. 37, 1950, p. 260; Meiss 1951, p. 149 n. 71; Meiss 1961, pp. 125–26 n. 5; Sweeny 1966, pp. 18–19, repro. p. 90; Berenson 1968, p. 436; Van Os 1969, p. 112, fig. 51; Fredericksen and Zeri 1972, p. 133 (Master of the Ovile Madonna); Hériard Dubreuil and Ressort 1977, p. 3; De Benedictis 1979, p. 85; Sutton 1979a, p. 388, fig. 3; De Botton 1980, figs. 2–3; Michiel Franken in Van Os et al. 1989, p. 39; Boskovits 1990, p. 36; Steinhoff-Morrison 1990, pp. 542–55; A. Labriola in *Saur,* vol. 15, 1992, p. 110; Philadelphia 1994, repro. p. 184; Frinta 1998, repro. p. 221

COMPANION PANEL for PLATE 15

Tabernacle: *Virgin and Child Enthroned with Five Angels, Cherubim and Seraphim, and Saints Paul, Mary Magdalene, Peter, and Catherine of Alexandria;* in the reveals of the arch: *Saints John the Evangelist, Anthony Abbot, John the Baptist, and Nicholas of Bari(?);* in the trefoil: *The Redeemer.* See fig. 15.5

c. 1355–60

Tempera and tooled gold on panel: overall 25⅝ × 18⅛ × 4⅛″ (65 × 46 × 10.5 cm). Boston, Isabella Stewart Gardner Museum, no. P15n8

The spiral colonettes, finials, and carved floral border of the gable are modern. The sky is repainted. The lower portion from about the knees of Saints Anthony Abbot and Nicholas of Bari(?) is considerably damaged.

INSCRIBED ON THE BOOK OF THE REDEEMER: *EGO/ SUM/ LUX/ MUN/ DI/ Q/ UI C RED* (derived from John 8:12: "I am the light of the world: he that believes [or followeth] me . . ."); ON THE BAPTIST'S SCROLL: *ECCE. AGNUS. DEI. EC[CE]* (John 1:29: "Behold the Lamb of God, behold"); BELOW THE EVANGELIST: abbreviation for the saint's name in Latin; BELOW THE BAPTIST: abbreviation for the saint's name in Latin

PROVENANCE: Purchased in Italy by Samuel Gray Ward of Massachusetts, after 1883; by descent to Mrs. C. B. Perkins; purchased, Isabella Stewart Gardner, July 27, 1911

SELECT BIBLIOGRAPHY: Berenson 1917, pp. 38, 41–42, 48; L. Venturi 1933, plate 90; Klesse 1967, p. 197 n. 62; Hendy 1974, p. 51; De Botton 1980; Steinhoff-Morrison 1990, pp. 542–51

CENNI DI FRANCESCO
(*Cenni di Francesco Cenni di Ser Cenni*)

FLORENCE, FIRST DOCUMENTED 1369;
DIED 1414, FLORENCE

Two facts about Cenni di Francesco have been securely documented. First, on March 23, 1369, he matriculated in the Guild of the Physicians and Apothecaries (Arte dei Medici e Speziali), to which Florentine painters also belonged. The registration lists him as a resident of the neighborhood of San Lorenzo.[1] Second, his death in 1414 was recorded on the rolls of the company of San Luca, the brotherhood of Florentine painters.[2] In the nineteenth century, because of the similarity of the names, Cenni di Francesco was erroneously identified with Cennino Cennini, the author of the famous artist's technical treatise *Il Libro dell'arte* (The Craftsman's Handbook) of about 1390.[3]

Cenni di Francesco's only signed and dated work, the 1410 mural cycle in the oratory of the company of the Croce del Giorno in San Francesco in Volterra,[4] provides the basis for the reconstruction of his oeuvre. There are also at least six other dated works.[5] An indication of the artist's early training comes from the predella that he painted in the mid-1370s for Giovanni del Biondo's altarpiece of Saint John the Evangelist from Orsanmichele in Florence.[6] This collaboration suggests that he had apprenticed with Giovanni, and, indeed, Cenni's bright colors and the sharp outlines of his figures show the influence of that artist.

Cenni's most important work in Florence was done for the church of Santa Trinita. The first chapel on the right, dedicated to Saint Benedict and under the patronage of the Gianfigliazzi family, contains murals by him, and the large altarpiece in the J. Paul Getty Museum also came from this chapel.[7] The latter, which is Cenni's only complete surviving altarpiece, represents his personal interpretation of the large-scale altarpieces of the Coronation of the Virgin that were popular in Florence in the late fourteenth century.

Cenni's later years seem to have been spent largely outside Florence as numerous pictures by him still exist in the regions of the Val di Pesa and Val d'Elsa.

Federico Zeri and Miklós Boskovits have identified many of Cenni's works. In addition, Boskovits has recognized Cenni di Francesco's authorship in works that Richard Offner had assigned to the "Master of Rohoncz," after a painting belonging to the Fundación Colección Thyssen-Bornemisza in Madrid.[8]

1. "Cennes Francisci Ser Cennis pictor populi sci Laurentii," Florence, Archivio di Stato, Arte dei Medici e Speziali, no. 9, folio 96 recto. A Cenni di Francesco, who was listed in the 1427 tax records (*catasto*) as a hotelkeeper (*albergatore*) living in the via San Gallo in the San Lorenzo neighborhood, may be a descendant, most likely a grandson. In 1427 he was thirty-eight years old and his mother, Margherita, was seventy. This would mean that the painter was born around 1340.
2. Colnaghi (1928, p. 69) and all subsequent authors record the date as 1415, but since the month is not in the record, this would only be true, according to the old Florentine calendar, if he had died before March 25, then the beginning of a new year. The records of the company of San Luca offer no further information, because an artist's death was recorded on the membership lists by either cancelling or adding to the roman numeral indicating the year of his enrollment. In Cenni's case, since an extra C had to be added to account for the change of the century to the 1400s, the earlier date had to be erased. Florence, Archivio di Stato, Accademia del Disegno, no. 1, folio 5 verso.
3. The misidentification persisted well into the twentieth century, as Brogi photographs of Cenni di Francesco's mural cycle in Volterra (see below) attribute them to Cennino Cennini.
4. Fremantle 1975, figs. 785, 788–96.
5. They are the 1370 triptych in San Cristofano at Perticaia, near Rignano sull'Arno (Boskovits 1975, plate 86); the 1383 murals in the church of San Donato in Polverosa in Florence (for a detail, see fig. 16.5); the 1393 mural in the Palazzo Comunale of San Miniato al Tedesco (Fremantle 1975, fig. 779); the 1400 triptych in San Giusto in Montalbino, near Montespertoli (Fremantle 1975, fig. 784); the 1408 polyptych in the Pinacoteca e Museo Civico di Palazzo Minucci Solaini of Volterra (no. 19; Fremantle 1975, fig. 781); the 1411 altarpiece of Saint Jerome in the Museo Diocesano d'Arte Sacra in San Miniato al Tedesco (for the main panel, see Berti and Paolucci 1990, color repro. p. 91; for the predella, see San Miniato 1979, repro. p. 38); and the 1413 murals of San Lorenzo in Ponte in San Gimignano (Fremantle 1975, figs. 787, 797).
6. Florence, Galleria dell'Accademia, no. 446; Boskovits 1975, plate 85.
7. No. 21.PB.31; Strehlke 1992, fig. 1.
8. No. 1930.13; Boskovits 1990, color repro. p. 55.

Select Bibliography
Vasari 1568, Schorn ed., vol. 1, 1832, p. 337; Crowe and Cavalcaselle 1864–66, vol. 1, 1864, pp. 478–79; Vasari 1568, Milanesi ed., vol. 1, 1878, p. 645 n. 1; Cavalcaselle and Crowe, vol. 2, 1883, pp. 206–8; Crowe and Cavalcaselle 1903–14, vol. 2, edited by R. Langton Douglas, 1908, pp. 249–51; [Morton H.] Bernath in Thieme-Becker, vol. 6, 1912, p. 281; Colnaghi 1928, p. 69, no. 48; Zeri 1963a, pp. 247, 255 n. 5; Vasari 1550 and 1568, Bettarini and Barocchi eds., *Commento*, vol. 11-1, 1967, pp. 638–40; Boskovits 1968; Cole 1969; Wilkins 1969; *Bolaffi*, vol. 3, 1972, pp. 246–47; Boskovits 1975, pp. 126–28, 285–94; Fremantle 1975, pp. 381–90; Anna Padoa Rizzo in *DBI*, vol. 23, 1979, pp. 535–37; Alessandro Angelini in Turin 1987, cat. 4; Emanuela Andreatta in Berti and Paolucci 1990, pp. 251–52; Strehlke 1992; Susanne Pfleger in *Dictionary of Art* 1996, vol. 6, p. 168; Werner Jacobsen in *Saur*, vol. 17, 1997, p. 518

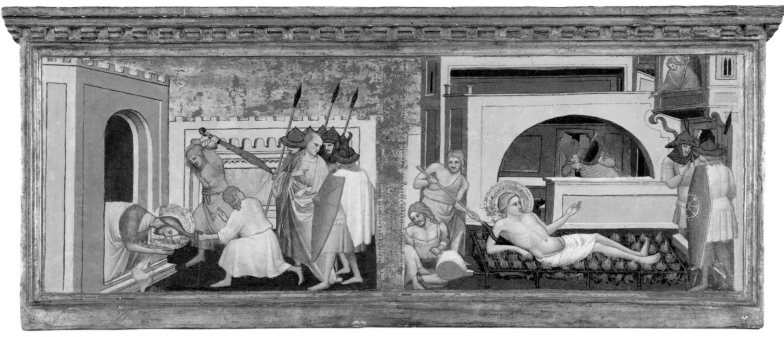

PLATE 16A

FIG. 16.1 Cenni di Francesco. Predella panel of an altarpiece:
Beheading of Saint John the Baptist, c. 1370–75. Tempera and tooled
gold on panel; 10 × 13″ (25.4 × 33 cm). Present location unknown

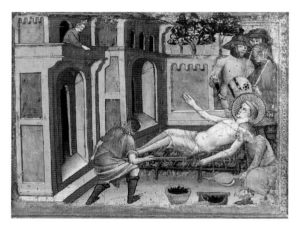

FIG. 16.2 Cenni di Francesco. Predella panel of an altarpiece:
Martyrdom of Saint Lawrence, c. 1370–75. Tempera and tooled gold
on panel; 10¼ × 13¼″ (26 × 33.5 cm). Florence, Museo Stibbert,
no. 16213

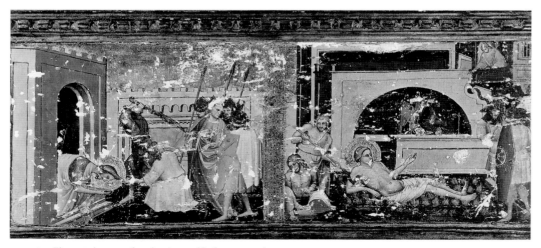

FIG. 16.3 Plate 16A in 1937, after cleaning and before restoration

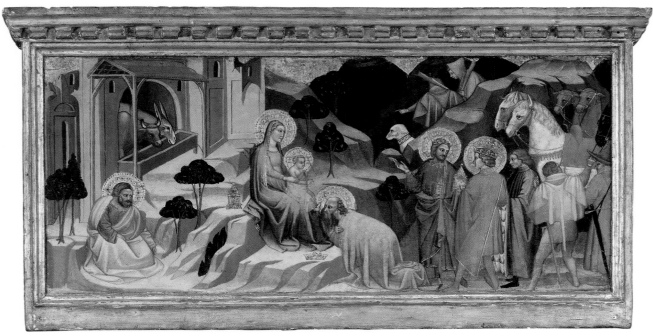

PLATE 16B

PLATE 16A (JC INV. 1290)

Predella panel of an altarpiece:
Martyrdoms of Saints John the Baptist and Lawrence

c. 1385

Tempera, silver, and tooled gold on panel with horizontal grain, transferred to another panel; 13 × 30⅜ × ⅞″ (33 × 77 × 2 cm); painted surface 9½ × 27¼″ (24 × 69 cm); central gold division, width 1¼″ (3 cm)

John G. Johnson Collection, inv. 1290

PUNCH MARKS: See Appendix II

TECHNICAL NOTES

This painting, along with Cenni's *Adoration of the Magi* (plate 16B [JC inv. 1291]) and *Martyrdom of Saint Bartholomew and the Miracle of the Bull* (plate 16C [JC inv. 1292]), was originally painted on a single, long plank of wood. When the predella was disassembled at an unknown date, the ends of the crenellated strip at the top of the moldings, which appear to be original, were mitered, and pieces of them were attached to continue the profile around the sides of this and the other panels.

Throughout the predella a thin layer of light orange bole was used beneath the gold of the halos and background; the latter is punched with a simple star-shaped pattern. The mordant used for the decorative detailing throughout is an ocher color. Here the soldiers' helmets and lance tips as well as the executioner's sword are silver leaf on mordant. There are surface abrasion and numerous losses;

the latter are documented in a photograph of the painting in its unrestored state (fig. 16.3).

The panel, which had been thinned and cradled, previously exhibited much cleavage and flaking of a type usually caused by exposure to heat. At the Fogg Art Museum in 1936–37, George Stout treated these problems by transferring the paint layers to a composite support with a wood core. An extensive photographic documentation of his treatment is in the archives of the Johnson Collection.

PROVENANCE
See plate 16C (JC inv. 1292)

COMMENTS
The panel is divided into two scenes. On the right is the beheading of John the Baptist, as recounted in Matthew 14:6–12. A rare feature shows a man tugging at the saint's long hair to uncover his neck for the executioner. A similar depiction of the executioner's assistant can be seen in another panel by Cenni di Francesco (fig. 16.1) as well as in a late thirteenth-century mosaic in the Florentine baptistery.[1]

On the right is the martyrdom of Saint Lawrence, a church deacon tortured and executed by order of the third-century Roman emperor Decius. Cenni's representation follows the popular account in Jacopo da Varazze's *Golden Legend* (c. 1267–77, Ryan and Ripperger ed. 1941, pp. 441–42).

> "Let an iron bed be brought," said Decius, "that this obstinate fellow may take his rest thereon!" Then the executioners stripped him and stretched him on a gridiron, pressing him down with iron forks; and they heaped burning coals beneath. . . .

And with joyous mien he [Lawrence] said to Decius: "Behold, wretch, thou hast well cooked one side! Turn the other, and eat!"

This subject can also be seen in another painting by Cenni di Francesco (fig. 16.2). For further comments, see plate 16C (JC inv. 1292).

1. Paolucci 1994, atlas vol. color plate 810.

Bibliography
See plate 16C (JC inv. 1292)

PLATE 16B (JC INV. 1291)

Predella panel of an altarpiece:
Adoration of the Magi

c. 1385

Tempera and tooled gold on panel with horizontal grain; 13 × 25¼ × 1″ (33 × 64 × 2.5 cm), painted surface 9⅝ × 22⅛″ (24.2 × 56 cm)

John G. Johnson Collection, inv. 1291

INSCRIBED ON THE REVERSE: *CITY OF PHILADELPHIA/ JOHNSON COLLECTION* (stamped in black ink)

PUNCH MARKS: See Appendix II

TECHNICAL NOTES
Like plates 16A and 16C (JC invs. 1290, 1292), this painting was originally painted on a single, long plank of wood. It is the only panel that was never thinned. Three nails, driven in from the front

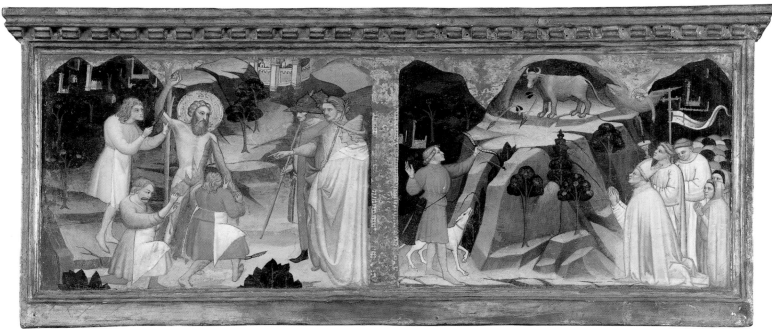

PLATE 16C

center, attached a now-lost vertical batten that served as an internal support for the predella, which was probably box-shaped.

Unlike plates 16A and 16C (JC invs. 1290, 1292), this painting was not restored at the Fogg Art Museum in the 1930s, but it too was subject to widespread flaking, which in 1941 and 1953 David Rosen tried to repair by sawing slots into the back of the panel along the grain and inserting splines to flatten it. At this time the panel was also infused with wax. In 1961 Theodor Siegl again treated the flaking.

PROVENANCE
See plate 16C (JC inv. 1292)

COMMENTS
Seated on a rocky ledge, the Virgin holds Jesus on her knee as the eldest of the Magi kneels to kiss his feet. The two other kings, attired in contemporary dress like their retinue, look on. The group is accompanied by three horses and two camels. Joseph is seated at the left below the stable, where the ox and ass feed at a trough. In the middle distance two shepherds descend the mountain with a dog.

For further comments, see plate 16C (JC inv. 1292).

Bibliography
See plate 16C (JC inv. 1292)

PLATE 16C (JC INV. 1292)

Predella panel of an altarpiece:
Martyrdom of Saint Bartholomew and the Miracle of the Bull

c. 1385

Tempera, silver, and tooled gold on panel with horizontal grain, transferred to another panel; 13 × 30 3/8 × 7/8″ (33 × 77 × 2.1 cm); painted surface 9 7/8 × 27 1/4″ (25 × 69 cm); central gold division, width 7/8″ (2.1 cm)

John G. Johnson Collection, inv. 1292

TECHNICAL NOTES
This painting, together with plates 16A and 16B (JC invs. 1290, 1291), was originally painted on a single, long plank of wood.

There are large losses in the scene of Saint Bartholomew's martyrdom (fig. 16.4), but the losses in the other scene are minor. The soldiers' helmets are silver leaf on mordant.

This panel, which had been thinned and cradled, was subject to blistering and cleavage. Like plate 16A (JC inv. 1290), George Stout treated this painting at the Fogg Art Museum in 1936–37. A complete photographic documentation of his work is in the archives of the Johnson Collection.

PROVENANCE
Plates 16A–C (JC invs. 1290–92) were owned by the Florentine dealer Luigi Grassi. In a letter to Johnson

dated Stockholm, December 15, 1914, Osvald Sirén wrote that they were said to come from "a little place in the Mugello" (the region to the northeast of Florence). Sirén mediated their sale, offering them to Johnson on July 25, 1914, with an attribution to Orcagna; at this point Johnson bought only the *Adoration,* for 21,000 lire. On December 15, 1914, the other two panels were again offered to the collector for 2,500 dollars, and, upon purchase, were sent to him on June 10 of the following year.[1]

COMMENTS
The panel is divided into two scenes. On the left is the martyrdom of Saint Bartholomew. It takes place in a landscape with castles and a walled city in the distance, meant to represent India, where the apostle preached Christianity. The Indian king Astrages, standing on the right between a soldier and a councilor, ordered Bartholomew's execution after he had converted the king's brother Polemius.[2] Three men peel the skin of the naked apostle, who is tied to a bare tree trunk.

On the right are two episodes from the legend of Saint Michael Archangel. A bull had wandered from the herd of a rich man named Garganus (shown at the left as a fashionably dressed young man with a hunting dog) and climbed the summit of Mount Gargano in Apulia. Frustrated in his attempts to bring the bull down, Garganus tried to shoot it with a poisoned arrow, which boomeranged and killed him instead. Following this death, the local bishop was consulted about the odd events.

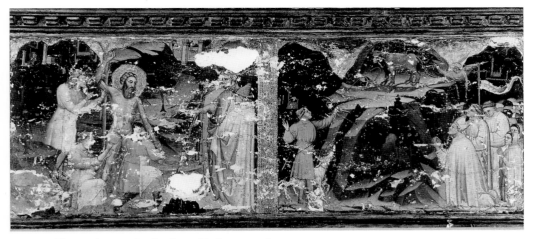

FIG. 16.4 Plate 16C in 1937, after cleaning and before restoration

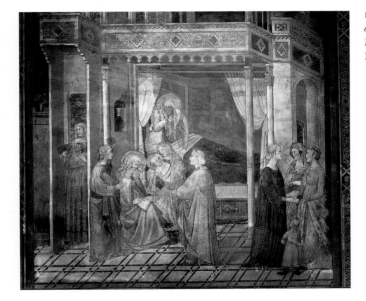

FIG. 16.5 Cenni di Francesco. *Birth of Saint John the Baptist*, 1383. Mural. Florence, church of San Donato in Polverosa

After three days of fasting he had a vision, in which the archangel announced that Mount Gargano was his chosen dwelling place on earth. As shown to the right, the bishop then led the town's populace to the mountain, where they knelt in prayer outside the cave in which the archangel in the form of the bull had appeared.[3] The composition closely follows an early trecento mural illustrating this legend in the Velluti chapel in Santa Croce in Florence.[4]

Miklós Boskovits (1968) attributed this predella panel and plates 16A and 16B (JC invs. 1290, 1291) to Cenni di Francesco. The three scenes were originally painted on a single plank of wood, with the *Adoration* at the center. The main section of the altarpiece cannot be identified among Cenni's known work. Based on the figures on the predella, it may have depicted the Virgin and Child with Saints John the Baptist, Lawrence, Bartholomew, and Michael Archangel, but other arrangements are also possible. The dimensions of the panels suggest

that the predella measured 81⅞″ (207.8 cm) in length, meaning that the altarpiece was large. This measurement corresponds to Cenni's altarpiece from Santa Trinita in Florence, now in the J. Paul Getty Museum, which, with its frame, is 91¾″ (233 cm) long.[5] That altarpiece contains the Coronation of the Virgin in the center of the main section and eleven saints in each lateral panel. In the Getty predella wide framing elements with coats of arms divide the Burial of the Virgin in the center from pairs of scenes depicting saints' legends on either side. The Johnson predella may have been similarly constructed. A gold strip separates each pair of side scenes, but the elements that divided them from the lost center panel are gone.

The Getty altarpiece dates to the mid- to late 1390s,[6] but the Johnson predella must be somewhat earlier, yet probably not as early as the date of about 1370–75 that Boskovits has suggested. Two of the compositions are similar to scenes from a dispersed

predella by Cenni that Boskovits also dated about 1370–75, the *Beheading of Saint John the Baptist* (fig. 16.1) showing an assistant executioner tugging the saint's hair[7] and the *Martyrdom of Saint Lawrence* (fig. 16.2) showing similar architecture. The Johnson panels can also be compared with Cenni's murals in San Donato in Polverosa in Florence (fig. 16.5), dated 1383. Although the mural is much more detailed than the Johnson *Adoration,* in both scenes the relationship of the figures and various episodes to the landscape setting is similar, possibly indicating a close date.

1. See letters from Sirén to Johnson dated Florence, July 25, 1914; Stockholm, September 22 and December 15, 1914; and New York, June 10, 1915.
2. Jacopo da Varazze c. 1267–77, Ryan and Ripperger ed. 1941, p. 483.
3. Jacopo da Varazze c. 1267–77, Ryan and Ripperger ed. 1941, p. 579.
4. Kaftal 1952, fig. 833. This has been recently attributed to Jacopo del Casentino (c. 1279–1349/58) and dated shortly after 1321. See Ladis 1984.
5. No. 21.PB.31; Strehlke 1992, fig. 1.
6. Strehlke 1992, pp. 21–22, 34. Boskovits (1975, pp. 287, 290) dated the altarpiece 1385–90 and the murals in the Gianfigliazzi chapel of Santa Trinita, from which the altarpiece comes, to 1410–15. Such a wide difference in date is unlikely, and Cenni's other dated works of 1408–13 in Volterra, San Miniato al Tedesco, and San Gimignano (see p. 71 n. 5) would seem to exclude such a late date for the murals.
7. Sold London, Christie's, November 27, 1970, lot 13 (as Giovanni del Biondo). Boskovits (1975, pp. 288–89) reconstructed this predella and attributed it to Cenni di Francesco. A third scene, the *Temptation of Saint Anthony Abbot,* is also in the Museo Stibbert in Florence (no. 16214; Cantelli 1974, p. 69, no. 532 [as Florentine School, fourteenth century]).

Bibliography
Sirén 1917, pp. 228–29; Van Marle, vol. 3, 1924, p. 516; Sirén 1927, pp. 17–18; Berenson 1932, p. 239; Salvini 1934a, pp. 205–6 n. 1; Berenson 1936, pp. 205, 208; Johnson 1941, p. 8 (Giovanni del Biondo); Offner 1947, p. 212 n. 1; Berenson 1963, p. 86, plate 302; Sweeny 1966, p. 34, repro. pp. 94–96 (Giovanni del Biondo); Boskovits 1968, pp. 284–85, fig. 11; Fredericksen and Zeri 1972, p. 219 (Florence, fourteenth century); Boskovits 1975, p. 286, plate 88c, fig. 312; Hériard Dubreuil 1978, pp. 57, 95 n. 30; Offner 1981, p. 51 (Rohoncz Master); Hériard Dubreuil 1987, pp. 62, 117, figs. 145, 313; Philadelphia 1994, repro. pp. 186–87; Ada Labriola in Milan 1997, pp. 78–79; Frinta 1998, pp. 53, 487

BERNARDO DADDI

FLORENCE, FIRST DOCUMENTED 1312–20;
DIED BEFORE AUGUST 18, 1348, FLORENCE

Bernardo Daddi began his career at a time when Giotto dominated Florentine painting. In order to carve out a market for himself in the face of the older artist's premier position, Daddi offered a luxurious alternative to Giotto's sober style.[1] He was thus satisfying an ever-rising demand in Florence for sumptuous display in painting, which up until then had been a specialty of Sienese artists, some of whom also worked in Florence. Conscious of their success and influenced by their examples, Daddi developed his own brand, characterized by richly ornamented fabrics and gold backgrounds and decorations.

Daddi's altarpieces became enduring models for two generations of Florentine artists. His multitiered polyptych from the church of San Pancrazio set the standard for most large-scale Florentine altarpieces of the trecento.[2] It has a unity of design that was rarely achieved in complexes of so many compartments and levels. In addition, the *Coronation of the Virgin* from the church of Santa Maria Novella established an iconographic type for the subject.[3]

Daddi was a master at painting narrative scenes on a smaller scale. These pictures have a fairy-tale quality, which strikes a nice balance between incidental anecdote and sparse and direct storytelling. Daddi also made a specialty of small-scale paintings for private devotion. His triptych[4] dated 1333 in the Museo del Bigallo in Florence is the first surviving example of a type of work that would come to characterize Florentine painting and be as much a commodity of the city's luxury trade as its famous silks.

Demand for Daddi's paintings was enormous. By the 1330s he probably had to hire many assistants, and, to expedite production, he made use of cartoons and repeated figures in different works.

Probably because Giorgio Vasari did not dedicate a full biography to the artist, there was little interest in Daddi before this century. Richard Offner revived his critical fortunes in 1930 with a monograph of what he considered Daddi's securely identified works, which he followed with several volumes on Daddi's close followers. Offner's catalogues were rigid in their definition of autography, and the historian often assigned to followers paintings that Daddi had signed and dated. The Italian scholar Roberto Longhi was highly critical of Offner's method, arguing that Offner accorded Daddi undue importance and that his restrictive catalogue gave a false view of the artist's production.

1. In a document of 1432 on the restoration of his now-lost altarpiece dated 1335 in the chapel of Saint Bernard in the Palazzo Vecchio in Florence, Daddi is called "a pupil of Giotto" (*discepolo di Giotto* [see Offner/Boskovits 1989, p. 60]). This is a misconstrued perception of the artist, for Daddi may not have ever actually passed through Giotto's workshop.
2. Florence, Uffizi, no. 8345; and a number of other collections. See the reconstruction in Offner/Boskovits 1989, plate XIV; see also plates XIV–XV. Recent unpublished research by Paula Lois Spilner has shown that this was originally in the cathedral of Santa Maria del Fiore.
3. Florence, Galleria dell'Accademia, no. 3449; Tartuferi 2000, post-restoration color repros.
4. Offner/Boskovits 1989, plate XXII.

Select Bibliography
Vasari 1568, Milanesi ed., vol. 1, 1878, p. 673; Vitzthum 1903; Georg Vitzthum in Thieme-Becker, vol. 8, 1913, pp. 253–54; Van Marle, vol. 3, 1924, pp. 348–408; Offner 1930; Offner 1934; Offner 1947; Longhi 1950a; Offner 1958; Longhi 1959, esp. p. 34; Zeri 1971, pp. 11–16; D. Bina in *Bolaffi*, vol. 4, 1973, pp. 99–102; Bellosi 1977a, pp. 11–17; Boskovits 1984, pp. 68–74; Enza Biagi in *Pittura* 1986, p. 567; Giovanna Ragionieri in *Pittura* 1986, pp. 296–97; Miklós Boskovits in Offner/Boskovits 1989, pp. 33–54; Offner/Boskovits 1989; Enrica Neri Lusanna in *Dictionary of Art* 1996, vol. 8, pp. 441–44; Ada Labriola in *Saur*, vol. 23, 1999, pp. 355–57

PLATE 17 (JC INV. 344)

Three center panels of an altarpiece: *Virgin and Child with Saints John the Baptist and Giles, Two Prophets, and Christ the Redeemer*

1334

Tempera, silver, and tooled gold on panel with vertical grain; overall with frame 48¼ × 55½ × 2⅝″ (122.5 × 141 × 6.5 cm); center panel without frame 33¼ × 17⅝ × ½″ (84.2 × 44.7 × 1.1 cm), painted surface 32⅜ × 16¾″ (82 × 42.5 cm); left panel without frame 30⅛ × 14¼ × ½″ (76.5 × 36 × 1.1 cm), painted surface 29⅛ × 13⅜″ (74 × 33.8 cm); right panel without frame 30⅜ × 14⅛ × ½″ (77 × 35.7 × 1.1 cm), painted surface 29⅛ × 13¼″ (74 × 33.5 cm)

John G. Johnson Collection, inv. 344

INSCRIBED ON THE LOWER FRAME OF THE LEFT PANEL: S[AN]C[TU]S IOH[ANN]ES B[AP]T[IST]A (Saint John the Baptist); ON THE CENTER PANEL: [AN]NO D[OMI]NI M.CCC.XXX.IIII (Year of the Lord 1334); ON THE RIGHT PANEL:_S[AN]C[TU]S EGIDIUS ABBAS (Saint Giles Abbot); ON THE REVERSE: JGJ COLL. (stamped in black ink on the cradle of John the Baptist); *25-1931-124* (in red) *Philadelphia* (in light red pencil); *CITY OF PHILADELPHIA/ JOHNSON COLLECTION* (stamped many times in black ink on the cradle elements); *JOHNSON COLLECTION* (stamped in black ink)

PUNCH MARKS: See Appendix II

TECHNICAL NOTES
Before Johnson bought this work, the three panels were excised from the original frame.[1] The lateral

FIG. 17.1 X-radiograph of a detail of the upper part of the frame of plate 17, showing a hole at the top of the frame division where a finial was once inserted

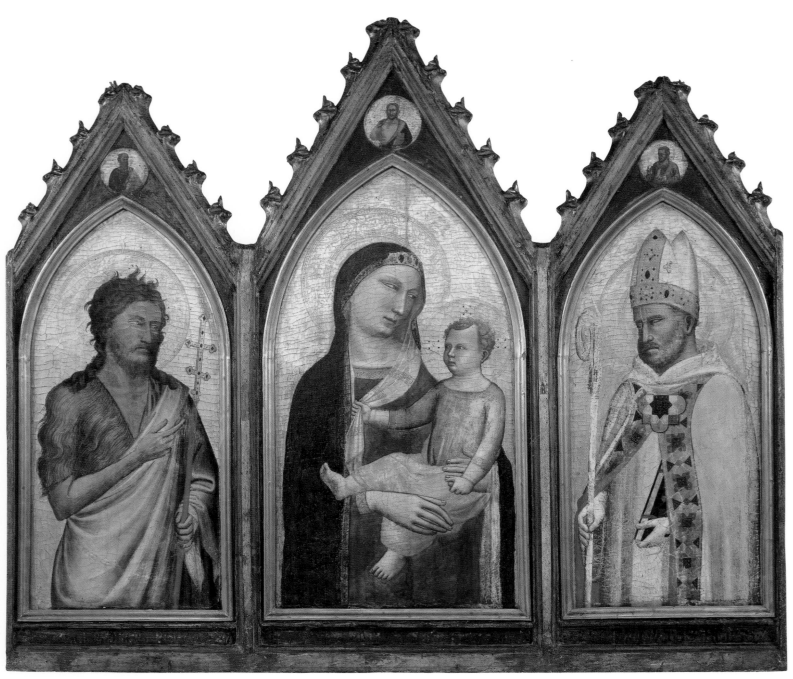

PLATE 17

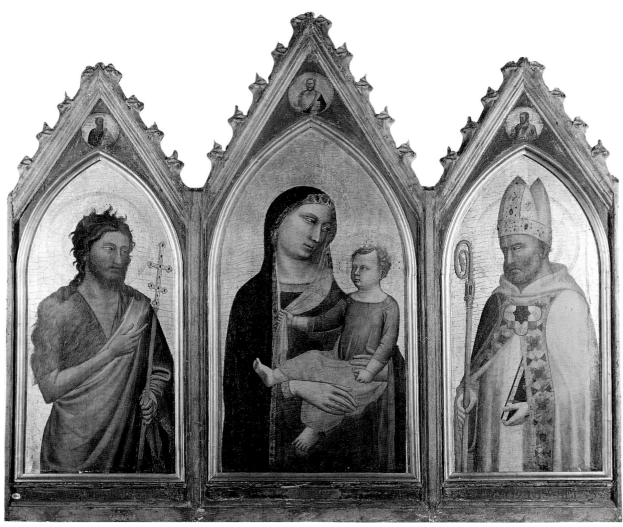

FIG. 17.2 Photograph of plate 17 as it appeared in 1913

panels each consist of a single member of poplar that has been thinned and cradled. The center panel is composed of two members of poplar joined 9⅞″ (25 cm) from the left edge. In 1941 David Rosen removed the cradle of the center panel, which he then mounted on plywood. As all panels retain traces of their original barbe on all four sides, their dimensions were not altered, and they were reset in the outer elements of the same, but considerably restored, frame.

An X-radiograph is helpful in identifying the original parts of the frame; they are the sections with inscriptions at the base and the bead above them, the spandrels with roundels in the pinnacles, and the foliate decoration along the top (fig. 17.1). The spandrels that create the arches are approximately ⅜″ (0.7 cm) thick. They were glued to the face of the panels, which are now approximately 1″ (2.5 cm) thick. Although they were painted, the spandrels do not have the linen layer found on the painted surface of the main panels.[2] Holes at the top of each frame division indicate where finials were once inserted (fig. 17.1).

The frame's backing, the vertical moldings at the sides and between the panels, and the base are not original. It is not known when they were added, but the gilded inner moldings seem to be a more recent modification than the other elements. At some point, the outer frame was painted gray with some yellow detailing. The gray was probably used to imitate the original silver that had turned black, which can be observed with the microscope in areas of flaked and cracked paint. Patterns in the spandrels and the inscriptions at the base were executed in silver sgraffito on green and red fields. The inscription below the Virgin and Child is now almost illegible, and the sgraffito pattern in the spandrels is now nearly gone due to the abrasion of the paint.

Even though cartoons were likely used to lay out the composition, infrared reflectography revealed little visible drawing and no evidence of a transfer. The examination did show that Saint John's lower finger was repositioned and that his staff was painted over the costume; however, the staff's position was predetermined by incisions in the gesso.

The decoration of the halos was incised: the saints' halos consist of Kufic-style lettering with hatching between the characters, and the Virgin's halo has a floral pattern. The Baptist's gilt cross was glazed along the shaded edges in a red tone; its front surface was also glazed and now appears as a pale gray-brown. Lakes of red, white, and a dark color were used for the jewels.

The paint surface and the mordant gilt decoration of the costumes are badly abraded. In many areas only the reddish brown mordant remains, whereas in other sections the mordant itself has been removed. The edges of the panels have been regilt in the areas that were originally covered by the inner engaged molding, which was lost during the disassembly.

In 1920 Carel de Wild did some minor treatment. At that time it was noted that the painting was in a "fair state of preservation, even good." Only a few retouches were observed, and gold was flaking in one panel. A photograph (fig. 17.2) gives a good idea of the appearance of the painting before David Rosen

PLATE 18 (JC CAT. 117)
Lateral panel of an altarpiece: *Saint John the Evangelist*

c. 1345–48

Tempera and tooled gold on panel with vertical grain, arched; 27⅝ × 16⅛ × 1⅛″ (70 × 41 × 2.8 cm); painted surface 25⅜ × 14⅜″ (64.2 × 36.5 cm)

John G. Johnson Collection, cat. 117

INSCRIBED ON THE REVERSE: *117 in 2523* (in crayon); *Fiesole,/* [illegible] *Angelico./ Beato fra Angelico/ born 1387* (in ink on a paper sticker); *St Stephen Deacon/ Martyr* (in pencil); *Andrea Orcagna/ Tuscan School/ 1315–1376/ see same artist's work/ in National Gallery* (on another paper sticker in ink, which is crossed out and the following is written over it in pencil): *Lippi Memmi/ Sienese/ Allegretto Nuzi*); *City of Philadelphia/ Johnson Collection* (stamped in black ink)

PUNCH MARKS: See Appendix II

TECHNICAL NOTES

The panel consists of a single plank that has been thinned, and its edges planed. The applied moldings are new. The gold ground was scraped off, and the panel was regessoed, regilt, and retooled.[1] Bits of the original gold and a single original punch mark survive along the edges of the figure. On the right side, some of the new gold was removed, revealing the nonoriginal gesso layer. In the lower right the newer gesso layer was exposed to reveal traces of the original gold and gesso. The mordant gilt details on the blue garment retain most of their gold surface, though on the book they are less well preserved.

The paint surface is very worn. There are major losses in the green lining of the saint's robe and other scattered losses in the blue undergarment. The right side of the robe is also very abraded. The right side of the saint's face is worn to the green underlayer.

When the panel was inspected by Hamilton Bell and Carel de Wild on March 13, 1920, they noted that it was entirely repainted and regilt (fig. 18.1). After David Rosen cleaned the picture in 1941, losses were not repainted, and it was judged "unworthy of exhibition" or further publication. In 1987 Eugenie Knight cleaned isolated areas and inpainted several losses to demonstrate various Italian inpainting techniques, which can still be seen on the saint's proper right sleeve.

PROVENANCE

Sold to John G. Johnson by Langton Douglas on November 17, 1907 (or 1909), for 100 pounds sterling.

COMMENTS

The half-length youthful saint wears a green-lined pink robe and a blue tunic, and holds a red book.

Bernhard Berenson (1913) attributed this panel to Allegretto di Nuzio (q.v.), calling it "a suave conception, anticipating late Umbrian dreaminess, yet a relatively early work."[2] Only Luigi Serra (1929) questioned Berenson's attribution. Until 1978 these

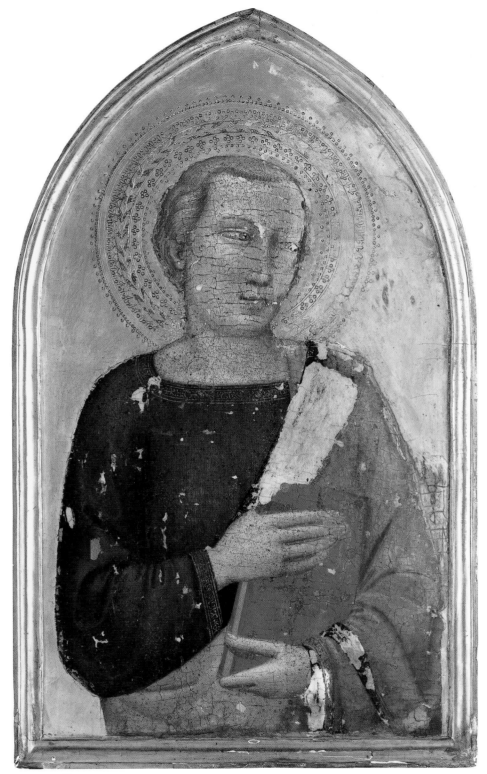

PLATE 18

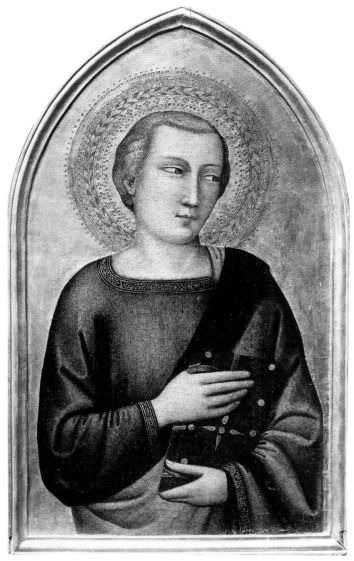

The *pieve* of San Giovanni Maggiore (Saint John the Evangelist) in Panicaglia is the most likely original location of Daddi's reconstructed altarpiece. Not only does this country church near Borgo San Lorenzo in the Mugello, northeast of Florence, own the panel of Saint John the Baptist, but the presence of Saint John the Evangelist in the altarpiece suggests that the painting was executed for a church dedicated to that saint.

Noting that in 1513 Pope Leo X de' Medici granted patronage rights over the *pieve* to the Florentine brothers Francesco and Andrea Minerbetti, Boskovits (1990) has posited that they or a descendant may have transferred Daddi's altarpiece from a family chapel in Florence to the country church. The Minerbetti had patronage of two important chapels in Santa Maria Novella in Florence. Established in the late 1200s, the Minerbetti chapels were dedicated to Saints Thomas Aquinas and Thomas Becket.[5] Although Santa Maria Novella boasted four altarpieces by Daddi, the dedications and founding dates

FIG. 18.2 Bernardo Daddi. Detail of Saint Michael Archangel in *Crucifixion and Saints*, 1348. Tempera and tooled gold on panel; overall 54½ × 69¾" (138.2 × 176.7 cm). London, Courtauld Institute of Art, Gambier-Parry, no. 127

as well as all subsequent opinions were based on the panel in its uncleaned state, as it appeared in Berenson's catalogue (fig. 18.1). In November 1978 Miklós Boskovits visited the Johnson Collection and noted that the painting was probably an "unrecognized Bernardo Daddi." Boskovits (1990) later proposed that the panel came from a disassembled pentatych (fig. 18.3) that consisted of *Saint James Major* in Gazzada, near Varese (fig. 18.4); the *Virgin and Child* in Barcelona (fig. 18.5); *Saint John the Baptist* from Panicaglia, near Borgo San Lorenzo (fig. 18.6); and *Saint Zenobius(?)* in York (fig. 18.7). The Johnson painting would have been on the far left.[3] Boskovits's reconstruction seems to be correct, but, whereas the shape of the Johnson and York panels seems to be near original, the other panels have had additions that made them rectangular.

Richard Offner (1947, pp. 103, 114; 1958, p. 152)

had separately assigned all but the Johnson *Saint John the Evangelist* to an artist he called "assistant of Daddi." But as Boskovits (1990, p. 64 n. 13) has observed, the works Offner assigned to this supposed assistant really were produced by Daddi himself late in his career, when he had begun to paint the broader, planar facial features, slanted eyes, and sideways glances that characterize these panels. The *Saint John the Evangelist* clearly resembles the Saint Michael Archangel (fig. 18.2) in the Courtauld altarpiece of 1348, from the church of San Giorgio a Ruballa, near Florence, which is one of Daddi's last works. The *Saint James Major* also compares favorably to his counterpart in the same altarpiece. In addition, Boskovits (1990) noted the similarity of the Barcelona *Virgin and Child* and another late work by Daddi, the 1347 *Virgin and Child with Angels* in Orsanmichele in Florence.[4]

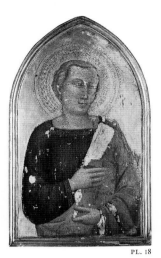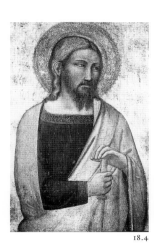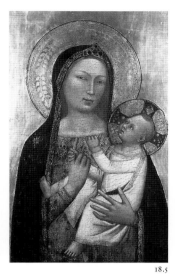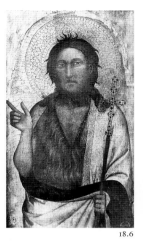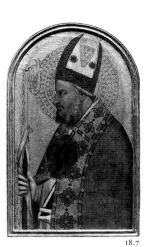

PL. 18 18.4 18.5 18.6 18.7

FIG. 18.3 Original configuration of the known extant panels of Bernardo Daddi's altarpiece, c. 1345–48. Left to right: PLATE 18; FIG. 18.4 *Saint James Major.* Tempera and tooled gold on panel; 24 × 15¾″ (61 × 40 cm). Gazzada, Fondazione Paolo VI. See Companion Panel A; FIG. 18.5 *Virgin and Child.* Tempera and tooled gold on panel; 33⅛ × 21⅝″ (84 × 54.8 cm). © Madrid, Fundación Colección Thyssen-Bornemisza; on deposit, Barcelona, Pedrables no. 1928.11. See Companion Panel B; FIG. 18.6 *Saint John the Baptist.* Tempera and tooled gold on panel; 24⅝ × 14⅜″ (62.5 × 36.5 cm). Panicaglia (near Borgo San Lorenzo), *pieve* of San Giovanni Maggiore; on deposit, Florence, Museo Diocesano di Santo Stefano al Ponte. See Companion Panel C; FIG. 18.7 *Saint Zenobius(?).* Tempera and tooled gold on panel; 25⅞ × 15¾″ (65.5 × 40 cm). York City Art Gallery, no. 806. See Companion Panel D

of the Minerbetti chapels preclude the Panicaglia altarpiece from being one of them, as does the absence of either Saint Thomas Aquinas or Saint Thomas Becket from the latter painting.

1. In letters to the Johnson Collection dated Albany, November 25 and December 3, 1980, Mojmír Frinta has suggested that the punches are modern.
2. He thought it close to a picture of five apostles in the Musée des Beaux-Arts, Strasbourg (no. 202; Moench 1993, color repro. p. 9).
3. Boskovits (1984) had previously recognized that the Johnson panel, *Saint James Major,* and the *Virgin and Child* went together; and Werner Cohn (1957) had already grouped the *Virgin and Child, Saint John the Baptist,* and *Saint Zenobius(?).*
4. Offner/Boskovits 1989, plate XVIII.
5. See Paatz, vol. 3, 1952, pp. 703, 735. The altars were destroyed during the mid-sixteenth-century renovation of the church.

Bibliography

Berenson 1913, p. 63, repro. p. 306 (Allegretto di Nuzio); Post 1915, p. 214; Van Marle, vol. 5, 1925, p. 160, fig. 100; Comstock 1927, p. 22, repro. p. 24; Serra 1929, p. 296 n. 8; Berenson 1932, p. 400; Berenson 1936, p. 344; Johnson 1941, p. 12 (Allegretto di Nuzio); Sweeny 1966, p. 59 (Allegretto di Nuzio); Berenson 1968, p. 304; Fredericksen and Zeri 1972, p. 4 (Allegretto di Nuzio); Boskovits 1984, p. 340, plate CLXVIIa; Offner/Boskovits 1989, p. 86; Boskovits 1990, pp. 62–67, fig. 2a; Philadelphia 1994, repro. p. 190; Frinta 1998, pp. 62, 94, 294 repro., 364

COMPANION PANELS for PLATE 18

A. Lateral panel of an altarpiece: *Saint James Major.* See fig. 18.4

c. 1345–48

Tempera and tooled gold on panel; 24 × 15¾″ (61 × 40 cm). Gazzada, Fondazione Paolo VI

PROVENANCE: Don Guido Cagnola, early twentieth century; bequeathed to the Holy See, 1946

SELECT BIBLIOGRAPHY: Boskovits 1984, p. 341; Boskovits 1990, pp. 62–67

B. Center panel of an altarpiece: *Virgin and Child.* See fig. 18.5

c. 1345–48

Tempera and tooled gold on panel; 33⅛ × 21⅝″ (84 × 54.8 cm). © Madrid, Fundación Colección Thyssen-Bornemisza; on deposit, Barcelona, Pedrables no. 1928.11

PROVENANCE: Italian art market, c. 1860; Clouds, Wiltshire, The Honorable Percy Scawen Wyndham, by 1870; by descent to Captain Richard Wyndham; London, vicomte d'Hendecourt; Lucerne and New York, Böhler and Steinmeyer, by 1927; purchased, Baron Thyssen-Bornemisza, 1928

EXHIBITED: London 1930, no. 19a; Munich 1930, no. 95

SELECT BIBLIOGRAPHY: Offner 1930, p. 12; Offner 1947, pp. 60–61, 103–4, 150, 231; Cohn 1957, p. 176; Offner/Boskovits 1989, pp. 71, 74; Boskovits 1990, pp. 62–67

C. Lateral panel of an altarpiece: *Saint John the Baptist.* See fig. 18.6

c. 1345–48

Tempera and tooled gold on panel; 24⅝ × 14⅜″ (62.5 × 36.5 cm). Panicaglia (near Borgo San Lorenzo), *pieve* of San Giovanni Maggiore; on deposit, Florence, Museo Diocesano di Santo Stefano al Ponte

PROVENANCE: Panicaglia, *pieve* of San Giovanni Maggiore

SELECT BIBLIOGRAPHY: Niccolai 1914, p. 461; Offner 1958, p. 152; Offner/Boskovits 1989, p. 85; Boskovits 1990, pp. 62–67

D. Lateral panel of an altarpiece: *Saint Zenobius(?).* See fig. 18.7

c. 1345–48

Tempera and tooled gold on panel; 25⅞ × 15¾″ (65.5 × 40 cm). York City Art Gallery, no. 806

PROVENANCE: Armley House, Yorkshire, Right Reverend Dr. John Gott; by descent to William Maitland Gott; Paris, Paul Bottenwieser; sold to F. D. Lycett Green, Fincochs, Goudhurst, Kent, 1937; given to the York City Art Gallery, 1955

SELECT BIBLIOGRAPHY: Offner 1947, p. 114; Offner/Boskovits 1989, p. 87; Boskovits 1990, pp. 62–67

DALMASIO

(Dalmasio di Jacopo degli Scannabecchi)

BOLOGNA, DOCUMENTED 1342–73

In 1950 Roberto Longhi[1] recapitulated many years of research concerning Dalmasio—a Bolognese artist to whom he attributed a group of paintings that, while related stylistically to the painter Vitale da Bologna (q.v.), showed signs of Tuscan influence. Thus Longhi provocatively asked, "Who is this Bolognese who acts so absolutely Tuscan?"[2]

Longhi put the name "Dalmasio" in quotation marks because associating any work to the historical figure was uncertain then, as it still is today. But Longhi felt that Dalmasio more than any other known Bolognese artist best fit the bill among Bolognese artists, because the group included the murals of the Bardi di Vernio chapel in Santa Maria Novella in Florence, which would explain the artist's pronounced Tuscan qualities.[3] In addition, Richard Offner[4] recognized that the same artist painted murals in San Francesco in Pistoia,[5] the Tuscan city where Dalmasio is documented in 1356 and 1365. An inscription suggests these paintings can be dated to 1343, meaning that Dalmasio had worked in Pistoia at an early date.[6] The Florence murals, which seem later, must at least date after 1335, the year that the chapel's patronage was turned over to the heirs of Riccardo di Ricco de' Bardi.[7] The decoration was probably completed in the 1340s under the supervision of Riccardo's brother Andrea, a friar at Santa Maria Novella, who died in 1349.[8]

The two cycles show that the Bolognese painter was able to procure important commissions in Tuscany.[9] This may be the result of his close connection with Giotto, who painted an altarpiece[10] commissioned by Gera di Taddeo Pepoli for the church of Santa Maria dell'Angelo in Bologna. The predella of that work has even been attributed to Dalmasio.[11]

The precise date of the altarpiece is not known, but, even if Dalmasio did not assist on it, the presence of Giotto and his workshop in Bologna would have been of prime importance for Dalmasio's formation. Santa Maria dell'Angelo was established in 1330, although construction may have begun as early as 1328, when Pepoli returned to Bologna from political exile. Giotto's work in Bologna has often been dated either before 1328 or about 1334–35.[12] However, he could have been in the city earlier, for although documents place him in Naples intermittently from December 1328 to December 1333, Giotto must have spent some of this time elsewhere.[13] The Neapolitan documents, for example, are silent on Giotto from January 1330 to May 1331. According to an early sixteenth-century chronicle (see Vitale da Bologna, plate 85 [JC cat. 1164]), Giotto also painted murals for the chapel of the castle of Galliera, which the cardinal legate Bertrand du Pouget (or Poyet) had built in 1329–30; Bertrand du Pouget left Bologna in March 1334.

Dalmasio could well have become connected with Giotto's workshop as an assistant on the altarpiece for Pepoli or the project for Bertrand du Pouget. Certainly, this would help explain the Giottesque quality of much of his relatively early work, including the *Virgin and Child with Dog* in the Johnson Collection (plate 19 [JC cat. 3]).[14] Debate has centered on whether the large triptych dated 1333 in the Louvre (see fig. 19.3) is by him.[15] It would be his earliest dated painting and would as such establish him as one of the founders of Bolognese painting.

The *Crucifixion* in the Acton Collection dates from his first contact with Giotto.[16] The calm, isolated Christ depends on Giotto's panel of the same subject now in Munich.[17] The Tuscan influences increase in Dalmasio's later work. However, a picture like the *Crucifixion* in the Pinacoteca Nazionale of Bologna[18] could not have been painted by anyone but an artist from Bologna. The facial expressions, in which sorrow is reduced to a grimace or the suppression of a smile, betray the Bolognese origins. Futhermore, the leaner and more ordered compositions, the abandonment of subsidiary episodes, and the preoccupation with mass and form all reflect Dalmasio's years of experience in Tuscany.

There are no documents to confirm if Dalmasio is indeed the artist of these paintings. The fact that he is securely placed in Pistoia in 1356 and 1365 provides but meager proof. The Pistoia documents speak of only one minor project for the church of San Giovanni Fuorcivitas. But in a well-known document of about 1348–49, in which this same church solicited names of artists to paint an altarpiece, Dalmasio is not mentioned.[19] No Bolognese record relates Dalmasio to a commission for a work of art, although he is always called a painter in the legal documents. He was the father of the painter Lippo di Dalmasio and brother-in-law of Simone de' Crocifissi.

1. Bologna 1950, pp. 15–16.
2. "Chi è questo bolognese che così intesamente toscaneggia?" (Longhi *Opere*, vol. 6, 1973 [1934–35], p. 34).
3. They illustrate scenes from the life of Saint Gregory the Great; Mellini 1970, figs. 18–31 (some in color).
4. Bologna 1950, p. 16.
5. Mellini 1970, figs. 1–17.
6. Giovanni Previtali in Vasari 1568, Club del Libro ed., vol. 1, 1962, p. 326 n. 2.
7. Luciano Bellosi (1977a) argued, however, that 1335 was a *terminus ante quem*.
8. Boskovits (1975, p. 205 n. 131) dates it after Andrea's death.
9. Boskovits (1975, p. 206 n. 134) has recognized other murals in Pistoia as well as Pisa.
10. Bologna, Pinacoteca Nazionale, no. 284; Previtali 1993, color plate cxii.

11. Michel Laclotte quoted in Previtali 1974, p. 149 n. 208; and in Paris 1978, p. 62 n. 7.
12. Previtali 1993, p. 127.
13. Boskovits 1990, p. 210 n. 12.
14. In addition, the above-mentioned murals in Pistoia represent the life of Saint Francis of Assisi and are themselves derivations of Giotto's cycle of c. 1292 in the Upper Church of San Francesco in Assisi (Zanardi 1996 [for post-1974–83 restoration color repros.]). The Giottesque cycle was probably used as a model, because the friars in Pistoia wished to have images that recalled the paintings in their order's mother church. Copies of the compositions may have been available in the workshop of Giotto.
15. The painting has been attributed to Jacopino di Francesco (later called the Pseudo–Jacopino di Francesco) by Longhi (in Bologna 1950, p. 18 [the picture was then in Moulins, Musée d'Art et Archéologie]), Bellosi (1977, pp. 23–24), and Laclotte and Elisabeth Mognetti (1977, cat. 101); to Dalmasio by Pier Giovanni Arcangeli (quoted by Castagnoli in Arcangeli 1978, p. 100), and Robert Gibbs (in D'Amico, Grandi, and Medica 1990, p. 90), and, with a question or an attribution to an anonymous master, by Laclotte (in Paris 1978, p. 16); to the so-called Master of 1333 by Carlo Volpe (in *Tomaso* 1979, p. 242), Daniele Benati (in *Pittura* 1986, p. 215), Andrea Bacchi (in *Pittura* 1986, pp. 614–15), Laclotte and Mognetti (1987, p. 118), and Laclotte (in D'Amico, Grandi, and Medica 1990, p. 7); and to a painter of the Bolognese school by Arnauld Brejon de Lavergnée and Dominique Thiébaut (1981, p. 254).
16. Florence, New York University, Villa La Pietra, Acton Collection, Conti inventory 1995, no. xxi.c.14; Longhi *Opere*, vol. 6, 1973, plate 45.
17. Alte Pinakothek, no. 667; Previtali 1993, color plate LXXXIII. This is part of a dispersed polyptych from a Franciscan church. Dillian Gordon (1989) has suggested that it comes from San Francesco in Rimini.
18. No. 215; Arcangeli 1978, color plate VII. From the same altarpiece as the *Flagellation* in the Seattle Art Museum no. It 37/B63852.1; Shapley 1966, fig. 196.
19. For a full reprint of the document, see Ladis 1982, p. 257.

Select Bibliography
Longhi *Opere*, vol. 6, 1973 (1934–35), pp. 33–34; Aldo Foratti in Thieme-Becker, vol. 29, 1935, pp. 528–29; Filippini and Zucchini 1947, pp. 57–61; Roberto Longhi in Bologna 1950, pp. 15–16 (Longhi 1950, pp. 11–12; *Opere*, vol. 6, 1973, pp. 160–61); Coletti 1950, pp. 245–47; Longhi 1950, pp. 11–12; Giovanni Previtali in Vasari 1568, Club del Libro ed., vol. 1, 1962, p. 326 n. 2; Bellosi 1965, p. 21; Previtali 1967, pp. 109, 143 n. 208; Mellini 1970; Serena Padovani in *Bolaffi*, vol. 4, 1973, p. 108; Bellosi 1974, pp. 38, 84, 87, 104 n. 62; Previtali 1974, pp. 109, 141 n. 208; Boskovits 1975, esp. pp. 40, 151–52, 203–4 n. 1, 205 nn. 131, 133–36; Bellosi 1977a, pp. 23–24; Pier Giovanni Castagnoli in Arcangeli 1978, pp. 96–105; Michel Laclotte in Paris 1978, pp. 14–17; Gibbs 1979, pp. 563–64; Carlo Volpe in *Tomaso* 1979, pp. 241–42; Gibbs 1982; Daniele Benati in *Pittura* 1986, pp. 567–68; Previtali 1993, pp. 114, 147 n. 209; Skerl Del Conte 1993, pp. 144–53; Robert Gibbs in *Dictionary of Art* 1996, vol. 8, p. 471

PLATE 19 (JC CAT. 3)

ATTRIBUTED TO DALMASIO

Valve of a diptych: *Virgin and Child with Dog*

c. 1335–40

Tempera and tooled gold on panel with vertical grain; overall with applied moldings 18⅜ × 12 × ⅞″ (46.6 × 30.4 × 2.1 cm), painted surface 15⅜ × 9⅛″ (39 × 23 cm)

John G. Johnson Collection, cat. 3

INSCRIBED ON THE REVERSE: *CITY OF PHILADELPHIA/ JOHNSON COLLECTION* (stamped in black); *EIN734A* (in pencil); *47.1931.26* (in ink on a sticker)

TECHNICAL NOTES

The panel retains its original thickness, as the remnants of a porphyry-colored ground with a geometric pattern on the back attest (fig. 19.1). The fact that the reverse is decorated suggests that the panel was a valve of a diptych. The pattern, which would have been visible when the diptych was closed, now appears to be cropped on the left, but originally would have continued onto the other, now-lost valve and thus have been centered on the two panels when the diptych was open. While exposed wood on the right side of the *Virgin and Child* suggests that the panel was slightly planed, old nails visible in X-radiograph probably indicate the location of the hinges there. The applied moldings were regessoed and regilt and the outer bead was added later. The rest is original, including the paint that laps onto the inner edge on all four sides.

In an early restoration, some of the background was regilt to hide the Virgin's original three-pointed tiara, which could only be discerned upon close examination of the panel. After Teresa Lignelli cleaned the picture in 1993, the crown's form became much clearer (fig. 19.2). This cleaning also revealed remains of finely painted red and blue jewels in the tiara. Gesso-filled holes on either side of the Virgin's head indicate that at some point a metal crown had been attached to the panel. Both the Virgin's and Christ's halos are incised and not punched.

The paint is much abraded, and most of the mordant gilding is gone. There are numerous small losses in the faces as well as a good deal of damage in the Virgin's mantle. The highlights on Christ's red blanket have gone dark.

When Carel de Wild restored the picture in May 1920, he and Hamilton Bell noted that the panel had been almost entirely repainted. In 1941 David Rosen cleaned it of old repaints and varnish; he also retouched, resurfaced, and waxed the picture. Some minor selective inpainting was done by Mark Aronson in 1988. In the spring of 1993, after Lignelli's cleaning, Roberta Rosi carried out the inpainting.

PROVENANCE

There is no record of when or where John G. Johnson bought this picture.

COMMENTS

The half-length Virgin supports the Christ Child in her left arm. Their cheeks touch as he playfully tugs at her veil while holding a small white lapdog. The Virgin holds a slightly open book that rests on the edge of the frame.

Bernhard Berenson (1913) attributed this painting to the school of Bernardo Daddi (q.v.). When he judged it an "unequal work" but "undoubtedly Florentine," he was probably comparing it with works by Daddi such as the half-length image of the Virgin and Child he owned.[1] Berenson (1932) later changed his mind and assigned it to an immediate follower of Giotto. While this attribution was maintained in later Johnson Collection catalogues, it also represents the then-uncertain scholarship on the earliest Giottesque painters.

A letter to Barbara Sweeny from Federico Zeri, dated Rome, August 20, 1956, demonstrates how puzzling the picture could be, and more importantly, how Berenson's original judgment about its uneven quality seemed an opinion of another epoch: "Its quality is indeed superb, and I would exclude for such a gem a non-Florentine origin. I think that the attribution to an immediate follower of Giotto is correct; but I don't think that our present knowledge about Giotto's immediate pupils in their earliest moments is able to suggest a definite name."

Burton Fredericksen and Federico Zeri (1972) later concluded that the panel was the work of the Bolognese painter Dalmasio. They were supported by Luciano Bellosi (1974) and Pier Giovanni Castagnoli (in Arcangeli 1978). Bellosi emphasized that this attribution had previously been withheld because most scholars thought that the paintings had been grouped under the label of "Dalmasio" and dated to the 1360s, whereas the Johnson picture seemed much too Giottesque to warrant such a late date.

Daniele Benati (in *Pittura* 1986) returned to the question of the attribution of the painting, suggesting instead that it was by a Bolognese painter whom he called the Master of 1333, based on a triptych of that date now in the Louvre (fig. 19.3). Others have sometimes attributed this triptych to the Pseudo-Jacopino or Dalmasio himself, within whose work, I believe, it fits well.

While all writers have commented on the Giottesque style of this panel, only one similarly small-scale painting of a Virgin and Child attributed to Giotto exists (fig. 19.4). Although that painting dates much earlier than the present work, a similar painting must have been known to Dalmasio. It offers a rare glimpse into how the Florentine master conceived of a picture of this size. The Virgin is shown half-length with the Child reaching for her veil. Although the original frame does not exist, it,

FIG. 19.1 Reverse of plate 19, showing the original painted decorative pattern

like the frame in the Johnson picture, probably acted as a sort of parapet for the figure, creating a sense of intimacy and spatial illusion.

Dalmasio was indiscriminate in his borrowing from Giotto, as if his initial contact with the Florentine in Bologna had led to his discovery of the whole range of the master's work. He seems to have been consciously interested in the early work. For example, in 1343 he used Giotto's murals of about 1292 in Assisi[2] as a model for his murals in San Francesco in Pistoia. His model for the Virgin's forceful pose in the Johnson panel, in which she supports the Child with one arm, is Giotto's early altarpiece made for the Florentine church of the Badia, probably in the late 1290s.[3] Dalmasio also looked at more recent works by the Florentine. For example, he copied the pose of the Virgin's left hand from Giotto's now little-known *Virgin and Child with Angels* in the church of Santa Maria a Ricorboli in Florence (fig. 19.5).

Certain aspects of Dalmasio's style open questions about whether he may have been an assistant in Giotto's workshop in Florence during the last years of the master's life. From paintings such as Giotto's *Virgin* at Ricorboli or his mural of the *Virgin and Child with Allegories of the Neighborhoods of Florence* in the Bargello in Florence,[4] Dalmasio would have

gleaned his particularly tight manner of modeling faces with an emphasis on their underlying structural components. Sometimes this simply translates into overly pronounced jawbones, but in general Giotto's lessons for Dalmasio were not superficial. Like his Florentine model, the Bolognese painter rounds off his faces in deep shadow while keeping the prominent parts in highlight. The flesh is slightly gray in contrast to the brighter orange used by his Bolognese contemporaries. Dalmasio's eyes, like those by Giotto, communicate with the viewer, whether by glancing furtively or staring directly. The Johnson *Virgin and Child with Dog* therefore must date to the period when Dalmasio was probably closest to the workshop of Giotto, which suggests contact in Florence and thus a date in the mid- to late 1330s.

The iconography of the Johnson panel is unusual. While the Christ Child is often showing playing with a bird—a symbol of the Passion—a dog is rare. It may be a reference to the Dominican order of preaching friars known as the *domini canes,* or the "watchdogs of the Lord." Their association with dogs derives from a legend involving Joan Aza, the mother of the founder of the order, Saint Dominic, who dreamed that she gave birth to a dog with a flaming torch in his mouth who would figuratively set the world on fire.[5]

Only one other painting showing the Christ Child holding a lapdog is known—the altarpiece by Tomaso da Modena of about 1360 in the chapel of the Holy Cross in Karlstejn castle, outside Prague (fig. 19.6), which shows the dog licking the tip of Christ's index finger. Olga Pujmanová (1980) suggested that the dog was a reference to the Dominicans, who held particular influence at the court of King Charles IV of Bohemia, who commissioned the painting.[6] That the Johnson *Virgin and Child with Dog* may be a specific reference to the Dominicans can also be deduced by the color of the cruciform in Christ's halo, which, instead of the usual red, is blue, the color identified with the order of angels known as the cherubim, who were associated with the Dominicans because of their knowledge.[7]

In the *Divina Commedia* (begun c. 1307–8), Dante makes this point: "One prince [Saint Francis] was all seraphic in his ardor;/ the other [Saint Dominic], for his wisdom, had possessed/ the splendor of cherubic light on earth" (*Paradiso* 11:37–39). Earlier the Dominican scholar Saint Thomas Aquinas had explained in the *Summa theologica* (begun c. 1266) that the cherubim represented the "fullness of science."

The theme of learning is likewise suggested by the Virgin's slightly open book, which implies that she was either reading to the Child or teaching him to read. Depictions of the Virgin holding both the Child and a book are relatively rare in early trecento art, but Dalmasio did show the Virgin holding a book in his small panel in New Haven[8] and the *Virgin and Child Enthroned with Six Angels,* last recorded in the Askew Collection in New York.[9]

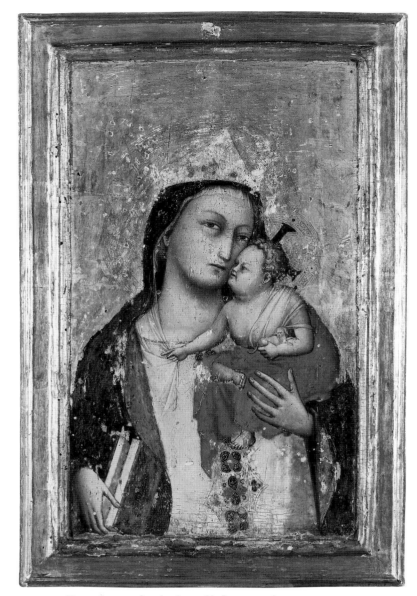

FIG. 19.2 Plate 19 in 1993, after cleaning and before restoration

The Virgin's conical crown (fig. 19.2) gives her a regal look that is uncommon in such small-scale compositions. She is only rarely crowned in pictures of the Virgin and Child enthroned and even more rarely in simple images of the Virgin and Child. Even in scenes of the Virgin in Paradise, where she usually appears crowned, conical or triangular crowns are the exception. Throughout the fourteenth century this type of headdress is specifically associated with earthly emperors. It can be seen, for example, on the head of the emperor in the *Miracle of the Bull* of 1332–35 by Maso di Banco in the Bardi di Vernio chapel in Santa Croce in Florence.[10] In a number of paintings in which both Christ and the Virgin are crowned, Christ wears the conical crown and the Virgin the more common diadem.[11] Dalmasio's use of it here is one of the earliest known examples.[12]

The stripe of the Virgin's undergarment, which has a geometric design, resembles the pallia or orphries of ecclesiastic robes, such as those worn by the bishop saint Egidius in the Johnson Collection's altarpiece by Bernardo Daddi (see plate 17 [JC inv. 344]). Its presence on the Virgin's dress implies that she is wearing a priest's vestments. Although examples of a similarly dressed Virgin are rare,[13] occasionally she wears other types of ecclesiastical costume. For example, the Virgin of the Assumption sometimes wears a bishop's stole.[14]

1. Florence, Harvard University Center for Italian Renaissance Studies at Villa I Tatti, c. 1340; Offner/Boskovits 1989, plate XIII.
2. Upper church of San Francesco; Zanardi 1996, post-1974–83 restoration color repros.

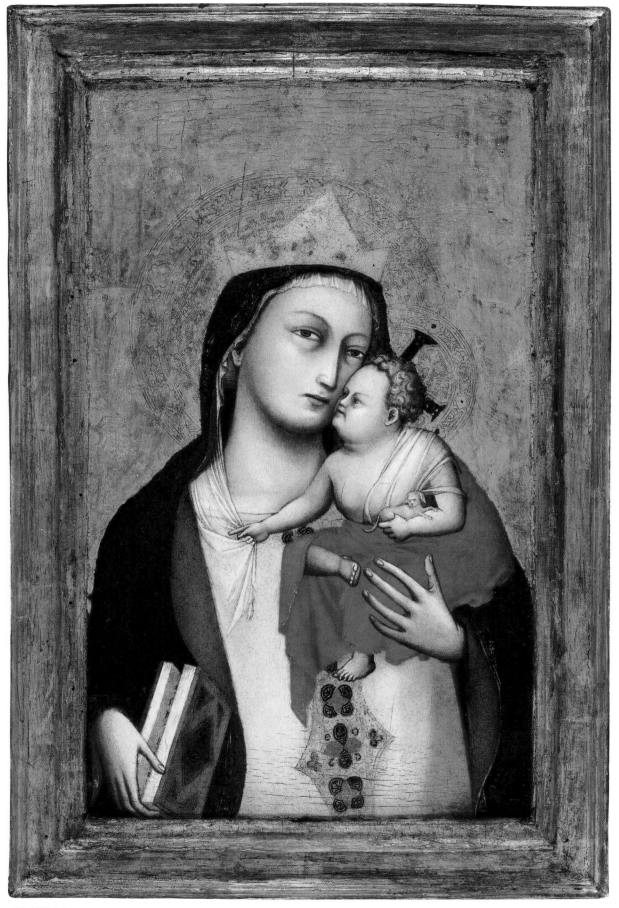

PLATE 19

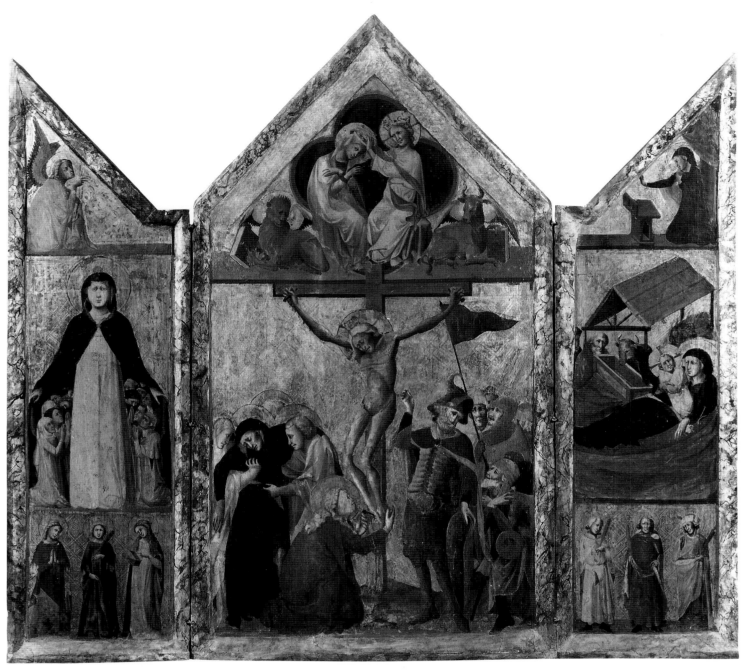

FIG. 19.3 Attributed to Dalmasio. Triptych: (center) *Crucifixion and the Coronation of the Virgin;* (left wing) *Annunciate Angel, Virgin of Mercy, and Three Female Martyr Saints;* (right wing) *Virgin Annunciate, Nativity, and Three Male Martyr Saints,* 1333. Tempera and tooled gold on panel; closed 53¼ × 28¾″ (135 × 73 cm). From a confraternity dedicated to Saint Vitale. Paris, Musée du Louvre, no. 20.197

3. On deposit, Florence, Uffizi; Previtali 1993, color plate XXXII.

4. Previtali 1993, figs. 399–401.

5. See Kaftal 1952, col. 312, fig. 357.

6. Alternatively, Robert Gibbs (1989, p. 189) proposed that the dog might refer to the Passion of Christ. Psalm 21:17, sometimes associated with the crucified Christ, reads, "For many dogs have encompassed me." However, this would imply a negative connotation, which the lapdogs of the paintings in Philadelphia and Karlstejn do not seem to embody.

7. Carl Brandon Strehlke in New York 1988, p. 194.

8. Yale University Art Gallery, no. 1943.260; Seymour 1970, fig. 72.

9. Longhi *Opere,* vol. 6, 1973, plate 46.

10. There the empress wears a similar but shorter crown; Acidini Luchinat and Neri Lusanna 1998, postrestoration repros. p. 179.

11. For example, Buffalmacco's *Last Judgment* of the 1330s in the Camposanto of Pisa (Bellosi 1974, fig. 2); Nardo di Cione's *Paradise* of c. 1351–57 in the Strozzi chapel of Santa Maria Novella in Florence (Offner 1962, plate 1); and Andrea Orcagna's altarpiece *Christ Enthroned and Saints,* dated 1357, in the same chapel (Offner 1960, plate x).

12. It was used by Bernardo Daddi (q.v.) in the *Coronation of the Virgin* from Santa Maria Novella in Florence of c. 1345–48 (Florence, Galleria dell'Accademia no. 3449; Offner 1947, plate XXII[12] [as assistant of Daddi]). Most examples of this type of crown occur in paintings from the workshop of the Cione and by artists associated with them. See, for example, Jacopo di Cione's altarpiece from San Pier Maggiore in Florence (fig. 37.3), or his *Coronation of the Virgin* of 1372–73 from the Florentine mint (Galleria dell'Accademia, no. 1 456; Bomford et al. 1989, color plate 170). It also appears in two depictions of the Coronation of the Virgin by the Master of San

FIG. 19.4 Attributed to Giotto (Florence, c. 1266–1337). *Virgin and Child,* mid-1330s. Tempera and tooled gold on panel; 13 × 9½″ (33 × 24 cm). Oxford, Ashmolean Museum, no. A332

FIG. 19.5 Giotto and workshop (Florence, c. 1266–1337). Detail of *Virgin and Child with Angels,* c. 1330–35. Tempera and tooled gold on panel; overall 29⅛ × 23¼″ (74 × 59 cm). Florence, church of Santa Maria a Ricorboli

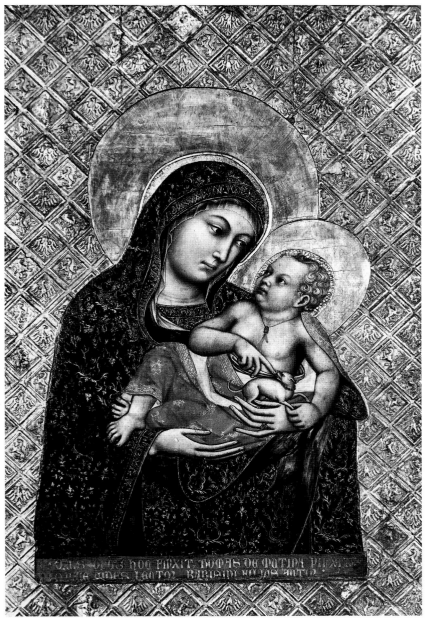

FIG. 19.6 Tomaso da Modena (Modena, 1325/26; last documented 1379). Center panel of an altarpiece: *Virgin and Child with a Lapdog,* c. 1360. Tempera and tooled gold on panel; 22⅛ × 16¼″ (56 × 41.3 cm). Karlstejn, Czech Republic, castle, chapel of the Holy Cross

Lucchese: the destroyed altarpiece in San Lucchese in Poggibonsi and the small altarpiece in the Lindenau-Museum in Altenburg, Germany (no. 18; Boskovits 1975, plate 30, fig. 22). In north Italy, Giusto de' Menabuoi adapted the same sort of headgear for the Virgin in his 1378 mural of the Virgin Orant in the baptistery of Padua (Spiazzi 1989, color plates 157–58), as well as for the *Coronation of the Virgin* in his triptych of 1367 in the National Gallery in London (Davies and Gordon 1988, plate 27).

13. The Virgin in the altarpiece signed by Niccolò di Ser Sozzo and Luca di Tommè in 1362 is crowned and has

a pallium sewn on the front of her dress (Siena, Pinacoteca Nazionale, no. 51; Torriti 1977, fig. 162 [color]).

14. See Bartolomeo Bulgarini's (q.v.) *Assumption of the Virgin* from the hospital of Santa Maria della Scala in Siena (Pinacoteca Nazionale, no. 61; Torriti 1977, fig. 143 [color]).

Bibliography
Berenson 1913, p. 5 (school of Bernardo Daddi); Sirén 1917, pp. 122, 124; Van Marle, vol. 3, 1924, pp. 249–50, fig. 144; Comstock 1928, p. 90; Berenson 1932, p. 237; Berenson 1936, p. 203; Johnson 1941, p. 7 (immediate follower of

Giotto); Suida 1950, p. 57; Berenson 1963, p. 84; Sweeny 1966, p. 33, repro. p. 85 (immediate follower of Giotto); Fredericksen and Zeri 1972, p. 63 (Dalmasio); Bellosi 1974, pp. 84, 104 n. 63, fig. 160; Pier Giovanni Castagnoli in Arcangeli 1978, pp. 97–98; Pujmanová 1980, pp. 308, 329, fig. 6; Daniele Benati in *Pittura* 1986, pp. 215, 615, fig. 323; Andrea Bacchi in *Pittura* 1986, p. 615; Gibbs 1989, p. 189 n. 65; Previtali 1993, color plate CXII; Philadelphia 1994, repro. p. 190; Daniel Benati in *Saur,* vol. 23, 1999, p. 539

FRA DIAMANTE
(Diamante di Feo)

TERRANUOVA, BORN 1430; LAST
DOCUMENTED 1498, FLORENCE

Little is known about Diamante di Feo's early
life, other than that he was born in Terranuova
in the Valdarno south of Florence and became a
Carmelite friar at the convent in Prato at a young
age. Through his order's connections he must have
come to know the Carmelite friar Filippo Lippi, for
whom he worked for over twenty years. In 1447
Diamante is documented as helping gild Lippi's
altarpiece of the Coronation of the Virgin, commis-
sioned by Francesco Maringhi for Sant'Ambrogio
in Florence.[1] Starting in 1454 he collaborated with
Lippi on the murals of the *collegiata* (later cathe-
dral) of Prato, a project that was not finished until
1466. Part of the delay was due to Diamante's three-
year imprisonment by the archbishop of Florence
for having renounced the Carmelite order for the
Vallombrosans in October 1460. In July of that year
Diamante had already painted the figures of Saints
Giovanni Gaulberti and Alberto of Trapani.[2] In
October 1465, after his release, he assisted Lippi on
the last scenes to be completed: *Herod's Feast* and
the *Lapidation of Saint Stephen*.[3] The *Nativity* Dia-
mante painted for Santa Margherita in Prato, from
which the artist had a prebend, probably dates to
the next year.[4]

In the spring of 1467 Lippi transferred his shop
to Spoleto, and probably from there in May 1468
Diamante went to Rome to discuss a project with
Cardinal Marco Barbo, with whom he may have
negotiated a commission for Lippi, who sent two
small paintings to Barbo from Florence in June
1468. In the spring of 1469 Diamante was again in
Rome. Lippi died in October of that year, leaving
his son Filippino in Diamante's care.

Diamante's activity after Lippi's death has not
been seriously studied. In May 1470 he is recorded
as painting a wall hanging with the arms and por-
trait of Cesare Petrucci for the Palazzo dei Signori
of Prato. In 1472 he joined the painters' confrater-
nity of San Luca in Florence, where he was then a
resident in the Vallombrosan monastery of San
Pancrazio. Sometime in the late 1470s or early 1480s
he seems to have worked in the Vatican for Pope
Sixtus IV Della Rovere, who granted him a pension
of one hundred *scudi* that was to be administered
and paid for by the Vallombrosans of Poppi in Tus-
cany. The pension has been assumed to relate to
work in the Vatican. Ernst Steinmann (1901) had
suggested that Diamante was the artist of some of
the murals of popes in the Sistine chapel, but this
attribution was correctly refuted by Herbert Horne
(1901). However, the Johnson panel (plate 20 [JC
cat. 55]), which may date to this period, shows that
Diamante felt the influence of a younger generation

of Florentine artists, including Sandro Botticelli,
who was then at work in the Sistine chapel. Dia-
mante's papal pension caused no end of troubles.
Arguments over it and some other financial privi-
leges that the artist enjoyed led to his second
imprisonment in 1489. He had powerful friends,
however: on January 2, 1498, the Ferrarese diplomat
Manfredino Manfredini wrote on the painter's
behalf to Ercole I d'Este, calling him "an excellent
painter, judging by the work one can see in Rome."[5]
It is not known when or where Fra Diamante died.

Although there are no independently documented
paintings by Diamante, Mary Pittaluga (1941) attrib-
uted to him works in Filippo Lippi's oeuvre in
which a distinct assistant's hand can be discerned.
This is most true of the Prato works. However, a
picture like the *Presentation in the Temple* in Santo
Spirito (see fig. 20.3) can probably be considered
one of Diamante's independent works. This is also
true of other paintings that likely date to the 1450s,
such as the altarpiece in Budapest (see fig. 20.2).
However, in the 1460s Diamante began to show
some distinctiveness of style. The Louvre *Nativity,*
first attributed to him by Luciano Bellosi (1983–84),
is a truly original creation, even if the airborne
angels were copied from both Lippi and Pesellino's
(q.v.) altarpiece for the company of the Preti della
Trinità,[6] which Lippi's workshop completed when
Pesellino died.

1. Florence, Uffizi, no. 8352; Ruda 1993, color plates 77–79.
2. Ruda 1993, color plates 148–49.
3. Ruda 1993, color plates 155–56.
4. No. 1343; Ruda 1993, plate 177.
5. "Excellente pittore, per vedersene in Roma evidente
 opera" (cited by Eve Borsook in *DBI*, vol. 39, 1991,
 p. 635).
6. London, National Gallery, nos. 727, 3162, 3230, 4428,
 4858A–D; and St. Petersburg, The State Hermitage
 Museum, no. 5511. For the reconstruction, see Gordon
 1996, and Gordon 2003, color repro. p. 261, and p. 271,
 fig. 9.

Select Bibliography
Vasari 1550 and 1568, Bettarini and Barocchi eds., vol. 3
(text), 1971, pp. 333, 339; Gaetano Milanesi in Vasari 1568,
Milanesi ed., vol. 2, 1878, pp. 640–42; Cavalcaselle and
Crowe, vol. 5, 1892, pp. 245–56; Ulmann 1890, pp. 60–65;
Steinmann 1901, vol. 1, pp. 190, 201–8; Horne 1908, pp.
88–89; A. Venturi, vol. 7, pt. 1, 1911, pp. 579–88; Georg
Gronau in Thieme-Becker, vol. 9, 1913, pp. 202–3; Col-
naghi 1928, p. 88; Van Marle, vol. 9, 1929, pp. 631–38; G.
Gronau 1938, pp. 134–38; Pittaluga 1941; Bacci 1944a, pp.
142–43; Berenson 1963, pp. 58–59; *Bolaffi*, vol. 4, 1973, p.
139; Borsook 1975; Borsook 1981, pp. 163, 195 n. 113; Bellosi
1983–84, esp. pp. 49–55; Alessandro Angelini in Cherubini
1991, pp. 942–43; Eve Borsook in *DBI*, vol. 39, 1991, pp.
634–36; Ruda 1993, passim; Eliot W. Rowlands in *Diction-
ary of Art* 1996, vol. 8, pp. 850–51; Gabriele Fattorini in
Saur, vol. 27, 2000, pp. 67–68

PLATE 20 (JC CAT. 55)

ATTRIBUTED TO FRA DIAMANTE
An Evangelist(?), a Bishop Saint, and a Papal Saint

Mid-1480s

Tempera and tooled gold on canvas, transferred from
panel; 71¾ × 41⅛" (182 × 104.4 cm)

John G. Johnson Collection, cat. 55

TECHNICAL NOTES
The X-radiograph shows that only about 50 percent
of the painting is original and that it consists of large
fragments that were transferred from wood to canvas
and joined by a highly deceptive restoration (fig. 20.1),
which was probably done in Paris for Joseph Spiri-
don in the early 1900s.[1] It is difficult to distinguish
original from nonoriginal areas because of the way
the old fragments were reworked to blend seamlessly
with the restoration. The restorer not only filled and
inpainted major losses, which can be discerned in the
X-radiograph or by careful inspection of the surface,
but also deceptively reworked much of the authentic
surface with glazes and fine touches of paint. Origi-
nal incisions in the gesso were extended across the
fills. Although all of the mordant gilding has been
redone with gold on a clear oil size, gaps in this
restored gilding show evidence of the original. The
tooling of the gilded background may be original,
but even this is difficult to determine because of the
restoration. The straight lines of the architecture are
scored. Infrared reflectography revealed little visible
underdrawing in original areas, except for some
hatching in the cloak and the right hand of the cen-
tral saint. Other original underdrawing may have
been lost in the transfer of the fragments to canvas.

On August 1919 Hamilton Bell noted a little flak-
ing in the upper right. On January 21, 1921, during
inspection with Carel de Wild, Bell noted that the
painting had been transferred to canvas and that it
was "very badly retouched, in fact almost all mod-
ern." T. H. Stevenson varnished the work on January
24, 1925. Theodor Siegl, on June 19, 1956, also noted
extensive retouching. At that time he treated some
bad flaking and retouched many small losses.

PROVENANCE
A bill from Joseph Spiridon to John G. Johnson,
dated Paris, August 1905, probably refers to this pic-
ture: "Verrocchio. Three Saints—Frs. 30,000."

COMMENTS
Three saints stand in an enclosed space where the
walls and floor are inlaid with porphyry and colored

marbles. There is an open step in the right fore-
ground. The gold background has a brocade pattern.

The saints are not easily identified. On the left is
a bearded man holding a book and wearing an
orange mantle over a blue tunic. He may be Saint
John the Evangelist, who is the most commonly
depicted Gospel writer. But as John is traditionally
dressed in blue and red, this could be another
Evangelist instead, possibly Saint Mark, who some-
times wears an orange mantle.[2] In the center is an
abbot or bishop carrying a pastoral staff, and on the
right is a pope carrying an astral cross.

Because the painting has been transferred from
wood to canvas, technical evidence is of almost no
help in trying to understand its original function.
The panel may have been an independent work and
not part of a larger altarpiece with the Virgin and
other saints. The figures are presented in an enclosed
space as if they are meant to be alone. None of their
gazes is focused on a central image, as would occur
in an altarpiece with the Virgin and Child as the
main subject. Here, one saint looks out toward the
viewer, another gazes down, and the third looks up
to the left.

Independent panels of saints began appearing in
Italian painting about the middle of the fifteenth
century. An early example from the late 1450s is
Filippo Lippi's overdoor showing seven saints
seated in conversation, from the Palazzo Medici in
Florence.[3] Lippi also painted an independent *Saints
Francis and Dominic* for the Ceppo Nuovo in Prato
in 1454.[4] Another similar painting from an oratory
near the Carmine in Prato, made in Lippi's work-
shop by Fra Diamante, shows three saints in a land-
scape setting.[5] Such an arrangement must have
gained a certain popularity with the installation in
1467–68 of Piero del Pollaiolo's *Saints Vincent,
James Major, and Eustache,*[6] which showed the three
saints standing on an inlaid marble floor, in the
mortuary chapel of the cardinal of Portugal in San
Miniato al Monte in Florence.[7]

The attribution of the Johnson painting has
been a matter of some dispute. When Joseph Spiri-
don sold it to John G. Johnson, it was attributed to
Andrea Verrocchio, and in 1909 William Rankin
published it as from the school of that painter. In a
letter dated Settignano, January 16, 1906, Bernhard
Berenson wrote Johnson: "Your tall panel with St.
Gregory and two other full length saints interests
me very much. It is of the school of Fra Filippo."
However, in 1913 Berenson published it as by
Francesco Botticini, comparing it to "one of those
moments when he painted such a grand work as
Mme. André's '*Pietà.*'"[8]

In a lecture on the Johnson Collection given on
May 17, 1926, Richard Offner disagreed with Beren-
son's published opinion: "This is by a follower of
Fra Filippo, but not by Botticini, who is much more
Verrocchiesque than this. I have not as yet been
able to make an exact attribution of this picture.
The cold light on the drapery is typical of the Lippi

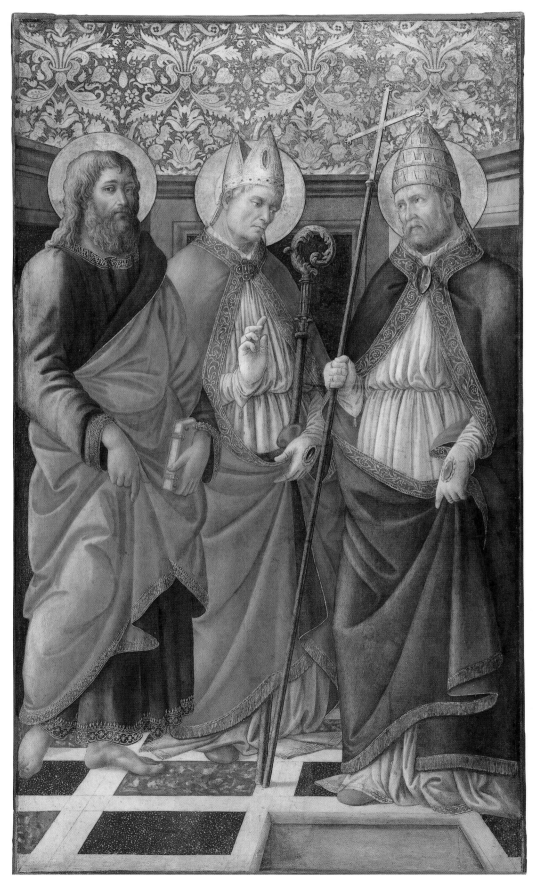

PLATE 20

Johnson saints to him. But a label calling them Florentine, ca. 1460, might be in order."

The painting would seem to come from Diamante's late period, after Filippo Lippi's death. The facial types and the figures relate to the series of popes that Sandro Botticelli and his workshop painted on the walls of the Sistine chapel in 1481–82 (fig. 20.4). If the Evangelist on the left can be identified with Saint Mark, the picture may be associated with Cardinal Marco Barbo, whom Diamante first met when he negotiated a commission for Lippi in 1468. The Venetian-born Barbo, a relative of Pope Paul II, was the cardinal presbyter of the basilica of San Marco in Rome, where he helped oversee the rebuilding of the basilica and the adjacent Palazzo Venezia for the pope.[10] San Marco honored both the Evangelist and the early Christian papal saint Mark, who had founded the church in the fourth century. The two saints are the subject of a double-sided processional standard, or *gonfalone,* by Melozzo da Forlì (1438–1494),[11] which is still in the church and may have been commissioned by Pope Paul or the cardinal. It could well be that Diamante's painting was similarly connected with Barbo patronage at San Marco. It is likewise of some interest that a fellow member of Diamante's Vallombrosan order, the Tuscan painter Don Giuliano Amidei (first documented 1446; died 1496), also worked for San Marco, as well as the Vatican, as an illuminator of papal manuscripts.[12] Furthermore, Johnson seems to have purchased this painting from Spiridon in 1905 as part of a group that included many pictures from an unidentified Roman collection, perhaps suggesting a Roman provenance for this work.

FIG. 20.1 Diagram of the restored zones (shaded) of plate 20

school, though the style is somewhat evolved beyond Lippi himself; not quite so primitive." However, at the Museum the Berenson attribution was maintained until 1941, when it was changed to Pesellino in the checklist of the Johnson Collection compiled by Henri Marceau and Barbara Sweeny. The shift was nonetheless reflected in the posthumous edition of Berenson's lists (1963), edited by Michael Rinehart and Luisa Vertova Nicholson on the basis of notes on Berenson's photographs. There the picture was listed as Pesellino "in great part." On December 6, 1977, Everett Fahy wrote to Joseph Rishel from New York that he had long thought it by Fra Diamante, comparing it to paintings in Budapest (fig. 20.2), Santo Spirito at Prato (fig. 20.3), and the Museo Civico at Prato.[9] However, he concluded that "since the Frate [friar] is such a shadowy figure, I would not assign the

1. This restoration has much in common with that of Defendente Ferrari's *Enthroned Virgin and Child* in the Johnson Collection (cat. 276; Philadelphia 1994, repro. p. 191).
2. See Fra Angelico's (q.v.) Linaioli altarpiece in Florence, Museo Nazionale di San Marco, Uffizi, no. 879 (Spike 1996, color repro. p. 114), as well as his San Marco altarpiece in the same museum (Spike 1996, color repro. p. 125).
3. London, National Gallery, no. 667; Gordon 2003, color repro. p. 143.
4. This picture is now lost. See Borsook 1975, p. 86, document 132.
5. Cambridge, Harvard University Art Museums, Fogg Art Museum, c. 1460, no. 1963.111; Bowron 1990, fig. 595.
6. Florence, Uffizi, no. 1617; Cecchi 1999, postrestoration fig. 9 (color).
7. Later examples include Cosimo Rosselli's *Saints John the Baptist, Barbara, and Matthew* of 1468 from Florence, Santissima Annunziata (Florence, Galleria dell'Accademia, no. 8635; Bonsanti 1987, color repro. p. 38); Francesco Botticini's *Three Archangels* of c. 1470 from Florence, Santo Spirito (Florence, Uffizi; Berenson 1963, plate 1062); Bastiano Mainardi's *Saints James, Stephen, and Peter* of the 1490s from Florence, Santa Maria Maddalena de' Pazzi (Florence, Galleria dell'Accademia, no. 1621; Van Marle, vol. 13, 1931, fig. 141); and Filippino Lippi's *Saints Roch, Sebastian,*

FIG. 20.2 (*above*) Fra Diamante. Altarpiece: *Virgin and Child Enthroned with Saints Lawrence and Anthony Abbot and a Servite Friar as Donor,* mid-1450s. Tempera on panel; 55¾ × 57⅛″ (141.5 × 145 cm). © Budapest, Szépmüvészeti Múzeum, no. 45

FIG. 20.3 (*right*) Fra Diamante. Altarpiece: *Presentation in the Temple and Saints and Friars,* mid-1450s. Tempera and gold on panel; 78 × 66⅛″ (198 × 168 cm). Prato, church of Santo Spirito

Jerome, and Helen of 1481–82 in Lucca, church of San Michele in Foro (Neilson 1938, fig. 11).

8. *Pietà with Saints Louis of Toulouse, Dominic, James, and Nicholas;* Paris, Musée Jacquemart-André, no. 944; Venturini 1994, fig. 98.

9. No. 10; Lippi 1994, fig. 30 (color).

10. On the cardinal, see Germano Gualdo in *DBI,* vol. 6, 1964, pp. 249–52; and Mantese 1964, pp. 147–53. On the rebuilding, see Rome 1980.

11. Clark 1990, color plate III (the pope) and black-and-white plate II (the Evangelist).

12. In San Marco he painted the ceiling; see Rome 1980, p. 75. On this artist, see Gaudenz Freuler in Lugano 1991, pp. 250–52; and Giovanna Damiani in Berti 1992, esp. pp. 68–71, 84–87, both of whom cite earlier sources.

Bibliography
Rankin 1909, p. lxxxii (school of Andrea Verrocchio); Berenson 1913, p. 33, repro. p. 260 (Francesco Botticini); Burroughs 1931, p. 65 n. 1; Van Marle, vol. 13, 1931, pp. 412–413; Berenson 1932, p. 443; Degenhart 1932, p. 411; Johnson 1941, p. 13 (Pesellino); Berenson 1963, p. 168; Sweeny 1966, pp. 62–63, repro. p. 126 (Pesellino); Fredericksen and Zeri 1972, p. 162 (Pesellino); Philadelphia 1994, repro. p. 190

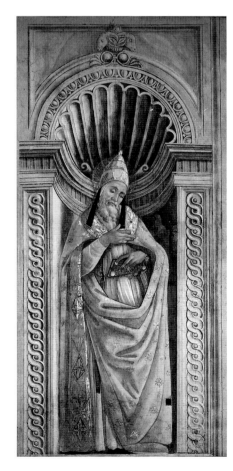

FIG. 20.4 Sandro Botticelli (Florence, 1445–1510). *Saint Stephen Pope,* 1481–82. Mural; 82¾ × 31½″ (210 × 80 cm). Vatican City, Palazzi Vaticani, Sistine chapel

Domenico di Bartolo

SIENA, FIRST DOCUMENTED 1420;
LAST DOCUMENTED 1444–45, SIENA

Domenico di Bartolo, from Asciano near Siena, is first documented in 1420 as an apprentice on an unidentified project for the cathedral of Siena. He next appears on the membership rolls of the Sienese painters' guild that were compiled starting in 1427. His training probably took place in the shop of the painter Martino di Bartolomeo (q.v.).[1] Although Martino's style was rooted in trecento models, he was nonetheless on intimate personal and working terms with Siena's best and most progressive sculptors, Francesco di Valdambrino and Jacopo della Quercia. It was through his contacts with the latter that Domenico would learn a new, more modern, figural style. His first extant signed and dated painting, the *Virgin of Humility and Four Music-Making Angels* of 1433,[2] is a true Renaissance work of art: the figures are arranged in a spatially suggestive circular composition and are weighed down by a sense of physical gravity. While some critics have argued that Domenico owes this achievement to contemporary Florentine painting, in fact his dialect is thoroughly Sienese. The painting's sculptural qualities bespeak the influence of Jacopo della Quercia, and its many didactic inscriptions come from the series of Mariological sermons Saint Bernardino was writing in Siena in the early 1430s. The humanistic lettering, in ancient Roman style, of some of the inscriptions is one of the earliest examples in painting and the first by a Sienese artist.

Because Domenico had made a now-lost portrait drawing of the German ruler Sigismund when he was in Siena in 1432–33 on his way to be crowned Holy Roman Emperor in Rome, the artist was commissioned in 1434 to design a plaque of the emperor and his councillors for the pavement of Siena's cathedral.[3] Around the same time Jacopo della Quercia, then building superintendent of the cathedral, also arranged for Domenico to paint murals depicting the lives of Siena's four patron saints in the sacristy.

From 1436 to 1438 Domenico was in Siena only intermittently. Traveling first to Florence, Domenico painted the high altarpiece for the church of the Carmine, of which the Princeton *Virgin and Child Enthroned* (see fig. 21.7) is probably the central section, and another now-lost picture for Santa Trinita. In 1438 he signed and dated an altarpiece for the convent of Santa Giuliana in Perugia.[4]

His Florentine and Perugian sojourns colored the Sienese artist's subsequent production at home. Their immediate effect is evident in his mural of a scene seemingly from the life of Saint Crescentius, probably of 1437; it is the only surviving mural from his project for the sacristy of the cathedral. The rendering of architecture in this painting shows that he had learned the new technique of scientific perspective in Florence.

Domenico's next and last mural cycle, for the Pilgrims' Hospice (the Pellegrinaio) of the hospital of Santa Maria della Scala in Siena,[5] demonstrates both his inventiveness and his eclecticism. He was the artistic director of the project, executed under the rector Giovanni Buzzichelli, which included two scenes by Vecchietta and Priamo della Quercia (q.v.). The charitable duties of the hospital painted on the right wall were the first scenes to be executed and include rationally depicted architectural environments that in some cases portray actual spaces in the hospital populated by persons that the artist would have seen there. His reporting of Sienese life continues a long tradition in the city's art that originates in Ambrogio Lorenzetti's *Good and Bad Government* of 1338 in the Palazzo Pubblico.[6] The left wall contains scenes of the hospital's history, which precipitated a change in style that seems meant to evoke "olden times." The architecture is fantastical, as Gothic ornament weighs down and covers up imaginary Renaissance structures that seem lifted out of an architect's model book. The figures are similarly exotic and strangely posed.

Domenico's last commission, the *Virgin of Mercy* for the Palazzo Pubblico,[7] was interrupted by his death sometime in late 1444 or early 1445 and was completed by Sano di Pietro (q.v.). A close examination of the division of labor and the *giornate* may suggest, however, that they had collaborated on the project from the beginning.

1. Zeri 1986a.
2. Siena, Pinacoteca Nazionale. For a postrestoration color reproduction, see Florence 1992, p. 61.
3. Brandi 1949, p. 163.
4. Perugia, Galleria Nazionale dell'Umbria, no. 88; F. Santi 1969, plates 88a–g.
5. Christiansen, Kanter, and Strehlke 1988, pp. 47–51, figs. 10–18; Torriti 1987 (all color plates).
6. Castelnuovo 1995.
7. Christiansen, Kanter, and Strehlke 1988, p. 141, fig. 2.

Select Bibliography
Vasari 1550 and 1568, Bettarini and Barocchi eds., vol. 2 (text), 1967, pp. 11–12; Romagnoli before 1835, vol. 4, pp. 437–59; Milanesi 1854–56, vol. 1, 1854, p. 49; vol. 2, 1854, pp. 161–62, 171–73; Crowe and Cavalcaselle 1864–66, vol. 3, 1866, pp. 50–57; Cavalcaselle and Crowe, 1883–1908, vol. 9, 1902, pp. 3–14; Wagner 1898; Berenson 1909, pp. 54, 161–62; Bernd Curt Kreplin in Thieme-Becker, vol. 13, 1920, pp. 535–37; Van Marle, vol. 8, 1927, pp. 533–59; Berenson 1932, pp. 170–71; Brandi 1934; Gengaro 1936; Ragghianti 1938, pp. xxii–xxiv; Longhi 1940, p. 189 n. 28 (Longhi *Opere*, vol. 8, pt. 1, 1975, pp. 60–61 n. 28); Pope-Hennessy 1944, pp. 139–40; Pope-Hennessy 1947, pp. 14–16, 28–29; Brandi 1949, pp. 105–20, 248, 262–64; Carli 1956, pp. 59–60; Berenson 1968, pp. 109–10; Carli 1971, pp. 28–29; Gallavotti 1972; *Bolaffi*, vol. 4, 1973, pp. 169–72; Gallavotti Cavallero 1974; Brown 1976; Strehlke 1984; Strehlke 1985; Cecilia Alessi in *Pittura* 1986, pp. 618–19; Zeri 1986a; Torriti 1987; Carl Brandon Strehlke in Christiansen, Kanter, and Strehlke 1988, esp. pp. 249–57; Strehlke 1989, pp. 271–78; Laura Cavazzini in Florence 1992, pp. 150–51; Giovanna Damiani in *Dictionary of Art* 1996, vol. 9, pp. 94–95; Boskovits 2001; Ladis 2003

PLATE 21 (JC CAT. 102)
Virgin and Child

Signed and dated 1437

Tempera and tooled gold on panel; $24\frac{1}{2} \times 17\frac{3}{8} \times 1\frac{1}{2}''$ ($62.2 \times 44 \times 3.6$ cm), painted surface $21\frac{1}{8} \times 14''$ (53.5×35.5 cm)

John G. Johnson Collection, cat. 102

INSCRIBED ON CHRIST'S SCROLL: *M*[in gold]*E DULCIS IN TE NON DESINIT USQUE P[RA]ECLARI/ IGNEM UT NO[MIN]IS PARCE MITIS EGO* (The source of this phrase is not known. It is difficult to read and appears fragmentary.); ON CHRIST'S HALO: *MU[N]DI EGO* (corrupted abbreviation of John 8:12: "I am the light of the world"); ON THE VIRGIN'S HALO: *AVE REGI[N]A C[AELORUM]* (contraction of the antiphon intoned at Compline on the Feast of the Purification: "*Ave Regina Caelorum*" [Hail Queen of the Heavens]); ON THE BOTTOM OF THE FRAME: *DOM[ENICUS] DESENIIS ME PINXIT ANNO D[OMIN]I MCCCCXXXVII* (Domenico of Siena painted me the year of the Lord 1437); ON THE REVERSE: *Chenue/ 5, Rue de la Terrasse/ Paris* (printed)/ *John G Johnson* [illegible] (in pencil on a red oval sticker); *Chenue/ 5, Rue de la Terrasse/ Paris* (printed)/ *2/ Braner/ 1 panneau Vierge* (in ink on a red oval sticker); *Chenue/ Emballage. Transports/ 5, rue de la Terrasse* (printed on a blue oval sticker with illegible writing in pencil); *DOMINICUS [——] MCCC-CXXXVII/ 1437/ Si Legge nel fregio* (One reads in the border)/ *[——]*) (in ink); *Domenico di Bartolo Ghezzi* (with biographical information in German, in black ink on a paper sticker); remnants of a red wax seal; *102/ In 1257* (in pencil, twice); *CITY OF PHILADELPHIA/ JOHNSON COLLECTION* (stamped in ink, abraded); *34 - 22 = 6* [?] (in pencil)

PUNCH MARKS: See Appendix II

EXHIBITED: Philadelphia 1920; Philadelphia Museum of Art, *Nativity* (November 23, 1934–January 7, 1935), no catalogue; Paris 1935, no. 140; Philadelphia Museum of Art, John G. Johnson Collection, Special Exhibition Gallery, *From the Collections: Paintings from Siena* (December 3, 1983–May 6, 1984), no catalogue

TECHNICAL NOTES
The panel consists of a single, vertically grained member with $1\frac{5}{8}''$ (4 cm)-wide horizontally grained strips at the top and bottom; each strip is made up of two pieces of wood—one is $1''$ (2.5 cm) wide and the other is $\frac{5}{8}''$ (1.5 cm) wide. The inner strips were nailed to the center panel; the outer strip was then

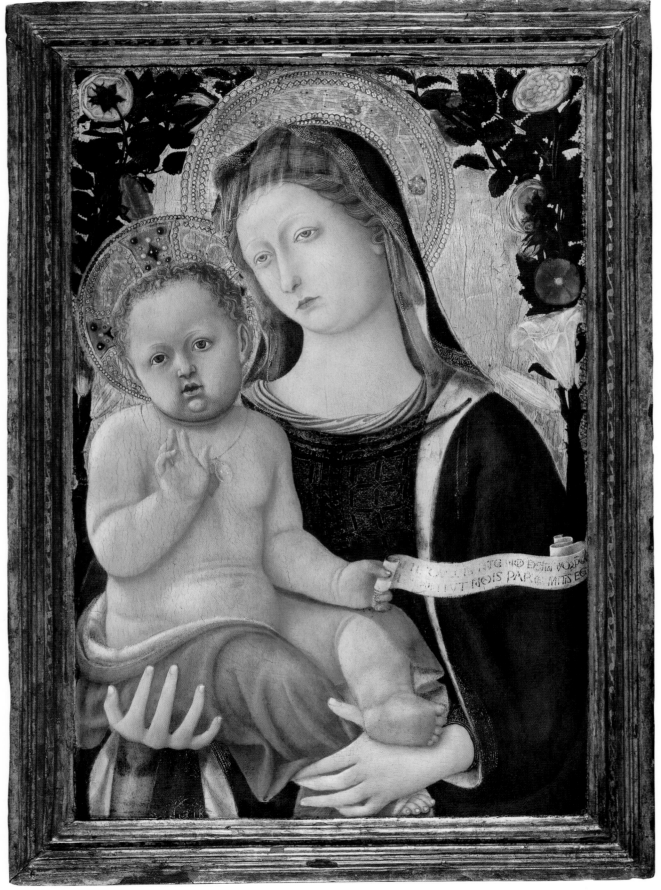

PLATE 21

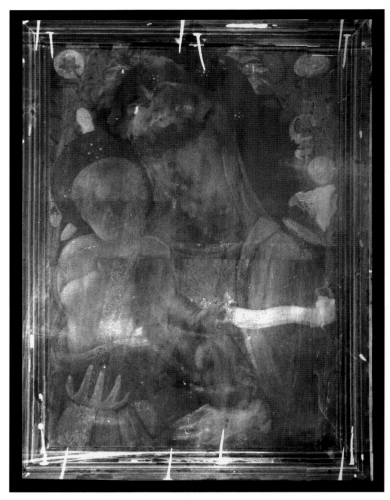

FIG. 21.1 X-radiograph of plate 21, showing the structure of the panel and applied moldings

FIG. 21.2 Reverse of plate 21, showing the gesso-covered back and the strips of wood at the top and bottom

FIG. 21.3 Infrared reflectographic detail of plate 21, showing the underdrawing of Christ's foot and the Virgin's left hand

glued to the inner strip and reinforced with nails. This construction is visible in the X-radiograph (fig. 21.1). The moldings of the original engaged frame were glued to the front and reinforced by nails. The carpenter mistakenly cut the molding too short at the top left and had to fill the missing area with a small insert. A hole drilled through the panel at the top probably was for a hook or a cord. The panel has a slightly convex warp and has pulled away from the upper horizontal member. There is also some splitting in the engaged frame.

The panel has not been thinned; on the reverse it is covered by gesso and on the sides by a seemingly original red paint meant to imitate porphyry (fig. 21.2). The recess in the frame profile was decorated with a red-glaze sgraffito, much of which is intact. The artist's signature in this same recess is painted in black on a white background over gilding.

While the major design areas were incised in the gesso, the artist did not closely follow all the outlines. Infrared reflectography (fig. 21.3) showed that all features of the design were underdrawn with brush. Visible dots within the underdrawing may also

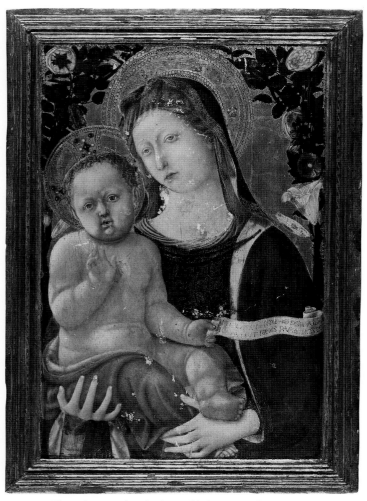

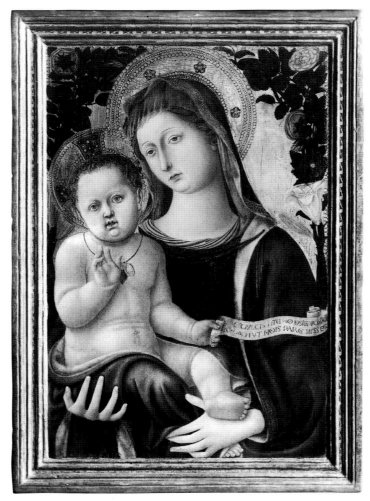

FIG. 21.4 Plate 21 in 1993, after cleaning and before restoration

FIG. 21.5 Photograph of plate 21 as it appeared in 1913

indicate the use of pounced cartoons, particularly for the contours of Christ. The scroll in his hand was painted over the existing drawn fingers.

The background is gilded over a dark red bole, and the flowers and other decoration are painted over the gold. The unevenly worn mordant-gilt decoration is best preserved over the Virgin's undergarment. In other areas, like the border of her mantle and of Christ's blanket, the gilding is either gone or quite abraded. The mordant is pigmented brown, and there are some traces of red glaze over the gold.

The paint has scattered but minor flake losses, which are evident in the post-cleaning photograph (fig. 21.4). The paint is also badly abraded, which, as an early photograph (fig. 21.5) indicates, took place when David Rosen cleaned it in 1942. The flesh paint was particularly affected, with the green underpaint exposed in all but the highlights. The paint in the highlights has a chalky, pitted appearance, due to strong cleaning agents. The best-preserved flesh area is the shadow of the Christ Child's chin. The Virgin's blue drapery retains little of its shadows or original surface. Her green dress was originally

decorated with mordant gilding and a green glaze that is largely gone. Some of the damage done by the earlier restoration was addressed in 1993, when David Skipsey removed Rosen's retouching and Roberta Rosi mitigated some of the effects of the abrasion by sensitive reconstruction of the surface based on the early photograph (fig. 21.5). However, in spite of the abraded condition of much of the painting, some remarkably fine details remain, including the gauze of the Virgin's veil, the ermine on Christ's blanket, the delicate pattern of the mordant gilding, and the rose arbor.

PROVENANCE
John G. Johnson owned the panel by 1909. Labels on the back indicate that it was shipped to him from Paris. There is also writing in Italian and German, suggesting other, earlier provenances.

COMMENTS
The half-length Virgin holds the Christ Child as he makes a gesture of benediction with his right hand and holds an inscribed scroll in his left. In the

background grows a trellis of red and white roses and lilies, which traditionally refer to the Virgin's purity. The arbor might also be a reference to the *hortus conclusus,* or "enclosed garden," from Canticles 4:12, which in medieval commentaries was often intended as an allegory of the Virgin.

The sculptural quality of the two figures derives from Jacopo della Quercia. The general outlines of the composition come from the *Virgin and Child* in his marble altarpiece in the Trenta chapel in Lucca.[1] The Virgin herself can be compared with the Virgin in the lunette of the now-dispersed altarpiece that Quercia designed and sculpted for Cardinal Antonio Casini in about 1437. The rigidly classical face of Domenico's Virgin was also a feature of Quercia's early work, in particular the polychromed wood Virgin in San Martino in Siena.[2]

Domenico di Bartolo may have known Gentile da Fabriano's *Virgin and Child* now at the Yale University Art Gallery.[3] This picture, which was purchased by James Jackson Jarves in Florence in the 1850s, is usually dated to the mid-1420s, when Gentile worked in Florence and Siena,[4] although

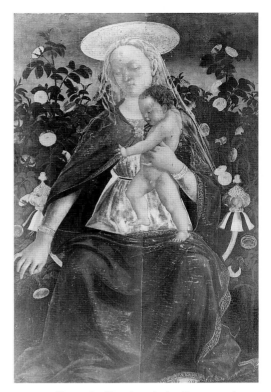

FIG. 21.6 Domenico Veneziano (active Florence and Perugia, first documented 1438; died 1461). *Virgin and Child in a Rose Garden*, c. 1430–35. Tempera and tooled gold on panel; 33⅞ × 22½″ (86 × 57 cm). Bucharest, Muzeul Nazional de Arta al Romanei, inv. 7970/4

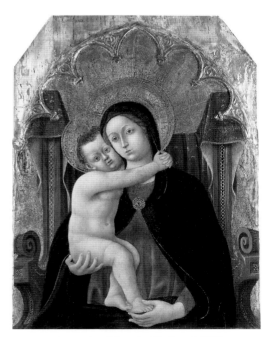

FIG. 21.7 Domenico di Bartolo. *Virgin and Child Enthroned*, c. 1437. Tempera and tooled gold on panel; 37¼ × 27¾″ (94.5 × 70.5 cm). Princeton University, The Art Museum, Bequest of Dan Fellows Platt, no. 41962-58

Andrea De Marchi (1992, p. 101) has suggested that it was painted about late 1417 or early 1418, during Gentile's sojourn at Brescia in northern Italy. It was Gentile who introduced the climbing roses in such compositions.

The same motif of the roses can be found in Domenico Veneziano's *Virgin and Child in a Rose Garden* (fig. 21.6), now in Bucharest, which was probably painted in Florence in the early 1430s. Like Domenico Veneziano,[5] Domenico di Bartolo also worked in Florence during this period; for example, the surviving central section of his altarpiece probably for the church of the Carmine (fig. 21.7) dates about the same time as the Johnson Collection's picture. The Johnson *Virgin and Child* also has a marked Florentine quality. Its half-length scheme recalls Florentine sculptural reliefs executed in the workshops of Donatello and Ghiberti, where the Virgin and Child's pose was more thoroughly explored than ever before and exerted an enormous influence on its subsequent treatment in painting. De Marchi (in Florence 1992, p. 70) noted that in Domenico's panel the Virgin's foreshortened hand, which holds the weight of the baby, corresponds to its counterpart in Donatello's marble relief known as the *Pazzi Madonna* (fig. 21.8). Domenico need not have known the original, because it was the first marble relief to be reproduced widely in stucco.

The inscription in humanist lettering on the scroll held by the infant Jesus relates this picture to the artist's *Virgin of Humility and Four Music-Making Angels* of four years earlier.[6] Several of the many inscriptions in that picture come from specific sources in the sermons of Saint Bernardino, a Sienese contemporary of the artist, that dealt with the Virgin Mary and the various meanings of her name. Although the specific source of the inscription in the Philadelphia painting has not been identified and the Latin is corrupt and unclear, it likely reflects ideas of Bernardino. The inscription does refer to the name of Christ, which specifically recalls Bernardino's most famous contribution to popular religion: the cult of the name of Jesus.[7] It is likely that this painting was made for a sophisticated patron attracted to the preacher's ideas.

1. Seymour 1973, plates 28–36.
2. Seymour 1973, plates 60a, b.
3. No. 1871.66; De Marchi 1992, plate 29.
4. Christiansen 1982, pp. 101–2.
5. The two artists would come in contact again in Perugia in the late 1430s, when Domenico di Bartolo was working on the altarpiece of Santa Giuliana and the Venetian painter was in the employ of the ruling Baglioni family. And, in fact, the Johnson picture, which is dated 1437, could have conceivably been painted in Perugia, as Domenico seems to have left Florence in that year. (According to Sienese and Florentine practice, as well as that of many other Italian cities, the year

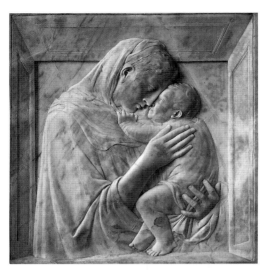

FIG. 21.8 Donatello (Florence, c. 1386–1466). *Virgin and Child (Pazzi Madonna)*, c. 1428–30. Marble; 29⅝ × 27⅝″ (75 × 70 cm). Berlin, Staatliche Museen Preussischer Kulturbesitz, Skulpturensammlung, inv. 51

1437 corresponds to what in modern times would be March 25, 1437–March 25, 1438.)
6. Siena, Pinacoteca Nazionale; Florence 1992, repro. p. 61.
7. On this cult, see Francesco d'Antonio, plate 24 (JC cat. 17).

Bibliography
Berenson 1909, p. 161; Perkins 1910, repro. p. 72; Berenson 1913, p. 56, repro. p. 294; Brown and Rankin 1914, p. 359; Tancred Borenius in Crowe and Cavalcaselle 1903–14, vol. 5, 1914, p. 142 n. 1; Bernd Curt Kreplin in Thieme-Becker, vol. 13, 1920, p. 535; Philadelphia 1920, p. 4; Van Marle, vol. 9, 1927, pp. 541–43; Misciatelli 1928, p. 111; L. Venturi 1931, plate CCXXII; Berenson 1932, p. 171; Edgell 1932, pp. 200, 202; Paris 1935, p. 64, no. 140; Berenson 1936, p. 147; Johnson 1941, p. 5; Pope-Hennessy 1944, p. 114, plate IIA; Pope-Hennessy 1947, pp. 14, 28, plate XXXIX; Brandi 1949, pp. 105, 114; Sandberg-Vavalà 1953, p. 252; Meiss 1963a, p. 165 n. 57; Sweeny 1966, pp. 26–27, repro. p. 112; Berenson 1968, p. 109, plate 792; Fredericksen and Zeri 1972, p. 66; Levi D'Ancona 1977, p. 349; Wohl 1980, pp. 15–16; Strehlke 1985, pp. 65–69, 195, fig. 13; Cecilia Alessi in *Pittura* 1986, p. 618; Andrea De Marchi in Bellosi 1990, p. 200; Laura Cavazzini in Florence 1992, p. 151; Giovanna Damiani in Florence 1992, p. 63; Andrea De Marchi in Florence 1992, p. 70, repro. p. 68; Philadelphia 1994, repro. p. 190; Giulietta Chelazzi Dini in Chelazzi Dini, Angelini, and Sani 1997, p. 254; Giovanna Damiani in *Dictionary of Art* 1996, vol. 9, p. 94; Frinta 1998, pp. 92, 187, 211, 352, 354

DOMENICO DI ZANOBI
(*Master of the Johnson Nativity*)

FLORENCE, SECURELY DOCUMENTED
1467–81

The "Master of the Johnson Nativity" was the name given by Everett Fahy (1966) to a fifteenth-century Florentine artist on the basis of the *Adoration of the Christ Child* (plate 22 [JC cat. 61]) in the Johnson Collection.[1] Fahy (1966, 1976, written communications 1984, 1985) made lists of twenty-eight paintings by him, and Gemma Landolfi (in Dalli Regoli 1988) published an almost complete repertory of photographs of the master's work. Annamaria Bernacchioni (1990, 1990a, in Gregori, Paolucci, and Acidini Luchinat 1992) later identified the artist as Domenico di Zanobi.

Domenico di Zanobi began his career in the circle of Filippo Lippi and Pesellino (q.v.). Bernacchioni has suggested that he is the Domenico recorded as working with Lippi in Prato in 1460 on an altarpiece for the company of the Preti di Santa Trinità in Pistoia.[2] This altarpiece had been left unfinished when Pesellino died, and Lippi received the commission to complete it as well as to paint an antependium for the altar in 1467.[3]

Domenico di Zanobi was in fact long associated with Lippi's studio. Not long after Lippi's death, he collaborated with the artist's son Filippino on an altarpiece for the Florentine church of San Firenze that had been left unfinished by Filippino.[4]

In 1467 Domenico di Zanobi rented Paolo Uccello's former workshop on the via delle Terme in Florence, which he shared with Domenico di Michelino, a painter of Angelican stamp, who had a thriving clientele in the Florentine provinces. The two artists collaborated at least once, when Domenico di Zanobi painted the predella for Domenico di Michelino's altarpiece of the *Virgin and Child and Saints John the Evangelist, Cosmas, Damian, and Thomas the Apostle* in San Miniato al Tedesco,[5] which had been commissioned by Giovanni Chellini, a physician best known for his patronage of Donatello. Later Chellini's son Bartolomeo called on Domenico di Zanobi to paint the *Coronation of the Virgin and Saints Bartholomew, Cosmas, Lucy, Damian, and Sebastian* for the oratory of Santa Maria di Fortino in San Miniato al Tedesco,[6] which can be dated to 1476 on the basis of the carpenter's bill.

In the 1470s Domenico di Zanobi had also received two important commissions for Florentine churches. He painted the *Lamentation over the Dead Christ* in Santa Felicita for Caterina Frescobaldi Pitti in 1470,[7] and shortly thereafter made the painting of the Virgin of "Soccorso" for the Velluti chapel in Santo Spirito.[8] The latter shows a curious scene in which the Virgin protects a baby, conceived in sin during Holy Week, from the grasp of the devil.

In his style, Domenico di Zanobi shows the influence of several contemporary Florentine masters. In one early work, such as the *Crucifixion* in the Fogg Art Museum in Cambridge,[9] it is Andrea Castagno, whereas in others, like the Johnson *Adoration,* it is Alesso Baldovinetti. But by 1476 the artist was beginning to adapt his style to that of a new generation of Florentine artists, for the figures of Cosmas and Damian in his *Coronation* show the influence of Sandro Botticelli. Domenico frequently only borrowed minor elements, such as a landscape or a figure, although he sometimes shamelessly copied an entire picture; his now-lost *Virgin and Child with Saints Francis of Assisi and Sebastian,*[10] for example, is a virtual reproduction of Pesellino's *Virgin and Child with a Swallow* in the Isabella Stewart Gardner Museum in Boston.[11] The duplication of such a famous composition may have been requested by a patron.

1. Bernhard Berenson (1913, p. 35) had considered the artist to be a close follower of Cosimo Rosselli, and he noted that a painting then in the collection of Marcello Galli-Dunn in Poggibonsi was by the same hand (Dalli Regoli 1988, fig. 204).
2. London, National Gallery, nos. 727, 3162, 3230, 4428, 4858A–D; and St. Petersburg, The State Hermitage Museum, no. 5511. For the reconstruction, see Gordon 1996, and Gordon 2003, color repro. p. 261 and p. 271, fig. 9.
3. Formerly Berlin, Kaiser-Friedrich-Museum, no. 95; Marchini 1975, fig. 164; Ruda 1993, plate 308. The antependium depicted the Virgin of Mercy. Although the altarpiece was destroyed in World War II, photographs clearly indicate that the angels lifting the Virgin's mantle are by a different artist, possibly Domenico di Zanobi.
4. Florence, Galleria dell'Accademia, c. 1470–75, no. 4632; Gregori, Paolucci, and Acidini Luchinat 1992, color repro. p. 49; black-and-white details in Dalli Regoli 1988, figs. 236–37.
5. Church of Santi Jacopo e Lucia; Gregori, Paolucci, and Acidini Luchinat 1992, p. 48, fig. 1.1.
6. Museo dell'Arciconfraternita di Misericordia; Dalli Regoli 1988, color plates 184–90, figs. 241–51.
7. Dalli Regoli 1988, fig. 200 (pre-restoration).
8. Dalli Regoli 1988, color plates 191–94.
9. No. 1927.200; Dalli Regoli 1988, fig. 201; Bowron 1990, fig. 593.
10. Dalli Regoli 1988, fig. 271.
11. No. P16w11; Hendy 1974, repro. p. 179.

Select Bibliography
Fahy 1966, p. 28 n. 2; Fahy 1976, pp. 172–73; Gemma Landolfi in Dalli Regoli 1988, pp. 243–327; Bernacchioni 1990, p. 109 n. 43; Bernacchioni 1990a, esp. pp. 5–6, 12 n. 10; Annamaria Bernacchioni in Gregori, Paolucci, and Acidini Luchinat 1992, pp. 177–78; Chiara Lachi in Mannini 1995, p. 34; Anna Maria Bernacchioni forthcoming

PLATE 22 (JC CAT. 61)
Adoration of the Christ Child

After 1467

Tempera and tooled gold on canvas, transferred from panel; 34⅝ × 19⅜" (87.8 × 49 cm), painted surface 33½ × 18⅛" (85 × 46 cm)

John G. Johnson Collection, cat. 61

TECHNICAL NOTES

Although the painting was transferred to canvas at an unknown date, there is evidence of an old nail in the mid- to lower left side and of a barbe on all four sides. The painting is abraded throughout and much retouched. Christ's face and his swaddling clothes are the areas most affected, and the sky in the background is also quite worn. The best-preserved sections are the faces of the Virgin and Saint Joseph and the middle-ground landscape with the shepherd and his flock. Some missing parts of the mordant gilt decoration have been reconstructed in paint or shell gold.

The painter's technique is very simple. The brushwork is broad and coarse, and forms are reduced to their basic tones. Details such as eyes are outlined in sepia and reinforced in black.

The painting received conservation attention in 1925, but the records do not document what was done. In June 1927 T. H. Stevenson cleaned the picture and noted its poor state. At this point the flaking was laid down. In March 1956 Theodor Siegl waxed the entire surface to prevent further flaking. This wax has been subsequently removed.

The painting is displayed in an arched tabernacle frame with an acroterium and scroll decoration. Parts of the structure of the frame appear old and are possibly original, although it has been entirely regessoed and regilt. Under the microscope an older layer of gold was discerned in areas of loss.

PROVENANCE

There is no record of this painting before Berenson's catalogue of 1913.

COMMENTS

The Virgin is shown kneeling in adoration of the Christ Child, who is wrapped in swaddling clothes and propped up on a saddle as Joseph rests at the left. Behind a low brick wall are an ox and ass, the manger, and a shepherd with his flock. A landscape with a meandering river is seen in the distance.

The iconography of the Adoration of the newborn Christ depicted here is based on the late thirteenth-century Franciscan *Meditations on the Life of Christ:*

Unable to contain herself, the mother stooped to pick Him up, embraced Him tenderly and, guided by the Holy Spirit, placed Him in her lap and began to wash Him with her milk, her breasts filled by heaven. When this was done, she (wrapped Him in the veil from her head[1]

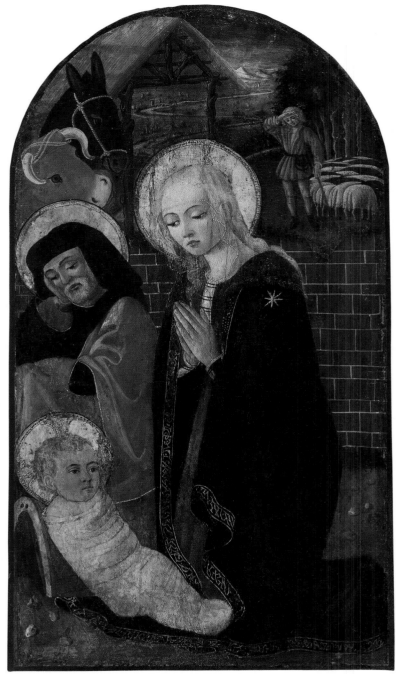

PLATE 22

and) laid Him in the manger. The ox and the ass knelt with their mouths above the manger and breathed on the Infant as though they possessed reason and knew that the Child was so poorly wrapped that He needed to be warmed, in that cold season. The mother also knelt to adore Him and to render thanks to God. . . . Joseph adored Him likewise.[2]

Saint Bridget of Sweden's vision of the Nativity in 1373, which gained wide circulation in Italy, described a similar scene:

When therefore the Virgin felt, that she already had borne her child, she immediately worshipped him, her head bent down and her hands clasped, with great honour and reverence. . . . She herself and Joseph, put him into the manger, and on their knees they worshipped him with immense joy and happiness.[3]

The Adoration of Christ was not a common subject until the mid-fifteenth century, when the theme enjoyed great popularity as a subject for paintings in private settings, for which Domenico

FIG. 22.1 Domenico di Zanobi. *Adoration of the Christ Child*, c. 1455–70. Tempera and tooled gold on panel; 35½ × 19¾″ (90.2 × 50.2 cm). Reading, Pennsylvania, The Reading Public Museum, no. 1951.33.1

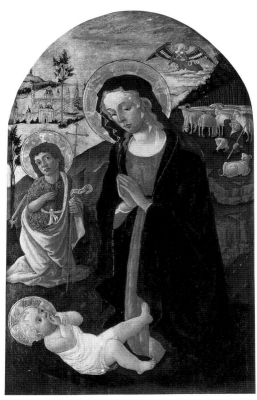

FIG. 22.2 Domenico di Zanobi. *Adoration of the Christ Child with the Young Saint John the Baptist*, c. 1455–70. Tempera and tooled gold on panel; 48¾ × 26″ (123.6 × 66 cm). Present location unknown

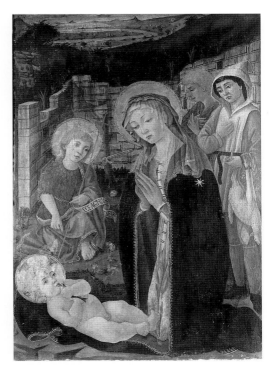

FIG. 22.3 Domenico di Zanobi. *Adoration of the Christ Child*, c. 1455–70. Tempera and tooled gold on panel; 35 × 24½″ (88.9 × 62.2 cm). Brechin, Scotland, Kinnaird Castle, Southesk Collection

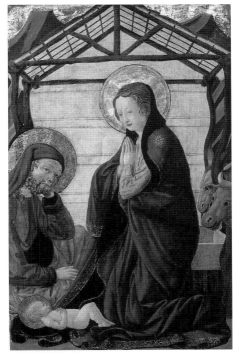

FIG. 22.4 Giovanni di Francesco (q.v.). *Adoration of the Christ Child*, c. 1445. Tempera and tooled gold on panel; 19¾ × 12½″ (50.2 × 31.7 cm). Berea, Kentucky, Berea College, Study Collection, no. 140.15 [K1128]

di Zanobi's numerous depictions were intended.[4] Most of these pictures have arched tops, such as the one seen here, but the artist also made rectangular panels in which the variant on the basic composition tends to be more elaborate (figs. 22.1–22.3).

Domenico di Zanobi's composition derives from ones by Filippo Lippi,[5] although a painting by Giovanni di Francesco (fig. 22.4) is strikingly similar to it for the prominence of Joseph and the animals in the manger. The background of the Johnson painting resembles in part Alesso Baldovinetti's *Nativity of Christ*,[6] although the standing shepherd, seen from behind in Baldovinetti's mural, is shown frontally by Domenico di Zanobi. The use of the Baldovinetti painting as a model would date this picture after 1462, but more probably it was done after 1467, the year Domenico left Filippo Lippi's employ and set up a studio with Domenico di Michelino in Florence, and thus would have been looking at other models.

1. In the painting the Virgin is wearing only her sheer inner veil, suggesting the baby's wrap is her outer white veil.
2. Ragusa and Green 1961, pp. 33–35.
3. Cornell 1924, pp. 12–13. For more on Saint Bridget and her connection to Italy, see Niccolò di Tommaso, plate 62 (JC cat. 120).
4. Bicci di Lorenzo's (q.v.) *Adoration of Christ* of 1435, in the church of San Giovanni dei Cavalieri di Malta in Florence, is an early example in a public setting (Berenson 1963, fig. 509).
5. Florence, Uffizi, no. 8350. Ruda 1993, color plate 131.
6. Florence, Santissima Annunziata; Kennedy 1938, plate 93.

Bibliography

Berenson 1913, p. 61 (school of Cosimo Rosselli); Van Marle, vol. 11, 1929, p. 617; Johnson 1941, p. 14 (school of Cosimo Rosselli); Musatti 1950, p. 123 n. 34; Fahy 1966, p. 28 n. 2; Sweeny 1966, p. 68, repro. p. 144 (school of Cosimo Rosselli); Fredericksen and Zeri 1972, p. 130 (Master of the Johnson Nativity); Fahy 1976, p. 172; Gemma Landolfi in Dalli Regoli 1988, p. 309, fig. 202; Annamaria Bernacchioni in Gregori, Paolucci, and Acidini Luchinat 1992, p. 159; Philadelphia 1994, repro. p. 191

DUCCIO
(Duccio di Buoninsegna)

SIENA, FIRST DOCUMENTED 1278;
DIED 1318, SIENA

Duccio is first documented in 1278, when he was paid for painting twelve chests for the Siena municipal archives; he received similar small-scale painting projects from the archives throughout his career. Otherwise, records related to the artist consist largely of the many fines he received for infractions of Sienese law, including failing to muster for the militia in December 1302. Three precious records for paintings in public places survive, but the many projects that Duccio took on for private patrons—such as altarpieces for family chapels and portable tabernacles—are all undocumented.[1]

Duccio's contract for the huge *Maestà* (also known as the Rucellai *Madonna*), ordered by the brotherhood of Santa Maria dei Laudesi for the church of Santa Maria Novella in Florence, was drawn up on April 15, 1285.[2] He may have completed the commission by October 8 of the same year, when Duccio is recorded in Siena. The picture, which is the basis for attributions of all early works by the master, demonstrates the intimacy with French Gothic art that distinguishes his style from those of his great Florentine contemporaries Cimabue and Giotto. A "Duch de Siene," or "Duccio of Siena," is recorded as living and paying taxes in Paris on the rue des Precheurs in 1296 and 1297. While this person may possibly be identified as Duccio, the Rucellai *Madonna* suggests that he may have also traveled to France at least a decade earlier.

As early as the fifteenth century, Duccio's authorship of the Rucellai *Madonna* had been forgotten, and the painting was attributed by Florentine writers to the hometown painter Cimabue. The design of the oculus in the apse of the cathedral of Siena has also sometimes been given to Cimabue, although the window, executed in 1287–88, is clearly of Duccesque style and represents an elaboration of the ideas about architecture and space he developed in the *Maestà*.[3]

One of Duccio's works that had the greatest influence on local Sienese painting—another altarpiece of the *Maestà* for the chapel of the Palazzo Pubblico—is lost. Duccio received final payment for the project on December 4, 1302 (the same day he was fined for violating the Sienese building code). The execution had probably taken several years, as documentation indicates that the picture had been in place for some time. This is supported by the fact that in May of that year Duccio is recorded as working with a group of artists on a mosaic for the apse of the cathedral of Pisa, which suggests that he did not have pressing obligations in Siena.

According to the payment document, the Palazzo Pubblico *Maestà* had a predella, which would make it one of the first altarpieces to be so furnished. Judging from the many Duccesque compositions made by Sienese artists in the next two decades that must have been influenced by this *Maestà*, its predella probably consisted of scenes illustrating Christ's infancy and Passion.

Duccio's great *Maestà* (see figs. 23.8, 23.9) was commissioned on October 9, 1308, for the high altar of the cathedral of Siena. Besides the principal image of the Virgin and Child enthroned with saints and angels, it consisted of many individual narrative scenes painted on both sides. Duccio encountered difficulties executing this large project, and in about 1310 a new estimate was needed to account for its enormity. This document described the narratives more precisely. Because it also suggests a certain urgency to complete the work, Duccio was authorized to hire more assistants. James H. Stubblebine (1979) proposed that these included some of the principal Sienese painters of the period: Segna di Bonaventura, Ugolino di Nerio (q.v.), Simone Martini, Pietro Lorenzetti (q.v.), and Ambrogio Lorenzetti. Although many of these artists had probably trained with Duccio, they were not necessarily his collaborators on this project. However, one chronicler, Paolo di Tommaso Montauri, writing in the early fifteenth century, acknowledged the presence of assistants in Duccio's workshop: "Master Duccio made it [the *Maestà*], who was one of the finest masters who ever were in the world; and so were some of his assistants who learnt from him."[4] However, the painting was cohesive in style and only in the upper right register is another specific hand—though close to Duccio's—really visible. The finished painting, intended to serve as a symbol of the city in an important public place, was carried to the cathedral in an official procession on June 11, 1311.

Duccio lived for seven more years, but no additional works are documented. Paintings from this period show the participation of some of his collaborators on the cathedral *Maestà*. Such is the case with the polyptych in the Pinacoteca Nazionale in Siena (see fig. 84.9).

Duccio had a wife named Tavinia and seven children. On October 16, 1319, his family renounced any rights to his estate, most likely because the artist left only debts.

1. All known documents for Duccio are in Stubblebine 1979, pp. 191–208.
2. On deposit Florence, Uffizi; illustrated after its restoration in 1989 in Uffizi 1990, color plate p. 21.
3. Enzo Carli (1946) was the first to attribute the window to Duccio. For a summary of the later literature and a report on the recent restoration, see Luciano Bellosi and Alessandro Bagnoli in Bagnoli et al. 2003, pp. 166, 168, 170, 178, color repros. pp. 167, 169, 171–81, 183.
4. Quoted in White 1979, p. 103.

Select Bibliography
Weigelt 1911; Lusini 1912; Lusini 1912a; Carli 1946; Brandi 1951; Carli 1961; Baccheschi 1972; Stubblebine 1979 (with documents and earlier bibliography); White 1979; Deuchler 1984; Ragionieri 1989; Dillian Gordon in *Dictionary of Art* 1996, vol. 9, pp. 341–50; Satkowski 2000; Victor M. Schmidt in *Saur*, vol. 30, 2001, pp. 153–57; Bagnoli et al. 2003

PLATE 23 (JC CAT. 88)

WORKSHOP OF DUCCIO

Pinnacle panel of an altarpiece: *Angel*

Finished 1311

Tempera and tooled gold on panel with vertical grain; overall 9⅝ × 6¾″ (24.2 × 17 cm); width at top 2⅜″ (6 cm); width at bottom 2⅞″ (7.1 cm); depth 7⁄16–½″ (1–1.3 cm). Additions: top ⅝″ (1.5 cm); right ⅜″ (1 cm)

John G. Johnson Collection, cat. 88

INSCRIBED ON THE REVERSE: *JOHNSON COLLECTION/ CITY OF PHILADELPHIA/ JOHNSON COLLECTION* (stamped several times in black ink); *88* (in pencil)

PUNCH MARKS: See Appendix II

EXHIBITED: Philadelphia Museum of Art, John G. Johnson Collection, Special Exhibition Gallery, *From the Collections: Paintings from Siena* (December 3, 1983–May 6, 1984), no catalogue; Siena 2003, no. 33

TECHNICAL NOTES

The panel, which was probably a pinnacle of Duccio's *Maestà* for the cathedral of Siena, was most likely thinned in 1771, when the altarpiece was disassembled. The edges were also damaged. The upper left corner, including part of the wing, is lost but has been restored. Although there is no evidence of a barbe, which would indicate that the panel once had applied frame moldings, the edge of gold that would have extended a bit from the frame onto the surface of the painting can be observed through the translucent brown of the wing on the left. A small wood addition was made to the panel to give the arch a point. This probably reconstructs the original shape, as a scored line in the upper right suggests. There are other small additions of wood on the right and in the upper left. These and the addition to the top are clearly visible on the reverse (fig. 23.1).

The outlines of the figure and wings are incised against the gold. The angel's hair resembles that in Duccio's angels in the van Heek Collection and formerly in the Stoclet Collection (figs. 23.2, 23.4), although the contours of the latter are more lobed.

The incised tooling of the halo consists of a foliate pattern against a hatched screen in the inner circle.

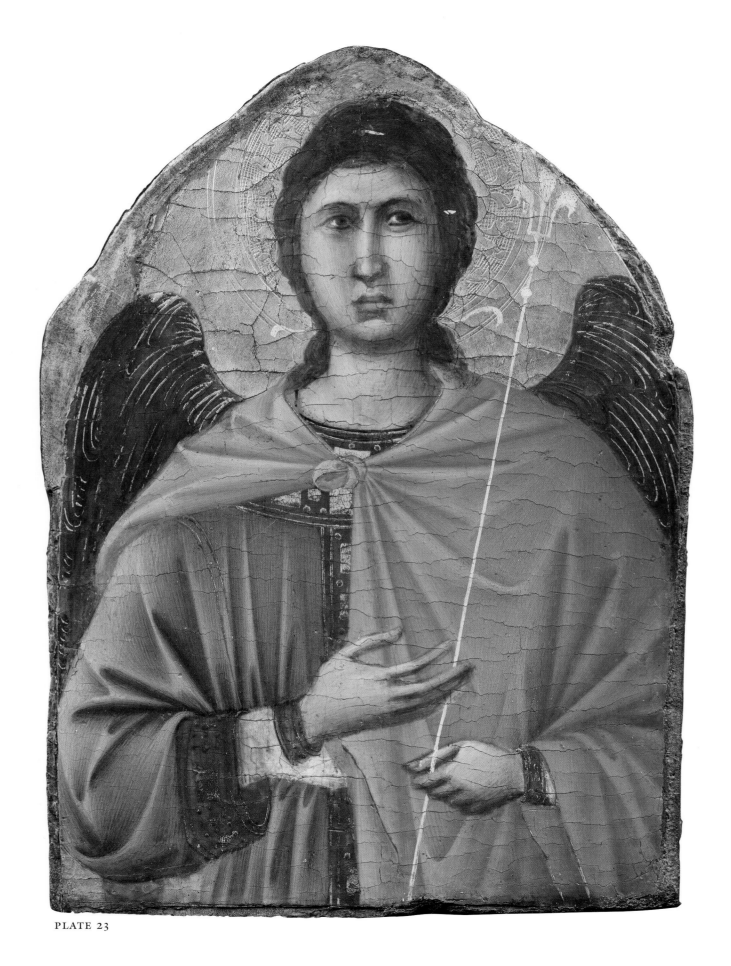

PLATE 23

FIG. 23.1 Reverse of plate 23, showing the vertically grained wood

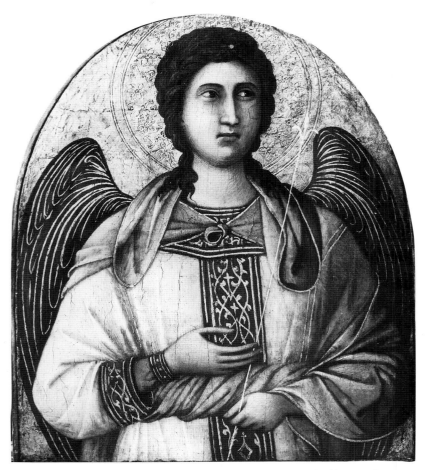

FIG. 23.2 Workshop of Duccio. *Angel,* finished 1311. Tempera and tooled gold on panel. Last recorded Brussels, Adolphe Stoclet Collection. Present location unknown. See Companion Panel A

Similar hatching appears in the incised borders of other panels of the *Maestà,* including the top border of the gabled panel of the Virgin's funeral procession (see fig. 23.7), to which one of the pinnacle panels with the angels must have been originally attached. This is the only gabled panel that retains its top edge.[1] A similar tooling is found in the halo of the archangel Gabriel in the *Annunciation* from the predella.[2] Two of the three companion panels (figs. 23.2, 23.3) retain their original tooling, but they have the same simple incised patterns and no hatched screen. The halo of the van Heek *Angel* (fig. 23.4) was redone.

A split down the center of the Johnson panel that is most apparent in the right eye and the right edge of the nose is easily visible in old photographs.[3] In 1913 Bernhard Berenson curiously described the picture as "too much rubbed away" and did not illustrate it in his catalogue of the Johnson Collection. However, the paint surface is in an excellent state, and there is, in fact, little paint loss along the split and very little abrasion. The mordant gilding is rubbed. The mordant itself is a deep yellow ocher.

On April 17, 1922, Hamilton Bell inspected the picture with T. H. Stevenson before repairs were made and wrote the following: "A good deal retouched. Has been cracked down left. Cleated at back and refilled which is drying out a little. Small blister in lower part laid down with Canada balsam." In 1942 David Rosen cleaned the panel, refilled the cracks, and retouched and varnished the panel. Theodor Siegl impregnated the panel with wax in 1957 and retouched the face. The retouching was adjusted in 1988 by Mark Tucker.

PROVENANCE

The *Maestà,* of which this panel was probably a part, was commissioned on October 9, 1308, by Jacopo di Gilberto Mariscotti, the *operaio,* or super-intendent of the works of Siena cathedral. The altarpiece was installed on the main altar on June 11, 1311, after being carried through the streets in a public procession that began at noon from the house owned by the Muciatti family, just outside the city walls, where Duccio and his assistants had worked

on the painting. At that time the high altar was directly under the dome, where the crossing of the church is now, and was approached by a flight of steps. The canons' choir was behind the altar.[4] The altar itself had been executed in about 1260 by the workshop of the sculptor Nicola Pisano.[5]

Only six years after the *Maestà* was installed, a major renovation of the cathedral was begun. In 1317 its east wall was destroyed (and Duccio's own stained-glass oculus temporarily put into storage) to extend the choir back two bays. The crypt below the choir was also removed, and the choir was raised to the same level as the nave. At this point further work was long delayed, and other, more grandiose projects to enlarge the cathedral to the south abandoned. The building of the new choir and additional renovations did not actually start until 1356 and were not completed until 1375. However, during this whole period the altarpiece remained in the church, and at least one document reveals that it was the object of veneration.[6] In 1375 the main altar and, consequently, the *Maestà* were moved back two bays.

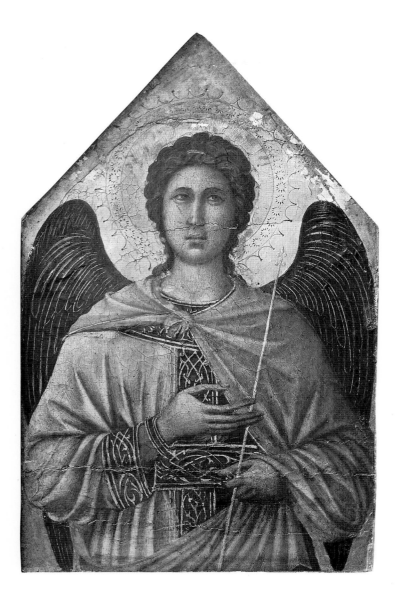

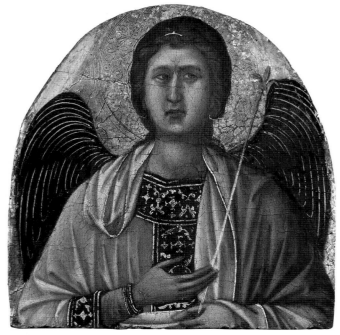

FIG. 23.3 (*above*) Workshop of Duccio. *Angel,* finished 1311. Tempera and tooled gold on panel; 7¼ × 7″ (18.4 × 17.8 cm). South Hadley, Massachusetts, Mount Holyoke College Art Museum, Bequest of Mrs. Caroline R. Hill, no. P.PI.45.1965. See Companion Panel B

FIG. 23.4 (*left*) Workshop of Duccio. *Angel,* finished 1311. Tempera and tooled gold on panel; 11⅞ × 7¼″ (30 × 18.3 cm). 's Heerenberg, The Netherlands, Dr. J. H. van Heek Collection, Foundation Huis Bergh, inv. 10. See Companion Panel C

In July 1506, on the orders of the despot of Siena, Pandolfo Petrucci, the altarpiece was removed from the main altar and placed in a side chapel of the left transept. A tabernacle of 1467–72 by Vecchietta, originally in the hospital church of Santa Maria della Scala in Siena, took its place on the high altar.[7] While the *Maestà* seems to have remained in the side chapel, in the mid-sixteenth century Giorgio Vasari (1550 and 1568, Bettarini and Barocchi eds., vol. 2, 1967, p. 260) claimed that he could not find it. This may have been because only one side of the altarpiece was visible, whereas Vasari was looking for a two-sided panel that, according to Lorenzo Ghiberti's description of 1447–55 (Bartoli ed. 1998, p. 90), had the "Coronation of Our Lady" on the front.[8]

On July 18, 1771, the altarpiece was sawn by the cabinetmaker Galgano Casini into several vertical sections and through the middle to separate front and back. The panels were transported to the small Sienese church of Sant'Ansano, where they remained until 1776, when they were returned to the cathedral.

The front was installed in the chapel of Saint Ansano and the back near the altar of the Sacrament. The predella and gabled panels were placed in the sacristy, where they were inventoried in 1798, without specific descriptions, by the rector, Adriano Gori Pannilini, who seems to have listed twelve of the pinnacle scenes and eight predella panels.[9] This list indicates that some sections had already been dispersed to private collections. These must have included the pinnacles with angels, because Gori Pannilini made no mention of them. In 1878 the remaining sections of the *Maestà* were brought to the Opera della Metropolitana. This seems to have sparked interest in the painting, because certain panels that had gone into private Sienese and provincial collections over the past hundred years were then located and sold to collectors abroad.

John G. Johnson bought the *Angel* from Count Guido Chigi Saracini in 1910 through the mediation of Herbert Horne. Horne may have obtained it from the Florentine dealer Luigi Grassi, who was selling paintings from the Chigi Saracini Collection.

Horne offered a group of pictures, including this *Angel,* to Johnson, in a letter dated Florence, April 27, 1910:

> Dear Mr. Johnson, Although in your last letter to me, you wrote that for the moment you were not buying anything more, I am venturing to tell you of some important pictures which have suddenly come into the market here. You can but say *no.* Among them are nearly all the best Sienese pictures in the Saracini collection at Siena. You will find them all cited in Berenson's lists of Sienese pictures. Of these the following I think, may interest you: . . . 3. Duccio. ½ length figure of an angel on gold, an admirable small example of this very rare master.

On May 8, Horne wrote again: "I have now had another opportunity of seeing these pictures again. I especially commend the Duccio to you. He is the rarest of all the great Sienese: and this little panel could be had at a not unreasonable price." He described the panel more thoroughly in a letter dated July 5:

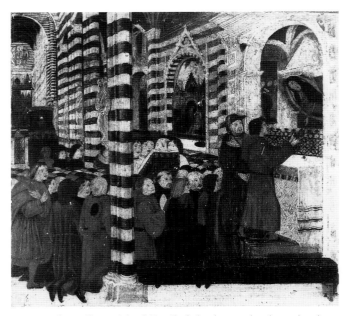

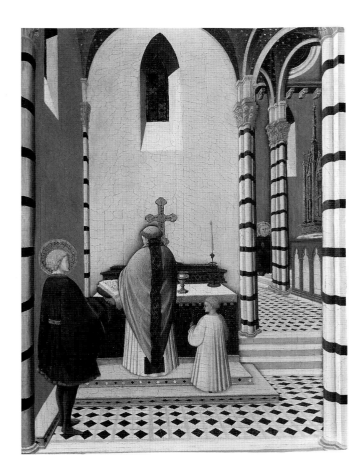

FIG. 23.5 (*above*) Sienese School. Detail of a book cover showing an interior view of Siena cathedral (with Duccio's *Maestà* in the upper left), dated 1482 (modern 1483). Tempera and tooled gold on panel; overall 23¼ × 15¾″ (59 × 40 cm). Siena, Archivio di Stato

FIG. 23.6 (*right*) Master of the Osservanza (q.v.). Panel from an altarpiece: *Saint Anthony Abbot as a Young Man Attending Mass* (showing a detail of Duccio's *Maestà* in the upper right), 1440s. Tempera and tooled gold on panel; 18½ × 13¼″ (46.8 × 33.4 cm). Berlin, Staatliche Museen, Gemäldegalerie, cat. 63D

Duccio. Half length figure of an archangel on gold ground. This panel which looks so large in the photo is, in fact, quite a small one, & measures 22 centm. in height & 16 centm. in breadth. It is in the same state as the preceding.[10] Lire 8000 ital. is asked for it. It is a small, but very characteristic example of the master. I need not remind you, how rare his pieces are.

Johnson accepted the offer made by Horne, who wrote on August 10 to say that he was arranging shipment of the *Angel* "as soon as framed."

The collection inherited by Guido Chigi Saracini had been formed in the early years of the nineteenth century by Count Galgano Saracini, who had a small catalogue of his holdings printed in 1819.[11] Unfortunately, neither the *Angel* nor the *Virgin and Child* by Pietro Lorenzetti (see plate 39A [JC cat. 91]), from the same collection, can be identified in this catalogue, which does not represent all of Saracini's holdings. He collected his early Sienese paintings at the time of the Napoleonic suppression of Italian religious institutions in the late 1700s and early 1800s, and the *Angel* must have entered the collection before 1798, since Gori Pannilini's inventory of the disparate pieces of the *Maestà* still held by the cathedral in that year does not include a pinnacle panel.

COMMENTS

The half-length angel is depicted looking forward and holding a white staff surmounted by a trident in his left arm.

Cesare Brandi (1951), Enzo Carli (1961), and James H. Stubblebine (1969a, 1979) proposed that this panel and three others with angels (figs. 23.4–23.6) were part of Duccio's *Maestà*[12] for the Sienese cathedral based on the mention of the little angels at the top of the altarpiece in a document that records a revised estimate for the project made by two outside assessors:

> In the name of the Lord, amen. This is the agreement that Buonaventura Bartalomei and Parigiotto arrived at together concerning the work on the back side of the panel. They acknowledge that there are, to begin with, thirty-four scenes but on account of the fact that some of these are larger than the average, and also because of the little angels on top, and because of any other work that might require painting, they will consider the scenes to be thirty-eight; and he [Duccio] is to have and ought to have two and one-half gold florins for each scene.[13]

There is no other specific evidence that the *Maestà* had pinnacles with angels. Although pinnacles can be made out in the one early visual depiction of the

altarpiece—the cover for the account book of the tax office (*gabella*) for 1483 (fig. 23.5)—the angels cannot be discerned. An earlier painting of the cathedral (fig. 23.6) by the Master of the Osservanza (q.v.) shows a side view of the *Maestà* that suggests how elaborate the frame was.

The pinnacles with angels would have surmounted the row of seven gabled panels at the upper part of the altarpiece, which showed on the front the death and burial of the Virgin and on the back Christ's appearances after the Resurrection. Originally there were at least twelve pinnacles. There would have been an angel above each gable except for those in the center, which would have had images of greater symbolic importance, such as God the Father, Christ the Redeemer, or narrative scenes of the Ascension of Christ or the Assumption of the Virgin.

Only two of the gabled panels survive in their original dimensions: the *Funeral Procession of the Virgin* (fig. 23.7) and the *Incredulity of the Apostle Thomas*.[14] The top width of the former panel is 9¹⁄₁₆″ (23 cm),[15] a measurement that roughly corresponds to the bottom width of the pinnacles with angels. Because the tops of the four surviving panels were cut away in 1771, it is not possible to match their wood grain to that of the pinnacles to see if they were

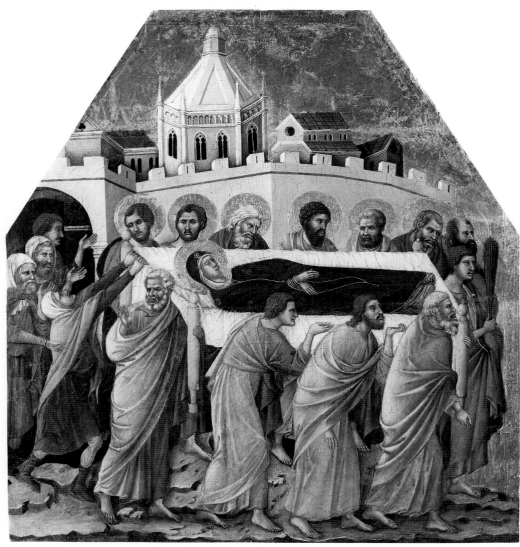

FIG. 23.7 Duccio. Panel from the *Maestà: Funeral Procession of the Virgin,* finished 1311. Tempera and tooled gold on panel; approximately 22⅝ × 20½″ (57.5 × 52 cm). Siena, Museo dell'Opera della Metropolitana

tion on the back (fig. 23.9), all carry similar staffs. An explanation for its presence comes from the apocryphal Gospel of Saint Bartholomew in which Satan, or Belial, explains the origins of the twelve archangels, which corresponds to the original number of angels in the pinnacles: "For they are the rod-bearers (lictors) of God, and they smite me with their rods. . . . These are the (twelve . . .) angels of vengeance which stand before the throne of God: these are the angels that were first formed."[17] A scene in a mid-thirteenth-century dossal from the church of Sant'Angelo in Vico l'Abate, attributed to Coppo di Marcovaldo, shows God presenting the archangels with their rods.[18] A painting of the 1330s by Niccolò di Segna (q.v.) in the wing of a polyptych in the Pinacoteca Nazionale of Siena shows the archangel Michael holding a staff like those in Duccio's *Maestà,* suggesting that this iconography persisted in Sienese art for several decades.[19] However, angelic symbolism does not seem to have been set: in the late thirteenth-century mosaics of the baptistery of Florence the various hierarchies of angels are shown, and it is not the archangels but the Virtues and Dominions who carry rods.[20]

Angels were also the theme of the furnishings that decorated the altar where Duccio's *Maestà* originally stood. A payment from 1339 to one Pietro di Tofano for 150 candles "to be burnt by the angels" refers to candlesticks in the form of angels; the cathedral inventory of 1423 describes some of these angels.[21] A canopy suspended above the *Maestà,* which can be seen on a book cover made for the Sienese *gabella* in 1483 (fig. 23.5), contained tabernacles from which carved and gilded angels were lowered during mass to hold the host, chalice, and hand cloth used during the Eucharist.

Angels had been incorporated as separate elements in the crowning sections of Sienese altarpieces since at least the last quarter of the thirteenth century. They were also a common element in the spandrels of the gabled dossals developed by Guido da Siena and other Sienese artists in the 1270s and 1280s.[22] In 1291 Vigoroso da Siena separated the angels into individual crowning elements with arched tops,[23] a move that Stubblebine (1969a, p. 145) suggests might have been inspired by a lost altarpiece by Duccio.

Two altarpieces by Duccio and his workshop represent a more advanced development of the scheme used by Vigoroso. In both cases, each part of the altarpiece is contained in its own section. The larger of the two (see fig. 84.9),[24] which comes from Santa Maria della Scala in Siena, echoes Duccio's work on the *Maestà* for the cathedral. The other altarpiece (fig. 23.10), as Joanna Cannon (1982, pp. 79–80) has argued on iconographic and historical grounds, likely dates about 1306 and comes from San Domenico in Siena, making it a precedent for the *Maestà.*[25]

Carli (1961) noted that the angels on the pinnacles of the *Maestà* must have been executed by Duccio's assistants. Stubblebine (1979, pp. 39–40) attributed

indeed painted on the same piece of wood. However, in at least one case, the evidence would seem to suggest that they were not. Wendy Watson has found that the wood grain of the *Angel* at Mount Holyoke College (fig. 23.3) and of its corresponding gabled panel runs horizontally, whereas the grain of the panels in the Johnson and van Heek (fig. 23.4) collections runs vertically. (The direction of the grain of the *Angel* once in the Stoclet Collection is not known.) These differences suggest that the upper sections of the altarpiece were assembled in a piecemeal fashion. Either the angels were not planned from the beginning and had to be added when it was decided to crown the already prepared gables in such a manner, or there was not always a sufficient amount of wood to cut the gable and pinnacle from the same piece.

Stubblebine (1969a, p. 147) proposed specific positions on the altarpiece for the angels based on

their poses, which, he argued, indicated how far they may have been placed from the center of the altarpiece. He used Duccio's altarpiece (see fig. 84.9) in the Pinacoteca Nazionale of Siena as a guide.[16] He suggested that the frontal poses of the Mount Holyoke, van Heek, and Johnson angels meant that they were placed in the two outer positions on either the front or the back of the altarpiece, probably on the right end. The angel in the Stoclet Collection turns toward his left, suggesting that he was one of the inner angels looking toward the center on the left side of the altarpiece on either the front or back.

The angels hold staffs that are crowned with what appears to be a fleur-de-lis, or in the Johnson angel, a trident. The angels surrounding the Virgin's throne on the front of the *Maestà,* Gabriel in the scene of the Annunciation on the front predella (fig. 23.8), and the archangel in the scene of the Resurrec-

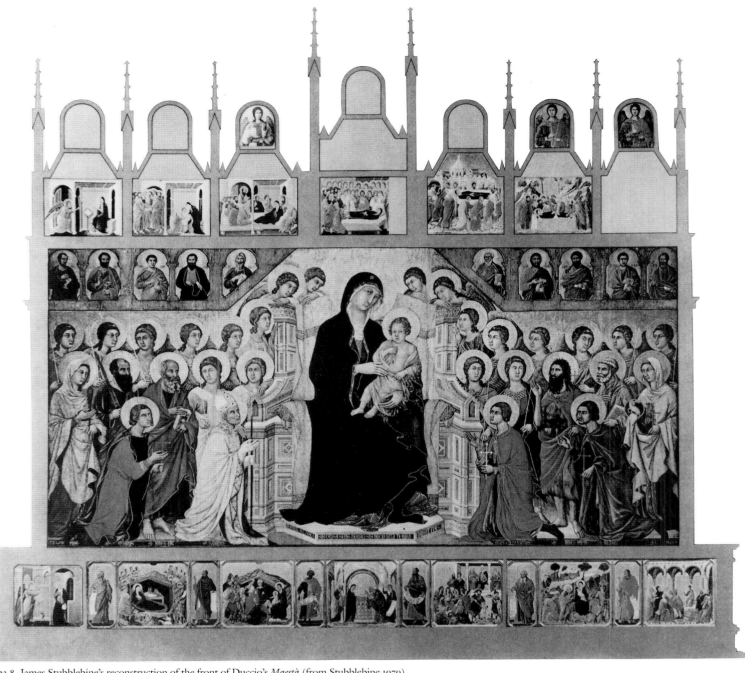

FIG. 23.8 James Stubblebine's reconstruction of the front of Duccio's *Maestà* (from Stubblebine 1979)

them to the so-called Casole Fresco Master, also known as the Master of the Aringhieri, whose name refers to a mural in the *collegiata* of Santa Maria Assunta in Casole d'Elsa,[26] a town to the west of Siena, commissioned by Raniero Porrini, a local citizen who became bishop of Cremona. The best-preserved angel on the left of the Virgin's throne in the mural repeats the pose of the Johnson Collection's *Angel*. Stubblebine (1979, p. 114) dated the mural to about 1317, the year of Porrini's death, or a few years after, but it could also be dated during his lifetime. An examination of this anonymous mas-

ter's much better-preserved painting (fig. 23.11), once in Santa Croce in Florence, suggests that if this artist did collaborate on the *Maestà*, he fashioned the angels to conform closely with the stylistic unity that Duccio wished to preserve throughout.

1. The panel of the *Incredulity of the Apostle Thomas*, in the Museo dell'Opera della Metropolitana in Siena, is the only other gabled panel that was not cropped at the top. Although most of the tooled border at the top and side edges does not survive, there is a bit on the left side that resembles the hatched tooling of the Johnson *Angel* (Bagnoli et al. 2003, postrestoration color repro. p. 226).

2. London, National Gallery, no. 1139; Davies and Gordon 1988, pp. 16–17, plate 17.

3. Sweeny 1966, plate 88.

4. See Diagram 14 by Kees van der Ploeg in Van Os 1984.

5. A fragment of the altar was found under the choir floor in 1870. It is now in the Museo dell'Opera della Metropolitana (Van Os 1984, fig. 21).

6. In 1339 the city government paid Pietro di Tofano for 150 candles to illuminate it (Stubblebine 1979, p. 34).

7. Bellosi 1993, p. 204, fig. 1 (color).

8. The *Coronation* may have been in the lost central pinnacle. It has sometimes been wrongly identified with a painting in Budapest (Szépmüvészeti Múzeum, no. 16; Bagnoli et al. 2003, color repro. p. 263).

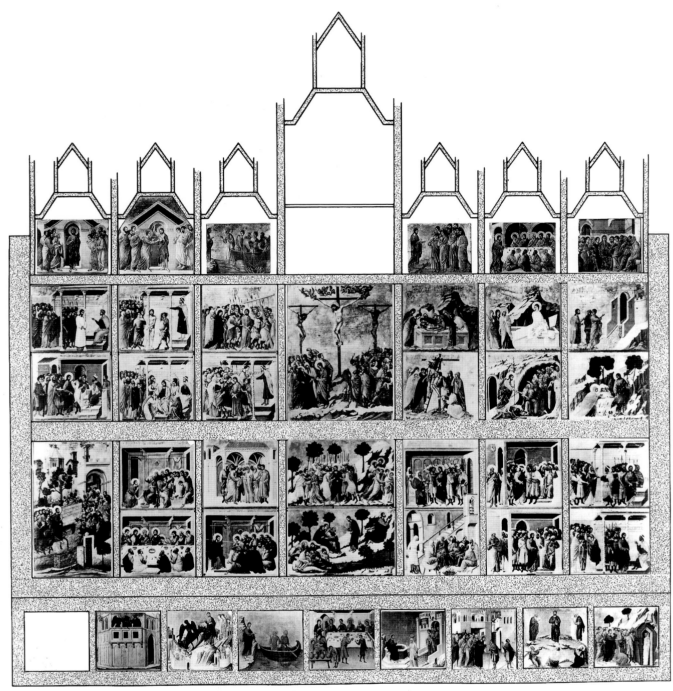

FIG. 23.9 John White's reconstruction of the back of Duccio's *Maestà* (from White 1979)

9. See Lusini 1912, pp. 74–75, 77. He cites folio 49 of Inventory no. 525 in the Archivio dell'Opera della Metropolitana, where Gori Pannilini recorded "In the Sacristy: Twelve small old paintings on panel by Duccio" (In Sagrestia: Dodici quadretti in tavola antichi di Duccio); and "8 very old small paintings on panel" (N.8 quadretti in tavola di antichissima pittura).

10. He referred to paintings by Giovanni di Paolo (q.v.) now in the Walters Art Museum, Baltimore (Zeri 1976, plates 58–61), describing their condition as "original state, never having been cleaned or restored."

11. *Relazione* 1819.

12. In 1911 Curt Weigelt recognized that the Johnson Collection's *Angel* and the one then in Berlin and now in South Hadley (fig. 23.3) came from the same altarpiece, which he proposed to be similar to Duccio's polyptych of c. 1306 (or c. 1310?) (fig. 23.10). Raimond van Marle (vol. 2, 1924) grouped the same two with an angel he had seen on the market in Florence and two others then in the Loeser Collection in Florence. It is not clear if any of these angels are the same as those now in the van Heek Collection (fig. 23.4) and formerly in the Stoclet Collection (fig. 23.2).

The *Angels* that Van Marle saw may also be those once in the Pannilini Collection at San Giovanni d'Asso (near Siena), which were displayed at the 1904 exhibition of Sienese art held at the Palazzo Pubblico (Siena 1904, pp. 125–26). However, they measured 13 × 9½″ (33 × 24 cm)

and therefore could not have come from the same series as the Johnson panel. Their present whereabouts are unknown, but two angels of c. 1335 in the Cleveland Museum of Art (nos. 62.257, 62.258) by Niccolò di Segna (q.v.) have about the same dimensions (each 12¼ × 9⅛″ [31 × 23 cm]) and may, therefore, have come from the same altarpiece. Laurence B. Kanter (1994, p. 83 n. 1) proposed that the Cleveland *Angels* were from San Giovanni d'Asso and that they as well as a pinnacle of the Redeemer in the North Carolina Museum of Art in Raleigh (no. GL60.17.2, 17⅞ × 14¼″ [45.4 × 36.2 cm]; Stubblebine 1979, plate 536) were part of a triptych still in the *pieve* of that village (Stubblebine 1979, plates 531–33).

Van Marle (1931) also incorrectly identified the *Angel*

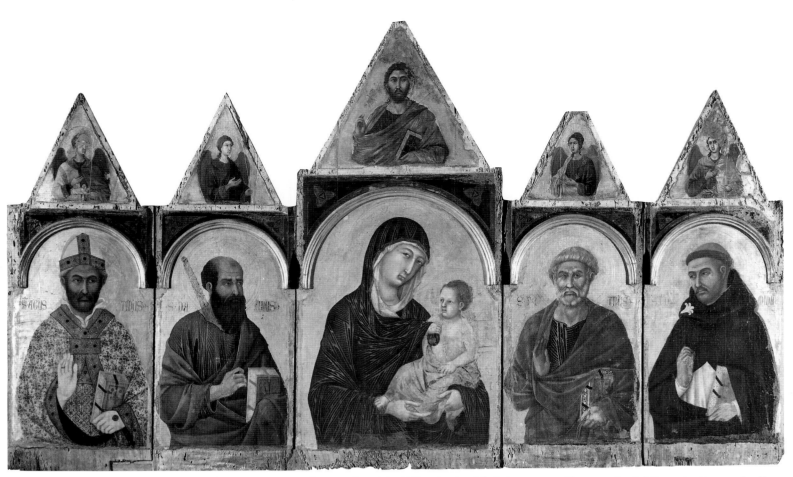

FIG. 23.10 Duccio. Altarpiece: *Virgin and Child with Saints Augustine, Paul, Peter, and Dominic with Four Angels and the Redeemer,* c. 1306. Tempera and tooled silver and gold on panel; 56½ × 95⅛″ (143.5 × 241.4 cm). Before restoration in 2003. Possibly from Siena, San Domenico. Siena, Pinacoteca Nazionale, no. 28

with Instruments of the Passion, now in the Museum of Fine Arts, Boston (no. 1978.466, 12 × 8¼″ [30.5 × 20.9 cm]; Stubblebine 1979, fig. 535), as belonging to the same group. It in fact comes from the same polyptych as the *Angel with Instruments of the Passion* (9¾ × 6½″ [24.8 × 16.5 cm]) in the Frick Art Museum, Pittsburgh (1973.26; Stubblebine 1979, fig. 534). Stubblebine attributed both works to the Sansepolcro Master, probably to be identified with Francesco di Segna. Kanter (1994, p. 81) proposed that they might be the work of the so-called Goodhart Ducciesque Master. The panels probably date c. 1330–40.

13. "In nomine domine amen. Questa è la concordia che Buonaventura Bartalomei et Parigiotto ebero insieme del fatto de la tavola de'lavorio de la parte dietro. Conoscono ce sono trenta quatro storie principalmente le quali stimano per la magiorezza d'alcuna d'esse storie a le comunale et per li angieletti di sopra et per alcun'altra opera se vi si richiedesse di penello che le dette storie sieno trenta otto per trenta otto sia pagato et abia et aver debia di ciasceduna storia due fiorino d'oro et mezzo" (Siena, Archivio dell'Opera della Metropolitana, *Libro dei documenti artistici,* no. 1, now lost; see Stubblebine 1979, pp. 203–4). Gaetano

Milanesi (1854–56, vol. 1, 1854, p. 178) thought the document might date to 1310, but any date after the original contract of October 9, 1308, is possible.

14. See n. 1 above.
15. White 1973, p. 343.
16. No. 47; Bagnoli et al. 2003, postrestoration color repro. p. 235.
17. James 1953, p. 176.
18. Currently on deposit in Florence, Museo Diocesano di Santo Stefano al Ponte; Tartuferi 1990, fig. 76.
19. No. 38; Torriti 1977, fig. 75 (color).
20. Paolucci 1994, atlas vol., plates 726, 731.
21. Stubblebine 1979, p. 34.
22. Torriti 1977, pp. 32–33, figs. 18–19.
23. Bon Valsassina and Garibaldi 1994, color repro. p. 91.
24. Pinacoteca Nazionale di Siena, no. 47; Torriti 1977, pp. 52–54, figs. 41–45.
25. See also Roberto Bartalini in Bagnoli et al. 2003, pp. 200, 202, 204, postrestoration color repros. pp. 201, 203, 205–7.
26. Stubblebine 1979, figs. 272–73. Most recently see Maria Merlini in Bagnoli et al. 2003, pp. 306–11.

Bibliography
Langton Douglas in Crowe and Cavalcaselle 1903–14, vol. 3, 1908, p. 20 n.; Weigelt 1911, p. 26; Berenson 1913, p. 51 (Duccio); Breck 1913, p. 112 n. 1; Van Marle, vol. 2, 1924, pp. 94–96; Van Marle 1926, p. 4; Comstock 1927b, p. 70; Handbook 1931, p. 41, repro. p. 38 (school of Duccio); Berenson 1932, p. 177; Berenson 1936, p. 152; Johnson 1941, p. 6 (Duccio); Brandi 1951, p. 145, plate 106; Carli 1961, p. 23; Cooper 1965, p. 163; Sweeny 1966, p. 28, repro. p. 82 (Duccio); Eimerl 1967, pp. 76–77, 193, repro. p. 77; Groningen 1969, cat. 3; Stubblebine 1969a, figs. 2, 6; Baccheschi 1972, p. 94 n. 101, fig. 101; Fredericksen and Zeri 1972, p. 68 (school of Duccio); Stubblebine 1973, pp. 183, 187–88; White 1973, pp. 335, 555, 557–59, fig. 74; Stubblebine 1979, pp. 32, 33, 39–40, 111, fig. 124; White 1979, pp. 86, 180 n. 11; Deuchler 1984, p. 215; Sutton 1985, p. 133, fig. 5; Janneke Pandees in Van Os et al. 1989, pp. 46–48; Ragionieri 1989, p. 130, repro. p. 133; Strehlke 1990, p. 435, fig. 13; Strehlke 1991, p. 200; Philadelphia 1994, repro. p. 191 (Duccio di Buoninsegna and workshop); Victor M. Schmidt in *Saur,* vol. 30, 2001, p. 157; Giovanna Ragionieri in Bagnoli et al. 2003, pp. 216, 232, color repro. p. 253

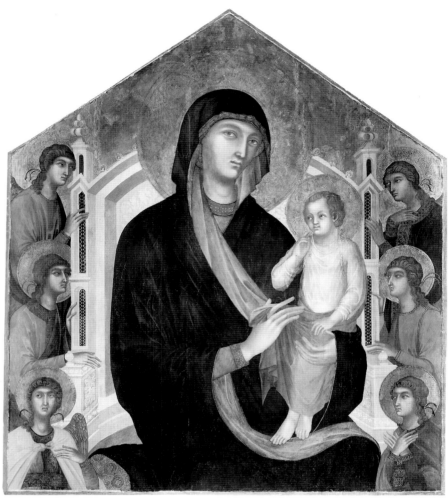

FIG. 23.11 Casole Fresco Master, also known as the Master of the Aringhieri (Siena, early 1300s). *Virgin and Child Enthroned with Six Angels,* c. 1320–25. Tempera and tooled gold on panel; 74½ × 65⅝″ (189 × 166.5 cm). From Florence, church of Santa Croce. London, National Gallery, no. 565

COMPANION PANELS for PLATE 23

The following list only includes the surviving pinnacle panels of angels thought to come from Duccio's *Maestà*.

A. Pinnacle panel: *Angel.* See fig. 23.2

Finished 1311

Tempera and tooled gold on panel. Last recorded Brussels, Adolphe Stoclet Collection. Present location unknown

PROVENANCE: Unknown

SELECT BIBLIOGRAPHY: Stubblebine 1969a; Victor M. Schmidt in *Saur,* vol. 30, 2001, p. 156; Giovanna Ragionieri in Bagnoli et al. 2003, pp. 216, 232

B. Pinnacle panel: *Angel.* See fig. 23.3

Finished 1311

Tempera and tooled gold on panel with horizontal grain; 7¼ × 7″ (18.4 × 17.8 cm). South Hadley, Massachusetts, Mount Holyoke College Art Museum, Bequest of Mrs. Caroline R. Hill, no. P.P1.45.1965

PROVENANCE: Purchased by Johann von Rumohr for the Kaiser-Friedrich-Museum, Berlin, 1829; deaccessioned and purchased by Caroline R. Hill, c. 1922; on deposit, Wellesley College, Massachusetts, c. 1951; bequest of Caroline R. Hill to Mount Holyoke College Art Museum, 1965

EXHIBITED: Siena 2003, no. 34

SELECT BIBLIOGRAPHY: Stubblebine 1969a; Jean C. Harris in Harris 1984, p. 59; Victor M. Schmidt in *Saur,* vol. 30, 2001, p. 156; Giovanna Ragionieri in Bagnoli et al. 2003, pp. 216, 232

C. Pinnacle panel: *Angel.* See fig. 23.4

Finished 1311

Tempera and tooled gold on panel with vertical grain; 11⅞ × 7¼″ (30 × 18.3 cm). 's Heerenberg, The Netherlands, Dr. J. H. van Heek Collection, Foundation Huis Berg, inv. 10

PROVENANCE: Purchased by the present owner from Gebr. Douwes, Amsterdam

EXHIBITED: Amsterdam 1934, no. 109; Groningen 1969, no. 3; Utrecht 1969, no. 3

SELECT BIBLIOGRAPHY: Groningen 1969, no. 3; Stubblebine 1969a; Janneke Panders in Van Os et al. 1989, pp. 46–48; Frinta 1998, p. 181; Victor M. Schmidt in *Saur,* vol. 30, 2001, p. 156; Giovanna Ragionieri in Bagnoli et al. 2003, pp. 216, 232

FRANCESCO D'ANTONIO

FLORENCE, BORN C. 1393/94;
LAST DOCUMENTED 1433, FLORENCE

Francesco d'Antonio's earliest signed work is a triptych of the Virgin and Child with Saints Lawrence and Giovanni Gualberti commissioned by one Don Gabriele for the altar of an unidentified Vallombrosan church in 1415, probably around the time the artist entered the guild of Florentine painters.[1] The Virgin is clearly based on a painting by Lorenzo Monaco (q.v.), who was most likely Francesco's master.

On three occasions during the 1420s Francesco d'Antonio is documented as having been associated with Masolino (q.v.). In September 1422 he witnessed a rental contract drawn up between Masolino and the sculptor Bernardo di Pietro Ciuffagni; in March 1424 he and Masolino as well as the painters Lippo d'Andrea and Pietro Chellini were sued, probably regarding work in Empoli; and on January 25, 1427, Francesco and Masolino were sued by the goldsmith Lionardo di Donato Rucellai for an earlier, unspecified debt. Masolino was away from Florence from September 1426 to May 1428, so it is possible that in his absence Francesco handled their joint affairs. During this time he may have also come in contact with Masaccio (q.v.), who was Masolino's next partner.

A triptych composed of a panel of the Virgin and Child in the Denver Art Museum[2] that once bore Francesco's signature and two panels with saints in the Museo Nazionale di San Matteo in Pisa[3] probably date to around the time of his first contacts with Masolino in the early 1420s and may, in fact, be based on a lost composition by Masolino. The organ shutters that Francesco painted for Orsanmichele in Florence,[4] which were paid for in 1429, are decorated with figures of the Evangelists that are derived from Masolino's murals in the vaulting of the Castiglioni chapel of San Clemente in Rome.[5] Francesco's tabernacle in the via della Scala in Florence is also based on a Masolinesque matrix.[6] It was probably painted shortly after 1430, when the building was donated to the painters' guild by Lisa di Ranieri Paganelli.[7]

The predella panel (see fig. 24.8) of the altarpiece[8] commissioned by Rinieri di Luca di Piero Rinieri is among the first Florentine paintings to show the influence of Masaccio's nudes in the Brancacci chapel[9] in the Carmine in Florence. The Christ Child in the main panel of this altarpiece also recalls the same figure in Masaccio's now-disassembled Pisa altarpiece of 1426.[10] Roberto Longhi (1940) created four categories to classify Florentine artists' responses to Masaccio's innovations: the "scatter-brained," the "indifferent," the "confused," and the "astonished"; he placed

Francesco among the "astonished," noting that he was one of the first to risk taking up the young Masaccio's pictorial motifs. Even so, the artist only picked up bits of the Masaccesque language.

While Francesco d'Antonio's hand is easily recognized, in compositions he rarely ventures very far from the models of Masolino. Yet despite his dependency on one of the principal masters of early Renaissance Florence, his work exhibits great range in quality. Probably after the 1430s, with Masaccio dead and Masolino outside Florence, Francesco had trouble establishing an independent style. He is last documented in 1433 as paying dues to the painters' guild, but it is not known how much longer he was active as a painter.

1. Cambridge, England, Fitzwilliam Museum, no. M33; Berenson 1963, fig. 713. The inscription is incomplete, but seems to be dated 1415; the coat of arms on the triptych has not been identified. See Goodison and Robertson 1967, pp. 55–58.
 Francesco's enrollment in the guild is recorded in the rolls begun in 1409, but that year is only a *terminus post quem* (Gronau 1932, p. 382). He rematriculated on November 21, 1429. The last notice related to the artist concerns the payment of dues made on March 24, 1433 (modern style). He is thought to have been born c. 1393/94, because in a tax declaration of July 1427 he wrote that he was 33 years old.
2. E-IT-18-XV-928; Shapley 1966, fig. 250.
3. Nos. 47, 51; Zeri 1949, figs. 7–9.
4. Florence, Galleria dell'Accademia, nos. 9271–72; Fremantle 1975, figs. 877–80; Berti and Paolucci 1990, repro. p. 185 (the angels in color).
5. Baldinotti, Cecchi, and Farinella 2002, postrestoration color plates 62–63. Vincenzo Farinella (in ibid., pp. 137–44, 177–86) argued for an attribution to Masaccio. The murals as a source for the Evangelists was noted by Perri Lee Roberts (1993, pp. 61 n. 44, 105, 110). Mario Salmi (1948, p. 218) thought that they might reflect the Evangelists that were painted, probably also by Masolino, in the destroyed vaulting of the Brancacci chapel. It should also be noted that Francesco's figures are very close to the four sculptures of the same subjects commissioned for the façade of the Florence cathedral from Nanni di Banco, Donatello, Niccolò di Pietro Lamberti, and Ciuffagni. The statues are now in the Museo dell'Opera del Duomo; see Pope-Hennessy 1985, figs. 79–82.
6. Fremantle 1975, figs. 874–75.
7. Ennio Guarnieri in Bargellini and Guarnieri, vol. 7, 1987, pp. 182–84.
8. Avignon, Musée du Petit Palais, nos. M.I. 431, 475–76; Laclotte and Mognetti 1987, pp. 89, 91. It has been suggested (Laclotte and Mognetti 1977, n.p.; Laclotte and Mognetti 1987, p. 90) that the kneeling man in the left pilaster of the predella is the founder of the Gesuati order, the Blessed Giovanni Colombini. The Gesuati were particularly devoted to Saint Jerome, whose legend is depicted in the predella. Eugene Rice (1983, p. 151 n. 1; 1985, pp. 99–100) accepted this identification and suggested that the altarpiece may have come from the Gesuati's now-destroyed Florentine church of

Santa Trinita Vecchia on the via Guelfa.
9. Baldini and Cavazza 1990, postrestoration color repros.
10. Strehlke 2002, color plate 9.

Select Bibliography
Vasari 1550 and 1568, Bettarini and Barocchi eds., vol. 2 (text), 1967, pp. 306–7; Milanesi 1883, pp. 12–13, 96–97; Van Marle, vol. 9, 1927, p. 170; Colnaghi 1928, p. 105; Salmi 1929; Berenson 1932, pp. 39–40; Gronau 1932; Van Marle, vol. 16, 1937, pp. 192, 194, 195–96 n. 1; Longhi 1940, pp. 177–78, 186–87 n. 24 (Longi *Opere*, vol. 8, pt. 1, 1975, pp. 43, 56–57 n. 24); Berenson 1963, pp. 62–64; Shell 1965; Fremantle 1975, pp. 425–32; Fremantle 1975a; Giuseppe Mantovani in *Bolaffi*, vol. 5, 1975, pp. 11–14; Beck 1978, p. 51, appendix document 16; Stubblebine 1980, pp. 222–23; Rice 1983; Waadenoijen 1983, p. 53 n. 18; Rice 1985, esp. pp. 99–100; Francesca Petrucci in *Pittura* 1987, p. 626; Emmanuela Andreatta in Berti and Paolucci 1990, p. 254; Joannides 1993, pp. 28, 31–32, 56, 85, 247, 281, 306–7, 312, 322, 379, 418, 433, 464, 467; Roberts 1993, pp. 9, 43, 61 n. 44, 167–68 (documents II and V), 170–71 (document XI), 179, 210, 212, 215; Cecilia Frosinini and Hellmut Wohl in *Dictionary of Art* 1996, vol. 11, p. 683; B. Edelstein in *DBI*, vol. 49, 1997, pp. 658–59

PLATE 24 (JC CAT. 17)
Christ Healing a Lunatic and Judas Receiving Thirty Pieces of Silver

c. 1425–26

Tempera and gold on linen; $45\frac{1}{8} \times 41\frac{3}{4}''$ (114.5 × 105.9 cm)
John G. Johnson Collection, cat. 17

EXHIBITED: Amsterdam 1909; Philadelphia 1920, cat. 17 (as Masaccio); Tokyo 1987, no. 37; Florence 1990, no. 70 (as Masaccio[?] and Andrea di Giusto); Venice 1994, no. 51 (as attributed to Andrea di Giusto or Francesco d'Antonio); Washington, D.C., National Gallery of Art, December 18, 1994–March 19, 1995

TECHNICAL NOTES
The support consists of three pieces of linen fabric (the fiber confirmed by polarized light microscopy)—a full-height piece at left and two fragmentary pieces joined horizontally at right (fig. 24.1)—sewn together with an overcast stitch before the ground layer was applied.[1] The warp direction of all three pieces is vertical and the edges at the vertical seam are selvages. The horizontal seam between the two right-hand pieces was originally an overlap (the overlapping portion on the back is now missing) with two parallel lines of stitching binding and joining the raw edges. Since the left and two right support sections came from the

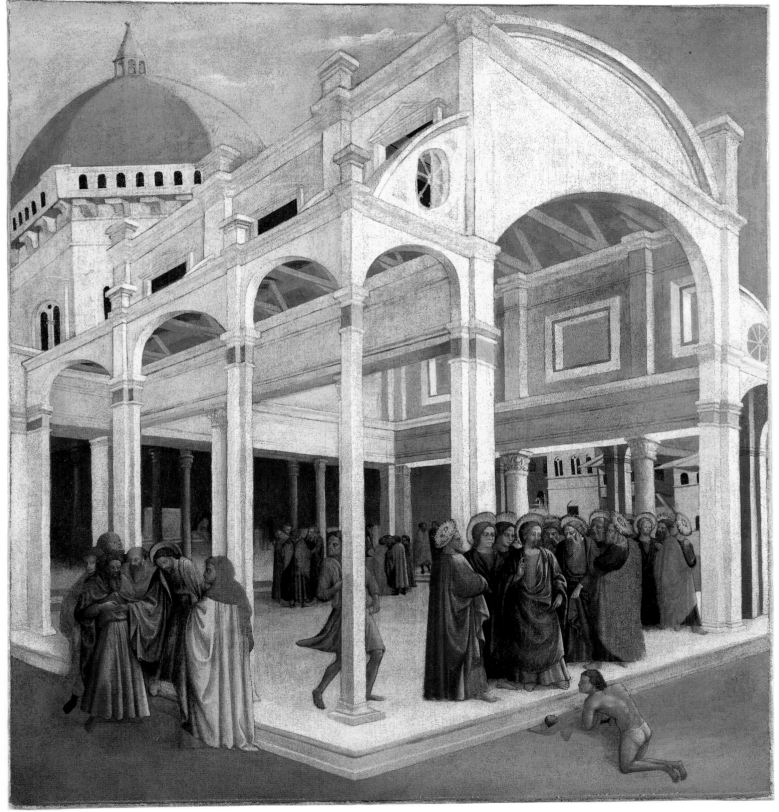

PLATE 24

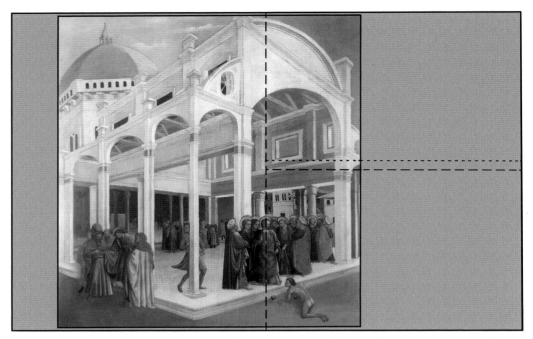

FIG. 24.2 X-radiographic detail of plate 24, showing the cusping in the canvas at the bottom

FIG. 24.1 Diagram by Mark Tucker of the canvas and original dimensions of plate 24, showing the original vertical seams of the joined selvage edges centered, and the horizontal seam of the overlapped raw edges extended to the right side

same piece of fabric in the same weave orientation, it is quite possible that the vertical seam originally fell at the center of the painting. This would be where Christ stands, and, in fact, his figure is bisected exactly by the seam. An X-radiograph (fig. 24.2) shows cusping in the canvas at the top and bottom edges, indicating their relative proximity to the original edges.[2] There is no cusping along the left and right, suggesting that the canvas was cut there. Vertical scratches in the gesso ground visible in the X-radiograph show it was applied with a trowel.

The composition was probably worked out in a preliminary drawing, although no signs of transfer to the canvas have been detected in the close examination. The longer orthogonals were drawn with a straightedge, whereas the orthogonals of many of the smaller elements do not converge on the vanishing points, suggesting that they were drawn freehand. Only a few scored lines can be seen, especially in the exterior and interior windows of the clerestory. In addition, a compass was swung to set the exterior and interior edges of the lateral arch of the first bay of the left side aisle, which accounts for the awkwardness of the arches that do not properly recede on a plane. This may reflect the artist's struggle with the then-unsolved problem of how to render receding curves in perspective. The paint is especially

thin over the lines of the drawing in the architecture. It appears that in execution these lines were left visible as divisions between adjacent color areas. At the last stage they were reinforced with paint.

There is also underdrawing (figs. 24.4, 24.5) in the drapery of all the figures and in the halos. The latter clearly shows that the halos were conceived as three-dimensional disks. The X-radiograph (fig. 24.3) shows that the flesh tones of the figures were underpainted in an apparently uniform tone. This may have been to provide a smooth base for the rendering of the features. Polarized light microscopy confirmed that the halos were painted in ultramarine, whereas the other blues are azurite. Christ's robe is a mix of both.

Several early writers commented on the painting's condition. In 1888 Wilhelm Bode described it as "very retouched." Herbert Horne wrote to John G. Johnson from Florence on June 9, 1911, that "it was in very bad condition and that when it was transferred to canvas apparently in the early part of the last century it was largely repainted," a comment he made based on a photograph. The painting is actually recorded as being on panel in the Somzée sale in 1904 and on canvas in the Sedelmeyer sale in 1907. The original support was in fact canvas, but it seems to have been mounted on panel in the sixteenth century (see Provenance). Obviously, sometime between the

two sales in 1904 and 1907 the canvas was removed from the panel and relined. On May 22, 1913, Frank Jewett Mather wrote Johnson from Princeton:

> A project I really have more at heart is that you should have the repaint rubbed off your Masaccio by Hammond Smith or other competent person. It is a picture of such art historical importance that we ought to know just what its evidence brings. I have no doubt that cleaning would bring out much beautiful work by Masaccio now hopelessly garbled.

Years later, on May 4, 1942, he wrote to Henri Marceau: "I understand your reluctance to go down to the ruined temple scene. Still I'd do it. There's better than an off chance that you will recover the wraith of a Masaccio."

In 1956 Theodor Siegl examined the painting, but did little actual conservation work. In 1973, in response to inquiries by James H. Beck, Siegl reexamined the canvas and determined that it was original. He removed the old lining and relined it in addition to cleaning the picture and inpainting losses. A photograph of the cleaned work clearly shows the extent of paint loss (fig. 24.6), much of which may have been caused by removing the canvas from the former wood support and then folding or rolling it. The paint is abraded throughout.

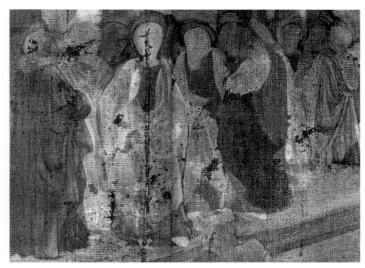

FIG. 24.3 X-radiographic detail of plate 24, showing the uniform tone of the underpainting of the flesh of Christ and the apostles in the foreground

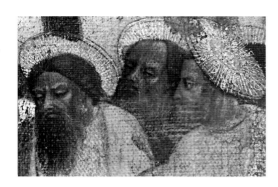

FIG. 24.4 Infrared reflectographic detail of plate 24, showing the three-dimensional drawing of the haloes of the figures in the foreground

FIG. 24.5 Infrared reflectographic detail of plate 24, showing the underdrawing in the drapery of the figures in the foreground

PROVENANCE

In 1550 and again in 1568 Giorgio Vasari, in his life of Masaccio (q.v.), described the picture as being in the house of the painter Ridolfo del Ghirlandaio (1483–1561): in the 1550 text he wrote that Masaccio

> was very zealous in his work and ingenious and admirable in solving problems of perspective, as one can see in his picture consisting of small figures which is today in the house of Ridolfo del Ghirlandaio. There, besides Christ who liberates a possessed man of a demon, are the most beautiful houses drawn so that they show both the inside and outside. He achieved this by not taking them from the front, but at an angle, because that afforded the greater difficulty.[3]

Alessandro Parronchi (1963) and Beck (1977, p. 49) identified the painting as a "perspective" that had entered the collection of Cosimo I de' Medici shortly after 1560, based on a description of the work in an annotation of 1562–64 in the Medici inventory of 1560: "A painting on wood, three *braccia* long and two wide,[4] depicting a perspective with many small figures, by the hand of the painter Masaccio, donated by Carota the woodworker, as in the daybook at page 309."[5] Antonio di Marco, called Carota (1485–1568), was one of the woodworkers who, in about 1533, executed the ceiling

and desks designed by Michelangelo for the Laurentian Library.

The painting was purchased by the British collector William Blundell Spence in 1877 from the Palazzo Guadagni in Piazza Santo Spirito in Florence.[6] Spence wrote from Nice to Sir Frederick Burton on December 11:

> I bought last summer in the Palazzo Guadagni of Florence several pictures. Among them was one of the Quattrocento which has turned out to be a picture by Masaccio accurately described by Vasari in his life and it represents the miracle of the boy brought by his father and restored to health. It is about 3 feet by 2½ and the architecture of the temple very elaborate as a piece of perspective.[7]

In 1888 Bode wrote that he had seen it at Spence's in Florence several years before. From Spence it passed to the Léon Somzée Collection in Brussels, where it was sold in May 1904 (lot 306, repro. opp. p. 14 [as Masaccio on wood]). It then passed through Charles Sedelmeyer in Paris, who sold it to Professor Otto Lanz of Amsterdam for 1,650 francs at a Parisian auction on June 3–5, 1907 (lot 151, repro. p. 161 [as Masaccio on canvas]). A letter from Herbert Horne to Johnson, dated Florence, June 9, 1911, indicates that by that point the latter had

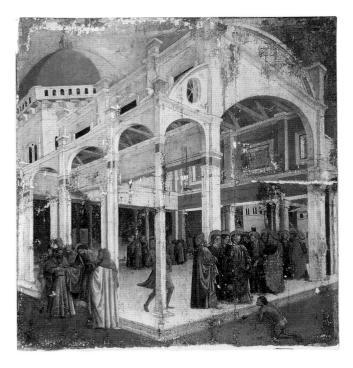

FIG. 24.6 (*left*) Photograph of plate 24 in 1913, after cleaning and before restoration

FIG. 24.7 (*below*) Layout of the perspective of plate 24 executed by Irma Passeri. The arrows and light gray colors show where the piers should have been placed in a geometrically consistent projection of the perspective.

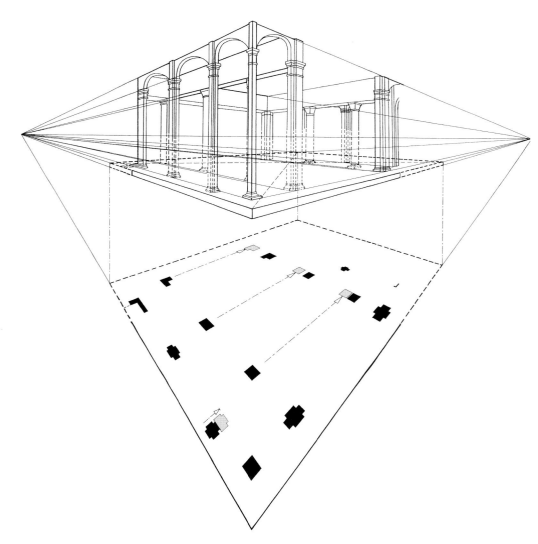

purchased the painting from Lanz: "As to the picture which you bought from Dr. Lanz (of Amsterdam) I know it only from the photograph. I made more than one offer to buy it but he always asked a price which I could not afford and which seemed to me too high for its condition."

COMMENTS

The scene takes place in an open building with a multifaceted dome meant to represent the temple in Jerusalem (see Giovanni di Paolo, plate 31 [JC cat. 105]). To the left Judas, identified by a dark blue halo, accepts thirty pieces of silver from the elders to betray Christ (Matthew 26:14–15).[8] To the right Christ, surrounded by a group of apostles, performs a miracle by raising his hand toward two figures on the street outside, where a man clad only in underpants kneels over a child in red.

Although the Gospels do not record that Christ performed such a miracle in the temple, Matthew 17:14–20 does describe how a man brought his lunatic son to Christ for healing after none of his disciples had been able to cure him. The verses that immediately follow (22–23) would explain the combination of the miracle with Judas's betrayal: "Jesus said to them: The Son of man shall be betrayed into the hands of men: And they shall kill him, and the third day he shall rise again." The passage (verses 23–26) further recounts the story of the tribute money, or tax, that Christ and the apostles had to pay, which Masaccio depicted in the murals of the Brancacci chapel in the mid-1420s.[9] The grouping of Christ and the apostles in the Johnson painting reflects the arrangement of the central group in the tribute money scene. The seminude man kneeling in the foreground is also derived from a figure in Masaccio's *Apostle Peter Baptizing the Neophytes* in the same chapel.[10]

As first noted by Roberto Longhi (1927, p. 65; 1940, p. 161), the combination of the scenes of Judas receiving blood money and Christ healing the lunatic occurs in a nearly contemporary silver plaque (see fig. 24.12), often attributed to Filippo Brunelleschi, though recently it has been proposed that it was designed by Leon Battista Alberti, about 1439–42.[11] There the two scenes are set in a city square in front of idealized antique and modern architecture. Clear correspondences between figures in the plaque and in Masaccio's paintings in the Brancacci chapel can also be found. In addition, as Paul Joannides (1993, p. 467) observed, the apostle seen from behind in the far right of the Johnson Collection's painting is the same—but reversed—as the apostle in the front right of the silver plaque.

ATTRIBUTION: William Blundell Spence's identification of the Johnson painting as the work by Masaccio described by Vasari in 1550 as being in the house of Ridolfo del Ghirlandaio was supported by August Schmarsow (1895–99, 1928a), Wilhelm R. Valentiner (letter to Johnson, dated New York, May 16, 1911), Herbert Horne (letter to Johnson, dated

FIG. 24.8 Francesco d'Antonio. Scene from the predella of the Rinieri altarpiece: *Dream of Saint Jerome*, c. 1426–30. Tempera and gold on panel; 7½ × 14⅝″ (19 × 37 cm). Avignon, Musée du Petit Palais, no. M.I.475

Florence, June 9, 1911), and Frank Jewett Mather (letter to Johnson, dated Princeton, May 22, 1913; letter to Henri G. Marceau, dated Washington's Crossing, May 4, 1942; and his article of 1944). The auction catalogues of the Somzée (1904) and Sedelmeyer (1907) collections simply attributed the picture to Masaccio. Bernhard Berenson (1913, pp. 12, 14) was much more cautious, suggesting that it was an "imitation of or possibly a copy after a lost work." However, Berenson had trouble even with the idea that the picture was a copy, and wrote that "if it were a copy after Masaccio [it] would thus suggest questions regarding him not easy to answer. . . . Perhaps however, the problems here suggested have no real existence, for it is more than likely that Vasari was mistaken in ascribing to Masaccio the design which probably is the creation of his imitator Andrea di Giusto."

In Berenson's lists (1932, 1936, 1963) the picture appeared as the work of Andrea di Giusto. Jacques Mesnil (1927), Mario Salmi (1932; 1948), Longhi (1940), Alessandro Parronchi (1966), and Luciano Berti (1964 and in Berti and Paolucci 1990) all concurred but recognized the possibility that Masaccio had had a hand in the design. Shell (1965) attributed the execution to Francesco d'Antonio and suggested that it was a copy from about 1430 after a lost original. He, however, felt that the design should be attributed to Masolino rather than Masaccio.

Shell's attribution of the figures to Francesco d'Antonio was accepted by Beck (1977), who, however, believed that the painting was essentially designed by Masaccio, and Joannides (1993), who, like Shell, thought that Masolino was most likely responsible for its conception. The most telling comparison with Francesco d'Antonio's known work is perhaps with the figures in his predella to

the Rinieri altarpiece of about 1426–30 (fig. 24.8). Furthermore, although Francesco is recorded as being associated with Masolino on three occasions, this does not exclude the possibility that he worked with Masaccio on the Johnson painting.

THE ORIGINAL SIZE: Beck (1978) noted that in the 1560 inventory of the collection of Cosimo I de' Medici the picture was described as a panel, whereas in the catalogue of the 1907 Somzée sale it was described as a canvas. He and Theodor Siegl excluded any possibility that the painting had been transferred from wood to canvas and concluded that the canvas was original. Beck (1978, pp. 49–50) compared it with a mid-fourteenth-century picture in the Museo dell'Opera del Duomo in Florence[12] that was originally on canvas but, probably for preservation purposes, was mounted on wood. He and Siegl also noted that the Johnson Collection's picture was cut on the left and right, which the lack of cusping of the canvas on the sides indicates. This had to occur sometime between 1562 and 1564, when it is recorded in an annotation to the 1560 Medici inventory as two by three *braccia*, which is about 3′ 10″ × 5′ 8⅞″ (1.2 × 1.8 m),[13] and 1907, when it is next recorded in the Somzée catalogue as 3′ 4⅝″ × 3′ 7⅜″ (1 × 1.1 m). The difference in the height is rather insignificant, but the considerable loss in width indicates that the composition originally extended to either side. The amount of loss to the sides is consistent with the absence of the weave cusping along the vertical edges.

Beck (1978, fig. 7) presented a drawing of what the whole composition might have looked like, which he based on Vasari's description of "houses drawn so that they show both the inside and outside." However, if the seam fell in the center, and the original width of the painting was three *braccia*,

or about 5′ 8⅞″ (175 cm), then about 6⅛″ (15.5 cm) of the painting is missing from the left edge and about 21½″ (54.5 cm) from the right. The viewer's observation point would have been farther to the left in the composition: the right vanishing point would have fallen on the canvas surface near the right edge and the left one far outside the edge of the canvas on that side.

The canvas does not seem to have been so radically cropped in height because there is pronounced weave cusping (fig. 24.2). This would mean that the present dimension of about 3′ 8⅞″ (114 cm) in height is not much different from the two *braccia*, or 3′ 10″ (116.7 cm) given in the 1560 inventory. It appears, then, that the truncation at the top of the left pier flanking the main portal of the temple is an original feature of the design. According to the steep perspective established by the artist, the depiction of the full height of this pier, if it were to correspond in height to the pier on the far side of the portal, would have required a minimum of about 9″ (23 cm) more in height beyond the present top edge, a possibility that the combined evidence rules out.

THE PERSPECTIVE: The perspective of the painting has been the object of much study. Parronchi (1959, fig. 3; 1964) demonstrated that the orthogonals receded to two vanishing points at the far ends of the horizon line, which he noted was the scheme Brunelleschi used to paint a perspectival rendering of the Palazzo Vecchio in Florence. The date of Brunelleschi's lost painting is much debated,[14] but the most likely period is 1424–25, when he was involved in the construction of the cupola of the city's cathedral and made a painting of the baptistery from the main entrance of the cathedral.

Shell (1965, p. 466 and fig. 3), while acknowledging the perspectival qualities of the Johnson picture, sought to demonstrate that Francesco d'Antonio's perspective was much more haphazard than Brunelleschi's and that the orthogonals did not merge on two precise vanishing points. However, careful examination of the principal orthogonals shows that they do converge on two vanishing points, although the artist did have trouble with some of the details, and the projection of the perspective can at best be called simplistic and imprecise (fig. 24.7). For instance, orthogonals that do not run along a continuous straightedge (such as the capitals of the piers) do not in every case converge on the vanishing points. In addition, the rounded shapes and the arches were drawn with a compass as arcs of a circle and not in proper recession. The arches of the first and second bays of the left aisle are of equal size, with only the third bay adjusted in size to account for its recession in space. The piers and columns likewise fall in uneven spacing as they recede. Nevertheless, Francesco d'Antonio achieved a convincing sense of rational space by carefully hiding some of the inconsistencies with figure groups. For example, the

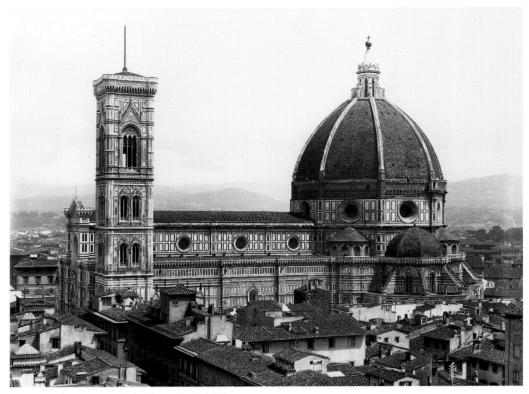

FIG. 24.9 Florence, cathedral of Santa Maria del Fiore

FIG. 24.10 Model of the cathedral of Santa Maria del Fiore; elements from the late fourteenth century(?) with additions by Filippo Brunelleschi (Florence, 1377–1446) of c. 1419 or 1429. Wood; center section 39⅜ × 35½″ (100 × 90 cm), each side section 21¾ × 24⅞ × 13⅞″ (55 × 63 × 35 cm). Florence, Museo dell'Opera del Duomo

pier before which Christ and the apostles stand has been pushed back and out of line with the others.

THE ARCHITECTURE: The architecture of the Johnson canvas, while admittedly eclectic, is decidedly Brunelleschian. The cupola, the arched gallery surrounding its base, and the lantern resemble Brunelleschi's project for the cathedral of Santa Maria del Fiore in Florence (fig. 24.9), which was under construction at the time that this painting was executed, probably sometime between 1424 and 1429. Brunelleschi had first presented his plan in 1417. In 1418–19, together with Nanni di Banco and Donatello, he built a large brick model with painted and gilded wood detailing and displayed it outside the cathedral next to the bell tower. There were other models as well,[15] and the project was officially approved in July 1420. While most of the models were destroyed, elements of some of them may survive in part in a model in the Museo dell'Opera del Duomo (fig. 24.10). An earlier model of the whole church, including the then-proposed cupola, made in 1367 by Giovanni di Lapo Ghini according to the specifications of a special artists' committee, was kept in the nave of the cathedral. This model was reflected in a mural of 1367–68 by Andrea di Bonaiuto in the Spanish chapel in the convent of Santa Maria Novella in Florence.[16] Likewise, the Johnson painting seems to present Brunelleschi's plan as it would have appeared in the brick and wood model of 1418–19 and during the cupola's initial phase of construction.

Brunelleschi's model of 1418–19 probably showed the design for the lantern and *ballatoio*, or walkway, at its base. On July 20, 1420, Brunelleschi and other members of the commission appointed to oversee the construction of the cupola drew up an elaborate statement in which the project is described in detail, with particular attention given to the exterior gallery around the drum.[17] The Johnson painting shows the *ballatoio* plan as described by Brunelleschi and others in 1420: a covered ambulatory with arched openings supported on a console and another walkway above. This ambulatory, however, was never executed.[18] Curiously, in the painting the *occhi,* or circular windows, at the base of the cupola are not depicted at all. The same is true of the earlier mural by Andrea di Bonaiuto. Although in a 1364 plan *occhi* were conceived for the side aisles,[19] no definitive decision had been made concerning their placement on the drum. The *occhi* were added between 1410 and 1413, before any final decision had been made about the design of the cupola.[20] Brunelleschi's famous model of 1418–19 seemingly only represented the cupola, so it may not have included the *occhi.*[21]

As construction of the dome was nearing completion, Brunelleschi's design for the lantern of the cathedral was changed in 1432. In fact, earlier models of it were ordered to be destroyed, and Brunelleschi was hired to create a new one. The Johnson painting reflects the older design and follows the simple trecento project seen in Andrea di Bonaiuto's mural. As can be surmised from the mural and the Johnson painting, Brunelleschi's first design was most likely derived from the mid-twelfth-century lantern on the baptistery of Florence.[22]

Other details of the architecture reflect Brunelleschian ideas. The window on the far left of the tribune resembles the typically Gothic windows of the fourteenth-century cathedral, but with the addition of a Renaissance frame with a triangular pediment. The horizontal windows in the clerestory have similar frames, perhaps suggesting that Brunelleschi planned to update the style of the cathedral's existing construction. The modernity of the painting's architecture is most apparent in the two-storied central nave, defined by columns supporting an architrave. In the upper story squared pilasters continue the vertical thrust of the columns. In general, the structure reflects a knowledge—undoubtedly derived from Brunelleschi—of Roman early Christian basilican architecture, and particularly, as August Schmarsow (1928a, p. 121) noted, Old Saint Peter's and Saint John Lateran.

Joannides (1993, p. 467) suggested that the painting's architecture expresses a Ghibertian

FIG. 24.11 Giovanni Paolo Lasinio (1789–1855) and Giuseppe Rossi (died 1842), after Antonio Veneziano (active Florence and Pisa, documented 1369–87). *Death of Saint Ranieri and the Translation of His Corpse;* engraving after the mural of 1384–86 (Pisa, Camposanto). From *Pitture a fresco del Campo Santo di Pisa disegnate e incise* (Florence, 1832)

interpretation of Brunelleschian ideas. He related it to buildings in Ghiberti's reliefs for the first set of bronze doors for the Florentine baptistery, which were unveiled on Easter Sunday 1424: the slender piers on the temple's exterior are indeed very close to those in Ghiberti's *Christ among the Doctors;*[23] columns supporting an architrave are found in his *Flagellation;*[24] and Gothic and antique elements are nicely combined in his *Last Supper.*[25]

While the architecture of the Johnson canvas is at most eclectic, it is the earliest surviving example of interest in architectural views as an independent subject for painting, which only begins to be recorded in the mid-fifteenth century.[26] However, a number of trecento compositions inform the basic design. The representation of a large, open, cathedral-like building seen principally from the side, like the one in the Johnson painting, occurs in Taddeo Gaddi's *Presentation of the Virgin* in the Baroncelli chapel in Santa Croce, executed in the 1330s.[27] Miklós Boskovits (quoted in Beck 1977, p. 52) also noted that the temple in the Johnson picture is similar to the cathedral of Pisa in Antonio Veneziano's mural the *Death of Saint Ranieri and the Translation of His Corpse* (fig. 24.11) of 1384–86 in the Camposanto in Pisa. Christine Smith (in Millon and Magnago Lampugani 1994, p. 459) observed that the painter of the Johnson canvas would have known Stefano Fiorentino's now-lost lunette mural

in the cloister of the Florentine convent of Santo Spirito, where another scene of Christ removing a demon from a possessed person is staged in a complex architectural setting. In 1568 Vasari wrote that Stefano Fiorentino had

> rendered a building in perfect perspective, in a manner then hardly known, with good form and better knowledge in recession. And in this [mural] he worked in a modern manner and with the greatest judgment. He showed such art and invention and proportion in the columns, doors, windows, and frames, and a way that was so different from other masters, that it seemed that one began to discern the light of the good and perfect manner of the moderns.[28]

THE "CURING OF THE LUNATIC" AND BRUNELLESCHI: The interest in the scene of the curing of the lunatic enjoyed a revival in Florence during the 1420s. The near-contemporary silver plaque (fig. 24.12), for example, shows a similar vignette and is also set in an idealized architecture that somewhat reflects Brunelleschi's plans for the Florentine basilica of San Lorenzo.[29] Smith (in Millon and Magnago Lampugani 1994, p. 459) suggested that the choice of the scene in Johnson's painting may have been related to the doubts being expressed in Florence in the 1420s over whether the cupola

could be built. According to the Gospel account of the story, after Christ healed the boy, the apostles asked why they could not cast out the demon. Jesus responded: "Because of your unbelief. For, amen I say to you, if you have faith as a grain of mustard seed, you shall say to this mountain, Remove from hence hither, and it shall remove; and nothing shall be impossible to you" (Matthew 17:19). Thus the Francesco d'Antonio may have been made in response to the criticisms Brunelleschi faced regarding the cupola in 1425–26, especially from his most virulent critic, Giovanni di Gherardo Gherardi.[30] At about the same time Gherardi and Brunelleschi exchanged accusatory sonnets about each other.[31]

THE "CURING OF THE LUNATIC" AND SAINT BERNARDINO: Berti (1964, p. 144 n. 228) noted that the halos of Christ and the apostles are incised with the insignia of Saint Bernardino of Siena, which contains the symbol of the Name of Jesus he invented as a new devotion and frequently used in his sermons. Bernardino preached in Florence in Santa Croce between March 8 and May 3, 1424, and again between February 4 and April 18, 1425; he later returned for a brief period in late July and early August 1427.[32] Furthermore, in the 1480s Vespasiano da Bisticci (Greco ed. 1970–76, vol. 1, p. 250) notes that the saint also preached some very popular sermons in the cathedral, after which he visited the house of the humanist

FIG. 24.12 Attributed to Filippo Brunelleschi (Florence, 1377–1446) or after Leon Battista Alberti (Florence, 1404–1472). *Christ Healing the Lunatic Boy and the Blood Money,* c. 1425 or c. 1439–42. Silver with a gold, silver, and enameled frame; 6 × 7½″ (15 × 18.8 cm). Paris, Musée du Louvre, Département des Objets d'art

Giannozzo Manetti. Exactly when Bernardino preached in the cathedral is unknown, but it could have occurred during his short visit of 1427 or even during one of his visits to Santa Croce.

The biblical miracle in the painting might refer to incidents that took place in nearby Prato. On June 12, 1424, Bernardino is said to have cured a madwoman by showing her the cross and a tablet painted with the symbol of the Name of Jesus. A witness described the miracle and noted that there were "one hundred Florentine citizens present, who had never seen such an event."[33] During this same time, at the Porta Santa Trinità in Prato, a young man named Cosimo di Niccolò Lorenzi fell unconscious after having been hit by a bull. Bernardino knelt next to him and prayed until the youth stood up and walked.[34] Both of these episodes were later cited as miracles in the acts of the saint's canonization.[35]

Whether the choice of the subject of Christ healing the lunatic relates to Bernardino's extraordinary experience in Prato cannot be determined, but certainly the presence of his insignia on the halos suggests that the painting was at least produced around the time of one of his Florentine sojourns. The use of the lightweight canvas might mean that it was carried in procession during the ceremonies surrounding one of his sermons, which were extremely popular and emotional events. In Florence on one occasion his preaching in Santa Croce was interrupted by a crowd who wanted him to come out of the church to light a bonfire of vanities.[36] He was invited back to preach in 1426, most probably by Leonardo Bruni, chancellor of the Republic of Florence.[37] He did not return, however, until 1427.

In Rome during the spring of 1427[38] Bernardino was investigated for the orthodoxy of his cult of the Name of Jesus but was eventually exonerated. Many of the initial attacks concerning his cult had been made in Florence in 1424 by his bitter enemy, the Dominican Manfredo da Vercelli. Two letters written by the humanist Ambrogio Traversari, a monk at the Florentine convent of Santa Maria degli Angeli, show how closely Bernardino's trial was followed and with what joy his exoneration was greeted in the city.[39] The presence of the symbol on the halos in this picture thus might have been a response to attacks on the Name of Jesus, just as the architecture may have been an answer to the doubts about Brunelleschi's program for the cathedral's cupola.

COMMISSION AND FUNCTION: It is not clear who would have commissioned a picture such as this. Few paintings on canvas survive from before the late fifteenth century, and of those that do there is little, if no, documentation as to their use. However, there are contemporary canvas processional banners made for lay confraternities. A canvas by Spinello Aretino seems to have been made around 1375 for a brotherhood in Borgo San Sepolcro.[40] It was painted on both sides, making it particularly appropriate for use in a procession. Another canvas, showing the Decapitation of Saint John the Baptist, by a mid-trecento Florentine artist,[41] now in the Museo dell'Opera del Duomo of Florence, might have been a processional banner, although there is no record of its specific use. In the Florence cathedral there was also an altar complex that included a painting on canvas.[42] After the canonization of Saint Bernardino in 1450, several canvas banners were made celebrating the occasion.[43] In addition, his preaching in the squares of Italy inspired several artists to paint scenes of these events.[44]

The detail of the Johnson painting and especially its careful study of buildings and perspective would suggest that its use as a processional banner was rather limited, for its images would not have been readable at much distance. The artist may have used canvas instead of panel because he viewed the painting as an experiment in working out problems of representing buildings in perspective. However, the careful choice of the biblical text, especially as it might relate to criticism concerning Brunelleschi's cupola, and the presence of Bernardino's insignia on the halos would indicate that the painting was in fact prepared for or in response to a specific event.

1. On the structure of early canvas painting, see Villers 2000, pp. 6–9.
2. Cusping is a distortion in the weave of the canvas into arcs between points of attachment to a stretcher or board. The extent of the cusping diminishes with increased distance from the edges.
3. "Fu studiosissimo nello operare, e nelle difficultà della prospettiva, artificioso e molto mirabile, come si vede in una sua istoria di figure piccole, che oggi è in casa Ridolfo del Ghirlandaio, nella quale, oltra il Cristo che libera lo indemoniato, sono casamenti bellissimi in prospettiva, tirati in una maniera che e' dimostrano in un tempo medesimo il didentro et il difuori, per avere egli presa la loro veduta, non in faccia, ma in su le cantonate per maggior difficultà" (Vasari 1550 and 1568, Bettarini and Barocchi eds., vol. 3 (text), 1975, p. 126). He mistakenly described it as still in Ghirlandaio's collection in the 1568 edition (Vasari 1568, Milanesi ed., vol. 2, 1878, p. 290), even though by then it belonged to the Medici.
4. These dimensions are actually the reverse in respect to height and width.
5. "Un quadro di legname, di braccia tre lungo et largo dua, entrovi una prospettiva con alquante figurine, di mano di Masaccio pittore donò il Carota intagliatore di legname, come al giornale carta 309" (Florence, Archivio di Stato, *Guardaroba medicea, Filza* 65, folio 164 verso).
6. At this time the palace was owned by the Dufour Berte family (Ginori Lisci 1972, vol. 2, pp. 735–41). They gradually sold off the collection, and the Johnson picture is not listed in the description of the holdings published by Federigo Fantozzi in 1856 (pp. 692–96). On Spence, see Fleming 1973–79; and Callmann 1999.
7. On this letter, see Sweeny 1966, p. 1.
8. Judas has a similar halo in Lorenzo Monaco's *Man of*

Sorrows of 1404; Florence, Galleria dell'Accademia, no. 467; Eisenberg 1989, fig. 18, color plate details 1–2; Bonsanti 1987, color repros. pp. 78, 82.

9. Baldini and Casazza 1990, postrestoration color repro. p. 38.

10. Baldini and Casazza 1990, postrestoration color repro. p. 100.

11. Massimo Bulgarelli in Bellosi 2002, pp. 218–21.

12. *Decapitation of Saint John the Baptist*, no. 41; 44⅜ (including a 1⅝″ [4 cm] strip of replaced canvas) × 29⅝″ (112.5 × 75 cm); Becherucci and Brunetti 1969–70, vol. 2, plate 263. It is usually assumed that this painting was a processional banner.

13. This is using *braccia a terra,* which in Florence before 1782 equaled about 0.551202 meters (22″). If *braccia a panno* were used, the measurement would have been 0.58362 meters (23″). See Martini 1883, p. 206.

14. See Parronchi 1958, pp. 15–18; 1964, pp. 245–49. Parronchi based his dating on the 1425 return to Florence of Paolo dal Pozzo Toscanelli, a mathematician friend of Brunelleschi's who had previously taught in Padua.

15. The painter Giuliano d'Arrigo Pesello, who was on the advisory committee for the cupola, also produced wooden models in 1420 (Guasti 1857, p. 25, document 42) and 1425 (Guasti 1857, p. 33, document 60). In his written report on the project, Giovanni di Gherardo Gherardi refers to another wooden model made by Brunelleschi in c. 1419 (see n. 30 below). Brunelleschi and Ghiberti were commissioned to prepare yet another in September 1429 (Guasti 1857, pp. 33–34, documents 61–67). Probably other models were also made, as the building committees found them the best way to evaluate the project.

16. Offner and Steinweg 1979, plate 11.

17. "Fariassi un andito di fuori, sopra li occhi di sotto imbecchatellato con parapeti trasforati e d'altezza di braccia 2 o circa, al'avvenante delle trebunete di sotto; o veramente due anditi, l'uno sopra l'altro, in su una cornice ben ornata; e l'andito di sopra sia scoperto" (Let an outer ambulatory be constructed over the round windows below made up of open parapets of about two *braccia* in height, like the tribunes below. Actually [there should be] two ambulatories, one above the other, within a finely decorated cornice. The upper ambulatory should be open). Adapted from Saalman 1980, p. 73; on the date and meaning of this document, see Saalman 1980, pp. 77–97.

18. The only section of the *ballatoio* that was executed was the part that was built by Baccio d'Agnolo on the southeast side of the cathedral in 1514–15. It was never finished, seemingly because Michelangelo, who compared it to a grasshopper cage, said that it subverted Brunelleschi's design (Vasari 1568, Bettarini and Barocchi eds., vol. 3 [text], 1976, pp. 612–13). Alessandro Nova in Millon and Magnago Lampugnani 1994, pp. 593–97.

19. Guasti 1887, p. 158, document 119; Prager and Scaglia 1970, p. 7.

20. Guasti 1887, pp. 308, 313, documents 454, 466–67; Prager and Scaglia 1970, p. 19.

21. Antonio di Tuccio Manetti, the architect's biographer, noted that the excessive width of the stone fittings around these windows seems to have disturbed Brunelleschi, in particular with regard to his plan for the *ballatoio* (Manetti early 1480s, De Robertis and Tanturli ed. 1976, p. 115). The surviving wood model (fig. 24.10) of uncertain date has the *occhi,* but they are shown without their molding. The only explanations are either that that part of the model dates before 1413, or that, if Brunelleschi designed this model, he hoped a different solution would be eventually reached.

22. Saalman 1993, fig. 38.

23. Krautheimer 1982, plate 30.

24. Krautheimer 1982, plate 47.

25. Krautheimer 1982, plate 42.

26. As noted by Christine Smith (in Millon and Magnago Lampugnani 1994, p. 460), Filarete, writing in 1464, recorded that various artists painted views of buildings and places for Piero di Cosimo de' Medici and, Vasari, writing in the mid-1500s, mentioned a view of Venice with San Marco painted by Leon Battista Alberti. The Medici may have also owned Brunelleschi's views of the baptistery and the Palazzo Vecchio, or at least copies of them, as several versions of these subjects are recorded in the copy of the 1492 inventory of Lorenzo de' Medici's effects. See Spallanzani and Gaeta Bertelà 1992, pp. 21–22.

27. Ladis 1982, plate 4a–9. In the Florentine Filippo Villani's *De origine civitatis Florentiae et eiusdem famosis civibus* of 1381–82, Taddeo is described as being particularly talented in his representation of architecture. His fame with this regard did not die out in the following decades. A drawing after the mural exists (Ladis 1982, fig. 60) and, when they were in Italy in the early 1440s, the Limbourg brothers also made a copy of it, which they reemployed in an illumination of the *Très Riches Heures* (Chantilly, Musée Condé, Ms. 65; Meiss 1974, fig. 13).

28. Vasari 1550 and 1568, Bettarini and Barocchi eds., vol. 2, 1967, p. 134.

29. The frame has enameled medallions of the four doctors of the church that recall the founding of San Lorenzo by Saint Ambrose in 593. The two cupolas on the sides of the main, templelike building in the center derive from Brunelleschi's design for the cupola of the Old Sacristy of San Lorenzo. The building on the left recalls an ancient model: the tombs of the Republican baker M. Virgilius Eurysaces, outside the Porta Maggiore in Rome, which are in the unusual form of a furnace. This may refer to the fact that the area of San Lorenzo was historically one of the principal places in Florence for public furnaces (Bargellini and Guarnieri, vol. 4, 1978, pp. 144–45). For other elements on the architecture and the figures, see Massimo Bulgarelli in Bellosi 2002, pp. 218–21.

30. Gherardi's criticisms are contained in a written and illustrated report. Florence, Archivio di Stato, inv. Mostra 158; Millon and Magnago Lampugnani 1994, repro. p. 22. On him, see Saalman 1959.

31. Prager and Scaglia 1970, pp. 143–44, nos. v–vi.

32. Alessio 1899, p. 273; Howell 1913, p. 167.

33. Pacetti 1940–41, p. 296. The account is in a letter from one Sandro Marcoualdi to his brother in Dubrovnik, received July 4, 1424.

34. Pacetti 1940–41, pp. 296–97 n. 3.

35. In 1451 Giovanni da Modena included the two episodes on a canvas altarpiece showing Saint Bernardino and his miracles for a chapel dedicated to the saint in San Francesco in Bologna (now Pinacoteca Nazionale; Bernardini et al. 1987, repro. p. 56).

36. On the Florentine appearances, see Howell 1913, pp. 132, 135; and Hefele 1912, esp. p. 97 n. 1. On the bonfires, see Vespasiano da Bisticci 1480s, Greco ed. 1970–76, vol. 1, p. 246.

37. Donati 1894, esp. pp. 53–54.

38. There is some argument as to the date. Some authors prefer to place the event in 1426 (Pacetti 1943, p. 167).

39. Longpré 1935–37, pp. 467–68, 472–73.

40. New York, The Metropolitan Museum of Art, no. 13.175, 69 × 47″ (175.2 × 119.4 cm); Zeri and Gardner 1971, plates 24–25.

41. See n. 12 above.

42. *Intercession of Christ and the Virgin* (1402; canvas; 11¼ × 60¼″ [239.4 × 153 cm]; New York, The Metropolitan Museum of Art, no. 53.37), by Lorenzo di Niccolò, was part of this complex on the west wall of the cathedral. See Zeri and Gardner 1971, pp. 115–17 (with earlier bibliography), plate 33.

43. See n. 35 above for the canvas altarpiece by Giovanni da Modena. For another canvas banner of 1445, by Orazio di Jacopo, see Bologna 1987a, fig. 125. It is now in a private collection.

44. Shortly after the saint died, Sano di Pietro (q.v.) produced two detailed views of him preaching in the Campo and Piazza San Francesco in Siena (Christiansen, Kanter, and Strehlke 1988, p. 41, figs. 5, 6), and the banner that Benedetto Bonfigli made in 1464 for a lay confraternity dedicated to the saint in Perugia showed Bernardino before an exact view of the confraternity's seat and the church of San Francesco al Prato (Perugia, Galleria Nazionale dell'Umbria, no. 164; Mancini 1992, repro. p. 110).

Bibliography
Vasari 1550 and 1568, Bettarini and Barocchi eds., vol. 3 (text), 1967, plate 26 (Masaccio); Bode 1888, pp. 475–76 (impossible to judge if an original or a copy by Masaccio); Schmarsow 1895–99, vol. 2, 1896, pp. 89–96 (Masaccio); Becker 1904; Kern 1905, p. 40 (Masaccio); Berenson 1913, pp. 2–4, repro. p. 239 (imitator of Masaccio or copy of a lost work); Philadelphia 1920, p. 2 (Masaccio, possibly a contemporary copy); Mather 1923, p. 3; Mesnil 1927, pp. 45, 36, plate 7 (late imitator of Masaccio); Inaugural 1928, p. 9 (follower of Masaccio); Schmarsow 1928, pp. 119–26 (Masaccio); Schmarsow 1928a (Masaccio); Van Marle, vol. 10, 1928, pp. 304–5; Giglioli 1929, pp. 62–63 (not Masaccio); Lindberg 1931, pp. 53, 190–93, plate 98; Berenson 1932, p. 2 (Andrea di Giusto); Salmi 1932, pp. 78–79, 130, plate cxci (Andrea di Giusto); Oertel 1933, pp. 286–89, plate 50; Kennedy 1934, p. 397; Berenson 1936, p. 1 (Andrea di Giusto); Longhi 1940, p. 161 (Longhi *Opere,* vol. 8, pt. 1, 1975, pp. 23–23, fig. 19a)(Andrea di Giusto); Johnson 1941, p. 1 (Andrea di Giusto); Rosen 1941, p. 461, fig. 8 (Andrea di Giusto); Mather 1944, p. 185 (early Masaccio); Antal 1948, p. 332; Salmi 1948, p. 9, fig. 27; Steinbart 1948, p. 79; White 1957, p. 136, fig. 30a; Parronchi 1959, pp. 9–12, fig. 3; Klein 1961, p. 222 n. 35, fig. 10; Umberto Baldini in *Enciclopedia,* vol. 8, 1962, col. 875; Kitao 1962, p. 185 n. 37; Berenson 1963, p. 6 (Andrea di Giusto); Parronchi 1963, p. 6; Berti 1964, pp. 84–85, 144 n. 228, fig. 55; Parronchi 1964, pp. 270, 539–40, figs. 96–97; Shell 1965, figs. 1–9; Edgerton 1966, pp. 372–73 n. 29; Parronchi 1966, pp. 20–22, diagram p. 9, repro. p. 20; Sweeny 1966, p. 1, repro. p. 3 (Andrea di Giusto); Luciano Berti in Berti 1968, p. 102, fig. 27; Fredericksen and Zeri 1972, pp. 73, 617 (Francesco d'Antonio); Beck 1978, figs. 1–5, 7; Alessandro Angelini in Vasari 1550, Bellosi and Rossi ed. 1986, p. 268 n. 5; Perrig 1986, pp. 19, 37–38 nn. 48–49, fig. 12 (Andrea di Giusto); Decio Gioseffi in Toyko 1987, pp. 145–46, repro. p. 145 (color); Joannides 1987, pp. 15–16, fig. 22; Berti 1988, pp. 30–32, color plate p. 209; Rossella Foggi in Berti 1988, p. 208; Luciano Berti in Berti and Foggi 1989, p. 6, color plate p. 45; Rossella Foggi in Berti and Foggi 1989, p. 44; Baldini 1990, p. 34; Luciano Berti in Berti and Paolucci 1990, p. 200, color repro. p. 20; Droandi 1993, pp. 141–42; Joannides 1993, pp. 466–67, plate 478; Strehlke 1993, pp. 23–24, fig. 32; Ambrosio 1994, pp. 8–9, color plate 5 (Masaccio); Christine Smith in Millon and Magnago Lampugnani 1994, cat. 5, pp. 458–59; Cecilia Frosinini and Hellmut Wohl in *Dictionary of Art* 1996, vol. 11, p. 603; Hellmut Wohl in *Dictionary of Art* 1996, vol. 20, p. 536; B. Edelstein in *DBI,* vol. 49, 1997, p. 659

FRANCESCO DI VANNUCCIO

SIENA, DOCUMENTED 1356–89;
DIED BEFORE 1391(?), SIENA

There is some confusion as to the identity of the artist who signed his name as *Francischus de Vannuccio de Senis* (Francesco di Vannuccio of Siena) on a painting dated 1380, now in Berlin.[1] He has traditionally been identified with a Francio di Vannuccio who registered in the lists of the Sienese guild of painters when it was begun in the year 1356, and who appears again in the lists started in 1389. In 1361 the same Francio worked with Cristoforo di Bindoccio on some paintings in Montalcino near Siena.[2] A number of other documents record him as a painter engaged in minor commissions for the commune of Siena and the local hospital of Santa Maria della Scala, such as the decoration of the pennants of the commune's trumpets and the flag for the bell tower of the cathedral.[3] In 1388 he was paid for painting an altarpiece for the company of Sant'Antonio Abate in Siena.[4] Panels from this work might be identified with the *Virgin and Child* now in the church of San Giovannino in Pantaneto in Siena[5] and a fragmentary *Saint Anthony Abbot* in a German private collection.[6] Because Francio is not recorded in the tax rolls of 1391 for his neighborhood known as the Popolo del Pellegrino, where he had been registered since 1384, it is assumed he died sometime before that year.

Alternatively, Miklós Boskovits (1988, p. 35) has argued that the artist of the Berlin painting was one Francesco di Vannuccio Martini, who is enrolled in the lists of the Sienese painters' guild in 1389 and recorded as working with the painter Bartolo di Fredi in 1387. Another artist named Francesco di Vanni has also been suggested as a possible identity.[7]

On the basis of the signed picture in Berlin, Cesare Brandi (1931a, 1933) and Richard Offner (1932) attributed to the artist a group of paintings, most of which are small-scale diptychs and triptychs made for presumably rich private patrons. An elaborate use of gold, brilliant colors, and surface decoration distinguishes these works and places them in a tradition of Sienese painting that dates to Simone Martini and his school, who began satisfying a demand for such luxury items starting in the mid-1320s. These products found a ready market at home and abroad, and Francesco di Vannuccio and others did little to change what had become a winning formula.

1. Staatliche Museen, no. 1062B; Boskovits 1988, plates 45–47.
2. Cristoforo might be the artist who assisted Francio on a predella showing scenes from the legend of Saint Catherine of Alexandria and a Man of Sorrows (sold London, Sotheby's, June 21, 1978, lot D, repro. [as Francesco di Vannuccio]). This same artist could have

executed the Annunciation on the small coffin (1373[?]) in the Palazzo Pubblico of Siena, sometimes attributed to Francesco di Vannuccio. This has also been attributed to Cristoforo di Chosona on the basis of a document of 1373. See Alessandro Cecchi in Siena 1982, p. 258, repro. p. 285.
3. See Alessandro Cecchi in Siena 1982.
4. Milanesi, vol. 1, 1854, p. 35 n. 1.
5. Siena 1981, color plate III.
6. Zeri 1971, fig. 17.
7. See Alessandro Cecchi in Siena 1982, p. 282.

Select Bibliography
Milanesi, vol. 1, 1854, pp. 33 n. 1, 35 n. 1, 38, 305, 313; Thieme-Becker, vol. 12, 1916, p. 311; Brandi 1931a; Offner 1932; Brandi 1933; *Bolaffi*, vol. 5, 1974, pp. 122–25; Alessandro Cecchi in Siena 1982, pp. 282–86; Monica Leoncini in *Pittura* 1986, pp. 571–72; Boskovits 1988, p. 35; John Richards in *Dictionary of Art* 1996, vol. 11, pp. 696–97

PLATE 25 (JC CAT. 94)

Valve of a diptych: *Crucifixion with the Virgin and Saint John the Evangelist*

c. 1387–88

Tempera and tooled gold on panel with vertical grain, with applied moldings; overall $16\frac{7}{8} \times 12 \times 1\frac{1}{8}''$ (42.7 × 30.5 × 2.7 cm), painted surface $13\frac{3}{4} \times 9''$ (34.7 × 23 cm)

John G. Johnson Collection, cat. 94

INSCRIBED AT THE BOTTOM (see fig. 25.4): *hoc. hopus. neimille.* [blank coat of arms] *ccc. L [——] c[?]. ululii +* (this work in one thousand ccc. L [——]c[?] of July); ON THE CROSS: *INRI* (in sgraffito) [IESUS NAZARENUS, REX IUDAEORUM] (John 19:19: "JESUS OF NAZARETH, THE KING OF THE JEWS"); ON THE REVERSE: *Cavallini* (in graphite); *32* (in ink); *Buffalmaco* (in ink; not very legible under the varnish); *DURAND-RUEL/ PARIS 16, Rue Laffitte/ NEW YORK, 389, Fifth Avenue/ Ecole de Sienne N° 5740/ Le Christ en croix/ asss*; *PARIS, 16 rue Laffitte/ NEW YORK, 389 Fifth Avenue/ Ele de Sienne No. 2479/ Croix moss* (printed paper label with ink inscription)

PUNCH MARKS: See Appendix II

EXHIBITED: Philadelphia Museum of Art, John G. Johnson Collection, Special Exhibition Gallery, *From the Collections: Paintings from Siena* (December 3, 1983–May 6, 1984), no catalogue; Amsterdam 1994, cat. 21

TECHNICAL NOTES
The panel consists of a single plank with strips of wood applied to the top, bottom, and left edge, in addition to applied moldings.[1] The parchment that covered the seams of the added strips and a small imperfection in the center of the panel survives

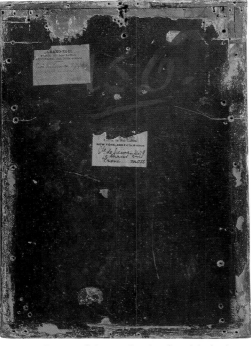

FIG. 25.1 Reverse of plate 25, showing the original paint

along the left and bottom edges and in the center. It has been removed along the top edge, thereby damaging the paint on the back (fig. 25.1), which was executed in imitation of porphyry. This was worked up with unusual care, with a reddish brown layer spattered with white and glazed with red lake, and then spattered again. There is vermilion paint on the sides. Two rough areas along the left indicate where there were once hinges.

The surface is covered with a pastiglia decoration embedded with several colored-glass stones, red ones in the spandrels of the arch and green ones in the cusps. Two of the stones in the cusps are missing, as are the stones in the central decoration of the spandrels. The colonnettes are also built up in pastiglia with tooled graining on their upper surfaces. The blue costumes, wings, and golden hair of the mourning angels were executed in sgraffito.

The outlines of the figures and the folds in the Virgin's blue mantle were incised. The gold and the bole were carefully scraped away to promote adhesion of the paint along the outlines of the figures.[2] The worn surface reveals drawing in the Virgin's undergarment and John's cape, but no other drawing was detected by infrared reflectography. The Virgin's garment is ultramarine underpainted in black. Its lining is mordant gilt and glazed green. John's robe is lined in pale pink ocher. The mordant is pigmented white.

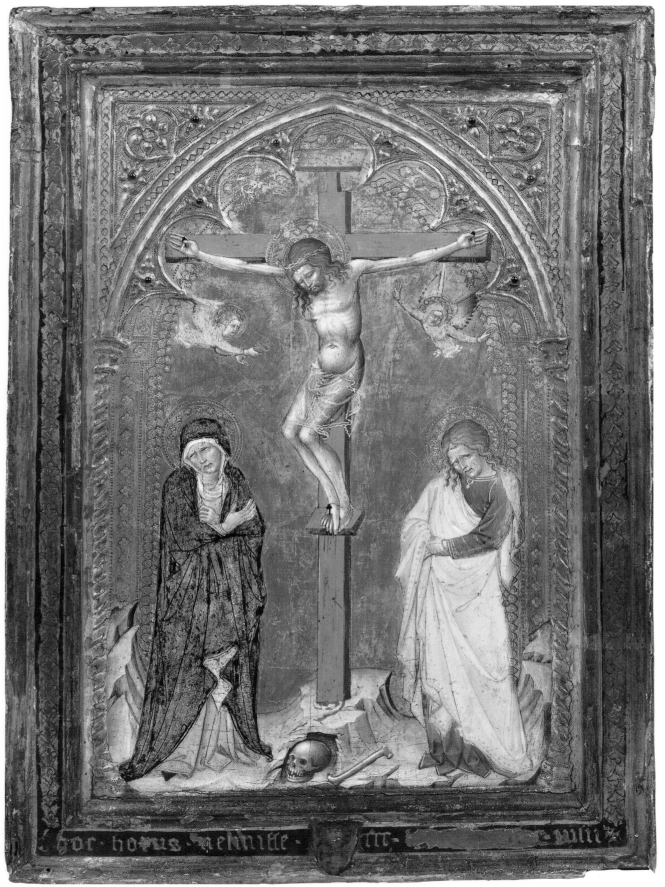

PLATE 25

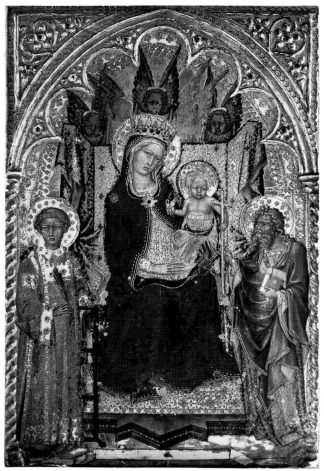

FIG. 25.2 Francesco di Vannuccio. *Virgin and Child with Saints Lawrence and Andrew*, c. 1387–88. Tempera and tooled gold on panel; 13⅞ × 9¼″ (35 × 23.5 cm). The Hague, Museum van het Boek-Museum Meermanno-Westreenianum, no. 806. See Companion Panel

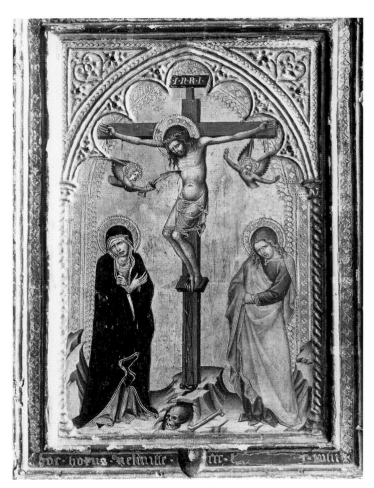

FIG. 25.3 Photograph of plate 25 as it appeared in 1913

The reproduction in Bernhard Berenson's 1913 catalogue (fig. 25.3) documents the state of the picture before it was cleaned by David Rosen in 1941. His cleaning not only left such areas as the gilt background, mordant gilt details, and the Virgin's mantle in a badly abraded state, but also removed such details as the blood flowing into the chalice from Christ's side wound and down the cross from his feet. By comparison, the figure of Christ is better preserved, as is the extreme lower edge of the panel, including the skull and bone.

PROVENANCE
The picture belonged to the Parisian gallery Durand-Ruel, which sold it to John G. Johnson

sometime between 1907 (Reinach, vol. 2, 1907), when it is recorded as still with Durand-Ruel, and 1909 (Rankin), when it is described as in Johnson's collection.

COMMENTS
The Virgin and Saint John the Evangelist mourn as Christ hangs dying on the wooden cross. His legs are intertwined and his feet are attached to the cross by a single nail. Two half-length angels fly on either side. The one on the left collects the blood spurting from the wound in his side in a chalice, which refers to the blood of Christ celebrated in the Eucharist of the mass.[3] The cross is set on the craggy mound of Golgotha, on which the skull and bone of Adam

can be seen, which recalls the legend that Christ was crucified at the place where Adam was buried.

The attribution to Francesco di Vannuccio seems to have been made by Berenson (see Rankin 1909), who saw it with the dealer Durand-Ruel.

The panel is the right valve of a diptych. Richard Offner (1932) recognized that the companion panel (fig. 25.2) was the *Virgin and Child with Saints Lawrence and Andrew* in The Hague. Unfortunately, that work is cut at the bottom and therefore does not retain any trace of the inscription, which probably identified the person who commissioned the diptych for his or her private use. At the center of the inscription of the Johnson Collection's panel is a shield (fig. 25.4), made of gesso raised in relief, that would

FIG. 25.4 Detail of an inscription on plate 25

have contained a coat of arms. Henk van Os (in Groningen 1969, cat. 7) proposed that the panel in The Hague also had a shield with a coat of arms. If this were indeed the case, the two shields probably displayed the arms of a husband and wife.

The date of the panel cannot be read because several numerals are lost. Stylistically, it has been related to the *Crucifixion* in Berlin, which is signed by Vannuccio and dated 1380. The wooden crucifix, the figure of Christ, and the posture of the Virgin are almost the same in both paintings, pointing to a certain proximity in date. Van Os (in Groningen 1969) and Boskovits (1988, p. 36) suggested that the Johnson panel dates after the Berlin painting. An argument in favor of a later dating for the Philadelphia work would be its similarities to a diptych by Paolo di Giovanni Fei (fig. 25.5) in Siena that stylistically can be dated to the 1390s. The figure of Christ in the Crucifixion of Fei's triptych of about the same period in the Pinacoteca Vaticana is also quite close to the one in the Johnson panel.[4] Fei also shows an angel collecting Christ's blood in a chalice.

In the inscription, the last figure before the word *lvlii*, for the month of July, looks like a *c* but is more probably half of a rotund *x* and thus represents part of the numeral for the day of the month. Considering the large size of the lacunae, which suggests that many numerals are gone, the year probably read 1387 *(mille. ccc. L[xxxvii])* or 1388 *(mille. ccc. L[xxxviii])*. This would correspond with the style of the picture, which suggests a date around 1390. However, within the lacunae, room must also be allowed for the standard formula for recording the day of the month, which was to write *die* (day) followed by a numeral. Therefore, we cannot be absolutely certain of the date.

1. This construction can be compared with that of the panel by Domenico di Bartolo, plate 21 (JC cat. 102).
2. This technique contrasts with *ritagliare*. See the diptych by Allegretto di Nuzio, plate 4 (JC cat. 118).
3. The angels collecting the blood from Christ's wounds in a chalice first appear in Italian art in Cimabue's two murals of the Crucifixion (c. 1288–92) in the Upper Church of San Francesco in Assisi as well as in Giotto's mural of the Crucifixion (c. 1308) in the Lower Church. Giotto had also included the motif in his mural of the subject in the Arena chapel in Padua (1303–5). For the Cimabue, see Bellosi 1998, color repro. p. 225. For Giotto, see fig. 87.3.
 The motif was adapted from Northern European—largely German—allegorical depictions of the Crucifixion in which *Ecclesia*, or the female personification of the Church, is shown collecting Christ's blood. See the many examples in Schiller, vol. 2, figs. 357, 364–65, 371–72, 424, 432, 442, 446, 450–52, 454, 513, 516.
4. No. 220; Volbach 1987, fig. 125.

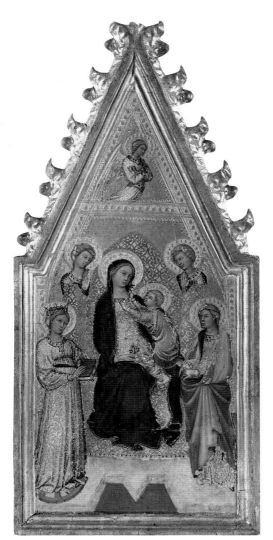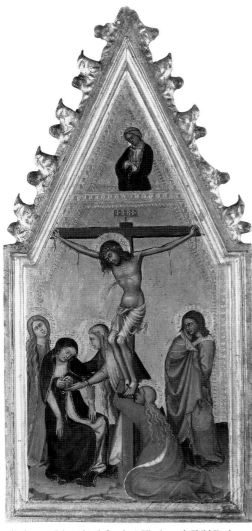

FIG. 25.5 Paolo di Giovanni Fei (Siena, first documented 1369; died 1411). Diptych: (left valve) *Virgin and Child Enthroned with Two Angels, Saints Catherine of Alexandria and Agnes,* and the *Annunciate Angel;* (right valve) *Crucifixion with the Virgin, the Three Marys, and John the Evangelist,* and the *Virgin Annunciate,* c. 1390–1400. Tempera and tooled gold on panel; each 19⅛ × 8¾″ (48.5 × 22.2 cm). Siena, Pinacoteca Nazionale, no. 146

Bibliography
Reinach, vol. 2, 1907, p. 434 (Sienese School); Rankin 1909, p. lxxx, repro. p. lxxix (Pietro Lorenzetti); Berenson 1913, p. 54, repro. p. 291; Brown and Rankin 1914, p. 406; Thieme-Becker, vol. 12, 1916, p. 311; Van Marle, vol. 2, 1924, p. 524; Van Marle 1929, p. 309; Weigelt 1930, p. 91 n. 108; Brandi 1931a, p. 41; Edgell 1932, p. 165, fig. 213; Offner 1932, pp. 90, 95–96; Johnson 1941, p. 7; Pope-Hennessy 1948, p. 138; Sweeny 1966, p. 30, repro. p. 91; M. Reinders and H. W. van Os in Groningen 1969, n.p. n. 7, fig. 7 (reconstruction); Fredericksen and Zeri 1972, p. 74; *Bolaffi,* vol. 5, 1974, p. 125; Alessandro Cecchi in Siena 1982, p. 282; Jan Euwals in Avignon 1983, p. 256; Monica Leoncini in *Pittura* 1986, p. 572; Boskovits 1988, p. 36; Jan Euwals in Van Os et al. 1989, pp. 58, 61; Henk van Os and Norbert Middelkoop in Van Os et al. 1994, pp. 69, 179, color plate 21b; Philadelphia 1994, repro. p. 192; Giulietta Chelazzi Dini in Chelazzi Dini, Angelini, and Sani 1997, repro. p. 198

COMPANION PANEL for PLATE 25

Valve of a diptych: *Virgin and Child with Saints Lawrence and Andrew.* See fig. 25.2

c. 1387–88

Tempera and tooled gold on panel; 13⅞ × 9¼″ (35 × 23.5 cm). The Hague, Museum van het Boek-Museum Meermanno-Westreenianum, no. 806

PROVENANCE: Purchased in the first half of the nineteenth century by Baron van Westreenen van Tiellandt

EXHIBITED: Groningen 1969, cat. 7; Avignon 1983, cat. 95; Amsterdam 1994, cat. 21

SELECT BIBLIOGRAPHY: Jan Euwals in Van Os et al. 1989, cat. 12, pp. 58–62; Henk van Os and Norbert Middelkoop in Van Os et al. 1994, pp. 69, 179

AGNOLO GADDI

(*Agnolo di Taddeo Gaddi*)

Agnolo Gaddi could lay claim to a distinguished artistic pedigree. As his student Cennino Cennini (c. 1390, Thompson ed. 1932–33, vol. 1, p. 1) would proudly record in the *Libro dell'arte* (The Craftsman's Handbook) that Agnolo was the son of Taddeo, Giotto's favorite pupil. Although Agnolo likely trained in the workshop of his father, the earliest document that mentions him dates three years after Taddeo's death in 1366. It concerns payments for lost murals in the Vatican palace, a commission Agnolo worked on with several other artists, including his brother Giovanni, Giottino, Giovanni da Milano, and Bartolomeo Bulgarini (q.v.).[1] The project, likely commissioned in preparation for the return of Pope Urban V de Grimoard to Rome, was probably directed by Giovanni da Milano, the eldest of the group and the most influential artist to work in Florence in the 1360s (his elegant Gothic style transformed the Giottesque language of much mid-trecento Florentine painting). His probable influence on Agnolo Gaddi would explain the artist's early movement away from the style of his father and toward a Gothic manner.

Most of Agnolo's career was spent in Florence and nearby Prato. He is most famous for three mural cycles. He began the first soon after a bequest of the Florentine patrician Michele di Vanni Castellani, made on July 9, 1383, for a chapel in Santa Croce in Florence, which Agnolo painted in collaboration with Gherardo Starnina (q.v.).[2] In the same church he painted murals of stories of the True Cross in the choir for the heirs of Alberto degli Alberti (died 1348), who had left money for the decoration.[3] Continual problems between the Alberti family and the church's friars, however, delayed its execution until sometime in the second half of the 1380s or early 1390s. Gaddi also painted an altarpiece in about 1385–95 in the family's oratory in Antella, near Florence, probably commissioned by Benedetto degli Alberti.[4] In 1392 the rich Pratese merchant Francesco di Marco Datini, who kept an eye on what the powerful Alberti family was doing in Florence, called Gaddi to help decorate his residence in Prato.[5] This connection probably procured Agnolo the commission for his third series of murals, painted between 1392 and 1395 in the chapel of the Sacro Cingolo of the *collegiata* of the same city, where the precious relic of the Virgin's belt (*cingolo*) was revered.[6]

In addition to his mural projects, Agnolo Gaddi was Florence's major painter of altarpieces in the last decades of the fourteenth century. His work in this area has been reconstructed by Miklós Boskovits (1975, pp. 295–304). Agnolo's elegant Gothic style

identified him as Florence's most modern painter. Patrons readily distinguished his production from the much more conservative work of painters like Jacopo di Cione and Niccolò di Pietro Gerini (qq.v.). In attracting commissions and workshop assistants Gaddi undoubtedly took advantage of his innovative style as well as his family's venerable artistic legacy. He trained the most important artists of the next generation, including Lorenzo Monaco (q.v.), with whom he collaborated on several altarpieces.

1. For the full documents and lists of artists then working in the Vatican, see Cavalcaselle and Crowe, 1883–1908, vol. 2, 1886, pp. 102–3 n. 2.
2. Cole 1977, plates 13–24; Baldini and Nardini 1983, color repro. pp. 210–25.
3. Cole 1977, plates 25–33.
4. On deposit, Gallerie Fiorentine; Boskovits 1975, fig. 266.
5. Cole 1977, plates 50–54.
6. Cole 1977, plates 55–78.

Select Bibliography
Vasari 1550 and 1568, Bettarini and Barocchi eds., vol. 3 (text), 1967, pp. 243–50; Osvald Sirén in Thieme-Becker, vol. 13, 1920, pp. 25–28; Salvini 1934; Salvini 1934a; Salvini 1936; Cole 1967; Miklós Boskovits in *Bolaffi*, vol. 5, 1974, pp. 184–86; Boskovits 1975, pp. 117–224, 295–304; Cole 1977; Boskovits 1978; Roberto Salvini in Baldini and Nardini 1983, pp. 185–225; Stefania Ricci in *Pittura* 1986, pp. 572–73; Andrew Ladis in *Dictionary of Art* 1996, vol. 11, pp. 891–93; Ada Labriola in *DBI*, vol. 51, 1998, pp. 144–48

PLATE 26 (JC CAT. 9)

Predella panel of an altarpiece: *Saint Sylvester and the Dragon*

c. 1380–85

Tempera and tooled gold on panel with horizontal grain; 12⅛ × 15¾ × 1″ (31.8 × 40 × 2.5 cm)

John G. Johnson Collection, cat. 9

INSCRIBED ON THE REVERSE: *No. 26* (in ink on a paper label); *No 26/ Giotto di Bondone/ dicepolo di Cimabue/ 1276 + 1336* (in ink on a paper label); *A 3.* (in ink); *Nº. 3* (in ink); *Giotto* (in ink); *JOHNSON COLLECTION/ PHILA.* (stamped twice in black)

PUNCH MARKS: See Appendix II

EXHIBITED: Philadelphia 1920

TECHNICAL NOTES

The support consists of a piece of wood to which each edge strips of wood, approximately ⅜″ (1 cm) wide, have been nailed. The panel has been thinned, and there are several old splits in the wood.

FIG. 26.1 X-radiograph of plate 26, showing the horizontally grained wood panel and strips of canvas

Four strips of canvas—visible in the X-radiograph (fig. 26.1)—were adhered to the panel before the application of gesso. The borders of the panel are red except for the corner triangles, which are gilded and punched. Much of the present red is repaint. The top edge retains evidence of a barbe, and on the left there is some punched gilding beneath the red paint. It seems likely that the top and bottom had applied frame moldings and that the sides had gilt divisions between other scenes of the predella. The corner triangles seem to have continued onto the adjacent vignettes. There are areas of minor loss and there is a larger loss in the head of the kneeling left magician. The tall papal tiara is painted over the tooled halo and, therefore, was conceived after the painting was begun.

The picture was cleaned by Theodor Siegl in the summer of 1973 and again by Teresa Lignelli in February 1993, after which the losses were inpainted by Roberta Rosi.

PROVENANCE

This picture is described by Bernhard Berenson in a letter written to John G. Johnson from Settignano on January 11, 1911: "With regard to your 14th Cent. picture I have already heard from [Osvald] Sirén. The predella with the martyrdom of a saint that I supposed you had understood him as saying to be by Giotto he really ascribes to Giottino. That is less startling but I scarcely think he can be right. It looks to me 50 years later." The letter suggests that Johnson purchased the picture from the critic Sirén.

COMMENTS

The scene, set in a rocky landscape with a few ruins meant to represent a cave in the environs of Rome, shows Pope Sylvester (reigned 314–35) accompanied

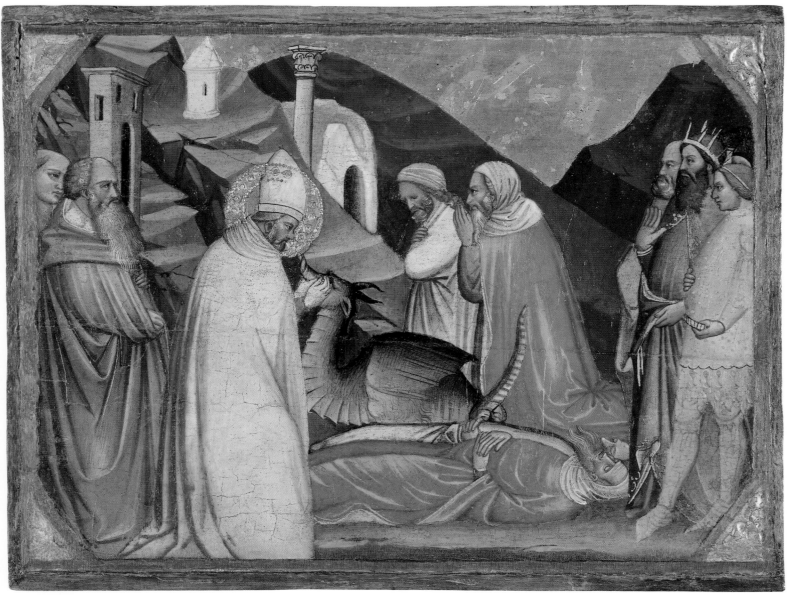

PLATE 26

by a young and an old attendant as he binds the jaws of a dragon. In the middle right two magicians lie faint on the ground, and above the same two rise up in veneration of the pope. The emperor Constantine the Great (reigned 306–37) looks on from the right with two attendants. The story is recounted in the *Golden Legend* by Jacopo da Varazze (c. 1267–77, Ryan and Ripperger ed., pp. 81–82):

> The priests of the idols came to Constantine and said: "Holy Emperor, there is a dragon in a cave, and since thou didst receive the faith of Christ, this dragon daily slays more than three hundred men with his breath!" The emperor reported the matter to Sylvester, who answered: "By the power of Christ, I shall render this dragon harmless!" And the priests promised that if he did this, they would be converted to Christ. Then Sylvester retired to pray. And the Holy Ghost appeared to him and said: "Go down without fear into the dragon's pit, taking two of thy priests with thee; and when thou standest before him, say these words to him: 'The Lord Jesus, born of a Virgin, crucified and buried, then risen from the dead and seated at the right hand of His Father, shall one day come to judge the living and the dead; and thou, Satan, await His coming in this place!' Thereupon thou shalt bind his maw with a cord, which thou shalt seal with a ring bearing the mark of the cross. . . ." Sylvester, with two priests, went down into the pit. . . . He addressed the dragon with the words of the Holy Spirit, then bound his jaws. . . . And coming out of the pit, he found two magicians, who had followed him to see if he dared to confront the dragon. These two lay almost lifeless on the ground, overcome by the pestilent breath of the monster. The saint revived them, and led them away completely restored; and straightway they were converted, and a great multitude with them.

Agnolo Gaddi's rendering of the story is a conflation of the two scenes in Maso di Banco's mural in the Bardi di Vernio chapel in Santa Croce in Florence (fig. 26.2): the binding of the dragon's jaws and the revival of the two magicians.[1] Agnolo has, however, adopted the most impressive feature of Maso's mural, the time lapse in which the magicians appear twice, first lifeless and then revived. Both Agnolo and Maso also show the emperor and his court watching the miracle.

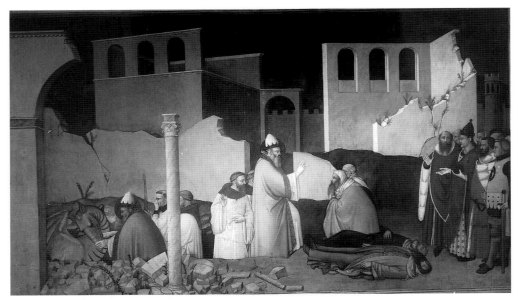

FIG. 26.2 Maso di Banco (Florence, documented 1338/42; died 1349). *Saint Sylvester Binds a Dragon and Revives Two Magicians,* c. 1332–35. Mural. Before restoration in 1998. Florence, church of Santa Croce, Bardi di Vernio chapel

As Georg Gronau noted in the 1931 auction catalogue of the Marczell von Nemes Collection, the Johnson panel was part of a predella of an altarpiece of which one other panel (fig. 26.3), representing the marytrdom of the apostle Andrew, is known. Both share similar dimensions as well as the same chamfered corners. No other sections of the predella or any part of the main altarpiece are known. The two existing scenes would have been originally placed under full-length images of Saints Sylvester and Andrew.

In 1913 Bernhard Berenson first published the Johnson Collection's panel as the work of a Florentine artist around the turn of the fifteenth century. He noted its similarities to the style of Agnolo Gaddi:

"Our predella has the taller proportions, the quicker movement, the more emphatic action, and the more rippling line of Florentine painting as Agnolo Gaddi left it rather than found it." In the 1931 Marczell von Nemes auction catalogue, Lionello Venturi suggested that the artist was the Master of the Manassei Chapel (later identified as Arrigo di Niccolò; q.v.). Roberto Salvini (1934a) recognized its association with Agnolo Gaddi by attributing the panel to the Vatican Master, an anonymous artist whose oeuvre is today largely recognized to be that of Agnolo. Miklós Boskovits (1975) was the first to assign the predella panels directly to Agnolo Gaddi; he dated the works about 1380–85. The closest parallels to the broad figural style and antecdotal quality of the Johnson predella panel and its companion are in the murals of the Castellani chapel in Santa Croce,[2] which was founded in 1383 and must have been built and decorated within the next two to three years.

1. Acidini Luchinat and Neri Lusanna 1998, postrestoration color repro. p. 211.
2. Cole 1997, plates 13–24; Baldini and Nardini 1983, color repro. pp. 210–25.

Bibliography
Berenson 1913, pp. 7–8, repro. p. 231 (Florence, end of the fourteenth or beginning of the fifteenth century); Philadelphia 1920, p. 2; Van Marle, vol. 9, 1927, p. 255; Georg Gronau in *Marczell von Nemes* 1931, p. 16; Lionello Venturi in *Marczell von Nemes* 1931, p. 16; Salvini 1934a, p. 223; Johnson 1941, p. 6 (Florence, late fourteenth century); Sweeny 1966, pp. 29–30, repro. p. 109 (Florence, c. 1400); Fredericksen and Zeri 1972, p. 76 (school of Agnolo Gaddi); Boskovits 1975, p. 297, fig. 244; Lippincott 1981, pp. 8–10, fig. 7, color detail p. 9 (attributed to Agnolo Gaddi); Philadelphia 1994, repro. p. 193

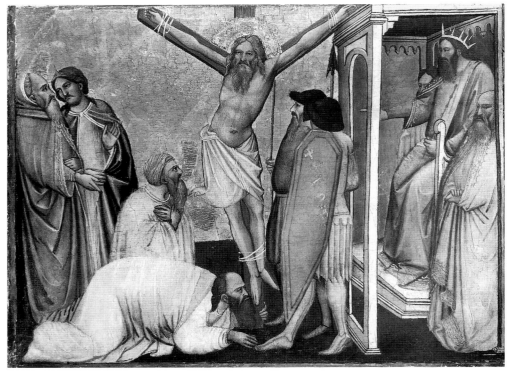

FIG. 26.3 Agnolo Gaddi. *Martyrdom of Saint Andrew,* c. 1380–85. Tempera and tooled gold on panel; 11⅛ × 14¾″ (28 × 37.5 cm). Milan, Rob Smeets. See Companion Panel

COMPANION PANEL for PLATE 26

Predella panel of an altarpiece: *Martyrdom of Saint Andrew.* See fig. 26.3

c. 1380–85

Tempera and tooled gold on panel; 11⅛ × 14¾″ (28 × 37.5 cm). Milan, Rob Smeets

PROVENANCE: Munich, Marczell von Nemes; sold Munich, Tonhalle, June 16, 1931, lot 8 (as Florentine Master, c. 1400); sold Amsterdam, Muller, March 18, 1952, lot 781 (as Florentine Master, c. 1400); sold London, Sotheby's, July 8, 1981, lot 87 (as Agnolo Gaddi); sold London, Sotheby's, July 8, 1998, lot 62 (as Agnolo Gaddi); Milan, Rob Smeets, 2003

SELECT BIBLIOGRAPHY: Georg Gronau in *Marczell von Nemes* 1931, p. 16; Salvini 1934a, p. 223; Kaftal 1952, p. 42; Sweeny 1966, pp. 28–29; Boskovits 1975, p. 301

NICCOLÒ DI PIETRO GERINI

FLORENCE, FIRST DOCUMENTED 1368; DIED 1415, FLORENCE

Niccolò di Pietro Gerini was the son of a butcher who actively participated in Florence's turbulent political scene of the 1370s and 1380s, twice serving as a *priore,* or top city official.[1] Except for the fact that Niccolò enrolled in the painters' guild in 1368, little is known of his early years. His possible identification with various persons named Niccholao, Niccolaio, and Niccholaio mentioned in documents related to the workshop of Jacopo di Cione (q.v.) would suggest he trained with him or his older brother Orcagna. In 1366 a Niccolao, called a *cofanerio,* or cabinetmaker (perhaps evidence of his initial training), was paid for his work on now-lost murals in the guild hall of the judges and notaries in Florence;[2] in 1370 a Niccolaio executed the design of the high altarpiece of San Pier Maggiore (see Jacopo di Cione, plate 37 [JC cat. 4]); and in 1372 the same artist began the *Coronation of the Virgin,* now in the Galleria dell'Accademia, commissioned by the Florentine mint.[3] Reasonable confirmation that this person is Niccolò di Pietro Gerini is found in the payment documents for a wall painting of the Annunciation in the Palazzo dei Priori of Volterra of 1383, on which Niccolò and Jacopo had worked together, because Niccolò's full name (Nicolao Pieri) is spelled out.[4] However, because the evidence is inconclusive, it is still possible that the artist who designed the San Pier Maggiore altarpiece and the *Coronation of the Virgin* for the mint is Niccolò di Tommaso (q.v.).

As was common practice in late trecento Florence, Gerini joined in partnerships with other artists to divide the work on major projects. His hand can be detected, for example, in the polyptych of the basilica of Santa Maria in Impruneta, finished in 1375, on which Pietro Nelli also collaborated. In Florence, Gerini and Ambrogio di Baldese painted murals on the façade of the Bigallo in 1386 and the audience hall of the Mercanzia, or merchant's court, in 1392–93. Gerini was among the three artists contracted to work on the high altarpiece of Santa Felicita in Florence, begun in 1399 (see fig. 11.3). The others were Spinello Aretino and Lorenzo di Niccolò; the latter has sometimes been erroneously considered Gerini's son.[5]

Gerini found a particularly receptive clientele in Pisa and Prato, executing in 1392 and 1395 mural cycles in the Franciscan convents of those towns.[6] Detailed correspondence and accounts—including autograph letters from the artist—document his other work in Prato for the famous merchant Francesco di Marco Datini:[7] murals in the interior of his house,[8] a now-lost crucifix for Santa Maria sopra Porto, and now-lost murals in San Francesco and the *collegiata* (now the cathedral). As a self-made man, Datini was very conscious of the other patrons of the artists who worked for him and was most pleased to learn that in 1395 Gerini was working for the Florentine patrician Jacopo degli Alberti in the convent known as the Paradiso degli Alberti.[9]

The correspondence reveals several key aspects of Gerini's attitudes about his work. First, although he worked in partnerships, he had a keen sense of pride in his personal style and the autography of his work. He asked, for example, that no other painter be allowed to touch his unfinished mural of the Crucifixion in San Francesco in Prato. Gerini likewise certainly did not appreciate interference in artistic decisions from either the patron or his delegates; with regard to the commission of the crucifix for Santa Maria sopra Porto, for example, he complained that Datini's adviser Giovanni Ducci, vicar of the convent of Santa Croce in Florence, was making ridiculous suggestions. And on occasion Gerini would even boast of his professional success, gloating over the great numbers, including *forestieri* (outsiders), who praised his murals in Pisa, and telling Datini that the crucifix could not have been better had it been designed by Giotto himself.

A historical evaluation of Gerini's work occurred in the nineteenth century. The Pisan antiquarians Alessandro Da Morrona (1812) and Giuseppe Rossi and Giovanni Paolo Lasinio (1820) were the first to record his signature and date on the mural cycle in Pisa. The German critic Carl Friedrich von Rumohr (1827) wrote several illuminating pages on the artist, prompting Giovanni Gaye to write in 1840 that the painter was "better known to the Germans than to the Italians."[10] Carlo Guasti (1871) found the numerous documents related to Gerini in the Datini archives, and Gaetano Milanesi (in Vasari 1568, Milanesi ed., vol. 1, 1878) located many others in the Florentine archives. J. A. Crowe and G. B. Cavalcaselle (1864) identified many works in Gerini's oeuvre and offered the first critical appraisal of them. In the twentieth century Richard Offner (1921) established a modern criterion for evaluating Gerini's production, and Frederick Antal (1948) made numerous important observations about his social milieu.

1. Pini and Milanesi 1876, vol. 1, no. 8.
2. Borsook 1982.
3. Giovanni Poggi in Sirén 1908, pp. 101–2. Bomford et al. 1989, color plate 170.
4. Battistini 1919.
5. On the correct identification, see Fahy 1978a.
6. The patron in Pisa was Lorenzo Ciampolini and in Prato, the Migliorati family. Those in Pisa are illustrated in Berenson 1963, plate 377; Fremantle 1975, fig.

652; and Boskovits 1975, fig. 188. The Prato project is illustrated in Baldini 1965 and Fremantle 1975, figs. 655, 657, 659–62.
7. See Mazzei, late fourteenth–early fifteenth century, Guasti ed. 1880, vol. 2, pp. 395–408; Pini and Milanesi, vol. 1, 1869, no. 8; Vasari 1568, Milanesi ed., vol. 1, 1878, pp. 585 n. 1, 640 n. 4, 675 n. 1, 691 n. 3; vol. 2, 1878, p. 8 n. 1.
8. Boskovits 1975, fig. 184.
9. Gregori and Rocchi 1985, figs. 62–86.
10. "Più noto ai tedeschi che agli italiani."

Select Bibliography
Mazzei, late fourteenth–early fifteenth century, Guasti ed. 1880, vol. 2, pp. 395–408; Da Morrona 1812, p. 63; Rossi and Lasinio 1820; Gaye, vol. 2, 1840, pp. 432–34; Crowe and Cavalcaselle 1864–66, vol. 1, 1864, pp. 365–66; vol. 2, 1864, pp. 20–23; Pini and Milanesi, vol. 1, 1869, no. 8; Guasti 1871 (reprinted Guasti 1874), pp. 71–86; Gaetano Milanesi in Vasari 1568, Milanesi ed., vol. 1, 1878, pp. 585 n. 1, 640 n. 4, 675 n. 1, 691 n. 3; vol. 2, 1878, p. 8 n. 1; Khvoshinsky and Salmi 1914, pp. 55–57; Osvald Sirén in Thieme-Becker, vol. 13, 1920, pp. 465–67; Offner 1921; Antal 1948, esp. pp. 210–13, 328–29; Miklós Boskovits in *Bolaffi,* vol. 5, 1974, pp. 340–42; Boskovits 1975, pp. 58–60, 98–101, 402–15; Fremantle 1975, pp. 313–22; Filippo Todini in Gregori and Rocchi 1985, pp. 80–93; Alessandra Guerrini in *Pittura* 1986, p. 642; Dillian Gordon in *Dictionary of Art* 1996, vol. 23, pp. 94–95

PLATE 27 (JC CAT. 8)
Christ in the Tomb and the Virgin

c. 1377

Tempera and tooled gold on panel with vertical grain; 40⅝ × 34″ (103.1 × 86.4 cm), painted surface 37⅞ × 30¾″ (96 × 78 cm)

John G. Johnson Collection, cat. 8

INSCRIBED ON THE REVERSE: *JOHNSON COLLECTION/ PHILA.* (stamped on a paper label); *8* (in pencil on the same label); scribbling in pencil on another paper label

PUNCH MARKS: See Appendix II

TECHNICAL NOTES
The panel consists of three members, each of which has a convex warp (fig. 27.1). There are splits following the wood joins, repaired at an early date with butterfly keys and splints of wood. There are also several other open splits: one runs from the top center approximately 10¼″ (26 cm) downward, and another from the bottom center approximately 7⅛″ (18 cm) upward. There is a large upper transverse member with an apparently original hanging hook in the center. The middle transverse member is not original, but it is old—certainly older than the above-mentioned repairs. Unlike the other trans-

FIG. 27.1 Reverse of plate 27, showing the structure of the panel

FIG. 27.2 Detail of the side of plate 27, showing some remnants of lime mortar and the spline covering the edge

verse members, the one at the bottom, which is also old, is made of a soft wood. Two other pieces of wood run along the sides of the panel; it is likely that they are also original or at least very old. Like all the other attached elements, these are adhered by heavy, old iron nails that were driven in from behind and bent over. In a few areas the nails have produced a ridge on the paint surface.

The picture retains a gilded molding that was attached by nails driven in from the front. The edges of the panel are masked by wood splines painted red (fig. 27.2). In addition, the splines show remnants of a lime mortar used for fitting the structure into an architectural setting. In areas where these splines no longer exist, the wood is not finished.

The construction of the panel itself is distinguished by several unusual features. In places, original gilding extends almost to the edge, beneath the moldings on the surface. The present frame moldings were nailed to the surface of the panel after it had been gilded and painted; at that point the moldings themselves were gilded. Regularly spaced tacking holes along the inner edges of the molding suggest that something was attached to protect the rest of the panel when the molding was gilded. Such

a covering may have also been used to protect the surfaces when the edges of the panel were being mortared into a niche.

An X-radiograph (fig. 27.3) shows that the panel has been adapted from its original form. Underneath the present molding, gold punch work is visible along the sides above the tomb and at the top. Also visible in the X-radiograph along the sides is the area where the panel's original frame moldings were removed. At the top not only was the molding removed but the wood beneath it was cut away. A new surface molding and splines of wood around the edges were attached before the panel was set into a niche. While it is not certain when this alteration took place, the carpentry and nails appear old, and there is nothing in the construction to suggest that it did not occur at an early date.

The X-radiograph also shows two pieces of canvas on the panel—one strip along the glue line of the center planks of wood and another patch that covers a knot in the wood in the upper right.

The painting has undergone a number of restorations. At some point the original gold was covered with mordant gilding. At an unknown date this was removed, although isolated patches of it still rest on the surface.

The heads of the two figures show oil retouching that includes such details as the Virgin's tears and veil and the blood on Christ's head. This retouching is worked in and around details of the original and may be very old, possibly from the sixteenth century. It occurs, however, only in isolated areas. For instance, even though Christ's torso is much abraded, it was not reworked as extensively as his face. While there are repaints in the Virgin's blue mantle, much of it has a good surface.

The red of the Virgin's dress is a restoration that was done in what appears to be egg tempera. The original color was dark blue. Microscopic examination reveals an intermediate layer of dark red paint, which may have been an earlier restoration or a preparatory layer for the vermilion.

The blood on Christ's side wound appears to have been executed in tempera and reinforced with oil. The blood on his hand and head is later oil paint. There were also several campaigns of extensive inpainting along the seams of the cracked joints.

The mordant gilding on the star on the Virgin's shoulder is restoration but was executed over the original design. The mordant gilding on Christ's loincloth is abraded.

When Hamilton Bell and Carel de Wild inspected the painting on April 23, 1920, they formed such a negative opinion that, although the picture needed cradling, they decided the job was "not worth doing" since the panel was "almost entirely repainted. Very poor work." On May 16, 1955, Theodor Siegl consolidated loose paint flakes and small losses in the face and body of Christ, largely along the cracks in the panel. He also noted that the surface was "fairly clean."

FIG. 27.3 X-radiograph of plate 27, showing the construction of the panel

PROVENANCE

In November 1909 Johnson bought this painting and one of Saint John the Baptist[1] from Herbert Horne for a total of 11,000 Italian lire. Johnson had first seen the painting in Horne's house on his visit to Florence in the summer of 1909 (see Horne letters dated Florence, October 25 and November 22, 1909, and January 31, 1910). In his November letter Horne wrote the following on the painting's attribution and provenance:

The Pieta which I think is doubtless by Niccolo di Piero Gerini, and one of his better works, must have been originally painted for the Florentine church of Ognissanti, which in the "Tre-cento" belonged to the "Umiliati," an order who employed Giotto, Giovanni da Milano and many of the best Trecento masters to decorate their church. In 1554, the church and convent of Ognissanti were granted by the Grand Duke Cosimo I to the Franciscans; and the convent of S. Caterina delle Ruote was given to the "Umiliati" in lieu of their original house. To S. Caterina, the "Umiliati" carried many of their pictures, and among the rest must have been the "Pieta," which for long hung in the passage leading to the choir of the church, as a label on the back of the panel records. The order of the "Umiliati" having been suppressed, in 1591, the convent of S. Caterina became a home for abandoned children; and so it remained until 1778, when it was suppressed by the Grand Duke Pietro Leopoldo, and the building and its contents granted to the elementary schools bearing his name. Sometime in the last century, the former convent of S. Caterina was sold by the Leopoldine Schools,

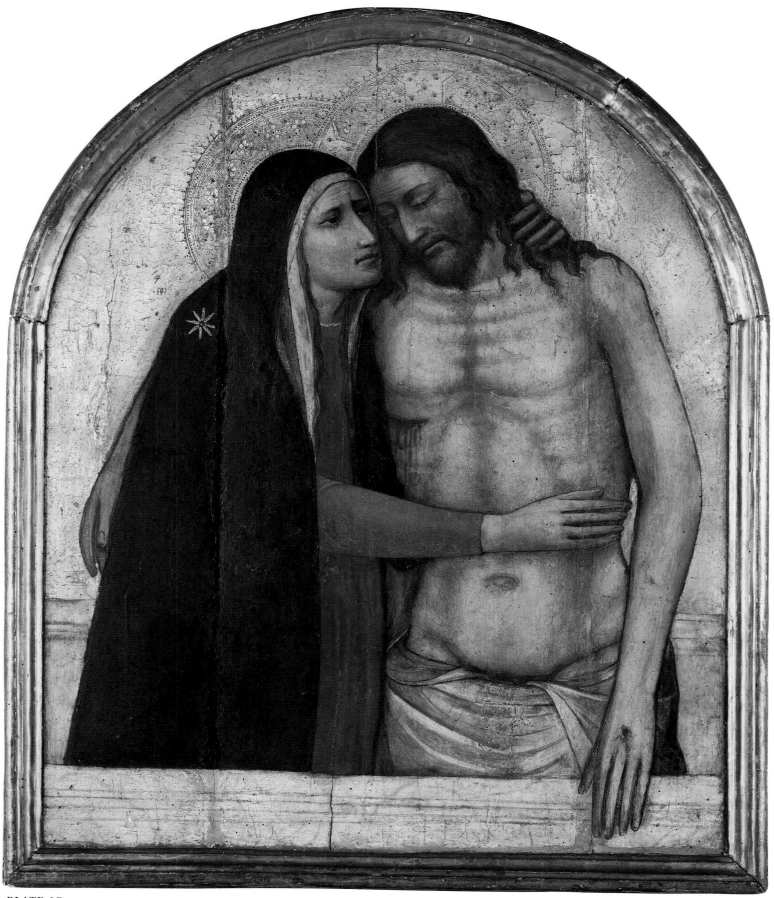

PLATE 27

and all the pictures and other moveable property were taken to the former Spedale di S. Paolo, in the "Piazza di S. Maria Novella" which also came into their possession at the time of the suppression: and the "Pieta" was still hanging on the walls of the Refectory of S. Paolo, when I bought it, two or three years ago.

The label on the back of picture that Horne mentioned is no longer present, and unfortunately there is no transcription of it in the Johnson Archives. While Horne's suggestion that the painting came from the Umiliati's church of the Ognissanti is likely, it cannot be absolutely confirmed, for when the order exchanged the Ognissanti with the Franciscan Capuchins for Santa Caterina delle Ruote in 1554,[2] the Umiliati did not take all works of art with them to their new location as many were in family chapels.[3] The Umiliati were actually suppressed in 1571, not 1591, as Horne wrote, and the *beni,* or holdings, in Santa Caterina delle Ruote were given to the Knights of the Order of Santo Stefano. In 1591 the Bigallo, an important Florentine charitable organization, acquired Santa Caterina delle Ruote to run as a hospice. In 1778, after the suppression of the Bigallo, Santa Caterina delle Ruote became first a school and then a tobacco factory. In 1789, when the hospital of San Paolo dei Convalescenti—the "Spedale di S. Paolo" Horne mentions—became a school, the movable property of Santa Caterina delle Ruote was transferred there.[4]

COMMENTS

The Virgin stands in the tomb, holding up the Dead Christ. Their heads touch, and his right arm has slumped over her shoulder. The two figures dominate the picture surface to create an immediate and moving effect. A suggestion of space is conveyed by Christ's left arm, which hangs over the front edge of the tomb and appears to be within the viewer's reach.

Horne sold the painting to Johnson as a Gerini. Later Richard Offner (1921, 1981) and Bernhard Berenson (1932) described it as a workshop production based on the master's design. Given Gerini's working methods and practice of collaboration, and the fact that the heads were skillfully repainted, probably in the sixteenth century, the absolute autography of this picture is impossible to determine. The image, however, is one of the most powerful inventions of Gerini's oeuvre.

Because of a certain consistency in style over time, the chronology of Gerini's undated works is difficult. As Offner (1921, 1927) suggested, several features argue for a dating in the early to mid-1380s. The Virgin's loose hair and the emphasis on Christ's rib cage relate the picture to the large altarpiece of the *Lamentation* Gerini made for Orsanmichele in Florence before 1388.[5] Furthermore, both works would seem to predate the *Baptism of Christ* in London, which is documented to 1387.[6] That picture signals the start of a smoother handling in the nude body of Christ, which is seen also in two other

Pietàs by Gerini: the panel, now in Arezzo, usually dated about 1400,[7] and his very late mural in the former church of Santa Veridiana in Florence.[8] The closest analogies to the Johnson panel are to be found in Gerini's crucifix, dated 1380, in Santa Croce in Florence, in which, for example, the mourning Virgin in the terminal is very similar.[9]

The Johnson picture is a rare depiction of the Virgin supporting Christ in the tomb. Christ as the Man of Sorrows is usually represented as alone in the tomb, with his arms either crossed against his chest or outstretched to show his wounds.[10] One of the earliest examples is an altarpiece made by the Sienese painter Simone Martini.[11] An early Florentine example is found in a polyptych attributed to Taddeo Gaddi, possibly from Santa Croce in Florence, but the mourning Virgin is not present.[12] A 1365 painting by Giovanni da Milano shows the Virgin supporting the Dead Christ and, in an act of empathy and sorrow, touching the wound in his side.[13] The Johnson painting is a variation on the theme that emphasizes the Virgin's compassion and participation in Christ's suffering by showing her embracing him within his own tomb.

An important precedent for Gerini's composition is found in a painting of about 1362 by the Neapolitan Roberto d'Oderisio, in which both the Virgin and Saint John are in the tomb with Christ, and the symbols of the Passion are depicted in the background.[14] It is unclear if the Neapolitan's composition was influenced by Tuscan examples or vice versa. A now-fragmentary mid-trecento mural that was part of the decoration of the old Florentine cathedral (now in the crypt of the present cathedral) shows the Virgin mourning by Christ's tomb and the Passion symbols, and may have been the model for the Roberto d'Oderisio painting and several late trecento Florentine variants.[15] In addition, Gerini represented a version of this same composition in a painting once in Santissima Annunziata in Florence,[16] and he painted at least two other depictions of the Virgin in the tomb with Christ: the painted altar frontal of the chapter house of San Francesco in Prato in about 1395[17] and a mural for San Felice in Piazza in Florence.[18] Other rare examples of this iconography occur in manuscripts by the Brussels Initials Master (Italian, late 1300s–early 1400s).[19] In the 1420s Giovanni Toscani (q.v.) would depict such a Man of Sorrows on the back of his altarpiece for Santissima Annunziata in Orbetello.[20]

The purpose and original location of the Johnson panel are problematic. The most obvious comparison is with the painting by Giovanni da Milano, which is an independent image whose medium size suggests that it was either made for a small private chapel or possibly, because of its long, narrow shape, hung on a pilaster in a church. Although Gerini's painting is larger and broader, its unusual form indicates that it, too, must have been an independent devotional image. It was most likely made for a private Florentine burial chapel known as an

avello, which was set into an arched niche that sometimes contained an image. Only frescoed examples such as the one painted by Giovanni Toscani for the Ardinghelli chapel in Santa Trinita (see fig. 82.7) survive in situ, but many of these burial spaces must have also had panel paintings. A lunette-shaped painting by Giovanni da Milano showing the Virgin and Child with two donors, in the Metropolitan Museum of Art in New York, most likely decorated such a chapel.[21] The Man of Sorrows was an even more appropriate subject for an *avello* and is in fact the theme of the niche in the Ardinghelli chapel.

On the basis of archival research and the now-lost label on the reverse of the picture, Herbert Horne proposed a provenance for the Johnson painting of the Florentine church of the Umiliati. Indicative of the order's sympathy for a painter like Gerini are the murals that were executed in the sacristy of the Ognissanti in the 1390s by a Gerinesque painter, possibly Gerini's erstwhile partner Pietro Nelli.[22] In addition, the iconography of the Man of Sorrows seems to have enjoyed a certain fortune in the Umiliati monastery in Florence, as a detached mural of a single image of the subject, by Lorenzo Monaco (q.v.), comes from the refectory there.[23]

The only place in the church of the Ognissanti that today presents itself as a possible candidate for the original location of Gerini's *Christ in the Tomb and the Virgin* is the Gucci family's tomb, dated 1377, found under a staircase at the end of the left transept.[24] The back wall of the deep-set niche of this tomb is painted with a depiction of the instruments of the Passion. Although it cannot be proved the painting came from this space, also because the church has undergone numerous renovations, it would have constituted a particularly appropriate image for a tomb.

1. Biagio d'Antonio, cat. 77; Philadelphia 1994, repro. p. 81.
2. For the Johnson panel, an original provenance from Santa Caterina delle Ruote is unlikely. The cathedral's canons lived there until 1435, when Augustinian nuns took over the premises. They, however, were forcibly removed in 1491, and all their property became the possession of the canons. Before the Umiliati assumed possession in 1554, several other monastic communities had lived in the convent. On the complicated history of Santa Caterina delle Ruote, see Richa, vol. 7, 1758, esp. pp. 274–78; Paatz, vol. 1, 1940, pp. 429–33; and Fantozzi Micali and Roselli 1980, pp. 96–97.
3. Those that were not transferred include at least three important paintings, now in the Uffizi, that decorated the church and sacristy: Giotto's *Maestà* then probably on the rood screen of the Ognissanti (inv. 8344; Uffizi 1992, postrestoration color repro. p. 9); Giovanni da Milano's high altarpiece, now fragmentary and in part dispersed (inv. 459 [five main panels and predella]; Marcucci 1965, figs. 48a–l); and Bernardo Daddi's (q.v.) triptych, then in the sacristy (see fig. 17.6). For a further reconstruction of the Giovanni di Milano, see Cavadini 1980, pp. 60–71. Giotto's *Dormition of the Virgin* in Berlin (Staatliche Museen, no. 1884; Boskovits 1988, pp. 57–58, plates 102–8, color plate 1

[detail]) was described by Lorenzo Ghiberti in the mid-fifteenth century as being in the church, but all trace of it was lost by 1568, when Vasari was writing, making it possible that it was one of the paintings that the Umiliati took with them.

4. On San Paolo dei Convalescenti, see Paatz, vol. 4, 1952, pp. 602–8; and Fantozzi Micali and Roselli 1980, pp. 234–35.

5. On deposit in San Carlo dei Lombardi, Florence, from the Gallerie Fiorentine (no. 8490; Cohn 1956, pp. 176, 177 nn. 48–52; Marcucci 1965, plate 66).

6. National Gallery, no. 579; Davies and Gordon 1988, plate 60.

7. From the church of Santissima Annunziata, Florence; now on deposit in the Museo Statale in Arezzo from the Gallerie Fiorentine (inv. 6148; Marcucci 1965, p. 114, cat. 74, fig. 73).

8. Boskovits 1975, fig. 174.

9. Photo Alinari 3916.

10. Panofsky 1927; Bertelli 1967; Schiller, vol. 2, 1968, pp. 212–15, 225–29; Stubblebine 1969; and Van Os 1978.

11. From Pisa, church of Santa Caterina; Pisa, Museo Nazionale di San Matteo; Martindale 1988, plates 49–52. There the mourning Virgin is depicted in a separate compartment on the left. For a similar iconography in the Johnson Collection, see Taddeo di Bartolo's predella (plate 78 [JC cat. 95]). Pietro Lorenzetti (q.v.) painted a similar predella for the altarpiece of the Blessed Umiltà (now in the Uffizi, inv. 8347, 6120–26, 6129–31; Volpe 1989, figs. 154–59).

12. Present location unknown; Ladis 1982, pp. 84–85, figs. 2–3.

13. Florence, Galleria dell'Accademia, no. 8467; Tartuferi 2001, postrestoration color repro; and Boskovits and Tartuferi 2003, plates 33–35. The coat of arms indicates that it was executed for a member of the Florentine Strozzi and Rinieri families.

14. Cambridge, Harvard University Art Museums, Fogg Art Museum, no. 1937.49; originally the center of the altarpiece of the main chapel of the Incoronata in Naples, built by Queen Giovanna to house a relic of the Crown of Thorns. Bowron 1990, fig. 498; Leone de Castris 1986, color plate 67.

15. Florence 1967, pp. 47–48, cat. 23, plates XXXVI–XXXVII (Florence, mid-fourteenth century); Bargellini 1970, color repros. pp. 77, 80–81, 96–97.

16. See n. 7 above.

17. Baldini 1965, color plate XIV.

18. Meoni 1993, color plate X.

19. Book of Hours, c. 1402, Madrid, Real Biblioteca, Ms. 2099, folio 172 verso; and the Hours of Charles the Noble, c. 1405, Cleveland Museum of Art, no. 64.360, p. 255. Both illustrated in Meiss 1967, figs. 808–9.

20. Florence, Galleria dell'Istituto degli Innocenti, no. 34 verso; Bellosi 1977, plate 49.

21. No. 07.200, 27⅛ × 56¾″ (68.9 × 144.1 cm); Zeri and Gardner 1971, plate 19.

22. Boskovits 1975, p. 418, fig. 195.

23. Florence, Galleria dell'Istituto degli Innocenti, no. 248; Bellosi 1977, plate 285; Eisenberg 1989, fig. 169.

24. Ronan 1982, cat. p. 47, entry no. 13, plate 13.

Bibliography
Berenson 1913, p. 7, repro. p. 230; Osvald Sirén in Thieme-Becker, vol. 13, 1920, p. 466; Offner 1921, p. 237; Van Marle, vol. 3, 1924, p. 624 n. 1; Offner 1927, p. 90; Berenson 1932, p. 396; G. G. King 1934, p. 297, fig. 3; Berenson 1936, p. 340; Johnson 1941, p. 12; Berenson 1963, p. 160; Sweeny 1966, p. 57, repro. p. 103; Fredericksen and Zeri 1972, p. 81 (attributed to Niccolò di Pietro Gerini); Offner 1981, p. 84; Philadelphia 1994, repro. p. 193

PLATE 28 (JC INV. 1163)

Section of an altarpiece: *Scourging of the Four Crowned Martyrs*

c. 1385–90

Tempera, silver, and tooled gold on panel with vertical grain; 23⅝ × 16⅞ × 1¼″ (60 × 43 × 3.2 cm)

John G. Johnson Collection, inv. 1163

INSCRIBED ON THE REVERSE: *R. Dogana di Milano* (an export stamp, dated August 12, 1909, repeated many times)

PUNCH MARKS: See Appendix II

TECHNICAL NOTES
The panel consists of three vertical members. There are joins 1⅜″ (3.5 cm) and 9¾″ (24.8 cm) from the left. Strips that were later added to the sides support the nonoriginal applied frame moldings. The presence of original decoration on the reverse (see fig. 28.5) indicates that the panel retains its original thickness. Still visible, despite having been painted over, is a vertical strip of blue paint with gold stars in relief extending some 5½″ (14 cm) from the left of the reverse. The inner edge of this strip has its original barbe. Originally the paint abutted a vertical transverse batten, about 1⅝″ (4.2 cm) wide. This was removed, but remnants of the batten's wormeaten wood and residues of glue remain. The rest of the reverse was not decorated and would not have been visible to the viewer.

The top edge of the panel has been cut, but the gold background retains part of the punch pattern that originally defined the top. Scored lines demarcate the other three edges.

Silver glazed with red to indicate blood was used for the morning star wielded by the torturer, and silver was used for his belt buckle. The now-abraded mordant gilding has an unpigmented mordant.

A large area of retouched loss is in the upper right, above the martyrs' heads. The painting is otherwise in fair condition. In 1956 Theodor Siegl made minor repairs, but no other previous treatment is recorded.

PROVENANCE
The picture was sold to Johnson by Osvald Sirén as a work by Jacopo di Cione. Although the letter Sirén sent Johnson from Islinge-Lidingö, Sweden, is undated, it is known that the painting entered the collection in 1914. The export stamp on the reverse indicates that it left Italy in 1909. It is proposed here that the picture originally came from the church of Orsanmichele in Florence (See Comments).

COMMENTS
The setting is an open tribunal hall. On the right are the Four Crowned Martyrs, bound and wearing only underpants. They are being flogged by a torturer with an instrument known as a morning star, which consists of three spiked spheres on whips attached to a cane. Traces of the martyrs' blood can be discerned on the silver spikes. On the left the Roman tribune Lampidarius, who ordered their beating, is strangled by two devils as two of his courtiers watch. In the upper left Christ, among a host of red seraphim and barely visible blue cherubim, sends down four golden rays of divine light.

The most detailed account of this episode in the legend of the Four Crowned Martyrs was written in the tenth century by the Neapolitan subdeacon Pietro.[1] The Roman emperor Diocletian (reigned 284–305) much desired the services of these four stonemasons, but their refusal to craft pagan images or to make a sacrifice to the sun god caused him to have them tortured:

> Then the tribune, in that he saw their constancy and that by no reason would they be induced to bend, hurried to relate all to Caesar. Caesar replied: "Because in any case I so desire to have them because of their incomparable and proficient skill, we suggest that you scourge them with whips and scorpions; perhaps they will relent and obey our desire." Then five days later he [the tribune] sat enthroned before the temple of the sun and ordered that they be brought in. Because of their lack of terror he showed them all types of torments saying: "As you wish to be renowned among friends of the sacred Empire, we now order you to sacrifice to the sun god; and failing to do so, your bodies will undergo all type of torture." The saints answered saying: "We must say this, so we now say to you, that neither tortures or flattering words will separate us from the charity of the Lord Jesus Christ." Then the angry tribune ordered that they be stripped and whipped with scorpions. But the Lord showed the power of his name and the virtue of their sanctity. That same hour Lampidarius the tribune, taken by a demon, expired.[2]

A twelfth-century transcription of this text is found in a *Passionale sanctorum,* now in the Biblioteca Mediceo-Laurenziana in Florence; it was donated by Cosimo and Lorenzo de' Medici to the Franciscan friary of San Francesco del Bosco in 1435 and probably was in Florence before that.[3] The numerous other manuscripts of the *Passionale sanctorum* with texts about the Four Crowned Martyrs that can now be found in Florentine libraries suggest that the saints' legend was familiar in late medieval Florence.[4]

It was only in the twentieth century that scholars have sorted out the confusing identity and history of the cult of the Four Crowned Martyrs.[5] The most common explanation in the late Middle Ages was provided by Jacopo da Varazze in the *Golden Legend* (c. 1267–77, Ryan and Ripperger ed., p. 662):

> The Four Crowned Martyrs were Severus, Severianus, Carpophorus, and Victorinus, who were beaten to death with leaded scourges by order of

FIG. 28.1 X-radiograph of plate 28, showing the vertically grained wood panel

Martyrs before the Emperor (fig. 28.3) in the Denver Art Museum; and the *Burial of the Four Crowned Martyrs* (fig. 28.4) in the Birmingham Museum of Art in Alabama.[8] An examination of the paintings suggests that they formed the lateral wings of a tabernacle that was meant to hang on a pier of a church and that had an image of the four saints in the center.

The reverses of the Johnson, Florence, and Birmingham panels (figs. 28.5–28.7) have strips of blue dotted with gold stars that extend approximately 5½–5⅞″ (14–15 cm) from the left edge. In the uncut Johnson panel the inner edge of this area has a barbe that would have originally abutted a vertical batten approximately 1⅝″ (4.2 cm) wide. In the Birmingham panel a corresponding but smaller painted area, ¼″ (0.6 cm) wide, shows evidence of distressed wood that suggests a similar makeup. The bare wood in this area of the Florence panel has been smoothed. From this evidence we can conclude that the backs of the panels were partially visible and that each lateral wing was somehow spanned by a vertical batten. The panel in Denver lost any paint that was on the back when it was thinned for cradling. X-radiographs of it and the Johnson panel (fig. 28.1) have revealed that they were painted on the same plank of wood, although the scenes were not necessarily adjoining. The order of the panels is not completely certain, as it is likely there are two missing scenes. The Florence panel would have been on the top left because it was originally arched, and the Johnson and Birmingham panel would have been on the right of the complex, with the Birmingham panel, which depicts the last episode of the story, probably at the bottom.

The complex can be compared with two tabernacles executed in the first half of the 1370s by Giovanni del Biondo for altars on piers in the cathedral of Florence, now in the Museo dell'Opera del Duomo: *Martyrdom of Saint Sebastian and Four Scenes from His Life*[9] and *Saint Catherine of Alexandria and Eight Scenes from Her Legend* (fig. 28.8).

The model for these pier or pilaster paintings was the tabernacle of Saint Matthew (fig. 28.9), now in the Uffizi, that was designed by Orcagna and finished by his brother Jacopo di Cione in about 1367–68 for the pier belonging to the Guild of Bankers (Arte del Cambio) in Orsanmichele. Not a simple triptych that hung flat on the front wall of the pier, this picture had wings that were fixed at an angle to cover the two side walls as well.[10]

The subject of the Johnson picture and its companion panels suggests that they, too, were painted for the Guild of Stonemasons and Woodworkers and hung on their interior pilaster in Orsanmichele, even though this theory cannot be proved by documentation or provenance.

Orsanmichele was the site of the loggia of the grain and cereal market built in the 1200s where a church dedicated to the archangel Michael had previously stood. An image of the Virgin that hung

Diocletian. Their names were unknown at the time, and were not discovered until many years later, when the Lord revealed them. Consequently it was decreed that their memory should be honoured under the names of five other martyrs, Claudius, Castorius, Symphorianus, Nicostratus, and Simplicius, who suffered death two years after the martyrdom of the first four. The latter five were skilled in the art of sculpture, and when they refused to carve an idol for Diocletian, or to offer sacrifice, he ordered them to be placed alive in leaden chests and thrown into the sea, about the year of the Lord 287. Pope Melchiades then decreed that the former four should be honoured under the names of the latter five, and should be called the Four Crowned Martyrs. Hence, although at a later time their names came to light, the custom obtained of calling them by that common title.

In many European cities, including Florence, the Four Crowned Martyrs were the patron saints of the stonemasons and woodworkers, and, by extension, sculptors. In Florence the interior piers and pilasters of Orsanmichele have murals with images of the patron saints of the city's guilds. The pier belonging to the Guild of Stonemasons and Woodworkers (Arte dei Maestri di Pietra e Legname) was decorated in 1403 by Ambrogio di Baldese and Smeraldo di Giovanni with a rare representation of all five martyrs.[6] The exterior niche of the same building under the guild's patronage contains a sculpture by Nanni di Banco of only the Four Crowned Martyrs.[7] It dates shortly after 1414–15 and suggests that both traditions easily coexisted.

The Johnson picture can be related to three other panels showing scenes from the legend: the *Emperor and His Entourage before a Column* (fig. 28.2) in a private collection in Florence; the *Four Crowned*

PLATE 28

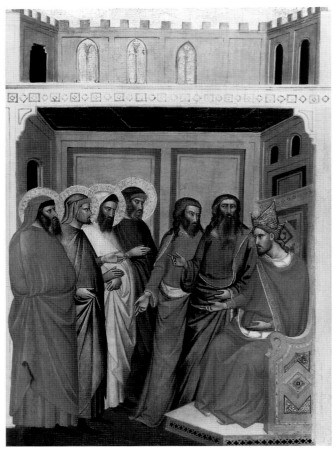

FIG. 28.2 Niccolò di Pietro Gerini. *Emperor and His Entourage before a Column*, c. 1385–90. Tempera and tooled gold on panel; 21½ × 17½″ (54.5 × 44.5 cm). Florence, private collection. See Companion Panel A

FIG. 28.3 Niccolò di Pietro Gerini. *Four Crowned Martyrs before the Emperor*, c. 1385–90. Tempera and tooled gold on panel; 24¾ × 17¾″ (63 × 45 cm). Denver Art Museum, E-IT-18-XV-927 (Kress 17). See Companion Panel B

in the loggia became the object of popular devotion, and in 1291 a religious and charitable society was founded in its honor. After a reconstruction of the loggia in 1337, it was decreed on April 12, 1339, that the twelve major guilds of Florence and the political party known as the Parte Guelfa each be assigned an exterior pier on which to place a tabernacle for an image of its patron saint.

A similar arrangement was made for the interior, where the so-called minor guilds were also allocated space. By 1351 (and in fact most likely shortly after 1339) some interior piers and pilasters were already decorated, as it is known that Jacopo del Casentino's tabernacle of Saint Bartholomew for the Guild of Grocers (or Cheesemongers) (Arte dei Pizzicagnoli) was then hanging on the west face of the central east pier.[11] In 1367 the Guild of Bankers, a major guild, commissioned the three-sided tabernacle of Saint Matthew for the interior pilaster on the south side of the oratory. Most guilds originally opted to hang a panel painting on the face of their assigned piers, although some piers were painted. From the minutes of deliberations on April 30, 1381, in which the Guilds of Locksmiths (Chiavaioli) and Vintners (Vinattieri) were assigned their locations, it can be

deduced that the following guilds already had been allocated a space and possibly had decorated it: in the central east pier, the Locksmiths, Grocers, and Bakers (Fornai); and in the central west pier, the Vintners, Cloth Dealers (Rigattieri), and Harness-Makers (Correggiai). The document states that the Locksmiths were assigned the north wall of the central east pier, across from the one belonging to the Guild of Carpenters (Arte dei Lignaioli), and that the Vintners were placed across from the pilaster of the Stonemasons and Woodworkers.[12] The minutes of April 1381 also record that many of the piers and pilasters in Orsanmichele had not yet been furnished with tabernacles. It is probable that the painting for the pier of the Guild of Stonemasons and Woodworkers was completed sometime before 1392, when a document mentions that the pilaster of the Guild of Armorers (Corazzai) had not yet been decorated, implying that by that point most of the other pilasters in the oratory had been provided with tabernacles.[13] A date around 1385–90, the period of Gerini's closest association with Orsanmichele, is likely.

At about the same time the rest of the oratory's interior decoration was completed. In 1386 the

loggia of Orsanmichele was finally enclosed, and stained glass for the windows commissioned. A program for mural paintings in the vaults was conceived by the poet Franco Sacchetti and executed by Ambrogio di Baldese, Mariotto di Nardo, and Lorenzo di Bicci. Around 1402 it was decided to remove the guilds' panel paintings and replace them with murals. Presumably each guild retained its original painting. It is known, for example, that Orcagna's Saint Matthew altarpiece was sent to the Florentine hospital of San Matteo, patronized by the Guild of Bankers. Several other paintings that once hung in Orsanmichele can also be traced, including some that entered Florentine museums through the Camera del Commercio, the organization that came into possession of former guild property after of the guilds were suppressed in 1770.[14]

If the tabernacle by Gerini was from the pilaster of the Guild of Stonemasons and Woodworkers, then sometime around 1402 it was probably moved to the guild's hall in the present chiasso dei Baroncelli in Florence.[15] However, as almost all records of the guild are lost, it has proved impossible to confirm this, and none of the fragments can be traced

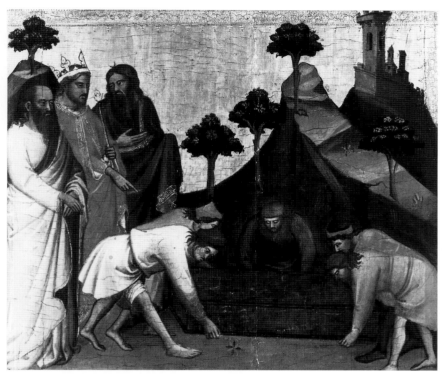

FIG. 28.4 Niccolò di Pietro Gerini. *Burial of the Four Crowned Martyrs*, c. 1385–90. Tempera and tooled gold on panel; 15⅞ × 18″ (40.3 × 45.7 cm). Birmingham (Alabama) Museum of Art, Gift of the Samuel H. Kress Foundation, 1961.119 (Kress 1719). See Companion Panel C

FIG. 28.5 Reverse of plate 28, showing some of the original star pattern on the left. The back of this panel has been repainted.

FIG. 28.6 Reverse of fig. 28.2, showing traces of the original blue paint on the right

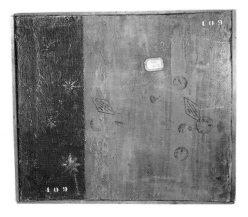

FIG. 28.7 Reverse of fig. 28.4, showing the original blue paint with stars on the left

prior to the early twentieth century. The document indicates that the guild's pilaster had been assigned by that point and that it was the same pier on the north wall that would be painted in 1403 with five crowned martyrs by Ambrogio di Baldese and Smeraldo di Giovanni. This means that Gerini's tabernacle would have been originally located on a pilaster directly opposite the one on the south side of the oratory that held Orcagna's large triptych of Saint Matthew, which in some respects was the model for the Gerini. Of all the tabernacles that can be traced to Orsanmichele, Orcagna's is the only one that had wings with scenes from the life of a saint. Its lateral panels each measure approximately 74¾ × 29½″ (190 × 75 cm). The Johnson panel and its companions are considerably narrower, which suggests that they did not wrap around the pier and that Gerini's tabernacle was most likely flat. Because a portion of the backs of the Johnson, Florence, and Birmingham panels are decorated, it can be assumed that these sections jutted out from the front face of the pilaster and thus were visible. The front of the pilaster is 63⅜″ (161 cm) across, but at each side there is a recessed area 16½″ (40 cm) wide. The backs of the wings

may have been partly visible if they overlapped the recesses, or they may have actually extended beyond the pilaster on either side. Further conclusions are impossible since the tabernacle's central section and all of its framing elements are missing.

Gerini had a close association with Orsanmichele: he designed several of the stained-glass windows;[16] painted the large *Lamentation* now in San Carlo dei Lombardi across the street from the oratory;[17] and, after the tabernacles were removed from the interior, executed some of the murals that replaced them.[18] There is no specific mention of the altarpiece in the documents of Orsanmichele. The payments were probably made by the guild itself, as was the case with the payments to Orcagna and his workshop for the Saint Matthew tabernacle. In 1404, when a mural was executed to replace Gerini's tabernacle, it was the directors of Orsanmichele who paid the artists.

1. See Savio 1901.
2. Author's translation from the Latin as transcribed by Hippolytus Delehaye in *AA.SS.*, Novembris III (1910), pp. 783–84.
3. Ms. Mugellanae, De Nemore codex VIII. See Bandini

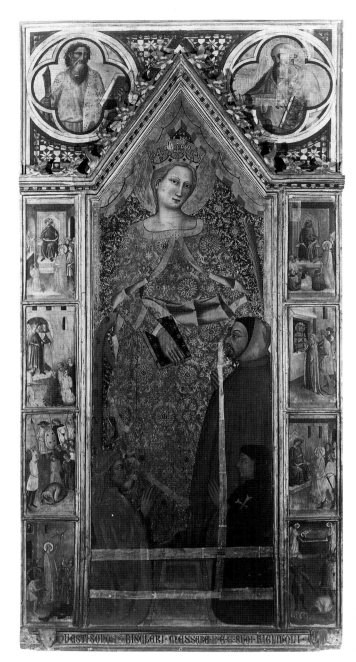

FIG. 28.8 Giovanni del Biondo (Florence, first documented 1365; died October 1398). Tabernacle: *Saint Catherine of Alexandria and Eight Scenes from Her Legend,* 1370s. Tempera and tooled gold on panel; 64⅛ × 26″ (163 × 66 cm). Before restoration. Florence, Museo dell'Opera del Duomo, no. 43

it was a painting on wood, made up of three panels, depicting Saint Matthew and his legend, that took up three sides of the interior pilaster). Published by Giovanni Poggi in Sirén 1908, p. 99. See also Offner and Steinweg 1965, p. 21 and n. 10.

11. Now Florence, Galleria dell'Accademia, inv. 440 (105 × 48″ [266 × 122 cm]); Finiello Zervas 1996, atlas vol., color repro. 974. Bernardo Daddi's (q.v.) *Saint John the Baptist,* dated 1346 (33⅞ × 29⅛″ [86 × 74 cm]), on deposit in San Martinone a Gangalandi, near Florence (property of the Gallerie Fiorentine, no. 6164), may also have come from Orsanmichele. See Finiello Zervas 1996, text vol., p. 630; atlas vol., color repro. 969.

12. Finiello Zervas 1997, pp. 96–97, docs. 201–2. She corrects erroneous transcriptions that recorded the year as 1380.

13. Cohn 1956, p. 174.

14. The latter include the following now in the Accademia in Florence: the *Annunciation* by an anonymous Florentine artist in collaboration with Ambrogio di Baldese, made for the Guild of Carpenters after 1380 (inv. 6098; Finiello Zervas 1996, atlas vol., color repro. 970 [for the present attribution, see Boskovits 1975, pp. 273–74]); Lorenzo di Bicci's *Saint Martin* and in the predella the *Saint Dividing His Cloak,* from the pilaster of the Guild of Vintners, dating after 1381 (inv. dep. 174; Finiello Zervas 1996, atlas vol., color repro. 973); and Giovanni del Biondo and Cenni di Francesco's (q.v.) *Saint John the Evangelist* and in the predella *Ascension of Saint John the Evangelist,* made for the Guild of Silk Merchants (Arte della Seta), c. 1375–80 (inv. 444/446; Finiello Zervas 1996, atlas vol., color repro. 972). This group may also include Gerini's *Saint Eligius Shoeing the Detached Hoof of a Horse,* c. 1375–80, in the Musée du Petit Palais in Avignon (no. м.i. 387; Finiello Zervas 1996, atlas vol., color repro. 975), a predella panel from the lost altarpiece of the Guild of Blacksmiths (Arte dei Fabbri). On the identification of these paintings, see Cohn 1956; and Finiello Zervas 1996, text vol., pp. 630–36.

In addition, Bernardo Daddi's *Archangel Michael* (c. 1328; 82¹¹/₁₆ × 43⁵/₁₆″ [210 × 110 cm]; Offner 1989, plate iii), now in the parish church of Crespina, may originally have been in Orsanmichele, which is known to have had an image of the archangel ever since the church dedicated to the saint was destroyed to make way for the loggia. Although the early provenance of the painting cannot be traced, when it was donated to the present church in 1806 it was called an Orcagna, which might reflect a tradition that it came from Orsanmichele, as Orcagna's tabernacle of the Virgin, which includes a painting of the Virgin by Daddi, is the oratory's most prominent work of art. A trecento copy of the painting of the archangel of nearly the same dimensions was once in the Buitoni Collection in Perugia. Another earlier reflection of the composition is found in a painting of the archangel (Ladis 1984, color plate ii), from the Acton Collection in Florence, which has been recently attributed to Jacopo del Casentino and may have come from the Velluti chapel in Santa Croce. However, a reason to doubt that the Daddi was originally in Orsanmichele is that a mural painting, dated 1377, that seemingly replaced the earlier panel painting, does not reflect Daddi's composition (see Artusi and Gabbrielli 1982, color plate p. 9).

15. Artusi 1990, p. 184.

16. On the windows and their iconographic program, see Finiello Zervas (1991), who cites earlier bibliography. Boskovits (1975, p. 407) attributes to Gerini the *Presentation of the Virgin,* the *Presentation of Jesus,* and the *Foundation of Santa Maria Maggiore,* which he dates

1791–93, vol. 1, 1791, cols. 565–78. The above text is found on folio 245 of the codex, and the Medici dedication to San Francesco del Bosco on the last folio.

4. For those in the Biblioteca Laurenziana, see "Vitae sanctorum . . . Quattuor coronati" in Bandini 1774–78, vol. 5; and Bandini, 1791–93, vol. 3.

5. The most complete studies are those by Hippolytus Delehaye in *AA.SS.,* Novembris III (1910), pp. 748–84; Amore 1965, pp. 177–243; and Amore's articles in the *Bibliotheca sanctorum,* vol. 10, 1968, cols. 1276–86 (with an iconographic study by Pietro Cannata), 1286–1304; and in Höfer and Rahner, vol. x², 1965, cols. 781–82.

6. Finiello Zervas 1996, color plates 293–94. The artists did not receive final payment until April 23, 1405. See Finiello Zervas 1997, p. 119, doc. 280.

7. Finiello Zervas 1996, color repro. 214.

8. The Johnson panel's connection with the painting now in Denver, first published by Berenson (1963, pp. 159–60), was recognized by an anonymous researcher at the Frick Art Reference Library in New York (transcription of a letter from Ethelwyn Manning to Henri G. Marceau, dated New York, June 3, 1943, in the Johnson Collection Archives). Shapley (1966, p. 43) associated the Denver and Philadelphia paintings with the one in Florence. She also suggested the possibility that the Birmingham panel came from the same altarpiece but questioned the discrepancy in its measurements.

9. No. 42, overall 88⅛ × 91¾″ (224 × 233 cm); Luisa Becherucci in Becherucci and Brunetti 1969–70, vol. 2, pp. 283–84, cat. 42, figs. 261–62, color plate 259.

10. In a document of 1402 the painting is described as "da Orto San Michele solea essere una tavola di legname di tre facie, dipinta di San Mateo e la sua storia, che pigliava tre faccie del pilastro drento" (from Orsanmichele

c. 1395–1405. In fact, they were actually made by Lorenzo Ghiberti in 1429. However, a document indicates that Gerini was working on other windows earlier, as a payment for a window was made to him on December 10, 1388 (Florence Archivio di Stato, Orsanmichele 209, carta 75 recto).

17. Marcucci 1965, plate 66. This is on deposit from the Gallerie Fiorentine (no. 8490) to the church, which may have been its original location. It is unclear if, as Cohn (1956, pp. 176, 177 nn. 48–52) proposed, it was once on the altar of Saint Anne in the oratory. In any case, the painting includes the arms of Orsanmichele, which proves that it was commissioned by its *capitani*, or directors. On the basis of a citation in a poem by Franco Sacchetti, Cohn suggested a date before 1388.

18. On these murals, see Boskovits (1975, p. 407); and Finiello Zervas 1996, text vol., pp. 493, 500, 502, 509–11, 540–42, 544–47; atlas vol., color plates 266–67, 289–95, 317, 329–34, 446–52, 459–67, 478–501. The *Saint Nicholas of Tolentino,* patron of guilds, is documented as being painted by Gerini in 1408–9 (Khvoshinsky and Salmi 1914, p. 55 and Finiello Zervas 1997, p. 122).

Bibliography
Sirén 1914a, pp. 330, 335, fig. 6 (Jacopo di Cione); Valentiner 1914, p. 197, repro. p. 391 (quoting Osvald Sirén, as by Jacopo di Cione); Sirén 1917, p. 259; Van Marle, vol. 3, 1924, p. 508 n. 1; Berenson 1932, p. 396; Berenson 1936, p. 340; Johnson 1941, p. 12; Du Colombier 1952, p. 215; Kaftal 1952, p. 383; Berenson 1963, p. 160; Shapley 1966, p. 43; Sweeny 1966, pp. 57–58, repro. p. 104; Fredericksen and Zeri 1972, p. 81; Boskovits 1975, p. 406; Hériard Dubreuil and Ressort 1979, p. 19 n. 2; Philadelphia 1994, repro. p. 193; Finiello Zervas 1996, text vol., p. 636; atlas vol., color repro. 978

COMPANION PANELS for PLATE 28

A. Section of an altarpiece: *Emperor and His Entourage before a Column.* See fig. 28.2

c. 1385–90

Tempera and tooled gold on panel; 21½ × 17½″ (54.5 × 44.5 cm) (originally arched). Florence, private collection

PROVENANCE: Florence, Charles Loeser; sold, London, Sotheby's, December 9, 1959, lot 32; Marshall Spink; Munich, Julius Böhler; sold, London, Christie's, July 16, 1971, lot 76

EXHIBITED: Munich 1966, no. 8, plate XVII

SELECT BIBLIOGRAPHY: Offner 1921, p. 238; Offner 1927, p. 91; Boskovits 1975, p. 411; Finiello Zervas 1996, text vol., p. 636

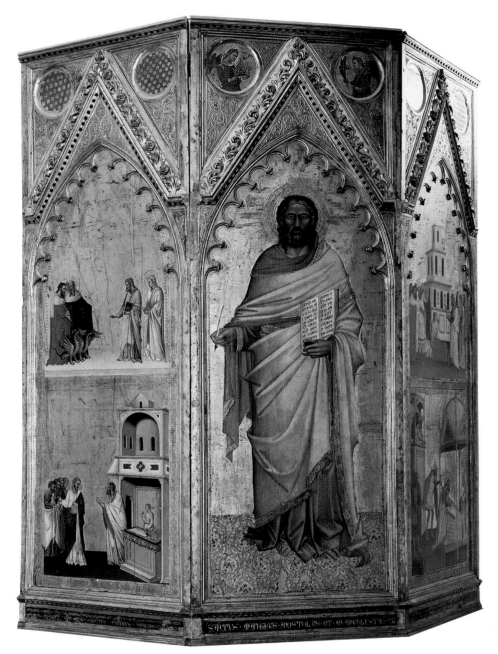

FIG. 28.9 Andrea di Cione, called Orcagna (Florence, first documented 1343; died c. 1368), and Jacopo di Cione (q.v.). Tabernacle: *Saint Matthew and Four Scenes from His Legend,* c. 1367–68. Tempera and tooled gold on panel; 114 × 104″ (290 × 265 cm). Florence, Galleria degli Uffizi, no. 3163

B. Section of an altarpiece: *Four Crowned Martyrs before the Emperor.* See fig. 28.3

c. 1385–90

Tempera and tooled gold on panel; 24¾ × 17¾″ (63 × 45 cm). Denver Art Museum, E-IT-18-XV-927 (Kress 17)

PROVENANCE: Rome, Contini Bonacossi Collection; New York, Samuel H. Kress Collection, acquired 1928; given by the Samuel H. Kress Foundation to the Denver Art Museum, 1954

SELECT BIBLIOGRAPHY: Shapley 1966, p. 43 (with references and opinions); Fredericksen and Zeri 1972, p. 81; Boskovits 1975, p. 405; Finiello Zervas 1996, text vol., p. 636

C. Section of an altarpiece: *Burial of the Four Crowned Martyrs.* See fig. 28.4

c. 1385–90

Tempera and tooled gold on panel; 15⅞ × 18″ (40.3 × 45.7 cm) (cropped at the bottom and left). Birmingham (Alabama) Museum of Art, Gift of the Samuel H. Kress Foundation, 1961.119 (Kress 1719)

PROVENANCE: Florence, Contini Bonacossi Collection; New York, Samuel H. Kress Collection, acquired 1950; given by the Samuel H. Kress Foundation to the Birmingham Museum of Art, 1952

SELECT BIBLIOGRAPHY: Shapley 1966, p. 43 (with references and opinions); Fredericksen and Zeri 1972, p. 81; Boskovits 1975, p. 403; Finiello Zervas 1996, text vol., p. 636

GIOVANNI DAL PONTE
(*Giovanni di Marco*)

Giovanni di Marco is known as Giovanni dal Ponte because his workshop was near the Ponte Vecchio in Florence. Although he was trained in the traditions of the late fourteenth century, he was able to adapt his manner to reflect the style of more advanced artists. He, in fact, would serve as a bellwether of trends in Florentine painting for about three decades. In 1410 Giovanni di Marco joined the Guild of the Physicians and Apothecaries (Arte dei Medici e Speziali), to which the painters belonged, and three years later he enrolled in the company of San Luca, another painters' organization. No earlier activity is known.

Giovanni di Marco's first important work is the *Coronation of the Virgin* of about 1414–20, now in Chantilly.[1] The painting suggests a relationship with Lorenzo Monaco (q.v.) because it takes full account of that artist's altarpiece[2] of 1413 for Santa Maria degli Angeli in Florence. Whether Lorenzo was Giovanni's master is not known, but he did seem to have a role in promoting his career. Giovanni's altarpiece of about 1415–20, now in London, comes from a dependency of Santa Maria degli Angeli, the nunnery of San Giovanni Evangelista in Pratovecchio.[3] As Lorenzo Monaco was a monk at Santa Maria degli Angeli, he could easily have obtained this commission for Giovanni. The stamp of Lorenzo Monaco can still be seen in Giovanni's altarpiece *The Mystic Marriage of Saint Catherine of Alexandria* in Budapest,[4] which is dated 1421. In 1418 Giovanni had worked beside another probable apprentice of Lorenzo, the young Fra Angelico (q.v.), on the decoration of the Gherardini chapel in Santo Stefano al Ponte in Florence. This work, unfortunately, is lost, as are the *cassone* panels that Giovanni painted in 1422 for the wedding of the granddaughter of the Florentine patrician Ilarione de' Bardi. However, the latter may have resembled a *cassone* panel by the artist now in the Musée Jacquemart-André in Paris.[5]

Although Giovanni was sent to debtors' prison for eight months in 1424, he did not miss the excitement that Masaccio (q.v.) was just beginning to stir up in Florence. Giovanni later painted an altarpiece for the church of San Pier Scheraggio in Florence that represents one of the earliest and most sophisticated interpretations of Masaccio's art. This painting, of which only the predella and pilasters survive,[6] shows an awareness of Masaccio's and Masolino's (qq.v.) earliest work in the Brancacci chapel of Santa Maria del Carmine as well as of Masaccio's mural known as the *Sagra,* showing the consecration of the Carmine.[7]

In the 1430s Giovanni painted a number of altarpieces for churches in the Florentine countryside,

including the one that contained the Johnson panel. He also received a number of other important commissions in Florence. In 1429 he had formed a partnership with Smeraldo di Giovanni, a modest painter of *cassoni*. In that year and the next, as well as in 1434 and 1435, they collaborated on the murals of two chapels in Santa Trinita in Florence.[8] In 1434 Giovanni di Marco also painted an altarpiece for San Salvatore in Florence.[9] The papal notary who drew up the contract for that painting, Angelo degli Atti, commissioned another for his own hometown of Todi,[10] but by this time Giovanni's work had become formulaic and uneven. During the last decade of his life the major innovations in Florentine art as represented by the work of Fra Angelico had largely eluded him.

Giorgio Vasari's sixteenth-century biographies of the painter are terribly confused, particularly as to his dates of activity, which Vasari places in the early trecento. He does, however, report that Giovanni was a "friend of literate persons." As he also mentions Giovanni's documented financial difficulties, Vasari's description of the artist's friendships has a ring of truth. Giovanni's *cassone* paintings, which are among the most sophisticated secular paintings made in Florence in the 1420s and 1430s,[11] suggest something of the artist's own literary interests as well as those of his patrons and friends. A fragment of a *cassone* in the Fogg Art Museum in Cambridge, showing Dante and Petrarch, is an example of these interests.[12]

1. Museé Condé, no. 3; Guidi 1968, fig. 25. On the dating of this picture, once thought to be 1410, see Guidi 1968, p. 31. It was made for the church of Santa Maria in Bovino, near Florence, on commission of a certain Piero di Zanobi.
2. Florence, Uffizi, no. 885; Ciatti and Frosinini 1998, postrestoration color plate I.
3. National Gallery, no. 580; Gordon 2003, color repro. p. 105.
4. Szépművészeti Múzeum, no. 1139; Guidi 1968, figs. 27–30. According to the inscription, it was made for one Lapo di Tommaso Cobacinio.
5. No. 1053; Watson 1979, plate 65.
6. Florence, Uffizi, no. 1620; Berti and Paolucci 1990, color repro. pp. 176–77.
7. For the Brancacci chapel, see postrestoration color repros. in Baldini and Cavazza 1990. For copies of the *Sagra,* see Joannides 1993, plates 455–57.
8. These murals are in a fragmentary state. See Marchini and Micheletti 1987, figs. 93–101 (color and black-and-white).
9. On deposit in Florence, Museo Nazionale di San Marco; Guidi 1968, fig. 36.
10. Vatican City, Pinacoteca Vaticana, no. 11 (85); Guidi 1968, fig. 35.
11. Watson 1979, pp. 78–80, 103.
12. No. 1919.24; Bowron 1990, fig. 555. It probably dates from the mid-1430s.

Select Bibliography
Vasari 1550 and 1568, Bettarini and Barocchi eds., vol. 3 (text), 1967, pp. 235, 239–41; Gamba 1904; Toesca 1904a; Gamba 1906; Horne 1906; Horne 1906a; Salvini 1934b; Guidi 1968; Guidi 1970; Shell 1972; *Bolaffi* 1974, vol. 6, pp. 51–52; Fremantle 1975, pp. 355–66; Mack 1980; Francesca Petrucci in *Pittura* 1987, pp. 640–41; Luciano Bellosi and Monica Folchi in Madrid 1990, pp. 146–52; Emanuela Andreatta in Berti and Paolucci 1990, p. 256; Skaug 1994, pp. 298–99; Eunice D. Howe in *Dictionary of Art* 1996, vol. 12, pp. 700–701; Michela Becchis in *DBI*, vol. 56, 2001, pp. 182–85

PLATE 29 (JC INV. 1739)
Right wing of an altarpiece: *Saints Germinianus(?) and Francis of Assisi*

C. 1434–35

Tempera and tooled gold on panel with vertical grain; 38⅛ × 21⅞ × ⅝″ (96.8 × 55.3 × 1.4 cm) (without cradle)

John G. Johnson Collection, inv. 1739

INSCRIBED ON THE REVERSE: *CITY OF PHILADELPHIA/ JOHNSON COLLECTION* (stamped in black ink numerous times on the cradle); *IN 1739* (in pencil on a paper sticker)

TECHNICAL NOTES
The panel consists of a single plank that has been thinned, cradled, and cut at the top and bottom. Narrow strips of wood, approximately ¼″ (0.6 cm) wide, have been added to the sides. Originally the panel ended in a Gothic arch that an unidentified restorer transformed into a rectangle by cropping the top and straightening the curved edges at the sides, fitting them with triangular inserts (see fig. 29.4). The wood additions and some of the surrounding areas were regilt. All the gold carries a toned varnish and pervasive retouching in bronze powder. An area of the green foreground in the lower right was covered with modern water gilding that effectively lowered the horizon line by 3¼″ (8.2 cm).

About ⅜″ (1 cm) of the left edge of the painting is repainted, and most of the areas of the costume of the bishop saint to the left of the crozier are repainted in oil. However, his gloved right hand is original. The top of the crozier is all restoration. Areas of tooled granulation in the gold near his halo probably reflect some of the original design of the crozier, which would have curled behind the halo. Along the original parts of the right edges are remnants of punched trefoil arches that would have bordered the inner edges of the arched frame.[1]

Much of the painting is in excellent condition. This is particularly true of the saints' faces, which appear to be some of the best-preserved passages of

fifteenth-century painting in the Johnson Collection. By contrast, Saint Francis's habit is not in good shape. Infrared reflectography revealed numerous losses and abrasions in this area, which had been well masked by an earlier restorer. Some broad-brushed underdrawing was also visible in the infrared reflectography, especially in the white undergarment of the bishop saint. Much of the mordant gilt decorative details on his costume is abraded. For instance, in the orphrey only the brown mordant is visible. The white highlights on the jewels in his miter are restoration. The jewels themselves were surrounded by mordant gilt bezels, but the gilding is now missing.

On June 25, 1920, Hamilton Bell and Carel de Wild determined that the panel was in "very fair condition" and that it was a "genuine but not good picture." In 1956 Theodor Siegl treated the panel with wax for flaking, which was most serious in the upper sides. He also retouched some losses around the feet of Saint Francis. Some of the flaking had to be treated again in 1964.

PROVENANCE

Pisa, 1830s; Paris, Charmetant Collection; sold Paris, Hôtel Drouot, May 22–23, 1908, lot 134 (as fourteenth-century Sienese school, identifies the bishop saint as Magnus, bishop of Oderzo); purchased by John G. Johnson from Osvald Sirén, 1914.

Sirén's letter, dated New York, April 13, 1914, offering the panel to Johnson, reads:

> I thought of bringing with me a very interesting picture which I have discovered here, if you are interested. It is the right wing of an altar triptych, representing S. Gemignano (holding a town in his hand) and S. Francis; the master is Giovanni dal Ponte. Perhaps you remember his works in the Uffizi, in the National Gallery, Budapest Museum, Chantilly, very remarkable powerful figures influenced by Masaccio. The work's about 1400–1440. Now, this painting is of his very best quality, never touched and in perfect condition. It has a great monumental beauty. 96 cm. high, 56 cm. broad. As you have not this master represented I thought you might be interested. If you are so and are disposed to secure it, I could take it over to you. The price is $2,200; the importance of the picture makes me think that this price is comparatively low. If my memory does not fail, the corresponding wing of this same altarpiece is in the Museum at Hanover [see fig. 29.2]. I hope to be able to find a reproduction of it.

COMMENTS

To the right of the panel is Saint Francis of Assisi holding a book in one hand and an astral cross in the other. To the left an abbot or bishop saint holds a model of a city. The catalogue of the Charmetant sale of 1908 and Osvald Sirén's letter of 1914 offering

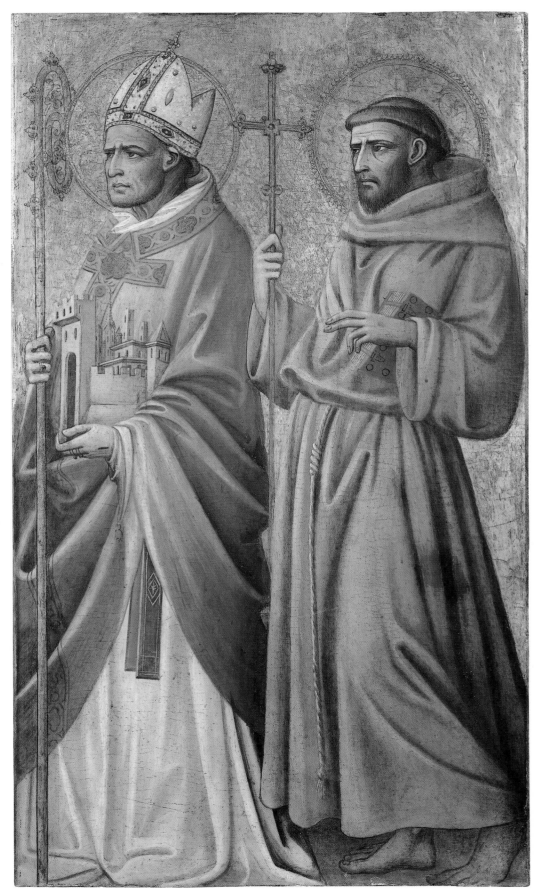

PLATE 29

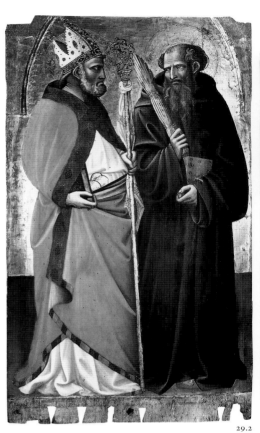

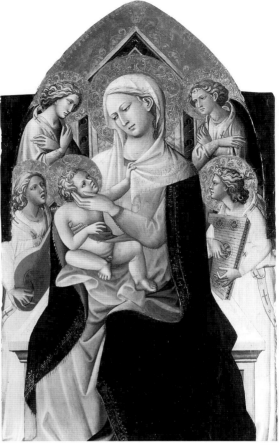

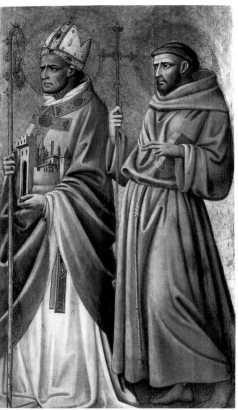

29.2

29.3

PL. 29

FIG. 29.1 Original configuration of the known extant panels of Giovanni dal Ponte's altarpiece, c. 1434–35. Left to right: FIG. 29.2 *Saints Nicholas of Bari and Benedict.* Tempera and tooled gold on panel (showing the surviving bare wood at the bottom); 40⅜ × 23⅝″ (102.5 × 60 cm). Hanover, Germany, Niedersächsisches Landesmuseum, Landesgalerie, inv. KM87 (278). See Companion Panel A; FIG. 29.3 *Virgin and Child Enthroned with Four Angels.* Tempera and tooled gold on panel; 46¾ × 26⅞″ (118.7 × 68 cm). M. H. de Young Memorial Museum, Fine Arts Museums of San Francisco, Gift of the Samuel H. Kress Foundation, no. 61.44.5 [K1556]. See Companion Panel B; PLATE 29

the panel to Johnson identified him as Geminianus.

A late fourth-century bishop of Modena,[2] Geminianus, or Gemignano as he is known in Italian, was highly venerated in the Tuscan city of San Gimignano, of which he was the patron. Giovanni dal Ponte's depiction of the saint closely follows an iconography widely diffused in that city's art.[3] He also had a cult in Pontremoli near Pisa.

As Sirén (see Provenance), Barbara Sweeny (1966), and Curtis Shell (1972) noted, the panel constitutes the right wing of a triptych (fig. 29.1). Horne, Sirén, and Shell all recognized that the other lateral panel was *Saints Nicholas of Bari and Benedict* (fig. 29.2) in Hanover, Germany.[4] Shell further identified the central panel as the *Virgin and Child Enthroned with Four Angels* (fig. 29.3) in San Francisco, which is also shown in a drawing (fig. 29.5) by Johann Anton Ramboux of about 1833–43.[5] Ramboux, who drew copies of many works of art in Italy, often provided precious inscriptions as to

their locations. This particular drawing is mounted on a piece of paper with the notation "von einem Temperagemälde in Pisa" (from a tempera painting in Pisa), which indicates that the altarpiece was in that city at that date. It might also mean that the painting had come from a nearby town such as Pontremoli, where the established cult to Saint Geminianus was located.

Shell suggested that the triptych was painted about 1434–35 based on its relationship to two dated works by Giovanni: the altarpiece of the Annunciation[6] of 1434, in Santa Maria in Rosano, near Florence, and the *Annunciation with Saints Louis of Toulouse and Anthony of Padua* of the following year, in the Pinacoteca Vaticana.[7] The design of the lateral panels of the altarpiece in Rosano is particularly close to that of the triptych. Shell also noted how in the triptych the Masaccesque qualities of Giovanni dal Ponte's earlier work were attenuated to achieve a less stark and more lyrical style. He did,

however, comment that the figure of Saint Nicholas of Bari in the lateral panel in Hanover seemed to be inspired by Masaccio and Masolino's Saint Martin in *Saints John the Evangelist(?) and Martin of Tours* in the Johnson Collection (see plate 44B [JC inv. 409]). Geminianus's crozier in the Johnson panel is also similar to Masaccio's original design for Martin's crozier, which, like the example in the Giovanni dal Ponte panel, was to be seen from the side, with the curled head foreshortened.

1. The punches correspond to numbers 161 and 291 in the chart of Giovanni dal Ponte's punch marks in Skaug 1994, chart 10.3. Saint Francis's halo also has punch mark number 61.
2. Giuseppe Russo in *Bibliotheca sanctorum*, vol. 6, 1965, cols. 97–99.
3. See Kaftal 1952, cols. 440–41, figs. 515–16; and Maria Chiara Celletti in *Bibliotheca sanctorum*, vol. 6, 1965, cols. 100–104.
4. Sirén (in a letter to Johnson, dated Florence, July 25,

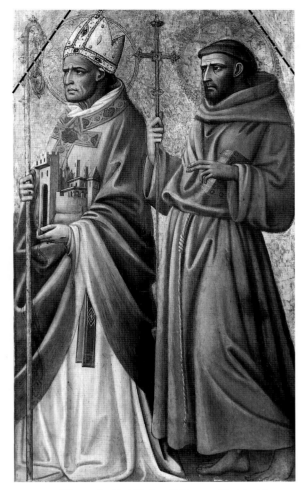

FIG. 29.4 Diagram by Mark Tucker of plate 29, with dotted lines showing the replaced sections of wood at the upper corners of the panel. These areas and the adjacent original surface have been gilt over to modify the original arched-top format, which corresponds to that seen in fig. 29.2.

FIG. 29.5 Johann Anton Ramboux (German, 1790–1866). Drawing after Giovanni dal Ponte, c. 1833–43. *Virgin and Child Enthroned with Four Angels* (see fig. 29.3). Ink on paper; 14¾ × 20″ (37.3 × 50.6 cm). Frankfurt, Städelsches Kunstinstitut, no. 1565

1914) later mistakenly identified the other lateral panel as being the *Saints Michael Archangel and Bartholomew* in the Musée des Beaux-Arts in Dijon (no. 1182; Guidi 1968, fig. 23).

5. The drawing is inscribed: "Spinelo Aretino circa 1390,/ Scuola Senese/ mori d'eta dianni 93 al 1400" (Spinelo Aretino circa 1390,/ Sienese school/ died at the age of 93 in 1400).

6. Fremantle 1975, p. 362, plate 741.

7. Guidi 1968, fig. 35.

Bibliography
Johnson 1941, p. 8; Berenson 1963, p. 92; Sweeny 1966, p. 35, repro. p. 107; Fredericksen and Zeri 1972, p. 91; Shell 1972, p. 44, fig. 6; Francesca Petrucci in *Pittura* 1987, p. 641; Philadelphia 1994, repro. p. 195; Frinta 1998, pp. 48, 133, 143, 240; Michela Becchis in *DBI*, vol. 56, 2001, p. 184; Hiller von Gaertringen 2004, p. 207 n. 13

COMPANION PANELS for PLATE 29

A. Lateral panel of an altarpiece: *Saints Nicholas of Bari and Benedict.* See fig. 29.2

c. 1434–35

Tempera and tooled gold on panel; 40⅜ × 23⅝″ (102.5 × 60 cm) (cut at the top). Hanover, Germany, Niedersächsisches Landesmuseum, Landesgalerie, inv. KM87 (278)

PROVENANCE: August Kestner, who probably bought it during his residence in Rome in 1825–49; by descent to his nephew Herman (1810–1890), who gave it to the city of Hanover as part of the Kestner-Museums, 1884

SELECT BIBLIOGRAPHY: Von der Osten 1954, p. 122, no. 278; Shell 1972, p. 44

B. Center panel of an altarpiece: *Virgin and Child Enthroned with Four Angels.* See fig. 29.3

c. 1434–35

Tempera and tooled gold on panel; 46¾ × 26⅞″ (118.7 × 68 cm) (cut at the bottom). M. H. de Young Memorial Museum, Fine Arts Museums of San Francisco, Gift of the Samuel H. Kress Foundation, no. 61.44.5 [K1556]

PROVENANCE: Florence, Contini Bonacossi; New York, Samuel H. Kress Foundation, acquired 1948; given by the Samuel H. Kress Foundation to the M. H. de Young Memorial Museum, The Fine Arts Museums of San Francisco, 1961

SELECT BIBLIOGRAPHY: Berti 1961, p. 87 n. 4; Berenson 1963, p. 92; Shapley 1966, p. 92; Shell 1972, p. 44

GIOVANNI DI FRANCESCO

FLORENCE, 1428(?)–1459, FLORENCE

In his Florentine tax return of 1451, Giovanni di Francesco gave his age as twenty-three. This seems to have been a false statement, however, because it would mean that he would have been fourteen when he enrolled in the painters' guild on January 26, 1442 (modern style). There are few other known dates in his life. The Giovanni da Rovezzano who is documented as painting an altarpiece for the Brigittine convent of the Paradiso degli Alberti near Bagno a Ripoli in 1439 is probably the same person as Giovanni di Francesco, who was from a hamlet of Rovezzano, near Florence, called Crevelleria. It is also known that in 1445 Giovanni had to settle a debt for his deceased father with the monastery of Santa Maria degli Angeli in Florence, and that in 1449 he sold the family home in Rovezzano. In 1450 he sued Filippo Lippi for being in arrears in paying him for the restoration of a painting by Giotto, which Giovanni claimed to have finished eight years earlier. The dispute landed both artists in prison. Although under torture Lippi admitted falsifying the receipt of Giovanni's payment, the case was not settled until 1455.[1] In September 1459 Giovanni di Francesco died and was buried on the twenty-ninth in his parish church of Sant'Ambrogio in Florence.

Giovanni's artistic activity can be reconstructed on the basis of two dated works: his altar frontal in the church of San Biagio in Petriolo, near Florence, which is dated January 9, 1455 (modern style),[2] and his painted lunette in the loggia of the hospital of the Innocenti in Florence, which is documented 1458–59.[3] In 1917, on the basis of the mural, Pietro Toesca identified Giovanni di Francesco as the artist then known as the Master of the Carrand Triptych, after an altarpiece named for Louis Carrand, who gave it to the Museo Nazionale del Bargello in 1888.[4] It was originally in the Florentine church of San Niccolò Oltrarno. The only other work by Giovanni that can be dated somewhat securely is the frame of a terracotta relief of the Virgin and Child painted with four prophets[5] that clearly derives from Paolo Uccello's painted clock face of 1443 in the cathedral of Florence.[6] Because of Giovanni's similarities to Uccello, Roberto Longhi

(1928) assigned to him works such as the murals in the chapel of the Assunta in the cathedral of Prato[7] and the *Nativity with Saints* in the Staatliche Kunsthalle in Karlsruhe.[8] Longhi (1940, p. 179; 1952a, p. 32) later attributed these works to Uccello himself, an opinion over which scholars have since differed.[9]

By the late 1440s Giovanni di Francesco came under the influence of Domenico Veneziano, from whom he learned what would become the most characteristic feature of his own style: the careful observation of light on physical forms. In this, his work parallels that of Piero della Francesca. Significantly, Giovanni's predella with stories from the legend of Nicholas of Bari in the Casa Buonarroti in Florence[10] reflects his knowledge of Piero's murals of San Francesco in Arezzo, most particularly the battle scene with the Defeat of Chosroes.[11] Giovanni's death in 1459 can, therefore, be considered a *terminus ante quem* for Piero's cycle.[12] Giovanni di Francesco's crucifix in the church of Sant'Andrea in Brozzi near Florence also probably dates to the late 1450s.[13]

In 1974 Burton Fredericksen identified Giovanni di Francesco with the Master of Pratovecchio, an otherwise anonymous artist given that name by Longhi (1952a) after a now-disassembled altarpiece from the Camaldolese monastery in Pratovecchio. Fredericksen formulated his hypothesis by associating an altarpiece in the J. Paul Getty Museum in Los Angeles,[14] attributed to the Master of Pratovecchio, with the 1439 altarpiece for the convent of Paradiso near Bagno a Ripoli, which is very likely the work of Giovanni di Francesco.[15] Luciano Bellosi (1990, pp. 28–31) refuted this theory because of differences between the contract and the finished work,[16] and because of his belief that the Paradiso painting had to date later than 1439. It is possible, however, that the altarpiece may not have been finished for a few years, during which time the program may have changed. If Fredericksen's theory is correct, then the oeuvre of the Master of Pratovecchio would represent Giovanni di Francesco's earliest production.[17]

1. Kennedy 1938, p. 215 n. 206.
2. Bellosi 1990, color repro. p. 51.
3. Bellosi 1990, fig. 41.

4. Inv. 2025c; Bellosi 1990, color repro. p. 49. It was probably commissioned for a member of the Gianni family.
5. Formerly Berlin, Kaiser-Friedrich-Museum, no. 74; lost 1944; Bellosi 1990, fig. 6.
6. Borsi and Borsi 1994, color repro. pp. 118–19.
7. Borsi and Borsi 1994, pp. 188–95. On this question, see also Padoa Rizzo 1997, esp. pp. 17–99.
8. No. 404; Bellosi 1990, fig. 51.
9. For a review of recent opinions, see Alessandro Angelini in Bellosi 1990, pp. 73–77.
10. Bellosi 1990, color repros. pp. 57–61. Originally in the Cavalcanti chapel of Santa Croce in Florence. It has been in the Buonarroti Collection since 1620.
11. Maetzke 1998, postrestoration color repro. pp. 150–51.
12. Or at least the left wall, which may have been completed first. See Luciano Bellosi in Bellosi 1990, p. 42, as well as the differing opinion in Ginzburg 1991.
13. Bellosi 1990, figs. 4–5.
14. Inv. 67.PA.1; Fredericksen 1974, figs. 1–11; Bellosi 1990, fig. 19.
15. The original commission of January 1430 (modern style) was given not to Giovanni but to his uncle Giuliano di Jacopo, a painter with a shop on the corso degli Adimari in Florence; he probably never began work on the altarpiece. On Giuliano di Jacopo, who must have been Giovanni di Francesco's first contact with the artistic world, see Procacci 1960, pp. 22–23, 31, 51 n. 98.
16. The major change is that Saint Bridget is not surrounded by members of her order as specified in the contract.
17. Bernhard Berenson (1932, pp. 341–42; 1963, pp. 87–88) placed the works that Longhi considered by the Master of Pratovecchio in his lists for Giovanni di Francesco. The theory that Fredericksen put forth with reserve has been supported by Everett Fahy (1978, p. 35), Roberto Salvini (in Kent et al. 1981, pp. 241–52), with question by Giuseppina Bacarelli (in Gregori and Rocchi 1985, pp. 99–100), and Keith Christiansen (1990a, p. 738). Besides Bellosi, Andrea De Marchi (in Bellosi 1990, pp. 149–51) has come down firmly against the possible identification.

Select Bibliography
Weisbach 1901a; Toesca 1917; Longhi 1928; Berenson 1932, pp. 341–42; Berenson 1932a; Offner 1933, p. 177; Giovannozzi 1934; Longhi 1952a (Longhi, *Opere*, vol. 7, pt. 1, 1975, pp. 99–122); Fredericksen 1974; *Bolaffi* 1974, vol. 6, p. 47; Fahy 1978, p. 35; Roberto Salvini in Kent et al. 1981, pp. 241–52; Luciano Bellosi in Bellosi 1990, pp. 11–47; Christiansen 1990a, p. 738; Ginzburg 1991; Anna Padoa Rizzo in *Dictionary of Art* 1996, vol. 12, pp. 712–13

PLATE 30 (JC CAT. 59)

Virgin and Child in Glory with Seraphim and Saint Anthony Abbot, a Knight Saint (Saint Julian?), Saint Ansanus(?), and Saint Lawrence

c. 1454

Tempera and tooled gold on panel with vertical grain; 22⅞ × 15¼ × 1⅜″ (58 × 38.5 × 3.5 cm), painted surface 22½ × 12⅜″ (57.2 × 31.2 cm)

John G. Johnson Collection, cat. 59

INSCRIBED ON THE REVERSE: *59* and *N. 1395* (on a paper label); *CITY OF PHILADELPHIA / JOHNSON COLLECTION* (stamped in black ink); a faded ink sketch showing the outlines of the composition with the saints identified in English

TECHNICAL NOTES

The panel consists of a single member, which has not been thinned. Although the edges that indicate the location of the original engaged frame have been filled, a barbe on all four sides of the painted surface is clearly discernable. The gold halos are incised; the halos of the Christ Child and the seraphim are mordant gilt. Some mordant gilt detailings in the costumes, such as the knob on the knight saint's sword, have been lost.

The panel, probably much soiled by candle smoke, was vastly repainted. The original sky, apparently ultramarine, was thickly repainted in a coarsely ground blue, presumably azurite, and pinkish clouds were also added. The Virgin's blue mantle was likewise repainted in the same coarse blue. The deep red highlights of Saint Lawrence's robe are also new, as are certain details painted in green, particularly in the costumes of the two saints in the back. Although the flesh tones were not extensively repainted, except for scattered highlights, they appear blotchy because of ingrained dirt. A hole for a nail driven from the front below the seraph at the Virgin's feet is probably where an ex-voto or a candleholder was attached. Fragments of possibly original hanging hardware are on the back of the panel.

In 1919 Hamilton Bell noted old cracks on the panel and thought that it should be cradled. But when he and Carel de Wild inspected it on May 15, 1920, they decided a cradle was not needed. They also said that the picture was in more than fair condition and had only some local repainting.

PROVENANCE

Johnson owned the painting by April 1906. In a letter dated the twenty-second of that month Bernhard Berenson acknowledged having received a photograph of it: "Again many thanks for the additional photographs. . . . The others I seem to have known

PLATE 30

except the Madonna with 4 saints of the School of Baldovinetti, possibly by the so-called 'Master of the Carrand Altarpiece.'" It was published later that year by the Princeton University professor Frank Jewett Mather, Jr., in "Recent Additions to the Collection of Mr. John G. Johnson, Philadelphia."

Comments

The Virgin sits among the clouds of heaven as she holds the nude Christ Child on her lap, with a seraph below her and three seraphim above. Four saints surround the pair. Anthony Abbot (left) and Lawrence (right) are easily identified. Anthony wears gray and black monastic robes and holds a book and a tau-shaped walking stick. In the clouds below is his attribute, the pig.[1] Lawrence wears a deacon's robes and holds a book and a martyr's palm, with the grill of his martyrdom below.

The two other saints are young men in contemporary dress. One grasps a sword, and the other carries a palm of martyrdom and what appears to be a red heart.[2] The latter is most likely Saint Ansanus. In the 1420s Francesco d'Antonio (q.v.) painted him in a mural in the church of San Niccolò Oltrarno in Florence; there he is dressed in clothing of similar make and color and holding what also appears to be a heart.[3] The other figure may be one of any number of knight saints. A likely identity is Saint Julian the Hospitaller, who was very popular in Florence. A close iconographic comparison can be made with Masolino's *Saint Julian*.[4]

In a letter dated Settignano, April 22, 1906, and in the 1913 Johnson catalogue, Berenson attributed the picture to the Master of the Carrand Triptych, subsequently identified as Giovanni di Francesco. He compared it with the *Virgin and Child Enthroned with Saints Bernard and Romauld*,[5] once in the collection of Werner Weisbach, and called it one of the painter's late works. Frederick Antal (1925) concurred with Berenson's dating, whereas Vera Giovannozzi (1934) called it an early work by Giovanni di Francesco. In a sensitive analysis Luciano Bellosi (in Bellosi 1990) recognized how the picture related to a change in the artist's work that occurred when he came under the influence of Domenico Veneziano, which Bellosi dates to the mid- to late 1440s. (If, unlike Bellosi, one accepts Fredericksen's 1974 hypothesis that the Master of Pratovecchio and Giovanni di Francesco are one and the same, the date would probably be a few years later.) In the Johnson panel Domenico Veneziano's influence manifests itself in the atmospheric effects of the sky and in the reliance on highlights in the modeling of forms that infuse the picture with light. However, the extensive repaints of the Johnson picture necessitate caution about any conclusion based on its pictorial effects.

Originally the Johnson painting probably closely resembled the well-preserved Carrand altarpiece in Florence[6] in such aspects as the position of the Christ Child and the hand gestures of the saints. The sky may also have been similar to that in the Carrand pinnacle panel in which Saint Thomas receives the Virgin's belt,[7] where the artist carefully observed how the color changes in intensity and the clouds become wispier as they move away from the horizon line. Similar effects can be noted in Giovanni di Francesco's predella from the Casa Buonarroti.[8] A date for the Johnson panel close to 1454, the year of his altar frontal in the church of San Biagio in Petriolo,[9] is likely.

1. Friars of the Antonine hospital order raised pigs for their fat, which was used to treat the disease known as Saint Anthony's Fire.

2. Berenson (1913) incorrectly identified them as Cosmas and Damian, whereas Frederick Antal (1925) called them Paul and Cosmas. However, Cosmas is rarely represented without Damian, and Cosmas usually holds a surgical instrument, not a heart, as in the Johnson picture. While Paul traditionally does carry a sword, he is usually represented as an older, balding man with a long beard.

3. See Berti and Paolucci 1990, color repro. p. 143. In the mural, however, the object is shown as bluish, not red as in the Johnson panel. Another close comparison is with a mid-fifteenth-century mural by Paolo Schiavo (q.v.) (*Pittura* 1987, repro. p. 726) in the church of Santissima Annunziata in Florence, where the figure also holds the palm of martyrdom. Saint Ansanus similarly carries a red heart in the predella by Paolo Uccello from Quarate (now Florence, Museo Diocesano a Santo Stefano al Ponte; Bellosi 1990, color repro. p. 79).

4. On deposit in Florence, Museo Diocesano di Santo Stefano al Ponte; Strehlke 2002, plate 5.

5. Fredericksen 1974, fig. 33.

6. Museo Nazionale del Bargello, inv. 2025C; Bellosi 1990, color repro. p. 49.

7. See the black-and-white detail in Bellosi 1990, repro. p. 48.

8. Bellosi 1990, color repros. pp. 57–61.

9. Bellosi 1990, color repro. p. 51.

Bibliography
Mather 1906, p. 352 (school of Pesellino); Rankin 1909, p. lxxxii (immediate following of Masaccio); Berenson 1913, p. 59, repro. p. 263 (Master of the Carrand Triptych); Toesca 1917; Antal 1925, p. 25; Van Marle, vol. 10, 1928, pp. 383–93; Berenson 1932, p. 342; Offner 1933, p. 177 n. 34; Giovanozzi 1934, p. 339; Berenson 1936, p. 279; Johnson 1941, p. 10 (Master of the Carrand Triptych); Hans Vollmer in Thieme-Becker, vol. 37, 1950, p. 65; Berenson 1963, p. 88; Sweeny 1966, p. 34, repro. p. 119; Fredericksen and Zeri 1972, p. 88; Fredericksen 1974, pp. 24–25, fig. 34; Luciano Bellosi in Bellosi 1990, p. 47; Philadelphia 1994, repro. p. 195; Anna Padoa Rizzo in *Dictionary of Art* 1996, vol. 12, p. 713

GIOVANNI DI PAOLO
(*Giovanni di Paolo di Grazia*)

SIENA, FIRST DOCUMENTED 1417;
DIED 1482, SIENA

Giovanni di Paolo's first documented activity dates to September 5, 1417, when Fra Niccolò Galgani, librarian of the convent of San Domenico in Siena, paid him for painting miniatures in an unidentified Book of Hours belonging to Donna Anna,[1] wife of the Milanese jurist Cristoforo Castiglioni.[2] In 1400–1404 Castiglioni had ordered a commission for Milan's cathedral, and in that capacity would have come to know the art of two Lombard illuminators working there, Giovannino de' Grassi and Michelino da Besozzo. Castiglioni could have introduced Giovanni di Paolo to Lombard miniature painting, and indeed the artist's drapery style on occasion approximates the sinuous manner of Michelino. Giovanni might also have been in personal contact with the Limbourg brothers, French illuminators who were in Siena around 1413. Giovanni's precocious assimilation of both Lombard and French Gothic art accounts for much in his stylistic development, including the nervous linear quality that distinguishes his pictorial forms from those of his Sienese contemporaries. Whether he apprenticed with Taddeo di Bartolo or Martino di Bartolomeo (qq.v.), both of whom have been suggested, this Northern element is indispensable for understanding the work of Giovanni di Paolo.

Giovanni's activity as a miniaturist early in his career helps explain his later accomplishments in the field. The illuminations in a choral book for the Augustinian monks at Lecceto, near Siena,[3] and the illustrations to *Paradiso* in a *Divina Commedia* for Alfonso of Aragon, king of Naples,[4] are among his greatest achievements.

The painter's other early documented commission, also handled by Galgani, was for an image of the Blessed Catherine of Siena (1347–1380; canonized 1461).[5] The Sienese Dominicans were then actively promoting her canonization, and this was a particularly important moment in the process in which the testimony of her last surviving acquaintances was being gathered. The artist's connection with this Dominican circle accounts for his sensitive handling of her iconography when he painted the first cycle of scenes from her life years later.[6] His ties also led to commissions for four other altarpieces in San Domenico.[7]

Most of Giovanni di Paolo's major commissions came from local monastic communities: besides the Dominicans, he worked for the Franciscans (on one occasion, in 1445–46, in collaboration with Sano di Pietro [q.v.]), the Servites, the Augustinians, and the Cistercians. His *Crucifixion* from the church of the Osservanza near Siena[8] was probably commis-

sioned by Saint Bernardino, whose image he later painted several times. A richly inventive artist, Giovanni di Paolo excelled in narrative subjects. His best work depicts the episodes from the lives of saints or evocative subjects such as the cantos of Dante's *Paradiso*.

In 1463 Giovanni was one of the "illustrious painters of Siena"[9] who produced an altarpiece for Pope Pius II Piccolomini's newly constructed church in Pienza.[10] During the last years of his long life, his abilities deteriorated and assistants sometimes intervened, but despite age, his imagination did not wane, as the lively predella scenes of the San Galgano altarpiece of about 1470 attest.[11] On January 29, 1482 (modern style), he made his last will and was buried sometime before March twenty-seventh in the chapel dedicated to his namesake John the Baptist, which he had endowed in a previous testament, in the now-destroyed church of Sant'Egidio in Siena.

1. Koudelka 1959, pp. 114, 133–34, 137–38. A namesake baptized in 1403 has caused some confusion about the artist's actual birth date and early career.
2. In 1418 Anna also commissioned a crucifix from Jacopo della Quercia, with Galgani as intermediary. She and her husband resided in Siena from 1415 to 1419. In 1412 Anna's brothers assassinated the duke of Milan, Giovanni Maria Visconti, so the couple may have been regarded with some favor in then ferociously Republican Siena. Castiglioni was himself a university professor as well as a third cousin of Cardinal Branda Castiglioni, patron of Masolino (q.v.) and the Sienese Vecchietta. On the Castiglioni, see Paolo Mari in *DBI*, vol. 22, 1979, pp. 140–46.
3. C. 1442; Siena, Biblioteca Comunale, Ms. G.I.8; Christiansen, Kanter, and Strehlke 1988, pp. 180, 182–87.
4. C. 1438–44; London, British Library, Yates Thompson Ms. 36; in color in Pope-Hennessy 1947, 1993.
5. It was ordered in 1418 by Franceschino Castiglioni, Cristoforo's son and judicial colleague, for a nun named Niccolina of the Sienese convent of Santa Marta.
6. Christiansen, Kanter, and Strehlke 1988, black-and-white and color repros. pp. 225–39.
7. The little-studied early *Christ Suffering and Triumphant* (early 1420s; Siena, Pinacoteca Nazionale, no. 212; Torriti 1977, fig. 368 [color]) was probably on the altar dedicated to the crucifix. This altar was commissioned by Francesco Bellanti, bishop of Grosseto, whose arms appear on the back, although its later provenance has it in the church of San Niccolò al Carmine, Siena. The other polyptychs named after the patron families Pecci (1426), Branchini (1427), and Guelfi (1445) are disassembled. For their reconstruction and patronage, see Bähr 1987.
8. Siena, Pinacoteca Nazionale, no. 200; Torriti 1977, figs. 378–79 (color).
9. Piccolomini 1458–64, Totaro ed. 1984, p. 1764.
10. Carli 1966, color plates XII–XIV.
11. Siena, Pinacoteca Nazionale, no. 198; Torriti 1977, fig. 104 and figs. 405–8 (color).

Select Bibliography
Romagnoli before 1835, vol. 4, pp. 309–30; Milanesi, vol. 1, 1854, p. 48, vol. 2, 1854, pp. 241–42, 301, 340, 372, 389; Borghesi and Banchi 1898, pp. 135–36, 182–83, 233; A. Venturi, vol. 7, pt. 1, 1911, pp. 498–501; Curt H. Weigelt in Thieme-Becker, vol. 14, 1921, pp. 133–37; Van Marle, vol. 9, 1927, pp. 390–465; Gengaro 1932; Pope-Hennessy 1938; Bacci 1941b; Brandi 1941; Brandi 1947; Pope-Hennessy 1947, pp. 12–13, 26–28; Brandi 1949, pp. 89–103, 201–7, 257–62; Van Os 1971; Bähr 1987; Carl Brandon Strehlke in Christiansen, Kanter, and Strehlke 1988, pp. 168–242; Pope-Hennessy 1988; Strehlke 1989, pp. 278–82; Pope-Hennessy 1993; Giovanna Damiani in *Dictionary of Art* 1996, vol. 12, pp. 714–16; Panders 1997; Carolyn C. Wilson in *DBI*, vol. 56, 2001, pp. 138–46

PLATE 31 (JC CAT. 105)
Predella panel of an altarpiece: *Christ on the Way to Calvary*

Early 1430s

Tempera and gold on panel with horizontal grain; panel 12⅜ × 13⅛ × 5/16″ (31.5 × 33.3 × 0.8 cm), painted surface 12⅜ × 12¼″ (31.5 × 31.2 cm)

John G. Johnson Collection, cat. 105

EXHIBITED: San Francisco 1939a, no. 32; Philadelphia Museum of Art, John G. Johnson Collection, Special Exhibition Gallery, *From the Collections: Paintings from Siena* (December 3, 1983–May 6, 1984), no catalogue; New York 1988, cat. 27

TECHNICAL NOTES
The panel, consisting of a single member, has been cropped at the bottom and thinned.

There are losses throughout the left and right edges in the area of the tooled gold borders that separated this scene from the others in the predella (see figs. 31.2–31.4); there are traces of the borders' punched and incised decoration as well. Gilding from the now-lost original applied moldings extends beneath the paint along the top and bottom edges. Remains of the gesso barbe in the lower edge show that that border has not been greatly disturbed. In general the paint surface is in excellent shape except for isolated areas of loss and areas of abrasion in the sky, exposing the gesso (fig. 31.1). The gold halos are quite abraded, and only traces of the gold mordant design in the soldiers' costumes survive.

David Rosen removed the yellowed varnish and retouched losses in 1937. Five years later he replaced the cradle with a plywood backing. In 1962 Theodor Siegl adjusted Rosen's discolored retouchings. Mark Aronson treated it in 1987–88, removing the plywood backing, cleaning the painting, and reconstructing lost areas.

FIG. 31.1 Plate 31 in 1988, after cleaning and before restoration

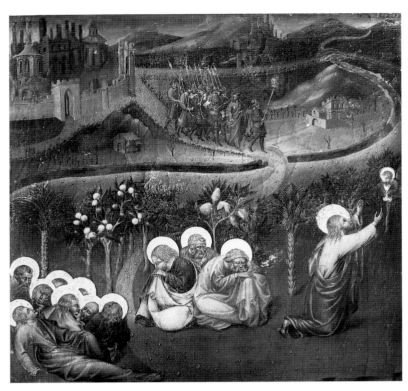

FIG. 31.2 Giovanni di Paolo. *Christ in the Garden of Gethsemane,* early 1430s. Tempera and tooled gold on panel; 12⅝ × 12⅞″ (32 × 32.5 cm). Vatican City, Pinacoteca Vaticana, no. 129. See Companion Panel A

PROVENANCE
Purchased from an unknown source on the advice of Roger Fry for 200 pounds sterling in 1906 (see Fry's cable to Johnson, dated London, October 5, 1906; and further correspondence from Fry dated London, December 23, 1906).

COMMENTS
Christ, led by a group of Roman soldiers, is leaving Jerusalem on his way to be crucified. A dark-haired man, seen from behind, pulls him forward with a noose, another tormentor pushes him on, and a third man helps carry the weight of the cross. A soldier prevents the Virgin and the crowd behind her, spilling out of the city gate, from approaching Christ. To the left John the Evangelist, seen from behind, restrains the Virgin, who lifts her arms as if to embrace the cross. Behind her Mary Magdalene, in red, raises her arms in a gesture of despair. The halos of the holy figures consist of inner and outer circles that are not concentric, which makes them appear to radiate out. Sculptures of winged figures fill the arcade of the city wall, and two heads in shell-shaped roundels decorate the city gate.

The scene represents the moment the Virgin meets Christ on the way to Calvary as described in the *Meditations on the Life of Christ,* a popular late thirteenth-century devotional text by an anonymous Franciscan monk, probably Fra Giovanni da San Gimignano, but often called the Pseudo-Bonaventure:

When, . . . outside the gate of the city, at a cross-roads, she encountered Him, for the first time seeing Him burdened by such a large cross, she was half dead of anguish and could not say a

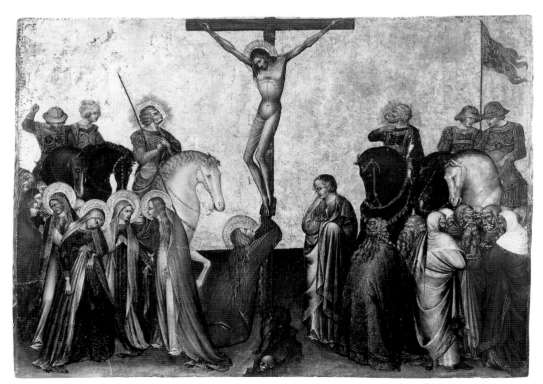

FIG. 31.3 Giovanni di Paolo. *Crucifixion,* early 1430s. Tempera and tooled gold on panel; 11½ × 16⅝″ (29 × 42 cm). Altenburg, Germany, Lindenau-Museum, no. 77. See Companion Panel B

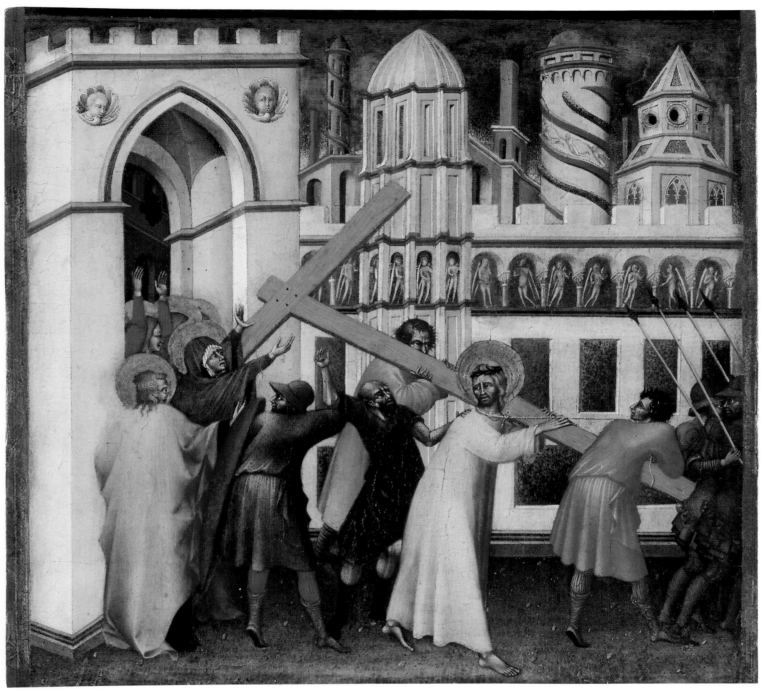

PLATE 31

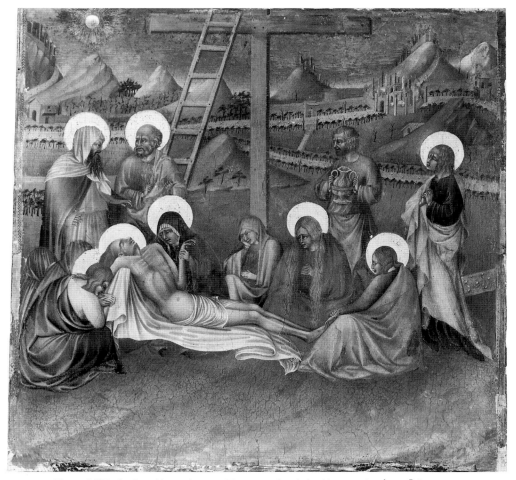

FIG. 31.4 Giovanni di Paolo. *Deposition,* early 1430s. Tempera and tooled gold on panel; 12½ × 12⅞" (31.8 × 32.5 cm). Vatican City, Pinacoteca Vaticana, no. 124. See Companion Panel C

companion pieces have painted backgrounds. The rest of the altarpiece does not survive.

The predella dates to the early 1430s and represents an important step in the development of Giovanni di Paolo's narrative painting after the predella of the Pecci altarpiece of 1426 from San Domenico in Siena.[3] The Johnson painting repeats many details of the *Way to Calvary* (fig. 31.6) in Baltimore, which is from the latter: the Virgin with her arms uplifted toward the cross; the soldier pushing her back; and the positions of Christ, the man leading him by the noose, and Simon Cyrene. These elements are in turn based on older prototypes, derived particularly from Simone Martini's *Way to Calvary* from the Orsini polyptych, now in the Louvre (fig. 31.7), where the Magdalene standing with her arms raised as the procession turns the corner was first introduced. Since Giovanni di Paolo did not know the Orsini altarpiece, which was then in France, his model must have been a copy or another similar composition. One such intermediary could have been the same scene from the predella of Christ's Passion of about 1415–20 by Andrea di Bartolo (q.v.),[4] which shows, for example, the man leading Christ by a rope found in both the Baltimore and Philadelphia panels but not in Simone's scene. In the Johnson painting Giovanni di Paolo distances himself from his Pecci predella by reducing the number of figures to the essential.

Two edifices in the background of the Johnson panel are imaginative reconstructions of Roman monuments. The round tower with the spiraling decoration recalls Trajan's Column and the multistoried building set in the wall, the Septizonium.[5] The octagonal building on the far right is a specific reference to Jerusalem, well known in Sienese painting, that was introduced by Duccio in the scene of Christ entering Jerusalem from the *Maestà* (1311), then on the cathedral's high altar.[6] The public would have identified it as the Jewish temple, which was frequently represented in medieval painting as centrally planned.[7] It has been argued that Duccio's *Entry into Jerusalem* from the *Maestà* contains a detailed depiction of the ancient city based on Flavius Josephus's comment, in his *Bellum iudaicum* of A.D. 75–79, that the Jerusalem skyline was distinguished by many square towers and an octagonal one that King Herod had built and dedi-

word to Him; nor could He speak to her, He was so hurried along by those who led Him to be crucified. But after going a little farther on, the Lord turned to the weeping women and said to them, "Daughters of Jerusalem, do not weep for me but for yourselves," etc. as is more fully related in the Gospel (Luke 23:28).[1]

The artist has emphasized the cross's unusual length, which in the *Meditations* and other sources is said to have been fifteen feet long.[2] The figure who

helps Christ carry it is not mentioned in the *Meditations,* but he is named as Simon Cyrene in Luke 23:26.

The painting is part of a predella (fig. 31.5) depicting Christ's Passion. The other extant sections are *Christ in the Garden of Gethsemane* (fig. 31.2), the *Crucifixion* (fig. 31.3), and the *Deposition* (fig. 31.4). A fifth scene, probably the *Resurrection,* is missing. The panels would have been arranged chronologically, with the *Crucifixion,* the widest of the group, in the center. As is customary, that scene retains the traditional gold ground, whereas the

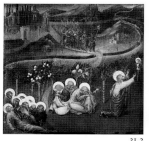
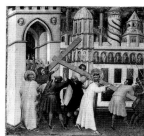
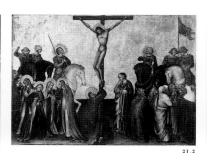
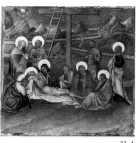

31.2 PL. 31 31.3 31.4

FIG. 31.5 Original sequence of Giovanni di Paolo's predella, early 1430s. Left to right: FIG. 31.2, PLATE 31, FIGS. 31.3, 31.4, missing panel

cated to his friend Phasaelus.[8] Giovanni di Paolo was not unaware of this tradition. In the earlier Pecci predella panel he included two polygonal buildings that could stand for both the temple and Phasaelus's tower, and in the overall views of Jerusalem in the two panels of the present predella now in the Vatican (figs. 31.2, 31.4) there are several centrally planned edifices and variously shaped towers. In fact, in this predella Giovanni di Paolo took the trouble to show Jerusalem from a different viewpoint in each scene.

The Vatican panels contain panoramic nocturnal landscapes that are very close compositionally to the landscape in Giovanni's predella panel showing the *Flight into Egypt*,[9] also dating to the mid-1430s. This is the moment at which the artist takes the most care in integrating the action within the landscape surroundings and gives atmospheric effects the greatest consideration. In his later production landscapes become fantastic, as cultivated rows of fields and mountains seem to float and recede so sharply into the picture plane that perspective becomes as much a decorative element as a spatial one. The more naturalistic period of the thirties reflects Giovanni di Paolo's acquaintance with Gentile da Fabriano's Strozzi altarpiece in Florence (see fig. 82.8), which he copied in several paintings of these years, and Sassetta's *Virgin of the Snow* altarpiece in the cathedral of Siena.[10] The nocturnal scenes and the golden setting sun of the Vatican panels come from the Gentile, and the wispy clouds in the Johnson panel find resonance in the subtle effects of the Sassetta.

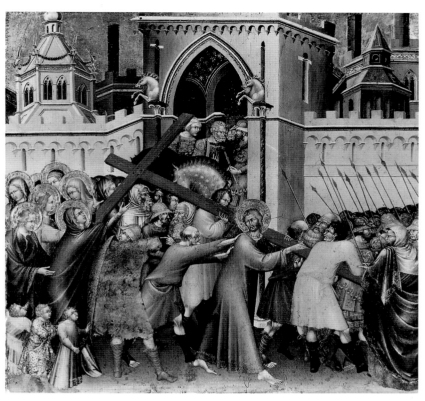

FIG. 31.6 Giovanni di Paolo. Predella panel of an altarpiece: *Way to Calvary,* 1426. Tempera and tooled gold on panel; 16 × 17⅛″ (40.6 × 43.5 cm). Baltimore, The Walters Art Museum, no. 78b

1. Ragusa and Green 1961, p. 332.
2. Ragusa and Green 1961, p. 331.
3. Baltimore, The Walters Art Museum, nos. 78a–d; Zeri 1976, vol. 1, plates 58–61 and color plate B; and Altenburg, Germany, Lindenau-Museum, no. 77; Oertel 1961, plate 25.
4. Madrid, Fundación Colección Thyssen-Bornemisza; Boskovits 1990, color repro. p. 17.
5. Nash 1968, vol. 1, pp. 302–5. The same set of monuments had been used to evoke a Roman setting for the mural of the *Liberation of Peter of Assisi* in the Upper Church of San Francisco, Assisi (Zanardi 1996, postrestoration color repro. p. 353). The more commonly depicted Trajan's Column can be seen in Taddeo di Bartolo's map of Rome in the Palazzo Pubblico, Siena (Meiss 1974, plate vol., fig. 731).
6. Siena, Museo dell'Opera della Metropolitana; Stubblebine 1979, plate 100.
7. Krinsky 1970, pp. 1–19. For example, in Ambrogio Lorenzetti's *Presentation of Christ in the Temple* of 1342, originally in Siena cathedral, the same polygonal form crowns the top of the building. Florence, Uffizi, no. 8346; Chelazzi Dini, Angelini, and Sani 1997, postrestoration color repro. p. 173.
8. Deuchler 1979, 1980.
9. Siena, Pinacoteca Nazionale, no. 176; Torriti 1977, fig. 374 (color).
10. 1431–32; Florence, Uffizi, Contini Bonacossi Collection; Israëls 2003, color plate 1.

Bibliography
Berenson 1909, p. 78; Rankin 1909, p. lxxx; Berenson 1913, p. 57, repro. p. 296; Breck 1914, pp. 177, 284; Tancred Borenius in Crowe and Cavalcaselle 1903–14, vol. 6, 1914, pp. 177–78 n. 1; C. H. Weigelt in Thieme-Becker, vol. 14, 1921, p. 136; Comstock 1927a, p. 54; Van Marle, vol. 9, 1927, p. 330 n. 1; Brandi 1930–31, p. 726; Kimball 1931, repro. p. 25; Berenson 1932, p. 247; Gengaro 1932, p. 32; Berenson 1936, p. 213; E. King 1936, p. 231 n. 28; Pope-Hennessy 1938, pp. 29, 52 n. 75, plate XB (includes the Altenburg panel in the predella); San Francisco 1939a, repro. no. 32; Johnson 1941, p. 8; Rosen 1941, p. 461, fig. 9; Brandi 1947, pp. 24, 73 n. 35, 121; Brandi 1949, p. 259; Coor 1961a, p. 59; Oertel 1961, pp. 90–92; Sweeny 1966, pp. 34–35, repro. p. 117; Berenson 1968, p. 179; Krinsky 1970, p. 12; Fredericksen and Zeri 1972, p. 90; Zeri 1976, vol. 1, p. 117; Volbach 1987, pp. 43–44; Carl Brandon Strehlke in Christiansen, Kanter, and Strehlke 1988, pp. 172–75, repro. p. 173; Philadelphia 1994, repro. p. 196; Carolyn C. Wilson in *DBI*, vol. 56, 2001, p. 139

COMPANION PANELS for PLATE 31

A. Predella panel of an altarpiece: *Christ in the Garden of Gethsemane.* See fig. 31.2

Early 1430s

Tempera and tooled gold on panel with horizontal grain; 12⅝ × 12⅞″ (32 × 32.5 cm). Vatican City, Pinacoteca Vaticana, no. 129

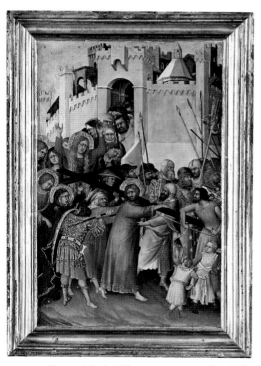

FIG. 31.7 Simone Martini (Siena, c. 1284–1344). Panel of a portable altarpiece: *Way to Calvary,* c. 1326. Tempera and tooled gold on panel; 11⅞ × 8⅛″ (30 × 20.5 cm). Paris, Musée du Louvre, no. 670 bis

The picture is cut down slightly on the top, bottom, and left. On the right there are traces of the original punched gold border.

PROVENANCE: See Companion Panel C

SELECT BIBLIOGRAPHY: See Companion Panel C

B. Predella panel of an altarpiece: *Crucifixion.*
See fig. 31.3

Early 1430s

Tempera and tooled gold on panel with horizontal grain; 11½ × 16⅝″ (29 × 42 cm). Altenburg, Germany, Lindenau-Museum, no. 77

The punched gold border appears on all sides except for the bottom.

PROVENANCE: Purchased by Bernhard August von Lindenau in Italy, 1848

SELECT BIBLIOGRAPHY: Van Marle, vol. 9, 1927, p. 445; Pope-Hennessy 1938, pp. 29, 52, 169; Brandi 1941, p. 244 n. 34; Brandi 1947, p. 73 n. 35; Brandi 1949, p. 259; Oertel 1961, pp. 90–92 (with earlier bibliography); Volbach 1987, pp. 43–44; Carl Brandon Strehlke in Christiansen, Kanter, and Strehlke 1988, pp. 172–75; Carolyn C. Wilson in *DBI*, vol. 56, 2001, p. 139

C. Predella panel of an altarpiece: *Deposition.* See fig. 31.4

Early 1430s

Tempera and tooled gold on panel with horizontal grain; 12½ × 12⅞″ (31.8 × 32.5 cm). Vatican City, Pinacoteca Vaticana, no. 124

Remnants of the punched gold border appear on all four sides.

PROVENANCE: How and when this panel and *Christ in the Garden of Gethsemane* (Companion Panel A) came to be owned by the Vatican are unknown. They were part of the collections of the Biblioteca Apostolica Vaticana, from which they passed into the Museo Sacro (in 1880 recorded in case R, III, no. 139, and case R, IV, no. 140, respectively), and into the Pinacoteca in 1908.

SELECT BIBLIOGRAPHY: Barbier de Montault 1867, p. 159; Toesca 1904, p. 306; Vatican City 1913, pp. 82–83; D'Archiardi 1929, p. 16; Van Marle, vol. 9, 1927, p. 425; Berenson 1932, p. 247; Gengaro 1932, pp. 13, 21; Vatican City 1933, pp. 35–36; Pope-Hennessy 1938, pp. 29–30, 36, 52, 54; Brandi 1941, p. 244; Brandi 1947, pp. 24, 73; Volbach 1987, pp. 43–44, cat. 50; Carl Brandon Strehlke in Christiansen, Kanter, and Strehlke 1988, pp. 172–75; Carolyn C. Wilson in *DBI*, vol. 56, 2001, p. 139

PLATE 32A (PMA 1945-25-121)
Saint Lawrence

Early 1430s

Tempera, silver, and tooled gold on panel with vertical grain; 9½ × 9½ × ⅞″ (24 × 24 × 2 cm); painted surface, diameter 8¼″ (21 cm)

Philadelphia Museum of Art. Purchased from the George Grey Barnard Collection with Museum funds. 1945-25-121

INSCRIBED AT LOWER LEFT: *121* (on a paper sticker); ON THE REVERSE: *3.* (in black ink); *16* (in crayon); *45-25-121* (in red)

PUNCH MARKS: See Appendix II

TECHNICAL NOTES
The panel is cut at the top and bottom; it is thinned and much worm eaten. On the reverse toward the corners there are four holes that contain remnants of wood dowels, suggesting that the panel came from the end of a box predella or the bottom of a box-shaped pilaster (see plate 32B [PMA 1945-25-122]). Another square nail hole, which can be seen at the bottom front toward the right, may have been used to attach the panel to a supporting element.

On the reverse there is some old filling of worm-eaten areas. Two old butterfly inserts reinforce the panel. Vertical cracks, 2⅛″ (5.2 cm) from the right, run through the panel from the bottom, and there are other cracks in the saint's face.

Two strips were added at either side (approximately ¼″ [0.6 cm] wide at the left and approximately ⅞″ [2 cm] wide at the right) to accommodate the nonoriginal gilt pastiglia enframement.

The gold background of the roundel is new. Some of the original gold can be seen below the figure's chin, in the area of the grill, and on the ornament of his costume. The robe is now worn to a reddish bole but originally would have been silver leaf with sgraffito decoration, some of which is still visible on close inspection. A little of the silver, now tarnished to black, survives on the grill. The green palm of the saint's martyrdom, which was painted directly over the red bole and some of the gold, is very worn. The flesh areas are well preserved and are fine examples of closely knit strokes of tempera applied over green underpaint. The outlines of the figure were all incised.

PROVENANCE
See plate 32B (PMA 1945-25-122)

COMMENTS
The tonsured young deacon Saint Lawrence, looking right, is shown half-length as he holds the grill on which he was martyred. For further comments, see plate 32B (PMA 1945-25-122).

Bibliography
See plate 32B (PMA 1945-25-122)

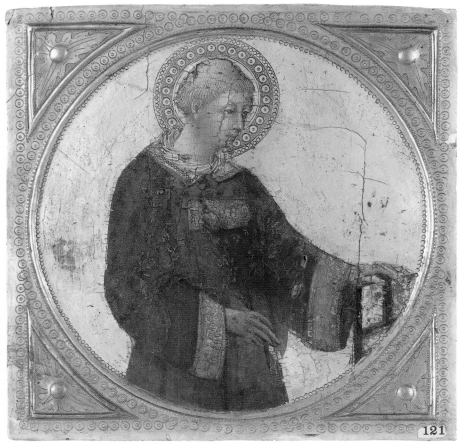

PLATE 32A

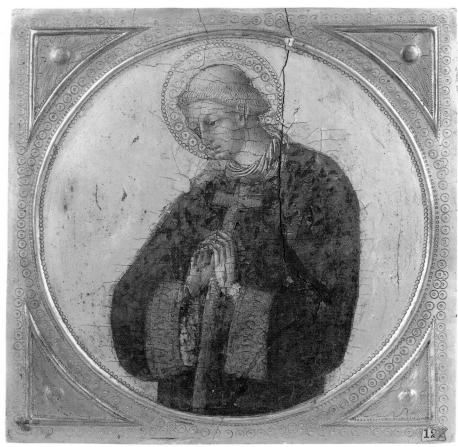

PLATE 32B

A Deacon Saint

Early 1430s

Tempera and tooled gold on panel with vertical grain; 9⅝ × 9⅝ × ⅞″ (24.2 × 24.2 × 2 cm); painted surface, diameter 8¼″ (21 cm)

Philadelphia Museum of Art. Purchased from the George Grey Barnard Collection with Museum funds. 1945-25-122

INSCRIBED AT LOWER LEFT: *122* (on a paper sticker); ON THE REVERSE: *Orcagna* (in black ink on the upper butterfly key); *45-25-122* (in red)

PUNCH MARKS: See Appendix II

TECHNICAL NOTES

The panel is cut at the top and bottom; it is also thinned and worm eaten. On the reverse toward the corners there are four holes that contain remnants of wood dowels. At the bottom left from the reverse there is also the exposed channel of a square nail hole stained with rust. The nail would have been driven from another panel, perpendicular to this one. The dowels, the nail channel, and the two panels' vertical grain suggest that they came from the bottom of a box-shaped pilaster or were at the ends of a box predella.

Extending three-quarters of the length of the panel, from the top, is a vertical crack, approximately 22.9″ (9 cm) from the right. At a later date the panel was enlarged by two additions to either side (approximately ½″ [1.2 cm] wide at the left and approximately ⅞″ [2.2 cm] wide at the right) to accommodate the nonoriginal gilt pastiglia enframement.

The gold background of the roundel is new. Some of the original gold can be seen along the edge of the figure, below his chin, and in the ornament of his robe. The gold is best preserved inside his right sleeve, although traces of paint indicate that there the gold was probably painted a green tone. As in the *Saint Lawrence*, the robe is worn to a reddish bole, but it originally would have been silver leaf decorated with sgraffito. Some of the sgraffito and traces of a white paint are still visible on close inspection. Despite the panel's many alterations, this figure's flesh is remarkably well preserved.

PROVENANCE

This and the *Saint Lawrence* were purchased by the Museum from the estate of George Grey Barnard.

COMMENTS

The young tonsured saint in the robes of a deacon of the church is shown praying. Although he does not have any specific attributes, he may be Stephen, a deacon and the first martyr of the church, whose death by stoning is told in Acts 7:57–59. Since he is frequently shown with Saint Lawrence, the other early deacon-martyr, who appears in the other

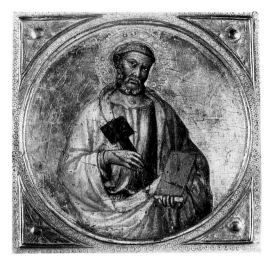

FIG. 32.1 Martino di Bartolomeo (q.v.). *Saint Peter,* early 1430s. Tempera and tooled gold on panel; 9⅝ × 9⅝″ (24.3 × 24.2 cm). York City Art Gallery, no. 779a

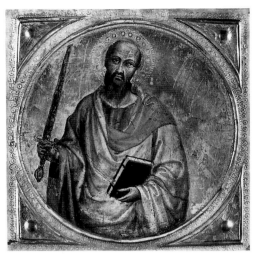

FIG. 32.2 Martino di Bartolomeo (q.v.). *Saint Paul,* early 1430s. Tempera and tooled gold on panel; 9¾ × 9⅝″ (24.5 × 24.2 cm). York City Art Gallery, no. 779b

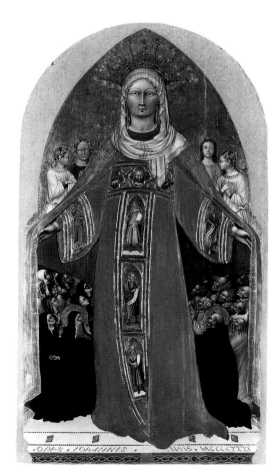

FIG. 32.3 Giovanni di Paolo. *Virgin of Mercy with the Blessed Giuliana Falconieri(?) and Saint Filippo Benizzi(?), the Faithful, and Angels,* 1431. Tempera and tooled gold on panel; 76 × 41″ (193 × 104 cm). Siena, church of Santa Maria dei Servi

grained wood, making it very unlikely that, even if they originally did belong together, all four would have come from a predella, since a predella consisting of such medallions would have been composed of a single plank of horizontally grained wood (see Taddeo di Bartolo, plate 78 [JC cat. 95]). The four dowel holes on the back of each of the Philadelphia panels might suggest that these two were part of a piece of furniture, such as a sacristy cupboard.[1] However, they also could have formed part of the lateral pilasters of an altarpiece or the base of a pilaster to an altarpiece as part of the ends of a box predella. By contrast, the panels in York have eight shallow saw cuts in the back—two toward the end of each edge, at right angles to it—which suggest another type of construction.[2]

Zeri proposed that the four panels, which he presumed were part of a collaborative project, provided evidence that Giovanni di Paolo began his career in the shop of Martino di Bartolomeo. While Giovanni di Paolo may have passed through Martino's workshop, the difference in style between the saints by Giovanni di Paolo and those by Martino di Bartolomeo would suggest that if they did collaborate on these paintings, by this point the younger artist was no longer under the influence of Martino. While the two panels by Giovanni di Paolo can be dated early in his career, they are not his first known works, but probably date to the early 1430s. They can be compared with the kneeling figures in Giovanni di Paolo's *Virgin of Mercy* (fig. 32.3), signed and dated 1431, in the church of Santa Maria dei Servi in Siena, or even to the figures in Giovanni di Paolo's predella of which the Johnson Collection's *Christ on the Way to Calvary* (plate 31 [JC cat. 105]) is a part.

panel from the same predella, this identification is likely. However, because Stephen is usually shown with the stones of his martyrdom on his head and with a palm of martyrdom, which are not seen here, the figure may also be the early Christian deacon-martyr Vincent of Zaragoza. Although Vincent is frequently depicted with a millstone, the instrument of his martyrdom, there are Sienese paintings showing him only in deacon robes, as seen in the upper tier of Pietro Lorenzetti's (q.v.) altarpiece in the *pieve* in Arezzo (see fig. 39.5), commissioned in 1320.

The attribution of this panel and *Saint Lawrence* to Giovanni di Paolo was first made by Martin Weinberger in his 1941 catalogue of George Grey Barnard's estate. It has been proposed that two other panels come from the same complex: *Saint Peter* (fig. 32.1) and *Saint Paul* (fig. 32.2), both in the York City Art Gallery. These are not by Giovanni di Paolo, but by the much older Martino di Bartolomeo (q.v.). Federico Zeri (quoted in York 1975; Zeri 1986) also noted that the York panels are of the same size and have the same tooling and pastiglia decoration as the Philadelphia paintings. Zeri thought that they constituted a predella to an altarpiece. However, it is not clear if the panels actually do belong together. The similarities in size and decoration are inconclusive, since the Philadelphia panels have been enlarged and the enframement, including the pastiglia, is new. While these changes may have been made when they were excised from a larger complex, in order to mask damage to their original appearance, there is no way of confirming this. Furthermore, the pastiglia decoration of the panels in York appears to be original. Like the pieces in Philadelphia, the York panels are on vertically

1. Few sacristy cupboards survive. Fragments of one by Benedetto di Bindo (q.v.) are found in the Museo dell'Opera della Metropolitana in Siena (Brandi 1949, plates 11–15), and there is an earlier example by Memmo di Filippuccio Memmi in San Lucchese in Poggibonsi (Siena 1985, color and black-and-white repros. pp. 34–39).
2. I am grateful to Richard Green for information on the panels in York.

Bibliography
Weinberger 1941, no. 121, plate XXXVIII; Philadelphia 1965, p. 35; Brigstocke 1967, p. 739; Fredericksen and Zeri 1972, p. 620; York 1975, p. 4; Strehlke 1985a, pp. 5, 12 n. 14, figs. 5a, b; Zeri 1986, figs. 4a, b; Philadelphia 1994, repros. pp. 195–96; Ada Labriola in Filieri 1998, p. 206

PLATE 33 (JC INV. 723)

Lateral panel of an altarpiece: *Saint Nicholas of Tolentino Saving a Shipwreck*

1457

Tempera and gold on panel with vertical grain; 20½ × 16¾ × ½ to ¹¹⁄₁₆″ (52 × 42.3 × 1.2 to 1.7 cm)

John G. Johnson Collection, inv. 723

INSCRIBED ON THE REVERSE: *Box 72* (in pencil); *Inv # 723* (in pencil, twice); *13 x 22 - 3* (in blue chalk); *Inv 723* (in black chalk); *22* (in pencil)

EXHIBITED: Siena 1904, Sala XXXV: 7, no. 2634; New York 1936, no. 25 (not included in the subsequent traveling exhibition); San Francisco 1939, no. Y-4; Philadelphia Museum of Art, John G. Johnson Collection, Special Exhibition Gallery, *From the Collections: Paintings from Siena* (December 3, 1983–May 6, 1984), no catalogue

TECHNICAL NOTES

The picture is painted on a single plank of poplar that was cut from near pith in the center of the tree. This cut resulted in a discontinuous split that runs through the center of the panel, making it very fragile. The panel also has several surface irregularities, three of which were covered by oblong canvas patches before the gesso ground was applied; they are faintly visible in the X-radiograph (fig. 33.1). However, a scratch in the wood (9⅞ × ¼″ [25 × 0.5 cm]), extending from the bottom right edge through the center, was not corrected before the ground was applied. The panel was later thinned and cut at the bottom, and the back beveled on the other three sides.

The panel originally had gilt applied moldings. Gold leaf can also be seen extending about ¼–½″ (0.5–1 cm) under the paint around all four edges, also suggesting that not much wood was lost at the bottom. The gilding that would be painted over was first covered with a layer of white paint in a process known as *ritagliare* (see Allegretto di Nuzio, plate 4 [JC cat. 118]).

Infrared reflectography revealed extensive freehand drawing that differs from the final painted image. In the drawing, for example, the sailors tended to be stockier with more prominent arms and elbows, and the broken sails and masts in the sky are positioned differently (fig. 33.2). Although in most cases the painted design follows the outlines incised in the gesso rather than the underdrawing, those around the saint show that the artist had originally conceived him with much thicker proportions. The saint's halo was incised, whereas the gold rays of light around him were done in sgraffito. Details of the ship were incised into the wet paint toward the end of the execution. The waves were modeled in scumbled highlights and a green shadow glaze, now turned brown. The sailors were painted on top of the already painted boat.

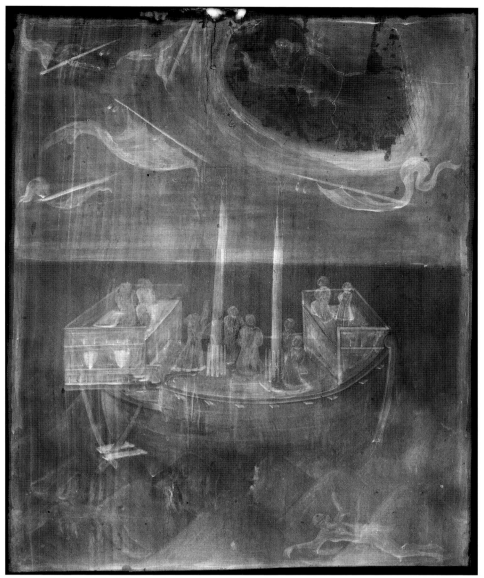

FIG. 33.1 X-radiograph of plate 33, showing the vertically grained wood panel

The most significant paint loss occurs in the sky, where paint has flaked off the gold around the saint. The area around the halo is missing and repainted, and there is damage in his forehead. Other sections have scattered damages. The mermaid's head was vandalized with scratches.

In 1957 Theodor Siegl cleaned the painting of surface dirt and did some minor retouching. In 1993 David Skipsey examined the picture and wrote a detailed report of its condition before treating it. He removed Siegl's synthetic varnish and earlier overpaints. He also adjusted the overpainting to enhance the image's readability. The greatest improvement in the painting's appearance was in the area around the saint, where a close reading of the incised sgraffito lines supported Skipsey's careful reconstruction of the original gold rays.

PROVENANCE

Probably Montepulciano, church of Sant'Agostino, before 1862; Siena, Antonio Palmieri-Nuti, 1904; Godefroy Brauer; sold to Johnson by A. S. Drey, Munich, for 2,000 German marks, 1914 (see Drey to Johnson, Munich, February 17, 1914), seemingly on the advice of Wilhelm R. Valentiner (undated correspondence).

COMMENTS

Nine kneeling passengers of a wrecked ship invoke the aid of Saint Nicholas of Tolentino, who appears in the sky emanating golden light, wearing the black, girded Augustinian habit. The belt is gilt. With his right hand he quells the storm, and in his left he holds a lily, symbol of his role as a confessor, or nonmartyr, saint. The sails that have broken

away from the masts blow furiously in the wind, and a mermaid swims in the turbulent waves that recede in the distance. The sky is dark except for a yellowish orange streak at the horizon.

The panel formed part of an altarpiece in Montepulciano. The other extant sections are the central panel showing the full-length standing image of the saint (fig. 33.3), signed and dated 1457, now on the second altar on the right in Sant'Agostino, in Montepulciano, and a side panel, *Saint Nicholas of Tolentino Interceding at Ventorinus's Funeral* (fig. 33.4) in Vienna. The date of the Montepulciano panel has been often incorrectly read as 1456. The dimensions indicate that the original altarpiece was composed of four scenes, two placed vertically on each side of the center; two of the side panels are missing. The model for the altarpiece was Simone Martini's *Beato Agostino Novello* of about 1324, in which the blessed Augustinian appears in full length in the center and representations of his posthumous miracles are paired on each side.[1]

Comparison of the X-radiographs (figs. 33.1, 33.5) shows that the Johnson panel and the panel in Vienna were painted on the same plank of wood. The grain at the top of the Vienna panel matches that at the bottom of the Johnson panel, indicating that the latter was on the top.

The altarpiece was an important manifestation of the cult for Saint Nicholas of Tolentino. Although revered as a saint soon after his death in 1306, he was not canonized until 140 years later, by Pope Eugenius IV Condulmer. But even before his tomb in Tolentino in the Marches was a pilgrimage site known for its thaumaturgic powers, it had a Giottesque wall painting cycle by a Riminese master in his sepulchral chapel that documented his life and many miracles.[2] Popes Innocent VI d'Aubert and Boniface XI Tomacelli had issued bulls in 1357, 1390, and 1400 confirming popular devotion to Nicholas, but the Avignon papacy (1305–77) and church schism (1378–1418) delayed official recognition. Eugenius's reasons for sanctifying him were motivated in part by his plan for monastic regeneration and the establishment of an Observant, or reform, branch of the Augustinian order.[3] Nicholas was known to have championed an earlier reform movement in the order and to have supported the unification of three hermetic monastic groups under Augustinian rule in 1259. This period of the order's history was much on the minds of Augustinian theologians in the first half of the fifteenth century. While in Siena in about 1429, the Augustinian Andrea Biglia wrote the tract *De ordinis nostri forma et propagatione,* which expounded, among other things, Nicholas's importance in the order.[4]

Before his canonization in 1446 few images of Nicholas of Tolentino existed in Sienese territory. A mural dated 1375 in the Augustinian hermitage in Lecceto, about ten miles outside Siena, is one of the rare extant examples.[5] From the late trecento Lecceto was the center of the Augustinian Observant

FIG. 33.2 Infrared reflectographic detail of plate 33 (before treatment), showing the broken sails and mast below the saint

movement. The revival that swept the order particularly during Eugenius IV's papacy had its effect on the arts, as Lecceto and other Augustinian establishments in the area became important patrons.

As evidence for the canonization of Nicholas of Tolentino, Pope Eugenius's commissioners put forth the depositions of 371 witnesses to his miracles gathered in 1325. In 1446 the Sienese government obtained a copy of this testimony as a guide for promoting the canonization of a recently deceased native, Bernardino Albizzeschi.[6] The interest that the text excited in Siena meant that information on Nicholas's life and miracles was easily accessible to an artist like Giovanni di Paolo, who was already well introduced into Augustinian circles. Pietro da Monte Rubiano's biography of the saint, written in 1326, was probably also available.

Judging from the number of Giovanni di Paolo's Augustinian commissions, he was the order's preferred local artist. He worked on two choral books for Lecceto; executed a mural for its dependency in San Leonardo al Lago; and, besides this altarpiece for Montepulciano, painted at least two others for Augustinian houses. One, now in New York, also includes Saint Nicholas of Tolentino.[7]

The artist based the altarpiece's central image of Nicholas of Tolentino (fig. 33.3) on an iconographic formula that had been recently coined for Bernardino. For example, Nicholas's elevation over a circular map and the position of his attributes derive from one of the first images of Bernardino, made even before his canonization, by Pietro di Giovanni d'Ambrogio.[8] In addition, Bernardino is similarly elevated over a map in a painting made in 1450 by Sano di Pietro (q.v.) at the time of the saint's canonization.[9] Taddeo di Bartolo had used the cartographic motif in his personification of the virtue Justice in the chapel of Siena's Palazzo Pub-

blico (1407–8),[10] and Domenico di Niccolò dei Cori had included it in his intarsia allegories of the Credo for the same chapel (1415–28).[11] The tradition probably ultimately derives from a lost map of the world by Ambrogio Lorenzetti that was in the same building. Maps of this sort were a popular motif in Sienese painting, and Giovanni di Paolo had already adapted them on several occasions.[12]

The star in the image of Saint Nicholas refers to the one that, according to legend, followed Nicholas from his hometown, Castel Sant'Angelo in Romagna, to Tolentino. The book's inscription, "I served the principles of my father to which I remain devoted," alludes to the precepts of the Augustinian Rule and to Saint Augustine, the order's supposed founder.[13] The words can be interpreted as a reference to the rebirth of the order under the Observants, the validity of the union of 1259, and the order's spiritual descent from Augustine.

The prominence of Nicholas's belt, which is worked in gold, in the central panel as well as in the related pictures in Philadelphia and Vienna is unusual before this period. Even though a regular part of the Augustinian habit, it is not always so distinct in paintings of Augustinian monks. The establishment in 1439, by Cesareo Orsini, of a lay group called the Cinturati, who wore the belt of the habit, may have influenced Giovanni di Paolo.[14]

The Johnson picture of the miracle of Saint Nicholas of Tolentino's rescue of a shipwreck does not follow the description in Pietro da Monte Rubiano's 1326 biography of the saint, in which three lit candles that appear in the sky are not extinguished by the storm.[15] This detail is also absent from an early mural of the subject in the Tolentino chapel,[16] suggesting that both pictures might be based on an eyewitness account of the miracle, such as that of Antonio di Tomaso de Parisinis, who told

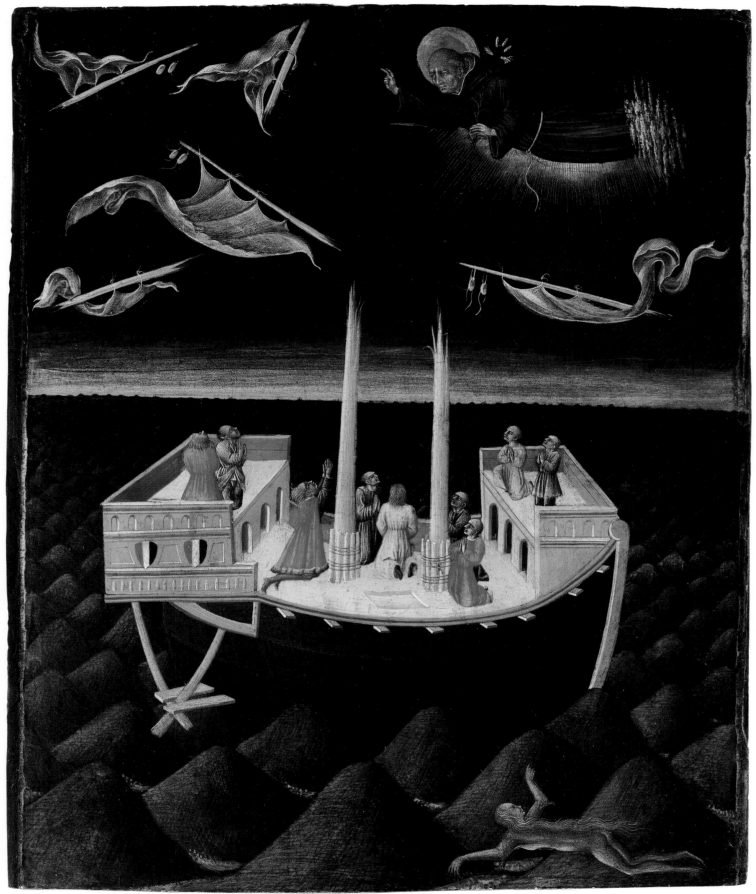

PLATE 33

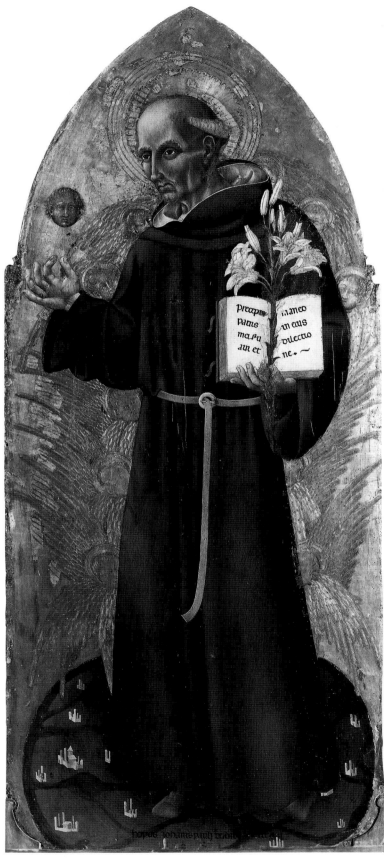

FIG. 33.3 Giovanni di Paolo. *Saint Nicholas of Tolentino in Glory*, 1457. Tempera and tooled gold on panel; 70⅞ × 24⅞″ (180 × 63 cm). Montepulciano, church of Sant'Agostino. See Companion Panel A

of how, when a storm took his ship by surprise in 1317 and caused the sails to go out of control, he had called on the saint to save him.[17]

However, the force of visual and hagiographical tradition also held sway. The scene quotes a frequently painted shipwreck miracle performed by Nicholas of Bari, who is closely associated with his namesake's legend. That Nicholas is said to have appeared in a dream of the Augustinian friar's mother while pregnant, and to have, along with Christ and the Virgin, welcomed him into heaven. Giovanni di Paolo undoubtedly knew two depictions in Florence of the shipwreck miracle of Nicholas of Bari by Gentile da Fabriano[18] and Lorenzo Monaco (q.v.).[19] The siren comes from Gentile, although Giovanni di Paolo mistakenly showed her swimming toward the ship, instead of fleeing from the saint's powers. The broken masts and sails appear in a similarly ragged state in the Lorenzo Monaco. Giovanni di Paolo also adapted Lorenzo Monaco's sparse and empty setting, but made it more threatening. Unlike Gentile and Lorenzo Monaco, Giovanni offers no comforting view of the shore and shows a sky that has completely darkened. The Sienese painter concentrates on the emotional content of the narrative and is little interested in naturalistic conformity, as the waves seem to be an endless chain of uniformly shaped hills, and the boat appears to have little navigational possibility.

The curious side runner at the boat's aft is a simplified version of a model in Ambrogio Lorenzetti's *Saint Nicholas of Bari Miraculously Stocking Merchant Ships*.[20] Similar runners are found in numerous depictions of fifteenth-century boats. The two coats of arms on the side of the boat in the Johnson picture, composed of parallel red, white, and black fields, may be of the altarpiece's patron, but they have not yet been identified.

The companion panel in Vienna depicts Saint Nicholas of Tolentino interceding at a funeral. It follows the text of the testimony of several witnesses in the manuscript in Siena and in Pietro da Monte Rubiano's biography of the saint,[21] who describe how, in the early 1300s, the wife of one Ventorinus of Parma invoked the saint to resuscitate her deceased husband. The literary descriptions all emphasize how the funeral preparations had already begun before the man was brought back to life. Ventorinus's wife is not shown in the painting; there is only the funeral procession winding through the empty city streets and a man carrying a coffin out of the house. The lack of a specific reference to Ventorinus and his wife has sometimes caused the scene to be described as Nicholas staying a plague, because he was famous as an intercessor. In 1449 his image was carried in Pisa for this reason, and there are several depictions of him saving cities from the scourge.[22] However, the single funeral bier in the Vienna picture indicates that it indeed represents Ventorinus's funeral preparations.

Although the center section of the altarpiece is

now in Sant'Agostino in Montepulciano, it is not certain whether that was its original location. The church was renovated in 1784. During the Napoleonic period, its friars were disbanded, and afterward the Servite order took over the church.[23] The first written description of Sant'Agostino appears in Francesco Brogi's index of 1897,[24] where he records only the image of the saint and its frame made up of eighteenth-century votive pictures. This indicates that the altarpiece was dismembered sometime before this date.

Contributing to the uncertainty of the original placement of the altarpiece is the fact that Montepulciano actually had two Augustinian communities. The other was Santa Mustiola, directly across the street from Sant'Agostino, where the Palazzo Cancini now stands. Sant'Agostino took over Santa Mustiola in 1794, and it is likely that works of art in Santa Mustiola found their way to the other church. Unfortunately, little is known of either establishment in the fifteenth century. Sant'Agostino underwent a great expansion in the early part of the century, and in the 1430s and 1440s a new façade was constructed on the design of Michelozzo, with financing provided from a bequest by the humanist Bartolomeo Aragazzi.[25] Of the church of Santa Mustiola, it is known that Pope Eugenius IV elected a Sienese friar, Bartolomeo di Domenico, to become its rector in 1443.[26] If this friar was still there a decade later, he may have been Giovanni di Paolo's connection for the commission. During the fifteenth century Montepulciano was under the control of the Florentine government, and although Sienese artists had worked there at the very turn of the century, there had been no artistic contacts of note between Montepulciano and Siena since Taddeo di Bartolo's high altarpiece in the cathedral of 1401.[27] In fact, Giovannni di Paolo was the only Sienese artist to receive important commissions in Montepulciano in the mid-fifteenth century; around the same time as the Saint Nicholas of Tolentino altarpiece he painted an altarpiece for Santi Giovanni Battista e Giovanni Evangelista, for which the predella survives in part.[28] His Augustinian connections can account for the commission of the Nicholas of Tolentino painting, but it is also of some significance that he was out of Siena in 1456, one of the most crucial years in the city's history, when a conspiracy to overthrow the government was discovered. As a result, many citizens fled, while others were executed or exiled. Although there is no evidence as to what happened to Giovanni di Paolo at this time, some exiles found refuge in Montepulciano; he may have had connections with them.

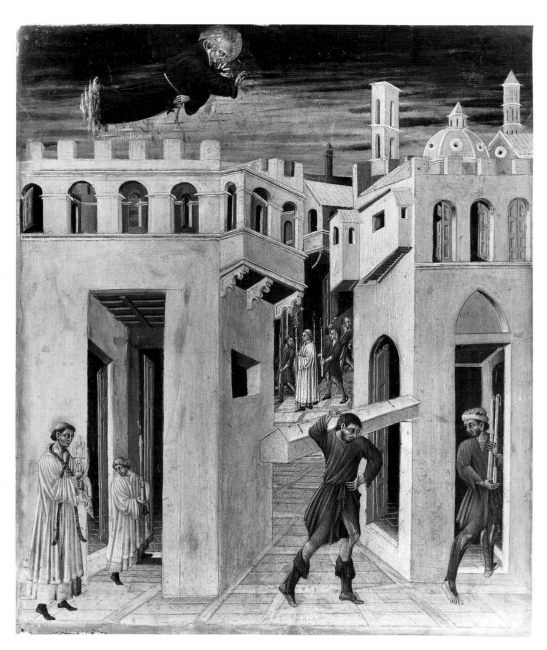

FIG. 33.4 (*above*) Giovanni di Paolo. *Saint Nicholas of Tolentino Interceding at Ventorinus's Funeral*, 1457. Tempera and tooled gold on panel; 19¾ × 16¾″ (50 × 42.5 cm). Vienna, Gemäldegalerie der Akademie der bildenden Künste, inv. 1177. See Companion Panel B

FIG. 33.5 (*left*) X-radiographic detail of fig. 33.4, showing the upper part of the vertically grained wood panel

1. From Siena, Sant'Agostino; on deposit, Pinacoteca Nazionale; Siena 1985, color plate p. 57.
2. Illustrated in Centro Studi Agostino Trapè 1992.
3. On the Observant order in Tuscany, see K. Walsh 1972 and Alessi et al. 1990.
4. Biglia c. 1429, Arbesmann ed. 1965, pp. 204–7.
5. Vailati Schoenburg Waldenburg 1983, p. 8, fig. 3.

6. Occhioni 1984. On the Sienese government and this text, see Liberati 1936.
7. The Metropolitan Museum of Art, no. 32.100.76; Zeri 1980, plates 40–41.
8. 1444; Siena, Pinacoteca Nazionale, no. 203; Pavone and Pacelli 1981, fig. 14.
9. Siena, Pinacoteca Nazionale, no. 253; Torriti 1977, fig. 316.
10. Symeonides 1965, plate LXXIIC.
11. Boespflug 1985, color repros. pp. 10, 13, 21.
12. See the predella panel of the *Creation of the World and Expulsion from Paradise* (New York, The Metropolitan Museum of Art, no. 1975.1.31; Christiansen, Kanter, and Strehlke 1988, color repro. p. 195), and the illumination in folio 178 recto of the *Divina Commedia* (London, British Library, Yates Thompson Ms. 36; Pope-Hennessy 1993, color repro. pp. 162–63).
13. The opening lines of the Augustinian Rule are inscribed on another Giovanni di Paolo altarpiece showing Augustine consigning the rule to the monks (c. 1470–75; Avignon, Musée du Petit Palais, no. 91; Laclotte and Mognetti 1987, repro. p. 110).
14. Balbino Rano in *DIP*, vol. 1, 1973, cols. 374, 379.
15. *AA.SS.*, Sept. III, pp. 663–64, nos. 82–83.
16. Kaftal and Bisogni 1978, fig. 1026.
17. Occhioni 1984, p. 320, lines 58–86:

Item dixit quod dum quodam tempore ipse testis esset Ancone cum quodam socio suo nomine Petrozono de Tholentino et vellet venire versus portum Civitanove per mare, intraverunt quamdam barcham ipse et socius eius predictus cum pluribus aliis sociis de diversis locis, quos non cognoscebat; et dum irent per mare versus dictum locum, mare fuit fortiter turbatum et erant tam magni mantelli quod videbatur barcha ipsa volvi subtus supra et quam plures barche perierunt illa nocte, tam magne tempestates fuerunt nocte prefata; et testis timens submergi in mari, vovit se beato dicto Nicholao supplicans ei reverenter et cum devotione magna quod rogaret Deum quod precibus ipsius beati Nicholai liberaret eum a dicto periculo et tempestate; et, si liberaretur, ipsemet veniret ad visitandum sepulcrum suum et archam suam cingere circum circa de cera. Et facto dicto voto, licet tempestas esset magna in mari, tamen circum circa barcham ipsam erat magna tranquillitas; et sic steterunt sani et salvi cum tranquillitate in dicto loco in mari, ubi stabant per spatium trium horarum et postmodum cessavit tempestas et venerunt ad portum Civitanove sani et salvi de mane tempestive. Interrogatus de tempore, dixit quod currebant anni Domini MCCCXVII, de mense augusti, de die seu nocte illa non recordatur. Interrogatus de presentibus, dixit ut supra. Interrogatus de loco, dixit quod in mari prope Sanctum Clementem. Interrogatus ad cuius invocationem fuit factum dictum miraculum, dixit quod ad invocationem ipsius. Interrogatus quibus verbis interpositis, dixit ut supra. Interrogatus de nominibus illorum circa quos factum fuit miraculum, dixit ut supra. Interrogatus si cognoscebat predictos cum eo existentes, dixit quod cognoscebat dictum Petrozonum, alios non. Interrogatus quantum duravit tranquillitas post miraculum factum, dixit ut supra quod sani et salvi iverunt Civitanovam. (Item. Similarly he said that when sometime ago the witness himself, who was in Ancona with his former associate named Petrozono da Tolentino, wanted to come by sea to the port of Civitanuova, he and his

said partner with many other associates from different places, whom he did not know, came on a certain boat. When they came by sea to the said place, the sea was very rough and the winds were so great that the ship was seen to turn over on itself. Indeed many ships were lost that night, because the storm got stronger during the night. The witness, fearing that he would fall into the sea, made a vow to the said blessed Nicholas, reverently and with great devotion, asking him to plead the Lord, by his prayers to the blessed Nicholas himself, to liberate him from the said danger and storm. If saved, he would himself come to visit his tomb and to embellish his altar with candle wax. And once he made this plea, although the sea storm was at its fiercest, around his ship there was the greatest tranquillity, where it stood for the space of three hours. After the storm subsided, they came to the port of Civitanuova healthy and safe from the storm. Asked about when this occurred, he said that it happened in the year of the Lord 1307, in the month of August, but that he did not remember the day or night. Asked about who was there, he said as above. Asked about the place, he said it was in the sea before San Clemente. Asked about the names of those who were there at the miracle, he said as above. Asked if he knew the said persons, he said that he knew the said Petrozono, the others no. Asked about how long the tranquillity lasted after the miracle happened, he said as above and that all went healthy and safely to Civitanuova.

18. 1425; from the Quartesi altarpiece in Florence, San Niccolò Oltrarno; now Vatican City, Pinacoteca Vaticana, no. 249; De Marchi 1992, color plate 66.
19. C. 1423–24; originally part of the altarpiece of the Strozzi chapel in Florence, Santa Trinita; Florence, Galleria dell'Accademia, no. 8615; Scudieri and Rasario 2003, color plate 1.4a.
20. C. 1330; from an altarpiece in Florence, San Procolo; now Florence, Uffizi, inv. 8349; Marcucci 1965, fig. 111b.
21. Siena, Biblioteca Comunale degli Intronati, Ms K.I.14, folios 55 verso–61 recto; Occhioni 1984, pp. 152–53; *AA.SS.*, Sept. III, nos. 72–77, p. 662 n. q, p. 694, no. 192. See also Pope-Hennessy 1983, pp. 52, 56.
22. For images of the saint staying plagues in Empoli and Pisa, see Sainati 1886, p. 159; and Kaftal, 1952, col. 772, fig. 867.
23. Fumi 1894, p. 28.
24. Brogi 1897, p. 286.
25. Lightbown 1980, vol. 1, pp. 225–27.
26. Benci 1646, pp. 181–82.
27. Symeonides 1965, plates XX–XXXII.
28. Brogi 1897, p. 305; Pope-Hennessy 1987, pp. 125–27. See the reconstruction and reproductions in Christiansen, Kanter, and Strehlke 1988, pp. 210–13; Riedl 1986.

Bibliography

Tancred Borenius in Crowe and Cavalcaselle 1903–14, vol. 6, 1914, p. 178 n.; Perkins 1904, p. 583; Perkins 1904a, pp. 149–50; Ricci 1904, pp. 72–73, 104, fig. 75; Siena 1904, p. 341; Jacobsen 1908, p. 48; Berenson 1909, p. 180; Breck 1914, p. 177, fig. 1, pp. 284–87; C. H. Weigelt in Thieme-Becker, vol. 14, 1921, p. 136; Dami 1923–24, pp. 294, 298, repro. p. 291; Comstock 1927a, p. 54; Van Marle, vol. 9, 1927, pp. 430–31, 447; Kimball 1931, repro. p. 24; Berenson 1932, p. 247; Gengaro 1932, p. 32; Barr 1936, repro. p. 201, no. 25; Benson 1936, repro. p. 6 (detail); Berenson 1936, p. 213; Davidson 1936, repro. p. 10; Pope-Hennessy 1938, pp. 76–78, 89, 108; San Francisco 1939, p. 29, repro. Y-1; Brandi 1947, pp. 47, 74 n. 36, 85 n. 69, 121; Pope-Hennessy 1947, frontispiece, p. 26; Kaftal 1952, col. 772, fig. 869; Carli 1956, p. 63, plate 115; Sweeny 1966, p. 35, repro. p. 118; Berenson 1968, p. 179; Fredericksen and Zeri 1972, p. 90; Zeri 1980, p. 22; Pope-Hennessy 1983, pp. 52, 56; Cole 1985, pp. 79–80, fig. 51; Riedl 1986, p. 18; Laurence B. Kanter in Christiansen, Kanter, and Strehlke 1988, p. 358; Carl Brandon Strehlke in Christiansen, Kanter, and Strehlke 1988, pp. 204, 211–12, 222–23; Carl Brandon Strehlke in Christiansen, Kanter, and Strehlke 1989, pp. 225–37; Van Os 1990, pp. 49–51, fig. 27; Philadelphia 1994, repro. p. 196; Contrusceri 1995, repro. p. 118; Carl Brandon Strehlke in Philadelphia 1995, repro. p. 164; Trnek 1997, p. 36; Carolyn C. Wilson in *DBI*, vol. 56, 2001, p. 141

COMPANION PANELS for PLATE 33

A. Center panel of an altarpiece: *Saint Nicholas of Tolentino in Glory.* See fig. 33.3

1457

Tempera and tooled gold on panel with vertical grain; 70⅞ × 24⅞″ (180 × 63 cm). Montepulciano, church of Sant'Agostino

INSCRIBED ON THE BOOK: *Precepta/ patris/ mei servavi et/ maneo/ in cuius/ dilection/ ne* (Corruption of John 15:10–11: "If you keep my commandments, you shall abide in my love; as I also have kept my Father's commandments, and do abide in his love. These things I have spoken to you, that my joy may be in you, and your joy may be filled"); ON THE BOTTOM: *OPUS IOHANNIS PAULI DE SENIS MCCCLVIII* (Work of Giovanni di Paolo from Siena 1457)

PROVENANCE: First recorded in the present location by Francesco Brogi, 1862 (Brogi 1894, p. 286)

EXHIBITED: Cortona 1970, no. 29

SELECT BIBLIOGRAPHY: Brogi 1897, p. 286; De Nicola 1918a, p. 54; Van Marle, vol. 9, 1927, p. 458 (as Giacomo del Pisano and described as Saint Bernardino); Pope-Hennessy 1938, pp. 62, 104, 172; Brandi 1947, pp. 34, 47, 111, 126; Berenson 1963, p. 178; Margherita Lenzini Moriondo in Cortona 1970, pp. 23–24, no. 29; Pope-Hennessy 1983, pp. 52, 56; Carl Brandon Strehlke in Christiansen, Kanter, and Strehlke 1988, p. 268; Van Os 1990, pp. 49–51; Carolyn C. Wilson in *DBI*, vol. 56, 2001, p. 141

B. Lateral panel of an altarpiece: *Saint Nicholas of Tolentino Interceding at Ventorinus's Funeral.* See fig. 33.4

1457

Tempera and tooled gold on panel with horizontal grain; 19¾ × 16¾″ (50 × 42.5 cm). Vienna, Gemäldegalerie der Akademie der bildenden Künste, inv. 1177

PROVENANCE: Given to the Gemäldegalerie by Johann von und zu Liechtenstein, 1896

SELECT BIBLIOGRAPHY: Eigenberger 1927, vol. 1, pp. 162–63; Vienna 1972, p. 19, no. 12; Pope-Hennessy 1983, pp. 52, 56; Cole 1985, pp. 79–80; Carl Brandon Strehlke in Christiansen, Kanter, and Strehlke 1988, p. 218; Trnek 1997, p. 36; Carolyn C. Wilson in *DBI*, vol. 56, 2001, p. 141

GIOVANNI DI PIETRO
(also known as *Nanni di Pietro*)

SIENA, DOCUMENTED 1439–68;
DIED BEFORE MAY 1479

Giovanni di Pietro, also known by his diminutive first name Nanni, was the brother of the painter Vecchietta. In 1439 the hospital of Siena paid a Nanni di Pietro, possibly the same artist, a small sum for unspecified work in one of its wards, and in 1440 he was paid for minor decorations in the city's cathedral. Otherwise, nothing else is known of Giovanni di Pietro until 1452, when he and his younger colleague Matteo di Giovanni gilded a now-lost statue by Jacopo della Quercia for the cathedral of Siena. In Matteo's property tax return of the following year Giovanni is named as his partner, with whom he shared living quarters. In a separate declaration of the same year Giovanni claimed an eighteen-year-old daughter for whom he could not afford a dowry. If she were born when he was about twenty-five, which was then the legal age in Siena and thus the earliest he could have been married, he would have been born around 1403.

In 1454 Nanni was paid independently for unspecified work in the Siena cathedral, and in 1463, for painting a tabernacle for the company of Sant'Ansano. Parts of this can be identified with fragments in various collections.[1] They represent unidentified scenes featuring the *balzana*, or the black-and-white flag that was an attribute of Saint Ansanus. Using those panels as touchstones, the artist's hand can be identified in several of the pilaster figures and predella scenes of an altarpiece by Matteo di Giovanni in Sansepolcro,[2] as well as in the earlier altarpiece (see fig. 34.5) from San Pietro a Ovile in Siena, to which the Johnson Collection's predella panels (plates 34A–B [JC cats. 107–8]) belong. These two altarpieces show that despite his youth, Matteo was the dominant artistic personality in the partnership. The partners' contracts were fluid, and during their association, both artists worked on their own commissions. In 1454, for example, Giovanni decorated Siena cathedral's organ shutters, and in 1457 he and Matteo worked together as part of a group of artists decorating the chapel of Saint Bernardino in the cathedral.

In 1464 Giovanni di Pietro filed a tax return declaring property given to him by his brother and lamenting that he was old and alone. Happily, the last known notice for him reports a late second marriage in 1468. Vecchietta's will of 1479 indicates that Giovanni had died before this date, because Vecchietta left property to a nephew named as "Pietro, [son] of the late master Nanni" (Petro olim Nanni magistri).

1. They were attributed to him by Everett Fahy (unpublished research). Gaudenz Freuler (in Lugano 1991, pp. 98–99) reproduced them.
2. Museo Civico; Chelazzi Dini, Angelini, and Sani 1997, repro. p. 271.

Select Bibliography
Bacci 1944, p. 242; Pope-Hennessy 1944, p. 143; Nancy Coe Wixom in Cleveland 1974, p. 73; Strehlke 1985, pp. 8–10; Carl Brandon Strehlke in Christiansen, Kanter, and Strehlke 1988, pp. 264–69; Cecilia Alessi in Alessi et al. 1990, pp. 241, 245–46; Christiansen 1990, p. 211; Keith Christiansen in New York 1990, pp. 6–11; Gaudenz Freuler in Lugano 1991, pp. 98–100; Strehlke 1991a, p. 467; Alessandro Angelini in Bellosi 1993, p. 130; Luciano Bellosi in Bellosi 1993, p. 87 n. 45; Andrea De Marchi in Gasporotto and Magnani 2002, pp. 64–65; Pia Palladino in Gasparotto and Magnani 2002, pp. 49–56; Ludwin Paardekooper in Gasparotto and Magnani 2002, pp. 77–97

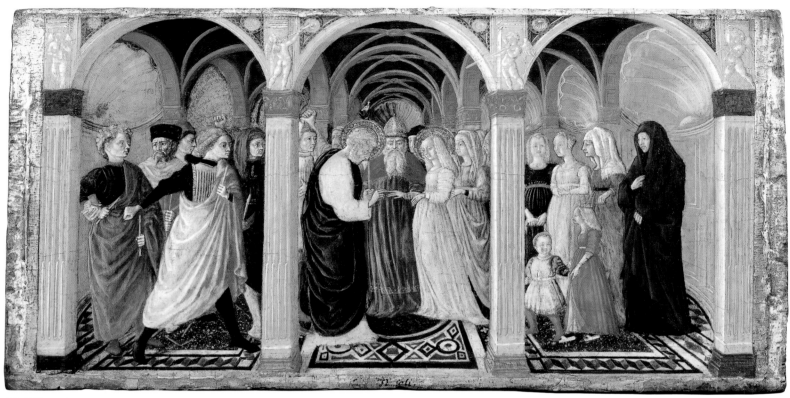

PLATE 34A

PLATE 34A (JC CAT. 107)

ATTRIBUTED TO GIOVANNI DI
PIETRO

Predella panel of an altarpiece: *Marriage of the Virgin*

c. 1455
Tempera and tooled gold on panel with vertical grain; overall 9½ × 18¼ × ½″ (24 × 46.3 × 1 cm), painted surface 9 × 16¾″ (22.6 × 42.3 cm)

John G. Johnson Collection, cat. 107

INSCRIBED ON THE BOTTOM BORDER: *G[i]o.[——] Fi[e]soli* (Giovanni [da] Fiesole [Fra Angelico])

PUNCH MARKS: See Appendix II

EXHIBITED: New York 1939, no. 248 (as Matteo di Giovanni); Philadelphia Museum of Art, John G. Johnson Collection, Special Exhibition Gallery, *From the Collections: Paintings from Siena* (December 3, 1983–May 6, 1984), no catalogue (as Giovanni di Pietro); New York 1988, cat. 45a (as Giovanni di Pietro)

TECHNICAL NOTES
The panel consists of one member that has been thinned. A barbe at the top and bottom and inscribed lines at the side mark the edges of the painted surface. The gold borders at the sides are original and were used to divide the predella scenes. The gold borders at the top and bottom are later additions. Lines were incised in the gesso to lay out the architecture, including details such as the shell shapes in the niches.

The panel was described by Bernhard Berenson in a letter to John G. Johnson, dated Paris, April 27, 1909, as being "in perfect condition." Good detail photographs were published by Adolfo Venturi (1913) and Berenson (1913). In 1920 the panel was inspected by Carel de Wild and Hamilton Bell, who commented on its fair state and noted some blistering, which de Wild retouched locally. When David Rosen treated the picture in 1941, he removed the old cradle, mounted the panel on plywood, and cleaned and retouched the surface. Rosen's cleaning, however, abraded the paint surface, particularly in the shading in the shell niches on the left. Abrasion of pink tones gave the flesh a grayish color, and abrasion of the blues caused details such as the Virgin's dress to appear whitish. The red lakes are faded and now look pink. The modeling of much of the drapery is less distinct than that seen in the early photographs.

In 1988 Suzanne Penn removed Rosen's plywood backing, since the panel was found to be structurally sound. She also removed Rosen's varnish and retouching, and inpainted scattered, small losses. Much of the abrasion was considered too extensive to retouch.

PROVENANCE
See plate 34B (JC cat. 108)

COMMENTS
In the center of the temple, which recalls the church architecture of the Florentine Filippo Brunelleschi, the high priest Abiathar holds the Virgin's arm as Joseph slips a ring on her finger. Joseph also carries a rod that has sprouted leaves on which a white dove rests. Looking on from the right is a group of women and two children, all attired in mid-fifteenth-century dress, except for the woman wrapped in a cumbersome mantle. To the left, the Virgin's unsuccessful suitors, also in contemporary dress, brandish broken rods. All had been participants in the contest for the Virgin's hand that the high priests held among the unmarried men of the House of David. After each bachelor had placed a rod on the altar of the temple, only Joseph's flowered, and thus he was declared the victor.[1] For further comments, see plate 34B (JC cat. 108).

1. The story comes from the fourth-century apocryphal Gospel of Saint Matthew. It was popularized in several late medieval texts, such as the *Golden Legend* of c. 1267–77, by Jacopo da Varazze, and the *Meditations on the Life of Christ* of c. 1300, by the so-called Pseudo-Bonaventura, who was probably Fra Giovanni da San Gimignano. Giotto included this incident in the scene in the Arena chapel (1303–5) in Padua. See Basile 2002, postrestoration color repro. p. 145.

Bibliography
See plate 34B (JC cat. 108)

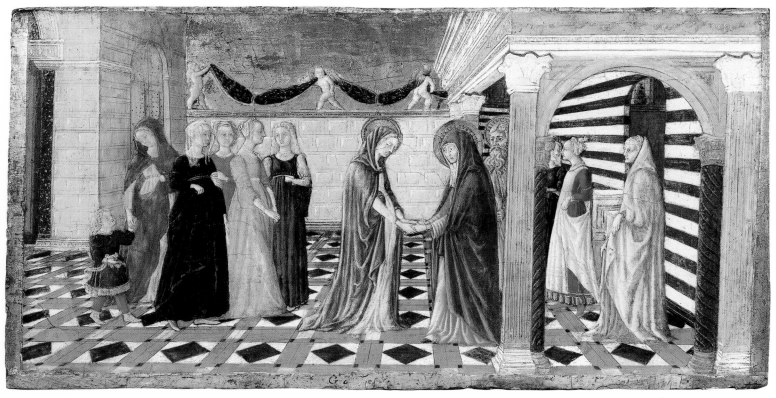

PLATE 34B

PLATE 34B (JC CAT. 108)

ATTRIBUTED TO GIOVANNI DI PIETRO

Predella panel of an altarpiece: *Virgin Returning to the House of Her Parents*

c. 1455

Tempera and tooled gold on panel with vertical grain; overall 9½ × 18⅛ × ½″ (24 × 46 × 1.1 cm), painted surface 8⅞ × 17⅜″ (22.4 × 44 cm)

John G. Johnson Collection, cat. 108

INSCRIBED ON THE BOTTOM BORDER: *Gio[vanni da] Fies[o]li* (Giovanni da Fiesole [Fra Angelico])

PUNCH MARKS: See Appendix II

EXHIBITED: New York 1939, no. 249 (as Matteo di Giovanni); Philadelphia Museum of Art, John G. Johnson Collection, Special Exhibition Gallery, *From the Collections: Paintings from Siena* (December 3, 1983–May 6, 1984), no catalogue (as Giovanni di Pietro); New York 1988, cat. 45b (as Giovanni di Pietro)

TECHNICAL NOTES

The panel consists of one member that has been thinned. Gesso barbes at the top and bottom and incised lines at the sides mark the boundaries of the painted surface. The gold borders at the sides are original and divided the predella scenes. The gold borders at the top and bottom are later additions. The architecture is laid out with incised lines in the gesso. Lines were scored in the paint of the pediment of the building on the right for sharper definition of details. Except for the putti, which are set against the gold, the figures were not laid out with incised lines, and no underdrawing was visible in infrared reflectography.

The panel was described by Bernhard Berenson in a letter to John G. Johnson, dated Paris, April 27, 1909, as being "in perfect condition." A good photograph of the work appears in Berenson's 1913 catalogue. In 1920 the painting was inspected by Carel de Wild and Hamilton Bell, who commented on its fair state only noting some flaking, which de Wild retouched locally. In 1941 David Rosen treated the picture by removing the old cradle, mounting the panel on plywood, and cleaning and retouching the surface. The painting's original appearance has been distorted by the abrasion of the blues and by the fading of the red lakes and the thin pigmented layers used in the final modeling of the flesh tones.

In 1988 Suzanne Penn removed Rosen's plywood backing and made repairs to the horizontal split, approximately 8″ (20.3 cm) long, that runs through the panel in the upper right. Penn also removed Rosen's varnish and retouching and inpainted scattered losses.

PROVENANCE

This panel and the *Marriage of the Virgin* (plate 34A [JC cat. 107]) are from the predella of an altarpiece in the Sienese parish church of San Pietro a Ovile in Siena. Cesare Brandi (1931) suggested that it was originally in the company of San Giovanni della Morte in Siena. However, since this association was suppressed in 1785, any transfer of an altarpiece to another location would have occurred after that date. But in 1752 Giovanni Antonio Pecci (p. 118) had already described an altarpiece by "Matteo da Siena" in San Pietro a Ovile, making it unlikely that the altarpiece came from San Giovanni della Morte.

The altarpiece was disassembled sometime before 1765–66, when the French painter Jean-Robert Ango made drawings of the two Johnson predella panels, which were in the collection of Jacques-Laure, chevalier de Breteuil, ambassador of the Order of Malta to Rome. The drawings, now owned by Breteuil's descendants, contain inscriptions stating that the pictures are after Fra Angelico's altarpiece in the convent of Santa Maria sopra Minerva in Rome. The ambassador returned to France in 1777, taking his collection with him.[1] The other panel of the predella, which does not seem to have been in the Breteuil Collection, was catalogued by Fréderic Villot in 1849. The Johnson predella panels turned up in the early twentieth century at the Kleinberger Galleries in Paris. It was at this point that Bernhard Berenson wrote to John G. Johnson about them from Paris on April 27, 1909:

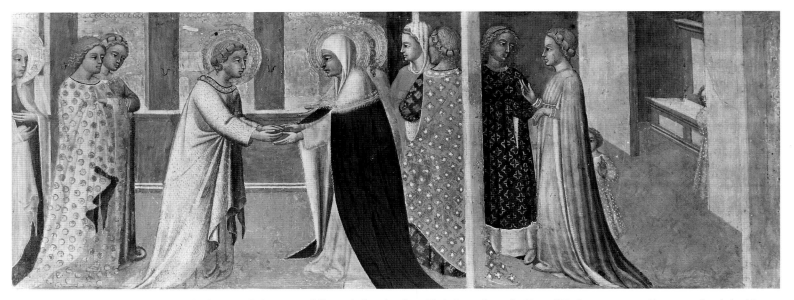

FIG. 34.1 Pellegrino di Mariano (Siena, active by 1449; died 1492). Predella panel of an altarpiece: *Virgin Returning to the House of Her Parents*, c. 1460s. Tempera and tooled gold on panel; 5⅞ × 15″ (15 × 38 cm). Vatican City, Pinacoteca Vaticana, no. 171

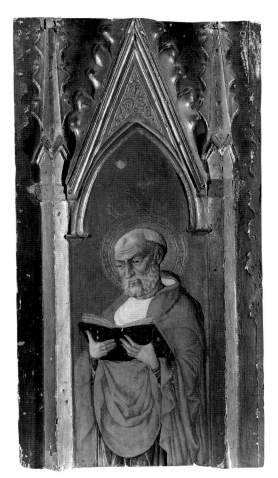

FIG. 34.2 Matteo di Giovanni (Siena, first documented 1452; died 1495). *Saint Jerome*, c. 1455. Tempera and tooled gold on panel; overall 27¼ × 14¾″ (69 × 37.5 cm). New York, Piero Corsini, Inc. See Companion Panel B

Salomon Reinach told me that both the Louvre & Martin le Roy were eager to get 2 little panels ascribed to Giovanni di Paolo belonging to Kleinberger, & that K. was asking 100,000 frs. for them. They found that price somewhat excessive.

I have just seem them, & cannot tell you how enchanted I am with them, except that I know you will share all my enthusiasm for them. I have never seen in their kind more delicious feeling, & more gorgeous jewel-like colouring. . . . I am extremely eager that you should have them, & as K. is very anxious to have my patronage, & yours as well, he has consented to reduce the price to 60,000 fr. (sixty thousand). I am pretty sure that it is sounding bottom, & that they are really worth it.

The two predella represent the Sposalizio [Marriage] & the Visitation. They are in perfect condition. I am inclined strongly to the opinion that they are not by Giovanni di Paolo, but by his much greater & very rare fellow townsman Vecchietta. But it is the painting & not a name I urge upon you.

On May 14, Johnson wrote from Philadelphia to an unidentified correspondent: "I would like very much if you could see one of the most delicious Dyptychs of the Sienna School I can recall. It is

attributed to Giovanni di Paolo, but it is far and away, if by him, the best thing I have ever produced. It represents in one panel the Marriage and in the other the Visitation. It is really most enchanting."

From Settignano on May 22, Berenson wrote again to Johnson: "I am truly delighted that you are getting Kleinberger's predella. I envy you in their possession, but as I cannot afford them, I am very happy that they are to be yours."

COMMENTS

The Virgin reaches out her hands to greet a haloed older woman while an old man, also with a halo, looks on. Under the portico there are three women in elegant contemporary dress, as another group of five women and a young child stand behind the Virgin. The scene takes place in a paved square with Renaissance architecture. On the back wall three putti hold up a garland. The portico to the right consists of a fantastic combination of fluted piers with Corinthian capitals, twisted green porphyry columns supporting arches, and a carved architrave. It is attached to a striped building whose open door has a stained-glass window. In details like the striping and window, the building recalls the cathedral of Siena.

In the past the scene has been identified as the

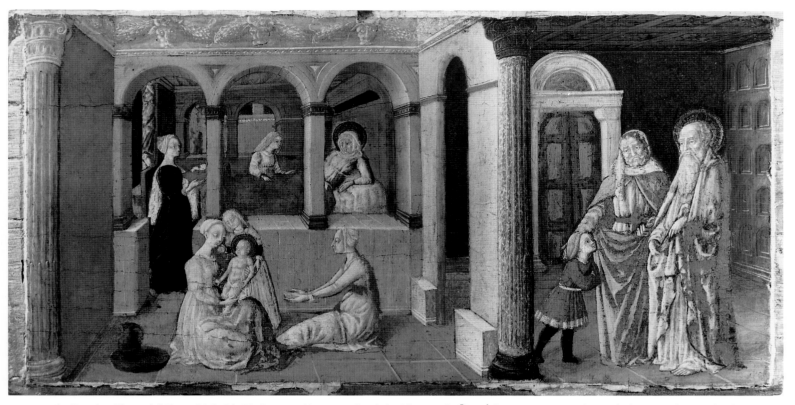

FIG. 34.3 Attributed to Giovanni di Pietro. *Birth of the Virgin*, c. 1455. Tempera and tooled gold on panel; 8⅞ × 17½″ (22.5 × 44.5 cm). Paris, Musée du Louvre, inv. 814. See Companion Panel C

Visitation because it depicts two women embracing (see Paolo Schiavo, plate 75A [JC cat. 124]). However, the more likely subject is the Virgin's return to her parents' home, a story made popular in Jacopo da Varazze's account in the *Golden Legend* (c. 1267–77, Ryan and Ripperger ed. 1941, pp. 523–24), which tells of how Mary, newly wed, returned home accompanied by seven virgins. Although only five companions are represented in the present panel, no attendants and certainly no old man are traditionally shown at the Visitation.[2]

The subject of the Virgin's return to the house of her parents is rare in Italian art. Except for its appearance in Giotto's Arena chapel in Padua,[3] it is found almost exclusively in Siena. The most famous depiction was in a cycle of the Virgin's life on the façade of the hospital of Santa Maria della Scala, which was painted in 1335 by Pietro (q.v.) and Ambrogio Lorenzetti and Simone Martini.[4] Although the murals were destroyed, a number of works based on the hospital cycle exist, including the Johnson Collection's *Marriage of the Virgin* and the *Virgin Returning to the House of Her Parents*. The interpretation that is the closest to the one in the Johnson panel is found in Pellegrino di Mariano's predella, in the Pinacoteca Vaticana (fig. 34.1), where, as in the Philadelphia painting, the Virgin

first greets her mother. However, she is shown first embracing her father in Bartolo di Fredi's version of the scene, in an altarpiece painted in 1383–88 for San Francesco in Montalcino,[5] and in Sano di Pietro's (q.v.) depiction in a predella for an altarpiece in the Palazzo Pubblico of Siena, commissioned in 1448 and finished in 1451.[6] The contract for Sano's predella in fact specifically states that he was to copy the hospital cycle.[7]

The two scenes in the Johnson Collection along with a third, *Birth of the Virgin* in the Louvre (fig. 34.3), come from the predella of an altarpiece (fig. 34.4) dedicated to the legend of the Virgin (fig. 34.5) still in situ in the parish church of San Pietro a Ovile in Siena.[8] A fourth scene, probably depicting the Presentation of the Virgin in the temple, is lost. The main part of the altarpiece is a copy of the *Annunciation*, dated 1333, by Simone Martini and Lippo Memmi, then in the cathedral of Siena.[9] Saints John the Baptist and Bernardino appear in the lateral sections of the Ovile altarpiece, and Saints Peter and Paul and the Crucifixion are depicted in the pinnacles. Another pinnacle piece, representing Saint Jerome (fig. 34.2), is with Piero Corsini, Inc. in New York.

A recent restoration of the main section still in the church and the acute observations of Keith

Christiansen and Laurence B. Kanter[10] have made it clear that the altarpiece was a collaboration between Matteo di Giovanni and Giovanni di Pietro.[11] The *Annunciation,* the *Crucifixion* in the central pinnacle, and the predella are by Giovanni di Pietro. The figural style of the predella relates stylistically to his now-scattered panels that may come from the company of Sant'Ansano, and likely date 1463.[12] The Virgin of the *Annunciation* is clearly by the same hand that painted the *Virgin and Child and Saints* in the Cleveland Museum of Art,[13] which is generally attributed to Giovanni di Pietro.

By contrast, the lateral panels and lateral pinnacles of the altarpiece represent an important, early phase in Matteo di Giovanni's development that predates his altarpiece of 1460 from the Saint Anthony chapel of the Siena baptistery,[14] which also includes a standing figure of Saint Bernardino. In the Ovile altarpiece, Matteo di Giovanni is still bound to the model of such artists as Pietro di Giovanni d'Ambrogio and Vecchietta, whereas in the baptistery altarpiece the influence of the Florentine sculptor Donatello, who arrived in Siena in 1457, is felt.

A notable difference between the two hands can be seen in the pinnacles. Matteo di Giovanni's Saints Peter and Paul sport shadowed halos drawn in a perspective calculated to be seen from below,

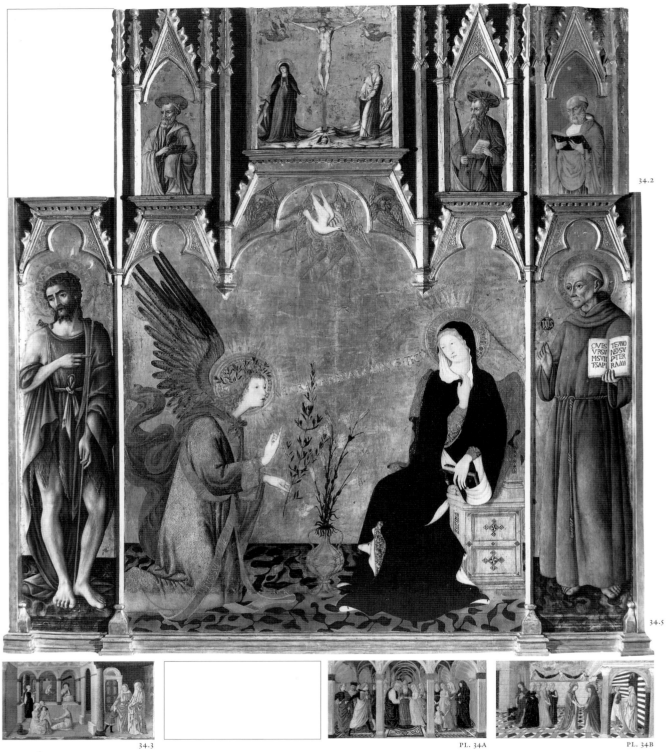

34.2

34.5

34.3 PL. 34A PL. 34B

FIG. 34.4 Original configuration of the known extant panels of Matteo di Giovanni and Giovanni di Pietro's San Pietro Ovile altarpiece, c. 1455. Main panel (FIG. 34.5): *Annunciation with Saints John the Baptist and Bernardino;* pinnacles: *Saint Peter, the Crucifixion with Mary and Saint John the Evangelist, and Saint Paul.* Tempera and tooled gold on panel; 99¼ × 94⅛″ (252 × 239 cm). Siena, church of San Pietro a Ovile. See Companion Panel A. Pinnacles: (left) missing panel; (right) FIG. 34.2. Predella (left to right): FIG. 34.3, missing panel, PLATES 34A, 34B

but Giovanni di Pietro was not capable of such subtlety, and his halos in the *Crucifixion* are flat and not modeled.

While three extant predella scenes are clearly based on the lost façade murals from the hospital of Santa Maria della Scala, their connection to the hospital may not be only iconographic. Payment records (see Appendix I, plate 34) indicate that in December 1460 and February 1461 the hospital's comptroller reimbursed Matteo di Giovanni for work in San Pietro a Ovile, which might refer to the altarpiece. However, in light of the style of Matteo's dated altarpiece of 1460, a date at least five years earlier seems more likely. If the payments of 1460–61 do relate to the altarpiece, they may well be a final accounting for work done sometime before. The documents further suggest that the church had had trouble raising the funds on its own, since it asked the hospital to cover the expenses with other monies it owed the church. All these arrangements may have led to a delay in the payment. The hospital's involvement in an altar of the church is not unusual. The hospital administered many bequests that benefited other institutions. It may, for example, in this case have been the executor of a will of someone who had left funds for a chapel. A similar situation occurred in 1469, when Ambrogio di Tommaseo di Giovanni Salimbeni asked the hospital to oversee the work on a new chapel and the painting of a crucifix for the same church.[15] In the present altarpiece the predella scenes that repeat the cycle on the hospital's façade visually confirm the hospital's patronage of the chapel.

Saint Bernardino's presence in a scheme that celebrates the art of the Sienese trecento is particularly significant because he was one of its foremost champions. In his 1427 Lenten sermons he lauded the virtue of the Virgin's humility by describing the depiction of her manner in Simone Martini and Lippo Memmi's *Annunciation,* which he called an example that contemporary Sienese women should emulate.[16] He also mentioned the scenes on the hospital's façade. The saint was a great supporter and admirer of the hospital, which dedicated a chapel in his memory after his canonization in 1450. The altarpiece must date a few years after that event. The iconography of the lateral panel with Saint Bernardino corresponds to that which had already been established in paintings by Pietro d'Ambrogio di Giovanni before the saint was canonized.

Adolfo Venturi (vol. 7, pt. 1, 1913), who knew the predella paintings when they were being sold in Paris in 1909, attributed them to Lorenzo da Viterbo (c. 1444–72[?]). Bernhard Berenson (1913) correctly placed them in the school of Siena, attributing them to Lorenzo Vecchietta, Giovanni di Pietro's brother. Raimond van Marle (vol. 9, 1927) gave them to the school of Sassetta, a position followed in some of the subsequent literature. In 1932 Berenson changed his earlier opinion and

called them the early work of Matteo di Giovanni, an attribution also supported by Roberto Longhi (1940). John Pope-Hennessy (1944) recognized that the predella panels in the Johnson Collection were by the same painter who executed the *Annunciation* in San Pietro a Ovile, and suggested that they may have come from the same altarpiece. Cesare Brandi (1949) and Evelyn Sandberg Vavalà (1953) both thought that the panels were by Pietro di Giovanni d'Ambrogio, a view echoed in Barbara Sweeny's catalogue (1966) and Burton Fredericksen and Federico Zeri's lists (1972). Alessandro Angelini (in Bellosi 1993; Chelazzi Dini, Angelini, and Sani 1997) and Andrea De Marchi (in Gasparotto and Magnani 2002) have argued that the altarpiece is entirely the work of Matteo di Giovanni.

1. Breteuil 1986, esp. p. 21.
2. Earlier Sienese depictions of the Visitation, such as the mural by a follower of Paolo di Giovanni Fei in San Francesco (Carli 1971a, color plate 109) and the Malavolti altarpiece of 1397 by Bartolo di Fredi from San Domenico (Chambéry, Musée des Beaux-Arts; Freuler 1994, fig. 305 [color]), are quite different.
3. Basile 2002, postrestoration color repro. p. 153.
4. Péter 1931, esp. pp. 16–17, 25, 27. Simone Martini probably executed the *Return of the Virgin to the House of Her Parents* (Keith Christiansen in Christiansen, Kanter, and Strehlke 1988, pp. 150–56). See also Eisenberg 1981, p. 136.
5. Part of a side panel of the Montalcino altarpiece; now Siena Pinacoteca Nazionale, no. 100; Freuler 1994, fig. 180 (color).
6. Altenburg, Germany, Lindenau-Museum, no. 70(16); Christiansen, Kanter, and Strehlke 1988, color repro. p. 151.
7. See Eisenberg 1981; Keith Christiansen in Christiansen, Kanter, and Strehlke 1988, esp. pp. 146–47; and Christiansen 1994.
8. Strehlke 1985a, pp. 8–10.
9. Florence, Uffizi, nos. 451–53; postrestoration color illustrations in Cecchi 2001.
10. Quoted by Carl Brandon Strehlke in Christiansen, Kanter, and Strehlke 1988, p. 265. See also Christiansen 1990, p. 211; and Keith Christiansen in New York 1990, pp. 6–11.
11. The painting had been attributed to Matteo di Giovanni alone (first by Romagnoli before 1835, vol. 4, p. 662; and recently by Luciano Bellosi in Bellosi 1993, p. 87 n. 45, and by Alessandro Angelini in Bellosi 1993, p. 130), Giovanni di Pietro alone (Strehlke 1985a, pp. 8–10), and Domenico di Bartolo alone (Brandi 1931), as well as to three painters in collaboration—Giovanni di Pietro, Matteo di Giovanni, and an artist close to Domenico di Bartolo (Van Os 1990, pp. 218–19 n. 15).
12. Lugano 1991, repro. pp. 98–99.
13. No. 56.719; Cleveland 1974, fig. 28.
14. Siena, Museo dell'Opera della Metropolitana; Bellosi 1993, color repro. p. 133.
15. Girolamo Macchi, *Memorie,* late seventeenth–early eighteenth century. Siena, Archivio di Stato, Ms. D-110, folio 298 verso. This may refer to the crucifix by Giovanni di Paolo in the same church (Brandi 1947, fig. 33).
16. Bernardino 1424–25, Bargellini ed. 1936, p. 671; Carli 1976, pp. 171–72.

Bibliography

Berenson 1913, pp. 58–59, repro. p. 108 (Lorenzo Vecchietta); A. Venturi, vol. 7, 1913, pt. 1, p. 474; pt. 2, pp. 247–50, figs. 193–98 (Lorenzo da Viterbo); Crowe and Cavalcaselle 1903–14, vol. 5, edited by Tancred Borenius, 1914, p. 153 n. 2; Schubring 1923, p. 322 nn. 434–35, plate CII; Van Marle, vol. 9, 1927, p. 62; Lisini 1928, repro. opp. p. 265 (cat. 107); Misciattelli 1929, p. 119, plates 5–6; Brandi 1931; Berenson 1932, p. 352; Gengaro 1933; Gengaro 1934, p. 182; Berenson 1936, p. 302; Van Marle, vol. 16, 1937, pp. 246, 362; New York 1939, pp. 121–22, nos. 248–49, plate 9; Longhi 1940, p. 187 n. 24 (Longhi *Opere,* vol. 8, pt. 1, 1975, p. 58 n. 124); Weller 1940, p. 172 n. 20, fig. 3 (cat. 107); Johnson 1941, p. 11 (Matteo di Giovanni); Pope-Hennessy 1944, p. 143, plate IIIb (cat. 107); Brandi 1949, pp. 139, 222–23 nn. 101–3, plates 188–89; Sandberg Vavalà 1953, p. 261; Sweeny 1966, p. 64, repro. p. 121 (Pietro di Giovanni d'Ambrogio); Fredericksen and Zeri 1972, p. 165 (Pietro di Giovanni d'Ambrogio); Brejon de Lavergnée and Thiébaut 1981, p. 182; Strehlke 1985a, pp. 8–10, plates 14–15; Breteuil 1986, p. 21; Carl Brandon Strehlke in Christiansen, Kanter, and Strehlke 1988, cats. 45 a, b, repros. pp. 266–67; Cecilia Alessi in Alessi et al. 1990, p. 245, fig. 42 (cat. 107); Christiansen 1990, p. 211; Keith Christiansen in New York 1990, pp. 6–11; Van Os 1990, pp. 106, 183, 218–19 n. 15; Gaudenz Freuler in Lugano 1991, p. 99, fig. 3; Alessandro Angelini in Bellosi 1993, p. 130, fig. 5 (cat. 107) on p. 131; Luciano Bellosi in Bellosi 1993, p. 87 n. 45; Cecilia Alessi in Alessi and Martini 1994, pp. 52–54; Philadelphia 1994, repros. p. 196; Alessandro Angelini in Chelazzi Dini, Angelini, and Sani 1997, pp. 269, 271; Frinta 1998, pp. 81, 471, 473; Keith Christiansen in Sansepolcro 1998; Gasparotto and Magnani 2002, figs. 4–5, p. 215; Andrea De Marchi in Gasporotto and Magnani 2002, pp. 64–65; Pia Palladino in Gasparotto and Magnani 2002, pp. 51–54; Ludwin Paardekooper in Gasparotto and Magnani 2002, esp. p. 84

COMPANION PANELS for PLATES 34A–B

A. Matteo di Giovanni (with the possible collaboration of Giovanni di Pietro). Main panel of an altarpiece: *Annunciation with Saints John the Baptist and Bernardino;* pinnacles: *Saint Peter, the Crucifixion with Mary and Saint John the Evangelist, and Saint Paul.* See fig. 34.5

c. 1455

Tempera and tooled gold on panel; 99¼ × 94⅛" (252 × 239 cm). Siena, church of San Pietro a Ovile

INSCRIBED IN PASTIGLIA ACROSS THE ANNUNCIATION: *AVE GRATIA PLENA DOMINUS [TE]CU[M]* (Luke 1:28: "Hail [Mary], full of grace, the Lord is with thee"); ALONG THE BORDER OF GABRIEL'S CLOAK: *ET AIT GABRIEL EI: NE TIMEAS, MARIA INVENISTI ENIM GRATIAM APUD DEUM: ECCE CONCIPIES IN UTERO, ET PARIES FILOUM, ET VOCABIS NOMEN EIUS IESUM.* (Luke 1:30–31: "And Gabriel said to her: Fear not, Mary, for thou hast found grace with God. Behold thou shalt conceive in thy womb, and shalt bring forth a son; and thou shalt call his name Jesus."); ON THE VIRGIN'S HALO: *ECCE ANCILLA DOMINI, FIAT MIHI* (Luke 1:38: "Behold the handmaid of the Lord, be it done to me"); ON THE BAPTIST'S HALO: *ECCE AGNUS DEI QUI TOLLIT PECCA[TA]* (John 1:29: "Behold the Lamb of God, behold him who taketh away the sin"); ON BERNARDINO'S HALO: *MANIFESTAVI*

NOMEN TUUM HOMINIBUS (John 17:6: "I have manifested thy name to the men" [text for the antiphon of the first vespers for the feast of the Ascension, recited by Bernardino as he lay dying]); ON BERNARDINO'S BOOK: *QU[A]E S/ URSU/ M. SUN/ T. SAPI/ TE. ET NO/ N. Q[UAE]. SU/ P[ER]. TER/ RAM* (Bernardino, *De Passione Christi*, chapter 2: "Know those things which are from above and which are not of the earth")

EXHIBITED: Siena 1904, Sala XXIII, no. 7; Siena 1994, cat. 3

SELECT BIBLIOGRAPHY: Brandi 1931; Keith Christiansen in New York 1990, pp. 6–11; Cecilia Alessi in Alessi 1990, p. 245; Cecilia Alessi in Alessi and Martini 1994, pp. 52–54; Alessandro Angelini in Chelazzi Dini, Angelini, and Sani 1997, pp. 269, 271; Andrea De Marchi, Pia Palladino, and Ludwin Paardekooper in Gasporotto and Magnani 2002, pp. 64–65; 51–54; and 84 (respectively)

B. Matteo di Giovanni. Pinnacle panel of an altarpiece: *Saint Jerome.* See fig. 34.2

c. 1455

Tempera and tooled gold on panel; overall 27¼ × 14¾" (69 × 37.5 cm), painted surface 20⅞ × 8⅜" (53 × 21.3 cm). New York, Piero Corsini, Inc.

PROVENANCE: Purchased in Italy by Charles Eliot Norton, 1850–70; Mrs. Richard Norton; sold, New York, Christie's, May 31, 1990, lot 66 (as circle of Lorenzo da Viterbo)

EXHIBITED: New York 1990; Sansepolcro 1998

SELECT BIBLIOGRAPHY: Keith Christiansen in New York 1990, pp. 6–11; Andrea De Marchi, Pia Palladino, and Ludwin Paardekooper in Gasporotto and Magnani 2002, pp. 64–65; 51–54; and 84 (respectively)

C. Attributed to Giovanni di Pietro. Predella panel of an altarpiece: *Birth of the Virgin.* See fig. 34.3

c. 1455

Tempera and tooled gold on panel; 8⅞ × 17½" (22.5 × 44.5 cm). Paris, Musée du Louvre, inv. 814

PROVENANCE: Louvre, from 1849

SELECT BIBLIOGRAPHY: Brandi 1949, pp. 139, 222–23 n. 101; Louvre 1960, no. 50; Brejon de Lavergnée and Thiébaut 1981, p. 182; Andrea De Marchi, Pia Palladino, and Ludwin Paardekooper in Gasporotto and Magnani 2002, pp. 64–65; 51–54; and 84 (respectively)

BENOZZO GOZZOLI
(*Benozzo di Lese di Sandro*)

FLORENCE, C. 1421/22–1497, PISTOIA

In his tax return of 1442 Lese (Alessio) di Sandro declared that his twenty-year-old son, Benozzo, was learning to paint. Benozzo was probably helping Fra Angelico (q.v.) with the murals in the cells of the convent of San Marco in Florence.[1] Two years later, Vittore Ghiberti employed Benozzo to help him execute the frames of the Florentine baptistery doors. Soon after, however, Gozzoli left to join Angelico, working with him on the chapel of Saint Brixius in the cathedral of Orvieto in 1447,[2] and in the Vatican in 1448 and 1449. Although in 1449 the officials of Orvieto's cathedral refused Gozzoli's request to complete the chapel that Angelico had left unfinished (later completed by Luca Signorelli), the artist subsequently found work in Umbria. In his altarpiece of about 1450 for San Fortunato in Montefalco,[3] he adopted the rectangular format seen in the altarpieces by Angelico for the high altar of San Marco[4] and by Domenico Veneziano for Santa Lucia dei Magnoli in Florence.[5] The influence of these two artists is seen as well in Gozzoli's masterpieces, the murals for the chapels of Saint Jerome and Saint Francis in San Francesco, also in Montefalco, dated 1452.[6] They attest to his skillful interpretation of Angelico's and Domenico Veneziano's luminous effects. The next year Benozzo is documented as working on murals in Santa Rosa in Viterbo,[7] and his altarpiece for the Sapienza Nuova in Perugia is dated 1456.[8] In 1458 he returned to Rome, painting banners for the coronation of Pope Pius II Piccolomini and drawing after antique statues.[9] A year later Gozzoli was back in Florence, working on the murals of the chapel of the Magi in the Palazzo Medici,[10] which included numerous portraits of the Medici and their retainers, as well as a self-portrait. This connection to the Medici probably led to his commission for the altarpiece that contained the Johnson predella panel (plate 36 [JC cat. 38]), which he painted for an organization supported by the family. Between 1464 and 1467 the artist lived in San Gimignano, where he painted the choir of Sant'Agostino.[11] In January 1469 Gozzoli is recorded as working on wall paintings of Old Testament stories in the Camposanto, or civic cemetery, of Pisa.[12] Even after this project was completed in 1485, Gozzoli continued to work in Pisa, although in January 1497 he is documented in Florence as an official appraiser of Alesso Baldovinetti's paintings for the Gianfigliazzi chapel in Santa Trinita.[13] Later that year Gozzoli tried to escape the plague by moving to Pistoia, where he died on October 4.

The name "Gozzoli" does not appear in any written source before the second edition (1568) of Vasari's *Lives*.

1. Bellosi (1990, p. 44) attributed the *Adoration of the Magi* in cell 39 to Gozzoli (Ahl 1996, color plate 17).
2. Ahl 1996, color plates 39–42.
3. Pinacoteca Vaticana, no. 262; Ahl 1996, color plate 46.
4. Florence, Museo Nazionale di San Marco; Hood 1993, color plate 85.
5. Florence, Uffizi, no. 884; Florence 1992, color repro. p. 95.
6. Ahl 1996, plates 50–57, 60–64, 66–68, 70–79 (black-and-white and color).
7. They are now known only through preparatory drawings and copies made by Francesco Sabbatini in c. 1632 (Ahl 1996, plates 80–90 [black-and-white and color]).
8. Perugia, Galleria Nazionale dell'Umbria, no. 124; Garibaldi 1998, p. 143, fig. 13.
9. See Antonio Natali in Florence 1992, p. 22, no. 1.1.
10. Postrestoration color repros. in Acidini Luchinat 1993.
11. Ahl 1996, plates 145–55, 157–59, 161, 164–72 (black-and-white and color).
12. These were badly damaged by fire in 1944. Ahl 1996, plates 198, 202–3, 205, 207–31 (black-and-white and color).
13. Kennedy 1938, figs. 141–50.

Select Bibliography
Georg Gronau in Thieme-Becker, vol. 3, 1909, pp. 341–49; Emma Micheletti in *DBI*, vol. 8, 1966, pp. 572–75; Padoa Rizzo 1972; *Bolaffi*, vol. 6, 1974, pp. 124–26; Roberto Bartalini in Florence 1990, pp. 109–13; Padoa Rizzo 1992; Acidini Luchinat 1993; Ahl 1996; Alisa Turner in *Dictionary of Art* 1996, vol. 13, pp. 259–62; Garibaldi 1998; Toscano and Capitelli 2002

PLATE 35 (JC INV. 1305)
Man of Sorrows with the Virgin and Saint John the Evangelist and the Symbols of the Passion

1440s

Tempera and tooled gold on panel with diagonal grain; 9⅛ × 8¾ × ¼″ (23 × 22 × 0.5 cm)

John G. Johnson Collection, inv. 1305

TECHNICAL NOTES

When John G. Johnson bought this picture, the panel was rectangular (fig. 35.1) and the background had been painted out. Sometime around 1973 Theodor Siegl removed the additions to restore the painting to its original circular shape. The fact that the left and right sides of the panel are still straight reflects the adjustments made when it was transformed into a rectangle. The panel is thinned and mounted on plywood. Diagonal cracks across the center disfigure the surface.

In 1973 the panel was cleaned of all repaints to reveal the traditional symbols of the Passion, known as the *arma Christi,* many of which were found to be damaged. The picture is badly abraded. Infrared reflectography shows drawing in the figure of Christ as well as in the drapery of the Virgin (figs. 35.2, 35.3).

PROVENANCE

Because this painting does not appear in any of John G. Johnson's catalogues, it is not clear when it was purchased. It may have been acquired after 1914.

COMMENTS

Christ, crowned with thorns and wearing only a loincloth, stands in the tomb with his arms extended. The cross is behind him, and in the background are symbols of the Passion that represent the Denial of Peter, the Mocking of Christ, and Pontius Pilate Washing His Hands. The Virgin and Saint John the Evangelist sit mourning on the rocks in front of the tomb.

Diane Ahl, on a visit to the Johnson Collection on August 4, 1986, noted the image's derivation from Fra Angelico's (q.v.) mural *Man of Sorrows with the Virgin, Saint Thomas Aquinas, and the Symbols of the Passion* of about 1441 in cell 27 of the convent of San Marco in Florence.[1] Images of the Man of Sorrows combined with symbols of the Passion, often shown only in the form of abbreviations such as a head or a hand, gained a certain popularity in Florence in the late trecento. Both the Gozzoli and Angelico paintings can be related to a renowned 1404 example by Lorenzo Monaco (q.v.).[2] Smaller versions of the image were also popular. One, by the Master of the Johnson Tabernacle (q.v.), included a certificate from the bishop of Florence, suggesting how prized these pictures were as devotional objects.[3]

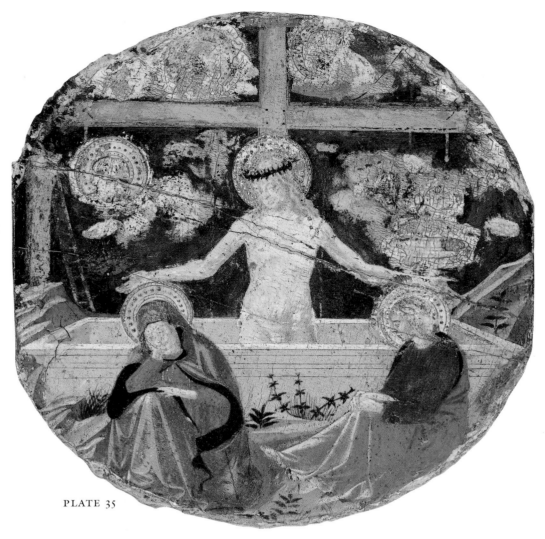

PLATE 35

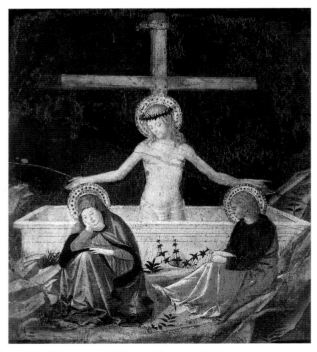

FIG. 35.1 Photograph of plate 35 as it appeared before 1973

FIG. 35.2 Infrared reflectographic detail of plate 35, showing the underdrawing of the Virgin

FIG. 35.3 Infrared reflectographic detail of plate 35, showing the underdrawing of Christ

The Johnson painting was assigned to Benozzo Gozzoli in the 1941 checklist of the Johnson Collection, but there is no record in the files of how this attribution was derived. In 1954 Luisa Vertova told Barbara Sweeny that the panel was the work of the school of Benozzo Gozzoli. Anna Padoa Rizzo (1969, 1972, 1992) published it as an autograph painting by Gozzoli, dating it about 1447 based on its relationship to a *Crucifixion* in a Parisian private collection.[4] In a letter dated August 26, 1986, Ahl expressed some doubts about the attribution to Benozzo Gozzoli but did not exclude it altogether. In her monograph (1996) she cautiously assigned it to an associate of Fra Angelico, possibly Benozzo. She dates the painting about 1438–40. Burton Fredericksen and Federico Zeri (1972) attributed it to the school of Pesellino (q.v.).

This painting closely relates to another round panel by Gozzoli—an *Annunciation* (fig. 35.4) once in the San Diego Museum of Art and then at Piero Corsini, Inc. in New York.[5] Although the Johnson picture is badly rubbed, the manner of depicting drapery folds by broad areas of highlights is the same in the two pictures. They both show Gozzoli at a very early moment in his career, when he was stylistically the closest to Fra Angelico.

As the provenance of the Johnson Collection's picture is not known, it cannot be proved that the two panels came from the same source. They could have been the roundels of a predella. However, other functions are possible, including the decorations on a sacristy cupboard or portable paintings such as those shown to condemned criminals on the way to the gallows.[6]

1. Hood 1993, p. 214, plate 212.
2. Florence, Galleria dell'Accademia, no. 467; Eisenberg 1989, figs. 18–19.
3. On the art market with Stefano Piacenti in Prato; Florence 1990b, color repro. p. 149. This same artist did several paintings of the image.
4. Ahl 1996, plate 300.
5. Sold New York, Sotheby's, January 10, 1991, lot 1 (as Benozzo Gozzoli); reproduced in color in the sale catalogue and in Padoa Rizzo 1992, p. 42.
6. On this genre of paintings, see Edgerton 1985, pp. 141–46, 180–84, 192–99; and Strehlke 1998, p. 30.

Bibliography
Johnson 1941, p. 8; Sweeny 1966, p. 36, repro. p. 128; Padoa [Rizzo] 1969, p. 52; Fredericksen and Zeri 1972, p. 162 (school of Pesellino); Padoa Rizzo 1972, p. 103, fig. 8; Padoa Rizzo 1992, p. 38, repro. no. 13; Philadelphia 1994, repro. p. 197 (attributed to Benozzo Gozzoli); Ahl 1996, pp. 233–34, 242–43, plate 301

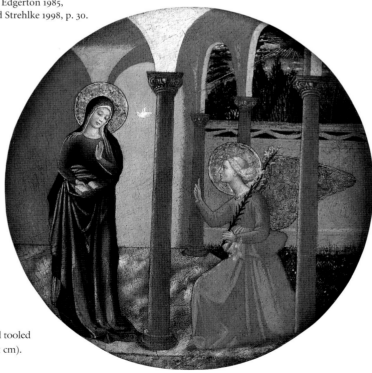

FIG. 35.4 Benozzo Gozzoli. *Annunciation*, 1440s. Tempera and tooled gold on panel; diameter 9½" (24.1 cm). New York, Piero Corsini, Inc.

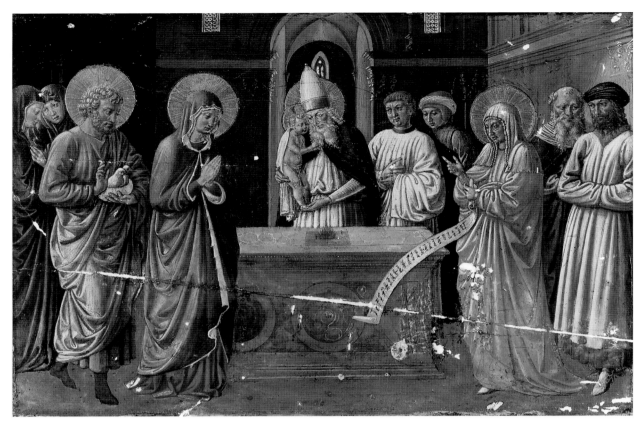

FIG. 36.1 Plate 36 in 1993, after cleaning and before restoration

PLATE 36 (JC CAT. 38)
Predella panel of an altarpiece: *Purification of the Virgin*

1461–62

Tempera and tooled gold on panel with horizontal grain; 9¾ × 14½ × ½″ (24.6 × 36.6 × 1 cm), painted surface 9½ × 14⅛″ (24 × 35.8 cm)

John G. Johnson Collection, cat. 38

INSCRIBED ON THE REVERSE: *M.A.* (in ink); *190/T.C./ with N° 119/ M[——] R[——]*(on a piece of torn paper); red wax seal with a large bee surrounded by little bees [The emblem of Grand Duke Ferdinando I de' Medici] (see fig. 36.4); damaged red wax seal with two rampant animals and a devil surprising a woman at a spinning wheel (see fig. 36.5)

EXHIBITED: Philadelphia 1920, cat. 38; New York, The Metropolitan Museum of Art, The Cloisters, *Seven Joys of Our Lady* (December 20, 1944–January 21, 1945), no catalogue; Montefalco 2002, cat. 35

TECHNICAL NOTES
The panel has been thinned. Sections of the barbes are present at the top and bottom, and gold bands bordered by a dark line are visible at the sides.

The paint surface has suffered numerous small losses (fig. 36.1). One large loss, which has been filled and retouched, extends across the lower half of the panel. A photograph records its state in 1913 (fig. 36.3). According to Hamilton Bell, on March 4, 1924, T. H. Stevenson laid down blisters. In 1947, when David Rosen treated the picture,[1] many of the finer effects were damaged, including cast shadows of the figures and altar, and the veins of the marble on the altar. And, in addition, considerable flesh tone was overcleaned to reveal green underpainting. In April 1993 Stephen Gritt removed Rosen's restoration, and Roberta Rosi inpainted losses and abrasions.

Underdrawing is visible throughout the panel (fig. 36.2). In addition, the straight lines and arches of the architecture were incised in the gesso with a ruler and compass.

PROVENANCE
The panel is from the predella of an altarpiece that belonged to the company of Santa Maria della Purificazione e di San Zanobi, a boys' confraternity in the convent of San Marco in Florence. In 1506 the altarpiece was moved to the company's new oratory on the via San Gallo. In 1730 and 1757 Antonmaria Biscioni recorded it in the refectory of

the hospital of Melani (also known as the hospital of the Pellegrini), which was next door to the oratory and under the company's control.[2] In 1775 the hospital was suppressed and its buildings purchased by Orazio di Zanobi Pucci.[3] The confraternity was not suppressed until 1802, but it is likely that the altarpiece was broken up before that date, because the wax seals on the reverse of this panel and its companion in Washington, D.C. (see fig. 36.7) have the emblem of Duke Ferdinando I de' Medici (1551–1609). The predella panel in the British royal collection (see fig. 36.8) was purchased in Italy in the 1790s. Sometime after 1802 the main panel of the altarpiece (see fig. 36.11) passed to the Rinuccini family in Florence, where it is recorded in 1842.[4]

When Bernhard Berenson offered the painting to Johnson in a letter dated Settignano, May 27, 1911, it had been in the collection of Don Jaime de Bourbon at Castle Frohsdorf in Austria:

This time I enclose a photograph of a jewel. It is of Benozzo Gozzoli and of as fine a specimen as has come into the market in my day. As the photo is the size of the original the delicacy of the effect is scarcely brought out. It is a fairly early work, and yet, although redolent still of

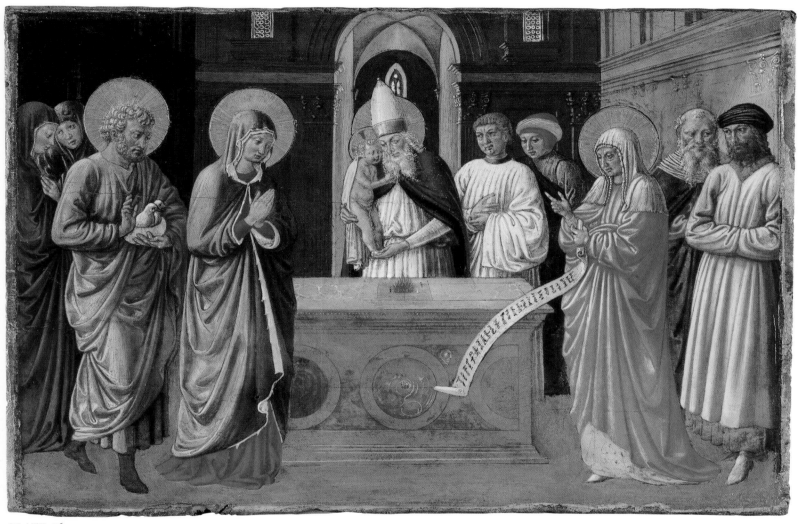

PLATE 36

FIG. 36.2 Infrared reflectogram of plate 36, showing the underdrawing of the Virgin

Fra Angelico, Benozzo here is already himself. But I need not belabour you with my prose on a matter that will be obvious to your eyes.

The surprising thing is the price only £2400 (Two thousand four hundred pounds) in London. It is not half fetched by the last Benozzo sold, the Rodolphe Kahn [Kann] one [fig. 36.6] which was not half so attractive and not of such fine quality. Its provenance too is interesting. It is hot from the collection of Don Jaime de Bourbon, Duke of Madrid, and at present belongs to my old dealer friend O. Gutekunst, a much less rapacious animal than my more recent dealer acquaintances.

According to a letter to Johnson from P. & D. Colnaghi & Co., dated London, June 9, 1911, the firm shipped the painting on the SS *St. Paul*.

COMMENTS

The elderly Simeon, dressed as a high priest, stands behind an altar holding the naked Christ Child. On the left are the Virgin and Saint Joseph, with the latter carrying two turtledoves. On the right the haloed prophetess Anna holds a long scroll.

The painting represents the Purification of the Virgin and the Presentation of the Christ Child in the temple of Jerusalem as recounted in Luke 2:22–39. The two events were conflated into a single church feast known as the Purification. Also called Candlemas in English, or Candelora in Italian, the Purification was celebrated as a midwinter festival marked by the distribution of candles and candlelight processions that particularly delighted children, who were often allowed to play a role in the ritual.[5] Appropriately, this painting comes from an altarpiece (see fig. 36.10) made for a Florentine boys' association dedicated to the feast: the company of Santa Maria della Purificazione e di San Zanobi. Its headquarters were in the Dominican Observant convent of San Marco, and the setting in the Johnson picture recalls Michelozzo's architecture for the convent's church.

The careful observation of light in the church interior shows that Gozzoli was mindful of the text of Luke 2:32, in which the infant Christ is prophesied as "a light to the revelation of the Gentiles." The importance of light is further underscored by an inscription on the Virgin's robe in the main section of the altarpiece (see fig. 36.11), whose text comes from the antiphon sung at the canonical hour of Compline on the feast day of the Purification.

The Johnson painting is the center section of the altarpiece's predella. The other panels are the *Saint Zenobius Raising a Child from the Dead on the Via degli Albizzi, Florence* (fig. 36.6); the *Dance of Salome and the Beheading of Saint John the Baptist* (fig. 36.7); the *Fall of Simon Magus* (fig. 36.8); and *Saint Dominic Resuscitating the Nephew of Cardinal Napoleone Orsini* (fig. 36.9). The main panel is the *Virgin and Child Enthroned with Angels and Saints John the Baptist, Zenobius, Jerome, Peter, Dominic, and Francis of Assisi* (fig. 36.11) in the National Gallery in London.[6] The altarpiece's lost frame is described in a 1518 inventory as "a beautiful fully gilt frame and above the frame other beautiful gilt ornaments."[7]

A contract for the painting was drawn on August 30, 1461, at a meeting held by the custodians of the confraternity to discuss raising money to commission an altarpiece.[8] Dated October 23, 1461, the final contract states that Domenico di Stefano, a linen merchant and custodian of the company, had hired Benozzo Gozzoli to paint a gold-ground altarpiece that was to resemble the high altarpiece of the church of San Marco. The saints to be included were specified, as were the conditions that Saint Zenobius should wear pontifical vestments and that Saints Jerome and Francis should be kneeling. It was further required that two boys dressed in white and crowned with olive wreaths should hold shields inscribed with *P.S.M.*, an acronym of the company,

in the section of the predella where coats of arms were usually shown. While the predella scenes themselves were not identified, it was stated that under each saint in the main panel there should be a story from his life. The total payment of 300 lire was to be split in three parts: 100 lire at the start, 80 lire six months later, and the rest after delivery. Benozzo was to pay all his expenses out of this fee, although it was implied that he was to be supplied with the panel. The work was to be completed by the calends, or the beginning, of November of the following year.

Records of some of the payments to Gozzoli survive in an account book kept by the sacristans of the company, Zanobi di Matteo and Giovanni di Ser Nicholaio. The disbursements, however, did not follow the terms of the contract. Furthermore, the payments continued for a year beyond the due date, possibly indicating delays in the execution.[9] The last payment was made on August 10, 1463.

In a letter to Johnson dated Settignano, October 28, 1911, Bernhard Berenson identified the Johnson Collection's panel as coming from the predella of the altarpiece. The contract does not mention a scene of the Purification of the Virgin, as it only specifies that each saint was to have an episode represented in the predella. However, the choice of the subject for the central scene obviously reflected the dedication to the Purification of the company that commissioned the altarpiece. The Mariological scene probably took the place of the proposed legends of Saints Jerome and Francis.[10]

The company of Santa Maria della Purificazione is said to have been founded in 1427 as an offshoot of another boys' club, whose membership had grown too large.[11] The company's principal supporter was the prior of San Marco, Saint Antonino Pierozzi. His interest in the Purification is attested by his own cell, which contained a scene of the subject painted by Fra Angelico in 1441.[12]

In 1444 Cosimo de' Medici, who had paid for the restructuring of the convent and church of San Marco, saw to it that the company got new quarters in the second cloister. The group took possession of them on the feast day of Saints Peter and Paul—June 29, 1444—with a solemn procession of all the young members dressed in white. In 1448, in the introduction to the company's rules, Antonino described the new space as consisting of a chapel, an oratory, a well, and a garden.[13] The chapel seems to have been the preserve of Cosimo de' Medici himself,[14] for Antonino wrote that Cosimo personally had an unidentified altarpiece of Saints Cosmas and Damian installed there. Although Antonino did not mention any decoration for the oratory, ledgers from the Medici bank record payments for a wooden choir and cupboard for the space.[15] It went without an altarpiece for a long time, and even after Gozzoli's painting was completed—presumably after August 1463—work on the oratory did not stop: a supplication was sent to Pope Paul II Barbo asking for permission to collect funds to complete it.[16]

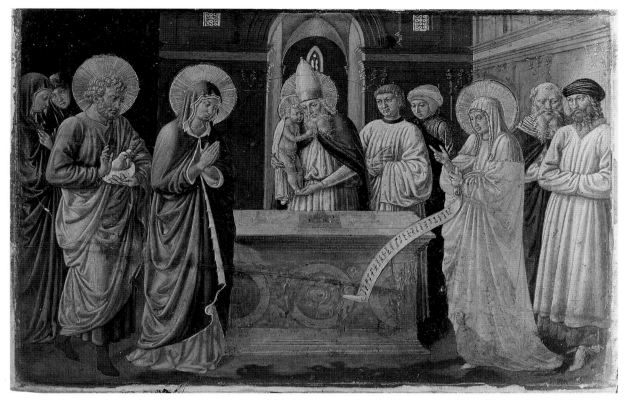

FIG. 36.3 Photograph of plate 36 as it appeared in 1913

FIG. 36.4 Wax seal showing the emblem of Grand Duke Ferdinando I de' Medici (1551–1609) on the reverse of plate 36

FIG. 36.5 Wax seal on the reverse of plate 36

1. Sweeny 1966, color repro. opposite p. 129.
2. In Borghini 1584, Biscioni ed. 1730, p. 271 n. 4; and Richa, vol. 5, 1757, p. 335. Also on the company, see Diane Ahl in Wisch and Ahl 2000, pp. 46–73; and Ann Machette in Wisch and Ahl 2000, pp. 74–101.
3. Davies 1961, p. 76 n. 16.
4. Davies 1961, p. 75.
5. Stefan Lochner's representation of the scene in his altarpiece (Zehnder 1993, fig. 4) of 1447 in the Hessisches Landesmuseum Darmstadt shows a number of children holding candles observing the sacred event. Sano di Pietro (q.v.) also depicted the distribution of candles during this feast in a choir book for the cathedral of Siena (cod. 27.11, carta 34 verso). See Ciardi Dupré 1973, color plate 3.
6. Anna Padoa Rizzo (in Padoa Rizzo and Casini Wanrooij 1985, figs. 1a–b) identified a pilaster panel by Benozzo Gozzoli and another by Domenico di Michelino as coming from the same altarpiece. Diane Ahl (1996, pp. 215, 300 n. 151) rightly rejects this connection. The two panels depict standing saints. However, the presence of John the Baptist in the panel by Gozzoli would exclude this association, because that saint is represented in the main part of the altarpiece.
7. "Bella chornicie tutta messa doro E sopra la chornicie altrii adornamenti messi doro begli." Ahl 1996, p. 224; see also Cust and Horne 1905, p. 383.
8. Florence, Archivio di Stato, Corporazioni Religiose Soppresse da Pietro Leopoldo, 1649, p. xxx 14, folios 155 verso–156. Most recently published by Ahl 1996, p. 11a. See also Chambers 1970, pp. 53–55; Glasser 1977, pp. 31, 64–70; Hope 1990, pp. 539–40, 543–44, 567 n. 20.

9. The first recorded payment was made on September 8, 1461: "Ala tavola nostra, per dipintura, lire trenta sei e soldi tredici, e quali denari si dettono a Benonzo di Lese dipintore sono per parte dipintura di detta tavola" (For painting of our altarpiece, 36 lire and 13 soldi, which are given to Benozo [*sic*] di Lese, painter, for the painting of the said altarpiece); Florence, Archivio di Stato, Corporazioni Religiose Soppresse da Pietro Leopoldo, 1654, int. 30, folio 108 verso. Other payments are listed in the same account book on January 8, 17, and 24, 1462 (folio 108 verso); August 29, 1462 (folio 109); November 28, 1462, and February 24, 1463 (folio 109 verso); and May 15 and August 10, 1463 (folio 109 verso). The account cannot be entirely reconstructed because a separate, special register for the altarpiece referred to in one of the above-recorded payments (folio 109 verso) does not survive. I thank Caroline Elam for the references to these documents. The first payment has been published by Ahl (1996, p. 277).
10. Together the existing panels of the predella measure approximately 67" (170 cm) in length, the same width as the main panel. The two panels with the children bearing shields with the company's arms would have been located under the lateral pilasters.
11. Based on the account given in Richa (vol. 5, 1757, pp. 329–33), some sources suggest that the company dates as early as the last years of the thirteenth century and that it was established in San Marco when the Benedictine Silvestrines still occupied the convent. The Dominican Observants took over the convent in early 1436.

FIG. 36.6 Benozzo Gozzoli. *Saint Zenobius Raising a Child from the Dead on the Via degli Albizzi, Florence*, 1461–62. Tempera and tooled gold on panel; 9½ × 13⅜″ (24 × 34 cm). Berlin, Staatliche Museen Preussischer Kulturbesitz, Gemäldegalerie, no. 60c. See Companion Panel A

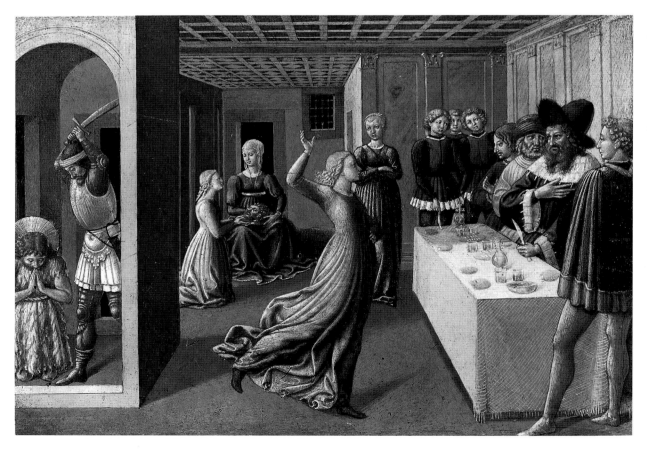

FIG. 36.7 Benozzo Gozzoli. *Dance of Salome and the Beheading of Saint John the Baptist*, 1461–62. Tempera and tooled gold on panel; 9⅜ × 13½″ (23.8 × 34.3 cm). Washington, D.C., National Gallery of Art, Samuel H. Kress Collection © 1995 Board of Trustees, 1952.2.3 (1086). See Companion Panel B

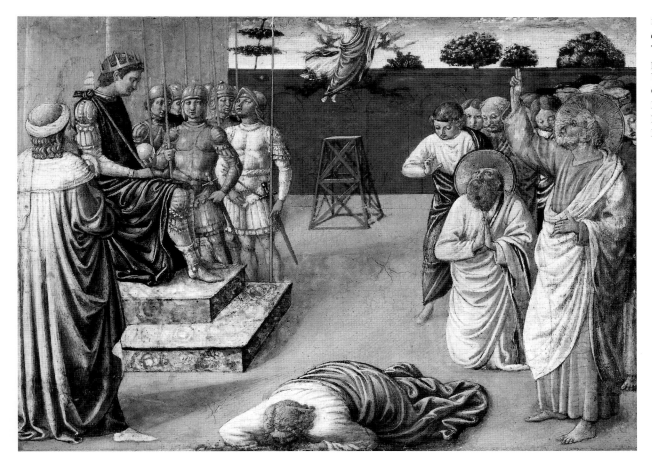

FIG. 36.8 Benozzo Gozzoli. *Fall of Simon Magus,* 1461–62. Tempera and tooled gold on panel; 9⅝ × 13⅝″ (24.3 × 34.5 cm). United Kingdom, The Royal Collection, Her Majesty Queen Elizabeth II; on deposit, London, National Gallery. See Companion Panel C

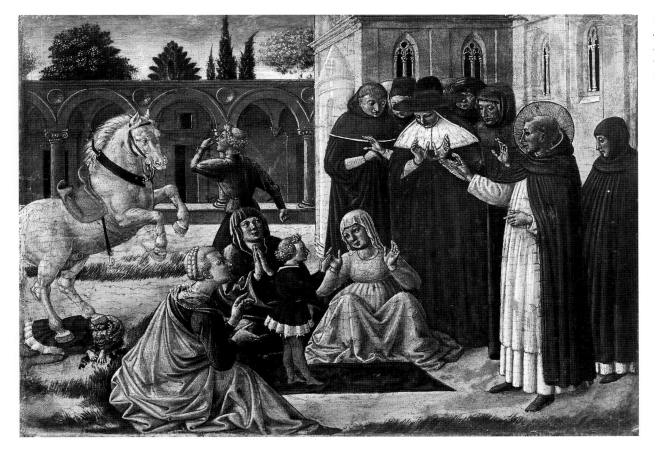

FIG. 36.9 Benozzo Gozzoli. *Saint Dominic Resuscitating the Nephew of Cardinal Napoleone Orsini,* 1461–62. Tempera and tooled gold on panel; 9⅞ × 13⅞″ (25 × 35 cm). Milan, Pinacoteca di Brera, no. 475. See Companion Panel D

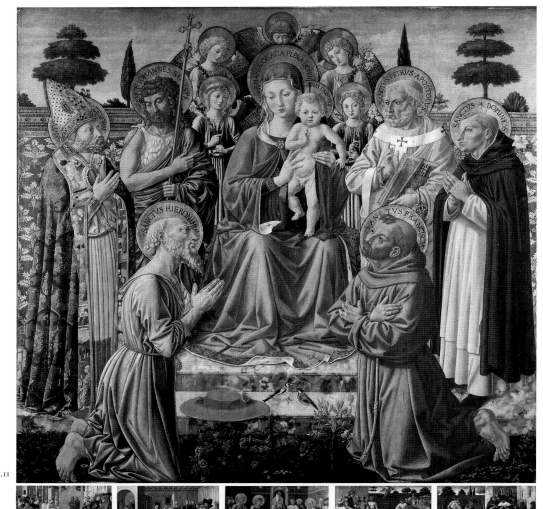

sixteenth-century copies of the original 1440s documents. I thank Caroline Elam for this information.
16. "Cum itaque Oratorium Purificationis B. Mariae Virginis, & S. Zenobii noviter reparari incoatum; . . . ut Ecclesia ipsa, seu Oratorium, quod nondum perfectum existit, in suis structuris, & hedificiis perficiatur, & manuteneatur" (As the oratory of the Purification of the Blessed Virgin Mary and Saint Zenobius has newly begun repairs, . . . so that the church [San Marco] itself, as well as the oratory, which is not yet completed, can finish its facilities and building and be taken care of) (cited in Richa, vol. 5, 1757, p. 331).

Bibliography
Vasari 1550 and 1568, Bettarini and Barocchi eds., vol. 3 (text), 1971, p. 376; Suida 1911, plate 11; Berenson 1913, pp. 24–25, repro. p. 241; Bell 1920, p. 6; Philadelphia 1920, pp. 2–3; Berenson 1932, p. 264; Johnson 1941, p. 8; Davies 1951, pp. 58–59 n. 13; Shapley 1952, pp. 84–85, fig. 6; Davies 1961, pp. 74, 75–76 n. 13; Berenson 1963, p. 96; Emma Micheletti in *DBI*, vol. 8, 1966, p. 574; Sweeny 1966, pp. 25–26, color plate opposite p. 129; Fredericksen and Zeri 1972, p. 25; Padoa Rizzo 1972, p. 128, fig. 121; Shearman 1983, p. 134; Francesca Fumi in Vasari 1550, Bellosi and Rossi ed. 1986, pp. 402–3 n. 2; Padoa Rizzo 1992, p. 74, no. 36; repro. p. 76; Angelo Tartuferi in Brena 1992, p. 29; Strehlke 1993, p. 13, fig. 14; Philadelphia 1994, repro. p. 196; Ahl 1996, pp. 112–19, 225, plate 142; reconstruction, plate 135; Diane Ahl in Wisch and Ahl 2000, pp. 49, 63–64, plate 12; Miklós Boskovits in Toscano and Capitelli 2002, pp. 260–67, color plate 35; Rosaria Mencarelli in Milan 2003, p. 11, color plate 5; Miklós Boskovits in Boskovits and Brown 2003, pp. 346–51, fig. 3d

36.11

FIG. 36.10 Original configuration of the known extant panels of Benozzo Gozzoli's Purification altarpiece, 1461–62. Main panel (FIG. 36.11): *Virgin and Child Enthroned with Angels and Saints John the Baptist, Zenobius, Jerome, Peter, Dominic, and Francis of Assisi*. Tempera and tooled gold on panel; 63⅞ × 67″ (162 × 170 cm). London, National Gallery, no. 283. See Companion Panel E. Predella (left to right): FIGS. 36.6, 36.7, PLATE 36, FIGS. 36.8, 36.9

36.6 36.7 PL. 36 36.8 36.9

COMPANION PANELS for PLATE 36

A. Predella panel of an altarpiece: *Saint Zenobius Raising a Child from the Dead on the Via degli Albizzi, Florence*. See fig. 36.6

1461–62

Tempera and tooled gold on panel; 9½ × 13⅜″ (24 × 34 cm). Berlin, Staatliche Museen Preussischer Kulturbesitz, Gemäldegalerie, no. 60c

PROVENANCE: Same as the Johnson Collection's panel to c. 1775; Rome, Prince Curti Lepri; Rome, Carinci, 1898; Paris, Rodolphe Kann Collection; purchased by the Kaiser-Friedrich-Museum, Berlin, 1909

SELECT BIBLIOGRAPHY: Ricci 1904a, pp. 1–2; Cust and Horne 1905; Padoa Rizzo 1992, p. 72, no. 33; Ahl 1996, pp. 112–19, 225; Miklós Boskovits in Toscano and Capitelli 2002, pp. 260–67

B. Predella panel of an altarpiece: *Dance of Salome and the Beheading of Saint John the Baptist*. See fig. 36.7

1461–62

Tempera and tooled gold on panel; 9⅜ × 13½″ (23.8 × 34.3 cm). Washington, D.C., National Gallery of Art, Samuel H. Kress Collection © 1995 Board of Trustees, 1952.2.3 (1086)

PROVENANCE: Same as the Johnson Collection's panel to c. 1775; Venice, Conte Vittorio Cini; New York, Wildenstein's; New York, Samuel H. Kress Foundation, acquired

Other information on the convent can be found in Monti 1927, vol. 1, p. 184; Hatfield 1970, p. 127 and n. 88; Trexler 1974, p. 207 and n. 2.
12. Hood 1993, color plate 217 (see also pp. 224–32 for an interpretation of the scene).
13. "Et nella entrata del sopradecto luogo e [è] una capella titolata in sancto cosimo e damiano et detteci el detto Cosimo una tavola colle figure di detti sancti dipinti, cioè sancto cosimo et damiano, che servissi allo altare di detta capella: dietro a detta capella e [è] l'oratorio nostro titolato oratorio della purificatione della vergine Maria, madre di Giesu Cristo et di sancto zenobio con sagrestie et altre stanze apartenente a detto luogo et corte et pozzo et orto" (And at the entry of the above-mentioned place is a chapel dedicated to Saints Cosmas and Damian and the said Cosimo [de' Medici] had a painting placed there with the figures of

the said depicted, that is Saints Cosmas and Damian, which served as the chapel's altarpiece [not identified]. Behind the said chapel is our oratory dedicated to the Purification of the Virgin Mary, mother of Jesus Christ, and to Saint Zenobius, with sacristies and other rooms belonging to the said place and a courtyard, well, and garden) (Morçay 1914, p. 474, no. 71; cited in Morçay 1913, p. 15 n. 2).
14. Cosimo had been responsible for the Dominican Observants' move to San Marco in 1439, and he paid for the renovation of the church and convent. In addition, he maintained a double cell for himself in the friars' dormitory, which has a mural by the young Gozzoli from 1442 (Ahl 1996, plate 17).
15. Florence, Archivio di Stato, Corporazioni Religiose Soppresse da Pietro Leopoldo, 1646, int. 7, *Libro dello schrivano*, 1501–20, folios 240 recto and verso. They are

1949; given by the Samuel H. Kress Foundation to the National Gallery of Art, 1952

SELECT BIBLIOGRAPHY: Shapley 1952; Shapley 1966, p. 116; Shapley 1979, pp. 229–30; Padoa Rizzo 1992, p. 74, no. 34; Ahl 1996, pp. 112–19, 225–26; Miklós Boskovits in Toscano and Capitelli 2002, pp. 260–67; Miklós Boskovits in Boskovits and Brown 2003, pp. 346–51

C. Predella panel of an altarpiece: *Fall of Simon Magus.* See fig. 36.8

1461–62

Tempera and tooled gold on panel; 9⅝ × 13⅝″ (24.3 × 34.5 cm). United Kingdom, The Royal Collection, Her Majesty Queen Elizabeth II; on deposit, London, National Gallery

PROVENANCE: Same as the Johnson Collection's panel to c. 1775; purchased by William Young Ottley in Italy, c. 1791–98; purchased from Warner Ottley, William's brother, by Prince Albert, July 14, 1846; Osborne House, Isle of Wight, until April 1902; Buckingham Palace, London, until 1965; Hampton Court, 1965–75, when it was lent to the National Gallery, London

EXHIBITED: London 1930, no. 80; London 1946, no. 180; Birmingham 1955, no. 58; Montefalco 2002, cat. 36

SELECT BIBLIOGRAPHY: Cust and Horne 1905; Shearman 1983, pp. 133–34, no. 132; Padoa Rizzo 1992, p. 74, no. 37; Ahl 1996, pp. 112–19, 225; Miklós Boskovits in Toscano and Capitelli 2002, pp. 260–67

D. Predella panel of an altarpiece: *Saint Dominic Resuscitating the Nephew of Cardinal Napoleone Orsini.* See fig. 36.9

1461–62

Tempera and tooled gold on panel; 9⅞ × 13⅞″ (25 × 35 cm); Milan, Pinacoteca di Brera, no. 475

PROVENANCE: Same as the Johnson Collection's panel to c. 1775; purchased by the Brera from the sculptor Cavaliere Achille Alberti, September 1900

EXHIBITED: Florence 1990, cat. 17; Montefalco 2002, cat. 37; Milan 2003

SELECT BIBLIOGRAPHY: Ricci 1904a, pp. 1–2; Roberto Bartalini in Florence 1990, p. 118; Padoa Rizzo 1992, p. 74, no. 35; Angelo Tartuferi in Brera 1992, pp. 28–30; Ahl 1996, pp. 112–19, 225; Miklós Boskovits in Toscano and Capitelli 2002, pp. 260–67; Rosaria Mencarelli in Milan 2003, pp. 8–19; Andrea Carini in Milan 2003, pp. 42–43

E. Main panel of an altarpiece: *Virgin and Child Enthroned with Angels and Saints John the Baptist, Zenobius, Jerome, Peter, Dominic, and Francis of Assisi.* See fig. 36.11

1461–62

Tempera and tooled gold on panel; 63⅞ × 67″ (162 × 170 cm). London, National Gallery, no. 283

INSCRIBED ON THE VIRGIN'S HALO: *.AVE MARIA GRATIA PLENA DOMINU'* (Luke 1:28: "Hail [Mary], full of grace"); ON THE BORDER OF HER ROBE: *AVE REGINA CELORUM MATER ANGELORUM SANCTA ES QVA MUNDO LUX EST ORT[A]* (contraction of the antiphon intoned at Compline on the day of the feast of the Purification: *Ave Regina Caelorum. Ave Domina Angelorum. Salve Radix. Salve Porta. Ex Qua Mundo Lux Est Orta* [Hail, Queen of heaven; hail, Mistress of the Angels, hail, root of Jesse; hail, the gate through which the Light rose over the earth]); ON CHRIST'S HALO: *HIESUS CRISTUS* (Jesus Christ); ON ZENOBIUS'S HALO: *.SANTU' ZENOBIUS.* (Saint Zenobius); ON THE BAPTIST'S HALO: *.SANCT' IOHANNES BATISTA.* (Saint John the Baptist); ON JEROME'S HALO: *.SANCTUS HIERONIMU'* (Saint Jerome); ON PETER'S HALO: *.SANCTUS PETRUS APOSTOLUS.* (Saint Peter Apostle); ON PETER'S COLLAR: *TU ES PETRUS & SUPER ANC* (Matthew 16:18: "Thou art Peter; and upon this"); ON PETER'S BOOK: *TU ES CRISTUS FILIUS DEI VIVI.* (Matthew 16:16: "Thou art Christ, the Son of the living God"); ON DOMINIC'S HALO: *.SANCTUS DOMINICUS.* (Saint Dominic); ON FRANCIS'S HALO: *.SANCTUS FRANCISCUS.* (Saint Francis)

PROVENANCE: Same as the Johnson Collection's panel to c. 1775; after 1802(?) to the Rinuccini family in Florence, where it is recorded in 1842; left unsold at the sale of the estate of Marchese Pietro Francesco Rinuccini, 1852, cat. 131; purchased from the estate by the National Gallery, London, 1855

SELECT BIBLIOGRAPHY: Davies 1951, pp. 57–59; Davies 1961, pp. 73–76; Dunkerton et al. 1991, pp. 64, 122, 129, 131; Padoa Rizzo 1992, p. 72, no. 32; Ahl 1996, pp. 112–19, 224–25; Miklós Boskovits in Toscano and Capitelli 2002, pp. 260–67

JACOPO DI CIONE

FLORENCE, FIRST DOCUMENTED 1365;
DIED 1398/1400, FLORENCE

Jacopo di Cione came from a family of Florentine artists: of his three brothers, Nardo was a painter; Andrea, called Orcagna, a painter and sculptor; and Matteo, a sculptor. Jacopo, the youngest, was named as an heir in Nardo's will in 1365. His first documented project dates to the next year, when he executed now-lost mural paintings for the headquarters of the Guild of Judges and Notaries (Arte dei Giudici e Notai) in Florence. In 1368, the same year he entered the Florentine painters' guild, he agreed to finish the *Saint Matthew* tabernacle (see fig. 28.9) for the Guild of Bankers (Arte del Cambio) in place of his brother Andrea, who was incapacitated by illness. Jacopo may not have actually painted any of the picture himself, for the document related to this commission most likely refers to an obligation with the Cioni workshop.[1] As documents for his principal altarpieces and mural cycles attest, on major projects Jacopo worked in collaboration and seems largely to have executed other artists' designs. For the murals for the Guild of Judges and Notaries, he collaborated with a certain "Niccholo," described in the documents as a *cofaneio*, which probably means a painter of chests. A Niccolò and a certain Simone also initiated the *Coronation of the Virgin* of 1372–73 for the offices of the Florentine mint in 1372.[2] Not until the following year was Jacopo entrusted with the commission, which probably means that he finished a preexisting design. A "Niccolaio," possibly the same Niccolò, appears in the surviving documentation as the designer of the main altarpiece of San Pier Maggiore in Florence. Although Jacopo's name is absent from the records, most critics agree that the execution is his.

In 1383 Jacopo worked with Niccolò di Pietro Gerini (q.v.) on a mural in the Palazzo dei Priori in Volterra.[3] Gerini in fact may be the Niccolò mentioned in the earlier documents, although that figure has also been identified with Niccolò di Tommaso (q.v.), an older painter who left Florence for Naples in 1372.

In 1386 Francesco di Marco Datini, a merchant from Prato, ordered from Jacopo di Cione five paintings of the Virgin and Child with saints, which were sent for sale to his firm's branch in Avignon. The total cost of the paintings was 26 florins. Gerini may have negotiated Jacopo's commission with Datini, one of many Tuscan businessmen who trafficked Italian paintings internationally, because he was the entrepreneur's preferred painter and had decorated his house.

Jacopo died at some point between May 2, 1398, and the end of 1400. Although there are no signed or precisely documented paintings by him, a large body of works has been attributed to him on the basis of the *Coronation of the Virgin* of 1372–73. Stylistically, Jacopo derives from his older brother Andrea, although works attributed to Jacopo's late period show the influence of Gerini and Giovanni del Biondo.

Surviving his brothers Nardo and Andrea by about thirty years, Jacopo kept the family workshop going to the end of the fourteenth century. Under Jacopo it had become the purveyor of a conservative style, producing religious images of great majesty that often seem to be miraculous apparitions. This aulic manner countered the grim reality of Florence during the 1370s and 1380s, which was beset by political and financial troubles as well as the plague, papal interdiction, and working-class revolt.

1. Boskovits 1975, pp. 51, 209 n. 36.
2. Florence, Galleria dell'Accademia, no. 456; Bomford et al. 1989, color plate 170.
3. Bomford et al. 1989, color plates 173–76.

Select Bibliography
Giovanni Poggi in Sirén 1908, pp. 99–102; Hans D. Gronau in Thieme-Becker, vol. 26, 1932, p. 39; Offner and Steinweg 1965; *Bolaffi*, vol. 6, 1974, pp. 296–97; Boskovits 1975, esp. pp. 50–54, 94–98, 321–30; Fremantle 1975, pp. 161–72; Borsook 1982; Enzo Biagi in *Pittura* 1986, p. 587; Bomford et al. 1989, pp. 140–89; Andrea G. De Marchi in *Enciclopedia dell'arte medievale*, vol. 7, 1996, pp. 244–46; Gert Kreytenberg in *Dictionary of Art* 1996, vol. 7, pp. 337–39; Gert Kreytenberg in *Saur*, vol. 19, 1998, pp. 260–61

PLATE 37 (JC CAT. 4)

Predella panel of an altarpiece: *Saint Peter Liberated from Prison*

1371

Tempera and tooled gold and silver on panel with horizontal grain; panel 15 3/8 × 20 1/2 × 1" (39 × 52.1 × 2.5 cm), painted surface 14 3/4 × 20 1/4" (37.2 × 51.4 cm)

John G. Johnson Collection, cat. 4

INSCRIBED ON THE REVERSE: Black wax seal with traces of a spread eagle's wings [see fig. 37.4]; *Orcagna/ Peter Delivered from Prison/ In two compartments* (in ink on a paper sticker); *School of Andrea Orcagna/ "St. Peter Freed from Prison."/ Consul Weber Sale in Berlin/ Feb:1912 No 2 in catalogue* (in ink on a paper sticker); printed sticker with the name and London address of Dowdeswell & Dowdeswells; illegible pencil inscription, possibly *Dowdeswell/ 1300; JOHNSON COLLECTION/ PHILA.* (stamped in ink)

PUNCH MARKS: See Appendix II

TECHNICAL NOTES
The panel, consisting of one plank of wood, retains its original thickness. The original frame barbe is preserved on all but the left side. The top and bottom right corners are incised with miter marks. In the upper left corner the linen beneath the gesso ground is visible.

During the execution the artist changed the entrance to the prison from an arched doorway to the present rectangular format. Infrared reflectography showed some evidence of simple brush drawing and, on the reverse of the panel, a crude but apparently original drawing of a haloed figure holding a staff (fig. 37.1).

The photograph of the painting in the Johnson catalogue of 1913 (fig. 37.2) records the picture's appearance before the restorer David Rosen cleaned it in October 1944, retouching very few of the losses.[1] In 1993 Roberta Rosi selectively inpainted them to reduce disturbing abrasions and clarify previously illegible areas, such as the proper left wing and hand of the angel on the right.

The surface is also very abraded, particularly in the flesh tones. The face of Saint Peter in prison is worn to the gesso. In the 1913 photograph this face appears to have been reworked in the early nineteenth century, but it is unclear how damaged it was at that point. The faces of the soldiers in prison had been vandalized with a blunt instrument.

Silver applied on mordant was used for the mordant leafing of the helmets, some armor details, and the grating of the prison. These areas are abraded, but the silver that survives still appears metallic. Much of the mordant gilt patterns on the costumes has survived, although in some places only the red mordant has been preserved.

PROVENANCE
The panel comes from the predella of the high altarpiece of San Pier Maggiore in Florence. The altarpiece was transferred, probably in 1611–15, to the Della Rena family chapel.[2] After the church's destruction in 1784, the altarpiece was consigned to the Pucci family. Francesco Lombardi and Ugo Baldi purchased it from Marchese Roberto Pucci in 1846. In 1857 the National Gallery in London acquired the principal central and upper sections from Lombardi and Baldi.[3] In 1898 Edward F. Weber of Hamburg purchased the Johnson panel in London, possibly from the dealer Dowdeswell, as a stamp on the reverse may suggest.[4] The painting was sold in Berlin at the Kunst-Auction-Haus on February 20–22, 1912 (lot 2), as in the manner of Andrea Orcagna. Johnson subsequently purchased it at Bernhard Berenson's recommendation as expressed in a letter dated

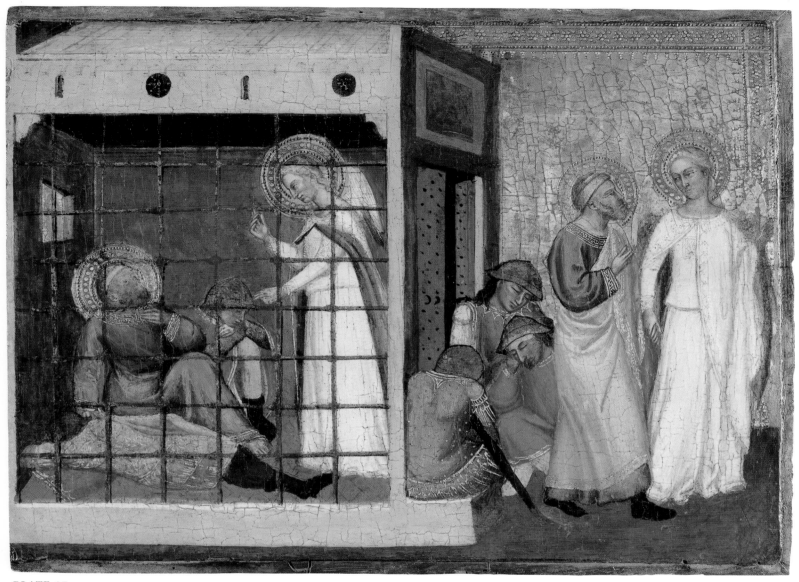

PLATE 37

Settignano, March 9, 1912. It is not clear, but Johnson may have acquired it from Dowdeswell.

COMMENTS

The painting depicts two episodes in the liberation of Saint Peter from prison. On the left the prison interior is viewed through a grate. Already released from the chains, Peter is rising from the floor in response to the angel's gesture. He is barefoot and wears a blue garment. Two guards sleep next to him. On the right the angel leads him away. Peter now wears sandals and a yellow mantle. Three guards sleep at the prison door, as described in the Acts of the Apostles (12:5-10):

Peter therefore was kept in prison. But prayer was made without ceasing by the church unto God for him. And when Herod would have brought him forth, the same night Peter was sleeping between two soldiers, bound with two chains: and the keepers before the door kept the prison. And behold an angel of the Lord stood by him: and a light shined in the room: and he striking Peter on the side, raised him up, saying: Arise quickly. And the chains fell off from his hands. And the angel said to him: Gird thyself, and put on thy sandals. And he did so. And he said to him: Cast thy garment about thee, and follow me. And going out, he followed him, and he knew not that it was true which was done by the angel: but thought he saw a vision. And passing through the first and the second ward, they came to the iron gate that leadeth to the city, which of itself opened to them. And going out, they passed on through one street: and immediately the angel departed from him.

The artist ignored two essential details of the biblical account: the supernatural light and the angel striking Peter. This distinguishes the Johnson panel from most other Italian depictions of the scene, which derived from a mural in the atrium of the destroyed Old Saint Peter's in Rome. A reliable copy of that painting is the thirteenth-century mural in the church of San Pietro in Grado near Pisa,[5] where the angel bends down and touches the saint's shoulder. In the Johnson panel the drama is diffused, as the angel merely gestures to Peter. While most early paintings of the story depict only the first episode, a precedent for showing both scenes can be found in a late thirteenth-century altarpiece by the Sienese Guido di Graziano.[6]

FIG. 37.1 Infrared
reflectogram of the reverse of
plate 37, showing a drawing of
a haloed figure

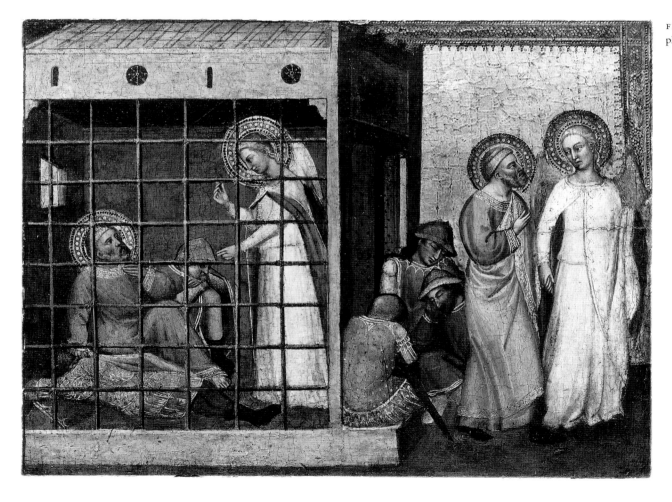

FIG. 37.2 Photograph of
plate 37 as it appeared in 1913

The Johnson panel comes from the predella of an enormous, now disassembled, altarpiece. In 1965 Offner and Steinweg were the first to reconstruct the painting. A photomontage of the altarpiece that includes a proposal of its original framing was compiled by the curators of the London exhibition *Art in the Making* in 1989 (fig. 37.3). The predella represents a Petrine cycle, from left to right: the arrest of Saint Peter (fig. 37.5), his liberation from prison (the Johnson panel), Peter raising the son of Theophilus (fig. 37.6), the chairing of Peter (fig. 37.7), the last meeting of Peter and Paul (fig. 37.8), and finally the crucifixion of Peter (fig. 37.9). The beheading of Saint Paul (fig. 37.10), who shares a feast day with Saint Peter (June 29), appeared at the bottom of the right pilaster. Presumably a lost panel depicting the conversion of Saint Paul would have been below the left pilaster.

The altarpiece replaced one in San Pier Maggiore by the so-called Master of Santa Cecilia (sometimes identified as Gaddo Gaddi) showing Saint Peter enthroned, which had been paid for in 1307 by the company of San Pietro, a lay confraternity associated with the church.[7] While the new painting reflected the compositional scheme established in the late 1340s by Bernardo Daddi (q.v.) for the altarpiece in the Saint Peter Martyr chapel of Santa Maria Novella in Florence,[8] it also is an example of a trend toward altarpieces of greater scale and complexity; in fact, several churches commissioned works similar to the one in San Pier Maggiore.[9]

PAYMENT AND DATE: Payment documents for the San Pier Maggiore altarpiece are not complete.[10] In 1370 a Niccolaio was reimbursed for the design *(disegnare),* and by late 1371 the actual painting was finished. Documents record that sections of the altarpiece were being brought to the hospital of Santa Maria Nuova, not far from San Pier Maggiore and actually the site of the company of San Luca, the artists' brotherhood, to be varnished and then fitted together by a carpenter. Since gold leaf was still being applied to the frame as late as December 17, 1371, the altarpiece probably was not installed until the following year, perhaps in time for the feast of the chairing of Saint Peter, or *Cathedra Petri,* on February 22.

The payment documents mention three painters—Niccolaio, the designer of the composition; Tuccio di Vanni; and Matteo di Pacino. The last-mentioned artist, who has been identified as the Master of the Rinuccini Chapel, seems to have been only marginally involved, since his distinctive hand cannot be detected in any of the surviving pieces.[11] However, a part of the altarpiece was reported as being in his house. Tuccio di Vanni probably had only a minor role in this project, but at the same time he was executing mural paintings in San Pier Maggiore's choir. Niccolaio is probably the Niccolò who is recorded as designing the *Coronation* for the

FIG. 37.3 Jill Dunkerton's reconstruction of the San Pier Maggiore altarpiece, with plate 37 in the predella, third from left (from Bomford et al. 1989)

Florentine mint, which Jacopo di Cione finished.[12] Because that painting and the San Pier Maggiore altarpiece share many aspects of design and execution, both probably involved a similar collaboration.

Although Niccolaio has been identified with both Niccolò di Pietro Gerini and Niccolò di Tommaso,[13] it is most likely, as was proposed in the 1989 catalogue *Art in the Making,* that Gerini was Jacopo di Cione's collaborator on the San Pier Maggiore

FIG. 37.4 Black wax seal on the reverse of plate 37

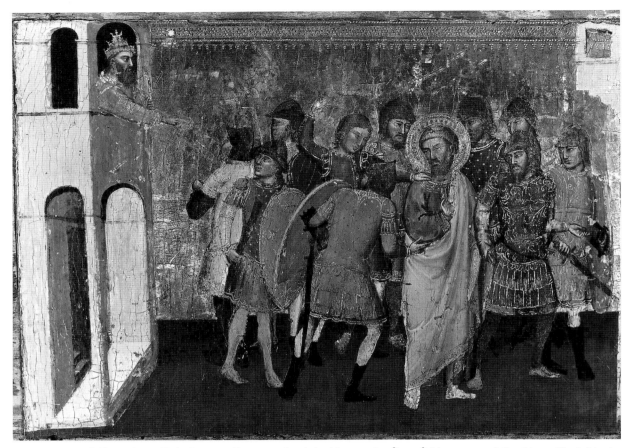

FIG. 37.5 Jacopo di Cione. *Arrest of Saint Peter,* 1371. Tempera and tooled gold on panel; 14⅝ × 20¾″ (37.2 × 52.7 cm). Providence, Rhode Island School of Design, Museum of Art, Gift of Manton B. Metcalf, no. 22.047. See Companion Panel A

project. As Niccolaio is recorded as designing the altarpiece, he may have been responsible for supervising the project.

One document suggests that the final payments for the new altarpiece were made only in 1383.[14] In that year the bursar and chaplain of the church, Ser Taddeo, received 25 gold florins from one Andrea di Franceschino degli Albizzi for "help for the high altarpiece."[15] This sum had been forthcoming from the widow of the latter's distant cousin Ser Romolo di Lapo degli Albizzi, Monna Tessa di Marco di Lapo Pucci. The document further indicates that the patronage of the high altar had passed from the company of San Pietro to the Albizzi, who lived near the church and who in those years were the most politically powerful family in Florence. They already controlled the patronage of four chapels in San Pier Maggiore, and two members of the family, daughters of Bartolomeo Alessandri degli Albizzi, were members of its nunnery.[16]

Since the altarpiece's iconography is intimately connected with the ceremony for the entry of a new bishop (see below), the commission may have resulted from the wish of the Albizzi to demonstrate their connection to the bishop of Florence,

Cardinal Pietro Corsini (in office 1363–70), who was their cousin.[17] The delay in the payment may have been caused by the papal interdict against Florence in 1375 and the exile in 1378–81 of Andrea degli Albizzi. Andrea's connection to San Pier Maggiore was close; he was deputy of the parish in 1386.

ALTARPIECE AND ICONOGRAPHY: The history of San Pier Maggiore determined much of the altarpiece's iconography as well as the selection of the saints in the main sections in London. The church no longer exists, but the model held in the painting by the titular saint, the apostle Peter, records its appearance in the 1370s. It had undergone several reconstruction campaigns in the course of the century, the latest having been twenty years earlier.

At least from the thirteenth century San Pier Maggiore had been the site at which newly elected bishops were received, seated, and then symbolically married to the local church as personified by the convent's abbess. The proceedings are recorded in several sources: the oldest, which dates to 1286, describes the installation of the bishop Jacopo Castelbuono da Perugia (in office 1275–86); another also offers a detailed account of the ceremony for

Angelo Acciauoli (in office 1383–87), the first to have occurred since the altarpiece was installed thirteen years earlier.[18] Records of the purchase of new accessories for this investiture indicate that the presence of the new altarpiece had led to a general refurbishing, for while San Pier Maggiore's earlier altarpiece by the Master of Santa Cecilia depicted only the chairing of Saint Peter, this new one contained a full repertory of iconographic references relating to the new bishop's installation.

On the morning of Acciauoli's arrival, the bishop was enthroned on the high altar before the painting, and laudatory sermons were preached. The inscription on the scroll that Saint John the Evangelist holds in the left lateral panel now in London was obviously selected to refer to this enthronement ceremony: "After this I saw a great multitude, which no man could number, of all nations, and tribes, and peoples, and tongues, standing before the throne, and in sight of the Lamb, clothed with white robes, and palms in their hands" (Apocalypse 7:9). In the afternoon the abbess gave the new bishop a ring of symbolic marriage, and the two sat on a common throne that was probably much the same as Christ and the Virgin's

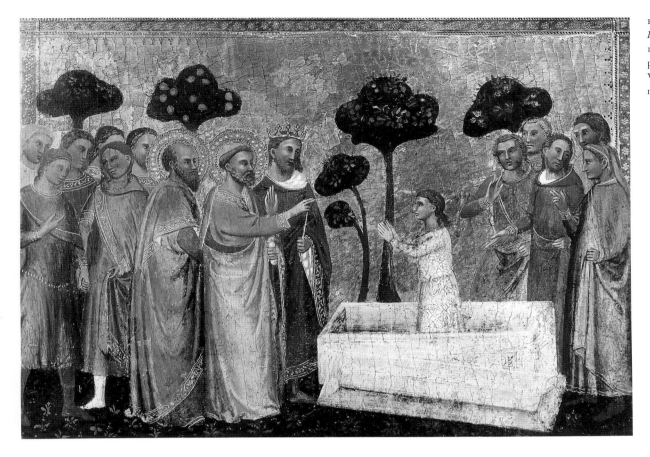

FIG. 37.6 Jacopo di Cione. *Saint Peter Raising the Son of Theophilus*, 1371. Tempera and tooled gold on panel; 15½ × 21⅛″ (39.4 × 53.5 cm). Vatican City, Pinacoteca Vaticana, no. 113. See Companion Panel B

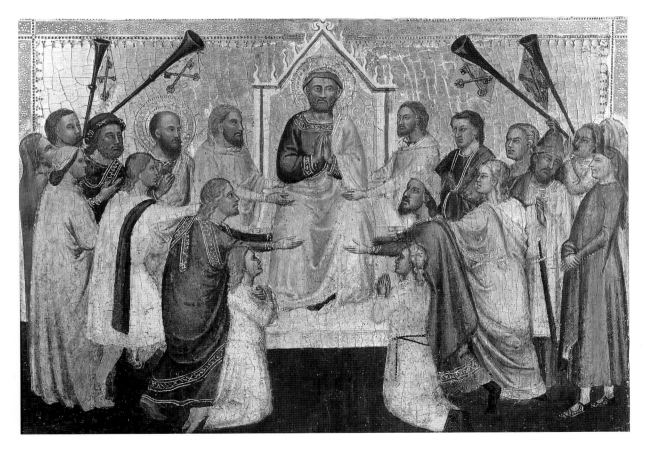

FIG. 37.7 Jacopo di Cione. *Chairing of Saint Peter at Antioch*, 1371. Tempera and tooled gold on panel; 15½ × 21⅛″ (39.4 × 53.5 cm). Vatican City, Pinacoteca Vaticana, no. 107. See Companion Panel C

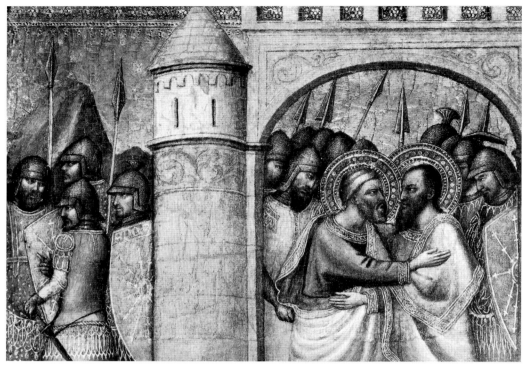

throne in the Coronation scene of the altarpiece. The prominence of Saint Catherine of Alexandria among the multitude of saints in the London panels may also allude to the ring, because of the popularity of the legend of her mystic marriage with Christ (see plate 38 [JC cat. 6]). During the subsequent procession from San Pier to the cathedral, the bishop was required to kneel at a point in the borgo degli Albizzi, a short distance from the church, where an earlier Florentine bishop, Saint Zenobius, who is also depicted among the altarpiece's saints, is said to have raised a boy from the dead. The location in the center sections of the predella of the scenes of Peter raising the son of Theophilus from the dead (fig. 37.6), an obvious corollary to Zenobius's miracle, and the chairing of Peter as bishop of Antioch (fig. 37.7), are clear references to the pageantry of the bishop's entry.

The main scene of the Coronation of the Virgin alludes to the point at which the bishop actually takes possession of the cathedral, where the same scene is depicted in a mosaic (c. 1296), in the interior lunette over the central portal, through which the bishop passed in procession.[19] The cathedral itself was formerly dedicated to Saint Reparata, who is

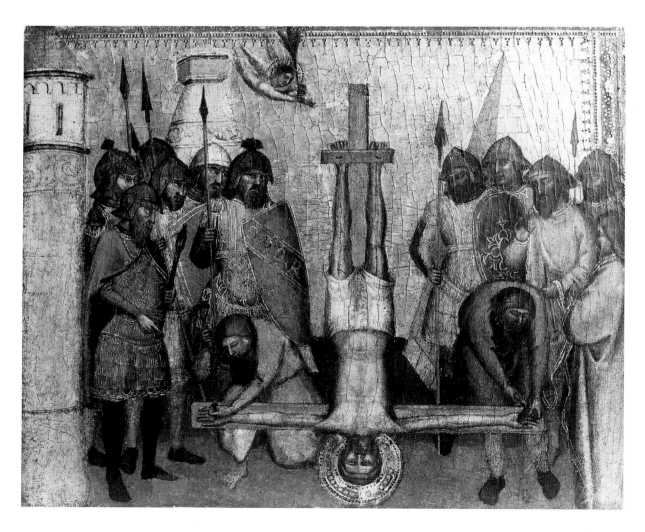

FIG. 37.8 (*above*) Jacopo di Cione. *Last Meeting of Saints Peter and Paul in Rome*, 1371. Tempera and tooled gold on panel; 9⅞ × 13⅞″ (25 × 35 cm). Present location unknown. See Companion Panel D

FIG. 37.9 (*left*) Jacopo di Cione. *Crucifixion of Saint Peter*, 1371. Tempera and tooled gold on panel; 13¾ × 4⅞″ (34.7 × 12.2 cm). Vatican City, Pinacoteca Vaticana, no. 21.04. See Companion Panel E

also present among the saints in the main section of the altarpiece.

Included in the central sections are also Benedict, who refers to the monastic order of Benedictine nuns that had occupied the site of San Pier Maggiore since the eleventh century. Benedict's sister, Scolastica, the founder of the female order, is also present. The depiction of Giovanni Gualberto, the Florentine founder of the Vallombrosan order and a church reformer, may have more specific connotations. One tradition states that he excluded the clerics of San Pier Maggiore from the simony charges that he leveled against the Florentine church; another has it that Gilsa Firidolfi (Ricasoli), who endowed the convent in 1066, was also the founder of the first female community of Giovanni Gualberto's Vallombrosans.[20]

The absence in the predella of common episodes from Peter's life, such as his calling or his denial of Christ, proves how closely the altarpiece was planned in connection with San Pier Maggiore and the church calendar. Western Christendom celebrated three feasts in Peter's honor—his liberation from prison (*Vinculis petri*, August 1), his chairing (February 22), and his martyrdom (June 29)—each of which occupied a special place in the calendar of San Pier Maggiore. By contrast, his calling was commemorated during the feast of his brother, Saint Andrew. Scenes from Saint Paul's life are included in the predella below each pilaster because he and Peter were connected not only historically but also liturgically in the church calendar. On June 29 their joint feast was celebrated as well as that of Peter's martyrdom. The next day was reserved for Paul alone, to honor his conversion, and that is probably the missing scene that would have been under the left pilaster. The scene of the last meeting of Peter and Paul before their respective martyrdoms commemorates their shared feast. Narrative reasons probably dictated the inclusion of the arrest of Saint Peter, because it precedes his liberation and gives it added drama. The importance of these scenes to San Pier Maggiore is further shown by the fact that illuminations of them appear in an early fourteenth-century missal from its convent by the Master of the Dominican Effigies.[21] Furthermore, in one of a series of choir books from San Pier Maggiore illuminated in the 1370s, contemporaneous with the altarpiece, there are scenes of his chairing and of his liberation from prison.[22]

As Jacopo da Varazze explained in the *Golden Legend* (c. 1267–77, Levasti ed., vol. 1, p. 355), the liberation of Peter is associated with the church's victory over the malignant; the chairing, with the church militant; and the martyrdom, with the church triumphant. Jacopo da Varazze allegorizes the liberation as follows: "secondly he [Peter] is exalted in the church of the malignant in that he destroyed it and converted it to the faith; and this appertains to the second feast that is called *ad vincula,* because he then destroyed the church of the malignants and converted many to the faith."

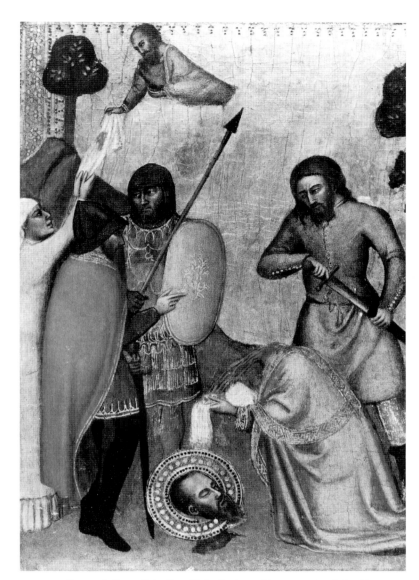

FIG. 37.10 Jacopo di Cione. *Beheading of Saint Paul*, 1371. Tempera and tooled gold on panel; 13⅝ × 9½″ (34.5 × 24 cm). Present location unknown. See Companion Panel F

Jacopo di Cione's painting became a model for Petrine iconography in Florence. About 1430–35 Giovanni dal Ponte (q.v.) adapted compositions of the predella in an altarpiece for the San Pier Scheraggio in Florence.[23]

1. Illustrated after Rosen's treatment, Sweeny 1966, p. 97.
2. Bietti Favi 1977–8, p. 480. Davies (1961, p. 396 n. 23) suggested that it was not removed from the choir when a tabernacle by Desiderio da Settignano was installed in the mid-fifteenth century (possibly the one now in Washington, D.C., National Gallery of Art, Kress N.A. 1624; Cardellini 1962, fig. 312).
3. In the National Gallery report on the acquisition of the altarpiece, it was described as being in a new frame, in which the pinnacle panels did not fit—implying that Lombardi and Baldi had disassembled and reframed the altarpiece (cited in Offner and Steinweg 1965, p. 44).
4. Weber 1898, plate 53; Woermann 1907, p. 4, no. 2 (as in the manner of Andrea Orcagna).
5. Wollesen 1977, plate 15. On this and the earlier tradition, see Wollesen 1977, pp. 40–43.
6. Formerly known as the Master of Saint Peter; from Siena, church of San Pietro in Banchi; now Siena, Pinacoteca Nazionale, no. 15; Bagnoli et al. 2003, color repro. p. 82.
7. Now Florence, church of San Simone; Offner 1931, plate VI.
8. Florence, Galleria dell'Accademia, no. 3449; Tartuferi 2000, postrestoration color repros.
9. See, for example, the altarpiece by Niccolò di Pietro Gerini and Pietro Nelli for Santa Maria in Impruneta (Bomford et al. 1989, fig. 121).
10. Published by Giovanni Poggi in Sirén 1908, pp. 100–101; Offner and Steinweg 1965, pp. 41–42; and Bomford et al. 1989, pp. 197–200 (with an English translation).

11. On the identification, see Bellosi 1973, pp. 179–200.

12. Florence, Galleria dell'Accademia, no. 456; Bomford et al. 1989, color plate 170.

13. For summary of the discussion, see Boskovits 1975, p. 209 n. 33; Borsook 1982, pp. 86–89; and Bomford et al. 1989, pp. 185, 195.

14. I am grateful to Monica Bietti Favi for sharing this information from her unpublished doctoral dissertation; see Bietti Favi 1977–78, pp. 242–43. See also Bomford et al. 1989, p. 156.

15. "Aiuto alla tavola dell'altare maggiore."

16. Levi D'Ancona 1979, pp. 463, 487. On the Albizzi genealogy, see Litta 1819–85, Albizzi, 27 genealogical tables; Levi D'Ancona 1979, genealogical table, p. 486.

17. J. Chiffoleau in *DBI*, vol. 29, 1983, pp. 671–73.

18. Richa, vol. 1, pt. 1, 1754, pp. 128–32.

19. Attributed to Gaddo Gaddi, sometimes identified as the Master of Santa Cecilia; Acidini Luchinat 1995, color repro. p. 217, fig. 16.

20. On the absolution from simony, see Richa, vol. 1, pt. 1, 1754, p. 127; on Gilsa Firidolfi (Ricasoli), see Passerini 1861, pp. 19–21.

21. Florence, Museo Diocesano di Santo Stefano al Ponte, folios 222 verso, 236 verso, 237 verso, 245 recto; Anna Elisa Benedetti in Florence 1982, pp. 141–60; the liberation from prison (folio 245 recto) is reproduced on p. 159.

22. Baltimore, The Walters Art Museum, Ms. 10.153. Mirella Levi D'Ancona (1979, esp. pp. 480–87) attributes the liberation scene (folio 35 verso) to Tommaso del Mazza (q.v.). It shows the angel leading Peter out of the prison, and not the first episode of the story. She dates the manuscript on spurious iconographic reasons, however, suggesting that the chairing refers to the schism of the church that began in 1378 and that the liberation of Peter refers to the end of the Avignon papacy in 1377. In fact, these subjects are perfectly in accord with the iconographic traditions of Petrine feasts and of San Pier Maggiore. Her other suggestion—that another scene of Peter with the communion chalice and wafer (folio 16 verso; Levi D'Ancona 1979, fig. 13) might allude to the end of the papal interdict against Florence—is more convincing. On this manuscript, see also the text and black-and-white and color illustrations in Kanter et al. 1994, pp. 178–83. The relevant illumination appears in color on p. 179, where it is correctly attributed to Cenni di Francesco (q.v.).

23. Florence, Uffizi, no. 1620; Berti and Paolucci 1990, color repros. pp. 176–77.

Bibliography
Giorgio Vasari (1568) in Bettarini and Barocchi eds., vol. 2 (text), 1967, p. 218 (Orcagna); Weber 1898, plate 53; G. Poggi in Sirén 1908, pp. 99–102; Berenson 1913, p. 5, repro. p. 226 (Giovanni da Milano); Van Marle, vol. 4, 1924, p. 238 n. 2; Berenson 1932, p. 275; Offner 1933, p. 84 n. 59; Berenson 1936, p. 236; Johnson 1941, p. 9; Gronau 1945; Offner 1947a, pp. 43–61, fig. 3; Davies 1951, pp. 302–7; Kaftal 1952, cols. 801, 809, 812, fig. 915; Paatz, vol. 4, 1952, pp. 639, 653–54 nn. 54–55; Steinweg 1957–59; Davies 1961, pp. 389–96; Berenson 1963, p. 105; Offner and Steinweg 1965, pp. 54–55, plate III; Sweeny 1966, pp. 40–41, repro. p. 97; Boskovits 1975, p. 322; Fremantle 1975, p. 170, fig. 337; Bietti Favi 1977–78, pp. 214–43, 465–83, 759–65; Volbach 1987, pp. 21–22; Davies and Gordon 1988, p. 51; Bomford et al. 1989, p. 156, fig. 112; Philadelphia 1994, repro. p. 210; Andrea G. De Marchi in *Enciclopedia dell'arte medievale*, vol. 7, 1996, p. 244; Gert Kreytenberg in *Dictionary of Art* 1996, vol. 7, p. 338; Frinta 1998, p. 48

COMPANION PANELS for PLATE 37

Only the predella panels of the altarpiece will be considered here. For the other sections, see Davies 1961, pp. 389–96; Offner and Steinweg 1965, pp. 31–74; Davies and Gordon 1988, pp. 45–54; and Bomford et al. 1989, pp. 156–89. It is not certain exactly when the altarpiece was disassembled, but it occurred sometime before 1857, when the National Gallery in London purchased its principal sections from the Florentine dealers Francesco Lombardi and Ugo Baldi. The first specific mention of a predella panel, the Vatican's *Crucifixion of Saint Peter* (fig. 37.9), dates to 1857.

A. Predella panel: *Arrest of Saint Peter.* See fig. 37.5

1371

Tempera and tooled gold on panel; 14⅝ × 20¾″ (37.2 × 52.7 cm). Providence, Rhode Island School of Design, Museum of Art, Gift of Manton B. Metcalf, no. 22.047

PROVENANCE: Essex, Stanstead Hall, W. Fuller Maitland Collection; New York, Vladimir Simkhovitch Collection; sold, New York, Anderson Galleries, January 14, 1922, lot 487 (attributed to Taddeo Gaddi); given to the Rhode Island School of Design, Museum of Art, by Manton B. Metcalf, 1922

EXHIBITED: Providence 1923–24, cat. 5

SELECT BIBLIOGRAPHY: Providence 1923, no. 103; Offner 1933, p. 84 n. 59; Gronau 1945, p. 143; Offner 1947a, pp. 43–61; Kaftal 1952, cols. 801, 809, 812; Steinweg 1957–59, pp. 232, 236 n. 9, 238; Offner and Steinweg 1965, pp. 50–51 (with complete bibliography); Boskovits 1975, p. 329; Fremantle 1975, p. 170

B. Predella panel: *Saint Peter Raising the Son of Theophilus.* See fig. 37.6

1371

Tempera and tooled gold on panel; 15½ × 21⅛″ (39.4 × 53.5 cm). Vatican City, Pinacoteca Vaticana, no. 113

PROVENANCE: See Companion Panel C

SELECT BIBLIOGRAPHY: See Companion Panel C

C. Predella panel: *Chairing of Saint Peter at Antioch.* See fig. 37.7

1371

Tempera and tooled gold on panel; 15½ × 21⅛″ (39.4 × 53.5 cm). Vatican City, Pinacoteca Vaticana, no. 107

PROVENANCE: Recorded in the Museo Cristiano of the Biblioteca Apostolica, Vatican City, from 1864 to c. 1908, when it was transferred to the Pinacoteca Vaticana

SELECT BIBLIOGRAPHY: Grimouard de Saint-Laurent 1864, p. 100, engraved plate opposite p. 93; Barbier de Montault 1867, p. 148; D'Archiardi 1929, p. 29; Gronau 1945, p. 143; Offner 1947a, pp. 43–61; Kaftal 1952, cols. 801, 809, 811–12; Steinweg 1957–59; pp. 232, 236, 238, 242; Offner and Steinweg 1965, pp. 58–59; Boskovits 1975, p. 329; Volbach 1987, pp. 21–22

D. Predella panel: *Last Meeting of Saints Peter and Paul in Rome.* See fig. 37.8

1371

Tempera and tooled gold on panel; 9⅞ × 13⅞″ (25 × 35 cm) (cut on all sides but the top; a strip at the bottom is new). Present location unknown

PROVENANCE: Radensleben, von der Quast Collection, 1865; Lugano, Heinrich Thyssen-Bornemisza Collection, 1957; sold, London, Sotheby's, November 27, 1963, lot 103 (as Jacopo di Cione); sold, London, Leonard Koetser Gallery, 1964

EXHIBITED: London, Leonard Koester Gallery, *Twelfth Annual Spring Exhibition of Flemish, Dutch, and Italian Old Masters,* 1964, no. 22

SELECT BIBLIOGRAPHY: Fontane 1865, p. 519 n. 19; Offner 1947a, pp. 43–61; Kaftal 1952, cols. 801, 812, 815; Heinemann 1958, p. 79, no. 311a; Steinweg 1957–59, pp. 232, 236–37; Offner and Steinweg 1965, pp. 62–63; Boskovits 1975, p. 326

E. Predella panel: *Crucifixion of Saint Peter.* See fig. 37.9

1371

Tempera and tooled gold on panel; 13¾ × 4⅞″ (34.7 × 12.2 cm). Vatican City, Pinacoteca Vaticana, no. 21.04

PROVENANCE: Rome, Curray Collection; sold, Rome, February 3, 1859, lot 178 (as Simone Martini); Cogiatti; Étienne Pascalis and descendants, c. 1859–1958; to Édouard Bernard, 1958, who presented it to the Vatican

SELECT BIBLIOGRAPHY: Steinweg 1957–59; Kaftal 1952, cols. 801, 812; Offner and Steinweg 1965, pp. 65–67; Boskovits 1975, p. 329; Volbach 1987, pp. 21–22

F. Predella panel: *Beheading of Saint Paul.* See fig. 37.10

1371

Tempera and tooled gold on panel; 13⅝ × 9½″ (34.5 × 24 cm). Present location unknown

PROVENANCE: Milan, Galleria Edmondo Sacerdoti, 1961

EXHIBITED: Florence, Palazzo Strozzi, *Mostra Mercato Internazionale dell'Antiquariato,* September 16–October 16, 1961

SELECT BIBLIOGRAPHY: Kaftal 1952, col. 788; Steinweg 1961, p. 127 n. 23; Offner and Steinweg 1965, p. 70; Boskovits 1975, p. 327

PLATE 38 (JC CAT. 6)

Mystic Marriage of Saint Catherine of Alexandria, Saint Louis of Toulouse, and a Female Monastic Donor

c. 1375–80

Tempera and tooled gold on panel with vertical grain; 31⅞ × 24¾ × ⅜″ (81 × 62.6 × 0.8 cm)

John G. Johnson Collection, cat. 6

INSCRIBED ON THE REVERSE: *CITY OF PHILADELPHIA/ JOHNSON COLLECTION* (stamped in black on the cradle)

PUNCH MARKS: See Appendix II

EXHIBITED: Philadelphia 1920, no. 6 (as Agnolo Gaddi)

TECHNICAL NOTES

The panel is cut on all four sides, thinned, cradled, and waxed on the back. Because the joints are not visible, it is not possible to tell how many members make up the support.

The picture's surface is generally in very good condition and its grayed surface is only lightly abraded. There is a large loss in the Virgin's halo and at the top of her head. There is also loss along the bottom and in the costume of the donor figure on the right. The surface is disrupted in a horizontal line across the Virgin's chest, but there is no loss of paint in this area. Much of the mordant gilding in the patterned borders of the costumes and on Saint Catherine's book has flaked away, leaving visible impressions on the surface. This is also true of the donor's rosary beads, which have been retouched in gray. Spots of now-darkened blue, white, and red pigment were used to imitate jewels in Saint Catherine's crown. Her pale green undergarment modeled with blue is decorated in sgraffito.

On March 4, 1924, T. H. Stevenson laid down flaking. In 1937 David Rosen treated the panel again by setting down loose paint along the cracks. He also impregnated the panel with wax. Although Rosen erroneously believed that there were considerable repaints present, he did not clean the panel. In 1956 Theodor Siegl reattached flaking paint.

PROVENANCE

Nothing is known of the picture's early history or purchase. Johnson owned it in 1905, as F. Mason Perkins's article of that year attests.

COMMENTS

Christ, depicted as a bearded young man, places a ring on the finger of the kneeling Saint Catherine of Alexandria. The Virgin holds the right arms of the two celebrants. To the left Saint Louis of Toulouse is depicted on a smaller scale than the other holy figures. On the right, on an even smaller scale, is the painting's kneeling donor. She holds prayer beads and wears the habit of the Poor Clares, the female branch of the

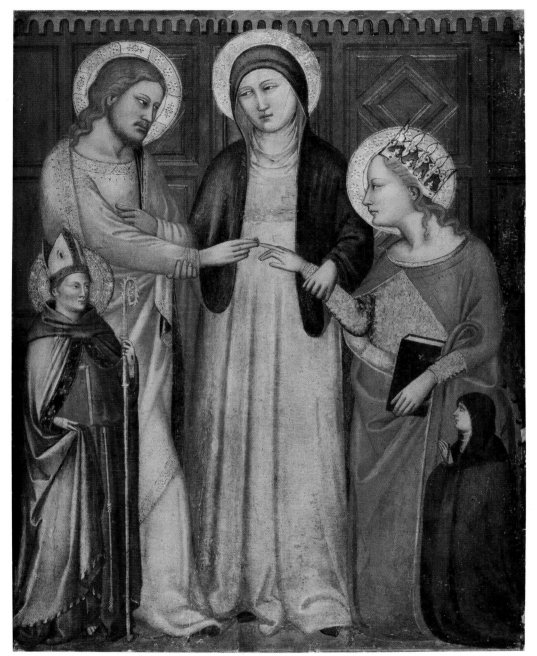

PLATE 38

Franciscan order founded by Saint Clare of Assisi. The background is a wood-paneled wall.

Saint Catherine's crown and book are the symbols of her royal origins and knowledge. According to the mid-thirteenth-century *Golden Legend,* she told her persecutor, the Roman emperor Maxentius, that she was "born to the purple and not ill instructed in the liberal learning."[1] A spiked wheel appears behind her; for refusing to sacrifice to

pagan idols she was sentenced to be tortured on the wheel, which instead miraculously broke into pieces, decimating her tormentors.

Saint Louis of Toulouse wears a bishop's miter and green mantle over a brownish gray Franciscan habit and carries a pastoral staff and a book. Louis was the son of King Charles II of Naples, from whose insignia the fleur-de-lis pattern on the orphrey of the mantle derives. After joining the

so-called spiritual, or radical, Franciscans, Louis abdicated his right to the Neapolitan throne. His father, however, arranged to have him made bishop of Toulouse, but, despite the new position, Louis continued to wear the Franciscan habit under the bishop's garb.

The main subject of the panel is the mystic marriage of Saint Catherine of Alexandria, a legend invented in the fourteenth century.[2] The earliest known depiction of about 1325—a scene in a painting containing a full cycle of Catherine's life by a follower of the Master of Santa Cecilia—predates the first surviving literary account of about 1337.[3] In most paintings of the subject, as in this text, Christ is represented as an infant carried by the Virgin. The Johnson picture belongs to a small group showing Christ as an adult, an iconographic peculiarity that seems to have originated in Franciscan circles. The first known example is a relief of about 1345 in the Franciscan friary of Santa Chiara in Naples, by Giovanni and Pacio da Firenze.[4] It is not clear if there was a literary precedent for this version. The Franciscan friar Pietro's *Nova legenda,* a life of Saint Catherine, dating about 1400, describes Christ as "a very handsome youth about twenty-five years old."[5] A work of art may have colored his perception of the scene. The episode was also enacted in mid-fourteenth-century sacred plays, in which young men may have taken the part of Christ.[6]

The presence of Louis of Toulouse and a Franciscan donor in this painting confirms the interest that the subject held for the Franciscans, whose basilica in Assisi contains a chapel dedicated to the saint. Although the mural of 1368 of the subject by Andrea de' Bartoli follows the older formula, another wall painting of about 1316–18 in the basilica attributed to the so-called Master of the Vele, showing the mystic marriage of Saint Francis with Lady Poverty, both as adults,[7] may well have given rise to the iconographic variant as seen in the Johnson panel.

Here the Virgin plays the role of a priest officiating at a wedding. Her hands clasp the right arms of the celebrants in order to bring Christ's hand forward to place the ring on Catherine's finger. This replicates the pose of the rabbi in the *Marriage of*

the Virgin of about 1370 by Matteo di Pacino in the Rinuccini chapel of Santa Croce in Florence.[8] Usually, however, the officiator holds the woman's hand with his right hand and the man's arm with his left, as in Taddeo Gaddi's mural of the *Marriage of the Virgin* in the Baroncelli chapel of the 1330s in Santa Croce,[9] and Giovanni del Biondo's *Mystic Marriage of Saint Catherine of Alexandria with Donor,* now in Allentown, Pennsylvania.[10]

Most early critics attributed the Johnson painting to Agnolo Gaddi, but both Bernhard Berenson (1913) and Richard Offner (lecture at the John G. Johnson Collection in 1928) recognized its Cionesque qualities. Offner later (in Offner/Maginnis 1981) included it in a group by an anonymous artist designated the Master of the Prato Annunciation, after an altarpiece in Santo Spirito in Prato.[11] Three of the works in this group are dated: an altarpiece of 1383,[12] a Virgin and Child of 1386,[13] and another altarpiece of 1391.[14] The Johnson painting is closest in date to the first two. Noting both their close similarities to Jacopo di Cione's work of the 1370s as well as the gap in his known production in the 1380s and 1390s, Miklós Boskovits (1975) proposed that the so-called Master of the Prato Annunciation is really Jacopo di Cione in his late career, a suggestion that seems to be correct.

Boskovits dated the Philadelphia panel 1375–80, a period when the artist had come under the influence of Giovanni del Biondo. The broad modeling of the figures, the slanted eyes, the figures that occupy the whole picture plane, and the restricted space can all be seen in Giovanni del Biondo's earlier *Mystic Marriage of Saint Catherine* in Allentown.

Giovanni del Biondo's painting is likewise one of the few other examples of the subject with an adult Christ. Since this artist, Jacopo di Cione, and Puccio di Simone, also executed the scene with the infant Christ, patrons must have individually requested how they wanted Christ to appear.[15] The medium size of the Johnson painting suggests that it was for a private altar, possibly in the cell of the donor. Its original location is not known, but given the donor's Clarissan habit, it may have come from one of the order's convents in Florence, such as Santa Maria in Monticelli, which was suppressed in 1808.[16]

1. Jacopo da Varazze c. 1267–77, Ryan and Ripperger ed. 1941, p. 710.
2. Knust 1890; Varnhagen 1891, pp. 18ff.; Offner 1947, p. 228 n. 1; Meiss 1951, pp. 107–13.
3. From Arezzo, church of Santi Lorentino e Pergentino; now Los Angeles, J. Paul Getty Museum, no. 73.PA.69; Offner 1931, plate XVIII.
4. A. Venturi, vol. 4, 1906, fig. 206.4.
5. "Juvenis pulcherrimus quasi viginti quinque annorum" (Knust 1890, p. 53).
6. Bronzini 1952.
7. Previtali 1993, color plate XCVII (as "Parente di Giotto").
8. Baldini and Nardini 1983, color illus. p. 181.
9. Ladis 1982, plate 4a-11.
10. C. 1370–75; Allentown Art Museum, Kress 1150; Offner and Steinweg 1969, plate II.
11. Boskovits 1975, plate 89b.
12. Florence, church of Santi Apostoli, on deposit from the Gallerie Fiorentine, no. 8607; Marcucci 1965, fig. 83.
13. Florence, Conte Mirari-Pelli-Fabbroni Collection; Boskovits 1975, fig. 120 (detail).
14. Honolulu Academy of Arts, no. HAA 2834; Boskovits 1975, plate 92b.
15. For a Jacopo di Cione painting with an infant Christ, see Avignon, Musée du Petit Palais, no. 103 (Laclotte and Mognetti 1977, fig. 103); and for one by Giovanni di Biondo, see the panel formerly in Milan, Longari Collection (Offner and Steinweg 1969, plate XL). For a Puccio di Simone painting with the adult Christ, see the triptych in Corsham Court, Wiltshire, England, Methuen Collection (Offner 1947, plate XLVII); and for one with the infant Christ, see the work formerly in Berlin, Bottenwieser Collection (Offner 1947, plate LIII).
16. Paatz, vol. 4, 1952, pp. 334–43; Fantozzi Micali and Roselli 1980, p. 197.

Bibliography
Perkins 1905, pp. 113–14 (an artist close to Taddeo Gaddi); Sirén 1908, p. 93, plate 27 (Agnolo Gaddi); Sirén 1908a, p. 194, plate IV (Agnolo Gaddi); Rankin 1909, p. lxxxi (Agnolo Gaddi); Berenson 1913, p. 6 (Agnolo Gaddi); Brown and Rankin 1914, p. 363; Philadelphia 1920, p. 2; Osvald Sirén in Thieme-Becker, vol. 13, 1920, p. 28; Van Marle, vol. 3, 1924, pp. 553–52; Richard Offner, verbal communication, 1928; L. Venturi 1931, plate L; Berenson 1932, p. 275; Salvini 1934, p. 32 n. 1; Berenson 1936, p. 236; Salvini 1936, pp. 13, 28–29 n. 9; Johnson 1941, p. 9; Antal 1948, p. 229 n. 175; Offner 1947, pp. 207, 228 n. 1; Meiss 1951 p. 110 n. 24; Berenson 1963, p. 105; Sweeny 1966, p. 41, repro. p. 98; Fredericksen and Zeri 1972, p. 102 (school of Jacopo di Cione); Boskovits 1975, pp. 227 n. 69, 322; Frinta 1998, pp. 136, 431; Offner 1981, p. 51; Philadelphia 1994, repro. p. 210

PIETRO LORENZETTI

SIENA, FIRST DOCUMENTED 1306;
LAST DOCUMENTED 1345, CASTIGLIONE
DEL BOSCO (SIENA)

Pietro Lorenzetti, one of the greatest painters of the trecento, and his equally accomplished brother Ambrogio (first documented 1319; died 1348) were the sons of one Lorenzo (or Lorenzetto). The two artists' exact dates and places of birth are not known. However, they were probably Sienese natives, as they sometimes signed paintings *de Senis* (from Siena).[1]

On February 25, 1306 (modern style), a Petruccio di Lorenzo was paid a small sum for painting part of the altarpiece of the Nine (the elected oligarchy in Siena) in the Palazzo Pubblico of Siena. This is probably Pietro Lorenzetti. The diminutive "Petruccio," for "Pietro," may have been used to indicate his youth. However, in Siena a person had to be at least the legal age of twenty-five to receive payment directly, which means that the artist must have been born no later than 1281. The document seems to refer to the same painting for which a payment to Duccio (q.v.) is recorded in December 1302, suggesting that Pietro Lorenzetti was compensated for assisting the older master on the project. James Stubblebine (1979, p. 4) proposed that Pietro may have painted some of the scenes on the back predella of Duccio's great *Maestà* (see figs. 23.8, 23.9), which he is documented as having trouble finishing in 1310.[2] While this does not seem to be true, Lorenzetti's debt to Duccio is clearly visible in the *Virgin and Child* from the *pieve* of Santa Maria in Cortona.[3] The dependence of the Cortona painting on Duccio's *Maestà* may suggest that it too, like the painting in Siena, was a public commission. A possible date for the work would be after early September 1312, when the Holy Roman Emperor Henry VII granted Cortona independent status from nearby Arezzo, an event that may have been cause for commissioning an altarpiece for the town's principal church.[4] But Lorenzetti would soon lose his Duccesque imprint. For instance, in his altarpiece in the Seattle Art Museum[5] the influence of Duccio is evident only in the minor figures painted in the pinnacle panels, not in the main panels.

There are no documented paintings by Lorenzetti until 1320. The only picture that might have a claim as a fixed point in the early chronology—the altarpiece of the Blessed Umiltà in the Uffizi (see fig. 39.9), originally in the Florentine church of San Giovanni Evangelista in Faenza[6]—has been the object of much debate. Old sources record an inscribed date of 1316, but because the numbers were difficult to read and only a copy of an earlier inscription, an alternative reading of 1341 has gained

general acceptance in recent years.[7] However, the form of the altarpiece—a standing saint flanked by scenes—could suggest an earlier dating. It recalls Simone Martini's altarpiece for the tomb of the Blessed Agostino Novello (died 1309) in the Sienese church of Sant'Agostino, which was most likely installed by 1324, if not earlier.[8] Likewise, Lorenzetti's altarpiece was probably made for the Blessed Umiltà's tomb in Florence not long after her death in 1310.[9]

If the 1316 date for the Blessed Umiltà altarpiece is accepted, it becomes a good *terminus post quem* date for Pietro Lorenzetti's undocumented activity in the Lower Church of San Francesco in Assisi, where he painted the south transept with scenes of the Passion of Christ.[10] One of the notable features of his Assisi murals is the innovative representation of architecture. In contrast to the discrete and box-like Duccesque architecture in the Blessed Umiltà altarpiece, with the figures carefully fitted into the composition, the Passion cycle shows grandiose theatrical spaces where the actors can seemingly move at free will.[11] The experience in Assisi brought Lorenzetti in direct contact with the work of Giotto and his shop, who had painted the north transept of the Lower Church before Lorenzetti worked on the south transept.[12] Arguably his contact with Giotto helped give greater monumentality to Lorenzetti's figures, although Lorenzetti also explored areas in which the Florentine had little interest: landscape, architecture, genre, and effects of nocturnal and interior light. In works such as the *Deposition*,[13] Pietro also proved himself to be able to express extreme emotions through facial expression and gesture.

The patron of the Assisi wall paintings is not known, although donor portraits and coats of arms are visible below the main scene of the Crucifixion.[14] The date of the murals is a more complex problem. They may well have been finished before September 9, 1319, when the Ghibellines forcibly took Assisi with the support of Bishop Guido Tarlati, the bishop-ruler of Arezzo. The Ghibelline rule lasted until 1322. There is, however, no reason to suppose, as some authors have suggested, that work in the basilica was suspended during this period. It is known, for example, that in 1320 Tarlati's agents commissioned from Pietro Lorenzetti an altarpiece for Santa Maria della Pieve in Arezzo (see fig. 39.5), and it would only be logical to suppose that this commission was based on the bishop's familiarity with the artist's work in Assisi. Another guide to dating is Lorenzetti's crucifix from the church of San Marco in Cortona,[15] which is close to the one in the Crucifixion scene in Assisi. An indication of the date of the Cortona crucifix is provided by Segna di

Bonaventura's very similar example in the church of Sante Flora e Lucilla in Arezzo,[16] which is indirectly documented by a notarial source recording the artist there in the summer of 1319.

Lorenzetti's other work in Assisi is a mural of the Virgin and Child with Saints John the Baptist and Francis in the chapel of the Lower Church originally built by Cardinal Napoleone Orsini about 1300.[17] Here Lorenzetti has created a particularly sophisticated architectural setting that unifies the composition. The elegant pose and costumes of the Virgin and Child recall some of Simone Martini's nearly contemporary work in Assisi, where he was probably active around 1316 if not earlier, as well as the parts of the *Maestà* in the Palazzo Pubblico in Siena that were repainted by Martini in 1321.[18] Lorenzetti's Orsini mural is usually considered earlier than his Passion cycle, but there is not any technical evidence for this. However, it probably dates sometime before March 10, 1320, when Assisi's Ghibellines stole the papal treasury on deposit in the convent of San Francesco, along with some of Cardinal Orsini's personal effects. Outraged by this theft, the cardinal decided not to make the chapel his burial place,[19] which may well be the reason that Lorenzetti painted only one scene there and that the rest of its walls were never decorated. The stained-glass window in the chapel may date to 1318 or soon after, when glassmakers from Murano were given permission by the Venetian government to work in Assisi.[20] Presumably the wall painting had to be executed after the window was installed.

The altarpiece for Santa Maria della Pieve in Arezzo was commissioned by two representatives of Bishop Tarlati on April 17, 1320, a month after a local woman made a large bequest for an altarpiece.[21] The contract says that Lorenzetti "had been from Siena" (fuit de Senis), possibly, but not necessarily, indicating that he had been away from Siena for a period of time. The document stipulates that Bishop Tarlati would determine which saints would be represented, but, despite his personal involvement, Aretine citizens made donations toward its costs. Contributions continued to be received as late as January 3, 1324, suggesting that the altarpiece had not been completed by that date. Vasari wrote that Lorenzetti also painted the now-lost murals in the apse of the *pieve*. The artist is recorded as working in Arezzo with two otherwise unknown Sienese painters—"Mino pictore Vollie" and "Mino pictore Pacis de Senis"—who may have assisted him on these projects.

The saints in the Arezzo altarpiece closely resemble the saints in Lorenzetti's small disassembled polyptych for the church of Santi Leonardo e Cristoforo in Monticchiello near Pienza.[22] From

this same period come the earliest small-scale paintings by the artist: the *Crucifixion with Saints Francis and Clare,* in the Fogg Art Museum,[23] and the *Crucifixion with Saints Catherine of Alexandria and Lucy,* in a private collection.[24]

After working in Assisi and Arezzo, Lorenzetti is next recorded in Siena, where in 1326 he was paid for murals in the official residence of the superintendent of the cathedral. Around this same time he may have also executed the wall paintings in the chapter house of the Sienese convent of San Francesco, although earlier dates have also been proposed.[25]

The artist's first major documented work in Siena to survive is an altarpiece (see fig. 39.6) for the church of San Niccolò al Carmine. It is signed with a date that can be read as either 1327 or 1328.[26] In 1329 the Sienese government provided the friars there with funds to cover their debt to Lorenzetti so that the altarpiece could be installed. Another, unfortunately lost, painting by the artist for the church of the Umiliati in Siena was recorded in a sixteenth-century source as signed and dated in 1329. In 1332 Pietro dated a polyptych, of which three panels with saints survive, for the parish church of Santa Cecilia in Crevole, an important center in the Sienese bishopric's independent fiefdom.[27] In 1335, with his younger brother, Ambrogio, and Simone Martini, Pietro executed now-lost murals of the life of the Virgin on the façade of the hospital of Santa Maria della Scala in Siena. These paintings would prove to be very influential in later Sienese art.[28]

In the same year that he painted the Santa Maria della Scala murals Pietro was contracted to produce an altarpiece for the chapel of Saint Savino in the cathedral of Siena. The famous *Nativity of the Virgin,*[29] now in the Museo dell'Opera della Metropolitana, and a section of the predella[30] are all that survive of it. A grammar teacher named Ciecho was paid a gold florin to translate the legend of Saint Savino from Latin to Italian to guide the painter in composing the scenes of the predella. Although the document that records this fact has been interpreted as indicating that Pietro knew little or no Latin, it actually offers the more surprising revelation that the life of Savino, one of the patron saints of Siena, was apparently not very well known and thus had to be explained to the artist. The altarpiece took a long time to complete, as Pietro signed the main panel only at the time of its installation in 1342. The delay may have been due to his work on other projects: a lost painting by Pietro dated 1337 was recorded in the chapel of Saint Sebastian in San Martino in Siena, and in 1340 he signed the *Virgin and Child with Eight Angels* from the church of San Francesco in Pistoia.[31] His last dated work, of November 18, 1345, is the mural in the chapel of San Michele in Castiglione del Bosco, near Montalcino.[32] As nothing else is known of Pietro, he probably died shortly thereafter—possibly, like his brother, Ambrogio, in the plague of 1348.

While the decades of Pietro's maturity are better documented than those of his youth, the precise nature of his relationship with his brother has not been properly explored. In his *Commentarii,* written around 1447, the Florentine sculptor Lorenzo Ghiberti portrayed Ambrogio as a hero of Sienese art and said nothing about Pietro. This influenced the way subsequent writers saw the brothers; in fact, until the nineteenth century there was little interest in Pietro Lorenzetti. The two artists did collaborate on at least one project, the façade for Santa Maria della Scala. Given their family relationship, it is likely that they maintained a common workshop.[33] However, in contrast to one's perception of how late medieval artists' workshops functioned, stylistically the Lorenzetti brothers show a fierce independence from one another, and on major commissions they always worked separately. However, there are many small luxury paintings dating to the late 1330s and the 1340s that are certainly products of their family enterprise.

1. An origin in the Sienese countryside cannot be excluded. Later in life Pietro owned property near the town of Montalcino, south of Siena, and many of his commissions outside the city came from localities in that area.
2. Stubblebine suggested that he worked on the *Temptation on the Temple* and the *Wedding in Cana,* in the Museo dell'Opera della Metropolitana in Siena; the *Temptation on the Mountain,* in the Frick Collection in New York; *Christ and the Woman of Samaria,* in the Fundación Colección Thyssen-Bornemisza in Madrid; and the *Healing of the Man Born Blind,* in the National Gallery in London (Stubblebine 1979, figs. 91–92, 94–96, respectively).
3. Cortona, Museo Diocesano; Volpe 1989, plates 83, 83a (black-and-white and color). In 1502 the *pieve* of Santa Maria became the cathedral.
4. Lorenzetti's other painting in Cortona (Museo Diocesano; Volpe 1989, plate 96) is the crucifix originally in the church of San Marco, a parish church that had also been a "civic" temple ever since 1261, when the patronage of the city was changed from Saint Eusebius to Saint Mark the Evangelist in honor of the white Ghibellines' reentry and the exile of the Aretines. The church was connected with the Casali, who would become the *signori,* or lords, of Cortona.
5. Kress 277; Volpe 1989, fig. 95.
6. Volpe 1989, figs. 141–62 (black-and-white and color); and pp. 175–76 (reconstructions). The church was destroyed in the early 1500s. It was located where the Fortezza da Basso is now.
7. On this scholarly controversy, see Volpe 1989, pp. 174–84.
8. On deposit in Siena, Pinacoteca Nazionale; Siena 1985, color repros. pp. 57, 59, 64–67 (postrestoration). On the date, see Alessandro Bagnoli in Siena 1985, p. 60.
 Like Simone Martini's painting and Lorenzetti's Florentine altarpiece, Pietro Lorenzetti's *Saint Leonardo and a Freed Prisoner,* now in Riggisberg, Switzerland (Abegg-Stiftung; Volpe 1989, fig. 91 [color]), probably also had side panels with scenes depicting the life of Saint Leonardo. Close in date to the Blessed Umiltà altarpiece, this altarpiece was probably made for the Augustinian hermitage of San Leonardo al Lago near Siena.
9. In 1311, a year after her death, she was exhumed and

placed in a new tomb. In 1317 her cult received special indulgences from twenty-one bishops at the papal court in Avignon. See Giuseppe Cantagalli in *Bibliotheca sanctorum,* vol. 12, 1969, cols. 818–22.
10. Volpe 1989, plates 2–7, figs. 2–82a (color and black-and-white).
11. Boskovits (1988, p. 89) proposed, with good reasoning, a date in the early 1330s. However, the handling of the architecture and the relationship of figure to architecture are much less sophisticated than in the predella of Lorenzetti's altarpiece for the Carmine in Siena (Volpe 1989, figs. 109–13), which was finished by 1329, if not before. See text discussion below.
12. See Previtali 1993, plates XCVII–XCVIII, CI–CIV, figs. 169, 174–75, 325–26, 328, 330 (black-and-white and color).
13. Volpe 1989, fig. 9.
14. Volpe 1989, figs. 14–16 (black-and-white and color). The coat of arms consists of a rampant lion on a shield with a cross. It is shown twice. There is a portrait of a layman on the right and there was once another portrait on the left, presumably of another man with the same family name. (If it had been a woman, she would likely have been on the right, which is the distaff side in heraldry.) I. B. Supino (1924, pp. 176–84) recognized that the arms may be those of Giovanni di Simone, identified as a stonemason from Como whose sepulchral monument is in the basilica's cemetery. However, the date on the inscription on the tomb is open to interpretation—*S[EPULCHRUM] MAGISTRI JOH[AN]NIS MAGISTRI SY[M]ONIS DEFU[N]CTI. A.D. MCCCXXX. VII DIE JULII* (Sepulcher of Master Giovanni of the late Master Simone A.D. MCCCXXX. VII of July). Supino read it as 1330 or 1337. Pietro Scarpellini (in Ludovico da Pietralunga c. 1570–80, Scarpellini ed. 1982, pp. 328, 332, 340 nn. 1–2), noting that the *XXX* seems to be a later addition, suggested a date of 1307. However, the *VII* appears to refer to the day, July 7. See also Palumbo 1963, pp. 164–71. While the two donors of the Passion cycle may have been Giovanni di Simone and a male relative, it is still not clear that the coat of arms refers to the same family. On this issue, see also Carl Brandon Strehlke in Morello and Kanter 1999, p. 48.
15. See n. 4 above.
16. Stubblebine 1979, figs. 315–18.
17. Volpe 1989, fig. 1.
18. For the Assisi murals, see Martindale 1988, plates 20–48, color plates I–VII. For the *Maestà* after conservation, see Bagnoli 1999.
19. See Hueck 1983, p. 188; 1986, p. 91. In April 1323 the cardinal was able to recover some of his personal property. See Fortini 1940, p. 315 n. 77.
20. Pietro Scarpellini in Ludovico da Pietralunga c. 1570–80, Scarpellini ed. 1982, pp. 343–45; Marchini 1973, pp. 130–36.
21. Guerrini 1988.
22. Volpe 1989, figs. 84–88 (black-and-white and color). Lorenzetti painted another altarpiece for the nearby church of Santi Stefano e Degna in Castiglione d'Orcia. Only the *Virgin and Child* (Volpe 1989, fig. 89), which is still in the church, survives.
23. No. 43.119; Volpe 1989, fig. 90 (color).
24. Bagnoli et al. 2003, color repro. p. 411.
25. Two detached murals survive, although they may not have been painted at the same time. The *Crucifixion* (Volpe 1989, fig. 100) is in the church of San Francesco, and *Christ Risen* (Volpe 1989, fig. 101) is in the Museo dell'Opera della Metropolitana of Siena.
 Renovations in the church began in 1326, but it is not

clear if they affected the chapter house. Ambrogio Lorenzetti also painted a now-lost cycle for the church's chapter house and cloister. The cloister murals probably date around 1336.

26. Most of the altarpiece is in the Pinacoteca Nazionale in Siena. Other panels are in the Norton Simon Museum, Pasadena, and the Yale University Art Gallery, New Haven.
27. It was commissioned by an otherwise unidentified Lorenzo. Now in Siena, Pinacoteca Nazionale, nos. 82, 81, 79; Volpe 1989, figs. 120–22.
28. Copies were made by Sano di Pietro (q.v.). See Eisenberg 1981; Keith Christiansen in Siena 1988, repros. pp. 146–51 (black-and-white and color); Christiansen 1994. See also Giovanni di Pietro (plates 34A–B [JC cats. 107–8]).
29. Volpe 1989, figs. 153, 153a, color plate 11.
30. London, National Gallery, no. 1113; Volpe 1989, fig. 124 (color).
31. Florence, Uffizi, no. 445; Volpe 1989, figs. 135, 135a.
32. Volpe 1989, fig. 177.
33. Erling Skaug (1994, p. 229) has shown that in Pietro's c. 1327–28 Carmine altarpiece he borrowed punches from Ambrogio as well as Simone Martini.

Select Bibliography
Vasari 1550–68, Bettarini and Barocchi eds., vol. 2 (text), 1967, pp. 143–47; Romagnoli before 1835, vol. 2, pp. 355–94; Crowe and Cavalcaselle 1864–66, vol. 2, 1864, pp. 117–34; DeWald 1929; Cecchi 1930; DeWald 1930; Péter 1931; Péter 1933; Sinibaldi 1933; Volpe 1951; Carli 1956; Luisa Becherucci in *Enciclopedia*, vol. 8, 1958, pp. 687–700; Brandi 1958; Carli 1960; Volpe 1965; Maginnis 1971; Maginnis 1974; Maginnis 1975; Maginnis 1975a; Maginnis 1975b; Bellosi 1976; Maginnis 1976; Maginnis 1976a; Maginnis 1980; Maginnis 1980a; Seidel 1981; Carlo Volpe in Siena 1982, pp. 145–46; Maginnis 1984; Monica Leoncini in *Pittura* 1986, pp. 590–91; Cannon 1987; Bellosi 1988; Frugoni 1988; Guerrini 1988; Volpe 1989; Boskovits 1991; Guiducci 1992; Skaug 1994, esp. pp. 226–29; Strehlke 1994; Bartalini 1996; Cristina De Benedictis in *Enciclopedia dell'arte medievale*, vol. 7, 1996, pp. 884–92; H. B. J. Maginnis in *Dictionary of Art* 1996, vol. 19, pp. 664–68; Cannon and Vauchez 1999; Olson 1999; Carl Brandon Strehlke in Morello and Kanter 1999, pp. 46, 48; Freni 2000; Strehlke 2001; Schwarz 2002; Christiansen 2003; Michel Laclotte in Bagnoli et al. 2003, pp. 404–10.

PLATE 39A (JC CAT. 91)

Center panel of an altarpiece: *Virgin and Child Enthroned and Donor*

c. 1320

Tempera and tooled gold on panel with vertical grain; $49\frac{5}{8} \times 29\frac{3}{4} \times \frac{1}{2}$ to $\frac{5}{8}''$ ($126 \times 75.6 \times 1.2$ to 1.4 cm)

John G. Johnson Collection, cat. 91

INSCRIBED ON THE LOWER EDGE: *PETR[U]S LA[UR]E[NT]I[I] [DE SENI]S [——] ME* (Pietro Lorenzetti from Siena [——] me) [fig 39.1]; ON THE REVERSE: *JOHNSON COLLECTION* (stamped in black ink)

EXHIBITED: San Francisco 1939a, no. 36; Philadelphia Museum of Art, John G. Johnson Collection, Special Exhibition Gallery, *From the Collections: Paintings from Siena* (December 3, 1983–May 6, 1984), no catalogue

TECHNICAL NOTES
The now-thinned and cradled support comprises three members (width of center $24\frac{5}{8}''$ [62.7 cm]; of left $2\frac{1}{4}''$ [5.7 cm]; of right $2''$ [5 cm]) that are butt-joined with what appears to be the cheese and lime adhesive as described by Cennino Cennini, which in the X-radiograph (fig. 39.2) shows as two vertical white lines running the length of the panel. The wood is knotty, and the most prominent knot, which is to the left of the Virgin's head, was patched with a rectangular inlay during construction of the panel. The X-radiograph also shows the holes made by three large nails driven from the front of the panel during construction to attach a now-missing batten across the reverse, just above the center. Smaller nail holes, regularly spaced near the vertical edges, indicate the apparent attachment of colonnettes that covered the divisions between this center panel and the flanking panels of the original altarpiece. The presence of such panels to either side is indicated by six holes, $\frac{3}{16}$ to $\frac{1}{4}''$ (0.5 to 0.6 cm) in diameter and 2 to $2\frac{1}{4}''$ (5 to 5.7 cm) in depth, drilled in the Johnson panel's outside edges. These holes originally held dowels that joined or aligned the central panel with side panels. In addition, six rectangular wood inserts extend in from the sides of the panel to span the joints. The inserts are visible on the X-radiograph but are more easily viewed from the back of the panel. These inserts may be remnants or modifications of carpentry related to the panel joints, not necessarily to the adjoining panels.

The innermost step of the engaged molding of the cusped arch at the top is original; a fine weave linen, applied to the panel surface before the gesso preparation, laps up onto this original piece. The outer two steps of the molding were added in a 1992–93 restoration based on the original arched molding profile of the first tier of the altarpiece by Pietro Lorenzetti in Arezzo (fig. 39.5). The spandrels with angels (plates 39B–C [PMA EW1985-21-1, 2]) were both painted on a separate single piece of wood

nailed and glued to the upper part of the *Virgin and Child Enthroned and Donor.* When the spandrels were removed and cut into two separate panels in the nineteenth century, the main panel retained the bottom strip of wood from the spandrels that had formed the innermost molding step. In 1993, when the panels were reassembled, the presence of this wood confirmed that the three pieces had originally been part of the same complex (fig. 39.3).

The outlines of all of the figures of the *Virgin and Child* were incised, and the final painted design, with one exception, exactly coincides with the incisions. The exception occurs on the seat of the throne, where the artist has painted a red drapery over incisions indicating the front and back edges of the seat. Furthermore, there are no other incisions outlining this red drapery, suggesting that the artist added it as the painting progressed.

There are large areas of loss in the bottom half of the picture (fig. 39.4). It is likely that the panel stood in water at some point, resulting in a band of loss along the bottom edge and to the sides of the throne, where water would have traveled up the panel joints, causing significant loss to major folds of the Virgin's mantle. In spite of these losses, the paint surface is very well preserved, and the painting retains a remarkably intact and continuous grayed patina.

The background gilding is in a generally good state except for scattered losses and limited abrasion. The mordant gilt details are very abraded. The mordant is dark brown.

In August 1919 Hamilton Bell noted that the painting was cracked and needed immediate attention. Unspecified repairs were made by Carel de Wild in December 1920. At that point he and Bell noted many local retouches. In 1922, 1924, and 1926 T. H. Stevenson treated flaking. In 1929 the painting was sent to Boston to be treated by Herbert Thompson, who put a new cradle on it. Theodor Siegl treated flaking problems in 1956, 1961, 1962, and 1964, as did Louis B. Sloan in 1977. In 1990 Mark Tucker discovered fragments of an inscription indentified by Carl Strehlke as Pietro Lorenzetti's signature. These

were further revealed in 1992–93 when all repaints were removed by Teresa Lignelli. The extensive losses were retouched using an inpainting technique known as *tratteggio,* in which discrete and small vertical strokes of paint are systemically applied to match color. This makes the reconstruction inconspicuous at a normal viewing distance, but readily discernible on close inspection. Each point of the present restoration was based on information gained over a prolonged, close study of the painting's original surface and other comparable works by Pietro Lorenzetti (Treatment Report, John G. Johnson Collection Archives and Lignelli 1997).

PROVENANCE

According to Ernest DeWald (1930) and Langton Douglas (letter to the Frick Art Reference Library, New York, dated February 17, 1931), the *Virgin and Child* once was in the collection of the Chigi Saracini in Siena. However, this cannot be confirmed by other records. F. Mason Perkins (1912) wrote that he had seen it about 1900 in the Torrini antique shop in Siena. It later passed to Dormer Fawcus of Quinto al Mare, near Genoa, and from him to Ulrich Jaeger of Quinto al Mare, from whom Douglas seems to have obtained it about 1908. Shortly after he offered it to John G. Johnson as a work of Ambrogio Lorenzetti, an attribution that Douglas himself published in 1902. In a letter to Johnson dated New York, February 9, 1909, Mary Berenson indicated that Douglas had consulted the Berensons about the acquisition: "He [Bernhard Berenson] says that the photograph is not of an Ambrogio, but of a Pietro Lorenzetti. He hopes you will buy it, as it is an admirable picture. He has known the picture for some time; it was in Mr. Ulrich Jaeger's collection at Genoa. It is of course less valuable than an Ambrogio would be, but still it is well worth adding to your collection." On the original location, see Comments.

COMMENTS

The Virgin and Child sit on a throne set on a marble platform. In the lower left a tonsured donor in a black habit, either a monk or a friar, kneels in ado-

ration. In each spandrel an angel, with folded arms resting on the molding of the frame, looks down on the scene.

The composition is calculated to be seen from the donor's viewpoint at the lower left. The Virgin, seated slightly off-center with her body bent toward the right, turns the Christ Child in his direction. The Child's outstretched arms underscore the sudden and transitory nature of this action, as he has only begun to form a gesture of blessing.

The source of illumination comes from the upper left. It not only lights the figures but also underscores their solid, sculptural quality. Unlike most trecento Madonnas, this Virgin does not wear a deep ultramarine mantle, which over time would have become soiled and flat. She has instead a light blue, almost white, costume in which both the undergarment and mantle are of the same material.[1] The bright color allows for a more striking play of light and dark and a more evident rendering of the drapery folds that reveal more clearly the underlying forms of the Virgin's body. The gold brocade foliate pattern carefully follows the folds of the drapery, with elements of the design becoming smaller in the depths of the folds to increase the sense of spatial illusion. The gold fringe of the mantle stops just at the edge of the platform, drawing one's attention to the step that sets the holy figures apart and places them farther back in the space. The fringed cloth of honor on the throne has the same pattern as the Virgin's costume, but because it is red, her body is profiled against it.

The halos of the Virgin and Child draw particular attention to the relationship of the two figures and their placement within the three-dimensional space. While contained within the confines of the upper arch of the trefoil, the Virgin's halo—like the Virgin herself—is off-center and thus cropped by the molding of the frame. Christ's halo is hidden behind the Virgin's shoulder on the left and masks the finial of the throne on the right.

The Johnson Collection's painting was first published in 1902 by Langton Douglas as one of Ambrogio Lorenzetti's earliest works. Most other

FIG. 39.1 Reconstruction by Mark Tucker of Pietro Lorenzetti's signature on plate 39A. The areas in white indicate the surviving elements.

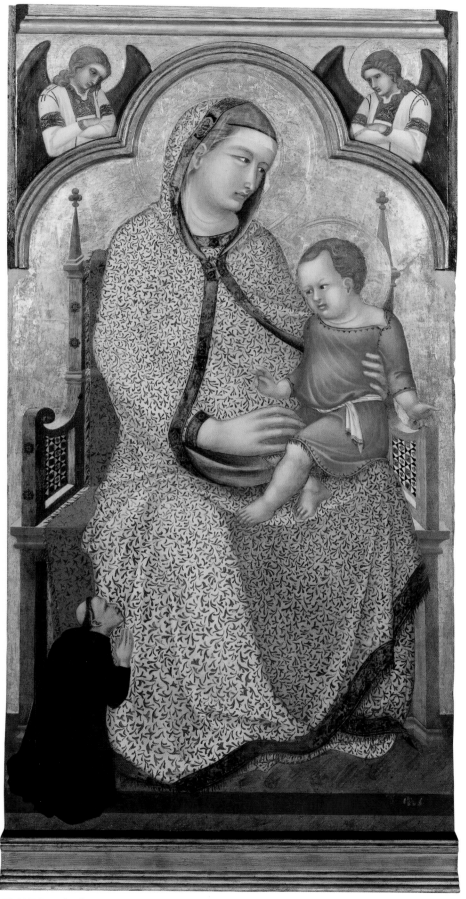

PLATES 39A–C

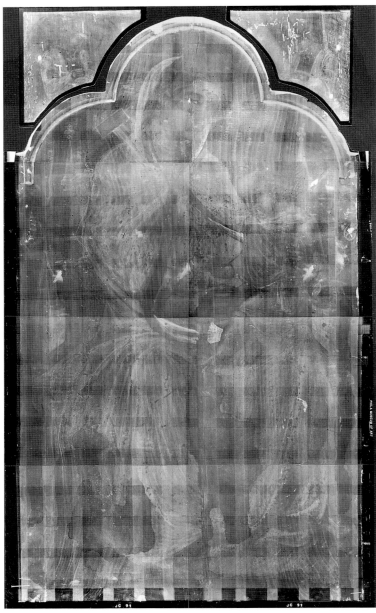

FIG. 39.2 Overall view of the X-radiograph composite of plates 39A–C, showing the position of the spandrels

FIG. 39.3 Reversed prints of the backs of the spandrels (plates 39B–C), showing the continuity of their grain with that of the inner molding step on the central panel (plate 39A)

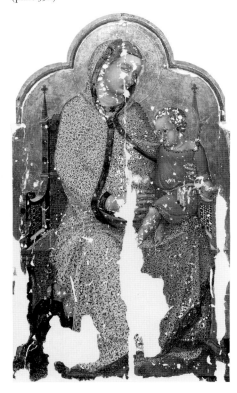

FIG. 39.4 Plate 39A in 1992, after cleaning and before restoration

authors, however, have accepted it as an early work of Ambrogio's brother, Pietro,[2] an attribution that is now borne out by the signature that was found during conservation in 1992–93.

RECONSTRUCTION: The panel constituted the center of a large polyptych. No other panels are known to exist, but, because the Virgin and Child are full-length, it is likely that standing saints were depicted. By contrast, the main figures in Pietro Lorenzetti's polyptych in Arezzo (fig. 39.5) are only three-quarters in length.

In the Johnson painting the dais on which the throne sits and the placement of the signature (fig. 39.1) provide valuable evidence about the original form of the polyptych. As in Pietro Lorenzetti's

Cortona *Virgin and Child*[3] of about 1312 and his later Carmine altarpiece, finished by 1327 or 1329 (fig. 39.6), the signature appears on the front face of the dais. However, it is fragmentary and must have continued onto at least one or more of the missing right lateral panels. The entire phrase likely reads: *PETRUS LAU-RENTII DE SENIS ME PINXIT ANNO DOMINI 13[——]*. The date may have been written in numerals or words or in a combination of both. It is also possible that the donor was identified in the left lateral panels in an inscription that gave his title and name, and that finished with a common statement such as *me fecit fieri* (had me made). Although the specifics and indeed the very existence of the donor's inscription can only be hypothesized, its placement on the now-missing left panels must have been the same as on

the main pane; that is, along the front of the dais, which means that the dais would have continued onto the other panels. If this was indeed the case, Pietro Lorenzetti's altarpiece was one of the first Italian polyptychs in which a continuous ground line unified the individual parts.

Only a few surviving altarpieces from the 1320s show full-length figures.[4] An altarpiece executed by Giotto in the late 1320s or early 1330s for the church of Santa Maria dell'Angelo[5] in Bologna probably is the best contemporary comparison for the original appearance of Pietro Lorenzetti's polyptych. In 1325 Lippo Memmi painted an altarpiece for the Pisan church of San Paolo in Ripa consisting of full-length seated saints in individual compartments with a common ground line.[6] However, because the

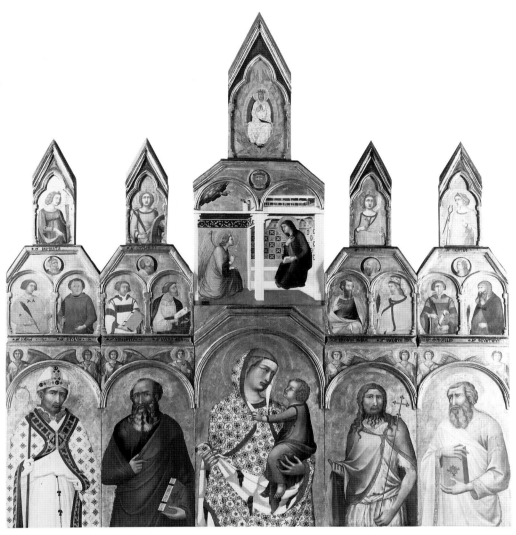

FIG. 39.5 Pietro Lorenzetti. Altarpiece: *Virgin and Child with Saints and Angels, the Annunciation, and the Assumption of the Virgin*, 1320–24. Tempera and tooled gold on panel; 117¼ × 121⅝″ (298 × 309 cm). Arezzo, church of Santa Maria della Pieve

central section of this altarpiece is not identified, it cannot be determined if the space was consistently unified. An altarpiece by Meo da Siena in Gubbio seems to have been specifically derived from a Lorenzetti prototype, possibly even the one that had the Johnson painting in the center.[7]

It is doubtful that the saints in the lateral panels of Pietro Lorenzetti's altarpiece would have been so much smaller than the Virgin. While a common ground line seems the most logical means of unifying an altarpiece consisting of many compartments, it was not, in fact, consistently employed. For example, Bernardo Daddi's altarpiece of the late 1330s from San Pancrazio in Florence shows the saints in the side panels on the same brocade-covered ground, but the Virgin, Child, and angels in the central

panel are in a different space.[8] In his Carmine altarpiece Lorenzetti himself sets the figures in the side panels apart from the central image. However, in that work the central panel includes two standing figures and angels in addition to the enthroned Virgin and Child.[9] Still, Lorenzetti's own interest in spatial consistency is apparent in much of his work, including the mural in the Orsini chapel of San Francesco in Assisi[10] and the *Birth of the Virgin*,[11] dated 1342, from the cathedral of Siena.

The Johnson altarpiece may also have served as a model for Sienese artists several decades later. A number of large-scale polyptychs by Luca di Tommè and Niccolò di Ser Sozzo (fig. 39.7), and Paolo di Giovanni Fei take up the formula of Pietro's earlier altarpiece in which a continuous platform unites the

separate compartments.[12] A good comparison can also be made with Lippo Vanni's polyptych in the Sienese church of San Francesco (fig. 39.8).

No other parts of the Johnson painting's altarpiece are known. Gaudenz Freuler (in Lugano 1991) suggested that a panel showing Saint Anthony Abbot in a Swiss private collection[13] and another showing the Dead Christ in the Museo Civico Amedeo Lia in La Spezia[14] formed its predella. However, as the present author (1991a) has argued, those panels are stylistically of a later date than the Johnson painting; furthermore, they are both on vertically grained wood, which would indicate that they came from a different sort of structure than a predella, perhaps a sacristy press.[15]

The donor in the Johnson painting bears some similarities to the female donor in Lorenzetti's Blessed Umiltà altarpiece (fig. 39.9). Both, for example, wear costumes whose hems appear to continue beyond the left edge of the picture. However, the woman is depicted in three-quarter view, whereas the monk or friar is strictly in profile. The latter is also shown in direct relation to the Virgin and Child, with whom he establishes eye contact, whereas the donor of the Blessed Umiltà altarpiece stares into space, which makes her seem remote from the standing saint. No other full-length images of donors can be found in Lorenzetti's large-scale works.[16]

LOCATION: The original location of the altarpiece is not known, although the presence of a monk or friar as the donor suggests a church of a monastery or convent. The donor is tonsured and wears a black habit, whose dark color indicates several possible identities: a Benedictine monk, perhaps of the reform Vallombrosan order, or a friar of either the Servite or Augustinian orders. However, the Augustinians and the Vallombrosans can almost certainly be excluded from consideration by comparison with near-contemporary depictions of their habits.[17] Identification with a Benedictine monk is not as easily excluded. However, a comparison of this figure with the Benedictine saints Benedict and Silvestro Gozzolini in Niccolò di Segna's (q.v.) altarpiece of the 1320s,[18] most likely from the Benedictine Silvestrine church of Santo Spirito in Siena, shows that the hood of this classic Benedictine habit, when not worn over the head, tended to rest on the top of the shoulders and not fall behind the back as it does in the Johnson painting. A close comparison for both the donor's pose and dress is the kneeling, haloed friar—possibly the Blessed Gioacchino Piccolomini (died 1305)—in Ugolino di Nerio's crucifix (fig. 39.10) in the church of San Clemente a Santa Maria dei Servi (known as Santa Maria dei Servi) in Siena.[19] Ugolino's depiction of him is so close to that of the donor in the Johnson panel that it seems to be dependent on it.

The Servite convent in Siena was rebuilt in the second and third decades of the trecento. The friars

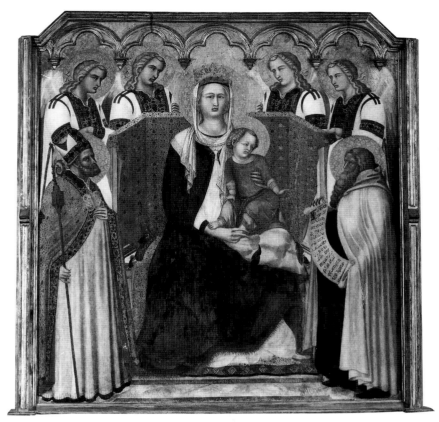

FIG. 39.6 Pietro Lorenzetti. Center panel of an altarpiece: *Virgin and Child with Angels and Saint Nicholas of Bari and the Prophet Elijah,* finished between 1327 and 1329. Tempera and tooled gold on panel; 65 × 59″ (165 × 150 cm). From Siena, church of San Niccolò al Carmine. Siena, Pinacoteca Nazionale, n.I.B.S. no. 16a

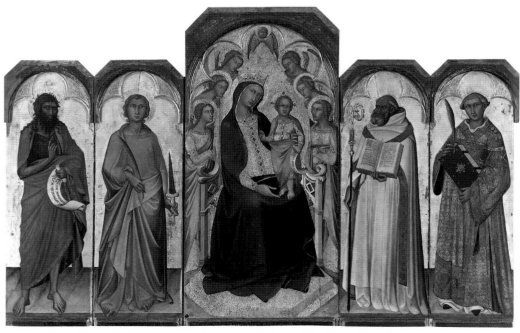

FIG. 39.7 Luca di Tommè (Siena, documented 1356–89) and Niccolò di Ser Sozzo (Siena, documented 1344–63). Altarpiece: *Virgin and Child with Angels and Saints John the Baptist, Thomas, Benedict, and Stephen,* 1362. Tempera and tooled gold on panel; 75¼ × 116⅞″ (191 × 297 cm). Siena, Pinacoteca Nazionale, no. 51

were aggressive fundraisers who were known to be concerned about the financing of not only the building itself but also its decoration. In October 1319 they solicited the communal government for funds to help pay for an altarpiece (for this document, see Appendix I, plate 39).[20] This painting has never been identified, but the style of the Johnson panel and the fact that its donor was a Servite friar raise the possibility that it is from that very altarpiece. The painting that the Servites had commissioned is described as a *tabula,* or panel painting, in which the Virgin and Child are to be depicted,[21] but the projected total cost of 300 lire indicates it was to be a polyptych of considerable size. After it was determined that private donations would unlikely be forthcoming for the project, the city government agreed to pay 100 lire in four installments over the next two years directly to the painter. The decision was not unanimous, as in the vote that was taken 15 city councillors were opposed to the proposition, although 194 voted in favor. Unfortunately, the document does not mention the artist's name,[22] but it does suggest that the painting had not yet been begun or had just been begun in about 1319, and that the project might not be finished for several years. Other records[23] show that payments to the Servites were duly made by the Sienese government through 1323.[24]

Alternately, the presence of a donor in the Johnson painting could argue against its association with the altarpiece for which the Servites requested public funding. Yet because the document does state that both the prior and the convent were making the solicitation for help, it is likely that the donor friar in the painting would be the prior of the church. Nonetheless, the priors changed almost annually. The prior in 1319, when the petition was made, was Fra Francesco di Feo.[25] Nothing else is known of him.

A possible provenance for the Johnson painting from Santa Maria dei Servi in Siena suggests its comparison with the principal earlier painting in the church—Coppo di Marcovaldo's *Enthroned Virgin and Child with Angels* of 1261 (fig. 39.11). Lorenzetti's Virgin seems to be a conscious response to the grandiose image of Coppo's Virgin, which is also shown slightly off-center and turning to the left. The faces of Coppo's Virgin and Child had been repainted in the early 1300s by a painter close to Duccio, and Lorenzetti's altarpiece would seem to be a further attempt at modernization of the church's decoration. It is unclear exactly where the new painting would have been placed. Its size would suggest the high altar, but the October 1319 document (see Appendix I, plate 39) only states that the altarpiece was intended for the "ornament of the church" (*ornamentum ecclesiae*) and should provide "consolation for those who come to the church to hear the daily [or divine] office" (in consolationem eorum qui ad ipsam accedunt ecclesiam ad divina officia audendum). If indeed Lorenzetti's

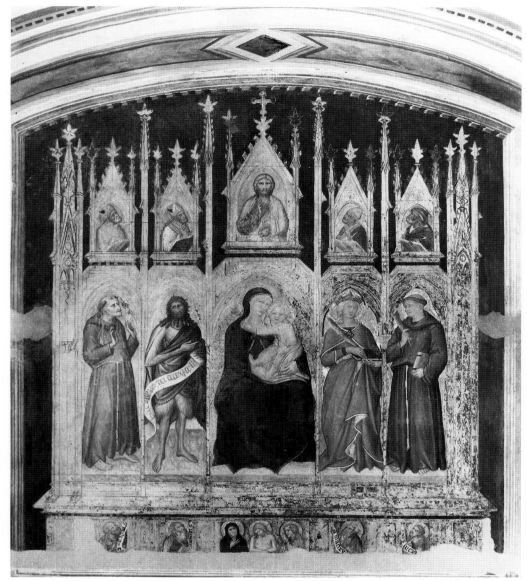

FIG. 39.8 Lippo Vanni (Siena, documented 1340–75). Altarpiece: *Virgin and Child and Saints Francis, John the Baptist, Catherine of Alexandria, and the Blessed Pietro da Siena*, 1360s. Mural; 114⅛ × 102⅜″ (290 × 260 cm). Siena, church of San Francesco

FIG. 39.9 Pietro Lorenzetti. Center panel of an altarpiece: *Blessed Umiltà and Donor*, 1316(?). Tempera and tooled gold on panel; 50⅜ × 22½″ (128 × 57.2 cm). From Florence, church of San Giovanni Evangelista in Faenza. Florence, Galleria degli Uffizi, no. 8347

painting had been installed on the high altar, it was replaced between 1498 and 1501 by Bernardino Fungai's new altarpiece.[26]

DATE: While most scholars have largely been in accord with dating the Johnson painting early in Pietro Lorenzetti's career, there has been discussion about whether it should date before or after Pietro's altarpiece (fig. 39.5) commissioned by Bishop Guido Tarlati for the *pieve* of Arezzo in 1320,[27] a work probably completed in early 1324. The Virgin in the Philadelphia painting is very close in type to the one in the Arezzo altarpiece, suggesting that the two works must be closely dated. However, the structure of the Arezzo

altarpiece is not much different from that of Duccesque altarpieces of a decade or more before, such as the polyptych in the Pinacoteca Nazionale in Siena.[28] If, as suggested above, the altarpiece to which the Johnson panel belonged had full-length figures and a common ground line that unified the individual compartments, its appearance was decidedly different from the Arezzo altarpiece. While this analysis could imply a date after the Arezzo painting, Pietro Lorenzetti's career rarely presents such a linear development. For example, in many ways his even later Carmine altarpiece of 1327–29 is more traditional than either the Arezzo altarpiece or the Johnson *Virgin and Child*. The central imagery of the Carmine

FIG. 39.10 Ugolino di Nerio (q.v.). Detail of the donor in the *Crucifix*, c. 1315–20. Tempera and tooled gold on panel; overall 158 × 96″ (401 × 244.5 cm). Siena, church of San Clemente a Santa Maria dei Servi

altarpiece is in fact more closely related to classic Sienese civic Madonnas, such as Duccio's *Maestà* of 1311 from the cathedral and Simone Martini's *Maestà* of 1315–21 in the Palazzo Pubblico.

If the October 1319 document can be associated with the Johnson painting, it means a dating that is nearly contemporaneous to the Arezzo altarpiece. As the document outlines, the payment was scheduled to take place over two years, possibly to keep pace with the painting's execution. The contract for the Arezzo altarpiece was drawn up in April 1320, a month after a private donation had been made for the panel. While that document states that Pietro "had been from Siena" (fuit de Senis), it is not clear if this meant he had been away from his native city for a long time. In any case, no schedule for com-

pletion of the altarpiece is included in the Aretine document, and money was still being raised for that painting as late as January 1324. It is probable that at some point work on the two projects overlapped, a pattern that would be consistent with Pietro's later working pattern.[29]

1. This is also true of the Virgin in Lorenzetti's Arezzo altarpiece (see fig. 39.5), although there she wears light pinkish clothes. See Volpe 1989, fig. 97 (color).
2. Giulia Sinibaldi (in Thieme-Becker, vol. 23, 1929, pp. 387–88) and Millard Meiss (1931) questioned the attribution at first, but each changed his mind in subsequent publications (Sinibaldi 1933; Meiss 1955). Mojmír S. Frinta (1976) attributed it to a close colleague of Pietro Lorenzetti's.
3. Museo Diocesano; originally Cortona, *pieve* of Santa

Maria (now the cathedral); Volpe 1989, plates 83, 83a (black-and-white and color).
4. Gardner von Teuffel 1979, p. 47; Van Os 1984, p. 80.
5. Bologna, Pinacoteca Nazionale, no. 284; Previtali 1993, color plate c x 11. On the name of the church, later known as Santa Maria degli Angeli, see Massimo Medica in Bologna 1996, p. 18 n. 10.
6. For a summary of the discussion of its reconstruction and earlier bibliography, see Marianne Lonjon in Avignon 1983, p. 142; and Giovanna Damiani in Siena 1985, pp. 82, 84. Reproductions of the panels can be found in Mallory 1975, figs. 5–11, where they are attributed to the Saint Thomas Master. On the altarpiece's date and provenance, see Caleca 1976, pp. 51–52.
7. Museo Civico; Todini 1989, fig. 245.
8. Florence, Uffizi, no. 8345; and a number of other collections. See the reconstruction in Offner/Boskovits 1989, plates xiv–xv. Paula Spilner has recently shown that this was originally in the cathedral in Florence.
9. For a photographic reconstruction of the Carmine altarpiece, see Volpe 1989, p. 136.
10. Volpe 1989, fig. 1.
11. Siena, Museo dell'Opera della Metropolitana; Volpe 1989, color plate 11.
12. See also the following altarpieces in the Pinacoteca Nazionale in Siena: by Luca di Tommè, from San Pietro a Venano, near Gaiole in Chianti (1360s; Torriti 1977, fig. 169), and the Capuchin church of San Quirico d'Orcia (1367; no. 109; Torriti 1977, fig. 170 [color]); and by Paolo di Giovanni Fei, from Sant'Andreino at Serre di Rapolano (c. 1390; no. 300; Torriti 1977, figs. 202–3 [black-and-white and color]).
13. 19¼ × 15⅜″ (49 × 39 cm); Lugano 1991, color repro. p. 38.
14. 19¼ × 23⅝″ (49 × 60 cm); Lugano 1991, repro. p. 37; Zeri and De Marchi 1997, color plate 79.
15. For an earlier sacristy press from the late 1200s by Memmo di Filippuccio, in the basilica of San Lucchese in Poggibonsi, see Siena 1985, cat. 1.
16. Lorenzetti's late reliquary, divided between the Harvard University Center for Italian Renaissance Studies at Villa I Tatti in Florence and a private New York collection (Volpe 1989, figs. 131–32 [black-and-white and color]), has a friar donor shown twice. In Volpe's monograph and earlier studies cited there, he is identified as a Franciscan, but he is more likely an Augustinian.
17. Unlike Augustinians, who usually wear a belt, the donor here does not seem to be girded. However, as Pietro Lorenzetti's own image of Saint Leonardo in an Augustinian habit (Riggisberg, Switzerland, Abegg-Stiftung; Volpe 1989, fig. 91 [color]) does not show this belt, this is not proof enough. Still, the habit in the Johnson painting differs from that worn by another contemporary Augustinian, the Blessed Agostino Novello, in Simone Martini's nearly contemporary tabernacle from Sant'Agostino in Siena (on deposit in the Pinacoteca Nazionale; Siena 1985, color repro. p. 57). This painting probably dates around 1324, if not before (see Alessandro Bagnoli in Siena 1985, p. 60). There, even though the belt is not visible, the habit is definitely girded, and a white undergarment can be seen at the sleeves and as a lining of the hood.

A Vallombrosan provenance for the Johnson panel can be excluded on the basis of its comparison with Pietro Lorenzetti's own altarpiece of the Blessed Umiltà for the Florentine Vallombrosan church of San Giovanni Evangelista in Faenza (fig. 39.9). In several scenes Vallombrosan monks are shown in a two-tone habit in which the mantle is open at the side, and the hood, when not worn on the head, reaches to the monk's

FIG. 39.11 Coppo di Marcovaldo (Florence, documented 1260–76). *Enthroned Virgin and Child with Angels,* 1261. Tempera and tooled gold on panel; 86⅝ × 49¼" (220 × 125 cm). Siena, church of San Clemente a Santa Maria dei Servi

waist. See, in particular, Volpe 1989, fig. 146 (color).

18. New York, The Metropolitan Museum of Art, no. 24.78; Zeri 1980, plate 1.

19. Bagnoli et al. 2003, postrestoration color repros. pp. 359, 361. The cross was probably installed on a rood screen. Its design is based on Pietro Lorenzetti's cross from San Marco in Cortona (Volpe 1989, fig. 96). Interestingly, Niccolò di Segna's father based his cross (Stubblebine 1979, figs. 315–18) in Sante Flora e Lucilla in Arezzo, seemingly commissioned in 1319, on the same model. On the attribution to Ugolino di Nerio, see Aldo Galli in Bagnoli et al. 2003, pp. 358–60.

20. See also Lusini 1908, pp. 34, 55 n. 83.

21. This description does not exclude the depiction of other subjects, particularly of saints. For instance, Duccio's 1311 *Maestà* from Siena cathedral, which showed the Virgin and Child with saints and angels, is described in documents as both the *tabule beate Marie semper virginis* (panel painting of the Blessed Mary, always a virgin) and as the *tavola de la Vergine* (panel of the Virgin). See Stubblebine 1979, p. 205, documents 43–44.

22. Other authors have identified the painting with one of two still in the church. V. Lusini (1908, p. 34), H. Hager (1962, p. 199 n. 157), and Michael Mallory (1974, p. 190; 1975, p. 16) identified it as Lippo Memmi's *Vir-*

gin and Child (Siena 1985, color repro. p. 87). Serena Padovani (1979, p. 87 n. 8) first proposed an identification with the *Virgin and Child* (Stubblebine 1979, fig. 343, as the Seminary Madonna Master) by Segna di Bonaventura, which she proposed was the center of a lost polyptych. Her opinion was followed by Elisabetta Avanzati (in Siena 1985, p. 86) and Joanna Cannon (1994, p. 52).

23. Partially published in Padovani 1979, p. 87 n. 8. See Appendix I, plate 39.

24. A decade later the city also contributed 50 lire toward the total cost of 150 gold florins for Pietro Lorenzetti's altarpiece for the church of San Niccolò al Carmine. In this case the money was given after the painting was completed.

25. Fra Filippo Montebuoni Buondelmonte, writing c. 1600–1636, in Girolamo Manenti, *Compendi di cartapecore scritte esistenti in diversi archivi,* 1722, Siena, Archivio di Stato, *Manoscritti* B 79, folio 96 verso. I thank Rolf Bagemihl for his help on this issue. It is possible that this Francesco is the Servite friar whom Montebuoni Buondelmonte (folio 80 verso) says became bishop of Ceneda, near Belluno in northern Italy, in 1320. Ferdinando Ughelli (1720, cols. 206–7) identifies the bishop of that city from 1320 to 1349 as Francesco Ramponi, but it is unclear if they are the same person.

26. Christiansen, Kanter, and Strehlke 1988, p. 353, figs. 1, 76a–d.

27. Carl Brandon Strehlke (1985a) and Max Seidel (1981) preferred a date after the Arezzo polyptych. Millard Meiss (1931, 1955), Pietro Toesca (1951), Miklós Boskovits (1986), and Carlo Volpe (1989) dated it before 1320. Boskovits proposed c. 1316–20 and Volpe, c. 1319. In addition, Meiss noted that an early date is indicated by the lack of punching in the gold. There is only a simple pointed punch, which is the same one that the artist used in the altarpiece in Arezzo (fig. 39.5). However, this still provides a wide margin for the date of the Johnson painting. Ernest DeWald (1930) and Luisa Becherucci (in *Enciclopedia,* vol. 8, 1958, col. 695) dated the painting close to the Carmine altarpiece of 1327.

28. Bagnoli et al. 2003, postrestoration color repro. p. 235; see also fig. 84.9.

29. For example, the Carmine altarpiece was consigned in 1329, the same date recorded on a lost painting for the church of the Umiliati. The *Birth of the Virgin* altarpiece was commissioned in 1335 and consigned in 1342, during which time many other projects intervened.

Bibliography

Douglas 1902, p. 345 (Ambrogio Lorenzetti); Langton Douglas in Crowe and Cavalcaselle 1903–14, vol. 3, 1904, p. 119 (Ambrogio Lorenzetti); Suida 1911, plate x (angels); Gielly 1912, p. 454 n. 1; Perkins 1912, pp. 40–41; Berenson 1913, p. 52, repro. p. 288; Douglas 1914, vol. 2, p. 345; Fogg 1919, p. 104; Van Marle, vol. 2, 1924, p. 608 (p. 370 n. 2); vol. 5, 1925, fig. 272; Gielly 1926, p. 114; DeWald 1929, pp. 146, 165, fig. 27; Giulia Sinibaldi in Thieme-Becker, vol. 23, 1929, pp. 387–88; Cecchi 1930, p. 41; DeWald 1930, pp. 18, 37, fig. 27; Handbook 1931, p. 41, repro. p. 8; Kimball 1931, repro. p. 23; Meiss 1931, p. 380 n. 6; L. Venturi 1931, plate 64; Berenson 1932, p. 293; Edgell 1932, p. 115, fig. 122; Douglas 1933, p. 108; Péter 1933, p. 168; Sinibaldi 1933, pp. 160–61, 166–67, plate VIII; Tietze 1935, no. 32 (repro.); Berenson 1936, p. 252; Tietze 1939, p. 309, no. 32 (repro.); San Francisco 1939a, no. 36 (repro.); Johnson 1941, p. 9; Ragghianti 1949, p. 78, fig. 56; Toesca 1951, p. 560 n. 83; Sandberg Vavalà 1953, p. 157; Shorr 1954, p. 33, type 5

Siena 3 (repro.); Meiss 1955, p. 120 n. 21; Béguin 1957, p. 60; Luisa Becherucci in *Enciclopedia,* vol. 8, 1958, col. 695; Volpe 1960, p. 264; Volpe 1965, p. 35; Sweeny 1966, frontispiece (color), black-and-white repro. p. 43; Berenson 1968, pp. 220–21; Fredericksen and Zeri 1972, p. 109; Maginnis 1975b, pp. 45–55; Frinta 1976, p. 278; Max Seidel in Siena 1979, p. 49; Sutton 1979a, p. 388, fig. 4; Carlo Volpe in Larousse 1979, cols. 1050–51; Maginnis 1980, p. 125; New York, Christie's, June 12, 1981, p. 10; Seidel 1981, passim, esp. pp. 115, 156; Pietro Scarpellini in Ludovico da Pietralunga c. 1570–80, Scarpellini ed. 1982, p. 337; Maginnis 1984, pp. 193, 197–99, fig. 23; *Philadelphia Inquirer,* June 30, 1985, p. 5; *Reading (Pa.) Eagle,* July 7, 1985, p. B-18; Strehlke 1985a, pp. 3–5, fig. 1; Strehlke 1985b, repro. p. 10 (Pietro Lorenzetti); Boskovits 1986, p. 3; Volpe 1989, pp. 28, 32–33, 118–19, color repro. p. 118; Boskovits 1991, p. 387; Gaudenz Freuler in Lugano 1991, pp. 36–39, repro. p. 37; Strehlke 1991a, p. 466; Philadelphia 1994, repro. p. 212; Carl Brandon Strehlke in Philadelphia 1995, repro. p. 162; Cristina De Benedictis in *Enciclopedia dell'arte medievale,* vol. 7, 1996, p. 886; H.B.J. Maginnis in *Dictionary of Art* 1996, vol. 19, p. 666; Kirsh and Levenson 2000, p. 173, figs. 178–80 (color); Strehlke 2001

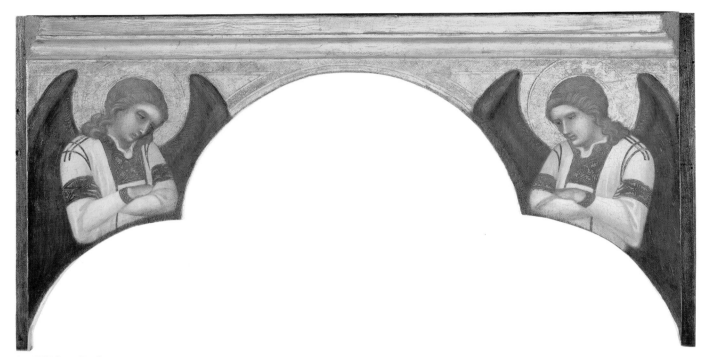

PLATES 39B–C

Two spandrels of an altarpiece: *Angels*

c. 1319–20

Tempera and tooled gold on panel with vertical grain; left 9⅞ × 10¼ × ⅜″ (25.3 × 26 × 1 cm); right 9⅞ × 10½ × ⅜″ (25.3 × 26.6 × 1 cm)

Philadelphia Museum of Art. Purchased with the George W. Elkins Fund, the W. P. Wilstach Fund, and the J. Stogdell Stokes Fund. EW1985-21-1, 2

EXHIBITED: Philadelphia Museum of Art, John G. Johnson Collection, Special Exhibition Gallery, *From the Collections: Paintings from Siena* (December 3, 1983–May 6, 1984), no catalogue

TECHNICAL NOTES

The two spandrels were originally painted on the same piece of wood attached to the main panel by nails and glue. When the spandrels were removed, the main panel retained the bottom strip of wood from the spandrels that had formed the innermost molding step (see fig. 39.3). In the X-radiographs the nail holes are visible. In 1992–93 George Bisacca treated the panels at the Metropolitan Museum of Art, removing an old backing board and then remounting them together. The paint surface is in good condition and contains only a few small, scattered losses (fig. 39.12), which were inpainted by Teresa Lignelli in 1993.

PROVENANCE

These paintings are first recorded in the collection of Leon Ouroussoff, Russian ambassador to Vienna.

They later came into the possession of Carl W. Hamilton in New York.[1] After the dispersal of his collection they were with the dealer Joseph Duveen in New York, from about 1931 to 1933,[2] from whom they were purchased by the art critic Royal Cortissoz. They next passed into the collection of his niece Dorothy P. West. The panels were auctioned, but not sold, at Christie's in New York on June 12, 1981 (lot 127; repros. pp. 108–9), and were subsequently exhibited at the Metropolitan Museum of Art in New York and at the Philadelphia Museum of Art with the *Virgin and Child Enthroned and Donor* (plate 39A [JC cat. 91]). The Philadelphia Museum acquired them from the West estate in 1985.

COMMENTS

Each spandrel shows an angel, with arms folded, looking down in adoration.

In 1929 Ernst DeWald first noted that these two spandrels, then in a New York private collection, belonged to the *Virgin and Child* in the John G. Johnson Collection. For further discussion, see Comments for plate 39A (JC cat. 91).

1. Henri Marceau, in a letter to the Frick Art Reference Library in New York, dated January 14, 1947, wrote that in Hamilton's collection these spandrels were used to enframe a *Virgin and Child* by Luca di Tommè, which he said was a Kress gift to the National Gallery of Art in Washington, D.C. (no. 452). However, I can find no record of this picture.
2. L. Venturi 1931, comments to plate 64.

Bibliography
See plate 39A (JC cat. 91)

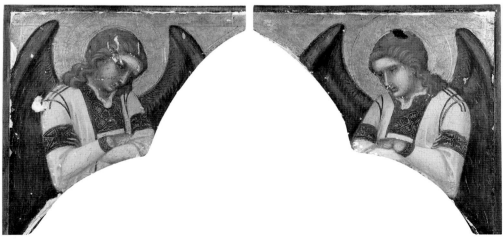

FIG. 39.12 Plates 39B–C, after cleaning and before restoration

LORENZO MONACO
(*Piero di Giovanni,* also called *Don Lorenzo*)

FLORENCE, FIRST DOCUMENTED 1390;
DIED MAY 24, 1424(?), FLORENCE

Piero di Giovanni entered the Camaldolese monastery of Santa Maria degli Angeli in Florence as a novice in late 1390. Adopting the name Lorenzo di Giovanni, he took his vows as a monk on December 10, 1391; as a subdeacon on September 21, 1392; and as a deacon on February 26, 1396. He never became a priest, however, but instead moved out of the monastery to set up his own workshop sometime between 1394 and 1398.[1] In 1402 the artist is recorded as a resident of the Florentine parish of San Bartolo del Corso. In 1415 the monastery sold him a lifelong lease on a house and garden to use as his workshop.[2] A contract for the rent of this property made with someone else in 1426 provides indirect evidence of Lorenzo's death. Documents cease to speak of him after August 7, 1422, and he may have died on May 24, 1424.[3]

Piero di Giovanni had already worked as a painter before becoming a monk. In 1387–88 he executed the predella of an altarpiece by Agnolo Gaddi (q.v.), which had been commissioned by Bernardo di Cino Bartolini de' Nobili for the chapel of Saints James and John "Decollato" (Beheaded) in Santa Maria degli Angeli in Florence.[4] His subsequent entry into the monastery may have been in part motivated by his desire to work with the monks Don Simone and Don Silvestro dei Gherarducci, who were the leading artists in the so-called school of the Angeli, then the most active workshop of manuscript production and illumination in Florence. Like Don Silvestro, Lorenzo Monaco worked as both a painter and an illuminator.

Lorenzo Monaco's earliest independent commission, probably dating around 1394, was for the high altarpiece for the Augustinian convent of San Gaggio in Florence.[5] Stylistically, it relates to his miniature of Saint Jerome in a choral book, dated 1394, from Santa Maria degli Angeli.[6] Around the time of the San Gaggio commission he painted another altarpiece for a chapel in the Carmine in Florence.[7] In 1399–1400 he was paid by Chiaro Ardinghelli for another, now-lost altarpiece in the Carmine.

Two of his early works embodied the Camaldolese order's devotional ideals: *Christ in Gethsemane,* of about 1400,[8] from Santa Maria degli Angeli, and the *Man of Sorrows with Instruments of the Passion,* dated 1404,[9] were both meant to be contemplated during prayer. He later executed the signed *Coronation of the Virgin* for the high altar of the church, dated February 1413 (1414 modern style).[10] This is a masterpiece of the Florentine International Gothic style. All three paintings offer similarities to the figures and particularly the sinuous drapery of Lorenzo Ghiberti's contemporary Florentine works—the first gilt bronze doors of the baptistery[11] and the statue of Saint John the Baptist for Orsanmichele[12]—that suggest a mutual exchange of ideas between the two artists. Lorenzo continued to develop this elegant style in his last major works in Florence for the churches of Santa Trinita and Sant'Egidio[13] as well as in numerous private commissions.

Judging from the large number of small- and medium-scale works made for lay and ecclesiastical patrons, Lorenzo Monaco's workshop must have expanded considerably after 1415, when Santa Maria degli Angeli leased him the house with a garden. In the first decade of the century similar works had been wholly autograph and include some of the artist's masterpieces, such as the great triptych of Passion scenes, dated 1408, now divided between the Louvre in Paris[14] and the Národní Galerie in Prague.[15] Later productions, however, were executed by or with the help of assistants.

1. Levi D'Ancona 1958, p. 178 n. 2.
2. It is generally stated that the document names Don Lorenzo as being from Siena. See Eisenberg 1989, pp. 212–13, document 11. However, a close examination of the original proves that the relevant word is not very clear and may or may not be "Siena."
3. Levi D'Ancona 1958, p. 175 n. 3.
4. The main section of Gaddi's altarpiece is in Berlin, Staatliche Museen (no. 1039; Cole 1977, plate 1). The surviving parts of the predella are reconstructed and illustrated by Gronau 1950, pp. 217–21; and Zeri 1964–65, pp. 554–58. Bruce Cole (1977, pp. 85–87) and Marvin Eisenberg (1989, p. 201) deny the attribution of the predella to Lorenzo Monaco.
5. The surviving sections of the altarpiece are divided among many museums. For a photomontage reconstruction, see Boskovits 1988, plate 146.
6. Florence, Biblioteca Mediceo-Laurenziana, cod. cor. 5, folio 138; Eisenberg 1989, fig. 1.
7. This altarpiece is divided among several museums and a private collection. See Eisenberg 1989, figs. 215–23. Its provenance from the Carmine is explained in Zeri 1964–65, p. 4 n. 1. Zeri dates the altarpiece between the predella to Agnolo Gaddi's Nobili altarpiece and the San Gaggio altarpiece. It seems to me that the Carmine altarpiece may come after the San Gaggio altarpiece.
8. Florence, Galleria dell'Accademia, no. 438; Bonsanti 1987, color repro. p. 78; Eisenberg 1989, figs. 7–14, color plates 1–2 (details).
9. Florence, Galleria dell'Accademia, no. 467; Bonsanti 1987, color repro. p. 82; Eisenberg 1989, figs. 18–19.
10. Florence, Uffizi, no. 885; Ciatti and Frosinini 1998, plate 1.
11. Contracted in 1404 and 1407; casting of the frame begun in 1415; installed on Easter Sunday 1424; Krautheimer 1982, plates 18–54.
12. Cast 1414; Krautheimer 1982, plates 3–5.
13. Eisenberg 1989, figs. 82–97, 102–27, 201–2, color plates 11, 13–16; Ciatti and Frosinini 1998, plate XXXVI.
14. No. R.F. 965; Eisenberg 1989, fig. 33.
15. No. 428; Eisenberg 1989, figs. 34–37, color plate 6.

Select Bibliography
Wilhelm Suida in Thieme-Becker, vol. 23, 1929, pp. 391–93; Levi D'Ancona 1958; *Bolaffi,* vol. 7, 1975, pp. 42–44; Boskovits 1975, esp. pp. 132–36, 337–55; Anna Padoa Rizzo in Marchini and Micheletti 1987, pp. 108–15; Eisenberg 1989; Emanuela Andreatta in Berti and Paolucci 1990, pp. 257–58; Laurence B. Kanter in Kanter et al. 1994, pp. 220–306; James Czarnecki in *Dictionary of Art* 1996, vol. 19, pp. 678–85; Ciatti and Frosinini 1998; Freuler 2001

PLATE 40 (JC CAT. 10)
Virgin of Humility

c. 1420

Tempera and tooled gold on panel with vertical grain; overall (with additions) 33⅜ × 19⅞ × ⅜″ (84.6 × 50.5 × 1 cm); painted surface (excluding additions), height 26⅜″ (67 cm); top, width 17⅜″ (44 cm); bottom, width 19⅞″ (50.5 cm)

John G. Johnson Collection, cat. 10

INSCRIBED ON THE CHRIST CHILD'S SCROLL: *EGO SUM LUX MU[NDI]* (John 8:12: "I am the light of the world") (in glazed brown paint); ON THE MODERN FRAME: *AVE MARIA GRATIA PLENA* (Luke 1:28: "Hail [Mary], full of grace") (in gilding); ON THE REVERSE: *10 i.n. 2060* (in pencil, twice, on two cradle members)

PUNCH MARKS: See Appendix II

EXHIBITED: Philadelphia Museum of Art, Sixty-ninth Street Branch, *Religious Art of Gothic and Renaissance Europe* (December 1, 1931–January 4, 1932), no catalogue

TECHNICAL NOTES

The panel is thinned and cradled. It consists of two members joined 5″ (12.5 cm) from the right. The top was cut off and replaced with a piece of new wood, 7″ (17.6 cm) in height. A small oak strip, ⅝″ (1.5 cm) high, has also been added to the bottom. The linen layer is visible in several places on the sides, underneath the gesso. The gold on the sides has been redone. There is no barbe on any side, indicating that the edges were planed.

The Virgin's gilt cushion was textured with a graining punch consisting of six squared dots arranged in a circle. The gold was modeled with glazes and then embellished with a white floral pattern and borders with Kufic-style letters. Several punch patterns decorate the halos. The red star, or *stella maris,* on the Virgin's right shoulder is repaint that rests in depressions left by the mordant of an earlier gilt star. Next to it is a smaller, more elaborate gilt star that is probably not original. Mordant gilding on the borders of the costumes survives to a great extent. The mordant is pigmented white. The artist has carefully oriented the gilt needle-lace fringe of the Virgin's mantle to suggest the turning of the fabric as the lining becomes visible.

The contours as well as the drapery of the Virgin's azurite robe are outlined by incised lines. For better adhesion of the paint, the gold and even the top layer of gesso were scraped off inside the incised lines in areas where color was to go. For the underdrawing, see Comments.

The paint surface is lightly to moderately abraded, particularly in the flesh tones. However, a number of fine details survive. The areas along the cracks and the bottom edge are retouched.

PROVENANCE

John G. Johnson bought the painting through the mediation of Osvald Sirén (see Sirén's

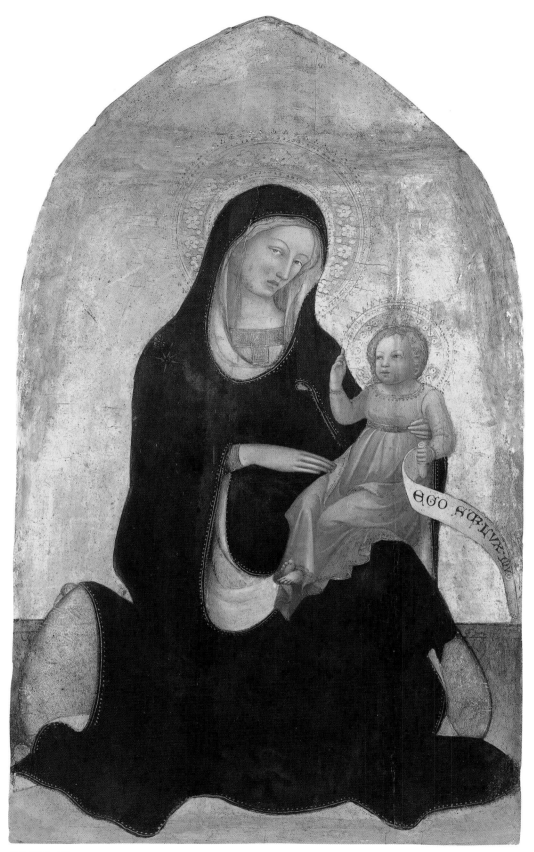

PLATE 40

FIG. 40.1 (*above left*) Infrared reflectographic detail of plate 40, showing dotted lines of a pricked cartoon along the outlines of the Virgin's features

FIG. 40.2 (*above right*) Infrared reflectographic detail of plate 40, showing the underdrawing of the Virgin's mantle

FIG. 40.3 (*right*) Infrared reflectographic detail of plate 40, showing the underdrawing of the Christ Child

correspondence dated Stockholm, September 30, October 24, and November 26, 1908). Their letters suggest that the picture had been purchased in Florence. During this period Sirén found another painting (see Allegretto di Nuzio, plates 1A–E [JC cat. 5]) for Johnson through the Florentine dealer Aranaldo Corsi, although a similar connection with this panel cannot be proved.

COMMENTS

The Virgin of Humility is seated on a cushion. On her right shoulder is the *stella maris*.[1] The blessing Christ Child holds a scroll with Gothic lettering. The floor is marble and the background, gold.

While the Virgin's humility was the subject of sermons by Saint Bernard of Clairvaux and others in the twelfth century, and hence by the fourteenth century a common theological conceit, it did not appear as a subject in art until about 1340.[2] About 1340–43 Simone Martini painted a mural of the first known example in the tympanum of Notre Dame des Doms in Avignon for Cardinal Jacopo Stefaneschi.[3] A small panel depicting this subject by his brother-in-law Lippo Memmi dates from around the same time,[4] and another, by Bartolomeo da Camogli, is inscribed 1346.[5] In the next half century the Virgin of Humility was most often encountered in small-scale paintings used for private devotion. Its rapid spread may have been due in part to the Dominicans; certainly the subject was popular in their churches and convents. A prior of Lorenzo Monaco's own Camaldolese monastery of Santa Maria degli Angeli and later general of the order, Ambrogio Traversari, had also spoken of humility as the queen of the virtues.[6] And at least one painting of the subject, Don Silvestro dei Gherarducci's

FIG. 40.4 Lorenzo Monaco. Pinnacle: *Virgin of Humility* and *Christ the Redeemer;* predella: *Christ as Man of Sorrows,* c. 1415. Tempera and tooled gold on panel in a modern neo-Gothic frame; painted surface of the main panel 34½ × 20½″ (87.4 × 52 cm). The Toledo (Ohio) Museum of Art, Purchased with funds from the Libbey Endowment, Gift of Edward Drummond Libbey, no. 1945.30

FIG. 40.5 Infrared reflectographic detail of fig. 40.4, showing evidence of a transfer drawing around the mouth and nose of the Christ Child

Virgin of Humility and Angels, comes from Santa Maria degli Angeli.[7]

The popularity of the subject within Lorenzo Monaco's oeuvre is enormous: in Marvin Eisenberg's monograph (1989) twenty-four examples by either Lorenzo or his shop are illustrated. Lorenzo Monaco's first known example was for a full-scale altarpiece, dated 1404, for the parish church of San Donnino on the outskirts of Empoli.[8] This is one of the few paintings of the subject that can be found in a painting for a church altar;[9] Lorenzo Monaco's subsequent productions, in fact, are all on the scale of private pictures. Unfortunately, few original owners are known, although some undoubtedly were laypersons. Indeed, the *Virgin of Humility* in the Brooklyn Museum of Art (see fig. 40.6) has Medici arms, and the one in the Louvre has Alberti arms.[10]

The Johnson picture is one of several paintings of the Virgin of Humility by Lorenzo Monaco or his workshop in which variants of the same composition appear. Although Eisenberg (1989) has considered many of them, including the one in the Johnson Collection, to be productions of Lorenzo Monaco's workshop, the artist must have exerted considerable control over their execution. No two of the surviving examples are absolutely alike. Infrared reflectography of the Johnson picture helps us to understand how they were produced. Dotted lines found in the features of both faces, the hair, the scroll, and the lower border of the Virgin's mantle indicate that a pricked cartoon was used to transfer major elements of the design to the gessoed panel (figs. 40.1–40.3). As was common practice, many of the other folds in the Virgin's mantle were incised, as were all the outlines of the composition. This suggests that there may have been drawings only of isolated elements rather than a cartoon of the whole composition; some of these drawings could have also been used for other paintings.

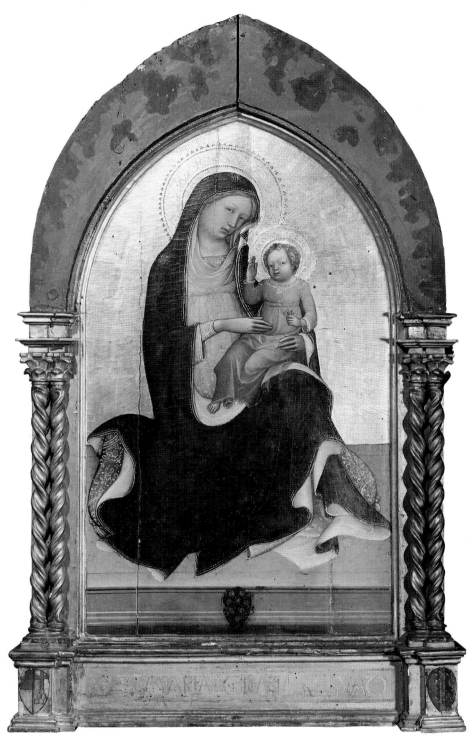

FIG. 40.6 Lorenzo Monaco. *Virgin of Humility*, c. 1415. Tempera and tooled gold on panel; 33¼ × 18¾″ (84.5 × 47.5 cm) (with inner molding). Brooklyn Museum of Art, Bequest of Frank L. Babbott, no. 34.842

FIG. 40.7 Detail of fig. 40.6, showing dots around the Virgin's eyes

Laurence B. Kanter (in Kanter et al. 1994, p. 305) related the origins of the composition in which the blessing Child holds a scroll to a *verre églomisé* in Turin that is dated 1408.[11] The same type is found in Lorenzo Monaco's paintings in Toledo (fig. 40.4) and Brooklyn (fig. 40.6). Infrared reflectography of the Toledo painting (fig. 40.5) shows that a pricked cartoon was also used to transfer the design. However, the variation in details of composition of that panel as well as its smaller dimensions indicate that the same cartoon was not used for both the Toledo and the Philadelphia paintings. The Brooklyn painting shows underdrawing in infrared reflectography, but no evidence of a *spolvero*. There are, however, dots on the paint surface—for example, around the Virgin's eyes—that might indicate some sort of design transfer (fig. 40.7).

The Johnson picture is more monumental in scale than Lorenzo Monaco's earlier depictions of the Virgin of Humility. For instance, compared with the painting in Toledo, the Child in the Johnson panel is larger and the scroll seems like an oversized detail instead of being neatly contained in the curve of the Child's drapery. However, in composition the Johnson picture is more modest. Whereas in all Lorenzo Monaco's other compositions of the subject the Virgin's mantle is open and the vertical folds of her undergarment are used as a foil for the mantle's curved folds, here the mantle is wrapped across her front. In other works, the undergarment was also frequently elaborated with a shell or mordant gilt design, an embellishment that the patron of the Johnson picture either did not want or could not afford.

The original composition of this group of paintings was conceived after the painter had come under the influence of Lorenzo Ghiberti. Stylistically, the sinuous Gothic lines and the interest in varying the fall of the drapery recall Ghiberti's first Florentine baptistery doors and his statues for the exterior

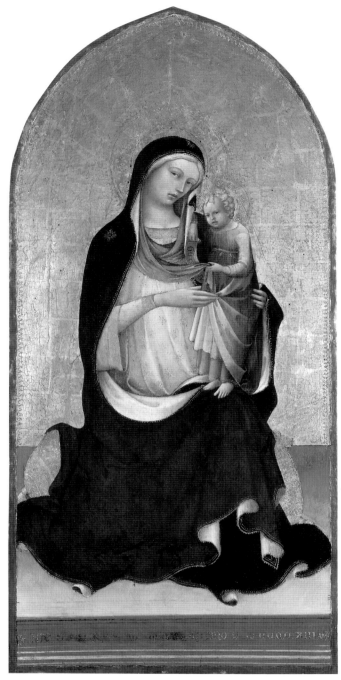

FIG. 40.8 Lorenzo Monaco. *Virgin of Humility*, 1413. Tempera and tooled gold on panel; 46 × 21⅞″ (116.8 × 55.3 cm). Washington, D.C., National Gallery of Art, Samuel H. Kress Collection, no. 514 (Kress 1293)

the National Gallery of Art in Washington, D.C. (fig. 40.8), where the position of the Virgin and the cascade of the drapery around her lap and the cushion are almost identical. The variations between the two are minimal. The Washington or a similar Virgin must have been the model for the Toledo, Brooklyn, and Johnson pictures. Another *Virgin of Humility* by Lorenzo, closely related to this group, is in the Louvre.[15] There the Child is also standing and the position of the Virgin's right hand and some of the drapery differs from those in the other pictures, but certain punch marks in the Virgin's halo are also found in the Johnson panel.

1. For its symbolism, see Battista di Gerio, plate 12 (JC cat. 12).
2. The most complete discussions are Meiss 1951, pp. 132–56; and Van Os 1969, pp. 75–142.
3. Martindale 1988, plates 104–5.
4. Berlin, Staatliche Museen, no. 1072; Boskovits 1988, plate 136.
5. Palermo, Galleria Regionale della Sicilia; Meiss 1951, fig. 129; and, without the predella, in *Bolaffi*, vol. 2, 1972, color repro. opposite p. 368.
6. Eisenberg 1989, pp. 56–57 n. 57.
7. C. 1370–75; Florence, Galleria dell'Accademia, no. 3161; Boskovits 1975, plate 79; Bonsanti 1987, color repro. p. 88.
8. Empoli, Museo della Collegiata; Eisenberg 1989, figs. 20–21; Berti and Paolucci 1990, color repro p. 79. On the suppressed church of San Donnino, see Bucchi 1916, p. 127.
9. The dated *Virgin of Humility and Saints* by Gregorio di Cecco, for the Tolomei chapel in the cathedral of Siena, is another unusual and early example (now Siena, Museo dell'Opera della Metropolitana; Chelazzi Dini, Angelini, and Sani 1997, color repro. p. 210).
10. No. M.I. 381; Eisenberg 1989, fig. 144.
11. Turin, Museo Civico d'Arte Antica, no. V.O. 152–3024; Eisenberg 1989, fig. 140.
12. Krautheimer 1982, plate 3.
13. Florence, Galleria dell'Accademia, no. 8458; Bonsanti 1987, color repro. p. 94; Eisenberg 1989, figs. 77–80, color plate 12 (detail).
14. Florence, Uffizi, no. 466; Eisenberg 1989, fig. 82.
15. No. M.I. 381; Eisenberg 1989, fig. 144.

Bibliography
Sirén 1909, p. 36; Berenson 1913, p. 8; Van Marle, vol. 9, 1927, p. 130; Berenson 1932, p. 301; Berenson 1936, p. 258; Johnson 1941, p. 9; Berenson 1963, p. 20; Sweeny 1966, p. 44; Fredericksen and Zeri 1972, p. 11; Boskovits 1975, p. 341; Fahy 1982, p. 241; Eisenberg 1989, pp. 88, 160, 170, fig. 148; Strehlke 1991a, p. 468; Laurence B. Kanter in Kanter et al. 1994, pp. 305–6, fig. 122; Philadelphia 1994, repro. p. 212 (workshop of Lorenzo Monaco)

niches of Orsanmichele, such as *Saint John the Baptist*.[12] Miklós Boskovits (1975, pp. 341, 350, 354) dated the Johnson and Toledo pictures relatively early— about 1405–10—whereas he placed the Brooklyn *Virgin of Humility* at about 1415–20. Everett Fahy (1982, p. 88), who was the first to note the connection between the three pictures, dated the Brooklyn panel about 1415. Eisenberg (quoted in Toledo 1976, p. 99) related the Toledo painting to Lorenzo Monaco's *Annunciation* altarpiece said to be from

the church of San Procolo in Florence, which he dated 1418–20.[13] More recently Eisenberg (1989) compared the Brooklyn picture, and by extension the ones in Toledo and Philadelphia, with the Virgin in the artist's *Adoration of the Magi* (c. 1420–22) from the high altar of Sant'Egidio in Florence.[14] Kanter (in Kanter et al. 1994, p. 306) thought that the Philadelphia panel was dated around 1420.

The closest analogy to the Johnson painting is provided by the *Virgin of Humility*, dated 1413, in

LORENZO VENEZIANO

VENICE, DATED WORKS 1356–72;
POSSIBLY STILL ACTIVE 1379

Lorenzo Veneziano dominated Venetian painting for two decades, but no records securely documenting his life exist. However, many signed and dated altarpieces allow for a reconstruction of his career. Lorenzo's first major surviving work was the altarpiece commissioned by the senator Domenico di Niccolò Lion in 1357–58 for the church of Sant'Antonio Abate in Venice.[1] It shows an artist rooted in Venice's Byzantine tradition and suggests that he may have trained with its major proponent, Paolo Veneziano. A decade later, in the altarpiece one Tomaso Proti commissioned from Lorenzo Veneziano for a chapel in the cathedral of Vicenza,[2] the basic imprint of Paolo Veneziano remains, but Lorenzo's figures have become more solid and statuesque. The expressiveness in the curve of their bodies is inherently Gothic, not Byzantine. The flesh tones tend to be ruddier, and highlights less sharp and stylized. The catalyst for this development must have been Guariento, a Paduan artist who had been hired to paint a *Coronation of the Virgin* for the Palazzo Ducale in Venice in 1365–66.[3] The huge mural represented a virtual declaration that Venetian art would move away from its conservative Byzantine traditions and adapt the Gothic styles already favored elsewhere. Lorenzo was the first native artist to take full account of this change. In an altarpiece[4] from the monastery of Santa Maria della Celestia in Venice, the playful Mother and Child, the complicated carving of the throne, and the music-making angels show that Lorenzo had thoroughly absorbed Guariento's message. This is further evident in the highly ornamented but realistic details that animate Lorenzo's late work, such as the flowered meadow carpet in the 1371 *Annunciation* altarpiece[5] in the Gallerie dell'Accademia in Venice. Lorenzo also abandoned Paolo Veneziano's elegant miniaturistic manner of painting narrative scenes. For example, in Lorenzo's predella of 1370 showing the life of the apostle Peter,[6] large figures dominate their surroundings and seem to control their own actions. It almost recalls the playfulness of the early thirteenth-century mosaics of the Old Testament in the narthex of San Marco in Venice.

One of Lorenzo's last-known works was for the Ufficio della Seta, the government office that controlled the silk trade.[7] Yet despite the painting's location there, the textiles it depicts are not as elaborate as those in some of Lorenzo's other paintings, which almost seem like advertisements for Venetian luxury products. However, Lorenzo was himself a good ambassador for Venetian painting on the terra ferma: in the 1350s he worked in Verona,[8] in 1366 he executed the above-mentioned Proti altarpiece for the cathedral in Vicenza, and in 1368 he painted the main altarpiece for the church of San Giacomo Maggiore in Bologna.[9]

A painter named Lorenzo Veneziano is documented as paying a tax to support Venice's war against Chioggia in 1379, but he may not be the same person as the present artist.

1. Venice, Gallerie dell'Accademia, inv. 5, cat. 10; Lucco 1992, fig. 54. The central pinnacle dates to the sixteenth century.
2. Lucco 1992, fig. 386 (color). The reproduction is cropped at the top.
3. Lucco 1992, figs. 51–53 (black-and-white and color).
4. Milan, Brera; Lucco 1992, fig. 64 (color).
5. Invs. 201–2, 217, 219–20; Lucco 1992, fig. 60 (color).
6. Reconstructed in Boskovits 1988, fig. 155.
7. The main panel showing Christ's Resurrection is now in Milan, Museo d'Arte Antica, Civiche Raccolte d'Arte, Castello Sforzesco (no. 300; Fiorio and Garberi 1987, color repro. p. 17). The side panels are in Venice, Gallerie dell'Accademia (invs. 203, 221, cats. 5, 5a; Lucco 1992, figs. 61–62 [color]).
8. A lost painting by Lorenzo once in Verona was dated 1356. In the same city there is also a crucifix (Lucco 1992, fig. 465 [color]) by him in San Zeno Maggiore and a mural (Pallucchini 1964, fig. 488) in Sant'Anastasia. The latter includes portraits of Cangrande II and his wife, Elisabeth Wittelsbach of Bavaria, which for dynastic reasons date it between 1358 and 1359.
9. Reconstructed by Carlo Volpe in Bologna 1967, pp. 93–99; and De Marchi 1995, p. 112. See also plate 41 below.

Select Bibliography
Lanzi 1809, Capucci ed., vol. 2, 1970, p. 9; vol. 3, 1974, pp. 9–10; Cavalcaselle and Crowe 1883–1908, vol. 4, 1887, pp. 286–96; Venturi 1907, pp. 23–29; Testi 1909, pp. 208–32; Van Marle, vol. 4, 1924, pp. 39–58; Berenson 1932, p. 306; Longhi 1947, pp. 80–85 (Longhi *Opere*, vol. 10, 1978, pp. 66–68); Berenson 1957, pp. 98–99; Pallucchini 1964, pp. 163–81; *Bolaffi*, vol. 7, 1975, pp. 29–31; Mauro Lucco in *Pittura* 1986, p. 593; Boskovits 1988, p. 101; Francesca d'Arcais in Lucco 1992, pp. 55–61; Mauro Lucco in Lucco 1992, pp. 529–30; Andrea De Marchi in *Italies* 1996, pp. 58–69; Francesca Flores d'Arcais in *Enciclopedia dell'arte medievale*, vol. 7, 1996, pp. 894–97; John Richards in *Dictionary of Art* 1996, vol. 19, pp. 683–84; Daniele Ferrara, Luisa Arrigoni, and Antonio Cassiano in Flores d'Arcais and Gentili 2002, pp. 200–209.

FIG. 41.1 Lorenzo Veneziano. *Birth of the Virgin*, c. 1368. Tempera and tooled gold on panel; 15 × 11½″ (38 × 29 cm). Last recorded Venice, private collection. Present location unknown. See Companion Panel A

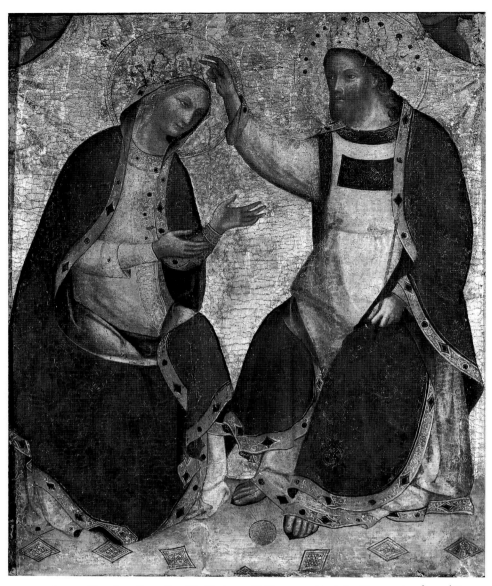

FIG. 41.2 Lorenzo Veneziano. *Coronation of the Virgin*, c. 1368. Tempera and tooled gold on panel; 30¾ × 24½″ (78 × 62 cm). Tours, Musée des Beaux-Arts, no. 63-2-14. See Possible Companion Panel A

PLATE 41 (JC CAT. 128)

Predella(?) panel of an altarpiece: *Marriage of the Virgin*

c. 1368

Tempera and gold on panel with horizontal grain; 7¾ × 10½″ (19.7 × 26.6 cm), painted surface 7½ to 7¾ × 10½″ (19.1 to 19.5 × 26.6 cm)

John G. Johnson Collection, cat. 128

INSCRIBED ON THE REVERSE: *128* (in red crayon); *JOHNSON COLLECTION/ PHILA.* (stamped twice in black ink)

TECHNICAL NOTES
Original tool marks on the reverse indicate that the panel, which has a convex warp, was not thinned.

Although the panel is trimmed on all four sides, the paint surface retains for the most part its original dimensions as indicated by the barbe of paint and margin of wood that survive at the bottom. The major change is that the trilobe top was cut to give the scene its present rectangular format. A barbe in the upper right outlining the blue tiled roof and the white wall indicates the edges of an original engaged frame. There is no barbe on the upper left, which may mean that originally a single frame enclosed two or more scenes or that the molding was not physically attached to the panel at this point. After the moldings were removed, the uncovered area was painted with illusionistic architecture and the uppermost corner gilded.

The paint surface is soiled and has scattered losses, scratches, and abrasions, and has lost modeling in some areas. The white highlights in the costumes and on the flesh are reasonably well preserved. The flesh is built up in strong vermilion tones. The areas between the halos of the rabbi, the Virgin, and the woman next to her are worn to the ground. A brown mordant survives in the trim of costumes, but the gilding is worn. The mordant gilding on the clasp and the ornament on the rabbi's costume and on the tassels of his stole is missing. In these areas the underlying paint also flaked away. The blue-gray mantle of the third figure from the right is old retouching that was painted over an original green color. There is no resoration record for this picture.

PROVENANCE
Unknown. It is suggested in the Comments that the painting came from San Giacomo Maggiore in Bologna.

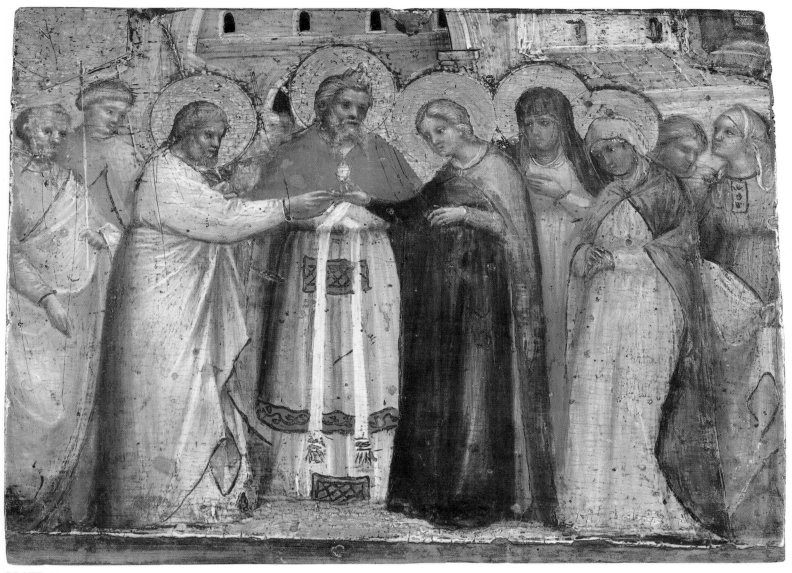

PLATE 41

COMMENTS

The scene takes place outside the temple in Jerusalem. A rabbi officiates while Joseph, carrying a flowering rod, gives a ring to the Virgin, who is accompanied by two maidservants and two haloed women—possibly Saints Anne and Elizabeth. Two men carrying rods are the Virgin's rejected suitors.

According to legend,[1] all of the Virgin's suitors had to place rods on the altar of the temple, with the one whose rod flowered winning her hand. The prototype for numerous representations of the subject—Giotto's mural of about 1305 of the *Marriage of the Virgin*[2] in the Arena chapel in Padua, showing the Virgin accompanied by three young women and the rejected suitors violently protesting Joseph's victory—was not followed in this picture, in which the suitors are depicted in quiet repose and the Virgin is accompanied by two older women.

When Bernhard Berenson (1913) published the picture as by an Umbro-Florentine artist he wrote, "Its author is inferior to the one last discussed (plates 75A–D [JC cats. 124–27]; now called Paolo

Schiavo), and nearer to Arcangelo di Cola, but on a much lower level still." Federico Zeri, on a visit to the Johnson Collection in 1959, suggested that the panel was by Giusto de' Menabuoi. He repeated this opinion in his and Burton Fredericksen's 1972 census of Italian paintings in North American collections, although Fredericksen attributed it to Lorenzo Veneziano instead. Andrea De Marchi (in Tamassia 1995, p. 69) compared the painting with another picture of the same subject by Lorenzo Veneziano, which was sold at auction in New York in 1931.[3]

Filippo Todini, in a letter dated La Torrita, March 14, 1986, wrote that the Johnson panel was certainly by Lorenzo Veneziano and that it might in fact be part of the same complex as the *Birth of the Virgin* (fig. 41.1), last recorded in a Venetian private collection. That panel retains its original height but has been cropped on the sides. Is is approximately 7¼" (18.3 cm) higher than the Johnson panel. Like the upper part of the *Birth of the Virgin,* the missing part of the Johnson panel was probably architecture.

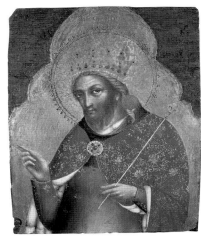

FIG. 41.3 Lorenzo Veneziano. *Saint Leonard,* c. 1368. Tempera and tooled gold on panel; 13½ × 10¾" (34.5 × 27.5 cm). Siracusa, Museo Nazionale di Palazzo Bellomo. See Possible Companion Panel B

FIG. 41.4 Lorenzo Veneziano. *Saint Bartholomew,* c. 1368. Tempera and tooled gold on panel; 18⅛ × 12½" (46 × 31.5 cm). Bologna, Pinacoteca Nazionale, no. 55 (222). See Possible Companion Panel C

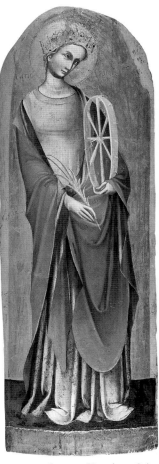

FIG. 41.5 Lorenzo Veneziano. *Saint Catherine of Alexandria,* c. 1368. Tempera and tooled gold on panel; 39 × 13" (99 × 33 cm). Milan, private collection. See Possible Companion Panel E

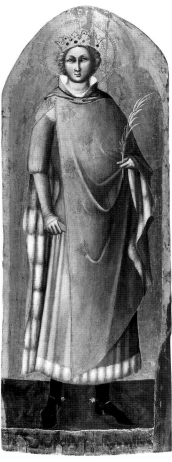

FIG. 41.6 Lorenzo Veneziano. *Saint Sigismund,* c. 1368. Tempera and tooled gold on panel; 39 × 14¼" (99 × 36 cm). Milan, private collection. See Possible Companion Panel D

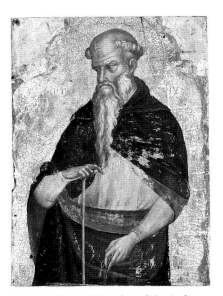

FIG. 41.7 Lorenzo Veneziano. *Saint Anthony Abbot,* c. 1368. Tempera and tooled gold on panel; 18⅛ × 12½" (46 × 31.5 cm). Bologna, Pinacoteca Nazionale, no. 56 (226). See Possible Companion Panel F

Unfortunately, nothing is known of the panels' original context. The height and the trilobe shape of the *Birth of the Virgin* would suggest that they were both part of a very large altarpiece, considering that the scene in Venice is approximately 4¾″ (12 cm) higher than Lorenzo's predella panels for the Saint Peter altarpiece.[4] While the Johnson and Venice panels were most likely from a predella of an altarpiece, they could have been narrative scenes in the upper part of an altarpiece, such as can be seen in Paolo Veneziano's mid-fourteenth-century altarpiece from the church of Santa Chiara in Venice.[5]

The inclusion of scenes from the Virgin's birth and marriage in the same predella implies that the altarpiece was dedicated to her. The most probable theme of the central panel would have been the Coronation of the Virgin. One known candidate suggests itself: the dispersed polyptych from the high altar of the Augustinian church of San Giacomo Maggiore in Bologna. Early sources record that its main subject was the Coronation of the Virgin and that it was completed and signed by Lorenzo Veneziano in May 1368. Stylistically, this date fits well with the predella panels, as they conform to the Gothic language that Lorenzo took up in the mid-1360s.

Since the mid-1340s the church had owned an altarpiece by Paolo Veneziano,[6] indicating that the friars had a taste for large, elaborate Venetian polyptychs. They were gathering funds for the new altarpiece by Lorenzo Veneziano at least as early as 1362, five years before he completed it.[7] In 1636 it was dismantled, and sometime later the central panel of the Coronation of the Virgin turned up in the Ercolani Collection in Bologna. At that point the panel measured approximately 52 × 30″ (132 × 76 cm)[8] and contained several inscriptions, including the artist's signature.[9] Carlo Volpe (in Bologna 1967, pp. 93–99) suggested that the *Coronation of the Virgin* now in Tours (fig. 41.2) is the same panel. It has no inscriptions and has been cut on all four sides.

Volpe estimated that the total altarpiece would have measured approximately 118″ (300 cm) in width. Since no complete description of the polyptych exists, other sections cannot be securely identified, but two panels by Lorenzo Veneziano in the Pinacoteca Nazionale of Bologna—*Saint Bartholomew* (fig. 41.4) and *Saint Anthony Abbot* (fig. 41.7)—are generally accepted to have been part of it. Although both have been cropped at the top and bottom, each is 12½″ (31.5 cm) wide, meaning that they were wide enough to have a panel the width of the Johnson piece with its lost framing under it. In addition, Andrea De Marchi (1995, p. 112; *Italies* 1996, p. 67) has suggested that two other panels in a private collection, showing Saint Sigismund (fig. 41.6) and Saint Catherine of Alexandria (fig. 41.5), might also have come from the altarpiece. Both have the same format and same type of punch work as the panels in Bologna.

Another panel showing Saint Leonard, now in Siracusa (fig. 41.3), has sometimes been associated with the two saints in Bologna (Cuppini 1949; Bologna 1951, pp. 27–28 [as Master of Arquà]; Palluchini 1964, p. 174). However, Carlo Volpe (in Bologna 1967, pp. 94–95) rejected this association. De Marchi (in *Italies* 1996, p. 67 and n. 5) suggested that it was part of the upper register of the altarpiece above Saint Bartholomew. This panel is not cropped and the inscription is at the top.

The appearance of the Lorenzo Veneziano can be reconstructed based on a near-contemporary copy by Giovanni da Bologna (fig. 41.8), made for the Bolognese church of San Marco before 1370, prior to that artist's move to Venice. This altarpiece still has its predella, which consists of panels with a trilobe arch just like the one on the panel in Venice and originally on the panel in Philadelphia; however, the Bologna predella scenes are much smaller in scale.

1. A popular account of the story appeared in Jacopo da Varazze's *Golden Legend* of c. 1267–77 (Ryan and Ripperger ed. 1941, p. 524).
2. Basile 2002, postrestoration color repro. p. 145.
3. New York, American Art Association, November 20, 1931, lot 53 (as Lorenzo Veneziano); Tamassia 1995, repro. p. 70. This panel retains elements of its original arched frame with a flame motif, showing that it was not part of a predella, but placed in the upper part of an altarpiece.
4. The predella panels are in the Staatliche Museen in Berlin (nos. 1140, 1140A, III.80). Each panel is approximately 10¼″ (26 cm) high. See Boskovits 1988, figs. 150–54, and the reconstruction in fig. 155.
5. Venice, Gallerie dell'Accademia, inv. no. 16; Lucco 1992, fig. 30. See also fig. 86.3. For a narrative pinnacle panel by Lorenzo Veneziano see n. 3 above.
6. Bologna 1967, figs. 57–64, plates XXVII–XXIV. It was once incorrectly identified as the polyptych by Lorenzo Veneziano (Filippini 1922).
7. In that year a Messer Facino, a merchant in Bologna who was originally from Lucca, left 175 lire to pay for the painting and other work in the church. He also expressed the desire to be buried near the tomb of his son, which was near the high altar. See Deanna Lenzi in Bologna 1967, p. 227.
8. "Longa piedi 3 oncie 3 e larga piedi 2" (Lanzi 1809, Capucci ed., vol. 2, 1970, p. 9).
9. He signed it: "mccclxviii Die IV Mensis Mai explicitum fuit hoc Opus pictum manu Laurencii de Veneciis" (1368 day 4 of the month of May, this work was painted by the hand of Lorenzo of Venice). In another inscription it is recorded that one Francesco di Giovanni Maragani of Bologna had paid for one-third of the expenses: "Franciscus quondam Domini Joannis Maragnani dedit pro anima Dominae Totae Tertiam partem totius precii" (Francesco of the late Don Giovanni Maragnani gave for the soul of Donna Tota one-third of the total cost). (An alternative reading is: "Franciscus q.d. Johannis Maragnani de Bononia fecit pro ancona ista tertiam partem totius pretii" [Francesco of the late Giovanni Maragnani of Bologna paid for this altarpiece one-third of the total price]).

Bibliography

Berenson 1913, p. 75 (Umbro-Florentine, toward 1425); Johnson 1941, p. 17 (Umbro-Florentine, c. 1425); Sweeny 1966, p. 78 (Umbro-Florentine, toward 1425); Fredericksen and Zeri 1972, pp. xxii, 94, 112 (Giusto de' Menabuoi or Lorenzo Veneziano); Philadelphia 1994, repro. p. 212; De Marchi 1995, pp. 112, 116 n. 5; Tamassia 1995, p. 69; Andrea De Marchi in *Italies* 1996, p. 67 n. 3

COMPANION PANEL for PLATE 41

A. Predella(?) panel of an altarpiece: *Birth of the Virgin*. See fig. 41.1

c. 1368

Tempera and tooled gold on panel; 15 × 11½″ (38 × 29 cm). Last recorded Venice, private collection. Present location unknown.

PROVENANCE: Unknown

SELECT BIBLIOGRAPHY: Pallucchini 1964, p. 176

POSSIBLE COMPANION PANELS for PLATE 41

A. Center panel of an altarpiece: *Coronation of the Virgin*. See fig. 41.2

c. 1368

Tempera and tooled gold on panel; 30¾ × 24½″ (78 × 62 cm) (cut on all sides). Tours, Musée des Beaux-Arts, no. 63-2-14

PROVENANCE: Bologna, church of San Giacomo Maggiore; Bologna, Scuola della Madonna della Consolazione, 1491–1616; Bologna, chapter house, church of San Giacomo Maggiore, 1616; Bologna, chapel of San Lorenzo, 1616–36; Bologna, Ercolani Collection, by the late 1700s; Paris and Tours, Octave Linet; Linet bequest to the Musée des Beaux-Arts, 1963

EXHIBITED: Paris 1956, cat. 49 (as Venetian school, close to Niccolò di Pietro); Tours 1996, cat. 11

SELECT BIBLIOGRAPHY: Laclotte 1964, pp. 186–87; Pallucchini 1964, p. 179; Carlo Volpe in Bologna 1967, pp. 93–99; Andrea De Marchi in *Italies* 1996, pp. 64–69; Tours 1998, p. 27

B. Pinnacle panel of an altarpiece: *Saint Leonard*. See fig. 41.3

c. 1368

Tempera and tooled gold on panel; 13½ × 10¾″ (34.5 × 27.5 cm). Siracusa, Museo Nazionale di Palazzo Bellomo

INSCRIBED: *LEONARVS* (Leonard)

PROVENANCE: Possibly Bologna, church of San Giacomo Maggiore; Siracusa, Archbishop Giuseppe Maria Antonelli; Siracusa, Museo Archeologico Nazionale, 1907

SELECT BIBLIOGRAPHY: Cuppini 1949; Bologna 1951, pp. 27–28; Pallucchini 1964, p. 174; Carlo Volpe in Bologna 1967, pp. 94–99; Andrea De Marchi in *Italies* 1996, p. 68 and n. 5; Andrea De Marchi in Barbera 1999, pp. 18–23

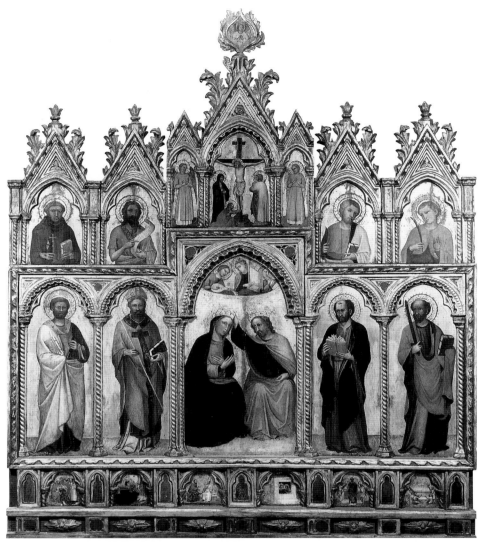

FIG. 41.8 Giovanni da Bologna (Bologna, active c. 1360–93). Altarpiece: *Coronation of the Virgin with Saints, the Crucifixion, and Stories of Saint Mark,* before 1370. Tempera and tooled gold on panel; 74 13/16 × 90 9/16″ (190 × 230 cm). From Bologna, church of San Marco. Bologna, Pinacoteca Nazionale, inv. 227

C. Lateral panel of an altarpiece: *Saint Bartholomew.* See fig. 41.4

c. 1368

Tempera and tooled gold on panel; 18⅛ × 12½″ (46 × 31.5 cm) (cut at top and bottom). Bologna, Pinacoteca Nazionale, no. 55 (222)

INSCRIBED: *BARTOLAME* (Bartholomew)

PROVENANCE: See Possible Companion Panel F

SELECT BIBLIOGRAPHY: See Possible Companion Panel F

D. Lateral panel of an altarpiece: *Saint Sigismund.* See fig. 41.6

c. 1368

Tempera and tooled gold on panel; 39 × 14¼″ (99 × 36 cm). Milan, private collection

INSCRIBED: *SIGISMU[NDUS]* (Sigismund)

PROVENANCE: See Possible Companion Panel E

SELECT BIBLIOGRAPHY: See Possible Companion Panel E

E. Lateral panel of an altarpiece: *Saint Catherine of Alexandria.* See fig. 41.5

c. 1368

Tempera and tooled gold on panel; 39 × 13″ (99 × 33 cm). Milan, private collection

INSCRIBED: *CATARINA* (Catherine)

PROVENANCE: Possibly Bologna, church of San Giacomo Maggiore; sold, New York, Sotheby's, March 4, 1973, lot 162 (as Venetian, 1340–50)

SELECT BIBLIOGRAPHY: De Marchi 1995, pp. 112, 116 n. 5; Andrea De Marchi in *Italies* 1996, p. 67

F. Lateral panel of an altarpiece: *Saint Anthony Abbot.* See fig. 41.7

c. 1368

Tempera and tooled gold on panel; 18⅛ × 12½″ (46 × 31.5 cm) (cut at top and bottom). Bologna, Pinacoteca Nazionale, no. 56 (226)

INSCRIBED: *ANTONIUS* (Antony)

PROVENANCE: Bologna, church of San Giacomo Maggiore; Bologna, Scuola della Madonna della Consolazione, 1491–1616; Bologna, chapter house, church of San Giacomo Maggiore, 1616; Bologna, chapel of San Lorenzo, 1616–36; Bologna, Accademia di Belle Arti

SELECT BIBLIOGRAPHY: Carlo Volpe in Bologna 1967, pp. 93–99; Bernardini et al. 1987, p. 37, nos. 55–56; Andrea De Marchi in *Italies* 1996, p. 67

MARTINO DA VERONA
(*Martino di Alberto*)

DIED 1412, VERONA

One of the few documented facts about the life of Martino di Alberto is that he wrote his will on September 27, 1412, and died shortly thereafter, as his estate was inventoried on October 20.[1] His birth date is not known, and other information about him is scarce. However, numerous murals by the artist can still be found in Veronese churches. The basis for the reconstruction of his career is the signed wall painting that frames the pulpit carved by Antonio da Mestre in San Fermo Maggiore. The pulpit was commissioned by the jurist Barnaba da Morano (died 1411) in 1396, and it is likely that the paintings date soon after.[2] Around 1410–11 Martino painted the murals (see fig. 42.4) that surround the tomb of the same patron.[3] At the time of Martino's death, his work on the tomb had still not been paid. Martino also signed a mural of the mass of Saint Gregory in the crypt of San Zeno.[4] These are his only documented works and the basis for other attributions.

One of Martino's earliest works is the mural, dated 1390,[5] in the lunette of the tomb of Federico Cavalli (died 1390) in the Cavalli family chapel in Sant'Anastasia in Verona.[6] Martino also executed several other votive murals in this same chapel, including a scene from the life of Saint Eligius.[7] In 1392 he painted the Pellegrini tomb in the same church.[8]

These murals demonstrate Martino's close relationship to Altichiero, who painted the principal scene in the Cavalli chapel in about 1369.[9] Martino frequently returned to the basic scheme of Altichiero's compositions, transforming that artist's figures and architectural settings into formulaic types that he repeatedly employed in projects for Veronese churches, quite a number of which survive.[10]

Although Evelyn Sandberg Vavalà has proposed the attribution of certain panels to Martino da Verona,[11] none of this activity has been documented. In addition, Gian Lorenzo Mellini (1969, figs. 1–2, 4, 7–24, 27–28) attributed to him the illuminations in the choir books of the cathedral of Salò.

1. Brenzoni 1972, p. 196.
2. Lucco 1989–90, figs. 201, 203 (color); Aliberti Gaudioso 1996, color repros. pp. 48–49.
3. Lucco 1989–90, figs. 202 (color) and 204 (black-and-white); Aliberti Gaudioso 1996, color repros. pp. 51–52.
4. Lucco 1989–90, fig. 205.
5. The date can also be read as 1397. See Fabrizio Pietropoli in Aliberti Gaudioso 1996, p. 87.
6. Lucco 1989–90, fig. 210 (color); Aliberti Gaudioso 1996, color repro. p. 87.
7. Lucco 1992, figs. 489–90; Aliberti Gaudioso 1996, repro. p. 88.
8. Aliberti Gaudioso 1996, repro. p. 85.
9. Lucco 1992, figs. 476–77 (color).

10. One of the murals (Aliberti Gaudioso 1996, color repros. pp. 63–64), in Santo Stefano, is dated 1396. The murals in the triumphal arch and apse of San Zeno were probably executed by Martino around 1399 or shortly after (Aliberti Gaudioso 1996, color repros. pp. 108–9). A large *Last Judgment* (Lucco 1989–90, fig. 208; Aliberti Gaudioso 1996, color repro. p. 100) and a *Coronation of the Virgin* (Aliberti Gaudioso 1996, color repros. pp. 98–99) in Sant'Eufemia are also by him, and his hand can be discerned as well in the choir of Santissima Trinità (Lucco 1989–90, fig. 207; Aliberti Gaudioso 1996, color repros. pp. 110–12).

The murals in Montéccia di Crosara (*Pittura* 1986, fig. 194; Aliberti Gaudioso 1996, color repros. pp. 132–34), near Verona, have been called a collaborative work of Martino and Battista da Vicenza, but as Fabrizio Pietropoli (in Aliberti Gaudioso 1996, pp. 132–34) has recently shown, the scenes attributed to Battista da Vicenza are probably by a follower of that artist.

11. Sandberg Vavalà (1929a, esp. p. 387, figs. 3–14; see also Richter 1936, plates 1–8, 10) attributed to Martino a series of paintings, now in the Princeton University Art Museum, showing scenes from the life of the Virgin and Christ (nos. 1935-13–20) as well as a *Virgin and Child Enthroned* (no. 1935-22). Frank Jewett Mather (in Richter 1936, p. 55) disputed her attribution of the scenes. Otherwise the pictures have not been well studied. The scene of the Annunciation (Richter 1936, plate 4) copies Martino da Verona's mural of the same subject in Santo Stefano, Verona, suggesting perhaps that it and the rest of the same series are by a follower.

Select Bibliography

Simeoni 1909, pp. 197–99; Gerola 1910; Simeoni 1910; Sandberg Vavalà 1926, pp. 218–58; Sandberg Vavalà 1929a, pp. 387–411; Raffaello Brenzoni in Thieme-Becker, vol. 24, 1930, pp. 182–83; Magagnato 1962, pp. 91–93; Maria Teresa Cuppini in Verona 1969, pp. 321–27; Mellini 1969; Brenzoni 1972, pp. 196–97; *Bolaffi*, vol. 7, 1975, pp. 242–43; Mauro Lucco in *Pittura* 1986, pp. 125–26, 636; Mauro Lucco in Lucco 1989–90, vol. 1, p. 356; Esther Moench Scherer in Lucco 1989–90, vol. 1, pp. 151–53; Magagnato 1991, pp. 68–69; Fabrizio Pietropoli in Aliberti Gaudioso 1996, pp. 48–52, 63–64, 85–89, 98–100, 108–12, 132–34, 356

PLATE 42 (JC INV. 3024)

ATTRIBUTED TO MARTINO DA VERONA

Section of an altarpiece: *Saint Eligius's Mother Told of Her Son's Future Fame*

c. 1397–1400

Tempera and tooled gold on panel with horizontal grain; 20 × 26 1/2 × 3/8″ (50.9 × 67.5 × 1.2 cm), painted surface 19 5/8 × 26 1/2″ (50.1 × 67.5 cm)

John G. Johnson Collection, inv. 3024

INSCRIBED ON THE REVERSE: *4492/ Andrea Orcagna* (in blue ink on a paper label); *ascribed* (in black crayon); *JOHNSON COLLECTION/ PHILA.* (stamped in black on the new cradle member); *3024* (in yellow crayon); *From Dr. P. Mund*[?] *Paris*[?] (in black crayon on an older cradle member); *3024* (in black crayon); *30[24]* (written twice in black crayon on older cradle members)

PUNCH MARKS: See Appendix II

TECHNICAL NOTES

Wood strips are attached to all four sides of the picture, but the now-thinned and -cradled original support appears to consist of two planks of horizontally grained wood, joined 3 5/8″ (9.4 cm) from the bottom. A crack runs across the center of the picture. The channel of an old but not necessarily original nail, driven in from the bottom, can be discerned in the lower left of the reverse.

The sides and the bottom edge of the panel seem to be cut by some amount, as there is no clear evidence of a barbe, nor, as in the upper part, does the apparently original gesso extend beyond the edges of the design. All of this suggests that the panel was installed in a separate frame within the altarpiece. When the altarpiece was disassembled, the gold background was painted blue and the architecture was extended in order to give the panel a rectangular shape. These repaintings were later removed, revealing the lobed top edge.

The principal lines in many of the details of the architecture were incised in the gesso before the painting was done. During execution, however, some of the windows were slightly repositioned. There is also a minor pentimento in the hand of the man standing beside the bed. Infrared reflectography did not reveal any visible drawing.

The condition of the paint surface varies. There is abrasion in the architecture, and retouching can be discerned along the center crack, in other isolated areas, in the corners, and along all the edges.

(text continues on page 240)

PLATE 42

FIG. 42.1 Attributed to Martino da Verona. *Birth of Saint Eligius*, c. 1397–1400. Tempera and tooled gold on panel; 19½ × 28″ (49.5 × 71.1 cm). Present location unknown. See Companion Panel A

FIG. 42.2 Attributed to Martino da Verona. *Consecration of Saint Eligius as Bishop of Noyon*, c. 1397–1400. Tempera and tooled gold on panel; 19⅛ × 26⅜″ (48.7 × 67 cm). Oxford, Ashmolean Museum, no. A732. See Companion Panel B

FIG. 42.3 Attributed to Martino da Verona. *Saint Eligius Heals the Leg of a Stolen Horse*, c. 1397–1400. Tempera and tooled gold on panel. Present location unknown. See Companion Panel C

The costumes of the figures before the bed are fairly well preserved, with individual strokes of the modeling evident.

On April 5, 1922, Hamilton Bell and T. H. Stevenson described the picture as having been "shockingly repainted." Although Stevenson replaced one slat of the old cradle with a cherry one and laid down flaking on the robe of the monk, it is not clear what else he did; at some point he may have removed some of the later repaintings. The picture had to be treated again on January 24, 1924. On November 28, 1962, Theodor Siegl faced the panel to prevent paint cleavage near the center split and lower section. This facing was removed by David Skipsey in May 1993.

PROVENANCE
John G. Johnson purchased this panel sometime after 1914. A notation on the back states that it came from a Dr. P. Mund, but the name and the city are hard to read, and no further information is available.

COMMENTS
The painting shows two episodes in the pregnancy of Saint Eligius's mother; both take place in bedrooms of the same building. On the left the mother dreams of an eagle, which is seen hovering over the roof. On the right servants gather around as she describes her dream to a bearded man dressed in black. According to the legend, he is a priest who interpreted the dream as foretelling the fame of the woman's unborn child, the future Saint Eligius.

Eligius (or in French, Eloi) was born about 588–90 in Chaptelet in the Haute-Vienne and died in 660.[1] A goldsmith in the service of the Merovingian kings of France, particularly Clothar II and Dagobert I, he was famous for his designs as well as his economical use of precious metals. He left goldsmithing, however, when he was appointed bishop of Noyon in 641 and began preaching throughout much of Flanders and northern France. An account of his life was written shortly after his death by his friend Saint Ouen, but Eligius's great popularity, especially outside France, dates to the late Middle Ages and invariably to the rise of guilds for goldsmiths and blacksmiths.

Roberto Longhi (1958) and Federico Zeri (1958b) recognized that the Johnson Collection's panel and three other extant panels—the *Birth of Saint Eligius* (fig. 42.1) in an unknown location; the *Consecration of Saint Eligius as Bishop of Noyon* (fig. 42.2) in the Ashmolean Museum in Oxford; and *Saint Eligius Heals the Leg of a Stolen Horse* (fig. 42.3) in an unknown location—were from the same altarpiece.

Longhi (1958, p. 64) described the artist as someone who "despite the fact he did not touch excellence, is among the most adept in the narrative language of Altichiero, and, in any case, is much better than Martino da Verona, Battista da Vicenza, and Jacopo da Verona." While Longhi and Zeri argued that the high quality of the pictures tended to set them apart from the work of any known

FIG. 42.4 Martino da Verona. Detail of the decoration of the tomb of Barnaba da Morano, c. 1410–11. Mural. Verona, church of San Fermo Maggiore

painter active in Verona in the late fourteenth century, they are in fact quite close to the style of Martino da Verona. Although it is difficult to attribute such panel paintings to him because all of his known works are wall paintings, certain similarities can be found. The architecture of the Johnson panel, for example, is very close to that found in the Annunciation[2] in the triumphal arch of Santissima Trinità in Verona, and the figural types—particularly in the panel in Oxford—can be found in the murals (fig. 42.4) surrounding the tomb of Barnaba da Morano in San Fermo Maggiore.[3]

The four surviving panels were undoubtedly part of a larger complex. As the scenes are much larger than most predella panels, they probably surrounded a large central image, which may have been of the saint or another religious figure. In all likelihood there were two scenes of Saint Eligius on each side. Several such altarpieces from the Veneto survive intact, including Simone da Cusighe's *Virgin of Mercy and Eight Stories from the Legend of Saint Bartholomew*, dated 1394, from the parish church of Sacile, near Pordenone (fig. 42.5). This is a particularly relevant example because its central image shows the Virgin of Mercy protecting members of a flagellant confraternity. It is likely that the present

altarpiece with the scenes of Saint Eligius, who was particularly revered by guilds of goldsmiths and blacksmiths, was also made for some type of corporation. In Verona both of these guilds celebrated his feast. The Guild of Blacksmiths (Arte dei Fabri o Ferrari) can be excluded, since it did not set up its altar to the saint in the Servite church of Santa Maria della Scala until 1588.[4]

The chapel of the Guild of Goldsmiths (Arte degli Orefici) was located in an oratory dedicated to Saint Eligius that was attached to the hospital church of Santa Maria della Misericordia. In 1397 a description of the property of this guild listed only a painted cross on the altar and no altarpiece.[5] In 1497 Antonio Badile was hired to paint two altarpieces for the goldsmiths, one with three saints and another of the Pietà with other figures; neither survives.[6] A new church was built in the 1520s. The two paintings by Badile were transferred here, and in 1610–12 Vincenzo Ligozzi seems to have painted an altarpiece of Saint Eligius with a predella showing the saint making a gold chalice.[7] The earlier church may have also had an altarpiece of Saint Eligius, although one does not appear in the published documents. It could have been made after 1397 and removed or destroyed when the new church was built.

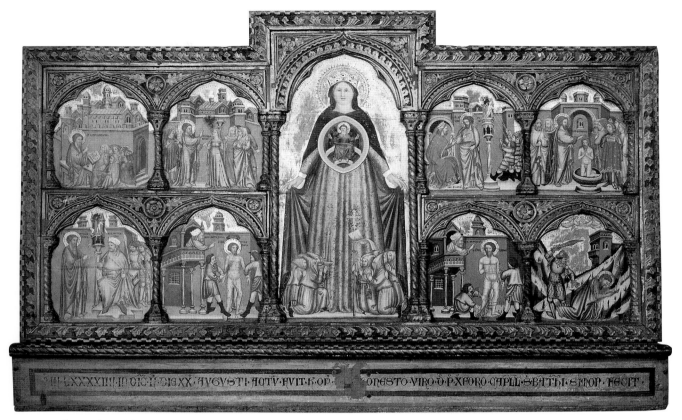

FIG. 42.5 Simone da Cusighe (Belluno, first documented 1386; died before 1417). Altarpiece: *Virgin of Mercy and Eight Stories from the Legend of Saint Bartholomew,* 1394. Tempera and tooled gold on panel; with original frame 34⅝ × 71¾″ (88 × 182 cm). From Sacile (Pordenone), parish church. Venice, Gallerie dell'Accademia, inv. 548, cat. 18; on deposit, Galleria Giorgio Franchetti alla Ca' d'Oro

Eligius was a popular saint in Verona and is found in the calendars of Veronese liturgical manuscripts.[8] At least one scene from his life was depicted in an anonymous mid-fourteenth-century mural cycle from the destroyed church of Santa Felicita, fragments of which are in the Museo degli Affreschi di G. B. Cavalcaselle.[9] And one of Martino da Verona's murals of about 1390 in the Cavalli family chapel in Sant'Anastasia shows Eligius as a blacksmith.[10] Other Veronese depictions of the saint are published by George Kaftal and Fabio Bisogni (1978, col. 273).

1. See Pierre Villette in *Bibliotheca sanctorum,* vol. 4, 1964, cols. 1064–70.
2. Lucco 1989–90, fig. 207; Aliberti Gaudioso 1996, color repros. pp. 110–12.
3. See in particular Lucco 1989–90, fig. 202 (color).
4. Biancolini, vol. 8, 1771, p. 195; Scarcella 1948, p. 9.
5. Biadego 1890, pp. 38–39, document II.
6. Biadego 1890, pp. 13, 43–44, document VI.
7. Biadego 1890, pp. 28, 53–54, document XI.
8. Franco Segala in Verona 1988, p. 451.
9. Lucco 1992, fig. 445 (color); Aliberti Gaudioso 1996, color repro. p. 88.
10. Maria Teresa Cuppini in Verona 1970, pp. 76–77, cat. 18, figs. 33–34; Anna Malavolta in Verona 1988, pp. 387–88, repro. p. 388; Lucco 1992, figs. 489–90.

Bibliography
Johnson 1941, p. 6 (Florentine, early fifteenth century); Longhi 1958, pp. 64–65 (Longhi *Opere,* vol. 10, 1978, pp. 131–32); Zeri 1958b, fig. 18; Sweeny 1966, p. 79, repro. p. 108 (Veronese, late fourteenth century); Fredericksen and Zeri 1972, p. 249 (Veronese, fourteenth century); Lloyd 1977, pp. 1–2; Kaftal and Bisogni 1978, col. 276, fig. 329; Philadelphia 1994, repro. p. 175 (follower of Altichiero)

COMPANION PANELS for PLATE 42

A. Section of an altarpiece: *Birth of Saint Eligius.* See fig. 42.1

c. 1397–1400

Tempera and tooled gold on panel; 19½ × 28″ (49.5 × 71.1 cm). Present location unknown

PROVENANCE: According to a letter from G. L. Taylor of the Ashmolean Museum to Barbara Sweeny, dated Oxford, November 16, 1956, the panel had been brought to the Ashmolean in 1953 by a Miss Arundale, who thought her father had bought it in the 1890s. It was in a Christie's sale in London in April 1935 but failed to make its reserve. She later sold it at the Montpelier Galleries in London, June 14, 1956, lot 105 (as Tomaso da Modena).

SELECT BIBLIOGRAPHY: Longhi 1958; Zeri 1958b; Kaftal and Bisogni 1978, col. 276

B. Section of an altarpiece: *Consecration of Saint Eligius as Bishop of Noyon.* See fig. 42.2

c. 1397–1400

Tempera and tooled gold on panel; 19⅛ × 26⅜″ (48.7 × 67 cm). Oxford, Ashmolean Museum, no. A732

PROVENANCE: Given by the daughters of J. R. Anderson to the Ashmolean Museum, 1947

SELECT BIBLIOGRAPHY: F. Bologna 1955, p. 37; Zeri 1958b; Lloyd 1977, pp. 1–2; Kaftal and Bisogni 1978, col. 280

C. Section of an altarpiece: *Saint Eligius Heals the Leg of a Stolen Horse.* See fig. 42.3

c. 1397–1400

Tempera and tooled gold on panel. Present location unknown

PROVENANCE: In a letter dated Rome, October 29, 1956, Federico Zeri told Barbara Sweeny that this panel was "years ago on sale in North Italy."

SELECT BIBLIOGRAPHY: Longhi 1958; Zeri 1958b; Kaftal and Bisogni 1978, col. 280

Martino di Bartolomeo

Son of the goldsmith Bartolomeo di Biagio, Martino di Bartolomeo was registered in the rolls of the Sienese painters' guild that were begun in 1389.[1] Nothing, however, is known of his early activity in Siena. Like another Sienese artist, Taddeo di Bartolo (q.v.), Martino di Bartolomeo found work in Lucca and Pisa. He painted a series of illuminations in the choir books of the cathedral of Lucca,[2] which for internal iconographic reasons must date after 1391. They probably are close in date to the mural cycle in the church of San Giovanni Battista in Cascina, near Pisa, which the artist signed in 1398.[3] In the first years of the new century, he collaborated with Giovanni di Pietro da Napoli on three altarpieces now in the Museo Nazionale di San Matteo in Pisa.[4]

Martino returned to Siena about 1405, when many commissions for the decoration of the interior of the cathedral became available. He was contracted to paint the murals in the chapels of Saints Crescenzio and Savino, but none of this work survives. Soon after, in 1407, he painted the vaults of the Sala della Balìa in the Palazzo Pubblico.[5] At this time he became a permanent resident of Siena, and his activities are well documented: besides painting, he took on restoration work, polychromed sculpture, and gilded objects such as the clocks and the sphere of the bell tower of the Palazzo Pubblico. In addition, he held elected and appointed political offices, including, in 1420, a year's term as keeper of the castle of Monte Agutolo. The many surviving contracts related to property sales and acquisitions show that Martino thrived financially.

In 1425 the artist painted an altarpiece for the chapel of the Guild of Butchers (Arte dei Carnaioli) in the church of Sant'Antonio in Fontebranda.[6] Its center section was a wood statue of Saint Anthony Abbot by Francesco di Valdambrino,[7] which Martino polychromed, as he did other important sculptures: the *Mourning Virgin and Saint John* by Domenico di Niccolò dei Cori for the chapel of the Crucifix in the Siena cathedral in 1415,[8] and the *Annunciation* by Jacopo della Quercia for the *collegiata* in San Gimignano in 1426.[9] Martino and Jacopo enjoyed an intimate relationship and served as godfathers for each other's children. Yet despite Martino's contacts with Jacopo and other progressive sculptors in Siena, his own style was conservative and changed little over three decades, staying particularly close to that of Taddeo di Bartolo. Although we know that those two artists had an acrimonious relationship, with Martino losing a legal battle with Taddeo in 1412, they may have known each other during their early years in Lucca and Pisa.

1. He was probably added to the list several years after 1389, as he was the sixty-first painter registered. The year of each enrollment is not recorded (Fehm 1972).
2. Filieri 1998, fig. 143, repros. pp. 208–14 (color and black-and-white).
3. Illustrated in Cristiani Testi 1978.
4. Carli 1974, figs. 76–77, 79.
5. Cairola and Carli 1963, figs. 106–10.
6. The altarpiece is reconstructed in Neri Lusanna 1981, pp. 330–31.
7. Now in San Domenico in Siena; Siena 1987a, color repro. p. 149.
8. Later moved to San Pietro a Ovile in Siena and now on deposit in the Museo dell'Opera della Metropolitana; Siena 1987a, color repro. p. 117.
9. Siena 1987a, color repro. p. 157.

Select Bibliography
Van Marle, vol. 3, 1924, pp. 582–92; Kurt Weigelt in Thieme-Becker, vol. 24, 1930, pp. 180–81; Berenson 1932, pp. 333–34; Brandi 1949, pp. 26–28; Berenson 1968, pp. 245–47; Bellosi 1975, pp. 57–58; *Bolaffi*, vol. 7, 1975, pp. 243–44; Cristiani Testi 1978; Carli 1981, pp. 253–56; Marco Ciatti in Siena 1982, pp. 304–5; Zeri 1986; Molten 1992; Ada Labriola in Filieri 1998, pp. 202–12

PLATE 43A (PMA 1945-25-120C)

Predella panel of an altarpiece: *Saint Barnabas Donating His Wealth to the Apostles John the Evangelist, James the Less, and Peter*

c. 1410

Tempera, silver, and tooled gold on panel with horizontal grain; overall 10⅝ × 15⅞ × 1¼″ (27 × 40.2 × 3 cm); addition on left ¼″ (0.5 cm); addition at top ⅛″ (0.2 cm); painted surface 9⅛ × 10¼″ (23 × 26 cm)

Philadelphia Museum of Art. Purchased from the George Grey Barnard Collection with Museum funds. 1945-25-120c

INSCRIBED ON THE REVERSE: *251* (in dark ink on a sticker)

PUNCH MARKS: See Appendix II

EXHIBITED: Philadelphia Museum of Art, John G. Johnson Collection, Special Exhibition Gallery, *From the Collections: Paintings from Siena* (December 3, 1983–May 6, 1984), no catalogue

TECHNICAL NOTES
The panel retains its original thickness with saw marks on the reverse. It was cropped at the top and left edges, outside the design area, and the missing wood was later replaced by additions. There are remnants of a border of punched rings in the gold at the top of the picture surface. The picture has a gesso barbe on all four sides. There were once applied frame moldings on the left, top, and bottom; as in the other panels, remnants of mostly corroded silver along the edges indicate that the moldings were silver. In the right margin there is evidence of a punched silver decoration, visible with a microscope, that may have been part of a pastiglia design used to divide the scenes of the predella. Silver was also used for the bowls of coins, one of which holds silver and the other gold.

An old loss in James the Less's hand was caused by a blow from a sharp object. The left edge of the picture is badly damaged, and the left side of the figure of John is repainted. The paint overall is moderately abraded. Underdrawing is visible with the naked eye in some of the draperies.

PROVENANCE
See plate 43D (PMA 1945-25-120d)

COMMENTS
In a courtyard the apostle Peter is distributing alms to three beggars and a woman with a child. Kneeling in front of them is Barnabas, a bearded old man, who offers bags and bowls of money to the two other apostles. Gertrude Coor (1961, p. 58) identified the apostle in the center as James the Less, first bishop of Jerusalem, because of his physical similarity to Christ, for the two were said to be brothers. The other apostle is the Evangelist John.

The scene comes from the Acts of the Apostles (4:36–37): "And Joseph, who, by the apostles, was surnamed Barnabas, (which is, by interpretation, the son of consolation,) a Levite, a Cyprian born, Having land, sold it, and brought the price, and laid it at the feet of the apostles."

For further comments, see plate 43D (PMA 1945-25-120d).

Bibliography
See plate 43D (PMA 1945-25-120d)

PLATE 43B (PMA 1945-25-120B)

Predella panel of an altarpiece: *Saint Barnabas Preaching*

c. 1410

Tempera, silver, and tooled gold on panel with horizontal grain; overall 10⅝ × 15¾ × 1⅜″ (27 × 39.9 × 3.3 cm); addition at top ¾″ (1.8 cm); painted surface 9⅛ × 10¼″ (23 × 26 cm)

Philadelphia Museum of Art. Purchased from the George Grey Barnard Collection with Museum funds. 1945-25-120b

INSCRIBED ON THE REVERSE: *252* (in dark ink on a sticker)

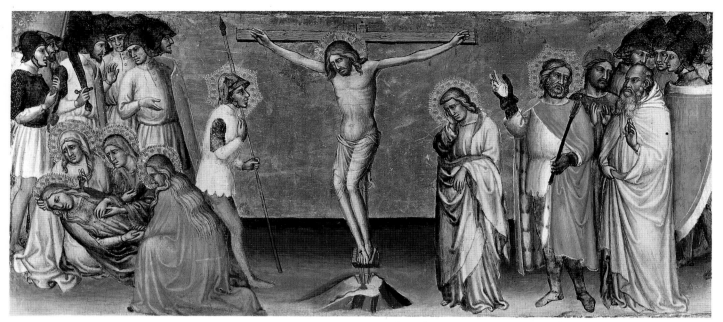

FIG. 43.1 Martino di Bartolomeo. *Crucifixion*, c. 1410. Tempera and tooled gold on panel; 9¼ × 20¾″ (24 × 53 cm). El Paso (Texas) Museum of Art, Samuel H. Kress Collection, no. 61.1.7/K110. See Companion Panel A

TECHNICAL NOTES

The panel was cropped at the top, outside the design area, and a strip of wood was added to compensate for the loss. The painting has a gesso barbe on all four sides. There were once applied frame moldings on the top and bottom, and in the left margin there is evidence of a punched silver decoration, visible with a microscope, that may have been part of a pastiglia design used to divide the scenes of the predella.

In the area behind the saint, a large section comprising the heads of the figures was lost and repainted in the late seventeenth or early eighteenth century. Underdrawing is visible with the naked eye in some of the draperies.

PROVENANCE

See plate 43D (PMA 1945-25-120d)

COMMENTS

Barnabas preaches to an audience seated on the floor of a hall. Another group of men sits listening behind the saint.

The audience is segregated by sex, which was common at public sermons in the fifteenth century, as can be seen in depictions of Saint Bernardino preaching in the squares of Siena.[1]

For further comments, see plate 43D (PMA 1945-25-120d).

1. See those by Sano di Pietro (q.v.) showing the saint's sermon in the Campo and in front of the church of San Francesco, now on deposit in the Museo dell'Opera della Metropolitana in Siena (Christiansen, Kanter, and Strehlke 1988, p. 41, figs. 5–6).

Bibliography
See plate 43D (PMA 1945-25-120d)

PLATE 43C (PMA 1945-25-120a)

Predella panel of an altarpiece: *Saint Barnabas Curing a Cripple and a Possessed Woman*

c. 1410

Tempera, silver, and tooled gold on panel with horizontal grain; overall 11 × 15¾ × 1¼″ (27.8 × 40 × 3 cm); addition at top ¾″ (1.8 cm); painted surface 9⅛ × 9⅞″ (23 × 25 cm)

Philadelphia Museum of Art. Purchased from the George Grey Barnard Collection with Museum funds. 1945-25-120a

INSCRIBED ON THE SCROLL: *I*[in red]*n principio erat v*[erbum]/ *et verbum erat ap*[ud Deum] (John 1:1: "In the beginning was the Word, and the Word was with God"); ON THE REVERSE: *250* (in dark ink on a sticker); *Nº 1515/ Nº. 491153/?*

TECHNICAL NOTES

The panel retains its original thickness with saw marks on the reverse. It was cropped at the top, outside the design area, and a strip of wood was added to compensate for the loss. The painting has a gesso barbe on all four sides. There were once applied frame moldings on the top and bottom, and in the right and left margins there is evidence of a punched silver decoration, visible with a microscope, that may have been part of a pastiglia design used to divide the scenes of the predella. As the left margin of this scene and the right margin of the preceding scene in the predella (plate 43B) show evidence of punch marks, an applied frame may have separated the center panel of the Crucifixion (fig. 43.1) from the pairs of scenes on either side.

The picture shows signs of having been in a fire, as there are burn marks at the top, above the central building, and in the addition at the top. This panel was badly overcleaned at an unrecorded date. Before that cleaning its condition was presumably comparable to that of the other scenes in the predella. The cleaning, however, broke through many thinner passages of paint and removed surface detail, such as the window by Saint Barnabas's halo and the mordant gilt details. Underdrawing is visible with the naked eye in some of the draperies.

PROVENANCE

See plate 43D (PMA 1945-25-120d)

COMMENTS

On a city street Barnabas, accompanied by two men, miraculously cures a crippled man who kneels in prayer and a possessed woman who is held back by a man. Another cripple, supported by hand crutches, awaits his turn, while three other men look at the miracles with amazement. The *Golden Legend* relates that in Cyprus Barnabas cured the sick by laying the Gospel of Saint Matthew on their heads.[1] Here, however, he holds a scroll with the incipit from the Gospel of John.

For further comments, see plate 43D (PMA 1945-25-120d).

1. Jacopo da Varazze c. 1267–77, Ryan and Ripperger ed. 1941, p. 307.

Bibliography
See plate 43D (PMA 1945-25-120d)

(text continues on page 246)

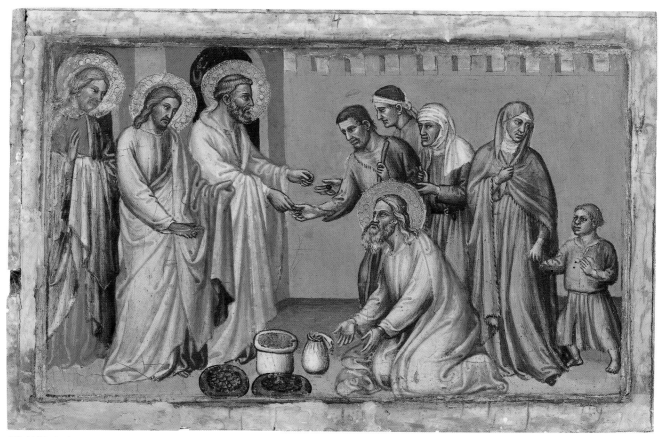

PLATE 43A

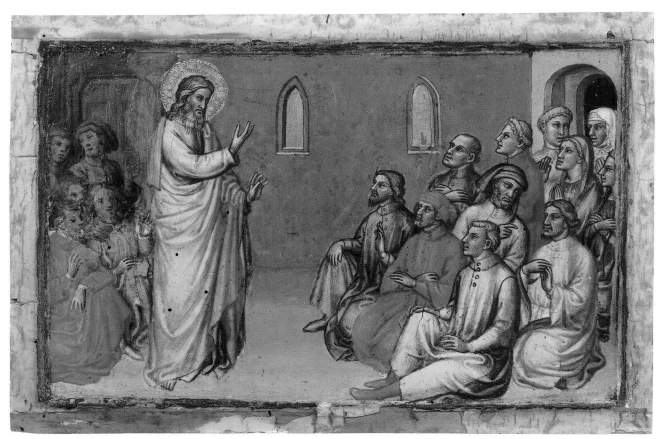

PLATE 43B

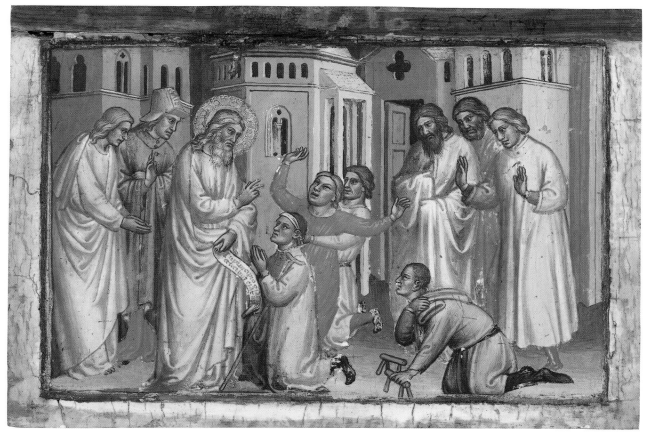

PLATE 43C

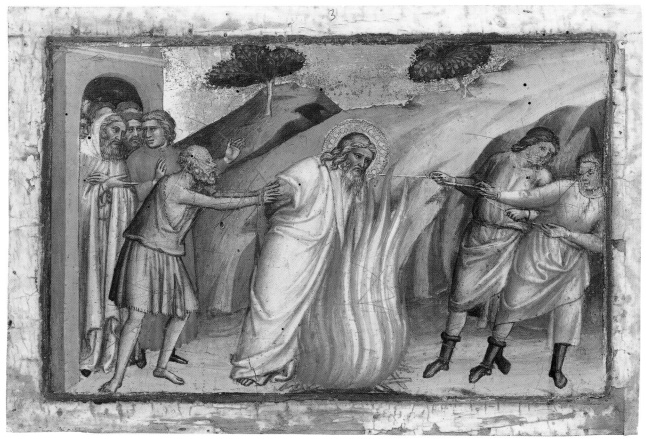

PLATE 43D

Predella panel of an altarpiece: *Saint Barnabas Being Brought to the Stake*

c. 1410

Tempera, silver, and tooled gold on panel with horizontal grain; overall 11⅛ × 15⅞ × 1⅜″ (28 × 40.3 × 3.3 cm); addition at top ⅞″ (2.1 cm); painted surface 9¼ × 10¼″ (23.5 × 26 cm)

Philadelphia Museum of Art. Purchased from the George Grey Barnard Collection with Museum funds. 1945-25-120d

INSCRIBED ON THE REVERSE: *253* (in dark ink on a sticker)

TECHNICAL NOTES

The panel was cropped at the top, outside the design area, and a strip of wood was added to compensate for the loss. There are remains of a border of punched rings in the gold at the top of the picture surface. The picture has a gesso barbe on all four sides. There were once applied frame moldings on the right, top, and bottom, and in the right margin there is evidence of a punched silver decoration, visible with a microscope, that may have been part of a pastiglia design used to divide the scenes of the predella.

Scratches have disfigured the three executioners and the fire. The executioners also have had their eyes gouged out. The paint surface is also generally quite abraded, and underdrawing is visible with the naked eye in some of the draperies.

PROVENANCE

Florence, Elia Volpi; sold, New York, American Art Association, April 2, 1927, lots 367–70 (as Spinello Aretino); purchased, George Grey Barnard; purchased by the Museum from Barnard's estate, 1945

COMMENTS

Barnabas's martyrdom occurs outside a city gate (the traditional place for public executions). A group of men looks on from the gate as two executioners pull the elderly saint by a rope into a blazing fire, while another pushes him in.

This and the other three Johnson panels are part of a predella of an altarpiece (see fig. 43.2). The predella's center section, in the El Paso (Texas) Museum of Art (fig. 43.1), depicts the Crucifixion. It also belonged to Elia Volpi and was sold at the same sale in New York as the Museum's panels. In 1961 Gertrude Coor identified the altarpiece to which the predella belonged as the *Virgin and Child Enthroned with Saints Lawrence, Barnabas, Augustine, and Ansanus* in the Pinacoteca Nazionale of Siena (fig. 43.3), because of the presence of Saint Barnabas in the altarpiece. The width of the center section of the altarpiece (approximately 24″ [61 cm]) corresponds to that of the *Crucifixion* and the width of the lateral panels (each approximately 16⅛″ [41 cm]) to that of each of the other scenes in the predella.

George Kaftal (1952) first identified the predella's subject as the legend of Saint Barnabas and ordered the panels accordingly. This sequence (as shown here), however, contradicts the order of their lot numbers in the Volpi sale catalogue and their accession numbers in the Philadelphia Museum of Art, but an examination of the wood grain confirms Kaftal's observations and suggests that they were painted on a single plank that was cut into individual panels when the altarpiece was disassembled.

Kaftal and Coor noted that Barnabas was rarely represented outside Florence. He was revered in that city because the Florentine victories over the Sienese town of Colle di Val d'Elsa in 1269 and over the Aretines at the battle of Campaldino in 1289 both occurred on June 11, his feast day. The olive branch he holds in several Florentine depictions seems to refer to these events. This attribute, which the saint also holds in Martino di Bartolomeo's altarpiece, would not, however, have carried the same meaning in Siena. The altarpiece thus may well have come from a church in Florentine territory, such as Colle di Val d'Elsa, where devotion to Barnabas could have been related to the thirteenth-century Florentine victory. Although Colle was then Florentine, by the early nineteenth century, when the altarpiece entered the collections of the Pinacoteca Nazionale in Siena, it had been assigned to the administrative province of Siena.[1] However, the olive branch may well have had other, nonpolitical meanings, and Martino's altarpiece may have once been in a Sienese church.

The painting probably does not date much after the artist's mural cycle of 1407 in the Sala della Balìa in the Palazzo Pubblico in Siena[2] or his altarpiece of 1408 consisting of a *Virgin and Child* in a private collection[3] and *Saints James the Great, Catherine of Alexandria, Mary Magdalene, and Ansanus* in the Pinacoteca Nazionale of Siena.[4] Coor (1961b) proposed a date of about 1410 for the altarpiece and Saint Barnabas predella, whereas Piero Torriti (1977) placed them almost a decade later.

1. Other paintings from suppressed churches and convents of Colle di Val d'Elsa also entered the Pinacoteca Nazionale. See, for example, *The Virgin and Child with Saints* (no. 7), attributed to Guido da Siena (Torriti 1977, fig. 10 [color]).
2. Cairola and Carli 1963, figs. 106–10.
3. Berenson 1968, plate 437.
4. No. 120; Torriti 1977, figs. 252–53 (color).

Bibliography
Weinberger 1941, p. 30, no. 120, plate 37; Kaftal 1952, cols. 129, 133, figs. 138–41; Coor 1961b; Philadelphia 1965, p. 35; Shapley 1966, p. 65; Berenson 1968, p. 246, plate 440; Fredericksen and Zeri 1972, p. 122; Torriti 1977, pp. 216–17; Marco Ciatti in Siena 1982, p. 305; Molten 1992, pp. 197–203, figs. 46–49

COMPANION PANELS for PLATES 43A–D

A. Predella panel of an altarpiece: *Crucifixion*. See fig. 43.1

c. 1410

Tempera and tooled gold on panel; 9¼ × 20¾″ (24 × 53 cm). El Paso (Texas) Museum of Art, Samuel H. Kress Collection, no. 61.1.7/K110

PROVENANCE: Florence, Elia Volpi; sold, New York, American Art Association, March 31–April 2, 1927, lot 366; Rome, Contini Bonacossi Collection; New York, Samuel H. Kress Foundation, acquired 1930; given by the Samuel H. Kress Foundation to the El Paso Museum of Art, 1961

SELECT BIBLIOGRAPHY: Coor 1961b, p. 58; Shapley 1966, p. 65; Molten 1992, pp. 159–60

B. Main section of an altarpiece: *Virgin and Child Enthroned with Saints Lawrence, Barnabas, Augustine, and Ansanus.* See fig. 43.3

c. 1410

Tempera and tooled gold on panel; 65⅜ × 94½″ (166 × 240 cm). Siena, Pinacoteca Nazionale, no. 160

INSCRIBED ON THE VIRGIN'S HALO: + *AVE MATER CRISTI SENPER* ("Hail Mother of Christ Always"); ON CHRIST'S HALO: *EG/ O SUM/ VIA [ET] VE/ RI[TATIS]* (John 14:6: "I am the way, and the truth"); ON CHRIST'S SCROLL: *Da me benedetto sempre [sia] chi con buon cuore dice Ave [Maria]* ("He who says with a good heart Ave [Maria] shall be always blessed by me")

PROVENANCE: Entered the Pinacoteca Nazionale between 1816 and 1842. Its former location is not recorded.

SELECT BIBLIOGRAPHY: Torriti 1977, pp. 216–17; Molten 1992, pp. 229–32

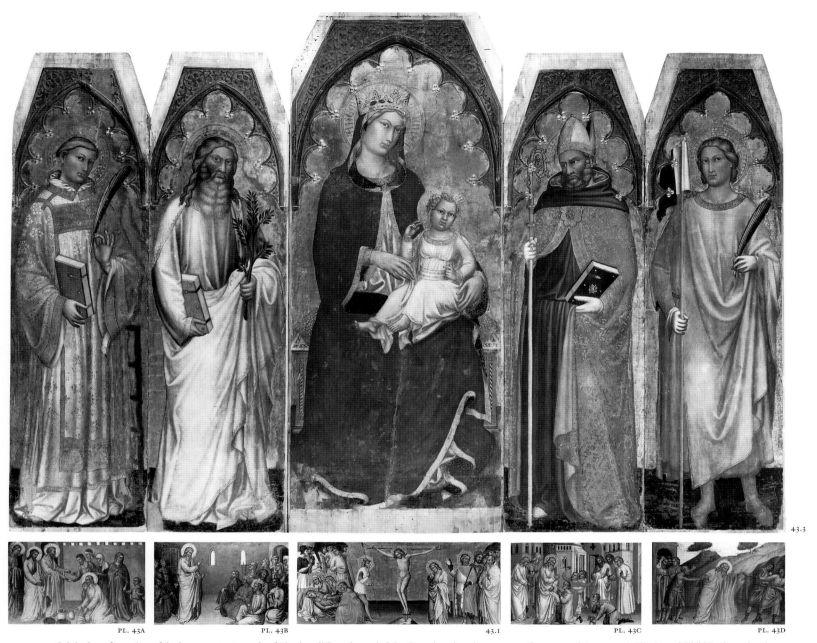

PL. 43A PL. 43B 43.1 PL. 43C PL. 43D

FIG. 43.2 Original configuration of the known extant panels of Martino di Bartolomeo's Saint Barnabas altarpiece, c. 1410. Center panel (FIG. 43.3): *Virgin and Child Enthroned with Saints Lawrence, Barnabas, Augustine, and Ansanus.* Tempera and tooled gold on panel; 65⅜ × 94½″ (166 × 240 cm). Siena, Pinacoteca Nazionale, no. 160. See Companion Panel B. Predella (left to right): PLATES 43A, 43B, FIG. 43.1, PLATES 43C, 43D

MASACCIO
(Tommaso di Ser Giovanni)

SAN GIOVANNI IN VALDARNO (THEN SAN
GIOVANNI IN ALTURA), NEAR FLORENCE,
DECEMBER 21, 1401–C. 1428–29, ROME

Masaccio is first recorded as a painter in Florence in 1418, although it is not known with whom he trained. By January 1422 he had matriculated in the painters' guild in that city. His first known work is an altarpiece dated April 23, 1422,[1] for the rural church of San Giovenale at Cascia di Reggello in the Valdarno.

Sometime in 1422–23 Masaccio collaborated with Masolino (q.v.) on the Carnesecchi altarpiece in Santa Maria Maggiore in Florence[2] and on the *Sant'Anna Metterza* altarpiece in Sant'Ambrogio of the same city.[3] For the former Masaccio executed the predella, and for the latter he painted the Virgin and Child and some of the angels, while Masolino painted Saint Anne and the other angels. It is not known why the two divided responsibilities in such a fragmentary way on the same panel. Their partnership is not recorded in documents, but, interestingly, their collaboration on these altarpieces may have been necessitated by the fact that Masolino had only just moved to Florence around September 1422 and had not yet enrolled in any professional organization. The *Sant'Anna Metterza* has also been dated to 1424–25, based on comparisons with Masolino's 1423 *Virgin and Child*[4] in the Kunsthalle in Bremen, and to his murals in Empoli, which were completed by November 1424.[5]

The two painters also collaborated on murals of the apostles Peter and Paul in the Serragli chapel in Santa Maria del Carmine, which were destroyed in 1675. According to Giorgio Vasari, Masolino painted Peter and Masaccio, Paul. The latter was said to have had the features of the Florentine statesman Bartolo di Angiolino Angiolini. Vasari's praise of Masaccio's picture for its ingenious foreshortening suggests that it may have been the model for several near-contemporary Florentine mural paintings of standing figures seen from below.[6] Two paintings of Peter and Paul that in 1492 were recorded as the work of Masaccio in the Medici palace, Florence, may also have been copies of the Carmine pictures.

The two artists' most significant partnership was their decoration of the Brancacci chapel in the Carmine.[7] Founded by a bequest of Piero Brancacci, who died in 1367, the chapel seems to have been further provided for by his son Antonio (died between 1383 and 1389) and constructed during the 1380s, but left unadorned. In 1419 after the death of Piero's granddaughter Ginevra, who had married Goro Dati, responsibility for the chapel seems to have passed to her cousin Felice di Michele Bran-

cacci (1382–1447). In one of his wills, dated 1432, he made a provision for completing the chapel's decoration, suggesting that he had been in charge of it.[8] It is not known when Masolino and Masaccio's work was contracted, although the date of mid-February 1424, when Felice Brancacci returned from a successful commercial and diplomatic mission to Cairo, is sometimes considered a *terminus post quem*.

Masolino probably would not have been available to work on the chapel before November 1424, when he was paid for his murals in Empoli. He was responsible for the decoration of the Brancacci chapel's vaulting, which was the first section to be painted. Only the underlying preparatory drawings, or sinopias, survive.[9] The upper tier of scenes on the wall has sections by both Masolino and Masaccio, which had to have been planned simultaneously, as the background of the compositions continues from one scene to another. It could well be that Masolino worked in the chapel sometime between November 1424 and September 1, 1425, when he left for Hungary. Masaccio may in fact have been hired because of Masolino's impending departure. Whatever the case, for a brief period the two artists were on the scaffolding of the Brancacci together.

After Masolino left, Masaccio worked on the lower tier alone. Sections of the scene of the resurrection of the son of Theolophilus were painted by Filippino Lippi in the 1470s. It is unclear if Masaccio had left them unfinished, or whether the parts that Lippi later filled in had been damaged in 1436, after the political exile of Felice Brancacci and some of his family. Lippi's paintings show portraits that would have replaced those of the Brancacci, which were destroyed after their exile. Lippi also painted three other scenes in the chapel that Masolino and Masaccio seemed to have left unfinished.

Masaccio had either completed his part of the project or temporarily abandoned the chapel in early 1426, when he accepted a commission for the now-disassembled altarpiece for the church of the Carmine in Pisa.[10] He signed the contract with the patron, Ser Giuliano di Colino degli Scarsi, in February 1426. Its execution took a little less than a year, during which the artist was helped by his brother Scheggia (q.v.) and the painter Andrea di Giusto. The final payment was made on Christmas Eve 1426.

While it is possible that some of Masaccio's work on the Brancacci chapel was not done until after he had completed the Pisa altarpiece, in his tax declaration of July 1427 he did not mention any outstanding payments for the project. As he carefully recorded other money owed to him, the absence of mention of the Brancacci commission might suggest that his contribution had been

finished or perhaps that he had been paid for his work to that point.

In the Carmine, Masaccio also painted the *Sagra,* showing the consecration of the church on April 19, 1422. Famous for its many portraits of contemporary Florentines, the picture was destroyed in 1598–1600, but over the years many local artists, including Michelangelo, made copies of parts of it. One of the earliest copies is the figure on the far left of Fra Angelico's *Dormition of the Virgin* in the Johnson Collection (see plate 7 [JC cat. 15]).

In his 1427 tax declaration Masaccio likewise made no reference to his final Florentine masterpiece, the mural of the Trinity in Santa Maria Novella,[11] which may have been undertaken sometime that year. It is in this painting that Masaccio most carefully worked out the representation of architectural space according to the scientific rendering of perspective. Masaccio is often seen as having conceived the painting in collaboration with the architect Filippo Brunelleschi, and, in fact, the triumphal arch is reminiscent of the latter's design for the Old Sacristy of San Lorenzo in Florence, which the architect was then working on.[12]

Masaccio arrived in Rome sometime after July 1427. It would be tempting to think that he may have sought employment there after the death of Gentile da Fabriano, who died on August 2, leaving a mural project in Saint John Lateran uncompleted. However, Masaccio's only secure Roman work is his participation on the Santa Maria Maggiore altarpiece (see plates 44A–B [JC invs. 408–9]), although his hand has been seen in one other Roman project: the Castiglioni chapel in the basilica of San Clemente,[13] an attribution that dates to Vasari. While it was Masolino who actually executed this chapel, Roberto Longhi (1940, pp. 163–66) has posited that Masaccio may have designed the Crucifixion on the altar wall. The participation of the Sienese Vecchietta has also been suggested.

A note written in 1429 on an update of Masaccio's tax declaration of 1427 reads: "dicesi è morte a Roma" (said to have died in Rome).[14] On circumstantial evidence Ugo Procacci (1976a, pp. 235–36) dated the painter's death to the month of June in 1428. However, many years later his brother Scheggia remembered that Masaccio had died in his twenty-eighth year, which could be taken to mean after his twenty-eighth birthday, on December 21, 1429.[15] An early cinquecento account raised the possibility that he had died by poisoning.[16] This same source records that after Masaccio's death Brunelleschi said, "We have experienced a great loss."[17] In 1436, in the dedication to the Italian edition of *On Painting,* Leon Battista Alberti acknowledged Masaccio's importance to Florentine art,

putting him on a par with Brunelleschi, Donatello, Lorenzo Ghiberti, and Luca della Robbia, all of whom he described as being equals of the ancients.[18] Vasari praised Masaccio as the founder of the modern manner in painting.

Masaccio's work became generally known through Thomas Patch's engravings of the Brancacci chapel published in 1790, which in England excited the interest of the antiquarian Horace Walpole. However, it was not until 1848, when Carlo Pini and Gaetano Milanesi published their notes to Vasari's life of Masaccio, that Masolino's contribution to the chapel was properly recognized. The cycle in San Clemente in Rome, engraved several times in the nineteenth century as the work of Masaccio, was not recognized to be by Masolino until 1869.[19] Just as the Nazarenes and Italian Purists contributed to the revival of interest in Masaccio and Masolino in the nineteenth century, twentieth-century art movements—in particular, Cubism and metaphysicism—have conditioned modern appreciation of Masaccio.

1. Strehlke 2002, color plate 2. See also Caneva 2001.
2. Strehlke 2002, color plates 5–6, fig. 64. See Roberto Bellucci and Cecilia Frosinini in Strehlke 2002, pp. 81–87.
3. Inv. 8386; Strehlke 2002, color plate 7. On the patronage, see Alessandro Cecchi in Cecchi 2002, pp. 28–29.
4. Inv. 164; Strehlke 2002, color plate 3.
5. Joannides 1993, color and black-and-white plates 53–56, 59, 66, 244–51, 254–55.
6. They are Paolo Uccello's *Saint Paul* of about 1433 in Prato cathedral and his other freestanding saints in that church, especially the *Blessed Jacopone da Todi* (Borsi and Borsi 1994, color repros. p. 192); and Domenico Veneziano's *Saints John the Baptist and Francis* of the early 1450s in Santa Croce in Florence (Wohl 1980, plates 138–48).
7. Postrestoration color repros. in Baldini and Casazza 1990.
8. In the 1470s the arms of his family, the Brancacci, his mother's, the Bardi, and the Dati were all displayed on vestments in the chapel, meaning all three families had rights to it.
9. Baldini and Casazza 1990, color repros. p. 291.
10. Strehlke 2002, color plates 9–19. On the reconstruction of this altarpiece, see Carl Brandon Strehlke; Roberto Bellucci and Cecilia Frosinini; Jill Dunkerton and Dillian Gordon; and Bellucci, Frosinini, and Mauro Parri respectively in Strehlke 2002, pp. 16–20; 54–55; 89–109; 165–201; Carl Brandon Strehlke in Bellosi 2002, pp. 146–50; Andrea De Marchi in Dalli Regoli and Ciardi 2002, pp. 202–5.

11. Danti 2001, postrestoration color plate 1. On the patronage, see Alessandro Cecchi in Baldinotti, Cecchi, and Farinella 2002, pp. 32–57; and Comanducci 2003.
12. Saalman 1993, plate 66.
13. Joannides 1993, color plates 136–50; and Baldinotti, Cecchi, and Farinella 2002, color plates 51–80. For a reevaluation of Masaccio's role, see the essay by Vincenzo Farinella, pp. 137–86.
14. Beck 1978, p. 26.
15. Manetti 1480s–90s, Milanesi ed. 1887, p. 165. On this problem, see Carl Brandon Strehlke in Strehlke 2002, p. 126.
16. Billi c. 1506–30, Benedettucci ed. 1991, p. 73.
17. "Noi abbiàno fatto una grande perdita" (Billi c. 1506–30, Benedettucci ed. 1991, p. 74).
18. Alberti 1436, Grayson ed. 1973, p. 7.
19. Zahn 1869, p. 166; Lübke 1870, pp. 285–86.

Select Bibliography
Complete references to the enormous bibliography on Masaccio can be found in Joannides 1993. Some of the best pages written on the painter are by Longhi (1940; *Opere*, vol. 8, pt. 1, 1975, pp. 3–84). Otherwise of specific use are Berti 1964 and 1968; Beck 1978; Baldini and Casazza 1990; the various documentary articles by Procacci (1932a, 1935a, 1953, 1976a); Hellmut Wohl in *Dictionary of Art* 1996, vol. 20, pp. 529–39; Caneva 2001; Ahl 2002; Bellosi 2002; Baldinotti, Cecchi, and Farinella 2002; Strehlke 2002

MASOLINO
(Tommaso di Cristofano Fini)

Masolino's family was originally from Panicale, a hamlet usually identified as being in the Valdarno, southeast of Florence, although Giorgio Vasari, perhaps mistakenly, placed it in the Val d'Elsa, a region southwest of Florence. He also recorded that Masolino worked for the sculptor Lorenzo Ghiberti in the early 1400s on the first gilt bronze doors of the Florentine baptistery, but this cannot be proved.[1] Vasari wrote that at age nineteen Masolino took up painting, apprenticing himself to Starnina (q.v.). This would have had to occur before 1413, when Starnina is recorded as dead. Alternatively, another cinquecento writer, Giambattista Gelli (c. 1550–60, Mancini ed. 1896, p. 45), proposed that Antonio Veneziano, who died in 1419,[2] was his master. However, it seems more likely that as a youth he did not actually train as a panel painter in Florence, but worked outside Florence with his father, who was a journeyman painter, probably involved in decorative wall painting.[3]

Nothing is securely known of Masolino until he was about thirty-nine years old, in 1422, when he rented a house in Florence from the sculptor Bernardo Ciuffagni. Another painter, Francesco d'Antonio (q.v.), served as Masolino's witness for the contract. In January 1423 Masolino joined the local painters' guild. As both these actions suggest a desire to settle and work in Florence, Miklós Boskovits (1987a, pp. 48–49) has proposed that he had not been in the city before this time, perhaps because of employment elsewhere with the condottiere Filippo Scolari, known as Pippo Spano. A member of the Florentine Buondelmonti family who had become military chief for King (later Holy Roman Emperor) Sigismund in Hungary and Bosnia, Pippo Spano visited his native city in 1410 and at that point hired a number of artists to accompany him back to Hungary. Masolino was employed by him there in 1425, but whether Masolino had worked for him before is conjecture.

Probably around the time Masolino rented his house in Florence, he collaborated with Masaccio (q.v.) on the Carnesecchi altarpiece for Santa Maria Maggiore[4] and on the *Sant'Anna Metterza* altarpiece for Sant'Ambrogio.[5] The collaboration may have been necessitated by the fact that Masolino had not yet joined the painters' guild and he needed to go into business with an artist who was already enrolled. His other work from this period includes the *Virgin and Child* in the Kunsthalle in Bremen, dated 1423.[6] It bears the arms of the Carnesecchi and Boni families, although the specific connection between the two families is not known. The largely

destroyed murals of the stories of the Holy Cross that he painted for the company of Sant'Elena in the *collegiata* of Santo Stefano in Empoli were paid for in November 1424.[7] In general, his other work in Empoli—the mural of the Pietà from the Scassinati chapel of Sant'Andrea[8] and some other fragmentary wall paintings in Santo Stefano—is thought to date around the same time.[9]

Probably sometime after November 1424 Masolino started to paint the mural cycle in the Brancacci chapel in the Carmine in Florence. His work there seems to have been finished before September 1, 1425, when he left for Hungary. In July of that year Masolino was also paid for painting some lost stage scenery—clouds and angels—for the confraternity of Sant'Agnese, which put on an annual mystery play of the Ascension in the Carmine.[10]

On September 1, 1425, Masolino signed a three-year contract to work for Pippo Spano in Hungary. Its terms are not known, but it is assumed that the painter was to decorate Pippo's various Hungarian residences. It is clear from a financial document of 1425 that Masolino would have been working under Matteo Ammannatini, the carpenter commonly known as the *Grasso Legnaiolo,* or the "Fat Woodworker," after a quattrocento novella about him by Antonio Manetti,[11] who had been Pippo Spano's superintendent of building since 1410. Pippo Spano's death on December 26, 1426, effectively terminated Masolino's contract, but the painter did not immediately return to Florence, for in July 1427 his father filled out a tax declaration noting that his son was still abroad. A commission, also mentioned in the tax returns of July 1427, to decorate the chapel of Guido del Foresta in San Francesco in Figline Valdarno, seems never to have been executed.

While Masolino is not recorded as being back in Florence until May 1428, when he collected payment for his work in Hungary, he may, in fact, have returned sometime in the autumn of 1427. Two of his Florentine altarpieces seem to date to this period. One, the so-called Goldman *Annunciation*[12] in the National Gallery of Art in Washington, D.C., may have been painted for Michele Guardini's chapel in San Niccolò Oltrarno. It is not clear from the patron's will of March 1427, in which the chapel is mentioned, whether it had already been provided with an altarpiece when the document was written. Vasari erroneously describes the *Annunciation* as the work of Masaccio, noting its fine perspective and the use of fading colors to convey distance.

In the summer or fall of 1428 Masolino presumably started working in Rome, where, besides the Santa Maria Maggiore altarpiece (see plates 44A–B [JC invs. 408–9]) that seems to have been completed after Masaccio's death presumably in mid- or late

1428, he painted a chapel in San Clemente for Cardinal Branda Castiglioni, apparently sometime before February 1431.[13] Although Masolino is again recorded in Florence in March 1429, that may have been only a short visit.

His most influential work, a mural cycle in the Orsini palace near the Tiber, was completed in 1432. It is generally thought to have been made for Cardinal Giordano Orsini.[14] The room Masolino decorated, known as the *sala theatri,* contained more than three hundred representations of historical figures from biblical, ancient, medieval, and modern times. The most contemporary person to be included was Timur, or Tamburlaine, who had died in 1405. The cycle was destroyed in the late fifteenth century, but numerous copies exist, including one by Leonardo da Besozzo, probably for a patron in Lombardy, and another by Barthélemy d'Eyck, presumably for King René of Anjou.[15]

Masolino's originals particularly impressed foreigners in Rome, such as the Florentine banker Giovanni Rucellai, who wrote about them in the diary of his Roman journey in 1450 (Rucellai 1457–73, Perosa ed. 1960, p. 76), and the architect Filarete, who mentioned them in his treatise of about 1453 (Finoli and Grassi ed. 1972, p. 261) and used them as a model for the decoration of the ruler's palace in his ideal city.

Masolino is recorded in Todi, north of Rome, in June 1432 and November 1433. There he painted a Virgin and Child in the Franciscan church of San Fortunato, which was then undergoing considerable transformations.[16] Shortly after working in Todi, Cardinal Branda Castiglioni asked the artist to accompany him to Lombardy, where the churchman, as a leader of the antipapal conciliar movement, had gone to distance himself from Pope Eugenius IV Condulmer. While in Lombardy, Castiglioni devoted himself to the embellishment of Castiglione Olona, the village that he had created as an ideal city in the alpine foothills.

The job in Castiglione Olona was so large that Masolino either brought with him or later called in two assistants from his Roman days: Vecchietta and Paolo Schiavo (q.v.). Masolino worked in the baptistery, the collegiate church, and the cardinal's palace.[17] His murals in the baptistery, inscribed 1435, reflect compositions of Gentile da Fabriano's lost mural cycle in Saint John Lateran in Rome. Although Masolino's murals in the vault of the collegiate church are signed but not dated, they are usually placed after those in the baptistery. Several of the scenes in the church were painted by Schiavo and Vecchietta. The dates of their return to Florence and Siena, which are 1437 and 1439, respectively, might indicate the far perimeters of the

chronology of their work in Castiglione Olona. They also suggest that the church decoration was completed in 1437, when Schiavo left; Vecchietta later painted the chapel and other murals in the cardinal's palace.[18] Masolino painted rooms in the residence, of which a landscape survives.

Masolino's death date has often been given as 1440, but it has been shown that the Masolino di Cristofano who is registered in Florentine *Libro de' morti* as having died in that year was in fact a cobbler. There is, however, an often-ignored document that records that a "Maso fiorentino" was living in Milan in 1444 and painted a now-lost altarpiece for Sant'Agostino in Crema in that year.[19] The picture in fact was painted between 1443 and 1444, and the local goldsmith and sculptor Fondulino di Giovanni Fonduliis (documented 1440–49) carved and gilded its enframement for the high altar between 1444 and 1449. This evidence suggests that Masolino continued to be active in Lombardy after 1440. Until 1443, he may have worked for Cardinal Branda Castiglioni, who died that year. The cardinal had palaces in both Milan and Pavia. The Sant'Agostino commission may have even come from the duchess Bianca Maria Visconti from Milan, who kept a close watch on the progress of the building in Crema.

Masolino's critical fortunes have been based almost entirely on Vasari's two brief biographies. While Vasari was aware that Masolino had worked in Rome, he attributed the Santa Maria Maggiore altarpiece and the San Clemente chapel to Masaccio. Most of Vasari's analysis of Masolino is based on the scenes in the Brancacci chapel. Masolino's paintings in Lombardy were not identified until the nineteenth century, and their discovery opened up studies of the artist.

1. For a summary of arguments for and against Masolino having an early career as a goldsmith, see Krautheimer 1982, pp. 108–9; as well as Procacci 1980, pp. 14–16; Boskovits 1987a, pp. 48–49; and Joannides 1987, p. 21.
2. For the 1419 date, see Czarnecki 1978, p. 8.
3. Roberto Bellucci and Cecilia Frosinini in Strehlke 2002, pp. 34–40.
4. The chapel was definitely complete by January 1428, although it could date much earlier. Several sources suggest that the walls of this chapel were painted with an Annunciation by Paolo Uccello. If so, Uccello's work must have been finished before August 1425, when he went to Venice for five years. On the collaboration, see Roberto Bellucci and Cecilia Frosinini in Strehlke 2002, pp. 81–87; Strehlke 2002, color plates 5–6, fig. 64.
5. Florence, Uffizi, inv. 8386; Strehlke 2002, color plate 7. On the patronage, see Alessandro Cecchi in Cecchi 2002, pp. 28–29.
6. Inv. 164; Strehlke 2002, color plate 3.
7. Joannides 1993, plates 53–54, 59, 66, 244–51, 254–55 (color and black-and-white).
8. Empoli, Museo della Collegiata; Joannides 1993, color plate 55.
9. Joannides 1993, color plates 56, 66.
10. On this play, see Henderson 1994, pp. 96–99. It has recently been shown by Nerida Newbigin (forthcoming) that the architect Filippo Brunelleschi did not design stage machinery as often as thought.
11. See Manetti early 1480s, De Robertis and Tanturli ed.

1976, pp. 3–44; as well as Gaetano Milanesi in Manetti 1480s–90s, Milanesi ed 1887, pp. xxii–xxxii.
12. No. 16; Strehlke 2002, color plate 24. See also Miklós Boskovits in Boskovits and Brown 2003, pp. 466–71.
13. Joannides 1993, color plates 136–50; and Baldinotti, Cecchi and Farinella 2002, color plates 51–80. For a reevaluation of Masaccio's role, see the essay by Vincenzo Farinella, pp. 137–86.
14. A late quattrocento description of the cycle identifies him as the patron, whereas earlier descriptions are silent on that point. See Simpson 1966, esp. pp. 135–40.
15. These copies are conveniently listed in Joannides 1993, pp. 452–55.
16. Joannides 1993, color plates 157–58.
17. Joannides 1993, color plates 175–84; and postrestoration illustrations in Bertelli 1998.
18. Bertelli 1987, figs. 24–31; and Bertelli 1998.
19. Terni de Gregory 1950, p. 159 n. 7; Carl Brandon Strehlke in Agosti et al. 1998, p. 32. A fragment of the upper section of this altarpiece might be the *Saint John the Evangelist,* first published as Masolino by Roberts 1998. See Bellosi 2002, color repro. p. 159 with an entry by Miklós Boskovits, p. 158.

Select Bibliography
As for Masaccio, the bibliography on Masolino is immense and often interrelated with the writings on the other artist. For a summary of references, see Joannides 1993 and Roberts 1993. Also of value are Longhi 1940 (*Opere,* vol. 8, pt. 1, 1975, pp. 3–84); Micheletti 1959; Vayer 1965; Boskovits 1987; Ferro 1995; Keith Christiansen in *Dictionary of Art* 1996, vol. 20, pp. 553–59; Gagliardi 1996; Bertelli 1998; O'Foghludha 1998; Roberts 1998; Carl Brandon Strehlke in Agosti et al. 1998, pp. 27–35; Callmann 1999; Baldinotti, Cecchi, and Farinella 2002; Strehlke 2002

MASACCIO AND MASOLINO

Lateral panel of an altarpiece:
Saints Paul and Peter

c. 1427–28

Tempera and tooled gold on panel with vertical grain;
45⅛ × 21⅜ × ½″ (114.5 × 54.4 × 1.3 cm)

John G. Johnson Collection, inv. 408

INSCRIBED ON THE REVERSE: *JOHNSON COLLECTION*
(stamped twice in black ink); *CITY OF PHILADELPHIA*
(stamped in black ink); *Inv. 408* (in pencil); *408* (in chalk);
408 (in pencil)

PUNCH MARKS: See Appendix II

EXHIBITED: Paris 1935, no. 305; Philadelphia 1950, no. 3

TECHNICAL NOTES

This panel and *Saints John the Evangelist(?) and
Martin* (plate 44B [JC inv. 409]) were originally a
single lateral panel of an altarpiece, painted on both
sides of one poplar board. It was sawn apart prior
to 1653. The arches were cropped and the moldings
dividing the spandrels from the picture surface
were removed probably sometime in the seven-
teenth or eighteenth century. The gold back-
grounds, except for the halos and the spandrels,
were regilt to appear unified.

A shallow rectangular indentation 1⅜ × 1⅛ × ⅛″
(3.5 × 3 × 0.4 cm) on the top right corner of the
panel is all that remains of a blind mortise. Plate
44B (JC inv. 409) no longer has any vestige of the
mortise, but the wood of both its corners has been
partially replaced. Similar mortises were observed
in the upper corners of one of the companion pan-
els in London (see fig. 44B.8), before it was trans-
ferred to a synthetic panel. Mortises (Strehlke 2002,
fig. 98) are still present at about 43¾″ (111 cm) from
the bottom in the upper parts of the related panels
in Naples (see figs. 44B.5, 44B.6). They would have
been fitted with a tenon that would have been used
to join and align the various panels of the altarpiece.

COMPOSITION: In 1964 Millard Meiss noted that

the identities of the two apostles had been switched
during the panel's execution: Peter was originally
Paul, and Paul, Peter. Further observations about
the program changes were published by Carl Bran-
don Strehlke and Mark Tucker in 1987 and 2002.
The original shape of Paul's sword can be detected
in the present Peter's robe, and Peter's keys show
up in the hand with which Paul now holds his
sword. An infrared reflectogram (fig. 44A.2) reveals
where sheets of silver leaf had been applied to the
sword. Tracings of the original incised lines (fig.
44A.3) indicate that the sword had pivoted away
from the figure, and that Peter had held out one key
horizontally as the other dangled beneath. An inci-

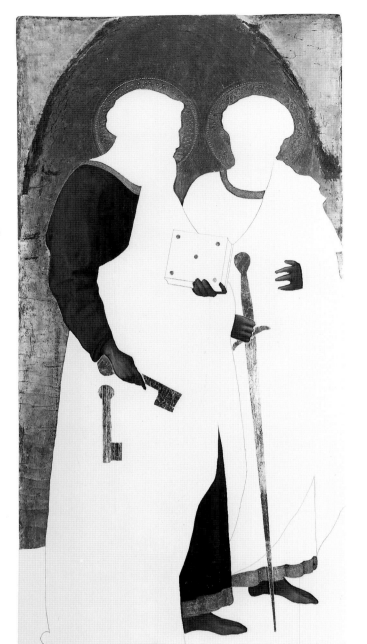

FIG. 44A.1 (*left*) Diagram by Mark Tucker of plate 44A, showing parts of the panel that were executed before the identities were changed

FIG. 44A.2 (*right*) Infrared reflectogram of plate 44A, showing the original position of Saint Paul's sword

sion also suggests that the figure that is now Paul
was to have a much shorter beard.

The technical evidence confirms that the execution
had already begun when the apostles' identities were
changed (fig. 44A.1). For example, the infrared photo-
graph shows that the original shape of the sword's
blade had been defined by a lower layer of paint (fig.
44A.2). Cross sections reveal that Peter's robe was sim-
ply painted over the silver leaf of the sword and that
Paul's costume was painted over Peter's keys. Among

the details that were painted before the figures were
repositioned are the ultramarine of the present Paul's
robe and the flesh of the two figures' hands and feet.
The present keys and sword were put in around exist-
ing sets of hands. The fingers of the original Saint
Paul's right hand were longer, and the hand itself was
open and resting on the sword's quillon. When the
figure had to be adapted to hold the keys, it appears
that the extended fingers were scraped off to give the
appearance of a closed hand. In a similar adaptation

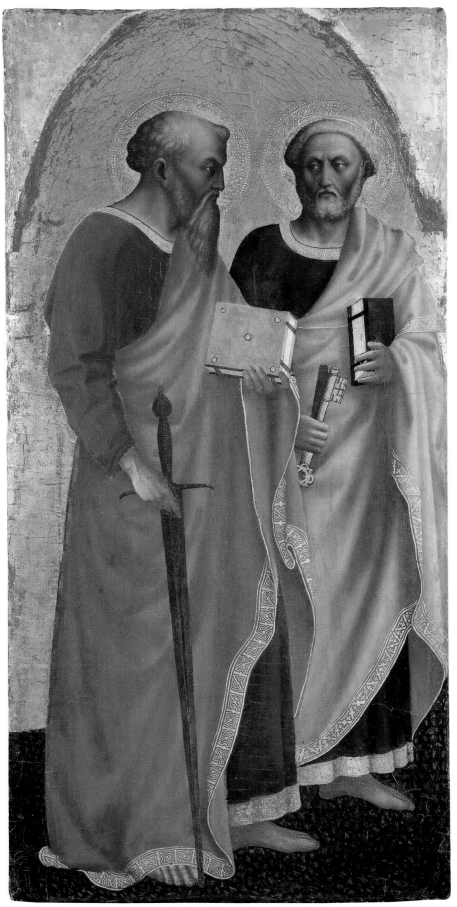

PLATE 44A

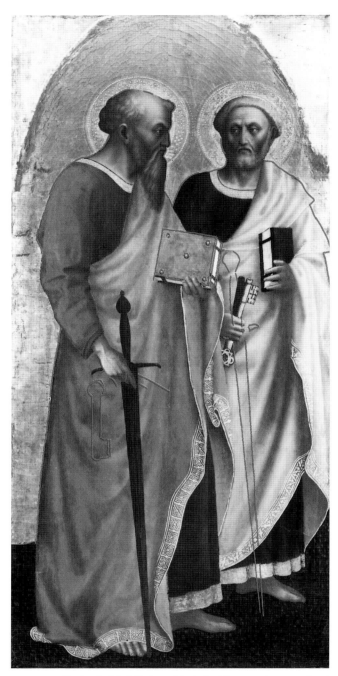

FIG. 44A.3 Tracing by Mark Tucker of the incised lines on plate 44A, showing aspects of the original composition

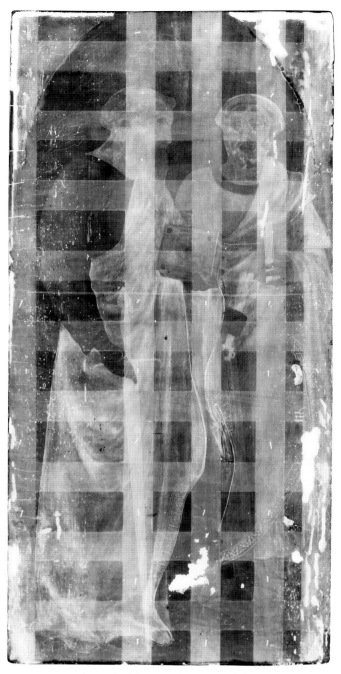

FIG. 44A.4 X-radiograph of plate 44A, showing the differences in the underpainting of the hands and feet versus the heads of the saints. The 1929 cradle on the reverse of the panel is particularly prominent in this X-radiograph.

the hilt of the sword seems to have been painted over the present Paul's right thumb.

MEDIUM AND PAINTING TECHNIQUE: The flesh areas of the panel are painted in two different techniques. The hands and feet are constructed in a classic tempera style: small, hatched brushstrokes over green underpainting can be seen in cross section (fig. 44A.5). By contrast, another cross section shows the artist of the faces developed their modeling over a whitish underpainting (fig. 44A.6). An

X-radiograph (fig. 44A.4) clearly demonstrates how the techniques produced different effects: the hands and feet are uniformly darker, exhibiting the low contrast between shadows, mid-tones, and highlights that typically results when thin tempera layers are applied directly to gesso. Brushwork visible in the X-radiographs corresponds directly to the chiaroscuro of the final image. By comparison, the faces and most of the drapery appear lighter, showing greater overall absorption of X-rays and unusually high-contrast patterns of broad, textured brushstrokes.

Analysis of samples from areas of flesh paint using Fourier transform infrared spectroscopy (FTIR) and gas chromatography (GC) confirmed the use of oil and egg tempera in different parts of the painting (Ken Sutherland and Beth Price, analytical report, 2002, Philadelphia Museum of Art, Conservation Department). FTIR data indicated the presence of a protein component in samples of paint taken from the feet of the two figures, consistent with an egg tempera medium. Samples taken from the heads of the two figures gave data with

FIG. 44A.5 Cross section of plate 44A, showing the mid-tone layer of Saint Peter's foot

FIG. 44A.6 Cross section of plate 44A, showing the whitish underpainting of Saint Paul's face

spectral features suggestive of an organic carboxylate component: this type of compound is typically formed from the reaction of an oil medium with pigment components such as lead white in the paint. GC data provided more precise information on the lipid component of the samples: results for the samples from the heads of the two figures indicated the use of linseed oil, based on the relative proportions of diagnostic fatty acids in the samples.[1] Samples taken from the feet of the two figures showed fatty acid ratios characteristic for an egg tempera medium. The FTIR analysis also provided information on pigment components of the paint samples: lead white (basic and neutral forms of lead carbonate) was detected in all of the flesh paint samples, and celadonite (a mineral component of green earth) was detected in the samples from the feet of the two figures, presumably deriving from the green underpaint in these areas.

The evidence of the cross sections taken from the panel points to two distinct painting techniques, which can be dated before and after the changes in composition, and suggest the involvement of two artists: one who started the panel, here identified as Masaccio; and another who changed the identities and finished the panel, here identified as Masolino. These changes in technique conform to the differences in their style seen also in other works, including the collaborative *Sant'Anna Metterza* in the Uffizi.[2] In a 1993 report on the painting techniques, David Skipsey noted:

> There are several surface features of the Philadelphia panels which may relate to the choice of media. The paint of the red drapery of Saint Paul is smeared and splashed over the edges of the blue paint of his sleeve, suggesting rapid application, lack of control over the medium, or both. There are many brush hairs caught in the paint of this drapery, particularly in the glazed shadows, which also suggests a vigorous working of the paint. Both the red drapery of Saint Paul and the yellow drapery of Saint Peter have a very smooth, blended appearance, with soft transitions between highlights and shadows. This is in sharp contrast with the appearance of the blue sleeve executed by Masaccio, which is painted as if lit sharply from the left, with the paint applied in short, stippled strokes, and cross-hatched in the shadows.

Comparison with one of Masolino's companion panels in Naples, the *Founding of Santa Maria Maggiore* (see fig. 44B.5), shows that there the artist had much the same trouble controlling the oil medium, especially in the area of the snow.

TREATMENT HISTORY AND CONDITION: In 1920 Carel de Wild made some local repairs to the painting and noted that there were some rather large existing repairs in the draperies. In 1929 the panel was cradled and restored by Herbert Thompson at the Boston Museum of Fine Arts, who wrote to Henri Marceau on February 19, 1930:

> The Masolino is quite a picture. It was set and cradled and then the real fun began. Some evil-minded animal had painted it fairly well all over using some extremely hard medium—likely boiled oil and hard varnish. The original colors were completely blotted out. This repaint was removed and the reason for repainting made clear. There were quite a number of injuries which had been painted in and then whole areas were gone over to cover up the repairs of the injuries.

The panel was cleaned and restored by David Skipsey in 1993. The cleaning revealed the original contours of the picture surface. It also uncovered the original gold background. Except for the halos, the background had been totally covered with new oil gilding.[3] The ultramarine of the undergarment of Paul is in a remarkably fine state of preservation. Peter's green undergarment and the binding of his book have turned brown due to discoloration of the copper resinate glazes. The surface of the vermilion has grayed in some places. The visible foot of Peter and the proper left foot of Paul are much abraded. By contrast, Paul's right foot is well preserved.

There is a large area of loss in the lower part of Paul's blue robe and other isolated losses in the feet and ground.

PROVENANCE
See plate 44B (JC inv. 409)

COMMENTS
Balding and with a long, pointed beard, Saint Paul is shown in profile holding a book and a sword, symbol of his martyrdom. Peter, seen frontally and looking at Paul, holds a gold and a silver key, symbol of the papacy, and a book. The two saints stand on a serpentine floor.

The two apostles were specifically connected with Rome, where they were martyred, and to the papacy. Martin V Colonna (reigned 1417–31), who was pope when this panel was painted, gave further luster to his role as the pope who brought the seat of the papacy back to Rome after a decades-long schism, by specifically asking to be buried in the basilica of Saint John Lateran "before the heads of Peter and Paul."[4] The relics of the apostles' heads were kept in a special altar in the crossing of that basilica, which had been constructed by Giovanni di Stefano on commission of Pope Urban V de Grimoard (reigned 1362–70), the first of the Avignon popes to restore the Curia to Rome.[5]

The decision to rearrange the positions of the two saints during the panel's execution may have been made so that the image would conform with the Roman iconographic tradition in which Paul was shown on the left and Peter on the right, which is how they appeared in such important settings as the reliquary altar of the Lateran; the apse mosaic of Old Saint Peter's, in which they flanked an enthroned Christ;[6] and the apse mosaic by Jacopo Torriti in Santa Maria Maggiore itself.[7]

For further comments, see plate 44B (JC inv. 409).

1. Linseed oil was identified on the basis of a high level of azelaic acid (an oxidation product characteristic of drying oils), in combination with a ratio of palmitic to stearic acid (P:S) of 1.4 and 1.5. The egg tempera samples showed only a small proportion of azelaic acid, along with higher P:S ratios (2.4 and 2.5). The diagnostic values for these ratios are drawn from the analysis of reference materials and from published studies (see Mills and White 1987, pp. 141–43).
2. Inv. 8386; Strehlke 2002, color plate 7.
3. The companion panels in Naples (figs. 44B.5, 44B.6) also had oil gilding. This suggests that all the panels were oil gilt before 1760, when they were still together in the Farnese Collection in Rome. The panels in Naples were removed from Rome in 1760.
4. "Ante capita apostolorum Petri et Pauli" (quoted by Arnold Esch in Rome 1992, pp. 639–40).
5. Pietrangeli 1990, color repro. p. 98.
6. Destroyed; copy reproduced in color in Grimaldi 1620, Niggl ed. 1972, fig. 84.
7. *Pittura* 1986, fig. 645 (color).

Bibliography
See plate 44B (JC inv. 409); Frinta 1998, p. 484

MASACCIO AND MASOLINO

Lateral panel of an altarpiece: *Saints John the Evangelist(?) and Martin of Tours*

c. 1427–28

Tempera, tooled gold, and silver on panel with vertical grain; 45⅛ × 21⅜ × ½″ (114.5 × 54.4 × 1.3 cm)

John G. Johnson Collection, inv. 409

INSCRIBED ON THE REVERSE: *JOHNSON COLLECTION* (in ink); *Inv. 408* (in crayon)

PUNCH MARKS: See Appendix II

EXHIBITED: Paris 1935, no. 306, Philadelphia 1950, no. 4

TECHNICAL NOTES

This panel and *Saints Paul and Peter* (plate 44A [JC inv. 408]) were originally a single lateral panel of an altarpiece, painted on both sides of one poplar board. It was sawn apart prior to 1653. The tops were cropped and the moldings dividing the spandrels from the picture surface were removed probably sometime in the seventeenth or eighteenth century. The gold backgrounds, except for the halos and the spandrels, were gilt.

COMPOSITION: In 1964 Millard Meiss noted that the identities of the two saints had been switched during the panel's execution: John the Evangelist was originally Martin of Tours, and Martin, John the Evangelist. Further observations about the program changes were published by Carl Brandon Strehlke and Mark Tucker in 1987 and 2002.

The incisions that laid out the original composition show the location of Martin's miter, pastoral staff, and border of his cope as first planned (fig. 44B.1). When the identities of the saints were changed, a number of other incisions were made to reposition the staff. This apparently involved some indecision: the first thought was that it should be slightly more vertical than it is now, as indicated by the long incised line. Had it been located on this axis, the staff would have passed behind the Evangelist's halo.

Before the changes were made, the following steps in the execution had been completed: the outlines of the original design were incised; the gold was laid down (including in the zones where the first Saint Martin's cloak was to be gilded and tooled); the halos were tooled; and the two faces and the Evangelist's long beard were painted.

The infrared reflectogram of the present Evangelist reveals heavily shadowed areas that outlined the edge of the jaw and chin, which would have been prominent features of the figure when he was originally the clean-shaven bishop Martin (fig. 44B.3). Additionally, the X-radiograph (fig. 44B.2) shows

the Evangelist's painted-out hair extending downward from the lower line of the original miter to the temples. By contrast, it also indicates that the top of Martin's head and the hair by his ear, now covered by the miter, were completed, and that the figure had a beard whose contours were traced by an incised line. A cross section from the chin contains a gray paint layer, which is apparently from the completed beard that had to be painted out on the face and scraped away beside the face to achieve a clean-shaven profile. The gap in the halo next to Martin's chin that resulted from the removal of the beard was thus gilded and tooled after the rest of the halo. Because several layers of paint had to be applied to cover the area, Martin's chin presents a very sharp, cutout appearance. In addition to these changes, lines were incised for the relocation of the staff and for the gold that was laid and tooled for Martin's orphrey. His miter was painted over the punched pattern of the halo and the edge of the spiraled head of the pastoral staff. The hands, books, and costumes were executed last and after the identities of the saints had been switched. A slight pentimento of a previous position of the thumb of the Evangelist's left hand is visible in the infrared reflectography.

MEDIUM AND PAINTING TECHNIQUE: The faces of the two saints were first painted with a white preparatory layer, as in plate 44A (JC inv. 408). No green underpainting was detected in cross sections of any of these flesh tones. Both faces were repainted in the same manner, possibly suggesting that the artist who began the execution of this panel was the same one who made the changes and finished it. This would most likely have been Masolino. In 1987 Mark Tucker and I suggested that Masaccio may have been responsible for the layout of the original composition in which the first pastoral staff is so ingeniously foreshortened.

The X-radiograph shows that this entire panel was painted like those parts of plate 44A that have been attributed to Masolino. Medium analysis has also shown a similar use of an oil and mixed oil/tempera technique in both Philadelphia works (Roberto Bellucci, Cecilia Frosinini, and Mauro Parri in Strehlke 2002, p. 242, based on research by Carl Brandon Strehlke and Mark Tucker).

TOOLING: The fine quality of the original tooling of these halos as well as those in plate 44A (JC inv. 408), and the style of all of them, can be related to the tooling of the halos in other works by Masaccio, including the *Saints Jerome and John the Baptist* in London (see fig. 44B.7), which comes from the same altarpiece. The inferior quality of the tooling undertaken after the design changes suggests that it was executed in haste and by a different artist— possibly a workshop assistant of Masolino's. This later tooling, which is characterized by an irregular graining in the background, can be compared with

the coarse tooling of the halos of the other companion panel in London, *Saints Gregory the Great and Matthias* (see fig. 44B.8). Interestingly, this same irregular graining can be seen in the morse on Saint Martin's costume, which was definitely executed by Masolino.

The pastoral staff was executed in silver, which has tarnished. Because of this, the details of the finial are more easily discerned in an infrared reflectogram than with the naked eye (fig. 44B.4). The silver of the columns in the orphrey of Martin's cloak is better preserved, as it was applied over gold. The gilt letters *M* on the cloak were executed in mordant.

TREATMENT HISTORY AND CONDITION: The panel has the same conservation history as plate 44A (JC inv. 408). David Skipsey's cleaning in 1993 revealed the original contours of the picture surface. It also uncovered the original gold background. Except for the halos, the background had been totally regilt. Like plate 44A (JC inv. 408), the gold was probably renewed before 1760. There are abrasions and losses in the mantle of the Evangelist, and there is another large loss below Martin's proper left hand.

PROVENANCE
The original location of the double-sided altarpiece that included the Johnson Collection's two panels is not documented. Any discussion has depended on Giorgio Vasari's description of the painting in the Roman basilica of Santa Maria Maggiore and the supposition, suggested by the picture's iconography, that it was commissioned by a member of the Colonna family and therefore placed on one of its altars in the basilica.

In 1568 Vasari recorded that one side of the altarpiece was in a small chapel near the sacristy of Santa Maria Maggiore:

> It shows four saints, so skillfully painted that they look as though they are in relief, with Our Lady of the Snow in the middle, and a portrait from the life of Pope Martin, who is marking the foundations of the church with a hoe and near to whom stands the Emperor Sigismund II [*sic*]. One day after Michelangelo and I had been studying this work he praised it very highly and remarked that those men had been contemporaries of Masaccio.[1]

From the text it seems, although it is not certain, that the altarpiece was installed against a wall and that only the side showing the founding of Santa Maria Maggiore in the center was visible. Vasari does not say which saints flanked the central image. Most earlier descriptions of the basilica do not mention the altarpiece,[2] except for a manuscript of about 1560, *Informazione per veder edifitii antichi di Roma* (Paris, Bibliothèque Nationale, Ms. ital. 1179, folio 328v), which John Shearman attributed to

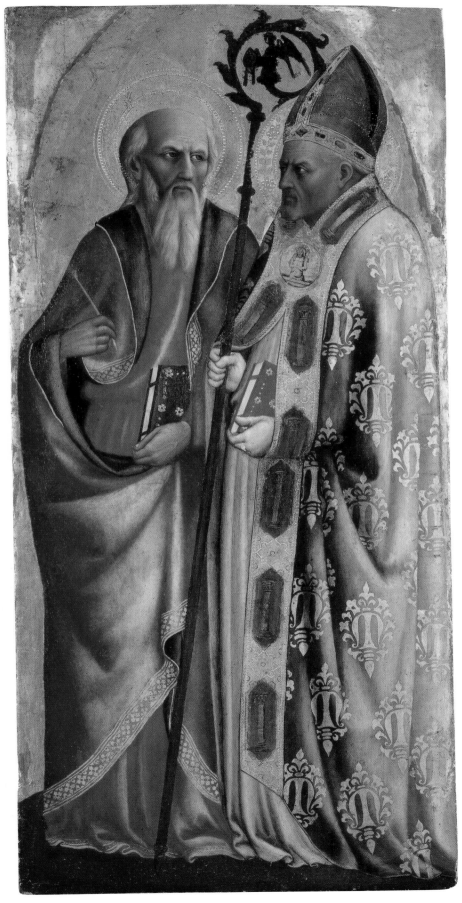

PLATE 44B

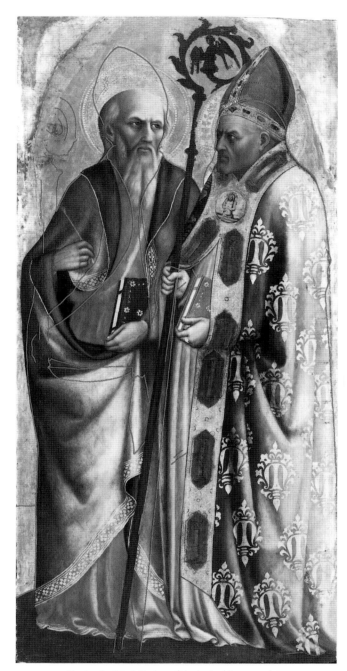

FIG. 44B.1 Tracing by Mark Tucker of the incised lines on plate 44B, showing aspects of the original composition

FIG. 44B.2 X-radiograph of plate 44B, showing underpainting similar to that in plate 44A (see fig. 44A.4). The 1929 cradle on the reverse of the panel is particularly prominent in this X-radiograph.

Pirro Ligorio. In it are two mentions of Masaccio, one in reference to the "sepoltura di Papa Honorio" (the tomb of Pope Honorius) and the other in reference to the "tavola a lato a la sagrestia" (painting next to the sacristy). It is unclear whether the author is attributing the tomb of Pope Honorius III, who died in 1227, to Masaccio or whether he saw another work by Masaccio near it. The "tavola a lato a la sagrestia" could be the Santa Maria Maggiore altarpiece in the same spot where Vasari later records seeing it.

Ugo Procacci (in Davies 1961, p. 355) suggested that when Vasari saw the altarpiece, it was on the altar of Saint John the Baptist, which Procacci described as being flanked by columns and situated between the canons' choir in the east end and the north aisle of the basilica. The suggested location of this chapel can be seen in a plan of Santa Maria Maggiore as it was thought to have looked before the time of Pope Paul V Borghese (reigned 1605–21). This plan was published in 1621 in Paolo de Angelis's monographic study of the basilica.[3] However, if the

painting had been on the altar of Saint John the Baptist at this point, both sides would have been visible, whereas Vasari only mentions one.[4] It is rather more likely that Vasari saw the painting on an altar near the tombs of Pope Nicholas IV Masci (reigned 1288–92), who was allied to the Colonna, and Cardinal Pietro Colonna (c. 1260–1326). According to Onofrio Panvinio (in Biasiotti 1915, pp. 34–35) this altar was near the door at the east end of the south aisle, not far from what was then the main sacristy. Such a location would fit with Vasari's statement

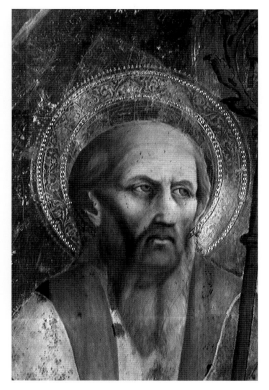

FIG. 44B.3 Infrared reflectographic detail of plate 44B, showing changes in the chin, jaw, and beard of Saint John the Evangelist

FIG. 44B.4 Infrared reflectographic detail of plate 44B, showing features no longer visible on the top of the pastoral staff of Saint Martin of Tours

that the painting was on an altar belonging to the Colonna family, near the sacristy. But because both sides of the altarpiece would not have been visible on this altar, its original location has to have been somewhere else.

A number of proposals about its original placement have been made. One that has gained a certain amount of acceptance is Roberto Longhi's (1952, p. 12) suggestion that the painting was removed from the high altar of Santa Maria Maggiore around 1461, when the Florentine sculptor Mino da Fiesole installed a ciborium, commissioned by Cardinal Guillaume d'Estoutville.[5] One of the scenes on Mino da Fiesole's ciborium showed the *Founding of Santa Maria Maggiore,* which is also depicted in the altarpiece (fig. 44B.5). Mino's ciborium, which was disassembled on the order of Pope Benedict XIV Lambertini (reigned 1740–58), had replaced one installed during the papacy of Leo III (reigned 795–816). Parts of Mino's ciborium are now walled in the basilica's tribune as well as in the chapter house.[6] If Masolino and Masaccio's altarpiece had been on this altar, it would have been placed under this ninth-century ciborium. One side of the altarpiece would have faced the congregation in the nave, and the other, the apse, where the basilica's canons had their choir. The general appearance of this part of the sanctuary dates to the time of Pope Nicholas IV, who had made considerable renovations to the basilica, including rebuilding the entire tribune and apse.[7] In 1296 Jacopo Torriti

finished the apse mosaic showing the *Coronation of the Virgin* and other stories from her life and death. Undoubtedly, this project was begun in Nicholas's lifetime, as he is depicted as a worshiper on the left.

The existence of the double-sided altarpiece on the altar below the ciborium cannot be documented. This altar was given the honor of being named a papal altar by Boniface IX Tomacelli (reigned 1389–1404),[8] which seemingly means that mass could be said there only by the pope or by those appointed by him. Giovanni Ferri (1907, pp. 156–57) transcribed records in which Martin V Colonna (reigned 1417–31) gave bishops special permission to say mass at the high altar in Santa Maria Maggiore. This indicates the pope's personal interest in the altar, but nothing more.

Whether a papal altar could have a painting placed on it has posed problems for scholars, since an altarpiece would conceivably have blocked the worshiper's view of a papal celebrant. Furthermore, throughout the Middle Ages the most important parts of the mass had to be celebrated by the priest *versus ad orientem,* or "facing east."[9] In the basilica of Saint Peter, this meant that the pope, in celebrating mass at the high altar, faced the worshipers, because, unlike most churches, it was oriented toward the west.[10] In other churches, like Santa Maria Maggiore, which faced east, the papal celebrant may have nevertheless still faced the worshipers, following the custom of Saint Peter's.

An important precedent for the Santa Maria

Maggiore altarpiece is the double-sided altarpiece by Giotto from Old Saint Peter's in Rome, commissioned by Cardinal Jacopo Stefaneschi, archpriest of the basilica. While in the past it has generally been assumed to have been on the high altar of that basilica,[11] there is no specific evidence for this. Bram Kempers and Sible de Blaauw (1987, esp. pp. 93–101) present convincing liturgical evidence for suggesting that it could not have been on that altar. They proposed instead that the altarpiece was actually made for the altar in the canons' choir, which, like the main altar, would have been able to accommodate a freestanding, double-sided painting. De Blaauw (1987, pp. 208–9), in researching medieval liturgical practices in Santa Maria Maggiore, located the canons' choir in the north side of the tribune, which is about where Vasari seems to have seen the altarpiece. Kempers and de Blaauw (1987) have also proposed that Giotto's altarpiece had also come from the canons' choir of Old Saint Peter's. Recently, Machtelt Israëls (2003, pp. 115–20 and fig. 54) located the canons' choir based on the will of Cardinal Antonio Corsini—the probable patron of the altarpiece (see below). Made of wood and situated to the north side of the main nave of the basilica, this choir existed only until 1460, when it seems to have been moved to the apse, and most likely the altarpiece or part of it was moved to the Colonna altar, where Vasari saw it about one hundred years later.

The Colonna altar in Santa Maria Maggiore was destroyed in 1574, when Pope Sixtus V Peretti

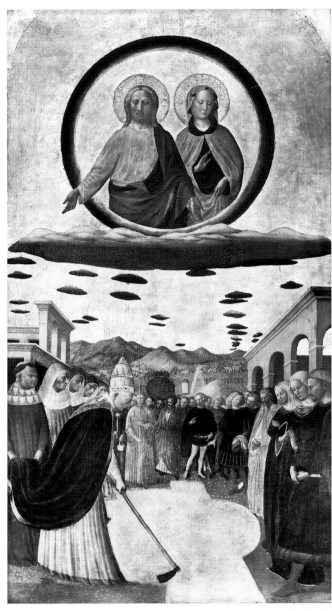

FIG. 44B.5 Masolino. *Founding of Santa Maria Maggiore,* or *Miracle of the Snow,* c. 1427–28. Tempera and tooled gold on panel; 56¾ × 29⅞″ (144 × 76 cm). Naples, Museo e Gallerie Nazionali di Capodimonte, no. Q42. See Companion Panel A

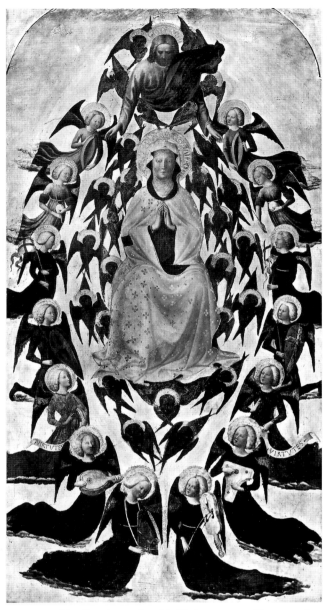

FIG. 44B.6 Masolino. *Assumption of the Virgin,* c. 1427–28. Tempera and tooled gold on panel; 55⅞ × 29⅞″ (142 × 76 cm). Naples, Museo e Gallerie Nazionali di Capodimonte, no. Q33. See Companion Panel B

(reigned 1585–90) exhumed Pope Nicholas IV's remains nearby and had a monument built by Domenico Fontana erected on the site (later moved to the west end of the basilica). Shortly thereafter, construction of the Pauline chapel, finished in 1611, completely transformed the northeast end of the basilica.

The subsequent history of Masaccio and Masolino's altarpiece is unclear until 1644, when the main panels, now in Naples (figs. 44B.5, 44B.6), London (figs. 44B.7, 44B.8), and Philadelphia, were recorded in an inventory of the Palazzo Farnese in

Rome, which shows that the painting had been disassembled into six pieces. They were in the third room of the picture gallery, near the library. The Philadelphia panels are described as follows: "A panel painting with a walnut frame and gilt background with Saint Peter and Saint Paul standing, by the hand of Pierino del Vago" (plate 44A [JC inv. 408]), and "a panel painting with a wood frame and a gilt background in which there is painted Saint Andrew and Saint Augustine, by the hand of Pierino del Vago."[12]

The paintings also appear in inventories of the

Farnese Collection of 1653, 1662–80, 1697, and 1728–34.[13] In the 1653 inventory, plate 44B (JC inv. 409) was described as "a painting with a gilt background with the pope with a chasuble, miter, and pastoral, and another saint standing with a book, on the left, with a walnut frame."[14] In this same inventory, plate 44A (JC inv. 408) is still attributed to the sixteenth-century painter Perino del Vaga, but in subsequent inventories this attribution is dropped. The inventory numbers of the 1662–80 inventory are still stamped on the backs of the panels in Naples.

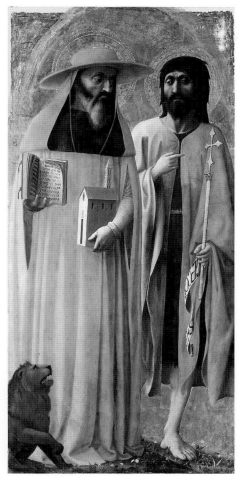

FIG. 44B.7 Masaccio and Masolino. *Saints Jerome and John the Baptist*, c. 1427–28. Tempera and tooled gold on panel; 44⅞ × 21⅝″ (114 × 55 cm). London, National Gallery, no. 5962. See Companion Panel C

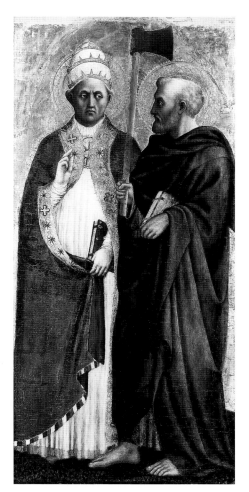

FIG. 44B.8 Masolino. *Saints Gregory the Great and Matthias*, c. 1427–28. Tempera and tooled gold on panel, transferred to synthetic panel; 45⅛ × 21⅝″ (114.5 × 55 cm). London, National Gallery, no. 5963. See Companion Panel D

London on June 30, 1915 (lot 111, as Tuscan School), to Langton Douglas, and purchased the next year by John G. Johnson from Kleinberger. Langton Douglas's letter to Johnson, dated London, July 23, 1916, survives:

> Of course the two wings that you have bought were once mine, like many other good Italian pictures in America. . . . I bought these panels from the Earl of Northesk's collection. They come from the same source as your Sassetta [inv. 1295] and your Pinturicchio [inv. 336]. All these things were bought in Rome, by a former Lord Northesk, about sixty odd years ago. He was quite a connoisseur of Italian art, knowing the best Roman society. He resided in Italy for some years.

COMMENTS

The older bearded and balding saint on the left holds a pen in his right hand and a book in his left, suggesting that he is one of the Evangelists. John the Evangelist is frequently painted as an elderly man and, like this figure, dressed in green and red.[23] However, he could also be the Evangelist Matthew, who was particularly venerated at Santa Maria Maggiore.[24]

The saint on the left is Martin of Tours (c. 316–397).[25] He is shown in three-quarter profile as a bishop holding a book and a pastoral staff and wearing a miter. His cope's gold orphrey is decorated with oblong medallions containing silver-leaf columns on a red field. This is the coat of arms of the Colonna family, whose members included Pope Martin V. These arms, the *M* pattern on the cope, and the portraitlike qualities of the face, which can be compared with the effigy on the pope's tomb (fig. 44B.10), suggest that the saint is meant to be a crypto-portrait of Martin V,[26] who was elected pope on Saint Martin's Day (November 11). There are also similarities between the figure and a drawing by the workshop of Pisanello (fig. 44B.9), which seems to be a copy of Gentile da Fabriano's portrait of the pope.[27]

Millard Meiss (1963) suggested that the morse on Martin's cloak, which bears an image of the *Vir dolorum,* or Christ as Man of Sorrows (fig. 44B.11), represented a piece of gold work that Lorenzo Ghiberti had executed for the pope. While the morse as well as the pastoral staff[28] may depict the pope's personal possessions, it is unlikely either one was by Ghiberti. The artist recorded that when the pope was in Florence in 1419, he designed for him a new miter and a morse with a Blessing Christ.[29]

Allan Braham (1980) identified the figure of John the Evangelist as a portrait of Emperor Sigismund I, king of Hungary from 1387 and Holy Roman Emperor from 1410,[30] comparing it with Sigismund's portrait in Vienna (fig. 44B.12). Braham reasoned that Sigismund was depicted in the altarpiece in recognition of his support for the Council of Constance, at which Martin V was elected, and his close

It is probable that the altarpiece entered the Farnese Collection via Cardinal Alessandro Farnese (1520–1589),[15] who was archpriest of the basilica of Santa Maria Maggiore from 1537 until his death.[16] It could also have come to the collection through Cardinal Odoardo Farnese (1573–1626), under whom Monsignore A. M. Santarelli, an active canon of the basilica, served as *maggiordomo* and *auditore.* For a while Santarelli was also secretary and tutor of the young Duke Odoardo Farnese. While he does not mention paintings in his autobiographical account of the basilica, written in the early 1600s (Santarelli 1647, esp. p. 97), he does speak of renovations around the tomb of Nicholas IV, which is where the altarpiece was most likely located.

The two central panels of the altarpiece were removed to Naples in 1760. The other panels entered the collection of Cardinal Joseph Fesch (1763–1839) in Rome in 1815.[17] They are recorded in the 1839

inventory of his estate as being of the period of Fra Angelico and were valued at 80 scudi each.[18] At this point the saints in plate 44A (JC inv. 408) were incorrectly identified as an apostle and Saint Ambrose. In 1841 a published catalogue of Fesch's collection, which was edited by the painters Vincenzo Camuccini and Giovanni Borrani, incorrectly identified the saints in plate 44B (JC inv. 409) as Saint Jerome and an apostle. Of this panel the editors wrote that "the colors in it are brilliant and recall the period of Beato Angelico,"[19] whereas, commenting on plate 44A (JC inv. 408), they wrote that "these small figures recall the period of Beato Angelico."[20] Sold in Rome at the Fesch sale of 1845,[21] they were bought by one Giuseppe Baseggio[22] for 178 scudi each.

The Johnson panels next entered the collection of the earl of Northesk, who bought them in Rome around 1850. They were then sold at Sotheby's in

FIG. 44B.9 (*above*) Workshop of Pisanello (Verona, first documented 1395; died 1455). *Pope Martin V and Other Figures,* c. 1431. Ink on paper; 6¾ × 9⅝" (17.2 × 24.3 cm). Moscow, State Pushkin Museum of Fine Arts

FIG. 44B.10 (*left*) Workshop of Donatello (Florence, 1386–1466). Tomb of Pope Martin V, installed 1443. Bronze. Rome, basilica of Saint John Lateran

diplomatic relations with the pope. Masolino may have had occasions to see Sigismund during the artist's stay in Hungary.[31] Alternatively, Meiss (1964, p. 183), followed by Silvia Maddalo (in Rome 1992, p. 55), proposed that the saint may be a memorial portrait of the pope's brother Giordano, who had died on December 27, 1423.

Martin was born Oddone Colonna in 1368. His election to the papacy in 1417 put an end to the schism that had divided the Roman church since 1378. He also restored Rome as the seat of the papacy. When he entered the city on September 28, 1420, its population numbered a mere twenty thousand. The papal historian and humanist Bartolomeo Platina (1474, Giada ed. 1913, p. 310) later wrote that Martin "found Rome so ruined and wasted that it had nothing of the face of a city. You could see its houses collapsing, its churches collapsed, the streets deserted, the city deep in mud and obliterated, suffering under the dearness and want of everything." Martin became a pope who put the streets back in order and ensured, it was said, that one could walk in Rome's woods with a purse of gold without being assaulted. While a number of projects in Martin's Rome got under way in time for the Jubilee of 1423, they were of a practical nature, such as repairs to the roof and the benediction balcony of Saint Peter's. More grandiose schemes were not taken on until the Jubilee was winding down. On

November 28, 1423, Martin issued a bull asking several cardinals, including Giordano Orsini, Rainaldo Brancaccio,[32] and Guillaume Fillastre, to inspect the condition of Rome's churches.[33] Their report does not survive, but, shortly after, the pope issued another bull ordering all cardinals (not only these three) to restore their titular church. About the same time, Nicolò Signorili wrote for the pope a guide of the principal relics of Rome's churches. Martin also oversaw the physical and spiritual restoration of several of Rome's basilicas. For example, in 1425 he conceded the basilica of San Paolo fuori le mura to the reform Benedictines. However, even though Santa Maria Maggiore, where the pope had lodged at one point in his early days in Rome, had a long association with the Colonna family,[34] his pet project was the Lateran. He had been archpriest of that basilica before his election as pope, and he was buried there as well. Important work in Santa Maria Maggiore was not undertaken until the next papacy.

RECONSTRUCTION OF THE ALTARPIECE:
The two panels in the Johnson Collection were originally painted on the front and back of a single panel that formed the lateral wing of a double-sided altarpiece (see fig. 44B.18). All the panels have been separated into two at least since 1653, when they are described as six individual pictures in the inventory

of the Farnese Collection. The other side panels are in the National Gallery in London: *Saints Jerome and John the Baptist* (fig. 44B.7) and *Saints Gregory the Great and Matthias* (fig. 44B.8). The central panels are in the Museo e Gallerie Nazionali di Capodimonte in Naples: the *Founding of Santa Maria Maggiore,* or *Miracle of the Snow* (fig. 44B.5) and the *Assumption of the Virgin* (fig. 44B.6).

The iconography of the altarpiece had specific significance for Santa Maria Maggiore, the first church in Rome to be dedicated to the Virgin. Its site was said to have been marked by a miraculous snowfall, shown in one of the panels in Naples. Every August 14, on the eve of the feast of the Virgin's Assumption, the subject of the other panel in Naples, Santa Maria Maggiore was the center of an important ceremony in which the icon of Christ *Acheropita,* kept at the Sancta Sanctorum, was brought by the pope in procession to the church for a ceremonial encounter with the icon now known as the *Salus populi romani,* one of the basilica's most precious relics.[35] The symbolic encounter is depicted in the upper part of the Naples *Miracle of the Snow* in which Christ and the Virgin are together in a mandorla. Furthermore, the apostle Matthias, represented in a panel in London, was buried under the high altar, and since the late thirteenth century the basilica had housed the relics of Saint Jerome, shown in the other London painting. The church also owned a relic of Zaccharias, father of John the Baptist, another of the figures in a London panel.[36]

Alexis-François Rio (1861, pp. 12–13), followed by G. B. Cavalcaselle and J. A. Crowe (1883–1908, vol. 2, 1883, pp. 285–87) and Eugene Müntz (1889, pp. 612–13), identified the Naples panels as fitting Vasari's description of the altarpiece. These panels were first attributed to Masolino by Bernhard Berenson (1896, p. 122). In 1930 Lionello Venturi recognized that the John G. Johnson Collection's panels had also belonged to the altarpiece. This reconstruction was accepted by all subsequent writers, except Kurt Steinbart (1948, p. 81). Kenneth Clark's 1951 publication of the two London panels, then recently acquired by the National Gallery, completed the reconstruction of the altarpiece's principal pieces. He was followed by Martin Davies (1951, 1961), who offered technical evidence that the altarpiece was double-sided. The only critic to voice an objection to this arrangement was John Pope-Hennessy (1952a), who then suggested that the altarpiece had been double-tiered.

There is no documentary and seemingly no physical evidence for determining which saints appeared on which side of the altarpiece. Vasari only described one side of the altarpiece, which had in the center the *Founding of Santa Maria Maggiore,* and he did not identify the saints, only saying that they seemed to be in relief, a statement that would best fit *Saints Jerome and John the Baptist* and *Saints Paul and Peter.* But because the saints in both these

FIG. 44B.11 (*above*) Detail of the Man of Sorrows from the morse of the cope of Saint Martin of Tours in plate 44B

FIG. 44B.12 (*right*) Unknown artist (Bohemian?). *The Holy Roman Emperor Sigismund I*, c. 1437. Oil on leather; 25¼ × 19¼ (64 × 49 cm). Vienna, Kunsthistorisches Museum, no. 2630

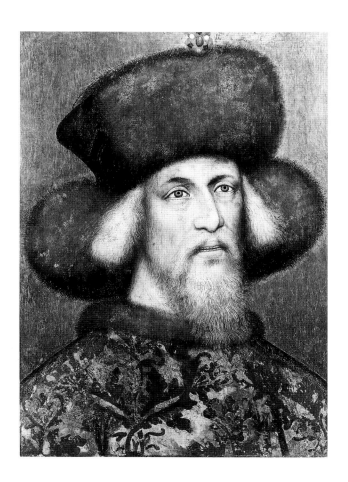

panels are oriented to the right, they could not have been on the same side of the altarpiece.

While subsidiary parts of the altarpiece undoubtedly existed, the three such panels that have been proposed cannot be proved to have come from the complex. The *Crucifixion* in the Pinacoteca Vaticana, once thought to be a pinnacle panel, is actually an independent painting.[37] Of the two predella panels that have been identified, one, also in the Pinacoteca Vaticana, is the *Entombment of the Virgin*.[38] The other, the *Marriage of the Virgin*, was lost during the Second World War.[39] Paul Joannides (1985; 1993, pp. 436–39) has suggested that these panels were the predella to the fragmentary Kress *Annunciation* in Washington, D.C.[40] Perri Lee Roberts (1993, pp. 212, 215) has rejected the predella panels' connection to either the Santa Maria Maggiore altarpiece or the Washington *Annunciation* and has attributed them to Francesco d'Antonio (q.v.).

While the Santa Maria Maggiore altarpiece does not seem to have influenced painting in Rome, it apparently provided a model for the layout of Vecchietta's altarpiece (fig. 44B.13) in the cathedral of Pienza, near Siena. Commissioned by Pope Pius II Piccolomini (reigned 1458–64), it shows the *Assumption of the Virgin* in the center with pairs of saints on either side. The papal saint in the left lateral is, like Martin of Tours in the Philadelphia panel, a crypto-portrait of the reigning pope, in this case Pius II. As

Vecchietta accompanied Masolino to Castiglione Olona and seems to have assisted him on other Roman projects, the dependency of his Pienza painting on the earlier Roman altarpiece may be quite close. If the Santa Maria Maggiore altarpiece in fact did not have a predella and pinnacles, its frame may have followed the Renaissance style seen on the painting by Vecchietta.

ATTRIBUTION: In the Farnese inventory of 1653 *Saints Paul and Peter* was curiously attributed to Perino del Vaga (1501–1547). No artist was named for the other panels of the altarpiece. In the 1841 Fesch catalogue they were assigned to the "epoch of Angelico." This attribution was changed to Gentile da Fabriano in the 1845 auction catalogue of the Fesch paintings. The panels were sold out of the earl of Northesk's collection in 1915 as Tuscan school. Langton Douglas, who bought them at the Northesk sale, told Johnson that the two panels were early works of Masaccio in a letter dated London, July 23, 1916:

I am confident myself that both these wings belong to Masaccio to his earlier period. One, the Saint Peter and Saint Paul, was painted entirely by himself. The other was painted by a pupil under his direction. [Charles S.] Ricketts and other critics agree with me. The Saint Peter certainly is too strong for Masolino, and the heavy

folds of the orfrey and the broad, simple, direct handling of the paint seem to me to be as signatures of Masaccio. I know of course that [Osvald] Sirén gives the panels to Masolino, as I did at the first glance.

Letters from Bernhard Berenson to Johnson followed.[41] On seeing the photographs of the paintings Berenson spoke of some problems he had with the attribution to Masolino, identifying in the panels evidence of what he called a "new phase" in the artist's work. Writing from I Tatti, Settignano, on September 10, 1916, Berenson said:

You will want to hear what I thought of the photos of the two panels you acquired recently fr.[om] Kleinberger. Well, I wish I could be as nearly sure of [Charles Evans] Hughes' election [as president] as I can that Sirén is nearly right in attributing them to Masolino. They obviously & conspicuously are worthy of him & very close to him. Doubtless before the originals I should not hesitate at all for then I should know what to allow for restoration etc. In the photos I find certain things wh.[ich] I do not recall elsewhere in Masolino. That may prove all the more interesting for if the panels turn out to be his, they would reveal him in a relatively new phase & thereby advance our knowledge of the master. In one point only I am not likely to agree with

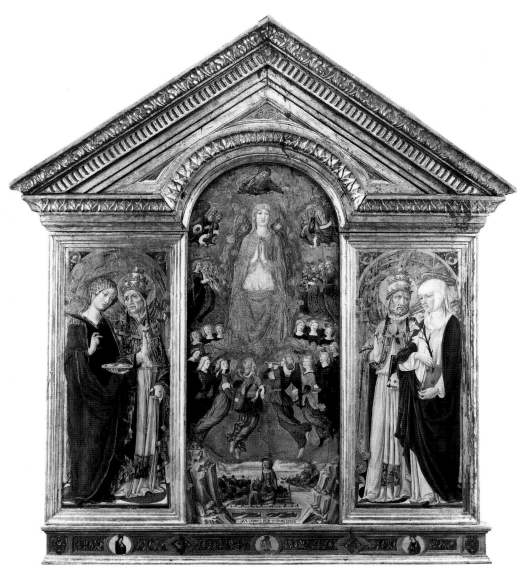

FIG. 44B.13 Vecchietta (Siena, 1410–1480). Altarpiece: *Assumption of the Virgin and Saints*, c. 1460. Tempera and tooled gold on panel. Pienza, cathedral

recognized that *Saints Jerome and John the Baptist* was by Masaccio, except for Davies (1951) and Bruce Cole (1980, p. 214), who both attributed it to Masolino, and Decio Gioseffi (1962), who opted for Domenico Veneziano. Carl Brandon Strehlke and Mark Tucker (in Strehlke 2002, pp. 111–60) have argued that the altarpiece was a collaboration from the start, with Masaccio responsible for the design of the side panels and Masolino responsible for the design of the central panels. Before his death, Masaccio was only able to finish one side panel— the *Saints Jerome and John the Baptist* in London and some of the work on the *Saints Paul and Peter*. The program of the altarpiece was changed either shortly before or after Masaccio's death, and the painting of the panels was completed by Masolino.

DATE: Several proposals have been made for the date of the altarpiece. Some argue that it was painted in Rome around 1423, possibly in connection with the Jubilee of that year (Meiss 1952; Parronchi 1966; Joannides 1987, 1993; Vincenzo Farinella in Pinelli 2001, pp. 341–42). Others believe that it was begun in 1427, shortly before Masaccio's death, and then completed by Masolino (Longhi 1940, 1951; Procacci 1952; Salmi 1952; Procacci 1953; Brandi 1957; Micheletti 1959; Meiss 1963; Berti 1964; Meiss 1964; Ikuta 1971–72; Procacci 1976a; Boskovits 1987; Strehlke and Tucker 1987; Roberts 1993). A third suggestion, first made by Clark (1951) and then modified by Longhi (1952), followed by Carlo Del Bravo (1969), is that it was begun in 1425–26 by Masaccio and then finished about 1428 by Masolino, possibly with an assistant. In addition, Frederick Hartt (1959) thought it may have been painted in Florence in 1423 and sent to Rome later. Based on circumstantial documentary evidence, I argue for a date around 1428.

COMMISSION: It is often assumed that the Santa Maria Maggiore altarpiece was commissioned by the Colonna family, because the figure of Saint Martin is a crypto-portrait of Pope Martin V Colonna himself, as the distinctive column of the Colonna family arms on the orphrey of the cope proves. Supporters of this argument find further evidence in the fact that the same facial features can be discerned in the figure of Pope Liberius in the *Founding of Santa Maria Maggiore* (fig. 44B.5), which may have been an attempt to associate Martin V with the fourth-century pope.[42] Furthermore, in the London panel (fig. 44B.7) Saint John holds a staff shaped like a column, yet another possible reference to the Colonna. However, the circumstances of its commission may have been similar to those of Giotto's double-sided altarpiece from Old Saint Peter's, which was undertaken by the papally appointed archpriest of the church, Jacopo Stefaneschi. During Martin V's reign the papally appointed archpriests of Santa Maria Maggiore were the Neapolitan Rainaldo Brancaccio[43] and the Sienese Antonio Casini.

Sirén. To my eyes both panels seem by the same artist altho' it would seem that the one with the Evangelist & Bishop [plate 44B (JC inv. 409)] has suffered much more from restoration.

After all whether actually Masolino's or not makes no great difference, for these pictures are immensely interesting & very impressive & if not by M.[asolino] they must be by another painter his equal whom we must place as high & study as lovingly.

I wish you could find out fr.[om] Kleinberger where they come from. Doubtless he got them from the Rev. Langton Bode [*sic,* for Douglas, or, in jest, in a reference to the contemporary German art historian Wilhelm Bode] who would know all about their pedigree.

In 1918 Maurice W. Brockwell published the panels for the first time. He called *Saints Paul and Peter* the possible work of Masolino and attributed *Saints John the Evangelist and Martin* to Masaccio. Lionello Venturi (1930) was the first to attribute both panels to Masolino. His opinion was followed by most critics except for Robert Oertel (1933), who insisted that the whole altarpiece was by Masaccio. Roberto Longhi (1940) noted a difference between the two Johnson panels. He proposed that *Saints John the Evangelist and Martin* might be by one of Masolino's students, either the young Vecchietta or Paolo Schiavo (q.v.). Ferdinando Bologna (1955) suggested that the assistant was Paolo Schiavo. Clark's publication of the London pieces in 1951 complicated questions of attribution. Most critics

FIG. 44B.14 Jacopo della Quercia (Siena, c. 1371/75–1438). Detail of *Saint Anthony Abbot Presenting Cardinal Antonio Casini to the Virgin and Child*, c. 1435. Marble, overall, width 48″ (120 cm). From Siena, cathedral, Casini chapel. Siena, Museo dell'Opera della Metropolitana

FIG. 44B.15 Detail of the head of the cardinal on the left in fig. 44B.5

FIG. 44B.16 Infrared reflectographic detail of fig. 44B.15, showing the adjustments made to the head of the cardinal

Miklós Boskovits (1987, p. 57) followed by Ria Mairead O'Foghludha (1998, pp. 240–62) suggested that Brancaccio was the patron. Brancaccio (who is not to be confused with the Brancacci of Florence) was the deacon of the cardinals and in that capacity had crowned Martin V at Constance. Giovanni de' Medici was his banker, and agents at the Roman branch of the bank were told that they could always extend credit to him. When Brancaccio drew up his will in 1427, Giovanni's son, Cosimo de' Medici, was present and appointed an executor.[44] The will, however, makes no provisions for an altarpiece in Santa Maria Maggiore; he left the basilica funds for a chalice and nothing else.[45] Therefore, if he had commissioned the altarpiece, he would have had to have done so before his death in 1427. However, as Andrea De Marchi (1992, pp. 212–13 n. 62) has shown, even if Brancaccio had commissioned the altarpiece during his lifetime, there is nothing to indicate that he would have hired Masolino and Masaccio to do the job. In fact, there is much evidence that his personal artistic tastes favored the international Gothic style.[46] And even though Brancaccio's tomb in Naples was executed by Michelozzo and Donatello, which might suggest a predilection for artists of the Florentine school, that commission had been arranged by Cosimo de' Medici as the cardinal's executor, not by the prelate himself.[47]

In 2002 Mark Tucker and I advanced the proposal that the patron of the altarpiece was Cardinal Antonio Casini of Siena,[48] Brancaccio's successor to the post of archpriest in Santa Maria Maggiore, and Machtelt Israëls (2003, especially pp. 107–50) arrived at the same conclusion independently. Casini was elected cardinal of San Macello on May 26, 1426, by Martin V, to whom he was related through his maternal grandmother (Israëls 2003, p. 111). Previously he had been a canon of the cathedral of Florence, bishop of Siena, and treasurer of the papal state. Casini was particularly close to Martin V and his family; in 1427, for example, Martin put him in charge of the education of his orphaned nephews.[49] Sometime after Casini had become a cardinal, he commissioned Masaccio to paint a small *Virgin and Child*, now in the Uffizi,[50] which is, if anything, a good indication of his artistic tastes. He also asked Jacopo della Quercia to execute a chapel for him in the Siena cathedral (see fig. 44B.14). Casini's devotion to Santa Maria Maggiore is no better indicated than by his desire to be buried there, as he indeed was *in medio ecclesiae* (in the middle of the church), in 1439. Casini may well be the corpulent tonsured cardinal (fig. 44B.15) holding the pope's robes in the central scene of the *Founding of Santa Maria Maggiore* in Naples, for the features correspond to his portrait in the relief by Jacopo della Quercia. This is also an area of the

painting that technical analysis (fig. 44B.16) shows underwent considerable change and adjustment, suggesting that Masolino worked hard to make it a recognizable portrait (Carl Brandon Strehlke and Mark Tucker in Strehlke 2002, p. 124, figs. 121–23).

No document has been found specifically referring to the Santa Maria Maggiore altarpiece, but there is a record concerning the bequest of another cardinal that might help place the painting in a chronological framework. On May 28, 1428, the canons of the basilica and one of its archpriests, the French cardinal Jean Rochetaillé, appealed to the pope to convert two bequests for uses other than those intended by the testors (see Appendix I, plate 44B). One was from Cardinal Pietro Morosini (died 1424), who had left 100 florins for a silver reliquary to house the relics of Saint Jerome. The canons shrewdly noted that a much larger sum of money would be needed for such a project. The other bequest was the 25 florins that Brancaccio had left for a chalice, which, according to the canons, the church did not need, since it was "full of chalices, having at least ten or twelve." They did not specify how the funds should be spent but only suggested that they should be used for necessary repairs in the church or for such other purposes as the amount permitted. The 125 florins was enough for an altarpiece; Masaccio's Pisa altarpiece for the notary Giuliano degli Scarsi, for example, had cost only 80 florins.

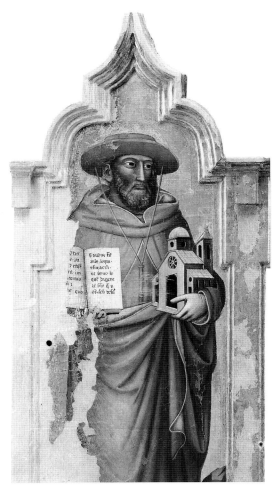

FIG. 44B.17 Mariotto di Nardo (Florence, c. 1373–1424). Lateral panel of an altarpiece: *Saint Jerome*, 1398. Tempera and tooled gold on panel. From Pian di Mugnone (Fiesole), hospital of San Giovanni Decollato; possibly originally in Florence, cathedral. Now Fiesole, oratory of Fontelucente

The pope and Cardinal Casini approved the canons' request, and the funds were put to another, unspecified use. The money could have gone into another work of art, in this case the altar and altarpiece for the canons' choir, which was very close to the altar with the relics of Saint Jerome.[51]

If Cardinal Morosini's bequest had helped pay for the Santa Maria Maggiore altarpiece, the Venetian heritage of this noted scholar of canon law might explain the unusual manner in which Saint Jerome is depicted in the painting, holding a book, inscribed with the first lines of Genesis, and a model of the church (fig. 44B.7).[52] There is only one earlier known Florentine example of Jerome with these attributes: Mariotto di Nardo's 1398 altarpiece showing the Assumption of the Virgin with Saints Jerome and John the Evangelist (fig. 44B.17). While it is likely that this painting was originally an altarpiece in the cathedral of Florence,[53] and, therefore, well known

to Masaccio, depictions of Jerome holding a model of a church were much more common in Venetian painting.[54] Other Venetians also had considerable influence in Santa Maria Maggiore. On June 24, 1423, Martin V gave the Venetian Cardinal Antonio Correr, founder of the monastic reform community of San Giorgio in Alga, permission to say mass at the papal altar.[55] Another prelate, Francesco Landi, known as the "Cardinal of the Venetians," had long lobbied for the establishment of a chapel in honor of the Assumption of the Virgin and Saint Francis in the church, which was approved by the canons in 1423 but only begun in July 1428, shortly after Landi's death the previous December.[56]

CONCLUSIONS: It is here suggested that Cardinal Antonio Casini, as archpriest of the basilica of Santa Maria Maggiore, commissioned Masaccio to paint the altarpiece in 1427. For this he may have used funds that had been left by Cardinals Morosini and Brancaccio for other purposes. The altarpiece seems to have been designed for the altar of the canons, which was the only one in the basilica that could accommodate a double-sided painting. Masaccio began by laying out the design and painting the panels of *Saints Jerome and John the Baptist* (fig. 44B.7), *Saints Paul and Peter* (plate 44A [JC inv. 408]), and *Saints John the Evangelist(?) and Martin of Tours* (plate 44B [JC inv. 409]). Before his death he only completed the painting of the first panel, but even parts of that were left unfinished. Masolino, who may have been involved with the project from the start, painted the central panels, the *Founding of Santa Maria Maggiore* (fig. 44B.5) and the *Assumption of the Virgin* (fig. 44B.6), now in Naples. He also painted *Saints Gregory the Great and Matthias* (fig. 44B.8) on a design by Masaccio that probably used elements of cartoons from the panels showing Saints Paul and Peter and Saints John the Evangelist and Martin. After starting to paint *Saints John the Evangelist(?) and Martin of Tours* he was asked, for unknown reasons, to switch the saints' identities. He also interchanged the identities of *Saints Paul and Peter,* in this case preserving as much of Masaccio's work as he could. Taking a step unusual in painting in this period, and that was markedly different from Masaccio's technique, Masolino rendered his contributions to the altarpiece in a largely oil-based medium.

The altarpiece's iconography pays homage not only to the Marian traditions of the basilica, the first church in Rome to be dedicated to the Virgin Mary, and some of the saints whose relics it housed, but also to the reestablishment of Rome as the center of the papacy under Martin V, who, in the altarpiece, is celebrated in the guise of his patron saint, Martin of Tours.

1. " . . . nella quale sono quattro Santi tanto ben condotti, che paiono di rilievo, e nel mezzo Santa Maria della Neve; et il ritratto di papa Martino di naturale, il quale con una zappa disegna i fondamenti di quella chiesa, et appresso a lui è Sigismondo Secondo imperatore. Considerando questa opera un giorno, Michelagnolo et io, egli la lodò molto, e poi soggiunse coloro essere stati vivi ne' tempi di Masaccio."

2. Nicolò Signorili's guide to the relics of Rome's churches, written for Pope Martin V in 1425 on commission of the Roman senate, does not mention it. Sections of the guide are published by Roberto Valentini and Giuseppe Zucchetti (1959, pp. 151–208), but the references to Santa Maria Maggiore are not fully transcribed. They can be consulted in Signorili's manuscript *De iuribus et excellentis urbis romanae* in the Biblioteca Apostolica Vaticana (Ms. vat. n. 3536, folio 58 recto). While his references to works of art are few, if Masaccio and Masolino's altarpiece had been recently installed at the pope's instigation in Santa Maria Maggiore, it might have merited some comment. Likewise, Domenico da Corella, writing in his *Theoticon* of about 1469 (Lami ed. 1742, pp. 62–63) is silent on the altarpiece, even though he speaks of other recent works of art in the basilica.

3. It should be noted that de Angelis's map presents several discrepancies with known evidence and does not correspond in detail to a description made of the church sometime before 1566 by Onofrio Panvinio (in Biasiotti 1915). Panvinio (in Biasiotti 1915, pp. 34–35) describes a Saint John the Baptist chapel near the church's principal entrance in the west end. He refers to it as still being under the patronage of the Colonna family, even though it had been conceded to Patrizio and Costanza Patrizi in 1558, when it was rededicated to the Virgin of the Snow, or the Founding of Santa Maria Maggiore, the main subject of the altarpiece described by Vasari. However, the altar was not renovated until the early seventeenth century. Around 1635 a painting by Giuseppe Puglia, called il Bastaro, was placed on the altar (Pietrangeli 1988, color repro. p. 282). It is possible that Masaccio and Masolino's altarpiece was on this altar for a period, possibly sometime after 1574 (see text below).

4. Boskovits (1987a, p. 57) notes that Vasari generally described both sides of double-sided altarpieces. However, the text suggests that in this case, he was only interested in the historical scene of the founding of the basilica. He may have simply failed to mention the other side.

5. See also Boskovits 1987a, p. 57; Strehlke and Tucker 1987, pp. 108–9; Fabrizio Mancinelli in Pietrangeli 1988, pp. 191–96; Monica Maggiorani and Cinzia Pujia in Baglione 1639, Barroero ed. 1990, p. 188 n. 137; Dunkerton et al. 1991, p. 252; Joannides 1993, p. 414; Roberts 1993, pp. 86–87.

6. Pani Ermini 1974; Caglioti 1987.

7. Marina Righetti Tosti-Croce in Pietrangeli 1988, pp. 129–38.

8. Taccone-Gallucci 1911, p. 40.

9. On this problem, see Vogel 1960; Nussbaum 1965; Gamber 1977; Gardner 1974, pp. 78–79; Gardner 1983, p. 298.

10. See Guillaume Durand's thirteenth-century *Rationale divinorum officiorum;* quoted in Vogel 1960, p. 459.

11. Hager 1962, p. 194; Kemp 1967, pp. 312–13; Gardner 1974, pp. 59–63, 73–79. For the altarpiece, now in the Pinacoteca Vaticana, see Previtali 1993, color plates CVIII–CXI, black-and-white figs. 497–500.

12. "4392. Un quadro in tavola con cornice di noce, fondo del quale è dorato, dentro è dipinto S. Pietro e S. Paolo in piedi, mano di Pierino del Vago"; and "4432. Un quadro in tavola con cornice di legno. il piano d'esso (dorato), dentro è dipinto S. Andrea e S.

SIDE A

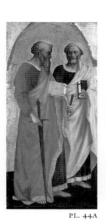

SIDE B

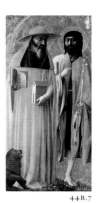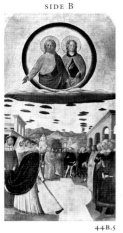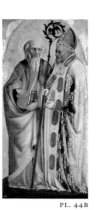

PL. 44A 44B.6 44B.8 44B.7 44B.5 PL. 44B

FIG. 44B.18 Suggested original configuration of the known extant panels of Masaccio and Masolino's double-sided Santa Maria Maggiore altarpiece, c. 1427–28. Side A (left to right): PLATE 44A, FIGS. 44B.6, 44B.8. Side B (left to right): FIGS. 44B.7, 44B.5, PLATE 44B

Agostino. mano di Pierin del Vago" (Bertrand 1994, pp. 177, 180).

13. See Bertini 1987, p. 229; Rosanna Muzii in Naples 1995, p. 101; and Davies 1961, p. 357.

14. "Un quadro fondo dorato con Papa con un pievale mitria e pastorale, et un altro Santo in piedi con un libro alla sinistra cornice di noce." See Davies 1961, p. 357.

15. On his collections, see Robertson 1992.

16. Taccone-Gallucci 1911, p. 58.

17. On his collection, see Thiébaut 1987, pp. 5–43.

18. Nos. 12841 and 13863; Thiébaut 1987, pp. 170–71.

19. "Le coloris [sic] en est fort, et rappelle l'époque de Beato Angelico" (Fesch 1841, no. 1339).

20. "Ces petites figures rappellent l'époque de Beato Angelico" (Fesch 1841, no. 1317).

21. Rome, Palazzo Falconieri (via Giulia, 1), March 17–18 and following, lots 886–87 (as Gentile da Fabriano).

22. There is much confusion about this fascinating figure, who bought 158 pictures at the Fesch sale. I thank Carol Togneri for information about him.

23. In the Fesch sales catalogue (1841, p. 60) he was incorrectly described as Jerome.

24. Nicolò Signorili, in his 1425 inventory of relics of the church, lists an arm of Saint Matthew Apostle. See n. 2 above.

25. He has also been described as Saint Ambrose (Fesch estate inventory, 1839; see Thiébaut 1987, p. 170), an apostle (Fesch 1841, p. 59), and Saint Massimo (Brockwell 1918).

26. First proposed by Salmi 1952, p. 15.

27. According to Vasari, a portrait from life of Pope Martin V also appeared in the central panel of the disassembled altarpiece (fig. 44B.5), where he is shown marking the foundations of Santa Maria Maggiore with a hoe, as the Emperor Sigismund I stands beside him. Here Martin would be assuming the identity of Pope Liberius (reigned 352–66), who founded the basilica.

Allan Braham (1980) has suggested that the figure of a pope, usually identified as Liberius or Gregory the Great, in another panel of the altarpiece in London (fig. 44B.8), may also be a crypto-portrait of Martin V, this time in the guise of Saint Martin I (reigned 649–53), who was the last pope to be honored as a martyr. However, the absence of a martyr's palm probably preclude such an identification. He is also probably not Liberius, as that pope was not venerated as a saint. On his identity as Gregory the Great, see, in particular, Davies 1961, p.

355; Vayer 1965, pp. 223–24; Roberts 1985; Roberts 1993, p. 87 n. 13; Joannides 1993, p. 417.

28. Strehlke and Tucker 1987, p. 111.

29. In the *Commentarii* Ghiberti wrote: "Pope Martin came to Florence [and] commissioned me to make a golden mitre and a morse for a cope. On [the miter] I made eight half-figures in gold, and on the morse I made a figure of Our Lord blessing" (Ghiberti 1447–55, Bartoli ed. 1998, p. 94).

30. Vasari had stated that Sigismund was depicted near the pope in the panel showing the founding of Santa Maria Maggiore, but gives no more specific identification. This figure is sometimes identified as the man in the center of the crowd in the background (Kéry 1972, pp. 78–83, fig. 57).

31. Gaetano Milanesi (in Vasari 1568, Milanesi ed., vol. 2, 1878, p. 294 n.) assumed that Masaccio would not have painted a fictive portrait of Sigismund, as he had not seen him, and the artist was not there by the time the emperor came to Rome in 1433 for his imperial coronation. Milanesi therefore posited that the altarpiece might be the work of the Marchigian painter Arcangelo di Cola, who was in Rome from May 1422 to work for Martin V, even though he is not documented as late as the 1433 coronation.

32. See n. 43.

33. See Giuseppe Lombardi in Rome 1992, p. 41, esp. n. 51, where he quotes Chácon 1677, p. 820.

34. In a letter of November 1425 to Niccolò Niccoli, the Florentine humanist Poggio Bracciolini says that the pope was then living on the Esquiline Hill near Santa Maria Maggiore (quoted by Concetta Bianca in Rome 1992, p. 88 n. 55). Many papal bulls were also dated "apud Sanctam Mariam Mariorem." The pope later moved to a palace near Santi Apostoli, where the Colonna had long had important property. He was said to live there in a miserly fashion (see Maria Grazia Blasio in Rome 1992, p. 115). However, the Colonna had a long association with Santa Maria Maggiore, where several cardinals of the family were buried, where they had commissioned the late thirteenth-century façade mosaics, and where they had patronage over four altars.

35. Belting 1994, esp. pp. 68–73; Wolf 1990.

36. See Signorili's manuscript cited in n. 2 above.

37. Schmarsow, vol. 3, 1898, pp. 86–88; Strehlke 2002, color plate 31. For a technical analysis, see Strehlke 2002, p. 244.

38. Schmarsow, vol. 3, 1898, pp. 74–78; Strehlke 2002, color plate 32.

39. Strehlke 2002, fig. 124; Pope-Hennessy 1943.

40. Nos. 336–37; Joannides 1993, hypothetical reconstruction plate 445; Strehlke 2002, color plate 24.

41. The first is dated, I Tatti, Settignano, July 8, 1916, when he had heard of Johnson's acquisition but not seen the photographs. "I am much excited to hear that you have acquired a Masolino. There is no reason why it should not be, for Masolino *now* is quite easy to know. Of course it was not quite so easy twenty years ago."

42. See n. 26.

43. On Brancaccio, see Dieter Girgensohn in *DBI*, vol. 13, 1971, pp. 797–99; and Lightbown 1980, vol. 1, pp. 52–82.

44. The will is transcribed in Lightbown 1980, vol. 2, pp. 293–97.

45. Lightbown 1980, p. 295. Brancaccio seems to have had little daily contact with Santa Maria Maggiore. He lived in a palace next to Santa Maria in Trastevere, and even asked that his funeral take place in Santa Maria sopra Minerva, giving Santa Maria Maggiore as an alternative location.

46. In his will he asks that his burial chapel in Sant'Angelo in Nilo in Naples be decorated in the manner of the Pappafava chapel in the same city. The artist of that chapel, known as the Master of Penna, worked in an exaggerated Gothic style. The mural on the façade of Sant'Angelo (Galante 1872, repro. p. 155), also commissioned by Brancaccio, shows a work much in the same vein, as do a series of seventeenth-century drawings after the much-ruined Brancaccio tabernacle that was on the façade of his Roman palace (Waetzoldt 1964, figs. 52–82). What best expresses Brancaccio's artistic tastes is the well-preserved triptych in the Museo Piersanti in Matelica (Macerata 1971, repro. p. 135), which shows the kneeling cardinal as donor.

47. Lightbown 1980, plates 22–45.

48. On Casini, see Werner Brandmüller in *DBI*, vol. 21, 1978, pp. 351–52; and Israëls 2003, especially pp. 103–26 and 145–63.

49. Andreas Rehberg in Rome 1992, pp. 270–71, 273, 282.

50. Strehlke 2002, color plate 21.

51. Israëls (2003, p. 112 n. 325) believes that this document can only refer to building in the church.

52. Bernhard Ridderbos (1984, esp. pp. 1–14) has shown that the symbolism of the church comes from the *Legenda de sanctis* of the Dominican Pietro Calo da Chioggia,

written between 1330 and 1340. In that text Jerome is said to have "radiated the sanctuary of god, changing away the darkness of errors."

53. Suggested by Boskovits (1968a, pp. 21, 30 n. 6). It may relate to documents of an altarpiece for an altar of the Virgin commissioned by the officials of the cathedral in 1398, under the direction of Giovanni di Lapo Rucellai and Jacopo di Niccolò Riccialbani. See Poggi 1909, Haines ed. 1988, pp. 202–5, documents 1006–16.

54. See the altarpieces by Jacobello di Bonomo of the 1370s in San Martino, Arquà Petrarca (Lucco 1992, fig. 79); and by Zanino di Pietro of c. 1410 in Avignon, Musée du Petit Palais (no. 251; Laclotte and Mognetti 1987, fig. 251), as well as the destroyed panel with Saint Jerome by Lorenzo Veneziano (q.v.) of about 1370, once in Berlin, Kaiser-Friedrich-Museum (Ridderbos 1984, fig. 3). Jerome also appears holding a church in Gentile da Fabriano's altarpiece from the church of Valle Romita, near Fabriano, painted, in fact, after 1405, during an interruption in Gentile's Venetian sojourn. The painting is now in the Brera in Milan (no. 497; De Marchi 1992, color plate 10).

55. Ferri 1907, p. 157.

56. Giovanna Curcio in Rome 1992, p. 549.

Bibliography

Giorgio Vasari (1568) in Vasari 1550 and 1568, Bettarini and Barocchi eds., vol. 3 (text), 1971, p. 128; Baldinucci 1681–1728, Ranalli ed., vol. 1, 1845, p. 476; Fesch 1841, pp. 59–60 ("epoch of Angelico"); Fesch 1845, pp. 188–89 (Gentile da Fabriano); Brockwell 1918, pp. 145–46, repros. II–III; L. Venturi 1930, pp. 165–79, figs. 2–3, reconstruction fig. 4; Valentiner 1931, pp. 413–16; L. Venturi 1931, plate CLVII; Berenson 1932, p. 338; Salmi 1932, pp. 72–73, 124–25, plates CLIX, CLX; Oertel 1933, pp. 277–79, figs. 48–49, diagram fig. 47; L. Venturi 1933, plate CLVII; F. Gilles de La Tourette in Paris 1935, pp. 136–38; Wassermann 1935, pp. 46–47; Berenson 1936, p. 300; Pope-Hennessy 1939, pp. 30–31, 54 n. 75; Longhi 1940, pp. 167–68 (Longhi *Opere*, vol. 8, pt. 1, 1975, pp. 30–31); Johnson 1941, p. 10; Pope-Hennessy 1943; Salmi 1948, pp. 39, 109–10, 139–40, 166, 208–9, 249, repros. pp. 177–78, diagram after Oertel p. 179; Steinbart 1948, pp. 80–81; Philadelphia 1950, nos. 3–4; Clark 1951, figs. 7–8; Davies 1951, pp. 272–80; Longhi 1951a (Longhi *Opere*, vol. 8, pt. 1, 1975, p. 75); Longhi 1952 (Longhi *Opere*, vol. 8, pt. 1, 1975, pp. 77–84); Meiss 1952, inv. 408 repro. p. 50; Pope-Hennessy 1952a; Procacci 1952, pp. 36–37; Salmi 1952, figs. 3–4; Procacci 1953, pp. 6–7, 47–55; F. Bologna 1955, p. 40; Hendy 1955, p. 34; Krautheimer 1956, p. 200; Brandi 1957, pp. 169–70; Umberto Baldini in *Enciclopedia*, vol. 8, 1958, cols. 870, 874; Hartt 1959, p. 163 n. 16; Micheletti 1959, p. 367; Berti 1961, p. 103; Davies 1961, pp. 352–61; Procacci 1961, p. 36; Gioseffi 1962, p. 70 n. 15; Middeldorf 1962, p. 284; Vayer 1962, pp. 159–75, figs. 32, 37–38; Waddingham 1962, p. 29; Berenson 1963, p. 137; Meiss 1963, pp. 143–44; Berti 1964, p. 153 n. 288; Kennedy 1964, pp. 30, 34–35, fig. 3; Meiss 1964, illustrations 1–2, 5, 7–13, 25; Molajoli 1964, p. 33; Bianchini 1965, p. 5; Vayer 1965, pp. 219–24; Parronchi 1966, p. 34; Sweeney 1966, pp. 48–50, repros. pp. 110–11; Berti 1967, pp. 127–29, 161; Buchowiecki 1967, p. 241; Berti 1968, pp. 100–101; Del Bravo 1969, nos. 13–15, 73–76, figs. 74, 76; Giovanni Previtali in *Encyclopædia universalis*, vol. 10, 1971, p. 583, fig. 1 and plate IV (color); Ikuta 1971–72, figs. 3–4, 13–18, 29–43; Fredericksen and Zeri 1972, p. 123; Kéry 1972, p. 82; Miklós Boskovits in *Bolaffi*, vol. 7, 1975, pp. 257, 267; Procacci 1976a, p. 236; Bra-

ham 1980, figs. 18–19, 24; Hartt 1980, pp. 194–95; Lightbown 1980, p. 113; Procacci 1980, pp. 14, 22; Wohl 1980, pp. 159–61; Hellmut Wohl in Ramsey 1982, p. 172, fig. 1; Fabrizio Mancinelli in New York 1983; Anna Cavallaro in Rome 1984, pp. 337–38, 343 n. 28, fig. VIII(d); Wohl 1984, p. 238; Joannides 1985; Roberts 1985; Alessandro Angelini in Vasari 1550, Bellosi and Rossi ed. 1986, pp. 269–70 nn. 9, 11; Pope-Hennessy 1986, pp. 21–22; Boskovits 1987; Caglioti 1987, p. 16; Colle 1987, p. 79, figs. 83c–d; Joannides 1987, p. 9; Strehlke and Tucker 1987, figs. 1–2, 9–15, 19–26; Thiébaut 1987, repros. pp. 170–71; Berti 1988, p. 58; Rossella Foggi in Berti 1988, p. 202; Joannides 1988, fig. 2; Fabrizio Mancinelli in Pietrangeli 1988, pp. 191–96, color repros. pp. 192–93; Carl Brandon Strehlke in Milan 1988, pp. 204–7; Rossella Foggi in Berti and Foggi 1989, p. 138; Dunkerton et al. 1991, pp. 252–55, no. 16, color repros. pp. 253, 255; De Marchi 1992, p. 213 n. 62; Silvia Maddalo in Rome 1992, pp. 53–55, fig. 20 (incorrectly as in a private collection); Droandi 1993, pp. 140–41; Joannides 1993, pp. 72, 79–80, 421–22; color plates 46, 51; repros. 421–22; reconstruction plates 421–22; Philadelphia 1993; Roberts 1993, pp. 86–98, 189–92, plates 37, 41; Philadelphia 1994, repro. p. 215; Spike 1995, p. 186, repro. p. 221; Valerio Guazzoni in Del Serra 1996, p. 91; Keith Christiansen in *Dictionary of Art* 1996, vol. 20, p. 556; Hellmut Wohl in *Dictionary of Art* 1996, vol. 20, pp. 535–36; Dunkerton 1997, pp. 30–31; O'Foghludha 1998; Kirsh and Levenson 2000, p. 311; Vincenzo Farinella in Pinelli 2001, pp. 341–42; Ahl 2002, plates 18–19, reconstruction by Rachel Billinge plates 15, 16; Perri Lee Roberts in Ahl 2002, pp. 102–3; Roberto Bellucci and Cecilia Frosinini in Ahl 2002, pp. 118–22; Dillian Gordon in Ahl 2002, pp. 132–37; Strehlke 2002, color plates pp. 13, 29–30; Roberto Bellucci and Cecilia Frosinini in Strehlke 2002, 54–55, 58–61, figs. 44–45; Roberto Bellucci, Cecilia Frosinini, and Mauro Parri in Strehlke 2002, pp. 236–43; Carl Brandon Strehlke and Mark Tucker in Strehlke 2002, pp. 111–29, figs. 102, 105–13; Carl Brandon Strehlke in Strehlke 2002, pp. 14–15, 21–24; Israëls 2003, pp. 104–26; Gordon 2003, pp. 224–47, figs. 10–13 (color and black-and-white), pp. 238–39

COMPANION PANELS for PLATE 44B

A. Masolino. Center panel of an altarpiece: *Founding of Santa Maria Maggiore*, or *Miracle of the Snow*. See fig. 44B.5

c. 1427–28

Tempera and tooled gold on panel; 56¾ × 29⅞" (144 × 76 cm). Naples, Museo e Gallerie Nazionali di Capodimonte, no. Q42

PROVENANCE: See Companion Panel B

EXHIBITED: Paris 1935, no. 302; Naples 1950, no. 5

SELECT BIBLIOGRAPHY: See Companion Panel B

B. Masolino. Center panel of an altarpiece: *Assumption of the Virgin*. See fig. 44B.6

c. 1427–28

Tempera and tooled gold on panel; 55⅞ × 29⅞" (142 × 76 cm). Naples, Museo e Gallerie Nazionali di Capodimonte, no. Q33

PROVENANCE: See plate 44B (JC inv. 409). The panels have been in Naples since 1760.

EXHIBITED: Naples 1950, no. 6

SELECT BIBLIOGRAPHY: Raffaello Causa in Naples 1950, pp. 42–44, nos. 5–6; Davies 1951, pp. 272–80; Molajoli 1960, p. 33; Davies 1961, pp. 352–61; Van Os 1968, pp. 12–14; Johannides 1993, pp. 414–22; Roberts 1993, pp. 189–92; Spinosa 1994, pp. 24–27; Rosanna Muzii in Naples 1995, pp. 101–3; Spike 1995, p. 186; Dillian Gordon in Ahl 2002, pp. 133–37; Perri Lee Roberts in Ahl 2002, pp. 102–3; Luciano Bellosi in Bellosi 2002, pp. 38–39; Roberto Bellucci and Cecilia Frosinini in Strehlke 2002, pp. 54–55, 58–61; Carl Brandon Strehlke and Mark Tucker in Strehlke 2002, pp. 111–29; Roberto Bellucci, Cecilia Frosinini, and Mauro Parri in Strehlke 2002, pp. 220–27; Gordon 2003, pp. 224–47

C. Masaccio and Masolino. Lateral panel of an altarpiece: *Saints Jerome and John the Baptist.* See fig. 44B.7

c. 1427–28

Tempera and tooled gold on panel; 44⅞ × 21⅝" (114 × 55 cm). London, National Gallery, no. 5962

INSCRIBED ON JEROME'S BOOK: *IN PRINCIPIO. C/ REAVIT. DEUM/ CELUM. ETTERA'/ TERRA. AUTEM/ EIAT. INNANIS/ ET VACUA. ET/ SPIRITUS. DOM/ MINI. TENEBA/ TUR. SUPER/ AQUAS. ECCETE/ RA* (Derived from Genesis 1:1–2: "In the beginning God created heaven, and earth. And the earth was void and empty, . . . and the spirit of God moved over the waters"); ON THE BAPTIST'S SCROLL: *ECCE [AGNU]S. DE[I]* (John 1:29: ". . . Behold the Lamb of God")

PROVENANCE: See Companion Panel D

SELECT BIBLIOGRAPHY: See Companion Panel D

D. Masolino. Lateral panel of an altarpiece: *Saints Gregory the Great and Matthias.* See fig. 44B.8

c. 1427–28

Tempera and tooled gold on panel, transferred to synthetic panel; 45⅛ × 21⅝" (114.5 × 55 cm). London, National Gallery, no. 5963

PROVENANCE: See plate 44B (JC inv. 409). After the Fesch sale in 1845, the paintings were purchased in Rome from Sir R. Shafto Adair, c. 1850. They were acquired from his descendant Major-General Sir Allan Adair by the National Gallery in 1950.

SELECT BIBLIOGRAPHY: Davies 1951, pp. 272–80; Davies 1961, pp. 352–61; Cole 1980, p. 214; Dunkerton et al. 1991, pp. 252–55; Joannides 1993, pp. 414–22; Roberts 1993, pp. 189–92; Spike 1995, p. 186; Dunkerton 1997, pp. 30–31; Dillian Gordon in Ahl 2002, pp. 133–37; Perri Lee Roberts in Ahl 2002, pp. 102–3; Roberto Bellucci and Cecilia Frosinini in Strehlke 2002, pp. 54–55, 58–61; Carl Brandon Strehlke and Mark Tucker in Strehlke 2002, pp. 111–29; Roberto Bellucci, Cecilia Frosinini, and Mauro Parri in Strehlke 2002, pp. 220–27; Gordon 2003, pp. 224–47

MASTER OF CARMIGNANO

FLORENCE, ACTIVE LATE FOURTEENTH
AND EARLY FIFTEENTH CENTURIES

The Master of Carmignano is the name given to
a painter on the basis of a group of fragmentary
murals in the church of San Michele in Carmignano,
a town northwest of Florence that probably dates in
the early part of the fifteenth century.[1] Miklós
Boskovits reconstructed the artist's oeuvre,[2] which
was later published by Federica Fiorillo (2001).
Like the better-known Master of Sant'Ivo (active
c. 1380–1410), to whom he bears some similarity, the
Master of Carmignano was formed in the tradition
of late trecento Florentine workshops like that of
Agnolo Gaddi (q.v.). His career must have paralleled
that of his more successful contemporaries Lorenzo
di Niccolò and Mariotto di Nardo. In a work such
as the mural of the Annunciation in Carmignano, the
influence of Lorenzo Monaco (q.v.) can be discerned,
and it was probably Lorenzo's example that led the
artist away from a tighter style, as exemplified by
paintings such as his *Virgin and Child* (plate 45 [PMA
1950-134-527]), and toward a softer and even more
decorative manner, as seen in the small tabernacle
of the *Virgin and Child and Saints* sold at Christie's
in London on July 9, 1993 (lot 60).

1. The murals, with their corresponding negative num-
 bers in Florence, Soprintendenza Speciale per il Polo
 Museale Fiorentino, Gabinetto Fotografico, are: *Death
 and Burial of Saint Catherine of Alexandria and Death
 of Saint Peter Martyr* (neg. no. 223508), *Virgin and
 Child Enthroned with a Deacon Saint* (neg. no. 223663),
 and *Annunciation* (neg. no. 69432). See Trenti
 Antonelli 1990, repros. pp. 6–7; and Fiorillo 2001,
 figs. 9–11.
2. He kindly allowed me to see his collection of pho-
 tographs of the artist's work.

Select Bibliography
Fiorillo 2001

PLATE 45 (PMA 1950-134-527)
Virgin of Humility

c. 1395–1400

Tempera, silver, and tooled gold on panel with vertical
grain; with original frame 41⅜ × 24 × 3⅞″ (105 × 61 × 10 cm),
painted surface 32⅝ × 20⅛″ (83 × 51 cm)

Philadelphia Museum of Art. The Louise and Walter
Arensberg Collection. 1950-134-527

INSCRIBED ON THE FRAME: *AVE MARIA GRATIA PLENA
DO. T.* (Luke 1:28: "Hail, [Mary,] full of grace, the Lord is
with thee") (in green over silver); COATS OF ARMS ON
THE BASE OF THE FRAME: LEFT: Per pale, the dexter
barry of eight, or and sable; the sinister per fess, or and

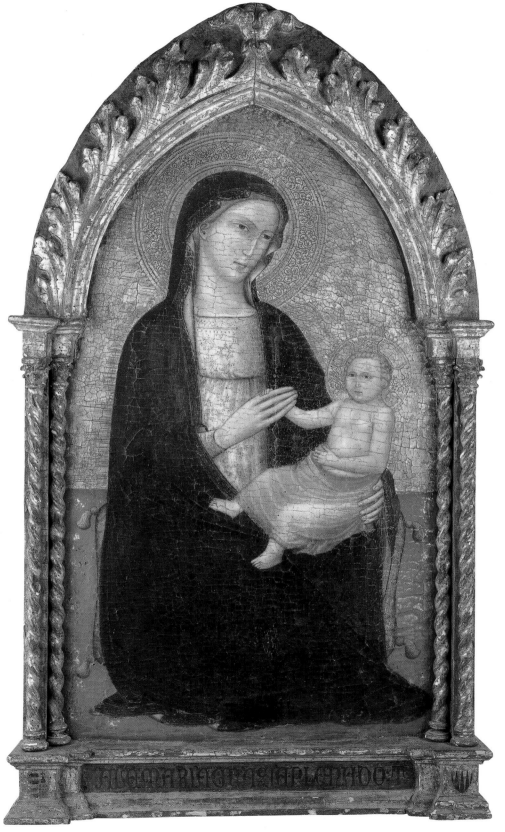

PLATE 45

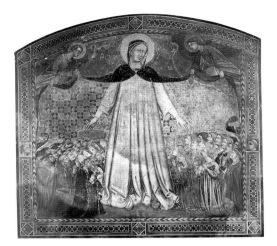

FIG. 45.1 Master of Carmignano. *Virgin of Mercy,* c. 1390–1400. Mural. Maiano (near Florence), ex-convent of San Martino

gules, in chief a mount sable, surmounted by a cross bourdonny of the same, in base with pellets sable; RIGHT: Per fess pily, or and sable, the center pile surmounted by an eight-pointed star gules; ON THE REVERSE: *449/ European* (in blue ink on a sticker)

PUNCH MARKS: See Appendix II

EXHIBITED: Los Angeles, City Hall, June 15–July 15, 1950, no catalogue

TECHNICAL NOTES

The panel retains its original thickness, and the engaged frame is original as well, although it has been repaired. The modern sections are clearly visible in the X-radiograph, which also shows some old nails and a seemingly original hammered-iron hanging ring. Nail holes are visible in the inner groove of the arched top of the frame, where decorative fretwork was originally attached.

Incised lines indicate the basic outlines of the composition. Infrared reflectography showed no evidence of visible drawing.

The paint surface is worn and rubbed throughout. Not all of the gold background is original, although the new gilding has been cleverly distressed to appear old. Only the brown mordant remains of the gilt decoration on the Virgin's costume. The gilt star on her right shoulder is barely visible. The gilt decoration on the red carpet is largely gone except near the edges, where it seems to have been reinforced.

The inscription on the base of the frame was executed in a now-darkened green pigment on a silver ground. Evidence of the silver can be found in the letter *P* in *PLENA,* but otherwise it is totally gone and only the deep red bole remains.

PROVENANCE

Florence, De Clemente; sold New York, American Art Association, Anderson Galleries, January 15–17, 1931, no. 498; Hollywood, California, Louise and Walter Arensberg

COMMENTS

The Virgin is seated on a white-tasseled pillow on a red carpet. Rays of light incised in the gold emanate from her. She holds the half-naked Christ Child, who grasps a pomegranate, a symbol of the Passion.

The Virgin of Humility was a popular subject for small-scale paintings such as this (see Lorenzo Monaco, plate 40 [JC cat. 10]). The panel probably comes from a private home. The two unidentified coats of arms on the base of the frame seem to be original and probably refer to the married couple who first owned the panel.

The Arensberg Collection Archives in the Philadelphia Museum of Art contain early records of opinions that the picture may be by a follower of Niccolò di Pietro Gerini (q.v.), or possibly by Rossello di Jacopo Franchi, Bicci di Lorenzo (q.v.) or an associate, or Mariotto di Nardo, all Florentine artists working in the late fourteenth and early fifteenth centuries. In a letter dated Florence, July 23, 1993, Miklós Boskovits noted that the Museum's panel was by the Master of Carmignano. Among the painter's works that bear great similarity to this panel are a mural of the Virgin of Mercy (fig. 45.1) in the ex-convent of San Martino in Maiano on the hills outside Florence and a *Virgin and Child with Saints John the Baptist and Francis of Assisi*[1] once in a Florentine private collection. The model for the pose of the Virgin's head seems to have been the Virgin in Mariotto di Nardo's altarpiece (fig. 45.2) in the *pieve* of San Donnino at Villamagna, near Florence, documented 1394–95. The Museum's picture probably dates not long after and is thus an example of the anonymous painter's earliest work, executed before he began to show the influence of Lorenzo Monaco in the first years of the fifteenth century.

1. Sold Milan, Finarte, November 24, 1965, lot 21 (repro.; as Florentine school, beginning of the fifteenth century). Florence, Soprintendenza Speciale per il Polo Museale Fiorentino, Gabinetto Fotografico, neg. no. 04293.

Bibliography
Philadelphia 1965, p. 35; Philadelphia 1994, repro. p. 200 (Italian, active Florence, c. 1400); Fiorillo 2001, pp. 333–34, 339 n. 9, fig. 1

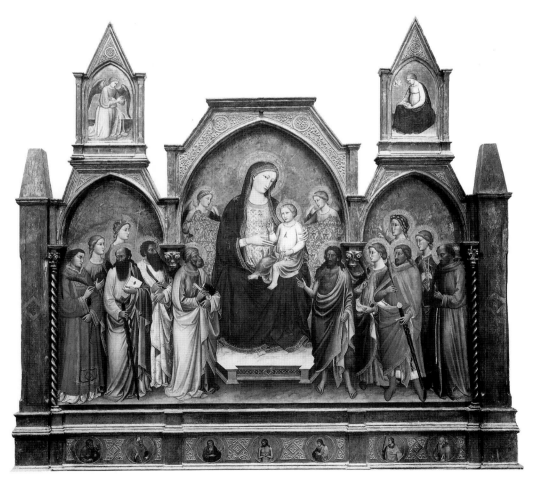

FIG. 45.2 Mariotto di Nardo (Florence, first documented 1394; died 1424). Altarpiece: *Virgin and Child Enthroned with Saints and Angels and the Annunciation,* 1394–95. Tempera and tooled gold on panel. Villamagna (Florence), *pieve* of San Donnino

MASTER OF THE CASTELLO NATIVITY

FLORENCE, ACTIVE MID-FIFTEENTH CENTURY

The Master of the Castello Nativity is the name given to a follower of Fra Filippo Lippi (c. 1406–1469) who painted the *Adoration of the Christ Child with the Young Saint John the Baptist and the Heavenly Host* (see fig. 46.3), once in the Medici villa at Castello, near Florence, and now in the Galleria dell'Accademia in Florence. The picture originally belonged to Piero de' Medici and his wife, Lucrezia Tornabuoni, and was therefore painted between 1444, when they married, and 1469, the year of Piero's death.

In the John G. Johnson Collection catalogue of 1913, Bernhard Berenson invented the name the "Master of Castello" because he recognized that the painting in Castello was the most important of a series of other similar compositions by the same hand. He described the artist as being "descended from Fra Angelico, and standing between Fra Filippo [Lippi] and [Alesso] Baldovinetti."[1] The artist in fact borrowed elements from all three of those painters. Berenson further described him with this Morellian analysis: "Apart from characteristics of expression and general effect which escape description, the most recognizable traits of our painter are a peculiar curve to the cut of the eyes and a singularly ill-formed hand, the fingers looking as if they had been slit out in limp stuff of some sort."

In the 1933 review of a Florentine exhibition of sacred art, Richard Offner made a significant contribution to the artist's oeuvre by assigning to him a large altarpiece from the parish church of Faltugnano, near Prato. The panels in the Johnson Collection of Saints Giusto and Clemente (plates 47A–B [JC cats. 24–25]) come from the predella of this altarpiece.

Wilhelm R. Valentiner (1937) identified the artist as the sculptor Andrea dell'Aquila, but his argument has proved groundless. More interesting is the suggestion, put forth by Chiara Lachi (1995, pp. 21–28), that the artist might be Piero di Lorenzo di Pratese di Bartolo (1410/14–May 9, 1487), who formed a *compagnia,* or partnership, with Pesellino (q.v.) in 1453.[2] She suggested that he had previously assisted Filippo Lippi on his principal altarpieces of the 1440s and proposed that he may be identified with one "Piero dipintore" (Pietro the painter), who is documented as having worked on Lippi's altarpiece for Sant'Ambrogio in Florence.[3] However, there is no proof that this Piere and Piero di Lorenzo are the same person.

1. Richard Offner, in a lecture given at the John G. Johnson house in 1926, maliciously derided Berenson's name for the painter: "It is a pity he [Berenson] allowed a picture so ruined and so remote in locality as the Castello one to give the name to the group."
2. For another suggestion concerning Piero di Lorenzo di Pratese, see Pseudo–Pier Francesco Fiorentino, plates 69–72 (JC cats. 39–42).
3. *Coronation of the Virgin;* Florence, Uffizi, no. 8352; Ruda 1993, color plate 77.

Select Bibliography
Berenson 1913, pp. 17–19; Berenson 1932a, pp. 831–37; Offner 1933, p. 177 and n. 36; Valentiner 1937, pp. 530–36; Hans Vollmer in Thieme-Becker, vol. 37, 1950, pp. 239–40; Berenson 1963, pp. 141–42; Berenson 1969, pp. 188–89; Lisa Venturi in *Pittura* 1987, pp. 677–78; Giovanna Damiani in Berti 1992, pp. 201–2; Lachi 1995; Chiara Lachi in Mannini 1995, pp. 36–39; Dempsey 2001

PLATE 46 (JC CAT. 23)
Adoration of the Christ Child

c. 1460–70

Tempera and tooled gold on panel, transferred to canvas; 44½ × 32⅝″ (113.2 × 82.9 cm)

John G. Johnson Collection, cat. 23

INSCRIBED ON THE REVERSE: *9-1928-2* (in red ink on a paper sticker); ON THE STRETCHER: *9627/ fra Angelico* (in black ink on a paper sticker); *23 in 704* (in pencil, twice), *JOHNSON COLLECTION/ PHILA* (stamped twice in black)

EXHIBITED: Philadelphia Museum of Art, *The Nativity* (November 23, 1935–January 7, 1936), no catalogue

TECHNICAL NOTES

The picture was transferred to canvas sometime before 1889. In 1919 paint cleavages were noted in the area of the Virgin's halo. Carel de Wild inspected the picture in 1921 and observed that it was much repainted (fig. 46.1). Richard Offner noted the same in a lecture given at the John G. Johnson house on May 17, 1926, and David Rosen confirmed these reports in 1941. In 1945, when Rosen removed the considerable overpaints, the very damaged figure of Saint Joseph was found on the left. Subsequently, he and Henri Marceau decided that the damage was too great to repair, and, except for selective inpainting, the picture was left in its unrestored state.

Under close examination the remains of two figures can be seen in the lower corners. They seem to be kneeling, and each carries a palm frond, symbol of martyrdom. There are a few traces of gold in the area of their halos, and their robes are red with some yellow. However, these figures were not part of the original plan of the picture, as they were executed over the already painted foliage and landscape as well as, on the right, the train of the Virgin's blue mantle. They may have been added at an early date for devotional reasons, and they were probably scraped away when a landscape was painted to disguise the damaged figure of Saint Joseph. It is not known why Joseph was so badly defaced. The parts of his robes that survive retain areas of highlights, indicating that the paint was not badly abraded, and there is no evidence of a candle burn or other damage in the support. At least some of the loss may have occurred during the transfer, which produced a lumpy surface throughout much of the center of the composition.

Despite the damaged state of the paint and mordant gilding, some interesting details about the painting can be observed. The angels' wings were executed in sgraffito with blue, green, and red glazes; this effect is best seen in the well-preserved dancing angel on the right of the group in the center. The gold rays emanating from the heavens were interspersed with dots and arranged in concentric semicircles of diminishing size that end in the star

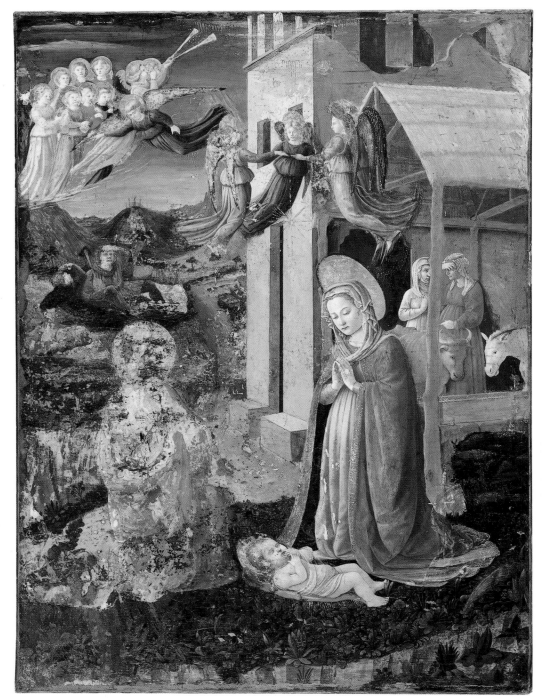

PLATE 46

that seems to be held on a golden string by the dancing angels. The well-preserved translucent clouds that envelop the rays of heaven and the rays around the angel announcing Jesus' birth to the shepherds are all that remain of some of this painting's more sophisticated pictorial effects.

PROVENANCE

The picture was sold in Paris from the collection of David P. Sellar at Galerie Georges Petit, June 6,

1889, lot 23 (as Fra Angelico). In 1898 the Parisian dealer Charles Sedelmeyer published it in a catalogue of his gallery, even though he had already sold it to John G. Johnson as by Fra Angelico.

COMMENTS

The Virgin and Saint Joseph kneel in adoration of the Christ Child, who lies nearly naked on a flowered meadow. Three angels dance in a circle overhead, as rays of heavenly light descend on them. In

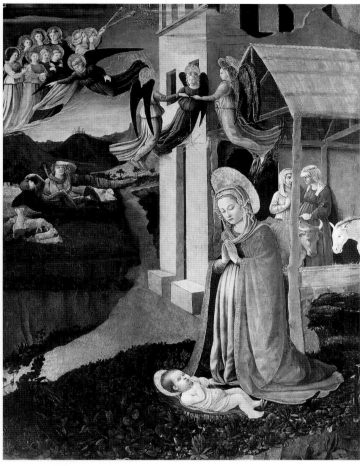

FIG. 46.1 Photograph of plate 46 as it appeared before 1941

the thatched-roof manger there are two female attendants and the ox and ass. Another group of heralding angels hover over the distant fields, while one of them announces Christ's birth to two shepherds in the field.

This composition of the Virgin and Child comes from Fra Filippo Lippi's *Adoration in the Forest* of 1459 (see fig. 71.1), which was originally in the chapel of the Medici palace in Florence. Lippi's picture was the prototype for many copies (see plate 71 [JC cat. 39]). Another picture by Lippi,[1] executed for the Florentine convent founded by Annalena Malatesta in 1453, also shows the Virgin in adoration of the Child, but instead of locating the scene in an isolated forest, as in the Medici picture, Lippi placed it before a manger and a group of ruined buildings. He also included Saint Joseph and singing angels.

The Master of the Castello Nativity painted several derivations (see figs. 46.3–46.7) of these two compositions by Lippi,[2] probably all dating between 1460 and 1470. The painting in the Accademia (fig. 46.3) belonged to Piero de' Medici and Lucrezia Tornabuoni, whom he married in 1444.[3] This distinguished provenance probably accounts for the picture's many reproductions. In 1638 this picture was recorded as being in the villa of Castello, but as Charles Dempsey has pointed out, it might also be the painting identified as "una Vergine Maria che adora Nostro Signore con più figure" (a Virgin Mary in adoration of our Lord with other figures) in the 1499 inventory of the

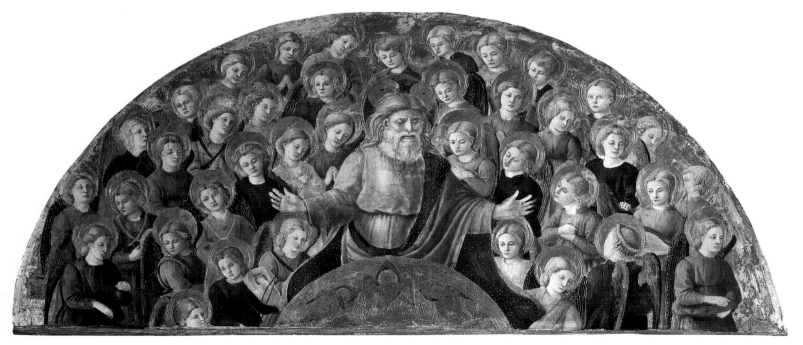

FIG. 46.2 Master of the Castello Nativity. *God the Father and Angels*, c. 1460–70. Tempera and tooled gold on panel; 13¼ × 30⅞″ (33.8 × 78.5 cm). Munich, Alte Pinakothek, inv. 646

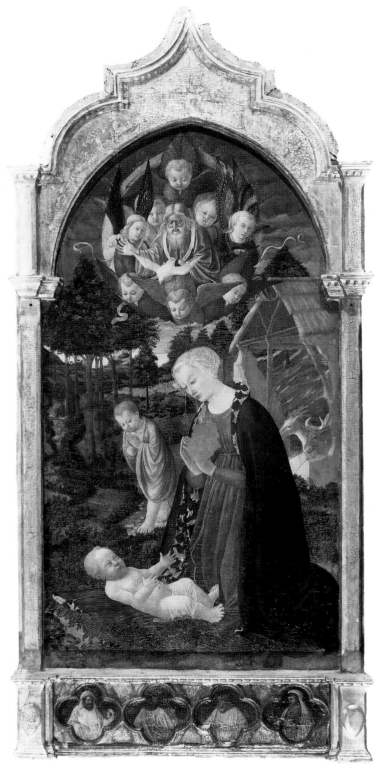

FIG. 46.3 Master of the Castello Nativity. *Adoration of the Christ Child with the Young Saint John the Baptist and the Heavenly Host,* before 1469. Tempera and tooled gold on panel; with parts of the original frame 83⅞ × 38½″ (213 × 98 cm). From Castello (near Florence), Villa Medici. Florence, Galleria dell'Accademia, no. dep. 171

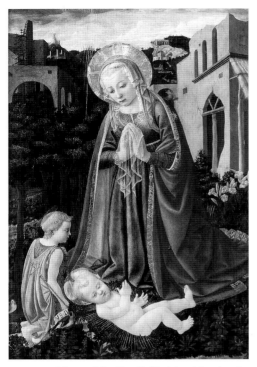

FIG. 46.4 Master of the Castello Nativity. *Adoration of the Christ Child with the Young Saint John the Baptist,* c. 1460–70. Tempera and tooled gold on panel; 43¾ × 30½″ (111.2 × 77.5 cm). San Marino, California, The Huntington Library, no. M. 16

FIG. 46.5 Master of the Castello Nativity. *Adoration of the Christ Child with the Young Saint John the Baptist,* c. 1460–70. Tempera and tooled gold on panel; 43⅝ × 28⅛″ (111 × 74 cm). From Livorno, church of San Giovanni Battista. Livorno, Museo Civico Giovanni Fattori, no. 12

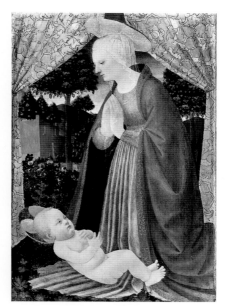

FIG. 46.6 Master of the Castello Nativity.
Adoration of the Christ Child, c. 1460–70.
Tempera and tooled gold on panel; 33⅛ × 22¾″
(84.4 × 57.8 cm). Cambridge, England,
Fitzwilliam Museum, no. M. 14

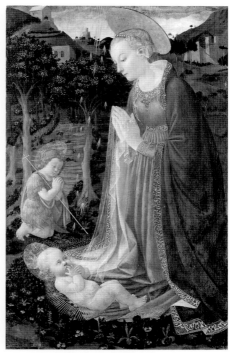

FIG. 46.7 Master of the Castello Nativity. *Adoration
of the Christ Child with the Young Saint John the
Baptist*, c. 1460–70. Tempera and tooled gold on
panel; 38½ × 24″ (98 × 61 cm). Private collection

Palazzo Medici in Florence, then the property of
Lorenzo di Pierfrancesco de' Medici and the heirs
of his brother Giovanni.[4] At that time the painting
was in Lorenzo's bedroom and was valued at 84 lire.
It may be the same "Nostra Donna con tabernacolo
dell'antico" (Our Lady with a tabernacle in the
antique style) that was brought to the chapel of
Castello in 1503.[5]

At the upper edge of the Johnson panel are the
remains of golden rays of light that suggest that
images of God the Father and the heavenly host are
missing. The panel in the Accademia shows God
the Father with the dove of the Holy Spirit and
angels hovering in the sky. In 1967 Millard Meiss
suggested that a panel in Munich (fig. 46.2), show-
ing God the Father with open arms and a host of
angels, might have been the top part of this panel, a
hypothesis supported by the fact that both panels
are almost the same width. However, the figure of
God the Father in the Munich painting might actu-
ally be interpreted as Christ, as his halo is inscribed
with the cruciform. Below this figure is a semicircle
of gold that Cornelia Syre (1990) has described as
the remains of a mandorla and halo, which led her
to suggest that the panel was actually the top part of
a scene of the Assumption of the Virgin. However,
Meiss's theory probably should not be discarded,
and it is very likely that the Munich painting
formed the top part of an *Adoration of the Child*,
which Chiara Lachi (1995) has proposed was the
*Adoration of the Christ Child with the Young Saint
John the Baptist* in San Marino, California (fig. 46.4).
The width of the Munich painting is in fact closer
to that of the San Marino panel, although the John-
son Collection's picture is just a few centimeters
broader. Furthermore, stylistically the angels in the

Munich painting are very close to those in the
Philadelphia painting.

In a letter dated Stockholm, February 5, 1908,
Osvald Sirén tentatively suggested attributing the
Johnson panel to Giovanni di Pietro da Rimini.[6] In
1909 William Rankin published it as the work of
Jacopo del Sellaio. Bernhard Berenson's entry about
this picture in the Johnson catalogue of 1913 is the
basis for the reconstruction of the oeuvre of the
Master of the Castello Nativity.

1. Florence, Uffizi, no. 8350. Ruda 1993, color plate 131.
2. See also the *Adoration of the Christ Child*, c. 1460–70,
 tempera and tooled gold on panel; Baltimore, The Wal-
 ters Art Museum, no. 37.467; Zeri 1976, plate 38, no. 46.
3. Their coat of arms, no longer visible, was recorded on
 the picture in an inventory dated 1638 (see Giovanna
 Damiani in Berti 1992, p. 201).
4. Dempsey 2001.
5. Shearman 1975, p. 26.
6. "The larger Nativity is a charming work by a very
 clever imitator of Fra Filippo; the only name I could
 suggest would be Giovanni da Rimini, but your picture
 is better and more close to Fra Filippo than the works I
 have seen by Giovanni."

Bibliography
Sedelmeyer 1898, p. 262, cat. 238, repro. (Fra Angelico);
Perkins 1905, p. 115 (manner of Fra Angelico); Rankin
1909, p. 85 (Jacopo del Sellaio[?]); Berenson 1913, pp.
17–19, repro. p. 244; Sirén 1925, p. 286; Inaugural 1928, p. 9;
Van Marle, vol. 11, 1929, p. 296; L. Venturi 1931, plate
CLXXXXVIII; Berenson 1932, p. 343; Salmi 1938, pp. 222–23,
226, 240, 244, 246, fig. 7; Johnson 1941, p. 11; Berenson
1963, p. 142; Henri Marceau in Acts 1963, p. 179, plate XL,
figs. 1a, b; Sweeny 1966, p. 51, repro. p. 125; Meiss 1967,
fig. 5; Fredericksen and Zeri 1972, p. 126; Zeri 1976,
pp. 75–76; Syre 1990, p. 108; Philadelphia 1994, repro.
p. 216; Lachi 1995, pp. 27, 48–49, 51, 100–102, figs. 21–22

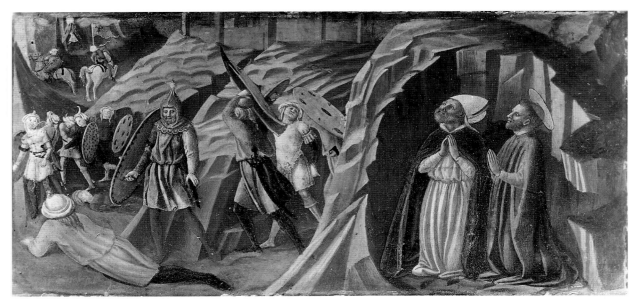

FIG. 47.1 Photograph of plate 47A as it appeared in 1913

PLATE 47A (JC CAT. 25)

Predella panel of an altarpiece: *Saints Giusto and Clemente Praying for Deliverance from the Vandals*

Before 1469

Tempera and gold on panel with horizontal grain; 8½ × 18¼ × ½″ (21.8 × 46.5 × 1.4 cm)

John G. Johnson Collection, cat. 25

INSCRIBED ON THE REVERSE: *Cat/ -25-* (in yellow chalk)

TECHNICAL NOTES

The panel is thinned and cradled. To either side there is a gold border with angled corners that was painted over by an early restorer. The gold border originally had an inner black line, traces of which remain. A black line also marked the top and bottom edges. The original barbe on both of these edges indicates that the panel had applied frame moldings.

Infrared reflectography showed some evidence of simple drawing and hatching. It is particularly visible on the back of the head of the soldier lying on the ground in the left foreground and in the legs of the soldier standing in front of him.

There is a loss in the horseman on the far left due to a disruption of surface, probably caused by an underlying nail. There are faint traces of two pink humanlike shapes, possibly spirits or angels, above the soldiers in the center who recoil in terror and protect themselves with shields. Almost all the mordant gilding is gone. A few traces remain in the costumes of the standing soldier in the foreground and of the two saints. The gilding of the saints' halos has disappeared, although the white mordant has survived. The halos are outlined in black.

On April 23, 1926, T. H. Stevenson ironed loose paint down with balsam. In 1941 David Rosen cleaned the panel of old varnish and retouchings. A comparison with a photograph of the painting before Rosen's cleaning of 1941 (fig. 47.1) reveals that general loss of surface and cast shadows has occurred.

PROVENANCE

See plate 47B (JC cat. 24).

COMMENTS

Saints Giusto and Clemente are shown kneeling in prayer in a rocky cave. The walled city of Volterra is seen in the background. Vandal soldiers are depicted fleeing and fighting among themselves in the crevices of the rocky hill.

For further comments, see plate 47B (JC cat. 24).

BIBLIOGRAPHY

See plate 47B (JC cat. 24).

PLATE 47B (JC CAT. 24)

Predella panel of an altarpiece: *Saints Giusto and Clemente Multiplying the Grain of Volterra*

Before 1469

Tempera and tooled gold on panel with horizontal grain; 8½ × 18¼ × ½″ (21.8 × 46.5 × 1.4 cm)

John G. Johnson Collection, cat. 24

INSCRIBED ON THE REVERSE: *cat -24* (in yellow chalk); *24* (in black pencil); *JOHNSON COLLECTION/ CITY OF PHILADELPHIA* (stamped twice in black)

TECHNICAL NOTES

The panel is thinned and cradled. To either side there is a gold border with angled corners that an early restorer painted over by extending the composition. Some of the repaintings have been removed, but others like the proper right edge of the woman at the far left have not been touched. The gold border originally had an inner black line, traces of which remain. A black line also marked the top and bottom edges. The original barbe on both of these edges indicates that the panel had applied frame moldings.

Infrared reflectography showed no visible evidence of drawing. It did show, however, that the blue cloak of the third man from the right was changed during the painting's execution. Originally

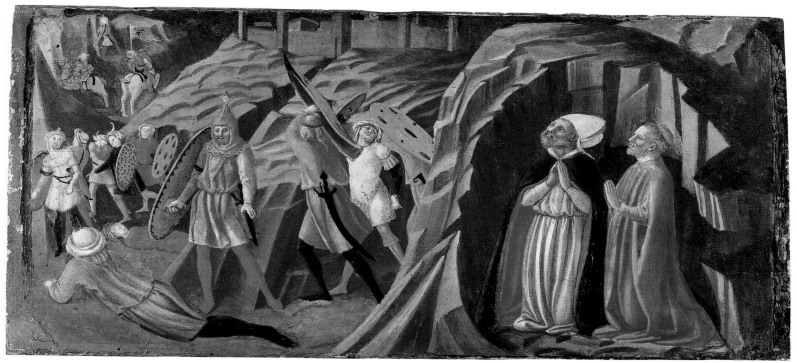

PLATE 47A

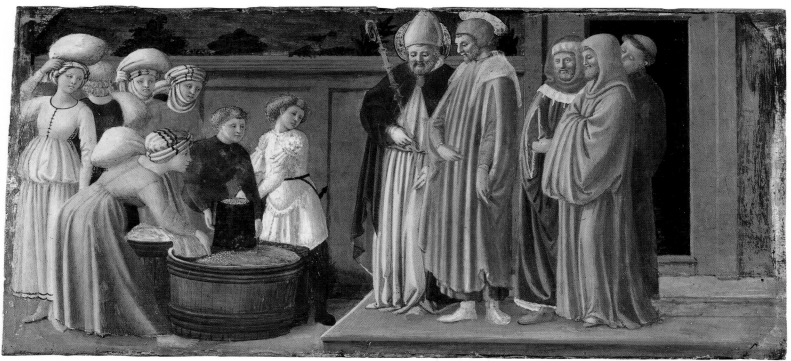

PLATE 47B

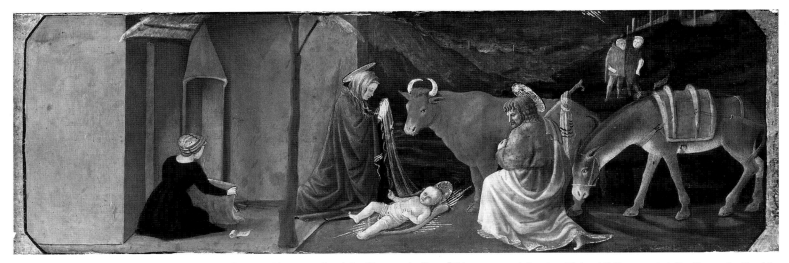

FIG. 47.2 Master of the Castello Nativity. *Nativity*, before 1469. Tempera and tooled gold on panel; $8\frac{1}{2} \times 25\frac{7}{8}''$ (21.6 × 65.7 cm). London, National Gallery, no. 3648. See Companion Panel A

its hem was higher, but now it falls almost to the pavement. The straight lines of the architecture were marked with scored incisions.

The gold of the saints' halos and the bishop's crozier was applied over a light brown mordant. Most of the gold has abraded from the crozier, and only the mordant remains. Traces of gold show that originally there was gilt decoration in the costumes of the woman in blue and the boy in green pouring grain into the barrel. The flesh tones are better preserved than those of the companion panel in the Johnson Collection (plate 47A [JC cat. 25]).

In August 1919 Hamilton Bell wrote that the picture was "safe," although there was blooming, or cloudiness, in the varnish. In April 1922 he inspected it with T. H. Stevenson in preparation for repairs, and they noted that the panel was "somewhat retouched." On April 23, 1926, Stevenson ironed loose paint down with balsam. In 1941 David Rosen cleaned the painting of old repaints and varnish, and retouched the losses. An old photograph published in Berenson's 1913 catalogue shows its state before Rosen's treatment. Although the modeling still seems fairly intact, general loss of surface appears to have occurred. The sense of the ambient light and cast shadows are also gone.

PROVENANCE
This picture and *Saints Giusto and Clemente Praying for Deliverance from the Vandals* (plate 47A [JC cat. 25]) are predella panels to the painting (figs. 47.3, 47.4) once on the high altar of Santi Giusto e Clemente in Faltugnano, near Prato, and now in the Museo dell'Opera del Duomo of Prato. It is not known when the predella was removed, but Guido Carocci, in a manuscript inventory of the art in the area, dated April 1893, did not record it.[1]

COMMENTS
Saint Giusto, in bishop's robes and holding a crozier, and Saint Clemente stand on a platform accompanied by three figures, two in monks' habits and a third in the fur-lined robes of a magistrate. Before them a woman and a boy pour a sack and bucket of grain into a wood barrel. Other figures carry sacks of grain on their heads and shoulders. It was Mario Salmi (1935) who identified this as a scene from the legend of Saints Giusto and Clemente.

The two panels formed part of a predella that Mario Salmi (1935) recognized as belonging to the altarpiece of Santi Giusto e Clemente in Faltugnano (fig. 47.4). The third panel of the predella is the *Nativity* in the National Gallery of London (fig. 47.2). X-radiographs[2] reveal that their original order, from left to right, was: *Saints Giusto and Clemente Praying for Deliverance from the Vandals* (plate 47A [JC cat. 25]), the *Nativity* (fig. 47.2), and *Saints Giusto and Clemente Multiplying the Grain of Volterra* (plate 47B [JC cat. 24]).[3] Since their total width ($62\frac{1}{2}''$ [158.7 cm]) corresponds closely to the width of the main panel from Faltugnano ($63\frac{3}{4}''$ [162 cm]), we can conclude that the predella did not have any other elements.

According to late medieval accounts, Giusto and Clemente, escaping the Goths in North Africa, settled in Volterra, where they conducted saintly lives. When the Vandals seized Volterra, exhausting its supplies, Giusto and Clemente ordered that bread be made with the remaining grain and thrown over the walls to show the troops that the city was not desperate. The two saints then went to a grotto outside the walls to pray. The confused Vandals started fighting among themselves and finally retreated. When the populace of Volterra went to the grotto, they found marks in the earth where the saints had

been kneeling. Giusto was made a bishop of the city, and he and Clemente subsequently fought to eradicate the Arian heresy in Volterra.

The direction of the wood grain suggests that the two stories shown on the Johnson panels were not placed in the usual chronological order from left to right but from right to left, possibly because the artist and his patron were not well versed in the details of the saints' legend. In fact, the loaves of bread, which, according to the account, caused the Vandals to break rank, are not shown in either predella scene.

While the saints' legend contains many discrepancies, devotion to them was considerable and dates to at least the seventh century, when a monastery was established in their honor on Monte Nibbio, outside Volterra. In 1113 this was taken over by the Camaldolese order. In addition, many other churches were dedicated to the saints. By the late thirteenth century Giusto and Clemente were the titular saints of seventy-eight churches in Tuscany alone, including the small parish church in Faltugnano, outside Prato in the Valle di Bisenzio on Monte della Calvana. This church was under the jurisdiction of the *pieve* of Santi Vito e Modesto in Soffignano (also called Susignano).[4] On March 7, 1469, Pope Paul II Barbo granted patronage of this *pieve* to Gino di Lando di Gino di Domenico da Prato of the Bonamici, a very wealthy Pratese family.[5] The coat of arms of this family is also found in the church of Santi Giusto e Clemente. Undoubtedly, at about the time the papal bull concerning Soffignano was issued, the Bonamici also gained official control of this church and saw to its restoration and decoration. The bull specifically states that Gino di Lando was given the *juspatronato*, or legal patronage rights, of the *pieve* because he had

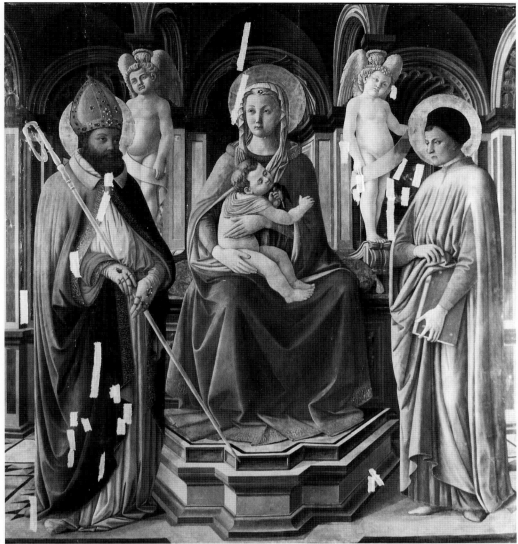

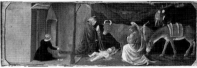
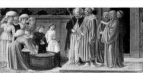

PL. 47A 47.2 PL. 47B

FIG. 47.3 Original configuration of the Master of the Castello Nativity's Faltugnano altarpiece, before 1469. Main panel (FIG. 47.4): *Virgin and Child Enthroned with Saints Giusto and Clemente of Volterra.* Tempera and tooled gold on panel; 68⅛ × 63¾″ (173 × 162 cm). Before restoration. Faltugnano, church of Santi Giusto e Clemente; on deposit, Prato, Museo dell'Opera del Duomo, inv. dep. no. 171. See Companion Panel B. Predella (left to right): PLATE 47A, FIG. 47.2, PLATE 47B

increased its wealth and made improvements. In the *catasto*, or Florentine tax return, of 1469,[6] Gino di Lando declared considerable agricultural properties in the area of Soffignano, as had his father in the *catasto* of 1459.[7] In 1469 Gino was twenty-eight years old and lived in the neighborhood of Capo di Ponte in Prato. He was married to Smeralda Buonristori, with whom he had five children—two girls and three boys. In 1471, according to the *estimo*, or local property tax declaration,[8] another son had been born and given the name of Vito, probably in

honor of his father's newly awarded patronage of the parish of Santi Vito e Modesto. This Vito seems to have died relatively young, as the 1487 *catasto* lists among Gino di Lando's orphaned sons another Vito, whose age is given as nine.[9]

The abbot of the monastery of Santi Giusto e Clemente in Volterra from 1461 to 1488 was Giusto di Gherardo Buonvicini, who in 1469 revived devotion to the two saints by restoring the high altar of the church and transporting the saints' relics there.[10] This may have encouraged the Bonamici

family to look after the restoration and decoration of the church in the Prato countryside dedicated to the same two saints.

In a thoughtful study of the Master of the Castello Nativity, Chiara Lachi (1995, pp. 31–35) dates the Faltugnano painting to the 1440s. She sees the artist as a close collaborator of Filippo Lippi and supposes, as had also Jeffery Ruda (1993, p. 491), that Lippi himself may have had a hand in the design of the altarpiece. She suggests, however, that the patrons were not the Bonamici but the Vinaccesi family, who had the patronage of the *pieve* until sometime before 1469.[11] While it is easy to see connections between the paintings of the Master of the Castello Nativity and Lippi's works of the 1440s, the former seems to have been a much later follower of Lippi and not to have embarked on an independent career until sometime in the late 1450s. For example, his principal painting, the *Adoration of the Christ Child* in the Accademia (see fig. 46.3), cannot date before its prototype, Lippi's altarpiece for the Medici palace,[12] which was executed in 1459. It would therefore seem that most of the master's other works have to be dated later. A further confirmation of an advanced dating are the marble angels of the throne of the painting in Prato, which, as Salmi (1938, p. 238) noted, Neri di Bicci (q.v.) copied in several works, all of which date after 1475.[13]

1. Florence, Soprintendenza per i Beni Archetettonici ed il Paesaggio e per il Patrimonio Storico Artistico e Demoetnoantropologico, Archivio Storico del Territorio, *Catalogo generale dei monumenti e degli oggetti d'arte del regno*, folder A/1529. Carocci attributed the altarpiece to Filippino Lippi.
2. The X-radiographs were examined in London with Jill Dunkerton of the National Gallery. She noted that the most distinctive connection is the wild grain on the left side of the *Nativity*, which matches up with the right side of plate 47A (JC cat. 25). The link between the left side of plate 47B (JC cat. 24) and the right side of the *Nativity* is established by a distinctive white flecking. See Gordon 2003, p. 250, fig. 2.
3. The technical evidence discards Salmi's proposal that another part of the predella was a panel once in the Chillingsworth Collection (Lachi 1995, repro. p. 99), showing the Adoration of the Magi (subsequently divided into three parts).
4. Repetti, vol. 2, 1835, p. 92.
5. Repetti, vol. 5, 1843, p. 420; Cappelletti, vol. 16, 1861, pp. 690–95. The papal bull is in Florence, Archivio di Stato, *Diplomatico* 79, March 7, 1468 (1469 modern style).
6. Florence, Archivio di Stato, *Catasto* 960, carte 499 recto–500 verso.
7. Florence, Archivio di Stato, *Catasto* 872, carte 1278 recto–1279 verso.
8. Fiumi 1968, pp. 325–27.
9. Florence, Archivio di Stato, *Catasto* 1134, carta 230 verso.
10. Consortini 1915, pp. 24, 50.
11. A document of January 1450 (published by Maria Pia Manni in Prato 1998, no. 21) shows that there was some activity concerning the decoration of the church before that date when the Ceppo of Prato, a charitable organization, contributed 16 lire to the remake of a

"tavola" at the request of the priest Francesco. While a "tavola" could be a painting, it is not clear from the document and the sum of money is very low. "Alla chiesa di santo justo da Faltugnano a di primo di giennaio lire 16 soldi o e quail gli dettono per a[i]uto d'una tavola rifatto di nuvo di ditta Chiesa per l'amore di Dio e per lei a Ser Francesco prete di detta Chiesa o come alle deliberazioni" (To the church of San Giusto in Faltugnano the frist of January 16 lire and no soldi which are a contribution for the new 'tavola' newly remade for the said Church, for the love of God, and for it [the church] to Ser Francesco priest of the said Church, as was deliberated). Prato, Archivio di Stato, Ceppo Nuovo, 306, Entrata e uscita al tempo di Lorenzo di Antonio Guazzelmi Camarlingo, 1449–1450, c. 73.

12. Berlin, Staatliche Museen, no. 69; Ruda 1993, color plate 27.

13. See, for example, *Virgin and Child;* Budapest, Szép-müvészeti Múzeum, no. 1228; Budapest 1991, p. 83; and *Virgin and Child with Saints,* Gallerie Fiorentine, no. 127; on deposit in Santa Margherita dei Cerchi, Florence (photo Alinari negative no. 1409).

Bibliography
Berenson 1913, p. 19, repro. p. 245 (unknown follower of Fra Angelico, close to the Master of the Castello Nativity); Van Marle, vol. 8, 1928, p. 161; Van Marle, vol. 9, 1929, p. 301; Berenson 1932, p. 196; Salmi 1935, pp. 416–19; Johnson 1941, p. 6 (Florentine, 1420–65); Rosen 1941, p. 458, fig. 1A; Kaftal 1952, pp. 606–10, figs. 698, 700; Berenson 1963, pp. 142, 219, plate 877; Parronchi 1964, p. 214 n. 2; Sabatino Ferrali in *Bibliotheca sanctorum,* vol. 7, 1966,

repro. cat. 24, cols. 42–43; Sweeny 1966, pp. 51–52, repro. p. 127; Fredericksen and Zeri 1972, p. 126; Parronchi 1981, p. 28, fig. 9; London 1983, p. 57; Cecilia Filippini in Lippi 1994, pp. 39–40, figs. 29 a, b (color); Philadelphia 1994, repro. pp. 215–16; Lachi 1995, pp. 31–35, 49, 95–100, color plate III, figs. 16–17; Chiara Lachi in Mannini 1995, p. 37; Gordon 2003, pp. 248–53, figs. 3–4, pp. 250–51; Kanter 2004, p. 107

COMPANION PANELS for PLATES 47A–B

A. Predella panel of an altarpiece: *Nativity.* See fig. 47.2

Before 1469

Tempera and tooled gold on panel; 8½ × 25⅞" (21.6 × 65.7 cm). London, National Gallery, no. 3648

There is a gold border with champered corners and a black inner outline.

PROVENANCE: Faltugnano, church of Santi Giusto e Clemente; London, Sir Henry Howorth; given by him to the National Gallery, 1922

EXHIBITED: London, Burlington Fine Arts Club, 1907, no. 2 (Florentine, ascribed to Fra Filippo Lippi or Pesellino); London, Burlington Fine Arts Club, 1920, no. 8 (Florentine, close to Pesellino, c. 1450); London, National Gallery, National Art Collections Fund exhibition, 1945–46, no. 30 (as school of Masaccio)

SELECT BIBLIOGRAPHY: Langton Douglas and Giacomo de Nicola in Crowe and Cavacaselle 1903–14, vol. 4, 1911, p. 64; Schmarsow 1930, pp. 2–3; Stechow 1930, p. 127;

Berenson 1932, p. 343; Salmi c. 1932, pp. 82, 130–31; Salmi 1948, p. 165; Davies 1951, p. 272; Parronchi 1957, pp. 26–27 n. 16; Davies 1961, pp. 351–52; Parronchi 1964, pp. 214–18; Parronchi 1974, p. 9; Parronchi 1981, p. 28; London 1983, p. 57; Cecilia Filippini in Lippi 1994, p. 39; Lachi 1995, pp. 99–100; Gordon 2003, pp. 248–53; Kanter 2004, p. 107

B. Main panel of an altarpiece: *Virgin and Child Enthroned with Saints Giusto and Clemente of Volterra.* See fig. 47.4

Before 1469

Tempera and tooled gold on panel; 68⅛ × 63¾" (173 × 162 cm). Faltugnano, church of Santi Giusto e Clemente; on deposit, Prato, Museo dell'Opera del Duomo, inv. dep. no. 171

PROVENANCE: Faltugnano, church of Santi Giusto e Clemente

EXHIBITED: Florence, convent of San Marco, *Mostra del Tesoro di Firenze Sacra* (May–August 1933), no. 107 (school of Filippo Lippi); Prato 1998, no. 21

SELECT BIBLIOGRAPHY: Offner 1933, p. 177; Salmi 1935, pp. 419–21; Valentiner 1937, p. 535; Salmi 1938, p. 238; Berenson 1963, p. 142; Sabatino Ferrali in *Bibliotheca sanctorum,* vol. 7, 1966, col. 42; Parronchi 1981, p. 28; London 1983, p. 57; Ruda 1993, p. 491; Cecilia Filippini in Lippi 1994, p. 39; Lachi 1995, pp. 31–35, 95–96; Maria Pia Mannini in Prato 1998, no. 21; Gordon 2003, pp. 248–53; Kanter 2004, p. 107

MASTER OF 1419
(*Battista di Biagio Sanguigni?*)

EMPOLI, 1392/93–SEPTEMBER 2, 1451, FLORENCE

The Master of 1419 is named after the date inscribed on a *Virgin and Child Enthroned* (see fig. 48.2) in the Cleveland Museum of Art, which was the center of an altarpiece commissioned by the Florentine patrician Antonio di Domenico Giugni for the church of Santa Maria a Latera, near Florence.[1] The painting's figural style and such details as the extravagant foliate shape of the arms of the Virgin's throne indicate that the artist came out of the International Gothic tradition, as represented by artists such as Rossello di Jacopo Franchi and the young Masolino (q.v.). However, unlike most works in the International Gothic style, the Cleveland picture shows a careful depiction of space that is remarkably innovative. It is the first dated painting in which the recession of the throne, dais, and pattern on the floor is rendered according to the rules of one-point perspective, which was then just beginning to be explored by Florentine painters. This same interest can be seen in the artist's altarpiece of Saint Julian from the *collegiata* of San Gimignano,[2] which Enzo Carli (in Cecchini and Carli 1962, pp. 86–87) suggested was executed in 1427 on commission of one Ser Giuliano di Martino de' Cetti.[3] Carli also proposed that the artist might be associated with the Florentine Ventura di Moro, who was working in San Gimignano in that year. This identification has not found favor in subsequent studies because of the differences in style between Ventura's known works and those that can be attributed to the Master of 1419. Besides the two above-mentioned altarpieces, all of the latter's known works are small-scale paintings of the Virgin and Child with saints, such as the one in the John G. Johnson Collection (plate 48 [JC cat. 21]).

More recently, Laurence B. Kanter (2002) has attempted to identify the Master of 1419 with Battista di Biagio Sanguigni on the basis of Sanguigni's documented illuminations. Originally from Empoli, Battista di Biagio Sanguigni is first recorded as an illuminator in 1415, when he joined the confraternity of San Niccolò di Bari in Florence, which held meetings in the basement of the Carmine. Sanguigni was very active in this association, sponsoring the membership of Fra Angelico (q.v.) in 1417 and serving as its rector in 1418. During this time it seems that the artist was living in a workshop rented from the monastery of Santa Maria degli Angeli, as he declared in his tax statement of 1427. This situation lasted at least until 1433. In 1435 he moved to Palaiuola, near the convent of San Domenico, in a house owned by Zanobi Strozzi (q.v.). In 1442 the Strozzi family agreed to support Sanguigni for life,

and in 1446 they ceded the Palaiuola property to him. Sanguigni died in 1451, after what was described as a "long illness" *(infermità lunga)*, and was buried in the church of Santa Trinita in Florence.

The artist's only surviving documented works are the illuminations of an antiphonary for the Augustinian nunnery of San Gaggio (outside the walls of Florence), for which a payment to Sanguigni from 1432 has been associated,[4] and an illumination in 1447 for a lost manuscript with the rules of the Compagnia della Purificazione.[5] On the basis of these works some of the illuminations in the third volume of an unfinished gradual for the convent of Santa Maria degli Angeli can be attributed to Sanguigni. He probably executed them in collaboration with Zanobi Strozzi after the death of Lorenzo Monaco (q.v.) in 1424.[6] Other documents record him as illuminating books for the hospital of Sant'Egidio in Florence in 1426–28 and 1451, and a book for one Bardo Bardi in 1433. In addition, in his 1427 tax declaration he records his work on *libricini da donna* (books for women), which were probably books of hours.

Although no documents concerning Sanguigni's activity as a panel painter have come to light, it seems likely that, like Zanobi Strozzi, he also executed altarpieces or assisted other artists in their execution.

1. On the Giugni and their commissions, see Carl Brandon Strehlke in Kanter et al. 1994, pp. 28, 38 nn. 20–24; and Strehlke 1998, pp. 13, 68 n. 6.
2. Berenson 1963, plate 551.
3. Miklós Boskovits (2002, pp. 336 n. 1 and 337 n. 9) has suggested that the 1427 date is too late and that the document does not refer to Cetti's commission. He dates the altarpiece in the early 1420s.
4. Florence, Museo Nazionale di San Marco. Kanter 2002, figs. 3–5; and Scudieri and Rasario 2003, color repros. pp. 27–28, 36, 38, 54, 91–104.
5. Scudieri and Rasario 2003, p. 49, fig. 10.
6. Florence, Biblioteca Mediceo-Laurenziana, cod. cor. 3. Sanguini would have been responsible for all the narrative miniatures except for folio 27 verso, which is likely by Lorenzo Monaco, as are the illuminations with the prophets. On this manuscript, see Kanter in Kanter et al. 1994, pp. 283–87; and Kanter 2002, pp. 325–27. For the illuminations attributed to Sanguigni, see Ciaranfi 1932, figs. 7, 9–14; and Kanter 2002, figs. 8–9. Sanguigni likely also executed two of the excised illuminations showing the Procession of Children in an initial *Q* (New York, Woodner Collection; Kanter et al. 1994, fig. 113 [color]), and the Ascension in an initial *V* (New York, Bernard H. Breslauer Collection; Kanter et al. 1994, color repro. p. 285). For other illuminations by him, see Scudieri and Rasario 2003.

Select Bibliography
Pudelko 1938, p. 63; Longhi 1940, pp. 177, 182 n. 15, 185 n. 21 (Longhi *Opere*, vol. 8, pt. 1, 1975, pp. 43, 53–54 n. 1); Collobi Ragghianti 1950a, p. 17; Nicolson 1954; Pouncey 1954; Cohn 1956b, pp. 49–52; Francis 1956; Enzo Carli in Cecchini

and Carli 1962, pp. 86–87, 94 n. 9; Levi D'Ancona 1962, pp. 54–59; Berenson 1963, pp. 217, 220; Parronchi 1964, pp. 132–33; Levi D'Ancona 1970; González-Palacios 1972; Skerl Del Conte 1979; Van Os 1983, p. 74; Cecilia Frosinini in *Pittura* 1987, pp. 683–84; Neri Lusanna 1990, pp. 4, 8, 16 n. 7; Laurence B. Kanter in Kanter et al. 1994, pp. 286–87; Carl Brandon Strehlke in Kanter et al. 1994, p. 26; Kanter 2002; Boskovits 2002; Magnolia Scudieri in Scudieri and Rasario 2003, pp. 33–43

PLATE 48 (JC CAT. 21)
Virgin and Child with Saints Lucy, John the Baptist, Rose, and Bartholomew

c. 1426

Tempera and tooled gold on panel with vertical grain; $22\frac{3}{4} \times 15\frac{7}{8} \times \frac{1}{4}''$ (57.9 × 40.5 × 0.5 cm), painted surface $22\frac{1}{2} \times 15\frac{3}{8}''$ (57.2 × 39.2 cm)

John G. Johnson Collection, cat. 21

INSCRIBED ON CHRIST'S TABLET: *abcdefg[———] lmnopqrstv*; ON THE REVERSE: *JOHNSON COLLECTION* (stamped in black on a cradle member)

PUNCH MARKS: See Appendix II

TECHNICAL NOTES
The panel, consisting of a single member, is thinned and cradled. Originally it had a peaked Gothic arch, which probably held a separate image of God the Father or the Crucifixion. The panel would have had an engaged frame with colonnettes and capitals. Areas where the capitals were removed to make the pointed arch appear round were filled. The top corners (diagonally about 1″ [2.5 cm] each) of the panel are new and were added to give the painting its rectangular shape. A barbe is visible on the sides and bottom of the painted image, indicating that those parts of the composition retain their original dimensions.

The gold background was retouched in bronze powder, now discolored. The paint is moderately abraded throughout. The Virgin's mantle was repainted in a uniform blue-black that covered large, unfilled losses and the mordant gilt border of the hem. The original design of the drapery can be seen in infrared reflectography, which also revealed other drawing in the top of the Child's tunic, in the folds of the Baptist's blue undergarment, and in his left sleeve. This last area was a jumble of lines that showed several changes in the form (fig. 48.1). No evidence of a cartoon was found.

There is mordant gilding in the costumes, with the diamond-and-cross motifs on Saint Bartholomew's

robe being the most elaborate. The handles of the vase in the foreground and the cross the Baptist holds were also executed in mordant gold. The mordant is a white tone.

In June 1927 Herbert Thompson restored the picture at the Museum of Fine Arts in Boston. He put on a new mahogany cradle and cleaned the surface of old varnish and repaint.

PROVENANCE
The painting's history before 1905, when F. Mason Perkins recorded it as being in John G. Johnson's collection, is not known.

COMMENTS
The Virgin and Child are shown seated on a throne. Jesus tugs at the Virgin's veil and holds a tablet with the letters of the alphabet written across the top. Four saints surround them: Saint John the Baptist, holding an astral cross; the early Christian martyr Saint Lucy, carrying a vessel containing her eyes and fire, symbol of her eternal devotion to Christ; Saint Rose, wearing a wreath of roses and carrying a nosegay; and Saint Bartholomew, carrying a book and a knife, symbol of his martyrdom by flaying.

Strangely, the painting entered John G. Johnson's collection as the work of Cimabue. Perkins (1905) was the first to correct this error. Bernhard Berenson (1913) called it Florentine, about 1425, saying that the painter "belongs to the group of Lorenzo Monaco and Bicci di Lorenzo [qq.v.]. The smudged faces and sloppy handling suggest Andrea di Giusto." Burton Fredericksen and Federico Zeri (1972), Miklós Boskovits (verbal communication, 1978), and Everett Fahy (letter dated New York, December 20, 1998) have attributed it to Andrea di Giusto's near contemporary, an artist known as the Master of 1419, after a dated panel in the Cleveland Museum of Art (fig. 48.2). Alternatively, Andrea De Marchi (verbal communication February 13, 1989) gave the picture to the Master of the Bracciolini Chapel, based on its similarity to two works by this artist: a painting[1] shown in a dealer's exhibition in Turin in 1987 and another in the Museum of Fine Arts, Boston.[2] While the Master of 1419 and the Master of the Bracciolini Chapel (named for his mural paintings in the Bracciolini chapel in San Francesco in Pistoia), share certain characteristics, such as their manner of depicting eyes and the attentuated proportions of their figures, the latter was tied to the formulas of late fourteenth-century painting and was much less interested in rendering spatial effects.

The Johnson painting is similar to other small-scale pictures by the Master of 1419 sold in Milan at Finarte on November 9, 1971.[3] Like those, the Johnson painting would have adorned a private residence. The image of the Christ Child with the tablet of the alphabet would have had particular appeal in such a setting. Giovanni Dominici, the

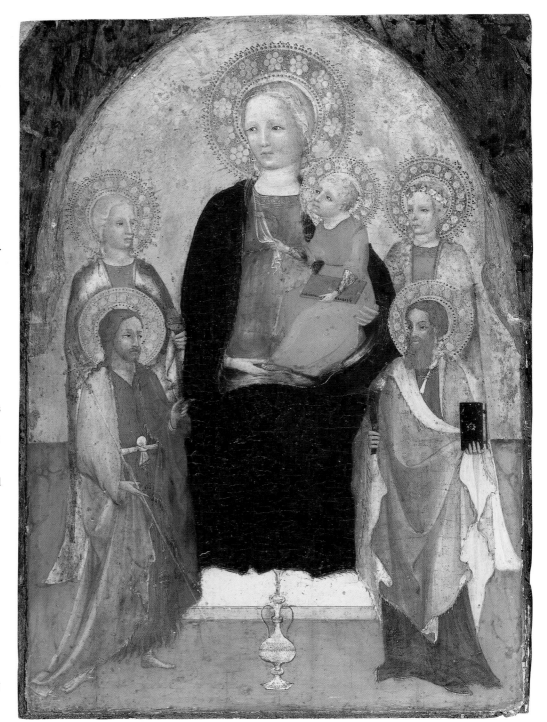

PLATE 48

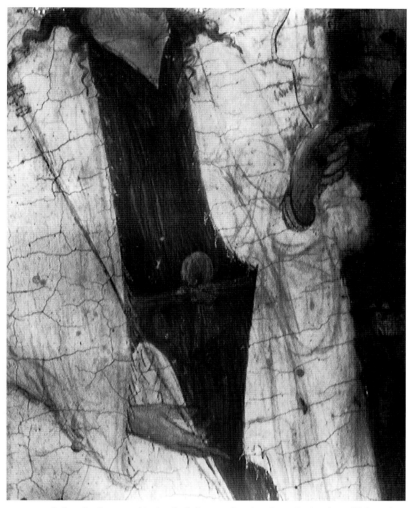

FIG. 48.1 Infrared reflectographic detail of plate 48, showing the underdrawing of Saint John the Baptist

contemporary Florentine Observant Dominican who wrote about infant education, recommended that such images be shown to children so that they could identify with the baby Jesus. By contrast, a few years later Saint Antonino, archbishop of Florence, inveighed specifically against images showing Jesus with a tablet of letters, as he had no need to learn from man.[4]

1. *Virgin and Child with Saints John the Baptist, Peter, and James Major, and a Bishop Saint;* Turin 1987, no. 7 (color).
2. *Virgin of Humility with Saints John the Baptist, James, Peter, and a Virgin Martyr,* no. 03.563; Murphy 1985,

repro. p. 148 (as Tuscan, first quarter of the fifteenth century).
3. González-Palacios 1972, figs. 38–39.
4. Gilbert 1959, p. 76.

Bibliography
Perkins 1905, p. 114 (Florentine, early fifteenth century); Berenson 1913, p. 16 (Florentine, c. 1425); Berenson 1932, p. 13; Berenson 1936, p. 11; Johnson 1941, p. 1 (Andrea di Giusto); Berenson 1963, p. 6; Sweeny 1966, p. 2 (Andrea di Giusto); Fredericksen and Zeri 1972, p. 138 (Master of 1419); Philadelphia 1994, repro. p. 215 (Master of the Bracciolini Chapel); Kanter 2002, p. 329, fig. 13; Boskovits 2002, pp. 334–35, 338, figs. 11–12

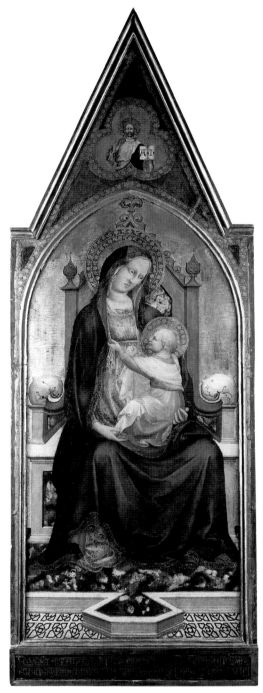

FIG. 48.2 Master of 1419 (Battista di Biagio Sanguigni?). Center panel of an altarpiece: *Virgin and Child Enthroned,* 1419. Tempera and tooled gold on panel; 77¼ × 26⅞″ (196.2 × 68.2 cm). From the church of Santa Maria a Latera, near Florence. Cleveland Museum of Art, no. 54.834

MASTER OF THE JOHNSON TABERNACLE

FLORENCE, ACTIVE MID-FIFTEENTH CENTURY

Federico Zeri first reconstructed the oeuvre of this anonymous master but never published the results of his research. Michel Laclotte and Élisabeth Mognetti (1976) referred to Zeri's identification in the catalogue of the Musée du Petit Palais in Avignon, where there is another panel by the artist, the *Arma Christi*.[1] Besides the Philadelphia and Avignon panels, the other works that Zeri recognized are the *Virgin and Child with Saints John the Baptist, Julian, Anthony Abbot, and Blaise and the Redeemer,* from the church of Santa Maria in Argiano, near Florence;[2] two predella panels showing the Nativity and the Adoration of the Magi, from the Centre Culturel du Palais Bénédictine in Fécamp, France; the *Virgin and Child with Angels,* from the hospital of Santa Maria Nuova in Florence;[3] and the *Virgin in Glory with Two Angels, Saints Catherine of Alexandria and Mary Magdalene, and the Archangel Raphael with Tobias,* in the Rijksmuseum Meermanno-Westreenianum in The Hague.[4]

Everett Fahy (correspondence dated New York, June 3, 1984; January 25, 1991; and April 20, 1999) named the painter after his most characteristic work—the triptych, or tabernacle in the John G. Johnson Collection (plate 49 [JC inv. 2034])—and added to his list of known works the *Arma Christi* in the Pinacoteca Ala Ponzone in Cremona;[5] the *Virgin and Child Enthroned with Saints Peter, Paul, and Catherine of Alexandria, and a Youthful Saint,* sold at auction in 1970;[6] the *Trinity with Saints John the Baptist, Jerome,*

Mary Magdalene, John the Evangelist, and Francis of Assisi, sold at auction in 1989;[7] the *Arma Christi,* on the art market in Prato in 1990;[8] and the *Virgin and Child with Saint John the Baptist and the Archangel Michael,* sold at auction in 1999.[9] In addition, Patrizia Barbieri (in Ravenna 1988, pp. 65–66) reported that Zeri assigned two more paintings to this artist: *Saints Mary Magdalene, Francis, Lawrence, and Paul,* sold at auction in 1982;[10] and a triptych in the Pinacoteca Comunale of Ravenna.[11] And, more recently, other works by the artist have been indentified

The painter is a follower of Bicci di Lorenzo (q.v.), to whom some of the above pictures have been previously ascribed, but he also shows the influence of a more modern master like Benozzo Gozzoli (q.v.). The Master of the Johnson Tabernacle's works can be dated to the 1450s and 1460s.

1. No. 20253; Laclotte and Mognetti 1987, p. 221, fig. 261.
2. San Casciano Val di Pesa, Museo di Arte Sacra; Proto Pisani 1989, repro. p. 32.
3. Florence, Museo di Palazzo Davanzati, Uffizi no. 3222; Uffizi 1979, repro. p. 165.
4. No. 810/63; Ekkart 1987, repro. p. 101.
5. No. 26; Puerari 1951, fig. 29.
6. London, Sotheby's, May 13, 1970, lot 82 (as Giovanni Dal Ponte [q.v.]).
7. New York, Sotheby's, October 13, 1989, lot 161.
8. With Stefano Piacenti; Florence 1990b, color repro. p. 149.
9. New York, William Doyle Galleries, January 27, 1999, lot 68.
10. New York, Christie's, November 5, 1982, lot 146 (as Spanish School, c. 1500).
11. No. 175; Ravenna 1988, p. 66, fig. 63.

PLATE 49 (JC INV. 2034)

Triptych: (center) *Virgin and Child Enthroned with a Music-Making Angel, a Child, and Saints Francis of Assisi, Thomas Aquinas, Dominic, John the Baptist, Peter Martyr, and Jerome;* (left wing) *Annunciate Angel and Calvary;* (right wing) *Virgin Annunciate and the Crucifixion with Saints Catherine of Siena and Mary Magdalene*

c. 1461

Tempera, tooled gold, and silver on panels with vertical grain; center: overall $21\frac{7}{8} \times 11\frac{1}{8} \times 1\frac{5}{8}''$ (55.5 × 28.2 × 4 cm), at base $3\frac{1}{8}''$ (8 cm), painted surface $17\frac{1}{8} \times 9\frac{1}{4}''$ (43.5 × 23.5 cm); left wing $19\frac{1}{4} \times 5\frac{3}{4} \times \frac{5}{8}''$ (49 × 14.5 × 1.5 cm); right wing $19\frac{5}{8} \times 5\frac{1}{2} \times \frac{5}{8}''$ (49.9 × 14 × 1.5 cm)

John G. Johnson Collection, inv. 2034

INSCRIBED ON THE BAPTIST'S SCROLL: *Ecce [Agnus Dei]* (John 1:29: "Behold [the Lamb of God]"); ON DOMINIC'S BOOK: *N* (in red; the rest, illegible, in black); ON THE BASE OF THE FRAME IN SGRAFFITO: *AVE. MARIA GRATTIA. PLENA DOM[INI]* (Luke 1:28: "Hail [Mary], full of grace, the Lord . . ."); ON THE REVERSE: *1010* and *15138* (in black crayon); *JOHNSON COLLECTION PHILA.* (stamped in black); *9* (in ink on a paper sticker)

TECHNICAL NOTES

An X-radiograph (fig. 49.1) revealed several features about the triptych's construction and execution. The linen layer in the side panels was cut after it was in place, leaving a neat margin of bare wood along the inner and bottom edges before the gesso was applied. This may suggest a change in the design to eliminate moldings in order to make the wing interiors flat. Nail holes along the edges of the gables of the central and side panels show where other moldings had been attached. As was common, these may have been crockets decorated with a carved flame motif. Nail holes along the outer edges of the wings also indicate a lost molding, perhaps an astragal molding that would have concealed the gap between the closed wings. The two hinges for each lateral wing and the eyehole hook at the center top are original. The hinges are doubled-over loops of wire, which were driven in the sides and out the back of the wings. The projecting ends were then spread apart and hammered flat before gessoing. The base is attached to the flat part of the

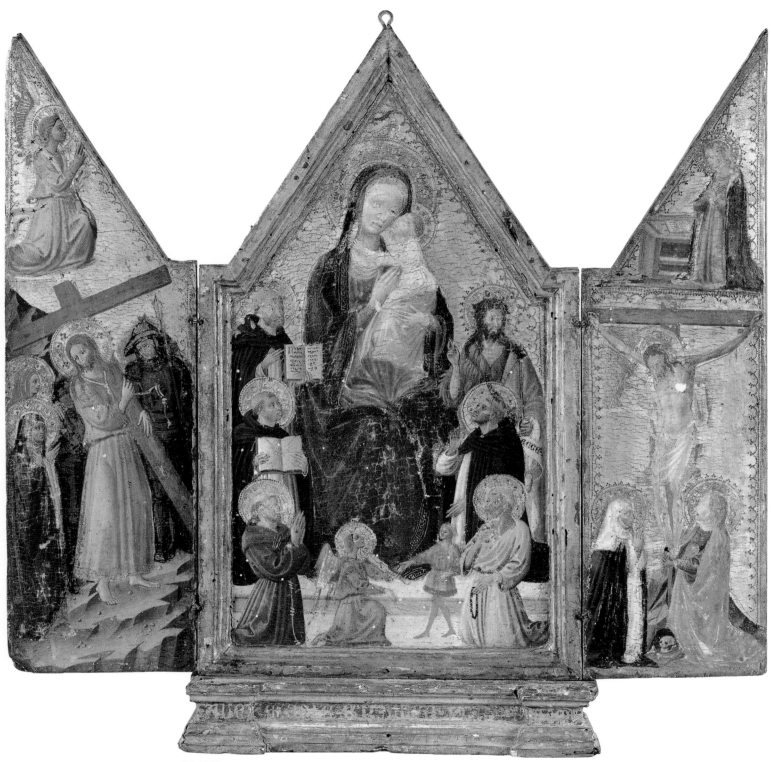

PLATE 49

main panel. It consists of a block of wood to which two smaller blocks have been attached to form the projections at either end. The decorative moldings were neatly mitered to follow the profile around the sides and front.

In the X-radiograph a dense layer, probably the white lead and glue mixture recommended by Cennino Cennini, can also be seen where the figures overlap the gold ground. This technique is called *ritagliare* (see Allegretto di Nuzio, plate 4 [JC cat. 118]); it reduced the likelihood of the paint flaking off the gold. Incised lines that were used to outline forms in the gesso are visible to the naked eye.

The paint surface is very abraded, especially in the faces and in the blues. The tarnished silver leaf of the two soldiers' armor in the left wing is abraded to the bole in many areas. The knife in Saint Peter Martyr's head is silver leaf applied on a transparent orange layer over the tooled gold of his halo.

On October 21, 1963, Theodor Siegl noted that the painting had once been partially cleaned and the losses filled, and that the base and outside of the wings were covered with new gesso and antiqued. Siegl did some additional cleaning on the central

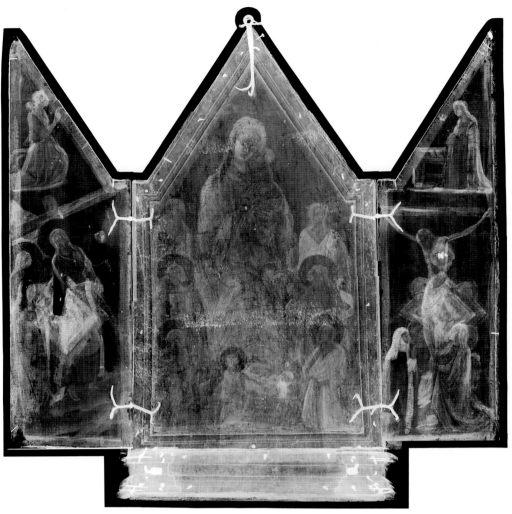

FIG. 49.1 X-radiograph of plate 49, showing the structure of the triptych, the hinges attaching the wings, and the hanging hook at the top center

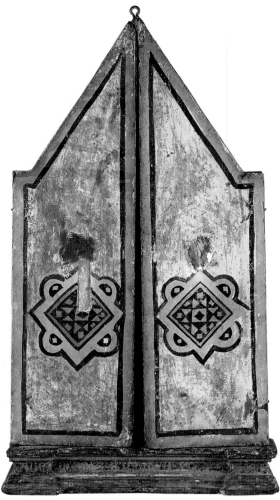

FIG. 49.2 Plate 49 with the wings closed, showing the painted decorative pattern

panel. He also treated the worm-eaten wood and flaking, and removed recent gesso and paint from the base and exterior side of the wings.

Close examination and the X-radiograph (fig. 49.1) show that the geometric pattern on the outside of the wings (fig. 49.2) is old. Traces of an incised design are all that remain of a later motif that was subsequently removed. The reddish paint on the back of the central panel is more recent.

PROVENANCE
Florence, Elia Volpi (Palazzo Davanzati); sold, New York, American Art Association, November 28, 1916, lot 1010 (repro., as primitive school of Florence, early fourteenth century); purchased by Kleinberger Galleries, New York, for John G. Johnson for 3,000 dollars

COMMENTS
The Virgin and Christ Child sit enthroned on a raised platform. Before them are the kneeling Saint Francis of Assisi, a kneeling angel playing the viol, a standing boy without a halo, and the kneeling Saint Jerome in a gray habit, beating his breast with a stone and holding prayer beads. Four saints are on the platform: Dominic, carrying an open book and lilies, symbol of his purity; Thomas Aquinas, holding an open book from which emanate golden rays, the latter a symbol of his divine learning; John the Baptist, pointing toward Christ; and Peter Martyr, holding a knife in his head, symbol of his martyrdom by heretics.

In the upper part of the left wing is the kneeling Annunciate Angel, and below, Christ is going to Calvary as the Virgin and Mary Magdalene look on.

In the upper part of the right wing the Virgin Annunciate kneels in front of a reading desk. Barely visible is a much abraded dove of the Holy Spirit. The Crucifixion is represented below in a scene that includes Mary Magdalene and a haloed nun in a black-and-white habit similar to that of the Dominican order. Her most likely identification is Catherine of Siena (c. 1347–1380). If this indeed is the case, the fact that she is shown with a halo would suggest that the painting dates after her canonization in 1461 by Pope Pius II Piccolomini. The saint's position at the bottom of the cross emphasizes the special relationship with Christ that, according to Catherine's biographers, her life exemplified: she lived the same number of years, she received the stigmata, and she had many visions in which Christ appeared.

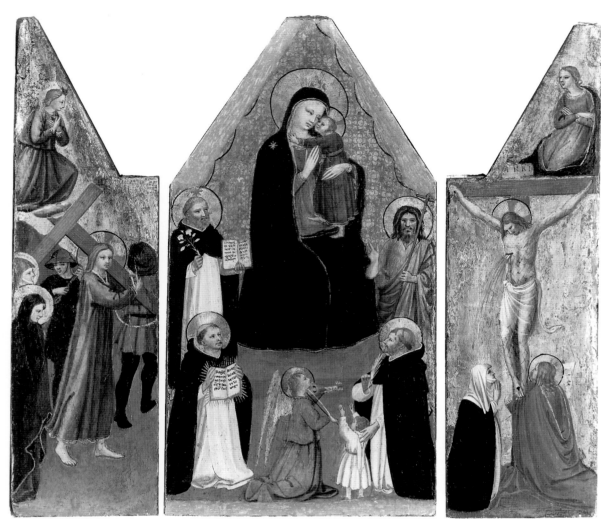

FIG. 49.3 Follower of Fra Angelico. Triptych: (center) *Virgin and Child Enthroned with Saints Thomas Aquinas, Dominic, John the Baptist, and Peter Martyr, a Dominican Novice, and a Music-Making Angel*; (left wing) *Annunciate Angel and Calvary*; (right wing) *Virgin Annunciate and the Crucifixion with the Blessed Catherine of Siena and Saint Mary Magdalene*, c. 1440–50. Tempera and tooled gold on panel; center 15⅛ × 7⅞" (38.3 × 20 cm); left wing 15⅛ × 4¼" (38.3 × 10.9 cm); right wing 15⅛ × 4½" (38.3 × 11.4 cm). Oxford, The Governing Body, Christ Church, cat. JBS 20

In 1964 Ellis Waterhouse (quoted in Sweeny 1966) identified the angel and the small standing figure at the bottom of the central panel as the archangel Raphael and Tobias. However, the boy does not have a halo or any of Tobias's other symbols, which are the fish and dog;[1] instead, he appears to be dancing to the angel's music. It is possible that the triptych was painted on the occasion of a boy's entry into a convent as a novice. Indeed, the presence of four Dominican saints—Dominic, Thomas Aquinas, Peter Martyr, and Catherine of Siena—indicates that it probably belonged to someone associated with that order.

An almost identical composition is found in a triptych (fig. 49.3) in Christ Church, Oxford, by a follower of Fra Angelico. The main difference is that there Catherine of Siena is depicted not with a saint's halo but with the rays of the beatified, indicating that the triptych was painted before her canonization in 1461. In the Oxford painting the boy is shown wearing a white habit as he is presented to the Virgin by Saint Peter Martyr. This suggests that he could be either a novice at a Dominican convent[2] or a new member of one of Florence's special confraternities for male children,[3] who wore white garments during public processions.[4] The Dominican iconography would have made the triptych appropriate for use by any one of these organizations, as the Dominicans were the order most closely associated with them. Whatever specific event may have inspired the painting of the Oxford triptych, the Master of the Johnson Tabernacle was probably asked to copy that picture for a similar occasion.

1. The same artist depicted Tobias with a fish and dog in a triptych in The Hague (Ekkart 1987, repro. p. 101).
2. Dominican friars could not take vows before they were fourteen, although there are records of some becoming novices at twelve and thirteen (Gilbert 1984, p. 282).
3. Trexler 1974; Trexler 1980, pp. 368–418. See also Benozzo Gozzoli, plate 36 (JC cat. 38); and Fra Angelico, plate 8 (JC cat. 14). Both come from works of art in confraternities for boys.
4. Trexler 1980, pp. 376–78.

Bibliography
Johnson 1941, p. 6 (Florentine, early fifteenth century); Berenson 1963, p. 219; Sweeny 1966, p. 36 (follower of Benozzo Gozzoli); Byam Shaw 1967, p. 40; Fredericksen and Zeri 1972, p. 29 (follower of Bicci di Lorenzo); Laclotte and Mognetti 1976, no. 261; Laclotte and Mognetti 1987, p. 220, no. 261; Ferrazza 1993, p. 219 n. 70, fig. 195; Strehlke 1993, p. 14; Philadelphia 1994, repro. p. 216

MASTER OF MONTELABATE

UMBRIA, DOCUMENTED 1285;
ACTIVE C. 1280–90

The name "Master of Montelabate" refers to the artist of the wall paintings in the chapter house of the Benedictine abbey of Santa Maria di Valdiponte in Corbiniano at Montelabate, near Perugia.[1] According to an eighteenth-century history (cited in Zampa 1908, p. 37), the abbot Ercolano (in office 1234–60) rebuilt the abbey, and in 1285 the abbot Trasmondo (in office 1266–85) had the choir painted.[2] This decoration is lost, but it is probable that the murals in the chapter house were executed at the same time. A detached mural painting depicting the Crucifixion with Saints Paul and Benedict from a dependency of the monastery, the abbey of San Paolo di Valdiponte, later known as the Badia Celestina, also near Perugia, is by the same artist.[3] According to Miklós Boskovits (1973, 1981), the artist also executed a crucifix (see fig. 50.4) in the Galleria Nazionale dell'Umbria in Perugia and the *Crucifix with the Mourning Virgin and Saint John the Evangelist, Two Angels, and a Kneeling Donor* in the Philadelphia Museum of Art (plate 50 [PMA 1952-1-1]), as well as wall paintings in the abbey of Santa Giuliana in Perugia.[4] Andrea De Marchi (in Bellosi 1988a) and Filippo Todini (1989) added *Saint Francis of Assisi and a Devotee* (plate 51 [JC inv. 325]) and the *Crucifixion with the Mourning Virgin, Saint John the Evangelist, and Two Franciscan Devotees* (see fig. 51.1) to the artist's oeuvre.

The Master of Montelabate belonged to the generation of Umbrian painters who began their careers in the orbit of the Master of Saint Francis (active c. 1264–72). They subsequently came under the influence of artists from outside the region who were working in the Upper Church of San Francesco in Assisi. The Master of Montelabate was acutely aware of the new developments in Assisi, where the decoration of the Upper Church was essentially completed during the reign of the first Franciscan pope, Nicholas IV Masci (reigned 1288–92). The Master of Montelabate was most attracted to Cimabue's murals in the transept[5] and adopted that painter's manner of modeling with sharp contrasts of light and shade as well as his predilection for exaggerated displays of emotion and human drama.

Boskovits, De Marchi, and Todini have noted the influence of the anonymous painter of a triptych in the Galleria Nazionale dell'Umbria in Perugia.[6] However, this artist, known as the Master of the Marzolini Triptych,[7] is much too bizarre and advanced in style to have been a real model for the Master of Montelabate, who rarely wanders past well-established forms. In fact, his adherence to

convention makes it difficult to accept Elvio Lunghi's (1981) attribution to him of a dramatic manuscript illumination of a Crucifixion from the cathedral of San Rufino in Assisi.[8]

The murals in Montelabate were made for a powerful and rich Benedictine abbey, and his crucifix in Philadelphia was ordered by a church official, possibly an abbot, who is depicted as the donor. These more conservative patrons may have found in the Master of Montelabate a safe interpreter of the radical art being painted on the walls of the Franciscan basilica in Assisi.

1. Todini 1989, fig. 76.
2. They were supposedly signed "Meus Senesium." If this is so, it cannot be the same Meo da Siena who worked in Perugia from about 1319, and who actually signed the painting for the high altar of the abbey of Montelabate (Perugia, Galleria Nazionale dell'Umbria, no. 22; F. Santi 1969, fig. 22a).
3. F. Santi 1969, fig. 11.
4. Boskovits 1981, figs. 51–52.
5. Bellosi 1998, color repros. pp. 148–49, 185, 187–90.
6. No. 877; F. Santi 1969, fig. 14.
7. For this master's style, see Bellosi 1998, p. 159.
8. Assisi, Archivio Capitolare di San Rufino, Ms. 8, p. 236; Todini 1989, fig. 81.

Select Bibliography
Boskovits 1973, pp. 9–10; Boskovits 1981, pp. 7–8, 25; Lunghi 1981, p. 61; Enrica Neri Lusanna in *Francesco d'Assisi* 1982, p. 182; Filippo Todini in *Francesco d'Assisi* 1982, pp. 171, 174; Corrado Fratini in *Pittura* 1986, p. 622; Filippo Todini in *Pittura* 1986, p. 383; Andrea De Marchi in Bellosi 1988a, p. 37; Todini 1989, p. 158

PLATE 50 (PMA 1952-1-1)
Crucifix with the Mourning Virgin and Saint John the Evangelist, Two Angels, and a Kneeling Donor

c. 1285–90

Tempera and tooled silver on panel; overall $73\frac{1}{4} \times 68\frac{7}{8} \times 1\frac{5}{8}''$ (186 × 175 × 4 cm)

Philadelphia Museum of Art. Purchased with the W. P. Wilstach Fund. 1952-1-1

INSCRIBED AT THE TOP: .*I[ESUS] C[HRISTUS] NAZARENUS./ REX. IUD[A]EORU[M].* (John 19:19: "JESUS [CHRIST] OF NAZARETH, THE KING OF THE JEWS")

PUNCH MARKS: See Appendix II

TECHNICAL NOTES

The crucifix is made up of five pieces of wood (fig. 50.2) plus the wedge-shaped section used for Christ's projecting halo. Many parts of the support show original tool marks on the reverse (fig. 50.1). There is evidence of four nails that attach the halo and the cross member. One of these nails, in the area of Christ's chest, may have attached a hanging element, such as a loop, to the back.[1] However, as the reverse of this area is covered by a modern metal reinforcing plate, this cannot be further investigated. The edges of the crucifix are original, and as there is no evidence of a barbe or nails that would have affixed moldings to the edges, there apparently never was any enframement. An old bent nail at the top of the cross indicates that there was once another element to the composition, most likely a round *cimasa,* or crowning element, in which God the Father or another figure was depicted.

FIG. 50.1 Detail of the reverse of plate 50, showing the original tool marks

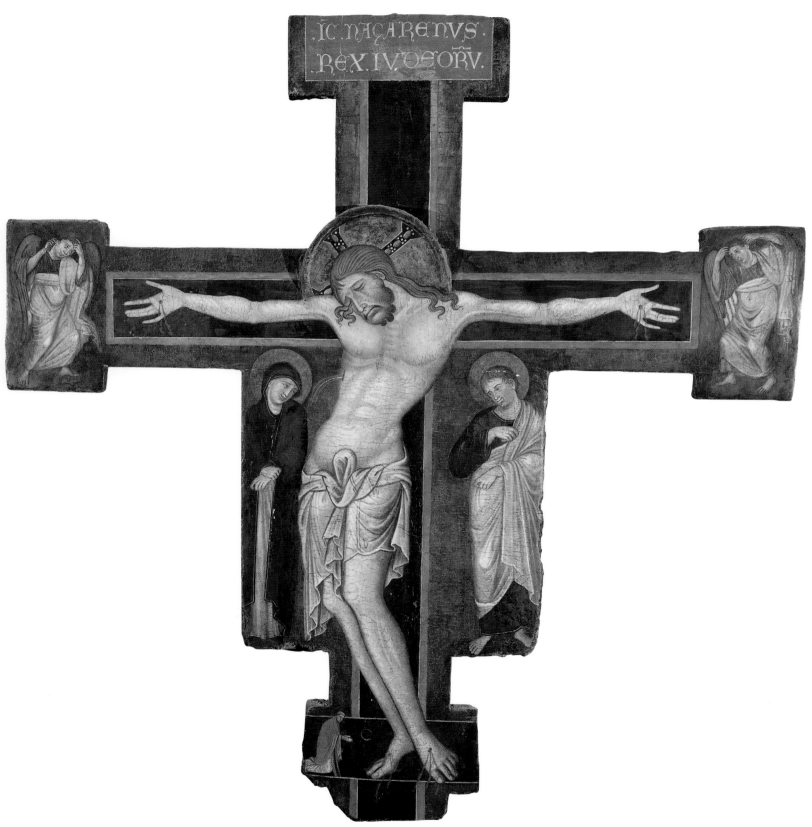

PLATE 50

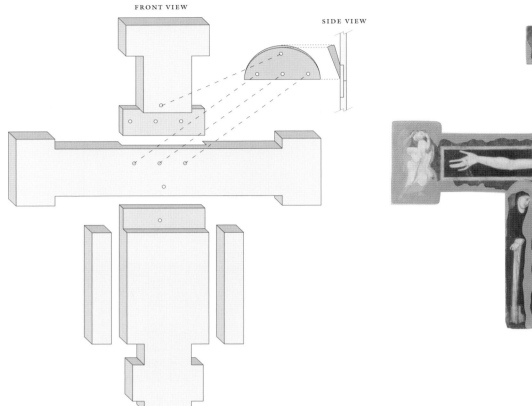

FRONT VIEW SIDE VIEW

FIG. 50.2 Diagram by Anandaroop Roy of
plate 50, showing the structure of the crucifix

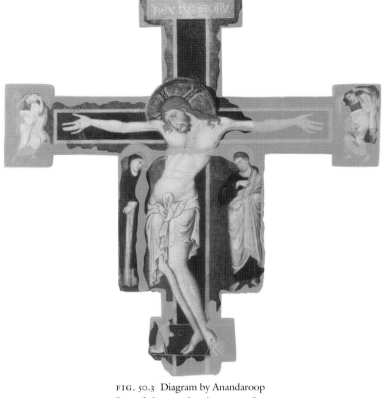

FIG. 50.3 Diagram by Anandaroop
Roy of plate 50, showing areas of
reconstructed loss (shaded)

The field of the crucifix and the halos were exe-
cuted in silver that is now largely tarnished or
obscured by layers of dark varnish. While such an
extensive use of silver is unusual, at least one
Umbrian cross of about the 1330s was similarly
executed with a silver-leaf background.[2] Examination
of the surface at 50x magnification did not reveal
the presence of any of the preparations typically
used to apply metal leaf, such as bole or a mordant.
The halos are decorated with a five-petaled flower
punch and an incised pattern. The halos now
appear gold and lighter than the tarnished silver
background, but this is due to later retouching.

Infrared reflectography showed evidence of
simple contour drawing and what appeared to be
original hatching in the red border of the arm of the
cross above Saint John. All the outlines that overlap
the silver background were incised with a stylus.

Shortly after its purchase by the Museum in
1952, this panel was treated by David Rosen. He dis-
assembled the cross, flattened the warp on the right
side of the horizontal member, and impregnated
some of the support with wax. He also cleaned the
paint surface and reconstructed large areas of the
design (fig. 50.3). The areas most affected by his
reconstruction are the left arm and hand of Christ,
the two angels, the top and right side of the Virgin's

blue mantle, and parts of the donor. He also used a
punch in imitation of the original for the parts of
the mourners' halos that had to be reconstructed.

PROVENANCE
Purchased by the Philadelphia Museum of Art from
the Florentine dealer Salvatore Romano, 1952

COMMENTS
The crucifix shows the dying Christ on an azurite-
painted cross with red and white outlines. Above
is the tablet with the inscription proclaiming him
"King of the Jews." In the left and right terminals
are angels shown pulling their hair in desperation.
The mourning Virgin and Saint John the Evangelist
stand in the apron of the cross. The donor, dressed
in red and white ecclesiastical robes, kneels at
Christ's feet. The crucifix would have originally
been mounted on a rood screen of a church,
which separated the nave, where laypeople could
circulate, from the sanctuary, which was reserved
for the clergy.

Edward Garrison (1949) catalogued the crucifix
as the work of a distant north Umbrian follower of
the Master of Saint Francis based on the similarities
to that artist's large crucifix of 1272, from the church
of San Francesco al Prato in Perugia,[3] seen in the

position of Christ's head, legs, and feet; the curvature
of his torso; and the fall of his hair.

Miklós Boskovits (1973) noted that the artist of
the Johnson crucifix was the same one who around
1285 painted a series of murals[4] in the chapter house
of the Benedictine abbey of Santa Maria di
Valdiponte in Corbiniano at Montelabate, near
Perugia, and the crucifix (fig. 50.4) now in the Gal-
leria Nazionale dell'Umbria in Perugia. Like the
Philadelphia crucifix, the crucifix in Perugia also
demonstrates the artist's familiarity with the work
of the Master of Saint Francis. The two mourners
are, in fact, copies of those on the apron of the
verso of the Master of Saint Francis's small proces-
sional cross in the Galleria Nazionale dell'Umbria.[5]

The Museum's crucifix presents some icono-
graphically archaic features for a late thirteenth-
century work. First, the mourning angels, which may
have been inspired by Cimabue's two murals of the
Crucifixion in the Upper Church of San Francesco
in Assisi,[6] were rarely depicted in the terminals of
these works.[7] Second, the depiction of mourners on
the apron of the crucifix had by that time largely
been abandoned in large crucifixes. It had been a
common feature of central Italian crucifixes about
hundred years earlier,[8] but in 1236 Giunta Pisano
initiated a change with a crucifix—now lost—for the

rood screen of the Lower Church of San Francesco that showed the dying Christ against a patterned apron with the mourners in the terminals.[9] The presence of Giunta's cross in Saint Francis's burial place, the mother church of the Franciscan order and a major pilgrimage site, guaranteed diffusion of this new iconography, which placed much more emphasis on the figure of Christ. Subsequent Umbrian crosses by the Master of Santa Chiara[10] and the Master of Saint Francis[11] followed Giunta's model. The Master of Saint Francis, for example, represented mourners and others who were present at the Crucifixion on the aprons of several small-scale processional crosses,[12] but he avoided doing so in his one large-scale crucifix. While the figures of Christ in the Master of Montelabate's crucifixes in Philadelphia and Perugia (fig. 50.4) bear similarities to those in these later crucifixes, the artist kept to some of the older schemes in other aspects of his composition.

Donors were not often depicted on crucifixes, but a notable precedent for such a representation was Giunta Pisano's lost cross of 1236, which showed the general of the Franciscan order, Fra Elia, as a devotee at Christ's feet. Evidence suggests that his presence on the cross in Assisi was not appreciated in Franciscan circles. For example, in the Master of Saint Francis's cross in Perugia the artist chose to show not the friar who had commissioned the work but rather Saint Francis in an act of devotion, kissing Christ's feet. The donor kneeling at the foot of the cross in Philadelphia is not a friar, for he wears the robes of an abbot or a bishop. If he had held either one of these offices, the absence of the symbols of his authority, the miter and pastoral staff, might be explained by his posture as a supplicant.

Although the provenance of this crucifix in the Philadelphia Museum of Art cannot be traced back very far, it may have come, like so many of the master's works, from the Benedictine monastery of Santa Maria di Valdiponte in Corbiniano at Montelabate near Perugia. In this case the donor figure might depict the abbot Trasmondo, who was in office from 1266 to 1285.

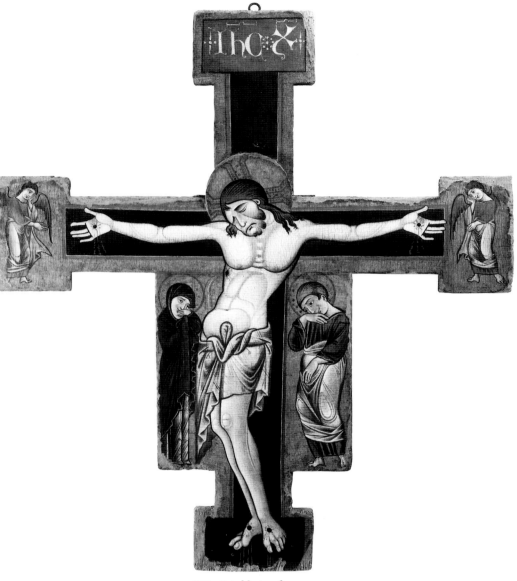

FIG. 50.4 Master of Montelabate. *Crucifix*, c. 1280s. Tempera on panel; 68⅛ × 60⅝" (173 × 154 cm). Perugia, Galleria Nazionale dell'Umbria, inv. 15

1. A similar element can be seen in Giotto's mural of the *Miracle at Greccio* in the Upper Church of San Francesco in Assisi (Zanardi 1996, postrestoration color repro. p. 195).

2. It is the crucifix formerly in the Foresti Collection in Carpi (Todini 1989, fig. 302), by the artist known as the Master of the Silver Crucifix, who frequently used silver backgrounds in his work. For a reproduction of the wings of a tabernacle in which the coloristic effect of the silver background is similar to that in the Philadelphia crucifix, see Todini 1989, color plates XIII–XIV.

3. Perugia, Galleria Nazionale dell'Umbria, no. 26; Todini 1989, plate IV.

4. For the *Crucifixion,* see Todini 1989, fig. 76.

5. No. 18; F. Santi 1969, fig. 9b.

6. Bellosi, 1998, color repros. pp. 148–49, 185, 187–90.

7. Crucifixes with angels in the terminals also seem to have been rare in Umbrian art. The type was more widely diffused in Tuscany, where at least three early thirteenth-century crosses by the Master of Bigallo have the mourners in the apron and angels in the terminals: they are now in the Art Institute of Chicago (1936.120; Lloyd 1993, repro. p. 147); Florence, Museo del Bigallo (Tartuferi 1990, fig. 25); and Rome, Galleria Nazionale d'Arte Antica di Palazzo Barberini (Tartuferi 1990, figs. 32–33). Other examples are also Tuscan: the crucifix of c. 1275 by the Master of San Miniato, in San Miniato al Monte, Florence (Tartuferi 1990, color plate VI); and the mid-thirteenth-century crucifix, possibly by a Sienese painter, originally in San Sisto in Piscina Pubblica, Rome, and now in the Collegio Angelico of Santi Domenico e Sisto, Rome (Sandberg Vavalà 1929, fig. 503 [color]). The scheme can also

be found in a late thirteenth-century crucifix in the convent of the Beato Mattia Nazzarei in Matelica in the Marches (Sandberg Vavalà 1929, figs. 422–23).

8. The best-known Umbrian example is the crucifix, dated 1187, by Alberto Sotio in the cathedral of Spoleto (Sandberg Vavalà 1929, figs. 56, 403).

9. Giunta's other crosses are reflections of the same scheme. They are in San Domenico, Bologna (Tartuferi 1990, color repro. p. 33); the Museo di Santa Maria degli Angeli, Assisi (Tartuferi 1990, color repro. p. 39); and the Museo Nazionale di San Matteo, Pisa (from the monastery of Sant'Anna; Tartuferi 1990, color repro. p. 57).

10. *Crucifix* from Gualdo Tadino, church of San

Francesco; now Gualdo Tadino, Pinacoteca Rocca Flea (Todini 1989, fig. 56); and *Crucifix of the Abbess Benedetta,* Assisi, basilica of Santa Chiara (Todini 1989, fig. 54 [detail]; Tartuferi 1990, repro. p. 88).

11. See n. 3 above.

12. See, for example, the Master of Saint Francis's cross in the National Gallery in London (no. 63.61; London 1989, color plate 38).

Bibliography
Garrison 1949, p. 183, repro. no. 457; Clifford 1953 (follower of the Master of Saint Francis); Philadelphia 1953, repro. p. 52 (Italian, c. 1280); Philadelphia 1965, p. 44 (follower of the Master of San Francesco); F. Santi 1969, p. 33; Boskovits 1973, pp. 10, 32 n. 38; Boskovits 1981, p. 25 n. 33; Enrica Neri Lusanna in *Francesco d'Assisi* 1982, p. 182; Filippo Todini in *Francesco d'Assisi* 1982, pp. 171–72; Corrado Fratini in *Pittura* 1986, p. 622; Todini 1989, p. 158, fig. 78; Philadelphia 1994, repro. p. 217

PLATE 51 (JC INV. 325)

ATTRIBUTED TO THE MASTER OF MONTELABATE

Saint Francis of Assisi and a Devotee

c. 1285

Tempera and silver on panel with horizontal grain; 7⅛ × 10⅛ × ⅝" (18 × 25.7 × 1.5 cm)

John G. Johnson Collection, inv. 325

INSCRIBED ON THE REVERSE: *Pietro Lorenzetti* (in pen or pencil); *City of Philadelphia/ Johnson Collection* (stamped, three times); *In 325* (in pencil); traces of embossed green paper on the bottom edge

TECHNICAL NOTES

The panel has been planed on all four sides and the back. There is no trace of a barbe that might indicate its original size. Although the background was blue, it now appears black. There is some retouching below Saint Francis's hand holding the book and the adjacent background, where there is a knot

in the wood. The mound on which the saint is standing is clearly visible in infrared reflectography. However, there does not seem to be any ground line under the figure of the devotee, which was painted over the blue background, suggesting that he was added late in the execution of the painting.

Francis's halo appears to be silver leaf. There is a film over the leaf, but it is unclear whether it is a color applied to give the appearance of gold or a deeply discolored varnish.

When inspected by Carel de Wild and Hamilton Bell on January 16, 1921, the panel was deemed to be in fair state. David Rosen cleaned the panel in 1941. In January 1957 Theodor Siegl retouched a scratch in the background between the two figures.

PROVENANCE

There is no record of John G. Johnson's purchase of this painting. Barbara Sweeny (1966) suggested that it occurred after the third volume of the collection's catalogue was published in 1914.

COMMENTS

Saint Francis of Assisi (c. 1181–1226; canonized 1228), standing on a mound, holds a book in one

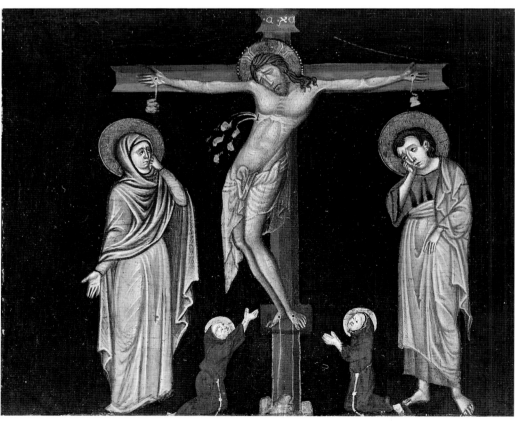

FIG. 51.1 Attributed to the Master of Montelabate. *Crucifixion with the Mourning Virgin, Saint John the Evangelist, and Two Franciscan Saints,* c. 1285. Tempera on panel; 7⅛ × 8¼" (18 × 21 cm). Last recorded Rome, private collection. Present location unknown

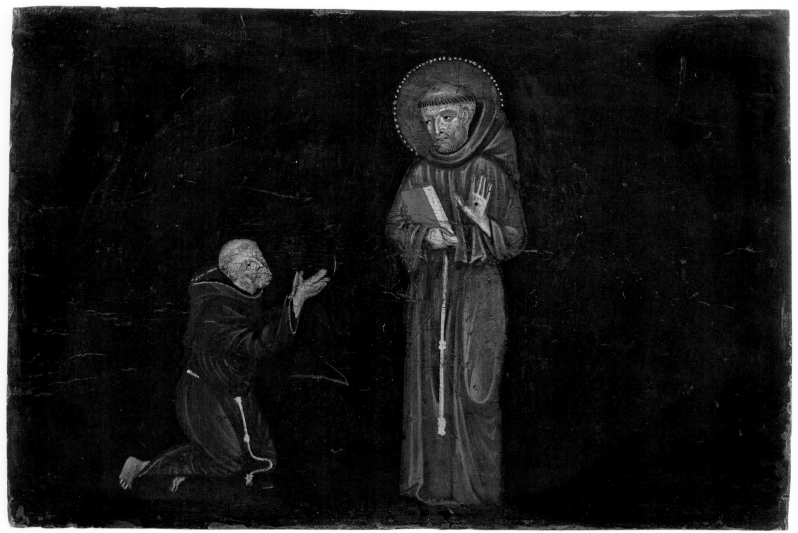

PLATE 51

hand and makes an open gesture with the other so that the stigmata is visible. To the left a barefoot friar kneels with his arms raised in supplication. Both figures are dressed in the simple hooded tunic of their order, which Francis had designed in the form of a cross. The three knots of the corded belt were said to symbolize the Franciscan vows of chastity, poverty, and obedience.

Not many small-scale images depicting Saint Francis alone or with other friars exist. One that bears certain similarities to the Johnson panel is a work by the Umbrian painter known as the Master of Farneto (active c. 1296–1306).[1] Once in the Belle da Costa Greene Collection, the now-lost painting shows Saint Francis standing with two other friars; all three figures have halos.

Raimond van Marle (1923) suggested that the Johnson picture was the lateral scene of a tabernacle. He compared it to paintings such as the panel of 1235 by Bonaventura Berlinghieri in the church of San Francesco in Pescia, in which the standing Saint Francis was flanked by scenes from his life.[2]

Edward Garrison (1949) more specifically related the picture to the *Crucifixion with the Mourning Virgin, Saint John the Evangelist, and Two Franciscan Saints* last recorded in a Roman private collection (fig. 51.1). He noted that they were both by the same artist and that they came from the same complex, although he did not attempt to reconstruct its original form. Andrea De Marchi (in Bellosi 1988a) proposed that the two panels formed a diptych. However, the pictures may rather have been part of the same panel, with the Philadelphia painting at the bottom.

Osvald Sirén (1922) assigned the Johnson picture to the Lucchese artist Barone Berlinghieri (documented 1228–82). Evelyn Sandberg Vavalà (1929) disputed this attribution and suggested instead the name of Salerno di Coppo, largely active in Pistoia. Roberto Longhi, in an essay written many years before its publication in 1948, described the painting as the work of the anonymous Pisan painter known as the Master of San Martino, after a *Maestà* from the Pisan church of San Matteo.[3] Garrison (1949), in his repertory of Italian Romanesque painting, stated his uncertainties about all the attributions, and Burton Fredericksen and Federico Zeri (1972) simply called it thirteenth-century Tuscan.

Ferdinando Bologna (1969a) was the first to suggest that the painting was not by a Tuscan artist but by an Umbrian follower of Cimabue. He thought that the same artist had also painted the cross from the church of San Francesco in Nocera Umbra.[4] De Marchi (in Bellosi 1988a) and Filippo Todini (1989) have since suggested that the painter of the small panels in Philadelphia and Rome is not that artist but the Umbrian follower of Cimabue known as the Master of Montelabate. The attribution of the Johnson painting depends on its stylistically more easily discernible panel of the Crucifixion (fig. 51.1), in which the figure of Christ can be compared with those in the master's larger-scale crucifixes, including the one in the Philadelphia Museum of Art (plate 50 [PMA 1952-1-1]).

1. Todini 1989, fig. 116.
2. *Pittura* 1986, fig. 358.
3. Pisa, Museo Nazionale di San Matteo; *Pittura* 1986, figs. 364–65 (color).
4. Nocera Umbra, Pinacoteca Comunale; Todini 1989, fig. 94.

Bibliography
Sirén 1922, p. 110, fig. 27; Van Marle, vol. 1, 1923, p. 344; Sandberg Vavalà 1929, p. 716; Sandberg Vavalà 1940, fig. 1; Johnson 1941, p. 14 (Salerno di Coppo); Longhi 1948, fig. 18 (Longhi *Opere*, vol. 7, 1974, fig. 17); Garrison 1949, p. 240, repro. no. 685; Sweeny 1966, p. 68, repro. p. 82 (Salerno di Coppo); F. Bologna 1969a, pp. 90, 110 n. 60; Fredericksen and Zeri 1972, p. 242 (Tuscan, thirteenth century); Andrea De Marchi in Bellosi 1988a, p. 37; Todini 1989, p. 158; Philadelphia 1994, repro. p. 217

MASTER OF THE OSSERVANZA

SIENA, ACTIVE C. 1430–50

Roberto Longhi (1940) was the first to recognize that a body of works attributed to Giovanni di Stefano, called Sassetta (first documented 1423; died 1450), was actually done by another painter who became known as the Master of the Osservanza on the basis of an altarpiece in the church of the Osservanza outside Siena.[1]

Five of the Master of the Osservanza's works can be dated and thus provide a basis for reconstructing the course of his career. The first is a group of miniatures cut out of a choir book probably made for the church of Sant'Agostino in Siena. Iconographic reasons suggest that they were made about 1430 in commemoration of the translation in that year of the relics of Saint Monica from Ostia to Rome.[2] The Augustinian friar Andrea Biglia, who wrote the service for that event, may well have commissioned the illuminations.

The other works by the Master of the Osservanza are altarpieces. The *Pietà with Saint Sebaldus and Donor,* in the collection of Monte dei Paschi in Siena, was painted before November 6, 1433, in memory of the Nuremberg citizen Peter Volckamer, who had died in Siena on September 5, 1432.[3] In 1436 Mano Orlandi commissioned the *Virgin and Child with Saints Jerome and Ambrose.*[4] This is now in the Osservanza, but around 1441 it had been installed in the church of San Maurizio, outside the gates of Siena. Documentation[5] related to the *Birth of the Virgin*[6] from the church of Sant'Agata in Asciano, outside Siena, is less precise, but an approximate date can be calculated. The painting's chapel was provided for in the will, dated 1437, of one Orazio Pasquini.[7] The altarpiece may have been finished before Pasquini's death in 1439 or in the following years under the direction of his in-law and executor Matteo Angeli, who was rector of the chapel in the mid-1450s. Stylistically, the painting does not seem much later than the altarpiece from the Osservanza. The altarpiece *Saint George Slaying the Dragon,* from San Cristoforo in Siena, was provided for by the will of the Sienese nobleman Giorgio Tolomei, dated August 1440.[8]

In addition to these works, the artist painted an altarpiece consisting of stories from the life of the hermit saint Anthony Abbot.[9] This was probably commissioned for a member of the Martinozzi family, whose arms are displayed in one of the scenes. It most likely came from an Augustinian church, as Anthony Abbot is dressed as a friar of that order, and in one scene the church of the Augustinian hermitage of Lecceto, outside Siena, can be discerned.

The identification of this master has been at the center of much art historical discussion in the past sixty years. Bernhard Berenson (1932) attributed some of his paintings to the young Sano di Pietro

(q.v.). This theory was elaborated in a more consistent way by Cesare Brandi (1949) and most recently reiterated by Miklós Boskovits (in Boskovits and Brown 2003, p. 479). Longhi (1940), however, saw the Master of the Osservanza as a slightly archaic Sassetta. Picking up on that idea, Alberto Graziani (1948) and John Pope-Hennessy (1956) proposed that he was Vico di Luca (documented 1426–44), an artist who collaborated with Sassetta in 1442. In an article that traced the original commissions of many of the master's paintings, Cecilia Alessi and Piero Scapecchi (1985) identified him with the Sienese Francesco di Bartolomeo Alfei (documented 1453–83) because of the latter's recorded activity in the Marches, which they erroneously thought was where some of the Master of the Osservanza's paintings were done. However, Alfei cannot be connected by documents to any of the artist's works, and his dates seem too late. Keith Christiansen (in Christiansen, Kanter, and Strehlke 1988) discussed the artist's work in full and proposed that he worked in a collaborative workshop, or *compagnia,* possibly with Sano di Pietro, for whom no works are documented before 1444.

Certainly Longhi's assessment that the painter was "a very noble artist of a culture parallel to that of Sassetta, but more insistently Gothic," is as valid today as when it was written in 1940.

1. *Osservanza* 1984, color repros. pp. 75–77. The predella is in the Pinacoteca Nazionale in Siena (no. 216; Torriti 1977, figs. 291–94 [color and black-and-white]).
2. They show the *Burial of Saint Monica and Saint Augustine Departing for Africa* (Cambridge, England, Fitzwilliam Museum, Marlay cutting It. 12; Christiansen, Kanter, and Strehlke 1988, cat. 9a, color repro. p. 101); the *Initial G, with the Virgin and Saints* (New York, The Metropolitan Museum of Art, no. 1975.1.2484; Christiansen, Kanter, and Strehlke 1988, cat. 9b, repro. p. 103); and the *Baptism of Saint Augustine Witnessed by Saint Monica* (Los Angeles, J. Paul Getty Museum, Ms. 90.MS.41; Getty 1991, fig. 25).
3. Gurrieri 1988, color repro. p. 299.
4. See n. 1 above.
5. Alessi and Scapecchi 1985, p. 15.
6. Asciano, Museo dell'Arte Sacra; Van Os 1990, fig. 104.
7. Pasquini was from the same Sienese parish as Mano Orlandi.
8. On deposit in Siena, Pinacoteca Nazionale; Christiansen, Kanter, and Strehlke 1988, fig. 29. The predella, by Sano di Pietro, is in the Pinacoteca Vaticana (nos. 133, 135; Christiansen, Kanter, and Strehlke 1988, figs. 31–32). See also Loseries 1987.
9. For the panels, which are in different museums, see Christiansen, Kanter, and Strehlke 1988, cats. 10a–h (color and black-and-white); and Boskovits and Brown 2003, pp. 408–95.

Select Bibliography
Berenson 1932, pp. 497–505; Longhi 1940, pp. 188–89 n. 26 (Longhi *Opere,* vol. 8, pt. 1, p. 60 n. 26); Graziani 1948; Brandi 1949, pp. 69–87, 254–55; Pope-Hennessy 1956; Carli 1957; Daniele Benati in Siena 1982, p. 393; Scapecchi 1983; Alessi and Scapecchi 1985; Loseries 1987; Cecilia Alessi in *Pittura* 1987, p. 683; Keith Christiansen in Christiansen, Kanter, and Strehlke 1988, pp. 99–123; Andrea De Marchi in Gurrieri 1988, pp. 298–302; Christiansen 1990, pp. 206–9; Cecilia Alessi in *Dictionary of Art* 1996, vol. 20, pp. 738–40; Miklós Boskovits in Boskovits and Brown 2003, p. 479

PLATE 52 (JC INV. 1295)

Predella panel of an altarpiece: *Christ Carrying the Cross*

c. 1440–45

Tempera and tooled gold on panel with horizontal grain; 14 1/2 × 18 1/2 × 1 3/8 to 1 1/2" (36.8 × 47 × 3.5 to 3.8 cm), painted surface 13 3/4 × 16 3/4" (35 × 42.7 cm)

John G. Johnson Collection, inv. 1295

INSCRIBED ON THE FLAG: *RQPS* (backward transcription of *SPQR* [Senatus populusque romanus] (The Senate and people of Rome); ON THE REVERSE: *CITY OF PHILADELPHIA/ JOHNSON COLLECTION* (stamped eight times in black); *# 1295* (in yellow crayon); *IN. 1295* (in black crayon)

PUNCH MARKS: See Appendix II

EXHIBITED: San Francisco 1939a, no. 49 (as Sassetta); Worcester 1951, no. 25 (as Sassetta); Philadelphia Museum of Art, John G. Johnson Collection, Special Exhibition Gallery, *From the Collections: Paintings from Siena* (December 3, 1983–May 6, 1984), no catalogue (as attributed to Sano di Pietro); New York 1988, no. 12b

TECHNICAL NOTES
The panel consists of a single piece of wood that has not been thinned. There are original tool marks on the reverse (fig. 52.1). The outer dimensions have been reduced by later planing of the top and bottom. The wood margins exposed when the original frame moldings were removed have been filled. An X-radiograph (fig. 52.2) reveals evidence of an old nail in the upper left.

Before painting, gold was applied for the halos, the costume of the central figure, and the hat of the rider in profile at the left; the latter two were subsequently embellished with sgraffito. Areas of paint loss show that the gilding of the halos extends a generous distance beneath the paint beyond the incised arc that serves as its outline. All other gold was applied in mordant gilding. The costumes of Longinius and the soldier at the right edge show remnants of silver leaf, as do the stirrups of the central centurion.

The X-radiograph (fig. 52.2) and the infrared photograph show that the artist first painted the

silhouette of the distant hills and sky across the full width of the composition, before laying in the buildings. The city gate was initially positioned at a sharply receding angle, which proved unsatisfactory and was changed. In doing so the artist also adjusted the height and width of the crenellations. No figures were painted until after these alterations were made. The building on the right was positioned with incised lines in the already finished landscape and then painted. The figures in the windows were added next, as the artist painted around the pole on the building's façade; the man in the far right window, however, was painted on top of the shutter. The left bracket of the exterior pole was shifted twice. The cross was painted last, over the figures and the soldiers' spears, a process that reduced the head of the man on the far left from a fully developed figure to nothing but facial features. Finally, the hills in the center of the composition were given a higher peak.

Most of the losses can be observed in a photograph taken in 1986, after cleaning but before inpainting (fig. 52.3). In addition, it is useful to compare this with an early twentieth-century photograph (fig. 52.4). The costume of the central centurion on horseback showed extensive damage, and in previous cleanings large areas of bole were exposed. The costume of Longinius, who is the man behind him, is also riddled with losses. The Virgin's mantle has suffered from abrasion, staining, and past overpainting. In an early restoration the punch work designs of the halos were filled with gesso, and the halos were entirely glazed with gold powder.

In 1921 Hamilton Bell and Carel de Wild decided that the painting was in good condition and did not need work. Ten years later, in April 1931, de Wild's son removed old varnish and retouching, and revarnished the surface. In August 1986 Suzanne Penn examined the panel and removed de Wild's discolored varnish and retouching. It was found that the spears of the lances were largely gone; in the restoration they were faithfully reconstructed utilizing original incised lines and comparisons with the companion panel in Kiev (see fig. 52.6). Mordant gilt details were reconstructed with shell gold, according to clear evidence of their shape and placement. The gilding of the armor of the central figure on horseback was not reconstructed. The exposed red bole was left untouched.

PROVENANCE

This panel, as well as the *Descent into Limbo* (see fig. 52.7) from the same predella, were purchased in Rome about 1860 by the eighth earl of Northesk. When his descendants dispersed his collection at Sotheby's in London on June 30, 1915, this panel was sold in lot 124 as Tuscan school. Langton Douglas purchased both panels and offered them to John G. Johnson in letters dated London, August 21 and 25, 1915, at first for a total of 1,050 pounds sterling and then for 500 pounds each. Johnson accepted

FIG. 52.1 Reverse of plate 52, showing the original tool marks

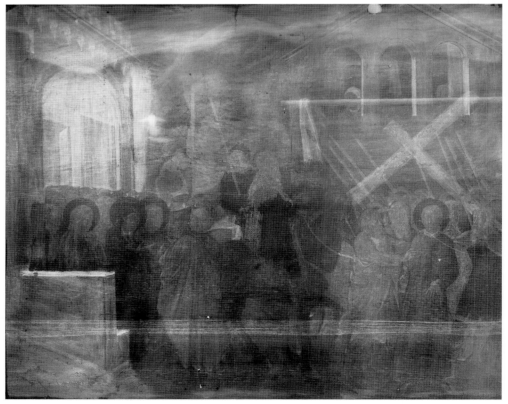

FIG. 52.2 X-radiograph of plate 52, showing the original mountain landscape across the top of the panel

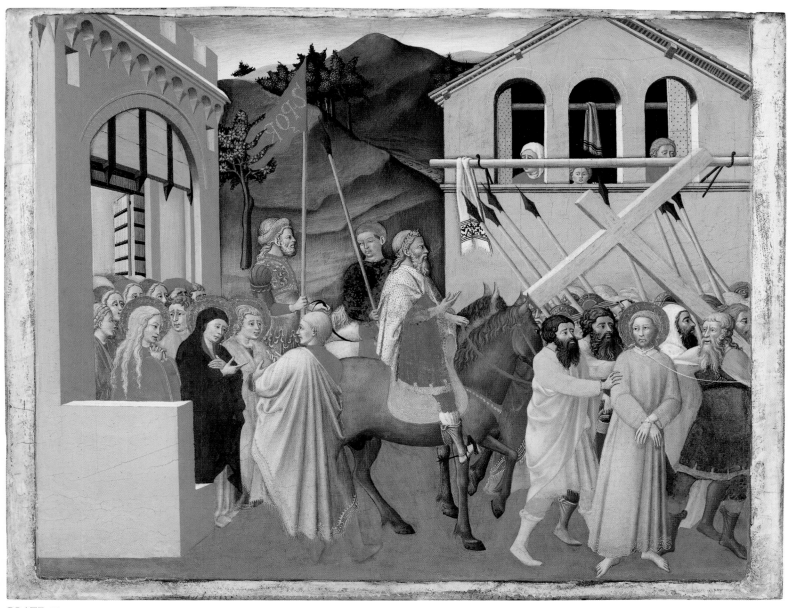

PLATE 52

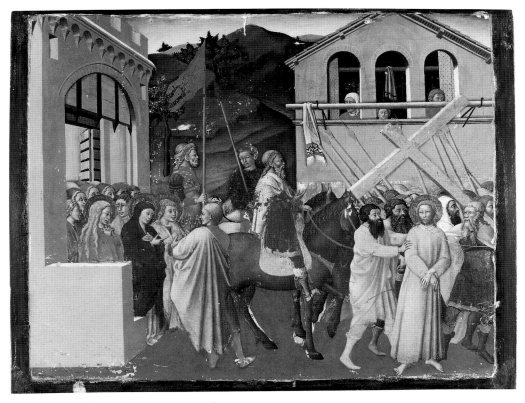

FIG. 52.3 Plate 52 in 1986, after cleaning and before restoration

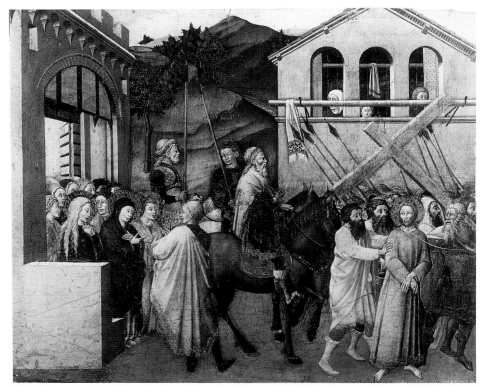

FIG. 52.4 Photograph of plate 52 as it appeared in the early twentieth century

the offer, but in the meantime Douglas had sold the *Descent into Limbo* (letter from Douglas, dated London, September 20, 1915).

COMMENTS

Christ, tied to a noose and his hands bound, is led to Calvary as the cross is carried in the crowd of soldiers behind him. The Virgin, Mary Magdalene, and John the Evangelist stand at the city gate. One of the three Romans on horseback is the centurion Longinius, who can be identified by his lance and diseased, closed eye, which, according to legend, would be healed at the Crucifixion by a drop of Christ's blood.[1]

The scene corresponds to the account in Luke 23:26–28: "And as they led him away, they laid hold of one Simon of Cyrene, coming from the country; and they laid the cross on him to carry after Jesus. And there followed him a great multitude of people, and of women, who bewailed and lamented him. But Jesus turning to them, said: Daughters of Jerusalem, weep not over me; but weep for yourselves, and for your children." In the painting, Simon of Cyrene, the bearer of the cross, is not visible.

The prototype for this representation of the subject was Duccio's (q.v.) scene of Calvary in the *Maestà* of 1308–11 in the cathedral of Siena.[2] In addition, as in Simone Martini's *Way to Calvary* of 1326 (see fig. 31.7), the scene is set outside Jerusalem's city gate, and the crowd is being held back from Christ. Yet whereas in the Simone Martini a soldier threatens the Virgin and her companions, here the young man seems to pity them, with his gesture adding a note of calm sadness and longing.

The panel is the second scene in a predella (fig. 52.11) consisting of stories from Christ's Passion, which has been reconstructed by F. Mason Perkins (1920, p. 18), Federico Zeri (1954), and Enzo Carli (1960a, pp. 333–34). The other paintings are the *Flagellation of Christ* (fig. 52.5) in the Vatican; the *Crucifixion* (fig. 52.6) in Kiev; the *Descent into Limbo* (fig. 52.7) in Cambridge, Massachusetts; and the *Resurrection* (fig. 52.8) in Detroit. The fact that the Jewish elders in the *Flagellation* and the soldiers and holy persons seen in the *Way to Calvary* reappear in the *Crucifixion* gives a visual unity to the predella. When the panels (except for the one in Kiev) came together in 1988–89 for an exhibition in New York, the similarities even in their present states of conservation were striking.

John Pope-Hennessy (1987, p. 110) identified that the *Virgin and Child Enthroned* (fig. 52.9) in New York was the center of the main section of the altarpiece, and Carli (1957, pp. 102–4; 1960, p. 338) recognized that *Saint John the Baptist* (fig. 52.10) in a private collection was possibly one of the side panels.[3] Both panels were once owned by Perkins. The inscription on Jesus' halo in the New York panel comes from John 19:19 and refers to the sign placed on the cross when he was crucified, a reference that would be appropriate in an altarpiece

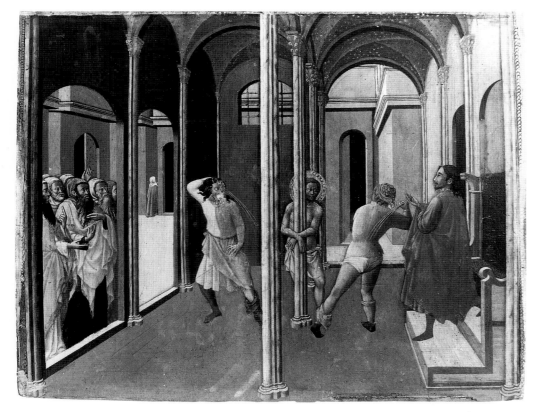

FIG. 52.5 Master of the Osservanza. *Flagellation of Christ*, c. 1440–45. Tempera and tooled gold on panel; 14⅜ × 18″ (36.5 × 45.7 cm). Vatican City, Pinacoteca Vaticana, inv. 232 (177). See Companion Panel A

FIG. 52.6 Master of the Osservanza. *Crucifixion*, c. 1440–45. Tempera and tooled gold on panel; 14⅝ × 27⅛″ (37 × 69 cm). Kiev, Bogdan and Varvara Khanenko Museum of Arts (also known as the Kiev Museum of Western and Oriental Art). See Companion Panel B

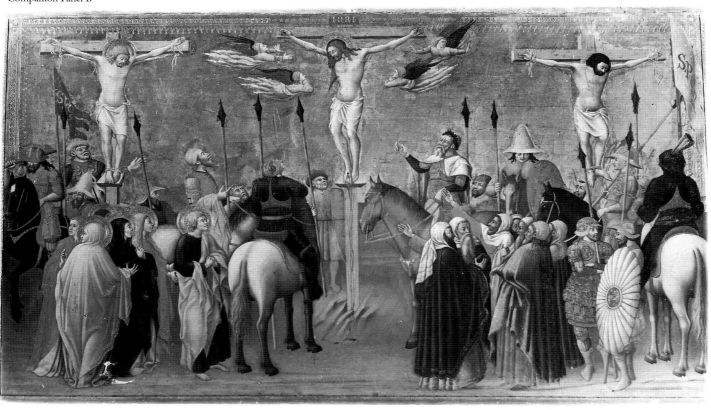

whose predella was dedicated to the Passion. Keith Christiansen (in Christiansen, Kanter, and Strehlke 1988, p. 136) has noted that the *Virgin and Child* was executed in collaboration with Sano di Pietro (q.v.).[4]

The original location of the altarpiece is not known, but Cecilia Alessi and Piero Scapecchi's (1985, pp. 36–37 n. 119) proposal that the mid-nineteenth-century Roman provenance of the Philadelphia panel and the *Descent into Limbo* might suggest a Roman source is unlikely. This altarpiece instead probably came from Siena or nearby, and, indeed, several of its iconographic and compositional details are found in contemporary Sienese art.[5]

The highly unusual depiction of the subject of the Descent into Limbo would seem to confirm a Sienese provenance, because it can be related to a local literary source: Niccolò di Mino Cicerchia's poem *La resurrezione*, written in the third quarter of the fourteenth century. The verse recounts how Christ, after storming hell, succored three patriarchs—Adam, Abel, and Noah;[6] they are probably the three figures kneeling before Christ in the painting.

Cicerchia was a lay follower of the Dominican Catherine of Siena (c. 1347–80; canonized 1461), and even accompanied her to Avignon in 1367. In 1364 he had composed a poem on the Passion that, together with *La resurrezione,* enjoyed a wide readership in Siena.[7] The use of Cicerchia's text as a source for the iconography of Limbo could suggest a Dominican context for the painting. In addition, in the mid-fifteenth century the subject

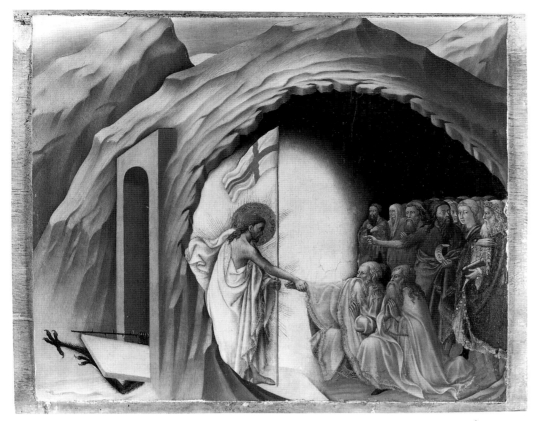

FIG. 52.7 Master of the Osservanza. *Descent into Limbo,* c. 1440–45. Tempera and tooled gold on panel; 15 × 18½″ (38 × 47 cm). Cambridge, Harvard University Art Museums, Fogg Art Museum, Gift of Paul J. Sachs, "A testimonial to my friend Edward W. Forbes," no. 1922.172. See Companion Panel C

FIG. 52.8 Master of the Osservanza. *Resurrection,* c. 1440–45. Tempera and tooled gold on panel; 14½ × 18⅛″ (36.9 × 45.9 cm). The Detroit Institute of Arts, Gift of Mr. and Mrs. Henry Ford II, no. 60.61. See Companion Panel D

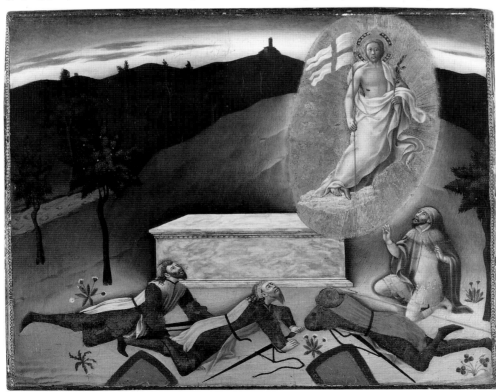

itself, although not often included in cycles of the Passion, was also the object of renewed interest after the discussions between the Latin and Greek churches at the Council of Ferrara and Florence of 1439 had focused on the concept. And, in fact, this predella was not the only contemporary work in Siena to address the issue.[8]

Perkins (1920) recognized that the Johnson Collection's panel and the *Descent into Limbo* were related to Sassetta, but he attributed them to a follower, who Bernhard Berenson (1932) thought might be the young Sano di Pietro. Pope-Hennessy (1939) gave the artist another name, calling him the Vatican Master after the panel from the same predella in the Pinacoteca Vaticana. Roberto Longhi (1940) was the first to recognize that the predella should be included among the works of the Master of the Osservanza, which all subsequent writers have accepted, although some have differed on the identification of this master. Barbara Sweeny (1966) published the panel as the work of Sano di Pietro, basing her opinion on her discussions with Cesare Brandi and Enzo Carli in Philadelphia.

1. Jacopo da Varazze c. 1267–77, Ryan and Ripperger ed. 1941, p. 191.
2. Siena, Museo dell'Opera della Metropolitana; Stubblebine 1979, plate 110.
3. By contrast, Henk van Os (1990, pp. 111–12) proposed that *Saint John the Baptist* was the lateral panel of the Master of the Osservanza's altarpiece of the Nativity, commissioned about 1447 by Matteo Angeli for Sant'Agata in Asciano, near Siena, and now in the Museo d'Arte Sacra (Van Os 1990, fig. 104).
4. Its composition derives from the *Virgin and Child* in the center of the altarpiece in the Osservanza in Siena (*Osservanza* 1984, color repro. p. 75).
5. For example, the resurrected Christ floating over the tomb (see fig. 52.8) is found in Lorenzo Vecchietta's 1445 reliquary doors from the sacristy of Santa Maria della Scala in Siena (now Siena, Pinacoteca Nazionale, no. 204; Torriti 1977, fig. 427), and a close derivation of the same figure of Christ was used by Sano di Pietro for his c. 1444–45 *Resurrection* from San Girolamo in Siena (now Cologne, Wallraf-Richartz-Museum, no. 726; Christiansen, Kanter, and Strehlke 1988, color repro. p. 143). Also, the rare representation of the Resurrection with a closed tomb occurs in Domenico di Niccolò dei Cori's intarsia choir stalls of 1415–28 (Boespflug 1985, color plate p. 35) in the chapel of the Nove of the Palazzo Pubblico in Siena. Both the *Resurrection* and the *Descent into Limbo* find parallels in the lunette of Sano di Pietro's altarpiece in the parish church of San Quirico d'Orcia (1460s; Van Os 1990, fig. 214).
6. Varanini 1965, pp. 389–90 nn. 24–28. Keith Christiansen (in Christiansen, Kanter, and Strehlke 1988, p. 133) has suggested that the two figures in the foreground might be the sons of Simeon—Carinus and Leucius (Varanini 1965, pp. 545–46)—who, according to the apocryphal fifth-century Gospel of Nicodemus (known in the Middle Ages as the *Gesta Pilati,* or *The History of Pilate*), were resurrected at the same time as Christ. They later told the elders in the temple in Jerusalem the story of Christ's descent into Limbo. Cicerchia's text has been shown to be dependent on the *Gesta,* but the Sienese writer did not include the episode concerning Carinus and Leucius. The presence

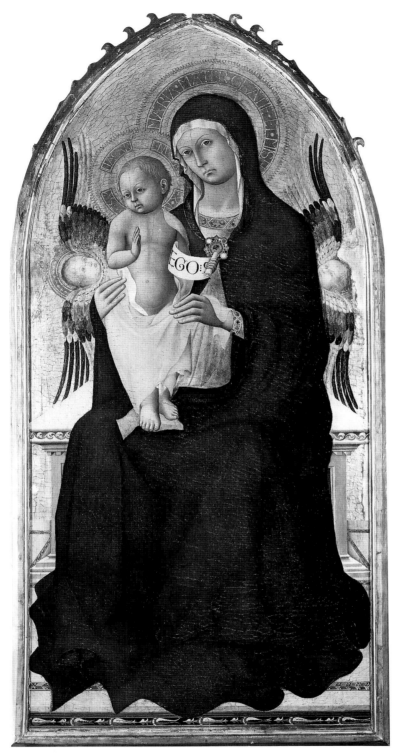

FIG. 52.9 Master of the Osservanza. *Virgin and Child Enthroned*, c. 1440–45. Tempera and tooled gold on panel; 56½ × 27⅜″ (143.5 × 69.5 cm). New York, The Metropolitan Museum of Art, Robert Lehman Collection, 1975 (1975.1.41). See Companion Panel E

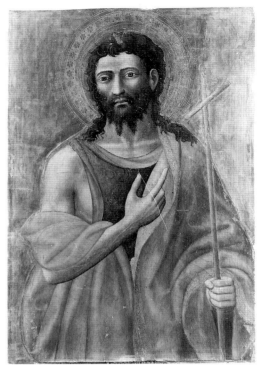

FIG. 52.10 Master of the Osservanza. *Saint John the Baptist*, c. 1440–45. Tempera and tooled gold on panel; 27¾ × 18¾″ (70.5 × 47.5 cm [cut]). Dallas, private collection. See Possible Companion Panel A

of a third head in the shadows behind the two kneeling men would suggest that Carinus and Leucius are not represented.

7. Meiss 1951, pp. 125–27; Pasquale Stoppelli in *DBI*, vol. 25, 1981, pp. 380–81.

8. For example, Vecchietta's near-contemporaneous depictions of the articles of the Creed in the sacristy of Santa Maria della Scala and in the vaults of the Sienese baptistery enter into the context of this theological debate, for they both include traditional representations of the *Descent into Limbo* (Van Os 1974, figs. 27, 44, plates 34–35). Also showing the subject are Sano di Pietro's altarpiece in San Quirico d'Orcia (see n. 5 above) and Giovanni di Paolo's (q.v.) *Last Judgment* of c. 1460 in the Pinacoteca Nazionale of Siena (no. 172; Torriti 1977, figs. 391–94 [color and black-and-white]).

Bibliography

Perkins 1918, p. 113; Perkins 1920, pp. 14–18, fig. 6; Comstock 1927c, p. 41; Van Marle, vol. 9, 1927, p. 330 n. 1; Kimball 1931, repro. p. 24; Berenson 1932, p. 500; Edgell 1932, p. 194, fig. 264; Gengaro 1933, p. 29; Berenson 1936, p. 430; Pope-Hennessy 1939, p. 17, plate xxxb; San Francisco 1939a, repro. no. 49; Longhi 1940, p. 188 n. 26 (Longhi *Opere,* vol. 8, pt. 1, 1975, p. 60 n. 26); Johnson 1941, p. 15 (Sassetta); Brandi 1949, pp. 254, 193 n. 45, plate 89; Worcester 1951, no. 25; Zeri 1954, p. 43; Carli 1956a, p. 54; Pope-Hennessy 1956, p. 365; Carli 1957, pp. 129–31; Carli 1960a, pp. 333–34; Sweeny 1966, pp. 68–69, color repro. opposite p. 117 (Sano di Pietro); Berenson 1968, p. 253; Fredericksen and Zeri 1972, p. 132; Alessi and Scapecchi 1985, pp. 28, 33 n. 4; Pope-Hennessy 1987, p. 110; Keith

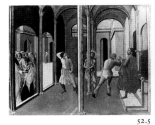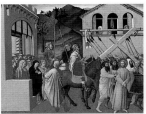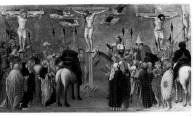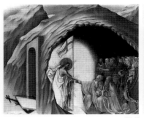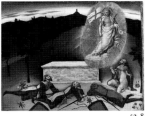

52.5 PL. 52 52.6 52.7 52.8

FIG. 52.11 Original sequence of the Master of the Osservanza's Passion predella, c. 1440–45. Left to right: FIG. 52.5, PLATE 52, FIGS. 52.6–52.8

Christiansen in Christiansen, Kanter, and Strehlke 1988, pp. 126–28, 130–33, color plate p. 131, X-radiograph p. 130; Christiansen 1990, p. 209; Philadelphia 1994, repro. p. 217; Cecilia Alessi in *Dictionary of Art* 1996, vol. 20, p. 738

COMPANION PANELS for PLATE 52

A. Predella panel of an altarpiece: *Flagellation of Christ.* See fig. 52.5

c. 1440–45

Tempera and tooled gold on panel; 14⅜ × 18″ (36.5 × 45.7 cm). Vatican City, Pinacoteca Vaticana, inv. 232 (177)

PROVENANCE: Unknown

EXHIBITED: New York 1988, no. 12a

SELECT BIBLIOGRAPHY: Pope-Hennessy 1987, p. 110; Volbach 1987, pp. 60–61; Keith Christiansen in Christiansen, Kanter, and Strehlke 1988, pp. 126–30; Christiansen 1990, p. 209

B. Predella panel of an altarpiece: *Crucifixion.* See fig. 52.6

c. 1440–45

Tempera and tooled gold on panel; 14⅝ × 27⅛″ (37 × 69 cm). Kiev, Bogdan and Varvara Khanenko Museum of Arts (also known as the Kiev Museum of Western and Oriental Art)

INSCRIBED ON THE CROSS: *INRI* [IESUS NAZARENUS, REX IUDAEORUM] (John 19:19: "JESUS OF NAZARETH, THE KING OF THE JEWS"); ON THE BANNERS: *SPQR, SPQR* [Senatus populusque romanus] (The Senate and people of Rome)

PROVENANCE: Unknown

SELECT BIBLIOGRAPHY: Zeri 1954, pp. 43–44; Kiev 1985, color plate 25; Pope-Hennessy 1987, p. 110; Keith Christiansen in Christiansen, Kanter, and Strehlke 1988, pp. 126–28

C. Predella panel of an altarpiece: *Descent into Limbo.* See fig. 52.7

c. 1440–45

Tempera and tooled gold on panel; 15 × 18½″ (38 × 47 cm). Cambridge, Harvard University Art Museums, Fogg Art Museum, Gift of Paul J. Sachs, "A testimonial to my friend Edward W. Forbes," no. 1922.172

INSCRIBED ON THE BAPTIST'S SCROLL: *ECCE. A[GNUS DEI]* (John 1:29: "Behold the Lamb of God")

PROVENANCE: Rome, purchased by the eighth earl of Northesk, c. 1860; sold, London, Sotheby's, June 30, 1915, lot 127 (as early Italian school); given to the Fogg Art Museum by Paul J. Sachs, 1922

EXHIBITED: New York 1988, no. 12c

SELECT BIBLIOGRAPHY: Perkins 1918, pp. 113–14 n. 5; Fogg 1919, p. 120; Perkins 1921, p. 17; Berenson 1932, p. 498; Pope-Hennessy 1956, p. 369; Pope-Hennessy 1987, p. 110; Keith Christiansen in Christiansen, Kanter, and Strehlke 1988, pp. 126–28, 133; Bowron 1990, p. 119; Christiansen 1990, p. 209; Van Os 1990, p. 112

D. Predella panel of an altarpiece: *Resurrection.* See fig. 52.8

c. 1440–45

Tempera and tooled gold on panel; 14½ × 18⅛″ (36.9 × 45.9 cm). The Detroit Institute of Arts, Gift of Mr. and Mrs. Henry Ford II, no. 60.61

PROVENANCE: London, convent of All Saints; sold, London, Sotheby's, June 24, 1959, lot 64 (as Master of the Osservanza); given to the Detroit Institute of Arts by Mr. and Mrs. Henry Ford II, 1960

EXHIBITED: New York 1988, no. 12d

SELECT BIBLIOGRAPHY: Carli 1960a, pp. 333–40; Pope-Hennessy 1987, p. 110; Keith Christiansen in Christiansen, Kanter, and Strehlke 1988, pp. 126–28, 135; Christiansen 1990, pp. 206, 209; Van Os 1990, p. 112

E. Center panel of an altarpiece: *Virgin and Child Enthroned.* See fig. 52.9

c. 1440–45

Tempera and tooled gold on panel; 56½ × 27⅜″ (143.5 × 69.5 cm). New York, The Metropolitan Museum of Art, Robert Lehman Collection, 1975 (1975.1.41)

INSCRIBED IN THE VIRGIN'S HALO: *MARIA · MATER · GRATIE · ET · MISER* (Mother Mary, grace and mercy); IN CHRIST'S HALO: *YESUS NAÇAR ENUS · R EX · IV[DAEO-RUM]* (John 19:19: "JESUS OF NAZARETH, THE KING OF THE JEWS"); ON CHRIST'S SCROLL: *EGO: S[UM VIA VERI-TATIS]* (John 14:6: "I am the way, and the truth")

PROVENANCE: Lastra a Signa (Florence), F. Mason Perkins; New York, Rita Lydig; sold, New York, American Art Association, April 4, 1913, lot 126 (as Sano di Pietro); Morton Meinhard; sold by his widow, New York, Parke-Bernet Galleries, May 4–5, 1951, lot 313 (as Sano di Pietro); acquired by Robert Lehman; bequeathed by Lehman to the Metropolitan Museum of Art, 1975

EXHIBITED: Paris 1957, no. 45 (as Sano di Pietro); Cincinnati 1959, no. 43 (as Sano di Pietro); New York 1988, no. 13 (as Master of the Osservanza)

SELECT BIBLIOGRAPHY: Pope-Hennessy 1987, p. 110; Keith Christiansen in Christiansen, Kanter, and Strehlke 1988, pp. 135–36; Christiansen 1990, p. 209

POSSIBLE COMPANION PANEL for PLATE 52

A. Lateral panel of an altarpiece: *Saint John the Baptist.* See fig. 52.10

c. 1440–45

Tempera and tooled gold on panel; 27¾ × 18¾″ (70.5 × 47.5 cm) (cut). Dallas, private collection

PROVENANCE: Assisi, F. Mason Perkins; sold, London, Sotheby's, April 8, 1987, lot 1 (as attributed to the Master of the Osservanza)

SELECT BIBLIOGRAPHY: Carli 1957, pp. 102–4; Carli 1960a, p. 338; Keith Christiansen in Christiansen, Kanter, and Strehlke 1988, p. 126; Van Os 1990, p. 111

MASTER OF THE PESARO CRUCIFIX

VENICE, ACTIVE LATE FOURTEENTH CENTURY

The "Master of the Pesaro Crucifix" was a name created by Miklós Boskovits (in Laclotte and Mognetti 1976) to distinguish the anonymous artist of a number of late fourteenth-century paintings. The only one of his works with a firm provenance is the *Virgin of Humility with the Annunciation* of about 1380–90 in the Brera in Milan, which comes from the Scuola dei Tessitori di Panni di Seta in Venice, the guild hall of the silk weavers.[1] While this proves that the artist was active in Venice, he also worked for centers along the Adriatic coast. The artist is named after a processional cross of about 1375–80, now in the seminary of Pesaro.[2] The *Crucifixion* (see fig. 53.8) in the Musée du Petit Palais in Avignon may have been made for a location in Venetian-controlled Dalmatia or Greece, because, as Michel Laclotte and Élisabeth Mognetti (1976, 1987) have noted, its Latin inscriptions were painted over in Greek, and a late fifteenth-century *Crucifixion*,[3] signed by the Cretan painter Andreas Pavias of Candia, is based on the one in Avignon or a common prototype. The most interesting works by the Master of the Pesaro Crucifix are a series of scenes that includes the panel in the Museum (plate 53 [PMA 1943-40-51]; see also figs. 53.2–53.5, 53.8).

The artist's style compares with that of several others working in Venice in the 1380s: the Emilian Giovanni Salamone di Albertino da Reggio, known as Giovanni da Bologna; the Venetian Stefano "Plebanus" di Sant'Agnese; the Venetian Jacobello di Bonomo; and the so-called Master of Sant'Elsino (see fig. 53.6). The Master of the Pesaro Crucifix's *Virgin of Humility* in the Brera specifically derives from Giovanni da Bologna's *Virgin of Humility* of about 1377–80 for the Scuola di San Giovanni Evangelista in Venice (now in the Gallerie dell'Accademia).[4] Like the Master of the Pesaro Crucifix, Jacobello di Bonomo and the Master of Sant'Elsino worked both in Venice and along both sides of the Adriatic coasts.[5] The Master of Sant'Elsino has been tentatively identified with a Dalmatian painter from Zara, Blaž di Luka Banič, who apprenticed with Jacobello in Venice in 1384.[6] The Master of the Pesaro Crucifix may also be of the same origin.[7]

1. No. Reg. cron. 605; Brera 1990, color repro. 173.
2. Bolzoni and Ghezzi 1983, fig. 4.
3. Athens, National Art Gallery and Alexandros Soutzos Museum, no. 144; Lambraki-Plaka 1999, plate 1 (color).
4. No. 230; Lucco 1992, fig. 70 (color).
5. Jacobello's altarpiece now in the cathedral of Saint Vitus in Prague has a Dalmatian provenance (Lucco 1992, fig. 78).
6. De Marchi 1987a, p. 25. The artist was traditionally

known as the Master of Sant'Elsino after his principal painting, an altarpiece in the National Gallery in London (no. 4250), which contains scenes from the life of Saint Helsinus (Davies and Gordon 1988, plates 5–11).
7. Several artists—Nicola de Blondis, Giovanni di Tomasino "de Poveglana de Padua," Stefano di Giovanni, and Meneghello di Giovanni de' Canalibus— are documented as working on both sides of the coast, but, unfortunately, their works are not known; see Alberto Cottino in Lucco 1992, p. 539.

Select Bibliography
Laclotte and Mognetti 1976, no. 132; Volpe 1977, pp. 74–75; Bolzoni and Ghezzi 1983; Van Os 1983, p. 74; De Marchi 1987a, pp. 25, 58 nn. 8–9; Laclotte and Mognetti 1987, p. 138; Milvia Bollati in Brera 1990, pp. 172–73; Mauro Lucco in Lucco 1992, p. 531

PLATE 53 (PMA 1943-40-51)

Panel of an altarpiece: *Saint Cecilia of Rome and Her Husband, Valerian, Being Crowned by an Angel*

c. 1375–80

Tempera and gold on panel with vertical grain; 20½ × 14¼ × ¼" (55.2 × 36.3 × 0.7 cm)

Philadelphia Museum of Art. Bequest of John D. McIlhenny. 1943-40-51

INSCRIBED ON THE REVERSE: Several seemingly random numbers and letters (in ink on the cradle members); *43-40-51* (in red paint)

TECHNICAL NOTES

The support consists of a single plank of wood that has been thinned and cradled; subsequent warping has produced a washboard effect.

The panel has been cut on all four sides, but scored lines may indicate those parts of the edges that would have been covered by a frame. The architecture was also carefully scored in the gesso before painting began. Infrared reflectography indicates the existence of some line drawing and a good deal of wash drawing. It also revealed how the artist blocked out the forms of the faces of the main figures in broad areas of light and shade (figs. 53.1a, b).

The paint surface is in fairly good condition. Despite the abrasion of the costumes of the main figures, their hands and faces remain well preserved.

All the mordant gilding is gone, and many of the areas where it had been are pitted. It once embellished the stars in the vault, Cecilia's and Valerian's capes and the buttons and cuffs of their sleeves, and the bolster and curtain of the bed. In addition, gilt rays emanated from the angel. A marbleized effect in the angel's cloud was created by manipulating red lake, white, and blue pigments while they were still wet. Remnants of a much-abraded colorless medium in the red bed curtain seem to have once been a light glaze applied to represent the gathering of the cloth.

PROVENANCE

Nothing is known of where John D. McIlhenny acquired this painting.

(text continues on page 306)

Figs 53.1a, b Infrared reflectograms of plate 53, showing the underdrawing of Saints Valerian (left) and Cecilia (right)

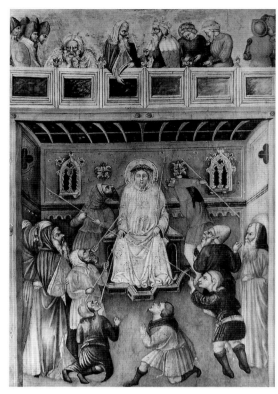

FIG. 53.2 Master of the Pesaro Crucifix. Panel of an altarpiece: *Mocking of Christ,* c. 1375–80. Tempera and tooled gold on panel; 20⅞ × 14⅝″ (53 × 37 cm). England, private collection

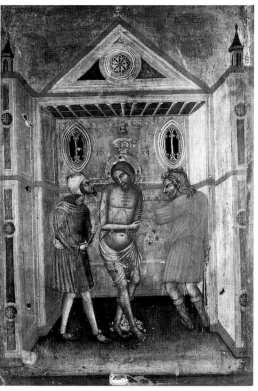

FIG. 53.3 Master of the Pesaro Crucifix. Panel of an altarpiece: *Flagellation of Christ,* c. 1375–80. Tempera and tooled gold on panel; 21½ × 14⅛″ (54.6 × 36 cm). Athens, National Art Gallery and Alexandros Soutzos Museum, Bequest of Athanasiadis-Bodosakis, no. 6989

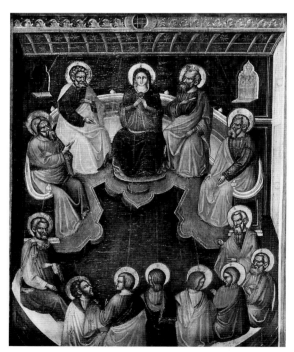

FIG. 53.4 Master of the Pesaro Crucifix. Panel of an altarpiece: *Pentecost,* c. 1375–80. Tempera and tooled gold on panel; 19½ × 15⅛″ (49.5 × 38.5 cm) (cropped at the bottom). Strasbourg, Musée des Beaux-Arts, no. 18

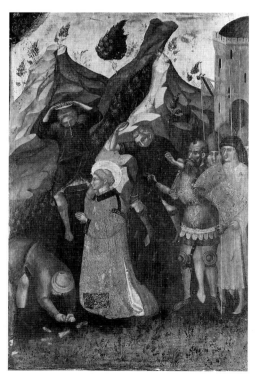

FIG. 53.5 Master of the Pesaro Crucifix. Panel of an altarpiece: *Stoning of Saint Stephen,* c. 1375–80. Tempera and tooled gold on panel; 22¼ × 14⅛″ (56.5 × 36 cm). Ferrara, Pinacoteca Nazionale, no. 318

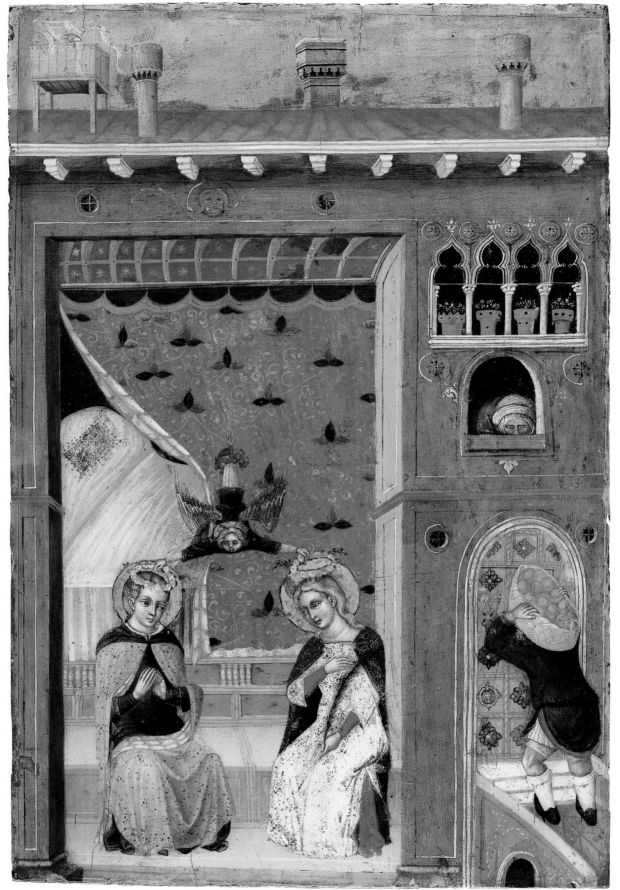

PLATE 53

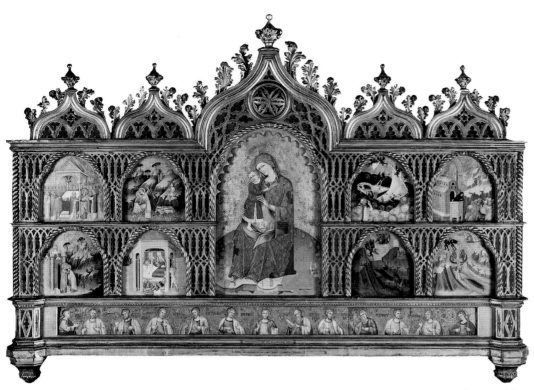

FIG. 53.6 Master of Sant'Elsino, possibly Blaž di Luka Banič (Dalmatia, active Venice and Zadar, 1380s). *Altarpiece of the Virgin Mary*, c. 1390. Tempera and tooled gold on panel in a nineteenth-century frame; without frame, approximately 29½ × 61½″ (75 × 156.1 cm). London, National Gallery, no. 4250

In a bedroom an angel is shown crowning Saint Cecilia, who holds a palm of martyrdom, and her husband, Saint Valerian. An ermine-lined curtain is thrown open to reveal an untouched bed. The household is undisturbed by the miraculous event: a maid looks down from a second-story window while outside a worker carries a basket of bread to the front door; this is an unusual detail also present in the scene of the Virgin's birth in an altarpiece by the so-called Master of Sant'Elsino (fig. 53.6).[1] In the Johnson panel the man's legs are foreshortened in order to show the strain of his burden. Features such as the wood deck on the roof, the clay chimneys, the row of Gothic windows with flowerpots on the sills, and the doorway reached by a bridge set the scene in Venice. Great attention was placed on the precise depiction of architectural details: the tiles of the roof and the supporting beams recede toward the center, nails are depicted in the intersections of the ceiling rafters, and the framing of the doorway and the window above it is carefully drawn to reflect a vantage point from the left.

Cecilia and Valerian were third-century Roman nobles who had been promised to each other in marriage, but she had secretly converted to Christianity and was dedicated to chastity. The pagan Valerian knew nothing of this before the wedding night. According to the account given by Jacopo da Varazze in *The Golden Legend* of about 1267–77 (Ryan and Ripperger ed. 1941, p. 691), on the wedding day Cecilia wore a hair shirt concealed by a splendid gold garment. Before the ceremony, she entrusted her maidenhood to God, and that night informed the groom that an angel, who guarded

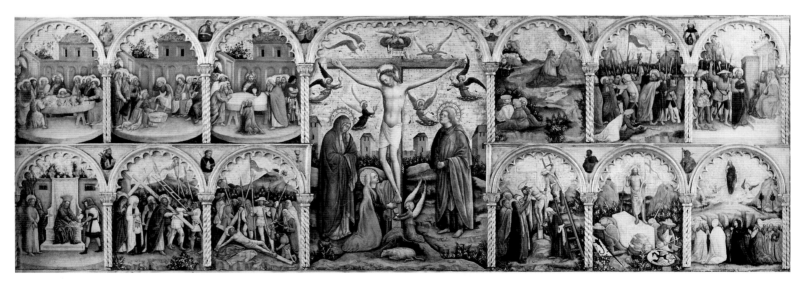

FIG. 53.7 Antonio Vivarini (Venice, active 1440?; died 1476/84) and Francesco de' Franceschi (Venice, active 1443–68). Altarpiece: *Crucifixion with Scenes of Christ's Passion*, 1440s. Tempera and tooled gold on panel; 26 × 80¾″ (66 × 205 cm). From Murano, convent of Corpus Domini. Venice, Gallerie dell'Accademia, inv. 1084, cat. 874; on deposit, Venice, Galleria Giorgio Franchetti alla Ca' d'Oro

her body with "exceeding zeal," was her lover. Valerian was also told that he could meet this rival if he agreed to be baptized. As his bride instructed, he immediately sought out Pope Urban I, who performed the ceremony. On his return home he found Cecilia with the angel, who "held two crowns fashioned of roses and lilies, of which he gave one to Cecilia and the other to Valerian, saying: 'Guard these crowns with spotless hearts and pure bodies, because I have brought them from God's Paradise to you, nor will they ever fade; and none can see them, save those who love chastity!'" The couple were later martyred for their refusal to renounce their faith.

Henri Marceau (1944) published this picture as a work of Jacobello del Fiore, based on a suggestion of Evelyn Sandberg Vavalà. Burton Fredericksen and Federico Zeri (1972) listed it as fourteenth-century Paduan. In 1976 Michel Laclotte and Élisabeth Mognetti cited Miklós Boskovits's opinion that it was by the so-called Master of the Pesaro Crucifix.

The Museum's panel relates in size and format to several others by the Master of the Pesaro Crucifix: the *Mocking of Christ* (fig. 53.2), the *Flagellation of Christ* (fig. 53.3), the *Pentecost* (fig. 53.4), and the *Stoning of Saint Stephen* (fig. 53.5). These paintings and others that are missing could have formed part of the same complex. Several reconstructions are possible. For example, they could have been grouped in two rows around a central image such as a Crucifixion, as seen in Antonio Vivarini's and Francesco de' Franceschi's much later altarpiece from the convent of Corpus Domini in Murano (fig. 53.7). If this were the case, the *Crucifixion* in Avignon (fig. 53.8) might be a candidate for the central section, as it is double the height of the smaller panels. However, the rectangular format of the Master of the Pesaro Crucifix's panels is unusual in Venetian fourteenth-century altarpieces, whose panels most often have trefoil tops. Indeed, the complex hypothetically reconstructed here may not have formed an altarpiece at all, but instead could have been the cover of a relic, the decoration of a rood screen, or an antependium of an altar. For instance, the panels by Paolo Veneziano and his sons that form the cover painted in 1345 for the *Pala d'oro* in San Marco in Venice are rectangular.[2] It is also possible that the Johnson panel was a valve of a diptych. A model for such an arrangement is an early trecento diptych in the J. Paul Getty Museum in Los Angeles, with the *Coronation of Saints Cecilia and Valerian* and the *Stigmatization of Saint Francis of Assisi*.[3]

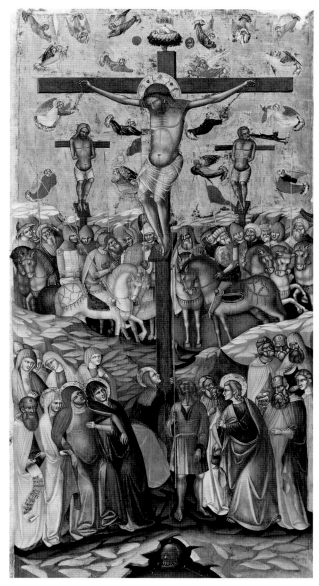

FIG. 53.8 Master of the Pesaro Crucifix. Panel of an altarpiece: *Crucifixion*, c. 1375–80. Tempera and tooled gold on panel; $44\frac{1}{2} \times 23\frac{1}{4}''$ (113 × 59 cm). Avignon, Musée du Petit Palais, no. M.I. 420

1. See also a panel of about 1400 in the Museé des Beaux-Arts in Strasbourg (inv. 449; Moench 1993, color repro. p. 79).
2. Muraro 1970, plates 41–63 (color and black-and-white).
3. No. 86.PB.490; Strehlke 1987, figs. 1a–c. For an attribution of this diptych to the Ligurian painter the Master of the Cross of Piani d'Ivrea, see Andrea De Marchi in *Italies* 1996, p. 49.

Bibliography

Marceau 1944, pp. 54, 59 (Jacobello del Fiore); Berenson 1957, p. 94; Philadelphia 1965, p. 35 (Jacobello del Fiore); Fredericksen and Zeri 1972, p. 235 (Padua, fourteenth century); Miklós Boskovits in Laclotte and Mognetti 1976, no. 132; Levi D'Ancona 1977, pp. 344–45, 354; Kaftal and Bisogni 1978, col. 205, fig. 247; Miklós Boskovits cited in Laclotte and Mognetti 1987, p. 138; Strehlke 1987, p. 86, fig. 3; Milvia Bollati in Brera 1990, p. 172; Rosalba D'Amico in Bentini 1992, p. 10; Mauro Lucco in Lucco 1992, p. 531; Moench 1993, p. 42; Philadelphia 1994, repro. p. 217; Lambraki-Plaka 1999, plate 1 (color)

MASTER OF THE POMEGRANATE

FLORENCE, ACTIVE C. 1450–75

Everett Fahy (written communication, New York, November 24, 1980) invented the name of this artist on the basis of the prominent pomegranate in the *Virgin and Child* in the Fogg Art Museum (see fig. 54.1). Fahy also identified six other pictures by the master: the *Virgin and Child Enthroned* (plate 54 [JC cat. 36]) in the John G. Johnson Collection; the *Virgin and Child* in Brussels;[1] the *Virgin and Child* in Florence;[2] the *Virgin and Child Enthroned* in Liverpool (see fig. 54.3); and the *Virgin and Child* sold in Cologne in 1976.[3] Like the so-called Pseudo–Pier Francesco Fiorentino (q.v.), this artist is closely related to Filippo Lippi and Pesellino (q.v.). In fact, Bernhard Berenson (1932a, 1969) had previously classified all of the paintings now attributed to the Master of the Pomegranate as copies after Pesellino.

1. Musée d'Art Ancien, no. 1492 (632); Berenson 1969, fig. 308.
2. New York University at the Villa La Pietra; Berenson 1969, fig. 306.
3. Kunsthaus Lempertz, June 14, 1976, lot 125, plate 5 (as Master of the Castello Nativity [q.v.]).

PLATE 54 (JC CAT. 36)
Virgin and Child Enthroned

c. 1450

Tempera and tooled gold on wood, arched; 51⅛ × 31¼″ (130 × 79.3 cm), painted surface 44⅛ × 24¾″ (112 × 62.7 cm)

John G. Johnson Collection, cat. 36

INSCRIBED IN THE CIRCLES OF THE VIRGIN'S HALO: *AV EM AR IA GR ATA PLE NA DN* [Ave Maria, gratia plena, Dominus (tecum)] (Luke 1:28: "Hail [Mary], full of grace, the Lord [is with thee]")

PUNCH MARKS: See Appendix II

TECHNICAL NOTES
The panel consists of three vertically grained planks of wood composed of a center plank 9½″ (24 cm) wide and two flanking planks, each about 4¾″ (12 cm) wide. There are a few depressions where short metal straps once bridged the right panel joint. The applied frame moldings are new.

The inscriptions in the circles in the Virgin's halo are executed in sgraffito and highlighted in red glaze, which is now almost completely gone. The former effect can be seen in the reproduction of the painting in Bernhard Berenson's 1913 catalogue.

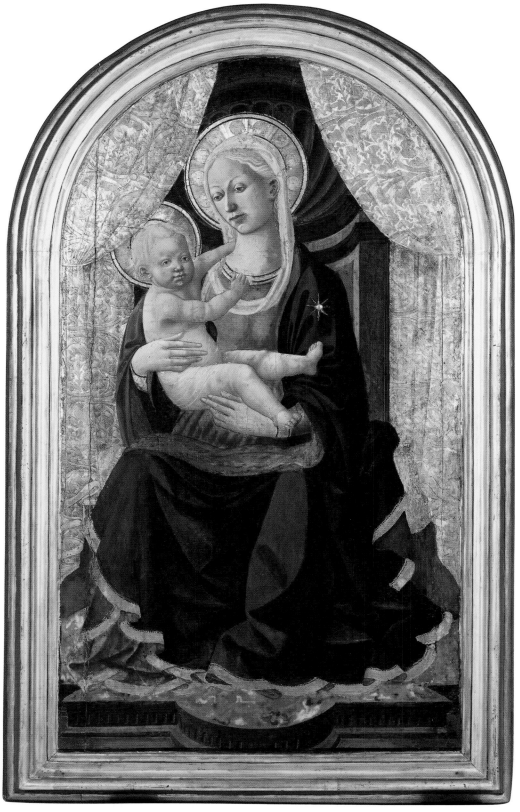

PLATE 54

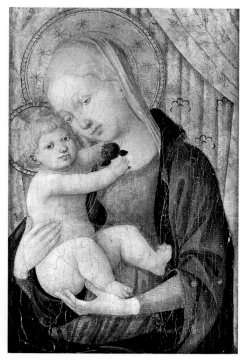

FIG. 54.1 Master of the Pomegranate. *Virgin and Child with Pomegranate,* 1450. Tempera and tooled gold on panel; 25⅛ × 18¼″ (63.8 × 46.4 cm). Cambridge, Harvard University Art Museums, Fogg Art Museum, no. 1927.198

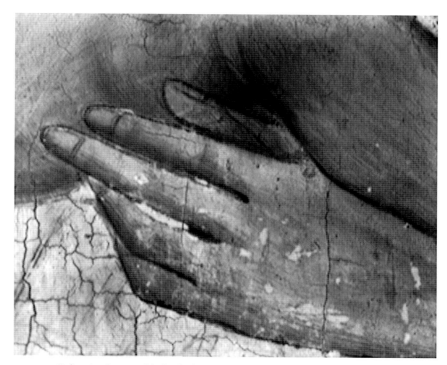

FIG. 54.2 Infrared reflectographic detail of plate 54, showing the underdrawing of the Virgin's left hand

The gold patterns on the curtain and pillow are incised. The gold star on the Virgin's left shoulder is built up in gesso relief. A pentimento can be seen in Christ's right hand, which was originally much larger. The reduced size necessitated some reworking of the gold leaf on the Virgin's collar.

Infrared reflectography, conducted in 1990, showed that while drawing the composition the artist widened the Virgin's neck. Her left hand shows evidence of having been executed using a pricked cartoon (fig. 54.2), which may have been the reverse of a cartoon used for the right hand. The infrared reflectography also revealed the existence of drawing for the drapery and architecture, and the use of a compass to lay out the semicircular lines in the niche.

A photograph from Berenson's 1913 catalogue suggests that the panel was much retouched when bought by Johnson. In August 1919 Hamilton Bell noted that the panel was in "fair condition for present." Carel de Wild later determined that it needed a cradle, but he said that the paint was in a fairly good state. A conservator named Weal did some retouching. In April 1921 another conservator named Kent cradled it. In 1947 David Rosen removed the cradle (see Introduction, fig. 21), after which the panel was impregnated with more than twenty pounds of wax and straightened with metal bars attached to the back. He also cleaned the painting, filled losses, retouched it, and revarnished it. His cleaning resulted in some damage in such

areas as the green lining of the Virgin's mantle and revealed general loss of surface. By 1956 there was an open split in the panel and extensive flaking to which Theodor Siegl responded by impregnating the entire surface with wax.

PROVENANCE
John G. Johnson owned the picture by 1901, when it was published by Mary Logan.

COMMENTS
An open curtain reveals the Virgin and Christ Child on a throne set in a shallow, semicircular niche.

Bernhard Berenson (1913) noted that the *Virgin and Child Enthroned* in Liverpool (fig. 54.3) was based on a reverse of the cartoon used for the Johnson panel. However, while the compositions are similar, the differences in size would have necessitated the making of separate cartoons. Furthermore, single-pricked cartoons of an entire composition or a figural group probably did not exist in this period. In fact, infrared reflectography shows that a pricked cartoon was used only in some sections of the Johnson painting.

The motif of the open curtain derives from Fra Angelico's (q.v.) Linaioli Tabernacle,[1] which he also used in a late *Virgin and Child*[2] of about 1450. The architecture of the latter is very similar to that in the Johnson picture,[3] and in both paintings the text in the Virgin's halo is inscribed in circles. The curtain

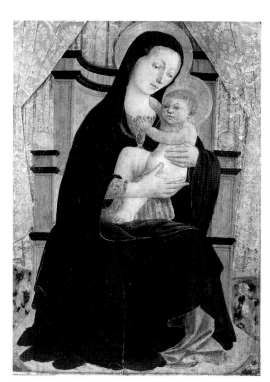

FIG. 54.3 Master of the Pomegranate. *Virgin and Child Enthroned,* 1450. Tempera and tooled gold on panel; 27½ × 18⅞″ (69.8 × 48 cm). Liverpool, The Board of Trustees of the National Museums & Galleries on Merseyside [Walker Art Gallery], inv. 2796

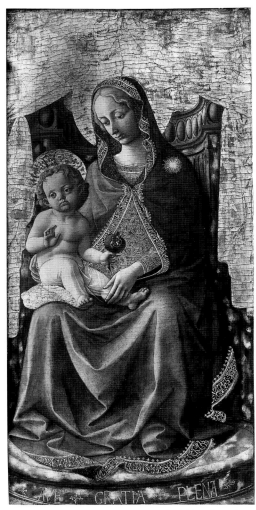

FIG. 54.4 Pesellino (q.v.). *Virgin and Child Enthroned,* c. 1445–50. Tempera and tooled gold on panel. Cetica (Florence), church of Sant'Angelo

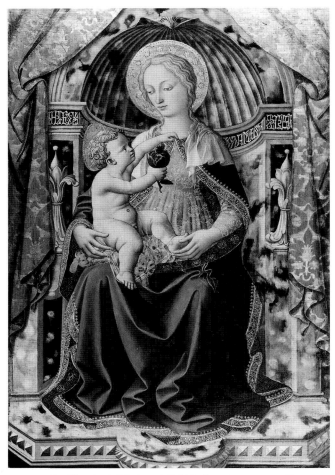

FIG. 54.5 Pesellino (q.v.). *Virgin and Child Enthroned,* c. 1440–45. Tempera and tooled gold on panel; 27⅛ × 18¾″ (69 × 47.5 cm). Dresden, Gemäldegalerie Alte Meister, cat. 7A

motif likewise became a favorite of Pesellino, who used it in the *Virgin and Child Enthroned* (fig. 54.4) of about 1445–50 in the church of Sant'Angelo at Cetica, a town in the mountains between Florence and Arezzo, as well as in the earlier small-scale *Virgin and Child* (fig. 54.5) of about 1440–45 in Dresden. It is the Dresden painting that provides the closest parallel for the composition of the Johnson Collection's panel, and, most particularly, for the position of the child's arms.

The Johnson painting is the largest picture in the Master of the Pomegranate's known oeuvre, but there is no evidence that it was the center of a larger complex.

1. 1432–33; Florence, Museo Nazionale di San Marco, Uffizi inv. 879; Spike 1997, color repros. pp. 114–15.
2. Turin, Galleria Sabauda; Pope-Hennessy 1974, fig. 105a.
3. A model for the architecture can also be found in Filippo Lippi's *Virgin and Child with Saints Francis, Damian, Cosmas, and Anthony of Padua,* now in the Uffizi (inv. 8354; Ruda 1993, color plate 93). It was commissioned by Cosimo de' Medici sometime before 1445 for the novitiate of Santa Croce in Florence.

Bibliography
Logan 1901, p. 338 ("compagno di Pesellino"); Berenson 1913, p. 23, repro. p. 249 ("compagno di Pesellino"); Hendy 1928, pp. 68, 74; Van Marle, vol. 10, 1928, p. 513; Berenson 1932, p. 443; Berenson 1932a, pp. 676–78, repro. p. 671; Berenson 1936, p. 381; Johnson 1941, p. 13 (old copy of Pesellino); Berenson 1963, p. 168; Liverpool 1963–66, vol. 1, p. 152; Sweeny 1966, p. 63, repro. p. 124 (old copy of Pesellino); Berenson 1969, p. 172, fig. 303; Fredericksen and Zeri 1972, p. 162 (follower of Pesellino); Philadelphia 1994, repro. p. 218

MASTER OF STAFFOLO
(*Costantino di Franceschino di Cicco di Nicoluccio?*)

FABRIANO, DOCUMENTED 1417–59

The "Master of Staffolo" is the name given to the painter of an altarpiece in the church of Sant'Egidio in the Marchigian town of Staffolo.[1] In 1948 Antonino Santangelo recognized that the same artist also painted a processional banner now in the Museo Nazionale di Palazzo Venezia in Rome.[2] Others later attributed many pictures to him, but the only work that can be dated with some certainty—the exterior mural of the church of the Madonna del Buon Gesù in Fabriano[3]—comes toward the end of his activity. The church's construction in 1456 provides a *terminus post quem* for the mural; however, the Master of Staffolo had begun his career in Fabriano about thirty years before. Like a number of local artists he prospered in the production of copies of two paintings that the region's most famous master, Gentile da Fabriano, had executed during a brief stay in his hometown in 1420: a processional standard showing the Coronation of the Virgin[4] and Saint Francis of Assisi Receiving the Stigmata,[5] and a lost painting known as the *Virgin of the Cradle*.

Considering the Master of Staffolo's prominence in the Marches in the second quarter of the fifteenth century, Andrea De Marchi (1992) proposed that the artist might be identified with the painter Costantino di Franceschino di Cicco di Nicoluccio,[6] who is best known for his involvement in Fabriano politics. He also served as a prior of the Guild of Merchants (Arte dei Mercanti), to which artists belonged, and on the board of the cathedral works and the hospital of Santa Maria del Buon Gesù. Documentation of his artistic activity is limited to a single record: in 1420 he was paid by the nearby commune of Arcevia for having painted the coat of arms of Pope Martin V Colonna.

1. Donnini 1971, fig. 2.
2. Rossi 1968, figs. 95–96.
3. Van Marle, vol. 8, 1927, fig. 186.
4. Los Angeles, J. Paul Getty Museum, no. 77.PB.92; De Marchi 1992, color plate 33.
5. Corte di Mamiano, Traversetolo (Parma), Fondazione Magnani; De Marchi 1992, color plate 32.
6. Fabia Marcelli (1998, pp. 151, 159 n. 11) showed that this painter was not the son of the painter Francescuccio Ghissi, as had been previously thought, but of another painter from Fabriano with a very similar name: Franceschino di Cicco (or Francesco) di Nicoluccio.

Select Bibliography

Anselmi 1906a; Sassi 1924, pp. 46–47; Santangelo 1948, p. 32; Zeri 1948, pp. 166–67 n. 2; Rossi 1968, p. 203; Donnini 1971; Zampetti 1971, pp. 24–26; Vitalini Sacconi 1972; Donnini 1974; Donnini 1976; Russell 1983; Chiara Francesca Coviello in *Pittura* 1987, p. 696; Donnini 1990; De Marchi 1992, pp. 112–13, 127, 129 n. 5, 130 n. 9, 134 n. 79; Stefano Felicetti in Marcelli 1998, pp. 218–23; Fabio Marcelli in Marcelli 1998, pp. 152–55, 159–60 nn. 19–23, 26–28; Cleri and Donnini 2002

PLATE 55 (JC CAT. 121)

Base of a processional standard: *Saint Francis of Assisi Receiving the Stigmata*

c. 1420

Tempera on panel with vertical grain; $6\frac{7}{8} \times 12\frac{1}{4} \times \frac{3}{8}''$ ($17.5 \times 31.2 \times 1$ cm), painted surface $5\frac{3}{4} \times 11\frac{3}{8}''$ (14.5×28.9 cm)

John G. Johnson Collection, cat. 121

INSCRIBED ON THE REVERSE: *121/ IN. 747* (in pencil); *121* (in yellow crayon); *CITY OF PHILADELPHIA/ JOHNSON COLLECTION* (stamped in black ink)

PUNCH MARKS: See Appendix II

TECHNICAL NOTES

The panel has been thinned, mounted onto another panel, and cradled. Originally the painting had another configuration, as can be seen in the infrared reflectogram (see fig. 55.3) and the X-radiograph (fig. 55.1). At some point the engaged frame was removed and two triangles of wood were added to the bottom corners to make the panel rectangular. The whole structure was then given a fictive white frame, and the bottom corners were painted to extend the landscape. An area in the bottom center ($\frac{7}{8} \times 1''$ [2.2×2.7 cm]) that was also filled and painted over is probably where a carrying pole had been attached when the original panel was part of a processional standard.

When the panel was reconfigured, the two side edges of the painted surface, which originally extended to the end of the present panel, were scraped back; the irregular edges of the areas that were scraped are particularly evident on the left, along the bell tower. On the corresponding right edge a bit of the original blue has survived. Interestingly, in this section both the underlying layer of *grosso* (coarse) gesso and the upper layer of *sottile* (refined) gesso, used in the panel's preparation, are clearly visible. The top edge, where the applied frame molding was formerly attached, has been completely filled.

Behind the figure of Saint Francis there is a slightly raised and warmer-toned area of paint that covers a patch of gold leaf (approximately $2 \times 2''$ [5×5 cm]) originally laid but not used for the halo. Although difficult to see in the illustration (fig. 55.1), the X-radiograph does show the incisions outlining the figures, architecture, and hills as well as a winged crucifix, which the artist did not paint within the incised area but slightly to the left of it. However, this area was damaged early in the painting's history, and the crucifix was replaced with a simpler seraph using the same head of Christ.

Although the varnish is grimy, the paint surface

is not in poor condition, and only areas of the sky have been significantly painted over.

A prominent crack, probably caused by the cradle, runs through the center of the panel; in August 1919 Hamilton Bell noted that this and other smaller cracks were reopening. The next year, on March 13, he and Carel de Wild inspected the panel and noted old retouches, and de Wild repaired flaking around the crack. In May 1955 Theodor Siegl applied a tissue facing to secure loose paint. In 1996 this facing was removed, when some cleaning tests in conjunction with its examination were done for this catalogue.

PROVENANCE
John G. Johnson purchased this panel from Dowdeswell and Dowdeswells in London in 1910 for 50 pounds sterling. The bill of September 1 reads: "Saint Francis receiving the Stigmata. A small picture ascribed to Pietro Lorenzetti. (Mr. Berenson thinks it was painted in the Marches)."

COMMENTS
The scene takes place in the rugged landscape of Mount La Verna, where on the night of September 14, 1224, Saint Francis of Assisi is said to have received the stigmata, or the impressions of Christ's crucifixion wounds. Here Francis kneels in an orant position as the stigmata are transmitted to him by golden rays issuing from a seraph in the sky. Unaware of the miracle, Francis's companion, Friar Leo, reads a book.

Bernhard Berenson (1913) recognized the relationship between this panel and Gentile da Fabriano's *Saint Francis of Assisi Receiving the Stigmata,* then in the Fornari Collection in Fabriano,[1] which was one side of a processional standard painted in the spring of 1420 for the Franciscan church of Fabriano. The other side, showing the Coronation of the Virgin, is in the J. Paul Getty Museum in Los Angeles.[2] Whereas Berenson thought that the Johnson Collection's painting predated Gentile's picture, Andrea De Marchi (1992) noted that the reverse was true. The fame that Gentile's standard enjoyed was such that several other artists painted derivations of it,[3] some of which date several decades later. The Master of Staffolo made at least three copies or versions of the scene of Saint Francis: the Johnson picture, a painting in a private Florentine collection (fig. 55.2), and one that is the base of a processional standard in Assisi.[4] The main part of the Assisi standard contains Saint Bernardino of Siena's emblem of the Name of Christ, which means that the work can be dated after 1425 on the basis of Bernardino's sermons in the town on September 9 of that year.[5] The Johnson panel, which originally was also the base of a standard, probably dates around the same time.

1. Corte di Mamiano, Traversetolo (Parma), Fondazione Magnani; De Marchi 1992, color plate 32.
2. No. 77.PB.92; De Marchi 1992, color plate 33.
3. The copies of *Saint Francis of Assisi Receiving the Stigmata* are listed by De Marchi (1992, p. 129 n. 5).
4. Assisi 1980, plate 39.
5. Pietro Scarpellini in Assisi 1980, pp. 51–55, plate XLVI, fig. 39.

Bibliography
Berenson 1913, p. 70, repro. p. 308 (school of Fabriano, precursor of Gentile); Van Marle, vol. 5, 1925, p. 198 n. 1; Johnson 1941, p. 6 (School of Fabriano, c. 1400); Sweeny 1966, p. 28 (School of Fabriano, c. 1400); Fredericksen and Zeri 1972, p. 243 (Umbria, fifteenth century); De Marchi 1992, p. 129 n. 5; Philadelphia 1994, repro. p. 218 (Master of Staffolo [Costantino di Francescuccio di Cecco Ghissi?]); Cleri and Donnini 2002, p. 72

FIG. 55.2 Master of Staffolo (Costantino di Franceschino di Cicco di Nicoluccio?). *Saint Francis of Assisi Receiving the Stigmata,* c. 1425–30. Tempera and tooled gold on panel; 6⅞ × 12⅜″ (17.5 × 31.5 cm). Florence, private collection

PLATE 55

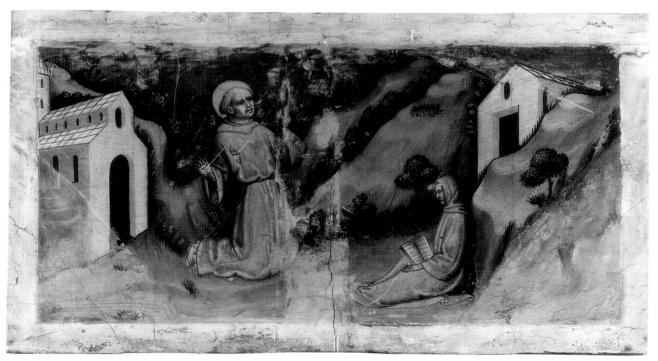

FIG. 55.3 Infrared reflectogram of plate 55, showing the additions to the lower left and right corners of the panel

Master of the Terni Dormition

The Master of the Terni Dormition is the name given by Federico Zeri (1963) to an anonymous painter who dominated artistic life in Spoleto and the surrounding communities from about 1380 to 1412. Zeri proposed that the artist had assisted Ugolino di Prete Ilario on the choir cycle of the cathedral in Orvieto.[1] After that decoration was finished about 1380, Ugolino's assistants migrated elsewhere: for example, Piero di Puccio (documented 1360–94) turned up in Pisa, Cola Petruccioli (first documented 1372; died 1401) in Perugia, and the Master of the Terni Dormition near Spoleto. One of the third artist's first works there gave him his name: the mural of the Dormition of the Virgin in San Pietro in Terni.[2]

Three other works can be dated. Only fragments remain of a mural showing the Coronation of the Virgin[3] in the church of Santa Maria in Vallo di Nera, near Spoleto, which was being decorated around 1383. A detached wall painting depicting the Virgin and Child with angels and Eve, in San Gregorio Maggiore in Spoleto,[4] bears a fragmentary date that can be read as 1388. A mural of the Virgin and two saints, above the portal of the ex-convent of San Niccolò in Spoleto, is inscribed 1412.[5]

The artist's influence was immense in the Spoleto area. Groups of paintings that Filippo Todini (in *Pittura* 1986 and Todini 1989) attributed to artists that he named the Master of the Terni Triptych and the Master of Pietrarossa are so close to the style of the Master of the Terni Dormition that the distinction of hands seems almost meaningless.[6] All of these artists must have worked in close collaboration. This would have followed the practice of Ugolino di Prete Ilario, who availed himself of numerous collaborators. Indeed, at this time team effort was necessary for the decoration of many Umbrian churches, which were characteristically spacious, with vast amounts of wall to paint, such as the above-mentioned Santa Maria in Vallo di Nera. In addition, Andrea De Marchi (1992, p. 133 n. 60) has suggested that a mural cycle of Arthurian legends in the Rocca of Spoleto was also produced by the master's workshop.

Much of the Master of the Terni Dormition's success can be attributed to the newly constituted Papal States, which had been established by the Spanish cardinal Egidio Albornoz in the mid-fourteenth century. Although in continual rebellion against the papal yoke, Spoleto was the center of the new state. From there the Master of the Terni Dormition was well positioned to become the leading figure of a homogeneous artistic culture that extended from Viterbo to Perugia.

Following Zeri's suggestion, Maria Rotunno (in Boskovits 1985) proposed that the Master of the Terni Dormition was either Cola di Pietro da Camerino (documented 1383–1401) or Francesco di Antonio da Orvieto (active c. 1370–93).[7] Both had been assistants to Ugolino di Prete Ilario in Orvieto. They later worked in Santa Maria in Vallo di Nera, jointly signing some murals there in 1383.[8] While the hands are difficult to separate, in 1393 Francesco di Antonio signed a polyptych, now in Moscow,[9] that would not seem to be by the artist of any of the Master of the Terni Dormition's assigned works. Todini (1991) alternatively suggested that he might be the Spoletan painter Domenico da Miranda, who is recorded as working for Pope Urban V de Grimoard in Rome in 1369. He was paid in 1395 for the illumination of an antiphonary for the cathedral of Spoleto and in 1404 for other work in the same city. While these dates fit well with the Master of the Terni Dormition's chronology, no work of art by Domenico da Miranda has been identified to confirm the supposition.

1. See also Todini 1989, color plates XX–XXIII, figs. 435–40.
2. Zeri 1992, figs. 53–54.
3. Todini 1989, figs. 517–18.
4. Zeri 1992, fig. 52.
5. Todini 1989, figs. 532–33. Bruno Toscano (in Pazzelli and Sensi 1984, p. 327) does not think it is by the same hand as the Johnson panel.
6. On these two artists, see Todini 1989, pp. 166, 205.
7. The suggestion was also taken up by Corrado Fratini (in Albornoz 1990).
8. Todini 1989, figs. 504, 506.
9. State Pushkin Museum of Fine Arts, no. 2500; Markova 1992, color repros. pp. 67–71. Here Francesco d'Antonio signs as being "from Ancona" (*de Ancona*). Todini (1989, p. 70) claims that the center panel of this triptych was also signed by Francescuccio Ghissi in 1350. While the center panel does contain two dates, 1350 and 1393, the reason for this is unclear. Stylistically, the second date is preferable. On this problem, see Lasareff 1971.

Select Bibliography
Zeri 1963, pp. 29–36 (Zeri 1992, pp. 43–48); Rossi 1977, pp. 58–59, esp. n. 19; Scarpellini 1976, p. 24; Corrado Fratini in Pazzelli and Sensi 1984, p. 343; Bruno Toscano in Pazzelli and Sensi 1984, pp. 326–28; Marina Rotunno in Boskovits 1985, p. 112; Corrado Fratini in *Pittura* 1986, pp. 606–7; Filippo Todini in *Pittura* 1986, p. 412; Todini 1989, pp. 130–31; Corrado Fratini in Albornoz 1990, esp. pp. 127, 132–33; Todini 1991, pp. 52, 55 n. 6; De Marchi 1992, p. 133 n. 60; Maria Rita Silvestrelli in Barroero et al. 1994, pp. 29–31, 46

PLATE 56 (JC CAT. 123)
Center panel of an altarpiece:
Coronation of the Virgin

c. 1415

Tempera and tooled gold on panel with vertical grain;
23 × 20 × 1″ (58.5 × 50.8 × 2.4 cm), painted surface 23 × 19½″
(58.5 × 49.4 cm)

John G. Johnson Collection, cat. 123

INSCRIBED ON THE REVERSE: *123/ IN 689* (in pencil);
CITY OF PHILADELPHIA/ JOHNSON COLLECTION (stamped
twice in black); *123* (in orange pencil); remnants of a torn
label, illegible

PUNCH MARKS: See Appendix II

TECHNICAL NOTES
The panel consists of a wide center plank with two
other strips that are 1⅛″ (3 cm) wide on the left and
1″ (2.5 cm) wide on the right. One of the holes for
the dowel that spanned the joint between the strips
and the central plank is visible in the upper left edge,
where the wood has been cut away. The panel has
been cut at the top and the original applied moldings
removed, an operation that truncated the three
angels playing musical instruments and other parts
of the composition. It is not clear when this occurred,
but afterward the back was painted with a geometric
pattern. The sides and the bottom were also cut.
However, because the bottom has some indication
of a barbe, not much composition was lost. Square
nail holes are visible in the bottom edge.

An old photograph (fig. 56.1) shows the state of
the panel before it was treated by David Rosen in
1941. He removed the upper corners, which had
been earlier restored to look like variegated marble,
with a circular saw, but left no notes as to why he
decided to do so. Two strips of gilt wood (each ¼″
[0.7 cm] wide) have been attached to the sides.

Rosen also cleaned the picture, badly abrading
the surface in the process. The grained gold of the
Virgin's undergarment was almost totally taken
off, so that the gesso is now visible; only a bit of its
original red glazing can be observed under the
microscope. Almost all the dark shadows of the
Virgin's white mantle have disappeared. Most of
the mordant gilding and of the mordant itself,
which was brown, was removed. The pattern on
the gilt decoration that can now be discerned is
mostly the original paint, which the mordant had
protected. All the ultramarine that lined the Virgin's
robe was removed, and her red shoe is badly
abraded. The feathery white highlights of Christ's
blue robe are also gone. Because the subtle tonal
changes in the brocade cloth of honor that gave the
form to the throne were compromised in the
cleaning, the background now has a flat appearance.
Yet although this modeling is now gone, the picture
represents a superb example of sgraffito. The glazed
colors were subtly modeled before the patterns were

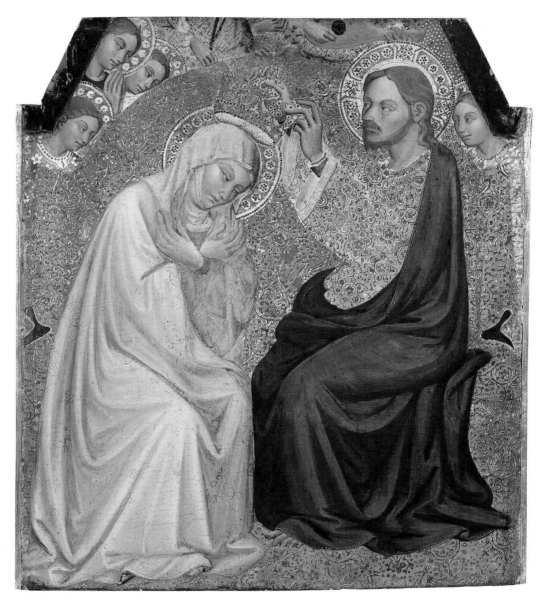

PLATE 56

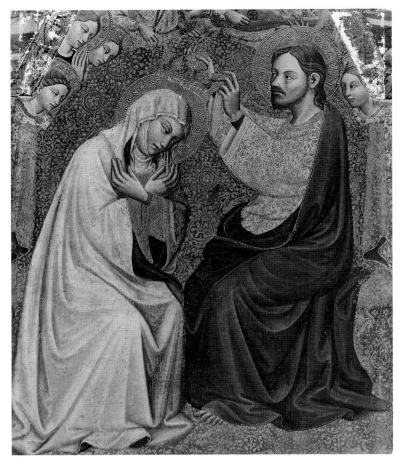

FIG. 56.1 Photograph of plate 56 as it appeared in 1913

scraped away to reveal the gold underneath, and a granular punching was used to enrich the design. While the riot of decoration makes it difficult at first to discern individual motifs, they were very carefully conceived. The cloth of honor, for example, is decorated with birds interspersed with stylized pomegranates.

In August 1919 Hamilton Bell described the panel as "safe for present." It was inspected by Carel de Wild on April 23 of the next year, when he noted that the paint was in good condition except for local retouches, and that the panel needed cradling. The cradling, however, was never done. In 1961 Theodor Siegl toned in two paint losses in Christ's blue mantle.

PROVENANCE
There is no record of the painting's provenance or of Johnson's purchase of it. It may have been made for San Bartolomeo a Marano, outside Foligno. See Comments.

COMMENTS
Seated on a bench throne covered by a cloth of honor, Christ crowns the Virgin while angels look on. The panel would originally have had a gabled top and presumably more angels. The figures of

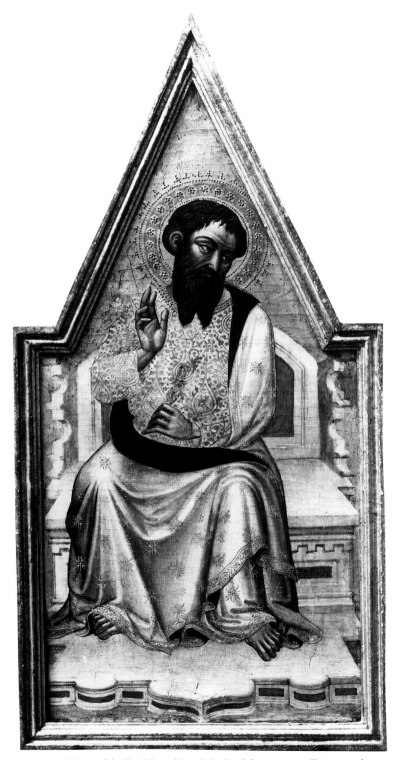

FIG. 56.2 Master of the Terni Dormition. *Saint Bartholomew*, c. 1415. Tempera and tooled gold on panel; 26⅜ × 12⅝″ (67 × 32 cm). Rome, Pinacoteca Capitolina, no. 353. See Companion Panel A

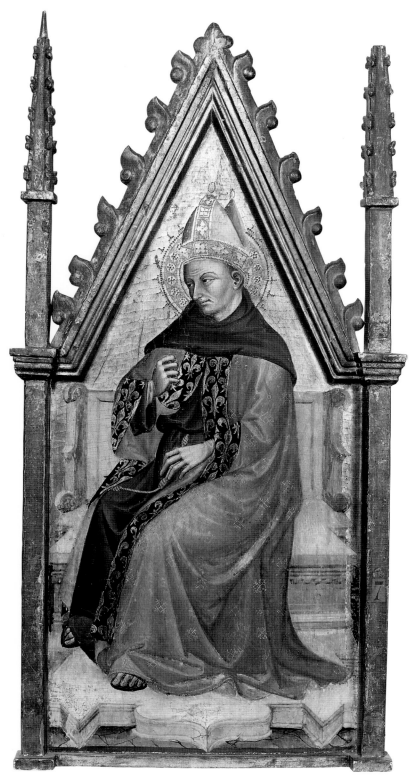

FIG. 56.3 Master of the Terni Dormition. *Saint Louis of Toulouse*, c. 1415. Tempera and tooled gold on panel; with frame 31½ × 15¾″ (80 × 40 cm). Private collection. See Companion Panel B

three angels playing musical instruments have been partially cut off.

Federico Zeri (1963) recognized that the picture was the center section of a triptych (fig. 56.4) whose side panels showed the full-length enthroned figures of *Saint Bartholomew* (fig. 56.2) and *Saint Louis of Toulouse* (fig. 56.3). He made the triptych an important component of his analysis of the Master of the Terni Dormition. But his attribution has not been universally accepted: Francesco Rossi (1977), Bruno Toscano (in Pazzelli and Sensi 1984), and Corrado Fratini (in *Pittura* 1986) did not include it in the master's oeuvre. Their arguments are, however, unconvincing.

The prototype for the *Coronation of the Virgin* was Ugolino di Prete Ilario's mural in the tribune of the cathedral of Orvieto.[1] This dependency seems to confirm Zeri's initial theory that the Master of the Terni Dormition assisted Ugolino di Prete Ilario there.

There is no evidence about the triptych's early provenance. The presence of Saint Louis of Toulouse in the painting suggests that it may have come from a Franciscan church. Toscano (in Pazzelli and Sensi 1984, p. 328) noted that the inclusion of the apostle Bartholomew might identify its original location as the Franciscan Observant church of San Bartolomeo a Marano, outside Foligno. In 1390 Marano, a fortress belonging to the ruling family of Foligno, was given by Ugolino II Trinci to his cousin Paolo Trinci, known as Paoluccio, to make into a Franciscan Observant convent.[2]

Paoluccio had long been a leader in a Franciscan reform movement dedicated to following Saint Francis's rule to live "simply and without gloss." Whether strict adherence to this principle was possible was then a topic of much debate, as the rule imposed absolute poverty, a prospect that the official church found threatening and sometimes heretical. However, Paoluccio's wish to become an Observant Franciscan was granted at a chapter of the Franciscans held in Foligno in 1368, when the general of the order, Tommaso da Frignano, saw fit to concede him the Franciscan convent of San Bartolomeo a Brogliano at the Castello di Colfiorito.[3] And Paoluccio did not stop there: by 1370 he had eleven Observant convents in Umbria and the Marches, and by 1390 they numbered twenty-three.

The Marano convent was rebuilt by Giovanni da Stroncone after Paoluccio's death in 1391 and dedicated in 1415. Such a date would fit stylistically with the Johnson painting, which also has parallels with the Master of the Terni Dormition's dated mural of 1412 in the ex-convent of San Niccolò in Spoleto.[4] That the convent at Marano was richly decorated seems to be confirmed by a comment made in 1467 by the Blessed Giovanni Bonvisi da Lucca, who called it the most beautiful and richest of the province.[5]

The presence of Saint Louis of Toulouse in the triptych specifically supports its Franciscan Observant and Trinci connections.[6] In 1340 Saint Louis's

56.2

56.1

56.3

FIG. 56.4 Configuration of the known extant panels of the Master of the Terni Dormition's Coronation of the Virgin altarpiece, c. 1415. Left to right: FIG. 56.2, FIG. 56.1, FIG. 56.3. The panels are aligned at the springing of the arches. The side panels are cropped at the bottom and are in non-original frames.

brother, Robert of Anjou, king of Naples, appointed Bishop Paolo Trinci, an uncle of Paoluccio, to be his ambassador to Pope Benedict XII Fournier. His assignment was to persuade the pope to grant Robert's brother-in-law Fra Felipe of Majorca the right to live according to the primitive Franciscan rule.[7] The mission, which failed, was a delicate one, as the papacy had sought to suppress Franciscans who wished to adhere strictly to Francis's own ideal of poverty. Later the Trinci themselves became supporters of the church-approved Observant movement.

1. Florence, Kunsthistorisches Institut, Fototeca, no. 452283 (pre-restoration).
2. On this convent, see Iacobilli 1647–61, vol. 1, 1647, pp. 474, 541; Bragazzi 1858, p. 89; Faloci Pulignani 1909, p. 99; Faloci Pulignani 1920, p. 78; and Messini n.d., p. 79.
3. On Paoluccio, see Mario Sensi in *Bibliotheca sanctorum,* vol. 12, 1969, cols. 660–63 (with bibliography);

and in particular, Faloci Pulignani 1920; and Iacobilli 1627. On Brogliano, see Cavanna 1910, pp. 352–55. The convent was largely destroyed in 1707.
4. Todini 1989, figs. 532–533.
5. Iacobilli 1647–61, vol. 1, 1647, p. 474.
6. The presence of Saint Louis of Toulouse in the lateral wing of another lost altarpiece by the Master of the Terni Dormition suggests that it was also for a convent of Paolo Trinci (Todini 1989, figs. 519–20). The center is lost or unidentified.
7. Faloci Pulignani 1920, p. 67.

Bibliography
Berenson 1913, p. 71, repro. p. 310 (Ottaviano Nelli); Comstock 1927, p. 30; Van Marle, vol. 8, 1927, p. 345 and n. 1; Berenson 1932, p. 385; Johnson 1941, p. 11 (Ottaviano Nelli); Zeri 1963, pp. 33–34, fig. 1b (Zeri 1992, pp. 46–47, fig. 43); Sweeny 1966, p. 52, repro. p. 99; Berenson 1968, p. 290; Fredericksen and Zeri 1972, p. 137; Scarpellini 1976, p. 24, fig. 7; Rossi 1977, pp. 58–59, esp. n. 19; Corrado Fratini in *Pittura* 1986, pp. 606–7; Todini 1989, vol. 1, p. 130; vol. 2, fig. 527; Philadelphia 1994, repro. p. 218; Frinta 1998, p. 115

COMPANION PANELS for PLATE 56

A. Lateral panel of an altarpiece: *Saint Bartholomew.* See fig. 56.2

c. 1415

Tempera and tooled gold on panel; 26⅜ × 12⅝″ (67 × 32 cm). Rome, Pinacoteca Capitolina, no. 353

PROVENANCE: Rome, Giulio Sterbini; given to the Pinacoteca Capitolina, 1936

SELECT BIBLIOGRAPHY: Zeri 1963, pp. 33–34 (Zeri 1992, p. 46); Rossi 1977, pp. 58–59; Bruno 1978, p. 3; Todini 1989, p. 130

B. Lateral panel of an altarpiece: *Saint Louis of Toulouse.* See fig. 56.3

c. 1415

Tempera and tooled gold on panel; with frame 31½ × 15¾″ (80 × 40 cm). Private collection

PROVENANCE: Paris, Goldschmidt

SELECT BIBLIOGRAPHY: Zeri 1963, pp. 33–34 (Zeri 1992, p. 46); Rossi 1977, pp. 58–59; Todini 1989, p. 130

NERI DI BICCI

FLORENCE, 1419–JANUARY 4, 1493,
(MODERN STYLE) FLORENCE

The son of the painter Bicci di Lorenzo (q.v.) and the grandson of Lorenzo di Bicci, Neri di Bicci worked first as his father's assistant and then took over the family business at his death in 1452. The following years, from 1453 to 1475, are well documented in the artist's own hand in his *Ricordanze* (Santi ed. 1976), which, by detailing most of his commissions and financial transactions, offers not only a record of Neri's career but also an invaluable account of Florentine workshop practice.

Neri's first important commissions were for the Spini chapel in Santa Trinita in Florence, where in 1452–53 he executed the murals and three years later the altarpiece of the Assumption of the Virgin.[1] The murals are entirely based on his father's workshop formulas, whereas the ambitious altarpiece, in which the twelve apostles are imaginatively grouped around the empty tomb, indicates that in a short time Neri had managed to update the traditions of the family's workshop by absorbing the latest developments in Florentine painting. Throughout his career Neri borrowed ideas from the principal painters of the city, first Fra Angelico (q.v.), Filippo Lippi, and Benozzo Gozzoli (q.v.), and later Antonio del Pollaiolo and Andrea Verrocchio. Because of this tendency Neri's work can be said to reflect Florentine painting styles spanning the second half of the fifteenth century,

even if he and his clients, some of the most important names in the city, were attracted to the most imitable ornamental elements such as classicizing architectural detailing and drapery. However, Neri di Bicci was by no means merely responding to the artistic style set by others. He collaborated with such prominent artists as the architect Giuliano da Maiano, who designed and executed frames for Neri's altarpieces. He also trained artists like Cosimo Rosselli, Bernardo di Stefano Rosselli, and Francesco Botticini, and he was frequently called in by patrons and artists alike to give judgments on the workmanship of some of the most important art executed in Florence during these years.

1. For the murals and altarpiece, see Marchini and Micheletti 1987, figs. 120–21; for the altarpiece, see also Laskin and Pantazzi 1987, fig. 9.

Select Bibliography
Neri 1453–75, Santi ed. 1976; Baldinucci 1681–1728, Ranalli ed., vol. 1, 1845, esp. pp. 430–38; Carlo Milanesi, Gaetano Milanesi, Carlo Pini, and Vincenzo Marchese in Vasari 1568, Le Monnier ed., vol. 2, 1846, pp. 226–62; Gaetano Milanesi in Vasari 1568, Milanesi ed., vol. 2, 1876, pp. 69–90; Georg Gronau in Thieme-Becker, vol. 3, 1909, p. 606; Colnaghi 1928, p. 43; Van Marle, vol. 10, 1928, pp. 523–46; Berenson 1932, pp. 385–89; Berenson 1963, pp. 152–58; B. Santi 1973, pp. 169–88; Cecilia Frosinini in *Pittura* 1987, pp. 715–16; Barr 1989; Thomas 1993; Thomas 1993a; Thomas 1995

PLATE 57 (PMA 1899-1108)

Altarpiece: *Virgin and Child Enthroned with Two Angels and Saints Ansanus(?), John the Baptist, Nicholas of Bari, Sebastian, Catherine of Alexandria, and Bartholomew*

1457(?)

Tempera, silver, and tooled gold on panel with vertical grain; $65 \times 64\frac{3}{8} \times$ approximately $\frac{3}{4}''$ ($165 \times 163.5 \times$ approximately 1.9 cm), painted surface $63\frac{1}{4} \times 63''$ (160.8×160.1 cm)
Philadelphia Museum of Art. The Bloomfield Moore Collection. 1899-1108

INSCRIBED ON THE HEART ANSANUS HOLDS: *IHS* (symbol for the name of Jesus); ON THE BAPTIST'S SCROLL: *ECCE AGN[US DEI]* (John 1:29: "Behold the Lamb of God"); ON THE BASE OF THE THRONE: *REGINA C[A]E LI L[A]ETTARE ALLELUIA QUIA [QUEM] ME[RUISTI]. P[ORTARE]* (from an antiphon sung in honor of the Virgin: "O Queen of Heaven, rejoice. Alleluia, for you were worthy of bearing him who"); ON THE REVERSE: *'99-1108* (in red)

TECHNICAL NOTES
The panel consists of five planks, which have been thinned and cradled. The joins to either side of the central plank have opened and been repaired. The painting has a gesso barbe and a margin of bare wood, about $\frac{3}{4}''$ (2 cm) wide, on all four sides, which indicates there was once an applied molding.

The paint and gold are very soiled. Paint has also lifted and flaked in a number of areas, mostly along the cracks and in the blue of the Virgin's mantle, which is later overpaint that covers the entire garment except for the borders, which are decorated with mordant gilding. Some brillant azurite can be seen where the overpaint blue has flaked away, and cross sections have confirmed that the mantle was originally painted in azurite with gray underpainting. Paint has also flaked where it overlaps the gold background. Some of these areas were retouched by Pasquale Farina, who cleaned and cradled the panel in 1919. His retouching is prominent in the curly hair of all the male saints except for Nicholas of Bari, who wears a miter, and the lips of the Christ Child, where the panel join that runs through them was repaired. The pattern of the mordant gilt decoration throughout is still discernible, even though much of the gold has flaked away. Silver was applied in leaf on Bartholomew's knife, but this is now mostly abraded. The silver that was adhered with mordant to the tip of Sebastian's arrow has also worn off. The once-green glaze that covered the serpentine-inlaid

(text continues on page 321)

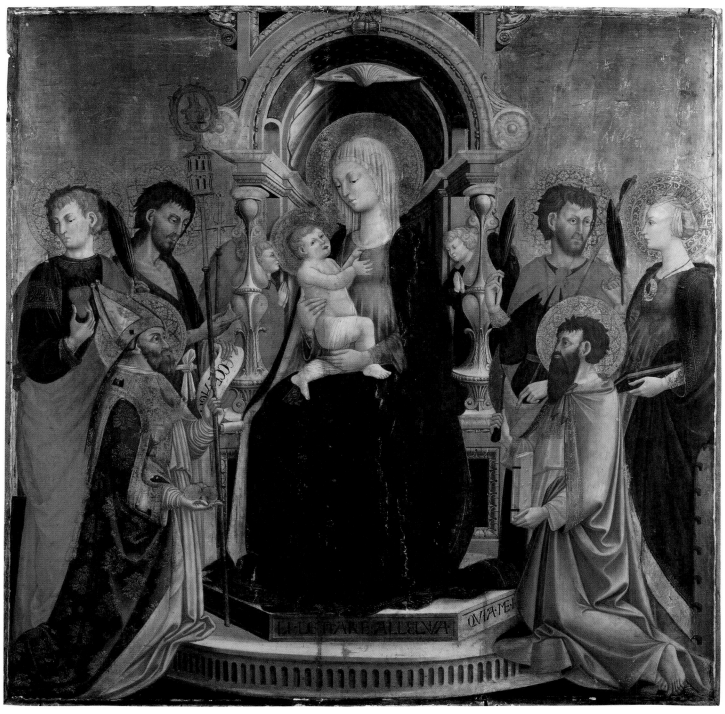

PLATE 57

panels of the throne and the costume of the angel on the right has turned a dark brown with age.

Despite the isolated flaking and retouching, the panel is in a fair state of preservation. The number of delicate details that survive in the figures serve as good examples of Neri di Bicci's technical proficiency and meticulousness. The stars in the vault of the throne, for instance, are completely gilt in the light areas and only partially gilt in the dark areas. The gilt pole of Nicholas's crozier and the Baptist's cross are carefully hatched with black paint where the gilding is mordant and overlaps the painted surface, giving them greater form. Where these instruments overlap the gold background, they are for the most part defined by granulation on the lighted side.

The halos are made up of a combination of punched and incised patterns. The lower gilt border of Catherine's cape is decorated with pseudo-Kufic letters.

Much of the underdrawing is visible to the naked eye, particularly in Bartolomew's yellow robe.

In 1996 and 1997 Nica Gutman consolidated old flaking on the panel and sampled areas of the blue mantle for analysis.

PROVENANCE

It is here proposed that the altarpiece was made for the church of Santa Maria alla Canonica in Putignano, near Greve in the Chianti, where it was replaced by another painting in 1763. Its subsequent history is not known. An annotation to a list of paintings given or bequeathed to the Museum by Mrs. Bloomfield Moore records that this work came from the Talleyrand Collection, which may refer to the statesman Charles Maurice de Talleyrand (1754–1838). In Moore's collection it was attributed to Benozzo Gozzoli (q.v.). Moore bought most of her paintings in Europe, and this one seems to have been purchased sometime after 1882. It was bequeathed to the Museum in 1899.

COMMENTS

The Virgin and Child sit on an elaborate throne with Renaissance architectural motifs as two angels worship them. They are surrounded by six saints, who can be identified by their attributes. Kneeling at the left is the bishop saint Nicholas of Bari, holding a pastoral staff and three golden balls, symbol of the dowry he secretly gave three indigent girls. Behind him is a young man, holding a martyr's palm and a heart, who is most likely Saint Ansanus, a fourth-century martyr who was beheaded near Siena. His cult enjoyed a wide popularity in all of Tuscany. Saint John the Baptist, in a hair shirt, points to Christ with one hand and grasps a scroll and cross in the other. Kneeling at the right is the bearded apostle Bartholomew, holding a book and the knife by which he was martyred. Behind him is Saint Sebastian, carrying a martyr's palm and an arrow. Saint Catherine of Alexandria's attributes are a crown, a book, a spiked wheel, and a martyr's palm.

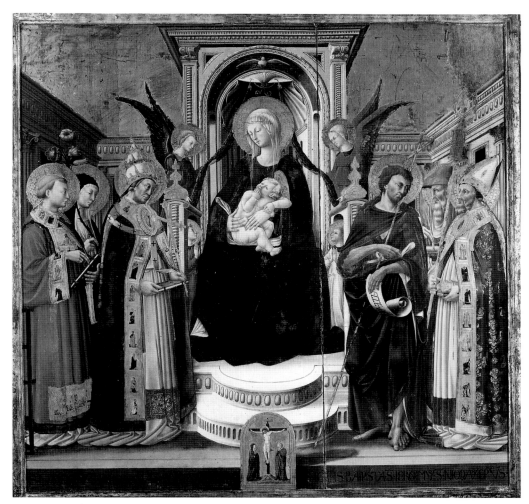

FIG. 57.1 Neri di Bicci. Altarpiece: *Virgin and Child with Two Angels and Saints Lawrence, Felicita (or Clare of Assisi), Sixtus, John the Baptist, Jerome, and Nicholas of Bari*, 1457. Tempera and tooled gold on panel; 92½ × 92½″ (235 × 235 cm). Viterbo, church of San Sisto

Except for a listing under Neri di Bicci's name in Burton Fredericksen and Federico Zeri's 1972 census of Italian paintings in North American public collections, this picture has never been studied. Stylistically it belongs to the 1450s, for the Virgin can be compared with the figure in the *Annunciation* that Neri painted for Caterina di Cristoforo Bagnesi and her husband, Ormanozo di Guido Dati, in September 1455.[1] The figures and the Renaissance motifs of the throne are also close to those in Neri's now-lost *Virgin and Child with Saints Margaret, Francis, James Major, and Bernardino*, commissioned by Bernardo di Lupo Squarcialupi in July 1454,[2] and his *Virgin and Child with Two Angels and Saints Lawrence, Felicita (or Clare of Assisi), Sixtus, John the Baptist, Jerome, and Nicholas of Bari* (fig. 57.1), commissioned by the Florentine prelate Giovanni Spinelli (or Spinellini) in 1457 for a "Messer Pietro," for the church of San Sisto in Viterbo.[3]

Saint Nicholas's pastoral staffs in the altarpieces in Viterbo and in Philadelphia are likewise the same. In addition, Anabel Thomas (correspondence dated London, October 9, 1995) has noted stylistic links between the Museum's painting and Neri di Bicci's Canneto altarpiece,[4] dated 1452; the altarpiece in the parish church of Miransù,[5] seemingly begun in 1457 and finished in 1459; and the *Virgin of Mercy* commissioned in 1457 for the church of Santa Maria delle Grazie in Arezzo.[6]

An altarpiece ordered from Neri di Bicci on Holy Saturday, April 16, 1457, as he described in his *Ricordanze* (1453–75, Santi ed. 1976, p. 74, no. 146), may be the work in question:

I record how on the said day I agreed to see for Messer Pagholo di . . . , prior of Putignano in Valdigreve, to the carpentry, painting, and furnishing, at my own expense, of an altarpiece 4

braccia [86⅝″ (220 cm)] wide and 4⅔ *braccia* [101″ (257 cm)] high, in the antique format, square, with a predella at the bottom, columns on the sides with molding, and above the molding a tympanum and scroll without a frieze and architrave. All the parts on the front, that is, the outer molding, should be worked in fine gold, the molding should be German blue azurite and decorated with stars; ultramarine should be used for Our Lady, whereas German blue for everything else. All should be well done and decorated at my expense, as stated above, and it needs to be finished for next June 1457. For the said altarpiece, that is, the carpentry, gold, azure, and workmanship, I shall have 34 florins or more, which will be decided by the abbot of San Pancrazio. If that sum is not enough, it will be 38 florins. And this was accorded with Lorenzo di Fulino di Cianpolo da Panzano, at the behest of the said Messer Pagholo and at his order. Furthermore, the said Lorenzo promised that the said Messer Pagholo will be aware of everything in a private communication, written down by the hand of the said Lorenzo, and countersigned by my own hand. In this panel I have to paint Our Lady with the Christ Child at her neck and three saints at each side, and in the predella three stories, of which I have a note in the hand of the said Lorenzo. They have to make the payment to me in the said manner, that is, for all of April, 14 florins, and after the panel is furnished, half of the rest, and the rest on the first day of November 1457, and in such a manner as had been said and agreed upon on the said day. On July 12, 1457, the said painting must be consigned to the said prior and the accounting worked out with him and Lorenzo da Panzano. We find that I had had up until this said day in a combination of money and grain in all 112 lire, 9 soldi, and 6 denari. To Account Book D at p. 25.[7]

On the same day Neri di Bicci (1453–75, Santi ed. 1976, p. 75, no. 147) ordered the panel and the frame for the altarpiece from Giuliano da Maiano; the frame was based on Neri's design. On July 12, 1457, the completed painting was handed over to Messer Pagholo of Santa Maria in Putignano in the Valdigrieve (Neri di Bicci 1453–75, Santi ed. 1976, p. 78, no. 154). On August 13 Neri di Bicci delivered to Putignano an altar frontal that was painted to resemble a colored brocade (Neri di Bicci 1453–75, Santi ed. 1976, p. 79, no. 156). It probably resembled the frontal that he had painted for the church of Santo Spirito in Florence, except that it had no figures.[8]

Because the saints in Neri's Putignano altarpiece are not identified in his *Ricordanze,* it is impossible to be sure that it is the painting now in Philadelphia. Two specific objections to such an identification can be raised. One might be that the patron's name saint, Paul, is absent. However, another example by

Neri di Bicci, the altarpiece (fig. 57.1) ordered by a Messer Pietro for the church of San Sisto in Viterbo, does not contain the patron's name saint either. The other objection might be that the Putignano painting was larger in both height and width than the Philadelphia panel, according to Neri's account. However, Neri's dimensions include the panel, predella, and frame, which may explain the difference in dimensions.

No mention of this or any other painting by Neri di Bicci from the church of Santa Maria alla Canonica in Putignano near Greve in the Chianti is found in the records of the Soprintendenze of Florence. However, the church was not inventoried until March 1896,[9] when its priest reported no works of artistic value. Earlier, the Neri di Bicci was not described in a diocesan visit of the church made in 1850.[10] Carlo and Italo Baldini (1979) have suggested that by this point the altarpiece may have been transferred to the now-destroyed church of San Lorenzo in Frassino, which had once been under the jurisdiction of Santa Maria alla Canonica. There is no documentation for this hypothesis, but it is possible that the painting was removed from Santa Maria alla Canonica around 1763, the date inscribed on the Baroque-style high altar constructed in the church by the prior Piero Lorenzo Galgi.[11] In 1741 this prior had described the high altarpiece as depicting "the Virgin and other saints and it is of wood with a very consumed wood frame."[12] This was probably Neri di Bicci's painting, but, since Galgi does not specify which saints were included, the identification cannot be certain. An inventory of the church made by the prior Santi Maria Natale Ferrini on August 25, 1771, reports that the new altar is furnished with a "painting on panel depicting the Holy Virgin Mary with other saints to the side, St. Peter, St. Paul, St. Catherine, St. John the Baptist, and St. Agatha,"[13] which is clearly not the work by Neri di Bicci. The painting that Ferrini described is no longer in the church, but it was probably commissioned for the new high altar in 1763.[14] Since, except for the Baptist and Catherine, the saints do not correspond to those in Neri di Bicci's altarpiece, the altar's dedication may have changed.

The Firidolfi family held patronage rights in Santa Maria alla Canonica from at least 1446,[15] when the patron was Benedetto Jotini de Firidolfi. In that year the church is said to have had only twenty parishioners. The painting then on the high altar was not in good shape, because it was described as a "painting of the Virgin Mary quite ugly and old."[16] Neri di Bicci was probably commissioned to paint an altarpiece to replace this one.

The last name of the prior Messer Pagholo is not recorded, but it is likely that he was a Firidolfi, since five of the documented priors of the church were from that family.[17] The Christian name of the prior in the late seventeenth and early eighteenth centuries, who was responsible for many renovations to the church, was Bartolomeo, suggesting a certain tradition of ven-

eration for the apostle Bartholomew in the Firidolfi family.[18] This could explain the apostle's presence in the foreground of Neri di Bicci's altarpiece.

1. B. Santi 1973, plate II.
2. B. Santi 1973, plates XI–XII. This was formerly with the dealer Böhler in Munich. It was subsequently cut into pieces and sold separately.
3. Giovanni Spinelli was an archdeacon of Santa Maria del Fiore in Florence. For more on him, see Thomas 1993a, p. 15 n. 39.
4. From San Giorgio in Canneto, now in San Miniato al Tedesco, Museo Diocesano d'Arte Sacra; San Miniato 1966, plate XVIII. The inscription states that the painting was sent to Canneto from Florence by one Niccolò di Antonio.
5. Thomas 1993a, figs. 1, 5 (black-and-white); Figline Valdarno 1991, figs. 7–8 (color).
6. Arezzo, Museo Statale d'Arte Medievale e Moderna, no. 27; Arezzo 1987, repro. pp. 64–65.
7. "Richordo chome a detto dì tolsi a far fare di legniame e dipignere e di tutto fornire a ogni mia ispesa da meser Pagholo di . . . priore di Putigniano in Valdigrieve [sic] una tavola d'altare di braccia quattro largha e alta braccia 4 e 2/3, formata al'anticha, quadra, chon predella da pie', cholonne da lato chogli sghuanci e sopra lo sghuancio 10 chorniciore e foglia sanza fregio e architrave; messa tute le parte dinanzi, cioè la faccia dinanzi, d'oro fine; isghuancio d'azuro di Magnia e stellato; Nostra Donna d'azuro oltramarino; ogni altra chosa d'azuro di Magnia: tuta bene fatta e ornata a mia ispesa chome detto di sopra e dèbola dare fatta per tuto giugnio prosimo 1457 e di detta tavola, cioè di legniame, oro, azuro e maistero io debo avere da f. 34 in su, ciò che dirà l'abate di Santo Branchazio, non bastando però e' f. 38 e chosì fu fatto d'achordo cho Lorenzo di Fulino di Cianpolo da Panzano, con chomesione del detto meser Pagholo e chon suo mandato, promettendo el detto Lorenzo che el detto meser Pagholo oserverà quanto per una iscrita privata, di mano di detto Lorenzo, soscritta di mia in suo proprio nome; nella quale tavola ò a fare Nostra Donna chol Figliuolo f. 38 [sic] in chollo e tre Santi da ogni parte e nella predella tre istorie, delle quali n'ò uno richordo di mano di detto Lorenzo. El paghamento mi debono fare in questo modo, cioè per tuto aprile f. 14 e dipoi fornita la tavola la metà di resto; el resto poi a dì primo di novembre 1457 e chosì chome detto e fatto d'achordo el detto dì. Rende' la detta tavola al detto priore a dì 12 di luglio 1457 e fe' chonto cho lui e Lorenzo da Panzano: trovamo avevo auto insino a detto di.ttra' danari e grano in tuto l. centododici s. 9 d. 6. A libro D a c. 25." (Florence, Biblioteca degli Uffizi, *Manoscritti 2,* folio 32 recto).
8. Acidini Luchinat 1996, p. 252, fig. 5 (color detail).
9. Florence, Soprintendenza per i Beni Architettonici ed il Paesaggio e per il Patrimonio Storico Artistico e Demoetnoantropologico, Archivio Storico del Territorio, *Catalogo generale dei monumenti e degli oggetti d'arte del regno,* 1896, folder A/1115.
10. Baldini and Baldini 1979, p. 177.
11. A former prior, Bartolomeo Firidolfi (in office 1674–1710), made other renovations to the church, which are recorded in inscriptions still found in the now-deconsecrated sanctuary. In 1691 he built the sacristy and a sacristy cupboard, and in 1706 he had tabernacles set in the wall for the Eucharist and holy oil.
12. "La Vergine e altri santi e di legno con sua cornice di legno molto usato" (Fiesole, Archivio Vescovile, *Inven-*

tario, 1740–48 [1741], XIX.17, carta 398 verso).

13. "Quadro di pittura in tavola rappresentante Maria SS. con altri santi a latere con S. Pietro, S. Paolo, S. Caterina, S. Giovanni Battista, e con S. Agata" (Fiesole, Archivio Vescovile, *Inventario* [1771] XIX.17, carta 416 recto).

14. As it is not described in the Soprintendenza's files of 1896 (see n. 9 above), it probably passed into the collections of the Firidolfi family (see text below), who gave up their patronage rights over the church in 1850. The last members of the family to hold patronage in 1850 were Giovanni Benedetto and Giuliano Firidolfi and their sister Lucrezia Firidolfi Ricasoli.

15. Baldini and Baldini 1979, p. 177.

16. "Tabula virginis mariae satis turpe et vetera" (Fiesole, Archivio Vescovile, *Visita di Benozzo Federighi,* 1441–60, 1446, carta 227 recto and verso).

17. Baldini and Baldini 1979, pp. 176–77.

18. See n. 11 above.

Bibliography

Fredericksen and Zeri 1972, p. 148; Philadelphia 1994, repro. p. 220.

PLATE 58 (JC INV. 2073)

Predella panel of an altarpiece: *Archangel Raphael Saving a Man from Attack*

c. 1462–71

Tempera and tooled gold on panel with horizontal grain; $8\frac{3}{8} \times 19\frac{1}{8} \times \frac{3}{8}''$ (21.5 × 48.5 × 1 cm), painted surface $7\frac{7}{8} \times 19\frac{1}{8}''$ (20 × 48.5 cm)

John G. Johnson Collection, inv. 2073

INSCRIBED ON THE REVERSE: *JOHNSON COLLECTION* (stamped); *2073* (in yellow crayon, pencil, and ink)

TECHNICAL NOTES

The panel, consisting of one member, has been thinned and cradled. The original lipped edges are visible at the bottom and top. When the predella that included this scene was disassembled, damage occurred in the center at the top and bottom, where there were probably nails. The original borders on either side consisted of punched gold-leaf pilasters in an antique style, which were overpainted to make the panel appear to be an independent painting. From what can be seen under the discolored varnish, the panel is otherwise in quite good condition. The shell-gold embellishments on the victim's costume and the angel are later additions, as is the painted ornament on the costume of the attacker, the angel's feathers, and the white highlights of the angel's garments. All the lines of the architecture are incised, although not all were followed in the execution of the painting, which presents different architecture than originally was envisioned. There was also some confusion as to the location of the vanishing point, as several lines were incised more than once along different axes.

PROVENANCE

Unknown

COMMENTS

The scene is set on an empty street near a bridge that crosses a small canal. The buildings are of gray stone with red stringcoursing. A thug dressed in a red doublet and green hose attacks a man with a sword. The victim wears a green gown and red mantle and holds the cloth of his hat, which has unraveled at his feet. The headdress was a typical Florentine *mazzocchio,* which was worn like a turban. An angel appears in the sky and stays the threatening sword.

Everett Fahy (1985) recognized that the Johnson Collection's panel came from the same predella as three other paintings that Alessandro Parronchi (1965) had identified as part of the same complex: *Archangel Raphael Leading a Woman Through a Town* (fig. 58.1); *Archangel Raphael Leading Two Dominican Cardinals on Horseback Across a River* (fig. 58.2); and *Archangel Raphael Saving an Attempted Suicide* (fig. 58.3). Each panel has the

distinctive pilaster framing elements that were masked in the Johnson Collection's picture. The latter two came from the collection of Albert Figdor and were attributed to Neri di Bicci, with question, by Max J. Friedländer in the 1930 auction catalogue of that collection. Henk van Os (1974) and Fahy (1985) confirmed an attribution to Neri di Bicci. Parronchi (1965), on the basis of the adept handling of the perspective, had attributed them first to a close follower of Paolo Uccello and later (1974, pp. 63–64) to Paolo's otherwise unknown son, Donato.

Van Os (1974, p. 93), who first recognized that the angel in then-known predella panels was Raphael, suggested that the scenes might have come from Neri di Bicci's altarpiece whose main panel was the *Archangel Michael, Archangel Raphael with Tobias, and Archangel Gabriel* (fig. 58.4), now in the Detroit Institute of Arts.[1] The Detroit panel, which comes from the Augustinian church of Santo Spirito in Florence, was ordered in 1471 by the wealthy grocer Mariotto di Marco della Palla, who had a shop in the via Porta Rossa. Neri di Bicci (1453–75, Santi ed. 1976, pp. 366, 372–73) recorded that Mariotto ordered the picture on May 7, that colors were purchased on July 8, and that the altarpiece was placed in the church on October 2. He described the predella as showing the "miracles of the Angel Raphael" (*miracholi dell'angelo Rafaello*). Another altarpiece by Neri di Bicci in Santo Spirito, commissioned by Francesco d'Antonio Mellini (called Francesco *zopo,* or the "cripple") in February 1462, consigned a year later, and presumably destroyed by fire in March 1471, also had a predella showing miracles of the archangel Raphael.[2] That altarpiece's recorded dimensions, $3\frac{1}{4} \times 3\frac{2}{3}$ *braccia* ($70\frac{1}{2} \times 79\frac{1}{2}''$ [179 × 202 cm]), are slightly smaller than those of the Detroit panel (without the predella).

The most valid objection to the association of the predella with either one of the two Santo Spirito altarpieces—the one commissioned in 1462, and presumably lost or damaged in the fire of March 1471,[3] or the Detroit painting, commissioned in May 1471—is that the style of the panels would seem to date to an earlier period. Fahy, for example, dated them about 1450. They may well come from an unrecorded commission that came before Neri di Bicci's surviving *Ricordanze,* which were begun in 1453. Then again, his style does not always show a consistent chronological development, and the artist also repeated compositions. The 1471 predella in fact probably was based on the 1462 predella, which in turn may have been based on an earlier representation of the "miracholi dell'angelo Rafaello."

1. Ultimately, however, van Os (1974) rejected his own suggestion, because one of the predella scenes (fig. 58.2) shows Dominican cardinals, whereas the Detroit painting came from an Augustinian church. He was followed in this opinion by Fahy. But this point alone

(text continues on page 326)

PLATE 58

FIG. 58.1 Neri di Bicci. *Archangel Raphael Leading a Woman Through a Town*, c. 1462–71. Tempera and tooled gold on panel; 8¼ × 18⅞″ (21 × 48 cm). Ferrara, private collection. See Companion Panel A

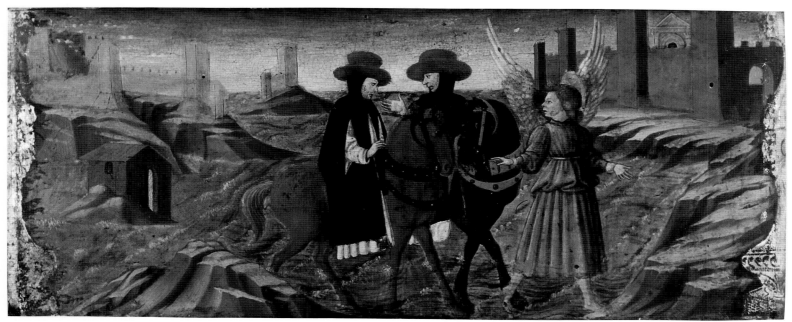

FIG. 58.2 Neri di Bicci. *Archangel Raphael Leading Two Dominican Cardinals on Horseback Across a River,* c. 1462–71. Tempera and tooled gold on panel; 8¼ × 19″ (21 × 48.2 cm). Rijswijk, Instituut Collectie Nederland, no. NK 1472. See Companion Panel B

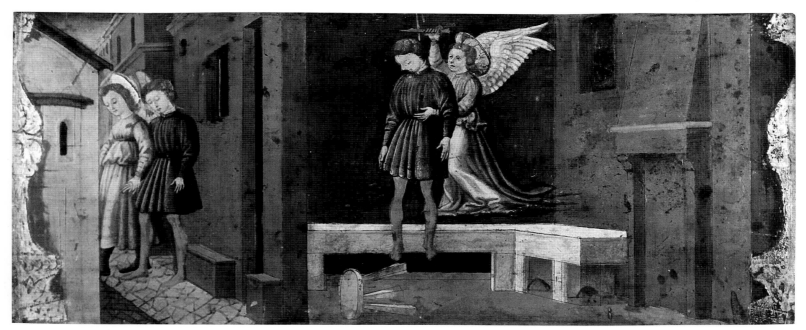

FIG. 58.3 Neri di Bicci. *Archangel Raphael Saving an Attempted Suicide,* c. 1462–71. Tempera and tooled gold on panel; 8¼ × 19″ (21 × 48.2 cm). Rijswijk, Instituut Collectie Nederland, no. NK 2703. See Companion Panel C

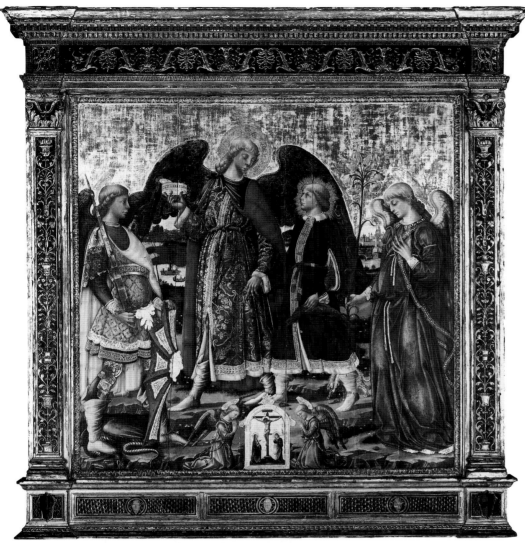

FIG. 58.4 Neri di Bicci. *Archangel Michael, Archangel Raphael with Tobias, and Archangel Gabriel*, c. 1462–71. Tempera and tooled gold on panel; 71 × 68¾″ (180.3 × 174.6 cm). The Detroit Institute of Arts, City of Detroit Purchase, no. 26.114

B. Predella panel of an altarpiece: *Archangel Raphael Leading Two Dominican Cardinals on Horseback Across a River*. See fig. 58.2

c. 1462–71

Tempera and tooled gold on panel; 8¼ × 19″ (21 × 48.2 cm). Rijswijk, Instituut Collectie Nederland, no. NK 1472

PROVENANCE: Vienna, Miller von Aicholz; Vienna, Albert Figdor; sold, Berlin, Paul Cassirer, September 29–30, 1930, lot 6 (as Neri di Bicci[?]); Amsterdam, J. Goudstikker Gallery, 1934

EXHIBITED: Amsterdam 1934, no. 255

SELECT BIBLIOGRAPHY: Berenson 1963, pp. 157–58; Parronchi 1965, pp. 169–74; Parronchi 1974, pp. 63–64; Van Os 1974, pp. 90–93; Wright 1980, p. 297; Fahy 1985

C. Predella panel of an altarpiece: *Archangel Raphael Saving an Attempted Suicide*. See fig. 58.3

c. 1462–71

Tempera and tooled gold on panel; 8¼ × 19″ (21 × 48.2 cm). Rijswijk, Instituut Collectie Nederland, no. NK 2703

PROVENANCE: Vienna, Miller von Aicholz; Vienna, Albert Figdor; sold, Berlin, Paul Cassirer, September 29–30, 1930, lot 6 (as Neri di Bicci[?]); Amsterdam, J. Goudstikker Gallery, 1934

EXHIBITED: Amsterdam 1934, no. 256

SELECT BIBLIOGRAPHY: Berenson 1963, pp. 157–58; Parronchi 1965, pp. 169–74; Parronchi 1974, pp. 63–64; Van Os 1974, pp. 90–93; Wright 1980, p. 297; Fahy 1985

is not enough to disassociate the predella panels from the altarpiece, for as Burton Fredericksen (unpublished manuscript) noted, there is what appears to be an Augustinian female tertiary in the predella panel now in Ferrara (fig. 58.1).

2. See Neri di Bicci 1453–75, Santi ed. 1976, pp. 176–77; and Venturini 1994, p. 45.

3. The predella may well have survived fire damage, as the burning rafters of the church would have mainly hit the top part of the altarpiece.

Bibliography
Fahy 1985; Philadelphia 1994, repro. p. 220

COMPANION PANELS for PLATE 58

A. Predella panel of an altarpiece: *Archangel Raphael Leading a Woman Through a Town*. See fig. 58.1

c. 1462–71

Tempera and tooled gold on panel; 8¼ × 18⅞″ (21 × 48 cm). Ferrara, private collection

PROVENANCE: Florence, private collection, c. 1965; Ferrara, private collection, c. 1974

SELECT BIBLIOGRAPHY: Parronchi 1965, pp. 169–74; Parronchi 1974, pp. 63–64; Van Os 1974, pp. 90–93; Fahy 1985

PLATE 59 (JC CAT. 27)

Main panel of an altarpiece: *Saint Thomas Receiving the Virgin's Belt with Saints Michael Archangel, Augustine, Margaret of Antioch, and Catherine of Alexandria*

1467

Tempera, tooled gold, and silver on panel with vertical grain; 64¾ × 65 to 65¼ × 1⅛″ (164.5 × 165 to 165.7 × 2.9 cm), painted surface 61⅜ × 61¾″ (155.8 × 157 cm)

John G. Johnson Collection, cat. 27

INSCRIBED ON THE REVERSE: *27-23* (in black crayon); *CITY OF PHILADELPHIA/ JOHNSON COLLECTION* (stamped several times in black); *JOHNSON COLLECTION/ PHILA.* (stamped several times in black); ON A LABEL: *11. Neri de* [sic] *Bicci* (typed); *27-23* (in pencil)

PUNCH MARKS: See Appendix II

TECHNICAL NOTES

The panel, which consists of what appear to be five members, retains most of its original thickness, even though it is cradled.[1] It also has its nearly original dimensions. The painting originally had applied frame moldings about 2″ (5 cm) wide, as indicated by the gesso barbes and a margin of bare wood along all four sides. Both the top and bottom margins have five holes from countersunk nails that would have been driven in from the front before the moldings were applied to the edges to attach horizontal battens to the back. Shallow protusions on the paint surface along the horizontal center line correspond to another row of these nails. There are other holes left from wrought nails that were used to affix the frame moldings.

The gold background is in good condition except in such isolated areas as along the cracks and above the Virgin's halo. All the mordant gilding has flaked off and pulled the underlying paint away. The Virgin's belt, which is one of the areas so affected, was also worked in a red lake glaze. Michael's sword is now tarnished silver leaf on bole. A small circular punch was used to grain and highlight the burnished metal leaf of the halos, sword, and crozier, and the gilt borders of the costumes.

Incised lines were used to outline the figures that would overlap the gold. In addition, the folds of Catherine of Alexandria's vermilion mantle are carefully incised, perhaps suggesting that the garment was originally going to be executed in blue, because drapery incisions are more commonly encountered in dark blue drapery. Carefully hatched underdrawing is visible with the naked eye in the Virgin's white mantle, in the two angels in purplish yellow in the lower part of the mandorla, and in the red parts of Augustine's miter. In addition, the crimson draperies of the Virgin and Saints Michael Archangel and Margaret are modeled in a combination of cross-hatching and glazing.

The paint surface is generally well preserved, with a number of delicate effects still intact. An undisturbed grayish surface can be observed on some of the flesh and costumes.

PROVENANCE

This altarpiece was made for the high altar of the church of San Michele in Prato in 1467. In 1503 it was replaced by Alessandro Allori's *Assumption of the Virgin*,[2] which remains in the church. Its subsequent history is not known. Although Guido Carocci records its former presence elsewhere in San Michele in a signed report, dated April 1893, he does not seem to have seen it there.[3] The panel was purchased by John G. Johnson between 1898 and 1905.

COMMENTS

The Virgin, seated on small clouds in a rayed mandorla surrounded by eleven angels, hands her belt to the apostle Thomas. Red roses and white lilies fill her empty tomb below.[4]

To the left are Saints Michael Archangel and Augustine. Michael is shown as a young soldier standing on a vanquished serpent that represents Lucifer, whom Michael, as standard bearer of the heavenly host, drove out of heaven.[5] Although Michael does not have wings, the triangular violet headdress denotes his angelic status. Augustine wears a black habit as well as a bishop's cope and miter.

To the right are Saints Margaret of Antioch and Catherine of Alexandria. Standing on a dragon, Margaret holds a book and a cross because she once made the sign of the cross to drive away a dragon that sought to devour her. Catherine of Alexandria wears a crown and holds a martyr's palm and a book. She stands on the spiked wheel that broke while her pagan tormentors were using it to torture her.

The central episode of Saint Thomas receiving the Virgin's belt is apocryphal. According to a popular account given by Jacopo da Varazze in *The Golden Legend* of about 1267–77 (Ryan and Ripperger ed. 1941, p. 454), Thomas was absent at the Assumption of the Virgin and, therefore, did not believe it took place. "But suddenly the girdle wherewith her body had been begirt fell unopened into his hands, that so he might understand that she had been assumed entire." Although Jacopo da Varazze emphasized the doubtful nature of the story,[6] and a contemporary of Neri di Bicci, the Florentine archbishop Antonino, railed against paintings of the subject,[7] its popularity in the fifteenth century remained unabated.

Neri di Bicci described the painting in an entry in his *Ricordanze* (1453–75, Santi ed. 1976, pp. 304–5), dated September 4, 1467:

> *The Altarpiece of San Michele of Prato:* I record that on the above-mentioned day, September 4, 1467, I consigned an altarpiece made and shaped like a square in the antique style, about 3½ *braccia* [76″ (193 cm)] long and 3⅔ *braccia* [115″ (292 cm)] high, in which was painted an Assumption of Our Lady with many angels and at the bottom Saint Thomas and to her right Saint Michael and Augustine and to her left Saint Margaret and Saint Catherine and in the predella three stories with other figures, all on a background of fine gold and worked with good and fine colors, which was commissioned to me by madonna Francesca, abbess of San Michele of Prato, and in the said and for the said church the contract was made for the said painting, which I took on to execute for her some time ago, for which, according to the agreement, she must give me 200 lire in the following manner; that is 47 lire, equal to the value of 10 *fiorini larghi*, were given to me before May 15, 1467, in four parts, as is recorded in my account book marked *E* on pages 121–122, and the remaining sum, which is 143 lire, must be paid to me in the next three years, to be made every year on the fourth of September, in installments of 47 lire, 13 soldi, 4 denari, beginning September 4, 1468, and as was agreed upon with Ser Guaspare di . . . , the Florentine notary, the said day, in the place of and in the name of the said madonna Francesca, his sister, and these same pacts I made concerning the above-mentioned 200 lire with madonna Francesca when I took on the said painting. Having been given . . . lire received at various times and occasions as is in the account book marked *D* on page. . . . To book D. on page 167.[8]

San Michele of Prato was a monastery of Benedictine nuns who observed the Augustinian rule. The archangel was included in the altarpiece because he was the titular of the church, and Saint Augustine was shown because he was said to have written the rule the nuns observed. Saints Margaret and Catherine were much venerated in such female monastic communities. The episode of the apostle Thomas receiving the Virgin's girdle had particular significance for Prato, where the *Sacro Cingolo,* or Holy Belt, was preserved in the city's main church, then the *collegiata.* The nuns of San Michele seem to have had a particularly close connection to this cult through their sister convent of San Martino, just outside Prato, which in 1426 had been joined to San Michele. San Martino owned the polyptych by Bernardo Daddi (q.v.) once in the chapel of the *Sacro Cingolo* in Prato. Its now-lost main panel probably showed the same scene as Neri di Bicci's painting. The altarpiece was sold back to the *collegiata* in 1438, but the predella, now in the Museo Civico, depicting the story of the relic's arrival in Prato after the First Crusade, was left behind.[9]

The relic was similarly the object of much veneration in the convent of Santa Margherita of Prato, where the painter Filippo Lippi was chaplain.

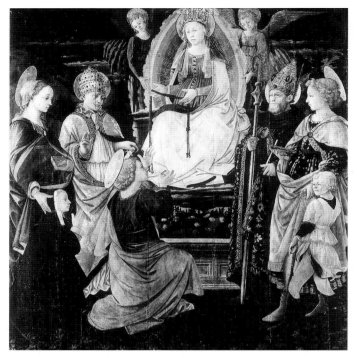

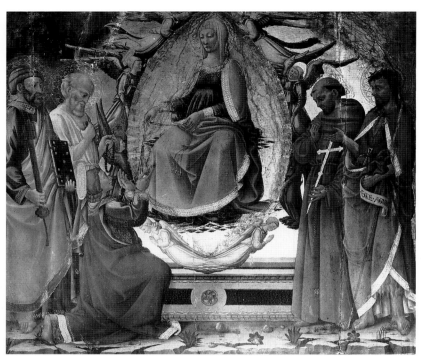

FIG. 59.1 Workshop of Filippo Lippi (Florence, c. 1406–1469) and Fra Diamante (q.v.). Altarpiece: *Assumption of the Virgin with Saint Thomas and Saint Margaret with the Abbess Donor, and Saints Gregory the Great, Augustine, and the Archangel Raphael with Tobias,* early 1460s. Tempera and tooled gold on panel; 75¼ × 73⅝″ (191 × 187 cm). Prato, Museo Civico, no. 28

FIG. 59.2 Neri di Bicci. Altarpiece: *Assumption of the Virgin with Saint Thomas and Saints Peter, Jerome, Francis of Assisi, and John the Baptist,* 1467. Tempera and tooled gold on panel; 56¾ × 65¾″ (144 × 167 cm). Florence, church of San Leonardo in Arcetri

Sometime in the early 1460s his workshop painted for its abbess Bartolomea de' Bovacchiesi an altarpiece of the Assumption and saints (fig. 59.1) that is almost identical in composition to the Neri di Bicci panel and that in fact may have provided a model for it.[10]

In the *Ricordanze* Neri di Bicci mentions that the San Michele altarpiece (fig. 59.4) had a predella with "three stories with other figures." One fitting this description exists in the Museu Nacional d'Art de Catalunya in Barcelona (fig. 59.3). It shows the Fall of the Rebel Angels, which relates to Saint Michael; the Dormition of the Virgin, which is the event that occurs just before the Virgin gives Thomas her belt; and Saint Catherine of Alexandria at the wheel, who is also depicted at the far right in the main panel. At either end of the predella are kneeling nuns; to the left a single nun, probably the abbess Francesca, is being presented by Saint Lawrence, and to the right two nuns are being presented by an unidentified female saint. Although the predella is 14⅛″ (35.9 cm) longer than the Johnson panel, the difference would have been made up by framing elements and possibly also by lateral pilasters. Furthermore, in Neri di Bicci's altarpieces, the predella tends to be considerably longer than the main panel.[11]

The nineteenth-century Pratese historian Gio-

vanni Pierallini thought that Neri di Bicci's altarpiece for San Michele had been taken from the church in the 1790s by Napoleonic troops and never returned.[12] In the early twentieth century the predella was with the Parisian dealer Ludovico de Spiridon. We do not know from whom John G. Johnson bought his panel, but as it was in his collection before 1905, when F. Mason Perkins published it, it may have also once been with Spiridon, who by that point had sold Johnson many old master pictures.

Neri di Bicci's description of the altarpiece as "in the antique style" is a reference to its contemporary Renaissance format in which the figures are shown in a uniform, rectangular picture field. Despite this, the figure style is conservative and recalls the largely curvilinear motifs of International Gothic painting, with which Neri and his patrons were most comfortable. The artist did not describe the frame in detail, but most likely it would have been made up of classicizing architectural elements.

The basic form of combining a central narrative scene with standing figures of saints is one that Neri repeated in several altarpieces, including a number in which Saint Thomas is shown receiving the Virgin's belt. Neri's patron at San Michele, Francesca, may have been familiar with one of them.[13] Closest

to the Johnson panel in composition and date is the *Assumption of the Virgin with Saint Thomas and Saints Peter, Jerome, Francis of Assisi, and John the Baptist* in the church of San Leonardo in Arcetri, Florence (fig. 59.2), which Neri painted for Bernardo Salviati and his wife, Mona India, a little over a month before he consigned the altarpiece to San Michele.[14] The Salviati commission was first recorded on June 1, 1467; Neri finished the work on August 11. The basic formula is the same as in the Johnson panel, although the latter is bigger, its gilding is more richly tooled, and its angels are greater in number. The Virgin and Thomas as well as the sarcophagus are obviously based on the same cartoons. The panel for the Salviati painting cost only 110 lire and 14 soldi, as opposed to the 200 lire paid for the San Michele panel. Because in his *Ricordanze* Neri wrote that he "took on to execute the San Michele altarpiece some time ago" and that the first payment was made on May 15, 1467, it was likely begun before the Salviati commission, and the speed with which the latter was executed may have depended on the ready availability of the cartoons from the San Michele altarpiece.[15] Neri's subsequent altarpieces of the same subject likewise depend on variations of the same cartoons.[16]

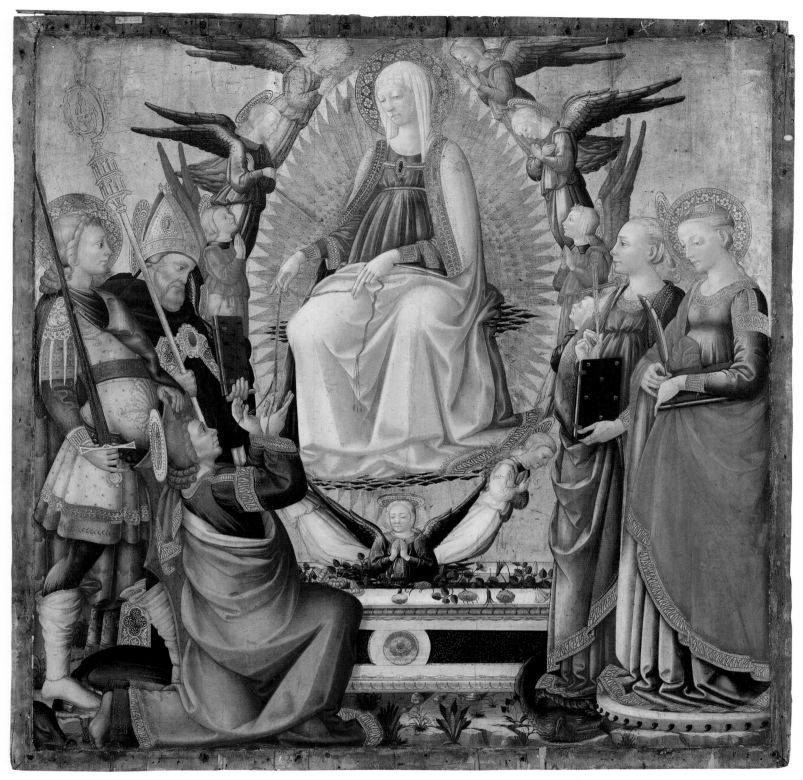

PLATE 59

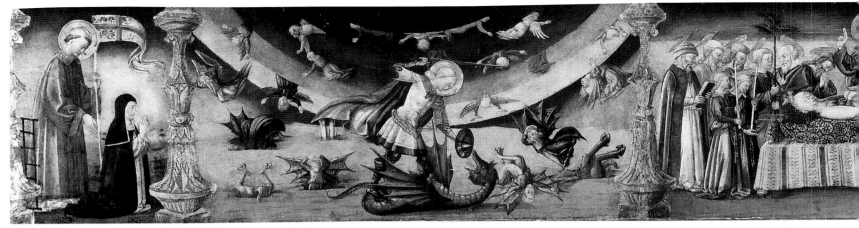

FIG. 59.3 Neri di Bicci. *Saint Lawrence Presenting a Kneeling Nun, the Fall of the Rebel Angels, the Dormition of the Virgin, Saint Catherine of Alexandria at the Wheel, and a Female Saint Presenting Two Kneeling Nuns,* 1467. Tempera and tooled gold on panel; 10⅞ × 78⅞″ (27.5 × 200.5 cm). Barcelona, Museu Nacional d'Art de Catalunya, no. 64972. See Companion Panel

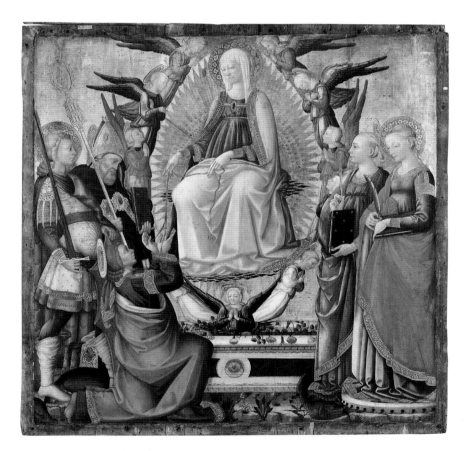

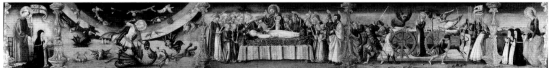

FIG. 59.4 Original configuration of Neri di Bicci's San Michele altarpiece, 1467: Main panel: PLATE 59; predella: FIG. 59.3

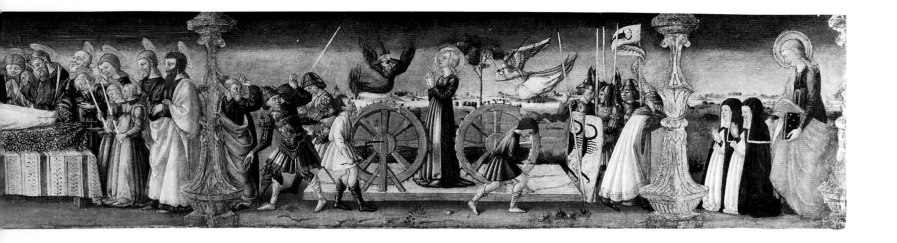

1. The cradle makes it difficult to see the seams between the members of the panel.
2. Lecchini Giovannoni 1991, fig. 386.
3. Florence, Soprintendenza per i Beni Architettonici ed il Paesaggio e per il Patrimonio Storico Artistico e Demoetnoantropologico, Archivio Storico del Territorio, *Catalogo generale dei monumenti e degli oggetti d'arte del regno,* folder A/1461.
4. The red roses signify the troops of martyrs and the white lilies represent the hosts of angels, confessors, and virgins (Jacopo da Varazze c. 1267–77, Ryan and Ripperger ed. 1941, p. 452).
5. The archangel's presence at the Virgin's Assumption is significant. According to *The Golden Legend,* three days after the Virgin's burial, Christ asked his apostles what honor he should convey on his mother; they replied that he should raise her body and place her at his right hand. When Christ assented, Saint Michael appeared and presented the Virgin's soul to him (Jacopo da Varazze c. 1267–77, Ryan and Ripperger ed. 1941, p. 454).
6. As evidence he cited a letter in which Saint Jerome wrote, "many other things are set down therein an apocryphal book attributed to John the Evangelist rather as symbol than as fact, as for instance that Thomas was absent and refused to believe when he arrived, and other like things, which manifestly are to be left aside rather than believed" (Jacopo da Varazze c. 1267–77, Ryan and Ripperger ed. 1941, p. 454).
7. In his *Summa theologica* (c. 1446–59) Antonino wrote, "But neither are they to be praised when they paint apocrypha, such as midwives at the Virgin's delivery, or her girdle being sent down by the Virgin Mary in her Assumption to the Apostle Thomas on account of his doubt, and the like" (quoted in Gilbert 1959, p. 76).
8. "*Tavola di San Michele di Prato:* Richordo ch'el sopradetto dì 4 di setenbre 1467 rendeì una tavola d'altare fatta e formata quadra al'anticha, di braccia 3½ per.lla largheza e braccia 3⅔ per.lla alteza incircha, nella quale era dipinto una Asunzione di Nostra Donna cho molti angioli e da pie' San Tomaso e da mano destra Santo Michele e Aghostino e da mano sinistra Santa Margherita e Santa Chaterina e nella predella 3 istorie chon altre fighure, mesa tuta d'oro

fine e.llavorata di buoni e fini cholori, la quale m'aloghò a fare madonna Francescha badessa di San Michele di Prato e in detta e per detta chiesa fa fare la detta tavola, la quale tolsì a fare più tenpo fa da lei, della quale mi de' dare d'achordo 1. dugento in questo modo, cioè 1. quarantasette per.lla valuta di f. 10 larghi mi dèttono insino a dì 15 di magio 1467 in 4 partite, chome a mia entrata segniato E a c. 121–22 e resto che sono l. 143 mi debono dare in tre anni prosimi a venire ogni anno a dì 4 di setenbre i. 47 s. 13 d. 4 inchominciando a dì 4 di setenbre 1468 a chosì d'achordo fatto chon ser Ghuaspare di . . . notaio fiorentino el detto dì in vece e nome di detta madonna Francescha sua sirochia e questi medesimi patti feci cholla sopradetta l. 200 madonna Francescha e quando tolsì la detta tavola. Annone dato l. . . . auti in più tenpi e in più volte chome a libro D a c. *A libro D a c. 167*" (Florence, Biblioteca degli Uffizi, *Manoscritti* 2, folio 129 recto).
9. For the predella (nos. 1–5), see Offner/Boskovits 1989, pp. 212–21, plate XI.
10. Ruda 1993, p. 465.
11. A photograph (Florence, Soprintendenza Speciale per il Polo Museale Fiorentino, Gabinetto Fotografico, neg. no. 14459 v.n.) of Neri di Bicci's Coronation of the Virgin altarpiece, without its frame, in San Giovanni dei Cavalieri di Malta in Florence, shows how the predella was made wider than the main picture to support both it and the frame.
12. Pierallini (1849, p. 155) learned of the altarpiece from a selection of the *Ricordanze* published in 1849 in the second volume of Vasari, edited by Vincenzo Marchese and the Milanesi brothers, Carlo and Gaetano, and issued by the Le Monnier publishing house (Vasari 1568, Le Monnier ed., vol. 2, 1846, p. 243).
13. The first was made for the Spini family's chapel in Santa Trinita in Florence and delivered on August 28, 1456. It is now in the National Gallery of Canada in Ottawa (no. 3716; Laskin and Pantazzi 1987, fig. 9). It was larger than the San Michele altarpiece, at 6 by 5 *braccia* (130 × 108″ [331 × 276 cm]) and contained more figures—all twelve apostles. This probably accounts for its greater price of 480 lire. In the Ottawa painting, Saint Thomas has the unusual position of kneeling on

the edge of the Virgin's tomb. In 1463 Neri consigned another altarpiece for the sacristy of the monastery of Camaldoli (Neri di Bicci 1453–75, Santi ed. 1976, pp. 187–88, no. 372). This cost 33 florins, or approximately 181 lire, with the frame subcontracted to Giuliano da Maiano for 6 florins. The altarpiece is lost or has not been identified. The next year Neri painted a similar altarpiece, with Saints John the Baptist, Nicholas of Bari, Julian, Francis, and Jerome, for the since-destroyed church of Santa Maria degli Ughi, Florence. It measured 5 by 4 *braccia* (108 × 86⅝″ [276 × 220 cm]) and cost 271 lire and 8 soldi. The painting is now in the State Pushkin Museum of Fine Arts in Moscow (no. 24; Moscow 1995, p. 107).
14. Neri di Bicci 1453–75, Santi ed. 1976, no. 567, pp. 299–300.
15. The figures in the Salviati altarpiece are approximately 3⅞″ (10 cm) shorter than those in the Johnson altarpiece.
16. They are the *Assumption with Saint Thomas and Saints Benedict, John the Baptist, Peter, Paul, Augustine, and Romuald* (1467; Bagno di Romagna, church of Santa Maria del Fiore); and the *Assumption with Saint Thomas and Saints John the Baptist and Bartholomew* (1470–75; San Miniato al Tedesco, Museo Diocesano d'Arte Sacra; Dalli Regoli 1988, figs. 19–26 [color and black-and-white]). At least two variants of the latter by Neri di Bicci exist; the *Assumption with Saint Thomas and Saints Mary Magdalene and Catherine of Alexandria* (present location unknown; last recorded in the collection of Marchese Ippolito Venturi Ginori; Florence, Kunsthistorisches Institut, photograph nos. 35957, 83715); and the *Assumption with Saints Mary Magdalene and Catherine of Alexandria* (Seville, Casa de las Dueñas; photograph at the Fototeca Berenson, Villa I Tatti, The Harvard University Center for Italian Renaissance Studies, Florence).

Bibliography

Neri 1453–75, Santi ed. 1976, p. 304–5; Perkins 1905, p. 115; Georg Gronau in Thieme-Becker, vol. 3, 1909, p. 606; Berenson 1913, p. 20; Van Marle, vol. 10, 1928, p. 544; Berenson 1932, p. 388; Berenson 1936, p. 344; Johnson 1941, p. 11; Berenson 1963, p. 157; Sweeny 1966, p. 56, repro. p. 131; Fredericksen and Zeri 1972, p. 148; Fremantle 1975, p. 450, fig. 934; Bruno Santi in Neri 1453–75, Santi ed. 1976, p. 305 n.;

Ruda 1993, p. 465; Philadelphia 1994, repro. p. 220; Prato 1995, fig. 14; Hiller von Gaertringen 2004, p. 288 and n. 28

COMPANION PANEL for PLATE 59

Predella panel of an altarpiece: *Saint Lawrence Presenting a Kneeling Nun, the Fall of the Rebel Angels, the Dormition of the Virgin, Saint Catherine of Alexandria at the Wheel, and a Female Saint Presenting Two Kneeling Nuns.* See fig. 59.3

1467

Tempera and tooled gold on panel; 10⅞ × 78⅞" (27.5 × 200.5 cm). Barcelona, Museu Nacional d'Art de Catalunya, no. 64972

PROVENANCE: Prato, church of San Michele; Florence, Conte Nardi, c. 1875; Pisa, Toscanelli Collection; Paris, Joseph Spiridon, 1883–1929; sold, Berlin, Cassirer & Helbing, May 1, 1929, lot 56 (as Neri di Bicci); Barcelona, Francisco Cambó, 1929–47; bequest of Francisco Cambó to Barcelona, Museu Nacional d'Art de Catalunya, 1949

EXHIBITED: Barcelona 1955–56, p. 293, no. 9; Madrid 1990, no. 11

SELECT BIBLIOGRAPHY: Luciano Bellosi and Monica Folchi in Madrid 1990, pp. 172–77

PLATE 60A (JC CAT. 30)

Predella panel of an altarpiece: *Two Sainted Popes*

Mid-1470s

Tempera and tooled gold on panel with horizontal grain; overall 7¼ × 11¼ × ⅝" (18.5 × 28.7 × 1.5 cm), without added strip at the top, height 6" (15.3 cm)

John G. Johnson Collection, cat. 30

INSCRIBED ON THE REVERSE: *361* (printed on a piece of paper glued to the added strip at the top); *CITY OF PHILADELPHIA/ JOHNSON COLLECTION* (stamped twice in black ink); *N. 1430/ IN 1360* (in pencil)

TECHNICAL NOTES

In infrared reflectography, there is some faint indication of landscape. For further comments, see plate 60F (JC cat. 32).

PROVENANCE

See plate 60F (JC cat. 32)

COMMENTS

Two bearded popes, turned to the right, are shown kneeling. They each carry a book and a ferula, the papal staff, and wear a two-crowned tiara. For further comments, see plate 60F (JC cat. 32).

Bibliography
See plate 60F (JC cat. 32)

PLATE 60B (JC CAT. 33)

Predella panel of an altarpiece: *Saint Cyril of Constantinople(?) and an Elderly Carmelite Saint (the Prophet Elijah?)*

Mid-1470s

Tempera and tooled gold on panel with horizontal grain; overall 6⅞ × 11⅛ × ⅝" (17.5 × 28.5 × 1.7 cm), without added strip at the top, height 5⅝" (14.2 cm)

John G. Johnson Collection, cat. 33

INSCRIBED ON THE REVERSE: *356* (printed on a piece of paper glued to the added strip at the top); *CITY OF PHILADELPHIA/ JOHNSON COLLECTION* (stamped twice in black ink); *4* (in pencil, twice); *worms* (in pencil); *33* (in yellow crayon); *33/ IN 1359* (in pencil)

TECHNICAL NOTES
See plate 60F (JC cat. 32)

PROVENANCE
See plate 60F (JC cat. 32)

COMMENTS

To the left is a kneeling saint, facing forward but looking to the left. He is bald, has a long white beard and a Carmelite habit, and holds a book in his left hand. He may be Saint Cyril of Constantinople, who, before joining the Carmelite order and becoming its general, was said to have been commissioned by Pope Alexander III Bandinelli (reigned 1159–81) to try to bring about the union of the Eastern and Western churches. He appears in Carmelite breviaries from about 1399, when he was proclaimed one of the order's confessors and doctors,[1] and in a mural painting by Starnina (q.v.) of 1404 in the Carmine in Florence.[2]

To the right and facing right is another elderly, bearded saint in Carmelite robes. He holds a book in his right hand and gazes on a ball of fire in his left. He may be the Old Testament prophet Elijah, to whom the Carmelites traced their origins, and who is sometimes represented as a saint in a Carmelite habit.[3] The ball of fire in his hand refers to an episode in which Elijah implored God to cause an animal sacrifice to be lighted with fire from heaven: "Then the fire of the Lord fell, and consumed the holocaust, and the wood, and the stones, and the dust, and licked up the water that was in the trench" (3 Kings 18:38).

George Kaftal identified these saints as Carmelites (verbal communication, November 12, 1954). However, in the Johnson Collection's 1966 catalogue they were incorrectly named Saints Anthony Abbot and Anthony of Padua.

For further comments, see plate 60F (JC cat. 32).

1. Adriano Staring in *Bibliotheca sanctorum,* vol. 3, 1963, cols. 1316–17.
2. Berti and Paolucci 1990, repro. p. 87. The mural is now detached and in the church's convent. The figure identified as Saint Cyril is in a white habit and has an abbot's staff. Unfortunately, the head is missing.
3. See the center section of Pietro Lorenzetti's altarpiece executed in 1327 for San Niccolò al Carmine in Siena (fig. 39.6).

Bibliography
See plate 60F (JC cat. 32)

PLATE 60C (JC CAT. 28)

Predella panel of an altarpiece: *Virgin and Saints John the Baptist and Jerome Adoring the Christ Child*

Mid-1470s

Tempera and tooled gold on panel with horizontal grain; overall 6⅞ × 11⅜ × 1⅛" (17.5 × 28.9 × 2.8 cm), without added strip at the top, height 5½" (14 cm)

John G. Johnson Collection, cat. 28

INSCRIBED ON THE BAPTIST'S SCROLL: *ECCE AGNUS DEI* (John 1:29: "Behold the Lamb of God"); ON THE REVERSE: *360* (printed on a piece of paper glued to the added strip at the top); two red wax seals, one the stamp of Carlo Lasinio, with the letters *C* and *L* interlaced, and the other with three intertwined wreaths and the inscription *INSIGNE CAMPO SANTO DI PISA*; *CITY OF PHILADELPHIA/ JOHNSON COLLECTION* (stamped five times in black ink); *28* (in yellow crayon); *28* (in black crayon); *in 1352* (in black crayon)

TECHNICAL NOTES

This panel has not been thinned, and there are remnants of old, presumably original, wood dowels on the back, which would have attached the brace of the once boxlike predella. Originally gilt balusters divided the scenes. Here the baluster on the right is slightly damaged; the base of the one on the left is covered by Saint John the Baptist's cloak. For further comments, see plate 60F (JC cat. 32).

PROVENANCE

See plate 60F (JC cat. 32)

COMMENTS

In the center the Virgin kneels in prayer as the naked Christ Child sleeps on her mantle. John the Baptist, in a red mantle and a hair shirt, kneels to the left as he holds a scroll in one hand and a long cross in the other. On the right Saint Jerome, dressed in a white robe, beats his breast with a rock as he holds a string of prayer beads. For further comments, see plate 60F (JC cat. 32).

Bibliography
See plate 60F (JC cat. 32)

PLATE 60D (JC CAT. 29)
Predella panel of an altarpiece: *Two Youthful Martyrs*

Mid-1470s

Tempera and tooled gold on panel with horizontal grain; overall 6¾ × 11⅜ × 1⅜″ (17.2 × 28.8 × 3.5 cm), without added strip at the top, height 5¼″ (13.5 cm)

John G. Johnson Collection, cat. 29

INSCRIBED ON THE REVERSE: *357* (printed on a piece of paper glued to the added strip at the top; *no. 15* (in blue pencil on the added strip); *29* (in yellow crayon); *CITY OF PHILADELPHIA/ JOHNSON COLLECTION* (stamped twice in black ink); *29/ IN 1324* (in pencil); two red wax seals, one the stamp of Carlo Lasinio, with the letters *C* and *L* interlaced, and the other with three intertwined wreaths and the inscription *INSIGNE CAMPO SANTO DI PISA*

TECHNICAL NOTES

The panel has not been thinned. Some drawing is visible with the naked eye, such as the hatching in

the cloak of the figure on the right. For further comments, see plate 60F (JC cat. 32).

PROVENANCE

See plate 60F (JC cat. 32)

COMMENTS

To the left is a kneeling young man, facing left, who holds a palm of martyrdom. He wears fine clothes, including an undergarment with ermine trim. Next to him, kneeling forward and looking to the right, is another young man, also holding a palm of martyrdom. In his right hand there is what appears to be a quill pen. For further comments, see plate 60F (JC cat. 32).

Bibliography
See plate 60F (JC cat. 32)

PLATE 60E (JC CAT. 31)
Predella panel of an altarpiece: *Saints Agnes and Clare of Assisi(?)*

Mid-1470s

Tempera and tooled gold on panel with horizontal grain; overall 7⅛ × 11¼ × ⅝″ (18 × 28.5 × 1.7 cm), without added strip at the top, height 6″ (15.3 cm)

John G. Johnson Collection, cat. 31

INSCRIBED ON THE REVERSE: *CITY OF PHILADELPHIA/ JOHNSON COLLECTION* (stamped six times in black ink); *31 IN 1363* (in pencil)

TECHNICAL NOTES

Infrared reflectography revealed what appeared to be a landscape background as well as hatched drawing on the ground. For further comments, see plate 60F (JC cat. 32).

PROVENANCE

See plate 60F (JC cat. 32)

COMMENTS

To the left is Saint Agnes, turned toward the left, holding a palm of martyrdom and a book on which a lamb lies. The lamb is a symbol of her name, which derives from *agnus*, the Latin word for the animal. Next to her is a haloed nun who reads a book and wears a black habit, a gray cape with a red cross on the shoulder, and a black and white veil. In the 1966 catalogue of the Johnson Collection, she was identified as a Dominican nun, but the habit belongs to the Poor Clares, or Franciscan nuns, who dress in a dark habit and veil and a white cape, whereas the Dominicans wear the opposite. The figure here is likely Clare of Assisi. For further comments, see plate 60F (JC cat. 32).

Bibliography
See plate 60F (JC cat. 32)

PLATE 60F (JC CAT. 32)
Predella panel of an altarpiece: *Saints Alberto of Trapani and Marcarius of Egypt(?)*

Mid-1470s

Tempera and tooled gold on panel with horizontal grain; overall 7⅛ × 11 × ⅝″ (18 × 28.1 × 1.7 cm), without added strip at the top, height 5⅞″ (14.9 cm)

John G. Johnson Collection, cat. 32

INSCRIBED ON THE REVERSE: *IN 1360 32* (in pencil); *32* (in yellow crayon); *CITY OF PHILADELPHIA/ JOHNSON COLLECTION* (stamped twice in black ink)

TECHNICAL NOTES

Like its companions from the same predella (plates 60A–E [JC cats. 28–31, 33]), this panel consists of a single plank of wood; it has been cut at the top and sides. A strip of wood, about 1¼ to 1½″ (3.1 to 3.7 cm) wide, has been added to the top of this and other panels, probably to hide damage that occurred during the predella's disassembly. More recently attached strips of wood on the sides and bottom have not been measured or illustrated.

As in all the panels, the background and ground have been repainted to mask the enlargement of the panel and the elaborate side balusters that originally served as a fictive frame, decorated with punch work and gilding, that divided the scenes of the predella. Infrared reflectography and X-radiography showed that in all the panels the fixtures and the balusters cast shadows from a light source at the left (fig. 60.1); the shadows extended to the horizon line, which was drawn across the panel. Infrared reflectography of this panel also revealed what appeared to be a landscape background as well as hatched drawing on the ground.

Later oil gilding covers the original punched decoration of the gold halos. The paint surface in all the panels is in fair condition.

PROVENANCE

The predella that included plates 60A–F (JC cats. 28–33) may have originally come from the church of Santa Maria del Carmine in Florence. In the early nineteenth century it formed part of Carlo Lasinio's collection in the Camposanto of Pisa. Johnson purchased plate 60C (JC cat. 28) and two other, unidentified panels from the same predella from Ludovico de Spiridon in 1905 (see correspondence from Spiridon to Johnson dated Paris, August 13, 1905) for 7,000 French francs. He claimed that they, as well as a painting of the *Virgin and Child* by Vincenzo Catena, a predella then attributed to Bartolo di Fredi (but in fact by Taddeo di Bartolo [q.v.]; see plate 78 [JC cat. 95]), and a *Virgin and Child* assigned to the atelier of Carlo Crivelli, came from a "Florentine gentleman," who may have been a

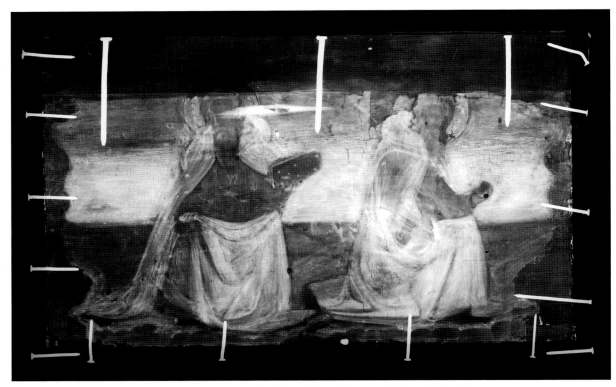

FIG. 60.1 X-radiograph of plate 60B, showing the original divisions of the gilt frame at the left and right side

member of the Capponi family. Spiridon tried to have Johnson recommend the three remaining predella panels by Neri di Bicci to the Philadelphia collector Peter A. B. Widener, but Johnson acquired them for himself sometime before 1913.

COMMENTS

To the left, looking back, is a young tonsured monk wearing the Carmelite habit of a black tunic and a white cloak. He carries in his right hand a stem of lilies and in his left a book. These are attributes of Saint Alberto of Trapani, also called Alberto Siculus. In 1420 all houses of the Carmelite order were instructed to have a rayed, or haloed, image of him.[1] His cult was given papal approval by Calixtus III Borgia in 1457 and was confirmed by Sixtus IV Della Rovere in 1476.[2]

To the right, gazing and pointing at a skull in his hand, is an elderly saint with a long beard; he also carries a staff. His habit consists of a light brown cloak over a dark gray garment. This hermit monk may be Marcarius of Egypt, who, while contemplating a skull, had a vision of the torments of the unredeemed. He is shown in the early trecento murals of the Camposanto of Pisa.[3]

This panel, along with plates 60A–E (JC cats. 28–31, 33), formed part of a predella (fig. 60.2) that was made from a single plank of wood. In 1905 Ludovico de Spiridon was selling the predella panels separately. Their original order, from left to right, can be determined by examination of the wood grain: a now-missing, unidentified panel; *Two Sainted Popes* (plate 60A [JC cat. 30]); *Saint Cyril of Constantinople(?) and an Elderly Carmelite Saint (the Prophet Elijah?)* (plate 60B [JC cat. 33]); *Virgin and Saints John the Baptist and Jerome Adoring the Christ Child* (plate 60C [JC cat. 28]); *Two Youthful Martyrs* (plate 60D [JC cat. 29]); *Saints Agnes and Clare of Assisi(?)* (plate 60E [JC cat. 31]); and *Saints Alberto of Trapani and Marcarius of Egypt(?)* (plate 60F [JC cat. 32]).

The presence of a number of Carmelite saints in the scenes suggests that the predella was made for an altarpiece in a Carmelite church. In an entry in his *Ricordanze* dated June 26, 1453, Neri di Bicci (1453–75, Santi ed. 1976, p. 8, no. 13) details the purchase and preparation of some wood planks "for work in the Carmine" (per lavoro del Charmino). He makes no further mention of this project, but it could well have been something for the lay confraternity known as the company of Santa Maria delle Laudi e

di Sant'Agnese, which met in the Carmine. Neri di Bicci was a member of this company, and over the years he held a number of official posts in its organization.[4] In addition to the Carmelite saints, the presence of Saint Agnes, to whom the company was also dedicated, would seem to confirm that the predella belonged to this group. Despite Neri's comment in the *Ricordanze*, the predella may not have been painted until after 1457, the year Calixtus III Borgia gave official approval to the cult of the Carmelite Alberto of Trapani, or after May 31, 1476, when it was confirmed by Sixtus IV Della Rovere. The predella probably dates after Sixtus's declaration, as the craftsmanship is not as high as in most of the artist's mid-career productions. It may have been made in the early 1470s, when Neri is described in documents several times as holding the position of *camarlingo* in the company of Santa Maria delle Laudi.

The arrangement of a group of saints around a central image was a common formula in Neri di Bicci's predellas. Often the figures are separated by fictive painted or gilt pilasters or columns, which in the Johnson panels resemble elaborate candelabra in the antique style that were, however, painted over when the predella was disassembled. Infrared

(text continues on page 338)

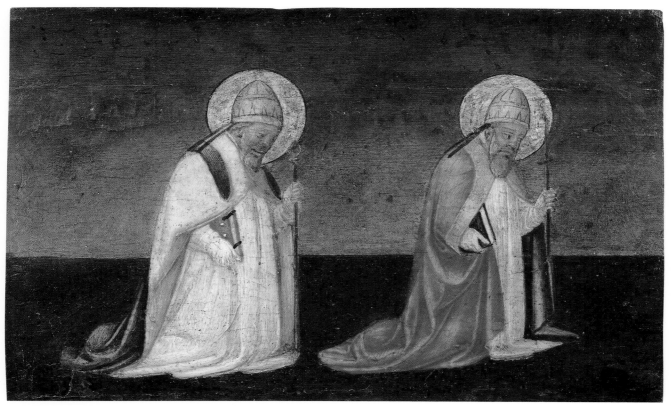

PLATE 60A

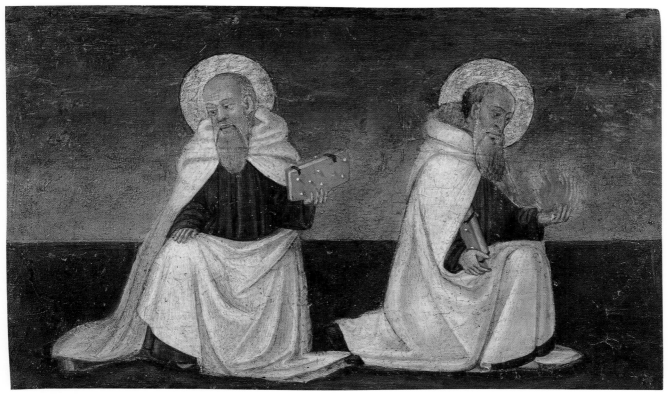

PLATE 60B

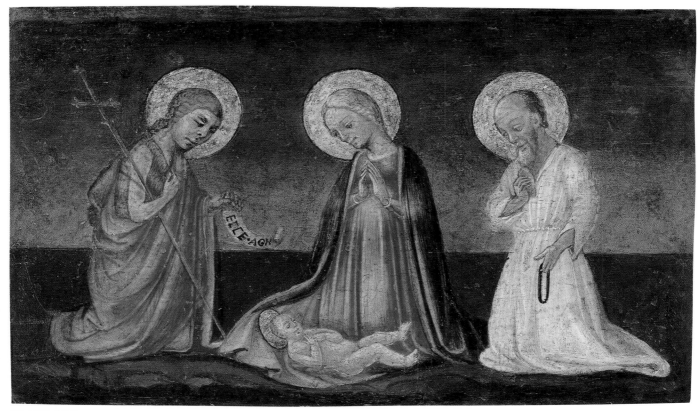

PLATE 60C

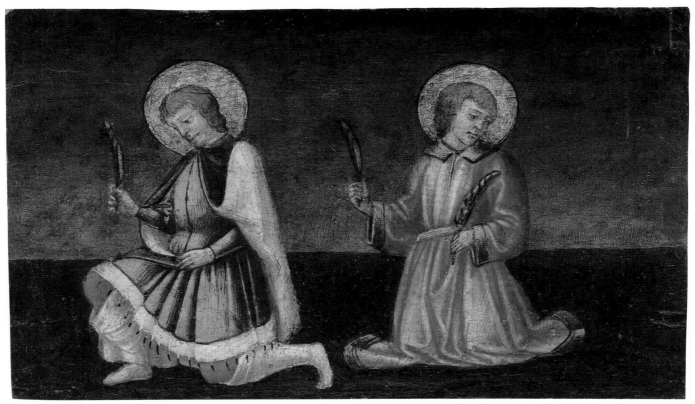

PLATE 60D

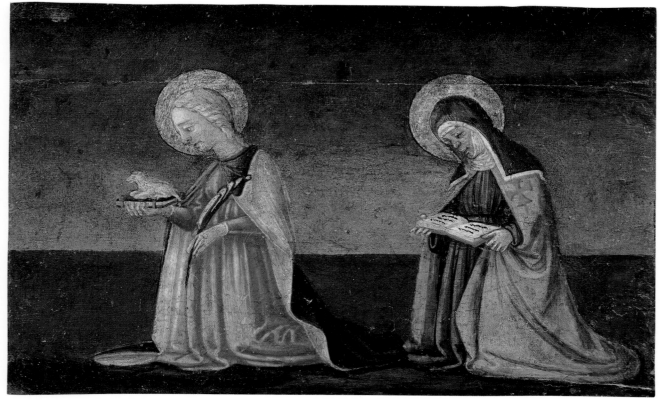

PLATE 60E

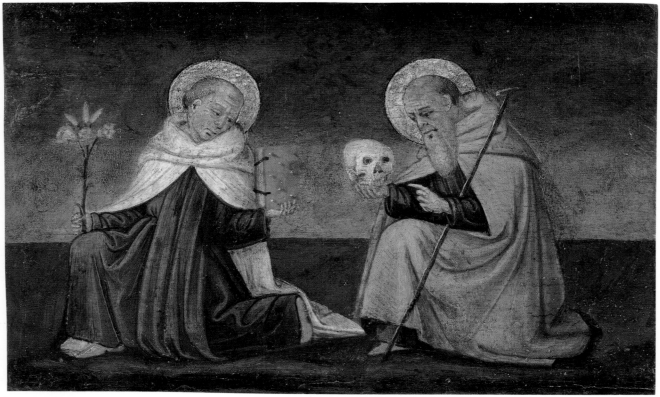

PLATE 60F

PL. 60A PL. 60B PL. 60C PL. 60D PL. 60E PL. 60F

FIG. 60.2 Original sequence of Neri di Bicci's predella, mid-1470s. Left to right: missing panel, PLATES 60A–F

reflectography indicates that there may have been some landscape elements in the background and that the sky may have been differentiated by clouds and other atmospheric effects.

1. An early image, originally in the Carmine in Florence, is found in the *Virgin and Child with the Blessed Angela of Bohemia, and Saints Angelus and Alberto of Trapani* (c. 1430) by Filippo Lippi, now in the Museo d'Arte Antica, Castello Sforzesco, Milan (no. 551; Ruda 1993, color plate 21).
2. Ludovico Saggi in *Bibliotheca sanctorum,* vol. 1, 1961, cols. 676–81.
3. Kaftal 1952, col. 653, fig. 748.
4. Anabel Thomas (letter dated London, October 9, 1995) has written that Neri definitely served as *capitano* between January and July 1454; as *sindaco* in July 1466; as *procuratore* in 1466; and as *camarlingo* in May and October 1471, June 1472, and April 1473. See also Thomas 1995, p. 145; and Barr 1989. See also Eckstein 1995, esp. pp. 44–49, 51–53.

Bibliography
Mather 1906, p. 351; Berenson 1913, p. 20; Berenson 1932, p. 388; Berenson 1936, p. 344; Johnson 1941, p. 11; Berenson 1963, p. 157; Sweeny 1966, p. 56; Fredericksen and Zeri 1972, p. 148; Philadelphia, 1994, repros. pp. 220–21

NICCOLÒ DI SEGNA

SIENA, DOCUMENTED 1331–1348,
SANSEPOLCRO

Son of the painter Segna di Bonaventura, Niccolò presumably trained with his father. After Segna's death, Niccolò set up on his own, signing a lease for a workshop in November 1331. However, his continued dependence on an old Duccesque formula derived from his father's practice is still evident in his *Virgin and Child*[1] from the *pieve* of San Galgano in Montesiepi, commissioned in 1336.[2] Niccolò's only other dated work is the crucifix of 1345 from the church of the Carmine in Siena,[3] which demonstrates the influence of Pietro Lorenzetti (q.v.).

As no other documents or dated works exist, establishing the chronology of the rest of Niccolò di Segna's paintings depends on identifying stylistic tendencies. In this regard, the large disassembled polyptych from the church of San Francesco in Prato is a hodgepodge.[4] Like the *Virgin and Child* from Montesiepi, the center section,[5] now in the Fondazione Giorgio Cini in Venice, recalls Duccio. The other panels, however, show the influences of Ugolino di Nerio (q.v.) and Pietro Lorenzetti, which suggests a date in the late 1330s. Niccolò's later work is less eclectic, because he eventually settled firmly in the orbit of Lorenzetti. Representative of this period is the 1345 crucifix and wall paintings in San Clemente a Santa Maria dei Servi in Siena.[6]

Niccolò had a brother named Francesco (documented 1328–39) who was also a painter; it has recently been shown (Polcri 1995) that it was Niccolò and not he who painted the altarpiece of the Resurrection in Sansepolcro.[7] Now in the cathedral, this altarpiece was probably painted mid-century for a Camaldolese church, sometime after Niccolò painted a lost altarpiece in 1346–48 for Sant'Agostino in the same town. Another artist who has been confused with Niccolò is the Master of the Buonconvento Crucifix,[8] who in fact was active in the 1320s and earlier.

1. This work has been stolen; Stubblebine 1979, fig. 477.
2. Bacci 1935.
3. Siena, Pinacoteca Nazionale, no. 46; Stubblebine 1979, figs. 495–97.
4. See the reconstruction by Henk van Os and reproductions in Groningen 1969, cats. 30–31. Not illustrated in van Os's reconstruction are *Two Angels* (Cleveland Museum of Art, nos. 62.257, 62.258; Cleveland 1974, figs. 48A–48B); *Redeemer Blessing* (Raleigh, North Carolina Museum of Art, no. Kress 219; Cleveland 1974, fig. 48A); and *Saint Francis* and *Male Saint* (Moscow, State Pushkin Museum of Fine Arts, nos. 2470, 2471; Kustodieva 1979, fig. 52).
5. Stubblebine 1979, fig. 480.
6. The murals are in the Petroni and Spinelli chapels. The chapel dedicated to John the Baptist and John the

Evangelist (now the Spinelli chapel) was financed by one Giovanni da Firenze in 1315, but the murals date after 1345, because the Blessed Pellegrino Laziosi is included among the images of the blessed members of the Servite order, and he did not die until around that year. The Saint Lawrence chapel was founded in memory of Guglielmo Petroni and his wife, Agnese Malavolti. Its murals probably date around the same period as those in the other chapel. See Lusini 1908, repros. pp. 18, 21–22, 25–28, 31; Carli 1981, figs. 195–97; Volpe 1989, repro. p. 297.
7. Stubblebine 1979, figs. 545–47.
8. On him, see Serena Padovani in Padovani and Santi 1981, pp. 18–20.

Select Bibliography
F. Mason Perkins in Thieme-Becker, vol. 25, 1931, p. 439; Berenson 1932, pp. 396–97; Bacci 1935; Bacci 1944, pp. 44–46; Berenson 1968, pp. 299–300; *Bolaffi*, vol. 8, 1975, pp. 139–40; De Benedictis 1976; De Benedictis 1979, pp. 8–9, 93–95; Stubblebine 1979, esp. pp. 138–41, 153–55; Giulietta Chelazzi Dini in Siena 1982, p. 226; Giovanna Damiani in Siena 1982, pp. 92–94; Monica Leoncini in *Pittura* 1986, p. 642; Polcri 1995; P. Torriti 1999; Beatrice Franci in Bagnoli et al. 2003, pp. 364–72; Alessandro Bagnoli in Bagnoli et al. 2003, p. 376

PLATE 61 (JC CAT. 90)

Crucifixion with the Virgin and Saints John the Evangelist and Mary Magdalene

Early 1330s
Tempera and tooled gold on panel with vertical grain; 13⅝ × 5⅜ × ¼″ (34.6 × 13.8 × 0.5 cm)
John G. Johnson Collection, cat. 90

INSCRIBED ON THE CROSS: *INRI* [IESUS NAZARENUS, REX IUDAEORUM] (John 19:19: "JESUS OF NAZARETH, THE KING OF THE JEWS")

PUNCH MARKS: See Appendix II

EXHIBITED: Philadelphia Museum of Art, John G. Johnson Collection, Special Exhibition Gallery, *From the Collections: Paintings from Siena* (December 3, 1983–May 6, 1984), no catalogue

TECHNICAL NOTES
The panel is thinned and mounted on plywood. A crack runs down most of the center. It has also been cut on all sides, although there is some evidence of a gesso barbe at the bottom. A margin of bare wood once covered by an attached molding is still present at the bottom edge. The very tip of the peak has new gesso, gilding, and punch work. The paint surface is worn throughout. The wear reveals that the earth-green underpainting of John's hands covered

a wider area than the hands themselves. This type of broader underpainting was also noted in Benozzo Gozzoli's *Man of Sorrows* (plate 35 [JC inv. 1305]). The inscription on the cross was executed in sgraffito, and much of the paint around the characters has flaked away. Infrared reflectography revealed no visible changes or underdrawing.

Around 1909 Luigi Cavenaghi cleaned the panel in Milan at the behest of Herbert Horne. In 1941 David Rosen removed the cradle, treated the panel with wax, and mounted it on a plywood panel. He also cleaned and retouched the painting.

PROVENANCE
John G. Johnson saw this panel at Herbert Horne's house in Florence in the summer of 1909. Horne wrote to him from Florence on March 25, 1912, offering to sell him the painting, which he attributed to Lippo Memmi:

> Do you remember that when you paid me a visit here, in Florence (was it three summers ago?) I showed you a little "Crucifixion" by Lippo Memmi of Siena: and you asked me if I would part with it? I answered, that I would send it first to Cavenaghi (for it was very dirty), and when it came back, I would let you know. Well, it came back just a couple of weeks ago! But it has gained infinitely, by its long sojourn at Milan. It is now in a pure & brilliant state. The photo makes it look black. It measures only 34 cm [13⅜″] high × 13½ cm [5¼″] wide. It is a late work of the period of the larger crucifixion in the Vatican Gallery.[1]

The painting was shipped to Johnson on April 19, 1912, at an insured value of 3,500 lire.

COMMENTS
Christ is shown hanging on the cross with blood flowing down his arms and out of the wound in his side. The Virgin and Saint John the Evangelist stand in mourning at the left and right. Mary Magdalene embraces the foot of the cross. The nest of pelicans above the cross symbolizes Christ's sacrifice, since, according to medieval legend, the bird would nourish her young with the blood of her own heart.

The *Crucifixion* borrows elements from both Ugolino di Nerio (q.v.) and Simone Martini, which suggests a date in the early 1330s. Saint John's pose comes from one seemingly invented by Ugolino, who used it in his *Crucifixion* of about 1325,[2] possibly once in the church of Santa Trinita in Florence, and another one (fig. 61.1) of about the same date, from the Franciscan convent of San Romano in Empoli.[3] Christ's elongated arms and low hanging

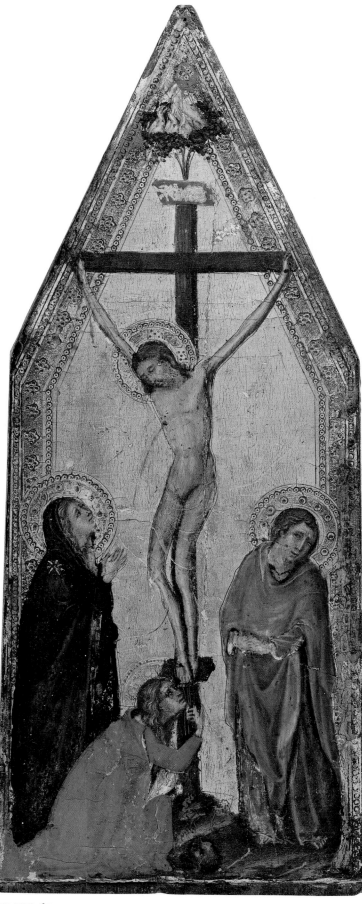

position are modeled on prototypes by Simone Martini from to the early to mid-1320s: the *Crucifixion* in the Fogg Art Museum (fig. 61.2) and the *Crucifixion* from the polyptych of about 1326 once belonging to Matteo Orsini and now in the Koninklijk Museum voor Schone Kunsten in Antwerp.[4]

Bernhard Berenson (1913, 1932, 1936, 1968) attributed the Johnson painting to Ugolino di Nerio on the basis of its Duccesque characteristics. Gertrude Coor (1955) placed it with Ugolino's following, and Burton Fredericksen and Federico Zeri (1972) called it simply fourteenth-century Sienese. Miklós Boskovits, during a visit to the Johnson Collection in November 1978, attributed it to Niccolò di Segna.[5] Stylistically, the *Crucifixion* compares with a crucifix (fig. 61.3) attributed to Niccolò di Segna, formerly in the Adolphe Stoclet Collection in Brussels.[6]

While it is possible that the Johnson Collection's *Crucifixion* was the valve of a diptych, panels with such sharply peaked gables are rare in diptychs. Instead, the picture may have been the pinnacle of an altarpiece.

1. Vatican City, Pinacoteca Vaticana, inv. 156; Volbach 1987, fig. 115.
2. Now in the collection of the earl of Crawford and Balcarres; Stubblebine 1979, fig. 391.
3. This may have originally been in the Bardi di Vernio chapel of Santa Croce in Florence; see Maginnis 1983.
4. No. 257; Martindale 1988, plate 120.
5. Boskovits (1982, p. 502) published this attribution in 1982 in a review of James H. Stubblebine's *Duccio di Buoninsegna and His School*. The painting is not reproduced in Stubblebine's book.
6. Sold London, Sotheby's, March 24, 1965, lot 10 (as Niccolò di Segna).

Bibliography
Berenson 1913, p. 52 (Ugolino di Nerio); Van Marle, vol. 2, 1924, p. 108; Berenson 1932, p. 583; Berenson 1936, p. 501; Johnson 1941, p. 17 (Ugolino di Nerio); Coor 1955, p. 159; Sweeny 1966, p. 438 (Ugolino di Nerio); Berenson 1968, p. 438; Fredericksen and Zeri 1972, p. 240 (Siena, fourteenth century); Boskovits 1982, p. 502; Philadelphia 1994, repro. p. 221; Frinta 1998, p. 452

PLATE 61

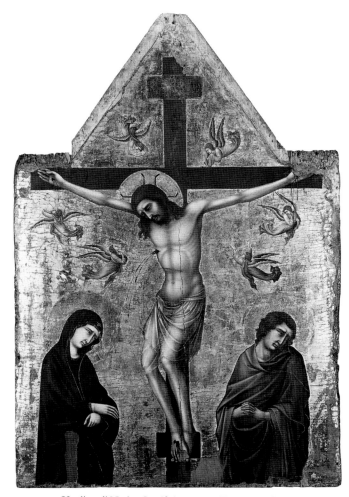

FIG. 61.1 Ugolino di Nerio. *Crucifixion,* c. 1325. Tempera and tooled gold on panel; 53⅛ × 35⅜″ (135 × 90 cm). From Empoli, convent of San Romano. © Madrid, Fundación Colección Thyssen-Bornemisza, no. 412

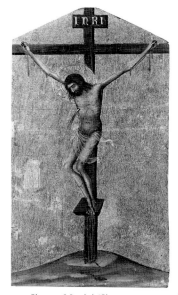

FIG. 61.2 Simone Martini (Siena, c. 1284–1344). *Crucifixion,* c. 1320. Tempera and tooled gold on panel; 9¾ × 5¼″ (24.8 × 13.4 cm). Cambridge, Harvard University Art Museums, Fogg Art Museum, Hervey E. Wetzel Bequest Fund, no. 1919.51

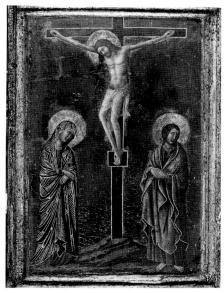

FIG. 61.3 Attributed to Niccolò di Segna. *Crucifix,* c. 1330. Tempera and tooled gold on panel; 11¾ × 7¾″ (29.8 × 19.7 cm). Last recorded Brussels, Adolphe Stoclet Collection. Present location unknown

Niccolò di Tommaso

FLORENCE, C. 1346–1376, FLORENCE

Niccolò di Tommaso's first-known work is a mural dated 1360 in the Palazzo Comunale of Pistoia.[1] The style suggests that the artist trained in the Florentine workshop of Andrea di Cione, called Orcagna, and his brothers Nardo and Jacopo (q.v.) di Cione. Niccolò, in fact, witnessed Nardo's last will and testament on May 21, 1365. There has been some question as to whether he designed the two most important altarpieces produced in the workshop when it was under the stewardship of Jacopo, for an otherwise anonymous Niccolò was reimbursed for the layout of the altarpiece of San Pier Maggiore in Florence in 1370 and for the design of the Florentine mint's *Coronation of the Virgin* in 1372.[2] However, it seems that this Niccolò was not Niccolò di Tommaso but Niccolò di Pietro Gerini (q.v.). In any case, it is known that Niccolò di Tommaso undertook other activities, including the role of architectural consultant for the cathedral of Florence in 1366 and 1367. In 1370 he began work on the now-lost high altarpiece of San Giovanni Fuorcivitas in Pistoia,[3] receiving final payment for this commission in 1372. In November of that year he was also paid for murals in the Antonine convent of Pistoia, better known as the Tau.[4] Like all the establishments of the order, it functioned as a hospital.

Through the founder of the Tau, Fra Giovanni Guidotti, Niccolò di Tommaso procured a prestigious commission for an altarpiece[5] for the Neapolitan church of the Antoniani a Foria, where Guidotti served as prior from about 1369. The arms on this picture indicate that it was paid for by Queen Giovanna I of Naples. In Naples Niccolò also painted a crucifix[6] for the confraternity of the Disciplina della Croce and a mural for the Del Balzo castle of Casaluce.[7]

The precise date of Niccolò's Neapolitan activity is not known. It could fall between 1372 and 1376, but a date before the Tau murals in Pistoia is not impossible. Few documents related to Niccolò exist after 1372, and the painter seems to have died between May and August 1376.

After his death Niccolò di Tommaso figures as a character in a short story by Franco Sacchetti that recounts a professional debate about who was the most successful painter in Florence.[8] The party finally decided that Florentine women outranked any artist, because their cosmetics were so deceptive.

1. Boskovits 1975, plate 32. It depicts Saints Zenobius and James Major holding up a monument with an image of the Virgin. Boskovits (1975, pp. 203–4 n. 111) proposed that the monument had been painted several decades earlier by Dalmasio (q.v.).
2. On this problem, see Jacopo di Cione, plate 37 (JC cat. 4).
3. See Ladis 1989, who identifies a possible component of it. The final payment came in 1372.
4. Carli 1977. On that very same day he is recorded as working in the sacristy of the cathedral of Pistoia (Gai 1970, pp. 78–80).
5. On deposit in Naples, Museo e Gallerie Nazionali di Capodimonte; F. Bologna 1969a, VII-78–79, figs. 101–3.
6. On deposit in Naples, Museo e Gallerie Nazionali di Capodimonte; F. Bologna 1969a, VII-83, fig. 112 (detail).
7. F. Bologna 1969a, VII-80–82, figs. 104–10.
8. Sacchetti before 1399, Pernicone ed. 1946, no. 136, pp. 300–303.

Select Bibliography
Offner 1927, pp. 109–26; Hans D. Gronau in Thieme-Becker, vol. 25, 1931, pp. 436–40; Offner 1956; Berenson 1963, pp. 161–63; F. Bologna 1969a, pp. 326–28; *Bolaffi*, vol. 8, 1975, pp. 140–45; Boskovits 1975, pp. 35–36, 202–4 nn. 108–15; Carli 1977; Tartuferi 1985, pp. 3–6, 11–13 nn. 1–14; Ladis 1989; Tartuferi 1993; Skaug 1994, esp. pp. 164–68; Skaug 2001; Skaug 2003

PLATE 62 (JC CAT. 120)

Triptych: (center) *Saint Bridget's Vision of the Nativity;* (base) *Virgin and Child;* (left wing) *Annunciate Angel and Saints Anthony Abbot, Catherine of Alexandria, Nicholas of Bari, and James Major;* (right wing) *Virgin Annunciate and the Crucifixion*

c. 1377

Tempera and tooled gold on panel with vertical grain; center with base 25 × 11⅜ × 1⅝″ (63.5 × 29 × 4 cm), without base 21¾ × 10⅜ × 1″ (55.2 × 26.5 × 2.5 cm), painted surface 19⅞ × 9¼″ (50.5 × 23.5 cm); left wing 21⅛ × 5 × 1⅛″ (53.6 × 12.7 × 3 cm), painted surface 18⅝ × 3⅞″ (47.3 × 10 cm); right wing 21 × 5 × 1⅛″ (53.5 × 12.7 × 2.8 cm), painted surface 18⅝ × 4″ (47.2 × 10.3 cm)

John G. Johnson Collection, cat. 120

INSCRIBED ON THE VIRGIN'S HALO: *AVE MARIA GRATIA* (Luke 1:28: "Hail [Mary], [full of] grace"); EMANATING FROM GOD THE FATHER: *HIC EST FILIUS MEUS* (Matthew 3:17: "This is my [beloved] Son") (in white on the gold ground); EMANATING FROM THE SERAPH ON THE LEFT: *GLORIA IN EXCELSIS DEO* (Luke 2:14: "Glory to God in the highest") (in mordant gilding); EMANATING FROM THE SERAPH ON THE RIGHT: *[E]T IN TERRA. PAX HOMNIBUS* (Luke 2:14: "And on earth peace to men of good will") (in mordant gilding); EMANATING FROM THE VIRGIN: *VIAT. DEUS MEUS DOMINUS MEUS FILIUS*

MEUS ("Come my God, my Lord, my Son") (in mordant gilding); ON THE CROSS: *I.N.R.I.* [IESUS NAZARENUS, REX IUDAEORUM] (John 19:19: "JESUS OF NAZARETH, THE KING OF THE JEWS")

PUNCH MARKS: See Appendix II

EXHIBITED: Philadelphia Museum of Art, Sixty-ninth Street Branch, *Religious Art of Gothic and Renaissance Europe* (December 1, 1931–January 4, 1932), no catalogue

TECHNICAL NOTES

Except for the right wing, the panel has not been planed, and tool marks and original red and black paint can be seen on the reverse of the main panel and left wing. The edges of the panels have a deep red paint that is not original. The location of the original hinges is indicated by holes on the back of the main panel and the sides. The base is attached to the main panel by nails that are visible on the reverse.

The gold ground is worn in the upper part of the central panel and in the base; otherwise it is in good to fair condition. A white mordant was used for gilding the inscriptions and some decorative details. Other decoration was executed in sgraffito. One of the most pleasant effects is the shimmering gold of the base, which was achieved by using a grain punch.

The outlines of the figures to be set against the gold ground were incised in the gesso, and there is also visible drawing. However, infrared reflectography did not reveal any underdrawing that was not visible on the surface. There is sgraffito decoration in the wings of the cherubim and seraphim, and in the repeating bird motif in the ground of the left wing.

In 1941 David Rosen aggressively cleaned the painting, and the paint is now badly abraded. The photograph used in Berenson's 1913 catalogue of the collection (fig. 62.1) suggests far less abrasion of the paint at that time, and on March 13, 1920, Hamilton Bell and Carel de Wild had noted that the work was in a good state. But in Rosen's effort to remove the darkened surface of the red, presumably vermilion, the robes of Saints Nicholas and Mary Magdalene were badly abraded. The ultramarine robes in the right wing also have extensive damage. There is old loss in the Virgin and Child in the base as well. The best-preserved parts are the saints in the left wing (excluding Anthony Abbot's face) and the flesh tones of the Virgin Annunciate in the right wing.

In 1920 de Wild repaired the frame, apparently reattaching and regilding the original moldings and removing the ornament on the upper edges. The present hinges date to Rosen's treatment.

PROVENANCE

A bill from the dealer Georges B. Brauer of 57 rue Pigalle, Paris, dated July 24, 1910, which reads,

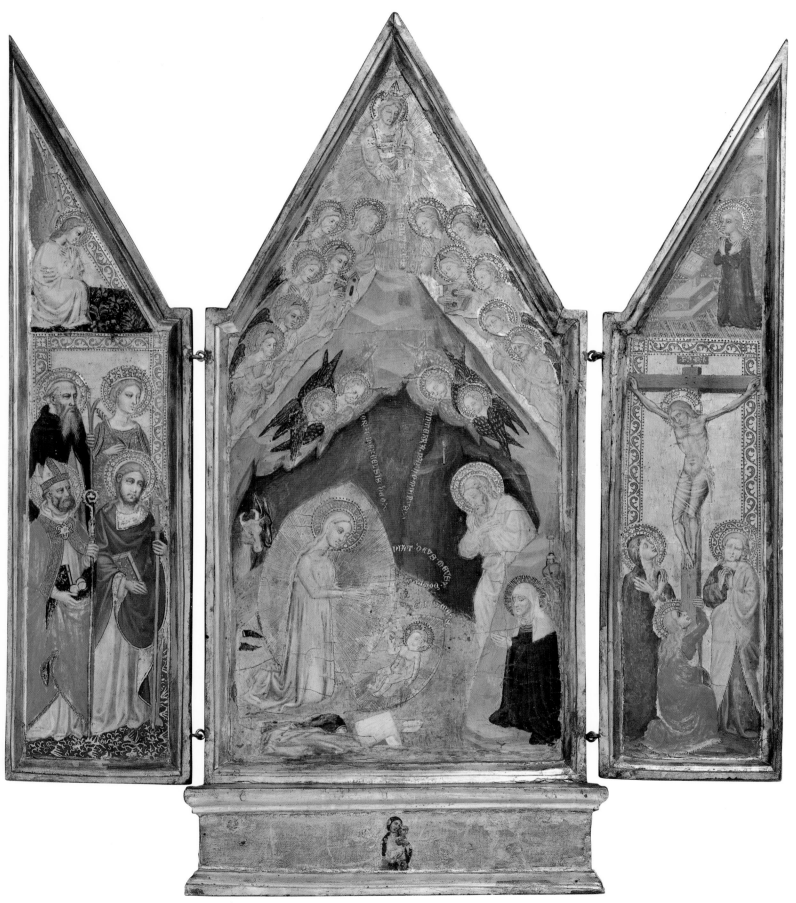

PLATE 62

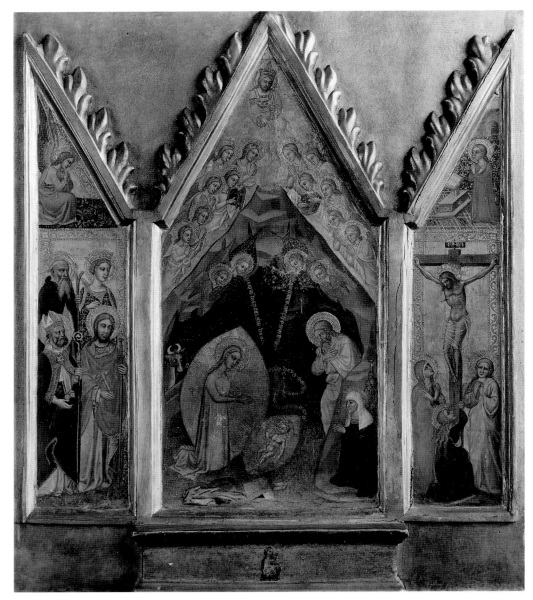

FIG. 62.1 Photograph of plate 62 as it appeared in 1913

God the Father, wearing a triangular crown and accompanied by a heavenly host, looks down from above. Inscriptions emanate from him, the Virgin, and the two seraphim.

This unusual depiction, including the inscriptions and all the details, comes from Bridget's account of her vision, which occurred during a visit to Bethlehem on March 13, 1372:

> When I was present by the manger of the Lord in Bethlehem . . . I beheld a virgin of extreme beauty. . . . well wrapped in a white mantle and a delicate tunic, through which I clearly perceived her virgin body. . . . With her was an old man of great honesty, and they brought with them an ox and an ass. These entered the cave, and the man, after having tied them to the manger, went outside and brought to the virgin a burning candle; having attached this to the wall he went outside, so that he might not be present at the birth. Then the virgin pulled off the shoes from her feet, drew off the white mantle, that enveloped her, removed the veil from her head, laying it by her side, thus remaining in her tunic alone with her beautiful golden hair falling loosely down her shoulders. Then she produced two small linen cloths and two woollen ones, of exquisite purity and fineness, that she had brought, in which to wrap up the child who was to be born; and two other small articles with which to cover and bind his head, and these she put down beside her in order to use them in due time. . . . And when all was thus prepared, the virgin knelt down with great veneration in an attitude of prayer, and her back was turned to the manger, but her face was lifted to heaven, towards the east. Thus with her hands extended and her eyes fixed on the sky she was standing as in ecstasy, lost in contemplation, in a rapture of divine sweetness. And while she was standing thus in prayer, I saw the child in her womb move and suddenly in a moment she gave birth to her son, from whom radiated such an ineffable light and splendour, that the sun was not comparable to it, nor did the candle, that St Joseph had put there, give any light at all, the divine light totally annihilating the material light of the candle, and so sudden and instantaneous was this way of bringing forth, that I could neither discover nor discern how, or by means of which member, she gave birth. Verily though, all of a sudden, I saw the glorious infant lying on the ground naked and shining. His body was pure from any kind of soil and impurity. Then I heard also the singing of the angels, which was of miraculous sweetness and great beauty. . . . When therefore the virgin felt, that she had already borne her child, she immediately worshipped him, her head bent down and her hands clasped, with great honour and reverence and said unto him, Be welcome my God, my Lord and my Son. . . . When this was done, the old man entered and prostrating himself to the floor, he wept for joy.[1]

"Vendu Monsieur John Johnson/ Philadelphia/ Tryptique peinture florentine du XIV siècle Fr 15000" (sold to Mr. John Johnson/ Philadelphia/ Triptych A Florentine picture of the 14th century 15,000 francs), probably refers to the purchase of this painting.

COMMENTS

There are four saints in the left wing: Anthony Abbot, with a walking stick; Catherine of Alexandria, with a crown, a martyr's palm, and a spiked wheel; the bishop Nicholas of Bari, with the three golden balls that he gave to an impoverished gentleman for his daughters' dowries; and James Major, with a pilgrim's staff. Above, the Annunciate Angel Gabriel kneels in a green meadow.

In the right wing there is a scene of the Crucifixion with the mourning Virgin and John the Evangelist, and Mary Magdalene embracing the cross. Above, the Virgin Annunciate kneels before a lectern.

The center section shows the vision of the Nativity of Saint Bridget of Sweden (1302–1373; canonized 1391), who kneels in prayer outside a grotto. She has a rayed halo and wears a black habit and white veil; a pilgrim's canteen hangs behind her. Inside the grotto, the Virgin kneels in adoration of the Christ Child. Her long blond hair is loose, and her mantle and shoes lie around her. Jesus is naked, but his swaddling clothes are on the ground in front of him. Joseph, folding his arms across his breast, is about to kneel. Rays of light form golden mandorlas around Christ and the Virgin, and a candle illuminates the back of the dark grotto. Two seraphim and two cherubim hover at the opening.

FIG. 62.2 (*above*) Niccolò di Tommaso. *Saint Bridget's Vision of the Nativity*, c. 1373–77. Tempera and tooled gold on panel; 17⅛ × 21⅛″ (43.5 × 53.8 cm). Vatican City, Pinacoteca Vaticana, no. 137 (172)

FIG. 62.3 (*right*) Neapolitan School. *Revelation of Saint Bridget of Sweden*, c. 1377. Tempera and gold on parchment; 10⅝ × 7⅜″ (26.9 × 18.6 cm). New York, The Pierpont Morgan Library, M.498, folio 4 verso

Immediately after her vision, Bridget dictated it to secretaries, who translated her account from Swedish to Latin. She returned to Rome via Naples in February 1373. By March she was in Rome, where she died in late July. At the time of her death, her principal secretary, Alfonso Pecha di Jaén, was in Avignon, bringing the last of her visionary revelations to Pope Gregory XI de Beaufort. In 1375 Alfonso began working on a final text of all of Bridget's visions. It was finished in early 1377, when the canonization process was officially initiated. Alfonso's personal copy of the revelations (fig. 62.3) was illuminated by a Neapolitan painter in these same years. In a letter written on January 15, 1378, Alfonso remarked on the many requests he received for copies of her accounts.[2] His letter contains a postscript written by Bridget's daughter Karin Ulfsdotter, in which she comments on the many images of her mother that existed in Italian churches; she noted that even the pope kept one in his bedroom. Four portraits of Bridget were known to exist in Neapolitan churches.[3] When Bridget was canonized in 1391, a Neapolitan pope, Boniface XI Tomacelli, was in office.

Niccolò di Tommaso's triptych in the Johnson Collection shows Bridget with the rays of the beatified, indicating that it was made before her canonization. This is also the case with two other paintings by Niccolò, one in the Pinacoteca Vaticana (fig. 62.2) and the other in the Yale University Art Gallery, New Haven.[4] Of the three, the Johnson picture is the most important.

At least one other depiction of Bridget's vision of the Nativity was painted before her canonization, for in 1380 Nicola Orsini, the lord of Nola, near Naples, and one of Bridget's former protectors, testified before a commission gathering evidence for Bridget's canonization about a painting in Naples "representing the birth of Christ in the manner in which the said lady related that it had been revealed to her."[5] The painting was in the conventual church of the Antoniani a Foria, for which Niccolò di Tommaso painted a triptych for one of Bridget's best friends, Queen Giovanna I of Naples.[6] Although Orsini identified neither its artist nor its patron, it is not unlikely that they were Niccolò di Tommaso and Orsini, respectively. Nicola Orsini was the son-in-law of Niccolò di Tommaso's other major Neapolitan patron, Raimondo Del Balzo,[7] who had commissioned the artist to paint a mural in the family's castle at Casaluce.[8]

Orsini is also a good candidate for the original owner of the Johnson triptych. Not only would he have known Niccolò through Del Balzo, he was an ardent supporter of Bridget, and his name saint—Nicholas of Bari—is in a position of honor in the left wing.

Niccolò di Tommaso himself may have met Bridget on any number of occasions in Naples, where she had lived from 1365 to 1367 and again from November 1371 to early March 1373, briefly stopping there also on her return from Palestine in February 1373.

1. Cornell 1924, pp. 11–13.
2. Nordenfalk 1961, p. 379.
3. Nordenfalk 1961, p. 381.
4. No. 1943.236; Seymour 1970, fig. 45. Both works are rectangular. The one in the Vatican was the center of a triptych. Offner (1956, p. 192) proposed that two other paintings also in the Vatican (inv. 212, 219; Rossi 1994, figs. 31–32 [as Policleto di Cola?]), showing Saints Anthony Abbot and John the Baptist in one and Saints Julian and Lucy in the other, were the side panels. This thesis has been rejected by Volbach (1987, p. 26). The painting in Yale was probably also part of a triptych.
5. Cornell 1924, p. 15.
6. The triptych is on deposit at the Museo e Gallerie di Capodimonte, Naples; (F. Bologna 1969a, VII-78–79, figs. 101–3).
7. Litta, 1819–85, Del Balzo, genealogical table XI.
8. It depicted Saint Peter Celestine V enthroned with his monks, other saints, and Del Balzo and his wife as donors (F. Bologna 1969a, VII-80–82, figs. 104–10).

Bibliography

Berenson 1913, p. 69, repro. p. 307 (following of Allegretto di Nuzio); Sirén 1921, pp. 101–2; Van Marle, vol. 4, 1924, p. 238 n. 2; Van Marle, vol. 5, 1925, p. 182 n. 1; Offner 1927, pp. 114–15, 117, fig. 9; Sandberg Vavalà 1927, p. 275 n. 6; Salmi 1929, p. 142; Berenson 1932, p. 398; Colasanti 1934, p. 345; Berenson 1936, p. 342; Meiss 1936, p. 459 n. 77; Johnson 1941, p. 12; Antal 1948, p. 199; Meiss 1951, p. 150 n. 73; Berenson 1963, p. 162; Sweeny 1966, p. 58, repro. p. 88; Seymour 1970, p. 66; Fredericksen and Zeri 1972, p. 150; Boskovits 1975, p. 202 n. 108; Fremantle 1975, fig. 363; Offner 1981, p. 91; Offner/Boskovits 1987, p. 110 n. 13; Volbach 1987, p. 26; Philadelphia 1994, repro. p. 221; Seidel 1996, p. 175, fig. 77; Skaug 2001, p. 198, 200, 202, figs. 6, 11

Nicola d'Ulisse da Siena

SIENA, FIRST DOCUMENTED 1430;
LAST DOCUMENTED 1470, NORCIA

Nicola d'Ulisse is documented in Siena as *allirato*, or on the tax rolls, from 1430 to 1452. However, only one work from Siena by him can be identified: the illuminations of a missal, written in 1428, for Cardinal Antonio Casini.[1] The artist is later recorded as "Nicola d'Ulisse from Siena, resident in Norcia,"[2] in a contract of 1442 for wall paintings in the tribune of Sant'Agostino[3] in Norcia. His only other documented contact with Siena occurred in 1451, when he painted a now-lost *Assumption of the Virgin* for the office of the officials of the Gabella, or tax office, in the Palazzo Pubblico. In 1460 Nicola called himself "a painter from Norcia,"[4] and in 1470 he is recorded as a home-owning citizen of the town.

Norcia in south Umbria was not without previous connections to Siena. During Pope Martin V Colonna's reign (1417–31) Nicola's one important Sienese patron, Cardinal Antonio Casini, had been papal governor of Umbria. In addition, the *baccalario*, or scholar in residence, of the convent of Sant'Agostino, where Niccola first worked in Norcia, was from Siena. Because Siena was the center of the Augustinian reform movement, it is not unlikely that these other Augustinians would have sought an artist from that city. Furthermore, other Sienese artists also received commissions in Umbria and the nearby Marches. Nicola had been preceded in the area, for example, by Angelo Maccagnino.[5] While no work by the latter remains, the *Saint Francis*[6] in the Pinacoteca Parrochiale of Corridonia in the Marches is what survives of an important altarpiece by the Sienese master Sassetta of the 1440s. In style Nicola d'Ulisse's *Risen Christ* (fig. 63.1), painted in the 1450s for the Benedictine abbey church of San Salvatore in Campi, near Norcia, is very like the Sassetta in that figures are outlined in the most simple way,[7] which is the manner that Nicola diffused in the region of Norcia for the next twenty years.

In 1457 the artist was granted safe conduct to bring himself, together with "his horses and his things," from Norcia to Ascoli Piceno in the Marches.[8] In 1461 he was in Cascia, near Norcia, where in October he

dated the wall paintings of the Passion in the choir of the Benedictine nunnery of Sant'Antonio.[9] Nicola signed this work with an unusual inscription in verse, in which he compared himself with the ancient artists Polyclitus and Pyrgoletes.

The next year Nicola executed now-lost wall paintings in Santa Maria di Borgo in Vittorito, near L'Aquila.[10] In 1466 he signed murals showing episodes of Christ in Limbo in San Salvatore in Campi.[11] In December of that year the priest of San Francesco in Fermo sued him for not finishing an altarpiece. Other disputes over unfinished works in the town of Montereale, near L'Aquila, and for the abbey of San Lorenzo di Rotella, near Ascoli Piceno, followed in 1468. In 1472 he painted a polyptych for the abbey of Sant'Eutizio in Val Castoriana, near Preci, for one Ser Antonutio di Antonio; this altarpiece is now in the Pinacoteca Comunale of Spoleto.[12] Nicola's crucifix, still in the church of this abbey, must date around the same time.[13]

Late in life the painter adopted his apprentice Bartolomeo di Giovanni Benedetti (called Scarpetta); such an action was not unusual,[14] and it probably indicates that Nicola had no one else to take over his business. Nicola d'Ulisse seems to have died before May 2, 1477, which is when his wife, a local woman named Angelella, is called a widow in a document.

In addition to the documented works, Filippo Todini (1989) has attributed to Nicola d'Ulisse a number of others, including *Saint Andrew Intervening at the Battle of San Ginesio and Fermo*[15] and a mural cycle in San Francesco of Cascia.[16]

1. Siena, Biblioteca Comunale degli Intronati, Ms. x.ii.2. The attribution is by Giulietta Chelazzi Dini (1977; and in Siena 1982); see Chelazzi Dini 1977, figs. xxii.23–25, 29, 31–40. Her attribution to Nicola of the illuminations of *Inferno* and *Paradiso* in a famous copy of Dante's *Divina Commedia* (London, British Library, Yates Thompson 36) cannot be accepted. For other views, see John Pope-Hennessy (1993, pp. 14, 16) and my review of the same (1995).

The Sienese missal is stylistically close to a *Crucifixion with the Mourning Virgin, John the Evangelist, and Mary Magdalene*, in a Florentine private collection (Todini 1989, color plate xxxiv).

2. "Nicholaus Ulissis de Senis habitator terre Nursie" (Cordella 1987, p. 111).
3. The other artists involved in the project were Bartolomeo di Tommaso; Andrea da Leccio, known as Andrea Delitio; Giambono di Corrado; and Luca di Lorenzo Alemano. The murals do not survive.
4. "da Nurscia pentore" (Cordella 1987, p. 99).
5. In 1439 Maccagnino had been imprisoned in Norcia for homicide. He later immigrated to Ferrara.
6. Boskovits 1983a, fig. 23.
7. In 1451 Nicola also painted a now-lost altarpiece, which depicted the life of Saint Benedict, for the other Benedictine abbey of Norcia (Cordella 1987, pp. 113–18).
8. Fabiani 1951, p. 146 n. 55. A fragment of the central section of a polyptych showing the Virgin and Child with two angels is in that city's Museo Diocesano (Todini 1989, p. 249). In 1458 he painted an image of Saint Anthony Abbot in the church of San Pietro Martire there (Todini 1989, fig. 731 [detail]).
9. Partially illustrated in Van Marle, vol. 8, 1927, figs. 240–42.
10. Fabiani 1951, p. 137 n. 56.
11. Chelazzi Dini 1977, figs. xxii.19–22.
12. Todini 1989, fig. 730. The missing central section consisted of a polychromed statue of Saint Eutizio, which was destroyed in a fire. The altarpiece was first attributed to Nicola d'Ulisse by Luciano Bellosi (quoted by Chelazzi Dini in Siena 1982, p. 372). Romano Cordella (1992) found the correct date of this work. Bellosi (see Siena 1982, p. 372) also attributed to him the *Crucifixion* formerly in the Spinelli Collection in Florence (reproduced as Nicola da Siena in Todini 1989, fig. 735), which had previously been attributed to Antonio da Viterbo (Volpe 1971, p. 49).
13. Chelazzi Dini 1977, fig. xxii.26.
14. For example, in 1451 Olivuccio di Ciccarello had done the same with Giambono di Corrado (Cordella 1987, p. 99).
15. Formerly San Ginesio, Sant'Agostino; now San Ginesio, Museo Civico; Todini 1989, fig. 729.
16. Todini 1989, color plate xxxiii, figs. 722–23; see also Toscano 1964, figs. 1–3, 6–7. Toscano had attributed it to Bartolomeo di Tommaso.

Select Bibliography
Borghesi and Banchi 1898, pp. 170–71; Gnoli 1923, p. 219; Van Marle, vol. 8, 1927, pp. 382–84; Toscano 1964, esp. p. 49; Chelazzi Dini 1977; Enrico Castelnuovo and Carlo Ginzburg in *Storia*, pt. 1, vol. 1, 1979, p. 318; Giulietta Chelazzi Dini in Siena 1982, pp. 371–76; Boskovits 1983a, pp. 267, 274 n. 45; Cordella 1987; Todini 1989, pp. 249–50; Cordella 1990, pp. 210, 213; Cordella 1992; Andrea De Marchi in Dal Poggetto 1998, pp. 33, 37–38 n. 42

PLATE 63A

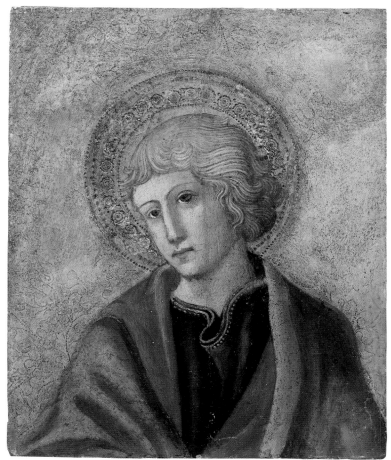

PLATE 63B

PLATE 63A (JC CAT. 103)
Panel of an altarpiece:
Saint Sebastian

c. 1460

Tempera and tooled gold on panel with vertical grain;
16¾ × 11⅞ × ¾″ (42.4 × 30 × 1.8 cm)

John G. Johnson Collection, cat. 103

INSCRIBED ON THE REVERSE: *103* (in yellow chalk);
JOHNSON COLLECTION / PHILA (stamped in black); *103 /
IN 75* (in pencil on a paper sticker)

PUNCH MARKS: See Appendix II

TECHNICAL NOTES
The panel is cradled. There are some vertical splits
near the center and much overpainting. The back-
ground consisted of a tooled textile pattern in gold
that was painted over in oil to resemble sky. Some
of the gold halo has also been repaired.

Infrared reflectography showed a change in the
drawing of the little finger and wrist of the hand.

In August 1919 Hamilton Bell noted that the
painting was safe for the present. The following April,
when he inspected it with Carel de Wild, they noted
that it was very overcleaned and much repainted,
that the blue background was modern, and that the
panel needed a cradle. Presumably de Wild cleaned
the picture. In March 1921 a conservator named
Kent cradled it. In 1955 and 1956 Theodor Siegl took
care of flaking problems.

PROVENANCE
Unknown

COMMENTS
The half-length figure of the young, partially nude
Saint Sebastian is shown holding arrows. Secretly a
Christian, even though he served as a captain of the
Praetorians in Diocletian's army in the third cen-
tury, Sebastian was shot with arrows under the
emperor's orders for offering support to Christian
martyrs. Sebastian recovered from this ordeal but
was ultimately killed for his opposition to the
emperor. In the late Middle Ages he became a pop-
ular saint who, because of his recovery from his first
attack, was invoked against the plague. For further
comments, see plate 63B (JC cat. 104).

Bibliography
See plate 63B (JC cat. 104).

PLATE 63B (JC CAT. 104)
Panel of an altarpiece:
Saint John the Evangelist

c. 1460

Tempera and tooled gold on panel with vertical grain;
13⅝ × 11 × ⅜″ (34.5 × 28 × 1 cm)

John G. Johnson Collection, cat. 104

INSCRIBED ON THE REVERSE: *104* (in yellow chalk);
CITY OF PHILADELPHIA / JOHNSON COLLECTION (stamped
in black)

PUNCH MARKS: See Appendix II

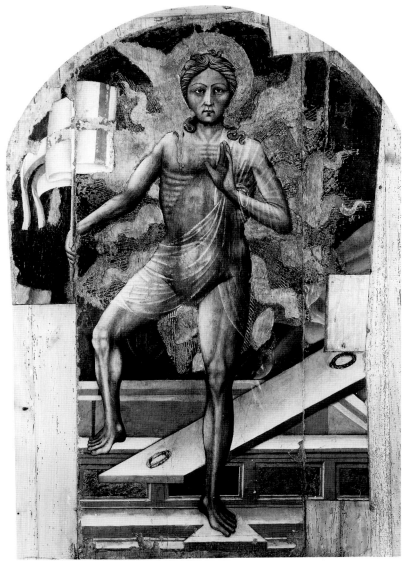

FIG. 63.1 Nicola d'Ulisse da Siena. *Risen Christ*, 1450s. Tempera and tooled gold on panel; 66⅞ × 44½″ (170 × 113 cm). From near Norcia, church of San Salvatore in Campi. Norcia, Museo Civico Diocesano "La Castellina"

This opinion was followed by Raimond van Marle (1927). Cesare Brandi (1949), however, briefly noted that he did not agree with the attribution. In a letter dated Rome, October 29, 1956, Federico Zeri wrote that the paintings seemed to be Florentine and close to the work of Giovanni dal Ponte (q.v.). Miklós Boskovits examined the panels in Philadelphia on November 1, 1978, and subsequently assigned them to Nicola d'Ulisse, publishing them as such in 1983. His opinion was accepted by Filippo Todini (1989).

The style is close to Nicola d'Ulisse's *Risen Christ* of the 1450s in Norcia (fig. 63.1). The head of Saint Sebastian can also be compared with that of Saint Placidus in the altarpiece in the Pinacoteca Comunale of Spoleto, which is documented as 1472.[3]

The two Johnson panels come from a disassembled altarpiece of which no other sections have been identified. Given the presence of Saint Sebastian, perhaps the structure can be related to a document concerning Nicola's commission to decorate the chapel of Saint Sebastian in the church of Sant'Agostino in Norcia, which was arranged on December 3, 1460, by the sons of the late Vanni Accursi.[4] Accursi had been one of the overseers of the mural project executed in the tribune of Sant'Agostino in 1442 by Nicola d'Ulisse with a group of other artists. Although the Accursi chapel no longer exists and no description of its contents has been discovered, it was likely furnished with an altarpiece. Indeed, the Johnson Collection's *Saint John the Evangelist* might represent Accursi's name saint, as Vanni is a diminutive of Giovanni, or John.

1. Oratory of Sant'Antonio, 1445; Pisani 1996, fig. 13 (detail).
2. No. 207; Torriti 1977, fig. 425 (color). Now usually given to a follower of Domenico di Bartolo (q.v.).
3. Todini 1989, fig. 730.
4. Cordella 1987, pp. 92, 105 n. 14.

Bibliography

Berenson 1913, p. 56 (Priamo della Quercia); Van Marle, vol. 9, 1927, p. 563; Johnson 1941, p. 14 (Priamo della Quercia); Brandi 1949, p. 227 n. 108; Sweeny 1966, p. 66 (Priamo della Quercia); Boskovits 1983a, p. 274 n. 45; Todini 1989, p. 250, vol. 2, fig. 724; Philadelphia 1994, repro. p. 221; Frinta 1998, repro. p. 168

TECHNICAL NOTES

The panel is cradled. It has a long vertical crack about 5⅛″ (13 cm) from the right and is much over-painted. The background consisted of a tooled textile pattern in gold that was painted over in oil to resemble sky. Some of the gold halo has also been repaired. There is original mordant gilding on the saint's collar.

A curious feature of the warm tones of the flesh is the admixture of large green particles, presumably malachite, which is not seen in the *Saint Sebastian* (plate 63A [JC cat. 103]) from the same altarpiece.

The painting seems to have had the same history of treatment as plate 63A (JC cat. 103), but there are no specific records in the files.

PROVENANCE

Unknown

COMMENTS

Bernhard Berenson (1913) suggested that this saint was either Stephen or Lawrence, but in the absence of their usual attributes of martyrdom, the young man is more likely John the Evangelist. He wears red and green, colors typical of John's costume (see Masaccio and Masolino, plate 44A [JC inv. 408]).

Berenson had attributed this and the painting of Saint Sebastian to the Sienese artist Priamo della Quercia (q.v.) by comparing the panels with the artist's altarpiece in Volterra[1] and to his *Virgin and Child with Angels* in Siena's Pinacoteca Nazionale.[2]

ANTONIO ORSINI
(Master of the Carminati Coronation)

FERRARA, DOCUMENTED 1432–91

Federico Zeri (1976) reconstructed the artistic personality of the Master of the Carminati Coronation in the catalogue of the Italian paintings in the Walters Art Museum in Baltimore. He named the painter after the *Coronation of the Virgin and Annunciation* of about 1430–35 in the collection of Rita Carminati in Gallarate, near Milan.[1] Zeri also recognized as the work of the same hand a *Last Supper*,[2] in the Walters Art Museum; its companion, *Christ in the Garden of Olives,* in a Milanese private collection; the two saints in the Johnson Collection (plates 64A–B [JC cats. 98a, b]); and two paintings of the Virgin of Humility of about 1430 in private collections.[3]

It was Serena Padovani (1976) who first suggested that the artist might be identified with Antonio Orsini, a Venetian painter of Milanese origins who worked in Ferrara. His only signed painting is the *Virgin of Humility with Saints John the Baptist and Nicholas of Bari,*[4] recorded in a Venetian private collection. Daniele Benati (in Vignola 1988) and Massimo Medica (in *Pittura* 1987) have been cautious about accepting Padovani's thesis, although the similarities between the two saints in the *Virgin of Humility* and the two panels in the Johnson Collection would seem to confirm her identification.

Orsini is first recorded when he is called a *magister,* or master, in a Ferrarese legal document of 1432. His most important painting—the *Ex-Voto of Suor Sara for the Peace of the Spanish Knights* (fig. 64.1)—also dates to that year. The picture commemorated the peace made by two knights just before engaging in combat.[5] The episode took place in Ferrara and was, subsequently, much celebrated there. The fact that Orsini received the commission indicates how highly he was regarded by the Ferrarese patrons. Four years later he painted three now-lost views of the city of Cremona for the marquis Leonello d'Este. Otherwise Orsini appears in documents only as appraising the works other artists made for the Este residence of Belriguardo: in 1451 he assessed some paintings by Galasso; in 1471, with Geminiano da Vicenza, paintings by Gerardo da Verona; and in 1472, with Baldassare d'Este, Cosmé Tura's now-lost murals in the chapel. Orsini may have lived for some years after this, as it is not until 1491 that he is mentioned as being dead.

1. Padovani 1976, fig. 45. A study of the coats of arms might determine for whom and where the picture was painted. It was previously in the famous Costabili Collection in Ferrara, making it likely that the picture was once in a Ferrarese church.
2. No. 37.753; Zeri 1976, plate 97.
3. Both are reproduced in Padovani 1976, figs. 48a, b.
4. Padovani 1976, fig. 41.
5. Ragghianti 1974.

Select Bibliography
Cittadella 1864–68, vol. 2, p. 130; Campori 1885, p. 542; A. Venturi, vol. 7, pt. 3, 1914, p. 514; Thieme-Becker, vol. 26, 1932, p. 60; Coletti 1951, pp. 94–97; Padovani 1976, pp. 46–50; Zeri 1976, p. 195; Massimo Medica in *Pittura* 1987, pp. 682–83, 721; Daniele Benati in Vignola 1988, pp. 50–51; Serena Padovani in Vignola 1988, p. 75

PLATE 64A (JC CAT. 98a)

Wing of a triptych: *Saint John the Baptist*

c. 1425

Tempera and tooled gold on panel with vertical grain; $12\frac{3}{8} \times 5\frac{1}{8} \times \frac{1}{8}''$ (31.3 × 13.1 × 0.3 cm)

John G. Johnson Collection, cat. 98a

INSCRIBED ON THE SCROLL: *E*[in red]*cce*/ *Agnus*/ *Dei*/ *Ecce quj*/ *tollis*[*it*]/ *peccha*/ *to mun*/ *di mi*/ *serere nobis* (John 1:29: "Behold the Lamb of God, behold him who taketh away the sin of the world"; and the liturgical response: "Mercy on us"); ON THE REVERSE: *JOHNSON COLLECTION*/ *PHILA.* (stamped in black ink); *23* (in faded red ink)

PUNCH MARKS: See Appendix II

TECHNICAL NOTES, PROVENANCE, COMMENTS, AND BIBLIOGRAPHY
See plate 64B (JC cat. 98b)

PLATE 64B (JC CAT. 98b)

Wing of a triptych: *Saint James Major*

c. 1425

Tempera and tooled gold on panel with vertical grain; $12\frac{3}{8} \times 5 \times \frac{1}{8}''$ (31.4 × 12.7 × 0.3 cm)

John G. Johnson Collection, cat. 98b

INSCRIBED ON THE REVERSE: *JOHNSON COLLECTION*/ *PHILA.* (stamped in black ink); *24* (in faded red ink)

TECHNICAL NOTES
Both this panel and *Saint John the Baptist* (plate 64A [JC cat. 98a]) are cut on all four sides and thinned. Indentations on the back of each panel (the right edge of Saint John the Baptist and the left edge of Saint James Major) indicate the location of hinges, showing that they were the wings of a triptych. The gold is particularly worn at the center of the other edges, indicating the location of the clasp that would have held the panels together when closed.

There is some new gold along the edges of both panels. The mordant gilt details in the borders of the costumes are for the most part gone. The flesh is well preserved. The gray upper surface of the paint layer has broken through only where the white highlights are the most built up. The green glazing of Saint James Major's book is repainting. The original color had flaked away because it had been glazed over gold. There are some scattered losses and retouch-

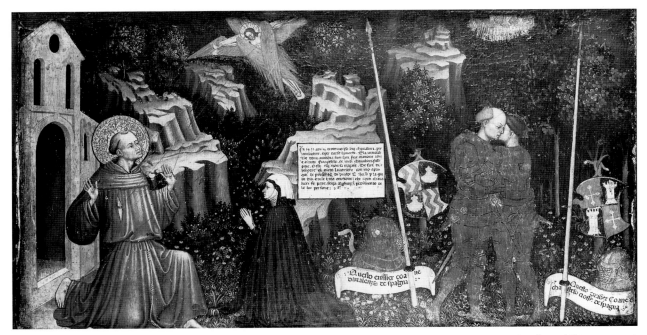

FIG. 64.1 Antonio Orsini. *Ex-Voto of Suor Sara for the Peace of the Spanish Knights,* 1432. Tempera and tooled gold on panel; 16⅞ × 30⅛″ (43 × 76.5 cm). Paris, Musée des Arts Décoratifs, inv. PE 84

ings throughout, most prominently in the Baptist's forehead. The surface of the paint film in Saint John the Baptist is slightly blanched.

In 1955 Theodor Siegl faced the panels because of flaking. In 1966 he removed the facing, treated the blistering, and retouched some losses.

PROVENANCE

The two panels were purchased by John G. Johnson before 1909, when they were first published as in his collection by William Rankin.

COMMENTS

The bearded Saint John the Baptist, looking to our right, stands in a rocky landscape. He wears a hair shirt and a mantle, and holds an astral cross and a scroll inscribed with the passage from the Gospel of John in which he identifies Christ as the Lamb of God. An empty bowl lies on the ground beside him.

The young blond-bearded Saint James Major, looking left, stands on a marble pavement. He carries a book and a walking staff, symbol of Compostela in Spain, the apostle's burial site and a great pilgrimage center.

Bernhard Berenson's indecision about these paintings in the Johnson catalogue of 1913 sums up all early opinions about the two panels. He entitled them "Two Delicately Wrought Little Gilt Panels" and said: "It is difficult to place these figures, with their intense expression and precise workmanship. There can be no doubt that they were painted about 1400, but where? Less improbably at Siena than elsewhere."

Despite Berenson's conclusion, the nervous swirl of the drapery, the gaunt figures, and even the tooling, which, even if "delicately wrought," hardly achieves the precision or high craftsmanship found in Siena at the turn of the fifteenth century, would argue for an origin outside Tuscany.

In 1976 Federico Zeri noted that the artist was the same as the painter of the *Coronation of the Virgin* in the Carminati Collection.[1] Serena Padovani's identification of the artist as Antonio Orsini is well confirmed by a comparison of the two saints in the Johnson Collection with those in the *Virgin of Humility,*[2] signed by Orsini. The tooling of the halos is also very similar.

As is appropriate for panels that were the wings

of a triptych, both saints look inward. The Baptist's gesture and inscription on his scroll suggest that the Virgin and Child appeared in the center panel. However, no candidate for this section of the triptych can be put forward.[3]

1. Padovani 1976, fig. 45.
2. Venice, private collection; Padovani 1976, fig. 41.
3. Two images of the Virgin of Humility in private collections (Padovani 1976, figs. 48a, b) have different tooling in the gold and an enframement consisting of elaborate pastiglia, whereas the saints in the Johnson Collection have flat gold punched borders.

Bibliography

Rankin 1909, p. lxxx (Siena or Umbria, early fifteenth century); Berenson 1913, p. 55, repro. p. 293 (Siena[?], c. 1400); Johnson 1941, p. 15 (Siena, c. 1400); Sweeny 1966, p. 72, repro. p. 101 (Siena, c. 1400); Fredericksen and Zeri 1972, p. 224 (Italian School, fourteenth century); Padovani 1976, p. 49, figs. 46a, b (Master of the Carminati Coronation/Antonio Orsini); Zeri 1976, vol. 1, p. 195 (Master of the Carminati Coronation); Daniele Benati in Vignola 1988, fig. 10; Massimo Medica in *Pittura* 1987, p. 683; Philadelphia 1994, repro. p. 222; Frinta 1998, pp. 135, 145, 210 repro., 415 repro.

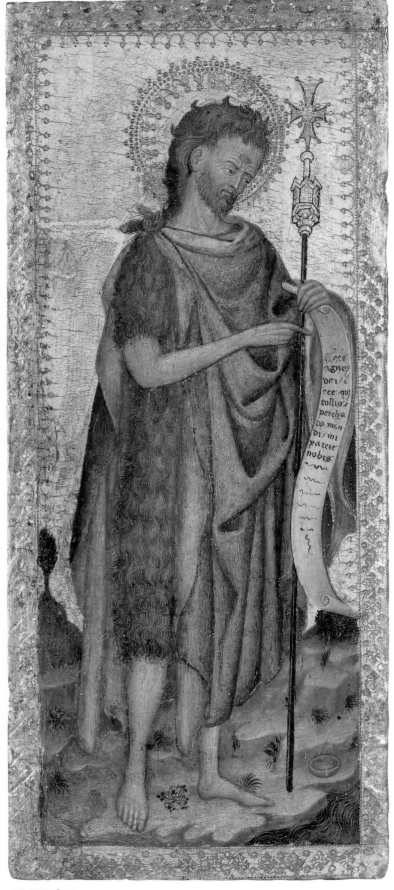

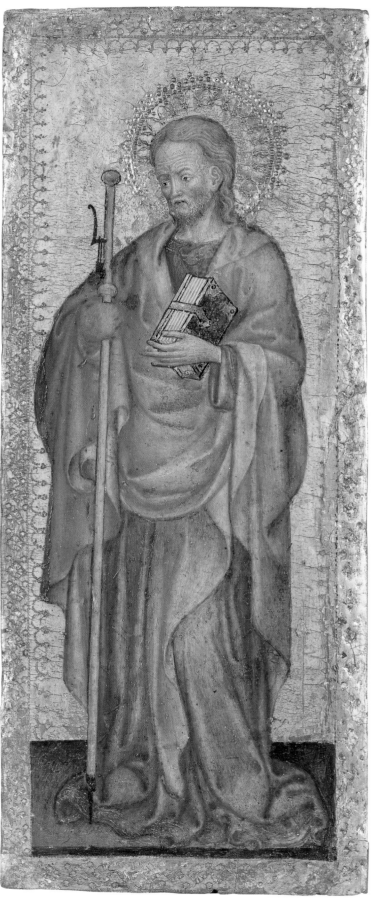

PLATE 64A PLATE 64B

PESELLINO
(*Francesco di Stefano*)

FLORENCE, 1422–1457, FLORENCE

Francesco di Stefano, called Pesellino, came from a family of Florentine painters. His father died when Francesco was a child. Francesco's nickname, meaning "little Pesello," distinguished him from his grandfather, the painter Giuliano d'Arrigo, known as Pesello, who maintained a studio in the corso degli Adimari (present-day via de' Calzaioli), which Pesellino inherited in 1447. Pesellino's earliest datable work is the predella[1] to an altarpiece by Filippo Lippi,[2] made about 1440–45 for the chapel of the Novitiates in Santa Croce in Florence. This type of collaboration was not unusual for Lippi, who, inundated with commissions, often turned to other artists to assist or complete projects.

Two of Pesellino's commissions from the late 1440s demonstrate the high caliber of his patronage: the miniatures illustrating the manuscript of the *Bellum Poenicum* of Silius Italicus,[3] made for Pope Nicholas V Parentucelli around 1447–48, and the *cassone* panels with the *Triumphs of Petrarch*,[4] ordered for the marriage of Piero de' Medici and Lucrezia Tournabuoni in 1444.

In 1453 Pesellino entered into a partnership with Zanobi di Migliore and Piero di Lorenzo del Pratese in which the three artists agreed to divide the profits. The arrangement was purely financial, meaning that the principals did not necessarily work together. Zanobi soon left the company, but Piero di Lorenzo stayed on. He actually might be the Pseudo–Pier Francesco Fiorentino (q.v.) who copied so many of Pesellino's compositions of the Virgin and Child. After Pesellino's premature death in 1457, Piero sued the artist's widow for a part of the money owed to her from the altarpiece for the company of the Preti della Trinità in Pistoia,[5] a commission Pesellino had undertaken in 1455 but did not live to finish. Filippo Lippi took over the project, which was finished with the help of Fra Diamante (q.v.) and a workshop assistant called Domenico.

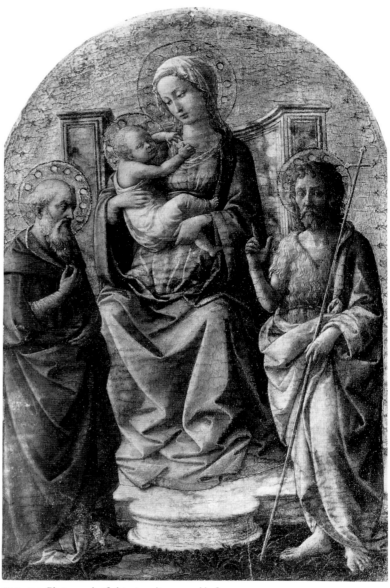

FIG. 65.1 Photograph of plate 65 as it appeared before 1913

1. Florence, Uffizi, no. 8355; and Paris, Louvre, no. 418; both in Ruda 1993, plate 253.
2. Florence, Uffizi, no. 8354; Ruda 1993, plates 93 (color), 252 (black-and-white).
3. Venice, Biblioteca Nazionale Marciana, Ms. lat. XII 68; and Saint Petersburg, The State Hermitage Museum, no. 1791; both in Bellosi 1990, figs. 83–86, color repros. pp. 129, 131, 133.
4. Boston, Isabella Stewart Gardner Museum, nos. P15e5-s, P15e18-s; Hendy 1974, repros. p. 177 (black-and-white), color plates V–VI (details).
5. London, National Gallery, nos. 727, 3162, 3230, 4428 4868a–d; and Saint Petersburg, The State Hermitage Museum, no. 5511. Dillian Gordon (1996) recognized that the painting in Russia belonged to this complex; Gordon 2003, color repros. pp. 260–87.

Select Bibliography
Weisbach 1901; Gronau in Thieme-Becker, vol. 26, 1932, pp. 463–64; Procacci 1960, pp. 30, 32, 34–37; Berenson 1963, pp. 167–68; Bellosi 1967, pp. 6–7, 9, 14; Degenhart and Schmitt, vol. 1, pt. 2, 1968, pp. 527–40; *Bolaffi*, vol. 8, 1975, pp. 441–44; Angelini 1986, pp. 33–38, 40; Alessandro Angelini in Bellosi 1990, pp. 125–27; Frances Ames-Lewes in *Dictionary of Art* 1996, vol. 24, pp. 537–39; Gordon 1996

PLATE 65 (JC CAT. 35)
Virgin and Child Enthroned with Saints Jerome and John the Baptist

c. 1448

Tempera and tooled gold on panel with vertical grain, arched; 12⅛ × 8 × ¼″ (30.7 × 20.2 × 0.5 cm)

John G. Johnson Collection, cat. 35

INSCRIBED ON THE REVERSE: *33/ 24* (in pencil); *JOHN-SON COLLECTION/ PHILA.* (stamped in black); ON THE FRIEZE OF THE FRAME: *AVE MARIA GRATIA PLENA* (fig. 65.6) (Luke 1:28: "Hail, [Mary,] full of grace");

(*text continues on page 355*)

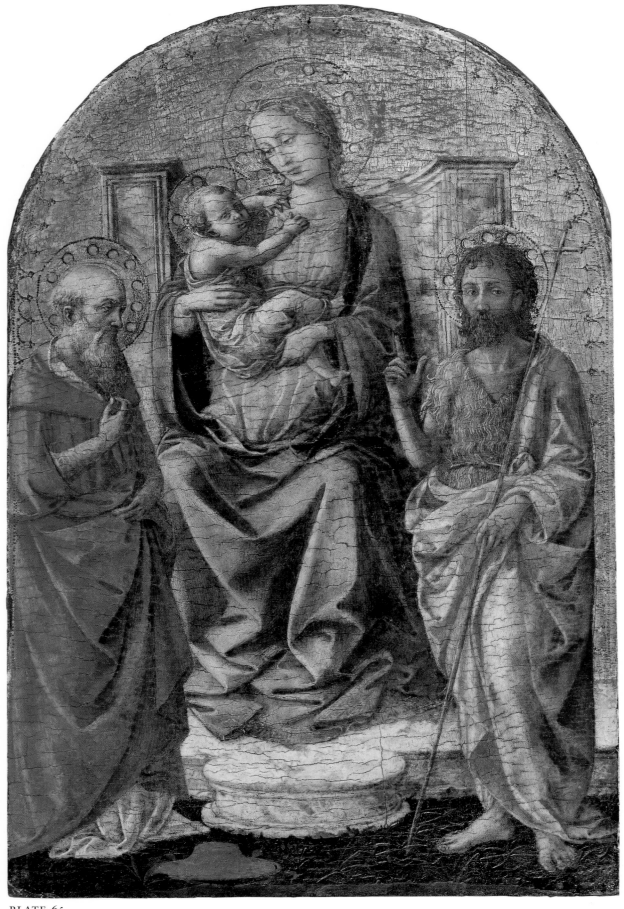

PLATE 65

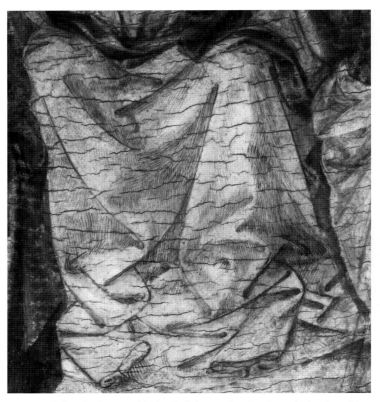

FIG. 65.3 Infrared reflectographic detail of plate 65, showing the underdrawing of Saint John the Baptist

FIG. 65.2 Infrared reflectographic detail of plate 65, showing the underdrawing of the Virgin's mantle

FIG. 65.4 (*left*) Pesellino. *Saint Philip Seated Holding a Cross,* late 1440s. Brush and brown wash, heightened with white gouache over black chalk, on paper; 10¾ × 7½″ (27.3 × 19.1 cm). New York, The Metropolitan Museum of Art, Rogers Fund, 1965 (65.112.1)

FIG. 65.5 (*right*) Pesellino. *Seated Male Figure,* c. 1450. Ink and brown wash on white paper; 8½ × 6½″ (23.6 × 16.4 cm). Florence, Gabinetto Disegni e Stampe degli Uffizi, inv. 234 E

FIG. 65.6 Gilded and painted tabernacle frame made in Florence, c. 1440–50, now on plate 65

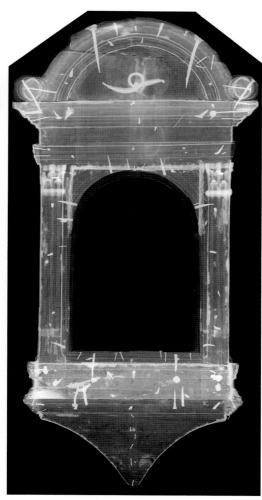

FIG. 65.7 X-radiograph of fig. 65.6, showing the structure of the frame and the original hanging hook in the center of the lunette

made between the time the panel was gilded and tooled and the foreground was painted, when an area was left in reserve for the hat. Later some of its red paint was extended over the foliage. The figure of Saint Jerome was also painted to the very edge at the left, covering the already punched border.

In 1937 David Rosen cleaned the painting. His treatment was aggressive, and he seems to have broken through many areas of original paint, retouching these sections in addition to losses. Photographs document the differences in the picture before his cleaning (fig. 65.1).

In 1941 the panel is recorded as having a cradle. This was removed sometime in the 1950s, and the panel was adhered to plywood with wax. In 1974 Theodor Siegel conducted cleaning tests around the Virgin's left cheek and the Baptist's left hand. Because he found that the paint was easily soluble, he had samples analyzed by Hermann Kühn in Munich to see if they were modern. However, these tests did not reveal any modern pigments, except for possibly Naples yellow in the throne, which might actually have been restoration. According to Kühn's analysis, all the other pigments are characteristic of the fifteenth century: vermilion, lead white, red lake, verdigris, azurite, and natural ultramarine. A recent X-radiograph and microscopic examination did not raise doubts about the panel's authenticity.

In 1996 the panel was cleaned by Claire Chorley, and inpainted in 2003 by Elise Effmann.

The painting has a fifteenth-century tabernacle frame (fig. 65.6), which, although not original to this panel, is of the period. The frame has been altered to fit the painting: the pilasters were lengthened by about ⅝″ (1.5 cm); the tip of the antependium is a replacement; the spandrels and volutes are new; and the predella is partially covered by a molding that obscures all but the lower part of the inscription. A dove with spread wings was once painted in the lunette of the tympanum. The capitals of the fluted pilasters were executed in pastiglia. The hanging hook, clearly seen in the X-radiograph (fig. 65.7), is original.

Provenance

In 1931 Lionello Venturi stated that the painting originally came from a private Florentine collection. It was later in the collection of Oscar Hainauer in Berlin, where it was catalogued in 1898 as the work of Filippo Lippi (no. 47). Lord Duveen purchased the painting in 1906. On April 19, 1913, Johnson bought it from the London dealer Dowdeswell and Dowdeswell for 3,500 pounds sterling.

Comments

The Virgin and Child are seated in a semicircular marble throne on a raised parapet. At the left is Saint Jerome in cardinal's robes; his hat lies on the ground. At the right is Saint John Baptist, pointing to the Christ Child.

ON THE REVERSE OF THE FRAME: *From/ DOWDESWELL AND DOWDESWELL/ Limited/ Publishers, Valuers of, and Dealers in/ Works of Fine Art* [with a worn New York City(?) address]/ *160, New Bond Street/ London W*

EXHIBITED: Berlin 1898 (as Filippo Lippi); Philadelphia 1920, no. 35 (as Pesellino); San Francisco 1939a, no. 44 (as Pesellino)

Technical Notes

The panel consists of a single board that has been thinned and mounted on a plywood support. Several small splits appear to have resulted from the flattening of the panel. The picture surface is slightly reduced, but there is evidence of a barbe along all the edges, indicating that there was an applied molding.

In an area of damage at the lower edge it is possible to make out a difference in the color and texture of the gesso layers, with smooth gesso (*gesso sottile*)

overlying a coarser one (*gesso grosso*). The ground has a very pronounced horizontal crackle pattern that wear in the gilding has made more evident.

An infrared reflectogram revealed a carefully modeled drawing that is most detailed in the Virgin's robe (fig. 65.2). The faces of all the figures have been drawn, as have the Baptist's legs and feet. A much looser drawing, executed with a brush, was used to reinforce areas that had to be painted over the gold or the grayish white underlayer of the throne, and particularly to create shadowed tones in the flesh and hair. This technique can be particularly observed in Saint John's hair and shoulder (fig. 65.3).

There are a number of pentimenti. The original plan was to show Jerome wearing the hat that is now on the ground before him, as indicated by the fact that some of the gold of the halo was purposively left plain to accommodate it. This change was

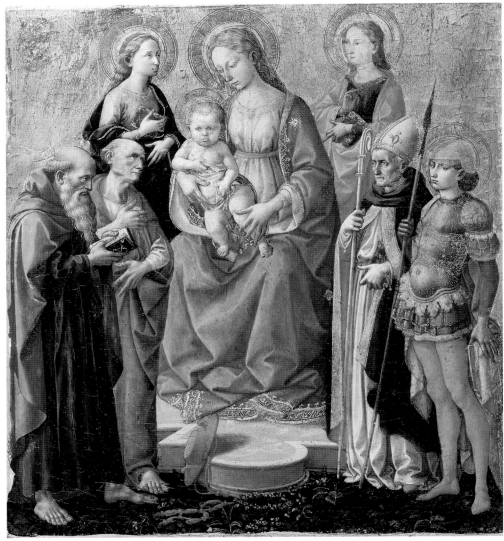

Isabella Stewart Gardner Museum in Boston.[4] An analogy for the figures of the Virgin and Child is provided by his early panel in Dresden (see fig. 54.5). A similar composition is also found in a slightly later panel in New York (fig. 65.8).

1. See, for example, two drawings in the Gabinetto Disegni e Stampe degli Uffizi, Florence: the *Mystic Marriage of Saint Catherine of Alexandria* (no. 1117E) and the *Blessing Redeemer* (no. 10E); Degenhart and Schmitt, vol. 1, pt. 4, 1968, plates 361a, b. For an analysis of other Pesellino underdrawings, see Gordon 2003, pp. 263–64.
2. For the history of Saint Jerome's cult, see the *Virgin of Humility and Saint Jerome Translating the Gospel of John,* attributed to Benedetto di Bindo, plate 13 (JC cat. 153).
3. Lindenau-Museum, no. 96; Ruda 1993, plates 38 (color), 216 (black-and-white).
4. Nos. P15e5-s, P15e18-s; Hendy 1974, repros. p. 177 (black-and-white), color plates V–VI (details).

Bibliography
Bode 1897, no. 47 (Filippo Lippi); Hans Mackowsky in Berlin 1898, repro. p. 36 (Filippo Lippi); Weisbach 1898, p. 158; Weisbach 1901, pp. 67–69, plate 10; Bode 1906, p. 15; Rankin 1909, p. lxxxi; Berenson 1913, p. 22, repro. p. 248; Fogg 1919, p. 62; Bell 1920, pp. 4, 6; Philadelphia 1920, p. 2; Hendy 1928, p. 74; Van Marle, vol. 10, 1928, pp. 496–98; Hendy 1931, p. 253; L. Venturi 1931, plate cxxxi; Berenson 1932, p. 443; Berenson 1936, p. 381; San Francisco 1939a, no. 44, repro.; Johnson 1941, p. 13; Berenson 1963, p. 169, plate 820; Sweeny 1966, p. 62, repro. p. 124; Fredericksen and Zeri 1972, p. 162; Philadelphia 1994, repro. p. 225; Lachi 1995, p. 27, repro. p. 107

FIG. 65.8 Pesellino. *Virgin and Child with Saints Anthony Abbot, Jerome, Cecilia(?), Catherine of Alexandria(?), a Bishop Saint, and Saint George,* 1450s. Tempera and tooled gold on panel; 10⅜ × 8″ (26.4 × 20.3 cm). New York, The Metropolitan Museum of Art, Bequest of Mary Stillman Harkness, 1950 (50.145.30)

An infrared reflectogram (fig. 65.2) shows with what detail Pesellino drew the composition on the gessoed panel in preparation for the painting. Such a careful drawing not only provides an authentication of the master's hand but also points to the much more summary working methods of the artists specializing in the repetition of his compositions, such as the Master of the Pomegranate and the Pseudo–Pier Francesco Fiorentino (qq.v.). A comparison of the infrared reflectograms of the Johnson panel and Pesellino's drawings in the Uffizi (fig. 65.5) and the Metropolitan Museum of Art (fig. 65.4) shows a very similar handling of the brush. Interestingly, these drawings and the underdrawing in the painting differ from the precise line drawings that Pesellino prepared for other paintings, some of which were painted by him for transfer to panel or by later copyists.[1]

The original owner of the Johnson Collection's painting is not known. The presence of Saint Jerome as a penitent cardinal suggests that it may have been painted for a humanistically inclined ecclesiastic devoted to the saint. One of Pesellino's earliest patrons, Pope Nicolas V Parentucelli, often identified with Jerome, but the conceit was common in the mid-fifteenth century.[2] Cardinal Niccolò Albergati of Bologna, for example, was one of the principal promoters of his cult. But this was also true of secular patrons such as Giovanni di Cosimo de' Medici, for whom Filippo Lippi probably executed the small panel *Saint Jerome Penitent,* now in Altenburg, Germany.[3] An original Florentine destination for the Johnson painting is suggested by the presence of the city's patron, John the Baptist.

Stylistically this panel dates around 1448, when Pesellino executed the *cassone* panels now in the

Pietro di Domenico da Montepulciano

No documents exist for Pietro di Domenico, but his name is known from two signed and dated pictures: the *Virgin of Humility with Angels* (fig. 66.1) in the Metropolitan Museum of Art in New York, which is dated 1420 and signed "petrus dominici demonte pulitiano" (Pietro di Domenico from Montepulciano),[1] and an altarpiece (fig. 66.2), dated 1422, from San Vito in Recanati. The inscription on the Metropolitan's painting further identifies the patron as a presbyter of San Vito named Francesco. The designation *demonte pulitiano* on that New York picture confused early authors as to the artist's origin. However, it does not refer to the famous Tuscan town of Montepulciano, but most likely to the village of Montepulciano near Filottrano in the Marches, because the greater part of the artist's works are in or from the Marches.

The polyptych (see fig. 66.4) from the high altar of the cathedral of Osimo was commissioned from Pietro di Domenico by Caterina, widow of the notary Antonio Fanelli. It dates two years before the signed painting in New York. Another altarpiece, once in the *collegiata* of Potenza Picena in the Marches and possibly originally in the cathedral of Loreto (fig. 66.3), may date even earlier.[2] These first commissions show that the artist worked within the prevailing modes of Venetian International Gothic painting such as that diffused in the Marches by the Venetian artist Jacobello del Fiore.

Murals recognized to be the work of Pietro di Domenico in the female convent of San Niccolò in Osimo can be dated after 1419,[3] and in or shortly after 1425 he painted others for one Giovanni di Guglielmo in the oratory of Santa Monica in Sant'Agostino in Fermo.[4] These projects and the two signed paintings of 1420 and 1422 show Pietro di Domenico branching out to embrace a more limpid style in which the modeling of the flesh is made visibly morbid through the use of darker tonalities, and the drapery is more fluid and descriptive of form. Undoubtedly, the artist

was acquainted with the art of Gentile da Fabriano, who had briefly returned to his native Fabriano in the Marches in 1420. In the *Virgin of Humility with Angels* of 1420 Pietro specifically adapts Gentile's manner of incising forms directly in the gold ground. Pietro may also have come to know Archangelo di Cola da Camerino, a Marchigian artist who spent time in Florence and Rome.

Pietro di Domenico was likely one of a number of Marchigian artists who went to Rome during the papacy of Martin V Colonna (reigned 1417–31), when many commissions became available. Even though no works by his own hand survive in that city, about 1422 a follower painted a series of murals in the oratory of the Annunziata in Riofreddo, near Tivoli, for a papal relative, the knight Antonio Colonna, as well as a few votive murals in Sant'Agnese in Rome.[5] Pietro di Domenico's style survived for some time in the work of another follower, Giacomo di Nicola da Recanati (documented 1414/15–66).

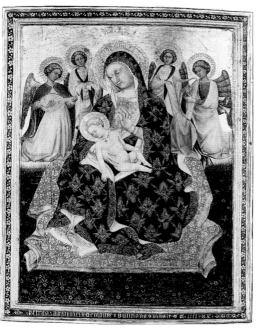

FIG. 66.1 Pietro di Domenico da Montepulciano. *Virgin of Humility with Angels*, 1420. Tempera and tooled gold on panel; with applied frame 34⅝ × 26¼" (87.9 × 66.7 cm). New York, The Metropolitan Museum of Art, Rogers Fund, 1907 (07.201)

1. The painting in New York is recorded from 1845 to 1870 in the choir of a Camaldolese convent near Naples, but this may not be its original location (Zeri 1980, p. 66).
2. Florence, Sotheby's, April 10, 1974, lot 194, color repro. See also Andrea De Marchi in Dal Poggetto 1998, p. 274.
3. Urbino 1970, repros. pp. 69–74 (details).
4. These have not been reproduced in full. For bibliographical references, see De Marchi 1992, p. 131 n. 28. They were detached from the walls in the early 1970s and are now on deposit at the Soprintendenza of Urbino.
5. For bibliography, see De Marchi 1992, p. 212 n. 61.

Select Bibliography
Boskovits 1977, p. 44; De Marchi 1987a, pp. 55–56; Andrea De Marchi in *Pittura* 1987, pp. 738–39; De Marchi 1992, esp. pp. 117, 120; Boskovits 1994, pp. 282, 295; Enrica Neri Lusanna in *Dictionary of Art* 1996, vol. 24, p. 780; Andrea De Marchi in Dal Poggetto 1998, pp. 33–35, 274–81; Andrea De Marchi in Liberati 1999, pp. 93–95

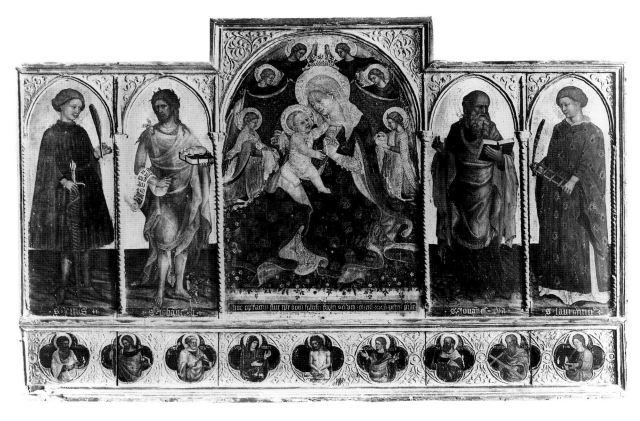

FIG. 66.2 Pietro di Domenico da Montepulciano. Altarpiece: *Virgin of Humility with Angels, Saints Vitus, John the Baptist, John the Evangelist, and Lawrence*; predella: *Man of Sorrows with the Mourning Virgin and Saint John the Evangelist, and Saints*, 1422. Tempera and tooled gold on panel; 50 × 78⅜″ (127 × 199 cm). From Recanati, church of San Vito. Recanati, Pinacoteca Comunale

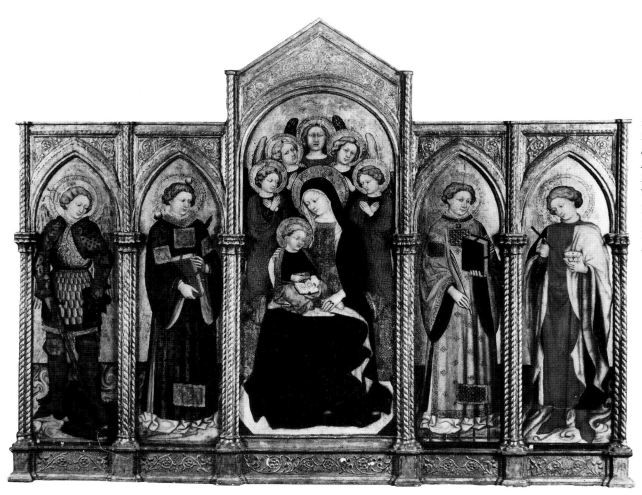

FIG. 66.3 Pietro di Domenico da Montepulciano. Altarpiece: *Virgin and Child with Angels, Saints Michael Archangel, Stephen, Lawrence, and Cosmas*, c. 1415–20. Tempera and tooled gold on panel; approximately 50¾ × 73⅝″ (129 × 187 cm). From Potenza Picena, *collegiata*. Florence, private collection

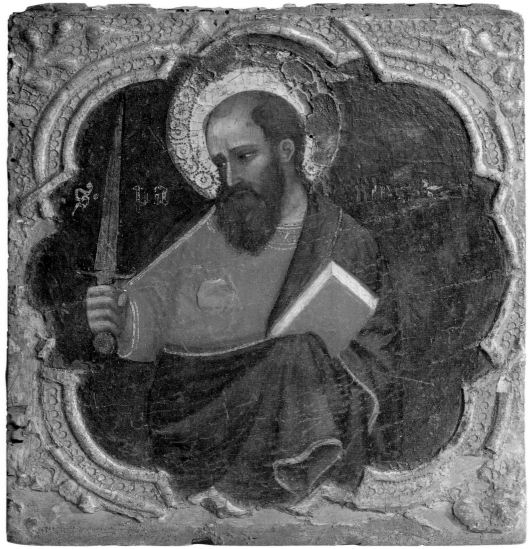

PLATE 66

PLATE 66 (JC CAT. 1170)
Predella panel of an altarpiece: *Saint Paul*

1418(?)

Tempera, silver, and tooled gold on panel with horizontal grain; 10 × 9¼ × ¼″ (25.5 × 23.7 × 0.5 cm), painted surface 8⅞ × 8⅝″ (22.5 × 22 cm)

John G. Johnson Collection, cat. 1170

INSCRIBED ON THE BACKGROUND: *S. Pa ulus* [Saint Paul] (in mordant gilding); ON THE REVERSE: *JOHNSON COLLECTION* (stamped in black); *1170* (in pencil)

PUNCH MARKS: See Appendix II

TECHNICAL NOTES
The panel is thinned and cut on all sides, and in many places the pastiglia decoration has flaked away. A bit of the barbe remains at the top and bottom along margins of bare wood that were originally covered by applied moldings. There is a nail in the area of Saint Paul's chest that probably once attached the panel to an internal member of the predella to which it belonged.

Parts of the halo are cracked, cupped, and obscured by darkened coatings. The mordant gilding has worn off the decoration on the book, parts of the hem of Paul's clothing, and the letters of the inscription. The gilding was applied on a transparent brown mordant. The sword was executed in a silver leaf, which retains some of its metallic quality. The dark background is apparently azurite. Paul's once-green mantle has darkened to brown due to discoloration of the copper-green glazes. The flesh tones and beard are well preserved. There is retouching in the area of the nail.

In the letter to John G. Johnson dated Princeton, May 22, 1913, Frank Jewett Mather, Jr., said that the panel had just been cleaned and cradled by Hammond Smith.

COMMENTS
The balding and bearded apostle Paul is shown bust-length, holding a book and a sword, the latter a symbol of his martyrdom by decapitation. The panel undoubtedly formed part of a predella probably much like the one by Taddeo di Bartolo (plate 78 [JC cat. 95]) in the Johnson Collection. Unfortunately, no other parts are known.

When Mather offered this picture to Johnson in 1913, he identified the artist as Starnina. As Mather had promised Johnson, he published it as such in *Art in America.* In the meantime, on June 4, 1913,

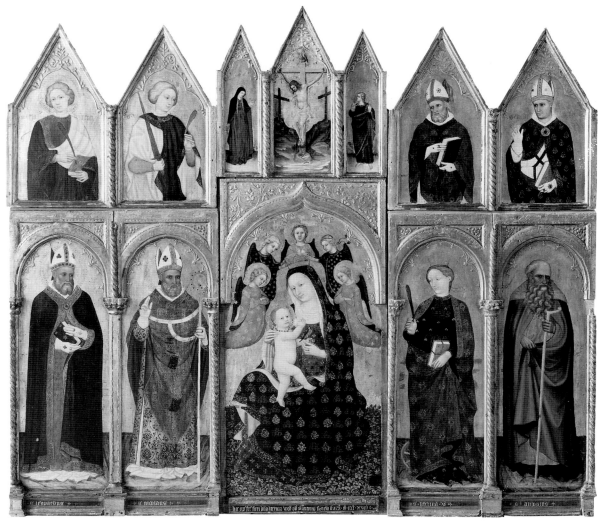

FIG. 66.4 Pietro di Domenico da Montepulciano. Altarpiece: *Virgin of Humility with Angels, Saints Leopardus, Nicholas of Bari, Catherine of Alexandria, and Anthony Abbot, and the Crucifixion and Other Saints,* 1418. Tempera and tooled gold on panel; 84⅝ × 96″ (215 × 244 cm). From Osimo, cathedral of San Leopardo. Osimo, Museo Diocesano

Bernhard Berenson wrote to Johnson saying that the panel was not the work of Starnina, although it was certainly Sienese:

> Many thanks for your letter enclosing the photograph of the St. Paul. It is by some Sienese between Vanni and Taddeo di Bartoli. I dare say I shall be able to tell you next winter, when I hope to see the original, just who did it. It is of slight importance at best & your catalogue will not miss it. Starnina cannot be thought of in this connection. He is to be sure a mere name for no existing work of his is known. But at all events

this much about him is certain, that he was a Florentine. Your St. Paul is Sienese.

During a visit to the Philadelphia Museum of Art on November 1, 1978, Miklós Boskovits assigned the panel to Pietro di Domenico da Montepulciano. He confirmed this attribution by letter, dated Florence, September 6, 1983. In a letter dated Novara, October 22, 1986, Andrea De Marchi agreed with Boskovits's identification, and they have each published the picture.

The Johnson Collection's picture can be compared with the medallions in the predella to Pietro

di Domenico's altarpiece (fig. 66.2) in Recanati. In fact, the figures of Paul and the pastiglia decoration in both are almost identical. Recently De Marchi (in Liberati 1999, p. 93) suggested that it was part of the lost predella of the artist's altarpiece for the cathedral of Osimo (fig. 66.4).

Bibliography

Mather 1913, pp. 179–80, repro. p. 181 (Starnina); Valentiner 1914, p. 200, repro. p. 399 (Siena, early fifteenth century); Johnson 1941, p. 15 (Siena, early fifteenth century); Sweeny 1966, p. 72 (Siena, early fifteenth century); Fredericksen and Zeri 1972, p. 240 (Siena, fourteenth century); Boskovits 1994, p. 282 n. 39, fig. 199; Philadelphia 1994, repro. p. 226; Andrea De Marchi in Liberati 1999, p. 93, repro. p. 95

PIETRO DI MINIATO
(*Pietro di Miniato di Meglio*)

FLORENCE, BORN C. 1366; ACTIVE PRATO;
DIED BETWEEN 1430 AND 1446

Pietro di Miniato, a modest follower of Agnolo
Gaddi and Cenni di Francesco (qq.v.), entered
the company of San Luca in Florence in 1392 and the
Guild of Physicians and Apothecaries (Arte dei
Medici e Speziali) in that city probably around the
same time. In the early fifteenth century, he moved to
Prato with his brother and partner Antonio; there he
spent the rest of his life. In 1409–10 he painted murals
in San Domenico for the famous local merchant and
Maecenas Francesco di Marco Datini. After Datini's
death in 1410, the estate kept Pietro di Miniato
employed, first with preparing ceremonial apparatus
for the funeral. Datini bequeathed funds for two
other projects in Prato that the artist also worked on:
an altarpiece[1] for San Matteo in 1412 and murals for
San Niccolò[2] in 1423. Between 1418 and 1423 he
painted a tabernacle outside the Porta Santa Trinità
on property that had belonged to Datini. Miklós
Boskovits (1970, 1975) identified a group of works that
can be attributed to the artist based on the surviving
paintings. He also reconstructed Pietro di Miniato's
Florentine period, recognizing as his works murals in
Sant'Ambrogio[3] and Santa Maria Novella.[4]

1. Prato, Museo Civico, no. 1308; Mannini 1990, color
 repro. p. 66.
2. One mural there has sometimes been attributed to him
 or his brother Antonio. See Boskovits 1970, p. 44 n. 24.
3. Boskovits 1975, fig. 423.
4. Cole 1969, fig. 28 (erroneously attributed to Cenni di
 Francesco).

Select Bibliography
Guasti 1871, esp. pp. 33–56; Van Marle, vol. 3, 1924,
pp. 559–60; Colnaghi 1928, pp. 183–84; Piattoli 1929–30,
pp. 113–15, 124–25; Thieme-Becker, vol. 27, 1933, p. 24;
Boskovits 1970, p. 38; *Bolaffi*, vol. 9, 1975, pp. 46–47;
Boskovits 1975, esp. pp. 416–17; Fremantle 1975, pp. 401–8

PLATE 67 (PMA 1950-134-532)
Crucifixion with the Mourning Virgin and Saint John the Evangelist

c. 1420

Tempera and tooled gold on panel with vertical grain;
22⅝ × 11⅛ × ¾″ (57.5 × 28.3 × 2 cm), painted surface 22⅝ ×
10⅜″ (57.5 × 26.5 cm)

Philadelphia Museum of Art. The Louise and Walter
Arensberg Collection. 1950-134-532

INSCRIBED ON THE CROSS: *I.N.R.Y.* [IESUS NAZARENUS,
REX IUDAEORUM] (John 19:19: "JESUS OF NAZARETH, THE
KING OF THE JEWS"); ON THE REVERSE: *1333/ European/
B (552)* (in blue ink on a white sticker)

PUNCH MARKS: See Appendix II

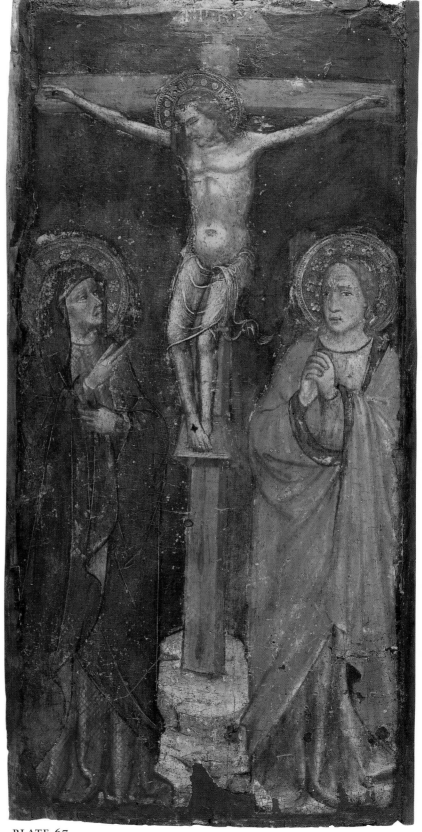

PLATE 67

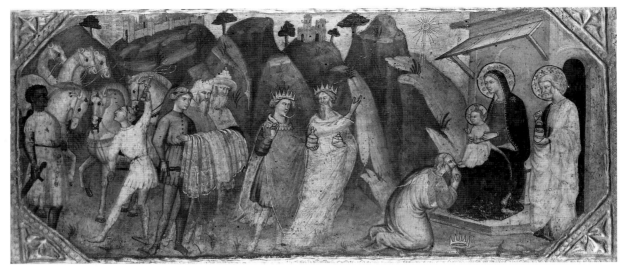

FIG. 67.1 Pietro di Miniato. Predella panel of an altarpiece: *Adoration of the Magi*, c. 1420. Tempera and tooled gold on panel; 11⅝ × 25⅝" (29.5 × 65.1 cm). Columbus (Ohio) Museum of Art, Gift of Ferdinand Howald, no. 31.37

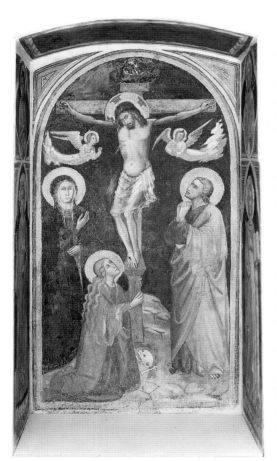

FIG. 67.2 Pietro di Miniato. Tabernacle: *Crucifixion with the Mourning Virgin, Saints John the Evangelist and Mary Magdalene, and Angels*, c. 1415–20. Detached mural; 59⅞ × 26¾ × 13⅜" (152 × 68 × 34 cm). Piazzanese (Prato), rectory of San Giusto

TECHNICAL NOTES

The panel, which is warped, is thinned and cut on all four sides. At a later date the reverse was painted to appear like porphyry. The back also shows evidence of where two horizontal battens were once attached by nails. Two strips of wood were added to either side in modern times.

Underdrawing can be seen with the naked eye in abraded areas of the paint surface. This is particularly true in the pink robe of Saint John the Evangelist. The drapery patterns of the Virgin's now-darkened blue robe were drawn in incisions. In addition, the Virgin's red dress is executed in a curious manner in which the hatching in red lake was done on the surface of already modeled folds.

The edges of the paint surface have suffered considerable loss from flaking. The paint and gold are very abraded. Interestingly, the blue of the background and the Virgin's mantle contain large agglomerates of white pigment. The Virgin stood out against the background because her mantle was modeled in black.

PROVENANCE

Nothing is known about the painting before it was in the collection of Louise and Walter Arensberg; it was given to the Philadelphia Museum of Art in 1950.

COMMENTS

Christ hangs on an unusually tall cross, with the Virgin to the left and John the Evangelist to the right. The background is dark blue. The panel's long and narrow shape suggests that it must have been an independent devotional painting rather than part of an altarpiece.

Everett Fahy (letter dated New York, March 11, 1985) suggested that the picture might be by Pietro di Miniato. It is, in fact, quite close to works that can be dated to his mid- and late career, such as the detached mural paintings of a tabernacle (fig. 67.2) of about 1415–20 from the rectory of San Giusto in Piazzanese, outside of Prato, as well as in its figure style to works like the predella showing the Adoration of the Magi (fig. 67.1) in the Columbus (Ohio) Museum of Art.[1]

1. It is also similar to a *Crucifixion* reproduced in Fremantle 1975, fig. 829; however, the dimensions and present whereabouts of that panel are not known.

Bibliography
Philadelphia 1994, repro. p. 226 (attributed to Piero di Miniato)

PRIAMO DELLA QUERCIA

BORN LUCCA(?); FIRST DOCUMENTED
PIETRASANTA, 1426; LAST DOCUMENTED
1468, SIENA

Priamo della Quercia was the son of the Sienese sculptor Piero d'Angelo, called della Quercia, and younger brother of the sculptor Jacopo della Quercia. It is not known when Priamo was born, but it may have been in Lucca, where his father is documented from 1387 to 1422. In 1426 Priamo is recorded in nearby Pietrasanta, where he rented a house and received payment for some paintings. Around this same time he may have painted a tabernacle altarpiece for the monastic church of Santi Michele e Pietro, called the Monastero dell'Angelo, outside Lucca.[1] In 1428 Priamo was working in the area on a now-lost polyptych for the church of San Lorenzo in Segromigno, and he is documented in the region until 1432. Several other paintings can be attributed to this early period: a triptych of the Crucifixion and saints[2] in a private collection; a *Virgin and Child*,[3] that seems to be based on a Bohemian prototype; and a *Virgin and Child with Angels*[4] and an altarpiece,[5] both in the Metropolitan Museum of Art in New York. Through his brother, Priamo became associated with the painter Domenico di Bartolo (q.v.), with whom he worked on the mural paintings in the Pellegrinaio of the hospital of Santa Maria della Scala in Siena; Priamo executed *The Blessed Agostino Novello Investing the Rector of the Hospital* (see fig. 68.2), for which he received payment in 1442. In 1440, when he had

just begun work on the Pellegrinaio mural, he was commissioned to paint the now-lost high altarpiece for the church of San Michele Arcangelo in Volterra, where he would spend most of the following years. In 1445 the artist painted a triptych now in the oratory of Sant'Antonio Abate in Volterra for the Dogana del Sale (the salt customs house).[6] Among his Volterra works, a *Saint Bernardino in Glory,* once in the oratory of the Santissimo Nome di Gesù, attached to the church of San Francesco;[7] and a small *Virgin and Child and Saints James and Victor,* from the hospital of Santa Maria Maddalena, are dated 1450;[8] a *Virgin and Child with Saints Vittore and Ottaviano*[9] comes from the courthouse.

In 1453 Priamo was documented in Siena, but in 1467 he was again recorded in Volterra, though neither document concerns works of art. In addition, Enzo Carli (1978, p. 58) and Franco Lessi (1986, p. 32) tentatively attributed to him the murals in the chapel of the Visitation, outside Porta Fiorentina.[10] Millard Meiss's (1964a; in Brieger, Meiss, and Singleton 1969, vol. 1) attribution to Priamo of the illuminations of *Inferno* and *Purgatorio* in the Yates Thompson *Divina Commedia* in the British Museum in London has been a matter of some debate and is not usually accepted today.[11]

1. Lucca, Museo Nazionale di Villa Guinigi, no. 147; Lucca 1968, figs. 66–67; Paoli 1985, figs. 24–27 (color).
2. Attributed to Priamo by Giulietta Chelazzi Dini in Siena 1975, p. 290; see also Pisani 1996, figs. 2a–c.
3. Sold, London, Sotheby's, December 6, 1995, lot 10, color repro.
4. No. 65.181.3; Baetjer 1995, repro. p. 60.
5. No. 41.100.35–37; Zeri 1980, plates 50–51. Federico Zeri (1980, p. 70) identified it as the high altarpiece for San Michele in Volterra, which was commissioned in 1440 (see text below). However, stylistically this date is too late.
6. Pisani 1996, fig. 13 (detail).
7. Volterra, Pinacoteca e Museo Civico di Palazzo Minucci Solaini; Paolucci 1989, color repro. p. 109.
8. Pinacoteca e Museo Civico di Palazzo Minucci Solaini; Paolucci 1989, color repros. pp. 112–13.
9. Pinacoteca e Museo Civico di Palazzo Minucci Solaini; Paolucci 1989, color repros. pp. 110–11.
10. These illustrate the Virgin and Child with Saint Nicholas of Tolentino in glory, God the Father and angels, and Saints Anthony Abbot, Victor(?), Jerome(?), and Anthony of Padua. The presence of Nicholas of Tolentino suggests a date around his canonization in 1446.
11. John Pope-Hennessy (1993, pp. 14–16) reasserted his former attribution to Vecchietta. See also Strehlke 1995 and the biography of Nicola d'Ulisse da Siena (q.v.) in this volume.

Select Bibliography
De Nicola 1918; Battistini 1919a; Van Marle, vol. 9, 1927, pp. 559–63; Bacci 1929, pp. 192–93, 303; P. in Thieme-Becker, vol. 27, 1933, pp. 395–96; Bacci 1936, pp. 431–37; Meiss 1964a; Millard Meiss in Brieger, Meiss, and Singleton 1969, vol. 1, pp. 71–80; *Bolaffi,* vol. 9, 1975, pp. 232–34; Giulietta Chelazzi Dini in Siena 1975, pp. 290–93; Giulietta Chelazzi Dini in Chelazzi Dini 1977, p. 204; Carli 1978, pp. 57–58; Zeri 1980, p. 70; Paoli 1985; Lessi 1986, pp. 32–33; Cecilia Alessi in *Pittura* 1987, p. 613; Pisani 1996

PLATE 68 (JC CAT. 20)

ATTRIBUTED TO PRIAMO DELLA QUERCIA

Front panel of a *cassone: Scenes from a Novella*

Early 1440s

Tempera and tooled gold on panel with horizontal grain; 17⅛ × 26⅝ × 1″ (43.4 × 67.5 × 2.5 cm)

John G. Johnson Collection, cat. 20

INSCRIBED ON THE REVERSE: *20/ 1874* (in black crayon); *20* (on tape); red wax seal with a coat of arms consisting of four mounts, surmounted by a palm tree and a star; black wax seal with an indistinguishable coat of arms, surmounted by an earl's five-point crown, circumscribed by a belt inscribed *jamais hors de l'ornière* (never out of the rut)

TECHNICAL NOTES

The panel, consisting of two pieces of wood joined ¾″ (2 cm) from the bottom, is unthinned and presents original saw marks on the back. It has a slight convex warp. All four sides have square nail holes, which probably indicate that some sort of enframement was attached. However, the date of these holes is not certain. Traces of wood remain glued to the left and right sides. The painting has a barbe at the top, bottom, and left; these edges all have painted black borders. There is no barbe on the right side, but instead an incised line and gray-green paint, which might be a division between this scene and a lost one to the right or simply a line of architecture, as the other architecture in the panel is also incised. If the latter is the case, the panel would have been only slightly truncated on the right. In addition, some of a linen layer applied to the panel before the gesso can be discerned at the right edge.

The panel is obscured by grime and quite abraded. The greens have darkened considerably over time, and the areas of azurite have lost their brilliance. The strips of black paint over the tooled gold in the center scene show numerous losses. The most serious loss in the paint occurs where there seems to have been a candle burn below the man in the vignette on the far right; there are also losses in his costume. The gray dress of the lady in the scene on the left is largely repaint, as is a good part of the costume of the kneeling woman in the center.

PROVENANCE

Unknown. The collection seals on the back have not been identified.

COMMENTS

This panel from the front of a *cassone* represents three episodes of an unidentified story. In the center a woman kneels in prayer in a barrel-vaulted room dominated by a gold statue of a nude man. In front of the statue there is a raised platform with what appear to be two boxes covered in cloth. The opening arch is flanked by roundels with reliefs of the Roman goddess Ceres holding a sprig of wheat (left) and Hercules holding a club (right). On the left, outside a columned arcade, a woman with two young girls turns to a man who gestures to her. On the right, outside a rusticated palace, a man and woman converse. All three episodes seem to show the same woman. A side end of the same *cassone* was probably decorated with a panel (fig. 68.1) formerly in the Kress Collection and now in the Discovery Museum in Bridgeport, Connecticut, which shows an enthroned king presiding over his court. A man lies vanquished at the foot of the throne, and a man and the same woman seen in the Johnson panel kneel before him.

The story of the two panels has not been properly identified. Bernhard Berenson (1913) first simply called it a mythological scene. Paul Schubring (1923) thought that the woman was Medea. Later Berenson (1932a), relating the Johnson painting to the panel now in Bridgeport, posited an identification with the Old Testament story of Esther. This opinion was followed by Roberto Longhi (1940), Cesare Brandi (1949), Barbara Sweeny (1966), and Fern Rusk Shapley (1966). In a letter dated Mentana, October 15, 1983, Federico Zeri justly noted that the Johnson panel could not represent Esther, as the woman is shown praying before a pagan statue, which is something Esther never did. In an early catalogue of the Kress Collection (Washington 1941) it was proposed that the panel in Bridgeport represented an episode in the second story of the fifth day of Boccaccio's *Decameron*, in which the adventures of Constantia and Martuccio Gomito in Tunis are narrated. However, the scenes in the Johnson panel relate in no way to other parts of that tale. Jerzy Miziolek did not include the panels in his list of the subjects of Tuscan *cassone* panels, and in a letter dated Warsaw, April 10, 1996, he was not able to identify the story.

Berenson (1913) first assigned the Johnson panel to the Florentine Andrea di Giusto, but in his posthumously published lists (1968), it appears as the

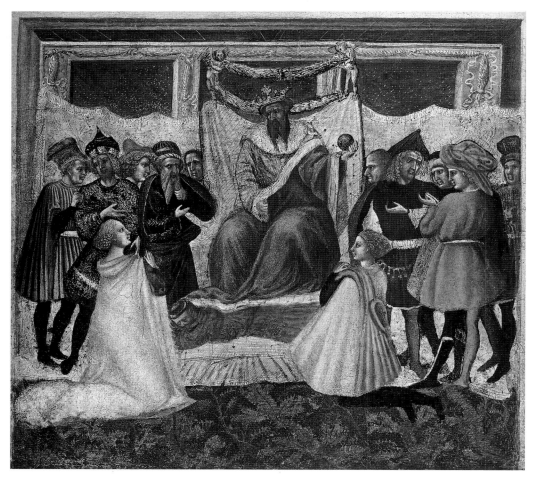

FIG. 68.1 Priamo della Quercia. *Scene of Judgment,* early 1440s. Tempera and tooled gold on panel; 17 × 18¼″ (43.2 × 46.4 cm). Bridgeport, Connecticut, The Discovery Museum, Kress 269. See Companion Panel

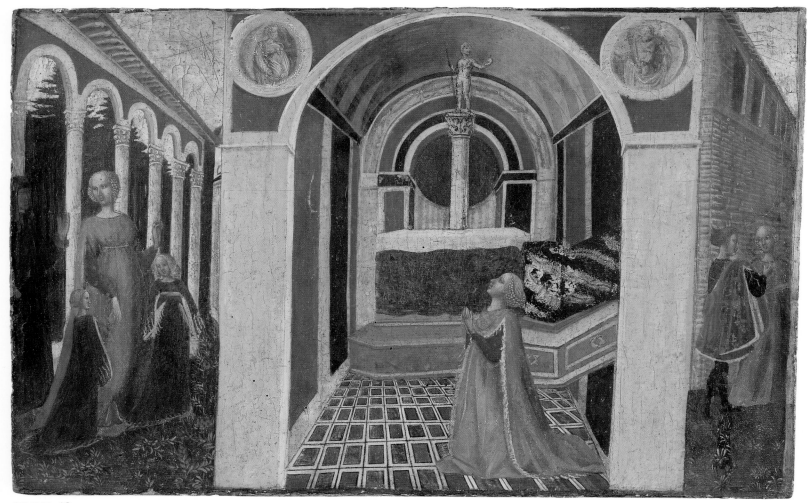

PLATE 68

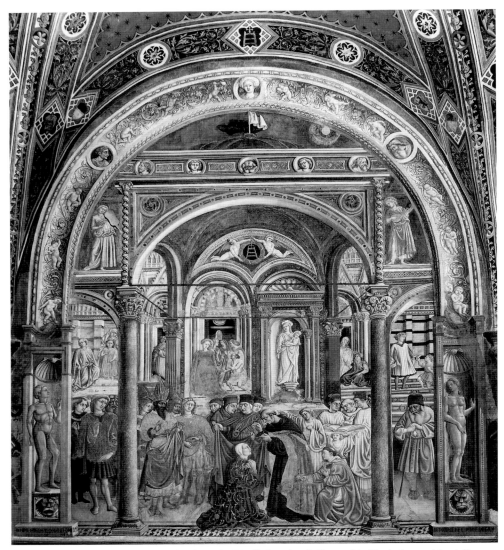

FIG. 68.2 Priamo della Quercia. *The Blessed Agostino Novello Investing the Rector of the Hospital*, 1442. Mural. Siena, hospital of Santa Maria della Scala, Pellegrinaio

work of the Sienese Domenico di Bartolo (q.v.), an attribution first made by Carlo Ragghianti (1938). John Pope-Hennessy (1944), however, rejected this argument. Longhi (1940), also recognizing that the painting was Sienese, made a tentative attribution to Vecchietta, which was the same name proposed by Adolfo Venturi in 1906 for the Kress panel. Brandi (1949) asserted that the painting was not Sienese but Florentine and possibly by the Master of the Strauss Madonna, active in the early 1400s. Burton Fredericksen and Federico Zeri (1972) listed it as Sienese. In 1995 Miklós Boskovits (verbal communication) suggested that the artist was Priamo della Quercia. His attribution seems to be correct, and the Johnson panel and the related one in Bridgeport can be compared with Priamo della Quercia's mural in the Pelle-

grinaio of Santa Maria della Scala in Siena (fig. 68.2). A date in the early 1440s, around the time of the execution of that scene, is most likely.

Bibliography
Rankin 1909, p. lxxxi (North Italian, perhaps of a follower of Pisanello); Berenson 1913, pp. 15–16, repro. p. 242 (Andrea di Giusto[?]); Schubring 1923, vol. 1, p. 237; vol. 2, plate 82; Van Marle, vol. 9, 1927, p. 252; Berenson 1932, p. 12; Berenson 1932a, pp. 519–20, repro. p. 518; Berenson 1936, p. 11; Ragghianti 1938, p. xxiii, fig. 2; Longhi 1940, p. 183 n. 19 (Longhi *Opere*, vol. 8, pt. 1, 1975, p. 50 n. 19); Johnson 1941, p. 1 (Andrea di Giusto); Pope-Hennessy 1944, p. 139; Brandi 1949, p. 187 n. 21; Shapley 1966, pp. 151–52; Sweeny 1966, p. 2, repro. p. 115; Berenson 1968, p. 109; Berenson 1969, p. 158, fig. 276; Fredericksen and Zeri 1972, p. 241 (Siena, fifteenth century); Philadelphia 1994, repro. p. 200 (unknown Tuscan artist)

COMPANION PANEL for PLATE 68
Side panel of a *cassone: Scene of Judgment*.
See fig. 68.1

Early 1440s

Tempera and tooled gold on panel; 17 × 18 ¼″ (43.2 × 46.4 cm).
Bridgeport, Connecticut, The Discovery Museum,
Kress 269

PROVENANCE: Vatican City(?); Rome, Giulio Sterbini(?);
Florence, Contini Bonacossi; New York, Samuel H. Kress
Foundation, acquired 1933; given by the Kress Foundation
to the Discovery Museum, 1961

SELECT BIBLIOGRAPHY: Berenson 1932a, pp. 519–20;
Berenson 1936, p. 11; Ragghianti 1938, p. xxiii; Longhi 1940,
p. 183 n. 18; Washington 1941, pp. 4–5, no. 246; Shapley 1966,
pp. 151–52; Berenson 1969, p. 158; Bridgeport [1962], n.p.

PSEUDO–PIER FRANCESCO FIORENTINO

(possibly *Piero di Lorenzo di Pratese;* 1410/14–May 9, 1487)

The so-called Pseudo–Pier Francesco Fiorentino was the head of a large Florentine workshop active by the mid-1450s, if not somewhat earlier. The name assigned to this artist is actually misleading, because the historical Pier Francesco Fiorentino (1444/45–last documented 1497) was at least a generation younger and worked largely in the area of San Gimignano in the last decades of the fifteenth century.

Federico Zeri (1976, pp. 80–85) did not believe that this anonymous master was really a single personality. As most of the paintings traditionally assigned to the artist are reproductions of pictures by Pesellino (q.v.), who died in 1457, and Filippo Lippi (c. 1406–1469), Zeri classified them as the work of "Lippi-Pesellino" imitators. While the hands vary, the workshop must have been initially headed by one individual.

The workshop specialized in reproducing two altarpieces Lippi had executed for the Medici family. The first was a triptych showing the Adoration of the Christ Child and Saints Michael Archangel and Anthony Abbot, which Giovanni de' Medici had ordered from Lippi as a gift for King Alfonso of Naples; it was delivered to Naples around May 1458. The Pseudo–Pier Francesco Fiorentino's copies of the work are quite important, not only because they record the now-lost center section (see fig. 70.2), but also because they preserved for the Florentine public an important composition that was no longer in the city. The artist probably worked closely with Lippi in developing variants of the painting, and indeed a number of them reproduce what appears to have been Lippi's original landscape background.

The workshop's copies of Lippi's *Adoration in the Forest*[1] were even more popular than those of his earlier Neapolitan triptych, undoubtedly because the *Adoration* was in the Medici palace on the via Larga in Florence, where it adorned the altar of the chapel painted with scenes of the procession of the Magi in 1459 by Benozzo Gozzoli (q.v.). Both Gozzoli's murals and Lippi's altarpiece were commissioned by Piero de' Medici. While most of the Pseudo–Pier Francesco Fiorentino's paintings are reductions of Lippi or Pesellino originals, he also made a full-scale version of the former's *Adoration* altarpiece (see fig. 71.1),[2] which further confirms their close working relationship.

The Pseudo–Pier Francesco's copies of Lippi were not restricted to the two Medici altarpieces. He occasionally quoted elements from Lippi's earlier altarpieces, such as the baby in the *Adoration of the Christ Child with Saints* of about 1453, from the

Annalena convent,[3] and the angel in the *Annunciation* of the 1440s, from the convent of the Murate in Florence.[4] In the Accademia Carrara in Bergamo there is also a copy[5] of Lippi's small panel of the penitent Saint Jerome,[6] which is recorded in the Medici household inventory of 1492. The original probably had been commissioned by Giovanni de' Medici, who was associated with the Hieronymite friars of Fiesole. The Pseudo-Pier's version suggests that another member of the Medici family or someone else connected to either the family or that order also wanted a copy. Similarly, the Pseudo-Pier copied Lippi's painting of the Annunciation now in the Palazzo Doria Pamphili in Rome.[7]

The artist's works after Pesellino are versions not of altarpieces but of paintings of the Virgin and Child originally made for private residences, including the *Virgin and Child with a Swallow* in the Isabella Stewart Gardner Museum in Boston[8] and the *Virgin and Child with the Young Saint John the Baptist and Two Angels* in the Toledo (Ohio) Museum of Art.[9] A copy of the latter panel, made for the Florentine mint in 1459, is the Pseudo–Pier Francesco's only dated picture.[10] Since the Pesellinesque compositions predate the altarpieces by Lippi that the artist imitated, it is likely that he was first associated with Pesellino.

A possible identity for the Pseudo–Pier Francesco is the painter Piero di Lorenzo di Pratese (1410/14–May 9, 1487), who had formed a partnership with Pesellino in 1453. After Pesellino's death, he entered into a legal dispute with the artist's widow, Tarsia, over his share of payments for an unfinished altarpiece[11] commissioned by the company of the Preti di Santa Trinità in Pistoia.[12] The documents indicate that Piero di Lorenzo even provided the first design for the painting,[13] although it was rejected and then given to Pesellino. Piero's argument that he deserved payment since he and Pesellino had divided all of their profits equally implies that he did not actually assist Pesellino on the altarpiece, but their close business relationship does indicate that he had access to Pesellino's designs. He may also have had Pesellino's permission to reproduce them. And he did remain active for nearly thirty years after his partner's death, for until a year before his own death, Piero di Lorenzo maintained the workshop on the corso degli Adimari (now called the via dei Calzaioli) that they had shared.[14]

If Piero di Lorenzo is in fact the painter who can be identified at the head of the Pseudo–Pier Francesco Fiorentino workshop, after Pesellino's death he may have styled a similar agreement with Filippo Lippi to copy his works, for it is unlikely that an artist would have so actively copied Lippi's altarpieces without the latter's permission. Lippi

was given the commission to finish Pesellino's altarpiece for the company of the Preti di Santa Trinità, which suggests that some of Pesellino's materials, possibly even cartoons, passed over to him. In any case, the Pseudo-Pier does not seem to have been one of Lippi's previously known assistants, and the established styles of the Pseudo-Pier cannot be discerned in any known autograph or workshop painting by Lippi.[15]

The Pseudo–Pier Francesco Fiorentino workshop continued for some time. As Zeri (1976, p. 81) has noted, a tondo[16] in the Pinacoteca of Arezzo copies Leonardo da Vinci's *Benois Madonna*[17] and therefore must probably date after 1478. Another painting[18] by the workshop is a copy of Antonello da Messina's *Annunciate Virgin,*[19] although the artist has transformed the subject into the Virgin adoring the Christ Child. In addition, like many contemporary Florentine artists, the master polychromed stucco copies of famous relief sculptures of the Virgin and Child, which were popular in Florence throughout the second half of the fifteenth century.[20]

Research in the conservation laboratories of the Philadelphia Museum of Art showed that two paintings attributed to him and his workshop (plates 70, 71 [JC cats. 40, 39]) were definitely transferred to the panel using a pricked cartoon, or *spolvero,* but whether they reemployed original designs by other artists or simply copied them, making their own cartoons, is not clear. The second alternative seems more likely.

Perhaps no other group of fifteenth-century paintings retains so many of their original frames as those by the Pseudo–Pier Francesco, including two of the four in the Johnson Collection (plates 69, 72 [JC cats. 41, 42]). The artisan who prepared the panel and probably the frame for Pesellino's altarpiece for the company of the Preti di Santa Trinità in Pistoia was Antonio Manetti,[21] an architect and highly sophisticated carver of intarsia who also made frames. It is likely that many of the frames for the paintings by the Pseudo–Pier Francesco Fiorentino came out of a single workshop such as that of Manetti.

1. Berlin, Staatliche Museen, no. 69; Ruda 1993, color plate 27.
2. The copy by the Pseudo-Pier, rather than Lippi's original, is now in the chapel.
3. Florence, Uffizi, no. 8550; Ruda 1993, color plate 124.
4. Munich, Alte Pinakothek, no. 1072; Ruda 1993, color plate 29.
5. No. 920 (513); Zeri and Rossi 1986, repro. p. 77.
6. C. 1460; Altenburg, Germany, Lindenau-Museum, no. 96; Ruda 1993, color plate 38. Ruda (1993, pp. 383–84) argues for an earlier date, in the 1430s.
7. Ruda 1993, color plates 91–92. The copy is in Berlin, Staatliche Museen, no. 1065; Ruda 1993, plate 267.

8. No. P16W11; Hendy 1974, repro. p. 179.

9. No. 44.34; Toledo 1976, color plate 1.

10. Florence, Uffizi, no. 486; Uffizi 1979, repro. p. 488.

11. London, National Gallery, nos. 727, 3162, 3230, 4428, 4868a–d; and Saint Petersburg, The State Hermitage Museum, no. 5511; Gordon 1996, fig. 24. Dillian Gordon (1996) recognized that the painting in Russia belonged to this complex. See also Gordon 2003, color repros. pp. 260–87.

12. Bacci 1941a, 1941b; Davies 1961, pp. 414–19.

13. Bacci 1941a.

14. Procacci 1960, pp. 56–60 n. 127.

15. Lippi had several assistants, but only works by Fra Diamante (q.v.) can be securely identified. A certain Domenico, called a *garzone*, or "apprentice," in the documents related to the completion of the Preti di Santa Trinità altarpiece, might be discerned as one of the hands in some of Lippi's late works. The angels lifting the Virgin's mantle in the *Virgin of Mercy* (1467; formerly Berlin, Kaiser-Friedrich-Museum, no. 95, destroyed in World War II; Ruda 1993, plate 308), which served as the antependium, bear some resemblance to his manner, but the old photographs are not good enough to support an attribution. They may actually be the work of Domenico di Zanobi (q.v.), formerly known as the Master of the Johnson Nativity.

16. No. 467.

17. Saint Petersburg, The State Hermitage Museum, no. 2773; Berenson 1963, fig. 932.

18. Present location unknown; Zeri 1958, fig. 17.

19. Munich, Alte Pinakothek; Sricchia Santoro 1986, color plate 23.

20. Middeldorf 1978.

21. For the most recent work on Manetti, see Haines 1983, esp. pp. 63–74, 135–36.

Select Bibliography
Logan 1901; Giglioli 1931; Van Marle, vol. 13, 1931, pp. 428–64; Berenson 1932; Berenson 1932a, pp. 691–94; Thieme-Becker, vol. 37, 1950, p. 281; Zeri 1958; Berenson 1963, pp. 177–79; Zeri and Gardner 1971, p. 106; Padoa Rizzo 1973; Middeldorf 1978; Holmes 2004

PLATE 69 (JC CAT. 41)
Virgin and Child Before a Rose Hedge

c. 1455–57

Tempera and tooled gold on panel with vertical grain; 29⅜ × 20½ × 1¾″ (74.5 × 52 × 4.5 cm), painted surface 25½ × 16⅝ × 1⅛″ (64.8 × 42 × 3 cm)

John G. Johnson Collection, cat. 41

INSCRIBED ON THE REVERSE: *Pier Francesco Fiorentino. Authorities: Bern.*[d] *Berenson/ Herbert Cooke/ 4:7:98* (on a piece of paper in the upper right); *40/ IN 1740* (in pencil); *JOHNSON COLLECTION/ PHILA* (stamped in black); *41* (in pencil on a label); *CITY OF PHILADELPHIA/ JOHNSON COLLECTION* (stamped several times in black)

PUNCH MARKS: See Appendix II

EXHIBITED: Philadelphia Museum of Art, Sixty-ninth Street Branch, *Religious Art of Gothic and Renaissance Europe* (December 1, 1931–January 4, 1932), no catalogue

TECHNICAL NOTES
The panel consists of a large, single plank of poplar with a ⅝″- (1.5 cm-) wide strip on the left. The original applied frame moldings have been regessoed and regilt. However, evidence of the original orange bole and some bright gilding remains along the inner edge of the picture surface. The red along the outer edges of the molding is later repaint, but as seen in other period examples, it may reflect a similar original color. The sides and the back were finished with white gesso. There are nail holes on all four edges, suggesting that other moldings were attached.

The original paint surface overlaps the inner edge of the molding. The gold star with rays and dots originally on the Virgin's right shoulder is now gone, and that area is pitted. The border of her mantle is decorated with Kufic-style lettering executed in sgraffito, though much of the paint has flaked off. The halos are worked in relief, with a combination of incised lines and flower punches. Carel de Wild's impression, recorded in January 1921, that the picture was in a "fair, even good state," is a balanced assessment of its condition today. Only the red lakes in the roses and the Virgin's dress seem conspicuously faded. In 1956 Theodor Siegl retouched some slight losses in the rose hedge. There is a long, horizontal scratch across the surface about 5⅞″ (15 cm) from the bottom.

PROVENANCE
On June 14, 1904, Bernhard Berenson wrote to John G. Johnson, requesting a photograph of "P. F. Fiorentino Mad.[onna] with rose-hedge." This means he had seen the picture in Philadelphia during his visit to Johnson's collection in February of that year.

FIG. 69.1 Pesellino (q.v.). *Virgin and Child*, c. 1455. Tempera and tooled gold on panel; 25¼ × 17¾″ (64 × 45 cm). Lyons, Musée des Beaux-Arts, no 1997.4

FIG. 69.2 Pseudo–Pier Francesco Fiorentino. *Virgin and Child with the Young Saint John the Baptist and an Angel*, late 1450s–60s. Tempera and tooled gold on panel; with original frame 41 × 40½″ (104 × 103 cm). London, National Gallery, no. 1199

PLATE 69

The nude Christ Child, steadied by the Virgin Mary, stands on a parapet against a background of red and white roses. His feet cast shadows on the parapet as do two of the rose stems on the far right.

The association of the Virgin with the rose, a symbol of purity, comes from the Song of Solomon 2:1: "I am the rose of Sharon." The combination of red and white roses is explained by a passage from Saint Bernard of Clairvaux's twelfth-century *De beata Maria virgine*: "Mary was therefore a white rose for chastity and a red rose for charity."[1] The rose hedge, which became a trademark of the workshop of the Pseudo–Pier Francesco Fiorentino, seems to have been introduced into Florentine painting by Domenico Veneziano in the *Virgin and Child* now in Bucharest (see fig. 21.6). In many instances, this simple, charming background was preferred over the architectural solutions provided by Pesellino (q.v.) and Filippo Lippi.

This picture is a copy of Pesellino's painting (fig. 69.1) known as the *Aynard Madonna*. But whereas Pesellino placed his figures in front of a variegated marble niche, the various versions of his picture produced by the Pseudo–Pier Francesco Fiorentino and his workshop eliminate the niche and put the figures before either a rose hedge, as here, or a simple gold ground.[2] As in the workshop's copies of other compositions, liberties were often taken; a young John the Baptist or an angel or both may be added, for example, and the simple rectangular form might become a tondo (fig. 69.2). While cartoons were probably used to transfer these compositions to the gessoed surface of the panel, infrared reflectography of this panel conducted in 1990, revealed no visible underdrawing or evidence of the use of a *spolvero*.

The sharp contrasts in the lights and darks of the flesh tones in the Johnson panel closely resemble those in the original by Pesellino. This may indicate that this copy dates soon after Pesellino's painting and possibly before that artist's death in 1457.

1. Quoted by Margit Lisner in Uffizi 1992, p. 57.
2. See, for example, Baltimore, The Walters Art Museum, no. 37.736; Zeri 1976, plate 43, no. 51.

Bibliography
Perkins 1905, repro. p. 116; Berenson 1909, p. 170 (Pier Francesco Fiorentino); Berenson 1913, p. 26 (Pier Francesco Fiorentino); Berenson 1916, n.p.; Brenzoni 1928, pp. 5–6, repro. p. 5; Van Marle, vol. 13, 1931, p. 466; Berenson 1932, p. 452; Johnson 1941, p. 13 (Pier Francesco Fiorentino); Davies 1961, p. 186 n. 1; Berenson 1963, p. 174; Sweeny 1966, p. 64, repro. p. 161 (composition of Pier Francesco Fiorentino); Fredericksen and Zeri 1972, p. 134; Philadelphia 1994, repro. p. 227; Gretchen A. Hirschauer in Boskovits and Brown 2003, p. 419

PLATE 70 (JC CAT. 40)
Virgin Adoring the Christ Child and Two Angels

After 1458
Tempera and tooled gold on panel with vertical grain; 19 ⅛ × 11 × ⅝″ (48.7 × 28 × 1.5 cm), painted surface 18 ⅝ × 10 ¼″ (47.2 × 26.1 cm)
John G. Johnson Collection, cat. 40

INSCRIBED ON THE REVERSE: *in/ 2298* (in pencil); *40* (in pencil); *JOHNSON COLLECTION* (stamped in black); *CITY OF PHILADELPHIA/ JOHNSON COLLECTION* (stamped in black)

PUNCH MARKS: See Appendix II

EXHIBITED: Philadelphia Museum of Art, Sixty-ninth Street Branch, *Religious Art of Gothic and Renaissance Europe* (December 1, 1931–January 4, 1932), no catalogue

TECHNICAL NOTES
The panel is thinned and cradled. A barbe on all four sides clearly indicates that the dimensions of the painted surface are original. A rabbet cut along the lower edge of the reverse is filled with a new piece of wood. The cracks in the angel and Child are associated with a large knot in the wood. In April 1920 Hamilton Bell noted that the painting "has been somewhat repainted," and Carel de Wild commented that "the flesh and mantle [were] much repainted." Although the faces are lightly abraded and scumbles have been applied over light areas, particular details have not been altered. In other sections that have been repainted, such as the white lines of the veil, the forms of the original have been followed. In addition, the Virgin's mantle has been retouched with oil, and most of its green lining is repainted. The drapery folds as originally painted are visible in infrared reflectography. There are also surviving traces of mordant gilt details in the Virgin's costume.

PROVENANCE
The picture's history is unknown until F. Mason Perkins published it as part of John G. Johnson's collection in 1905.

COMMENTS
Two angels present the nude Christ Child to the Virgin Mary, whose hands are clasped in prayer. The picture is a version of Filippo Lippi's now-lost central panel of the triptych commissioned by Giovanni de' Medici as a gift for King Alfonso of Naples. Filippo Lippi made a sketch of the triptych and its frame in a letter addressed to Giovanni de' Medici dated Florence, July 20, 1457.[1] It is known that the completed picture was in Naples by May 1458, as on May 27 and June 10 Medici wrote letters to Bartolommeo Serragli, his agent in that city, mentioning the king's reaction to the gift. The only surviving parts of the altarpiece are its wings, representing Saints Anthony Abbot and Michael, in the Cleveland Museum of Art.[2] Lippi's summary sketch shows that the composition consisted of three angels presenting the baby to the adoring Virgin in a woodland landscape. While many variants of the original exist, one of the best, and the only one to include the landscape, is by the Pseudo–Pier Francesco Fiorentino (fig. 70.2), also in Cleveland. It is thus likely that the Cleveland panel was made before Lippi's triptych left Florence for Naples, and that the artist worked in Lippi's shop. In the Johnson

FIG. 70.1 Infrared reflectographic detail of plate 70, showing the use of a pricked cartoon for the Virgin's facial features

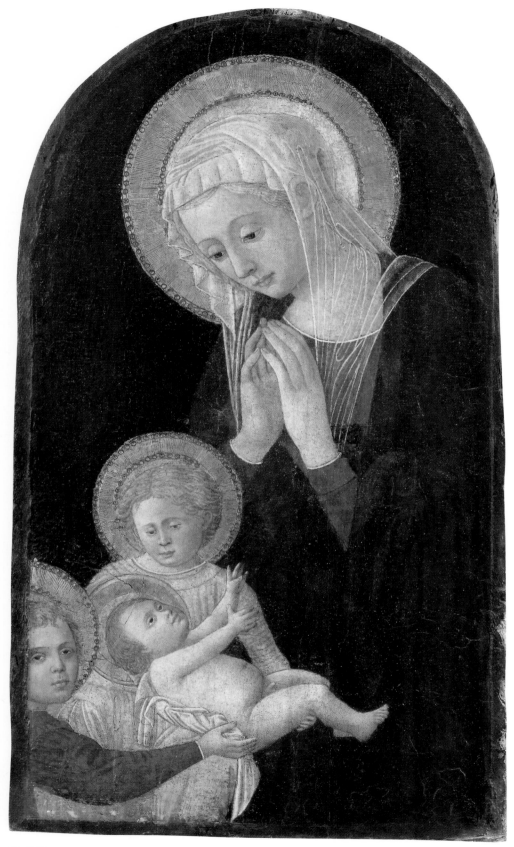

PLATE 70

picture, the landscape is eliminated, and the three angels reduced to two.

Infrared reflectography revealed some faint indication of underdrawing. Although it is difficult to read, it appears that some of this underdrawing was made by the use of a *spolvero,* suggesting that the composition was transferred to the panel from a workshop drawing by pouncing a pricked sheet leaving a row of dots later reinforced with lines. The use of the *spolvero* is most visible in the Virgin's hands and mouth (fig. 70.1) and in the mouth, nose, and hair of the angel on the left. Both the general outline and the curls of the hair are drawn.

1. Ruda 1993, plate 387.
2. Nos. 64.151, 64.150; Cleveland 1974, color plate XVI; Ruda 1993, color plates 113–14.

Bibliography
Perkins 1905, p. 116 (Pier Francesco Fiorentino); Berenson 1909, p. 169 (Pier Francesco Fiorentino); Berenson 1913, p. 26 (Pier Francesco Fiorentino); Brenzoni 1928, repro. p. 4; Van Marle, vol. 13, 1931, p. 435; Berenson 1932, p. 452; Berenson 1936, p. 388; Johnson 1941, p. 40; Berenson 1963, p. 174; Sweeny 1966, p. 64 (composition of Pier Francesco Fiorentino); Fredericksen and Zeri 1972, p. 134; Philadelphia 1994, repro. p. 227; Hiller von Gaertringen 2004, pp. 269, 274 n. 42

FIG. 70.2 Pseudo–Pier Francesco Fiorentino. *Virgin Adoring the Christ Child and Three Angels in a Landscape,* c. 1458. Tempera and tooled gold on panel; 38 1/4 × 21 5/8" (97.2 × 54.9 cm). Cleveland Museum of Art, Holden Collection, no. 16.802

PLATE 71 (JC CAT. 39)
Virgin Adoring the Christ Child

After 1460

Tempera and tooled gold on panel with vertical grain; 21 × 14¾ × ½″ (53.3 × 37.6 × 1.2 cm), painted surface 19⅛ × 13⅛″ (48.5 × 33.5 cm)

John G. Johnson Collection, cat. 39

INSCRIBED ON THE REVERSE: *39/ In 2981* (in black crayon, several times); *CITY OF PHILADELPHIA/ JOHNSON COLLECTION* (stamped several times in black ink); *JOHNSON COLLECTION* (stamped in black)

PUNCH MARKS: See Appendix II

EXHIBITED: Philadelphia Museum of Art, Sixty-ninth Street Branch, *Religious Art of Gothic and Renaissance Europe* (December 1, 1931–January 4, 1932), no catalogue

TECHNICAL NOTES

The panel is thinned and cradled. There is a large knot in the middle of the right side, where a crack runs the length of the panel. There is a barbe on all four sides, indicating that the dimensions of the paint surface have not been altered. Old nail holes across the top and bottom were used to attach a base and cornice to a frame. The present applied moldings are modern.

Mordant gilding was used for the decoration of the cuffs of the Virgin's costume, the rays of her halo, the pillow, and the dots on the green parapet.

The head of the Christ Child is completely repainted, as was first noted in December 1920 by Carel de Wild and Hamilton Bell. The green background is also repaint. However, the rest of the painting is well preserved, although there is repaint in such areas as the lips and cheeks of the Virgin.

In 1920 de Wild made minor unspecified repairs. In 1931 Raimond van Marle described the picture as "considerably restored."

PROVENANCE

The picture's history is unknown until F. Mason Perkins published the work as part of John G. Johnson's collection in 1905.

COMMENTS

The Virgin is shown in adoration of the Christ Child, who lies on a parapet with his head on a pillow.

This is a copy of the two main figures of Filippo Lippi's altarpiece the *Adoration in the Forest*,[1] from the chapel of the Medici palace in Florence. The Pseudo–Pier Francesco Fiorentino also made a full-scale copy of the painting (fig. 71.1), as well as numerous other copies of only the central figures. As in the Johnson Collection's painting, the baby is often depicted resting his head on a pillow (fig. 71.2). Many of these paintings also include the young Saint John the Baptist or one or more angels. An accurate number of all versions is not possible, because so many are in private hands and have changed ownership over the years.

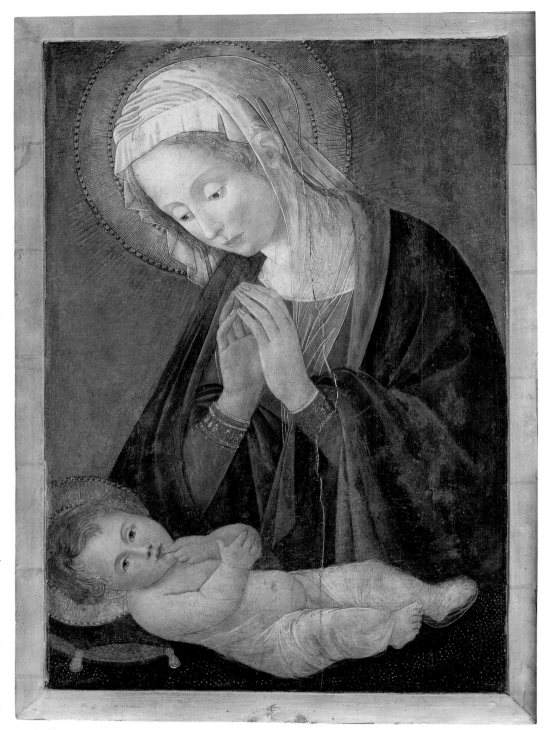

PLATE 71

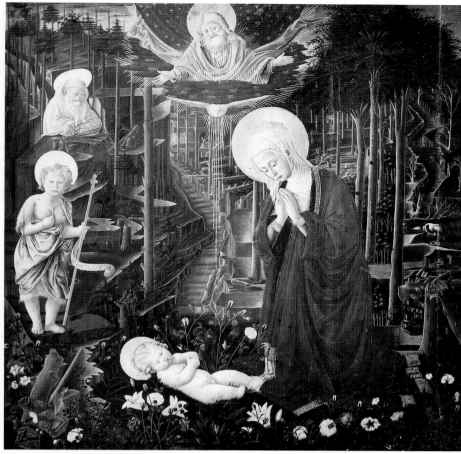

FIG. 71.1 Pseudo–Pier Francesco Fiorentino. Altarpiece, after the original altarpiece by Filippo Lippi: *Adoration in the Forest,* after 1459. Tempera and tooled gold on panel; $57 \times 56\frac{3}{4}''$ (145×144 cm). Florence, Palazzo Medici-Riccardi, chapel

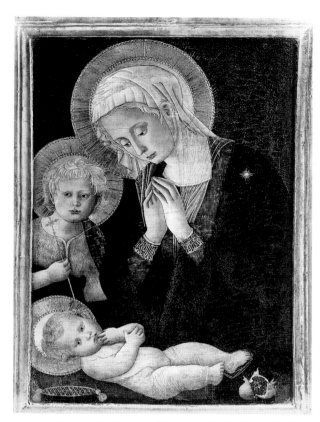

FIG. 71.2 Pseudo–Pier Francesco Fiorentino. *Virgin Adoring the Christ Child with the Young Saint John the Baptist and Angels,* 1460s. Tempera and tooled gold on panel. Gubbio, Museo e Pinacoteca Communali, Palazzo dei Consoli

FIG. 71.3 Infrared reflectographic detail of plate 71, showing the use of a pricked cartoon for the Christ Child's right hand

The popularity of the composition is undoubtedly due to the location of the original in the Medici palace, for most copies were likely made for families who wished to associate themselves in some way with the Medici regime that dominated Florentine life and politics in the mid-fifteenth century. Lippi himself repeated the basic elements of the composition in a painting he made for the hermitage of Camaldoli, which was commissioned by Lucrezia Tornabuoni, wife of Piero de' Medici, sometime around 1463.[2]

Infrared reflectography shows evidence of a pricked cartoon (fig. 71.3), or *spolvero,* to transfer the drawing, and in some areas, such as the Virgin's nostril, the artist did not even bother to connect the dots. This leads to the conclusion that the workshop kept ready cartoons to compose their many versions of the composition.

1. Berlin, Staatliche Museen, no. 69; Ruda 1993, color plate 27.
2. Florence, Uffizi, no. 8353; Ruda 1993, color plate 131.

Bibliography
Perkins 1905, p. 116; Berenson 1913, p. 26 (Pier Francesco Fiorentino); Van Marle, vol. 13, 1931, p. 438; Johnson 1941, p. 13 (Pier Francesco Fiorentino); Sweeny 1966, pp. 63–64 (composition of Pier Francesco Fiorentino); Fredericksen and Zeri 1972, p. 134; Zeri 1976, p. 84; Philadelphia 1994, repro. p. 227

PLATE 72 (JC CAT. 42)

WORKSHOP OF PSEUDO–PIER FRANCESCO FIORENTINO

Virgin and Child with Two Angels

1450s

Tempera and tooled gold on panel with vertical grain; with original frame 22⅞ × 15⅛ × 1¾″ (58 × 38.5 × 4.5 cm), painted surface 18½ × 10⅝″ (47 × 27 cm)

John G. Johnson Collection, cat. 42

INSCRIBED ACROSS THE BOTTOM: *IUSTA PETENTI GRATIOSA SINT* (Just supplicants shall be given grace) (in mordant gilding); ON THE REVERSE: *1* (in red crayon on a paper sticker); *654* (in pencil); *2* (in white chalk); ON THE REVERSE: *JOHNSON COLLECTION / PHILA.* (stamped in black ink)

PUNCH MARKS: See Appendix II

TECHNICAL NOTES

The panel consists of three members: the main plank with vertical grain, on which the picture was painted, which was extended by two strips of cross-grained wood at the top and bottom to accommodate the original applied frame moldings. The bottom piece was attached to the molding by two large nails. This piecemeal construction is somewhat similar to that found in the *Virgin and Child* by Domenico di Bartolo (plate 21 [JC cat. 102]). On the back are regularly spaced nails that attach the moldings to the panel.

The original dark blue frame has been repainted. The sides of the frame have also been repainted blue, but they were originally red or dark brown. The back is similarly repainted, though there are remnants of a yellow geometric pattern. The mordant gilt stars on the frame are modern. There are, however, the remains of some older stars, which the newer ones attempt to duplicate, although the alignment is off. The simplicity of this frame suggests that it may have originally been inserted in a larger marble or wood tabernacle.

A reddish orange mordant was used for the gilded letters, but the mordant elsewhere is unpigmented. Mordant gilding was used for the angels' halos, the decoration of their costumes and the Virgin's, and the vases. Most of this gilding is lost.

In an undocumented early restoration, the unsuccessful attempt to remove a grayish brown surface layer resulted in a mottled surface in the lights. A needle or some other sharp instrument was then used to scratch through the dark residues in an effort to reduce their patchy appearance. Rather mysteriously, lines of the architecture at left appear to have been scraped with a knife, revealing the gesso. The purple of the architecture has faded, although its original brilliance can be perceived where it was protected by now-missing mordant

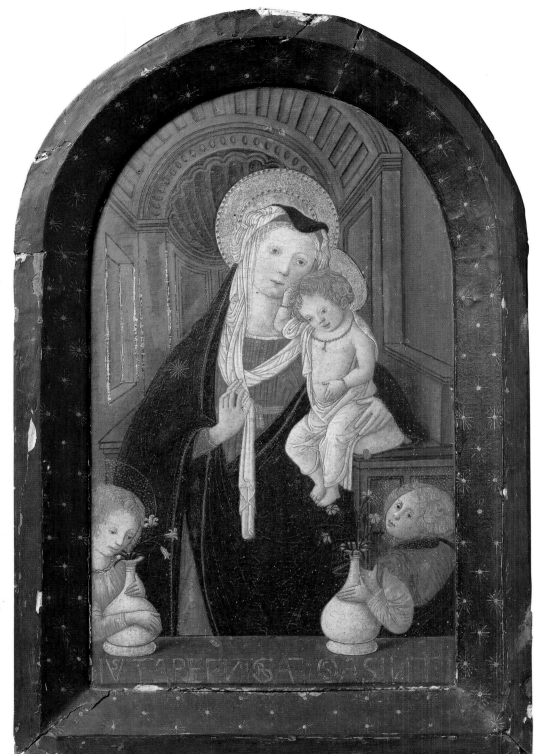

PLATE 72

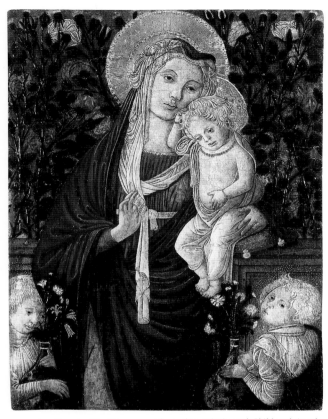

FIG. 72.1 Pseudo–Pier Francesco Fiorentino. *Virgin and Child and Angels Before a Rose Hedge,* c. 1440. Tempera and tooled gold on panel; 14⅜ × 10¾″ (36.5 × 27.3 cm). Brooklyn Museum of Art, Lydia R. Babbott Fund, no. 33

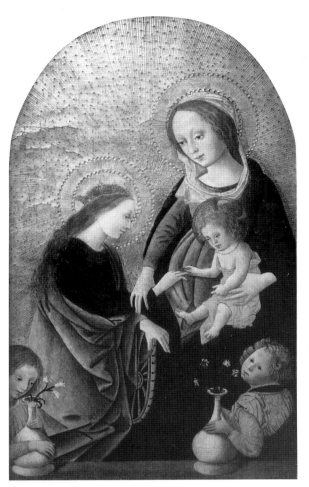

FIG. 72.2 Pseudo–Pier Francesco Fiorentino. *Mystic Marriage of Saint Catherine of Alexandria,* 1450s. Tempera and tooled gold on panel; 19 × 11″ (48.3 × 27.9 cm). Present location unknown

gilding, particularly in the inscription. The green lining of the Virgin's mantle is now almost totally black. Christ's necklace and bracelet have been repainted; the beads were originally gilded.

Infrared reflectography did not reveal much more drawing than can be seen on the surface. However, it did show that the architecture presented some problems for the artist, who redrew the lines and narrowed the oval forms in the arch of the shell niche. Like the architecture, the drapery folds in the Virgin's now-darkened blue mantle were indicated with incised lines.

The files present no history of treatment. Hamilton Bell noted in August 1919 that the panel was safe, but that the wood was very dry.

PROVENANCE
Unknown

COMMENTS
The Virgin stands in a niche before a parapet. She embraces the Christ Child, who sits on the edge of a ledge to the side. He scratches his head, and the

Virgin twines the fingers of her right hand in her long white veil. Two angels hold vases with white lilies and pink carnations.

The composition is an uncommon one for the Pseudo–Pier Francesco Fiorentino. A similar group of figures is found in a painting by him in the Brooklyn Museum (fig. 72.1), although there they stand before a rose hedge. Another related work was formerly in the Alexander Collection, London.[1] As Bernhard Berenson (1913) observed, the same angels and vases of flowers are repeated in the *Mystic Marriage of Saint Catherine of Alexandria* (fig. 72.2), then in the collection of Giacomo Ferroni in Rome.[2]

The fact that there are fewer surviving versions of this composition compared with others produced by the artist and his circle would suggest that it did not find a ready commercial outlet. Its rarity, however, makes it rather more appealing to the modern eye. Berenson (1913) hypothesized that it was a late work. However, the complicated interior architecture suggests that the artist was looking at Filippo Lippi's paintings of the late 1430s and 1440s

in which architectural settings and the relationship of figures to their interior surroundings were a major concern.

In technique this panel is quite different from the other works attributed to the Pseudo–Pier Francesco Fiorentino in the Johnson Collection. Thick lines of paint are used to draw out folds, there is no modeling, and the sharp contrasts between light and shade common to this artist and his workshop (see especially plate 69 [JC cat. 41]) are totally absent. These differences would suggest another hand, possibly even someone outside the workshop.

1. Photo: Courtauld Institute Galleries, neg. B71/1391.
2. Later sold London, Sotheby's, July 15, 1931, lot 116.

Bibliography
Berenson 1913, pp. 26–27 (Pier Francesco Fiorentino); Van Marle, vol. 13, 1931, p. 455; Johnson 1941, p. 13 (Pier Francesco Fiorentino); Sweeny 1966, p. 64 (composition of Pier Francesco Fiorentino); Fredericksen and Zeri 1972, p. 134 (Pseudo–Pier Francesco Fiorentino); Philadelphia 1994, repro. p. 227

Sano di Pietro

SIENA, 1405–1481, SIENA

Except for the fact that he was christened on December 2, 1405, nothing else is known of Sano di Pietro's early life until, at the age of twenty-three, he received payment for coloring Sassetta's now-lost presentation drawing of a design for the font of the Siena baptistery. At this point he also enrolled in the Sienese painters' guild. The next sixteen years of his career are a mystery, with no known work dating before the altarpiece for the Gesuati church of San Girolamo in Siena in 1444.[1] It is likely that during this period Sano, who frequently collaborated with other artists,[2] had formed a partnership with the Master of the Osservanza (q.v.).[3] However, based on the close similarities between the Gesuati altarpiece and the work of the Master of the Osservanza, several authors (Berenson 1932; Brandi 1949; and recently Miklós Boskovits in Boskovits and Brown 2003, p. 479) have made well-reasoned arguments that the artists are the same person. In any case, from 1444 until his death Sano ran one of the most successful workshops in Siena, painting numerous altarpieces, devotional panels, and manuscripts.

Nineteenth-century opinion of Sano di Pietro was quite high. Alexis-François Rio (1874), a French art critic and apologist for the Roman Catholic Church, praised what he described as the painter's naive religiosity. Local patriotism flavored the Sienese historian Gaetano Milanesi's (1854) evaluation of the artist. Although two monographs were devoted to Sano di Pietro in the 1920s, the constancy of his style and his numerous formulaic paintings of the Virgin and Child caused most twentieth-century critics to pass him off as dry and repetitive. However, his role in the art of fifteenth-century Siena was reconsidered at the exhibition of Sienese Renaissance painting in New York in 1988, when it was shown that Sano di Pietro was a consummate illuminator of manuscripts and one of the most talented painters of narrative stories, particularly those executed on a small scale in predella panels.

1. Siena, Pinacoteca Nazionale, no. 246 (Torriti 1977, figs. 298–301 [black-and-white and color]).
2. Sano worked with Vecchietta in 1439, with Domenico di Bartolo (q.v.) in 1444–45, and with Giovanni di Paolo (q.v.) between 1445 and 1447.
3. Keith Christiansen in Christiansen, Strehlke, and Kanter 1988, pp. 138–39.

Select Bibliography

Romagnoli before 1835, vol. 4, pp. 273–354; Milanesi, vols. 1–2, 1854, passim; Rio 1874, vol. 1, pp. 180–98; Borghesi and Banchi 1898, passim; A. Venturi, vol. 7, pt. 1, 1911, pp. 495–98; Gaillard 1923; Trübner 1925; Van Marle, vol. 9, 1927, pp. 466–532; Berenson 1932, pp. 497–505; F. Mason Perkins in Thieme-Becker, vol. 29, 1935, pp. 414–15; Brandi 1949, pp. 69–87, 254–57; Carli 1957, passim; Berenson 1968, pp. 373–83; *Bolaffi* 1976, vol. 10, pp. 141–43; Daniele Benati in Siena 1982, p. 401; Alessi and Scapecchi 1985; Cecilia Alessi in *Pittura* 1987, pp. 750–51; Loseries 1987; Keith Christiansen in Christiansen, Strehlke, and Kanter 1988, pp. 138–39; Mallory and Freuhler 1991; Cecilia Alessi in *Dictionary of Art* 1996, vol. 27, pp. 765–66

PLATE 73 (JC CAT. 106)

Virgin and Child with Four Adoring Angels

Tempera and tooled gold on panel with vertical grain; 23¾ × 23⅞ × ⅝″ (60.2 × 60.6 × 1.5 cm) (without cradle), painted surface 16⅜ × 12⅝″ (41.5 × 32 cm)

John G. Johnson Collection, cat. 106

INSCRIBED ON THE VIRGIN'S HALO: *AVE GRATI[A] PLENA DO[MINI]* (Luke 1:28: "Hail [Mary], full of grace, the Lord"); ON THE REVERSE: *JOHNSON COLLECTION/ CITY OF PHILADELPHIA* (stamped twice in black); *cat. 106* (in white chalk)

PUNCH MARKS: See Appendix II

EXHIBITED: Philadelphia Museum of Art, John G. Johnson Collection, Special Exhibition Gallery, *From the Collections: Paintings from Siena* (December 3, 1983–May 6, 1984), no catalogue (as workshop of Sano di Pietro)

TECHNICAL NOTES

The panel consists of one member, which has been thinned and cradled. There are several cracks; one, to the right of center, runs vertically down the full length of the panel. About 5⅞″ (15 cm) from the top right corner, there is an old hole (⅝″ [1.5 cm] in diameter) of the type that would have been drilled to receive a dowel, the purpose of which is unknown.

The original applied frame moldings have been removed. They were about ⅞″ (2.3 cm) wide and had been attached to the panel with nails, of which only the holes remain. The edges of the painted surface have been filled and repainted, suggesting that they were damaged when the moldings were taken off.

Except for the Virgin's blue mantle, which is almost completely repainted with blue and green glazes, the painting is in very good condition and is a fine example of the high level of Sano di Pietro's craftsmanship. The only losses are along the above-mentioned crack, in a small area through the posy that the Child holds, and in a few spots of flaking in the Virgin's left hand. Close examination shows that the mantle was scraped, perhaps to remove the original layer of what appears to be ultramarine, traces of which can still be seen along the edges. The red glazing over some of the mordant gilt pattern on Christ's blanket seems also to be original.

Except for the mantle, most of the picture has the characteristic gray surface associated with better-preserved tempera paintings. This gray might in fact be the artist's own egg-white varnish.[1] In particular, the flesh tones, which are made up of closely knit tempera strokes of light colors over a green underpainting, present a distinctly gray tonality.

The gold background is well preserved. It is worn to the deep red bole only to the right of the Virgin's head, on some of the inner lining of her mantle, and along the top edge. The undergarments of Christ and the Virgin were executed in sgraffito.

In a letter to John G. Johnson of March 10, 1905, Roger Fry described the Virgin's robe as "restored." In another letter, dated December 26, he wrote: "I have had it [the panel] in hand and given the back a good coating of varnish. Of course I don't know whether my treatment will have any effect in preserving your panel but it is worth trying." Hamilton Bell noted in 1919 that the panel needed to be cradled, which was done in March of 1921. In 1920 he and Carel de Wild commented that the paint surface was in a good state. Loose paint near the bottom and left side caused Theodor Siegl to face the panel in 1955. However, he removed the facing in July 1964, when he gave the picture a surface cleaning and applied a synthetic varnish.

PROVENANCE

John G. Johnson bought this painting in 1905 through Roger Fry, who wrote him on March 10 from Hampstead in London: "I send you a photograph of a Sano di Pietro that may interest you. It belongs to an American lady who has kept a shop in London for some years & is giving it up and going back to America. She wants to get rid of it and would like to get £100 for it. Perhaps she would take a little less." On December 26, he wrote Johnson that he had secured it for 100 pounds. An old sticker on the back of the frame is inscribed in pencil: *M^r Fry.*

COMMENTS

The Virgin holds the Christ Child, who grasps a goldfinch, symbol of his future suffering on the cross (see Battista di Gerio, plate 12 [JC cat. 12]), and a bunch of red flowers or berries. Four haloed heads of angels, wearing olive-leaf crowns, peer from the sides. Praying hands are visible on the lower right figure.

Sano di Pietro painted many variants of this composition, with the Virgin and Child shown either bust- or half-length, and saints sometimes replacing or appearing in addition to the angels. All of these pictures ultimately derive from the artist's

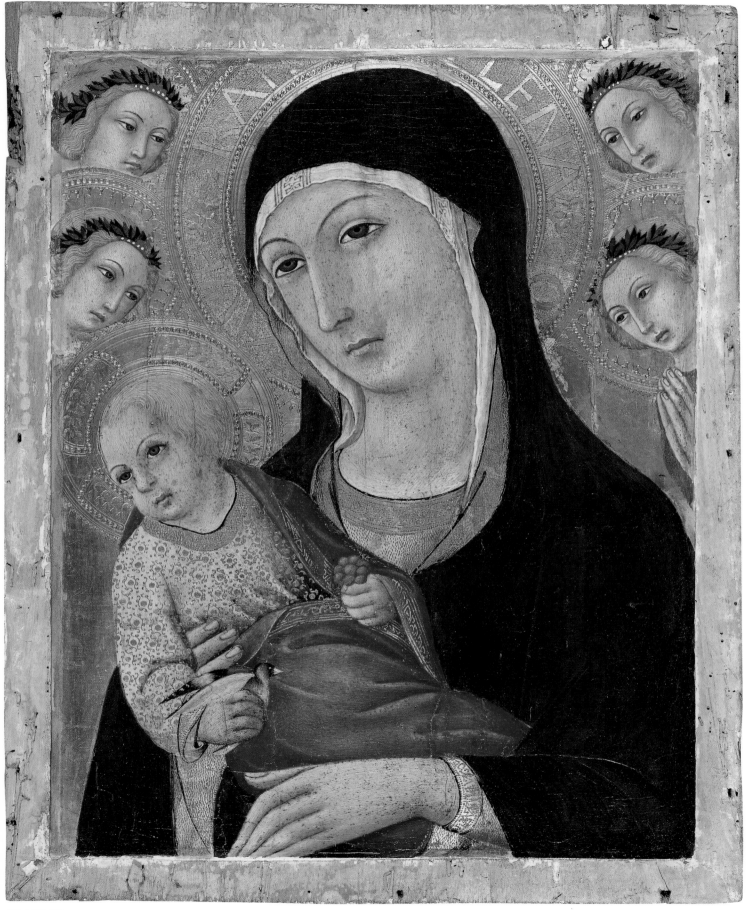

PLATE 73

SANO DI PIETRO 377

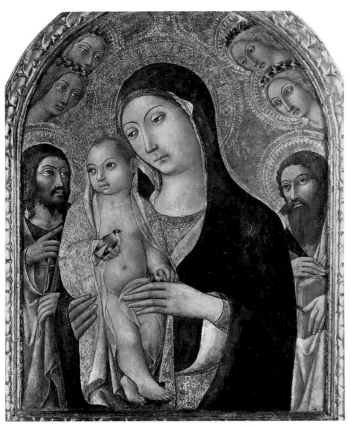

FIG. 73.1 Sano di Pietro. *Virgin and Child with Saints John the Baptist and John the Evangelist and Four Angels*, c. 1467–69. Tempera and tooled gold on panel, with original frame (the photograph is cropped at the top); 25 × 18″ (63.5 × 45.7 cm). El Paso (Texas) Museum of Art, Samuel H. Kress Collection, no. 61.1.8/K522

FIG. 73.2 Sano di Pietro. Reverse of fig. 73.1: *Emblem of Saint Bernardino*

altarpiece, dated 1444, for the Gesuati church of San Girolamo in Siena, in which a group of angels with garlanded headdresses adores the enthroned Virgin and Child.[2]

The inspiration for this type of devotional picture might have come from Saint Bernardino (1380–1444; canonized 1450), who was responsible for giving new fervor to the Sienese cult of the Virgin. The fact that Sano's *Virgin and Child with Saints John the Baptist and John the Evangelist and Four Angels* (fig. 73.1), in the El Paso Museum of Art in Texas, is painted on the back with the saint's personal

emblem (fig. 73.2) suggests that Bernardino did indeed have an influence on this sort of depiction.[3] Both Domenico di Bartolo and Sano di Pietro were devotees of the saint. Sano painted many individual portraits of him, and Bernardino is the saint who appears more often than any other in Sano's devotional pictures.

1. For differing opinions about glair, or egg-white varnish, see Del Serra 1985, p. 4; Bomford et al. 1989, pp. 182–85; and Dunkerton, Kirby, and White 1990.
2. Siena, Pinacoteca Nazionale, no. 246 (Torriti 1977,

figs. 298–301 [black-and-white and color]).
3. It may have been made as a processional standard for the confraternity of San Bernardino in Siena. See Gaillard 1923, p. 85; and Shapley 1966, p. 146.

Bibliography
Berenson 1909, p. 239; Rankin 1909, p. lxxx; Berenson 1913, p. 57; Van Marle, vol. 9, 1927, p. 527 n. 2; Berenson 1932, p. 500; Johnson 1941, p. 15; Sweeny 1966, p. 68, repro. p. 116; Berenson 1968, p. 377; Fredericksen and Zeri 1972, p. 182; Philadelphia 1994, repro. p. 229; Frinta 1998, pp. 56, 194, 261, 312, 328

Scheggia
(*Giovanni di Ser Giovanni*)

SAN GIOVANNI VALDARNO, 1406–1486, FLORENCE

Giovanni di Ser Giovanni, known as Scheggia, was the younger brother of Masaccio (q.v.). As a youth, Giovanni served as a soldier for the condottiere Braccio da Montone, but around 1420, probably with the help of his brother, he secured a position as an apprentice in the workshop of Bicci di Lorenzo (q.v.).[1] In 1426 Scheggia is documented as assisting Masaccio on the polyptych for the Carmine in Pisa.[2] The next year Masaccio included his brother in his Florentine tax declaration. After Masaccio's death in 1428, Scheggia assumed the responsibility of caring for their mother. In Florence he enrolled in the company of San Luca in 1430, the woodworkers' guild in 1432, and the painters' guild in 1433. His matriculation in the woodworkers' guild was necessary because he painted wooden furniture and decorative objects, such as commemorative birth salvers, and also produced intarsia, or wood inlaid panels.[3] His nickname, Scheggia, meaning "splinter," may refer to this activity. In 1439–40 he is also documented in the account books of the Florentine cathedral as part of the team that designed and executed the intarsia of the north sacristy.

Scheggia's only signed painting is the *Martyrdom of Saint Sebastian* in the oratory of San Lorenzo in San Giovanni Valdarno, the original home of his family.[4] In 1969 Luciano Bellosi associated this mural, which dates to 1456–57, with the work of an anonymous painter known alternately as the Master of the Cassone Adimari, after a painting once thought to represent the wedding celebrations of Boccaccio Adimari and Lisa Ricasoli,[5] or the Master of Fucecchio, after an altarpiece from the *collegiata* of Fucecchio, near Empoli.[6] The reconstruction of the artist's oeuvre under the name of the Master of the Cassone Adimari was the work of Roberto Longhi (1926, 1928, 1940, 1951, 1952a). Although he exaggerated the painter's relationship to Piero della Francesca and once mistakenly identified him with the Aretine painter Lazzaro Vasari, Longhi's attributions are essentially correct. Subsequently, Georg Pudelko (1932–34) named the artist after the Fucecchio altarpiece, which he recognized to be by the same hand. Bernhard Berenson (1963, pp. 62–64) included Scheggia's work among the paintings that he attributed to Francesco d'Antonio (q.v.).

The painting central to Scheggia's production is the salver depicting an allegory of Fame, now in the Metropolitan Museum of Art in New York, made for the birth of Lorenzo de' Medici in 1449.[7] This is recorded in Lorenzo's bedroom in an inventory of the Medici palace drawn up after his death in 1492. Scheggia's connection with the Medici and with Lorenzo in particular must have been close, as the same inventory records a *spalliera* by the artist that represented the famous joust of 1469 sponsored by Lorenzo.[8] Although this painting is now lost, Scheggia's four Petrarchan allegories in the Museo di Palazzo Davanzati in Florence might be another set of works described in the same inventory.[9]

Despite his modest talents, Scheggia was at home with the most advanced developments of Renaissance painting in Florence. He was well acquainted with the principles of scientific perspective and made much use of *all'antica* motifs. He painted contemporary stories, such as the Florentine street scene in the painting formerly thought to depict the Adimari-Ricasoli wedding, as well as classical themes. Being the brother of Masaccio gave him access to artistic circles and possibly patrons he might not otherwise have enjoyed. Scheggia was also the acknowledged source for Antonio di Tuccio Manetti's life of Masaccio recounted in *Huomini singhularii in Firenze dal MCCCC. innanzi* (1480s).

1. Beck 1971, p. 188; Beck 1978, pp. 9–11.
2. Strehlke 2002, color plates 9–19. Another of Bicci's apprentices, Andrea di Giusto, also worked on the project.
3. His grandfather was a *cassonaio*, or furniture-maker.
4. Bellosi and Haines 1999, fig. 10 (color). On its restoration, see Anna Maria Maetzke in Arezzo 1974. The inscription proved to be a later addition, but it might in any case reflect the actual date.
5. Florence, Galleria dell'Accademia, no. 8457; Cavazzini 1999, repro. pp. 58–59 (color). However, the association with the wedding, which took place on June 22, 1420, cannot be correct, since stylistically the painting cannot date before 1440. The picture is actually not a *cassone* front but a *spalliera* (wall panel).
6. *Virgin and Child in Glory with Saint Sebastian and Saints Lazarus, Mary Magdalene, and Martha, Who Depart by Sea to Marseilles.* Fucecchio, Museo Civico, no. 3; Bellosi and Haines 1999, fig. 3 (color).
7. No. 1995.7; Cavazzini 1999, repro. p. 51 (color).
8. Spallanzani and Gaeta Bertelà 1992.
9. No. 1611; Cavazzini 1999, repro. pp. 84–87 (color).

Select Bibliography
Longhi 1926, pp. 113–14 (Longhi *Opere*, vol. 2, 1967, p. 60); Longhi 1928, p. 38; Pudelko 1932–34, pp. 163 n. 1, 199; Longhi 1940, p. 187 n. 24 (Longhi *Opere*, vol. 8, pt. 1, 1975, pp. 57–58 n. 24); Longhi 1951, p. 56 (Longhi *Opere*, vol. 13, 1985, p. 298); Salmi 1951, pp. 182–83; Longhi 1952a, p. 21 (Longhi *Opere*, vol. 8, pt. 1, 1975, p. 108); Luciano Bellosi in San Miniato 1969, pp. 56–57; González-Palacios 1970; Anna Maria Maetzke in Arezzo 1974, pp. 88–89; Ahl 1981–82; Procacci 1984; Visonà and Bruschi 1986; Stefania Ricci in *Pittura* 1987, p. 645; Callmann 1988, pp. 8, 13 n. 16, 14 nn. 19–20; Emanuela Andreatta in Berti and Paolucci 1990, p. 256; Maria Sframeli in Berti and Paolucci 1990, pp. 214–15, 238–39, 240–41; Bellosi and Haines 1999; Cavazzini 1999; Strehlke 1999

PLATE 74 (JC CAT. 34)
Portrait of a Lady

c. 1460

Tempera and gold on panel, transferred to canvas; $17\frac{3}{8} \times 13\frac{7}{8}''$ (44 × 36 cm), painted surface $16\frac{1}{4} \times 13\frac{7}{8}''$ (42.3 × 35 cm)

John G. Johnson Collection, cat. 34

INSCRIBED ACROSS THE TOP: *GPI*

EXHIBITED: Allentown 1980–81, cat. 11 (as circle of the Master of the Castello Nativity [q.v.]); San Giovanni Valdarno 1999, no. 22

TECHNICAL NOTES

On all four sides there is evidence of a barbe, which survived the transfer of the painting from panel to canvas and indicates that the picture originally had applied moldings.

An X-radiograph (fig. 74.1) shows that a broadly brushed underpainting was used to fill in the area of the face in general. Such broad underpainting is similar to that seen in Masolino's work (see plates 44A–B [JC invs. 408–9]), though the handling and visual character of the paint here suggest tempera, not the oil medium that Masolino is known to have used.

Infrared reflectography did not reveal much drawing. There are some slight changes in the bottom of the chin and in the line of the nose, which was narrower and shorter. A double line on the eyelid and the presence of two eyebrows indicate that the position of the eye was adjusted. The hair was drawn in wash.

There is abrasion and repainting throughout. The most obvious areas of repaint are the eyebrow and the shadow under the nose. There are retouches throughout the dark background. The inscription is mordant gilding; the mordant is an ocher color. The dotted pattern of the dress is also mordant gilding, although here the gilding is missing. There is also new gilding on the woman's chemise, but it probably does not reflect the original.

In 1963 Theodor Siegl relined the painting and cleaned its surface.

PROVENANCE

The painting may be the picture described as a "profile probably by Francesco di Giorgio" in a letter from Bernhard Berenson to John G. Johnson dated The Deanery, Bryn Mawr, February 2, 1904. This is an attribution that William Rankin preserved in his 1909 article on the Johnson Collection. Otherwise the first notice of its entry into the collection was made by F. Mason Perkins in 1905, when he proposed Paolo Uccello as an alternative to the then-current attribution to Piero della Francesca.

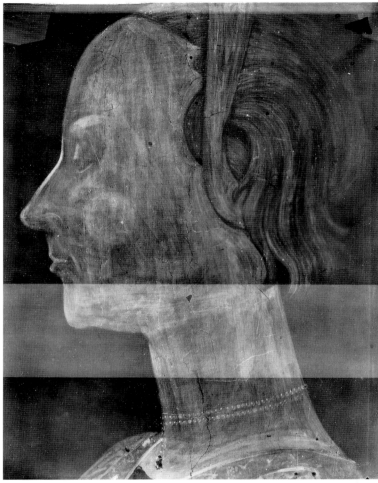

FIG. 74.1 X-radiographic detail of plate 74, showing the underpainting of the flesh. The stripe in the lower half is part of the modern canvas stretcher.

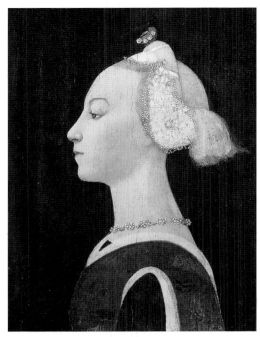

FIG. 74.2 Master of the Castello Nativity (q.v.). *Portrait of a Lady,* c. 1450–55. Tempera on panel, transferred to canvas; 15¾ × 10¾″ (40 × 27.3 cm). New York, The Metropolitan Museum of Art, The Jules Bache Collection, 1949, no. 49.7.6

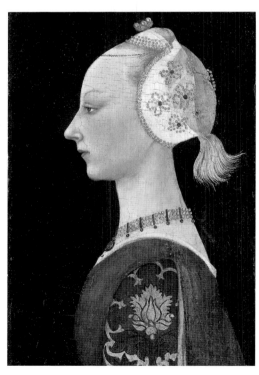

FIG. 74.3 Master of the Castello Nativity (q.v.). *Portrait of a Lady,* c. 1450–55. Oil(?) on panel; 17⅜ × 12⅝″ (44 × 32 cm). Boston, Isabella Stewart Gardner Museum, no. P27w58.15

COMMENTS

The woman is shown at bust length, in profile against a plain, dark background. She wears a brocade dress. As was the fashion in the mid-fifteenth century, her forehead has been shaved and her hair pulled up and held in place by a string around the top of the head and a white band over the ears. A jewel decorates the band. The hairstyle emphasizes the sitter's long neck on which a jeweled pendant hangs from a double-stranded bead choker.

The letters *G, P,* and *I* across the top may be the woman's initials. The *P* is crossed, indicating that it stands for *Pro, Per,* or *Par.* It probably formed part of the same word as the *I.* Together they could be a Florentine last name, of which the patrician families of Peruzzi[1] or Parenti are the most obvious candidates. Scheggia definitely worked for the former, as his only surviving piece of domestic furniture is an intarsia *cassone* with the Peruzzi arms.[2] The *G* may be the first letter of the sitter's name or, more likely, an abbreviation for the Latin word *Gens* or *Gentium,* meaning "family" or "of the family." In this case the family name would be in the Latin plural (for instance, *Peruzziorum*). The need to identify the sitter may suggest that the portrait is posthumous.

The letters are interspersed with symbols resembling fifteenth-century notarial marks, although their specific meaning is unclear. Scheggia, who was the son of a notary, employed the same sort of marks in the inscriptions identifying the saints in the altarpiece in the Museo Diocesano d'Arte Sacra of San Miniato al Tedesco.[3]

The attribution of the picture to the Master of the Fucecchio Altarpiece, now identified as Scheggia, was first proposed by Federico Zeri in a letter to Barbara Sweeny dated Rome, December 20, 1958. He dated the picture toward 1440–50. Other scholars often discussed the painting in terms of the work of Piero della Francesca, Paolo Uccello, and Domenico Veneziano, based on the fact that most surviving profile portraits have been associated with these masters. By contrast, Ruth Wedgwood Kennedy (1938) and John Pope-Hennessy (in Pope-Hennessy and Christiansen 1980) proposed an attribution to Neri di Bicci (q.v.).

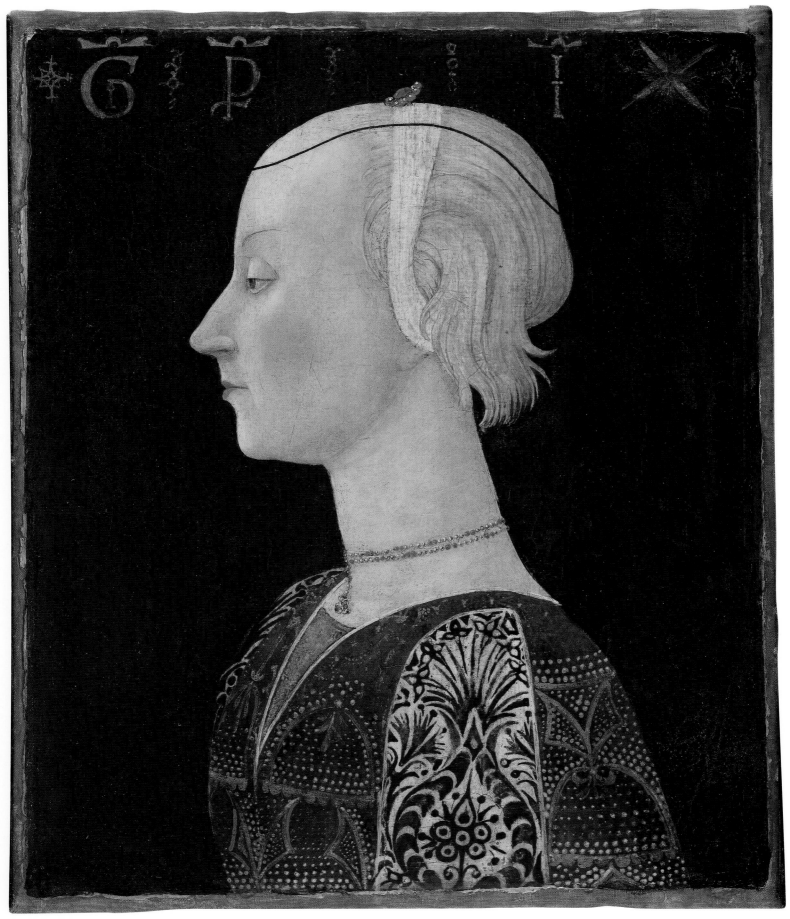

PLATE 74

Only a few independent Florentine profile portraits from this period survive, and most of them are of men. The rarer female portraits all date after 1440, with the earliest extant examples being the work of Filippo Lippi,[4] who established the formula of a strict profile that takes advantage of the high forehead and long neck then in fashion, and that emphasizes the depiction of rich ornament and costume. Lippi's ideas in turn may have derived from Pisanello, whose *Ginevra d'Este* of about 1433 in the Louvre is the earliest known independent Italian female portrait.[5]

Domenico Veneziano has been credited as the other major influence in the depiction of women in Florence. Although no female portrait by him survives, one is recorded in the inventory drawn up after Lorenzo de' Medici's death in 1492.[6] This or another painting by the artist may have been the model for a series of portraits on which the Johnson picture by Scheggia also depends, the principal examples being those attributed to the Master of the Castello Nativity (q.v.) in the Metropolitan Museum of Art (fig. 74.2) and in the Isabella Stewart Gardner Museum (fig. 74.3). The sitters in both are shown against a plain, dark background that emphasizes the sharply cut strict profile. Although Scheggia shows his subject in a slight three-quarter view, his painting follows this model in such aspects as the long neck broken by a choker, the blond hair curled over the ear, and the brocade of the dress.

Laura Cavazzini (1999) has noted similarities between the hairstyle in the Johnson portrait and those in works of the 1450s and 1460s, such as Desiderio da Settignano's marble female bust in the Museo Nazionale del Bargello in Florence.[7] Luciano Bellosi (in Bellosi and Haines 1999) has dated the Johnson portrait to the 1460s.

1. The marks between the *P* and *I* are not letters, as Frank Jewett Mather suggested in a letter to Johnson dated Princeton, February 19, 1914. Mather thought that the inscription might read "Peruzzi."
2. Cavazzini 1999, repros. pp. 48–49 (black-and-white and color).
3. See Dalli Regoli 1988, figs. 16–17 (details).
4. They are the portrait of a woman and man at the window in New York, The Metropolitan Museum of Art (1436[?]; no. 89.15.19; Ruda 1993, color plates 45–46) and the *Portrait of a Lady* in Berlin, Staatliche Museen (c. 1440–50; no. 1700; Ruda 1993, color plate 103). The sitters in the New York portrait are perhaps Lorenzo Scolari and Angiolina di Bernardo Sapiti, who married in 1436. However, the possibility that they are not a married couple is likely, and that it instead shows the homage of a man to his idealized or poetical lover.
5. No. R.F. 766; Campbell 1990, color plate 92.
6. Quoted in Wohl 1980, p. 350, document 5. It was a *colmetto,* or small tabernacle, with a head of a lady.
7. Cavazzini 1999, repro. p. 82.

Bibliography
Perkins 1905, p. 115 (Paolo Uccello); Grant 1908, pp. 145–47, repro. p. 147 (early Florentine, restored); Rankin 1909, p. lxxx (attributed to Francesco di Giorgio); Berenson 1913, pp. 21–22, repro. p. 247 (school of Domenico Veneziano); Van Marle, vol. 10, 1928, p. 240; Berenson 1932, p. 196; Berenson 1936, p. 169; Lipman 1936, pp. 72, 101, fig. 13; Kennedy 1938, pp. 131, 223 n. 223; Johnson 1941, p. 6 (Florentine, 1420–65); Pope-Hennessy 1950, p. 150; *Abbigliamento* 1962, plate 46; Berenson 1963, p. 219; Sweeny 1966, p. 52, repro. p. 125 (Master of Fucecchio); Fredericksen and Zeri 1972, p. 129 (Master of Fucecchio); Pope-Hennessy and Christiansen 1980, p. 59; Callmann 1980, p. 16, no. 11; Philadelphia 1994, p. 230; Craven 1997, p. 238, fig. 8, cat. 8; Luciano Bellosi in Bellosi and Haines 1999, repro. p. 91; Cavazzini 1999, pp. 82–83, no. 22, repro. p. 83 (color)

PAOLO SCHIAVO
(*Paolo di Stefano Badaloni*)

FLORENCE, 1397–1478, PISA

Giorgio Vasari, in the second edition (1568) of the *Lives,* includes an account of Paolo di Stefano Badaloni, known as Paolo Schiavo, toward the end of the biography of Masolino (q.v.). Noting Schiavo's skillful foreshortening of figures in a lost mural in the tabernacle on the Canto de' Gori in Florence,[1] Vasari comments that Paolo tried to follow Masolino's manner. Schiavo's talents in foreshortening can be seen particularly in the cycle of the life of Saint Stephen that he executed in the *collegiata* of Castiglione Olona in Lombardy in the mid-1430s, either under Masolino's direction or shortly after Masolino's death.[2] The date of Schiavo's activity there is open to question: it is assumed that Masolino was responsible for hiring him for this project, which had been commissioned by Cardinal Branda Castiglioni. The other Tuscan artist active at Castiglione Olona was the Sienese Vecchietta, who had probably already collaborated with Masolino in Rome on the Castiglioni chapel in the basilica of San Clemente.[3] Although Schiavo's hand has not been discerned in that chapel, he may have worked with Masolino on another Roman project, such as the lost murals of famous men in Cardinal Giordano Orsini's palace at Montegiordano and possibly even the Santa Maria Maggiore altarpiece (see plates 44A–B [JC invs. 408–9]). A previous connection with Masolino would seem to have been the prerequisite for Schiavo's call to Castiglione Olona.

Schiavo did not enroll in the painters' guild of Florence until December 8, 1429, when he was already thirty-two years old, suggesting that he may have been working outside the city for a period. His 1427 tax return gives no indication of any great activity in Florence at this point.[4] One of the few works that would seem to predate his work at Castiglione Olona is the altarpiece that included the Johnson panels (plates 75A–D [JC cats. 124–27]), but its provenance is not necessarily Florentine. Schiavo's other works from this period include a tabernacle depicting the Virgin and Child in the Fitzwilliam Museum in Cambridge,[5] which was made for an unidentified penitential confraternity whose members are shown in the predella. A set of two contemporary *cassoni* panels, now in the Museum of Fine Arts in Springfield, Massachusetts,[6] and the Yale University Art Gallery in New Haven,[7] tell an amorous story combining contemporary and ancient poetical sources.

All these works as well as the Castiglione Olona murals may predate the year 1436, when Schiavo signed a monumental wall painting of the Virgin and saints in San Miniato al Monte in Florence as *Paulus dei Stephani.*[8] Close in date to this is an altarpiece showing the Virgin and Child with four saints.[9] Two years later Schiavo finished two commissions for the Medici family: the tabernacle of the Mozzette at San Piero a Sieve[10] and an illumination of the Stigmatization of Saint Francis of Assisi for an antiphonary formerly belonging to the convent of San Bonaventura al Bosco ai Frati.[11] Around this same period he collaborated with Masaccio's brother Scheggia (q.v.) on a tabernacle for San Lorenzo in San Giovanni Valdarno.[12] No other works by Schiavo are documented until 1448, when he painted a *Crucifixion with Angels, the Abbess, Nuns, and Two Donors* for the convent of Sant'Apollonia in Florence.[13] This mural bears the arms of Pope Eugenius IV Condulmer, suggesting that it may have been executed in commemoration of privileges that he had granted the nunnery. Schiavo's most important late work consists of the murals and the altarpiece of the Assumption in the oratory of Santa Maria Assunta alla Querce, near Monticelli (Florence),[14] which he painted for the Mannelli family in about 1460.[15] In 1462 he worked in San Domenico in Pisa. He also worked for the Dominicans in Florence, designing on commission from one Fra Niccolò da Milano the embroideries for an altar frontal in Santa Maria Novella in 1466.[16] He may have moved to Pisa sometime after that, as that is where he died in 1478.

1. It is now known as the Canto de' Nelli, which is at the start of the present via dell'Ariento. The tabernacle does not survive.
2. Cattaneo and Dell'Acqua 1976, pp. 73–76.

3. Baldinotti, Cecchi, and Farinella 2002, postrestoration color plates 58–80. Vincenzo Farinella (in ibid., pp. 137–44, 177–86) gives a much greater role to Masaccio in the design and even the execution of this chapel.
4. Florence, Archivio di Stato, *Catasto* 77, folio 339 recto; see Improta and Padoa Rizzo 1989, p. 27.
5. No. 557; Watson 1979, plates 5–7.
6. No. 1962.01; Watson 1979, plates 1–4. Ellen Callman (1999a) erroneously attributed this *cassone* panel and the one in New Haven (see n. 7) to Masolino (q.v.).
7. No. 101; Watson 1979, plates 8–10.
8. Berenson 1968, plate 652.
9. Gallerie Fiorentine, inv. 104912; Fremantle 1975, fig. 1092.
10. Berenson 1968, plate 655.
11. Florence, Museo Nazionale di San Marco, Antifonario 584, folio 2 recto; Padoa Rizzo 1986, fig. 1.
12. San Giovanni Valdarno, Museo della Basilica di Santa Maria delle Grazie. Schiavo's panels show musical angels, Saint Blaise, and Saint Asanus; see Casciu 1993, repros. pp. 28–29.
13. Padoa Rizzo 1975, fig. 7. On the identification of the abbess-donor, see Horster 1980, p. 16; and Bacarelli 1984, pp. 141–42.
14. Trotta 1989, repros. pp. 293–99.
15. Cecilia Frosinini in Trotta 1989, pp. 289–94.
16. Improta and Padoa Rizzo 1989, figs. 1–15. He also designed an embroidery of the Coronation, now in the Cleveland Museum of Art (no. 53.129; Improta and Padoa Rizzo 1989, fig. 16). He is recorded as doing similar designs in Florence for the convent of Santa Maria degli Angeli in 1445 (Spencer 1991, p. 169 n. 28), and in Bagno a Ripoli (near Florence) for the convent of Paradiso degli Alberti (Improta and Padoa Rizzo 1989, pp. 45–46 n. 3).

Select Bibliography
Vasari 1568, Milanesi ed., vol. 2, 1878, pp. 266–67; Offner 1927, pp. 22–27; Colnaghi 1928, p. 200; Salmi 1928–29, pp. 18–30 n. 13; Georg Pudelko in Thieme-Becker, vol. 30, 1936, pp. 46–47; Longhi 1940, esp. pp. 187–88 n. 25 (Longhi *Opere*, vol. 8, pt. 1, 1975, pp. 58–60 n. 25); Richter 1943, pp. 3–5; Pouncey 1946; Berti 1952; Berti 1953; F. Bologna 1955; Linnenkamp 1958; Salmi 1961, pp. 7–8; Luisa Marcucci in *DBI*, vol. 5, 1963, pp. 66–68; Bellosi 1967, p. 4; Luciano Bellosi in Bellosi, Cantelli, and Lenzini Moriondo 1970, pp. 20–21; *Bolaffi*, vol. 8, 1972, pp. 317–18; Fremantle 1975, pp. 523–32; Padoa Rizzo 1975; Moran 1977; Watson 1979; Horster 1980, pp. 16–17; Padoa Rizzo 1986; Cecilia Frosinini in *Pittura* 1987, pp. 725–26; Improta and Padua Rizzo 1989; Emmanuela Andreatta in Berti and Paolucci 1990, p. 262; Leoncini 1991; Boskovits 1995a; Anna Padoa Rizzo in *Dictionary of Art* 1996, vol. 28, pp. 80–81

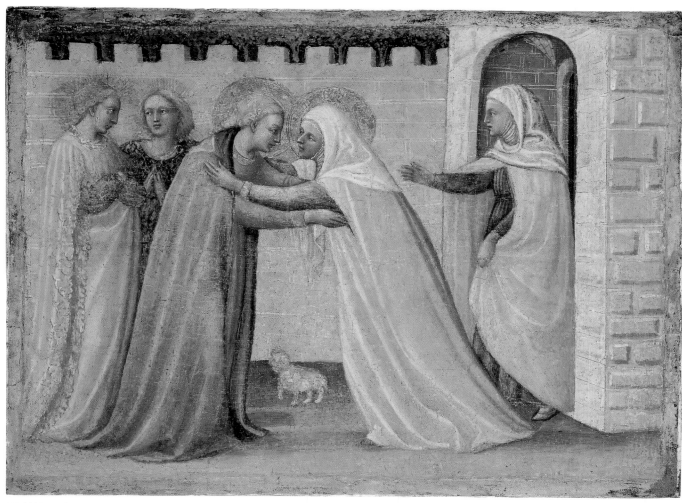

PLATE 75A

PLATE 75A (JC CAT. 124)
Predella panel of an altarpiece: *Visitation*

Late 1420s–early 1430s

Tempera and tooled gold on panel with horizontal grain; 8⅞ × 11⅞ × ⅜″ (22.6 × 30.3 × 0.8 cm), painted surface 8¼ × 11¼″ (21 × 28.5 cm)

John G. Johnson Collection, cat. 124

INSCRIBED ON THE REVERSE: *CITY OF PHILADELPHIA/ JOHNSON COLLECTION* (stamped several times in black); *124* (in white chalk)

EXHIBITED: Philadelphia Museum of Art, *The Nativity* (November 23, 1935–January 7, 1936), no catalogue; New York, The Metropolitan Museum of Art, The Cloisters, *Seven Joys of Our Lady* (December 20, 1944–January 21, 1945), no catalogue

TECHNICAL NOTES
See plate 75D (JC cat. 127)

PROVENANCE
See plate 75D (JC cat. 127)

COMMENTS
Elizabeth, mother of Saint John the Baptist, greets the Virgin, who is accompanied by two young maidens wearing contemporary attire. Unlike the other figures, who have halos, the maidens have golden rays emanating from their heads. Coming out of the stone gateway is Elizabeth's companion, who, like her mistress, is veiled and wears a wimple. A white cat or small dog stands between the two principal figures.

The source for the scene is Luke 1:39–45, which describes how, after the Annunciation, Mary went to visit her aged cousin Elizabeth, who was pregnant with John the Baptist. The presence of the attendants and the small animal adds to the domesticity of the story, which the Gospel places in the house of Elizabeth.

For further comments, see plate 75D (JC cat. 127).

Bibliography
See plate 75D (JC cat. 127)

PLATE 75B (JC CAT. 125)
Predella panel of an altarpiece: *Nativity*

Late 1420s–early 1430s

Tempera and tooled gold on panel with horizontal grain; 8⅞ × 12¾ × ½″ (22.6 × 32.5 × 1.2 cm), painted surface 8¼ × 12″ (21 × 30.5 cm)

John G. Johnson Collection, cat. 125

INSCRIBED ON THE REVERSE: *CITY OF PHILADELPHIA/ JOHNSON COLLECTION* (stamped in black); *125/ in 1289/ JGJ Coll/ Phila* (in pencil on a label)

EXHIBITED: Philadelphia Museum of Art, *The Nativity* (November 23, 1935–January 7, 1936), no catalogue; New York, The Metropolitan Museum of Art, The Cloisters, *Seven Joys of Our Lady* (December 20, 1944–January 21, 1945), no catalogue

TECHNICAL NOTES
See plate 75D (JC cat. 127)

PROVENANCE
See plate 75D (JC cat. 127)

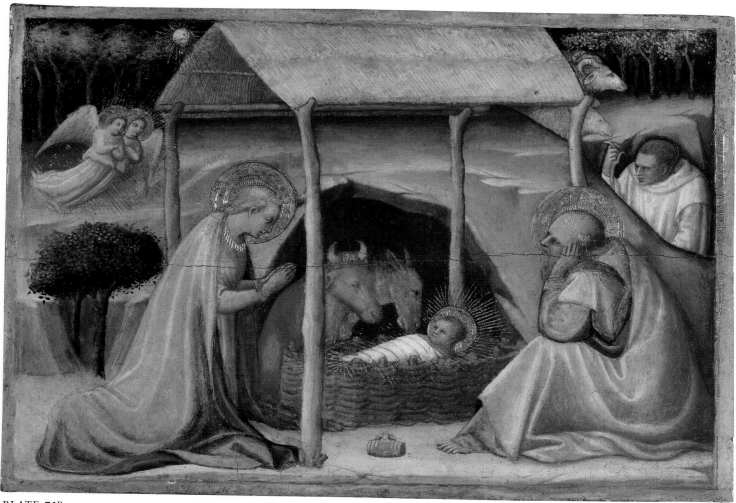

PLATE 75B

COMMENTS

To the left the Virgin kneels in adoration of the baby Christ, and to the right Joseph sits, resting his head on his hand. A shepherd looks on from a rocky crag to the left. Bernhard Berenson (1913, p. 74) suggested that this figure was a portrait of a Camaldolese monk, but the shepherd's pink robe discounts this, as a monk of that order would have been dressed in white. The rays of celestial light coming from the two angels, gold star, and baby contrast with the darkness of the night.

For further comments, see plate 75D (JC cat. 127).

Bibliography
See plate 75D (JC cat. 127)

PLATE 75C (JC CAT. 126)

Predella panel of an altarpiece: *Adoration of the Magi*

Late 1420s–early 1430s

Tempera and tooled gold on panel with horizontal grain; 8 7/8 × 12 5/8 × 1/2″ (22.5 × 32.2 × 1.2 cm), thinned 8 1/2 × 12″ (21.5 × 30.5 cm)

John G. Johnson Collection, cat. 126

INSCRIBED ON THE REVERSE: *CITY OF PHILADELPHIA/ JOHNSON COLLECTION* (stamped several times in black)

EXHIBITED: Philadelphia Museum of Art, *The Nativity* (November 23, 1935–January 7, 1936), no catalogue; New York, The Metropolitan Museum of Art, The Cloisters, *Seven Joys of Our Lady* (December 20, 1944–January 21, 1945), no catalogue

TECHNICAL NOTES
See plate 75D (JC cat. 127)

PROVENANCE
See plate 75D (JC cat. 127)

COMMENTS

Seated on a draped throne, the Virgin holds the infant Jesus, whose foot is being kissed by the oldest of the three kings. Next to the throne Joseph leans on his walking stick. The other two kings stand, carrying golden receptacles. They are dressed as contemporary young men and wear crowns over typically Florentine hats known as *mazzocchi*. On the right is a groom with two horses.

Guilia Scaglia (1968) suggested that the old king was a portrait of the emperor Sigismund, based on the resemblance of his fur hat, resting on the ground beside him, to others in images of the ruler,[1] who spent nine months in Siena, in 1432 and 1433, before going to Rome to be crowned on May 21, 1433. While Sigismund's features may have been familiar to the artist, it seems more likely that Schiavo, like others of his day, was simply inspired by foreign hats. Gentile da Fabriano, for example, painted a similar hat for the older king in his Strozzi *Adoration of the Magi* (see fig. 82.8).

The landscape, the Holy Family group, and the contemporary dress of the two young Magi recall some of the elements of Masaccio's central predella

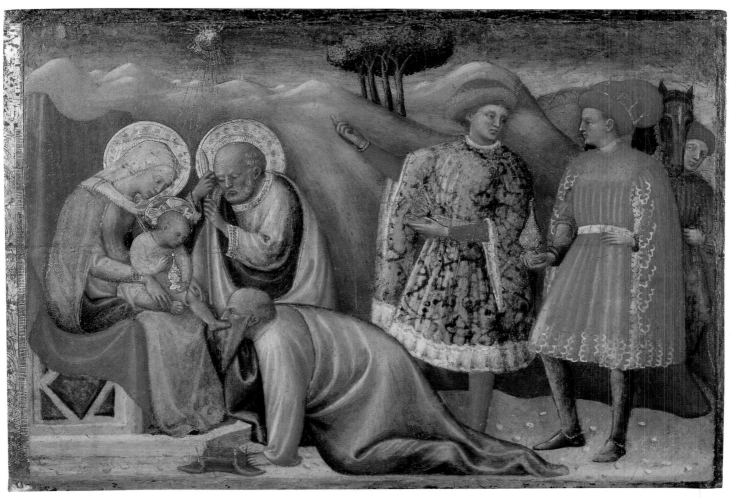

PLATE 75C

panel from his *Adoration of the Magi* altarpiece of 1426 from the Carmine in Pisa.[2]

For further comments, see plate 75D (JC cat. 127).

1. For bibliography on portraits of Sigismund, see Scaglia 1968, pp. 428–29 n. 4. Sigismund wears a similar fur hat in the portrait painted on parchment in Vienna, Kunsthistorisches Museum, inv. 2630 (no. 619); Vienna 1973, plate 1 (as Pisanello).
2. Berlin, Staatliche Museen, no. 58A; Strehlke 2002, color plate 16.

Bibliography
See plate 75D (JC cat. 127)

PLATE 75D (JC CAT. 127)

Predella panel of an altarpiece: *Flight into Egypt*

Late 1420s–early 1430s
Tempera and tooled gold on panel with horizontal grain; 11¾ × 8⅞ × ¾″ (30 × 22.5 × 2 cm), painted surface 8¼ × 11¼″ (21 × 28.5 cm)

John G. Johnson Collection, cat. 127

INSCRIBED ON THE REVERSE: *CITY OF PHILADELPHIA/ JOHNSON COLLECTION* (stamped several times in black ink); *School of Umbro Florentine* (in pencil); *inv 1287/ Phila* (in pencil on a torn label)

EXHIBITED: Philadelphia Museum of Art, *The Nativity* (November 23, 1935–January 7, 1936), no catalogue

TECHNICAL NOTES

A crack that runs horizontally about 4 to 4⅜″ (10 to 11 cm) from the top of this panel as well as of the *Visitation* (plate 75A [JC cat. 124]), the *Nativity* (plate 75B [JC cat. 125]), and the *Adoration of the Magi* (plate 75C [JC cat. 126]) indicates that they

were painted on a single plank of wood that was later cut into four sections. All the panels have been cradled.

Evidence of a barbe shows that there were applied frame moldings around the piece, which was the predella of an altarpiece. An incised gold band separated the scenes, although only the one between the center scenes survives in good condition. There is also indication of a gold border on the lower edges.

There are numerous losses throughout all four panels, and especially along the cracks in the surface, but none so large that it required significant reconstruction of the design. The gold decoration, which consists of both leaf and mordant gilding, is much abraded. In August 1919 Hamilton Bell inspected the panels and pronounced them safe. In April 1922 he and T. H. Stevenson noted that they contained much overpainting. The varnish was removed and paint flakes were laid down. David Rosen set down the flakes in 1944, and Theodor Siegl did the same again in March 1962. In June 1963 Siegl cleaned and retouched the panels.

The paint and gesso of this panel and plate 75A

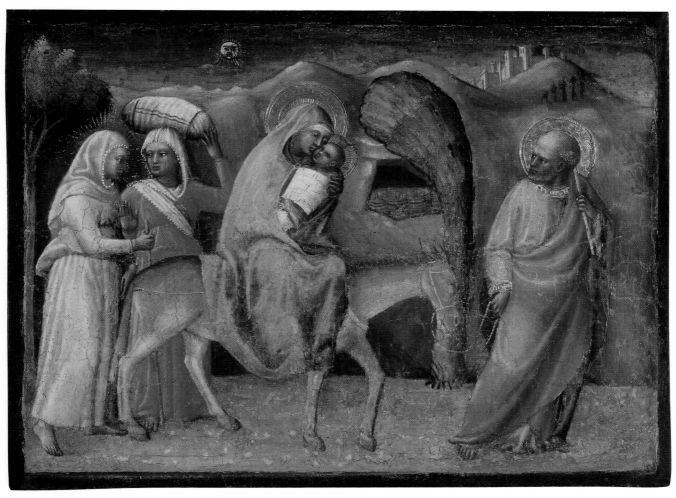

PLATE 75D

(JC cat. 124) were transferred to a new support at an unknown date, which accounts for their particularly bumpy and fragmented appearance.

PROVENANCE

The predella, consisting of four panels (plates 75A–D [JC cats. 124–27]), was sold by Lady Florence Abdy at Christie's in London on May 5, 1911, lot 140, as Gentile da Fabriano. Bernhard Berenson wrote to John G. Johnson from Claridge's Hotel in London on July 20, 1911:

> [The dealer] Trotti is keeping for you four fascinating predella panels which were sold at the Abdy sale as Gentile da Fabriano. They are in fact by a painter who comes very close to that master but to Fra Angelico as well. He is scarcely inferior to either & I am hot on his traces & hope to be able to make him give up his name. I doubt whether you will be able to resist them altho' the price is high.

On July 26 Trotti & Cie of Paris billed Johnson for 32,200 francs for all four paintings. Johnson wrote Wilhelm Valentiner about the purchase in an undated letter from the Hotel Ritz in Paris: "I secured 4 lovely little predella panels, in the style of Fra Angelico and B. Gozzoli, that were in the Abdy sale."

COMMENTS

Joseph leads the ass that the Virgin and Child ride as two handmaidens, one with a bundle on her head, follow. As in the *Visitation* (plate 75A [JC cat. 124]), golden rays emanate from the maidens' heads. They are presumably the same attendants, but now they are barefoot and wear simple dress. As the group passes, a palm tree bows. This may refer to an incident recounted in the Gospel of Pseudo-Matthew concerning a palm tree that bowed down to give its fruit to the Holy Family during a rest on their flight to Egypt.[1] The palm frames the grotto in the hill where Christ was born. It is early morning and the sun has just risen, chasing light and clouds over the hills and faraway city. The attention given to the depiction of the landscape and the atmospheric effects suggests a close familiarity with the predella panel of the same subject in Gentile da Fabriano's *Adoration of the Magi*, finished in May 1423 (see fig. 82.8).

Keith Christiansen (verbal communication, May 17, 1984) noted that these four panels formed the predella to an altarpiece (fig. 75.1), of which the main panels are in the Staatliche Museen in Berlin (fig. 75.2): in the center was the *Annunciation;* on the left, *Saint Jerome;* and on the right, *Saint Lawrence.* Ferdinando Bologna (1955) had previously noted the predella panels' connection with the two saints, then in East Berlin, but had not made the association with the *Annunciation,* then in West Berlin.[2] Stylistically similar are two small panels (figs. 75.3, 75.4) showing the apostles Peter and Paul, which may come from the left and right pilasters of the altarpiece.

Berenson's 1913 catalogue entry on the panels was unusually long. Noting that the painter of the predella had been influenced by Lorenzo Monaco, Gentile da Fabriano, and Fra Angelico, he tried to explain this diversity of sources by suggesting that the artist was a Marchigian working in Florence, most likely Arcangelo di Cola da Camerino. He published this opinion again (1929a, p. 142), but with some qualification: "I still hesitate, even though we know the artist so much better now, but I hesitate less." In 1932 he hesitated no more and

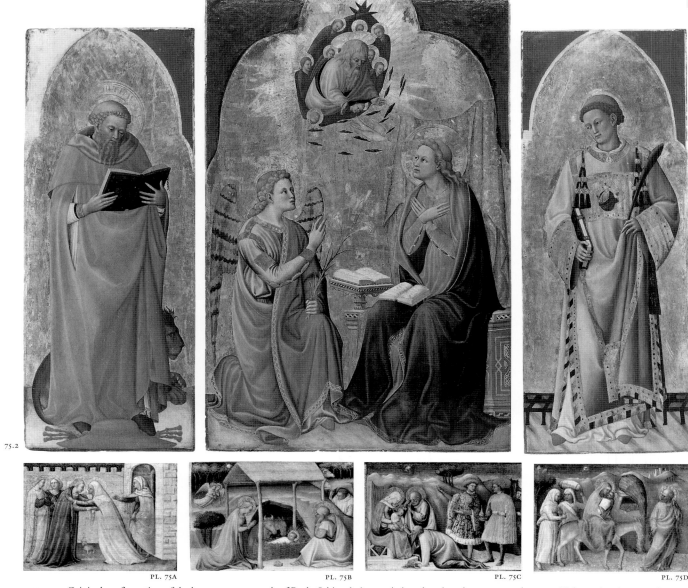

FIG. 75.1 Original configuration of the known extant panels of Paolo Schiavo's Annunciation altarpiece, late 1420s–early 1430s. Main section (FIG. 75.2): *Annunciation with Saints Jerome and Lawrence*. Tempera and tooled gold on panel; center panel 41⅜ × 27⅞″ (105.1 × 70.9 cm), left panel 38⅝ × 15⅝″ (98.2 × 39.7 cm), right panel 38⅝ × 15⅝″ (98.2 × 39.7 cm). Berlin, Staatliche Museen Preussischer Kulturbesitz, Gemäldegalerie, nos. 1123, 1136. See Companion Panels A–C. Predella (left to right): PLATES 75A–D

assigned them definitely to the painter. Richard Offner, in a lecture given in Philadelphia in 1926, contested Berenson's 1913 designation of them as "Umbro-Florentine," which Offner categorized as "a name derived from the theory that Gentile Fabriano influenced some of the Florentines." He described the *Flight into Egypt* as being particularly Masaccio-like.

Roberto Longhi (1940) was the first to recognize that the Johnson Collection's pictures were the work of Paolo Schiavo, dating them before the cycle in Castiglione Olona of the mid-1430s, and more specifically sometime after 1423, because of their stylistic relation to the predella of Gentile da Fabriano's Strozzi *Adoration of the Magi*. While Schiavo's altarpiece may have been done sometime in the late

1420s and therefore relatively early in his career, a later dating cannot be completely excluded. Miklós Boskovits (1995a) proposed a date of about 1430–35 for the predella. The Virgin of the *Annunciation* in the main panel is quite similar to the one in Schiavo's signed mural of 1436 in San Miniato al Monte.[3] In addition, similar figures of the Virgin and the archangel Gabriel in the main panel reoccur

in other murals by Schiavo: the *Annunciation* in the tabernacle of the Olmo[4] in Castello, near Florence, which dates to 1437, and the much later *Annunciation* in the oratory of Santa Maria Assunta at Le Querce, commissioned by the Mannelli family in the 1460s.[5]

The original provenance of the altarpiece is not known. Schiavo's tax records of 1427 give no record of any outstanding sums owed to him that might help trace its patronage, and his later tax declarations have not been located. It is not improbable that the altarpiece could have been painted for a church outside Florence, possibly during the painter's sojourns in Rome and Lombardy between 1427 and 1436. It was in fact during this time that the trilobe shape of the main panels in Berlin began to go out of favor in Florence but less so elsewhere.

1. James 1953, p. 75. This incident is depicted in the same way in the plaque of this subject in the bronze door of c. 1086 by Bonanno for the cathedral of Pisa (Schiller, vol. 1, 1966, fig. 326).
2. He instead suggested that the center of the altarpiece was a Virgin last recorded in the Galletti Collection at Torre di Gallo in Florence (Longhi 1940, fig. 55; Longhi *Opere*, vol. 8, pt. 1, 1975, fig. 70b).
3. Berenson 1968, plate 652.
4. Fremantle 1975, figs. 1106–7. This was for the Guidacci family's palace in that town. See Maria Pia Mannini in Castello 1984, pp. 39, 43.
5. Trotta 1989, repro. pp. 293–99.

Bibliography
Berenson 1913, pp. 72–75, repros. pp. 311–14 (Umbro-Florentine, toward 1425); Sirén 1916a, p. 173; Comstock 1927, pp. 23, 30, repros. p. 22; Offner 1927a, p. 24; Van Marle, vol. 9, 1927, p. 255 n. 1; Van Marle, vol. 10, 1928, p. 574 n. 2; Berenson 1929, p. 24, repro. p. 25 (cat. 124); Berenson 1929a, repro. p. 140 (cat. 124); Berenson 1932, p. 33; *United States Review*, December 21, 1936, n.p., repro.; Longhi 1940, pp. 187–88 n. 25 (Longhi *Opere*, vol. 8, pt. 1, 1967, pp. 58–60 n. 25); Johnson 1941, p. 2 (Archangelo di Cola da Camerino); F. Bologna 1955, pp. 38–39; Luisa Marcucci in *DBI*, vol. 5, 1963, p. 67; Sweeny 1966, pp. 5–6, repro. pp. 122–23 (Archangelo di Cola da Camerino); Berenson 1968, p. 20, plate 674 (cat. 125); Scaglia 1968, p. 434; Zampetti 1971, p. 78, figs. 53–57; *Bolaffi*, vol. 8, 1972, p. 317; Fredericksen and Zeri 1972, p. 185; Watson 1979–80, p. 11, fig. 8 (cat. 124); Christiansen 1982, pp. 37, 75 n. 40; Cecilia Frosinini in *Pittura* 1987, p. 725; Angelo Ottolini in Milan 1988, p. 208; Emmanuela Andreatta in Berti and Paolucci 1990, p. 262; Romano 1992, p. 478; Boskovits 1995a, p. 334, fig. 1 (cat. 125, detail); Anna Padoa Rizzo in *Dictionary of Art* 1996, vol. 28, p. 81

COMPANION PANELS for PLATES 75A–D

A. Center panel of an altarpiece: *Annunciation.*
See fig. 75.2

Late 1420s–early 1430s

Tempera and tooled gold on panel; 41⅜ × 27⅞″ (105.1 × 70.9 cm) (cropped; originally 4–5⅛″ [10–13 cm] higher). Berlin, Staatliche Museen Preussischer Kulturbesitz, Gemäldegalerie, no. 1136

PROVENANCE: See Companion Panel C

SELECT BIBLIOGRAPHY: See Companion Panel C

FIG. 75.3 Paolo Schiavo. Pinnacle panel: *Saint Peter,* late 1420s–early 1430s. Tempera and gold on panel; 14 × 3¾″ (35.7 × 9.4 cm). Wrocław, Poland, Muzeum Narodowe, no. VIII-742

FIG. 75.4 Paolo Schiavo. Pinnacle panel: *Saint Paul,* late 1420s–early 1430s. Tempera and gold on panel; 14 × 3¾″ (35.7 × 9.4 cm). Wrocław, Poland, Muzeum Narodowe, no. VIII-741

B. Lateral panel of an altarpiece: *Saint Jerome.*
See fig. 75.2

Late 1420s–early 1430s

Tempera and tooled gold on panel; 38⅝ × 15⅝″ (98.2 × 39.7 cm). Berlin, Staatliche Museen Preussischer Kulturbesitz, Gemäldegalerie, no. 1123

PROVENANCE: See Companion Panel C

SELECT BIBLIOGRAPHY: See Companion Panel C

C. Lateral panel of an altarpiece: *Saint Lawrence.*
See fig. 75.2

Late 1420s–early 1430s

Tempera and tooled gold on panel; 38⅝ × 15⅝″ (98.2 × 39.7 cm) (slightly cropped). Berlin, Staatliche Museen Preussischer Kulturbesitz, Gemäldegalerie, no. 1123

PROVENANCE: Acquired by the Berlin museum in 1821 from the English merchant Edward Solly

SELECT BIBLIOGRAPHY: Berenson 1968, p. 165; Cecilia Frosinini in *Pittura* 1987, p. 725; Emanuela Andreatta in Berti and Paolucci 1990, p. 262; Boskovits 1995, p. 333

STARNINA
(*Gherardo di Jacopo di Neri*)

BORN GAVILLE, NEAR FIGLINE VALDARNO;
FIRST DOCUMENTED FLORENCE, 1387;
LAST DOCUMENTED 1409, EMPOLI; DIED
BEFORE OCTOBER 28, 1413, FLORENCE(?)

In the second edition of his *Lives of the Artists* (1568), Giorgio Vasari wrote a laudatory biography of Starnina in which he discussed how a long sojourn in Spain had refined the artist's "uncouth" character. According to Vasari, on Starnina's return to Florence, his fellow citizens, who had once loathed him, greeted him with admiration. Vasari gave a political tinge to Starnina's expatriation by asserting that the tumultuous revolt in the 1380s of the lower-class woolworkers, called the *ciompi,* had driven him out of the city. Vasari also stated that Starnina studied with Antonio Veneziano, an artist active in Florence and Pisa, who likewise seems to have worked in Spain. In addition, the early sixteenth-century Florentine art-historical source known as the *Libro di Antonio Billi* claimed that Starnina had also sojourned in France.

Except for the *ciompi* revolt, which occurred about a decade too early to have been the reason that Starnina left Florence, the known facts do not contradict Vasari's account. Starnina, born in Gaville, near Figline Valdarno, enrolled in the Florentine painters' brotherhood, the company of San Luca, in 1387, and in the guild by the next year. However, nothing is known of his activity during this period, and by 1393 he was working in Toledo, Spain, on an altarpiece for the cathedral. He next appears in Valencia, where documents record his presence between June 1395 and June 1401, and call him a citizen of the city.[1] In 1395 he finished an altarpiece for the church of Sueca, outside Valencia, and from July 8, 1398, to March 17, 1400, he worked on a *retablo* for the church of San Agustí in Valencia. In November 1398 he was paid for a sepulchral monument in the Franciscan church of Valencia, and on August 22 of the following year, he received final payment for a painting of Christ. In June 1401 he worked on the decorations for the entry of King Martí I into Valencia. Yet despite his prolific output none of the documented Valencian works survive.

The artist returned to Florence soon after June 1401, probably because he had received the commission for wall paintings in a chapel of the Carmine from Tommaso di Guido di Pagni, count of Gangalandi.[2] The project was completed by October 2, 1404,[3] and shortly thereafter Starnina began work on an altarpiece, now disassembled and in various collections, commissioned by Cardinal Angelo Acciaiuoli for the *certosa* of Galluzzo.[4] That project was finished in 1407. Meanwhile, he had illuminated Dante's *Divina Commedia* for the Florentine Bencivenni family sometime after late April 1405[5]

and had painted a now-lost mural of Saint Dionigi on the exterior wall of the Palazzo di Parte Guelfa in Florence. On February 6, 1409, the confraternity of the Nunziata in Empoli commissioned a cycle of wall paintings, of which only two fragments survive.[6] The murals in Florence and Empoli, together with the Acciaiuoli altarpiece, which for a long time was not properly attributed to Starnina, provide the keys for the reconstruction of his work and for his identification as the artist previously known as the Master of the Bambino Vispo.[7]

After it was established that the Master of the Bambino Vispo was in fact Starnina, several authors sought to identify paintings from the artist's Spanish period. A number of repainted panels representing the apostles and scenes from Christ's life that come from Toledo cathedral may be in part by him.[8] A better preserved *Saint Thaddeus* from this same series has a style close to that of Starnina's presumed master Antonio Veneziano, suggesting that they may have collaborated on this project, although it is difficult to say if Starnina actually worked on that panel.[9] A Spanish work that is most certainly by Starnina is a triptych commissioned in about 1396–97 by Bonfacio, the brother of Saint Vincent Ferrer, for the charterhouse of Portacoeli in Valencia.[10] While not all scholars have agreed with this attribution, the dates would coincide with Starnina's stay in the city and, in particular, with the period in which he is not documented as working on any other project. In addition, the predella and the smaller scenes in the quatrefoils of this triptych resemble the predella panels of the Acciaiuoli altarpiece of 1404–7. The so-called Alpuente predella has also been attributed to Starnina because of its Italian qualities.[11] Starnina's *Last Judgment* in Munich[12] came from the college of Raimond Lulle in Majorca, but because the painting is small and therefore easily transported, it did not necessarily originate in Spain. Another small work by Starnina from his Spanish period is the *Virgin of Humility* in the Cleveland Museum of Art.[13]

What remains of Starnina's first-documented Florentine work, the Carmine cycle of 1404, shows that, despite his Spanish sojourn, he remained a Florentine painter. Starnina's Gothicism, even in its most eccentric phases, was consistently grounded in the principles of late trecento Florentine painting, and his compositions are almost always based on identifiable Florentine models. From what can be made of his figural style through the surviving remnants and Jean-Baptiste Séroux d'Agincourt's engravings[14] after the mural paintings, Starnina continued to be close to Antonio Veneziano. The saints standing in Gothic pavilions also recall Agnolo Gaddi's (q.v.) scenes of the church fathers in the choir of Santa Croce in Florence.[15]

Starnina's later works can be related to the dated murals in Empoli. These include an altarpiece in the Martin von Wagner Museum in Würzburg[16] and the Johnson Collection's painting. In these pictures Starnina's Spanish experiences have amalgamated with artistic contacts that he had made after returning to Florence, particularly with Lorenzo Monaco (q.v.) and Lorenzo Ghiberti.

1. Documents on the artist's Spanish period are transcribed in the original languages in Hériard Dubreuil 1987, pp. 157–62. English translations are provided in Lurie 1987, pp. 364–65 n. 28.
2. For the correct identification of the patron, see Goldenberg Stoppato 1991.
3. Only fragments of these murals survive; see Berti and Paolucci 1990, color repros. pp. 86–87.
4. The altarpiece was formerly identified as one that was originally in the Saint Lawrence chapel of the cathedral of Florence, which had been commissioned in 1422 in accordance with a much earlier bequest of Cardinal Pietro Corsini (died 1405). The confused history of this mistaken identity was sorted out by Jeanne van Waadenoijen (1974) and Cornelia Syre (1979).
 For the reconstruction of the Acciaiuoli altarpiece, see Oertel 1964; Volpe 1973a; Waadenoijen 1974; and Carl Brandon Strehlke in Benito Doménech and Gómez Frechina 2002, p. 22. A photomontage of a proposed original arrangement is in Syre 1979, plate 17.
5. Milan, Biblioteca Trivulziana, Ms. 2263. Andrea De Marchi (in Filieri 1998, p. 263, figs. 154–56 [black-and-white and color]) identified Starnina as the artist.
6. Empoli, Museo della Collegiata di Sant'Andrea; Berti and Paolucci 1990, color repro. p. 89.
7. The Master of the Bambino Vispo, or the Master of the Lively Child, was the name given to a late-Gothic painter by Osvald Sirén in 1904. Many attempts were made to identify him with a documented artist: Pietro di Domenico da Montepulciano (q.v.; Sirén 1906); Parri Spinelli (Sirén 1914); the Gil Master (Post, vol. 8, pt. 2, 1941, pp. 647–52); Miguel Alcanyís (since identified with the Gil Master; Post, vol. 12, pt. 2, 1958, pp. 597–98; Longhi 1965a; Boskovits 1975b); and Starnina (Berti 1964; Bellosi 1966a). Berti's and Bellosi's tentative identification was proved by Waadenoijen (1974, 1983) and Syre (1979).
8. The panels in the cathedral were repainted and reintegrated into two different altarpieces by Juan de Borgoña in the early sixteenth century (Bologna 1975, figs. 1–6).
9. Poughkeepsie, New York, Vassar College Art Gallery, no. 22.1; Vassar 1967, color repro. p. 3.
10. Valencia, Museu de Belles Artes, no. 2461; Benito Doménech and Gómez Frechina 2002, color repros. 23, 25, 27, 29–33.
11. One panel, depicting the Resurrection, is in an unknown location (formerly Vienna, Ernst Pollack Collection). The others are in the parish church of Collado, near Valencia; see Hériard Dubreuil 1987, figs. 208–12; and Benito Doménech and Gómez Frechina 2002, color repro. figs. 2.2–2.3. On this problem, see Antoni José i Pitarch in Luz 2001, pp. 272–74, and Carl Brandon Strehlke in Benito Doménech and Gómez Frechina 2002, pp. 24, 31–32, 237, 239.

12. Alte Pinakothek, no. 10201; Syre 1979, fig. 84. On its provenance, see Gabriel Llompart (1978, pp. 93–95), who proposed that it was from the Hieronymite monastery of Miramar, which King Martí I merged with San Jerònim de Cotalba, near Valencia, in 1401.
13. No. 85.8; Lurie 1989, color plate I.
14. Séroux d'Agincourt 1823, plate CXXI.
15. Baldini and Nardini 1983, p. 184.
16. No. 89, inv. F20; Syre 1979, fig. 127; Bosqué 1965, color repro. p. 61 (detail). See also Gordon 2003, pp. 364–75 and Kanter 2004, pp. 107–8.

Select Bibliography
Billi 1506–30, Frey ed. 1892, pp. 14–15; Magliabechiano 1536–42, Frey ed. 1892, p. 61; Gelli 1549, Mancini ed. 1896, p. 47; Vasari 1550 and 1568, Bettarini and Barocchi eds., vol. 2 (text), 1967, pp. 291–95; Baldinucci 1681–1728, Ranalli ed., vol. 1, 1845, pp. 331–32; Sirén 1904; Sirén 1906, pp. 222–23; Salmi 1913, p. 208; Sirén 1914; Sirén 1926, p. 123; Procacci 1932; Procacci 1933; Procacci 1933–36; Pudelko 1938; Post, vol. 7, pt. 2, 1939, pp. 790–91; vol. 8, pt. 2, 1941, pp. 647–52; vol. 13, 1966, p. 310; Longhi 1940, pp. 183–85 n. 20 (Longhi *Opere*, vol. 8, pt. 1, 1975, pp. 51–53 n. 20); Berti 1964, p. 138 n. 152; Oertel 1964; Bosque 1965, pp. 57–74, 89–111; Longhi 1965a (Longhi *Opere*, vol. 8, pt. 1, 1975, pp. 87–88); Bellosi 1966a, pp. 75–76; Volpe 1973a; Waadenoijen 1974; F. Bologna 1975; Boskovits 1975, esp. pp. 156–58, 254 nn. 292–94, 255 n. 296, 298, 300–301; Boskovits 1975b; Fremantle 1975, pp. 441–42; Sricchia Santoro 1976; Gilbert 1977; Luciano Bellosi in Florence 1978–79, pp. 144–47; Hériard Dubreuil and Ressort 1979, esp. pp. 17–19; Syre 1979; Waadenoijen 1983; Boskovits 1985; Paolucci 1985, pp. 69–71; Hériard Dubreuil 1987, esp. pp. 5–46, 157–62; Francesca Petrucci in *Pittura* 1987, pp. 757–58; Lurie 1989; Emmanuela Andreatta in Berti and Paolucci 1990, p. 264; Antonio Paolucci in Berti and Paolucci 1990, pp. 86–89; Andrea De Marchi in Filieri 1998, pp. 260–65; Carl Brandon Strehlke in Benito Doménech and Gómez Frechina 2002, pp. 22–33, 236–39

PLATE 76 (JC CAT. 13)
Lower center panel of an altarpiece: *Dormition of the Virgin*

c. 1404–8

Tempera and tooled gold on panel with vertical grain; left side, height 40⅜″ (102.5 cm); right side, height 40¾″ (103.5 cm); top, width 35⅞″ (91 cm); bottom, width 35⅝″ (90.5 cm); thickness 1⅛″ (2.9 cm)

John G. Johnson Collection, cat. 13

PUNCH MARKS: See Appendix II

EXHIBITED: London 1887, no. 202 (as Tuscan school); London 1893–94, no. 41 (as Umbrian school); London 1896, no. 144 (as Umbrian school); Philadelphia Museum of Art, John G. Johnson Collection, Special Exhibition Gallery, *A Closer Look at Paintings from the Johnson Collection: Related Works and Reconstructions* (March 29–August 3, 1980), no catalogue; Philadelphia Museum of Art, John G. Johnson Collection, Special Exhibition Gallery, *From the Collections: Spanish Gothic Painting* (January 19–July 14, 1985), no catalogue; Lucca 1998, no. 30a; Cambridge, Harvard University Art Museums, Fogg Art Museum, September 14–November 30, 1998, no catalogue; Philadelphia Museum of Art, *Gherardo Starnina: Reconstructing a Renaissance Masterpiece* (December 17, 1998–March 7, 1999), no catalogue

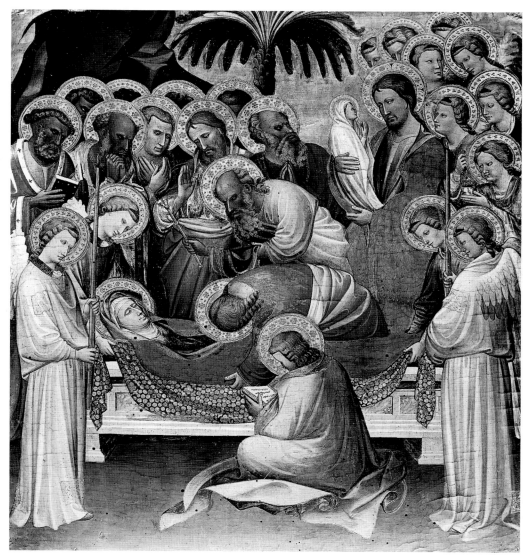

FIG. 76.1 Photograph of plate 76 as it appeared in 1913

TECHNICAL NOTES

The panel, consisting of three vertical members joined 7⅛″ (18 cm) and 28½″ (72.5 cm) from the left edge, is not thinned but is cropped at the top. There is a barbe at the bottom edge, indicating that the picture originally had an attached sill molding. The other sides do not have a barbe, and they have not been planed, suggesting that there were no applied moldings. There are what appear to be carpenter's marks on the panel's edges. Most likely the side panels of the altarpiece abutted the center panel, and framing elements such as colonnettes would have covered the gap between them.

On the reverse, 5⅛″ (13 cm) from the top, there is a horizontal batten mark 3⅜″ (8.5 cm) wide. The batten itself was attached with nails that were driven in from the front and are now cut off. The mark corresponds to those on the reverse of the two side panels in the Museo Nazionale di Villa Guinigi in Lucca (see figs. 76.3, 76.4). The upper corners of the Johnson panel, which are now painted, were originally bare gesso and would also have been covered by framing elements, most likely capitals. These capitals would probably have supported the frame on the now-separated upper part of the center panel (see fig. 76.2), which is surrounded by a barbe, indicating that it had an attached molding. Along the left edge of the painted surface of the Johnson picture, which would have been covered by a framing element, are several tests of punch marks that were not used on the panel itself.

Incised lines demarcate the forms that were adjacent to gilding and define the folds in the dark blue costumes of the Virgin and Christ as was common practice. They were also used to draw the straight edges of the tomb. Infrared reflectography did not detect any underdrawing.

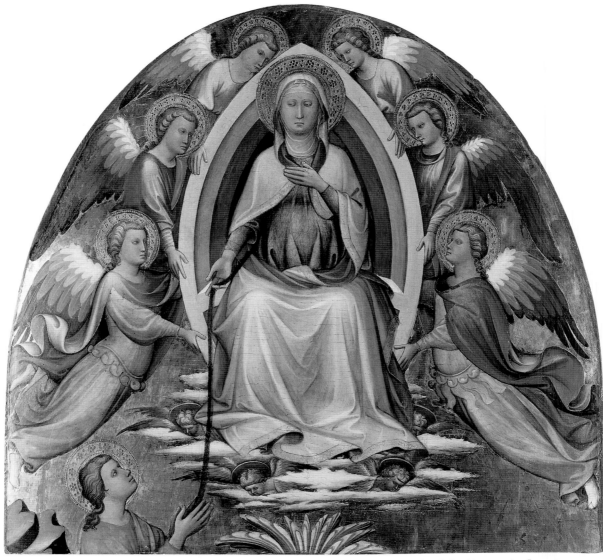

FIG. 76.2 Starnina. *Virgin Mary Giving Her Belt to Saint Thomas the Apostle*, c. 1404–8. Tempera and tooled gold on panel; 31⅞ x 33″ (81 x 83.8 cm). Cambridge, Harvard University Art Museums, Fogg Art Museum, Gift of Friends of the Fogg Art Museum Fund, no. 1920.1. See Companion Panel A

There is general abrasion of paint throughout the panel, and the gesso preparation shows through in many areas, such as the green clothing of the angel blowing the censer, which, like many of the green costumes, is poorly preserved. As a 1913 photograph (fig. 76.1) shows, much of this abrasion occurred during David Rosen's cleaning in 1947. However, despite this, many of the faces are still fairly well preserved. Those that had less paint applied over the green underpainting, such as the darker flesh of the older men and the pallid flesh of the dead Virgin, suffered more in the cleaning. Some of the better-preserved areas can be compared with the panel in the Fogg Art Museum (fig. 76.2), which is in a good state of preservation.

Mordant gilding is used as a decorative element in the Virgin's and Christ's costumes as well as in a few other details; the censer is also mordant gilt. The mordant is unpigmented. The pattern of the

Virgin's shroud was created in a sgraffito technique, and glazed after it was tooled.

In August 1919 Hamilton Bell and Carel de Wild noted that the picture needed cradling and that there was flaking in the drapery of the lower right corner. De Wild made unspecified repairs but did not cradle the picture. In 1947 David Rosen treated the panel. He drilled hundreds of small holes into the panel from the back and infused it with wax. He then attached a metal cradle. Labels on the back from the exhibitions of 1887 and 1893 were removed. He also cleaned the panel.

PROVENANCE
The panel is the lower part of the center section of an altarpiece that probably came from the church of the monastery of San Michele Arcangelo e San Pietro, known as the Monastero dell'Angelo, in Brancoli, outside Lucca. It is not known when it

was disassembled. In the nineteenth century the two lateral panels, which are now in the Museo Nazionale di Villa Guinigi in Lucca, were in the parish church of Tramonte, near Brancoli. Partial proof that the painting was originally in the Monastero dell'Angelo is that at least one other painting,[1] definitely known to have come from the same location, was transferred to the same parish church in Tramonte sometime in the nineteenth century, probably after 1830, when the architect Lorenzo Nottolini rebuilt the monastery in a Neoclassical style for the Passionist order.

Three other locations in or near Lucca have also been proposed. Rowlands (1996, p. 82) suggested that the altarpiece may have come from the parish church dedicated to the Assumption of the Virgin at Piazza di Brancoli, not far from Tramonte, where the panels now in Lucca were in the nineteenth century. Maria Teresa Filieri (in Filieri 1998, pp. 36–37) thought that

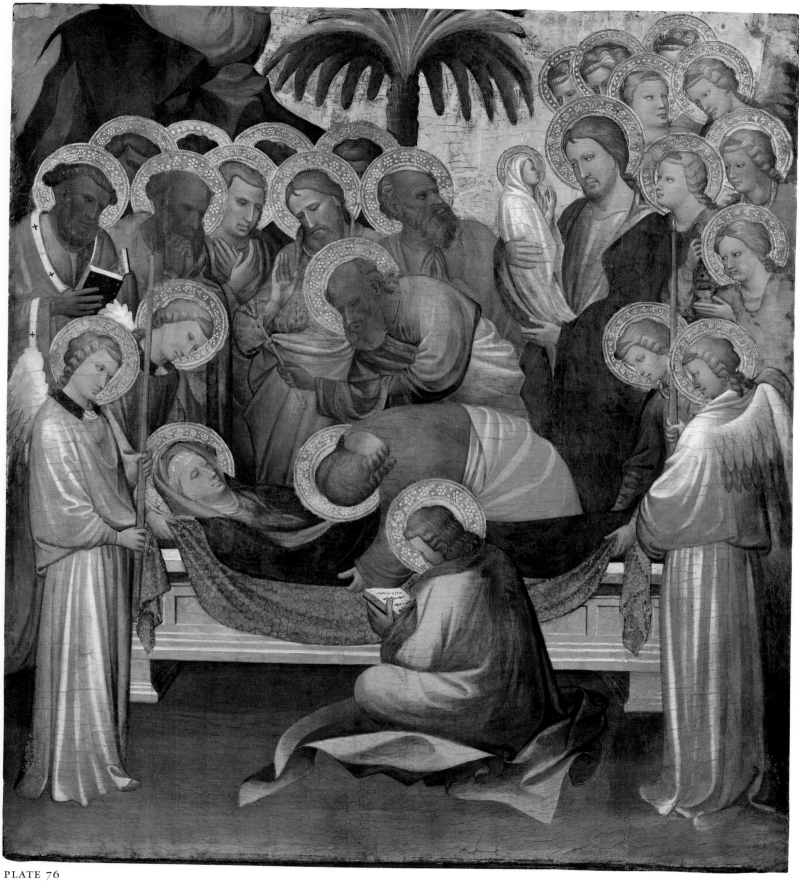

PLATE 76

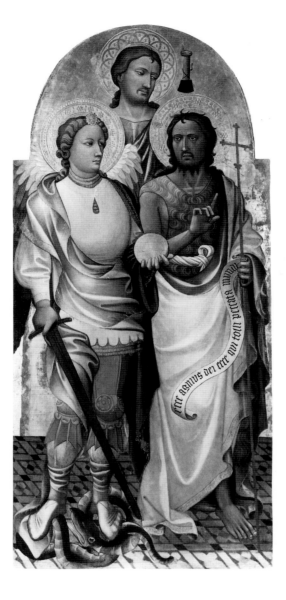

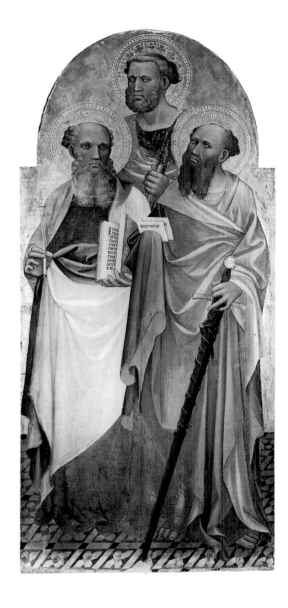

FIG. 76.3 (*left*) Starnina. *Saints Michael Archangel, James Major, and John the Baptist*, c. 1404–8. Tempera and tooled gold on panel; 51⅝ x 23⅝″ (131 x 60 cm). Lucca, Museo Nazionale di Villa Guinigi, inv. 287. See Companion Panel B

FIG. 76.4 (*right*) Starnina. *Saints John the Evangelist, Peter, and Paul*, c. 1404–8. Tempera and tooled gold on panel; 51⅝ x 23⅝″ (131 x 60 cm). Lucca, Museo Nazionale di Villa Guinigi, inv. 288. See Companion Panel C

the Starnina painting might be an altarpiece that was commissioned in 1407 by the priest Andrea del fu Pietro for the *pieve* of Lammari near Lucca, and that was funded with money that had been left about ten years earlier by one Michele di Arrigo Sartori. A record of an official pastoral visit of 1647 lists a painting of the Burial and Assumption of the Virgin with the apostles and other unidentified saints that would, in general, fit the Starnina altarpiece.

While Filieri's proposal is intriguing, it would not explain how the lateral panels later came to the church in Brancoli. In yet another proposal, De Marchi (in Filieri 1998, p. 270) suggested that the Starnina altarpiece was too important for an isolated church and must have been originally painted for a church in Lucca, suggesting San Michele in Foro, which is dedicated to the archangel. Documents show that officials of that church were already discussing a new altarpiece in 1390 and that funds became available for such a project in late 1404 and 1405. Apparently an altarpiece was being worked on in 1404. There are no records that describe the altarpiece

in San Michele in Foro, but this is also the case with the paintings in the Monastero dell'Angelo and the parish church of Piazza a Brancoli.

The Johnson panel first appeared in the nineteenth century, when it was in the collection of Charles Butler of London and Warren Wood, Hatfield. In 1912 the art dealer Arthur J. Sulley sold it to John G. Johnson.[2]

COMMENTS

Two angels, aided by a young apostle, lower the Virgin's body into the tomb, while on the right Christ, accompanied by a host of angels, gathers her soul in his arms. Of the apostles looking on, only the bearded man with his hands clasped in prayer seems to note Christ's presence. He may be Dionysius Areopagite, the disciple of Saint Paul who, according to the *Golden Legend* by Jacopo da Varazze (c. 1267–77, Ryan and Ripperger ed. 1941, p. 451), was said to have been present at the Virgin's burial and to have given an account of it in his *Book of the Names of God*. If the figure is in fact Dionysius, this would account

for the presence of thirteen, as opposed to the usual twelve, apostles in the panel. Saint Peter is the man on the left wearing a white stole with crosses, a liturgical garment reserved for popes. The older apostle using an aspergillum to sprinkle the Virgin's body with holy water may be Andrew, who is traditionally bearded and balding. On a rocky promontory in the upper left, the lower part of the red mantle of the kneeling apostle Thomas is visible. The rest of his figure can be seen in the upper section of the center panel in the Fogg Art Museum, which shows the Virgin giving Thomas her belt (fig. 76.2).[3] The two panels have been installed together and are exhibited as a unit at the Philadelphia Museum of Art and the Fogg Art Museum on a rotating basis.

The Philadelphia and Cambridge panels constitute the center section of an altarpiece (fig. 76.8), whose lateral panels now in Lucca represent Saints Michael Archangel, James Major, and John the Baptist (fig. 76.3) and Saints John the Evangelist, Peter, and Paul (fig. 76.4).[4] The three panels of the predella are the *Adoration of the Shepherds* (fig. 76.5) in a private

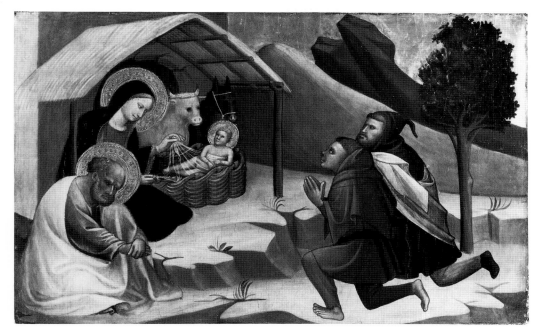

FIG. 76.5 Starnina. *Adoration of the Shepherds,* c. 1404–8. Tempera and tooled gold on panel; 13 x 20¼″ (33 x 51.5 cm). Turin, private collection. See Companion Panel D

collection, Turin; the *Adoration of the Magi* (fig. 76.6) in the Nelson-Atkins Museum of Art, Kansas City; and the *Presentation of Christ in the Temple* (fig. 76.7), in a private collection.[5]

Bernhard Berenson (1913) attributed the panel in the Johnson Collection to the Master of the Bambino Vispo, who has since been identified as Starnina. This attribution has been accepted by all authors except for Jeanne van Waadenoijen (1983) and Cornelia Syre (1979), who both thought it and the other panels of the altarpiece were by a follower of Starnina.

Zeri (1964) and González-Palacios (1971) noted that Starnina's altarpiece derives from the composition of Angelo Puccinelli's altarpiece (fig. 76.9) of 1386 for the church of Santa Maria Forisportam, Lucca. While there are differences between the two (for example, the Puccinelli does not include the episode of Saint Thomas receiving the Virgin's belt), the positions of the palm tree in the center and of Christ on the right instead of center are unique features of both of these paintings. These features are not found even in Giotto's *Dormition of the Virgin* of about 1310, which is a source for other details of the paintings.[6] The iconography and composition of an earlier *Dormition of the Virgin* by Starnina, now in the Art Institute of Chicago,[7] depart sufficiently from the Giotto to prove that it was not a preordained model. Another specific source for the Johnson-Fogg Starnina was Orcagna's relief in the tabernacle of Orsanmichele in Florence; executed between about 1352 and 1366, it was the first important work of art to combine the burial with the scene of the apostle Thomas receiving the Virgin's belt.[8]

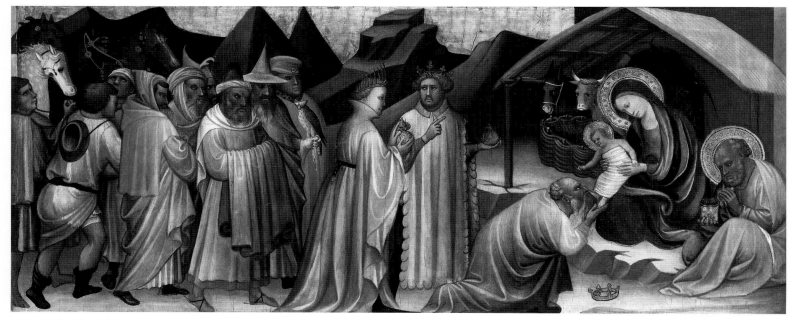

FIG. 76.6 Starnina. *Adoration of the Magi,* c. 1404–8. Tempera and tooled gold on panel; 13 × 31⅜″ (33 × 79.7 cm). Kansas City, The Nelson-Atkins Museum of Art, Gift of the Samuel H. Kress Foundation, no. F61-60. See Companion Panel E

The iconographical similarities of the Starnina and Puccinelli altarpieces may be tied to the spread of the Augustinian reform community of the Canon Regulars,[9] founded in 1401–2 by Bartolomeo Colonna and Leone Gherardini da Carate in suburban Lucca. On October 2, 1406, the local bishop, Nicolò di Lazzaro Guinigi, dispossessed the Benedictine nuns of the Monastero dell'Angelo and replaced them with a group of reform canons,[10] and two years later Santa Maria Forisportam became part of the same reform.[11] From this point the two communities were closely connected, and in 1512 the canons of the Monastero dell'Angelo moved their headquarters to Santa Maria Forisportam. Starnina's altarpiece could well have been commissioned after the reform of Santa Maria Forisportam in 1408. It would not have been unusual to ask the artist to use Puccinelli's altarpiece there as a model.

A date around 1408 also accords with the style of Starnina's altarpiece, which most closely resembles his murals of 1409 in Empoli.[12] The apostle Andrew in Empoli and the apostle sprinkling holy water in the altarpiece are nearly indentical. As noted by Andrea De Marchi (in Filieri 1998, p. 269), another indication for the date is the resemblance of the two lower angels in Lorenzo Ghiberti's stained-glass window of the Assumption in Florence cathedral, installed by June 1405.[13] The canons of the Monastero dell'Angelo may have ordered their altarpiece shortly after they took over the monastery in October 1406, or after the reform encompassed Santa Maria Forisportam in 1408. If the painting came from San Michele in Foro Lucca (see Provenance), it would have been begun as early as 1404.

1. An altarpiece by Priamo della Quercia (q.v.) now in the Museo Nazionale di Villa Guinigi, no. 147; Filieri 1998, color repros. pp. 343–45. On its provenance, see Linda Pisani in Filieri 1998, pp. 345–46.
2. See letter from Sulley to Johnson dated London, September 3, 1912.
3. On this subject, see Neri di Bicci, plate 59 (JC cat. 27). The association between the Johnson and Fogg panels was first recognized by F. Mason Perkins (1921, p. 44 n. 2).
4. Alvar González-Palacios (1971, p. 5) first made the association.
5. Andrea De Marchi (in Romano 1990, pp. 17–23) first noted that the Kansas City and private collection panels came from the predella of this altarpiece. At the suggestion of Federico Zeri, Eliot W. Rowlands (1996, pp. 78–82) added the *Presentation of Christ in the Temple* to this group.
6. Berlin, Staatliche Museen, no. 1884; Boskovits 1988, plates 102–8, color plate 1 (detail). Then in the Ognissanti, Florence.
7. No. 1933.1017; Lloyd 1993, color repro. p. 227.
8. Finiello Zervas 1996, atlas vol., color plate 798.
9. After 1446 the Canon Regulars were known as the Lateran Canons. See Carlo Egger in *DIP*, vol. 2, 1973, cols. 101–7.
10. Barsotti 1923, pp. 180, 226–27.
11. Barsotti 1923, p. 180; Giorgi 1974, pp. 21–24.
12. Empoli, Museo della Collegiata di Sant'Andrea; Berti and Paolucci 1990, color repro. p. 89.
13. Krautheimer 1982, fig. 7.

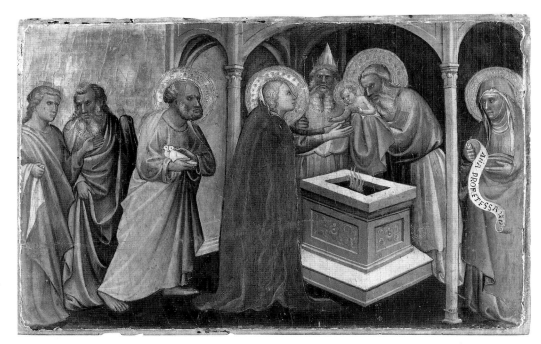

FIG. 76.7 Starnina. *Presentation of Christ in the Temple,* c. 1404–8. Tempera and tooled gold on panel; 13 × 20½″ (33 × 52 cm). Private collection. See Companion Panel F

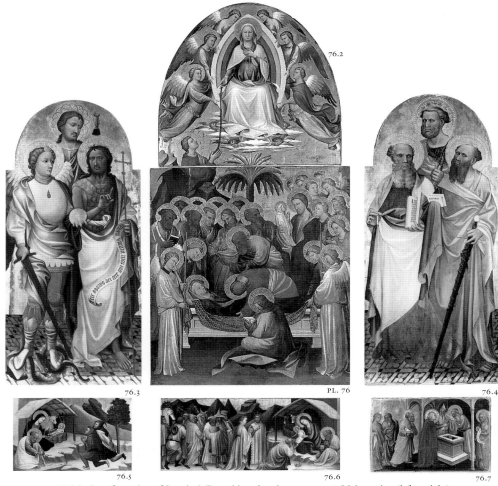

FIG. 76.8 Original configuration of Starnina's Dormition altarpiece, c. 1404–8. Main section (left to right): FIG. 76.3, PLATE 76 (below), FIG. 76.2 (above) as installed together, FIG. 76.4. Predella (left to right): FIGS. 76.5–76.7

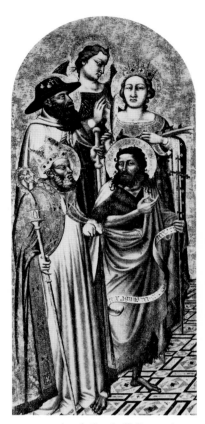
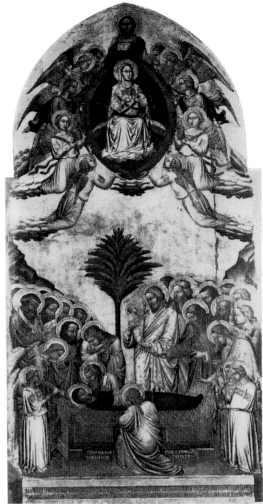
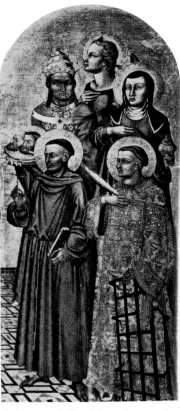

FIG. 76.9 Angelo Puccinelli (Lucca, documented 1379–1407). Altarpiece (reconstruction adapted from González-Palacios 1971): *Dormition and Assumption of the Virgin with Saints Nicholas of Bari, John the Baptist, James Major(?), Catherine of Alexandria, Francis, Lawrence, and Clare of Assisi, and the Blessed Urban V and Two Angels*, 1386. Tempera and tooled gold on panel; overall approximately 77⅛ × 38⅝″ (196 × 98 cm). Center panel: Lucca, church of Santa Maria Forisportam. Lateral panels: last recorded Radensleben, Germany, von der Quast Collection. Present location unknown

Bibliography
Reinach, vol. 1, 1905, repro. p. 480 (Umbrian School); Berenson 1913, p. 10, repro. p. 235 (Master of the Bambino Vispo); Sirén 1914, p. 16, plate VI; Perkins 1921, p. 43, plate p. 47; Van Marle, vol. 9, 1927, pp. 193, 196; Berenson 1932, p. 340; Colasanti 1934, p. 340; Berenson 1936, p. 277; Pudelko 1938, pp. 51, 53; Johnson 1941; Hans Vollmer in Thieme-Becker, vol. 37, 1950, p. 32; Berenson 1963, p. 140, plate 470; Zeri 1964, p. 235; Bosque 1965, pp. 57–58; Castelfranchi Vegas 1966, p. 48, color plate 86; Castelfranchi Vegas 1966a, color plate 28; Sweeny 1966, p. 51, plate 13 (Master of the Bambino Vispo); González-Palacios 1971, p. 5, figs. 4–7; Fredericksen and Zeri 1972, p. 125 (Master of the Bambino Vispo); Sricchia Santoro 1976, pp. 14, 22, 27–28, fig. 26; Syre 1979, p. 121; Waadenoijen 1983, pp. 60, 126 n. 1; Hériard Dubreuil 1987, pp. 9–10, 18, 29, 41, 50, 108, 112, fig. 12; Eisenberg 1989, pp. 21, 60 n. 73; Andrea De Marchi in Romano 1990, pp. 20, 23; Philadelphia 1994, repro. p. 232; Andrea De Marchi in Filieri 1998, pp. 266–71, color repro. p. 267; Philadelphia 1999, p. 36, repro. p. 37; Hiller von Gaertringen 2004, pp. 200–201 and n. 70

COMPANION PANELS for PLATE 76

A. Upper center panel of an altarpiece: *Virgin Mary Giving Her Belt to Saint Thomas the Apostle*. See fig. 76.2

c. 1404–8

Tempera and tooled gold on panel with vertical grain; 31⅞ × 33″ (81 × 83.8 cm). Cambridge, Harvard University Art Museums, Fogg Art Museum, Gift of Friends of the Fogg Art Museum Fund, no. 1920.1

INSCRIBED ON THE REVERSE: *Simone Memmi pinxit/ obit 1345* (in black ink); *2* (in ink on a paper label); two red wax seals of the tax office of the kingdom of Lucca; *378* and *N/ 2939* (stenciled in black)

PROVENANCE: Cambridge, Mrs. Jane Lowell Moore Collection; purchased for the museum through the Friends of the Fogg Art Museum Fund, 1920

EXHIBITED: See Companion Panel C

SELECT BIBLIOGRAPHY: Berenson 1932, p. 339; Berenson 1963, p. 139; Fredericksen and Zeri 1972, p. 125; Andrea De Marchi in Filieri 1998, pp. 266–71

B. Lateral panel of an altarpiece: *Saints Michael Archangel, James Major, and John the Baptist*. See fig. 76.3

c. 1404–8

Tempera and tooled gold on panel with vertical grain; 51⅝ × 23⅝″ (131 × 60 cm). Lucca, Museo Nazionale di Villa Guinigi, inv. 287

INSCRIBED ON THE BAPTIST'S SCROLL: *Ecce Agnus Dei qui tolli[t] peccata mundi* (John 1:29: "Behold the Lamb of God, [behold him] who taketh away the sin of the world")

PROVENANCE: See Companion Panel C

EXHIBITED: See Companion Panel C

SELECT BIBLIOGRAPHY: See Companion Panel C

C. Lateral panel of an altarpiece: *Saints John the Evangelist, Peter, and Paul.* See fig. 76.4

c. 1404–8

Tempera and tooled gold on panel with vertical grain; 51⅝ × 23⅝″ (131 × 60 cm). Lucca, Museo Nazionale di Villa Guinigi, inv. 288

INSCRIBED ON THE EVANGELIST'S BOOK: *In pr[incipio]/ erat/ verb[um]/ e[t] verb[um]/ erat/ apud/ Deum/ et D[eus erat verbum]* (John 1:1: "In the beginning was the Word, and the Word was with God, and the Word was God"); ON PAUL'S LETTERS: *ACorintios* (To the Corinthians); *[ARomano]s* (To the Romans)

PROVENANCE: Tramonte, near Brancoli, parish church, which was acquired by the municipality of Lucca, 1897

EXHIBITED: Lucca 1998, no. 30b; Cambridge, Harvard University Art Museums, Fogg Art Museum, September 14–November 30, 1998, no catalogue; Philadelphia Museum of Art, *Gherardo Starnina: Reconstructing a Renaissance Masterpiece* (December 17, 1998–March 7, 1999), no catalogue.

SELECT BIBLIOGRAPHY: Salvatore 1919, p. 99; Berenson 1932, p. 340; Martinelli and Arata 1968, pp. 149–50, fig. 65; González-Palacios 1971, p. 5; Syre 1979, p. 121; Andrea De Marchi in Filieri 1998, pp. 266–71.

D. Predella panel of an altarpiece: *Adoration of the Shepherds.* See fig. 76.5

c. 1404–8

Tempera and tooled gold on panel with horizontal grain; 13 × 20¼″ (33 × 51.5 cm), painted surface 12⅜ × 14½″ (31.5 × 49.5 cm). Turin, private collection

PROVENANCE: Anacapri, Mühlen Collection; Genoa, Viezzoli Collection; Turin, private collection, 1990

EXHIBITED: Turin 1990, no. 2; Lucca 1998, no. 30d

SELECT BIBLIOGRAPHY: Berenson 1936, p. 276; Pudelko 1938, p. 57 n. 24; Berenson 1963, p. 140; Syre 1979, p. 123; Waadenoijen 1983, p. 60 n. 1; Andrea De Marchi in Turin 1990, pp. 16–22; Andrea De Marchi in Filieri 1998, pp. 266–71.

E. Predella panel of an altarpiece: *Adoration of the Magi.* See fig. 76.6

c. 1404–8

Tempera and tooled gold on panel with horizontal grain; 13 × 31⅜″ (33 × 79.7 cm). Kansas City, The Nelson-Atkins Museum of Art, Gift of the Samuel H. Kress Foundation, no. F61-60

PROVENANCE: Paris, Kleinberger; Paris, Ali Loebl; sold by him to Stephane Bourgeois, New York, 1911; London, Langton Douglas; New York, Jules S. Bache, 1927; New York, Walter P. Fearon, 1928; New York, John Levy Galleries, 1931; New York, Samuel H. Kress Foundation, acquired 1938; on loan to Washington, D.C., National Gallery of Art, 1941–51; given by the Samuel H. Kress Foundation to the Nelson-Atkins Museum of Art, 1952

EXHIBITED: Detroit 1933, no. 14 (as Giovanni dal Ponte); Philadelphia Museum of Art, *Gherardo Starnina: Reconstructing a Renaissance Masterpiece* (December 17, 1998–March 7, 1999), no catalogue

SELECT BIBLIOGRAPHY: Shapley 1966, p. 91; Fredericksen and Zeri 1972, p. 125; Waadenoijen 1983, p. 60 n. 1; Hériard Dubreuil 1987, vol. 1, pp. 49–50; Lurie 1989, p. 373; Andrea De Marchi in Turin 1990, pp. 19, 23; Andrea De Marchi in Filieri 1998, pp. 266–71

F. Predella panel of an altarpiece: *Presentation of Christ in the Temple.* See fig. 76.7

c. 1404–8

Tempera and tooled gold on panel with horizontal grain; 13 × 20½″ (33 × 52 cm). Private collection

PROVENANCE: Berlin, Rudolph Schmidt; London, Mr. Gore; sold, London, Sotheby's, July 8, 1999, lot 59 (as Starnina); London, Rob Smeets

SELECT BIBLIOGRAPHY: Rowlands 1996, p. 80; Andrea De Marchi in Filieri 1998, p. 271

ZANOBI STROZZI
(*Zanobi di Benedetto di Caroccio degli Strozzi*)

FLORENCE, NOVEMBER 12, 1412–
DECEMBER 6, 1468, FLORENCE

Zanobi di Benedetto, a member of the prominent Strozzi family of Florence, is recorded in the 1427 tax return of his older brother Francesco, when he was living in the parish of San Martino a Brozzi, near Florence. At this point, they and their sister, Maddalena, were orphans. Sometime around 1427 Zanobi moved to Palaiuola, near the *badia* of Fiesole and not far from Fra Angelico's (q.v.) convent of San Domenico, where he entered the workshop of the illuminator Battista di Biagio Sanguigni (q.v.). The relationship between the two was quite close. In 1432, for example, when Maddalena Strozzi entered the Augustinian convent of San Gaggio just outside Florence, Sanguigni helped provide the dowry. His contribution may have been the illuminations that he executed in choral books for the convent.[1] Strozzi remained with Sanguigni until 1438, when Zanobi married his cousin Nanna di Francesco Strozzi. In 1439 Strozzi provided his former master with lifelong financial support, and in 1446 the Strozzi property at Palaiuola was conceded to him. That same year Strozzi moved from Palaiuola to the parish of San Paolo in Florence. The artist's aristocratic origins may explain the absence of his name from the registrars of Florentine artisans' guilds. When he died in 1468, Strozzi was buried in Florence in the Dominican convent of Santa Maria Novella.

Strozzi's work as an illuminator is well documented. In February 1445 he received payment for illuminations in two psalters of the cathedral of Florence,[2] and from June 4, 1446, to February 20, 1454, he was paid for illuminating choir books for the Dominican Observant convent of San Marco in Florence.[3] The illuminator Filippo di Matteo Torelli acted as intermediary for the second project, for which, according to a memorandum of May 2, 1449, Strozzi's miniatures had to be reviewed by Fra Angelico, who was the major influence on the younger artist's style. In about 1450 Strozzi illuminated a miniature of a miracle of Saint Zanobi for a lectionary of the Florentine cathedral.[4] In 1450 he was paid for a psalter destined for a cook of the Florentine *badia;* in 1456–57, again with Torelli serving as intermediary, for miniatures in an antiphonary

of the church of San Pancrazio in Florence;[5] and in 1458 for a Crucifixion in a missal for the city's cathedral.[6] In 1463 he took on a joint commission with Francesco d'Antonio del Cherico to illuminate antiphonaries for the cathedral.[7]

Besides his activity as an illuminator, Strozzi is also recorded as a panel painter. Between 1434 and 1439 he was reimbursed for an altarpiece in the chapel of Saint Agnes in the Florentine hospital church of Sant'Egidio,[8] and in 1448 he was paid for the cross to be used at funerals at the convent of San Marco. The cross has been sometimes identified with one now in the parish church of Mocogno, near Modena.[9]

Zanobi Strozzi has been confused with Domenico di Michelino, to whom Bernhard Berenson (1932, pp. 364–65; 1932a, pp. 521–24; 1963, pp. 60–61) attributed paintings by Strozzi. Roberto Longhi (1948a, p. 162) and Federico Zeri (1974, p. 92), however, baptized the master the "Pseudo–Domenico di Michelino" to distinguish his oeuvre from the rest of Berenson's grouping, whereas it was Longhi (1953, oral communication to Michel Laclotte, published in Paris 1956a, p. 68) who created the more independent name of the "Master of the Buckingham Palace Madonna" after a painting in the British royal collection.[10] Mario Salmi (1950) and Licia Collobi Ragghianti (1950a) proposed the identification with Zanobi Strozzi.

The artist's most important painting is the altar-piece of Saint Jerome from the convent church of the Hieronymite order in Fiesole.[11] It was commissioned by Giovanni de' Medici, probably about 1455, shortly after Strozzi had finished the choral books of San Marco.

1. Scudieri and Rasario 2003, repro. pp. 36, 38, 91–104 (color). On November 20, 1447, Strozzi was reimbursed for illuminating a scene in a gradual in this series. On its identity, see Laurence B. Kanter in Kanter et al. 1994, p. 287 n. 3; and Magnolia Scudieri in Scudieri and Rasario 2003, pp. 39, 41.
2. Florence, Museo dell'Opera del Duomo, Psalter N, inv. 3 (Levi D'Ancona 1959, fig. 1); and Psalter D, inv. 4.
3. The manuscripts are in the Museo Nazionale di San Marco. See Florence 1955, plates LXXXIII–LXXXIV; Levi D'Ancona 1959, esp. pp. 12–16, figs. 2, 7, 11, 13–14; Berti 1962–63, p. 207, fig. 1, p. 214, fig. 11; Garzelli 1985, figs. 1–5, 9–10, 13–14, color plate 1; San Marco 1990, pp. 26–28,

figs. 17–21 (color); and Scudieri and Rasario 2003, repro. pp. 169–84 (color).
4. Florence, Biblioteca Mediceo-Laurenziana, Edili 146, folio 114; Fabbri and Tacconi 1997, color plate 66; and Scudieri and Rasario 2003, repro. p. 190 (color).
5. A cutting is now in the Galleria di Palazzo Cini, Venice; Levi D'Ancona 1959, fig. 15.
6. Florence, Biblioteca Mediceo-Laurenziana, Edili 104, folio 150 verso; Scudieri and Rasario 2003, repro. p. 195 (color).
7. Florence, Biblioteca Mediceo-Laurenziana, Edili 149, 150–151; Levi D'Ancona 1959, fig. 17; Garzelli 1985, fig. 6; Fabbri and Tacconi 1997, color plates 74–75; Scudieri and Rasario 2003, repro. pp. 196–97 (color).
8. The central section of this altarpiece may be the *Virgin and Child with Angels* in the Museo Nazionale di San Marco in Florence, as was proposed by Licia Collobi Ragghianti (1950a, pp. 458, 468 n. 12, fig. 389). Mirella Levi D'Ancona (1960) disagreed with this identification because of the absence of Saint Agnes, the namesake of the chapel. However, only the central panel survives. Most recently on this painting, see Magnolia Scudieri in Scudieri and Rasario 2003, pp. 124–32, post-restoration color repro. p. 124.
9. Ghidiglia Quintavalle 1960, figs. 1–10. This cross is probably not by Strozzi.
10. No. 252; Shearman 1983, plate 213.
11. Avignon, Musée du Petit Palais, no. 139; Laclotte and Mognetti 1987, p. 144, color plate 139. On its dating, see Davies 1961, p. 121 n. 8.

Select Bibliography
Baldinucci 1681–1728, Ranalli ed., vol. 1, 1845, pp. 501–3; Gaetano Milanesi in Vasari 1568, Le Monnier ed., vol. 6, 1850, pp. 187–89; Gaetano Milanesi in Vasari 1568, Milanesi ed., vol. 2, 1878, pp. 520–21 n. 1; D'Ancona 1908; D'Ancona 1914, vol. 1, pp. 53–57; vol. 2, pp. 345–56; Longhi 1948a (Longhi *Opere*, vol. 8, pt. 1, 1975, pp. 93–94); Collobi Ragghianti 1950; Collobi Ragghianti 1950a; Salmi 1950; Collobi Ragghianti 1955; Michel Laclotte in Paris 1956a, p. 68; Levi D'Ancona 1959; Levi D'Ancona 1960; Levi D'Ancona 1962, pp. 261–68; Garzelli 1985, pp. 11–24; Garzelli 1985a; Francesca Petrucci in *Pittura* 1987, pp. 759–60; Carl Brandon Strehlke in Kanter et al. 1994, pp. 349–61; Annarosa Garzelli in *Dictionary of Art* 1996, vol. 29, pp. 785–86; Fabbri and Tacconi 1997, passim; Gordon 1998; London 1998; Carl Brandon Strehlke in Milan 2001, p. 44, fig. 12; Miklós Boskovits in Toscano and Capitelli 2002, pp. 133–41; Francesca Pasut, Federica Papi, and Giuseppe Zanichelli in Toscano and Capitelli 2002, pp. 146–55; Kanter 2002; Magnolia Scudieri in Scudieri and Rasario 2003, pp. 33–43, 125–41, 168–87, 201–8; Angela Dillon Bussi in Scudieri and Rasario 2003, pp. 195–98; Giovanni Lazzi in Scudieri and Rasario 2003, pp. 199–200

PLATE 77 (JC CAT. 22)
Annunciation

c. 1453

Tempera and tooled gold on panel with horizontal grain; 14.5 × 11¾ × ¼″ (36.8 × 29.8 × 0.7 cm), painted surface 12 × 11″ (30.5 × 27.8 cm)

John G. Johnson Collection, cat. 22

INSCRIBED ON THE REVERSE: *22* (on the central vertical cradle member); *In 1274* (in pencil, twice on cradle members); *OF PHILADELPHIA/ JOHNSON COLLECTION* (stamped four times in black ink)

PUNCH MARKS: See Appendix II

EXHIBITED: Philadelphia Museum of Art, Sixty-ninth Street Branch, *Religious Art of Gothic and Renaissance Europe* (December 1, 1931–January 4, 1932), no catalogue; New York, The Metropolitan Museum of Art, The Cloisters, *Seven Joys of Our Lady* (December 20, 1944–January 21, 1945), no catalogue; New York 1994, no. 55

TECHNICAL NOTES
The support consists of a single piece of very knotty wood that has been thinned and cradled. Viewed from the reverse, the panel is beveled along the top, bottom, and left. The right edge has been cut, suggesting that the existing support may have been taken from a longer plank, possibly a predella. There is a crack 8″ (20.4 cm) above the bottom that begins at the left edge and extends 4¾″ (12 cm) across the panel. There are also two other cracks that originate from the bottom corners and that almost completely span the panel.

There are no barbes, which may mean that the panel never had applied moldings. The border consists of a fictive frame that is defined by a pair of inscribed lines. The outlines of the figures and architecture were incised, and the final painting coincides exactly with these incisions. Pentimenti in the angel's robe, visible along the left edge, indicate that the fictive frame was painted last, following completion of the composition.

Gilding in the upper background, angel's wings, halos, and cloth of honor is applied over an orange-red bole. The feathers on the wings have been defined using an incised pattern and then further accented with glazes. The cloth of honor is decorated with an incised and punched border, and a stippling pattern is used to define lights in the modeling of the folds. At one point, the drapery was covered with a restorer's viridian glaze. Some remnants of the original green glaze, now turned dark brown, do survive. There is decorative mordant gilding in the robes of the figures, the canopy of the throne, and the rays coming from the angel and dove. The mordant color is white.

A minute crack in the top right was first noted in August 1919. The panel was cradled, probably by Carel de Wild, in December 1920. On January 15, 1921, Hamilton Bell noted that the flesh areas were overcleaned. In 1993 Teresa Lignelli cleaned the

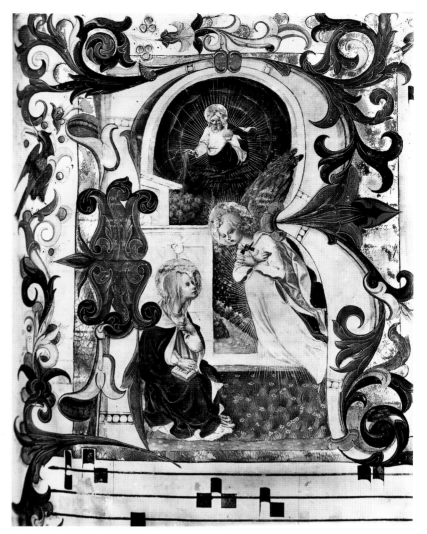

FIG. 77.1 Zanobi Strozzi. *Annunciation,* from a gradual (The Feast of the Annunciation to the Feast of Saint Andrew), 1453. Tempera on parchment; 24¼ × 18⅛″ (61.7 × 46 cm). Florence, Museo Nazionale di San Marco, Ms. 516, folio 3 recto

panel of its discolored varnish and old retouching, including the restorer's viridian glazing in the drapery of the throne.

PROVENANCE
Johnson owned this painting before 1904, as can be determined by Bernhard Berenson's request for a photograph of it in a letter dated the Deanery, Bryn Mawr, February 2, 1904. In a letter to Johnson dated Florence, February 28, 1912, Herbert Horne mentions that it had come from the London dealer Carfax.

COMMENTS
The archangel Gabriel, holding a white lily and flying on clouds, approaches the Virgin, who sits outdoors on a raised ledge under a balcony that has been draped as a throne. Her arms are crossed in a gesture of humility. The dove of the Holy Spirit with a cruciform halo descends from above. A simulated pink-and-red porphyry frame with an incised inner border surrounds the image.

Gabriel's forehead is marked by the red flame that is common in depictions of angels. The lily symbolizes the selection of Mary among the Virgins of Israel, and the wreath of red and white roses on his head represents her purity. In Dante's *Paradiso* (23:73) she is called "the rose in which the divine word was made flesh."

Herbert Horne, in his letter to Johnson of February 28, 1912, attributed the panel to Zanobi Strozzi based on an illumination (fig. 77.1) in a choral book from the Dominican Observant convent of San Marco in Florence, which on the basis of documentary evidence Paolo D'Ancona (1908) had associated with a payment to Strozzi dated 1453. Two other images (figs. 77.2, 77.3) of the Annunciation

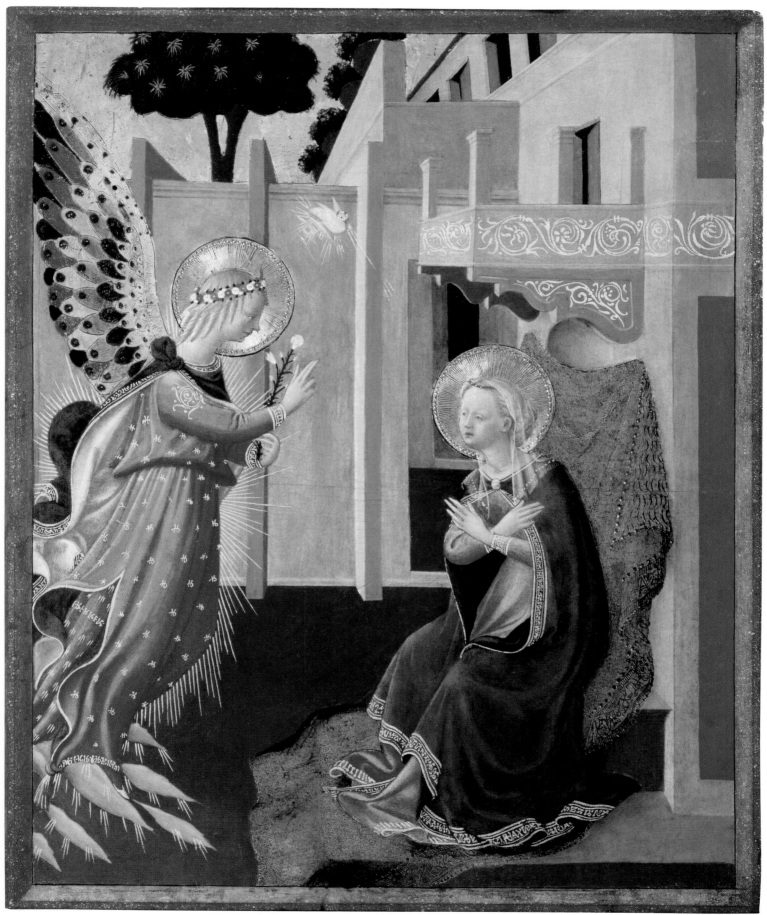

PLATE 77

ZANOBI STROZZI 401

FIG. 77.2 (*above*) Zanobi Strozzi. *Annunciation and Nativity,* from the Adimari Book of Hours, c. 1463. Tempera on parchment; each folio 5¼ × 3⅝″ (13.4 × 9.3 cm). Baltimore, The Walters Art Museum, Ms. w.767, folios 4 verso and 5 recto

FIG. 77.3 (*right*) Zanobi Strozzi. *Annunciation,* from a Book of Hours, c. 1465. Tempera on parchment; 49¼ × 35⅜″ (125 × 90 cm). Florence, Biblioteca Riccardiana, Ms. 457, folio 1 verso

in books of hours illuminated by Strozzi use the same composition and are a further confirmation of the attribution of the Johnson painting. Despite this support, Berenson (1913) attributed the picture to Domenico di Michelino, another follower of Fra Angelico; most other writers accepted this opinion until Licia Collobi Ragghianti (1950a) correctly attributed the *Annunciation* to Zanobi Strozzi, suggesting that it might be the predella to the *Virgin of Humility and Angels* in the British royal collections.[1] While it is not impossible that the Johnson Collection's painting was a predella panel, it is unlikely that it was part of the picture in England.

The iconography is unusual in that it shows Gabriel flying in on clouds. Fra Angelico, for example, who oversaw Zanobi's production of the San Marco choral books and was the greatest influence

on his work, only once painted the angel in this way, in a missal that comes from San Domenico in Fiesole and probably dates to Angelico's earliest period, about 1425.[2] An explanation for the unusual means of the angel's arrival is found in the text that accompanies Angelico's illumination, which comes from the introit used at mass on festivals dedicated to the Virgin, such as the Annunciation: "Drop down dew, ye heavens, from above, and let the clouds rain the just: let the earth be opened, and bud forth a saviour" (Isaiah 45:8).

Other features of Strozzi's picture, such as the Virgin's pose, can be found in the *Annunciation* of the reliquary that Angelico painted for the convent of Santa Maria Novella in Florence around 1434,[3] where the angel wears the same distinctive pink costume decorated with tufts of gold thread.

1. No. 252; Shearman 1983, plate 213.
2. Florence, Museo Nazionale di San Marco, Ms. 558, folio 33; Scudieri and Rasario 2003, repro. p. 88 (color).
3. Florence, Museo Nazionale di San Marco; Pope-Hennessy 1974, fig. 70.

Bibliography
Mather 1906, p. 351 (Domenico di Michelino); Rankin 1909, p. lxxxiii (Domenico di Michelino); Berenson 1913, p. 17, repro. p. 243 (Domenico di Michelino); Van Marle, vol. 10, 1928, p. 196; Berenson 1932, p. 365; L. Venturi 1933, plate cliv; Berenson 1936, p. 314; Prampolini 1939, p. 68, plate 64; Wehle 1940, p. 25; Johnson 1941, p. 11 (Domenico di Michelino); Collobi Ragghianti 1950a, p. 463, fig. 385; Sweeny 1966, p. 27, repro. p. 116 (Domenico di Michelino); Fredericksen and Zeri 1972, p. 127 (Pseudo–Domenico di Michelino); Strehlke 1990, pp. 429, 432, fig. 4; Philadelphia 1994, repro. p. 232; Strehlke in Kanter et al. 1994, pp. 358–61, color repro. p. 359; Gordon 1998, p. 523; Carl Brandon Strehlke in Milan 2001

TADDEO DI BARTOLO

SIENA, FIRST DOCUMENTED 1383;
DIED 1422

Taddeo di Bartolo enlisted in the rolls of the Sienese painters' guild in 1389, but, until 1400, all of his known work was produced outside the city. In 1389 he signed the altarpiece (see fig. 78.2) once in Collegarli, near San Miniato al Tedesco, a town between Pisa and Siena; the John G. Johnson Collection's predella (plate 78 [JC cat. 95]) comes from this work. In January 1392 Taddeo was contracted to paint now-lost murals of saints in the cathedral of Savona in Liguria. In March of the following year he accepted the Genoese patrician Cattaneo Spinola's order for two altarpieces for San Luca in Genoa, but they do not survive. His altarpiece, dated 1395, now in Grenoble,[1] comes from San Paolo all'Orto in Pisa, and a processional banner in the Museo Nazionale di San Matteo in Pisa was painted for the confraternity of San Donnino in that city.[2] In 1397 Taddeo painted an altarpiece for the Sardi chapel in the sacristy of San Francesco in Pisa.[3] The same year he painted the altarpiece of the Baptism of Christ for the *collegiata* of Triora, near Imperia in Liguria.[4]

Determining factors in Taddeo's development were his possible contacts with the works of Barnaba da Modena in Liguria and of Altichiero in Padua, where, according to Giorgio Vasari, Taddeo had gone during the rule of Francesco Carrara the Younger (in office 1390–1405). It was likely that the influence of these non-Tuscan artists moved Taddeo's style away from that of artists like the Sienese Luca di Tommè and Francesco di Vannuccio (q.v.), whose impact is still apparent in his Collegarli altarpiece of 1389, and toward a more pan-Italian and Gothic manner. This transformation made Taddeo one of the most interesting of Tuscan artists working at the turn of the century.

The artist's first-known Sienese work was the altarpiece,[5] dated 1400, for the confraternity of Santa Caterina della Notte, but his major commissions in his native city had to wait. The following year he signed the high altarpiece[6] in the cathedral of Montepulciano. In 1403 he painted both the two-sided altarpiece for San Francesco al Prato in Perugia[7] and the *Descent of the Holy Spirit* for Sant'Agostino in the same city.[8]

The year 1404 saw a notable change in the Sienese government, which may have led Taddeo to believe that important public commissions would be forthcoming. Such was indeed the case, and he permanently settled in the city. In 1404–6 Taddeo executed now-lost murals in the choir of the cathedral; in 1406–8 he painted the chapel of the Palazzo Pubblico with scenes from the life of the Virgin;[9] in 1414–17 he executed the murals in the antechapel with a Saint Christopher, allegories of the Virtues, and portraits from ancient Roman history;[10] and in 1416 he made a now-lost mural for the city gate of Porta Pispini. He also executed a few projects for cities close to Siena, including the *Last Judgment*[11] in the *collegiata* of San Gimignano, often incorrectly dated 1393, and at least two altarpieces for churches in Volterra.[12] In 1418 Taddeo was commissioned to make a mural for the Sienese city gate of Porta Romana, but the project was never completed because of his death in 1422.

1. Musée de Grenoble, state deposit 1876; Symeonides 1965, plate xa.
2. Symeonides 1965, plate xii.
3. The altarpiece is now in Budapest, Szépművészeti Múzeum, no. 53.500. For that and the murals, see Symeonides 1965, plates xia, xiii–xv.
4. Symeonides 1965, plate xiv.
5. Symeonides 1965, plate xviii.
6. Symeonides 1965, plates xx–xxxii.
7. For a reconstruction of the altarpiece, now disassembled and in various collections, see Solberg 1992.
8. Perugia, Galleria Nazionale dell'Umbria, no. 67; Symeonides 1965, plate li.
9. Symeonides 1965, plates lviii–lix.
10. Symeonides 1965, plates lxix–lxxiv.
11. Symeonides 1965, plates lxxv–lxxvii.
12. Both in Volterra, Pinacoteca e Museo Civico di Palazzo Minucci Solaini; Lessi 1986, color repros. pp. 14–17.

Select Bibliography
Vasari 1550–68, Bettarini and Barocchi eds., vol. 2 (text), 1967, pp. 309–12; Romagnoli before 1835, vol. 3, pp. 447–98; A. Venturi, vol. 5, 1907, pp. 751–58; F. Mason Perkins in Thieme-Becker, vol. 32, 1938, pp. 395–97; Rubinstein 1958, pp. 189–207; Symeonides 1965; Berenson 1968, pp. 418–23; Moran 1975; *Bolaffi*, vol. 11, 1976, pp. 3–5; Corti 1981; Neri Lusanna 1981; Luciano Bellosi in Siena 1982, pp. 292–94; Giulietta Chelazzi Dini in Siena 1982, pp. 335–37; Strehlke 1985a, pp. 5–6; Monica Leoncini in *Pittura* 1986, p. 663; Hansen 1989; Solberg 1991; Solberg 1992; Solberg 1992a; Gail E. Solberg in *Dictionary of Art* 1996, vol. 30, pp. 231–33; Gail E. Solberg in Schmidt 2002, pp. 198–227

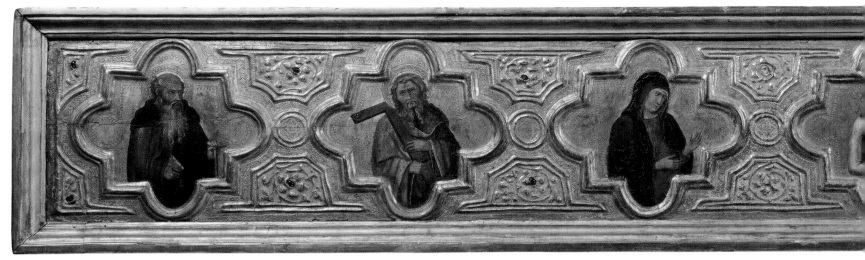

PLATE 78

PLATE 78 (JC CAT. 95)

Predella: *Saint Anthony Abbot, Saint Andrew, the Mourning Virgin, the Man of Sorrows, the Mourning Saint John the Evangelist, Saint Raphael Archangel, and Saint Lawrence*

1389

Tempera, tooled gold, and colored glass on panel with horizontal grain; 12⅝ × 89⅝ × 2⅛″ (32.2 × 227.5 × 5.5 cm); without modern applied frame 9⅝ × 82⅝ × 1½″ (24.5 × 210 × 3.8 cm); each quatrefoil approximately 9 × 9½″ (23 × 24 cm)

John G. Johnson Collection, cat. 95

INSCRIBED ON THE REVERSE: *Taddeo Bartoli Sienese* (in pencil on the frame); JOHNSON COLLECTION/ PHILA. (stamped twice in black ink); JOHNSON COLLECTION/ PHILA. (stamped) and 95 (in pencil on a label); 95 (in ink); 95 in/ 1502 (in ink); MAISON (scratched)

PUNCH MARKS: See Appendix II

EXHIBITED: Philadelphia Museum of Art, John G. Johnson Collection, Special Exhibition Gallery, *From the Collections: Paintings from Siena* (December 3, 1983–May 6, 1984), no catalogue

TECHNICAL NOTES

The predella consists of one plank of wood that retains its original thickness. It has, however, been reduced in width and length, since the wood that would have carried applied moldings has been removed. The predella was originally in the form of a box; at each end of the reverse is an area, approximately 1⅜″ (3.5 cm) wide, where side panels (fig. 78.1) were originally each joined by two long wrought nails driven in from the front. When the predella was disassembled, the side panels were removed and the nails were bent over. Centered in the

reverse of the panel there is the trace of a lost internal structural member that was 1″ (2.5 cm) wide. Strips of wood have been attached to all four sides to support the panel in its present frame; all are coniferous except for the bottom one, which appears to be poplar and predates the others. During disassembly the predella was cut between the figures of Christ and Saint John. The predella was later put back together, and this area was reinforced with inset oak strips and a metal plate at the bottom.

The frames of the quatrefoils surrounding the figures were executed in pastiglia in high relief, apparently applied over carefully fitted wood moldings. The decorative patterns between them were also done in pastiglia relief. The flat areas around the pastiglia are elaborately punched.[1] Originally, sixteen pieces of green glass were embedded in the pastiglia to imitate precious stones; four pieces, which are attached with green sealing wax, remain. Sealing wax fills some of the other areas that once held glass. It does not seem that either the glass or the wax is original, as it appears the glass would have been originally held in place by the built-up gesso of the pastiglia.

The gold is moderately worn, and in areas the deep red bole shows. Other worn areas in the gilding were liberally masked with gold overpaint. The paint has suffered where it overlaps the gold. Loss has occurred along the outlines of almost all the figures and along the inner edge of the bottom cusp of the quatrefoils; these and other areas of loss were overpainted in an early restoration. Saints Andrew and John the Evangelist and the Virgin are the most affected. The blue of the Virgin's mantle is much flaked and repainted. Saint Lawrence's hands, book, palm, and grill are largely repaint, although the red-orange of his costume executed in sgraffito is well preserved. The archangel's hands, his neck, the fish he holds, and his proper right wing are much repainted. His costume, also executed in sgraffito, has likewise suffered much loss. The delicate red brocade with a pomegranate design on his undergarment is much abraded and can only be detected on close inspection.

The figure of Christ is in remarkably good condition. Loss and repainting are apparent only along the edges of the lower cusp of the quatrefoil and along some of the edges of his hair. The mordant

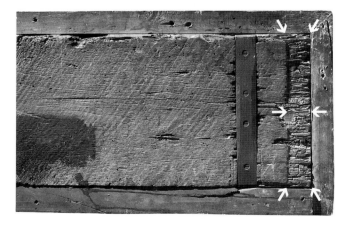

FIG. 78.1 Detail of the reverse of plate 78, showing an area where a side panel was originally attached on the right

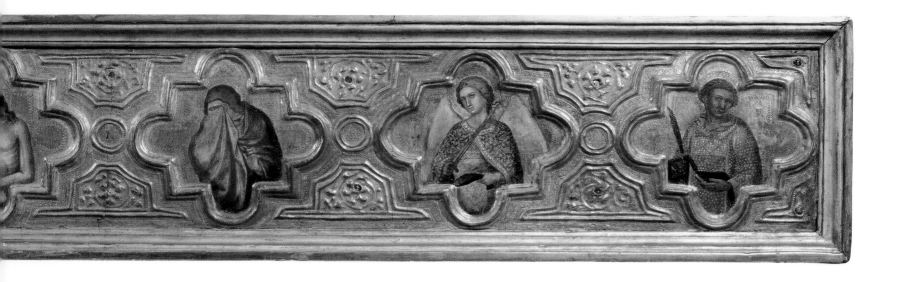

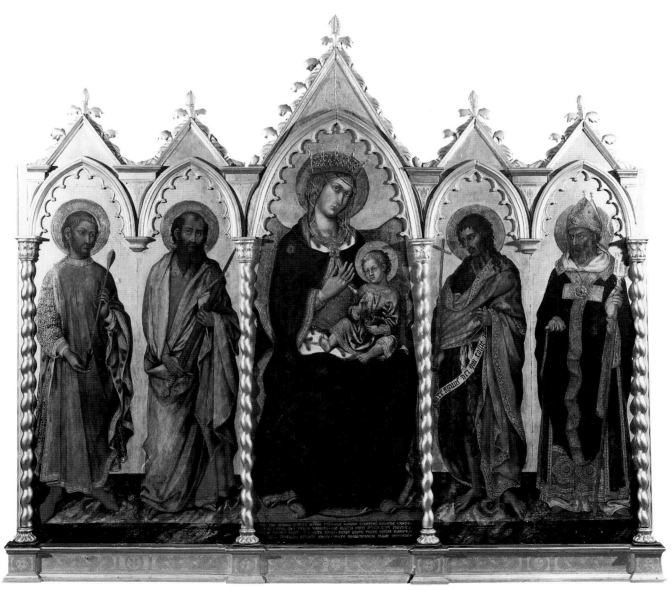

FIG. 78.2 Taddeo di Bartolo. *Virgin and Child with Saints Sebastian, Paul, John the Baptist, and Nicholas of Bari*, 1389. Tempera and tooled gold on panel, with modern frame; overall 58 × 79″ (147.3 × 200.6 cm). Present location unknown. See Companion Panel A

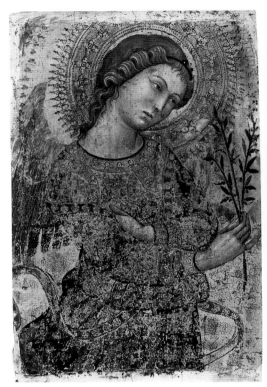

FIG. 78.3 Taddeo di Bartolo. *Annunciate Angel,* 1389. Tempera and tooled gold on panel; 12⅝ × 7⅞″ (32 × 20 cm). Bergen, Norway, Billedgalleri, no. 2. See Companion Panel B

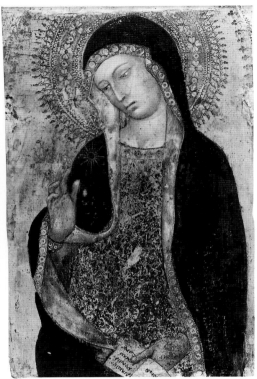

FIG. 78.4 Taddeo di Bartolo. *Virgin Annunciate,* 1389. Tempera and tooled gold on panel; 12⅝ × 7⅞″ (32 × 20 cm). Bergen, Norway, Billedgalleri, no. 2. See Companion Panel C

gilding of the rays emanating from his wounds is well preserved. The figure of Saint Anthony Abbot is also in good condition, as little of the paint overlaps the gold.

In 1919 Hamilton Bell wrote that the panel needed attention. When he inspected it with Carel de Wild in 1921, he wrote: "Fair state, some restorations. Madonna much restored." In 1958 Theodor Siegl noted the flaking in the Virgin as well as a vertical crack through the center and a horizontal crack starting at the left side. The cracking, however, had not caused damage to the paint.

PROVENANCE
Johnson purchased this predella as a work by Bartolo di Fredi (documented 1353; died 1410) from the Parisian dealer Ludovico de Spiridon in August 1905, who had procured it, along with five other pictures, from an anonymous "Florentine Gentleman" (see letter from Spiridon to Johnson, dated Paris, August 13, 1905). As Gail Solberg (1991, p. 698) proposed, this gentleman may have been a Capponi, because the main part of the altarpiece was said to have come from that family's palace in Florence.

COMMENTS
The three central medallions form an image of the Virgin and Saint John the Evangelist mourning Christ, who stands in the center as the Man of Sorrows, nude and with his arms crossed at the wrists.

The wounds of his hands and side are visible, and he wears the crown of thorns. To the left the Virgin gestures toward him in a manner that recalls medieval Roman icons of the Virgin *Advocata,* such as the renowned sixth- or seventh-century image in the Franciscan basilica of Santa Maria Aracoeli.[2] To the right John buries his face in his robe. The other saints are identifiable by their attributes. On the left are Anthony Abbot, holding a book and a tau-shaped walking stick, and the apostle Andrew, carrying the cross of his martyrdom. On the right are the archangel Raphael, holding a sword and a fish—the latter an allusion to the Old Testament story of Raphael and Tobias—and Saint Lawrence, dressed as a deacon and carrying a book, the grill of his martyrdom, and a martyr's palm.

The origins of the predella with the Man of Sorrows in the center can be traced to its use in Simone Martini's altarpiece of 1320 for the Dominican church of Santa Caterina in Pisa.[3] Joanna Cannon (1982, p. 73) has suggested that Martini's choice of subject was influenced by the Dominican order's promotion of the feast of *Corpus Domini,* established in 1264 (see Taddeo di Bartolo, plate 79 [JC cat. 101]), which celebrated the actual presence of Christ's body in the eucharistic host. The growing popularity of this feast explains the diffusion of the representation of the Man of Sorrows, with its emphasis on Christ's corporeal sacrifice, in fourteenth-century Italian art. With Martini's work

as the inspiration, the predella consisting of medallions also became common in Sienese art (see fig. 78.5),[4] and Taddeo di Bartolo employed the formula on a number of occasions.[5]

Bernhard Berenson (1913) thought the predella was an early work by Bartolo di Fredi and close to the style of Lippo Memmi. He later (1932), however, changed his attribution to Barna da Siena. Federico Zeri, in a letter to Barbara Sweeny dated Rome, December 20, 1958, was the first to recognize that the predella belonged to Taddeo di Bartolo's early work. The delicately painted saints in the artist's predella in Denver,[6] which is part of the altarpiece dated 1395 in Grenoble,[7] provide a close comparison and prove that the Johnson Collection's painting must indeed fall relatively early in the artist's career.

In 1985 I (Strehlke 1985a, p. 6) associated the Johnson predella with Taddeo di Bartolo's altarpiece (fig. 78.2) once in the oratory of San Paolo in the parish church of Santi Vito e Modesto in Collegarli in the Val d'Evola, which was part of the diocese of San Miniato al Tedesco. Although subjected to the rule of Florence since 1370, the town is not far from Pisa, where Taddeo was active early in his career. The altarpiece is dated 1389 and signed with a rhymed inscription that recalls Duccio's signature on the *Maestà* (see fig. 23.8). Solberg (1991) has further proposed that two panels showing the Annunciate Angel (fig. 78.3) and the Virgin Annunciate (fig. 78.4) were pinnacles of the same altarpiece. Two early descriptions of the altarpiece in situ do not mention the predella, but both accounts are summary.[8] The altarpiece and predella were probably separated when the main section entered Cardinal Joseph Fesch's collection before 1845.

Taddeo's inscription on the altarpiece mentions one Andrea Bindachi as the rector of the oratory.[9] The fact that his patron saint, the apostle Andrew, appears in the predella rather than the main panel suggests that Bindachi was not the patron but only the person who arranged the commission.[10]

1. One of these punches is very similar in shape to numbers 369 and 379 in Skaug 1994, vol. 2.
2. Schiller, vol. 4², 1980, fig. 448.
3. Pisa, Museo Nazionale di San Matteo; Martindale 1988 plates 49–52. There the Man of Sorrows is combined with the Virgin *Advocata.* The apostle Luke is on the other side.
4. There are examples by Naddo Ceccarelli at Princeton University, The Art Museum and by the Master of Panzano in the Museo Horne in Florence (no. 37; Rossi 1966, plates 35–39 [as Sienese School]). The former is the predella to an altarpiece in Siena, Pinacoteca Nazionale (no. 115; Torriti 1977, fig. 146 [color]), from Santa Maria della Scala in Siena.
5. The predella in the Denver Art Museum (no. E-24; Symeonides 1965, plate xb [as in New York, Mr. and Mrs. Simon Guggenheim Collection]) consists of an arcade of three-quarter-length saints; and his altarpiece of 1401 in the cathedral of Montepulciano (Symeonides 1965, plates xx–xxxxii) has narrative scenes in medallions. The Man of Sorrows is the main subject of the altarpiece depicted in Taddeo's *Saint*

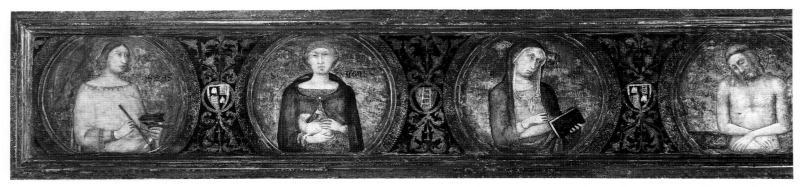

FIG. 78.5 Naddo Ceccarelli (Siena, documented 1347). Detail of a predella of an altarpiece: *Saints Cosmas, Agnes, the Mourning Virgin, and the Man of Sorrows,* c. 1345–50. Tempera and tooled gold on panel; overall 10¼ × 84¼″ (26 × 214 cm). From Siena, church of Santa Maria della Scala. Princeton University, The Art Museum, Bequest of Dan Fellows Platt, no. Y1962-57

Francis's Christmas Mass at Greccio, of 1403 (Hanover, Niedersächshishes Landesmuseum, Landesgalerie, no. 379; Symeonides 1965, plate XLIId). Its predella consists of figures in round medallions.

6. See n. 5 above.

7. Musée de Grenoble, state deposit 1876; Symeonides 1965, plate X.

8. Cited by Solberg 1991, pp. 1186–87, they are Michele Carlo Cortigiani's account of a pastoral visit made in Collegarli on December 1, 1683 (San Miniato al Tedesco, Archivio Arcivescovile, Visita pastorale, c. 274); and Domenico Maria Manni in Baldinucci 1681–1728, Manni ed., vol. 2, 1768, p. 231 n. 1.

9. He was from a Pisan family. Solberg (1991, pp. 1189–90) has shown that his family had some connection with the family of one of Taddeo di Bartolo's later Pisan patrons, the Sardi da Campiglia.

10. A comparison can be made with an inscription on Cenni di Francesco's (q.v.) 1370 altarpiece (Boskovits 1975, plate 86) in San Cristoforo a Perticaia (Rignano sull'Arno), near Florence. It identifies the church and society of the Virgin Mary and Saint Christopher as the patrons of the altarpiece, which was made during the time of the rector Peter. As in Taddeo's work, the rector's name saint, Peter, is absent from the surviving main sections of the altarpiece.

Bibliography

Mather 1906, p. 352 (Bartolo di Fredi); Berenson 1909, p. 141 (Bartolo di Fredi); Rankin 1909, p. lxxx (Bartolo di Fredi); Berenson 1913, p. 54, repro. p. 292 (Bartolo di Fredi); Brown and Rankin 1914, p. 342; Berenson 1932, p. 41; Berenson 1936, p. 35; Johnson 1941, p. 2; Sweeny 1966, pp. 6–7, repro. p. 92 (Barna da Siena); Berenson 1968, p. 26; Stubblebine 1969, p. 8, fig. 10; Fredericksen and Zeri 1972, p. 194; Preiser 1973, pp. 212, 380, fig. 200; Strehlke 1985a, pp. 5–6, figs. 3a–c; Solberg 1991, pp. 695–98, fig. 7; Philadelphia 1994, repro. p. 232

COMPANION PANELS for PLATE 78

A. Altarpiece: *Virgin and Child with Saints Sebastian, Paul, John the Baptist, and Nicholas of Bari.* See fig. 78.2

1389

Tempera and tooled gold on panel (with modern frame); cen-ter 58 × 23″ (147.3 × 58.4 cm); each wing 51 × 21″ (129.5 × 71.1 cm); total width 79″ (200.6 cm). Present location unknown

INSCRIBED ON SOCLE BELOW THE VIRGIN: *QUEL CHE DIPINSE QUESTA MADRE PURA CHE SEMPRE APECCA-TORI DIGRATIA EPIENA/ SI FU DI BARTOLOMEI TADEO DA SIENA. CON GLALTRI SANTI INTORN A SUA FIGURA/ PREGHA SEMPRE PER ME CON SANTO AMORE./ MADRE LA QUAL PER TE GRATIA CI PIOVE/ E NEL MILLE TRECENTO OTTANTA ENOVE. PRETE ANDRE BINDACHI ALLOR REC-TORE* (He who painted this pure mother, who is always full of grace for sinners, was Taddeo di Bartolomeo from Siena. With the other saints around her figure, always pray for me with holy love. Mother, who because of you, perpetual grace rains upon us. In one thousand three hundred eighty-nine. Father Andrea Binachi then Rector.); ON THE HALOS OF THE VIRGIN: [illegible]; OF SEBAS-TIAN: *SANTUS SEB[ASITANUS] M[ARTYRUS]* (Saint Sebastian Martyr); OF PAUL: *SANCTUS [P]A[U]LUS APOSTOLUS* (Saint Paul Apostle); OF THE BAPTIST: *SANCTUS IOHANNES BAPTTIS[TUS]* (Saint John the Baptist); OF NICHOLAS OF BARI: *SANTUS NICOLAS DE* (Saint Nicholas of [Bari]); ON THE VIRGIN'S CROWN: [illegible]; ON PAUL'S TEXT: *A ROMANOS* (to the Romans); ON THE BAPTIST'S SCROLL: *Ecce Agnus Dei qui tollit p[eccata]* (from John 1:29: "Behold the Lamb of God, behold him who taketh away the sin")

PROVENANCE: The altarpiece's history after it left the oratory of San Paolo in Santi Vito e Modesto in Collegarli, near San Miniato al Tedesco, is not clear. According to the catalogue of the sale of the collection of Thomas Blayds, Esquire, of Castle Hill, Englefield Green (sold London, Christie's, March 30–31, 1849, lot 183 [as Taddeo di Bar-tolo]), the altarpiece came from the Capponi Collection in Florence.[1] After the Blayds sale, it entered the collection of Sir Shafto Adair at Flixton Hall, Bungay, Suffolk (sold London, Christie's, December 8, 1950, lot 159 [as Taddeo di Bartolo]). The 1950 sales catalogue states that the picture had passed from the Capponi palace to Cardinal Joseph Fesch, but this cannot be securely documented.[2] On the back of a photograph in the Witt Library, London, it is said that one Smith bought the picture in 1950. Alter-natively, Enzo Carli (in Solberg 1991, p. 1188 n. 7) recalled that it had been purchased by a dealer named Manenti. Its present location is unknown.

1. It is not recorded in the list of Capponi holdings in Fantozzi 1842, pp. 393–403 n. 149, but it may have been sold earlier.

2. The altarpiece cannot be specifically identified among Fesch's holdings. Solberg (1991, p. 1188) suggests that any number of works listed as "polyptych of the Virgin and Child with Saints" (Fesch 1841, lots 2234, 2244, 2324, 2333, 2804) might be this work.

SELECT BIBLIOGRAPHY: Domenico Maria Manni in Baldinucci 1681–1728, Manni ed., vol. 2, 1768, p. 231 n. 1; Gaetano Milanesi in Vasari 1568, Milanesi ed., vol. 2, 1878, p. 42 n.; Cavalcaselle and Crowe 1883–1908, vol. 3, 1885, p. 257; A. Venturi, vol. 5, 1907, p. 756; Van Marle, vol. 2, 1924, p. 545; Brandi 1949, pp. 169–70; Symeonides 1965, pp. 31–34, 49–50, 89, 195–96; Berenson 1968, p. 418; Boskovits 1985a, p. 337 n. 13, no. 40; Strehlke 1985a, p. 6, fig. 7; Solberg 1991, pp. 1182–94

B. Pinnacle panel of an altarpiece: *Annunciate Angel.* See fig. 78.3

1389

Tempera and tooled gold on panel; 12⅝ × 7⅞″ (32 × 20 cm) (originally arched; cut at the top, trimmed at the sides and lower edges). Bergen, Norway, Billedgalleri, no. 2

PROVENANCE: See Companion Panel C

SELECT BIBLIOGRAPHY: See Companion Panel C

C. Pinnacle panel of an altarpiece: *Virgin Annunciate.* See fig. 78.4

1389

Tempera and tooled gold on panel; 12⅝ × 7⅞″ (32 × 20 cm) (originally arched; cut at the top, trimmed at the sides and lower edges). Bergen, Norway, Billedgalleri, no. 2

PROVENANCE: Given to the Billedgalleri by Gerhard Stub, Norwegian consul to Livorno, 1837

SELECT BIBLIOGRAPHY: Berenson 1932, p. 551; Rønning Johannesen 1961, pp. 21, 30; Symeonides 1965, p. 219; Berenson 1968, p. 418; Strehlke 1985a, p. 5; Solberg 1991, pp. 321–24

PLATE 79 (JC CAT. 101)

Predella panel of an altarpiece: *Saint Thomas Aquinas Submitting His Office of Corpus Domini to Pope Urban IV*

c. 1403

Tempera and tooled gold on a panel with vertical grain; 16⅞ × 15⅝ × 1⅛″ (43 × 37 × 3 cm), painted surface 14½ × 13″ (36.7 × 33.1 cm)

John G. Johnson Collection, cat. 101

INSCRIBED ON THE REVERSE: *BARTOLO DI MAESTRO FREDI* (in black ink)

PUNCH MARKS: See Appendix II

EXHIBITED: Philadelphia Museum of Art, John G. Johnson Collection, Special Exhibition Gallery, *From the Collections: Paintings from Siena* (December 3, 1983–May 6, 1984), no catalogue

TECHNICAL NOTES

The panel probably retains its original thickness, although the reverse is obscured by new gesso that is painted brown. A vertical crack, repaired with butterfly keys from the back, extends the length of the panel, about 4¾″ (12 cm) from the left. There is a shallow rabbet, approximately 1½″ (3.9 cm) wide, cut in the right edge of the reverse (fig. 79.1), which likely indicates that the panel was attached to other elements. Such attachment is further suggested by dowel holes visible on both sides at about the middle of the panel (7⅞″ [20 cm] from the bottom).

The barbe on all four sides of the painted surface indicates that the composition is not cropped and that there would have been applied moldings.

The paint is in good condition, having been retouched only along the crack. The fluid quality of the marbleizing in the spandrels and of the glazing on the center column suggests the use of an oil medium for this specialized purpose. Certain details were picked out with mordant gilding: the stars of the blue vault, the pattern and trim on the cloth over the bench, one of the pope's gloves, and the rays of light emanating from the book. Sgraffito was used in the execution of the throne, the pope's mantle, and the cloth of honor.

There is no record of restoration. However, there are some repairs to the gold, in particular on the right side of the background and in a section of the pope's orphrey above his proper left hand.

PROVENANCE

The picture's provenance is unknown. It was first published by Bernhard Berenson in 1913. In 1916 Langton Douglas unsuccessfully offered the panel now in San Antonio (fig. 79.2), which may be from the same predella, to John G. Johnson (Sutton 1979, pp. 432, 436). Gail Solberg (1991, pp. 701, 777) has suggested that Douglas may have once owned Johnson's panel,

because at one point he also owned the related *Death of Saint Peter Martyr* (see fig. 79.4) in Northampton.

COMMENTS

In August 1264 Pope Urban IV Pantaleon asked Thomas Aquinas to compose a liturgical office for the feast of *Corpus Domini* or *Corpus Christi*, which the pope had established in a bull issued on the eleventh of that month. Urban IV had been inspired to institute the feast after a miraculous occurrence in nearby Bolsena: While celebrating mass, a priest from Prague named Peter had had his doubts about the doctrine of transubstantiation allayed when the wafer dripped blood on the corporal, the cloth on which the eucharistic elements are placed. This doctrine, which maintains that during the sacrament of the Eucharist the wafer is transformed into Christ's body, was much discussed in the mid-thirteenth century, and thus on June 19, 1264, soon after the priest had revealed the mystery, the corporal was carried to the pope in Orvieto. Aquinas compiled the office in record time and presented it to Urban IV,

who is known to have circulated at least one copy before his death on October 2 in Perugia.

Previously identified (Berenson 1913) as Saint Dominic appealing to a king, the Johnson panel was correctly recognized as the presentation of Aquinas's office by Reverend Charles M. Daley, O.P. (letter to the John G. Johnson Collection, dated Oak Park, Illinois, February 7, 1935).

The scene is set in a hall consisting of two bays, whose vaults are painted blue with golden stars. The pope, wearing a tiara with one crown, is seated on a raised faldstool. Kneeling before him is Saint Thomas Aquinas in a Dominican habit, holding the manuscript of his office, from which golden rays shine. Six cardinals view the scene. The one closest to the pope holds a gilt chalice with a paten and a host in one hand and a chalice veil in the other; the cardinal in the center, who points toward the pope, wears a Dominican habit.

The scene of Thomas presenting the office of *Corpus Domini* to the pope was depicted on the reliquary of the corporal in 1337–38,[1] by Ugolino di Vieri,

FIG. 79.1 Reverse of plate 79, showing a shallow rabbet where this panel was attached to another panel

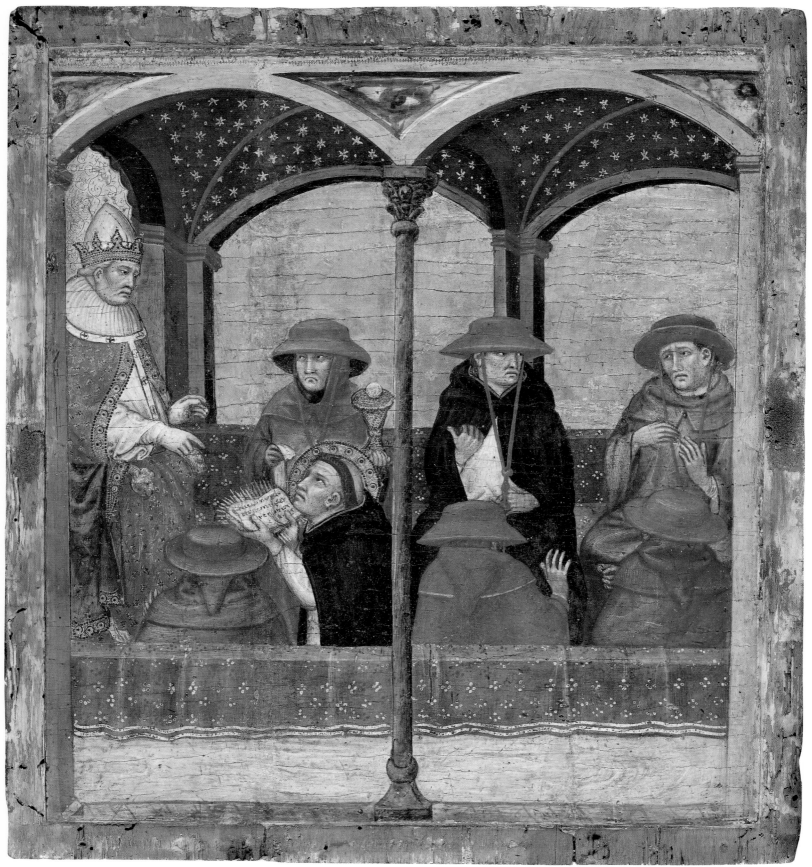

PLATE 79

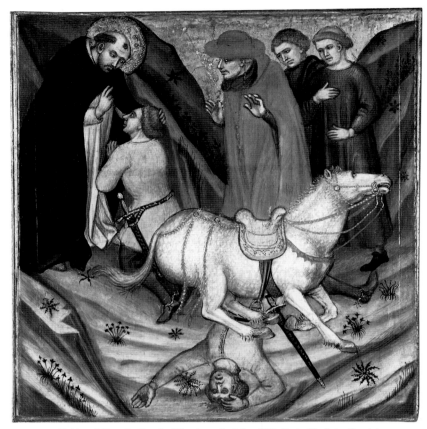

FIG. 79.2 Taddeo di Bartolo. *Death of Napoleone Orsini and His Revival by Saint Dominic,* c. 1403. Tempera and tooled gold on panel; 13⅝ × 13¼″ (34.5 × 33.6 cm). San Antonio, Texas, McNay Art Museum, Gift of Dr. and Mrs. Frederic G. Oppenheimer, no. 1955.11. See Companion Panel A

in the cathedral of Orvieto and in the mural cycle of 1357–64, by Ugolino di Prete Ilario and Giovanni di Buccio di Leonardello, decorating that same reliquary's chapel. In both of these representations the audience hall is depicted frontally, and the emphasis is on the pope, not Aquinas. By contrast Taddeo di Bartolo chose an arrangement by which the viewer looks into the hall from the side and can thus see the action in full. Berenson (1913) noted that Taddeo's composition was derived from Ambrogio Lorenzetti's mural *Boniface VIII Receives Saint Louis of Toulouse as a Novice* of about 1325 in San Francesco in Siena.[2] Variants are also found in two scenes of the predella of Pietro Lorenzetti's (q.v.) altarpiece of 1329 from San Niccolò al Carmine in Siena.[3]

The Johnson panel seems to have been part of a predella to an altarpiece. Solberg (1991) suggested

three other panels came from the same predella: *Death of Napoleone Orsini and His Revival by Saint Dominic* (fig. 79.2); *Crucifixion* (fig. 79.3); and *Death of Saint Peter Martyr* (fig. 79.4). The provenance of the first two panels can be traced to the collection of Johann Anton Ramboux, and it is likely that the third, which has a German provenance, also came from that collection. It is known that Ramboux purchased a large number of paintings in Siena in 1838,[4] although the Johnson panel cannot be traced back that far. The architecture in the Philadelphia painting, which is oriented to the right, suggests that the scene was set on the far left of the predella; its opposite on the right is missing. The two scenes showing stories from Saints Dominic and Peter Martyr's lives were respectively to the left and right of the center panel, which represented the Crucifix-

ion. The main sections of the altarpiece would have probably depicted the Virgin and Child with saints. Solberg (1991, p. 568) has suggested that a fragment in Siena showing the head of Saint Peter Martyr (fig. 79.5) was one of those saints.[5]

The Johnson panel is the only scene in the group that does not have horizontal wood grain. However, a shallow rabbet cut into the right edge (fig. 79.1) is certainly proof that the panel was inserted into a larger structure. If it was in fact part of the predella, it may have been at the bottom of an end pilaster, as in Taddeo di Bartolo's high altarpiece of 1401 for the cathedral of Montepulciano, where the end scenes of the predella have vertical grain and support pilasters.[6] While historiated predella panels under pilasters are not rare, they usually form part of a cycle dedicated to a single subject, such as the life of Christ, like the Montepulciano altarpiece, or a single saint.[7]

As it is most likely that the Johnson panel was positioned below an image of Saint Thomas Aquinas in the main section of the altarpiece, rather than being below a pilaster, it and its now-lost opposite on the other end of the predella could have been slightly raised with respect to the other scenes. A comparison can be made with Giovanni di Paolo's (q.v.) dispersed predella of about 1461 representing the life of Saint Catherine of Siena, a rare example of a Sienese predella not painted on a single plank of horizontally grained wood, and one in which several scenes, including those at the ends, jutted out from the sequence.[8]

Sibilla Symeonides (1965, pp. 99–100) proposed dating the Northampton panel to about 1403.[9] Solberg (1991, p. 568) concurred, based on comparison with the scenes of Taddeo's dispersed predella for the Perugian church of San Francesco al Prato in 1403.[10] This dating is probably correct, but analogies can also be made with his later works, such as the predella scenes of the 1411 altarpiece in Volterra.[11]

1. Cioni 1998, p. 468, fig. 1 (color).
2. Chelazzi Dini, Angelini, and Sani 1997, color repro. p. 149.
3. *Honorius IV Approves the Carmelite Rule of Saint Albert* and *Honorius IV Confers the New White Habit to the Carmelites;* Siena, Pinacoteca Nazionale, no. 84; Volpe 1989, figs. 112–13.
4. Ziemke 1969, pp. 287–88 n. 8.
5. Solberg noted that Niccolò Catalano (1652, p. 451) recorded in an engraving an untraced painting of Saint Francis by Taddeo di Bartolo that was then in San Domenico in Siena, which suggests that he painted an altarpiece for that church. It is possible that the present altarpiece came from San Domenico, because the predella shows stories of Dominican saints. If the lost *Saint Francis* was from this altarpiece, the missing predella panel may have depicted the *Meeting of Saints Dominic and Francis.*

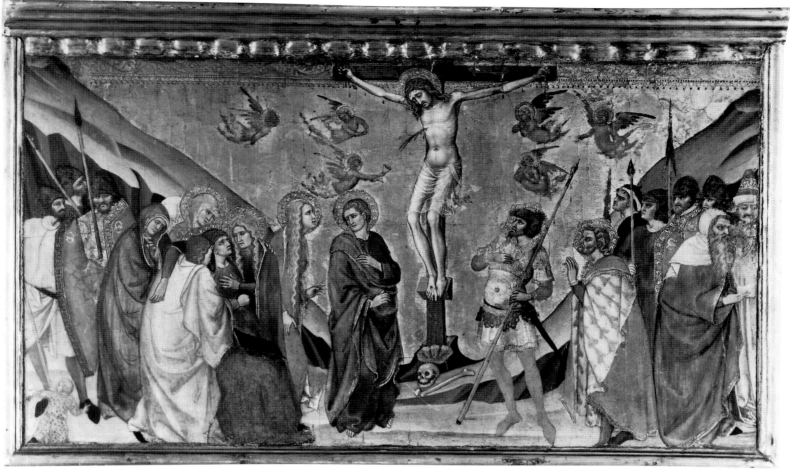

FIG. 79.3 Taddeo di Bartolo. *Crucifixion*, c. 1403. Tempera and tooled gold on panel; 16⅞ × 27½″ (43 × 70 cm). Private collection. See Companion Panel B

6. Symeonides 1965, plates XX–XXVI.
7. Two examples are the predella depicting the life of Christ in Sano di Pietro's (q.v.) Santa Bonda altarpiece in the Pinacoteca Nazionale, Siena (no. 226; Torriti 1977, fig. 318); and Giovanni di Paolo's (q.v.) predella with the life of Saint Stephen in Santo Stefano, Siena (mid-1400s; Van Os 1990, fig. 9).
8. See the reconstruction and discussion by Carl Brandon Strehlke in Christiansen, Kanter, and Strehlke 1988, pp. 218–42 n. 38, as well as Christiansen 1990, pp. 210–11; Boskovits 1990, pp. 104–13; and Lugano 1991, pp. 94–98 n. 31.
9. She suggested that it was made for an altarpiece in San Domenico in Perugia. Vasari had said that Taddeo executed now-lost murals for that church, but there is no evidence that he painted an altarpiece there.
10. Symeonides 1965, plates XXXVIII–XLIII. Six predella

panels are in the Niedersächsisches Landesmuseum, Landesgalerie, in Hanover, and a seventh one was last recorded in the 's Heerenberg Collection in Amsterdam. See also the reconstruction in Solberg 1992.
11. From the cathedral, now in the Pinacoteca e Museo Civico di Palazzo Minucci Solaini; in Lessi 1986, color repro. pp. 14–15.

Bibliography
Berenson 1913, p. 56; Berenson 1932, p. 552; Van Marle, vol. 2, 1934, p. 622 n. 11; Berenson 1936, p. 475; F. Mason Perkins in Thieme-Becker, vol. 32, 1938, p. 396; Johnson 1941, p. 16; Symeonides 1965, pp. 134, 248, plate XCII; Sweeny 1966, p. 75, repro. p. 102; Berenson 1968, p. 421; Fredericksen and Zeri 1972, p. 194; Solberg 1991, pp. 699–703, fig. 54; Philadelphia 1994, repro. p. 233; Roberts 2002, p. 116

COMPANION PANELS for PLATE 79

A. Predella panel of an altarpiece: *Death of Napoleone Orsini and His Revival by Saint Dominic.* See fig. 79.2

c. 1403

Tempera and tooled gold on panel with horizontal grain; 13⅝ × 13¼″ (34.5 × 33.6 cm). San Antonio, Texas, McNay Art Museum, Gift of Dr. and Mrs. Frederic G. Oppenheimer, no. 1955.11

PROVENANCE: Cologne, Johann Anton Ramboux, by 1862; Osvald Sirén; London, Langton Douglas, by 1916; sold, New York, American Art Galleries, January 23, 1918, lot 48 (as Taddeo di Bartolo); sold, New York, Stephane Bourgeois, to Philip J. Rosenthal; sold, New York, American Art Galleries, April 4, 1925, lot 105, repro. p. 59 (as Taddeo di Bartolo); New York, Richard Ederheimer, after 1931; San Antonio, Texas, Dr. and Mrs. Frederic G. Oppenheimer; given by the Oppenheimers to the McNay Art Museum, 1955

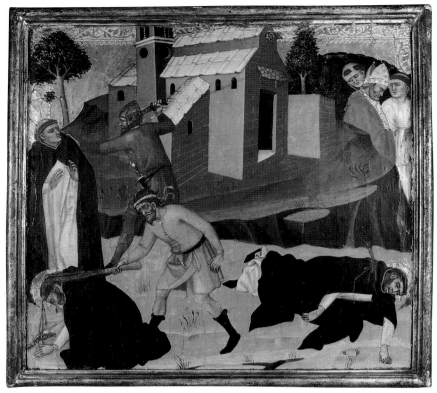

FIG. 79.4 Taddeo di Bartolo. *Death of Saint Peter Martyr*, c. 1403. Tempera and tooled gold on panel; 14½ × 15¼″ (36.2 × 38.6. cm). Northampton, Massachusetts, Smith College Museum of Art, no. 1958.38. See Companion Panel C

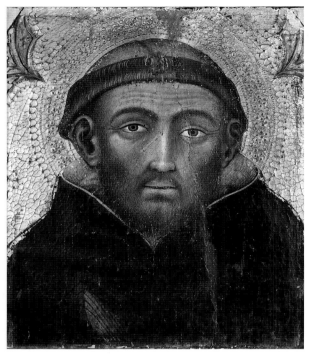

FIG. 79.5 Taddeo di Bartolo. *Saint Peter Martyr*, c. 1403. Tempera and tooled gold on panel; 14⅛ × 12″ (36 × 30.5 cm). Siena, Pinacoteca Nazionale, no. 129. See Companion Panel D

EXHIBITED: New York 1917, no. 49; Athens, Georgia 2002

SELECT BIBLIOGRAPHY: Ramboux 1862, p. 11, no. 58 (as Taddeo Gaddi); Sirén and Brockwell 1917, p. 130, no. 49; Coor 1956, p. 127; Symeonides 1965, pp. 46, 203; Berenson 1968, p. 421; Sutton 1979, pp. 432, 436; Solberg 1991, pp. 775–79; Roberts 2002, pp. 114–117, color repro. p. 115

B. Predella panel of an altarpiece: *Crucifixion.* See fig. 79.3

c. 1403

Tempera and tooled gold on panel with horizontal grain; 16⅞ × 27½″ (43 × 70 cm). Private collection

PROVENANCE: Cologne, Johann Anton Ramboux, by 1862; Cologne, Wallraf-Richartz-Museum, 1867; sold, October 3, 1935; London, Dr. Burg; Turin, Sebastiano Sandri, by 1954

SELECT BIBLIOGRAPHY: Ramboux 1862, p. 11, no. 57; Ramboux 1867, p. 12, no. 57; Cologne 1905, p. 118, no. 524 (as Tuscan school); Berenson 1932, p. 551; F. Mason Perkins in Thieme-Becker, vol. 32, 1938, p. 396; Coor 1959, pp. 76–77; Symeonides 1965, pp. 240–41; Berenson 1968, p. 419; Boskovits 1980, pp. 20–21 n. 36; Solberg 1991, pp. 1126–31

C. Predella panel of an altarpiece: *Death of Saint Peter Martyr.* See fig. 79.4

c. 1403

Tempera and tooled gold on panel with horizontal grain; 14½ × 15¼″ (36.2 × 38.6 cm). Northampton, Massachusetts, Smith College Museum of Art, no. 1958.38

INSCRIBED ON THE GROUND AT LOWER LEFT: *[C]redo* (I believe)

PROVENANCE: Münster art market, c. 1897–1911; London, Langton Douglas, c. 1916; London, Mrs. Langton Douglas, 1952; acquired by Smith College through the E. and A. Silberman Galleries, 1958

EXHIBITED: Bloomington 1945, no. 16, repro. (as Spinello Aretino)

SELECT BIBLIOGRAPHY: Symeonides 1965, pp. 99–100, 134, 214; Berenson 1968, p. 420; Solberg 1991, pp. 563–68

D. Fragment: *Saint Peter Martyr.* See fig. 79.5

c. 1403

Tempera and tooled gold on panel; 14⅛ × 12″ (36 × 30.5 cm). Siena, Pinacoteca Nazionale, no. 129

PROVENANCE: Siena, Pinacoteca Nazionale, since at least 1842

SELECT BIBLIOGRAPHY: Symeonides 1965, pp. 133, 227; Berenson 1968, p. 422; Torriti 1977, p. 199; Solberg 1991, pp. 568, 1027–30

Tommaso del Mazza
(*Master of Saint Verdiana*)

FLORENCE, DOCUMENTED 1377–92

In 1952 Wilhelm E. Suida (in Birmingham 1952) coined the name the "Master of Saint Verdiana" for the artist of two tabernacles then in the Kress Collection, one of which included an image of Saint Verdiana.[1] By contrast, Richard Offner (quoted in Shorr 1954; Offner and Steinweg 1965; and Offner/Maginnis 1981) called this same artist the "Master of the Louvre Coronation" by virtue of a painting of that subject by him in Paris.[2] Working from circumstantial evidence Miklós Boskovits (1975) and Barbara Deimling (1991) have since identified the painter as the historical Tommaso del Mazza based on an altarpiece[3] that he is documented as having painted in June 1392 on commission of Filippa Ammannati, for her late husband's chapel in San Francesco in Prato.[4] This altarpiece is clearly by the same hand that painted the works assigned to the Master of Saint Verdiana as well as a mural of the Blessing Christ in the house of Francesco di Marco Datini in Prato,[5] where Tommaso del Mazza is known to have executed murals in 1391. Tommaso had also worked for Datini in 1384, painting now-lost murals in San Francesco in Prato.

Another piece of circumstantial evidence helps to complete the puzzle. An altarpiece[6] of the late 1380s or early 1390s by the Master of Saint Verdiana, from the hospital of Bonifazio in Florence, was commissioned by the institution's founder, Bonifazio di Ugoletto Lupi, a former *podestà* of Florence who had employed Tommaso del Mazza to paint murals for the hospital. Although they do not survive, it is possible that Lupi would have asked the same artist to paint the altarpiece.

Little else is known of Tommaso del Mazza except that he registered in the Florentine painters' guild in 1377 and in the company of San Luca in 1390. In 1382 he ended a partnership with the painter Pietro Nelli, although the nature of their collaboration is not known.

Whatever his identity, like many Florentine artists of his generation, including Niccolò di Pietro Gerini (q.v.), this artist evolved out of the Cione workshop. Gaetano Milanesi (1878) suggested that Tommaso del Mazza might be the Tommaso di Marco identified by Giorgio Vasari as a pupil of Andrea di Cione, called Orcagna, on the basis of a now-lost altarpiece signed by Tommaso di Marco that Vasari had seen in a chapel of the rood screen of Sant'Antonio in Pisa. Further evidence of Tommaso del Mazza's possible connection to the Cione comes from a document in the Datini archive in which he and Gerini are recorded as returning together from Pisa to Florence in 1391.

The style of this artist's paintings is close to the manner of those whom Datini favored: Jacopo di Cione (q.v.) and Gerini. His small-scale paintings, particularly of the Virgin in glory, are his most inventive works.

1. They are now in the Birmingham Museum of Art in Alabama (no. 61.96 [K261]; Pasquinucci and Deimling 2000, plate XLII); and the High Museum of Art in Atlanta; (no. 58.49 [K1054]; Pasquinucci and Deimling 2000, plate LII). Saint Verdiana is in the latter.
2. No. 816; Pasquinucci and Deimling 2000, plate XLV. Originally Florence, Santissima Annunziata.
3. Present location unknown. Pasquinucci and Deimling 2000, plate LIV.
4. Alternatively, Luciano Bellosi (1983–84, p. 46) proposed that Tommaso del Mazza might be an artist whom he named the "Master of the Coniugi Datini," after paintings in Prato commissioned by Francesco di Marco Datini (see text below).
5. Pasquinucci and Deimling 2000, plate LVI.
6. Avignon, Musée du Petit Palais, nos. 161–63; Pasquinucci and Deimling 2000, plate XLIV.

Select Bibliography
Pini and Milanesi, vol. 1, 1876, nos. 9, 11; Gaetano Milanesi in Vasari 1568, Milanesi ed., vol. 1, 1878, p. 609 n. 3; Colnaghi 1928, p. 261; Piattoli 1929–30, pp. 416–24, 436–37, 540–45; Wilhelm E. Suida in Birmingham 1952, p. 23; Shorr 1954; Zeri 1959; Offner and Steinweg 1965, p. 37 n. 8; Boskovits 1967; Boskovits 1975, pp. 104–7, 228 n. 89; Fremantle 1975, pp. 293–302; Offner 1981, pp. 43–47; Enza Biagi in *Pittura* 1986, pp. 629–30; Deimling 1991; Barbara Deimling in Pasquinucci and Deimling 2000, pp. 109–369

PLATE 80 (PMA 1945-25-119)
Virgin of Humility and Eight Angels

c. 1370–75

Tempera and tooled gold on panel with vertical grain; 35¼ × 25½ × 1⅞″ (89.5 × 65 × 5 cm), painted surface 32½ × 27⅛″ (82.5 × 69 cm)

Philadelphia Museum of Art. Purchased from the George Grey Barnard Collection with Museum funds. 1945-25-119

INSCRIBED ON THE REVERSE: *119* (on a paper sticker on which *245* was crossed out); *45-25-119* (in red)

PUNCH MARKS: See Appendix II

TECHNICAL NOTES

The panel consists of two planks, 19⅞″ (50.5 cm) and 5½″ (14 cm) in width. It retains its original thickness and applied frame, which was attached by nails spaced at regular intervals. The upper member of the frame has become slightly detached. Butterfly keys set into the reverse reinforce the joint between the two planks as well as a crack that runs down the figure of the Virgin for the entire length of the panel. On the reverse (fig. 80.1) there is also a very old and possibly original hanging hook. A line of glue, 2½″ (6.5 cm) wide, along the top of the back, together with several old nail holes, indicate where a horizontal batten was once attached. Score marks on the back of the panel show where a batten was going to be glued or nailed, but there is no evidence that this was ever done.

It seems likely that David Rosen restored the painting, even though there is no record. A pre-restoration photograph (fig. 80.2) shows how severely the flesh and other areas have been abraded by cleaning. For example, the white veil that descends down the Virgin's proper right side and around her breast is now barely visible, and the area where it covered her pink dress is abraded to the gesso. And the many incised lines that outline the composition and define all the folds of the Virgin's mantle are much more apparent because of the abrasion. Traces of an even older campaign of restoration remain on the Virgin's blue mantle and its gilt lining.

Mordant gilding has flaked away in various places, and in the blue mantle the loss of the mordant has left a pitted surface. For the most part only the mordant of the delicate gilt design on the pink dress survives, and in some of those places the original intensity of the now-faded pink color can be seen. Traces of mordant gilding are also found in Jesus' yellow blanket and the angels' costumes. Originally the gold lining of the Virgin's mantle was glazed in green, a few traces of which remain. The pillow is gold with tooled graining, embellished with a pattern made of red and blue glazes, and its tassels are green.

The coats of arms in the lower corners have been effaced.

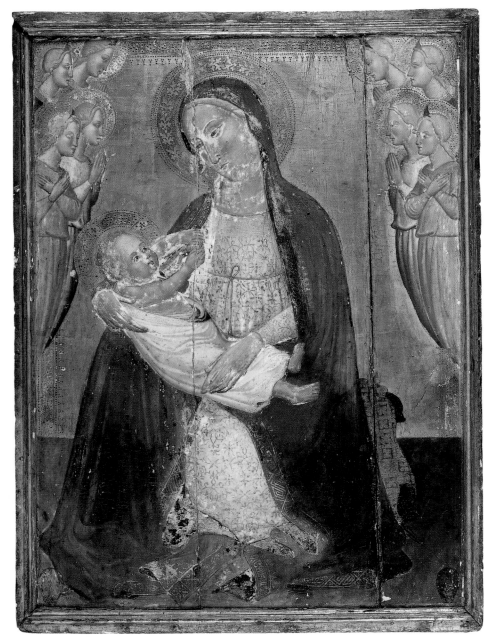

PLATE 80

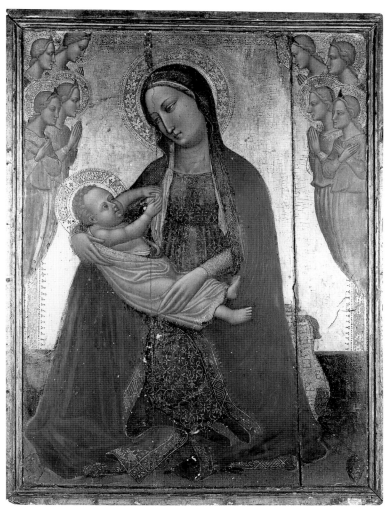

FIG. 80.1 Reverse of plate 80, showing the possibly original hanging hook at the top

FIG. 80.2 Plate 80 in the 1940s(?), before cleaning

PROVENANCE

Unfortunately, the two shields with coats of arms in the left and right bottom corners, which would have identified the painting's original owners, are now illegible. It is likely they were the arms of a married couple.

The dealer Elia Volpi, who had a gallery in the Palazzo Davanzati in Florence, sold this picture in New York at the American Art Association in the sale of March 31–April 2, 1927, as lot 371, attributed to "Daddo Daddi." It was bought by the Museum from George Grey Barnard's estate in 1945.

COMMENTS

Eight angels adore the Virgin of Humility.[1] This particular representation of the subject, which shows Jesus fondling his mother's breast, became a favorite in late fourteenth-century Florentine devotional art. While the Virgin and Child appear in much the same pose in an altarpiece (fig. 80.3) by Puccio di Simone, Millard Meiss (1951, p. 138) considered Jacopo di Cione's (q.v.) *Virgin of Humility* (fig. 80.4) in the National Gallery of Art the prototype for most subsequent depictions of the theme. However, Jacopo frequently made use of other

artists' designs, and, in this case, the painting by either Puccio di Simone or Tommaso del Mazza might have been the precedent. Tommaso del Mazza also made a variant of the same composition about 1380 for a small portable altarpiece[2] from the hospital of Santa Maria Nuova in Florence.

Federico Zeri (1976) suggested that the Philadelphia panel was the center of an altarpiece of which *Saint Michael Archangel Transfixing the Dragon* in the Walters Art Museum in Baltimore[3] and *Saint Catherine of Alexandria* in the Museo Horne in Florence were the side panels.[4] While the date and

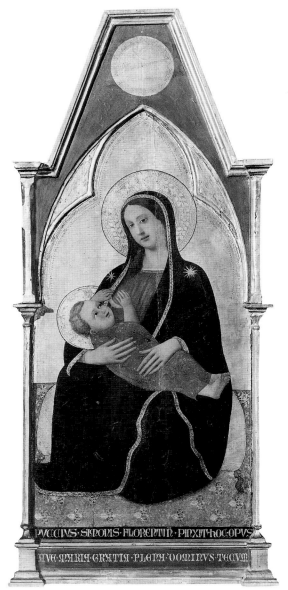

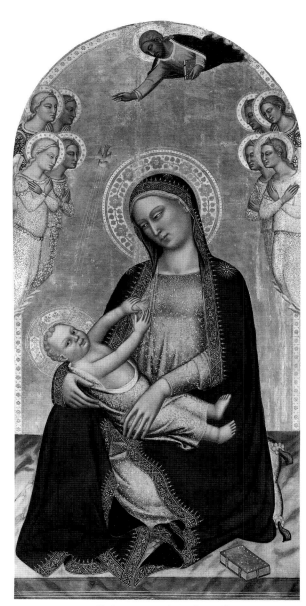

FIG. 80.3 Puccio di Simone (Florence, documented 1343–46; died before 1362). Center panel of an altarpiece: *Virgin of Humility,* c. 1348–55. Tempera and tooled gold on panel. From Arcetri (Florence), convent of San Matteo. Florence, Galleria dell'Accademia, no. 8569

FIG. 80.4 Jacopo di Cione (q.v.). *Virgin of Humility,* c. 1380–90. Tempera and tooled gold on panel; 55½ × 27⅛″ (141 × 69 cm). Washington, D.C., National Gallery of Art, Samuel H. Kress Collection, 1952.5.18.(814)/PA

the tooling of the gold of the three panels are very similar, the dimensions of the side panels are about half the height of the *Virgin of Humility,* which makes it unlikely that they are from a single complex.

1. On the Virgin of Humility, see plate 13 (JC cat. 153), attributed to Benedetto di Bindo; and plate 40 (JC cat. 10), by Lorenzo Monaco.

2. It shows the Virgin in glory nursing the Christ Child, with two angels and six saints. Now Florence, Galleria dell'Accademia, no. 3156; Pasquinucci and Deimling 2000, plate XXII.

3. No. 37.705; Pasquinucci and Deimling 2000, plate XXI.

4. No. 71; Pasquinucci and Deimling 2000, plate XX.

Bibliography
Weinberger 1941, p. 30, no. 119, plate XXXIX (follower of Orcagna, c. 1370–90); Meiss 1951, p. 138 n. 23; Offner and Steinweg 1965, p. 107 n. 5; Boskovits 1967, pp. 50, 58, fig. 17; Klesse 1967, p. 239, no. 128a; Zeri 1968, p. 71; F. Bologna 1969a, p. 24 n. 1; Fredericksen and Zeri 1972, p. 138 (Master of Santa Verdiana); Boskovits 1975, p. 383; Fremantle 1975, p. 298, fig. 605; Zeri 1976, p. 21; Deimling 1991, p. 406; Philadelphia 1994, repro. p. 234 (before cleaning); Barbara Deimling in Pasquinucci and Deimling 2000, pp. 114–16, 127, 160 n. 1, 187–90, 261 n. 1, and 342 n. 9, plate XXVIII

GIOVANNI TOSCANI
(*Giovanni di Francesco Toscani*)

ACTIVE FLORENCE, C. 1370/80–1430

Giovanni Toscani has been identified as the artist once known only as the Master of the Griggs Crucifixion, a name given by Richard Offner in 1933 to the person who produced a group of paintings in Florence in the 1420s in what might be termed a transitional style that embodied the Gothic linearism of Lorenzo Ghiberti as well as the new manner of Masaccio (q.v.). The name was derived from what was then considered the artist's most accomplished painting—the *Crucifixion* formerly in the Maitland Fuller Griggs Collection.[1] In 1966 Luciano Bellosi identified the master as Giovanni di Francesco Toscani based on payments made to him and his brother Domenico (died c. 1427) in 1423 and 1424 for work in the Ardinghelli chapel in Santa Trinita in Florence. Some mural paintings (fig. 82.8) in this chapel still survive, and fragments of the now-disassembled altarpiece are dispersed around the world, including the Johnson Collection (plate 82 [JC cat. 11]).

It has sometimes been suggested that the artist is the same as a Giovanni di Francesco who is recorded as assisting Ghiberti between 1404 and 1407 on the bronze doors of the baptistery in Florence.[2] Although this identification is unlikely, the Museum's early *Virgin and Child* (plate 81 [PMA 1943-40-45]) does indicate that Toscani's figural style derived from Ghiberti. The first documented fact of Toscani's activity is that in 1420 he served as a captain of the company of San Luca, although the official record of his matriculation into this Florentine painters' brotherhood dates to 1424. It was around this time that Toscani received his only known public commission—the *Incredulity of Saint Thomas*—for the courtroom of the Mercanzia, which was the Florentine tribunal for business disputes.[3]

Toscani's *catasto*, or tax return, of 1427 reveals quite a bit about the artist, for there he recorded that his brother was dead, that the funeral expenses were outstanding, and that his orphaned nephew had become his ward. He stated his profession as *cofaneio*, meaning that he produced *cassone* panels, a number of which still exist. One pair, dating before 1429, depicts Florentine street scenes of a horse race in the Piazza Santa Croce[4] and a proces-

sion of banners.[5] In the tax return Toscani listed among his debtors the Ardinghelli, who had not yet fully reimbursed him for his work in Santa Trinita. The Ardinghelli were connected to the powerful Strozzi by marriage, and it was in fact Palla Strozzi's accountants who had already paid for some of Toscani's work in the church. The Santa Trinita commission had thrust Giovanni into the inner circle of the Florentine merchant class, but as the tax records reveal, this seems to have done little for the artist financially, even if some of the expenses had been paid by Strozzi.

Another of Toscani's clients who was in arrears is called in his tax documents "Signore d'Urbino." This must be the ruler of Urbino, Guidantonio Montefeltro, who, the artist claimed, had still not paid him for an altarpiece executed in 1423, which may well have been a painting last recorded in Dr. Robert Jenkins Nevin's collection in Rome.[6] The Strozzi family may have been Toscani's contact to Guidantonio, as they were later briefly allied politically against the Medici. Guidantonio seems to have purchased art in Florence, for during these same years he commissioned parade armor from the Florentine shop of Giuliano d'Arrigo Pesello.[7]

In 1430 Toscani died and was buried in the Florentine cathedral of Santa Maria del Fiore. The 1430 tax return of his widow, Nicolosa, states that the Ardinghelli still had not paid their debt. Toscani also left an unfinished altarpiece of the Annunciation that he had been painting for Simone Buondelmonti, which another artist was called in to complete. This task fell to "Giuliano dipintore nel Corso," who was none other than the above-mentioned Giuliano d'Arrigo Pesello. However, Toscani may have been quite far along in the project at the time of his death, especially if, as I believe, his panels now in the Johnson Collection (plates 83A–B [JC cats. 18–19]) were part of its predella.

The painting was probably commissioned for the high altar of the now-destroyed church of Santa Maria Oltrarno in Florence, which was dedicated to the Annunciation and had traditionally been under the patronage of the Buondelmonti, who were from the same Florentine neighborhood as the Strozzi and Ardinghelli. Simone Buondelmonti was an important official in the Curia of Popes John XXIII Cossa

and Martin V Colonna. When Toscani died, the altarpiece did not immediately come into Buondelmonti's possession, for in her 1430 tax return the artist's widow reported that it was being kept by one Nicolai Niccoli. This might have been the great humanist and book collector Niccolò Niccoli, who had been associated in a search for Greek manuscripts with Simone's cousin Cristoforo, the archpriest of Santa Maria Oltrarno.

In her tax return of 1433, Nicolosa claimed that the Ardinghelli and the Buondelmonti had still not paid her the money they had owed her husband. The accounts in fact may never have been settled; in 1434 the Ardinghelli and Palla Strozzi were banished to Padua for their machinations against the Medici, and in 1433 Simone Buondelmonti was in debt for the enormous sum of 3,919 florins, his major creditor being Cosimo de' Medici.

1. New York, The Metropolitan Museum of Art, no. 43.98.5. However, the picture has since been identified as the work of Fra Angelico (q.v.); see Carl Brandon Strehlke in Kanter et al. 1994, pp. 324, 326, color repro. p. 325.
2. Bellosi 1966, p. 54. But also see Krautheimer (1982, p. 108), who believes that this Giovanni di Francesco was hardly more than a laborer.
3. Florence, Galleria dell'Accademia, no. 457; Bonsanti 1987, color repro. p. 78.
4. Cleveland Museum of Art, no. 16.801; Cleveland 1974, figs. 45, 45a.
5. Florence, Museo Nazionale del Bargello; Berti and Paolucci 1990, color repro. p. 129.
6. Bellosi 1966, figs. 26a, b.
7. Procacci 1960, pp. 21–23. Interestingly, Pesello had acquired his workshop in the corso degli Adimari from Palla Strozzi's son.

Select Bibliography
Gaetano Milanesi in Vasari 1568, Milanesi ed., vol. 1, 1878, p. 629 nn. 2, 5, p. 630 n. 3; vol. 2, 1878, p. 20 n. 1; Milanesi 1860, pp. 191, 207–10 (reprinted in Milanesi 1873, pp. 283, 319–21); Crowe and Cavalcaselle 1864–66, vol. 1, 1864, p. 424; Cavalcaselle and Crowe 1883–1908, vol. 2, 1883, pp. 129, 342–43; Gamurrini 1917–18, p. 91; Colnaghi 1928, p. 262; Offner 1933, p. 173; Hans Dietrich Gronau in Thieme-Becker, vol. 33, 1939, p. 313; Longhi 1940, p. 185 n. 22 (Longhi *Opere*, vol. 8, 1975, p. 54 n.); Bellosi 1966; *Bolaffi*, vol. 11, 1972, pp. 135–36; Nancy Coe Wixom in Cleveland 1974, pp. 127–29; Eisenberg 1976; Luciano Bellosi in Florence 1978–79, pp. 153; Padoa Rizzo 1982; Luciano Bellosi in Milan 1988, p. 196; Emanuela Andreatta in Berti and Paolucci 1990, p. 264; Maria Sframeli in Berti and Paolucci 1990, p. 128

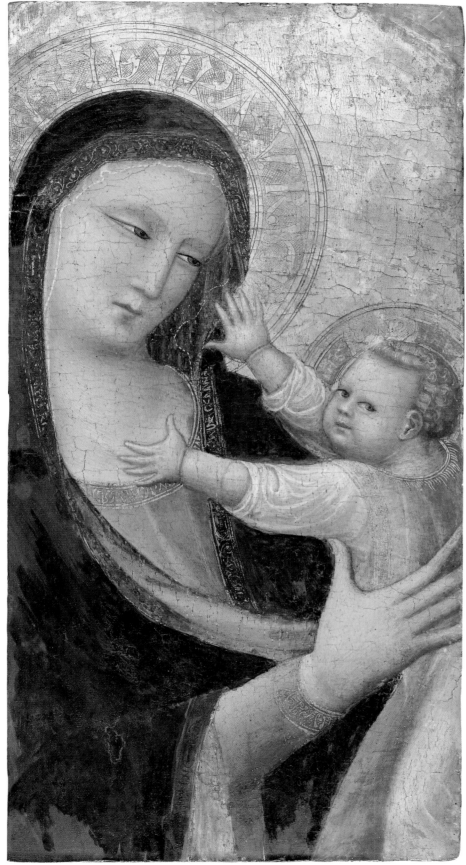

PLATE 81

PLATE 81 (PMA 1943-40-45)

Fragment: *Virgin and Child*

c. 1422–23

Tempera and tooled gold on panel with vertical grain; 20½ × 10½ × ½″ (52 × 26.8 × 1.2 cm)

Philadelphia Museum of Art. The John D. McIlhenny Collection. 1943-40-45

INSCRIBED ON THE VIRGIN'S HALO: [——]IS: IHIPAVRGU (unclear; it may also read IS: IBIHA VRGU); ON CHRIST'S HALO: IHS (symbol for the name of Jesus [twice]); ON THE REVERSE: 633-C (in black paint); 24 (in pencil); 11 (in black crayon); 158 (in pencil); '43-4-45 (in red paint); ON THE REVERSE OF THE FRAME: *Bernardo Daddi/ died 1380* (in ink on a label inscribed *JOHN D. McILHENNY/ GERMANTOWN, PA 74*)

EXHIBITED: Philadelphia 1926, p. 80 (as Tuscan, early fifteenth century)

TECHNICAL NOTES

The panel has been radically cut on all four sides and thinned, and the back side repainted in gray. Four strips of new wood have been nailed to the sides. The top was probably originally curved. The two top corners of the painting have been gessoed over and regilt, but it is not clear why. The surface rises slightly toward the edge of the upper right repair, suggesting that a barbe is present and that it is therefore an original edge.

The condition of the flesh tones and lips is generally good. However, the blue of the Virgin's mantle is completely repainted except for the partially surviving mordant gilt decoration. The mordant gilding on her pink dress and Christ's pink robe is well preserved. The mordant was white. The gold halos are incised.

PROVENANCE

The painting's provenance before its entry into the John D. McIlhenny Collection sometime before 1926 is not known. It may have come from an altarpiece in the Carmelite church of San Bartolomeo in Prato. In September 1899 Guido Carocci[1] described two panels of saints (figs. 81.1, 81.2) in the sacristy of that church as being close to the manner of Agnolo Gaddi and Lorenzo Monaco (qq.v.). It was subsequently suggested by Luciano Bellosi (1966) that they were the side panels to an altarpiece in which the McIlhenny *Virgin and Child* was the center; the altarpiece would have been disassembled before 1899.

COMMENTS

The Virgin gazes at the Christ Child, who raises his arms toward her. The proportions of the figures suggest that they were originally depicted full-length. The Virgin may have been seated on a throne, the ground, or a pillow in the guise of the Virgin of Humility. It is likely that the painting resembled the *Virgin of Humility* of about 1422, sometimes attributed to Masolino (q.v.), in the Uffizi.[2]

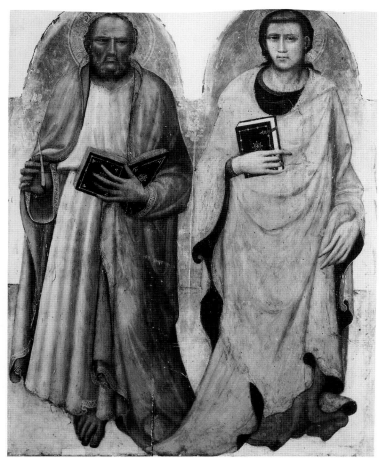

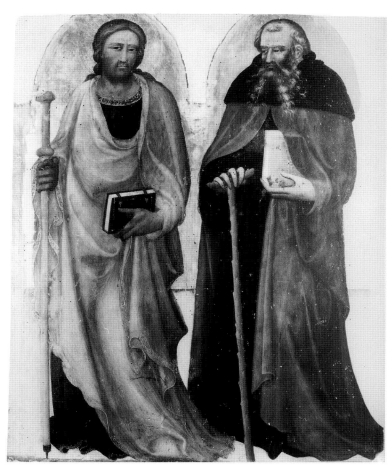

FIG. 81.1 Giovanni Toscani. *Saint John the Evangelist and an Apostle,* c. 1422–23. Tempera and tooled gold on panel; 40½ × 30¼″ (103 × 77 cm). Prato, church of San Bartolomeo; on deposit, Prato, Museo dell'Opera del Duomo. See Possible Companion Panel A

FIG. 81.2 Giovanni Toscani. *Saints James Major and Anthony Abbot,* c. 1422–23. Tempera and tooled gold on panel; 40½ × 30¼″ (103 × 77 cm). Prato, church of San Bartolomeo; on deposit, Prato, Museo dell'Opera del Duomo. See Possible Companion Panel B

The linear quality of Toscani's *Virgin and Child* is close to that in the works of Lorenzo Monaco and Lorenzo Ghiberti, who were his earliest influences. The Philadelphia panel can be compared with two other early paintings of the same subject: the *Virgin and Child* in the oratory of the Madonna delle Calle in Montemignaio,[3] and the *Virgin and Child* in San Donato in Calenzano.[4] The Calenzano *Virgin* has its original tabernacle frame, which reflects a Ghibertian model. Miklós Boskovits (1987a) compared it with Masolino's *Virgin and Child,* dated 1423, in the Kunsthalle in Bremen.[5]

As Bellosi suggested, the Philadelphia panel may have formed the central section of a polyptych whose lateral panels were *Saint John the Evangelist and an Apostle* (fig. 81.1) and *Saints James Major and Anthony Abbot* (fig. 81.2), both on deposit in the Museo dell'Opera del Duomo of Prato from the Carmelite church of San Bartolomeo. The polyptych would date around 1422–23, just before Toscani's Ardinghelli altarpiece (see plate 82 [JC cat. 11]). The painting, however, may have been simply part of a tabernacle

of the Virgin and Child like the above-mentioned Masolino in Bremen.

1. Florence, Soprintendenza per i Beni Architettonici ed il Paesaggio e per il Patrimonio Storico Artistico e Demoetnoantropologico, Archivio Storico del Territorio, *Catalogo generale dei monumenti e degli oggetti d'arte nel Regno.*
2. Strehlke 2002, color plate 1 (as central Italian Painter).
3. Bellosi 1966, fig. 18.
4. Bellosi 1966, fig. 19.
5. Inv. 164; Strehlke 2002, color plate 3.

Bibliography

Sirén 1914a, p. 264; Arthur Edwin Bye in Philadelphia 1926, p. 89 (Tuscan, early fifteenth century); Offner 1930, pp. 11, 91; Berenson 1932, p. 340; Offner 1933, p. 173 n. 17, plate II, D; Berenson 1936, p. 277; Marceau 1944, p. 54, repro. p. 58 (Master of the Griggs Crucifixion); Philadelphia 1965, p. 44 (Master of the Griggs Crucifixion); Bellosi 1966, p. 45; *Bolaffi,* vol. 11, 1976, p. 135; Fredericksen and Zeri 1972, p. 204; Boskovits 1987a, p. 52, fig. 11; Philadelphia 1994, repro. p. 234

POSSIBLE COMPANION PANELS for PLATE 81

A. Lateral panel of an altarpiece: *Saint John the Evangelist and an Apostle.* See fig. 81.1

c. 1422–23

Tempera and tooled gold on panel; 40½ × 30¼″ (103 × 77 cm). Prato, church of San Bartolomeo; on deposit, Prato, Museo dell'Opera del Duomo

PROVENANCE: Prato, church of San Bartolomeo

SELECT BIBLIOGRAPHY: Marchini 1942, pp. 98–100; Bellosi 1966, p. 45; Datini 1972, p. 67; *Bolaffi,* vol. 11, 1976, p. 135

B. Lateral panel of an altarpiece: *Saints James Major and Anthony Abbot.* See fig. 81.2

c. 1422–23

Tempera and tooled gold on panel; 40½ × 30¼″ (103 × 77 cm). Prato, church of San Bartolomeo; on deposit, Prato, Museo dell'Opera del Duomo

PROVENANCE: See Companion Panel A

SELECT BIBLIOGRAPHY: See Companion Panel A

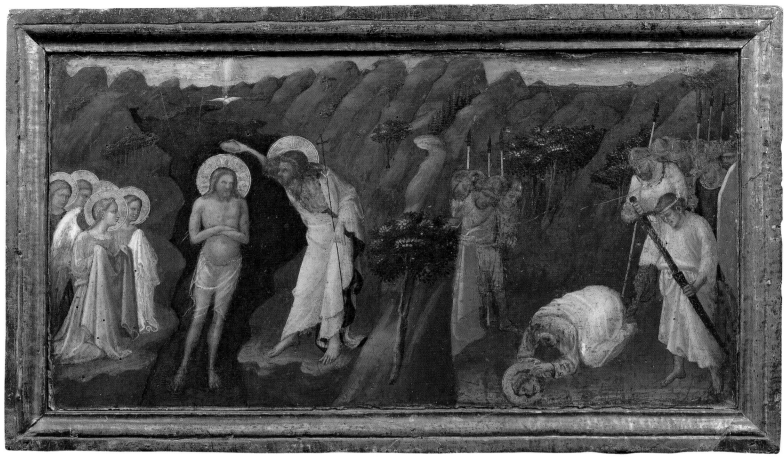

PLATE 82

PLATE 82 (JC CAT. 11)

Predella panel of an altarpiece:
Baptism of Christ and the Decapitation of Saint James Major

1423–24

Tempera and tooled gold on panel with horizontal grain; 15½ × 25⅜ × 1¼″ (39.2 × 64.4 × 3.2 cm), with later applied frame 16 × 24″ (40.8 × 60.9 cm), painted surface 13 × 24¼ × 1¼″ (33 × 61.5 × 3.2 cm)

John G. Johnson Collection, cat. 11

INSCRIBED ON THE REVERSE: *JOHNSON COLLECTION/ PHILA.* (stamped in black)

EXHIBITED: Philadelphia Museum of Art, Sixty-ninth Street Branch, *Religious Art of Gothic and Renaissance Europe* (December 1, 1931–January 4, 1932), no catalogue

TECHNICAL NOTES
The panel retains its original thickness. The moldings appear old and may have been salvaged when the altarpiece to which the panel originally belonged was broken up. One of the companion panels in Florence (fig. 82.1) is similarly framed. The Philadelphia moldings have been regilt. Some of their inner edges have traces of paint, which suggests that they were taken from another scene. Strips of wood have been added to the top, left, and right edges, probably to compensate for wood loss that occurred in the disassembly of the predella.

A gesso barbe with traces of gold is preserved on all four sides, indicating that the dimensions of the picture are original.

Traces of mordant gilding may be seen on the red shield to the far right and on the rays of the dove of the Holy Spirit in the Baptism scene. The gold halos are incised. There is much repaint. For example, areas that were once silver have been repainted in blue and gray. These include the executioner's sword, elements of the soldiers' uniforms, and the tips of their lances. The soldier behind the executioner once held an object—possibly tongs—executed in silver and outlined in black

paint; only fragments of the black outline survive.

The paint surface is abraded. Virtually all the mid-tones of the flesh are now gone. As a result, only the strongest highlights remain, and the flesh appears quite green. Abrasion and faded pigments have revealed some underdrawing. For example, there is irregular hatching in Christ's pink robe, which is held by an angel. Drawing is also visible in the Baptist's cloak.

PROVENANCE
The painting comes from the predella of the altarpiece of the Ardinghelli chapel in Santa Trinita in Florence, which remained there until at least 1776. It is not known when or where John G. Johnson acquired the panel.

COMMENTS
The panel contains two scenes that are set in the same landscape and divided by a mountain range. On the left is the Baptism of Christ. Saint John the Baptist stands on the bank of the Jordan as he leans

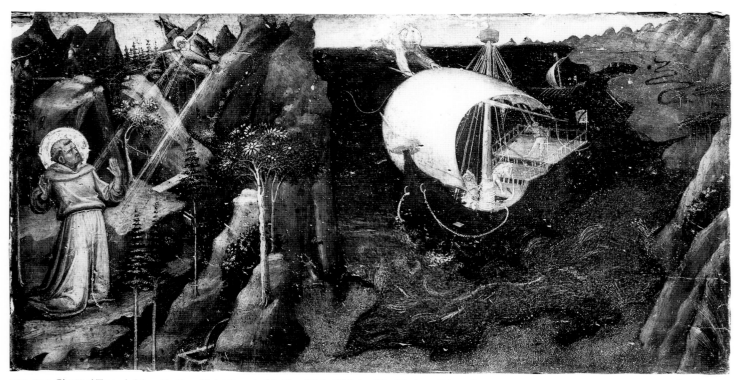

FIG. 82.1 Giovanni Toscani. *Stigmatization of Saint Francis of Assisi and Saint Nicholas of Bari Saving a Shipwreck*, 1423–24. Tempera and tooled gold on panel; 12¾ × 24″ (32.5 × 61 cm). Pictured here without frame moldings. Florence, Galleria dell'Accademia, no. 3333. See Companion Panel B

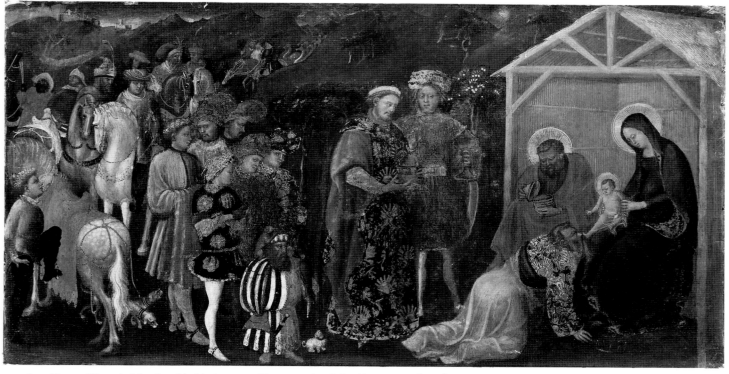

FIG. 82.2 Giovanni Toscani. *Adoration of the Magi*, 1423–24. Tempera and tooled gold on panel; 13⅜ × 25⅜″ (34 × 64.5 cm). Florence, private collection. See Companion Panel C

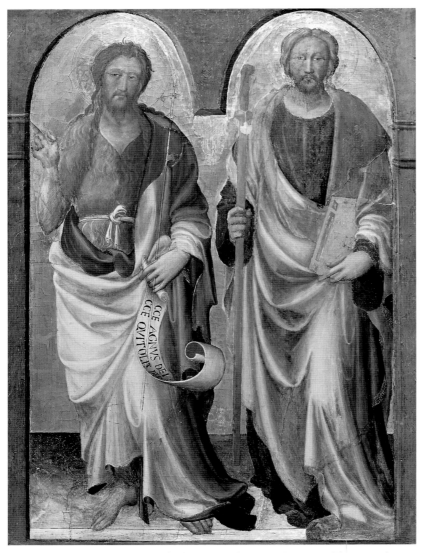

FIG. 82.3 Giovanni Toscani. *Saints John the Baptist and James Major*, 1423–24. Tempera and tooled gold on panel; 39¾ × 29½″ (101 × 75 cm). Baltimore, The Walters Art Museum, no. 37.632. See Companion Panel A

over Christ, who wears only his loincloth. On the opposite bank angels hold Christ's garments. To the right of the panel is the martyrdom of the apostle James Major, an event that is briefly recorded in the Acts of the Apostles 12:1–2. Here the saint has just been decapitated, as the executioner sheathes his sword and groups of soldiers stare as James's head rolls on the ground.

The other extant pieces of the predella to which this panel originally belonged are the *Stigmatization of Saint Francis of Assisi and Saint Nicholas of Bari Saving a Shipwreck* (fig. 82.1) and the *Adoration of the Magi* (fig. 82.2). The only surviving component of the main section of the altarpiece is the right lateral panel, *Saints John the Baptist and James Major* (fig. 82.3), under which the Johnson predella scene

would have been set. A painting of Saints Francis and Nicholas of Bari from the other lateral panel is missing. Three pinnacle panels still exist: *Annunciate Angel* (fig. 82.4), *Crucifixion with the Mourning Virgin and Saint John the Evangelist* (fig. 82.5), and *Virgin Annunciate* (fig. 82.6).

The center main section of Toscani's altarpiece was not a painting but a reliquary of the cross that had been donated by the chapel's founder, Niccolò Ardinghelli. This reliquary no longer exists; in 1487 the abbot of Santa Trinita commissioned Amerigo di Giovanni to replace the original reliquary with a new silver one.[1] Although Amerigo's reliquary is now lost, written accounts suggest that it incorporated pieces of the old one. It is not clear whether Amerigo's reliquary was originally kept in

the altarpiece. Although it was listed in an inventory of the chapel in 1505, by then it was not part of the altarpiece. Around 1665 a now-lost reliquary of the crucifix as well as images of Saint Giovanni Gualberti and the Blessed Umiltà were installed in the altarpiece.[2] In 1740 Bernardo Davanzati, the abbot of Santa Trinita, wrote a description of the altarpiece that serves as a precious record of the lost main panel.[3] In the upper section, above the sculptures, were three medallions, with the one in the center depicting God the Father and the dove of the Holy Spirit. Its original position over a reliquary of the cross would have been a reference to the Trinity, the titular of the church. The two other medallions depicted the prophets Isaiah and Jeremiah.

The altarpiece was in a chapel that Niccolò Ardinghelli had founded in 1399. It was at the top of the right aisle of the nave and adjacent to the transept. Niccolò had dedicated it to his namesake, Saint Nicholas of Bari, but because he had also donated the reliquary to the church, it was also known as the chapel of the Cross. In 1423 Niccolò's descendant Piero di Neri Ardinghelli commissioned from Giovanni and Domenico Toscani a complete refurbishment of the chapel, including mural paintings and a tabernacle altarpiece for the reliquary. Ardinghelli's marriage to Caterina di Niccolò di Nofri Strozzi on January 24, 1424 (modern style), provided the motivation for this project. The bride's uncle Palla Strozzi, the richest man in Florence, provided her with a dowry of 2,000 florins. At the time of the marriage he was still overseeing the decoration of his own newly constructed family chapel in the same church, where Gentile da Fabriano's altarpiece of the Adoration of the Magi (fig. 82.8) had been installed only a few months before, and where Lorenzo Monaco (q.v.) was still at work painting another altarpiece for the sacristy.[4]

Given the new family alliance formed by the marriage, Palla Strozzi had a strong interest in seeing that the Ardinghelli reliquary was housed in a properly appointed chapel as soon as possible. Thus, as part of his dowry obligations to his niece, he partially paid the Toscani brothers for their work in the chapel.[5] Some of the chapel's murals survive, including the one in the exterior entrance arch showing Saint Nicholas of Bari in glory[6] and another, in the interior arched niche that marked the family sarcophagus,[7] depicting the Pietà (fig. 82.7). The other walls and vaulting of the chapel were also painted, but nothing remains. The 1433 tax return of Toscani's widow states that Domenico executed the vaulting and Giovanni the rest.[8]

Gentile da Fabriano's *Adoration* altarpiece for the Strozzi influenced the style of the Toscani's altarpiece for the Ardinghelli. The Toscani panel of the *Adoration* (fig. 82.2) derives directly from the Gentile, and the bird's-eye-view landscapes of the two other predella scenes also presuppose Gentile.

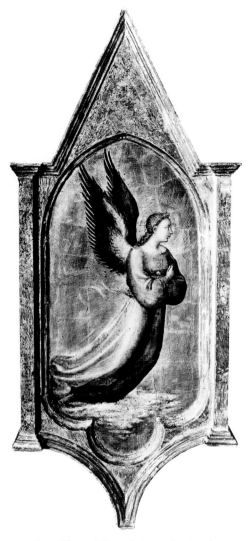

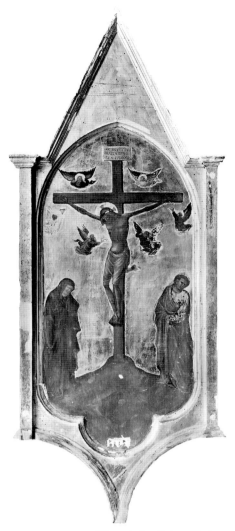

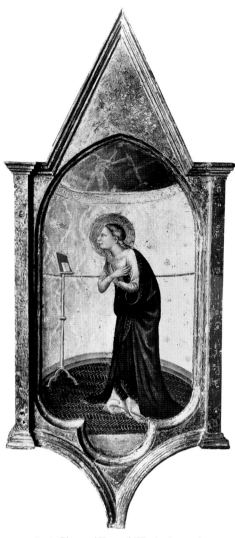

FIG. 82.4 Giovanni Toscani. *Annunciate Angel,* 1423–24. Tempera and tooled gold on panel; approximately 49¼ × 18⅛″ (125 × 46 cm). Rome, Carradini Collection. See Companion Panel D

FIG. 82.5 Giovanni Toscani. *Crucifixion with the Mourning Virgin and Saint John the Evangelist,* 1423–24. Tempera and tooled gold on panel; 49¼ × 18⅛ to 25⅝″ (125 × 46 to 65 cm). Florence, Galleria dell'Accademia, no. 6089. See Companion Panel E

FIG. 82.6 Giovanni Toscani. *Virgin Annunciate,* 1423–24. Tempera and tooled gold on panel; approximately 49¼ × 18⅛″ (125 × 46 cm). Rome, Carradini Collection. See Companion Panel F

Toscani also borrowed from other sources. The position of the Baptist is based on one in the same scene in Ghiberti's first bronze doors for the baptistery (installed 1424),[9] and the most immediate precedent for Toscani's depiction of the rare scene of Saint James Major's execution is Nicolò di Pietro Lamberti's sculptured predella of the niche of the Guild of the Furriers (Arte dei Vaiai e Pellicciai) on the façade of Orsanmichele in Florence.[10] The saint's frontal position and executioner sheathing his sword are also used in Agnolo Gaddi's (q.v.) wall painting in the choir of Santa Croce in Florence[11] as well as in works by Lorenzo Monaco and other late trecento and early quattrocento painters.

The use of a mountain range to divide two scenes was a common device. For example, Agnolo Gaddi used it in the above-mentioned mural in Santa Croce. The technique was also frequently employed in *cassone* paintings, including one by Toscani.[12] The artist also used it in the predella from the altarpiece last recorded in the Nevin Collection in Rome.[13]

1. Bemporad 1980, p. 51.
2. Dora Liscia Bemporad in Marchini and Micheletti 1987, p. 282.
3. Padoa Rizzo 1982, pp. 7–8.
4. Florence, Museo Nazionale di San Marco. Before Lorenzo Monaco's death only the predella and the pinnacles in the frame were painted. A number of years later Fra Angelico (q.v.) would finish it. See Pope-Hennessy 1974, plate 98; Eisenberg 1989, figs. 92–95, color plate 10; Spike 1997, color repro. p. 107.
5. On the Strozzi, the Ardinghelli, and Palla's payments to the Toscani, see Orlandi 1964, pp. 10, 46 n. 3, 171, 180, 181 and n. 1.
6. Marchini and Micheletti 1987, fig. 102.
7. In December 1403 Michele Ardinghelli had endowed the chapel for family burials. See Kent 1977, pp. 271–72.
8. Cited in Milanesi 1860, p. 210: "Più dovremo avere da Piero di Neri Ardinghelli per resto d'una cappella gli dipinse in Santa Trinita el detto Giovanni. Non se ne fe patto ne' convegna. Dipesela el resto. La volta fece fare Domenico, e 'l resto Giovanni. Ànne avuto fior. 23. No so se s'a avere più." (In addition we must have from Piero di Neri Ardinghelli the outstanding monies for a chapel that the said Giovanni painted in Santa Trinita. He never made a pact or a contract for it. He painted the remaining part. The vaulting was done by Domenico and the rest by Giovanni. They were paid 23 florins. I do not know if they are owed any more.)
9. Krautheimer 1982, plate 32.

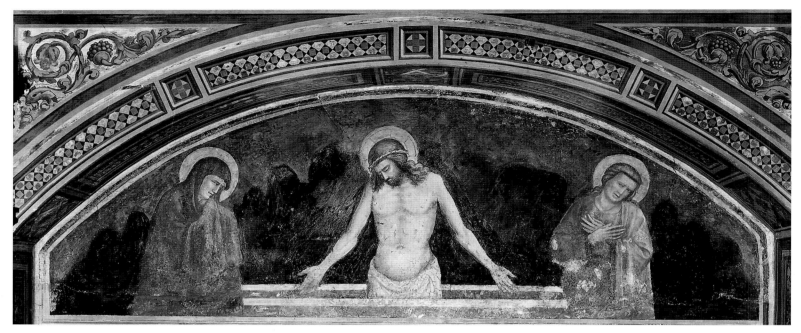

FIG. 82.7 Giovanni Toscani. *Christ in the Tomb and the Mourning Virgin and Saint John the Evangelist*, 1423–24. Mural. Florence, church of Santa Trinita, Ardinghelli chapel

10. Finiello Zervas 1996, atlas vol., color plate 83.

11. Cole 1977, fig. 33.

12. See his *cassone* with three stories of Venus (Brunswick, Maine, Bowdoin College Museum of Art, Kress 275; Shapley 1966, fig. 269).

13. Bellosi 1966, fig. 26b.

Bibliography
Gaetano Milanesi in Vasari 1568, Milanesi ed., vol. 2, 1878, p. 19; Richa, vol. 3, 1755, p. 163; Berenson 1913, pp. 8–9, repro. p. 233 (Florence, c. 1425); Van Marle, vol. 9, 1927, p. 177; Johnson 1941, p. 6 (Florence, c. 1425); Paatz, vol. 5, 1953, pp. 291–92, 357–58 nn. 226–28; Middeldorf 1955, p. 180; Bellosi 1966, pp. 50–51, 55; Sweeny 1966, p. 53, repro. p. 116 (Master of the Griggs Crucifixion); Fredericksen and Zeri 1972, p. 204; Zeri 1976, pp. 30–31; Eisenberg 1976, p. 279, fig. 22; Padoa Rizzo 1982, fig. 6; Anna Padoa Rizzo in Marchini and Micheletti 1987, pp. 123–25; Luciano Bellosi in Milan 1988, p. 196; Philadelphia 1994, repro. p. 235

COMPANION PANELS for PLATE 82

A. Lateral panel of an altarpiece: *Saints John the Baptist and James Major.* See fig. 82.3

1423–24

Tempera and tooled gold on panel (with modern simulated architectural frame, trimmed on all four sides, and the addition of triangular pieces of wood that disguise the original truncated arches of the panel); 39¾ × 29½″

(101 × 75 cm). Baltimore, The Walters Art Museum, no. 37.632

INSCRIBED ON THE BAPTIST'S SCROLL: *[E]CCE AGNUS DEI/ [E]CCE QUI TOL[L]IT PEC[CATA MUNDI]* (John 1:29: "Behold the Lamb of God, behold him who taketh away the sin of the world")

PROVENANCE: Rome, Don Marcello Massarenti; acquired by Henry Walters, 1902

SELECT BIBLIOGRAPHY: Eisenberg 1976, p. 279 n. 13; Zeri 1976, pp. 30–31 (with bibliography); Padoa Rizzo 1982, p. 6; Padoa Rizzo in Marchini and Micheletti 1987, pp. 123–27

B. Predella panel of an altarpiece: *Stigmatization of Saint Francis of Assisi and Saint Nicholas of Bari Saving a Shipwreck.* See fig. 82.1

1423–24

Tempera and tooled gold on panel; 12¾ × 24″ (32.5 × 61 cm). Florence, Galleria dell'Accademia, no. 3333

PROVENANCE: From the monastery of Vallombrosa, the mother congregation to which the church of Santa Trinita in Florence belonged

SELECT BIBLIOGRAPHY: Cavalcaselle and Crowe 1883–1908, vol. 2, 1883, pp. 344–45; Sirén 1909, pp. 34–35; Offner 1933, p. 173 n. 17; Pudelko 1938, p. 63 n. 31; Berenson 1963, p. 192; Bellosi 1966, p. 51; Zeri 1976, p. 30; Padoa Rizzo 1982, p. 6; Bonsanti 1987, p. 94; Anna Padoa Rizzo in Marchini and Micheletti 1987, pp. 123–27

C. Predella panel of an altarpiece: *Adoration of the Magi.* See fig. 82.2

1423–24

Tempera and tooled gold on panel; 13⅜ × 25⅜″ (34 × 64.5 cm). Florence, private collection

PROVENANCE: London, William Graham Collection; sold, London, Christie's, April 8, 1886, lot 229 (as Benozzo Gozzoli); purchased, London, Colnaghi; sold anonymously, London, Christie's, June 30, 1906, lot 125 (as Gentile da Fabriano); purchased, London, Wickes; Miss Mary Dodge and her heirs; London, Heim, c. 1982; Florence, private collection

EXHIBITED: London 1878, no. 149 (as Gentile da Fabriano); Milan 1988, no. 51

SELECT BIBLIOGRAPHY: Berenson 1931–32, p. 192; Berenson 1963, p. 193; Bellosi 1966, pp. 50–51; Zeri 1976, p. 30; Padoa Rizzo 1982, p. 6; Anna Padoa Rizzo in Marchini and Micheletti 1987, pp. 123–27; Luciano Bellosi in Milan 1988, pp. 196–97

D. Pinnacle panel of an altarpiece: *Annunciate Angel.* See fig. 82.4

1423–24

Tempera and tooled gold on panel; approximately 49¼ × 18⅛″ (125 × 46 cm). Rome, Carradini Collection

PROVENANCE: Unknown

SELECT BIBLIOGRAPHY: See Companion Panel F

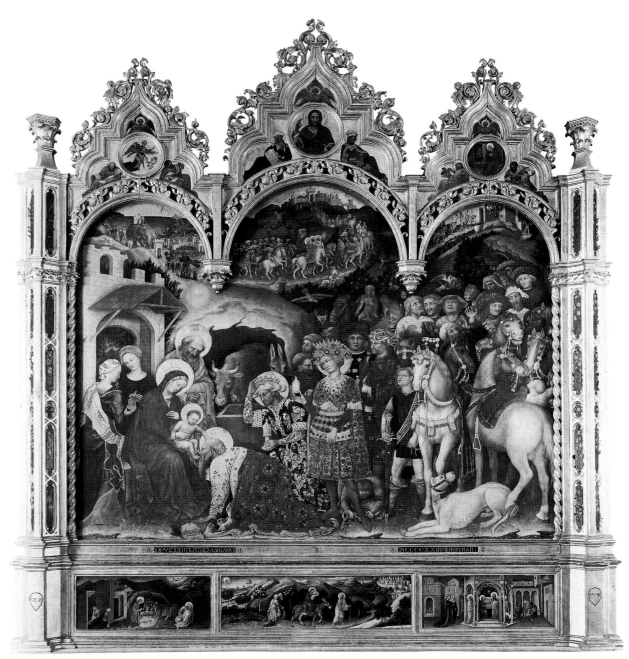

FIG. 82.8 Gentile da Fabriano (Marches, first documented 1408; died 1427). Altarpiece: *Adoration of the Magi,* finished May 1423. Tempera and tooled gold on panel; overall 68⅛ × 86⅝″ (173 × 220 cm). From Florence, church of Santa Trinita, Strozzi chapel. Florence, Galleria degli Uffizi, no. 295

E. Pinnacle panel of an altarpiece: *Crucifixion with the Mourning Virgin and Saint John the Evangelist.* See fig. 82.5

1423–24

Tempera and tooled gold on panel; 49¼ × 18⅛ to 25⅝″ (125 × 46 to 65 cm). Florence, Galleria dell'Accademia, no. 6089

INSCRIBED ON THE CROSS: *HIC EST IHS/ NACCARENO/ REX IUDEOS* (This is Jesus, the Nazarene, King of the Jews); ON THE REVERSE: *No. 35 Estratti del convento di S. Trinita di Firenze* (on a label)

PROVENANCE: Florence, Galleria dell'Accademia, by 1855

SELECT BIBLIOGRAPHY: Berenson 1963, p. 192; Bellosi 1966, p. 51; Zeri 1976, vol. 1, pp. 30–31; Padoa Rizzo 1982, pp. 6, 10 n. 8; Anna Padoa Rizzo in Marchini and Micheletti 1987, pp. 123–25

F. Pinnacle panel of an altarpiece: *Virgin Annunciate.* See fig. 82.6

1423–24

Tempera and tooled gold on panel; approximately 49¼ × 18⅛″ (125 × 46 cm). Rome, Carradini Collection

PROVENANCE: Unknown

SELECT BIBLIOGRAPHY: Berti 1964, p. 143 n. 202; Bellosi 1966, p. 51; Zeri 1976, pp. 30–31; Padoa Rizzo 1982, pp. 6, 10 n. 8; Anna Padoa Rizzo in Marchini and Micheletti 1987, pp. 123–27

PLATE 83A (JC CAT. 18)

Predella panel of an altarpiece: *Presentation of Christ in the Temple*

c. 1427–30

Tempera and gold on panel with horizontal grain; 7⅝ × 19¾ × ¾″ (19.4 × 50.3 × 2 cm), painted surface 7¼ × 19⅜″ (18.5 × 49.1 cm)

John G. Johnson Collection, cat. 18

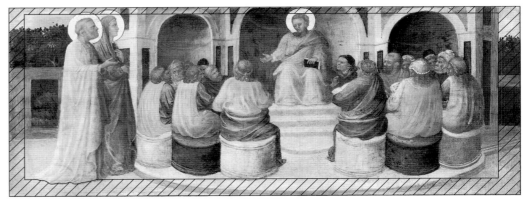

FIG. 83.1 Diagram by Anandaroop Roy of plate 83B, showing areas of reconstruction

TECHNICAL NOTES

The panel has been thinned. Strips of wood have been added to all four sides to form the present black border. Although the edges of the painted surface have been retouched and the bottom ⅜″ (1 cm) of the image is repaint, the design has not been extended as it was on the companion panel in the Johnson Collection (plate 83B [JC cat. 19]). The bole and gold that can be observed in paint losses on the left indicate that the panel was cut near the edge of the gold division that separated the scenes of the predella. The surface has been extensively reworked with glazes and opaque touches. The halos have been regilt. There is no record of when this restoration occurred, but it predates the 1883 sale of the panel (see Provenance for plate 83B [JC cat. 19]).

PROVENANCE

See plate 83B (JC cat. 19).

COMMENTS

The scene takes place in the temple in Jerusalem, which is depicted as an arched open loggia set in an enclosed square. Inside the temple, the Virgin hands the baby Jesus to the elderly Simeon, who, like the Holy Family, has a halo. An older woman next to

them may be the prophetess Anna. Joseph is by himself to the left, and a young man bearing two turtledoves is on the right. Other figures look on the scene both from inside the temple and from the street.

Luke 2:22–39 describes how, as prescribed by Mosaic law, Mary and Joseph brought the infant Christ to the temple. They also carried with them two turtledoves, or pigeons, as a sacrifice. The late thirteenth-century *Meditations on the Life of Christ*, probably by the Franciscan friar Giovanni da San Gimignano, explains that the couple brought this offering because they were too poor to afford a sacrificial lamb.[1] Simeon foresaw the child's role as the salvation of man, and Anna spoke of him as the redemption of Israel.

For further comments, see plate 83B (JC cat. 19).

1. Ragusa and Green 1961, pp. 56–57.

Bibliography
See plate 83B (JC cat. 19).

PLATE 83B (JC CAT. 19)

Predella panel of an altarpiece: *Christ Among the Doctors*

c. 1427–30

Tempera and gold on panel with horizontal grain; 7⅝ × 19¾ × ⅝″ (19.5 × 50.1 × 1.5 cm), painted surface 7⅜ × 19¼″ (18.7 × 48.8 cm) (original width 17½″ [44.5 cm])

John G. Johnson Collection, cat. 19

INSCRIBED ON THE REVERSE: *105* (in pencil on a torn piece of glued paper)

EXHIBITED: New York, The Metropolitan Museum of Art, The Cloisters, *Seven Joys of Our Lady* (December 20, 1944–January 21, 1945), no catalogue

TECHNICAL NOTES

The panel is thinned and glued to another piece of wood. Strips of wood have been added to the left side and the top. A restorer painted a black border

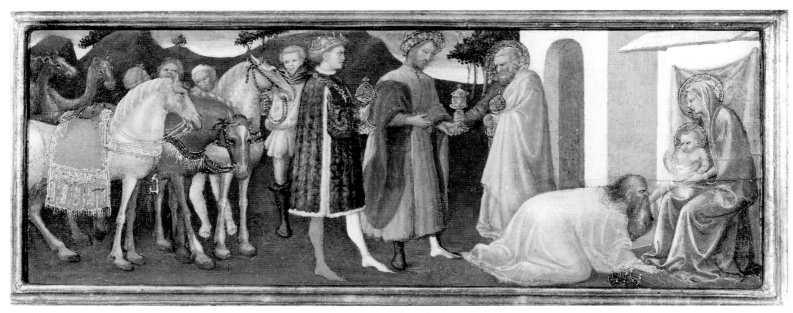

FIG. 83.2 Giovanni Toscani. *Adoration of the Magi*, c. 1427–30. Tempera and gold on panel; 6¾ × 18¼″ (17 × 46.5 cm). Melbourne, National Gallery of Victoria, Felton Bequest, 1966. See Companion Panel

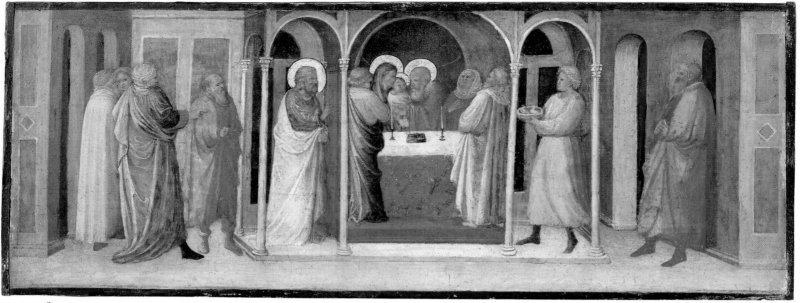

PLATE 83A

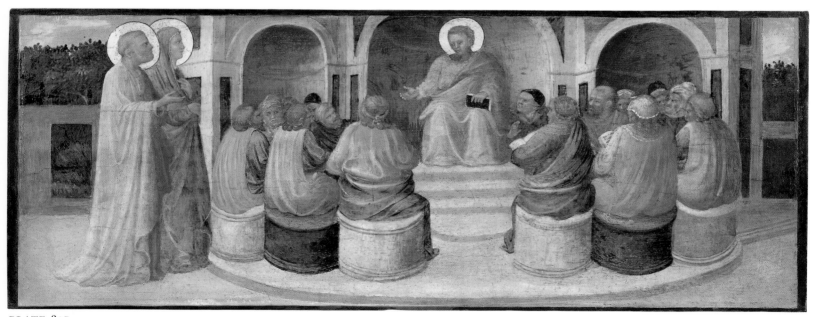

PLATE 83B

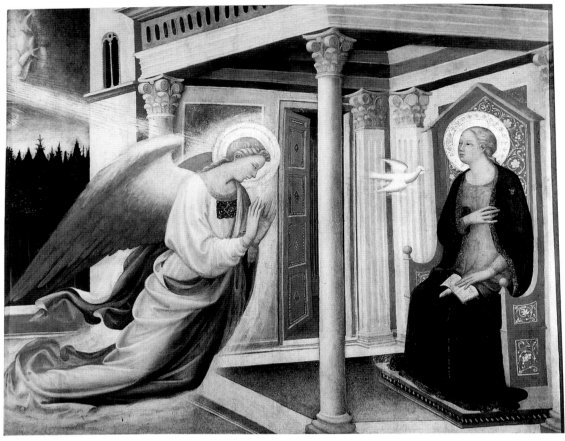

FIG. 83.3 Giovanni Toscani. *Annunciation,* c. 1427–30. Tempera and gold on panel; 50 × 63″ (127 × 160 cm). Washington, D.C., Georgetown University, Gift of Maria Coleman

on all four sides. The left and right edges of the composition are inventions that were painted over the gold divisions that separated the scenes of the predella (fig. 83.1). The top edge is restoration, as is about half of the lower edge, starting from the left. Although none of this reconstruction affects the figures, the surface has been extensively reworked with glazes and opaque touches. The halos have been regilt. There is no record of when this restoration occurred, but it predates the 1883 sale of the panel.

PROVENANCE

In the catalogue of the sale of the Toscanelli Collection in Pisa in 1883, Gaetano Milanesi wrote that this panel and its companion in the Johnson Collection, *Presentation of Christ in the Temple* (plate 83A [JC cat. 18]), were said to be from the Galleria Ugo Baldi, a mid-nineteenth-century Florentine dealer.[1] Sir William Neville Abdy sold the panel to Julius Böhler of Munich on May 5, 1911, at Christie's in London (lot 112 as Masaccio]). The next year Böhler sold it to John G. Johnson for 6,000 dollars (letter from Böhler to Johnson, dated New York, March 4, 1912).

For a possible provenance from Santa Maria Oltrarno, see Comments.

COMMENTS

The Virgin and Joseph, on the left, encounter the young Christ, who is seated on a raised platform in the temple, as he holds a discussion with the elders, who are seated on what appear to be drums of columns arranged in a circle.

The story comes from Luke 2:41–52. After Passover, which the Holy Family spent in Jerusalem, Mary and Joseph set off on the journey home, not noting the absence of the twelve-year-old Christ. After a day's travel they returned to Jerusalem to search for him, and after three days found Jesus in the temple, disputing with the elders, which is the moment shown in this panel.

In Tuscany this scene is found in only the most complete cycles of Christ's life. Trecento examples by Duccio (q.v.)[2] and Taddeo Gaddi[3] place Christ off-center and emphasize the dialogue between him and his parents. In the Johnson panel, however, Toscani follows Lorenzo Ghiberti's depiction on the first doors of the Florentine baptistery (installed on Easter Sunday 1424), in which Christ is shown on a raised platform in the apse of a basilican-style temple.[4] Yet whereas in the Ghiberti version the contact between Christ and his parents has not yet

taken place, in the Toscani interpretation Mary and Joseph have found Christ and seem to gesticulate in wonderment at what they encounter as he continues to talk to the elders.

A number of the other compositional devices Toscani has used come from Masaccio's (q.v.) mural painting *Raising of the Son of Theophilus and the Chairing of Saint Peter* (c. 1425–26)[5] in the Brancacci chapel of Santa Maria del Carmine in Florence. For example, Masaccio chose a circular arrangement for those who kneel around the enthroned Peter, and he also enclosed that scene with a garden wall inlaid with colored marble, beyond which plants could be seen.

Bernhard Berenson (1908), in reference to the *Presentation* (plate 83A [JC cat. 18]), which he had previously seen in a photograph, ventured an attribution to Masaccio. However, he changed his mind in Johnson's 1913 catalogue, calling both predella panels the work of "some mediocre, fluent little man inspired by Masaccio, but showing affinities with Giovanni del Ponte and the 'Maestro del Bambino Vispo [Gherardo Starnina (q.v.)].'" He suggested that this artist might be Andrea di Giusto, an attribution that gained currency because of his doc-

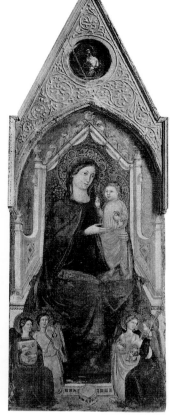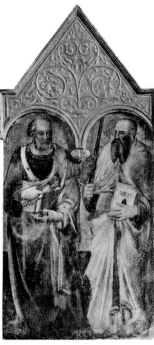

FIG. 83.4 Unknown artist (Florence, early fifteenth century). Center panel of an altarpiece: *Virgin and Child with Music-Making Angels*. Giovanni Toscani. Lateral panels of an altarpiece: (left) *Female Martyr Saint and Saint John the Baptist*; (right) *Saints Peter and Paul*, 1427–30. Tempera and tooled gold on panel; center 84¼ × 27⅞″ (214 × 71 cm); left 58⅝ × 25¼″ (149 × 64 cm); right 58⅝ × 25¼″ (149 × 64 cm). Taken from a 1901 photograph. Present location unknown

umented relationship with Masaccio. Roberto Longhi (1940) also noted the panels' dependence on Masaccio, but associated them with Arcangelo di Cola da Camerino. It was Luciano Bellosi's 1966 reconstruction of Giovanni Toscani's oeuvre that made it clear that the paintings were by him.

The predella to which the Johnson panels belonged also included, as Bellosi recognized, the *Adoration of the Magi* (fig. 83.2) in the National Gallery of Victoria in Melbourne. The inclusion of *Christ Among the Doctors* suggests that the predella formed part of a very complete cycle of the infancy of Christ. A fourth scene would probably have shown the Nativity, and depending on the size of the altarpiece, another panel may have depicted the Flight into Egypt or the Massacre of the Innocents.

Given that the Johnson and Melbourne panels formed part of a predella most probably depicting the infancy of Christ, it is likely that the main scene of the altarpiece would have been an Annunciation, which represents the moment of Christ's Incarnation. If this were indeed the case, it may have been the now-lost painting commissioned by Simone

Buondelmonti, probably for the now-destroyed church of Santa Maria Oltrarno in Florence.[6] A painting of this subject by Giovanni Toscani has been recently identified in the collection of Georgetown University (fig. 83.3) and may have been part of this commission.[7] Its width is right for the total length of the total width of the three predella panels. The fact that his biblical namesake, Simeon, is shown wearing a halo in the *Presentation* provides further possible confirmation of this identification. Left unfinished at Toscani's death in 1430, the project was subsequently handed over to Giuliano d'Arrigo Pesello for completion. In her 1433 tax return the artist's widow claimed that she had still not been paid for her husband's work on the altarpiece, which was then in possession of a certain Nicolai Niccoli.[8] This may have been the humanist book collector Niccolò Niccoli, who was associated with Simone's cousin Cristoforo, the archpriest of Santa Maria Oltrarno.

One other suggestion for the main section of the altarpiece, put forth by Bellosi (1966),[9] is a painting (fig. 83.4) sold at Heberle in Cologne on November

5–6, 1901 (lot 2 [as Allegretto di Nuzi (q.v.)]), which consists of a central panel of the Virgin and Child with angels and two lateral panels, one depicting a female martyr saint and Saint John the Baptist and the other Saints Peter and Paul. The lateral panels are by Giovanni Toscani, whereas the central panel is by an anonymous Florentine artist working in the International Gothic style. This painter could have been one of Toscani's more conservative contemporaries, such as Giuliano d'Arrigo Pesello, who completed parts of the Buondelmonti *Annunciation* left unfinished at Toscani's death.

1. Florence, Galerie Sambon, April 9–23, 1883, lot 56, plate XI (as Masaccio).
2. Bagnoli et al. 2003, postrestoration color repro. p. 215.
3. Florence, Galleria dell'Accademia; Ladis 1982, plate fig. 6b-5.
4. Krautheimer 1982, plates 30–31.
5. Joannides 1993, color plate 96.
6. On the church, see Paatz, vol. 3, 1952, pp. 155–59.
7. Miklós Boskovits in Bellosi 2002, pp. 60, 72 n. 19.
8. Cited in Milanesi 1860, p. 210: "Più quando morì Giovanni, lasciò una tavola d'altare, dentrovi la Nunziata. Non va compiuta: die'lla a compiere a Giuliano dipintore nel Corso. La detta tavola è di Simone Buondelmonte. Non è fatto mercato; è rimessa in Niccolaio Niccoli." (Moreover when Giovanni died, he left an altarpiece, with an Annunciation. It was not finished, and it was given to Giuliano, painter in the Corso, to finish. The said painting belongs to Simone Buondelmonte. He has not paid for it; it is being held by Niccolaio Niccoli.)
9. Bellosi knew only an old photograph of the painting in the Kunsthistorisches Institut, Florence. A photograph in the Witt Library, London, identifies it as having been sold at Heberle in 1901.

Bibliography
Berenson 1908, p. 84 (cat. 18; possibly Masaccio); Berenson 1913, pp. 14–15, repro. pp. 240–41 (school of Masaccio, possibly Andrea di Giusto); Van Marle, vol. 10, 1928, p. 304; Berenson 1932, p. 12; Berenson 1936, p. 11; Longhi 1940, p. 183 n. 23 (Longhi *Opere*, vol. 8, pt. 1, p. 55 n. 23); Johnson 1941, p. 1 (Andrea di Giusto); Berenson 1963, p. 6; Bellosi 1966, pp. 49–50, figs. 29a, b; Sweeny 1966, p. 2, repro. p. 114 (Andrea di Giusto); Fredericksen and Zeri 1972, p. 204; *Bolaffi*, vol. 11, 1976, pp. 135–36; Philadelphia 1994, repros. p. 235

COMPANION PANEL for PLATES 83A–B
Predella panel of an altarpiece: *Adoration of the Magi*. See fig. 83.2

c. 1427–30

Tempera and gold on panel with horizontal grain; 6¾ × 18¼″ (17 × 46.5 cm). Melbourne, National Gallery of Victoria, Felton Bequest, 1966

PROVENANCE: Edinburgh, Sellars; Archibald Anderson and descendants, Lancaster Herald; London, Herbert Bier; private collection; New York, Schaeffer Galleries, c. 1965; acquired by National Gallery of Victoria with the Felton Bequest, 1966–67

BIBLIOGRAPHY: *Apollo* (London), n. 5, vol. 82, no. 43 (September 1965), p. cxxxix; Bellosi 1966, pp. 49–50; Hoff 1967, pp. 72–73; Hoff 1973, p. 18; Hoff 1973a, pp. 86–87; *Bolaffi*, vol. 11, 1976, p. 136

UGOLINO DI NERIO

There are only three documented facts concerning Ugolino di Nerio's life: that he was paid for building a cistern in Siena in 1317; that he made a loan to a fellow Sienese citizen in 1325; and that he sold some land in the Sienese countryside in 1327. The document related to the land sale states that he was the son of the late Nerio, or Rainerio, who may have been the painter Nerio di Ugolino. Giorgio Vasari gave Ugolino di Nerio's death date as 1339 in the first edition of his *Lives* (1550) and as 1349 in the second (1568), although neither has been confirmed. Vasari knew his work from two paintings in Florence—the polyptychs on the main altars of Santa Maria Novella and Santa Croce. The latter (plate 84 [JC cat. 89]) was signed, as was possibly also the former, which is lost. The Santa Croce altarpiece, of which the Johnson panel is a fragment, is the only basis for the reconstruction of Ugolino's oeuvre.

Works attributed to Ugolino suggest that he began as a close collaborator of Duccio (q.v.). James Stubblebine (1973; 1979, pp. 40–41), in fact, has proposed that Ugolino painted the figures of the prophets in the predella of the front of Duccio's *Maestà* (finished 1311) for the cathedral of Siena (see fig. 23.8), although this is unlikely. Heptatypchs by Ugolino di Nerio in the Cleveland Museum of Art[1] and the Sterling and Francine Clark Art Institute in Williamstown (see fig. 84.10) are examples of the artist's style before he transferred to Florence, sometime probably after 1317.

Ugolino may have gone to Florence because he found himself in competition in Siena with the younger Simone Martini, who was receiving the most important commissions there, and whose work represented a turn away from the Duccesque style still perpetuated by Ugolino. Ugolino may also have been attracted to the possibility of painting large-scale altarpieces in Santa Croce and Santa Maria Novella. Hardly anything is known of the patronage of these works,[2] but the desire to hire one of Duccio's collaborators on the *Maestà* of 1311 may have been why the Florentines chose the Sienese Ugolino as opposed to the Florentine Giotto, who was, in fact, then away from Florence, or one of his local followers to paint the two altarpieces.

Ugolino's activity in Florence was not confined to the two altarpieces. It is doubtful if he ever returned permanently to Siena, as several of his paintings from the late 1320s can be traced to places with Florentine connections. These include the *Virgin and Child and Donor*[3] in the Misericordia of San Casciano Val di Pesa, the *Saint Verdiana*[4] from the oratory of the hospital in Castelfiorentino and now

in the Pinacoteca of that town, and the beautiful *Crucifixion* (see fig. 61.1) now in the Fundación Colección Thyssen-Bornemisza in Madrid. The latter comes from the Franciscan convent of San Romano near Empoli, but as Hayden B. J. Maginnis (1983) has proposed, it may have originally been in the Bardi di Vernio chapel in Santa Croce.[5]

1. Stubblebine 1979, fig. 385.
2. The Santa Croce altarpiece may have been commissioned by the Alamanni family. The Santa Maria Novella altarpiece was paid for by Fra Barone Sassetti.
3. Aldo Galli in Bagnoli et al. 2003, pp. 354–56, color repro. p. 355.
4. Stubblebine 1979, figs. 427–28.
5. Even the *Virgin and Child* (Stubblebine 1979, fig. 423) in the church of Santa Maria dei Servi in Montepulciano, south of Siena, comes from a family with a distinctly Florentine name, Baroncelli, who were patrons of Giotto and Taddeo di Bartolo (q.v.) in Santa Croce. The picture may, therefore, have been executed in Florence.

Select Bibliography
Bacci 1939, pp. 123–62; F. Mason Perkins in Thieme-Becker, vol. 33, 1939, pp. 542–44 (with complete bibliography); Coor 1955; *Bolaffi*, vol. 11, 1976, pp. 197–98; Stubblebine 1979, pp. 157–75, 211–12; Maginnis 1983; Dillian Gordon in *Dictionary of Art* 1996, vol. 31, pp. 532–34; Aldo Galli in Bagnoli et al. 2003

PLATE 84 (JC CAT. 89)
Pinnacle panel of an altarpiece: *The Prophet Daniel*

c. 1325

Tempera and tooled gold on panel with vertical grain; $17\frac{3}{4} \times 12\frac{1}{4} \times 1\frac{3}{4}''$ (45.1 × 31 × 4.5 cm), painted surface $18\frac{3}{4} \times 10\frac{1}{4}''$ (47.5 × 26 cm)

John G. Johnson Collection, cat. 89

INSCRIBED ON DANIEL'S SCROLL: *LAPIS ASCISUS E[ST] DE MO[N]TE SINE MANIBUS* (Daniel 2:45: "[According as thou sawest that] the stone was cut out of the mountain without hands."); ON THE BACKGROUND: *DANI*[fragmentary] *EL* (in black paint); ON THE REVERSE: *N/ 13* (in ink, crossed out); *Z Z/ O 748* (in ink); *413 V* (stenciled in black ink); *Ugolino da Siena/ no. 12* (in ink); *G2 1 BV* (stenciled in ink); remnants of the label from the 1878 Royal Academy exhibition

PUNCH MARKS: See Appendix II

EXHIBITED: Manchester 1857, no. 27; London 1878, no. 175; Philadelphia Museum of Art, John G. Johnson Collection, Special Exhibition Gallery, *From the Collections: Paintings from Siena* (December 3, 1983–May 6, 1984), no catalogue

TECHNICAL NOTES
The panel support is a single piece of vertically grained wood that retains its original thickness. The apex of the gable is formed by a separate small piece of wood secured cross-grain to the top of the plank with two nails. As can be seen in the X-radiograph, a large nail was also driven into the right gable edge during construction of the panel to secure a glued repair to a split in the plank (fig. 84.1). The panel reverse (fig. 84.2) is coated with a thin layer of gesso painted with a reddish color.

The applied frame molding on the gable is original; it is attached to the panel face with nails. A plain-weave canvas, seen in the X-radiograph, covers the panel extending at points onto the gable moldings. Dowel holes visible in the X-radiograph along the gable edges mark the points of attachment for decorative frame elements. These holes can also be seen in the X-radiograph of *David*, a companion pinnacle panel in the National Gallery in London (London 1989, fig. 63). In the pinnacle panel of *Moses* (Gordon and Reeve, 1984, fig. 11) also in London, this area shows similar evidence of a dowel hole for the attachment of other framing elements. In general the carpentry of the Philadelphia panel is directly comparable with the pinnacle panel of *David* and *Moses* (see fig. 84.4). Comparison with these other pinnacles reveals that projecting gable shoulders have been removed from the Philadelphia panel in addition to its side frame moldings. The gable molding has been regessoed and regilt. Before the

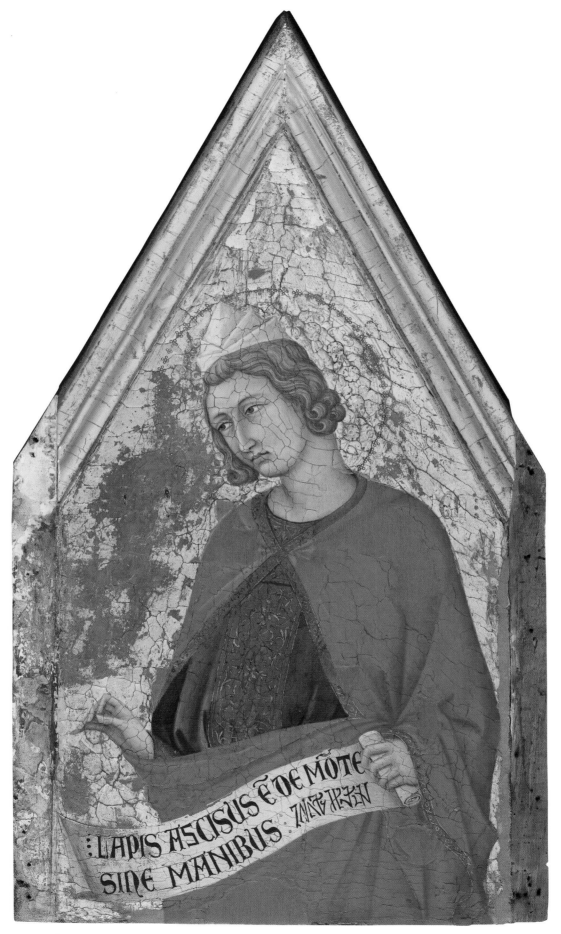

PLATE 84

UGOLINO DI NERIO 431

FIG. 84.1 X-radiograph of plate 84, showing the original triangular addition and repair to the split secured by nails near the top of the panel

FIG. 84.2 Reverse of plate 84, showing the original reddish paint

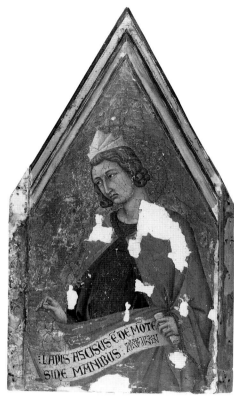

FIG. 84.3 Plate 84 in 2004, after cleaning and before restoration

altarpiece was disassembled, each of the pinnacle panels was originally part of the same plank of wood as the two altarpiece tiers beneath it.

There are considerable losses to the gold background and in the costume (fig. 84.3). However, the surviving paint surface is in good condition and the flesh areas in particular are remarkably well preserved. The inscription on the gold ground identifying the prophet is largely gone, except for a few traces of black paint. Much of the mordant gilding decorating the figure's costume is preserved, and the mordant is dark brown.

In August 1919 Hamilton Bell described the panel as being in "very bad condition." He inspected it with Carel de Wild on March 13, 1920, noting that almost the whole picture was "loose" from the panel and that the background was retouched.[1] De Wild made unspecified repairs. In June 1956 Theodor Siegl impregnated the entire surface with wax, and then varnished the painting. Between 1997 and 2004 the painting was the subject of studied examination and cleaning by Teresa Lignelli. Her restoration was carried out in a *tratteggio* technique, so that on close

inspection the inpainted losses would remain visibly distinguishable from the original surface.

PROVENANCE

The panel was part of the high altarpiece of the church of Santa Croce in Florence, as recorded by Giorgio Vasari in 1550. Sometime between July 1566 and April 7, 1569, it was moved to the center of the church and at a later date to the friars' dormitory, where it was described by Padre Guglielmo Della Valle in 1785 in a letter addressed to Abate Giovanni Cristoforo Amaduzzi. The painting was purchased by an Englishman, probably William Young Ottley, between 1791 and 1799. In 1835 Gustav Friedrich Waagen (1837) visited the Ottley Collection in London, where he saw the pieces of the altarpiece preserved. These were put up for sale on June 30, 1847, by Ottley's son, Warner, at Foster and Son in London, and *Daniel* (lot 9) was bought by one Mr. Anthony, who, according to Martin Davies (1961, p. 537 n. 13), was an agent for the Reverend J. Fuller Russell. Waagen (1854) wrote of seeing the painting in Russell's collection at Eagle House, near Enfield,

mistakenly identifying the prophet as "the youthfully conceived St. John alone." The painting was sold at the Fuller Russell sale at Christie's in London on April 18, 1885 (lot 84), to Charles Butler of London and Warren Wood, Hatfield. It was again sold, at the Butler sale at Christie's in London on May 25, 1911 (lot 84), and this time was purchased by the London firm Carfax & Co., which in turn sold it to John G. Johnson for 80 pounds. According to a consular invoice, Johnson came into possession of the panel on July 31, 1911.

COMMENTS

The three-quarter-length figure of the young prophet Daniel, attired in a loose red robe over a green garment, wears a white pyramidal hat. Looking down to the left, he holds a scroll inscribed with a passage taken from the book of his prophecies in which he interprets a dream of Nebuchadnezzar, king of Babylon, as a vision of the coming of a Messianic age. Christian writers would later understand this as a divination of the birth of Christ.

The painting was a pinnacle panel of the Santa

FIG. 84.4 Reconstruction (from Bomford et al. 1989) of Ugolino di Nerio's Santa Croce altarpiece, showing the surviving fragments: (A) *Isaiah,* London, National Gallery, no. 3376; (B) *David,* London, National Gallery, no. 6485; (C) *Moses,* London, National Gallery, no. 6484; (D) *Daniel,* John J. Johnson Collection, see PLATE 84 (JC cat. 89); (E) *Saints Matthew and James Minor,* Berlin, Staatliche Museen, cat. 1635E; (F) *Saints Bartholomew and Andrew,* London, National Gallery, no. 3473; (G) *Saint James Major and Philip,* Berlin, Staatliche Museen, cat. 1635C; (H) *Saints Simon and Thaddeus,* London, National Gallery, no. 3377; (I) *Saints Matthias and Elizabeth of Hungary(?),* Berlin, Staatliche Museen, cat. 1635D [see FIG. 84.7]; (J) *Saint John the Baptist,* Berlin, Staatliche Museen, cat. 1635; (K) *Saint Paul,* Berlin, Staatliche Museen, cat. 1635; (L) *Ten Angels,* Los Angeles County Museum of Art, no. 49.17.40; (M) *Saint Peter,* Berlin, Staatliche Museen, cat. 1635; (N) *Two Angels,* London, National Gallery, no. 3378; (O) *Two Angels,* London, National Gallery, no. 6486; (P) *Last Supper,* New York, The Metropolitan Museum of Art, Robert Lehman Collection, no. 1975.1.7; (Q) *Betrayal,* London, National Gallery, no. 1188; (R) *Flagellation,* Berlin, Staatliche Museen, cat. 1635A; (S) *Way to Calvary,* London, National Gallery, no. 1189; (T) *Deposition,* London, National Gallery, no. 3375; (U) *Entombment,* Berlin, Staatliche Museen, cat. 1635B; (V) *Resurrection,* London, National Gallery, no. 4191

Croce altarpiece, which was taken to England, probably by William Young Ottley, in the last decade of the eighteenth century. After the sale of Ottley's collection in 1847, the various panels were dispersed and some lost. Those that have been located are in collections in London, Berlin, Los Angeles, and New York, as well as Philadelphia (fig. 84.4). A drawing executed for the French art writer Jean-Baptiste Séroux d'Agincourt (fig. 84.5) the decade before its purchase by Ottley shows that the altarpiece was already in poor condition. The drawing, found by

Henri Loyrette in the Biblioteca Apostolica Vaticana in 1978, seems to reproduce the altarpiece's original appearance faithfully. Dillian Gordon's technical researches of 1984 (fig. 84.4)[2] confirmed the basic accuracy of Séroux d'Agincourt's drawing, although earlier reconstructions made by Davies (1951), Gertrude Coor (1955), and Davies (1961) before the discovery of the drawing had been essentially correct. Loyrette (1978) and Christa Gardner von Teuffel (1979) also made proposals based on the drawing. In addition, three engravings of saints in the altarpiece

were made by Giovanni Antonio Baccanelli in the seventeenth century.[3]

In Séroux d'Agincourt's drawing the prophet Daniel is not identified, but a figure in a pose similar to that of the Johnson Collection's *Daniel* is shown in the pinnacle on the far right. Loyrette rejected the association between the two, however, because the figure in the drawing is bearded and without a cap. But an X-radiograph of *Daniel* (fig. 84.1) showed that it was executed on the same piece of vertically grained poplar as *Saints Matthias and*

FIG. 84.5 Unknown artist (eighteenth century). Drawing of Ugolino di Nerio's Santa Croce altarpiece, 1780s. Ink on paper. Vatican City, Biblioteca Apostolica Vaticana, Vat. lat. 9847, folios 91 verso–92 recto

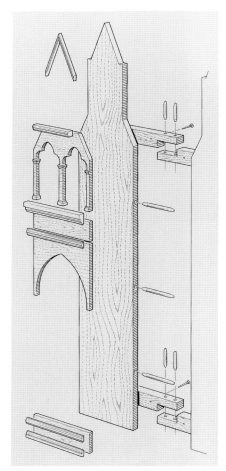

FIG. 84.6 Drawing showing the construction of a vertical unit of the Santa Croce altarpiece (from Bomford et al. 1989)

Elizabeth of Hungary(?) (fig. 84.7) in Berlin and, therefore, definitely belonged to the altarpiece, since each of its vertical units was composed of a single plank of wood (fig. 84.6).

The main altar of Santa Croce was under the patronage of the Alamanni family until at least 1439.[4] According to Vincenzo Borghini (1552–80, Lorenzoni ed. 1912, pp. 102–4), Ugolino's altarpiece bore their arms, which consisted of *liste azzure* on a *campo bianco,* or blue strips on a white field. The arms no longer exist, however, and are not visible in the drawing made for Séroux d'Agincourt.

The date of the altarpiece is uncertain, but it is often placed at about 1325 based on its relationship to Ugolino's now-lost painting once on the high altar of Santa Maria Novella, which is known to have been commissioned by Fra Barone Sassetti, who died in 1324. From an obituary in the church's necrology, it is often assumed that that altarpiece was in place before Sassetti's death, and records of payments for oil lamps to illuminate paintings in the church indicate that it may have been installed as early as 1323.[5] A seventeenth-century chronicler of the convent gave the date as 1320.

There is no record of whether Ugolino painted the Santa Croce altarpiece before or after the one in Santa Maria Novella. A memorandum related to a loan he made to a fellow resident of Siena, dated May 21, 1325,[6] is often cited as evidence that Ugolino had returned to Siena by this point and therefore that the Florentine altarpieces were finished. The document, however, is ambiguous; it says only that the painter—or someone on his behalf—made the loan, which means that Ugolino could well have still been in Florence.

The two polyptychs are thought to have been similar in type because of their common location on the high altars of recently built mendicant churches of comparable architecture. If any part of the Santa Maria Novella altarpiece survives, it may be the pinnacle panel depicting the prophet Isaiah in Dublin (fig. 84.8),[7] as well as the *Saint Peter* and *Saint Francis* in the Misericordia of San Casciano Val di Pesa.[8] While this is only conjecture, its similarity to the pinnacle panels of the Santa Croce altarpiece suggests that it came from an analogous structure. The *Isaiah* in Dublin would be precedent in date, because the gold is incised, not punched, and the manner more decidedly Duccesque than Ugolino's later work.

Ugolino's *Daniel* relates very closely to the pinnacle in an altarpiece in the Pinacoteca Nazionale in Siena (fig. 84.9) created in Duccio's workshop. It bears many similarities to the Santa Croce polyptych both in structure, such as the pairing of the prophets in the second tier, and in details, such as the resemblance between the figures of Daniel.[9] Also very close to the Johnson *Daniel* is the Daniel in the pinnacle in Ugolino di Nerio's early polyptych in Williamstown (fig. 84.10).[10] In all three images, the prophet wears the same folded triangular

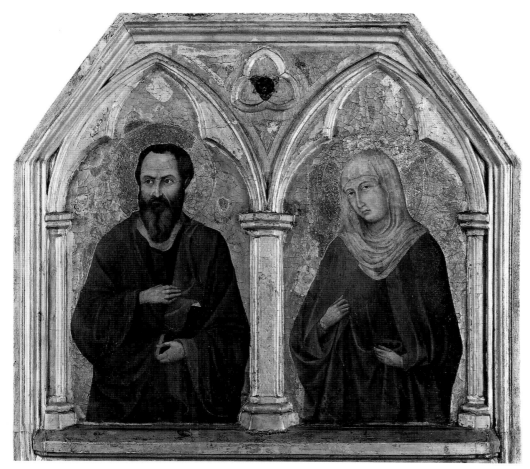

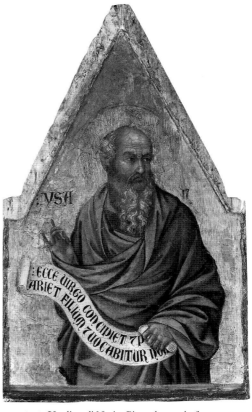

FIG. 84.7 Ugolino di Nerio. Panel of an altarpiece: *Saints Matthias and Elizabeth of Hungary(?)*, c. 1325. Tempera and tooled gold on panel; 22⅛ × 22⅜″ (56.2 × 56.9 cm). Berlin, Staatliche Museen Preussischer Kulturbesitz, Gemäldegalerie, cat. 1635D

FIG. 84.8 Ugolino di Nerio. Pinnacle panel of an altarpiece: *The Prophet Isaiah*, c. 1320–24. Tempera and tooled gold on panel; 15⅜ × 9⅞″ (39 × 25 cm). Dublin, National Gallery of Ireland, cat. 1112

cap, which was not the traditional manner of depicting the young Daniel. For example, he wears no hat in Duccio's *Maestà* for Santa Maria Novella.[11] However, Duccio did paint the prophet with a hat on the tympanum of the tabernacle in the National Gallery in London, executed around 1310–15, possibly for Cardinal Niccolò da Prato.[12] The inscription on the scroll in the latter is the same as in Ugolino's *Daniel*. In time the hat would become common in trecento Sienese images of the prophet.[13] For example, the Vertine Master used it in the pinnacle of Daniel from a lateral panel of his altarpiece in Volterra.[14]

1. In London 1989 (p. 111), it is erroneously stated that the Philadelphia panel is one of those from the same altar-piece with a curious pattern of small, V-shaped marks that are visible in X-radiographs and that indicate where the wood was gouged with a chisel to improve the adhesion of new fill material. The absence of these marks in the Philadelphia panel shows that it has a different restoration history from others from the same complex.

2. Davies and Gordon 1988; London 1989, pp. 98–123.
3. Gardner von Teuffel 1979, figs. 24–25.
4. Davies 1951, p. 410; Hall 1979, p. 154.
5. For the history of the Santa Maria Novella altarpiece, see Cannon 1982, pp. 87–91.
6. Stubblebine 1979, pp. 211–12.
7. See Gordon in Davies and Gordon 1988, p. 115 n. 45. Stubblebine (1979, pp. 181–82) attributed this to the Brolio Master.
8. Stubblebine 1979, figs. 417–18. See Aldo Galli in Bagnoli et al. 2003, pp. 354–55.
9. Stubblebine 1979, pp. 67–68.

10. Stubblebine (1979, pp. 182–83) denies the attribution to Ugolino di Nerio and calls the artist the Clark Polyptych Master, saying that it was painted between 1325 and 1330.
11. See the detail in Stubblebine 1979, fig. 20. Also see Cannon 1982, p. 77 and n. 62.
12. No. 566; Stubblebine 1979, figs. 128, 130.
13. Sometimes a Magus is depicted wearing a similar hat, as in the now-lost panel of the Adoration by a Duc-cesque follower called the Seminary Madonna Master (Stubblebine 1979, fig. 345).
14. Pinacoteca e Museo Civico di Palazzo Minucci Solaini, no. 15; Stubblebine 1979, fig. 290; Lessi 1986, color repro. p. 13. Stubblebine incorrectly identified the prophet as David.

Bibliography
Vasari 1550 and 1568, Bettarini and Barocchi eds., vol. 2 (text), 1967, pp. 139–40; Della Valle, vol. 2, 1785, p. 200;

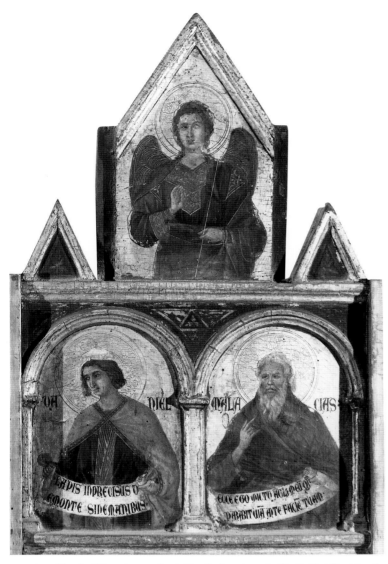

FIG. 84.9 Duccio di Buoninsegna (q.v.). Detail of a polytypch: *The Prophets Daniel and Malachi and an Angel*, c. 1311–17. Tempera and tooled gold on panel; overall 72⅞ × 101⅛″ (185 × 257 cm). Before restoration in 2003. From Siena, church of the hospital of Santa Maria della Scala. Siena, Pinacoteca Nazionale, no. 47

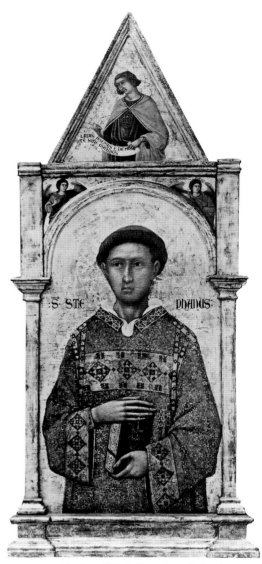

FIG. 84.10 Ugolino di Nerio. Lateral panel of an altarpiece: *Saint Stephen, Angels, and the Prophet Daniel*, c. 1317. Tempera and tooled gold on panel; altarpiece, overall 64½ × 134⅜″ (163.7 × 341.4 cm). Williamstown, Massachusetts, Sterling and Francine Clark Art Institute, no. 1962.148

Waagen 1837–39, vol. 1, 1837, pp. 393–95; Waagen 1838, vol. 2, pp. 121–23; Waagen 1854–57, vol. 2, 1854, pp. 461–62; George Scharf, Jr., in Manchester 1857, p. 15; London 1878, p. 35, diagram p. 34; Langton Douglas in Crowe and Cavalcaselle 1903–14, vol. 3, 1908, p. 23 n.; Berenson 1913, pp. 51–52, repro. p. 287; Berenson 1917, p. 33; Berenson 1918, p. 20; Perkins 1920, p. 205 n. 7; Van Marle, vol. 2, 1924, pp. 104–5; Weigelt 1930, p. 73 n. 33; Handbook 1931, p. 41; Kimball 1931, p. 23; Berenson 1932, p. 583; Edgell 1932, p. 62; Berenson 1936, p. 501; Johnson 1941, p. 17; Brandi 1951, p. 153; Davies 1951, p. 412; Toesca 1951, p. 519 n. 46; Coor 1955, p. 154; Carli 1956a, p. 25, fig. 8; Davies 1961, pp. 535–36; John Pope-Hennessy in Williamstown 1962, p. 9; Sweeny 1966, pp. 77–78, repro. p. 85; Berenson 1968, p. 438 (Ugolino); Fredericksen and Zeri 1972, p. 207; Loyrette 1978, p. 23 n. 43; Gardner von Teuffel 1979, p. 48 n. 69; Stubblebine 1979, pp. 67, 120, 164–66, fig. 406; Gordon and Reeve 1984, fig. 4 (reconstruction); Van Os 1984, p. 65, fig. 77; Giovanna Ragionieri in Vasari 1550, Bellosi and Rossi ed. 1986, pp. 135–36 n. 3; Boskovits 1988, p. 171; Davies and Gordon 1988, pp. 110–12, 115 n. 32; Bomford et al. 1989, pp. 100, 111, fig. 60 (reconstruction); Philadelphia 1994, repro. p. 236; Aldo Galli in Bagnoli et al. 2003, p. 348

COMPANION PANELS for PLATE 84
See fig. 84.4; Pope-Hennessy 1987, pp. 8–11; Boskovits 1988, pp. 163–76; Davies and Gordon 1988, pp. 99–116; Caroselli 1994, pp. 120–21

VITALE DA BOLOGNA
(*Vitale di Aimo degli Equi,* or *Vidalino Aymi de Equis*)

Vitale was the principal painter of fourteenth-century Bologna. His vivid and energetic style attracted the notice of many later critics, particularly such seventeenth-century writers as Giovanni Antonio Bumaldo (1641, p. 258) and Carlo Cesare Malvasia (1678, Zanotti ed. 1841, vol. 1, pp. 26–27), who sought to distinguish a Bolognese tradition of painting. Malvasia's comments about the artist, however, were not merely a literary exercise,[1] for he seems actually to have studied Vitale's works and wrote of the painter as someone "who manly shook up the cowardice of the older masters and ridding himself of that old-fashioned clumsiness, created rare inventions; that give life, and not less by working with expression as well as with gesture, are close to the truth, and play with verisimilitude."[2]

Vitale's position as the prime painter of the Bolognese trecento has been questioned in recent years, because it has been shown that the works of Dalmasio (q.v.) and of the so-called Pseudo–Jacopino di Francesco (active c. 1330–50) date much earlier than previously thought and are in fact contemporaneous with those of Vitale da Bologna. These three artists established a school of panel and mural painting in the late 1320s and early 1330s in a city where most of the local artistic activity had been given over to the production and illumination of books.

Vitale's first dated projects, in 1330 and in 1340, were for the church and convent of San Francesco in Bologna. Of these only the mural of the *Last Supper,*[3] from the refectory, survives. Painted in 1340, it and the stylistically close *Saint George and the Dragon,*[4] which is signed, provide the key for reconstructing the artist's early work, of which the Johnson *Crucifixion* is an important example.

The now-detached mural of the Annunciation and the Nativity from the inner façade of Santa Maria di Mezzaratta in Bologna was probably executed by Vitale soon after the church was built in 1338[5] for a confraternity that succored condemned criminals on their way to the gallows. Its walls were painted during the following decades in a piecemeal fashion, with Vitale returning several times to paint other scenes.[6] In 1345 he also painted an altarpiece for the oratory of Sant'Apollonia attached to Santa Maria di Mezzaratta; its central section consists of a Virgin and Child with donors known as the *Madonna dei denti.*[7] Close in date to his early murals in Mezzaratta is an altarpiece from Sant'Antonio Abate in Bologna, of which the four scenes depicting the life of the titular saint epitomize some of the best qualities of Vitale's art:[8] the figures, animated by elegant Gothic lines, never stand still, as if action is all.

Vitale established a reputation outside his native Bologna as well. In 1343, for example, he signed a contract with the bishop of Ferrara, Guido de Baiso, to provide painted wood statues for four tabernacles in that city's cathedral. These have not been identified, or else do not survive. Five years later he was called by the patriarch of Aquileia, Bertrand de Saint Geniès, to paint the main chapel and two others in the cathedral of Udine. Vitale seems to have completed the project in 1349.[9] Soon after, in 1351, he was commissioned by the abbot Andrea to execute murals for the Benedictine abbey of Pomposa, near Ferrara.

After his return to Bologna in about 1351–55 Vitale executed murals in San Francesco[10] and Santa Maria dei Servi.[11] On July 6, 1353, Riniero di Guglielmo Ghisilieri, prior of San Salvatore, commissioned an altarpiece for the chapel of Saint Thomas Becket.[12] The latter is Vitale's final dated work. The artist died between 1359, when he is last mentioned in Bologna, and 1361, when his son is described as of the "late painter Master Vitale."

1. He does credit a manuscript by one Baldi as the source for some of his information, but this has eluded identification.
2. "Quello che virilmente scossa la pusinallanimità dei passati, e quell'antica rozzezza spogliatosi, peregrine invenzioni; a dar moto, e non meno operando col discorso, che faticando con la mano, star attacato al vero, e scherza col verisimile" (Malvasia 1678, Zanotti ed. 1841, vol. 1, p. 27).
3. Bologna, Pinacoteca Nazionale; Bernardini et al. 1987, repro. p. 13 (detail).
4. Bologna, Pinacoteca Nazionale, no. 6394; Gnudi 1962, color plate 88.
5. Bologna, Pinacoteca Nazionale, nos. 6346–47, 6349–50, 6356; Gnudi 1962, plates xiii–xxviii (black-and-white and color).
6. Gnudi 1962, plates xl, xlii–xliii, xlv (black-and-white and color).
7. Bologna, Museo Davia Bargellini, no. 129; Gnudi 1962, plate xxix (color).
8. Bologna, Pinacoteca Nazionale, nos. 28–31; Gnudi 1962, plates xlix–lviii.
9. Bologna 1990, figs. 1–14 (color), diagram 36, figs. 66–71, 73–75.
10. Bologna, Pinacoteca Nazionale; Bologna 1990, fig. 34.
11. Gnudi 1962, plates lxix–lxxv (black-and-white and color).
12. Gnudi 1962, plates cii–cvii (black-and-white).

Select Bibliography
Bumaldo 1641, p. 258; Malvasia 1678, Zanotti ed. 1841, vol. 1, pp. 26–27; Baldinucci 1681–1728, Ranalli ed., vol. 1, 1845, pp. 63, 216, 250, 398; Lanzi 1809, Capucci ed., vol. 3, 1974, p. 9; Cavalcaselle and Crowe 1883–1908, vol. 4, 1887, pp. 56–59, 351; Frati 1909; Sandberg Vavalà 1929–30; Roberto Longhi (1934–35) in Longhi *Opere,* vol. 6, 1973, esp. pp. 6–8, 20–37, 59–64; B.C.K. in Thieme-Becker, vol. 34, 1940, pp. 426–27; Filippini and Zucchini 1947, pp. 230–35; Roberto Longhi in Bologna 1950, pp. 12–14 (Longhi *Opere,* vol. 6, 1973, pp. 157–60); Longhi 1950, pp. 7–10 (Longhi *Opere,* vol. 6, 1973, pp. 157–60); Gnudi 1962; *Bolaffi,* vol. 11, 1976, pp. 349–52; Pier Giovanni Castagnoli and Francesco Arcangeli in Arcangeli 1978, pp. 80–85; Gibbs 1982; D'Amico 1982; Daniele Benati in *Pittura* 1986, p. 670; D'Amico 1986; D'Amico and Medica 1986; Paolo Casadio in Bologna 1990, pp. 49–78; Boskovits 1993; Skerl Del Conte 1993, pp. 30–45; Conti 1994; Bologna 1996; Robert Gibbs in *Dictionary of Art* 1996, vol. 32, pp. 624–26; Strehlke 1997

PLATE 85 (JC CAT. 1164)
Valve of a diptych: *Crucifixion*

Early 1330s

Tempera, silver, and tooled gold on panel with vertical grain; 24⅜ × 15¾ × 1⅝″ (62 × 40 × 4 cm), main painted surface 21⅝ × 13⅜″ (55 × 34 cm)

John G. Johnson Collection, cat. 1164

INSCRIBED ON THE SCROLL ABOVE THE CROSS: *INRI* [IESUS NAZARENUS, REX IUDAEORUM] (John 19:19: "JESUS OF NAZARETH, THE KING OF THE JEWS"); ON THE REVERSE: *11* (stamped on a label)

PUNCH MARKS: See Appendix II

TECHNICAL NOTES
The panel is made of a single piece of unthinned wood. The reverse is painted in what appears to be red lead on a gesso layer. Most of the inner moldings of the frame, except for the one on the lower right, are original, as is the outer molding on the left; the outer moldings on the other sides are replacements. The inner moldings are not applied, but carved from the same wood as the panel. When the frame was reworked, it was regilt, and the sides were regessoed and painted ocher. Areas of flaking on the left reveal that the sides, like the back, were painted in red-orange. There are two old holes from nails driven into the top edge that may have been for a hanging device. Two wood repairs at the top and bottom corners of the right side may indicate where it was once attached to another panel.

The gold background is incised with a vine decoration on a cross-hatched field. This freehand design seems to have been executed after the panel was painted. Only the trailing section of Christ's loincloth was painted over the tooled decoration. A simple punch was used for the halos of Christ, the mourners at the foot of the cross, and the six mourning angels. The latter were painted directly over the gold, and only a few remnants of paint and glaze survive on them; some of their costumes and wings were executed in sgraffito. Three of the angels

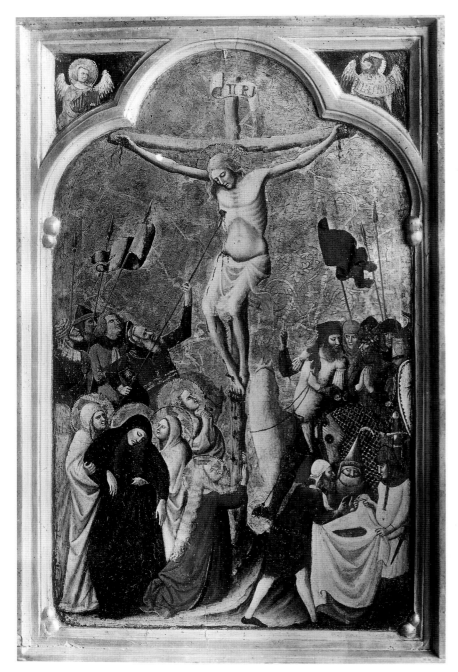

FIG. 85.1 Photograph of plate 85 as it appeared in 1914

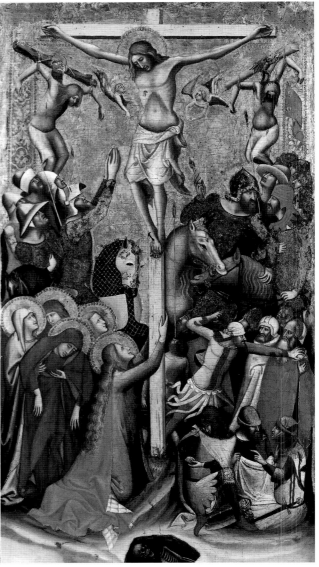

FIG. 85.2 Vitale da Bologna. *Crucifixion*, c. 1340. Tempera and tooled gold on panel; 36⅝ × 20⅛″ (93 × 51.2 cm). © Madrid, Fundación Colección Thyssen-Bornemisza, no. 1930.122

bore chalices to collect the blood of Christ's wounds. Flecks of corroded metal are visible in these areas, suggesting that the chalices were in silver leaf. Parts of the symbols of the two Evangelists in the spandrels were painted over gold and decorated in sgraffito. Although the head of the eagle (which represents John) was painted over the gold, it, unlike the angels, has not flaked. His costume, executed in sgraffito, has largely flaked away. The silver leaf of the soldiers' armor is applied to mor-

dant directly over the gesso. The silver is now largely gone, and what little survives is tarnished. The armor was outlined in black, and some of it was punched to resemble mail. In certain areas, particularly on the armor of the two centurions on the right, the silver was selectively embellished with mordant gilding. The heads of the lances were originally silver but have been repainted.

Brush drawing is visible to the naked eye in areas of thin paint. Those figures that border the gold

background are incised. The painting has a beautiful combination of colors and coloristic effects, especially in the costumes of the mourners, which are, from left to right, a pink modeled with orange, pink and crimson, deep and pale blue (now appearing green), pale violet, and vermilion modeled with crimson lake. The cross is painted with white and azurite, and originally would have been pale blue.

In 1945 David Rosen cleaned and retouched the picture. While old photographs (fig. 85.1) show that

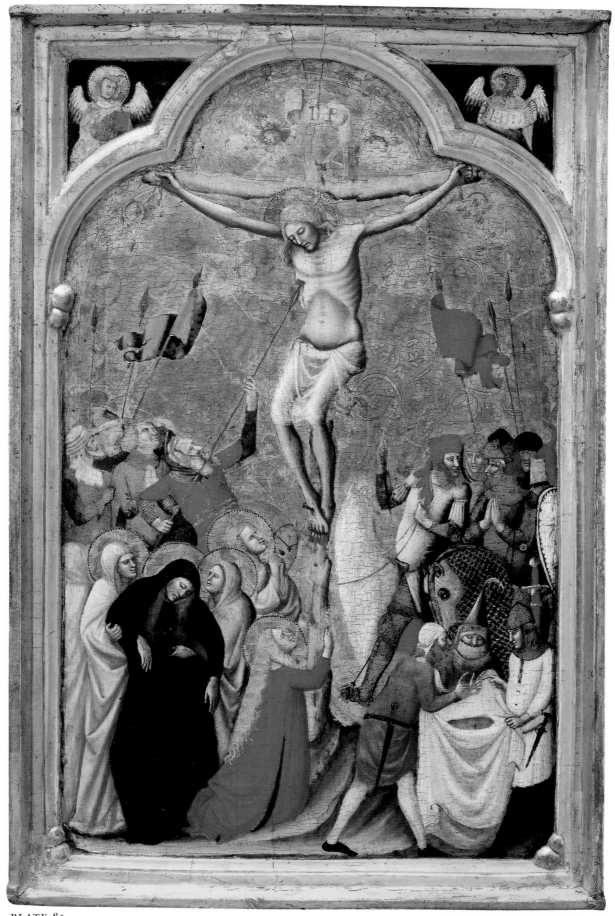

PLATE 85

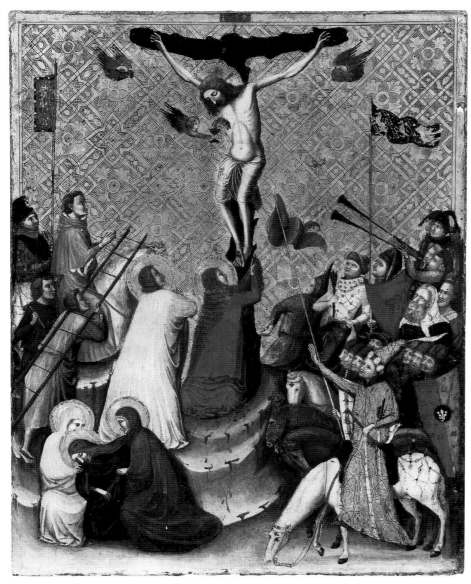

foot of the cross. Behind these mourners are soldiers on horseback, who, according to the Gospel of John (19:32–34), were instructed to break Christ's legs, but finding him already dead, "one of the soldiers with a spear opened his side, and immediately there came out blood and water." In later medieval accounts this soldier was named Longinus. On the right are other soldiers, including a centurion on a white charger, whose conversion at the Crucifixion is mentioned in all four Gospels. Matthew (27:54) goes further to say that all the soldiers keeping watch were converted: "Now the centurion and they that were with him watching Jesus, having seen the earthquake, and the things that were done, were sore afraid, saying: Indeed this was the Son of God." The painting adheres to this particular account by showing the centurion turn to the soldier next to him, who has his hands clasped in prayer. In the right foreground, three soldiers argue over Christ's mantle, an episode that appears in several Gospels, including Matthew 27:35: "And after they had crucified him, they divided his garments, casting lots; that it might be fulfilled which was spoken by the prophet, saying: 'They divided my garments among them; and upon my vesture they cast lots.'"

In the spandrels of the frame are the symbols of the Gospel writers Matthew (the angel) and John (a winged eagle) holding scrolls. This arrangement indicates that the Johnson painting was undoubtedly a valve of a diptych, whose other, now-lost panel would have shown symbols of the other two Evangelists—Mark and Luke—in its spandrels.

Previously assigned to the Tuscan artist Spinello Aretino, the *Crucifixion* was published as the work of Vitale da Bologna by Evelyn Sandberg Vavalà in 1929–30. She compared it with another *Crucifixion* by the artist, now in the Fundación Colección Thyssen-Bornemisza, Madrid (fig. 85.2). Alternatively, Roberto Longhi, in his lecture course at the University of Bologna in 1934–35, as well as in his essay in the catalogue of the 1950 exhibition of Bolognese trecento painting, wrote that the Johnson painting, while being very Vitalesque, was in fact by a Bolognese artist whom he nicknamed the "Cousin of the Riminese," because of the apparent influence from Riminese art. He compared the picture not only with the Thyssen *Crucifixion* but with the *Crucifixion* now in the Musée du Petit Palais in Avignon (fig. 85.3). Longhi suggested that the painter of these panels might be Jacopo de' Bavosi (documented 1362–83), who was also known as Jacopino di Francesco. However, as later research showed that the activity of the artist who painted the Johnson *Crucifixion* dated much later, he became known as the Pseudo–Jacopino di Francesco. In more recent times, scholars have placed the Johnson painting among Vitale da Bologna's earliest works, of the mid-1330s to about 1340, the date of the detached mural of the *Last Supper* from the refectory of the convent of San Francesco in Bologna.[2]

the angels had already been lost due to flaking, the picture was badly abraded during his treatment. Much of the mordant silver was apparently removed, and the ground now shows through. Little remains of the soldiers on the left and the white horse on the right. Other fine details were also lost. For example, no longer visible are Mary Magdalene's blond braid that is wrapped around the cross, the striping on the pink face-covering of the horse on the far right, and the staff held by the pointing centurion wearing the red hat.

In 1993 Roberta Rosi selectively inpainted the panel to unify the picture by making the worst losses and abrasions less obtrusive.

PROVENANCE

This painting was sold at an auction organized by Luigi Battistelli in Florence on February 5–10, 1912 (cat. 11; as Tuscan school).[1] John G. Johnson bought it sometime after 1913, as it does not appear in Bernhard Berenson's catalogue of that year. There is no document recording from whom he purchased it.

COMMENTS

The painting shows Christ on a cross made of unplaned logs, mourned by flying angels. In the left foreground are the fainting Virgin, supported by the two Marys (Matthew 28:56; Mark 15:40), and John the Evangelist. Mary Magdalene embraces the

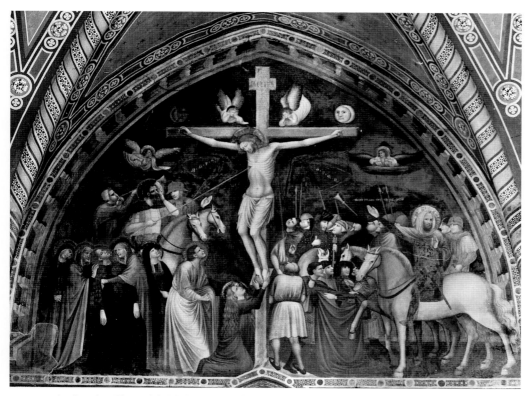

FIG. 85.4 Attributed to Giovanni da Rimini (Rimini, documented 1292–1336). *Crucifixion*, c. 1320. Mural. Jesi, church of San Marco

Italian paintings containing many episodes of the Crucifixion can be traced to the murals by Cimabue of about 1288–92[3] and by Pietro Lorenzetti (q.v.) of 1318–20[4] in the basilica of San Francesco in Assisi. It is also the same sort of Crucifixion painted by Duccio for the *Maestà* (see fig. 23.9) of 1311 for the cathedral of Siena. Obvious limitations of space meant that Crucifixions in panel paintings were usually restricted to the figure of Christ and the mourners, but there were exceptions. For example, a panel from the workshop of Pietro and Ambrogio Lorenzetti, dating to the early 1340s, includes a large array of figures.[5] Later the Sienese specialized in jewel-like depictions of such Crucifixion scenes. Other, even smaller panel paintings of this sort were made in Siena and Florence around the middle of the fourteenth century.[6] The popularity of this type of Crucifixion scene can be gauged by its common occurrence in French ivories, which were also available in Italy.

Giotto explored the subject on a small scale in a panel of about 1315 now in Berlin[7] and may also have painted such a Crucifixion on a large scale in Rimini. While his murals in San Francesco there, most likely painted in the first decade of the fourteenth century, are lost, several painters from Rimini (fig. 85.4), some of them active in Bologna, seem to have modeled their Crucifixions on a Giottesque prototype. A number of these artists, including

Pietro da Rimini (fig. 85.5) and Francesco da Rimini,[8] introduced the type to Bologna. However, further explanation seems needed for the almost exclusive preference for crowded scenes of the Crucifixion by Vitale (fig. 85.2) and the other Bolognese painters like Dalmasio (see fig. 19.3) and the Pseudo–Jacopino di Francesco (fig. 85.3). The key might be a prototype present or painted in Bologna at this time that most artists felt they had to follow. That might have been one of the murals, recorded as the work of Giotto, in the chapel of the castle in Galliera, immediately outside the walls of Bologna.

Information about the Galliera murals is scant. No complete description of them exists, and the castle was leveled in 1511. However, fragments seemed to have survived until 1661. Two fourteenth-century sources[9] mention Giotto as the artist of the chapel, and in the sixteenth century the painter Pietro Lamo (1560, 1844 ed., p. 27) described a few fragments by Giotto in what then remained of the vaulting of the destroyed castle. Their subject is not noted, but it is likely that a Crucifixion decorated a chapel.

The cycle would have been commissioned soon after the castle was built in 1329–30 for the cardinal Bertrand du Pouget (or Poyet), who had been sent by Pope John XXII d'Euse as papal legate to northern Italy in 1319. Pouget took up residence in Bologna in 1327, and is said to have soon after

employed two engineers from Siena to locate a site for a castle.[10] The castle, which for the local populace symbolized the suppression of liberty, was seized during an uprising in March 1334, and Florentine troops had to intervene to save the cardinal's life.

Giotto himself had a strong influence on the new generation of Bolognese painters. Although little is known of his work in Galliera, his altarpiece for Santa Maria dell'Angelo in Bologna survives.[11] Giotto's activity in the city has usually been put before December 8, 1328, when he is recorded in Naples in the court of Robert of Anjou, and April 12, 1334, when he is back in Florence.[12] However, he may have been called to Bologna in the interim.[13] His Santa Maria dell'Angelo altarpiece most likely dates after 1328, when Gera di Taddeo Pepoli, who commissioned it, returned from exile.[14]

An indirect confirmation that there was a crowded scene of the Crucifixion in a chapel of the castle at Galliera is Vitale's own mural of the subject of 1349 in the cathedral of Udine, which was commissioned by another appointee of John XXII, the patriarch of Aquileia, Bertrand de Saint Geniès, and is known through a contemporary derivation[15] by one of his followers in the cathedral of nearby Spilimbergo. John XXII, Bertrand du Pouget, and Bertrand de Saint Geniès all came from the region of Cahors in France, and to a certain extent must have shared the same taste. It is very likely that Bertrand de Saint Geniès knew of Vitale from his fellow Frenchman Bertrand du Pouget in Bologna and that he wanted something like what the papal legate had had painted at Galliera twenty years before. The mural in Galliera also seems to be reflected in an illumination (fig. 85.6) of about 1343 in a manuscript made by a Bolognese artist for Cardinal Bertrand de Deaux,[16] who had been in Bologna during the siege of Galliera in 1334. The interest of cardinals in this sort of scene is further attested to by the appearance of the donor, a cardinal on horseback worshiping the dying Christ, in the Pseudo–Jacopino di Francesco's *Crucifixion* now in Avignon (fig. 85.3).

1. See the letter from Burton Fredericksen, dated Malibu, January 27, 1976.
2. Bologna, Pinacoteca Nazionale; Bernardini et al. 1987, repro. p. 13 (detail).
 In letters to Barbara Sweeny dated Bologna, April 20 and May 19, 1966, Francesco Arcangeli writes that he disagrees with Longhi's opinion and believes that the Johnson panel is by Vitale. In oral communications, recorded in the curatorial files, Enzo Carli (1961) and Keith Christiansen (1982) attributed the painting to Vitale, and Mina Gregori (1983) said that it was close to Vitale.
3. Bellosi 1998, color repros. pp. 148–49, 185, 187–90.
4. Volpe 1989, fig. 8. There is also Lorenzetti's painted *Crucifixion* of c. 1320(?) or 1331 in San Francesco, Siena; see Volpe 1989, fig. 100.
5. Florence, Museo Stibbert, no. 10289; Volpe 1989, repro. p. 205.
6. For example, Naddo Ceccarelli's *Crucifixion* of c. 1350

FIG. 85.5 Pietro da Rimini (Rimini, documented 1324–38). *Crucifixion*, c. 1330. Tempera and tooled gold on panel; 24¾ × 12¾″ (63 × 32.5 cm). Hamburg, Hamburger Kunsthalle, no. 756

FIG. 85.6 Master of 1346 (Bologna, active mid-fourteenth century). *Crucifixion*, c. 1343. From the *Missal of Bertrand de Deaux*. Parchment; 14 × 9⅞″ (35.4 × 25.3 cm). Vatican City, Archivio Capitolare di San Pietro, B 63, folio 189r; on deposit, Vatican City, Biblioteca Apostolica Vaticana

in Baltimore, The Walters Art Museum, no. 37.737; see Zeri 1976, plate 20.

7. Staatliche Museen, no. 1074A; Boskovits 1988, plates 102–8, color detail plate I.

8. Bologna, church of San Francesco, 1312–21; D'Amico, Grandi and Medica 1990, color repro. p. 14.

9. See Massimo Medica in Bologna 1996, pp. 14–15, 18–19 nn. 11–13; and Strehlke 1997.

10. On the castle's history, see Ghirardacci and Solimani 1657, pp. 94–95; Masini 1666, Fanti ed. 1986, vol. 1, esp. pp. 328–29; Guidicini, vol. 3, 1870, pp. 273–74.

11. Bologna, Pinacoteca Nazionale, no. 284; Previtali 1993, color plates cxii–cxiii.

12. Previtali 1993, p. 127.

13. See, for example, Boskovits 1993, p. 180 n. 80; and Conti 1994, pp. 35, 43 n. 12.

14. On this dating, see Massimo Medica in Bologna 1996, p. 18 n. 10.

15. Furlan and Zannier 1985, fig. 5.64.

16. On the attribution of this manuscript, see Cassee 1980; Alessandro Conti in Arcangeli 1978, p. 86; and Conti 1981, esp. p. 92 and n. 40 (with other references).

Bibliography

Valentiner 1914, p. 198, repro. p. 392 (Spinello Aretino); Van Marle, vol. 3, 1924, p. 606; Sandberg Vavalà 1929–30, pp. 3–10, fig. 27; Sandberg Vavalà 1931, p. 20; Roberto Longhi (1934–35) in Longhi *Opere,* vol. 6, 1973, p. 73, fig. 84a; Johnson 1941, p. 3 (Bolognese artist, c. 1375–1400); Roberto Longhi in Bologna 1950, p. 18 (Longhi *Opere,* vol. 6, 1973, p. 162, fig. 84a); Longhi 1950, p. 14 (Longhi *Opere,* vol. 6, 1973, p. 162, fig. 84a); Suida 1950, p. 57; Philippe Verdier in Baltimore 1962, p. 32; Sweeny 1966, p. 13, repro. p. 102 (Bolognese, c. 1375–1400); Fredericksen and Zeri 1972, p. 100 (Jacopino di Francesco); Pier Giovanni Castagnoli in Arcangeli 1978, p. 82, color plate II; Carlo Volpe in *Tomaso* 1979, pp. 242–43, fig. 15; Massimo Ferretti in Bologna 1981, pp. 39, 54 n. 8; Grandi 1982, p. 136; Daniele Benati in *Pittura* 1986, pp. 219, 670, fig. 336; D'Amico 1986, pp. 44, 48, 61; D'Amico and Medica 1986, repro. p. 87; Rosalba D'Amico in D'Amico and Medica 1986, pp. 39, 42; Gibbs 1986; Massimo Medica in D'Amico and Medica 1986, pp. 88–90; Massimo Medica in Bernardini et al. 1987, p. 14, no. 23; Boskovits 1990, pp. 207, 210; Rosalba D'Amico in D'Amico, Grandi, and Medica 1990, pp. 46, 48, 58, 87, repro. p. 46; Michel Laclotte in D'Amico, Grandi, and Medica 1990, p. 7; Gaudenz Freuler in Lugano 1991, p. 134; Philadelphia 1994, repro. p. 236; Robert Gibbs in *Dictionary of Art* 1996, vol. 32, p. 625

PLATE 86 (JC CAT. 116)
Nativity and Adoration of Christ

c. 1290–1300

Tempera and tooled gold on panel with vertical grain, modern glass, and animal bones; $14\frac{3}{8} \times 11\frac{1}{2} \times$ approximately $1\frac{1}{8}''$ ($36.4 \times 29.3 \times$ approximately 2.8 cm), painted surface $13\frac{5}{8} \times 10\frac{5}{8}''$ (34.5×27 cm)

John G. Johnson Collection, cat. 116

INSCRIBED ON THE REVERSE: *116* (in pencil on a torn paper label); *CITY OF PHILADELPHIA/ JOHNSON COLLECTION* (stamped twice in black)

EXHIBITED: Palm Beach 1949, no. 6 (as Sienese, c. 1340)

TECHNICAL NOTES

The panel consists of one member, which has not been thinned. New strips of wood have been added to all four edges. The back (fig. 86.1) is gessoed and painted a red, except for an area $2\frac{1}{8}''$ (5.3 cm) wide and $9\frac{1}{2}''$ (24 cm) from the lower edge, which has two old nail holes where a transverse batten would have been attached to secure the panel to other elements in the original complex.

The moldings are not applied but carved out of the same piece of wood on which the picture was painted. The left molding is carved as a spiral column; the right one is smooth. Possibly the spiral column would have been on the outside edge of the complex. The bottom and top edges also show remnants of their carved moldings.

The spandrels each contain three compartments that have been carved into the panel. Their depth suggests that they were repositories for relics. It is possible that they were covered by glass panels that were gilded and etched with a design or an image. In a restoration that was executed at some point after the 1910s, most probably in 1941 by David Rosen, animal bones were inserted into these compartments, which were then covered by glass.

A 1913 photograph (fig. 86.2) from Berenson's catalogue documents how the painting looked before Rosen's cleaning in 1941. While on March 13, 1920, Hamilton Bell and Carel de Wild said that the panel had "been shockingly repainted," the old photograph suggests that much of the repainting was reasonably faithful to original forms. However, in the photograph it is obvious that the two angels at the top of the hill, the head of the shepherd on the far left, and the dark green foreground had been much retouched by an earlier restorer, who had particularly misunderstood the arm of the angel on the upper left. It is also possible that the rod that Joseph holds in the old photograph was not original. However, Rosen's cleaning quite clearly went beyond the removal of repaints. The picture is badly abraded, and much of the original modeling and a good amount of mordant gilt detail are lost. Rosen did not understand other details as well; for example, he overpainted as background the highlight defining the hand of the king pointing to the star.

The halos are all incised. There are no visible incisions for the outlines of the figures, but gold is found under many of the painted areas. Some drawing can be seen in abraded sections.

FIG. 86.1 Reverse of plate 86, showing the original red paint and the original location of the transverse beam

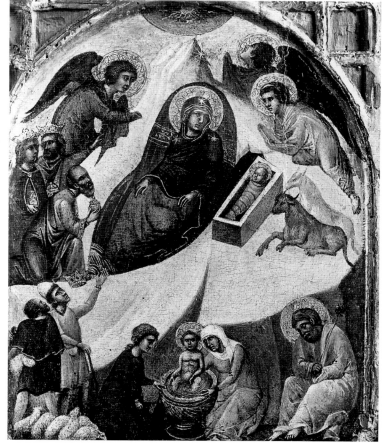

FIG. 86.2 Photograph of plate 86 as it appeared in 1913

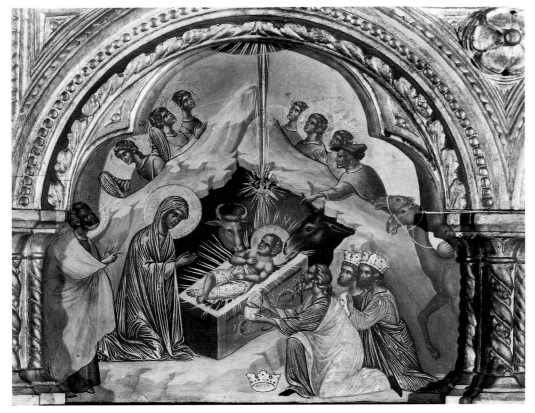

FIG. 86.3 Paolo Veneziano (Venice, dated works 1321–58; died before 1363). Detail of an altarpiece: *Adoration of the Magi*, c. 1350. Tempera and tooled gold on panel; 15¾ × 17¾″ (40 × 45 cm). From Venice, church of Santa Chiara. Venice, Gallerie dell'Accademia, no. 16(21)

In August 1919 Hamilton Bell noted cracks and flaking, which were treated by de Wild in 1920. As mentioned, Rosen cleaned the panel in 1941. On November 5, 1956, Theodor Siegl infused the panel with wax.

PROVENANCE
The painting was published by Adolfo Venturi in 1905 and 1906 as in the Sterbini Collection in Rome.

COMMENTS
On a steep and rocky ledge containing the small opening of a grotto, the Virgin reclines next to the newborn Christ Child, with the three Magi to the left and three angels with their hands covered in respect. In the center foreground two nurses bathe the baby, two shepherds with their flock look at the star on the left, and Joseph sits alone on the right. The firmament is represented by the blue semicircle at the top of the picture.

The iconography of the painting can be traced to Byzantine representations of the Nativity,[1] which became enduring models for Italian artists from the eleventh century to the early fourteenth century. This particular scene differs from most Italian derivations, however, in that the grotto is small and the ox and ass are shown outside rather than within it. It is also unusual in its inclusion of the three Magi.[2] However,

the motif does appear in a mid-fourteenth-century painting by Paolo Veneziano (fig. 86.3).

The attribution of this panel has long been the subject of speculation. Adolfo Venturi first published it in 1905 as the work of the Sienese painter Segna di Bonaventura (documented 1298–1326; died by 1331). Bernhard Berenson (1913a) wrote an article about the painting in which he concluded it was from the school of Pietro Cavallini (c. 1240–after c. 1330). The attribution to the Sienese school in the 1931 *Handbook* of the Philadelphia Museum of Art reflected the opinion of Richard Offner, but in 1947 he described it as early fourteenth-century Venetian. Edward B. Garrison (1949) listed it as Sienese from the second quarter of the fourteenth century; Pietro Toesca (1951) published it as Barnaba da Modena (documented 1361–86), and Burton Fredericksen and Federico Zeri (1972) described it as thirteenth-century Venetian.

When several scholars examined the painting at the Museum in 1961, the Venetian scholar Terisio Pignatti noted its similarities to a Roman painting based on a comparison to a triptych (fig. 86.4) in the Museo Correr that Roberto Longhi had published as Roman.[3] The Sienese scholars Enzo Carli and Cesare Brandi declared that the Johnson picture was certainly Venetian, to which the German scholar Robert Oertel replied, "No, not Venetian. It

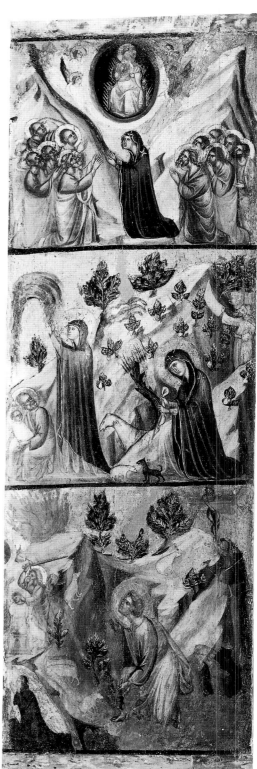

FIG. 86.4 Venetian-Adriatic School. Right wing of a triptych: (top to bottom) *Pentecost, the Holy Family in the Wilderness,* and *Old Testament Stories,* early 1300s. Tempera and tooled gold on wood; 48 × 16½″ (122 × 42 cm). Venice, Museo Correr, nos. 657, 973

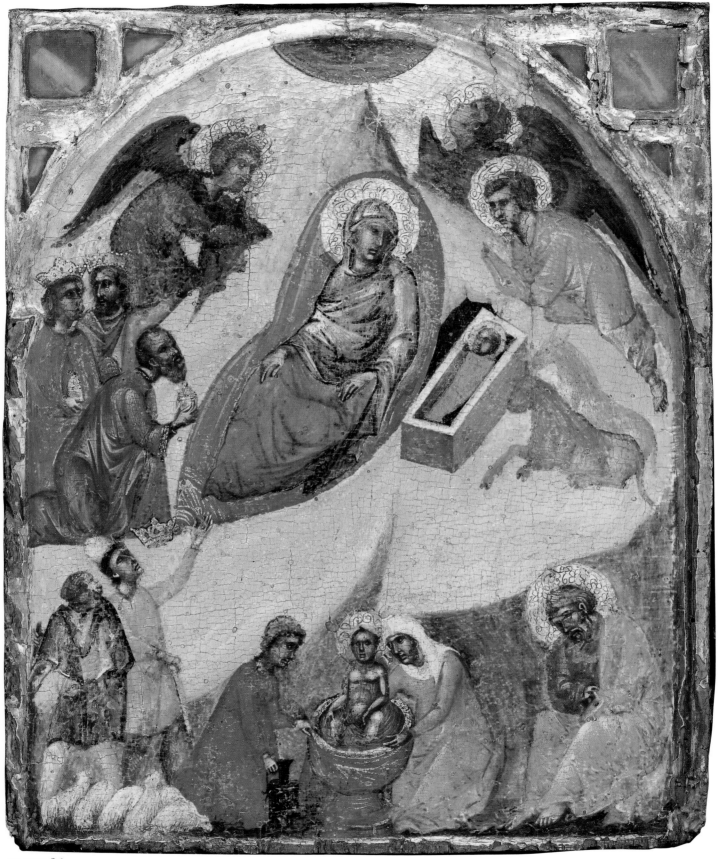

PLATE 86

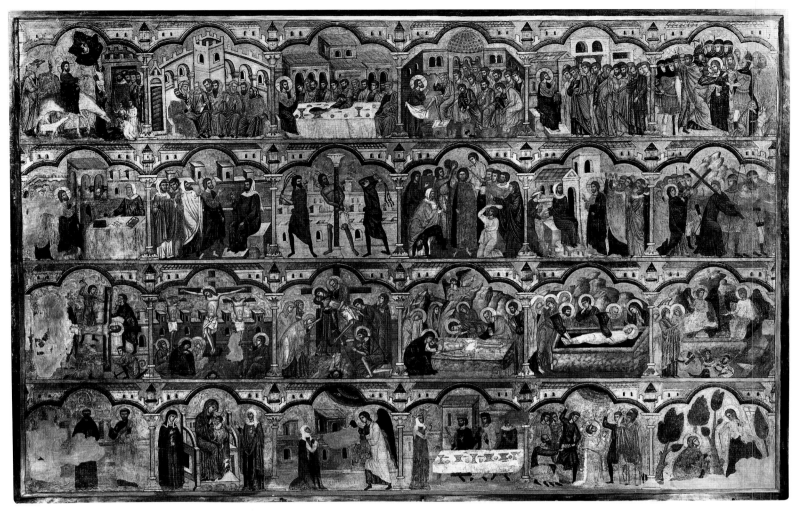

FIG. 86.5 Spanish School(?). Altarpiece: *Passion of Christ and Other Scenes*, 1290s. Tempera and tooled gold on panel; 39⅜ × 78″ (100 × 198 cm). From Palma de Mallorca, convent of Santa Clara. Palma de Mallorca, Museu Diocesà de Mallorca

is Sienese. Close to Duccio in the decorative treatment of halos & in the color."

During a 1965 visit to the Museum, Rodolfo Pallucchini, following Pignatti, did not think that it could be Venetian but did suggest that it might be Roman. Miklós Boskovits (verbal communication, December 5, 1996) compared the Johnson panel with the triptych in the Correr, noting that both were of early fourteenth-century Venetian or Adriatic manufacture.

The Johnson painting has a certain similarity to works produced by artists working in the Venetian-controlled Adriatic in the late thirteenth and early fourteenth centuries. The early designations of both this panel and the Correr triptych as Roman indicate just how the extensively artistic culture of central Italy had influenced early painters in Venice and its territories. A number of Venetian paintings of the Virgin, generally grouped around the anonymous artists known as the Master of Burano (or the Master of the Leningrad Triptych) and the Master of the

Madonna of Zadar,[4] likewise show a strong central Italian influence and can be considered to have been produced in the same milieu as the Johnson picture.

The Johnson panel was part of a larger complex that presumably included other scenes of the life of Christ. One of the few surviving altarpieces that would correspond to the size of the complex that included the Johnson panel is a late thirteenth-century panel (fig. 86.5) made for the convent of Santa Clara in Palma de Mallorca presumably by a Spanish artist imitating an Italian model.[5] However, another possible arrangement is suggested by a rare, late thirteenth-century Venetian painting (fig. 86.6) showing a group of narrative scenes around a central image of the Crucifixion.

The other scenes of the lost complex of the Johnson painting probably also had spandrels with compartments covered with glass panels that were gilded and etched in a technique known as *verre églomisé*. This type of decorated glass was produced in many parts of Italy, although the best-known

examples are from Umbria, where from about the 1280s it was a favorite material for reliquaries.[6] Painting frames with inset glass decoration also survive.[7] A trecento Bolognese painting in the Museo Horne in Florence,[8] for example, has a frame with many compartments for relics that were painted vermilion, as in the Johnson *Nativity*, although their glass covers are lost. *Verre églomisé* is also found in the spandrels of at least one Byzantine icon now in the Benaki Museum in Athens,[9] and in painted reliquaries by the Sienese artists Pietro Lorenzetti (q.v.)[10] and Naddo Ceccarelli.[11]

1. See Schiller, vol. 1, 1966, figs. 157–58.
2. Richard Offner (1947, p. 212 n. 3) lists a number of examples with the Magi.
3. Longhi 1948, p. 47. It is now considered early fourteenth-century Venetian or Venetian-Adriatic. See Mariacher 1957, pp. 157–59.
4. The works of these painters are outlined in Garrison 1949, passim; Prijatelj 1962; Palluchini 1964, pp. 12, 65–74; Lasareff 1965, esp. pp. 20–26; and Gamulin 1971,

pp. 18–21, 130–31 (with much earlier bibliography).
5. See Rosa Alcoy i Pedrós in Barcelona 1998, pp. 126–30.
6. See Cerri 1992; Hueck 1991; and Gordon 1994 (with earlier bibliography).
7. See Eisler 1961; and Bertelli 1970, 1972.
8. Inv. 66; Rossi 1966, p. 136, fig. 31 (as attributed to Jacopino di Francesco).
9. Gordon 2002.
10. The panel has been divided in two sections, now in Florence, Harvard University Center for Italian Renaissance Studies at Villa I Tatti, and a private collection. See Volpe 1989, figs. 131–32 (black-and-white and color).
11. Baltimore, The Walters Art Museum, no. 37.1159; Zeri 1976, fig. 25.

Bibliography
A. Venturi 1905, p. 424, fig. 2 (Segna di Bonaventura); A. Venturi 1906, pp. 30–33, fig. 11 (Segna di Bonaventura); Berenson 1913, pp. 65–67, no. 116, repro. p. 305 (school of Pietro Cavallini); Berenson 1913a, p. 4 (school of Pietro Cavallini); Van Marle 1921, p. 252; Van Marle, vol. 2, 1924, p. 140 n. 1; Handbook 1931, p. 43 (Sienese); Berenson 1932, p. 141; Berenson 1936, p. 122; Johnson 1941, p. 15 (Sienese, c. 1340); Offner 1947, p. 212 n. 3; Garrison 1949, p. 122, repro. no. 319; Toesca 1951, p. 748; Sweeny 1966, pp. 78–79, repro. p. 84 (Venetian, early fourteenth century); Berenson 1968, p. 83; Fredericksen and Zeri 1972, p. 244 (Venice, thirteenth century); Philadelphia 1994, repro. p. 199 (Italian[?], active Venice[?], c. 1290–1300)

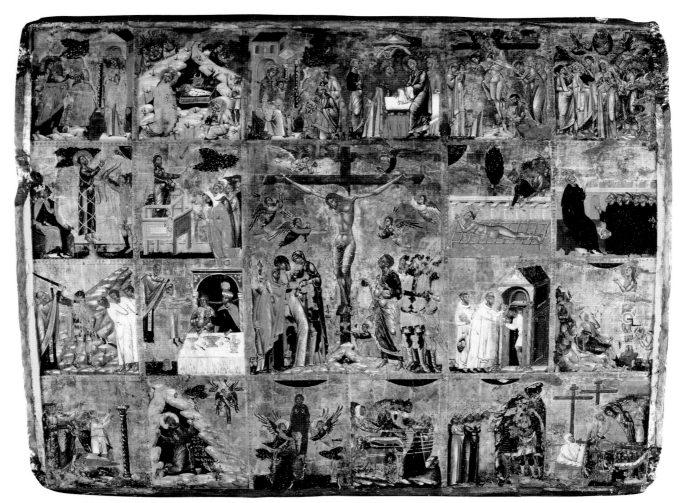

FIG. 86.6 Venetian School. Altarpiece: *Crucifixion and Scenes from the Life of Christ and the Legends of Saints,* 1290s. Tempera and tooled gold on panel; 26½ × 32⅞″ (67.3 × 84.4 cm). Sold London, Christie's, December 8, 1995, lot 62 (as Venetian School, c. 1380). Present location unknown

PLATE 87 (JC CAT. 1)
Crucifixion, Nativity, and Annunciation

c. 1320–30

Tempera and tooled gold on panel with vertical grain; with original applied frame 25 × 11 × 1⅛″ (63.3 × 30.3 × 3 cm), painted surface 22⅞ × 10¼″ (58 × 26.2 cm)

John G. Johnson Collection, cat. 1

INSCRIBED BELOW THE SAINT IN WHITE IN THE CRUCIFIXION: *Benedictus* (Benedict) (in gold); ON THE TABLET ON THE CROSS: *IN X U* [partially illegible] [IESUS NAZARENUS REX IUDAEORUM] (John 19:19: "JESUS OF NAZARETH, THE KING OF THE JEWS"), *IO: X J* ("Jesus Christ") (in very worn gold); ON GABRIEL'S SCROLL: *ave/ Mar/ ia gr/ ati/a p[l]ena Dom[inus]* (Luke 1:28: "Hail, [Mary,] full of grace, the Lord [is with thee]"); ON THE REVERSE: *CITY OF PHILADELPHIA/ JOHNSON COLLECTION* (stamped three times in black ink); *I/ IN740* (in pencil)

FIG. 87.1 Reverse of plate 87, showing the original paint

FIG. 87.2 X-radiograph of plate 87, showing the wood dowels attaching the applied moldings

TECHNICAL NOTES

The picture is painted on a single plank of wood with applied frame moldings. The original linen layer is visible on the sides and in areas of loss in the gold on the applied frame. The sides were painted vermilion; only some of the original survives, with much of what is visible being repaint. The reverse (fig. 87.1) is partially covered with a now very worn linen layer, which is painted to resemble serpentine, or verde antico, marble.

As can be seen in close visual examination, as well as in the X-radiograph, the moldings of the frame were attached by wooden dowels that were driven through both the moldings and the panel (fig. 87.2), a technique not evident in other early Italian paintings in the collection. A number of the dowels, which are square in shape and driven into round holes, have now slightly protruded through the surface of this panel.

On the right are three pairs of nail holes of the type usually associated with hinges. However, here the nails were driven at the sides of the panel and not near the front edge, as was more usually done to affix the hinges of folding panels. Because of the effects of wear, new gesso, and repaint, there is only faint evidence of corresponding holes on the left side. This would indicate that originally two other panels were attached to this painting, and that the complex was either a folding triptych or a free-standing altarpiece of at least three panels. At the top are the remains of a very worn old nail, which may be either a later addition or where a finial was attached. There are short nails driven in the sides of the panel on the top left and right corners of the arch, which may have affixed other ornaments.

The applied frame was partially regilt except for the bottom member, which was completely regilt. The bole in the regilded areas is a more vivid red than the original. All the gold decoration is incised, the background in a basket-weave design and the borders of the Crucifixion, the upper part of the Annunciation, and the halos in a simple vinelike pattern. There is considerable restoration of losses in the gilding. The mordant gilt details are mostly well preserved, except for those on the archangel Gabriel, which are restoration.

There are scattered losses throughout the painting, of which isolated areas of the Virgin Annunciate's red robe and the right part of Christ's rib cage are the most prominent. In addition, the costume of the female mourner at the far left of the Crucifixion is repainted, although her face is not. The cross was painted in a deep blue, presumably azurite, that has now darkened. In the Nativity the left part of the landscape and some of the two trees are also repainted. In the Annunciation the white dove is largely abraded, with parts of its head and wings discernible only under magnification. However, despite loss, the painting is in a fairly good state of preservation.

The picture was flaking in August 1919. Carel de Wilde took care of this in 1920, but he and Hamilton Bell still described the paint surface as being in a "fairly good state." In August 1956 Theodor Siegl removed surface dirt "without attacking old varnish and retouchings."

PROVENANCE

John G. Johnson purchased the panel from Ludovico de Spiridon, of 15 rue Ballu in Paris, on August 7, 1910, for 10,000 French francs, as a work "attributed to Giotto." Its previous history is not known.

COMMENTS

The arched panel contains three scenes. At the top is the Crucifixion showing the fainting Virgin, held up by three women, and Saint John the Evangelist

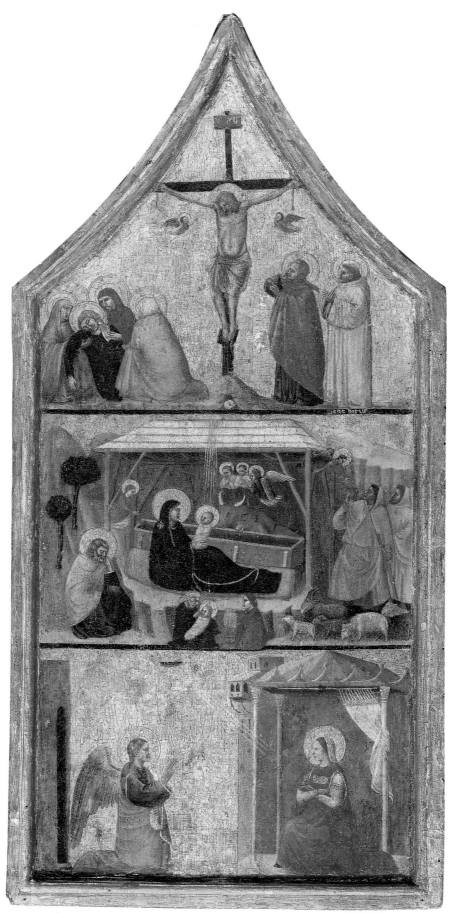

PLATE 87

PADUAN SCHOOL, C. 1320-30 449

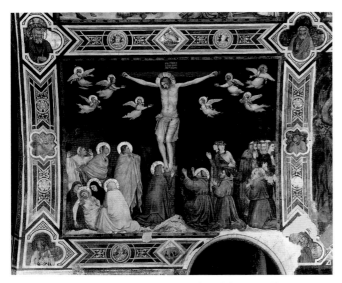

FIG. 87.3 Giotto (Florence, c. 1266–1337) and workshop. *Crucifixion,* c. 1308. Mural. Assisi, basilica of San Francesco, Lower Church

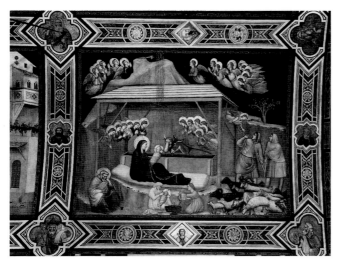

FIG. 87.4 Giotto (Florence, c. 1266–1337) and workshop. *Nativity,* c. 1308. Mural. Assisi, basilica of San Francesco, Lower Church

FIG. 87.5 Giotto (Florence, c. 1266–1337). *Virgin Annunciate,* c. 1303–5. Mural. Padua, Arena chapel

FIG. 87.6 Unknown artist (Italian). Figures after Simone Martini's and Giotto's murals in the Lower Church of the basilica of San Francesco in Assisi, after 1318. Gray wash and white gouache on green prepared parchment; $9\frac{1}{4} \times 11\frac{3}{8}''$ (23.5 × 28.8 cm). Cambridge, Harvard University Art Museums, Fogg Art Museum, Alpheus Hyatt Fund, no. 1932.65 recto

and Saint Benedict, in a white habit, mourning the Dead Christ. The center scene is the Nativity, which, like many early Italian depictions, shows the Christ Child being both held by his mother Mary and cared for by two nursemaids. The bottom scene is the Annunciation to the Virgin, who kneels in an open structure while the angel Gabriel greets her.

The Crucifixion and the Nativity are derived from wall paintings (figs. 87.3, 87.4) executed by Giotto and his workshop, probably around 1308, in the north transept of the Lower Church of San Francesco in Assisi. This cycle enjoyed an immense fame, and although drawings from other of its scenes (fig. 87.6) exist,[1] this is the only known copy in a small-scale panel painting. The Annunciation repeats the principal elements of Giotto's mural (fig. 87.5) in the Arena, or Scrovegni, chapel in Padua of about 1303–5.

However, one important difference between the murals and the Johnson panel is that Giotto's *Crucifixion* in Assisi shows Saint Francis and other Franciscan saints, whereas here a monk dressed in white is identified as Benedict, which indicates that the panel was most likely made for a member of the Benedictine order. Since he wears a white habit, as opposed to the more usual black, the owner proba-

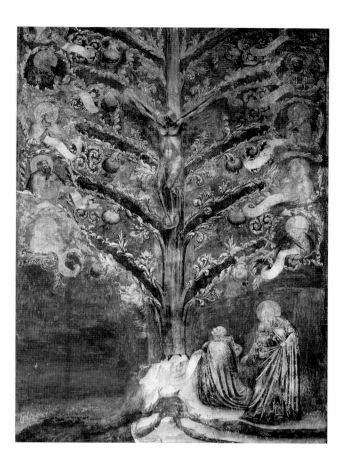

FIG. 87.7 (*above*) Nicolò da Padova(?), Master of the Choir of the Arena Chapel (Padua, documented 1320). Altarpiece: *Virgin and Child with Saints Francis of Assisi and Louis of Toulouse and Scenes from the Life of Christ,* c. 1320. Tempera and tooled gold on panel; 22 × 33½″ (56 × 85 cm). Ravenna, Pinacoteca Comunale, inv. 104

FIG. 87.8 (*right*) Master of Sesto al Reghena (Padua, active 1320s). *Tree of Life with Ludovico di Fantussio Della Frattina and Saint John the Evangelist,* c. 1325. Mural. Sesto al Reghena (near Pordenone), church of Santa Maria in Sylvis

bly belonged to the Camaldolese order, who wore white.[2]

Although Bernhard Berenson (1913) recognized the similarity between this *Annunciation* and Giotto's mural of the same subject in the Arena chapel (fig. 87.5), he thought that the artist of the Johnson work had been an assistant of Giotto before the master went to Padua. The Philadelphia panel has been little studied since Berenson wrote. In a conversation with Barbara Sweeny in 1939, Evelyn Sandberg Vavalà said, "Georg Pudelko has called this Riminese which I think undoubtedly correct." This opinion was also expressed by Keith Christiansen in a letter to Louise Lippincott, dated August 17, 1982, when he noted that a number of Riminese artists visited Assisi and had also been active in Padua. Small altarpieces in which several scenes from the life of Christ were depicted in vertical tiers are particularly characteristic of early fourteenth-century Riminese painting.[3] Riminese artists were active in the whole of Emilia Romagna, the Marches, and the Veneto.

Alternatively, Burton Fredericksen and Federico Zeri (1972) suggested that the Johnson painting might be the work of a fourteenth-century artist from Padua.

Stylistically, the painter of the Johnson panel can be best compared with the work of several modest painters active in Padua and other areas of the Veneto in the 1320s: the painter of the choir of the Arena chapel (the probable Nicolò da Padova), the Master of Galzignano, and the Master of Sesto al Reghena.

Nicolò da Padova, who worked in the Arena chapel sometime between 1317 and 1320,[4] was also documented as working in the church of Sant'Apollinare in Trent in 1320.[5] He, like the artist of the Johnson panel, directly copied Giotto's mural compositions for panel paintings. For example, the scenes in his altarpiece from a Franciscan church in Ravenna (fig. 87.7) are all derived from Giotto's paintings in Padua.

The Johnson painting can also be compared with the detached mural of the Crucifixion[6] from an oratory constructed in 1337 by Riccabona da Carrara, widow of Count Antonio da Lozzo, in Galzignano, near Este. This mural is based on Giotto's panel of the Crucifixion in Strasbourg.[7] Mauro Lucco (1977) has suggested that this artist, known as the Master of Galzignano, assisted Nicolò da Padova in the Arena chapel.

The third and most fruitful comparison can be made between the Johnson panel and the cycle in

the church of the Benedictine abbey of Santa Maria in Sylvis, at Sesto al Reghena near Pordenone, which was probably decorated under the stewardship of the powerful abbot Ludovico di Fantussio della Frattina, who was elected in 1325 and died in 1339.[8] His portrait as donor can be seen in the scene of the Tree of Life (fig. 87.8), in which the crucified Christ is similar to the Christ in the Johnson panel; some of the stories of the life of Saint Benedict (figs. 87.9, 87.10) and the death of the Virgin are also particularly close to figures in the Johnson painting. Many of the compositional schemes in the cycle of Sesto al Reghena, however, are more reminiscent of Giotto's work in the Magdalene chapel and the transept of the Lower Church of the basilica in Assisi than of his painting in the Arena chapel in Padua. The figure of the abbot donor itself recalls Simone Martini's mural of Cardinal Gentile Portino da Montefiore in the chapel of Saint Martin in the same basilica,[9] suggesting the work of an artist who was familiar with the Assisi complex. The cycle in Sesto al Reghena is in very poor condition and seems in fact to be by more than one hand. If indeed the Johnson panel and certain parts of the Sesto al Reghena series are by the same anonymous painter of probable Paduan origins, the artist may

FIG. 87.9 Master of Sesto al Reghena (Padua, active 1320s). Detail of mourners from the *Funeral of Saint Benedict*, c. 1325. Mural. Sesto al Reghena (near Pordenone), church of Santa Maria in Sylvis

FIG. 87.10 Master of Sesto al Reghena (Padua, active 1320s). Detail of mourners from the *Funeral of Saint Benedict*, c. 1325. Mural. Sesto al Reghena (near Pordenone), church of Santa Maria in Sylvis

have worked in Assisi before returning to Padua, possibly during the period of Giotto's second sojourn there in 1317.

As Saint Benedict's white habit suggests, it is likely that the panel was executed for a Camaldolese monk. While an order of Tuscan origins, the Camaldolese Benedictines had many important convents in northern Italy, including Sant'Apollinare in Classe in Ravenna, San Michele di Murano in Venice, San Benedetto in Padua, and Santa Maria della Vangadizza in Badia Polesine, near Rovigo. The Camaldolese also had an abbey in Assisi at San Silvestro al Monte Subasio, suggesting that monks of the order were familiar with the basilica of San Francesco, from which two of the scenes in the Johnson panel are derived.

1. For other trecento drawings after the cycle, see Chantilly, Musée Conde, no. F.R.I.1; Florence, Gabinetto Disegni e Stampe degli Uffizi, no. 9E; New York, The Pierpont Morgan Library, no. I.1 B; and Vienna, Albertina, inv. 4 (2. Garnitur) (see Degenhart and Schmitt, vol. 1, pt. 3, 1968, plates 79, 80, and vol. 1, pt. 1, fig. 166, respectively).

2. This is also true of the Cistercian order, but if the saint were a Cistercian, he would have been more likely identified as Bernard of Clairvaux. The Olivetans also wore white habits, but their order was not given full church recognition until the mid-fourteenth century.

3. For example, see the diptych *Scenes from the Passion of Christ*, attributed to Giovanni da Rimini; in Munich, Alte Pinakothek, no. WAF 837/838 (*Pittura* 1986, color plate 306); Giovanni da Rimini's diptych *Scenes of the Passion of Christ and Stories of the Virgin and Saints*, divided between Rome, Galleria Nazionale d'Arte Antica di Palazzo Barberini, no. 1441, and Alnwick Castle, England, duke of Northumberland, no. 648 (Rimini 1995, color repros. pp. 173, 175); Pietro da Rimini's triptych, divided among Madrid, Fundación Colección Thyssen-Bornemisza, no. 1979.63; Berlin, Staatliche Museen, no. 1116; and a private collection (reconstruction in Boskovits 1990, fig. 1); Francesco da Rimini's valve of a diptych, *Derision of Christ, Calvary, and the Annunciate Angel*, in a private collection (Rimini 1995, color repro. p. 223); Francesco da Rimini's diptych *Virgin and Child with Saints* and *Scenes of the Passion*, divided between Florence, Museo Stibbert, no. 10291, and Dublin, National Gallery of Ireland, no. 1022 (Rimini 1995, black-and-white and color repros. pp. 240–41); and Giovanni Baronzio's *Stories of Christ and Saints*, New York, The Metropolitan Museum of Art, no. 09.103 (Rimini 1995, color repro. p. 273).

4. On the dates of his activity there, see Flores D'Arcais 1994.

5. On his identification, see Boskovits 1990, p. 155 n. 2. See also Salmi 1931–35, pp. 250–52; F. Bologna 1969, pp. 76–78 n. 3, 106; Zuliani 1970, pp. 12, 22 nn. 6, 17; Lucco 1977, pp. 245–61; Francesca d'Arcais in *Pittura* 1986, p. 156; Francesca d'Arcais in Lucco 1992, p. 531; and Daniele Benati in Rimini 1995, p. 166. For the mural in Sant'Apollinare, see Lucco 1977, fig. 15.

6. Este, Museo Nazionale Atestino; Lucco 1992, fig. 132.

7. Musée des Beaux-Arts, no. 167. Previtali 1993, color plate XCV.

8. For a detailed documentary history of the abbey and its abbots, see Degani 1908 and more recently Trame 2000. The wall paintings are not documented.

9. Martindale 1988, plates 22, 24.

Bibliography
Berenson 1913, pp. 3–4, repro. p. 225 (unknown associate of Giotto); Van Marle, vol. 3, 1924, p. 274; Handbook 1931, p. 41, repro. p. 38 (follower of Giotto); Berenson 1932, p. 237; Berenson 1936, p. 203; Johnson 1941, p. 7 (immediate follower of Giotto); Berenson 1963, p. 84; Sweeny 1966, p. 33, repro. p. 83 (immediate follower of Giotto); Antonio Corbara in Macerata 1971, p. 198; Fredericksen and Zeri 1972, pp. 87, 235 (school of Giotto or Padua, fourteenth century); Corbara 1984, p. 48 n. 96, fig. 3 (Giottesque painter); Philadelphia 1994, repro. p. 199 (unknown artist, active Padua, c. 1320–30)

PLATE 88 (PMA 1950-134-195)
Virgin and Child

c. 1340–60

Tempera and gold on panel, transferred to canvas; 18¾ × 13¼″ (47.5 × 33.7 cm)

Philadelphia Museum of Art. The Louise and Walter Arensberg Collection. 1950-134-195

INSCRIBED ON THE REVERSE: *Transferred from wood onto canvas/ by Mary Ann Adler, 1950* (in ink)

EXHIBITED: Philadelphia Museum of Art, *Arensberg and Gallatin Collections* (Fall 1954), not in catalogue

TECHNICAL NOTES
The panel was transferred to canvas in 1950. Traces of the original barbe can be seen on the bottom edge and on the lower left and right sides.

The gold background is largely lost, and most of this area has been regessoed. It is particularly worn and fragmented along the outside edges and near Christ's head. A few traces of the original gold can be seen along the edges of the figures. Other traces of gilding in the background are new. The mordant gilt stars of the Virgin's kerchief are very worn, and in some areas only the light brown mordant remains.

The paint surface is in relatively good condition. What may be an original sandarac varnish still covers most of the drapery, giving the mordant gilt details a red tonality. This varnish has been cleaned off the flesh tones and the Virgin's white kerchief. The Virgin's blue mantle was painted with a coarsely ground blue, presumably azurite, pigment that now appears black.

The painting was treated in Los Angeles in 1950 by Mary Ann Adler, who worked on many of the Arensbergs' twentieth-century pictures.

PROVENANCE
The painting was bought by Walter C. and Louise Arensberg about 1949; the source is not known. The work was listed in their collection as no. 1408 as "probably pre-Giotto." It came to the Philadelphia Museum of Art in 1950.

COMMENTS
The Virgin is shown in half-length, as the infant Jesus suckles at her tiny right breast. The Virgin's blue mantle is dotted with stars, and her dress has a brocade of repeating pinecone motifs that is found in fourteenth-century Venetian textiles.[1] Christ wears a red undergarment with gold striations.

The diminutive size of the Child and the gold decoration on his cloak suggest a Byzantine proto-type, although it is not known whether a specific

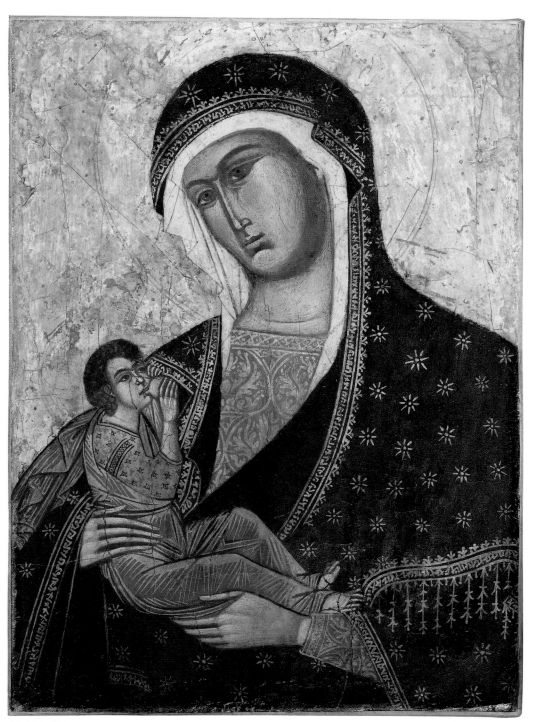

PLATE 88

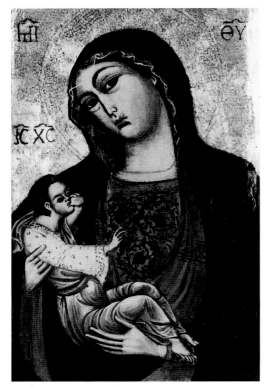

FIG. 88.1 Adriatic School. Detail of a triptych: *Virgin and Child,* c. 1340–60. Tempera and tooled gold on panel (repainted); overall 15 × 20⅛″ (38 × 51 cm). Rijeka (Fiume), Slovenia, shrine of the Madonna of Trsat

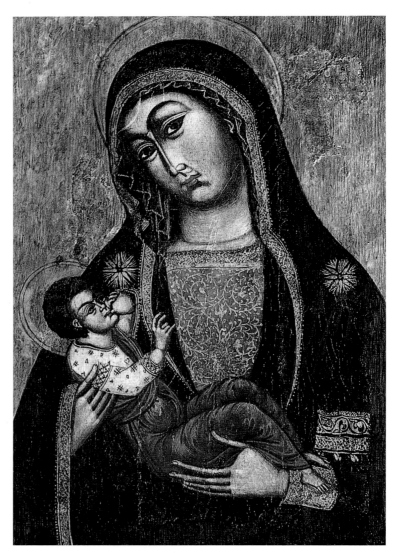

FIG. 88.3 Adriatic School. *Virgin and Child,* c. 1340–60. Tempera and gold on panel; 27⅜ × 19⅜″ (69.5 × 49 cm). Mdina (Valletta), Malta, cathedral, the Metropolitan Chapter

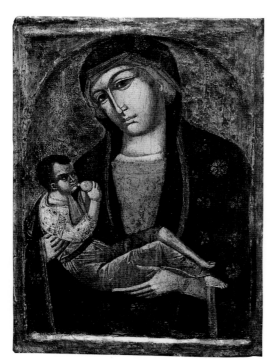

FIG. 88.2 Adriatic School. *Virgin and Child,* c. 1300–1350. Tempera and gold on panel; 11⅞ × 8¾″ (30 × 22 cm). Last recorded New York, Belle da Costa Greene Collection. Present location unknown

icon of the Madonna *Galaktotrophousa,* known in the West as *Maria lactans* (nursing Virgin), was used as a model. However, a number of pictures repeat variants of the same composition (figs. 88.1–88.4), which suggests either a common origin, such as a single workshop, or a common formula, most probably a Byzantine icon, since they all exhibit Venetian influences.[2]

Edward Garrison (1949) categorized these works as early trecento Dalmatian or Adriatic School. However, Grgo Gamulin (1971, p. 131; 1974, p. 201) has argued that this designation is rather imprecise, because only three of the paintings can be found in Dalmatia, and the only other one that might still be in its original location is a *Virgin and Child* (fig. 88.3) in the cathedral of Mdina (Valletta) in Malta. The

iconic nature of the image, however, suggests an origin in a region tied to Byzantine artistic formulas, probably the Adriatic, with the costumes in particular recalling early fourteenth-century Venetian painting.

Stylistic differences in the Virgin's headdress are useful in dating these pictures. In the earliest, the *Virgin and Child* once in the Greene Collection (fig. 88.2), the Virgin's hair is contained in a cap worn under her mantle, which is her common head covering in thirteenth-century painting. While in central Italy the cap is replaced by a loose veil under the mantle before 1300, in Venetian painting the older fashion persists into the early fourteenth century. It can still be seen, for instance, in Marco Veneziano's *Coronation of the Virgin,* dated 1324, in

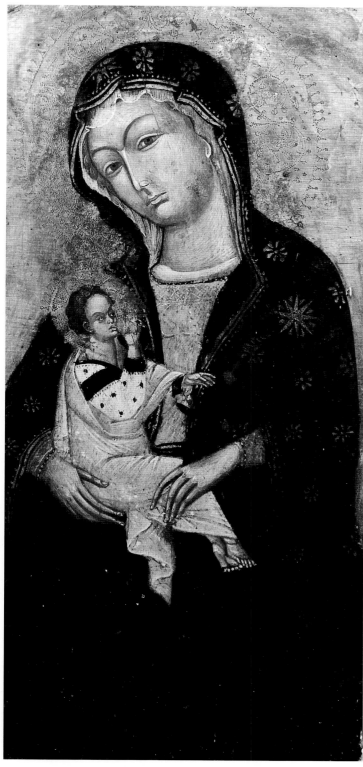

FIG. 88.4 Adriatic School. *Virgin and Child*, c. 1340–60. Tempera and gold on panel; 29⅝ × 13⅝″ (75 × 34.5 cm). Venice, Museo Correr, no. 974

the National Gallery of Art in Washington, D.C.[3] Paolo Veneziano (active 1333–58) dresses Virgins in this older manner in his early works, such as the *Virgin and Child* in San Pantalon in Venice.[4] But by at least August 1340, the date of his signed *Virgin and Child* in the Crespi Collection in Milan, he has adopted the newer style showing a loose veil rather than a cap.[5]

The Virgin in the Philadelphia painting is dressed with a veil, as are the Virgins in the paintings in Rijeka (Fiume) (fig. 88.1), Mdina (fig. 88.3), Piran,[6] and formerly in Florence.[7] A date between 1340 and 1360, which parallels Paolo Veneziano's mature activity, can thus be proposed. Whether the panels are from the same workshop and whether this workshop was in Venice or Dalmatia, are open questions. The pictures bear some stylistic resemblance to at least two other paintings by anonymous Adriatic artists: the *Virgin and Child* in the Museo Correr in Venice (fig. 88.4) and a fragment of a tabernacle illustrated by Garrison as then with the dealer G. Grassi in Rome.[8]

1. For a similar mantle, see the Virgin in a fragment of an early fourteenth-century Venetian tabernacle in the Museum of Western and Oriental Art in Kiev (no. 384; Pallucchini 1964, fig. 232). For a similar textile, see the one that was uncovered in the tomb of Cangrande (died 1329) in Verona (Lucco 1992, fig. 590).
2. Besides the ones illustrated in figs. 88.1–88.4, five other examples from the first half of the fourteenth century are known: *Virgin and Child with Two Angels,* Piran, Slovenia, church of San Michele (Garrison 1949, repro. no. 315A); *Virgin and Child with Fragments of Six Scenes,* present location unknown; formerly Rome, G. Grassi (Garrison 1949, repro. no. 380); *Virgin and Child,* Assisi, Museo del Sacro Convento (Assisi 1980, color plate 4; see text by Pietro Scarpellini [pp. 50–51], who dates it to the early fifteenth century); *Virgin and Child,* present location unknown; formerly Florence, Gentner Collection (Garrison 1949, repro. no. 85); and *Virgin and Child,* present location unknown; formerly Rome, Forlì Collection (Garrison 1949, repro. no. 346).
3. No. 1166; Shapley 1979, plate 237 (as the Master of the Washington Coronation of the Virgin).
4. Lucco 1992, fig. 11.
5. Lucco 1992, fig. 21 (color).
6. See n. 2.
7. See n. 2.
8. See n. 2.

Bibliography
Philadelphia 1965, p. 35; Fredericksen and Zeri 1972, p. 244 (Veneto-Byzantine); Philadelphia 1994, repro. p. 200 (Italian[?], active Adriatic coast, c. 1340–50)

PLATE 89 (JC CAT. 93)
Crucifixion

Mid-fourteenth century, repainted in the late nineteenth century

Tempera and tooled gold on panel with vertical grain; 23¼ × 9⅝ × ¾″ (59 × 24.5 × 2 cm), painted surface 19⅝ × 7⅞″ (50 × 19.9 cm)

John G. Johnson Collection, cat. 93

INSCRIBED ON THE CROSS: *I.N.R.I.* [IESUS NAZARENUS, REX IUDAEORUM] (John 19:19: "JESUS OF NAZARETH, THE KING OF THE JEWS"); ON THE FLAG: *SPQR* [Senatus populusque romanus] (The Senate and People of Rome); SCRATCHED ON THE REVERSE: *F. DOMINICUS* (F[riar] Dominic); *105* (on a paper sticker); *D107* (on a paper sticker); *JOHNSON COLLECTION/ PHILA.* (stamped several times)

TECHNICAL NOTES
The wood panel is exceptionally well preserved, except for some minor damage at the top. The applied moldings are original but the bottom piece has been replaced by a base, consisting of two pieces of wood. The surface of the frame retains the original gilding, whereas the outer edges have been regessoed and painted gold. Losses in the new gesso reveal that these edges were originally painted red. The reverse (fig. 89.1) was originally gessoed and painted to resemble an inlaid porphyry panel with an applied frame. Several grid patterns were scratched into the back at a later date. The decoration of the reverse, along with the lack of evidence of hinges on either side, suggests that the panel was an independent work that would have stood on a base. At some point a hole was drilled at the apex of the arch, probably to hold a knotted string for hanging.

 The picture was completely repainted and regilt, probably in the late 1800s. Small areas revealed during cleaning tests show that this was done to disguise the damaged original, and indeed the restorer painted his own tool marks. Removal of repaints in the left side uncovered some of the original punches. The mail on the soldier's armor had originally been incised.

 An X-radiograph (fig. 89.2) clearly demonstrates that the design was incised in the gesso and that a white sizing was applied over the areas where the paint would overlap the gold in a method known as *ritagliare* (see Allegretto di Nuzio, plate 4 [JC cat. 118]).

PROVENANCE
In the catalogues of the two sales of the Somzée Collection in Brussels, in which the painting appears as the work of Lippo Memmi (Brussels, Galerie Fievez, May 24, 1904, lot 285; and May

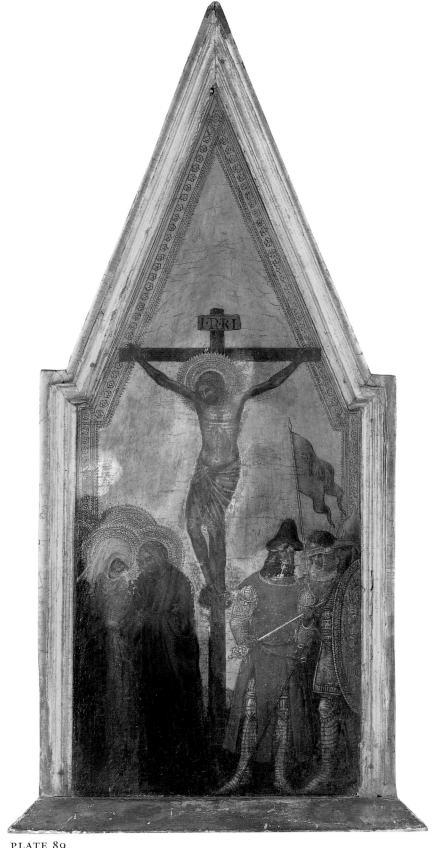

PLATE 89

FIG. 89.1 Reverse of plate 89, showing the original paint

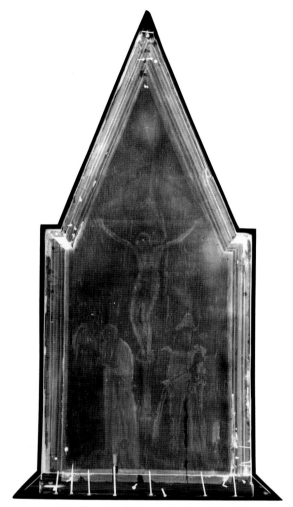

FIG. 89.2 X-radiograph of plate 89, showing the incisions of the design and the white size outlining the figures

27–29, 1907, lot 201), it is said to have come from the Chigi palace in Siena. The panel was probably not sold at the first Somzée auction. John G. Johnson bought it either at the second sale or afterward.

COMMENTS

Christ is on the cross. On the left John the Evangelist comforts the Virgin, and halos indicate the presence of two figures behind them. On the right are three Roman soldiers.

Bernhard Berenson (1913), who considered this an important work by the mid-fourteenth-century artist known as Barna da Siena, wrote that "this little masterpiece has the great distinction and lofty style of Barna." He went on to list the known works by the master and compared the Johnson painting with two scenes of the Crucifixion that he assigned to Barna.[1]

The condition of the panel makes attribution almost impossible, but it is certainly a Sienese picture of the mid-fourteenth century. In 1932 George Harold Edgell mentioned that he doubted Beren-son's attribution to Barna, but he did not openly question the authenticity of the picture. The supposed provenance from the Chigi palace in Siena, as stated in the Somzée auction catalogues, may have been invented to enhance the picture's value. It is not known at what point after entering the Johnson Collection the picture was first considered a fake, although it was omitted from the 1941 checklist of the collection. In 1964 Ellis Waterhouse suggested to Barbara Sweeny that it might be the work of the well-known restorer and falsifier Icilio Federico Joni (1866–1946), and she left it out of her 1966 catalogue.

The production of fakes and deceptive restorations of fourteenth-century Sienese art was a small industry in the late nineteenth and early twentieth centuries. In 1932 Joni himself wrote an autobiography in which he described how he fooled some of the major connoisseurs of the period, including Berenson.[2] He not only counterfeited works of art but ran a thriving restoration and framing business in addition to making reproductions for tourists. He is known to have restored many works of art that were bought by Johnson's contemporaries Frank Lusk Babbott and Dan Fellows Platt. One of Johnson's advisers, F. Mason Perkins, worked closely with Joni, frequently securing for him restoration work for American collectors. However, the poor quality of the restoration of the Johnson *Crucifixion* makes it unlikely that Joni was involved.

1. They are the panel by Naddo Ceccarelli in the Walters Art Museum in Baltimore (no. 37.737; Zeri 1976, plate 20); and a panel by an anonymous artist once in the collection of Richard von Kaufmann in Berlin (see the catalogue of the Von Kaufmann sale at Paul Cassirer and Hugo Helbing in Berlin, December 4, 1917, lot 8 [as Barna da Siena], repro. opposite p. 24).
2. On Joni, see Gianni Mazzoni in Siena 1988, pp. 198–206, with much earlier bibliography; and Mazzoni 2001.

Bibliography
Berenson 1913, pp. 53–54, repro. p. 290 (Barna); Fogg 1919, p. 106; Van Marle 1920, p. 121; Edgell 1924, p. 50; Van Marle, vol. 11, 1924, p. 197; Berenson 1932, p. 41; Edgell 1932, p. 164 n. 40; Berenson 1936, p. 35; Delogu Ventroni 1972, p. 61; Philadelphia 1994, repro. p. 209

PLATE 90 (PMA F1938-1-51)

Crucifixion with the Virgin and Saint John the Evangelist

Late fourteenth century, possibly repainted in the sixteenth century

Oil and gold on panel with vertical grain, arched; $26\frac{5}{8} \times 14 \times 1\frac{1}{8}''$ (67.6 × 35.5 × 3 cm)

Philadelphia Museum of Art. Bequest of Arthur H. Lea. F1938-1-51

INSCRIBED ON THE REVERSE: *1004* (in black ink); *F'38-1-51* (in red); ON THE BOTTOM OF THE REVERSE OF THE FRAME: *Bartolo* (in ink)

TECHNICAL NOTES

Consisting of two planks, the support probably retains its original thickness, although the back, stained a dark brown, bears incision marks that may have been made in preparation for a cradle that was never attached. The panel is slightly cropped at the bottom and along the straight edges of the sides. An X-radiograph shows a ragged linen layer applied on the bias before the panel was gessoed. It also shows nail holes at the bottom edge where frame moldings were affixed.

The panel has been completely repainted and regilt. The new gold is oil gilding. Examination of an area of flake loss on the right edge revealed another layer of original gold underneath. An intermediate layer of varnish and a layer of yellow paint between the old gold and the new gold account for the extensive traction cracking of the surface. Despite the thickness of the new materials, traces of the original punched tooling in the halos are evident, and some of a paint barbe even survives along the bottom. The repainting covers deep flake losses in the original surface.

PROVENANCE

The Philadelphia collector Isaac Lea (1792–1884) purchased the picture in Florence in 1852 on the advice of one Tito Gagliardi. Lea catalogued it as number 103 in an 1876 inventory of his collection. The painting descended to Arthur H. Lea (died 1938), who bequeathed it to the Museum with a collection of pictures that had been selected by director Fiske Kimball in 1933.

COMMENTS

Christ hangs on the cross as the standing Virgin and Saint John the Evangelist mourn at either side. A pelican and her young, a symbol of the Resurrection, appear at the top of the cross.

The picture was painted over a much older image. The repaints might conform to the original

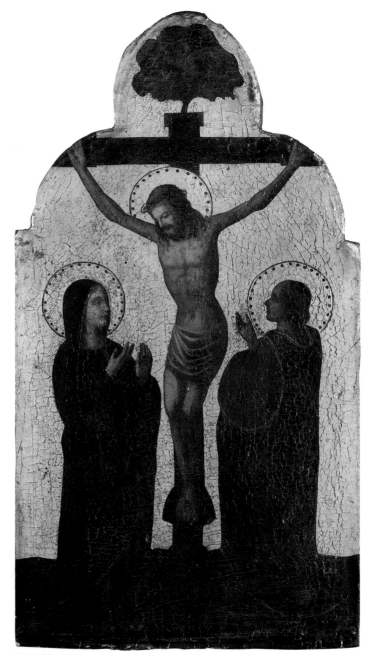

PLATE 90

composition. Certainly, the present scene suggests a late fourteenth-century Florentine manufacture; the large scale of the mourners and the Evangelist's turned back exclude a much earlier date. It is not clear when the panel was repainted. The modeling of Christ looks as though it could have been executed in the early sixteenth century.[1] The painting is very unlike the late nineteenth-century restorations or falsifications of early Italian painting.

The name *Bartolo* on the back of the frame may indicate earlier thoughts about the picture's attribution.

1. This was also noted by Miklós Boskovits during a visit to the Museum on October 28, 1995.

Bibliography
Philadelphia 1994, repro. p. 209 (Italian, unknown artist, nineteenth century, in a fifteenth-century style)

PLATE 91 (JC CAT. 100)

Center panel of a triptych:
Virgin of Humility with Two Cherubim and Two Music-Making Angels and the Crucifixion with the Virgin and Saint John

c. 1400

Tempera and tooled gold on panel with vertical grain; overall, with modern frame 16¼ × 8⅝ × ⅞″ (41.2 × 22 × 2.4 cm), painted surface 13½ × 7¼″ (34.5 × 18.3 cm)

John G. Johnson Collection, cat. 100

INSCRIBED ON THE LOWER RIGHT OF THE FRAME: *49* (printed on a paper label); ON THE REVERSE: a damaged red wax collector's seal (fig. 91.1) consisting of an umbrella and crossed keys over *R C / A* and an inscription on the border of which only *ANA* is still visible; *N° 4* (in ink); *13601* (in pencil); *64* (in white chalk)

PUNCH MARKS: See Appendix II

EXHIBITED: Philadelphia Museum of Art, John G. Johnson Collection, Special Exhibition Gallery, *From the Collections: Paintings from Siena* (December 3, 1983–May 6, 1984), no catalogue (as follower of Taddeo di Bartolo)

TECHNICAL NOTES
The panel consists of a single member that has been thinned. The tip of the pinnacle has been reconstructed. The moldings are new. The inner framing elements were executed in pastiglia.

Except for the flesh tones and the Virgin's mantle, the main composition of the painting was executed in sgraffito and glazing over gold. The flesh tones are very reddish. The flesh was first modeled in terre verte and white and then worked up with white and vermilion. The Crucifixion in the trilobe pinnacle is painted over the gold ground.

FIG. 91.1 The collector's red wax seal on the reverse of plate 91

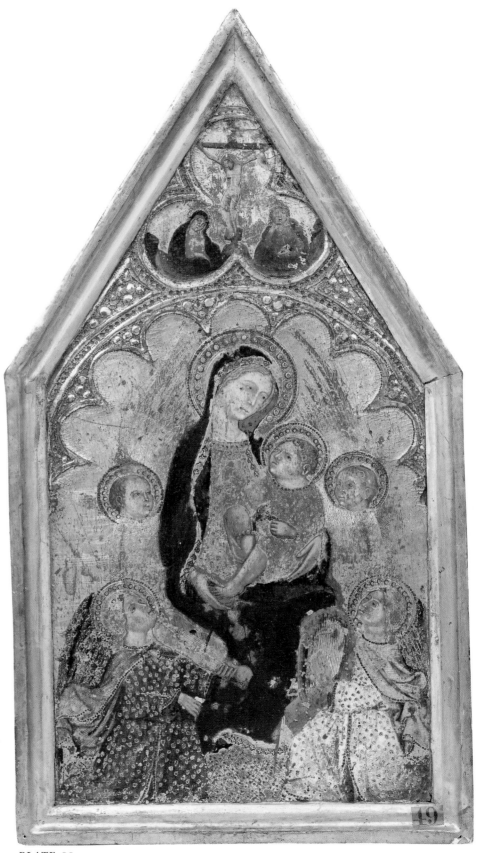

PLATE 91

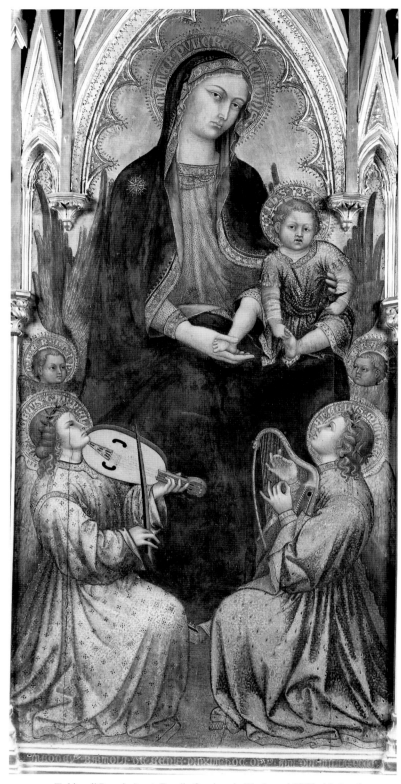

FIG. 91.2 Taddeo di Bartolo (q.v.). Detail of a triptych: *Virgin and Child with Angels,* 1400. Tempera and tooled gold on panel; overall approximately 59 × 45¼″ (150 × 115 cm). Siena, oratory of the confraternity of Santa Caterina della Notte

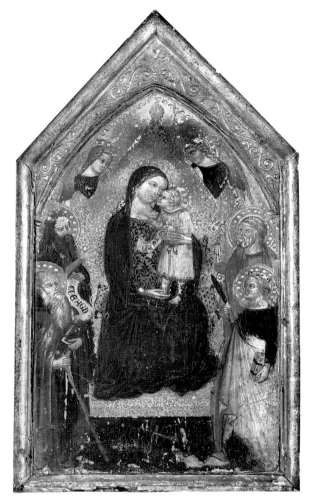

FIG. 91.3 Master of Panzano (Siena, active c. 1360–90/1400). *Virgin and Child with Angels and Saints Anthony Abbot, John the Baptist, Peter, and Catherine of Alexandria,* c. 1380–1400. Tempera and tooled gold on panel; 16⅜ × 9¼″ (41.5 × 23.5 cm). Siena, Pinacoteca Nazionale, no. 585

The paint surface is very worn. The gesso shows through in the blue mantle and other places.

In August 1919 Hamilton Bell thought that the panel may have a worm problem. In April of the next year he noted that at some point it had been "a good deal restored," and that the flesh had been scraped in the process. At the same time Carel de Wild described the painting as being "much damaged." In 1958 Theodor Siegl wrote that its heavy warp had caused the frame to split and a nail had caused a section of the original wood and paint in the Crucifixion scene to chip.

PROVENANCE
There is no record of the provenance of this picture. It was in John G. Johnson's collection by 1905, when F. Mason Perkins published it. The damaged red wax seal (fig. 91.1) on the back, which is probably of a former owner, has not been identified.

The seated Virgin holds the Christ Child on her lap. She is flanked by two winged cherubim. At her feet one angel plays a violin and another plays the harp. In the pinnacle there is a trefoil field in which Christ is shown on the cross, with the mourning Virgin and John the Evangelist seated on the ground below.

In the literature this panel has been associated with the Johnson Collection's *Virgin and Child Enthroned with Saints John the Baptist and James Major* (Andrea di Bartolo, plate 5 [JC cat. 99]) ever since they were first published in 1905 by F. Mason Perkins, who assigned them to a follower of Andrea Vanni. In 1904 Bernhard Berenson attributed them both to Taddeo di Bartolo (q.v.), although plate 5 is now given to Andrea di Bartolo (q.v.). As Cesare Brandi (1949, p. 251) noted, the main composition of the present painting derives from the center section of Taddeo di Bartolo's triptych (fig. 91.2) of 1400 in the Sienese oratory of the confraternity of Santa Caterina della Notte. Brandi proposed that the Johnson panel might be the work of Taddeo's adopted son and heir Gregorio di Cecco, who is known by a signed polytypch of 1423 in the Museo dell'Opera della Metropolitana in Siena.[1] In recent years Gregorio's oeuvre has been more precisely reconstructed, and both Miklós Boskovits (1980) and Luciano Bellosi (in Siena 1982) have excluded the Johnson painting from his catalogue. Boskovits associated the Johnson picture with a panel (fig. 91.3) in the Pinacoteca Nazionale of Siena that is usually given to the Master of Panzano. This painter seems to have been active from about 1360, and while it is not certain when his production ended, he probably did not work much beyond 1390 to 1400. Whereas the facial features of figures in the Johnson picture do bear some similarity to those in the panel by the Master of Panzano, they are not necessarily by the same hand. The Johnson work, for example, has much richer decorative effects than do the master's works. It is also unlikely that at the end of his career the older master would have copied a model by Taddeo di Bartolo. The Johnson painting was thus probably made soon after the original picture by Taddeo in Santa Caterina della Notte, and perhaps even in Taddeo's own workshop.

1. Chelazzi Dini, Angelini, and Sani 1997, color repro. p. 211.

Bibliography
Perkins 1905, p. 120 (follower of Andrea Vanni); Berenson 1909, p. 257 (Taddeo di Bartolo); Rankin 1909, p. lxxx (little later than Taddeo di Bartolo); Berenson 1913, p. 55 (Taddeo di Bartolo); Van Marle, vol. 2, 1924, p. 268 n. 2; Berenson 1932, p. 552; F. Mason Perkins in Thieme-Becker, vol. 32, 1938, p. 396; Johnson 1941, p. 16 (Taddeo di Bartolo); Brandi 1949, pp. 184 n. 18, 251–52, plate 41; Symeonides 1965, p. 250; Sweeny 1966, p. 74, repro. p. 100 (Taddeo di Bartolo); Fredericksen and Zeri 1972, p. 194 (studio of Taddeo di Bartolo); Boskovits 1980, p. 20 n. 36; Luciano Bellosi in Siena 1982, p. 346; Philadelphia 1994, repro. p. 200

Umbrian School, c. 1400

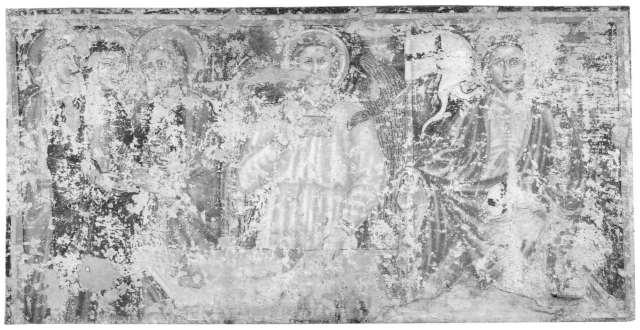

PLATE 92

PLATE 92 (PMA 1945-25-118)

Resurrection of Christ

c. 1400

Mural painting transferred to canvas; 45¼ × 87″ (115 × 221 cm)

Philadelphia Museum of Art. Purchased from the George Grey Barnard Collection with Museum funds. 1945-25-118

TECHNICAL NOTES

The mural painting was detached from the wall and transferred to canvas. There are numerous losses and lacunae; some had occurred before the painting was removed from the wall, others during the operation. There is now no evidence of *giornate,* or divisions, between each day's work.

The painting was executed in *buon affresco,* or in the wet plaster of the wall, with no evidence of *al secco* details, which would have been applied after the plaster dried. The halos, which were swung with a compass, are shaded to appear concave and have a certain thickness, with the edges visible.[1] For example, the outside edges of the halos of the three Marys are shaded from ocher to green. The background of the scene is a muted blue black. Sometimes this is used as an underlayer for either ultramarine or azurite applied *al secco.*

PROVENANCE

The painting came to the Museum with the purchase of George Grey Barnard's estate in 1945.

COMMENTS

In the center an angel stands behind Christ's open tomb. The three Marys approach from the left. Partially covered by a winding cloth, Christ emerges from the tomb holding a white banner with a red cross in his right hand and an orb in his left. The scene is cut at the bottom, where it may have depicted the sleeping soldiers; a fictive frame surrounds the other sides. The painting was probably part of a larger cycle. The most unusual feature of this composition is the centrality of the angel.

Poor condition and lack of provenance information make it almost impossible to evaluate this work. It entered the Museum from George Grey Barnard's estate as a north Italian painting of about 1350, possibly from Verona. Burton Fredericksen and Federico Zeri (1972) simply called it fourteenth-century Italian. In 1986 Alessandro Bagnoli suggested that it was either Umbrian or Marchigian. Writing from La Torrita (Assisi) on May 27, 1996, Filippo Todini noted its similarities to Orvietan painting of about 1400. The style, in fact, recalls that of painters working in southern Umbria in the late

fourteenth century. Its two most notable features are the frontal position of the figures and their open, almondlike eyes, which are also found in the work of artists who were involved in the large workshop of the Master of the Terni Dormition (q.v.). The painting can likewise be compared with the work of such artists as the Master of the Terni Triptych (active Spoleto, Terni, and environs, early fifteenth century)[2] and the Narni Master of 1409 (active Narni and environs, early fifteenth century).[3] However, nothing else by the painter of this mural has yet been identified.

1. As Mark Tucker has observed, this type of halo can be seen in the mural paintings in a fragmentary mid-fourteenth-century cycle by the so-called Master of Portaria in Santa Caterina in Portaria (near Aquasparta) in southern Umbria. See Todini 1989, figs. 332–33.
2. Todini 1989, figs. 543–55.
3. Todini 1989, figs. 556–75.

Bibliography
Weinberger 1941, p. 30, no. 118 (North Italian [Verona?], c. 1350); Fredericksen and Zeri 1972, p. 224 (Italian, fourteenth century); Philadelphia 1994, repro. p. 200 (Italian, active central Italy[?], c. 1375–1400)

PLATE 93 (JC CAT. 16)

Predella panel of an altarpiece: *Nativity of Christ and Annunciation to the Shepherds*

c. 1425–30

Tempera and tooled gold on panel with horizontal grain; 9⅞ × 15¾ × ⅜″ (25.2 × 40 × 1.1 cm), painted surface 9¼ × 15½″ (23.5 × 39.3 cm)

John G. Johnson Collection, cat. 16

INSCRIBED ON THE REVERSE: *16 in. 753* (in pencil); *CITY OF PHILADELPHIA/ JOHNSON COLLECTION* (stamped on the cradle)

EXHIBITED: Philadelphia 1920, cat. 16 (as school of Fra Angelico [q.v.]); Philadelphia Museum of Art, *The Nativity* (November 23, 1935–January 7, 1936), no catalogue

TECHNICAL NOTES

The panel consists of a single plank of wood that has been thinned and cradled. Its original applied moldings were removed and the barbes scraped level. The bare wood formerly covered by the moldings has horizontally scored lines on both the top and bottom, as well as small indentations made in preparation for gluing the moldings to the surface.

The painting was deceptively repainted to appear like a work by Fra Angelico. Much of the repainting was executed in a fine, hatched style. An infrared reflectogram (fig. 93.1) reveals that there was originally a field rather than a hill to the left of the shepherd. The present hill covers a number of frolicking animals. In the middle ground a rock was painted over a goat. Saint Joseph's proper right hand was painted out, and the head of the Virgin was originally more inclined. In addition, her hands were repositioned and painted over her mantle and the mordant gold of its border. Both her eyes and those of the Christ Child were also repositioned.

On April 7, 1924, T. H. Stevenson treated a flaking problem, and on December 18 of the same year, he retouched the old discolored inpainting. Theodor Siegel noted on June 2, 1956, that the picture had been extensively retouched. At that time, he treated and retouched losses caused by flaking. The picture has a thick layer of heavily discolored varnish.

PROVENANCE

It seems that this panel was sold to Johnson by an anonymous French marquis through Ludovico de Spiridon, who offered it to Johnson as "the very much admired work by Benozzo Gozzoli [q.v.]" in a letter dated Paris, February 8, 1904, at the cost of 4,000 French francs.

COMMENTS

At the right the Virgin and Saint Joseph kneel before the thatched manger and adore infant Christ, who lies in a basket, emanating rays of light. Supernatural light also streams down from the star, and two angels hover above the manger. At the left a shepherd watches his flock. His sheepdog has just spotted two other angels, who have come, carrying musical instruments, to announce Christ's birth. Two castles perched on hills enclose the background.

The panel was probably part of a predella to an altarpiece, but no other sections have been identified.

The picture prompted some perplexing comments from earlier writers. Bernhard Berenson wrote to Johnson from St. Moritz on August 18, 1904, telling him, on the basis of a photograph, that the painting was not a work of Benozzo Gozzoli, as it had been sold to him by Spiridon, "but [by an] Umbrian follower of Fra Angelico, perhaps an early work by [Bartolomeo] Caporali." Osvald Sirén, writing from Stockholm on February 5, 1908, came to a similar conclusion: "The Nativity with kneeling Mary and Joseph is also much under the influence of Angelico, but it is by a more primitive artist than the Annunciation. Possibly the artist is an Umbrian who has worked under Florentine influence. It belongs to the midst of the 15. century."

In his catalogue of 1913, Berenson described the Johnson panel as follows:

> This delightfully child-like painting, breathed upon, as it were, by the spirit of the "Fioretti" of St. Francis, is the work of an Umbrian follower of Fra Angelico. The Joseph is almost a transcript from that master, and there is something of him in the Madonna's face, but, for the rest, the character is purely Umbrian. Indeed, the pastoral scene echoes Ottaviano Nelli, the castles recall Andrea de Litio, and the draperies of the Blessed Virgin's mantle and dress, as well as the enamel-like technique, anticipate [Benedetto] Bonfigli and Caporali.

Commenting on this picture in his 1927 lecture at the Johnson Collection, Richard Offner noted: "Catalogued by Berenson as 'School of Fra Angelico.' It should be school of Benozzo Gozzoli. The type of vegetation is however, typical of Fra Angelico. This dotting of the ground with tiny plants begins with him and continues throughout the fifteenth century. But the angels are almost Umbrian." Since then the painting has not been the object of any serious study.

Condition was the cause of much of the early critical confusion about the picture and its association to Fra Angelico. As Berenson (1913) noted, the Saint Joseph was lifted from Angelico. The physiognomy of the saint's head recalls the Joseph in the *Nativity* painted on the doors to the Silver Cupboard from the Servite church of Santissima Annunziata in Florence, now in the Museo Nazionale di San Marco.[1] However, Berenson did not know that Joseph, as well as the Virgin, the Christ Child, and animals grazing in the fields were much overpainted, probably to make the picture look more

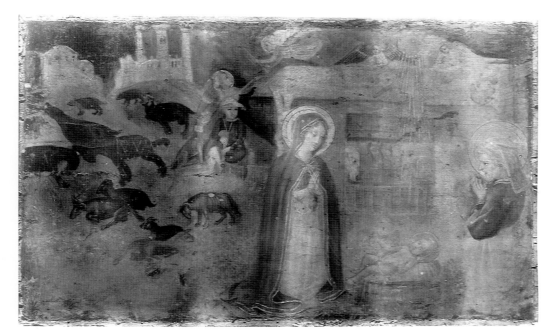

FIG. 93.1 Infrared reflectogram of plate 93, showing more animals in the field at left

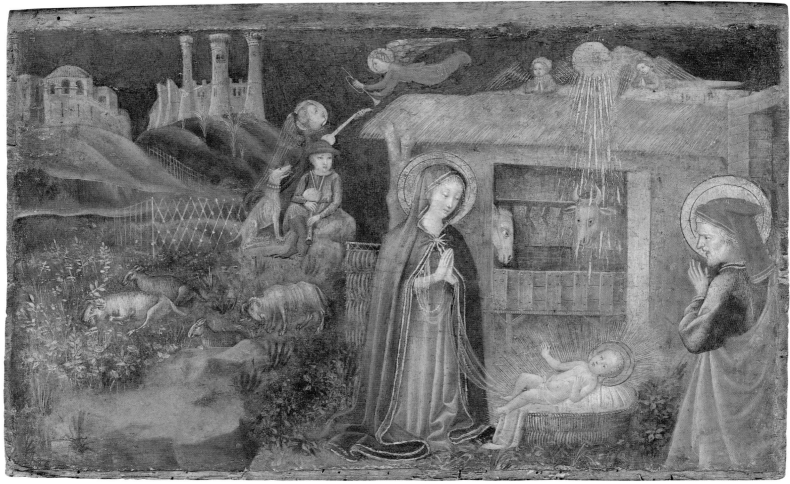

PLATE 93

like a painting by Fra Angelico or Benozzo Gozzoli and, therefore, more valuable.

The parts of the picture that are original and those that can be discerned through infrared reflectography suggest the hand of an Umbrian or Marchigian painter of the early 1400s. A close comparison can be made with a picture in the Pinacoteca Vaticana (fig. 93.2) that Miklós Boskovits (1977, p. 45 n. 42) attributed to Olivuccio di Ciccarello (first documented 1388; died 1439), a painter from Camerino who worked in Ancona, who has since (Mazzalupi 2002) been identified as the painter erroneously known as Carlo da Camerino.[2] Andrea De Marchi (1992, p. 122), however, suggested that the Vatican painting might be an early work of Bartolomeo di Tommaso,[3] and dated it about 1425, when the artist was in the Ancona workshop of Olivuccio. The undulating hills, the small castles in the distance, the many animals, and even the positions of the Holy Family suggest that the Vatican and Johnson pictures may have been painted by the same person or at least that their artists came from the same milieu.

Other telling comparisons with the Johnson panel can be made from the work of Ottaviano Nelli. The *Nativity,* for example, resembles his paint-

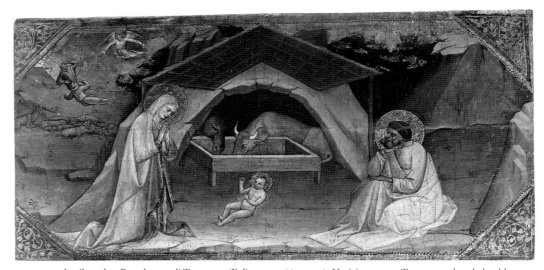

FIG. 93.2 Attributed to Bartolomeo di Tommaso (Foligno, 1408/11–1454). *Nativity,* c. 1425. Tempera and tooled gold on panel; 12⅛ × 18½″ (30.9 × 47.2 cm). Vatican City, Pinacoteca Vaticana, inv. 194 (40242)

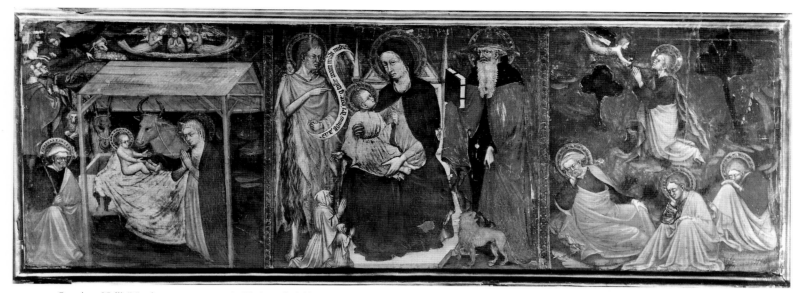

FIG. 93.3 Ottaviano Nelli (Marches, c. 1370–c. 1444). *Virgin and Child with Saints John the Baptist and Jerome, the Nativity, and Christ in Gethsemane,* c. 1424. Tempera and tooled gold on panel; 22⅞ × 63¾″ (58 × 162 cm). Formerly Foligno, Palazzo Trinci. Present location unknown

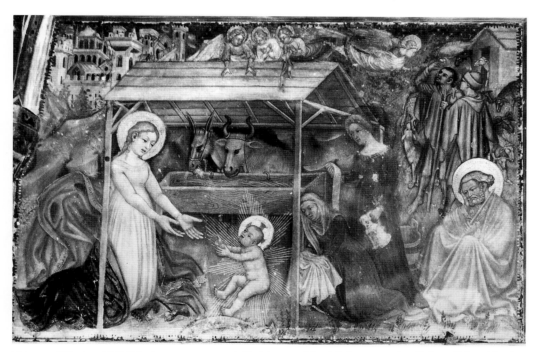

FIG. 93.4 Ottaviano Nelli (Marches, c. 1370–c. 1444). *Nativity,* 1424. Mural. Before restoration. Foligno, Palazzo Trinci

ings of the same subject (figs. 93.3, 93.4), and the facial features of the angels are close to those in Nelli's mural in the oratory of the Umiltà in Urbino.[4]

Attention to genre detail became the distinguishing characteristic of Marchigian and Umbrian painting in the early fifteenth century. Marchigian artists especially became famous for their elaborate depictions of scenes like the Nativity and the Adoration of the Magi. When the duke of Milan, Filippo Maria Visconti, commissioned a mural from Olivuccio di Ciccarello in 1429 for the holy sanctuary of Loreto, not far from Ancona, he provided a detailed description of what he wanted for the Magi, the people, and the animals in their train,[5] knowing that the local artists were expert at painting such scenes. The many charming details of the Johnson panel are reflections of this mastery.

1. Pope-Hennessy 1974, plate 132.
2. See also Andrea De Marchi in De Marchi and Giannatiempo López 2002, pp. 51–52; and Alessandro Marchi in De Marchi 2002, pp. 102–57.
3. See also Rossi 1994, pp. 99–102, no. 28.
4. Urbino, Soprintendenza, Gabinetto fotografico, neg. no. 2645B.
5. Patrizi 1928, pp. 27–28.

Bibliography
Rankin 1909, p. lxxxiii, repro. p. lxxxii (transitional style, north Italian); Berenson 1913, p. 12, repro. p. 238 (school of Fra Angelico, Umbrian follower); Philadelphia 1920, p. 2 (school of Fra Angelico); Van Marle, vol. 10, 1928, p. 161 (distantly connected with Fra Angelico); Johnson 1941, p. 1 (immediate follower of Fra Angelico); Sweeny 1966, pp. 3–4, repro. p. 108 (Umbrian follower of Fra Angelico); Fredericksen and Zeri 1972, p. 9 (follower of Fra Angelico); Philadelphia 1994, repro. p. 200 (Italian, active Marches, c. 1420)

SIENESE SCHOOL, C. 1904

PLATE 94 (PMA 1919-447)

Triptych: (center) *Virgin and Child Enthroned with Angels and Candle Bearers;* (center gable) *God the Father;* (left wing) *Saint Bernardino of Siena;* (right wing) *Female Saint*

c. 1904, in a fourteenth- and fifteenth-century manner

Aqueous medium (possibly tempera) and tooled gold on panel; overall 24¼ × 20⅛ × 1⅛″ (61.5 × 56.1 × 2.8 cm); center 24¼ × 28¼″ (61.5 × 28 cm); left wing 23⅜ × 5½″ (59.4 × 14.1 cm); right wing 23¾ × 5⅜″ (60.5 × 13.7 cm)

Philadelphia Museum of Art. Gift of John Harrison, Jr. 1919-447

TECHNICAL NOTES
The center section consists of one panel, whereas the wings are pieced together from several panels probably taken from an old piece of furniture or flooring. The moldings and foliate decoration are glued on. All the painting was executed on top of gilding over gesso. The gold is punched, in some cases with a roulette, and some of the decoration is in sgraffito. There is considerable flaking in the center section and the left wing, with the underlying gold and gesso showing through. In the right wing, the lower left corner is lost.

PROVENANCE
Probably purchased in Siena in the early 1900s by John Harrison, Jr., who donated it to the Museum in 1919. A similarly decorated leather book cover was given by Harrison and another member of his family in the same year.[1]

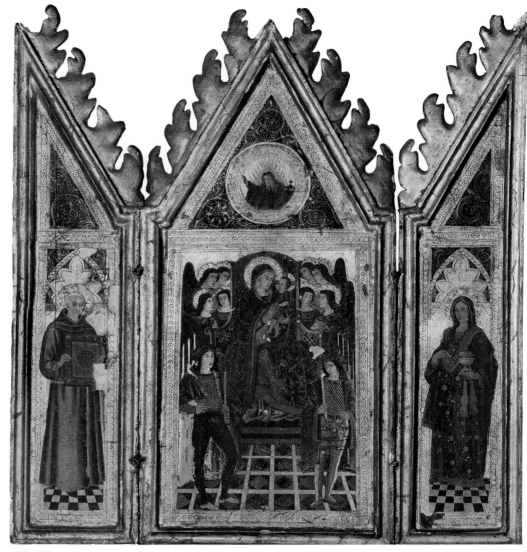

PLATE 94

COMMENTS
The painting was made in the early twentieth century in imitation of fourteenth- and fifteenth-century Sienese styles. The central group is a copy of Pietro Lorenzetti's (q.v.) *Virgin and Child with Angels* of 1343 in the Uffizi,[2] and Saint Bernardino in the left wing is based on Sano di Pietro's (q.v.) 1451 mural in the Palazzo Pubblico of Siena.[3] By contrast, the costumes of the candle bearers in the central panel are reminiscent of the pseudo-Renaissance costumes designed in 1904 for the famed Siena horse race known as the Palio.[4] This particular style was termed affectionately in Siena the *stile panfortesco*, after its resemblance to the wrappers for *panforte* cakes, a local specialty, with their mix of Italian Liberty and Renaissance motifs.[5]

The Philadelphia picture was probably never sold as an original work of art. It is typical of paintings made in an old style for tourists to Siena around the turn of the century, when there were enough British and American visitors to the town to support the publication of a weekly newspaper in English. Any number of shops sold such paintings, which became particularly popular in 1904, when a great exhibition of Sienese art was held in the Palazzo Pubblico. That same year a parallel exhibition of Sienese art in British collections was put on at the Burlington Fine Arts Club in London.

In this period the most renowned painter of both outright fakes and consciously modern imitations of older art was Icilio Federico Joni (1866–1946), who even redesigned the Renaissance costumes for five *contrade,* or neighborhoods, that ran in the Palio in 1928. His imitations of older art were produced in connection with the Regio Istituto Provinciale di Belle Arti di Siena as a way of promoting Sienese art abroad. They are, however, of much higher quality than this triptych, which is the work of an anonymous hand.

1. Frinta 1982, fig. 10 (erroneously as location unknown).
2. Inv. 445; Volpe 1989, fig. 135.
3. Berenson 1968, plate 352.
4. See Siena 1987, fig. 6. On the history of the Palio costumes, see Comucci 1926, pp. 124–25; Giovanni Cecchini in Falassi and Cantoni 1982, p. 343; and Siena 1987.
5. Siena 1987, fig. 62.

Bibliography
Philadelphia 1994, repro. p. 209

APPENDIX I: DOCUMENTS

PLATE 12

DOCUMENT 1
February 17, 1423

Presbiter Lucas quondam Iacobi rector ecclesie Sancti Quirici ad olivum Lucane. [——] rector cappellanie perpetue et altare Sancte Lucie in ecclesie Sancti Iohannis maioris constitute que dicitur de Spiafamis de Luca congnoscens se . . .

[line 17] . . . ad reparationis et istaurationis tectorum et per ornatu ecclesie predicte pro uno[?] decorare sumptuosa tabula picta cum ymaginibus sanctorum ad altarem maius dicte acclesie missale novo et optimo pretioso et calice pulcerrimo de argento et per istaurationem paramenti

(Presbyter Luca of the late Jacopo rector of the church of San Quirico all'Olivio in Lucca [——] the rector and chaplain of the altar of Saint Luke in the church of San Giovanni Maggiore degli Spiafami in Lucca agrees that [he will pay]

[line 17] … for the repair and installation of the roof, and for the ornament of the said church, a sumptuous painted panel with images of saints for the high altar of the said church, a new, precious, high-quality missal, a very beautiful silver chalice, and the repair of the vestments.)

[line 1] . . . confidat et sperat videlicet *[in the margin: dominum Andrea et magister Nicolaus et fratres]* quos ministros et executores constituit ad perfici faciendi dictam tabulam iam per ipsum factam et convenutam fieri de lignamine cum Mariano Micheli de Pisis Luce morante trahet et quam illam pingi et ornari faciant et poni et actari super dicto altari Sancte Lucie cum omnia sua dependentia more alteram qui est ad altare Sancti Eustachii trad[——].

Item etiam unam statuam de terra cocta figure et ymaginem Sancte Lucie ornatam sicut decet collocandam super muro qui est apud dicto altare cum omnem dependentiam.

([line 1] … it is hoped that [in the margin: Don Andrea and Master Nicholas and the friars] *that the administrators and executors will see to the making of the said panel by Mariano di Michele of Pisa, resident of Lucca as he usually does, and that it* [the panel] *be ornamented and painted and placed on the altar of Saint Luke with all its accoutrements in like manner to the altar of Saint Eustache.*

And also that a painted terracotta statue of Saint Luke be placed on the wall in front of this altar with all its accoutrements.)

Lucca, Archivio Arcivescovile, *Libri antichi di cancelleria, Instrumenta seu Rogitus Ioannis Thieri*, n. 52, cc. 147 recto, 148 recto. For a summary, see Concioni, Ferri, and Ghilarducci 1994, p. 190, no. 1013.

DOCUMENT 2
December 10, 1651

Eadem die [——] prosequendo Suam Visitationem accessit ad ecclesiam S. Quilici dicti all Olivo ecclesia . . .

Visitavit Altare maius sub titulo eiusdem Sancti Quilici Icona Habet Imaginem Beate Marie et S. Quilici, et aliorum Sanctorum in ornamento Ligneo

(And following his visitation to the church of San Quirico all'Olivo . . .

He visited the high altar which is dedicated to Saint Quirico and has an icon with the image of the Blessed Mary and Saint Quirico, and other saints on decorated wood.)

Lucca, Archivio Arcivescovile, *Visite pastorali*, 43 (1650–56), c. 1197 verso (new c. 1213).

PLATE 34

1460

Anne dati a dì 24 di Dicembre ll. sedici e quali sono per tanti buoni per noi e la chiesa di santo pietro ovile per detto Antonio di Stefano sopradetto e quali ll. 16 che giovanni e bartolomeo accordana a matteo dipentore sta ala postierla e sono achonti ala chiesa di santo pietro ovile delle decime. . . . L. 113. s. 16

(Paid December 24, sixteen lire, which are for the many vouchers for us [the Hospital of Santa Maria della Scala] *and the church of San Pietro Ovile from the abovementioned Antonio di Stefano. Giovanni and Bartolomeo gave the said 16 lire to Matteo the painter, who lives at the Postierla, and they have been credited to the church of San Pietro Ovile for the tithes. . . . Lire 113. soldi 16.)*

Siena, Archivio di Stato, Ospedale, no. 569, 1455–60, Q, folio 285.

Published: Bacci 1944, p. 242.

1461

Mo. Matheio di Giovanni dipentore die avere a dì v di ferraio e quindi sono i quali ll. quindici soldi o i quali questo dì gli facciamo buoni per la chiesa di san Pietro Ovile per decime deve avere di Ravaciano[?] e sono a chonci a detta chiesa a libro delle decime . . . L. 113 s. 15.

(Master Matteo di Giovanni, painter, is owed on February 5th fifteen lire and zero soldi for the tithes that are owed from Ravaciano[?] and they are put on the account of the said church in the book of tithes . . . Lire 113 soldi 15.)

Siena, Archivio di Stato, Ospedale, no. 564, 1455–60, Q, folio 373.

Published: Bacci 1944, p. 242; Ludwin Paardekooper in Gasparotto and Magnani 2002, p. 94.

PLATE 39

The discussion and vote of the Sienese General Council on the financing of an altarpiece for the church of San Clemente a Santa Maria dei Servi, Siena

October 16, 1319

Pro Priore & conventu fratrum Servorum Sanctae Marie In nomine Domini, amen. Anno ab incarnatione Domini MCCCXVIIIJ, indictione tertia die sextadecima mensis octubris, secundum morem et consuetudinem civitatis Senarum, Generali consilio campane et quinquaginta per terserium de radota civitatis et communis Senensium. In palatio dictae communis sono campane voceque preconia, de mandato magnifici et egregii viri domini Benedicti Ghaytani de Anania, comitis palatini, Dei gratia honorabilis potestatis communis Senensis, more solito congregato facta prius imposita de infrascriptis omnibus et singulis propositis seu propositae articulis de conscientia et consensu omnium dominorum quatuor provisorum communis Senarum, nobilis ac prudens Miles dominus Laurentius de Velletro Judex collateralis et dicti domini comitis potestatis absente a dicto consilio domino comite potestate predicto, in presentia tandem nobilis et potentis militis domini Thomassi domini Petri domini Thome de Filis Manetio de Trievo Dei gratia laudabilis capitanus communis et populi defensoris societatum et vicariatum civitatis Senarum, et sapientium ac discretorum virorum domini Açure de Meuania Judicis dicti domini capitani, et domini Bindi Angeli de Montefalcho, Judicis minoris sindici communis Senensis proposuit in dicto consilio et ab ipso consilio, consilium postulauit quod cum per dominos Novem gubernatores et defensores communis et populi Senensium prima die et postea sequenti die per ipsos dominos Novem & alios ordines civitatis Senarum, sit et fuerit sollemniter obtentum, stantiatum, decretum atque firmatum ad scrutinium ad bussolos et palloctas secundum formam statuti Senensis super infrascripta petitione cuius tenor talis est videlicet. Coram vobis viris sapientibus et discretis dominis Novem gubernatoribus et defensoribus communis et populi civitatis Senarum proponunt et dicunt prior et conventus fratrum ordinis Servorum beatae Virginis de Senis, quod ipsi ad laudem et reuerentiam Virginis gloriose ad cuius honorem eorum ecclesia est fundata fieri faciunt quemdam Tabulam in qua pingitur ymago beatae Virginis et eius filii benedicti, domini nostri Jhesu Christi, in ornamentum ecclesiae supradictae, et in consolationem eorum qui ad ipsam accedunt ecclesiam ad divina officia audendum, quae tabula quia ipsam sicut decus honorabilem fieri faciunt ad laudem Virginis suprascriptae costabit Trecentum libre et ultra denariorum Senensium minutorum. Quare cum dicti prior et conventus sint adeo pauperes que dictam tabulam solvere de suo non possent nisi ad hec dexteram communis quae nunquam eis in necessitatibus defuit se extendat, et nisi eis a piis et bonis personis civitatis Senarum, adiutori et subuentionis brachium

extendatur, supplicant vobis qui estis salus, refugium et conservatio communis et populi Senensium et religiosorum et pauperum dictae civitatis et comitatus ipsius, predicti Prior et conventus com omni deuotione qua possunt, quatenus intuitu misericordie et pietatis, et ad honorem et reuerentiam Virginis gloriose, et salvatoris nostri Jhesu Christi, vobis placeat et uelitis dexteram communis Senensis, dictis Priori et fratribus aperire et per vestrum salubre consilium et per consilium campane communis et populi civitatis Senarum, et per alia consilia oportuna firmare et stantiare et firmari et stantiari facere per illam viam et modum quibus videbitis convenire quod dictis priori et conventui pro dicta tabula fieri facienda illa pecunie quantitate, de pecunia communis Senensis pro elymosina quae sapiente uestre videbitur convenire et quod domini camerarius et quatuor provisores communis Senensis qui sunt vel erunt pro tempore teneantur et debeant ipsis prior et conventui dare de pecunia communis Senensis illam pecunie quantitatem qua uobis et uestro consilio videbitur convenire pro dicta tabula fieri facienda ad hoc quod dicta tabula compleri possit ad laudem Virginis gloriose et eius filii benedicti salvatoris domini nostri, ut ipsa gloriosa Virgo roget filium suum dominum nostrum ut civitatem et populum Senenses in pace et in unitate ac bona prosperitate conservet, Deus per sui gratiam vobis semper concedat id facere quod sit ad laudem sui sanctissimi nominis, salutem et pacificum statum communis et populi civitatis Senarum, augumentum et conservationem vestri officii.

Quod de pecunia communis Senensis mictantur et soluantur in solutione et summa pretii dictae tabulae de qua fit mentio in suprascripta petitione Centum libre denariorum Senensium modo et terminis infrascriptis uidelicet quod domini camerarius et quatuor provisores communis Senensis qui modo in officio president, debeant dare et soluere pictori dictae tabulae de pecunia communis Senensis pro pretio dictae tabulae viginti quinque libras denariorum Senensium. Et domini camerarius et quatuor provisores communis Senensis qui a kalendis januarii venturis usque ad kalendas julii sequentes in officio presidebunt dare et soluere teneantur et debeant prefato pictori dictae tabulae de pecunia communis Senensis alias uiginti quinque libras denariorum Senensium ex causa supradicta, et successive ita quodlibet officium dominorum camerariorum et quatuor provisorum communis senesis qui postea fuerint in officio uiginti quinque libras denariorum dare et soluere debeant, quousque dicta summa et quantitas centum librarum denariorum Senensium de pecunia communis Senensis dicto pictori dictae tabulae pretio dictae tabulae fuerint integre prosoluta, prout de predictis in dictis stantiamentis et decretis dictorum dominorum Novem et aliorum ordinum civitatis senarum scriptis ut dicitur manu Johannis Bonauenture notarii et scribe dicitur dominorum Novem et lectis in presenti consilio in vulgari sermone per me Franciscum Lanfranchi domini Genovensis della Volpe de Luca notarium officialem et scribam communis Senensis super reformationibus consiliorum dicti communis plenius ac latius continetur. Si videtur et placet dicto presenti consilio quod auctoritate, vigore, potestate et baylia huius presenti consilii de pecunia communis Senensis mictanturet solvantur in solutionem et summam pretii dictae tabulae de qua in suprascripta petitione fit mentio, centum libre denariorum Senensium modo et terminis in predictis stantiamentis et decretis dictorum

dominorum Novem et aliorum ordinum civitatis Senarum contentis, declaratis et specificatis. Et quod datio et solutio ipsarum librarum centum denariorum fiat et fieri possit et debeat de pecunia et avere communis Senarum per dominos camerarios et quatuor provisores communis Senarum de quibus et prout in dictis stantiamentis et decretis mentio fit, modis tamen et terminis supradictis pictori dictae tabulae de et pro pretio dictae tabulae et ex summa pretii dictae tabulae, prout in ipsis stantiamentis et decretis plenius continetur. Et quod dicta petitio prioris conventus fratruum predictorum et predicta stantiamenta et decreta dictorum dominorum Novem et aliorum ordinum civitatis Senarum, et omnia et singula in eis contenta declarata specificata et quodlibet eorum sint et esse intelligantur et debeant auctoritate et uigore huius presenti consilii firma, rata et valida. Et quod fieri procedat et antevadat et executioni et effectum demanderetur ad plenum in omnibus et per omnia prout et sicut in ipsis petitione, decretis et stantiamentis et quodlibet eorum plenius ac latius continetur et mentio fit in Dei nomine consulatis.

Mannus Guidi Ormanni surgens in dicto consilio ad dicitorium arringando super dicto primo dictae propositae articulo de facto dictae petitionis dictorum Prioris et conventus dictorum fratrum ordinis Servorum beatae Virginis de Senis, et dictorum stantiamentorum et decretorum dictorum dominorum Novem et aliorum ordinum civitatis Senarumsuper dicta petitione factorum et super hijs quae et de quibus in ipsis primo dictae propositae articulo petitione, stantiamentis et decretis continetur et mentio fit dixit et consuluit quod ita sit firmum et ratum et fiat observetur, procedat et antevadat et executioni et effectum demanderetur ad plenum, in omnibus et pro omnia prout et sicut in dicto primo dictae propositae articulo et in dictis petitione, stantiamenta et decretis plenius ac latius continetur et mentio fit.

Summa et concordia predicti consilii super dicto primo dictae propositae articulo de facto dictae petitionis dictorum prioris et conventus dictorum fratrum ordinis Servorum beatae Virginis et dictorum stantiamentorum et decretorum dictorum dominorum Novem et aliorum ordinum civitatis Senensis et super ipsis petitione stantiamentis et decretis et hijs quae et de quibus in eis continetur et mentio fit fuit voluit et firmauit secundum formam statutis Senensis cum dicto consilio et secundum dictum decretum et consilium dicti Manni consultoris, et fuit dictum consilium in concordia hoc modo videlicet quia facto et misso de predictis et super predictis sollenni et diligenti scrutinio et partito ad bussolas et palloctas secundum formam capituli consilii dicti communis Senensis positi sub rubrica qualiter fieri debeant expense communis per consiliarios in dicto consilio existentes et se cum decreto et consilio dicti Manni consultoris ad hec concordantes misse et reperte fuerint in bussolo albo del si centum nonaginta quatuor pallocte et in bussolo nigro del no in contrarium misse et reperte fuerint quindecim pallocte et sic dictum consilium fuit et est obtentum, firmatum et reformatum secundum formam statutis Senensis secundum dicti consilii dicti Manni consultoris ut supra pateat et plenius continetur.

Siena, Archivio di Stato, *Consiglio generale*, 92, folios 121 verso–122 verso. I thank Rolf Bagemihl for help with this transcription and those that follow for this entry.

Payments disbursed by the Sienese government toward the cost of an altarpiece for the church of Santa Maria dei Servi

December 31, 1319

Aconto xxv libre al convento de frati Servi Sancte Marie di Siena per aiuto ala loro tavola e detti denari lo demmo per forma dela riformagione del consiglio dela campana

Siena, Archivio di Stato, *Biccherna,* 138, folio 132, fourth entry.

June 31, 1321

Item xxv libre fratribus Servorum Sante Marie pro residuo centum librarum sibi concessarum per reformationem generalis consilii campane communis Senarum occasione cuiusdam tabule ut de dicta reformatione consilii patet manu ser Nicolai Andree notarii

Siena, Archivio di Stato, *Biccherna,* 140, folio 189, second entry.

December 31, 1321

Anco Al Convento de Frati de Servi Sante Marie i quali vintiecinque libre ebero per Dio per fare & compire i=loro choro per istançamento di conselgio di champana auemo lo stançamento Apo noi xxv lb

Siena, Archivio di Stato, *Biccherna,* 142, folio 166, fourth entry.

December 31, 1321

Item xv lb Conventui fratrum Servorum Sancte Marie quas vigintiquinque libras habuerunt pro deo pro faciendo & complendo coro eorum per stantiementum consilii campane habemus stantiamentum apud Nos

Siena, Archivio di Stato, *Biccherna,* 143, folio 106, fourth entry.

December 31, 1322

Anco al couneto de frati Servi Sante Marie da Siena i quali cinquanta libre lo fuoro dati per lo conseglio dela campana per Dio per limosina & pieta Aparne istançamento fecie fare dono Jacomo Camar[lengo][1]

1. A monk from San Galgano.

Siena, Archivio di Stato, *Biccherna,* 145, folio 149, second entry.

A line in the following entry concerns some money owed by the Sienese government to the friars of Santa Maria dei Servi, which may refer to the altarpiece:

February 14, 1323 (modern style)

dono Jacomo camarlingo die dare adi xiiii di feraio i quali denari fiorini trenta d'oro demo in sua mano contanti ch'auemo dala corte nuova scritte che debemo auere inançi fo. lxxiiij in ciento libre & diecie s. . . .

Anco Avemo Avuto nel di i quali die per noi a frati Serui Sante Marie in cinquanta libre sono a'escita L'utimo di ~~di fera~~[1] dicienbre entrata xx fiorini d'oro [2]

1. The scribe started to write the month of February but canceled this word in the original and entered "December" instead.
2. "Fiorini d'oro" (gold florins) is probably a slip for "fiorini," or simple florins.

Siena, Archivio di Stato, *Biccherna*, 384, folio LI verso (modern folio 52 verso).

Appeal of the Canons of the Basilica of Santa Maria Maggiore and Cardinal Jean Rochetaillé, Archpriest, Asking Pope Martin V to Convert Two Bequests to Other Uses

Rome, May 28, 1428[1]

Universis praesentes litteras inspecturis. Antonius miseratione divina sacrosanctae Romanae Ecclesiae tituli Sancti Marcelli presbyteri cardinalis salutem in domino et presentibus fidem indubiam adhibere notum facimus quod die date presentium exposito sanctissimo Domino nostro Domino Martino diuina providentia Papae Quinto, pro parte Reverendissimi in Christo patrium & domini Johannis eadem miserationae Santae Romanae Ecclesiae Presbyteri cardinalis Rothomagensis nuncupati Archipresbyteri Beatae Mariae Maioris de Urbe, necnon venerabilium virorum canonicorum et capituli eiusdem Ecclesiae, quod dudum bonae memoriae Dominus Petrus etc <u>Sanctae Mariae in Dompnica</u> [sic] Sanctae Romanae Ecclesiae Dyaconus cardinalis in suo ultimo testamento et alias legauit et donauit legaueratque ecclesiae predictae pro erigendo in altum corpus Beati Jeronimi Presbyteri confessoris sanctae Dei ecclesiae excellentissimi doctoris in eadem ecclesia iacentum ante cappellam gloriose Virginis Marie dictam ad presepe sub quodam Altari sub ipsius Sancti Jeronimi nomine erecto, <u>Centum Xorenos, et quia</u> in capsa argentea at alie honorabiliter eleuaretur supra dictum Altare ut ibi honorificentius veneraretur. Quod qui dicti centum floreni sic legati nec multo plures subficere possent ad erectionem premissorum et ipsa capsa in retectatione et alias indigebat multis reparationibus satis prope dictam summam, et si aliquid residui foret Ecclesiae ipsa quae adeo sumptuoso edificio fuerat primitis constructa quae, retineretur in debito esse fabrica illius non habebat <u>nec possidebat</u> et minus ipsi Archipresbyter et capitulum, et rationaliter residuum in necessariis reparationibus Ecclesiae possit et debeat applicari et verissimiliter ita intellexisse et voluisse dictum Dominum cardinalem ubi demonstrata intentio impleri non poterat sicut non potest. Et insuper quod etiam bonae memoriae Dominus Raynaldus etc Sancti Viti in Macello Sanctae Romane Ecclesiae Dyaconus Cardinalis, de Brancaciis vulgariter nuncupatus, Archipresbyter dictae Ecclesiae Beatae Marie Maioris dum uiueret eidem Ecclesiae legauerat semel et donauerat XXV. Ducatos siue florenos de camera semel solvendos pro uno calice fieri faciendo siue fiendo in dicta Ecclesia, a qua et in qua multas utilitates et honores consecutus fuerat per plures annos in quibus fuit Archipresbyter eiusdem Ecclesiae, et quod eadem Ecclesia pro presenti tali calice non indigebat, cum habundet in calicibus et fere decem uel duodecim habeat, sed quod in dictam reparationem et ruinositatem dictae Ecclesiae applicarentur et applicari possent et deberent, supplicando humiliter eidem Domino nostro quatenus dictos centum Ducatos de haereditate et ab executoribus et haeredibus dicti [domini (?)] [Ve]neciarum junioris, necnon consimiliter ab haeredittate executoribus et haredibus dicti Domini de Brancaciis dictos vigintiquinque florenos posse et debere leuare petere exigere et requirere per se uel deputatos ab eis seu noninibus eorum, eorumque haereditates haeredes et executores ac bona cuiuslibet eorum tamquam propriis legatum ad salutem animarum suarum relictum, fuisse et esse obligatos et bona ipsa propter hoc ypothecata. Et propter hoc posse agere in quocumque iudicio coram quibuscumque judicibus tam ecclesiasticis quam secularibus et in judicio stare et persequi usque ad plenam satisfactionem cum dampnis et expensis si quae sequerentur culpa et defectu haeredum aut executorum predictorum et sic recuperata reparata dicta cappella Sancti Jeronimi residuum dictorum centum florenorum una cum dictis vigintiquinque libere et licite applicare et conuerti in reparctionibus et ruinis magis necessariis dictae Ecclesiae de quibus eis uidebitur converti et applicari possent et valerent, et quod litteras cuiusmodi tenoris et alias opportunas sub sigillo nostro harum petitionem suarum predictarum cum responsione et concessione prefati Domini nostri quae fidem facere possent et deberent in quocumque judicio et extra ac coram quibuscumque personis ecclesiasticis et saecularibus ac si sub Bulla Apostolica confecte et expedite fuissent conficere et in meliori et efficaciori forma qua fieri posset ad euitandum diminutionem ipsarum pecuniarum quae necessarie sunt nec sufficiant ad reparationes predictas dare facere et expedire teneamur et debeamus pro tali et tanto bono decernere et declarare statuereque et ordinare sua sanctitas dignaretur cum clausulis opportunis. Prefatus igitur Dominus noster predictus sic ut prefertur expositi auditisque et intellectis ponderat omnibus cum circumstancijs pia consideratione motus, omnia et singula premissa quae ut supra narrantur petita fuerunt dicto Reuerendissimo Patri Domino Cardinali Archipresbytero et capitulo concessit et annuit, voluitque atque ordinauit atque decreuit et statuit ita fieri et totaliter impleri, per nosque super his fieri litteras opportunas et necessarias jucta ipsorum petitionem et requestam totiens quoteins requisiti fuerimus et fuissemus, quod iuxta ipsius Domini nostri mandatum fecimus et tenemur, quod ad vestram et quorumlibet quorum interest interesseque potest vel poterit in futurum et specialiter haeredum et executorum et bona tenentium dictorum Dominorum noticiam deducimus per presentes decernentes juxta eiusdem mandatum huiusmodi litteris nostris et contentis in eisdem fidem debere adhiberi ac etiam facere in quocumque Judicio et extra inter quascumque personas et ubicumque cum clausulis necessarijs et dependens quas pro expressis et specificatis habemus et adhberit volumus. In quorum testimonium presentes litteras fieri et concedi ac per nostrum secretarium more in similibus solito subscribi nostrique sigilli propensione voluimus atque mandauimus communiri. Datum et Actum Romae in domibus nostrae solitae residentie, sub anno Domini Millesimo quadrigentesimo vicesimo octauo die vicesimaquarta maii indictione VI.ta Pontificatus prefati Sanctissimi Domini nostri Martinj Pape quinti Anno undecimo

Gregorius secretarius prefati Reverenissimi domini cardinalis S. Marcelli subscripsit.

1. Underlining indicates words that were erased and corrected on the parchment.

Vatican City, Biblioteca Apostolica Vaticana, Santa Maria Maggiore, cartella 72, no. 190 [previously Pergamena, D II, 135 sigillo]. A transcription is also in Giuseppe Bianchini, *Historiae Basilicae Liberianae*, vol. 10, cc. 265 recto–267 verso, Rome, Archivio del Capitolo di Santa Maria Maggiore, Ms. 443. A summary is in Ferri 1907, p. 158. I thank Rolf Bagemihl for help with this transcription.

APPENDIX II: PUNCH MARKS

The standard of measurement is in millimeters,
shown in varying degrees of magnification.

ALLEGRETTO DI NUZIO
PLATES 1A–E (JC CAT. 5)

Saint Stephen's halo

Virgin's halo

Bishop Saint's halo

Christ's halo

PLATE 2 (JC CAT. 2)

Female martyr's halo

Upper-right border

Saint Lucy's halo

PLATE 3 (JC CAT. 119)

Virgin's halo

PLATE 4 (JC CAT. 118)

Man of Sorrows' halo

Virgin's halo

Christ Child's halo

ANDREA DI BARTOLO

PLATE 5 (JC CAT. 99)

PLATE 6A (JC CAT. 96)

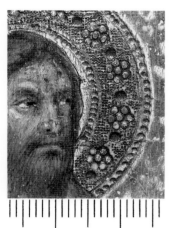

Saint John the Baptist's halo

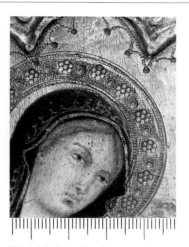

Virgin's halo and border

Saint James Major's halo

Halo and border

FRA ANGELICO

PLATE 8 (JC CAT. 14)

Halo

Arrigo di Niccolò

PLATE 11 (PMA 1950-134-528)

Halos of Saints Benedict and John the Evangelist

Halos of Saints Sebastian and Stephen

Textile on ground

Battista di Gerio

PLATE 12 (JC CAT. 12)

Virgin's halo

Christ Child's halo

Attributed to Benedetto di Bindo

PLATE 13 (JC CAT. 153)

Virgin's pillow

Saint Jerome's halo

Workshop of Bicci di Lorenzo

PLATE 14 (JC CAT. 7)

Virgin's halo

Bartolomeo Bulgarini

PLATE 15 (JC CAT. 92)

Border and Saint Savinius's orphrey

Annunciate Angel's halo and border

Cenni di Francesco

PLATE 16A (JC INV. 1290)

Center division

Gilt background of left scene

PLATE 16B (JC INV. 1291)

Christ Child's halo

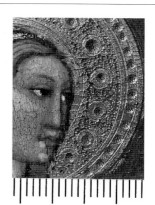

Virgin's halo

Bernardo Daddi

PLATE 17 (JC INV. 344)

Saint John the Baptist's halo

Halos of the Virgin and the Christ Child

Saint Giles's halo

PLATE 18 (JC CAT. 117)

Halo

Domenico di Bartolo

PLATE 21 (JC CAT. 102)

Right border

Virgin's halo

Christ Child's halo

Duccio

PLATE 23 (JC CAT. 88)

Francesco di Vannuccio

PLATE 25 (JC CAT. 94)

Halo

Virgin's halo and left border

Right border

Upper-left border

Agnolo Gaddi

PLATE 26 (JC CAT. 9)

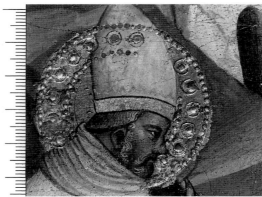

Saint Sylvester's halo

Upper-left corner

NICCOLÒ DI PIETRO GERINI

PLATE 27 (JC CAT. 8)

Christ's halo

PLATE 28 (JC INV. 1163)

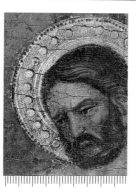

Halo of saint (far left)

GIOVANNI DI PAOLO

PLATE 32A (PMA 1945-25-121)

Decoration on Saint Lawrence's tunic

Halo

GIOVANNI DI PIETRO

PLATE 34A (JC CAT. 107)

Joseph's halo

PLATE 34B (JC CAT. 108)

Halos of Anne and Joachim

JACOPO DI CIONE

PLATE 37 (JC CAT. 4)

Halo of angel (left)

PLATE 38 (JC CAT. 6)

Saint Louis of Toulouse's halo

Saint Catherine of Alexandria's dress

Saint Catherine of Alexandria's halo

Lorenzo Monaco

PLATE 40 (JC CAT. 10)

Christ Child's halo

Pillow

Virgin's halo

Attributed to Martino da Verona

PLATE 42 (JC INV. 3024)

Eagle

Martino di Bartolomeo

PLATE 43C (PMA 1945-25-120a)

Saint Barnabas's halo

Masaccio and Masolino

PLATE 44A (JC INV. 408)

Saint Paul's halo

Saint Peter's halo

Saint Peter's collar

MASACCIO AND MASOLINO

PLATE 44B (JC INV. 409)

Saint Martin's orphrey

Saint John the Evangelist's halo

Saint Martin's halo and orphrey

MASTER OF CARMIGNANO

PLATE 45 (PMA 1950-134-527)

Virgin's halo

Coat of arms (right)

MASTER OF 1419

PLATE 48 (JC CAT. 21)

Christ Child's halo

Virgin's halo

MASTER OF MONTELABATE

PLATE 50 (PMA 1952-1-1)

Christ's halo

MASTER OF THE OSSERVANZA

PLATE 52 (JC INV. 1295)

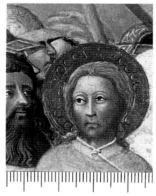

Christ's halo

MASTER OF THE POMEGRANATE

PLATE 54 (JC CAT. 36)

Virgin's hem

MASTER OF STAFFOLO

PLATE 55 (JC CAT. 121)

Saint Francis's halo

MASTER OF THE TERNI DORMITION

PLATE 56 (JC CAT. 123)

Halo of angel (top left)

Cloth on the throne to the right of Christ

Christ's halo

NERI DI BICCI

PLATE 59 (JC CAT. 27)

Gilt embellishment near the Virgin's right hand

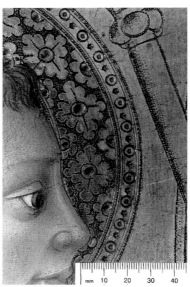

Saint Michael Archangel's halo and Saint Augustine's crozier

Halos of Saints Margaret and Catherine of Alexandria

NICCOLÒ DI SEGNA

PLATE 61 (JC CAT. 90)

Upper-right border

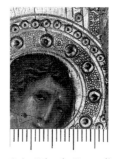

Saint John the Evangelist's halo and the right border

NICCOLÒ DI TOMMASO

PLATE 62 (JC CAT. 120)

Saint James Major's halo (left wing)

Base with Virgin and Christ Child

Saint John the Evangelist's halo (right wing)

NICOLA D'ULISSE DA SIENA

PLATE 63A (JC CAT. 103)

Halo

Left background

PLATE 63B (JC CAT. 104)

Halo

ANTONIO ORSINI

PLATE 64A (JC CAT. 98a)

Halo

PIETRO DI DOMENICO DA MONTEPULCIANO

PLATE 66 (JC CAT. 1170)

Halo

Upper-right border

Pietro di Miniato

PLATE 67 (PMA 1950-134-532)

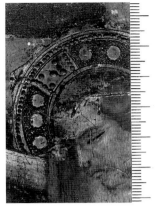

Christ's halo

Saint John the Evangelist's halo

Pseudo–Pier Francesco Fiorentino

PLATE 69 (JC CAT. 41)

PLATE 70 (JC CAT. 40)

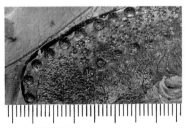

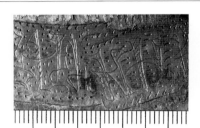

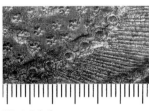

Christ Child's halo

Virgin's collar

Virgin's halo

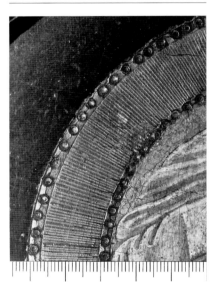

Virgin's halo

PLATE 71 (JC CAT. 39)

PLATE 72 (JC CAT. 42)

Halos of the Virgin and Christ Child

Virgin's halo

Sano di Pietro

PLATE 73 (JC CAT. 106)

Halos of the Virgin and angel

Starnina

PLATE 76 (JC CAT. 13)

Shroud

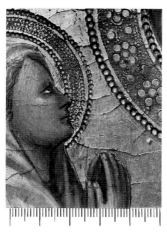

Halos of the Virgin's soul and Christ

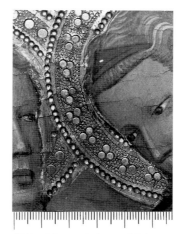

Halos of the angels (upper right)

Zanobi Strozzi

PLATE 77 (JC CAT. 22)

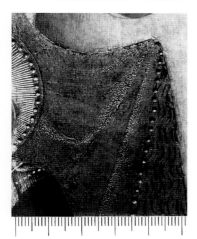

Virgin's halo and cloth of honor

Taddeo di Bartolo

PLATE 78 (JC CAT. 95)

PLATE 79 (JC CAT. 101)

Christ's halo

Upper-right border

Saint Anthony Abbot's halo

Chalice and Saint Thomas Aquinas's halo

TOMMASO DEL MAZZA

PLATE 80 (PMA 1945-25-119)

Virgin's halo and border

UGOLINO DI NERIO

PLATE 84 (JC CAT. 89)

Halo

VITALE DA BOLOGNA

PLATE 85 (JC CAT. 1164)

Saint John the Evangelist's halo

SIENESE SCHOOL, C. 1400

PLATE 91 (JC CAT. 100)

Angel (lower right)

Hem of the Virgin's mantle and the floor

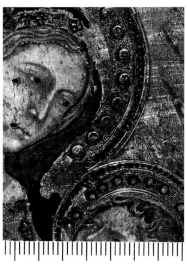

Halos of the Virgin and Christ Child

Bibliography

Bibliographical Abbreviations

AA.SS.
Joannes Bollandus, ed. *Acta sanctorum quotquot toto orbe coluntur, vel a catholicis scriptoribus celebrantur quæ ex latinis et græcis, aliarumque gentium antiquis monumentis.* 67 volumes. Paris, 1845–1949.

DBI
Dizionario biografico degli italiani. Vol. 1–. Rome, 1960– .

DIP
Dizionario degli istituti di perfezione. 10 vols. Rome, 1974–2003.

Abbigliamento 1962
Abbigliamento e costume nella pittura italiana: rinascimento. Rome, 1962.

Acidini Luchinat 1992
Cristina Acidini Luchinat, ed. *I restauri nel Palazzo Medici Riccardi: rinascimento e barocco.* Florence, 1992.

Acidini Luchinat 1993
Cristina Acidini Luchinat, ed. *Benozzo Gozzoli: la cappella dei magi.* Milan, 1993.

Acidini Luchinat 1995
Cristina Acidini Luchinat, ed. *La cattedrale di Santa Maria del Fiore a Firenze.* Texts by Cristina Acidini Luchinat et al. Florence, 1995.

Acidini Luchinat 1996
Cristina Acidini Luchinat with Elena Capretti, eds. *La chiesa e il convento di Santo Spirito a Firenze.* Florence, 1996.

Acidini Luchinat and Neri Lusanna 1998
Cristina Acidini Luchinat and Enrica Neri Lusanna, eds. *Maso di Banco: la cappella di San Silvestro.* Milan, 1998.

Acts 1963
Problems of the Nineteenth and Twentieth Centuries. Acts of the Twentieth International Congress of the History of Art. Vol. 4. Princeton, 1963.

Adinolfi 1881
Pasquale Adinolfi. *Roma nell'età di mezzo.* 2 vols. Rome, 1881.

Adinolfi 1881–82
Pasquale Adinolfi. *Roma nell'età di mezzo.* 2 vols. Rome, 1881–82.

Agosti et al. 1998
Barbara Agosti, Giovanni Agosti, Carl Brandon Strehlke, and Marco Tanzi. *Quattro pezzi lombardi (per Maria Teresa Binaghi).* Opuscoli edited by Sandro Lombardi, no. 10. Brescia, 1998.

Ahl 1980
Diane Cole Ahl. "Fra Angelico: A New Chronology for the 1420s." *Zeitschrift für Kunstgeschichte* (Berlin), vol. 43, no. 4 (1980), pp. 360–81.

Ahl 1981
Diane Cole Ahl. "Fra Angelico: A New Chronology for the 1430s." *Zeitschrift für Kunstgeschichte* (Berlin), vol. 44, no. 2 (1981), pp. 133–58.

Ahl 1981–82
Diane Cole Ahl. "Renaissance Birth Salvers and the Richmond *Judgment of Solomon.*" *Studies in Iconography* (Highland Heights, Ky.), vols. 7–8 (1981–82), pp. 157–74.

Ahl 1996
Diane Cole Ahl. *Benozzo Gozzoli.* New Haven, 1996.

Ahl 2002
Diane Cole Ahl, ed. *The Cambridge Companion to Masaccio.* Cambridge, 2002.

Alberti 1436, Grayson ed. 1973
Leon Battista Alberti. *De pictura,* in *Opere volgari* (pp. 5–107). Edited by Cecil Grayson. Vol. 3. Scrittori d'Italia, no. 254. Bari, 1973.

Albornoz 1990
Dall'Albornoz all'età dei Borgia: questioni di cultura figurativa nell'Umbria meridionale. Contributions by Federico Zeri et al. Atti del convegno di studi, Amelia, Teatro Sociale, October 1–3, 1987. Todi, 1990.

Alessi et al. 1990
Cecilia Alessi et al. *Lecceto e gli eremi agostiniani in terra di Siena.* Cinisello Balsamo (Milan), 1990.

Alessi and Martini 1994
Cecilia Alessi and Laura Martini, eds. *Panis vivus: arredi e testimonianze figurative del culto eucaristico dal VI al XIX secolo.* XXII congresso eucaristico nazionale. Siena, 1994. Exhibition, Siena, Palazzo Pubblico, Magazzini del Sale, May 21–June 26, 1994.

Alessi and Scapecchi 1985
Cecilia Alessi and Piero Scapecchi. "Il 'Maestro dell'Osservanza': Sano di Pietro o Francesco di Bartolomeo?" *Prospettiva* (Siena-Florence), no. 42 (July 1985; printed December 1986), pp. 13–37.

Alessio 1899
Felice Alessio. *Storia di San Bernardino da Siena e del suo tempo.* Mondovì, 1899.

Aliberti Gaudioso 1996
Filippa M. Aliberti Gaudioso, ed. *Pisanello: i luoghi del gotico internazionale nel Veneto.* Milan, 1996.

Allentown 1980–81
See Callmann 1980

Allgemeines Künstlerlexikon
Allgemeines Künstlerlexikon: Die bildenden Künstler aller Zeiten und Völker. Vols. 1–. Leipzig, 1983–.

Ambrosio 1994
Franco Ambrosio. *Masaccio.* Milan, 1994.

Amore 1965
Agostino Amore. "I santi Quattro Coronati." *Antonianum* (Rome), vol. 40, no. 2 (April 1965), pp. 177–243.

Amsterdam 1934
Amsterdam, Stedelijk Museum. *Italienische kunst in nederlandsch bezit.* Exhibition, July 1–October 1, 1934.

Amsterdam 1994
See Van Os et al. 1994

Angelini 1986
Alessandro Angelini. *Disegni italiani del tempo di Donatello.* Introduction by Luciano Bellosi. Florence, 1986. Exhibition, Florence, Gabinetto Disegni e Stampe degli Uffizi, 1986.

Anselmi 1893
Anselmo Anselmi. "Testamento del pittore Allegretto Nuzi da Fabriano." *Archivio storico dell'arte* (Rome), vol. 6 (1893), pp. 129–30.

Anselmi 1906
Anselmo Anselmi. "L'anno della morte e la chiesa ove fu sepolto Allegretto Nucci da Fabriano." *L'arte* (Rome), vol. 9 (1906), pp. 381–83.

Anselmi 1906a
Anselmo Anselmi. "Note d'arte antica marchigiana, II. Due ignoti pittori fabrianesi del quattrocento (Constantino e Pierfrancesco)." *Rivista marchigiana illustrata* (Rome), vol. 1, no. 6 (June 1906), pp. 190–92.

Antal 1925
Friedrich Antal. "Studien zur Gotik im Quattrocento: Einige italienische Bilder des Kaiser-Friedrich-Museums." *Jahrbuch der Preuszischen Kunstsammlungen* (Berlin), vol. 46 (1925), pp. 3–32.

Antal 1948
Frederick Antal. *Florentine Painting and Its Social Background: The Bourgeois Republic before Cosimo de' Medici's Advent to Power, XIV and Early XV Centuries.* London, 1948.

Antonino 1581
Antonino Pierozzi. *Summa sacrae theologiae.* Venice, 1581.

Antonino 1587
Antonino Pierozzi. *Chronicorum opus.* Lyon, 1587.

Arcangeli 1978
Francesco Arcangeli. *Pittura bolognese del '300: scritti di Francesco Arcangeli.* Introduction by Cesare Gnudi. Additional text by Pier Giovanni Castagnoli. Bologna, 1978.

Arezzo 1974
Arezzo, San Francesco. *Arte nell'aretino: recuperi e restauri dal 1968 al 1974.* Exhibition, December 14, 1974–February 2, 1975. Catalogue edited by Lionello G. Boccia, Carla Corsi, Anna Maria Maetzke, and Albino Secchi. Florence, 1974.

Arezzo 1979
Arezzo, San Francesco. *Arte nell'aretino: seconda mostra di restauri dal 1975 al 1979. Dipinti e sculture restaurati dal XIII al XVIII secolo.* Exhibition, November 30, 1979–January 13, 1980. Catalogue edited by Anna Maria Maetzke. Florence, 1979.

Arezzo 1987
Il Museo Statale d'Arte Medievale e Moderna in Arezzo. Texts by Anna Maria Maetzke et al. Florence, 1987.

Artaud de Montor 1843
Alexis-François Artaud de Montor. *Peintres primitifs: Collection de tableaux rapportée d'Italie.* Paris, 1843.

Artusi 1990
Luciano Artusi. *Le arti e mestieri di Firenze.* Quest'Italia: Collana di storia, arte e folclore, 150. Rome, 1990.

Artusi and Gabbrielli 1982
Luciano Artusi and Silvano Gabbrielli. *Guida storico artistica di Orsanmichele in Firenze / Historic and Artistic Guide to Orsanmichele in Florence.* Florence, 1982.

Assisi 1980
Il tesoro della basilica di San Francesco ad Assisi. Edited by Maria Grazia Ciardi Dupré Dal Poggetto. Introduction by Ulrich Middeldorf. Il miracolo di Assisi: collana storico-artistica della basilica e del sacro convento di S. Francesco-Assisi, 3. Assisi, 1980.

Avignon 1983
Avignon, Musée du Petit Palais. *L'Art gothique siennois: Enluminure, peinture, orfèvrerie, sculpture.* Exhibition, June 26–October 2, 1983. Florence, 1983.

Bacarelli 1984
Giuseppina Bacarelli. "Per l'architettura fiorentina del quattrocento: il chiostro di Sant'Apollonia." *Rivista d'arte* (Florence), vol. 37, 4th ser., vol. 1 (1984), pp. 133–63.

Baccheschi 1972
Edi Baccheschi. *L'opera completa di Duccio.* Introduction by Giulio Cattaneo. Classici dell'arte, 60. Milan, 1972.

Bacci 1913
Pèleo Bacci. "La 'tavola' di Battista di Gerio nella pieve di Camaiore." *Bullettino pisano d'arte e di storia* (Pisa), vol. 1, no. 2 (February 1913), pp. 33–34.

Bacci 1929
Pèleo Bacci. *Jacopo della Quercia.* Siena, 1929.

Bacci 1935
Pèleo Bacci. "Identificazione e restauro della tavola del 1336 di Niccolò di Segna da Siena." *Bollettino d'arte* (Rome), 3rd ser., vol. 29, no. 1 (July 1935), pp. 1–13.

Bacci 1936
Pèleo Bacci. *Francesco di Valdambrino, emulo del Ghiberti e collaboratore di Jacopo della Quercia.* Siena, 1936.

Bacci 1939
Pèleo Bacci. *Dipinti inediti e sconosciuti di Pietro Lorenzetti, Bernardo Daddi, etc. in Siena e nel contado.* Siena, 1939.

Bacci 1941
Pèleo Bacci. "Documenti e commenti per la storia dell'arte: il Pesellino, Fra Filippo Lippi, Domenico Veneziano, Piero di Lorenzo, Fra Diamante, Domenico discepolo di Fra Filippo, etc. e la tavola pistoiese della Trinità nella Galleria Nazionale di Londra." *Le arti* (Florence), vol. 3, no. 5 (June–July 1941), pp. 353–70.

Bacci 1941a
Pèleo Bacci. "Documenti e commenti per la storia dell'arte: il periodo pratese della tavola della SS Trinità." *Le arti* (Florence), vol. 3, no. 6 (August–September 1941), pp. 418–34.

Bacci 1941b
Pèleo Bacci. "Documenti e commenti per la storia dell'arte: ricordi della vita e dell'attività artistica del pittore senese Giovanni di Paolo di Grazia detto Boccanera (1399 circa–1482)." *Le arti* (Florence), vol. 4, no. 1 (October–November 1941), pp. 11–39.

Bacci 1944
Pèleo Bacci. *Fonti e commenti per la storia dell'arte senese: dipinti e sculture in Siena nel suo contado, ed altrove.* Accademia degli Intronati, Collezione di monografie d'arte senese, 1st ser., vol. 6. Siena, 1944.

Bacci 1944a
Pèleo Bacci. *Documenti e commenti per la storia dell'arte.* Florence, 1944.

Baetjer 1995
Katharine Baetjer. *European Paintings in The Metropolitan Museum of Art by Artists Born before 1865: A Summary Catalogue.* New York, 1995.

Baglione 1639, Barroero ed. 1990
Giovanni Baglione. *Le nove chiese di Roma.* Edited and with an introduction by Liliana Barroero. Notes by Monica Maggiorani and Cinzia Pujia. Parola e forma, 2. Fonti per la storia dell'arte e dell'architettura, 2. Rome, 1990.

Bagnoli 1999
Alessandro Bagnoli. *La Maestà di Simone Martini.* Cinisello Balsamo (Milan), 1999.

Bagnoli 2003
Alessandro Bagnoli, ed. *Duccio: alle origini della pittura.* Cinisello Balsamo (Milan), 2003. Exhibition, Siena, Santa Maria della Scala, Museo dell'Opera del Duomo, October 4, 2003–January 11, 2004.

Bähr 1987
Ingeborg Bähr. "Die Altarretabel des Giovanni di Paolo aus S. Domenico in Siena: Überlegungen zu den Auftraggebern." *Mitteilungen des Kunsthistorischen Institutes in Florenz* (Florence), vol. 31, nos. 2–3 (1987), pp. 357–66.

Baldini 1965
Umberto Baldini. *La cappella Migliorati nel S. Francesco di Prato.* Florence, 1965.

Baldini 1970
Umberto Baldini. *L'opera completa dell'Angelico.* Introduction by Elsa Morante. Classici dell'arte, 38. Milan, 1970.

Baldini 1977
Umberto Baldini. "Contributi all'Angelico: il trittico di San Domenico di Fiesole e qualche altra aggiunta." In *Scritti di storia dell'arte in onore di Ugo Procacci* (pp. 236–46). Edited by Maria Grazia Ciardi Dupré Dal Poggetto and Paolo Dal Poggetto. 2 vols. Milan, 1977.

Baldini 1986
Umberto Baldini. *Beato Angelico.* Collana "La Specola." Florence, 1986.

Baldini 1990
Umberto Baldini. *Masaccio.* Collana "La Specola." Florence, 1990.

Baldini and Baldini 1979
Carlo Baldini and Italo Baldini. *Pievi, parrocchie, e castelli di Greve in Chianti.* Vicenza, 1979.

Baldini and Casazza 1990
Umberto Baldini and Ornella Casazza. *La cappella Brancacci.* Milan, 1990.

Baldini and Dal Poggetto 1972
Umberto Baldini and Paolo Dal Poggetto, eds. *Firenze restaura: il laboratorio nel suo quarantennio.* Florence, 1972. Exhibition, Florence, Fortezza da Basso, March 18–June 4, 1972.

Baldini and Nardini 1983
Umberto Baldini and Bruno Naldini, eds. *Il complesso monumentale di Santa Croce: la basilica, le cappelle, i chiostri, il museo.* Florence, 1983.

Baldinotti, Cecchi, and Farinella 2002
Andrea Baldinotti, Alessandro Cecchi, and Vincenzo Farinella. *Masaccio e Masolino: il gioco delle parti.* Milan, 2002.

Baldinucci 1681–1728, Manni ed.
Filippo Baldinucci. *Notizie de' professori del disegno da Cimabue in qua.* Edited by Domenico Maria Manni. 21 vols. Florence, 1767–74.

Baldinucci 1681–1728, Ranalli ed.
Filippo Baldinucci. *Notizie dei professori del disegno da Cimabue in qua.* Edited by Ferdinando Ranalli. 5 vols. Florence, 1845–47. Reprint in 7 vols., with a critical note by Paola Barocchi and an analytical index by Antonio Boschetto. Florence, 1974–75.

Balniel, Clark, and Modigliani 1931
Lord Balniel and Kenneth Clark in consultation with Ettore Modigliani. *A Commemorative Catalogue of the Exhibition of Italian Art Held in the Galleries of the Royal Academy at Burlington House, London, January–March 1930.* London, 1931.

Baltimore 1962
Baltimore, Walters Art Gallery. *The International Style: The Arts in Europe around 1400.* Exhibition, October 23–December 2, 1962. Baltimore, 1962.

Bandini 1791–93
Angelo Maria Bandini. *Bibliotheca Leopolina Laurentiana seu catalogus manuscriptorum qui iussu Petri Leopoldi.* 3 vols. Florence, 1791–93.

Bandini 1774–78
Angelo Maria Bandini. *Catalogus codicum latinorum Bibliothecae Mediceae Laurentianae.* 5 vols. Florence, 1774–78.

Barbera 1999
Gioacchino Barbera, ed. *Restauri e ricerche: opere d'arte nelle provincie di Siracusa e Ragusa.* Palermo, 1999. Exhibition, Siracusa, Galleria Regionale di Palazzo Bellomo, June 5–September 5, 1999.

Barbier de Montault 1867
Xavier Barbier de Montault. *La Bibliothèque vaticane et ses annexes: Le Musée chretien, la salle des tableaux du moyen âge, les chambres Borgia, etc.* Rome, 1867.

Barcelona 1955–56
Barcelona, Palacio Municipal de Exposiciones. *III Bienal hispanoamerica de arte.* Exhibition, September 24, 1955–January 6, 1956.

Barcelona 1998
Barcelona, Museu Nacional d'Art de Catalunya. *Mallorca gótica.* Exhibition, December 17, 1998–February 28, 1999. Also shown Palma, Llotja, April–May 1999.

Bargellini 1970
Piero Bargellini, Guido Morozzi, and Giorgio Batini. *Santa Reparata: la cattedrale risorta.* Florence, 1970.

Bargellini and Guarnieri
Piero Bargellini and Ennio Guarnieri. *Le strade di Firenze.* 7 vols. Florence, 1977–87.

Barr 1936
Alfred H. Barr, Jr., ed. *Fantastic Art, Dada, Surrealism.* Essays by Georges Hugnet. New York, 1936. Exhibition, New York, The Museum of Modern Art, December 2, 1936–January 17, 1937.

Barr 1989
Cyrilla Barr. "A Renaissance Artist in the Service of a Singing Confraternity." In *Life and Death in Fifteenth-Century Florence* (pp. 105–25). Edited by Marcel Tetel, Ronald G. Witt, and Rona Goffen. Duke Monographs

in Medieval and Renaissance Studies, 10. Durham, N.C., 1989.

Barroero et al. 1994
Liliana Barroero, Vittorio Casale, Giovanna Sapori, Maria Rita Silvestrelli, and Caterina Zappia. *La pittura nell'Umbria meridionale dal trecento al novecento.* Interamna, 1. Terni, 1994.

Barsotti 1923
Giovanni Barsotti. *Lucca sacra: guida storico-artistico-religiosa di Lucca.* Lucca, 1923.

Bartalini 1995
Roberto Bartalini. "Maso, la cronologia della cappella Bardi di Vernio e il giovane Orcagna." *Prospettiva* (Siena), no. 77 (January 1995; printed June 1995), pp. 16–35.

Bartalini 1996
Roberto Bartalini. "I Tarlati, il 'Maestro del Vescovado,' e la pittura aretina della prima metà del trecento." *Prospettiva* (Siena), nos. 83–84 (July–October 1996), pp. 30–56.

Basile 1992
Giuseppe Basile, ed. *Giotto: la cappella degli Scrovegni.* Milan, 1992.

Basile 2002
Giuseppe Basile, ed. *Giotto: gli affreschi della cappella degli Scrovegni a Padova.* Milan, 2002.

Battistini 1919
Mario Battistini. "L'affresco di Jacopo Orcagna e di Niccolò di Pietro nel Palazzo dei Priori di Volterra." *L'arte* (Rome), vol. 32 (1919), pp. 228–29.

Battistini 1919a
Mario Battistini. "Maestro Priamo della Quercia." *Rassegna d'arte* (Milan), vol. 19 (1919), p. 232.

Battistini 1925
Mario Battistini. "Spogli d'archivio: Maestro Priamo della Quercia." *Rassegna volterrana* (Volterra), vol. 2 (1925), p. 40.

Baxandall 1986
Michael Baxandall. *Giotto and the Orators: Humanist Observers of Painting in Italy and the Discovery of Pictorial Composition, 1350–1450.* Corrected ed. Oxford-Warburg Studies. Oxford, 1986.

Beatson, Muller, and Steinhoff 1986
Elizabeth H. Beatson, Norman E. Muller, and Judith B. Steinhoff. "The St. Victor Altarpiece in Siena Cathedral: A Reconstruction." *The Art Bulletin* (New York), vol. 68, no. 4 (December 1986), pp. 610–31.

Becattini 1990
Ivo Becattini. "Il territorio di San Giovenale ed il trittico di Masaccio." In *Masaccio 1422/1989: dal trittico di San Giovenale al restauro della cappella Brancacci* (pp. 17–26). Atti del convegno, Pieve di San Pietro a Cascia, Reggello, April 22, 1989. Figline Valdarno, 1990.

Becherucci and Brunetti 1969–70
Luisa Becherucci and Giulia Brunetti, eds. *Il Museo dell'Opera del Duomo a Firenze.* 2 vols. Milan, n.d. [1969–70].

Beck 1971
James H. Beck. "Masaccio's Early Career as a Sculptor." *The Art Bulletin* (New York), vol. 53, no. 2 (June 1971), pp. 177–95.

Beck 1977
James H. Beck. "'Una prospettiva di mano di Masaccio.'" In *Studies in Late Medieval and Renaissance Painting in Honor of Millard Meiss* (pp. 48–53). Edited by Irving Lavin and John Plummer. 2 vols. New York, 1977.

Beck 1978
James H. Beck with Gino Corti. *Masaccio: The Documents.* Villa I Tatti, The Harvard University Center for Italian Renaissance Studies, 4. Locust Valley, N.Y., 1978.

Becker 1904
Felix Becker. "Neuigkeiten vom Kunstmarkte." *Der Kunstmarkt* (Leipzig), vol. 1, no. 35 (June 3, 1904), pp. 233–34.

Béguin 1957
Sylvie Béguin. "Antologia di artisti: 'La Vierge au baldaquin.'" *Paragone-arte* (Florence), vol. 8, no. 93 (September 1957), pp. 59–63.

Bell 1920
Hamilton Bell. "Temporary Exhibition from the Johnson Collection." *The Pennsylvania Museum Bulletin* (Philadelphia), vol. 17, no. 66 (October 1920), pp. 4–10.

Belli Barsali 1988
Isa Belli Barsali. *Lucca: guida alla città.* Lucca, 1988.

Bellini and Brunetti 1978
Fiora Bellini with Giulia Brunetti. *I disegni antichi degli Uffizi: i tempi del Ghiberti.* Introduction by Luciano Bellosi. Florence, 1978. Exhibition, Florence, Gabinetto Disegni e Stampe degli Uffizi, 1978.

Bellosi 1965
Luciano Bellosi. "Da Spinello Aretino a Lorenzo Monaco." *Paragone-arte* (Florence), n.s., vol. 16, no. 187/17 (September 1965), pp. 18–43.

Bellosi 1966
Luciano Bellosi. "Il Maestro della Crocifissione Griggs: Giovanni Toscani." *Paragone-arte* (Florence), n.s., vol. 17, no. 193/13 (March 1966), pp. 44–58.

Bellosi 1966a
Luciano Bellosi. "La mostra di affreschi staccati, al Forte Belvedere." *Paragone-arte* (Florence), n.s., vol. 17, no. 201/21 (November 1966; printed December 1966), pp. 73–79.

Bellosi 1967
Luciano Bellosi. "Intorno ad Andrea del Castagno." *Paragone-arte* (Florence), n.s., vol. 18, no. 211/31 (September 1967), pp. 3–18.

Bellosi 1973
Luciano Bellosi. "Due note per la pittura fiorentina di secondo trecento." *Mitteilungen des Kunsthistorischen Institutes in Florenz* (Florence), vol. 27, nos. 2–3 (1973), pp. 179–94.

Bellosi 1974
Luciano Bellosi. *Buffalmacco e il trionfo della morte.* Turin, 1974.

Bellosi 1975
Luciano Bellosi. "La mostra di Arezzo." *Prospettiva* (Siena-Florence), no. 3 (October 1975), pp. 55–60.

Bellosi 1976
Luciano Bellosi. "Letters: The Frescoes in the Lower Church at Assisi." *The Burlington Magazine* (London), vol. 118, no. 874 (January 1976), pp. 31–32.

Bellosi 1977
Luciano Bellosi, ed. *Il Museo dello Spedale degli Innocenti a Firenze.* Contributions by Attilio Piccini and Grazia Vailati Schoenburg-Waldenburg. Gallerie e musei minori di Firenze. Florence, 1977.

Bellosi 1977a
Luciano Bellosi. "Moda e cronologia, B: per la pittura di primo trecento." *Prospettiva* (Siena-Florence), no. 11 (October 1977), pp. 12–27.

Bellosi 1983–84
Luciano Bellosi. "Tre note in margine a uno studio sull'arte a Prato." *Prospettiva* (Siena-Florence), nos. 33–36 (April 1983–January 1984; printed May 1985), pp. 45–55.

Bellosi 1985
Luciano Bellosi. "Su alcuni disegni italiani tra la fine del due e la metà del quattrocento." *Bollettino d'arte* (Rome), ser. 6, vol. 70, no. 30 (March–April 1985), pp. 1–42.

Bellosi 1985a
Luciano Bellosi. *La pecora di Giotto.* Saggi, 681. Turin, 1985.

Bellosi 1988
Luciano Bellosi. *Pietro Lorenzetti at Assisi.* Assisi, 1988.

Bellosi 1988a
Luciano Bellosi, ed. *Umbri e toscani tra due e trecento.* Introduction by Enrico Castelnuovo. Texts by Alessandro Angelini et al. Turin, 1988. Exhibition, Turin, Antichi Maestri Pittori di Giancarlo Gallino & C., April 16–May 28, 1988.

Bellosi 1990
Luciano Bellosi, ed. *Pittura di luce: Giovanni di Francesco e l'arte fiorentina di metà quattrocento.* Milan, 1990. Exhibition, Florence, Casa Buonarroti, May 16–August 20, 1990.

Bellosi 1993
Luciano Bellosi, ed. *Francesco di Giorgio e il rinascimento a Siena, 1450–1500.* Milan, 1993. Exhibition, Siena, Sant'Agostino, April 25–July 31, 1993.

Bellosi 1998
Luciano Bellosi. *Cimabue.* Apparatus edited by Giovanna Ragionieri. Milan, 1998.

Bellosi 2002
Luciano Bellosi with Laura Cavazzini and Aldo Galli. *Masaccio e le origini del rinascimento.* Milan, 2002. Exhibition, San Giovanni Valdarno, September 20–December 21, 2002.

Bellosi and Haines 1999
Luciano Bellosi and Margaret Haines. *Lo Scheggia.* Florence, 1999.

Bellosi, Cantelli, and Lenzini Moriondo 1970
Luciano Bellosi, Giuseppe Cantelli, and Margherita Lenzini Moriondo. *Arte in Valdichiana dal XIII al XVIII secolo.* Introduction by Mario Salmi. Cortona, 1970. Exhibition, Cortona, Fortezza del Girifalco, August 9–October 10, 1970.

Belting 1981
Hans Belting. *Das Bild und sein Publikum im Mittelalter: Form und Funktion früher Bildtafeln der Passion.* Berlin, 1981.

Belting 1990
Hans Belting. *Bild und Kult: Eine Geschichte des Bildes vor dem Zeitalter der Kunst.* Munich, 1990.

Belting 1994
Hans Belting. *Likeness and Presence: A History of the*

Image Before the Era of Art. Translated by Edmund Jephcott. Chicago, 1994.

Bemporad 1980
Dora Liscia Bemporad. "Appunti sulla bottega orafa di Antonio del Pollaiolo e di alcuni suoi allievi." *Antichità viva* (Florence), vol. 19, no. 3 (May–June 1980; printed January 1981), pp. 47–53.

Benci 1646
Spinello Benci. *Storia di Montepulciano.* With appendices. Florence, 1646. Reprint, Verona, 1968.

Benito Doménech and Gómez Frechina 2002
Fernando Benito Doménech and José Gómez Frechina, eds. *Pintura europea del Museo de Bellas Artes de Valencia.* Valencia, 2002.

Bennett, Preston, and Shoreman 1991
Adelaide Bennett, Jean F. Preston, and William P. Shoreman. *A Summary Guide to Western Medieval and Renaissance Manuscripts at Princeton University.* Princeton, 1991.

Benson 1936
E. M. Benson. "Enjoying Your Museum." *The Pennsylvania Museum Bulletin* (Philadelphia), vol. 31, no. 170 (March 1936), pp. 2–15.

Bentini 1992
Jadranka Bentini, ed. *La Pinacoteca Nazionale di Ferrara: catalogo generale.* Introduction by Andrea Emiliani; scholarly consultation by Federico Zeri. Bologna, 1992.

Berenson 1896
Bernhard Berenson. *The Florentine Painters of the Renaissance with an Index to Their Works.* New York, 1896.

Berenson 1897
Bernhard Berenson. *The Central Italian Painters of the Renaissance.* New York, 1897.

Berenson 1908
Bernhard Berenson. "La Madonna pisana di Masaccio." *Rassegna d'arte* (Milan), vol. 8, no. 5 (May 1908), pp. 81–85.

Berenson 1909
Bernhard Berenson. *The Central Italian Painters of the Renaissance.* 2nd ed., rev. and enlarged. New York, 1909.

Berenson 1909a
Bernhard Berenson. "Un nuovo Lorenzo Monaco." *Rivista d'arte* (Florence), vol. 6 (1909), pp. 3–6.

Berenson 1913
Bernhard Berenson. *Catalogue of a Collection of Paintings and Some Art Objects.* Vol. 1, *Italian Paintings.* Philadelphia, 1913.

Berenson 1913a
Bernhard Berenson. "A Nativity and Adoration of the School of Pietro Cavallini in the Collection of Mr. John G. Johnson." *Art in America* (New York), vol. 1, no. 1 (January 1913), pp. 17–24.

Berenson 1916
Bernhard Berenson. *Pictures in the Collection of P.A.B. Widener.* Vol. 1. Philadelphia, 1916.

Berenson 1917
Bernhard Berenson. "Ugolino Lorenzetti." *Art in America* (New York), vol. 5, no. 6 (October 1917), pp. 259–75; vol. 6, no. 1 (December 1917), pp. 25–52.

Berenson 1918
Bernhard Berenson. *Essays in the Study of Sienese Painting.* New York, 1918.

Berenson 1922
Bernhard Berenson. "Prime opere di Allegretto Nuzi." *Bollettino d'arte* (Milan), 2nd ser., vol. 1, no. 7 (January 1922), pp. 297–309.

Berenson 1929
Bernhard Berenson. "Missing Pictures by Arcangelo di Cola." *International Studio* (New York), vol. 93, no. 386 (July 1929), pp. 21–25.

Berenson 1929a
Bernhard Berenson. "Quadri senza casa." *Dedalo* (Milan), vol. 10 (August 1929), pp. 133–42.

Berenson 1930
Bernhard Berenson. "Missing Pictures of the Sienese Trecento." *International Studio* (New York), vol. 97, no. 401 (October 1930), pp. 31–35.

Berenson 1930a
Bernhard Berenson. "Missing Pictures of the Sienese Trecento—Part II." *International Studio* (New York), vol. 97, no. 402 (November 1930), pp. 27–32.

Berenson 1930b
Bernhard Berenson. "A Reconstruction of Gualtieri di Giovanni." *International Studio* (New York), vol. 97, no. 403 (December 1930), pp. 67–71.

Berenson 1930c
Bernhard Berenson. "Quadri senza casa: il trecento senese—I, II." *Dedalo* (Milan-Rome), vol. 11, no. 2 (October 1930), pp. 263–84; no. 3 (November 1930), pp. 329–62.

Berenson 1931
Bernhard Berenson. "Lost Sienese Trecento Paintings—Part IV." *International Studio* (New York), vol. 98, no. 404 (January 1931), pp. 29–35.

Berenson 1931a
Bernhard Berenson. "Lost Paintings of XV-Century Siena—Part I." *International Studio* (New York), vol. 98, no. 405 (February 1931), pp. 24–29.

Berenson 1931b
Bernhard Berenson. "Missing Pictures of XV-Century Siena—Part II." *International Studio* (New York), vol. 98, no. 406 (March 1931), pp. 37–41.

Berenson 1931c
Bernhard Berenson. "Lost Works of the Last Sienese Masters—Part III." *International Studio* (New York), vol. 98, no. 407 (April 1931), pp. 17–22.

Berenson 1931–32
Bernhard Berenson. "Quadri senza casa: il trecento fiorentino—I, II, III, IV, V." *Dedalo* (Milan-Rome), vol. 11, no. 4 (July 1931), pp. 957–88; no. 5 (August 1931), pp. 1039–73; no. 8 (November 1931), pp. 1286–1318; vol. 12, no. 1 (January 1932), pp. 5–34; no. 3 (March 1932), pp. 173–93.

Berenson 1932
Bernhard Berenson. *Italian Pictures of the Renaissance: A List of the Principal Artists and Their Works with an Index of Places.* Oxford, 1932.

Berenson 1932a
Bernhard Berenson. "Quadri senza casa: il quattrocento fiorentino—I, II, III." *Dedalo* (Milan-Rome), vol. 12, no. 2 (July 1932), pp. 512–41; no. 3 (September 1932), pp. 665–702; no. 5 (November 1932), pp. 819–53.

Berenson 1936
Bernhard Berenson. *Pitture italiane del rinascimento: catalogo dei principali artisti e delle loro opere con un indice dei luoghi.* Translated from the English by Emilio Cecchi. Collezione "Valori plastici." Milan, 1936.

Berenson 1957
Bernhard Berenson. *Italian Pictures of the Renaissance: A List of the Principal Artists and Their Works with an Index of Places. Venetian School.* 2 vols. London, 1957.

Berenson 1963
Bernhard Berenson. *Italian Pictures of the Renaissance: A List of the Principal Artists and Their Works with an Index of Places. Florentine School.* 2 vols. London, 1963.

Berenson 1968
Bernhard Berenson. *Italian Pictures of the Renaissance: A List of the Principal Artists and Their Works with an Index of Places. Central Italian and North Italian Schools.* 3 vols. Rev. and enlarged ed. London, 1968.

Berenson 1969
Bernhard Berenson. *Homeless Paintings of the Renaissance.* Edited by Hanna Kiel. Introduction by Myron P. Gilmore. London, 1969.

Berlin 1898
Berlin, Kunstgeschichtlichen Gesellschaft. *Ausstellung von Kunstwerken des Mittelalters und der Renaissance aus Berliner Privatbesitz.* Exhibition, May 20–July 3, 1898. Catalogue edited by Wilhelm Bode. Berlin, 1899.

Berlin 1931
Berlin, Staatliche Museen, Kupferstichkabinett. *Beschreibendes Verzeichnis der Miniaturen, Handschriften, und Einzelblätter, des Kupferstichkabinetts der Staatlichen Museen, Berlin.* Catalogue by Paul Wescher. Leipzig, 1931.

Berlin 1978
Berlin, Staatliche Museen, Gemäldegalerie. *Führer durch die Austellung.* Berlin, 1978.

Berlin 1986
Berlin, Gemäldegalerie. *Gesamtverzeichnis der Gemälde / Complete Catalogue of the Paintings.* London, 1986.

Bernacchioni 1990
Annamaria Bernacchioni. "Committenti sanminiatesi nell'attività di Domenico di Michelino: i Borromei e i Chellini." *Bollettino dell'Accademia degli Euteleti della città di San Miniato* (San Miniato al Tedesco), no. 57 (December 1990), pp. 95–110.

Bernacchioni 1990a
Annamaria Bernacchioni. "Documenti e precisazioni sull'attività tarda di Domenico di Michelino: la sua bottega di via delle Terme." *Antichità viva* (Florence), vol. 29, no. 6 (November–December 1990; printed January 1991), pp. 5–14.

Bernardini et al. 1987
Carla Bernardini et al., eds. *La Pinacoteca Nazionale di Bologna: catalogo generale delle opere esposte.* Introduction by Andrea Emiliani. Bologna, 1987.

Bernardino 1425, Cannarozzi ed. 1934
Bernardino Albizzeschi. *Le prediche volgari: predicazione del 1425 in Siena.* Edited by Ciro Cannarozzi. Pistoia, 1934.

Bernardino 1424–25, Bargellini ed. 1936
Bernardino Albizzeschi. *Le prediche volgari.* Edited by Piero Bargellini. Classici Rizzoli. Milan, 1936.

Bernardino 1424–25, Pacetti ed. 1935
Bernardino Albizzeschi. *Le prediche volgari inedite.* Edited by Dionisio Pacetti. I classici cristiani, 56. Siena, 1935.

Bertelli 1967
Carlo Bertelli. "The 'Image of Pity' in Santa Croce in Gerusalemme." In *Essays in the History of Art Presented to Rudolf Wittkower on His Sixty-fifth Birthday* (pp. 40–55). Edited by Douglas Fraser, Howard Hibbard, and Milton J. Lewine. New York, 1967.

Bertelli 1970
Carlo Bertelli. "Vetri italiani a fondo d'oro del secolo XIII." *Journal of Glass Studies* (Corning, N.Y.), vol. 12 (1970), pp. 70–78.

Bertelli 1972
Carlo Bertelli. "Vetri e altre rose della Napoli angioina." *Paragone-arte* (Florence), vol. 23, no. 263 (January 1972), pp. 89–106.

Bertelli 1987
Carlo Bertelli. "Masolino e il Vecchietta a Castiglione Olona." *Paragone-arte* (Florence), n.s., vol. 38, no. 5/451 (September 1987), pp. 25–47.

Bertelli 1998
Carlo Bertelli. *Masolino: gli affreschi del battistero e della collegiata a Castiglione Olona.* Milan, 1998.

Berti 1952
Luciano Berti. "Note brevi su inediti toscani: Paolo di Stefano Badaloni detto Paolo Schiavo." *Bollettino d'arte* (Rome), 4th ser., vol. 37 (1952), pp. 178–81.

Berti 1953
Luciano Berti. "Note brevi su inediti toscani: Paolo di Stefano Badaloni detto Paolo Schiavo." *Bollettino d'arte* (Rome), 4th ser., vol. 38 (1953), pp. 278–79.

Berti 1961
Luciano Berti. "Masaccio 1422." *Commentari* (Rome), vol. 12, no. 2 (April–June 1961), pp. 84–107.

Berti 1962–63
Luciano Berti. "Miniature dell'Angelico (e altro)." *Acropoli* (Milan), vol. 2, no. 4 (1962), pp. 277–308; vol. 3, no. 1 (1963), pp. 1–38.

Berti 1964
Luciano Berti. *Masaccio.* Arte e pensiero, 6. Milan, 1964.

Berti 1967
Luciano Berti. *Masaccio.* University Park, Pa., 1967.

Berti 1968
Luciano Berti. *L'opera completa di Masaccio.* Introduction by Paolo Volponi. I classici dell'arte, 24. Milan, 1968.

Berti 1988
Luciano Berti. *Masaccio.* Essay by Umberto Baldini. Entries by Rossella Foggi. Florence, 1988.

Berti 1992
Luciano Berti, ed. *Nel raggio di Piero: la pittura nell'Italia centrale nell'età di Piero della Francesca.* Venice, 1992. Exhibition, Sansepolcro, Casa di Piero, July 11–October 31, 1992.

Berti and Foggi 1989
Luciano Berti and Rossella Foggi. *Masaccio: catalogo completo dei dipinti.* I gigli dell'arte, 7. Archivi di arte antica e moderna. Florence, 1989.

Berti and Paolucci 1990
Luciano Berti and Antonio Paolucci, eds. *L'età di*

Masaccio: il primo quattrocento a Firenze. Milan, 1990. Exhibition, Florence, Palazzo Vecchio, June 7–September 16, 1990.

Bertini 1987
Giuseppe Bertini. *La galleria del duca di Parma: storia di una collezione.* Bologna, 1987.

Bertrand 1994
Jestaz Bertrand, ed. with Michel Hochmann and Philippe Sénéchal. *Le Palais Farnèse, III, 3: L'Inventaire du palais et des propriétés Farnèse à Rome en 1644.* École Française de Rome. Rome, 1994.

Biadego 1890
Giuseppe Biadego. *L'arte degli orefici in Verona.* Verona, 1890.

Bianchini 1965
Maria Adelaide Bianchini. *Masolino da Panicale.* Maestri del colore, 80. Milan, 1965.

Biancolini
Giambatista Biancolini. *Notizie storiche delle chiese di Verona.* 8 vols. Verona, 1749–71. Reprint, Bologna, 1977.

Biancolini 1750
Giambatista Biancolini. *Notizie storiche delle chiese di Verona.* Vol. 3. Verona, 1750. Reprint, Bologna, 1977.

Biasiotti 1915
Giovanni Biasiotti. "La basilica di S. Maria Maggiore di Roma prima delle innovazioni del secolo XVI." *Mélanges d'archéologie et d'histoire de l'École Française de Rome* (Paris-Rome), vol. 35 (1915), pp. 15–41.

Bibliotheca sanctorum
Istituto Giovanni XXIII della Pontificia Università Lateranense. *Bibliotheca sanctorum.* 12 vols. Rome, 1961–69. Index and appendices, Rome, 1970, 1987.

Bietti Favi 1977–78
Monica Bietti Favi. "San Pier Maggiore, una chiesa scomparsa: dalle origini a tutto il trecento." Graduation thesis, Università degli Studi di Firenze, 1977–78.

Biglia c. 1429, Arbesmann ed. 1965
Andrea Biglia. "Fratris Andree Mediolanensis ad fratrem Ludovicum de ordinis nostri forma et propagatione incipit." Edited by Rudolph Arbesmann. *Analecta augustiniana* (Rome), vol. 28 (1965), pp. 186–218.

Billi c. 1506–30, Benedettucci ed. 1991
Il libro di Antonio Billi. Edited by Fabio Benedettucci. Letteratura artistica, 1. Rome, 1991.

Billi c. 1506–30, Frey ed. 1892
Il libro di Antonio Billi esistente in due copie nella Biblioteca Nazionale di Firenze. Edited by Carl Frey. Berlin, 1892.

Birmingham 1952
Birmingham (Ala.) Museum of Art. *The Samuel H. Kress Collection. Birmingham Museum of Art.* Catalogue by Richard Foster Howard. Birmingham, Ala., 1952.

Birmingham 1955
City of Birmingham (England) Museum and Art Gallery. *Exhibition of Italian Art from the 13th Century to the 17th Century.* Exhibition, August 18–October 2, 1955. Birmingham, 1955.

Blanc 1857
Charles Blanc. *Les Trésors de l'art à Manchester.* Paris, 1857.

Bloomington 1945
Bloomington, Indiana University Fine Arts Department. *An Exhibition of Medieval Art Lent by E. and A. Silberman Galleries, New York City.* Exhibition, October 17–November 17, 1945.

Bocchi, Cinelli ed. 1677
Francesco Bocchi. *Le bellezze della città di Firenze, dove a pieno di pittura, di scultura, di sacri templi, di palazzi, i più notabili artifizi e più preziosi sì contengono.* Revised by Giovanni Cinelli. Florence, 1677.

Bode 1888
Wilhelm Bode. "La Renaissance au Musée de Berlin. IV: Les peintres florentins du XVe siècle." *Gazette des beaux-arts* (Paris), 30th yr., 2nd ser., vol. 37, no. 6 (June 1888), pp. 472–89.

Bode 1897
Wilhelm Bode, ed. *Die Sammlung Oscar Hainauer.* Berlin, 1897.

Bode 1906
Wilhelm Bode. *Collection Oscar Hainauer.* Berlin, 1906.

Bode 1923
Wilhelm Bode. "Italian Portrait Paintings and Busts of the Quattrocento." *Art in America* (New York), vol. 12, no. 1 (December 1923), pp. 3–13.

Boespflug 1985
François Boespflug. *Le credo de Sienne.* Paris, 1985.

Bolaffi
Dizionario enciclopedico Bolaffi dei pittori e degli incisori italiani dall'XI al XX secolo. 11 vols. Turin, 1972–76.

Bologna 1950
Bologna, Pinacoteca Nazionale. *Guida alla mostra della pittura bolognese del trecento.* Exhibition, May–July 1950. Catalogue preface by Roberto Longhi. Bologna, 1950.

Bologna 1967
Il tempio di San Giacomo Maggiore in Bologna: studi sulla storia e le opere d'arte. Regesto documentario. Bologna, 1967.

Bologna 1981
Bologna, San Giorgio in Poggiale. *Rappresentazione dei magi: il gruppo ligneo di S. Stefano e Simone dei Crocifissi.* Exhibition, December 19, 1981–January 17, 1982. Catalogue by Massimo Ferretti. Rapporto della Soprintendenza per i Beni Artistici e Storici per le Province di Bologna, Ferrara, Forlì, e Ravenna, 32.

Bologna 1987
Bologna, Pinacoteca Nazionale and Museo Civico Medievale. *Il tramonto del medioevo a Bologna: il cantiere di San Petronio.* Exhibition, October–December 1987. Catalogue edited by Rosalba D'Amico and Renzo Grandi.

Bologna 1990
Bologna, San Giorgio in Poggiale. *Itinerari di Vitale da Bologna: affreschi a Udine e a Pomposa.* Exhibition, September 29–November 11, 1990. Catalogue texts by Cesare Gnudi and Paolo Casadio.

Bologna 1990a
See D'Amico, Grandi, and Medica 1990

Bologna 1996
Bologna, Musei Civici d'Arte Antica, Museo Civico Medievale. *Ospiti 3: Giovanni di Balduccio, natività.* Exhibition, November 2, 1996–January 31, 1997.

F. Bologna 1955
Ferdinando Bologna. "Due *santi* di Paolo Schiavo."

Paragone-arte (Florence), vol. 6, no. 62 (May 1955), pp. 36–40.

F. Bologna 1967
Ferdinando Bologna. "Contributi allo studio della pittura veneziana del trecento." *Arte veneta* (Venice), vol. 5 (1967), pp. 21–31.

F. Bologna 1969
Ferdinando Bologna. *I pittori alla corte angioina di Napoli, 1266–1414, e un riesame dell'arte nell'età fridericiana.* Saggi e studi di storia dell'arte, 2. Rome, 1969.

F. Bologna 1969a
Ferdinando Bologna. *Novità su Giotto: Giotto al tempo della cappella Peruzzi.* Saggi, 438. Turin, 1969.

F. Bologna 1975
Ferdinando Bologna. "Un altro pannello del 'retablo' del Salvatore a Toledo: Antonio Veneziano o Gherardo Starnina?" *Prospettiva* (Siena-Florence), no. 2 (July 1975), pp. 43–52.

Bolzoni and Ghezzi 1983
Giuseppina Bolzoni and Teresa Ghezzi. "Una Madonna veneziana del 1400 nella Pinacoteca di Brera: una ricerca." *Arte cristiana* (Milan), n.s., vol. 71, no. 698 (September–October 1983), pp. 29–94.

Bomford et al. 1989
David Bomford, Jill Dunkerton, Dillian Gordon, and Ashok Roy, with contributions by Jill Kirby. *Art in the Making: Italian Painting before 1400.* London, 1989. Exhibition, London, National Gallery, November 29, 1989–February 28, 1990.

Bonsanti 1987
Giorgio Bonsanti. *La Galleria dell'Accademia, Firenze: guida e catalogo completo.* Florence, 1987.

Bon Valsassina and Garibaldi 1994
Caterina Bon Valsassina and Vittoria Garibaldi, eds. *Dipinti, sculture, e ceramiche della Galleria Nazionale dell'Umbria: studi e restauri.* Florence, 1994.

Borghesi and Banchi 1898
Scipione Borghesi and Luciano Banchi. *Nuovi documenti per la storia dell'arte senese.* Siena, 1898.

Borghini 1552–80, Lorenzoni ed. 1912
Vincenzo Borghini. *Carteggio artistico inedito.* Edited by A. Lorenzoni. Vol. 1. Florence, 1912.

Borghini 1584, Biscioni ed. 1730
Raffaello Borghini. *Il riposo.* Florence, 1584. Edited by Antonmaria Biscioni. Florence, 1730.

Borroni Salvadori 1974
Fabia Borroni Salvadori. "Le esposizioni d'arte a Firenze dal 1674 al 1767." *Mitteilungen des Kunsthistorischen Institutes von Florenz* (Florence), vol. 18, no. 1 (1974), pp. 1–166.

Borroni Salvadori 1983
Fabia Borroni Salvadori. "Ignazio Enrico Hugford: collezionista con la vocazione del mercante." *Annali della Scuola Normale Superiore di Pisa* (Pisa) 3rd ser., vol. 13, no. 4 (1983), pp. 1025–56.

Borsi and Borsi 1994
Franco Borsi and Stefano Borsi. *Paolo Uccello.* Translated by Elfreda Powell. London, 1994.

Borsi, Morolli, and Quinterio 1979
Franco Borsi, Gabriele Morolli, and Francesco Quinterio. *Brunelleschiani: Francesco della Luna, Andrea di Lazzaro Cavalcanti detto il Buggiano, Antonio Manetti Ciaccheri, Giovanni di Domenico da Gaiole, Betto d'Antonio, Antonio di Betto, Giovanni di Piero del Ticcia, Cecchino di Giaggio, Salvi d'Andrea, Maso di Bartolomeo.* Fonti e documenti per la storia dell'architettura, 7. Rome, 1979.

Borsi, Quinterio, and Vasić Vatovec 1989
Stefano Borsi, Francesco Quinterio, and Corinna Vasić Vatovec. *Maestri fiorentini nei cantieri romani del quattrocento.* Edited by Silvia Danesi Squarzina. Rome, 1989.

Borsook 1975
Eve Borsook. "Fra' Filippo Lippi and the Murals for Prato Cathedral." *Mitteilungen des Kunsthistorischen Institutes in Florenz* (Florence), vol. 19, no. 1 (1975), pp. 1–148.

Borsook 1979
Eve Borsook. Review of Neri di Bicci 1453–75, Santi ed. 1976. *The Art Bulletin* (New York), vol. 61, no. 2 (June 1979), pp. 313–18.

Borsook 1981
Eve Borsook. "Cults and Imagery at Sant'Ambrogio in Florence." *Mitteilungen des Kunsthistorischen Institutes in Florenz* (Florence), vol. 25, no. 1 (1981), pp. 147–202.

Borsook 1982
Eve Borsook. "Jacopo di Cione and the Guild Hall of the Judges and Notaries in Florence." *The Burlington Magazine* (London), vol. 124, no. 947 (February 1982), pp. 86–88.

Boskovits 1966
Miklós Boskovits. *Frühe italienische Tafelbilder.* Budapest, 1966.

Boskovits 1967
Miklós Boskovits. "Der Meister der Santa Verdiana: Beiträge zur Geschichte der florentinischen Malerei um die Wende der 14. und 15. Jahrhunderts." *Mitteilungen des Kunsthistorischen Institutes in Florenz* (Florence), vol. 30, nos. 1–4 (December 1967–October 1968), pp. 31–60.

Boskovits 1968
Miklós Boskovits. "Ein Vorläufer der spätgotischen Malerei in Florenz: Cenni di Francesco di ser Cenni." *Zeitschrift für Kunstgeschichte* (Berlin), vol. 31, no. 4 (1968), pp. 273–92.

Boskovits 1968a
Miklós Boskovits. "Mariotto di Nardo e la formazione del linguaggio tardogotico a Firenze negli anni intorno al 1400." *Antichità viva* (Florence), vol. 7, no. 6 (November–December 1968), pp. 21–31.

Boskovits 1969
Miklós Boskovits. "Il problema di Antonius Magister e qualche osservanza sulla pittura marchigiana del trecento." *Arte illustrata* (Milan), vol. 2, nos. 17–18 (May–June 1969), pp. 4–9.

Boskovits 1970
Miklós Boskovits. "Due secoli di pittura murale a Prato: appunti e precisazioni." *Arte illustrata* (Milan), vol. 3, nos. 25–26 (January–February 1970), pp. 32–47.

Boskovits 1973
Miklós Boskovits. *Pittura umbra e marchigiana fra medioevo e rinascimento.* Studi nella Galleria Nazionale di Perugia. Florence, 1973.

Boskovits 1975
Miklós Boskovits. *Pittura fiorentina alla vigilia del rinascimento, 1370–1400.* Florence, 1975.

Boskovits 1975a
Miklós Boskovits. "Una scheda e qualche suggerimento: per un catalogo dei dipinti ai Tatti." *Antichità viva* (Florence), vol. 14, no. 2 (March–April 1975), pp. 9–21.

Boskovits 1975b
Miklós Boskovits. "Il Maestro del Bambino Vispo: Gherardo Starnina o Miguel Alcañiz?" *Paragone-arte* (Florence), vol. 26, no. 307 (September 1975), pp. 3–15.

Boskovits 1976
Miklós Boskovits. "Appunti sull'Angelico." *Paragone-arte* (Florence), vol. 27, no. 313 (March 1976), pp. 30–54.

Boskovits 1976a
Miklós Boskovits. *Un'adorazione dei magi e gli inizi dell'Angelico.* Monographien der Abegg-Stiftung Bern, 11. Bern, 1976.

Boskovits 1977
Miklós Boskovits. "Osservazioni sulla pittura tardogotica nelle Marche." In *Rapporti artistici fra le Marche e l'Umbria* (pp. 29–47). Atti del convegno interregionale di studio, Fabriano and Gubbio, 1974. Deputazione di storia patria per l'Umbria. Appendici al Bollettino, no. 13. Perugia, 1977.

Boskovits 1978
Miklós Boskovits. Review of Cole 1977. *The Art Bulletin* (New York), vol. 60, no. 4 (December 1978), pp. 707–11.

Boskovits 1979
Miklós Boskovits. "In margine alla bottega di Agnolo Gaddi." *Paragone-arte* (Florence), vol. 30, no. 355 (September 1979), pp. 54–59.

Boskovits 1980
Miklós Boskovits. "Su Niccolò di Buonaccorso, Benedetto di Bindo, e la pittura senese del primo quattrocento." *Paragone-arte* (Florence), vol. 31, nos. 359–61 (January–March 1980), pp. 3–22.

Boskovits 1981
Miklós Boskovits. "Gli affreschi della Sala dei Notari a Perugia e la pittura in Umbria alla fine del XIII secolo." *Bollettino d'arte* (Rome), 6th ser., vol. 56, no. 9 (January–March 1981), pp. 1–41.

Boskovits 1982
Miklós Boskovits. Review of Stubblebine 1979 and White 1979. *The Art Bulletin* (New York), vol. 64, no. 3 (September 1982), pp. 496–502.

Boskovits 1983
Miklós Boskovits. "La fase tarda del beato Angelico: una proposta di interpretazione." *Arte cristiana* (Milan), n.s., vol. 71, no. 694 (January–February 1983), pp. 11–24.

Boskovits 1983a
Miklós Boskovits. "Il gotico senese rivisitato: proposte e commenti su una mostra." *Arte cristiana* (Milan), n.s., vol. 71, no. 698 (September–October 1983), pp. 259–76.

Boskovits 1984
Miklós Boskovits. *A Critical and Historical Corpus of Florentine Painting: The Fourteenth Century. The Painters of the Miniaturist Tendency.* Sec. 3, vol. 9. Florence, 1984.

Boskovits 1985
Miklós Boskovits, with Marco Bona Castellotti et al. *The Martello Collection: Paintings, Drawings, and*

Miniatures from the XIVth to the XVIIIth Centuries. Florence, 1985.

Boskovits 1985a
Miklós Boskovits. "Iniziali miniate e tavolette di Biccherna: studi recenti sul 'dipingere in miniatura.'" *Arte cristiana* (Milan), n.s., vol. 73, no. 710 (September–October 1985), pp. 327–38.

Boskovits 1986
Miklós Boskovits. "Considerations on Pietro and Ambrogio Lorenzetti." *Paragone-arte* (Florence), vol. 37, no. 439 (September 1986; printed March 1987), pp. 3–16.

Boskovits 1987
Miklós Boskovits. "Il percorso di Masolino: precisazioni sulla cronologia e sul catalogo." *Arte cristiana* (Milan), n.s., vol. 75, no. 718 (January–February 1987), pp. 47–66.

Boskovits 1988
Miklós Boskovits. *Gemäldegalerie Berlin: Katalog der Gemälde: Frühe italienische Malerei.* Translated and edited by Erich Schleier. Berlin, 1988.

Boskovits 1990
Miklós Boskovits with Serena Padovani. *The Thyssen-Bornemisza Collection: Early Italian Painting 1290–1470.* Translated by Françoise Pouncey Chiarini. London, 1990.

Boskovits 1991
Miklós Boskovits. "Un libro su Pietro Lorenzetti." *Arte cristiana* (Milan), n.s., vol. 79, no. 746 (September–October 1991), pp. 387–88.

Boskovits 1993
Miklós Boskovits. "Per la storia nella pittura tra la Romagna e le Marche ai primi del '300—II." *Arte cristiana* (Milan), n.s., vol. 81, no. 756 (May–June 1993), pp. 163–82.

Boskovits 1994
Miklós Boskovits. *Immagini da meditare: ricerche su dipinti di tema religioso nei secoli XII–XV.* Vita e pensiero, 5. Milan, 1994.

Boskovits 1995
Miklós Boskovits. "Attorno al tondo Cook: precisazioni sul beato Angelico, su Filippo Lippi, e altri." *Mitteilungen des Kunsthistorischen Institutes in Florenz* (Florence), vol. 39, no. 1 (1995), pp. 32–68.

Boskovits 1995a
Miklós Boskovits. "Ancora su Paolo Schiavo: una scheda biografica e una proposta di catalogo." *Arte cristiana* (Milan), n.s., vol. 83, no. 770 (September–October 1995), pp. 332–40.

Boskovits 2001
Miklós Boskovits. "Domenico di Bartolo o Matteo di Giovanni." In *Opere e giorni: studi su mille anni di arte europea dedicati a Max Seidel* (pp. 299–306). Edited by Klaus Bergdolt and Giorgio Bonsanti. Venice, 2001.

Boskovits 2002
Miklós Boskovits. "Ancora sul Maestro del 1419." *Arte cristiana* (Milan), vol. 90, no. 812 (September–October 2002), pp. 423–38.

Boskovits and Brown 2003
Miklós Boskovits and David Alan Brown. *Italian Paintings of the Fifteenth Century.* Texts by Robert Echols et al. The Collections of the National Gallery of Art, Systematic Catalogue. Washington, D.C., 2003.

Boskovits and Tartuferi 2003
Miklós Boskovits and Angelo Tartuferi. *Dipinti.* Vol. 1, *Dal duecento a Giovanni da Milano.* Cataloghi della Galleria dell'Accademia di Firenze. Florence, 2003.

Boskovits, Mojzer, and Musci 1965
Miklós Boskovits, Miklós Mojzer, and Andreas Mucsi. *Das christliche Museum von Esztergom (Gran).* Budapest, 1965. German translation of the Hungarian edition, 1964.

Bosque 1965
Andrée de Bosque. *Artistes italiens en Espagne du XIVme siècle aux rois catholiques.* Paris, 1965.

Boucher de Lapparent 1978
Denise Boucher de Lapparent. "Le Maître de Panzano." *La revue du Louvre et des musées de France* (Paris), vol. 28, no. 3 (1978), pp. 165–74.

Bovero 1974
Anna Bovero. *L'opera completa del Crivelli.* Classici dell'arte, 80. Milan, 1974.

Bowron 1990
Edgar Peters Bowron. *European Paintings before 1900 in the Fogg Art Museum: A Summary Catalogue Including Paintings in the Busch-Reisinger Museum.* Cambridge, 1990.

Bragazzi 1858
Giuseppe Bragazzi. *Compendio della storia di Foligno.* Foligno, 1858.

Braham 1980
Allan Braham. "The Emperor Sigismund and the Santa Maria Maggiore Altar-piece." *The Burlington Magazine* (London), vol. 122, no. 923 (February 1980), pp. 106–12.

Brandi 1930–31
Cesare Brandi. "Gli affreschi di Monticiano." *Dedalo* (Milan), vol. 11 (1930–31), pp. 709–34.

Brandi 1931
Cesare Brandi. "Die Verkündigung in S. Pietro a Ovile." *Mitteilungen des Kunsthistorischen Institutes in Florenz* (Florence), vol. 3 (1931), pp. 323–48.

Brandi 1931a
Cesare Brandi. "An Unpublished Reliquary of Francesco di Vannuccio." *Art in America* (Westport, Conn.), vol. 20, no. 1 (December 1931), pp. 38–48.

Brandi 1933
Cesare Brandi. *La regia Pinacoteca di Siena.* Le guide dei musei italiani. Rome, 1933.

Brandi 1933a
Cesare Brandi. "Francesco di Vannuccio e Paolo di Giovanni Fei." *Bullettino senese di storia patria* (Siena), n.s., vol. 4 (1933), pp. 25–42.

Brandi 1934
Cesare Brandi. "Ein 'Desco da Parto' und seine Stellung innerhalb der toskanischen Malerei nach dem Tode Masaccios." *Jahrbuch der Preuszischen Kunstsammlungen* (Berlin), vol. 55 (1934), pp. 154–80.

Brandi 1941
Cesare Brandi. "Giovanni di Paolo." *Le arti* (Florence), vol. 3, no. 4 (April–May 1941), pp. 230–50; vol. 3, no. 5 (June–July 1941), pp. 316–41.

Brandi 1947
Cesare Brandi. *Giovanni di Paolo.* Florence, 1947.

Brandi 1949
Cesare Brandi. *Quattrocentisti senesi.* Collezione "Valori plastici." Milan, 1949.

Brandi 1951
Cesare Brandi. *Duccio.* Florence, 1951.

Brandi 1957
Cesare Brandi. "I cinque anni cruciali della pittura fiorentina del '400." In *Studi in onore di Matteo di Marangoni* (pp. 163–75). Pisa, 1957.

Brandi 1958
Cesare Brandi. *Pietro Lorenzetti: affreschi nella basilica di Assisi.* Collana d'arte sidera. Rome, 1958.

Brandi 1959
Cesare Brandi. *Il restauro della Maestà di Duccio.* Rome, 1959.

Breck 1913
Joseph Breck. "A Trecento Painting in Chicago." *Art in America* (New York), vol. 1, no. 2 (April 1913), pp. 112, 115.

Breck 1914
Joseph Breck. "Some Paintings by Giovanni di Paolo." *Art in America* (New York), vol. 2, no. 3 (April 1914), pp. 177–86; vol. 2, no. 4 (June 1914), pp. 280–87.

Brejon de Lavergnée and Thiébaut 1981
Arnauld Brejon de Lavergnée and Dominique Thiébaut, eds. *Catalogue sommaire illustré des peintures du musée du Louvre.* Vol. 2, *Italie, Espagne, Allemagne, Grande-Bretagne, et divers.* Paris, 1981.

Brenzoni 1928
Raffaello Brenzoni. "Una tavoletta ignorata di Piero Francesco Fiorentino." Journal unknown, pp. 3–6. Copy in John G. Johnson Collection, Curatorial Files.

Brenzoni 1972
Raffaello Brenzoni. *Dizionario di artisti veneti pittori, scultori, architetti, etc. dal XIII al XVIII secolo.* Florence, 1972.

Brera 1990
Pinacoteca di Brera: scuola veneta. Musei e gallerie di Milano. Milan, 1990.

Brera 1992
Pinacoteca di Brera: scuole dell'Italia centrale e meridionale. Musei e gallerie di Milano. Milan, 1992.

Breteuil 1986
Château de Breteuil. *Un Grand Collectionneur sous Louis XV: Le Cabinet de Jacques-Laure de Breteuil, bailli de l'Ordre de Malte, 1723–85.* Exhibition, May 1–November 11, 1986.

Bridgeport 1962
Bridgeport (Conn.) Museum of Art, Science, and Industry. *Samuel H. Kress Study Collection.* Bridgeport, 1962.

Brieger, Meiss, and Singleton 1969
Peter Brieger, Millard Meiss, and Charles S. Singleton. *Illuminated Manuscripts of the Divine Comedy.* 2 vols. Bollingen Series, 81. Princeton, 1969.

Brigstocke 1967
Hugh Brigstocke. "Reattributions of Some Italian Pictures." *Preview 80: City of York Art Gallery Quarterly* (York, England), vol. 20 (October 1967), pp. 739–43.

Brockwell 1918
Maurice W. Brockwell. "The Johnson Collection in

Philadelphia." *The Connoisseur* (London), vol. 50, no. 199 (March 1918), pp. 143–53.

Brockwell 1918a
Maurice W. Brockwell. "The Cook Collection: Part 3." *The Connoisseur* (London), vol. 50, no. 197 (January 1918), pp. 3–10.

Brogi 1897
Francesco Brogi. *Inventario generale degli oggetti d'arte della provincia di Siena.* Siena, 1897.

Bronzini 1952
Giovanni Battista Bronzini. "Una redazione versificata umbro-senese della leggenda di S. Caterina d'Alessandria." *Accademia Nazionale dei Lincei: rendiconti della classe di scienze morali, storiche e filologiche* (Rome), 8th ser., vol. 7, nos. 1–2 (January–February 1952), pp. 75–106.

Brown 1976
August Caesar Brown, Jr. "The Eight Surviving Pellegrinaio Frescoes of the Ospedale della Scala and Their Social and Visual Sources." Ph.D. diss., University of Pittsburgh, 1976.

Brown and Rankin 1914
Alice van Vechten Brown and William Rankin. *A Short History of Italian Painting.* New York, 1914.

Brownlee 1989
David B. Brownlee. *Building the City Beautiful: The Benjamin Franklin Parkway and the Philadelphia Museum of Art.* Philadelphia, 1989. Exhibition, Philadelphia Museum of Art, September 9–November 26, 1989.

Bruno 1978
Raffaele Bruno. *Roma: Pinacoteca Capitolina.* Musei d'Italia—Meraviglie d'Italia, 13. Bologna, 1978.

Bucchi 1916
G. Bucchi. *Guida di Empoli illustrata.* Florence, 1916.

Buchowiecki 1967
Walther Buchowiecki. *Handbuch der Kirchen Roms: Der römische Sakralbau in Geschichte und Kunst von der altchristlichen Zeit bis zur Gegenwart.* Vol. 1. Vienna, 1967.

Budapest 1991
Budapest, Szépművészeti Múzeum. *Old Masters' Gallery: A Summary Catalogue of Italian, French, Spanish, and Greek Paintings.* Edited by Vilmos Tátrai. London, 1991.

Bughetti 1941
Benvenuto Bughetti. "Il codice bernardiniano contentente gli schemi del santo in volgare per la quaresima di Firenze 1425 (Siena, Osservanza, Museo Castelli, n. 28)." *Archivum franciscanum historicum* (Quaracchi [Florence]), vol. 34, nos. 1–2 (January–April 1941), pp. 185–235.

Bumaldo 1641
Giovanni Antonio Bumaldo (Ovidio Montalbani). *Minervalia bononiensium civum anademata seu bibliotheca bononiensis.* Bologna, 1641.

Buoncore 2002
Vincenzo Buoncore. "Una tavoletta inedita di Tommaso del Mazza proveniente dall'*Etruria pittrice* del marchese Alfonso Tacoli-Canacci." *Arte cristiana* (Milan), vol. 90, no. 813 (November–December 2002), pp. 423–38.

Buranelli 2001
Francesco Buranelli, ed. *Il beato Angelico e la cappella*

niccolina: storia e restauro. Monumenti, Musei e Gallerie Pontificie. Novara, 2001.

Burroughs 1931
Alan Burroughs. "Some Aesthetic Values Recorded by the X-Ray." *Art Studies: Medieval, Renaissance, and Modern* (Cambridge, Mass.), vol. 8 (1931), pp. 59–72.

Busignani 1959
Alberto Busignani. "Note su alcuni fatti minori del secondo quattrocento fiorentino." *Arte figurativa antica e moderna* (Milan), vol. 7 (March–April 1959), pp. 20–25.

Byam Shaw 1967
James Byam Shaw. *Paintings by Old Masters at Christ Church, Oxford.* London, 1967.

Cadogan 1991
Jean K. Cadogan, ed. *Wadsworth Atheneum, Paintings.* Vol. 2, *Italy and Spain: Fourteenth through Nineteenth Centuries.* "Italian Paintings" by Jean K. Cadogan and Michael R. T. Mahoney. "Spanish Paintings" by George Kubler and Craig Felton. Hartford, 1991.

Caglioti 1987
Francesco Caglioti. "Per il recupero della giovinezza romana di Mino da Fiesole: il 'Ciborio della neve.'" *Prospettiva* (Siena-Florence), no. 49 (April 1987; printed December 1988), pp. 15–32.

Cairola and Carli 1963
Aldo Cairola and Enzo Carli. *Il Palazzo Pubblico di Siena.* Rome, 1963.

Caleca 1976
Antonino Caleca. "Tre polittici di Lippo Memmi: un'ipotesi sul Barna e la bottega di Simone e Lippo, 1." *Critica d'arte* (Florence), vol. 41, n.s., vol. 22, no. 150 (November–December 1976), pp. 49–59.

Callisen 1937
S. A. Callisen. "The Evil Eye in Italian Art." *The Art Bulletin* (New York), vol. 19, no. 3 (September 1937), pp. 450–62.

Callmann 1974
Ellen Callmann. *Apollonio di Giovanni.* Oxford, 1974.

Callmann 1975
Ellen Callmann. "Thebaid Studies." *Antichità viva* (Florence), vol. 14, no. 3 (May–June 1975), pp. 3–22.

Callmann 1977
Ellen Callmann. "An Apollonio di Giovanni for an Historic Marriage." *The Burlington Magazine* (London), vol. 119, no. 888 (March 1977), pp. 174–81.

Callmann 1980
Ellen Callmann. *Beyond Nobility: Art for the Private Citizen in the Early Renaissance.* Allentown, Pa., 1980. Exhibition, Allentown Art Musem, September 28, 1980–January 4, 1981.

Callmann 1988
Ellen Callmann. "Apollonio di Giovanni and Painting for the Early Renaissance Room." *Antichità viva* (Florence), vol. 27, nos. 3–4 (July–September 1988; printed November 1988), pp. 5–18.

Callmann 1999
Ellen Callmann. "Masolino da Panicale and Florentine Cassone Painting." *Apollo* (London), n.s., vol. 150, no. 450 (August 1999), pp. 42–49.

Campbell 1990
Lorne Campbell. *Renaissance Portraits: European*

Portrait-Painting in the 14th, 15th, and 16th Centuries. New Haven, 1990.

Campori 1885
Giuseppe Campori. "I pittori degli Estensi nel secolo XV." *Atti e memorie delle regie deputazioni di storia patria per le provincie modenesi e parmensi* (Modena), 3rd ser., vol. 3, pt. 1 (1885), pp. 525–604.

Caneva 2001
Caterina Caneva, ed. *Masaccio: il trittico di San Giovenale e il primo '400 fiorentino.* Milan, 2001.

Cannon 1982
Joanna Cannon. "Simone Martini, the Dominicans, and the Early Sienese Polyptych." *Journal of the Warburg and Courtauld Institutes* (London), vol. 45 (1982), pp. 69–93.

Cannon 1987
Joanna Cannon. "Pietro Lorenzetti and the History of the Carmelite Order." *Journal of the Warburg and Courtauld Institutes* (London), vol. 50 (1987), pp. 18–28.

Cannon 1994
Joanna Cannon. "The Creation, Meaning, and Audience in the Early Sienese Polyptych: Evidence from the Friars." In *Italian Altarpieces, 1250–1550: Function and Design* (pp. 41–80). Edited by Eve Borsook and Fiorella Superbi Gioffredi. Oxford, 1994.

Cannon and Vauchez 1999
Joanna Cannon and André Vauchez. *Margherita of Cortona and the Lorenzetti: Sienese Art and the Cult of a Holy Woman in Medieval Tuscany.* University Park, Pa., 1999.

Cantelli 1974
Giuseppe Cantelli, ed. *Il Museo Stibbert a Firenze.* Vol. 2 in 2 vols. Gallerie e musei minori di Firenze. Florence, 1974.

Cappelletti
Giuseppe Cappelletti. *Le chiese d'Italia dalla loro origine sino ai nostri giorni.* 21 vols. Venice, 1844–70.

Cardellini 1962
Ida Cardellini. *Desiderio da Settignano.* Studi e documenti di storia dell'arte, 3. Milan, 1962.

Carli 1946
Enzo Carli. *Vetrata duccesca.* Florence, 1946.

Carli 1955
Enzo Carli. *La pittura senese.* Milan, 1955.

Carli 1956
Enzo Carli. *Pietro Lorenzetti.* Milan, 1956.

Carli 1956a
Enzo Carli. *Sienese Painting.* London, 1956.

Carli 1957
Enzo Carli. *Sassetta e il Maestro dell'Osservanza.* I sommi dell'arte italiana. Milan, 1957.

Carli 1958
Enzo Carli. *Pittura medievale pisana.* Milan, 1958.

Carli 1958–61
Enzo Carli. *Pittura pisana del trecento.* 2 vols. Milan, 1958–61.

Carli 1960
Enzo Carli. *I Lorenzetti.* 2nd ed. Collezione silvana, 22. Milan, 1960.

Carli 1960a
Enzo Carli. "A 'Resurrection' by the Master of the Osservanza." Translated by Lawrence A. Wilson.

The Art Quarterly (Detroit), vol. 23, no. 4 (Winter 1960), pp. 333–40.

Carli 1961
Enzo Carli. *Duccio di Buoninsegna.* Milan, 1961.

Carli 1966
Enzo Carli. *Pienza: la città di Pio II.* Rome, 1966.

Carli 1971
Enzo Carli. *I pittori senesi.* Siena, 1971.

Carli 1971a
Enzo Carli. *L'arte nella basilica di S. Francesco a Siena.* Siena, 1971.

Carli 1974
Enzo Carli. *Il Museo di Pisa.* Pisa, 1974.

Carli 1976
Enzo Carli. "Luoghi ed opere d'arte senesi nelle prediche di Bernardino del 1427." In *Bernardino predicatore nella società del suo tempo* (pp. 155–86). Convegni del Centro di Studi sulla Spiritualità Medievale, 16, Todi, October 9–12, 1975. Todi, 1976.

Carli 1977
Enzo Carli. *Gli affreschi del Tau a Pistoia.* Quaderni d'arte. Florence, 1977.

Carli 1978
Enzo Carli. *Volterra nel medioevo e nel rinascimento.* Pisa, 1978.

Carli 1979
Enzo Carli. *Il duomo di Siena.* Genoa, 1979.

Carli 1981
Enzo Carli. *La pittura senese del trecento.* Milan, 1981.

Carli 1996
Enzo Carli. *Simone Martini: la Maestà.* Dentro la pittura. Milan, 1996.

Caroselli 1994
Susan L. Caroselli with contributions by Joseph Fronek and members of the Conservation Center. *Italian Panel Painting of the Early Renaissance in the Collection of the Los Angeles County Museum of Art.* Los Angeles, 1994. Exhibition, Los Angeles County Museum of Art, December 22, 1994–March 12, 1995.

Carotti 1901
Giulio Carotti. "Una tavoletta di Benozzo Gozzoli." *Rassegna d'arte* (Milan), vol. 1, no. 5 (May 1901), pp. 72–74.

Casciu 1993
Stefano Casciu. *Il Museo della basilica di Santa Maria delle Grazie: guida alle opere e itinerario storico-artistico nelle chiese di San Giovanni Valdarno.* Toscana musei. Montepulciano, 1993.

Cassee 1980
Elly Cassee. *The Missal of Cardinal Bertrand de Deux: A Study in Fourteenth-Century Bolognese Miniature Painting.* Translated by Michael Hoyle. Istituto Universitario Olandese di Storia dell'Arte, 9. Florence, 1980.

Castelfranchi Vegas 1966
Liana Castelfranchi Vegas. *Il gotico internazionale in Italia.* La pittura italiana. Rome, 1966.

Castelfranchi Vegas 1966a
Liana Castelfranchi Vegas. *Il gotico internazionale in Italia.* I maestri del colore, 255. Storia della pittura, vol. 5. Milan, 1966.

Castello 1984
Quartiere 9: Castello, campagna medicea in preferia urbana. Florence, 1984.

Castelnuovo 1995
Enrico Castelnuovo, ed. *Ambrogio Lorenzetti: il "Buon Governo."* Contributions by Maria Morica Donato and Furio Brugnolo. Dentro la pittura. Milan, 1995.

Catalano 1652
Niccolò Catalano. *Fiume del terrestre paradiso.* Florence, 1652.

Cattaneo and Dell'Acqua 1976
Enrico Cattaneo and Gian Alberto Dell'Acqua. *Immagini di Castiglione Olona.* Milan, 1976.

Cavalcaselle and Crowe 1883–1908
G. B. Cavalcaselle and J. A. Crowe. *Storia della pittura in Italia dal secolo II al secolo XVI.* 9 vols. Florence, 1883–1908.

Cavadini 1980
Luigi Cavadini, ed. *Giovanni da Milano.* Introduction by Mina Gregori. Valmorea (Como), 1980.

Cavanna 1910
Nicola Cavanna. *L'Umbria francescana illustrata.* Perugia, 1910.

Cavazzini 1999
Laura Cavazzini, ed. *Il fratello di Masaccio: Giovanni di ser Giovanni detto lo Scheggia.* Siena, 1999. Exhibition, San Giovanni Valdarno, Casa Masaccio, February 14–May 16, 1999.

Cecchi 1930
Emilio Cecchi. *Pietro Lorenzetti.* I geni e le opere. Milan, 1930.

Cecchi 1999
Alessandro Cecchi. "The Conservation of Antonio and Piero del Pollaiuolo's Altar-piece for the Cardinal of Portugal's Chapel." *The Burlington Magazine,* vol. 141, no. 1151 (February 1999), pp. 81–88.

Cecchi 2001
Alessandro Cecchi, ed. *Simone Martini e l'Annunciazione degli Uffizi.* Cinisello Balsamo (Milan), 2001.

Cecchi 2002
Alessandro Cecchi with Lucia Aquino. *Masaccio e i pittori del suo tempo agli Uffizi.* Milan, 2002.

Cecchini and Carli 1962
Giovanni Cecchini and Enzo Carli. *San Gimignano.* Milan, 1962.

Cennini c. 1390, Thompson ed. 1932–33
Cennino d'Andrea Cennini. *Il libro dell'arte.* Edited by Daniel V. Thompson, Jr. 2 vols. New Haven, 1932–33.

Centro Studi Agostino Trapè 1992
Centro Studi Agostino Trapè, ed. *Il cappellone di San Nicola da Tolentino.* Preface by Miklós Boskovits. Texts by Pietro Bellini et al. Cinisello Balsamo (Milan), 1992.

Cerracchini 1716
Luca Giuseppe Cerracchini. *Cronologia sacra de' vescovi e arcivescovi di Firenze.* Florence, 1716.

Cerri 1992
Francesca Cerri. "Le croci reliquiario di Gubbio: tecnica e stile." *Paragone-arte* (Florence), vol. 43, no. 3/503 (January 1992), pp. 3–11.

Chácon 1677
Alfonso Chácon. *Vitae et res gestae pontificum romanorum et S.R.E. cardinalium.* Vol. 2. Rome, 1677.

Chambers 1970
D. S. Chambers. *Patrons and Artists in the Italian Renaissance.* History in Depth. London, 1970.

Chelazzi Dini 1977
Giulietta Chelazzi Dini, ed. *Jacopo della Quercia fra gotico e rinascimento.* Atti del convegno di studi, Università di Siena, Facoltà di Lettere e Filosofia, October 2–5, 1975. Florence, 1977.

Chelazzi Dini, Angelini, and Sani 1997
Giulietta Chelazzi Dini, Alessandro Angelini, and Bernardina Sani. *Pittura senese.* Milan, 1997.

Cherubini 1991
Giovanni Cherubini, ed. *Ascesa e declino del centro medievale (dal mille al 1494).* Vol. 1 (in 2), *Prato: storia di una città.* Edited by Fernand Braudel. Prato, 1991.

Cherubini and Fanelli 1990
Giovanni Cherubini and Giovanni Fanelli, eds. *Il Palazzo Medici Riccardi di Firenze.* Texts by Cristina Acidini Luchinat et al. Florence, 1990.

Chigi 1625–26, Bacci ed. 1939
Fabio Chigi (later Alexander VII). "L'elenco delle pitture, sculture, e architetture di Siena compilato nel 1625–26 da Mons. Fabio Chigi, poi Alessandro VII, secondo il ms. Chigiano I.I.11." *Bullettino senese di storia patria* (Siena), n.s., vol. 10 (1939), pp. 197–213, 297–337.

Christiansen 1982
Keith Christiansen. *Gentile da Fabriano.* Ithaca, N.Y., 1982.

Christiansen 1987
Keith Christiansen. "Letters: The S. Vittorio Altarpiece in Siena Cathedral." *The Art Bulletin* (New York), vol. 69, no. 3 (September 1987), p. 467.

Christiansen 1990
Keith Christiansen. "Notes on *Painting in Renaissance Siena.*" *The Burlington Magazine* (London), vol. 132, no. 1044 (March 1990), pp. 205–13.

Christiansen 1990a
Keith Christiansen. Review of Bellosi 1990 and Berti and Paolucci 1990. *The Burlington Magazine* (London), vol. 132, no. 1051 (October 1990), pp. 736–39.

Christiansen 1994
Keith Christiansen. "Simone Martini's Altar-piece for the Commune of Siena." *The Burlington Magazine* (London), vol. 136, no. 1092 (March 1994), pp. 148–60.

Christiansen 2003
Keith Christiansen. "Paul Delaroche's *Crucifixion* by Pietro Lorenzetti." *Apollo* (London), n.s., vol. 157, no. 492 (February 2003), pp. 8–14.

Christiansen, Kanter, and Strehlke 1988
Keith Christiansen, Laurence B. Kanter, and Carl Brandon Strehlke. *Painting in Renaissance Siena, 1420–1500.* New York, 1988. Exhibition, New York, The Metropolitan Museum of Art, December 20, 1988–March 19, 1989.

Christiansen, Kanter, and Strehlke 1989
Keith Christiansen, Laurence B. Kanter, and Carl Brandon Strehlke with Mario Ascheri. *La pittura senese nel rinascimento: 1420–1500.* Cinisello Balsamo (Milan), 1989.

Ciaranfi 1925–26
Anna Maria Ciaranfi. "Domenico di Michelino." *Dedalo* (Milan), vol. 6 (1925–26), pp. 522–38.

Ciaranfi 1932
Anna Maria Ciaranfi. "Lorenzo Monaco Miniatore." *L'arte*, vol. 35, n.s., vol. 3, no. 4 (July 1932), pp. 285–317; no. 5 (September 1932), pp. 379–99.

Ciardi Dupré 1972
Maria Grazia Ciardi Dupré. *I corali del duomo di Siena.* Essay by Clemente Terni. Milan, 1972.

Ciardi Dupré Dal Poggetto 1973
Maria Grazia Ciardi Dupré Dal Poggetto. "Note sulla miniatura fiorentina del quattrocento, in particolare su Zanobi Strozzi." *Antichità viva* (Florence), vol. 12, no. 4 (July–August 1973), pp. 3–10.

Ciatti and Frosinini 1998
Marco Ciatti and Cecilia Frosinini with Maria Teresa Cianfanelli and Patrizia Riitano, eds. *Lorenzo Monaco, tecnica e restauro: l'Incoronazione della Vergine degli Uffizi, l'Annunciazione di Santa Trinita a Firenze.* Florence, 1998.

Cincinnati 1959
The Cincinnati Art Museum. *The Lehman Collection, New York.* Exhibition, May 8–July 5, 1959. Catalogue edited by Gustave von Groschwitz.

Cioni 1998
Elisabetta Cioni. *Scultura e smalto nell'oreficeria senese dei secoli XIII e XIV.* Florence, 1998.

Cipriani 1957
Renata Cipriani. "Giovanni da Vaprio." *Paragone-arte* (Florence), vol. 8, no. 87 (March 1957), pp. 47–53.

Ciraolo and Arbib 1924
Clara Ciraolo and Bianca Maria Arbib. *Il beato Angelico: la sua vita e le sue opere.* Preface by Adolfo Venturi. Collezione di monografie illustrate: pittori, scultori, architetti, 10. Bergamo, 1924.

Cittadella 1864–68
Luigi Napoleone Cittadella. *Notizie amministrative, storiche, artistiche relative a Ferrara ricavate da documenti.* 2 vols. Ferrara, 1864–68.

Clark 1951
Kenneth Clark. "An Early Quattrocento Triptych from Santa Maria Maggiore, Rome." *The Burlington Magazine* (London), vol. 93, no. 584 (November 1951), pp. 339–47.

Clark 1969
Kenneth Clark. *Piero della Francesca: Complete Edition.* 2nd rev. ed. London, 1969.

Clark 1990
Nicholas Clark. *Melozzo da Forlì: pictor papalis.* London, 1990.

Cleri and Donnini 2002
Bonita Cleri and Giampiero Donnini. *Il Maestro di Staffolo nella cultura artistica fabrianese del quattrocento.* Camerano, 2002.

Cleveland 1974
The Cleveland Museum of Art. *European Paintings before 1500: Catalogue of Paintings.* Pt. 1. Cleveland, 1974.

Clifford 1953
Henry Clifford. "An Italian Romanesque Cross of the Late XIII Century." *Philadelphia Museum of Art Bulletin*, vol. 48, no. 236 (Winter 1953), pp. 21–29.

Cohn 1955
Werner Cohn. "Il beato Angelico e Battista di Biagio Sanguigni." *Rivista d'arte* (Florence), vol. 30, 3rd ser., vol. 5 (1955), pp. 207–16.

Cohn 1956
Werner Cohn. "Un quadro di Lorenzo di Bicci e la decorazione primitiva della chiesa di Or San Michele di Firenze." *Bollettino d'arte* (Rome), 4th ser., vol. 41 (1956), pp. 171–77.

Cohn 1956a
Werner Cohn. "Nuovi documenti per il Beato Angelico." *Memorie domenicane* (Florence), 73rd yr., n.s., vol. 32, no. 4 (October–December 1956), pp. 218–20.

Cohn 1956b
Werner Cohn. "Notizie storiche intorno alcune tavole fiorentine del '300 e '400." *Rivista d'arte* (Florence), vol. 31, 3rd ser., vol. 6 (1956), pp. 41–72.

Cohn 1957
Werner Cohn. "Aggiunte all' 'Assistente di Daddi' e al 'Maestro di Fabriano.'" *Bollettino d'arte* (Rome), 4th ser., vol. 42, no. 2 (April–June 1957), pp. 175–76.

Cohn 1958
Werner Cohn. "Franco Sacchetti und das ikonographische Programm der Gewölbemalereien von Orsanmichele." *Mitteilungen des Kunsthistorischen Institutes in Florenz* (Florence), vol. 8, no. 2 (September 1958), pp. 67–77.

Colasanti 1934
Arduino Colasanti. "Quadri fiorentini inediti." *Bollettino d'arte* (Rome), 3rd ser., vol. 27, no. 8 (February 1934), pp. 337–50.

Cole 1967
Bruce Cole. "The Interior Decoration of the Palazzo Datini in Prato." *Mitteilungen des Kunsthistorischen Institutes in Florenz* (Florence), vol. 30, nos. 1–2 (December 1967), pp. 61–82.

Cole 1969
Bruce Cole. "Three New Works by Cenni di Francesco." *The Burlington Magazine* (London), vol. 111, no. 791 (February 1969), p. 83.

Cole 1977
Bruce Cole. *Agnolo Gaddi.* Oxford Studies in the History of Art and Architecture. Oxford, 1977.

Cole 1980
Bruce Cole. *Masaccio and the Art of Early Renaissance Florence.* Bloomington, Ind., 1980.

Cole 1985
Bruce Cole. *Sienese Painting in the Age of the Renaissance.* Bloomington, Ind., 1985.

Cole and Middeldorf 1971
Bruce Cole and Ulrich Middeldorf. "Masaccio, Lippi, or Hugford." *The Burlington Magazine* (London), vol. 118, no. 822 (September 1971), pp. 500–507.

D. Cole 1977
Diane Elyse Cole. "Fra Angelico: His Role in Quattrocento Painting and Problems of Chronology." Ph.D. diss., University of Virginia, 1977.

D. Cole 1977a
Diane Elyse Cole. "Fra Angelico: A New Document." *Mitteilungen des Kunsthistorischen Institutes in Florenz* (Florence), vol. 21, no. 1 (1977), pp. 95–100.

Coletti 1950
Luigi Coletti. "Sulla mostra della pittura bolognese del trecento, con una coda polemica." *Emporium* (Bergamo), 46th yr., no. 12; vol. 112, no. 672 (December 1950), pp. 243–60.

Coletti 1951
Luigi Coletti. "Su Antonio Orsini." *Arte veneta* (Venice), vol. 5 (1951), pp. 94–97.

Coletti 1963
Luigi Coletti. *Tomaso da Modena.* Edited by Clara Rosso Coletti. Preface by Sergio Bettini. Venice, 1963.

Colle 1987
Enrico Colle. *Masaccio.* San Giovanni Valdarno, 1987.

Collobi Ragghianti 1950
Licia Collobi Ragghianti. "Domenico di Michelino." *Critica d'arte* (Florence), 3rd ser., vol. 8, no. 5, fasc. 31 (January 1950), pp. 363–83.

Collobi Ragghianti 1950a
Licia Collobi Ragghianti. "Zanobi Strozzi pittore." *Critica d'arte* (Florence), 3rd ser., vol. 8, no. 6, fasc. 32 (March 1950), pp. 454–73; 3rd ser., vol. 9, no. 1, fasc. 33 (May 1950), pp. 17–27.

Collobi Ragghianti 1955
Licia Collobi Ragghianti. "Una mostra dell'Angelico." *Critica d'arte* (Florence), no. 10 (July 1955), pp. 389–94.

Collobi Ragghianti 1955a
Licia Collobi Ragghianti. "Studi angelichiani." *Critica d'arte* (Florence), no. 7 (January 1955), pp. 22–47.

Colnaghi 1928
Dominic Ellis Colnaghi. *A Dictionary of Florentine Painters from the 13th to the 17th Centuries.* Edited by P. G. Konody and Selwyn Brinton. London, 1928.

Cologne 1905
Cologne, Wallraf-Richartz-Museum. *Verzeichnis der Gemälde des Städtischen Museums Wallraf-Richartz zu Cöln.* Cologne, 1905.

Comanducci 2003
Rita Maria Comanducci. "'L'altare nostro de la Trinità': Massacio's Trinity and the Berti Family." *The Burlington Magazine* (London), vol. 145, no. 1198 (January 2003), pp. 14–21.

Comstock 1927
Helen Comstock. "Umbrian Paintings in American Collections." *International Studio* (New York), vol. 86, no. 356 (January 1927), pp. 21–30, 90–91.

Comstock 1927a
Helen Comstock. "Paintings by Giovanni di Paolo in America." *International Studio* (New York), vol. 87, no. 363 (August 1927), pp. 47–55, 82.

Comstock 1927b
Helen Comstock. "Panels from Duccio's *Majestas* for America." *International Studio* (New York), vol. 88, no. 364 (September 1927), pp. 63–70.

Comstock 1927c
Helen Comstock. "Paintings by Sassetta in America." *International Studio* (New York), vol. 88, no. 365 (October 1927), pp. 35–41.

Comstock 1928
Helen Comstock. "The Bernardo Daddis in the United States." *International Studio* (New York), vol. 89, no. 369 (February 1928), pp. 21–26, 94; vol. 89, no. 370 (March 1928), pp. 71–76, 90.

Comucci 1926
Alberto Comucci. *Siena e le sue contrade: breve cenno storico.* Siena, 1926.

Concioni, Ferri, and Ghilarducci 1994
Graziano Concioni, Claudio Ferri, and Giuseppe Ghilarducci. *Arte e pittura nel medioevo lucchese.* Introduction by Arnold Esch. Lucca, 1994.

Consortini 1915
Luigi Consortini. *La badia dei SS. Giusto e Clemente presso Volterra: notizie storiche e guida del tempio e del cenobio.* Lucca, 1915.

Consortini 1925
P. Luigi Consortini. "Osservazioni critiche sui Santi Giusto, Clemente, e Ottaviano protettori di Volterra, in risposta alla critica di Mons. F. Lanzoni alle loro leggende." *Rassegna volterrana* (Volterra), vol. 2, no. 2 (September 1925), pp. 75–91.

Conti 1981
Alessandro Conti. *La miniatura bolognese: scuole e botteghe, 1270–1340.* Fonti e studi per la storia di Bologna e delle province emiliane e romagnole, 7. Bologna, 1981.

Conti 1994
Alessandro Conti. "Maso, Roberto Longhi e la tradizione offneriana." *Prospettiva* (Florence-Siena), nos. 73–74 (January–April 1994), pp. 32–45.

Contrusceri 1995
Santi Contrusceri. "Tre dipinti di S. Nicola da Tolentino nel museo di Philadelphia—U.S.A.—I parte." In *San Nicola da Tolentino, agostiniano* (pp. 86–87). Tolentino, 1995.

Contrusceri 1995a
Santi Contrusceri. "Ricerca iconografica S. Nicola da Tolentino nel museo di Philadelphia." In *San Nicola da Toletino, agostiniano* (pp. 118–19). Tolentino, 1995.

Convenevole da Prato 1982
Convenevole da Prato. *Regia carmina, dedicati a Roberto d'Angiò re di Sicilia e di Gerusalemme.* Introduction, critical text, translation, and commentary by Cesare Grassi with texts by Marco Ciatti and Aldo Petri. 2 vols. Cinisello Balsamo (Milan), 1982.

Cooper 1965
Frederick A. Cooper. "A Reconstruction of Duccio's *Maestà*." *The Art Bulletin* (New York), vol. 47, no. 2 (June 1965), pp. 155–71.

Coor 1955
Gertrude Coor. "Contributions to the Study of Ugolino di Nerio's Art." *The Art Bulletin* (New York), vol. 38, no. 3 (September 1955), pp. 153–65.

Coor 1955a
Gertrude Coor. "A Painting of St. Lucy in the Walters Art Gallery and Some Closely Related Representations." *The Journal of the Walters Art Gallery* (Baltimore), vol. 18 (1955), pp. 79–90.

Coor 1956
Gertrude Coor. "Trecento-Gemälde aus der Sammlung Ramboux." *Wallraf-Richartz-Jahrbuch* (Cologne), vol. 18 (1956), pp. 111–31.

Coor 1959
Gertrude Coor. "Quattrocento-Gemälde aus der Sammlung Ramboux." *Wallraf-Richartz-Jahrbuch* (Cologne), vol. 21 (1959), pp. 75–96.

Coor 1961
Gertrude Coor. *Neroccio de' Landi, 1447–1500.* Princeton, 1961.

Coor 1961a
Gertrude Coor. "A Further Link in the Reconstruction of an Altarpiece by Andrea di Bartolo." *The Journal of the Walters Art Gallery* (Baltimore), vol. 24 (1961), pp. 55–60.

Coor 1961b
Gertrude Coor. "A Note on Some Predella Paintings by Martino di Bartolommeo." *Philadelphia Museum of Art Bulletin*, vol. 56, no. 268 (Winter 1961), pp. 56–60.

Corbara 1984
Antonio Corbara. "Il ciclo francescano di Francesco da Rimini." *Romagna arte e storia* (Rimini), vol. 4, no. 12 (September–December 1984), pp. 5–62.

Corbo 1969
Anna Maria Corbo. *Artisti e artigiani in Roma al tempo di Martino V e di Eugenio IV.* Raccolta di fonti per la storia dell'arte, 2nd ser., 1. Rome, 1969.

Corbo 1984
Anna Maria Corbo. "Relazione descrittiva degli archivi notarili romani dei secoli XIV–XV nell'Archivio di Stato e nell'Archivio Capitolino." In *Gli atti privati nel tardo medioevo: fonti per la storia sociale* (pp. 49–67). Edited by Paolo Brezzi and Egmont Lee. Atti del convegno, Rome, June 16–18, 1980. Rome, 1984.

Corella c. 1469, Lami ed. 1742
Domenico da Corella. *Operis, quod Theoticon, seu de vita & obitu B. Mariae Virginis inscribitur.* Books 3 and 4. In Giovanni Lami, *Deliciae eruditorum, seu veterum Anekdoton opusculorum collectanea.* Florence, 1742.

Cordella 1987
Romano Cordella. "Un sodalizio tra Bartolomeo di Tommaso, Nicola da Siena, Andrea Delitio." *Paragone-arte* (Florence), n.s., vol. 38, no. 5/451 (September 1987), pp. 89–122.

Cordella 1990
Romano Cordella. "Nuovi dati su alcuni pittori della Valnerina nel secondo '400." In *Dall'Albornoz all'età dei Borgia: questioni di cultura figurative nell'Umbria meridionale* (pp. 207–47). Contributions by Federico Zeri et al. Atti del convegno di studi, Amelia, Teatro Sociale, October 1–3, 1987. Todi, 1990.

Cordella 1992
Romano Cordella. "Nicola da Siena autore del politico di S. Eutizio nel 1472." *Spoletium* (Spoleto), vols. 33–34, nos. 36–37 (December 1992), pp. 106–7.

Cornell 1924
Hendrik Cornell. *The Iconography of the Nativity of Christ.* Uppsala Universitets Årsskrift. Uppsala, Sweden, 1924.

Corti 1981
Gino Corti. "La compagnia di Taddeo di Bartolo e Gregorio di Cecco, con altri documenti inediti." *Mitteilungen des Kunsthistorischen Institutes in Florenz* (Florence), vol. 25, no. 3 (1981), pp. 373–77.

Cortona 1970
See Bellosi, Cantelli, and Lenzini Moriondo 1970

Craven 1997
Jennifer E. Craven. "A New Historical View of the Independent Female Portrait in Fifteenth-Century Florentine Painting." Ph.D. diss., University of Pittsburgh, 1997.

Cristiani Testi 1978
Maria Laura Cristiani Testi. *Affreschi biblici di Martino di Bartolomeo in San Giovanni Battista di Cascina.* Pisa, 1978.

Crowe and Cavalcaselle 1864–66
J. A. Crowe and G. B. Cavalcaselle. *A New History of Painting in Italy from the Second to the Sixteenth Century.* 3 vols. London, 1864–66.

Crowe and Cavalcaselle 1903–14
J. A. Crowe and G. B. Cavalcaselle. *A History of Painting in Italy: Umbria, Florence, and Siena from the Second to the Sixteenth Century.* 6 vols. Vols. 1–2 edited by Langton Douglas assisted by S. Arthur Strong. Vol. 3 edited by Langton Douglas. Vol. 4 edited by Langton Douglas assisted by G. de Nicola. Vols. 5–6 edited by Tancred Borenius. London, 1903–14.

Crowe and Cavalcaselle 1908–9
J. A. Crowe and G. B. Cavalcaselle. *A New History of Painting in Italy.* Edited by Edward Hutton. 3 vols. London, 1908–9.

Cuppini 1949
Lorenzo Cuppini. "Un Lorenzo Veneziano a Siracusa." *Arte veneta* (Venice), vol. 3 (1949), pp. 159–60.

Cust and Horne 1905
Lionel Cust and Herbert P. Horne. "Notes on Pictures in the Royal Collections. Article VIII—*The Story of Simon Magus*, Part of a Predella Painting by Benozzo Gozzoli." *The Burlington Magazine* (London), vol. 7, no. 29 (August 1905), pp. 377–83.

Czarnecki 1978
James Gregory Czarnecki. "Antonio Veneziano, a Florentine Painter of the Late Trecento." Ph.D. diss., Indiana University, Bloomington, 1978.

Dahl 1840
J. C. Dahl. *Catalog ober det Bergenske Museums Malerisamling.* Bergen, Norway, 1840.

Dalli Regoli 1970
Gigetta Dalli Regoli. "La vacchetta pisana." *Critica d'arte* (Florence), vol. 35, n.s., vol. 17, no. 114 (November–December 1970), pp. 41–71.

Dalli Regoli 1988
Gigetta Dalli Regoli, ed. *Il "Maestro di San Miniato": lo stato degli studi, i problemi, le risposte della filologia.* Introduction by Federico Zeri. Texts by Serenella Castri, Gemma Landolfi, and Paola Richetti. Pisa, 1988.

Dalli Regoli and Ciardi 2002
Gigetta Dalli Regoli and Roberto Paolo Ciardi, eds. *Storia delle arti in Toscana: il quattrocento.* Florence, 2002.

Dal Poggetto 1969
Paolo Dal Poggetto, ed. *Museo di Fucecchio.* Fucecchio, 1969.

Dal Poggetto 1998
Paolo Dal Poggetto, ed. *Fioritura tardogotica nelle Marche.* Milan, 1998. Exhibition, Urbino, Palazzo Ducale, July 25–October 25, 1998.

Dami 1913
Luigi Dami. "Neroccio di Bartolomeo Landi." *Rassegna d'arte* (Milan), vol. 13, no. 9 (September 1913), pp. 137–43; vol. 13, no. 10 (October 1913), pp. 160–70.

Dami 1923–24
Luigi Dami. "Giovanni di Paolo miniatore e i paesisti senesi." *Dedalo* (Milan), vol. 4 (1923–24), pp. 269–303.

D'Amico 1982
Rosalba D'Amico. "La 'Madonna del Ricamo' di Vitale da Bologna del '300." *Strenna storica bolognese* (Bologna), vol. 32 (1982), pp. 169–83.

D'Amico 1986

Rosalba D'Amico. "Restauri di pitture murali del tre-cento bolognese: nuovi contributi per un itinerario gotico." In *Itinerari: contributi alla storia dell'arte in memoria di Maria Luisa Ferrari*, vol. 4 (pp. 31–86). Edited by Antonio Boschetto. Florence, 1986.

D'Amico 1994

Rosalba D'Amico. "Vitale in Santa Maria dei Servi e la cultura figurativa della metà del trecento a Bologna." *Strenna storica bolognese* (Bologna), vol. 44 (1994), pp. 181–93.

D'Amico and Medica 1986

Rosalba D'Amico and Massimo Medica, eds. *Vitale da Bologna*. Pinacoteca Nazionale di Bologna, Rapporti, 57. Bologna, 1986.

D'Amico, Grandi, and Medica 1990

Rosalba D'Amico, Renzo Grandi, and Massimo Medica. *Francesco da Rimini e gli esordi del gotico bolognese*. Texts by Daniele Benati, Robert Gibbs, Corinna Giudici, and Maria Giuseppina Muzzarelli. Introduction by Michel Laclotte. Bologna, 1990. Exhibition, Bologna, Lapidario del Museo Civico, October 6–November 25, 1990.

Da Morrona 1821

Alessandro Da Morrona. *Pisa antica e moderna*. Pisa, 1821.

D'Ancona 1908

Paolo D'Ancona. "Un'ignoto collaboratore del beato Angelico (Zanobi Strozzi)." *L'arte* (Rome), vol. 11, no. 2 (March–April 1908), pp. 81–95.

D'Ancona 1914

Paolo D'Ancona. *La miniatura fiorentina (secoli XI–XVI)*. 2 vols. Florence, 1914.

Daneu Lattanzi 1972

Angela Daneu Lattanzi. "I manoscritti e incunaboli miniati italiani della Biblioteca Bodleiana di Oxford nel catalogo di O. Pächt e J.J.G. Alexander." *Bollettino d'arte* (Rome), 5th ser., vol. 57, no. 1 (January–March 1972), pp. 46–56.

Danti 2001

Cristina Danti. "Il restauro della 'Trinità.'" In *Nel segno di Masaccio: l'invenzione della prospettiva* (pp. 53–56). Edited by Filippo Camerota. Florence, 2001. Exhibition, Florence, Galleria degli Uffizi, October 16, 2001–January 20, 2002.

D'Archiardi 1929

Pietro D'Archiardi. *I quadri primitivi della Pinacoteca Vaticana, provenienti della Biblioteca Vaticana e dal Museo Cristiano*. Rome, 1929.

Datini 1972

Giulio Datini, ed. *Musei di Prato: Galleria di Palazzo Pretorio, Opera del Duomo, Quadreria Comunale*. Musei d'Italia—Meraviglie d'Italia, 1. Bologna, 1972.

Davidson 1936

Martha Davidson. "Surrealism from 1450 to Dada and Dali." *The Art News* (New York), vol. 35, no. 11 (December 12, 1936), pp. 11–13, 22.

Davies 1951

Martin Davies. *National Gallery Catalogues: The Earlier Italian Schools*. London, 1951.

Davies 1961

Martin Davies. *National Gallery Catalogues: The Earlier Italian Schools*. 2nd rev. ed. London, 1961.

Davies and Gordon 1988

Martin Davies. *The Early Italian Schools: Before 1400*. Revised by Dillian Gordon. National Gallery Catalogues. London, 1988.

De Angelis 1621

Paolo de Angelis. *Basilica Sanctae Mariae Maioris de Urbe a Liberio Papa usque ad Paulum V Pont. Max. descriptio et delineatio*. Rome, 1621.

De Benedictis 1973

Cristina De Benedictis. *Giotto: bibliografia*. Vol. 2, *1937–1970*. Istituto Nazionale d'Archeologia e Storia dell'Arte. Bibliografie e cataloghi, IV. Rome, 1973.

De Benedictis 1976

Cristina De Benedictis. "I corali di San Gimignano, I: il secondo miniatore." *Paragone-arte* (Florence), vol. 27, no. 315 (May 1976), pp. 87–95.

De Benedictis 1979

Cristina De Benedictis. *La pittura senese, 1330–1370*. Florence, 1979.

De Blaauw 1987

Sible de Blaauw. *Cultus et decor: liturgie en architectuur in Laatantiek en middeleuws Rome: Basilica Salvatoris, Sanctae Mariae, Sancti Petri*. Delft, 1987.

De Boissard and Lavergne-Durey 1988

Élisabeth de Boissard and Valérie Lavergne-Durey. *Chantilly, Musée Condé: Peintures de l'école italienne*. Inventaire des collections publiques françaises, 34. Institut de France, II. Paris, 1988.

De Botton 1980

Judith de Botton. "Notes sur Bartolomeo Bulgarini." *Revue de l'art* (Paris), no. 48 (1980), pp. 26–29.

De Francovich 1927

Géza de Francovich. "Appunti su alcuni minori pittori fiorentini della seconda metà del secolo XV." *Bollettino d'arte* (Milan-Rome), vol. 6, no. 12 (June 1927), pp. 529–44.

Degani 1908

Ernesto Degani. "L'abbazia benedettina di Sesto in Silvis nella patria del Friuli." *Nuovo archivio veneto* (Venice), no. 67, n.s., no. 27 (1908), pp. 5–71; no. 68, n.s., no. 28 (1908), pp. 258–323.

Degenhart 1932

Bernhard Degenhart. "Di alcuni problemi di sviluppo della pittura nella bottega del Verrocchio, di Leonardo, e di Lorenzo di Credi." *Rivista d'arte* (Florence), vol. 14, 2nd ser., vol. 4 (1932), pp. 263–300, 403–44.

Degenhart and Schmitt

Bernhard Degenhart and Annegrit Schmitt. *Corpus der italienischen Zeichnungen, 1300–1450*. 2 vols. in 12 pts. Berlin, 1968–90.

Deimling 1991

Barbara Deimling. "Il Maestro di Santa Verdiana: un polittico disperso e il problema dell'identificazione." *Arte cristiana* (Milan), n.s., vol. 79, no. 747 (November–December 1991), pp. 401–11.

De la Mare 1985

A. C. De la Mare. "Further Italian Illuminated Manuscripts in the Bodleian Library." In *La miniatura italiana tra gotico e rinascimento* (vol. 2, pp. 127–54). Edited by Emanuela Sesti. Atti del II congresso di storia della miniatura italiana, Cortona, September 24–26, 1982. Storia della miniatura studi e documenti, 6. Florence, 1985.

Del Bravo 1969

Carlo Del Bravo. *Masaccio: tutte le opere*. Florence, 1969.

Del Bravo 1973

Carlo Del Bravo. "L'umanesimo di Luca della Robbia." *Paragone-arte* (Florence), vol. 24, no. 285 (November 1973), pp. 3–34.

Dell'Acqua 1959

Gian Alberto Dell'Acqua. *Arte lombarda dai Visconti agli Sforza*. Milan, 1959.

Della Valle

Guglielmo Della Valle. *Lettere senesi di un socio dell'Accademia di Fossano sopra le belle arti*. 3 vols. Venice, 1782–86. Reprint, Bologna, 1876.

Delogu Ventroni 1972

Sebastiana Delogu Ventroni. *Barna da Siena*. Biblioteca dell'Ussero. Pisa, 1972.

Del Puglia and Steiner 1963

Raffaella Del Puglia and Carlo Steiner. *Mobili e ambienti italiani dal gotico al floreale*. Vol. 1. Milan, 1963.

Del Serra 1985

Alfio Del Serra. "A Conversation on Painting Techniques." *The Burlington Magazine* (London), vol. 127, no. 982 (January 1985), pp. 4–16.

Del Serra 1996

Alfio Del Serra. *Raffaello e il ritratto di Papa Leone: per il restauro del "Leone X con due cardinali" nella Galleria degli Uffizi*. Cinisello Balsamo (Milan), 1996.

De Marchi 1985

Andrea De Marchi. "Per la cronologia dell'Angelico: il trittico di Perugia." *Prospettiva* (Siena-Florence), no. 42 (July 1985), pp. 53–57.

De Marchi 1986

Andrea De Marchi. "La mostra di *Pittura italiana del gotico e del rinascimento* a Praga." *Prospettiva* (Siena-Florence), no. 45 (April 1986; printed November 1987), pp. 69–77.

De Marchi 1987

Andrea De Marchi. "Michele di Matteo a Venezia e l'eredità lagunare di Gentile da Fabriano." *Prospettiva* (Siena-Florence), no. 51 (October 1987; printed September 1989), pp. 17–36.

De Marchi 1987a

Andrea De Marchi. "Per un riesame della pittura tardogotica a Venezia: Nicolò di Pietro e il suo contesto adriatico." *Bollettino d'arte* (Rome), 6th ser., vol. 72, nos. 44–45 (July–October 1987), pp. 25–66.

De Marchi 1992

Andrea De Marchi. *Gentile da Fabriano: un viaggio nella pittura italiana alla fine del gotico*. Milan, 1992.

De Marchi 1992a

Andrea De Marchi. "Una fonte senese per Ghiberti e per il giovane Angelico." *Artista* (Florence), 1992, pp. 130–51.

De Marchi 1994

Andrea De Marchi. "Diversità di Antonio da Fabriano." In *Un testamento pittorico di fine '400: gli affreschi restaurati di Antonio da Fabriano in San Domenico* (n.p.). Fabriano, 1994.

De Marchi 1995

Andrea De Marchi. "Una tavola nella Narodna Galeria di Ljubljana e una proposta per Marco di Paolo Veneziano." In *Gotika v Sloveniji* (pp. 241–56). Edited by Janez Höfler. Acts of the conference, Narodna

Galerija, Ljubljana, Slovenia, October 19–23, 1994. Ljubljana, 1995.

De Marchi 2002
Andrea De Marchi. *Pittori a Camerino nel quattrocento.* Jesi, 2002.

De Marchi and Giannatiempo López 2002
Andrea De Marchi and Maria Giannatiempo López, eds. *Il quattrocento a Camerino: luce e prospettive nel cuore della Marca.* Milan, 2002. Exhibition, Camerino, San Domenico, July 19–November 17, 2002.

De Marinis 1947
Tammaro de Marinis. *La biblioteca napoletana dei re d'Aragona.* 4 vols. Milan, 1947.

Dempsey 2001
Charles Dempsey. "A Hypothesis Concerning the 'Castello Nativity' and a Scruple about the Date of Botticelli's 'Primavera.'" In *Opere e giorni: studi su mille anni di arte europea dedicati a Max Seidel* (pp. 349–54). Edited by Klaus Bergdolt and Giorgio Bonsanti. Venice, 2001.

De Nicola 1913
Giacomo De Nicola. "Sassetta between 1423 and 1433." *The Burlington Magazine* (London), vol. 23, nos. 124–26 (July–September 1913), pp. 207–15, 276–83, 332–36.

De Nicola 1918
Giacomo De Nicola. "Studi sull'arte senese: I. Priamo della Quercia." *Rassegna d'arte* (Milan), vol. 18 (1918), pp. 69–74, 153–54.

De Nicola 1918a
Giacomo De Nicola. "The Masterpiece of Giovanni di Paolo." *The Burlington Magazine*, vol. 33, no. 185 (August 1918), pp. 45–54.

De Nicola 1921
Giacomo De Nicola. "Andrea di Bartolo: documenti inediti." *Rassegna d'arte senese* (Siena), vol. 14 (1921), pp. 12–15.

Detroit 1933
The Detroit Institute of Arts. *The Sixteenth Loan Exhibition of Old Masters: Italian Paintings of the XIV to XVI Century.* Exhibition, March 8–30, 1933.

Deuchler 1979
Florens Deuchler. "Duccio *Doctus*: New Readings for the *Maestà.*" *The Art Bulletin* (New York), vol. 61, no. 4 (December 1979), pp. 541–49.

Deuchler 1980
Florens Deuchler. "Siena und Jerusalem: Imagination und Realität in Duccios neuem Stadtbild." In *Europäische Sachkultur des Mittelalters* (pp. 13–20). Veröffentlichungen des Instituts für mittelalterliche Realienkunde Österreichs, 4. Vienna, 1980.

Deuchler 1984
Florens Deuchler. *Duccio.* Milan, 1984.

DeWald 1923
Ernest T. DeWald. "The Master of the Ovile Madonna." *Art Studies* (Cambridge), vol. 1 (1923), pp. 45–54.

DeWald 1929
Ernest T. DeWald. "Pietro Lorenzetti." *Art Studies* (Cambridge), vol. 7 (1929), pp. 131–66.

DeWald 1930
Ernest T. DeWald. *Pietro Lorenzetti.* Cambridge, 1930.

Dictionary of Art 1996
The Dictionary of Art. Edited by Jane Turner. 34 vols. London, 1996.

Dillon Bussi and Piazza 1995
Angela Dillon Bussi and Giovanni Maria Piazza, eds. *Biblioteca Trivulziana, Milano.* Le grandi biblioteche d'Italia. Fiesole, 1995.

Donati 1894
F. Donati. "Notizie su S. Bernardino con un documento inedito." *Bullettino senese di storia patria* (Siena), vol. 1 (1894), pp. 48–76.

Donnini 1971
Giampiero Donnini. "Contributi al Maestro di Staffolo." *Commentari* (Rome), n.s., vol. 22, nos. 2–3 (April–September 1971), pp. 172–75.

Donnini 1973
Giampiero Donnini. "Un'aggiunta al Ghissi e alcune considerazioni sul pittore." *Commentari* (Rome), n.s., vol. 24, nos. 1–2 (January–June 1973), pp. 26–34.

Donnini 1974
Giampiero Donnini. "Due aggiunte al Maestro di Staffolo." *Notizie da Palazzo Albani* (Urbino), vol. 3, nos. 2–3 (1974), pp. 31–35.

Donnini 1975
Giampiero Donnini. "On Some Unknown Masterpieces by Nuzi." *The Burlington Magazine* (London), vol. 117, no. 869 (August 1975), pp. 535–40.

Donnini 1976
Giampiero Donnini. "Una 'Pietà e santi' del Maestro di Staffolo." *Notizie da Palazzo Albani* (Urbino), vol. 5, no. 2 (1976), pp. 33–34.

Donnini 1977
Giampiero Donnini. "Schede di pittura marchigiana." *Antichità viva* (Florence), vol. 16, no. 5 (September–October 1977), pp. 3–10.

Donnini 1990
Giampiero Donnini. "Una congiunzione di cultura artistica sull'asse Camerino-Fabriano." *Antichità viva* (Florence), vol. 29, no. 6 (November–December 1990; printed January 1991), pp. 15–22.

Donnini 1996
Giampiero Donnini. "A proposito di Francescuccio Ghissi." *Arte cristiana* (Milan), vol. 84, no. 772 (January–February 1996), pp. 13–19.

Doria 1982
Antonella Doria. "I corali quattrocenteschi miniati di S. Stefano in Brolo." *Arte lombarda* (Milan), n.s., vol. 61, no. 1 (1982), pp. 81–92.

Douglas 1902
Langton Douglas. *A History of Siena.* London, 1902.

Douglas 1914
Langton Douglas. *Histoire de Sienne: L'art siennois.* Translated from the English by Georges Feuilloy. 2 vols. Paris, 1914.

Douglas 1933
Langton Douglas. *Storia d'arte senese.* Translated from the English by Pietro Vigo. Siena, 1933.

Droandi 1993
Attilio Droandi. *Masaccio: pittore di Valdarno.* Arezzo, 1993.

Du Colombier 1952
Pierre Du Colombier. "Les Quatre-Couronnés, patrons des tailleurs de Pierre." *La Revue des arts* (Paris), 2nd yr., no. 4 (December 1952), pp. 209–18.

Dufner 1975
Georg Dufner. *Geschichte der Jesuaten.* Uomini e dottrine, 21. Rome, 1975.

Dunkerton 1997
Jill Dunkerton. "Modifications to Traditional Egg Tempera Techniques in Fifteenth-Century Italy." In *Early Italian Paintings: Technique and Analysis* (pp. 29–34, 82–85). Edited by Tonnie Bakkenist, René Hoppenbrouwers, and Hélène Dubois. Proceedings of the symposium, Maastricht, October 9–10, 1996. Maastricht, 1997.

Dunkerton et al. 1991
Jill Dunkerton, Susan Foister, Dillian Gordon, and Nicholas Penny. *Giotto to Dürer: Early Renaissance Painting in The National Gallery.* New Haven, 1991.

Dunkerton, Kirby, and White 1990
Jill Dunkerton, Jo Kirby, and Raymond White. "Varnish and Early Italian Tempera Paintings." In *Cleaning, Retouching, and Coatings: Technology and Practice for Easel Paintings and Polychrome Sculpture* (pp. 63–69). Edited by John S. Mills and Perry Smith. Preprints of the contributions to the Brussels congress, September 3–7, 1990. London, 1990.

Dykmans 1981
Marc Dykmans. *Le Cérémonial papale de la fin du moyen-âge à la renaissance.* Vol. 2, *De Rome en Avignon, ou, le cérémonial de Jacques Stefaneschi.* Bibliothèque de l'Institut Historique Belge de Rome, 25. Brussels, 1981.

Eckstein 1995
Nicholas A. Eckstein. *The District of the Green Dragon: Neighborhood Life and Social Change in Renaissance Florence.* Florence, 1995.

Edgell 1924
George Harold Edgell. "The Boston 'Mystic Marriage of St. Catherine' and Five More Panels by Barna Senese." *Art in America* (New York), vol. 12, no. 2 (February 1924), pp. 49–52.

Edgell 1932
George Harold Edgell. *A History of Sienese Painting.* New York, 1932.

Edgerton 1966
Samuel Y. Edgerton, Jr. "Alberti's Perspective: A New Discovery and a New Evaluation." *The Art Bulletin* (New York), vol. 48, nos. 3–4 (September–December 1966), pp. 367–77.

Edgerton 1985
Samuel Y. Edgerton, Jr. *Pictures and Punishment: Art and Criminal Prosecution during the Florentine Renaissance.* Ithaca, 1985.

Edinburgh 1980
Edinburgh, National Gallery of Scotland. *Illustrations.* Edinburgh, 1980.

Eigenberger 1927
Robert Eigenberger. *Die Gemäldegalerie der Akademie der bildenden Künste in Wien.* 2 vols. Vienna, 1927.

Eimerl 1967
Sarel Eimerl and the editors of Time-Life Books. *The World of Giotto, c. 1267–1337.* New York, 1967.

Eisenberg 1976
Marvin Eisenberg. "'The Penitent St Jerome' by

Giovanni Toscani." *The Burlington Magazine* (London), vol. 118, no. 878 (May 1976), pp. 275–83.

Eisenberg 1981
Marvin Eisenberg. "The First Altar-piece for the 'Cappella de' Signori' of the Palazzo Pubblico in Siena: '. . . tales figure sunt adeo pulcre . . .'" *The Burlington Magazine* (London), vol. 123, no. 936 (March 1981), pp. 134–48.

Eisenberg 1989
Marvin Eisenberg. *Lorenzo Monaco*. Princeton, 1989.

Eisler 1961
Colin Eisler. "*Verré églomisé* and Paolo di Giovanni Fei." *Journal of Glass Studies* (Corning, N.Y.), vol. 3 (1961), pp. 31–38.

Ekkart 1987
R.E.O. Ekkart. *Catalogus van de schilderijen in het Rijksmuseum Meermanno-Westreenianum*. The Hague, 1987.

Enciclopedia
Enciclopedia universale dell'arte. 15 vols. Venice, 1958–67.

Enciclopedia medievale
Enciclopedia dell'arte medievale. 12 vols. Rome, 1991–2002.

Encyclopaedia universalis
Encyclopaedia universalis. Edited by Claude Grégory. 20 vols. Paris, 1968–75.

Essen 1968
Essen, Villa Hügel. *Marienbild in Rheinland und Westfalen*. Exhibition, June 14–September 22, 1968.

Fabbri and Tacconi 1997
Lorenzo Fabbri and Marica Tacconi, eds. *I libri del Duomo in Firenze: codici liturgici e biblioteca di Santa Maria del Fiore (secoli XI–XVI)*. Florence, 1997. Exhibition, Florence, Biblioteca Mediceo-Laurenziana, September 23, 1997–January 10, 1998.

Fabiani 1951
Giuseppe Fabiani. *Ascoli nel quattrocento*. Vol. 2, *Artisti, monumenti e opere d'arte*. Collana di pubblicazioni storiche ascolane, 3. Ascoli Piceno, 1951.

Fabriano 1993
Fabriano, San Domenico. *I legni devoti*. Exhibition, December 18, 1993–September 25, 1994. Catalogue edited by Giampiero Donnini. Introduction by Paolo Dal Poggetto.

Fahy 1966
Everett P. Fahy. "Some Notes on the Stratonice Master." *Paragone-arte* (Florence), n.s., vol. 17, no. 197 (July 1966), pp. 17–28.

Fahy 1976
Everett Fahy. *Some Followers of Domenico Ghirlandajo*. New York, 1976.

Fahy 1978
Everett Fahy. "Italian Paintings at Fenway Court and Elsewhere." *The Connoisseur* (London), vol. 198, no. 795 (May 1978), pp. 28–43.

Fahy 1978a
Everett Fahy. "On Lorenzo di Niccolò." *Apollo* (London), n.s., vol. 108, no. 202 (December 1978), pp. 374–81.

Fahy 1982
Everett Fahy. "Babbott's Choices." *Apollo* (London), n.s., vol. 115, no. 242 (April 1982), pp. 238–43.

Fahy 1985
Everett Fahy. "A Predella Panel by Neri di Bicci." *The Burlington Magazine* (London), vol. 127, no. 992 (November 1985), pp. 767–68.

Fahy 1987
Everett Fahy. "The Kimbell Fra Angelico." *Apollo* (London), n.s., vol. 125, no. 301 (March 1987), pp. 178–83.

Falassi and Cantoni 1982
Alessandro Falassi and Giuliano Catoni. *Palio*. Essay by Giovanni Cecchini. Milan, 1982.

Faloci Pulignani 1909
Michele Faloci Pulignani. *Guida illustrata di Foligno e dintorni*. Foligno, 1909.

Faloci Pulignani 1920
Michele Faloci Pulignani. "Il beato Paoluccio Trinci i minori osservanti, studio." *Miscellanea francescana* (Assisi), vol. 21 (1920), pp. 65–82.

Fantozzi 1842
Federigo Fantozzi. *Nuova guida, ovvero descrizione storico-artistico-critica della città e contorni di Firenze*. Florence, 1842.

Fantozzi 1856
Federigo Fantozzi. *Nuova guida ovvero descrizione storico-artistico-critica della città e contorni di Firenze*. Florence, 1856.

Fantozzi Micali and Roselli 1980
Osanna Fantozzi Micali and Piero Roselli. *Le soppressioni dei conventi a Firenze: riuso e trasformazioni dal sec. XVIII in poi*. Florence, 1980.

Fanucci Lovitch 1991
Miria Fanucci Lovitch. *Artisti attivi a Pisa fra XIII e XVIII secolo*. Biblioteca del "Bollettino storico pisano," strumenti, 1. Pisa, 1991.

Fanucci Lovitch 1995
Miria Fanucci Lovitch. *Artisti attivi a Pisa fra XIII e XVII secolo*. Preface Roberto Paolo Ciardi. Biblioteca del "Bollettino storico pisano," strumenti, 2. Pisa, 1995.

Farina 1929
Pasquale Farina. *To the Collectors of Paintings by Old Masters: The Misleading "Golden Glow."* Philadelphia, c. 1929.

Farina 1930
Pasquale Farina. *Why Collectors Dread Having Their Paintings Restored*. Philadelphia, c. 1930.

Fehm 1972
Sherwood A. Fehm, Jr. "Notes on the Statutes of the Sienese Painters' Guild." *The Art Bulletin* (New York), vol. 54, no. 2 (June 1972), pp. 198–200.

Fehm 1976
Sherwood A. Fehm. "Luca di Tommè's Influence on Three Sienese Masters: The Master of the Magdalen Legend, the Master of the Panzano Triptych, and the Master of the Pietà." *Mitteilungen des Kunsthistorischen Institutes in Florenz* (Florence), vol. 20, no. 3 (1976), pp. 332–50.

Ferguson et al. 1975
Carra Ferguson, David S. Stevens Schaff, and Gary Vikan, comps., under the direction of Carl Nordenfalk. *Medieval and Renaissance Miniatures from the National Gallery of Art*. Edited by Gary Vikan. Washington, D.C., 1975. Exhibition, Washington, D.C., National Gallery of Art, January 26–June 1, 1975.

Ferrazza 1993
Roberta Ferrazza. *Palazzo Davanzati e le collezioni di Elia Volpi*. Florence, 1993.

Ferretti 2002
Maria Ferretti. "La Madonna della Cingola nell'arte toscana." *Arte cristiana* (Milan), vol. 90, no. 813 (November–December 2002), pp. 411–22.

Ferri 1907
Giovanni Ferri. "Le carte dell'archivio liberiano dal secolo X al XV." *Archivio della regia Società Romana di Storia Patria* (Rome), vol. 30 (1907), pp. 119–68.

Ferro 1995
Margherita Ferro. "Masolino da Panicale e gli affreschi perduti di Montegiordano." *La Diana* (Siena), vol. 1 (1995), pp. 95–124.

Fesch 1841
Catalogue des tableaux composant la galerie de feu de Son Eminence le Cardinal Fesch. Rome, 1841.

Fesch 1845
Galerie de feu S.E. le Cardinal Fesch: Catalogue des tableaux des écoles italiennes et espagnole. Rome, 1845.

Figline Valdarno 1991
Figline Valdarno, Vecchio Palazzo Comunale. *Arte e restauri in Valdarno*. Exhibition, May 18–July 7, 1991. Catalogue edited by Caterina Caneva. Florence, 1991.

Filarete c. 1453, Finoli and Grassi ed. 1972
Antonio Averlino, called il Filarete. *Trattato di architettura*. Edited by Anna Maria Finoli and Liliana Grassi. Introduction and notes by Liliana Grassi. 2 vols. Classici italiani di scienze, tecniche e arti. Trattati di architettura, 2. Milan, 1972.

Filieri 1995
Maria Teresa Filieri. "Proposte per il 'Maestro dei Santi Quirico e Giulitta.'" *Arte cristiana* (Milan), vol. 83, no. 769 (July–August 1995), pp. 267–74.

Filieri 1998
Maria Teresa Filieri, ed. *Sumptuosa tabula picta: pittori a Lucca tra gotico e rinascimento*. Livorno, 1998. Exhibition, Lucca, Museo Nazionale di Villa Guinigi, March 28–July 5, 1998.

Filippini 1922
Francesco Filippini. "La ricostruzione di un polittico di Lorenzo Veneziano." *Rassegna d'arte antica e moderna* (Milan), vol. 9 (1922), pp. 329–33.

Filippini and Zucchini 1947
Francesco Filippini and Guido Zucchini. *Miniatori e pittori a Bologna: documenti dei secoli XIII e XIV*. Raccolta di fonti per la storia dell'arte, 6. Florence, 1947.

Finiello Zervas 1989
Diane Finiello Zervas. *The Parte Guelfa, Brunelleschi, and Donatello*. Villa I Tatti, The Harvard University Center for Italian Renaissance Studies, 8. Locust Valley, N.Y., 1989.

Finiello Zervas 1991
Diane Finiello Zervas. "Lorenzo Monaco, Lorenzo Ghiberti, and Orsanmichele—I and II." *The Burlington Magazine* (London), vol. 133, no. 1064 (November 1991), pp. 748–59; vol. 133, no. 1065 (December 1991), pp. 812–19.

Finiello Zervas 1996

Diane Finiello Zervas, ed. *Orsanmichele a Firenze / Orsanmichele Florence.* Texts by Paola Grifoni et al. 2 vols. Mirabilia italiae, 5. Modena, 1996.

Finiello Zervas 1997

Diane Finiello Zervas, ed. *Orsanmichele: Documents, 1336–1452 / documenti, 1336–1452.* Strumenti: Instituto di Studi Rinascimentali, Ferrara. Modena, 1997.

Fiorillo 2001

Federica Fiorillo. "Il Maestro di Carmignano: un tentativo di ricostruzione." *Arte cristiana* (Milan), vol. 89, no. 806 (September–October 2001), pp. 333–46.

Fiorio and Garberi 1987

Maria Teresa Fiorio and Mercedes Garberi. *La Pinacoteca del Castello Sforzesco.* Milan, 1987.

Fischel 1929

Oskar Fischel. *Die Sammlung Joseph Spiridon, Paris.* Berlin, 1929.

Fiumi 1968

Enrico Fiumi. *Demografia, movimento urbanistico e classi sociali in Prato dell'età comunale ai tempi moderni.* Biblioteca storica toscana, 14. Florence, 1968.

Fleming 1955

John Fleming. "The Hugfords of Florence, Parts I and II." *The Connoisseur* (London), vol. 136, no. 548 (October 1955), pp. 106–10; no. 549 (November 1955), pp. 197–206.

Fleming 1973–79

John Fleming. "Art Dealing in the Risorgimento." *The Burlington Magazine* (London), vol. 115, no. 838 (January 1973), pp. 4–16; vol. 121, no. 917 (August 1979), pp. 492–508; vol. 121, no. 918 (September 1979), pp. 568–80.

Florence 1955

Florence, Museo Nazionale di San Marco. *Mostra delle opere del beato Angelico nel quinto centenario della morte.* Exhibition, May–September 1955. Introduction by Mario Salmi.

Florence 1956

Florence, Palazzo Strozzi. *Mostra del Pontormo e del primo manierismo fiorentino.* Exhibition, March 24–July 15, 1956. Catalogue by Luciano Berti, Luisa Marcucci, and Umberto Baldini.

Florence 1967

Florence, Orsanmichele. *Omaggio a Giotto.* Celebrazioni nazionali nel VII centenario della nascita di Giotto. Exhibition, June–October 1967. Florence, 1967.

Florence 1972

See Baldini and Dal Poggetto 1972

Florence 1978

See Bellini and Brunetti 1978

Florence 1978–79

Florence, Museo dell'Accademia and Museo di San Marco. *Lorenzo Ghiberti: "materia e ragionamenti."* Exhibition, October 18, 1978–January 31, 1979. Catalogue edited by Luciano Bellosi.

Florence 1982

Florence, Centro d'Incontro della Certosa di Firenze. *Codici liturgici miniati dei benedettini in Toscana.* Exhibition, 1982. Catalogue edited by Maria Grazia Ciardi Dupré Dal Poggetto.

Florence 1986

See Angelini 1986

Florence 1986a

Florence, Palazzo Vecchio. *Capolavori & restauri.* Exhibition, December 14, 1986–April 26, 1987. Catalogue edited by Anna Forlani Tempesti.

Florence 1990

See Bellosi 1990

Florence 1990a

See Berti and Paolucci 1990

Florence 1990b

Florence, Fortezza da Basso. *La mostra mercato degli antiquari toscani.* Exhibition, June 2–17, 1990. Catalogue edited by Gianfranco Luzzetti et al.

Florence 1992

See Petrioli Tofani 1992

Florence 1992a

Florence, Galleria degli Uffizi. *Una scuola per Piero: luce, colore, e prospettiva nella formazione fiorentina di Piero della Francesca.* Exhibition, September 27, 1992–January 10, 1993. Catalogue edited by Luciano Bellosi. Venice, 1992.

Florence 1992b

See Gregori, Paolucci, and Acidini Luchinat 1992

Flores D'Arcais 1967

Francesca Flores D'Arcais. "Un affresco di scuola giottesca." *Padova e la sua provincia* (Padua), 13th yr., no. 9 (September 1967), pp. 6–9.

Flores D'Arcais 1994

Francesca Flores D'Arcais. "Precisazioni e proposte per la datazione della decorazione dell'abside della cappella degli Scrovegni." In *Studi di storia dell'arte in onore di Mina Gregori* (pp. 13–15). Cinisello Balsamo (Milan), 1994.

Flores D'Arcais 1995

Francesca Flores D'Arcais. *Giotto.* Milan, 1995.

Flores D'Arcais and Gentili 2002

Francesca Flores D'Arcais and Giovanni Gentili, eds. *Il trecento adriatico: Paolo Veneziano e la pittura tra oriente e occidente.* Cinisello Balsamo (Milan), 2002. Exhibition, Rimini, Castel Sismondo, August 19–December 29, 2002.

Fogg 1919

Cambridge, Fogg Art Museum, Harvard University. *Collection of Mediaeval and Renaissance Paintings.* Cambridge, 1919.

Fomichova 1992

Tamara D. Fomichova. *The Hermitage Catalogue of Western European Painting: Venetian Painting, Fourteenth to Eighteenth Centuries.* Moscow, 1992.

Fontane 1865

Theodor Fontane. *Wanderungen durch die Mark Brandenburg.* 2nd enlarged ed.; vol. 1. Berlin, 1865.

Fonti 1983

Fonti francescane: scritti e biografie di San Francesco d'Assisi, cronache e altre testimonianze del primo secolo francescano, scritti e biografie di Santa Chiara d'Assisi. Padua, 1983.

Fortini 1940

Arnaldo Fortini. *Assisi nel medioevo: leggende, avventure, battaglie.* Rome, 1940.

Foster 1995

Kathleen A. Foster. *Thomas Eakins Rediscovered: Charles Bregler's Thomas Eakins Collection at the Pennsylvania Academy of the Fine Arts.* With contributions by Mark Bockrath, Catherine Kimock, Cheryl Leibold, and Jeanette Toohey. New Haven, 1995.

Francesco d'Assisi 1982

Francesco d'Assisi: documenti e archivi, codici e biblioteche, miniature. Catalogue of the exhibitions organized by the Comitato Regionale Umbro per le celebrazioni dell'VIII centenario della nascita di san Francesco di Assisi. Milan, 1982.

Francis 1956

Henry S. Francis. "Master of 1419." *The Bulletin of the Cleveland Museum of Art,* vol. 43, no. 10 (December 1956), pp. 211–13.

Frati 1909

Lodovico Frati. "Un polittico di Vitale da Bologna." *Rassegna d'arte* (Milan), vol. 9, no. 10 (October 1909), pp. 171–72.

Fredericksen 1972

Burton B. Fredericksen. *Catalogue of the Paintings in the J. Paul Getty Museum.* Malibu, 1972.

Fredericksen 1974

Burton B. Fredericksen. *Giovanni di Francesco and the Master of Pratovecchio.* Malibu, 1974.

Fredericksen and Zeri 1972

Burton B. Fredericksen and Federico Zeri. *Census of Pre-Nineteenth-Century Italian Paintings in North American Public Collections.* Cambridge, 1972.

Fremantle 1975

Richard Fremantle. *Florentine Gothic Painters from Giotto to Masaccio: A Guide to Painting in and near Florence, 1300–1450.* London, 1975.

Fremantle 1975a

Richard Fremantle. "Some New Masolino Documents." *The Burlington Magazine* (London), vol. 117, no. 871 (October 1975), pp. 658–59.

Freni 2000

Giovanni Freni. "The Aretine Polyptych by Pietro Lorenzetti: Patronage, Iconography, and Original Settings." *Journal of the Warburg and Courtauld Institutes* (London), vol. 63 (2000), pp. 59–110.

Freuler 1985

Gaudenz Freuler. "L'altare Cacciati di Bartolo di Fredi nella chiesa di San Francesco a Montalcino." *Arte cristiana* (Milan), n.s., vol. 73, no. 708 (May–June 1985), pp. 149–66.

Freuler 1985a

Gaudenz Freuler. "Bartolo di Fredis Altar für die Annunziata: Kapelle in S. Francesco in Montalcino." *Pantheon* (Munich), vol. 43 (1985), pp. 21–39.

Freuler 1987

Gaudenz Freuler. "Andrea di Bartolo, Fra Tommaso d'Antonio Caffarini, and Sienese Dominicans in Venice." *The Art Bulletin* (New York), vol. 69, no. 4 (December 1987), pp. 570–86.

Freuler 1987a

Gaudenz Freuler. "Die Malavolti: Kapelle des Bartolo di Fredi und Paolo di Giovanni Fei in S. Domenico in Siena." *Pantheon* (Munich), vol. 45 (1987), pp. 39–53.

Freuler 1994

Gaudenz Freuler. *Bartolo di Fredi Cini: Ein Beitrag zur sienesischen Malerei des 14. Jahrhunderts.* Disentis, Switzerland, 1994.

Freuler 2001

Gaudenz Freuler. "Zum Frühwerk des Lorenzo Monaco." In *Opere e giorni: studi su mille anni di arte europea dedicati a Max Seidel* (pp. 211–23). Edited by Klaus Bergdolt and Giorgio Bonsanti. Venice, 2001.

Friedländer 1969

Max J. Friedländer. *Early Netherlandish Painting*. Vol. 4, *Hugo van der Goes*. Comments and notes by Nicole Veronee-Verhaegen. Translated by Heinz Norden. Leiden, 1969.

Friedmann 1946

Herbert Friedmann. *The Symbolic Goldfinch: Its History and Significance in European Devotional Art*. The Bollingen Series, 7. Washington, D.C., 1946.

Frinta 1967

Mojmír S. Frinta. "The Closing Tabernacle—A Fanciful Innovation of Medieval Design." *The Art Quarterly* (Detroit), vol. 30, no. 2 (1967), pp. 102–17.

Frinta 1971

Mojmír S. Frinta. "Note on the Punched Decoration of Two Early Painted Panels at the Fogg Art Museum: *St. Dominic* and the *Crucifixion*." *The Art Bulletin* (New York), vol. 53, no. 3 (September 1971), pp. 306–9.

Frinta 1976

Mojmír Frinta. "Deletions from the Oeuvre of Pietro Lorenzetti and Related Works by the Master of the Beata Umiltà, Mino Parcis da Siena, and Jacopo di Mino del Pellicciaio." *Mitteilungen des Kunsthistorischen Institutes in Florenz* (Florence), vol. 20, no. 3 (1976), pp. 271–300.

Frinta 1982

Mojmír S. Frinta. "Drawing the Net Closer: The Case of Ilicio Federico Joni, Painter of Antique Pictures." *Pantheon* (Munich), vol. 40, no. 3 (July–September 1982), pp. 217–24.

Frinta 1993

Mojmír Frinta. "Observations on the Trecento and Early Quattrocento Workshop." In *The Artist's Workshop* (pp. 18–34). Edited by Peter M. Lukehart. Studies in the History of Art, 38. Center for Advanced Study in the Visual Arts, Symposium Papers, 22. Washington, D.C., 1993.

Frinta 1998

Mojmír Frinta. *Punched Decoration on Late Medieval Panel and Miniature Painting*. Pt. 1, *Catalogue Raisonné of All Punch Shapes*. Prague, 1998.

Frosinini 1984

Cecilia Frosinini. "Il trittico Compagni." In *Scritti di storia dell'arte in onore di Roberto Salvini* (pp. 227–31). Florence, 1984.

Frosinini 1984a

Cecilia Frosinini. "Un contributo alla conoscenza della pittura tardogotica fiorentina: Bonaiuto di Giovanni." *Rivista d'arte* (Florence), vol. 37, 4th ser., vol. 1 (1984), pp. 107–31.

Frosinini 1984b

Cecilia Frosinini. "Aggiunte a Bonaiuto di Giovanni." *Antichità viva* (Florence), vol. 23, no. 6 (November–December 1984; printed April 1985), pp. 3–6.

Frosinini 1986

Cecilia Frosinini. "Il passaggio di gestione in una bottega fiorentina del primo rinascimento: Lorenzo di Bicci e Bicci di Lorenzo." *Antichità viva* (Florence), vol. 25, no. 1 (January–February 1986; printed September 1986), pp. 5–15.

Frosinini 1987

Cecilia Frosinini. "Il passaggio di gestione in una bottega pittorica fiorentina del primo '400: Bicci di Lorenzo e Neri di Bicci (2)." *Antichità viva* (Florence), vol. 26, no. 1 (January–February 1987; printed June 1987), pp. 5–14.

Frosinini 1990

Cecilia Frosinini. "A proposito del 'San Lorenzo' di Bicci di Lorenzo alla Galleria dell'Accademia." *Antichità viva* (Florence), vol. 29, no. 1 (January–February 1990), pp. 5–7.

Frosinini 1990a

Cecilia Frosinini. "Gli esordi del Maestro di Signa: dalla bottega di Bicci di Lorenzo alle prime opere autonome." *Antichità viva* (Florence), vol. 29, nos. 2–3 (September–October 1990; printed November 1990), pp. 18–25.

Frugoni 1988

Chiara Frugoni. *Pietro e Ambrogio Lorenzetti*. I grandi maestri dell'arte. Antella (Florence), 1988.

Fry 1906

Roger E. Fry. "Recent Additions to the Collection of Mr. John G. Johnson, Philadelphia." *The Burlington Magazine* (London), vol. 9, no. 41 (August 1906), pp. 351–63.

Fry 1930

Roger E. Fry. "Botticelli's Panels of the Life of the Virgin." Review of London 1930. *Pennsylvania Museum Bulletin* (Philadelphia), vol. 35, no. 134 (April 1930), p. 19.

Fumi 1894

Ersilio Fumi. *Guida di Montepulciano e dei bagni di Chianciano*. Montepulciano, 1894. Reprint, Bologna, 1978.

Furlan and Zannier 1985

Caterina Furlan and Italo Zannier. *Il duomo di Spilimbergo, 1284–1984*. Spilimbergo, 1985.

Gage 1993

John Gage. *Colour and Culture: Practice and Meaning from Antiquity to Abstraction*. London, 1993.

Gagliardo 1996

Matilde Gagliardo. "Una raccolta di 'scripta' dallo 'studio' del cardinale Giordano Orsini e gli affreschi delle sei età nel suo palazzo romano." In *Studi in onore del Kunsthistorisches Institut in Florenz per il suo centenario (1897–1997)* (pp. 107–18). Pisa, 1996.

Gai 1970

Lucia Gai. "Nuove proposte e nuovi documenti sui maestri che hanno affrescato la cappella del Tau a Pistoia." *Bullettino storico pistoiese* (Pistoia), 3rd ser., vol. 5, no. 2 (1970), pp. 75–94.

Gaillard 1923

Emile Gaillard. *Sano di Pietro: Un peintre siennois au XVe siècle, 1406–1481*. Chambéry, 1923.

Galante 1872

Gennaro Aspreno Galante. *Guida sacra della città di Napoli*. Naples, 1872. Edited by Nicola Spinosa. Naples, 1985.

Gallavotti 1972

Daniela Gallavotti. "Gli affreschi quattrocenteschi della sala del Pellegrinaio nello spedale di Santa Maria della Scala in Siena." *Storia dell'arte* (Florence), vol. 13 (January–March 1972; printed April 1973), pp. 5–42.

Gallavotti Cavallero 1974

Daniela Gallavotti Cavallero. "Un affresco ricostituito di Domenico di Bartolo: la 'Madonna del Manto' nello spedale di Siena." *Annuario dell'Istituto di Storia dell'Arte dell'Università di Roma* (Rome), vol. 1 (1974), pp. 169–98.

Gallavotti Cavallero 1985

Daniela Gallavotti Cavallero. *Lo spedale di Santa Maria della Scala in Siena: vicenda di una committenza artistica*. Preface by Cesare Brandi. Introductions by Duccio Balestracci and Gabriella Piccinni. Plans and diagrams by Mario Terrosi. Pisa, 1985.

Gallo 1926

Rodolfo Gallo. *La chiesa di Sant'Elena*. Venice, 1926.

Gamba 1904

Carlo Gamba. "Giovanni Dal Ponte." *Rassegna d'arte* (Milan), vol. 4, no. 12 (December 1904), pp. 177–86.

Gamba 1906

Carlo Gamba. "Ancora di Giovanni Dal Ponte." *Rivista d'arte* (Florence), vol. 4, nos. 10–12 (October–December 1906), pp. 163–68.

Gamba 1930–31

Carlo Gamba. "Dipinti fiorentini di raccolte americane all'esposizione di Londra." *Dedalo* (Milan), vol. 9, no. 3 (1930–31), pp. 570–99.

Gamber 1977

Klaus Gamber. "*Missa super populum celebrantur*: Nochmals zur Frage der Zelebration *versus populum*." *Das Münster* (Munich), vol. 30 (1977), pp. 63–64.

Gamulin 1971

Grgo Gamulin. *Madonna and Child in the Old Art of Croatia*. Translated by Leonardo Spatalin. Monuments of Croatia, Bk. 1. Zagreb, 1971.

Gamulin 1974

Grgo Gamulin. "La pittura su tavole nel tardo medioevo sulla costa orientale dell'Adriatico." In *Venezia e il levante fino al secolo XV*. Vol. 2, *Arte, letteratura, linguistica* (pp. 181–210). Edited by Agostino Pertusi. Atti del I convegno internazionale di storia della civiltà veneziana, Venice, Fondazione Giorgio Cini, June 1–5, 1968. Civiltà veneziana, studi, 27. Florence, 1974.

Gamurrini 1917–18

G. F. Gamurrini. "I pittori aretini dall'anno 1150 al 1527." *Rivista d'arte* (Florence), vol. 10, nos. 1–2 (1917–18), pp. 88–97.

Gardner 1974

Julian Gardner. "The Stefaneschi Altarpiece: A Reconsideration." *Journal of the Warburg and Courtauld Institutes* (London), vol. 37 (1974), pp. 57–103.

Gardner 1983

Julian Gardner. "Fronts and Backs: Setting and Structure." In *La pittura nel XIV e XV secolo: il contributo dell'analisi tecnica alla storia dell'arte* (vol. 3, pp. 297–322). Edited Henk W. van Os and J.R.J. van Asperen de Boer. Atti del XXIV congresso internazionale di storia dell'arte, Bologna. September 10–18, 1978. Bologna, 1983.

Gardner von Teuffel 1979

Christa Gardner von Teuffel. "The Buttressed Altarpiece: A Forgotten Aspect of Tuscan Fourteenth-

Century Altarpiece Design." *Jahrbuch der Berliner Museen* (West Berlin), n.s., vol. 21 (1979), pp. 21–65.

Garibaldi 1998
Vittoria Garibaldi, ed. *Beato Angelico e Benozzo Gozzoli: artisti del rinascimento a Perugia. Itinerari d'arte in Umbria.* Texts by Tiziana Biganti et al. Cinisello Balsamo (Milan), 1998. Exhibition, Perugia, Galleria Nazionale dell'Umbria, December 13, 1998–April 11, 1999.

Garrison
Eward B. Garrison. *Studies in the History of Mediaeval Italian Painting.* 4 vols. Florence, 1953–62.

Garrison 1949
Edward B. Garrison. *Italian Romanesque Panel Painting: An Illustrated Index.* Florence, 1949.

Garzelli 1972
Annarosa Garzelli. *Museo di Orvieto: Museo dell'Opera del Duomo.* Musei d'Italia—Meraviglie d'Italia, 2. Bologna, 1972.

Garzelli 1985
Annarosa Garzelli, ed. *Miniatura fiorentina del rinascimento, 1440–1525: un primo censimento.* 2 vols. Inventari e cataloghi toscani, 18–19. Scandicci (Florence), 1985.

Garzelli 1985a
Annarosa Garzelli. "Zanobi Strozzi, Francesco di Antonio del Cherico, e un raro tema astrologico del libro d'ore." In *Renaissance Studies in Honor of Craig Hugh Smyth* (pp. 237–44). Edited by Andrew Morrogh et al. Vol. 2. Villa I Tatti, 7. Florence, 1985.

Gasparotto and Magnani 2002
Davide Gasparotto and Serena Magnani. *Matteo di Giovanni e la pala d'altare nel senese e nell'aretino, 1450–1500.* Atti del convegno internazionale di studi, Sansepolcro, October 9–10, 1998. Montepulciano, 2002.

Gaye 1839–40
Giovanni Gaye. *Carteggio inedito d'artisti dei secoli XIV, XV, XVI.* 3 vols. Florence, 1839–40.

Gelli 1549, Mancini ed. 1896
Girolamo Mancini, ed. "Vite d'artisti di Giovanni Battista Gelli." *Archivio storico italiano* (Florence), 5th ser., vol. 17 (1896), pp. 32–62.

Gelli c. 1550–60, Mancini ed. 1896
Giambattista Gelli. "Venti vite d'artisti fiorentini." Edited by Girolamo Mancini. *Archivio storico italiano* (Florence), vol. 17 (1896), pp. 31–62.

Gengaro 1932
Marialuisa Gengaro. "Eclettismo e arte nel quattrocento senese: Giovanni di Paolo." *La Diana* (Siena), vol. 7, no. 1 (1932), pp. 8–33.

Gengaro 1933
Marialuisa Gengaro. "Il primitivo del quattrocento senese: Stefano di Giovanni detto il Sassetta." *La Diana* (Siena), vol. 8, no. 1 (1933), pp. 5–32.

Gengaro 1934
Marialuisa Gengaro. "Matteo di Giovanni." *La Diana* (Siena), vol. 9, nos. 3–4 (1934), pp. 149–85.

Gengaro 1936
Marialuisa Gengaro. "A proposito di Domenico di Bartolo." *L'arte* (Milan), 39th yr., vol. 7, no. 2 (April 1936), pp. 104–21.

Gennari Santori 2003
Flaminia Gennari Santori. *The Melancholy of Master-*

pieces: Old Master Paintings in America, 1890–1914. Milan, 2003.

Genthon 1948
István Genthon, ed. *Esztergom Müemlékei.* Vol. 1, Esztergom. Pt. 1, *Múzeumok, Kinestár, Könyvtár. Magyarország Müemléki Topográfája.* Budapest, 1948.

Gerola 1910
Giuseppe Gerola. "Il pittore Boninsegna da Clocego e la famiglia di Martino." *Atti del reale Istituto Veneto di Scienze e d'Arti* (Venice), vol. 59, pt. 2 (1909–10), pp. 407–18.

Getty 1991
"Acquisitions/1990: Manuscripts." *The J. Paul Getty Journal* (Malibu), vol. 19 (1991), pp. 142–45.

Ghiberti c. 1447–55, Bartoli ed. 1998
Lorenzo Ghiberti. *I commentarii (Biblioteca Nazionale Centrale di Firenze, II, I, 333).* Edited with an introduction by Lorenzo Bartoli. Biblioteca della scienza italiana, 17. Florence, 1998.

Ghidiglia Quintavalle 1960
Augusta Ghidiglia Quintavalle. "La 'croce per morti' di Zanobi Strozzi." *Bollettino d'arte* (Rome), 4th ser., vol. 45, nos. 1–2 (January–June 1960), pp. 68–72.

Ghirardacci and Solimani 1657
Cherubino Ghirardacci and Aurelio Solimani. *Della historia di Bologna.* Pt. 2. Bologna, 1657.

Gibbs 1979
Robert Gibbs. "Two Families of Painters at Bologna in the Later Fourteenth Century." *The Burlington Magazine* (London), vol. 121, no. 918 (September 1979), pp. 560–68.

Gibbs 1982
Robert Gibbs. "A Group of Trecento Bolognese Painters Active in the Veneto." *The Burlington Magazine* (London), vol. 124, no. 947 (February 1982), pp. 77–86.

Gibbs 1982a
Robert Gibbs. "Saleroom Note: Cristoforo da Bologna or Dalmasio?" *The Burlington Magazine* (London), vol. 124, no. 954 (September 1982), pp. 584–87.

Gibbs 1986
Robert Gibbs. Review of D'Amico and Medica 1986. *The Burlington Magazine,* vol. 128, no. 1004 (November 1986), p. 830.

Gibbs 1989
Robert Gibbs. *Tomaso da Modena: Painting in Emilia and the March of Treviso, 1340–80.* Cambridge, 1989.

Gielly 1912
Louis Gielly. "Pietro Lorenzetti." *La Revue de l'art ancien et moderne* (Paris), vol. 32 (July–December 1912), pp. 449–62.

Gielly 1926
Louis Jules Gielly. *Les primitifs siennois.* Paris, 1926.

Giglioli 1929
Odoardo H. Giglioli. "Masaccio: saggio di una bibliografia ragionata." *Bollettino del regio Istituto di Archeologia e Storia dell'Arte* (Rome), vol. 3, nos. 4–5 (1929), pp. 55–101.

Giglioli 1931
Odoardo H. Giglioli. "Relazioni tra un quadretto attribuito a Pier Francesco Fiorentino e un disegno di Pesellino." *Rivista d'arte* (Florence), vol. 13, 2nd ser., vol. 3 (1931), pp. 520–23.

Gilbert 1959
Creighton Gilbert. "The Archbishop on the Painters of Florence, 1450." *The Art Bulletin* (New York), vol. 41, no. 1 (March 1959), pp. 75–87.

Gilbert 1977
Creighton Gilbert. "The Patron of Starnina's Frescoes." In *Studies in Late Medieval and Renaissance Painting in Honor of Millard Meiss* (pp. 185–91). Edited by Irving Lavin and John Plummer. 2 vols. New York, 1977.

Gilbert 1984
Creighton Gilbert. "The Conversion of Fra Angelico." In *Scritti di storia dell'arte in onore di Roberto Salvini* (pp. 281–87). Florence, 1984.

Gilbert 1984a
Creighton Gilbert. "Tuscan Observants and Painters in Venice, ca. 1400." In *Interpretazioni veneziane: studi di storia dell'arte in onore di Michelangelo Muraro* (pp. 109–20). Edited by David Rosand. Venice, 1984.

Ginori Lisci 1972
Leonardo Ginori Lisci. *I palazzi di Firenze nella storia e nell'arte.* 2 vols. Florence, 1972.

Ginzburg 1991
Carlo Ginzburg. "Ancora su Piero della Francesca e Giovanni di Francesco." *Paragone-arte* (Florence), n.s., vol. 42, no. 29 (499), (September 1991), pp. 23–32.

Giorgi 1974
Giorgio Giorgi. *Le chiese di Lucca: S. Maria Forisportam.* Lucca, 1974.

Gioseffi 1962
Decio Gioseffi. "Domenico Veneziano: l' 'esordio masaccesco' e la tavola con i SS. Girolamo e Giovanni Battista della National Gallery di Londra." *Emporium* (Bergamo), vol. 135 (February 1962), pp. 51–72.

Giovannozzi 1934
Vera Giovannozzi. "Note su Giovanni di Francesco." *Rivista d'arte* (Florence), vol. 16, 2nd ser., vol. 6 (1934), pp. 337–65.

Giusti 1988
Annamaria Giusti. *Empoli: Museo della Collegiata, chiese di Sant'Andrea e S. Stefano.* Musei d'Italia—Meraviglie d'Italia, 19. Bologna, 1988.

Glasser 1977
Hannelore Glasser. *Artists' Contracts of the Early Renaissance.* New York, 1977.

Gnoli 1923
Umberto Gnoli. *Pittori e miniatori nell'Umbria.* Spoleto, 1923.

Gnudi 1962
Cesare Gnudi. *Pittura bolognese del '300: Vitale da Bologna.* Bologna, 1962.

Goldenberg Stoppato 1991
Lisa Goldenberg Stoppato. "Novità sul committente dello Starnina a Santa Maria del Carmine." *Paragone-arte* (Florence), n.s., vol. 42, no. 29 (499), (September 1991), pp. 73–81.

Gombrich 1955
E. H. Gombrich. "Apollonio di Giovanni: A Florentine Cassone Workshop Seen through the Eyes of a Humanist Poet." *Journal of the Warburg and Courtauld Institutes* (London), vol. 18, nos. 1–2 (1955), pp. 16–34.

González-Palacios 1970
Alvar González-Palacios. "Aspects of Tuscan Art."

Apollo (London), n.s., vol. 91, no. 95 (January 1970), pp. 75–76.

González-Palacios 1971
Alvar González-Palacios. "Posizione di Angelo Puccinelli." *Antichità viva* (Florence), vol. 10, no. 3 (May–June 1971), pp. 3–9.

González-Palacios 1972
Alvar González-Palacios. "Asta di dipinti dal XIV al XVIII secolo: 48 tarocchi di Bonifacio Bembo, Milano, Finarte, 9 Novembre 1971." *Arte illustrata* (Milan), vol. 5, no. 47 (January 1972), pp. 87–88.

Goodison and Robertson 1967
J. W. Goodison and G. H. Robertson. *Fitzwilliam Museum, Cambridge: Catalogue of Paintings*. Vol. 2, *Italian Schools*. Cambridge, 1967.

Gordon 1989
Dillian Gordon. "A Dossal by Giotto and His Workshop: Some Problems of Attribution, Provenance, and Patronage." *The Burlington Magazine* (London), vol. 131, no. 1037 (August 1989), pp. 524–31.

Gordon 1994
Dillian Gordon. "The Mass Production of Franciscan Piety: Another Look at Some Umbrian *Verre Églomisés*." *Apollo* (London), vol. 140, no. 394 (December 1994), pp. 33–42.

Gordon 1996
Dillian Gordon. "The 'Missing' Predella Panel from Pesellino's Trinity Altar-Piece." *The Burlington Magazine* (London), vol. 138, no. 1115 (February 1996), pp. 87–88.

Gordon 1998
Dillian Gordon, "Zanobi Strozzi's 'Annunciation' in the National Gallery." *The Burlington Magazine* (London), vol. 140, no. 1145 (August 1998), pp. 517–24.

Gordon 2002
Dillian Gordon. "The Icon of the Virgin Glykophilousa in the Benaki Museum, Athens (inv. no. 2972): The Verres Eglomisés." In *Byzantine Icons: Art, Technique, and Technology* (pp. 211–18). Edited by Maria Vassilaki. Heraklion, 2002.

Gordon 2003
Dillian Gordon. *National Gallery Catalogues: The Fifteenth-Century Italian Paintings*. Vol. 1. London, 2003.

Gordon and Reeve 1984
Dillian Gordon and Anthony Reeve. "Three Newly Acquired Panels from the Altarpiece for Santa Croce by Ugolino di Nerio." *National Gallery Technical Bulletin* (London), vol. 8 (1984), pp. 36–52.

Grandi 1982
Renzo Grandi. *I monumenti dei dottori e la scultura a Bologna (1267–1348)*. Collana studi e ricerche, n.s., Testi del Museo Civico Medievale di Bologna. Bologna, 1982.

Grant 1908
J. Kirby Grant. "Mr. John G. Johnson's Collection of Pictures in Philadelphia." *The Connoisseur* (London), vol. 21, no. 81 (May 1908), pp. 3–11; vol. 21, no. 83 (July 1908), pp. 143–51; vol. 22, no. 85 (September 1908), pp. 3–9; vol. 22, no. 87 (November 1908), pp. 141–52.

Grassi 1838
Ranieri Grassi. *Descrizione storica e artistica di Pisa e de' suoi contorni*. 3 vols. Pisa, 1838.

Graziani 1948
Alberto Graziani with a postscript by Roberto Longhi. "Il Maestro dell'Osservanza." *Proporzioni* (Florence), vol. 2 (1948), pp. 75–88.

Gregori, Paolucci, and Acidini Luchinat 1992
Mina Gregori, Antonio Paolucci, and Cristina Acidini Luchinat, eds. *Maestri e botteghe: pittura a Firenze alla fine del quattrocentro*. Cinisello Balsamo (Milan), 1992. Exhibition, Florence, Palazzo Strozzi, October 16, 1992–January 10, 1993.

Gregori and Rocchi 1985
Mina Gregori and Giuseppe Rocchi, eds. *Il "Paradiso" in Pian di Ripoli: studi e ricerche su un antico monastero*. Essays by Giuseppina Bacarelli et al. Florence, 1985.

Grillantini 1962
Carlo Grillantini. *Guida storico-artistica di Osimo*. Pinerolo, 1962.

Grillantini 1965
Carlo Grillantini. *Il duomo di Osimo nell'arte e nella storia*. Pinerolo, 1965.

Grimaldi 1620, Niggl ed. 1972
Giacomo Grimaldi. *Descrizione della basilica antica di S. Pietro in Vaticano: codice Barberini latino 2733*. Edited by Reto Niggl. Codices e vaticanes selecti, 32. Vatican City, 1972.

Grimouard de Saint-Laurent 1864
H. Grimouard de Saint-Laurent. "Aperçu iconographique sur Saint Pierre et Paul—deuxième partie." *Annales archéologiques* (Paris), vol. 24 (1864), pp. 93–102.

G. Gronau 1931
Georg Gronau. "Das Erzengelbild des Neri di Bicci." *Mitteilungen des Kunsthistorischen Institutes in Florenz* (Florence), vol. 3 (1919–32 [1931]), pp. 430–34.

G. Gronau 1932
[Georg] Gronau. "Francesco d'Antonio pittore fiorentino." *Rivista d'arte* (Florence), vol. 14, 2nd ser., vol. 4 (1932), pp. 382–85.

G. Gronau 1938
Georg Gronau. "In margine a Francesco Pesellino." *Rivista d'arte* (Florence), vol. 20, 2nd ser., vol. 10 (1938), pp. 123–46.

H. Gronau 1945
H. D. Gronau. "The San Pier Maggiore Altarpiece: A Reconstruction." *The Burlington Magazine* (London), vol. 86, no. 507 (June 1945), pp. 139–44.

H. Gronau 1950
H. D. Gronau. "The Earliest Works of Lorenzo Monaco." *The Burlington Magazine* (London), vol. 92, no. 568 (July 1950), pp. 183–88; vol. 92, no. 569 (August 1950), pp. 217–22.

Groningen 1969
Groningen, Museum voor Stad en Lande. *Sienese Paintings in Holland*. Exhibition, March 28–April 28, 1969. Also shown at Utrecht, Aartsbisschoppelijk Museum, May 2–June 9, 1969. Catalogue edited by H. K. Gerson and Henk van Os.

Grosseto 1964
Grosseto, Associazione "Pro Loco." *Arte senese nella Maremma grossetana*. Exhibition, Summer 1964. Exhibition catalogue by Enzo Carli.

Gualandi
Michelangelo Gualandi, ed. *Memorie originali italiane riguardanti le belle arti*. 6 vols. Bologna, 1840–45.

Guardabassi 1872
Mariano Guardabassi. *Indice-guida dei monumenti pagani cristiani riguardanti l'istoria e l'arte esistenti nella provincia dell'Umbria*. Perugia, 1872.

Guasti 1857
Cesare Guasti. *La cupola di Santa Maria del Fiore, illustrata con i documenti di Archivio dell'Opera Secolare*. Florence, 1857.

Guasti 1871
Cesare Guasti. *La cappella de' Migliorati, già capitolo de' francescani in Prato, dipinta nel secolo XIV*. Prato, 1871.

Guasti 1874
Cesare Guasti. *Belle arti: opuscoli descrittivi e biografici*. Florence, 1874.

Guasti 1887
Cesare Guasti, ed. *Santa Maria del Fiore: la costruzione della chiesa e del campanile secondo i documenti tratti dall'Archivio dell'Opera Secolare e da quello di Stato*. Florence, 1887.

G. Guasti 1871
Gaetano Guasti. *Memorie dell'immagine della chiesa di Maria V. del Soccorso e notizie di due pittori pratesi*. Prato, 1871.

G. Guasti 1888
Gaetano Guasti, comp. *I quadri della Galleria e altri oggetti d'arte del comune di Prato, descritti e illustrati con documenti inediti*. Prato, 1888.

Gudiol and Alcolea i Blanch 1986
Josep Gudiol and Santiago Alcolea i Blanch. *Pintura gótica catalana*. Barcelona, 1986.

Guerrini 1988
Alessandra Guerrini. "Intorno al polittico di Pietro Lorenzetti per la pieve di Arezzo." *Rivista d'arte* (Florence), 40th yr., 4th ser., vol. 4 (1988), pp. 3–29.

Guidi 1968
Fabrizio Guidi. "Per una nuova cronologia di Giovanni di Marco." *Paragone-arte* (Florence), n.s., vol. 19, no. 223/43 (September 1968), pp. 27–46.

Guidi 1970
Fabrizio Guidi. "Ancora su Giovanni di Marco." *Paragone-arte* (Florence), vol. 21, no. 239 (January 1970), pp. 11–23.

Guidicini
Giovanni Battista Guidicini. *Cose notabili della città di Bologna: ossia storia cronologica de' suoi stabili sacri, pubblici, e privati*. 5 vols. Bologna, 1868–73.

Guiducci 1992
Anna Maria Guiducci. "Una nuova 'Madonna col Bambino' di Pietro Lorenzetti." *Prospettiva* (Siena-Florence), no. 66 (April 1992), pp. 64–66.

Gurrieri 1988
Francesco Gurrieri with Luciano Bellosi, Giuliano Briganti, and Piero Torriti, eds. *La sede storica del Monte dei Paschi di Siena: vicende costruttive e opere d'arte*. Siena, 1988.

Hadley 1987
The Letters of Bernard Berenson and Isabella Stewart Gardner, 1887–1924, with Correspondence by Mary

Berenson. Edited and annotated by Rollin van N. Hadley. Boston, 1987.

Hager 1962
Hellmut Hager. *Die Anfänge der italienischen Altarbildes: Untersuchungen zur Entstehungsgeschichte des toskanischen Hochaltarretabels.* Römische Forschungen der Bibliotheca Hertziana, 17. Rome, 1962.

Haines 1975
Margaret Haines. "The Intarsias of the North Sacristy of the Cathedral of Florence." Ph.D. diss., Courtauld Institute of Art, University of London, 1975.

Haines 1983
Margaret Haines. *La Sacrestia delle Messe del duomo di Firenze.* Translated from the English by Laura Corti. Introduction by Giuseppe Marchini. Florence, 1983.

Hall 1979
Marcia B. Hall. *Renovation and Counter Reformation: Vasari and Duke Cosimo in Sta. Maria Novella and Sta. Croce, 1565–1577.* Oxford, 1979.

Handbook 1931
"Handbook of the Display Collection of the Art of the Middle Ages." *The Pennsylvania Museum Bulletin* (Philadelphia), vol. 26, no. 140 (March 1931), pp. 3–47.

Hansen 1989
Dorothee Hansen. "Antike Helden als 'causae': Ein gemaltes Programm im Palazzo Pubblico von Siena." In *Malerei und Stadtkultur in der Dantezeit: Die Argumentation der Bilder* (pp. 133–48). Edited by Hans Belting and Dieter Blume. Munich, 1989.

Harris 1984
Jean C. Harris, ed. *The Mount Holyoke College Art Museum: Handbook of the Collection.* South Hadley, Mass., 1984.

Hartt 1959
Frederick Hartt. "The Earliest Works of Andrea del Castagno. Part One." *The Art Bulletin* (New York), vol. 41, no. 2 (June 1959), pp. 159–88.

Hartt 1980
Frederick Hartt. *A History of Italian Renaissance Art: Painting, Sculpture, Architecture.* Rev. and enlarged ed. London, 1980.

Haskell 1999
Francis Haskell. "Botticelli, Fascism, and Burlington House—'The Italian Exhibition' of 1930." *The Burlington Magazine* (London), vol. 141, no. 1157 (August 1999), pp. 462–72.

Hatfield 1970
Rab Hatfield. "The Compagnia de' Magi." *Journal of the Warburg and Courtauld Institutes* (London), vol. 33 (1970), pp. 107–61.

Hefele 1912
Karl Hefele. *Der Hl. Bernardin von Siena und die franziskanische Wanderpredigt in Italien während des XV Jahrhunderts.* Freiburg im Breisgau, Germany, 1912.

Heinemann 1958
J. Rudolf Heinemann. *Sammlung Schloss Rohoncz.* Castagnola-Lugano, 1958.

Henderson 1994
John Henderson. *Piety and Charity in Late Medieval Florence.* Oxford, 1994.

Henderson and Joannides 1991
John Henderson and Paul Joannides. "A Franciscan

Triptych by Fra Angelico." *Arte cristiana* (Milan), n.s., vol. 79, no. 742 (January–February 1991), pp. 3–6.

Hendy 1928
Philip Hendy. "Pesellino." *The Burlington Magazine* (London), vol. 53, no. 305 (August 1928), pp. 67–74.

Hendy 1929
Philip Hendy. "'Ugolino Lorenzetti': Some Further Attributions." *The Burlington Magazine* (London), vol. 55, no. 320 (November 1929), pp. 232–38.

Hendy 1931
Philip Hendy. *The Isabella Stewart Gardner Museum: Catalogue of the Exhibited Paintings and Drawings.* Boston, 1931.

Hendy 1955
Philip Hendy. *National Gallery, London.* London, 1955.

Hendy 1974
Philip Hendy. *European and American Paintings in the Isabella Stewart Gardner Museum.* Boston, 1974.

Henniker-Heaton 1924
Raymond Henniker-Heaton. "An Early Florentine Madonna." *Art in America* (New York), vol. 12, no. 5 (August 1924), pp. 211–15.

Hériard Dubreuil 1975
Mathieu Hériard Dubreuil. "Découvertes: Le Gothique à Valence." *L'Oeil* (Paris), nos. 234–35 (January–February 1975), pp. 12–19, 66.

Hériard Dubreuil 1978
Mathieu Hériard Dubreuil. "Du nouveau sur un primitif espagnol." *L'Oeil* (Paris), nos. 270–71 (January–February 1978), pp. 53–59, 94–95.

Hériard Dubreuil 1987
Mathieu Hériard Dubreuil. *Valencia y el gótico internacional.* Translated from the French by Angela-Petra Salas Martinelli with Carlos Soler D'Hyver. Estudios universitarios, 21–22. 2 vols. Valencia, 1987.

Hériard Dubreuil and Ressort 1977
Mathieu Hériard Dubreuil and Claudie Ressort. "Aspetti fiorentini della pittura valenzana intorno al 1400 (I)." *Antichità viva* (Florence), vol. 16, no. 6 (November–December 1977), pp. 3–11.

Hériard Dubreuil and Ressort 1979
Mathieu Hériard Dubreuil and Claudie Ressort. "Aspetti fiorentini della pittura valenzana intorno al 1400 (II)." *Antichità viva* (Florence), vol. 18, no. 3 (May–June 1979), pp. 9–20.

Hermanin 1908
Filippo Hermanin. "Di alcune miniature della Biblioteca Vaticana con scene dell'antico studio bolognese nel trecento." *Vita d'arte* (Milan), vol. 4 (1908), pp. 108–19.

Hiller von Gaertringen 2004
Rudolf Hiller von Gaertringen. *Italienische Gemälde im Städel, 1300–1550: Toskana und Umbrien.* Edited by Herbert Beck and Jochen Sander. Kataloge der Gemälde im Städelschen Kunstinstitut Frankfurt am Main, 6. Mainz, 2004.

Hoeber 1902
Arthur Hoeber. "Art Collectors. John G. Johnson's Old and Modern Master Works." *The Commercial Advertiser* (New York), May 31, 1902, 2nd section, p. 4.

Höfer and Rahner
Josef Höfer and Karl Rahner, eds. *Lexikon für Theologie und Kirche.* 11 vols. Freiburg, 1957–67.

Hoff 1967
Ursula Hoff. *European Painting and Sculpture before 1800: National Gallery of Victoria.* Melbourne, 1967.

Hoff 1973
Ursula Hoff. *European Painting and Sculpture before 1800: National Gallery of Victoria.* 3rd ed. Victoria, Australia, 1973.

Hoff 1973a
Ursula Hoff. *The National Gallery of Victoria.* Introduction by Eric Westbrook. London, 1973.

Holmes 1930
Charles Holmes. "The Italian Exhibition." *The Burlington Magazine* (London), vol. 56, no. 323 (February 1930), pp. 55–72.

Hood 1986
William Hood. "Saint Dominic's Manners of Praying: Gestures in Fra Angelico's Cell Frescoes at S. Marco." *The Art Bulletin* (New York), vol. 68, no. 2 (June 1986), pp. 195–206.

Hood 1993
William Hood. *Fra Angelico at San Marco.* London, 1993.

Hope 1990
Charles Hope. "Altarpieces and the Requirements of Patrons." In *Christianity and the Renaissance: Image and Religious Imagination in the Quattrocento* (pp. 535–71). Edited by Timothy Verdon and John Henderson. Syracuse, N.Y., 1990.

Horne 1906
Herbert P. Horne. "Giovanni Dal Ponte." *The Burlington Magazine* (London), vol. 9, no. 41 (August 1906), pp. 332–37.

Horne 1906a
Herbert Horne. "Appendice di documenti su Giovanni Dal Ponte." *Rivista d'arte* (Florence), vol. 4, nos. 10–12 (October–December 1906), pp. 169–81.

Horne 1908
Herbert P. Horne. *Alessandro Filipepi, Commonly Called Sandro Botticelli, Painter of Florence.* London, 1908.

Horster 1980
Marita Horster. *Andrea del Castagno: Complete Edition with a Critical Catalogue.* Ithaca, N.Y., 1980.

Howell 1913
A. G. Ferrers Howell. *S. Bernardino of Siena.* Essay by Julia Cartwright. London, 1913.

Hueck 1983
Irene Hueck. "Il cardinale Napoleone Orsini e la cappella di S. Nicola nella basilica francescana ad Assisi." In *Roma anno 1300* (pp. 187–93). Edited by Angiola Maria Romanini. Atti della IV settimana di studi di storia dell'arte medievale dell'Università di Roma "La Sapienza," Rome, May 19–24, 1980. Rome, 1983

Hueck 1986
Irene Hueck. "Die Kapellen der Basilika San Francesco in Assisi: Die Auftraggeber und die Franziskaner." In *Patronage and Public in the Trecento: Proceedings of the St. Lambrecht Symposium* (pp. 81–104). Edited by Vincent Moieta. Abtei St. Lambrecht, Styria, Austria, July 16–19, 1984. Biblioteca dell' "Archivum Romanicum."

Ser. 1, vol. 202, Storia, letteratura, paleografia. Florence, 1986.

Hueck 1991
Irene Hueck. "Ein umbrisches Reliquiar im Kunstgewerbemuseum Schloss Köpenick." *Staatliche Museen zu Berlin: Forschungen und Berichte* (Berlin), vol. 31 (1991), pp. 183–88.

Iacobilli 1627
Ludovico Iacobilli. *Vita del beato Paolo detto Paoluccio de' Trinci da Foligno.* Foligno, 1627.

Iacobilli 1647–61
Ludovico Iacobilli. *Vite de' santi e beati dell'Umbria.* 3 vols. Foligno, 1647–61. Reprint, Bologna, 1971.

Ikuta 1971–72
Madoka Ikuta. "Il trittico della basilica di S. Maria Maggiore a Roma." *Annuario dell'Istituto Giapponese di Cultura in Roma* (Rome), vol. 9 (1971–72), pp. 37–73.

Improta and Padoa Rizzo 1989
Maria Cristina Improta and Anna Padoa Rizzo. "Paolo Schiavo fornitore di disegni per ricami." *Rivista d'arte* (Florence), vol. 41, 4th ser., vol. 5 (1989), pp. 25–56.

Inaugural 1928
"The New Museum of Art Inaugural Exhibition." *The Pennsylvania Museum Bulletin* (Philadelphia), vol. 23, no. 119 (March 1928), pp. 3–31.

Ioni 1932
Icilio Federico Ioni. *Le memorie di un pittore di quadri antichi.* San Casciano Val di Pesa, 1932. Reprint with an introduction by Umberto Baldini, Florence 1984. English translation as *Affairs of a Painter.* London, 1936.

Israëls 2003
Machtelt Israëls. *Sassetta's "Madonna della Neve": An Image of Patronage.* Leiden, 2003.

***Italies* 1996**
Italies: Peintures des musées de la région Centre. Paris, 1996.

Jacobsen 1908
Emil Jacobsen. *Das Quattrocento in Siena: Studien in der Gemäldegalerie der Akademia.* Zur Kunstgeschichte des Auslandes, vol. 59. Strasbourg, 1908.

Jacopo da Varazze c. 1267–77, Levasti ed.
Iacopo da Varazze. *Leggenda aurea volgarizzamento toscano del trecento.* Edited by Arrigo Levasti. 3 vols. Florence, 1924–26.

Jacopo da Varazze c. 1267–77, Ryan and Ripperger ed. 1941
Iacopo da Varazze. *The Golden Legend.* Translated and adapted from the Latin by Granger Ryan and Helmut Ripperger. 2 pts. London, 1941.

James 1953
Montague Rhodes James, trans. *The Apocryphal New Testament, Being the Apocryphal Gospels, Acts, Epistles, and Apocalypses, with Other Narratives and Fragments.* Corrected ed., newly trans. Oxford, 1953.

Jarves 1879
James Jackson Jarves. *Art Thoughts: The Experiences and Observations of an American Amateur in Europe.* Boston, 1879.

Joannides 1985
Paul Joannides. "A Masolino Partially Reconstructed." *Source: Notes in the History of Art* (New York), vol. 4, no. 4 (Summer 1985), pp. 1–5.

Joannides 1987
Paul Joannides. "Masaccio, Masolino, and 'Minor' Sculpture." *Paragone-arte* (Florence), n.s., vol. 38, no. 5/451 (September 1987), pp. 3–24.

Joannides 1988
Paul Joannides. "The Colonna Triptych by Masolino and Masaccio: Collaboration and Chronology." *Arte cristiana* (Milan), n.s., vol. 76, no. 728 (September–October 1988), pp. 339–46.

Joannides 1993
Paul Joannides. *Masaccio and Masolino: A Complete Catalogue.* London, 1993.

Johnson 1892
John G. Johnson. *Sight-Seeing in Berlin and Holland among Pictures.* Philadelphia, 1892.

Johnson 1933
A Picture Book of Some XIV and XV Century Italian Paintings from the John G. Johnson Collection, Philadelphia. Part 1, *Italian Paintings.* Philadelphia, 1933.

Johnson 1941
John G. Johnson Collection: Catalogue of Paintings. Foreword by Henri Marceau. Philadelphia, 1941.

Johnson 1941a
A Picture Book of Some XIV and XV Century Italian Paintings from the John G. Johnson Collection. Philadelphia, 1941.

Johnson 1948
A Picture Book of Some Italian, Flemish, Dutch, German, Spanish, French Paintings from the John G. Johnson Collection. Philadelphia, 1948.

Kaftal 1952
George Kaftal. *Saints in Italian Art: Iconography of the Saints in Tuscan Painting.* Florence, 1952.

Kaftal and Bisogni 1978
George Kaftal and Fabio Bisogni. *Saints in Italian Art: Iconography of the Saints in the Painting of North East Italy.* Florence, 1978.

Kanter 1983
Laurence B. Kanter. "A *Massacre of the Innocents* in the Walters Art Gallery." *The Journal of the Walters Art Gallery* (Baltimore), vol. 41 (1983), pp. 17–28.

Kanter 1986
Laurence B. Kanter. "Giorgio di Andrea di Bartolo." *Arte cristiana* (Milan), n.s., vol. 74, no. 712 (January–February 1986), pp. 15–28.

Kanter 1994
Laurence B. Kanter. *Italian Paintings in the Museum of Fine Arts, Boston.* Vol. 1, *13th–15th Century.* Introduction by Eric Zafran. Boston, 1994.

Kanter 2000
Laurence B. Kanter. "A Rediscovered Panel by Fra Angelico." *Paragone-arte* (Florence), 3rd ser., vol. 51, no. 29/599 (January 2000), pp. 3–13.

Kanter 2002
Laurence B. Kanter. "Zanobi Strozzi miniatore and Battista di Biagio Sanguigni." *Arte cristiana* (Milan), vol. 90, no. 812 (September–October 2002), pp. 321–31.

Kanter 2004
Laurence B. Kanter. "The National Gallery's New Catalogue of Fifteenth-Century Italian Paintings." *The Burlington Magazine* (London), vol. 146, no. 1211 (February 2004), pp. 105–8.

Kanter, Strehlke, and Dean 2001
Laurence B. Kanter, Carl Brandon Strehlke, and Clay Dean. *Rediscovering Fra Angelico: A Fragmentary History.* New Haven, 2001.

Kanter et al. 1994
Laurence B. Kanter, Barbara Drake Boehm, Carl Brandon Strehlke, Gaudenz Freuler, Christa C. Mayer Thurman, and Pia Palladino. *Painting and Illumination in Early Renaissance Florence, 1300–1450.* New York, 1994. Exhibition, New York, The Metropolitan Museum of Art, November 17, 1994–February 26, 1995.

Kauffmann 1973
C. M. Kauffmann. *Victoria and Albert Museum: Catalogue of Foreign Paintings.* Vol. 1, *Before 1800.* London, 1973.

Kemp 1967
Wolfgang Kemp. "Zum Programm von Stefaneschi-Altar und Navicella." *Zeitschrift für Kunstgeschichte* (Berlin), vol. 30, no. 4 (1967), pp. 309–20.

Kempers and de Blaauw 1985
Bram Kempers and Sible de Blaauw. "Pauselijk ceremonieel en kunst in middeleeuwen en renaissance." *Akt* (The Hague), vol. 9, no. 2 (1985), pp. 22–37.

Kempers and de Blaauw 1987
Bram Kempers and Sible de Blaauw. "Jacopo Stefaneschi, Patron and Liturgist: A New Hypothesis Regarding the Date, Iconography, Authorship, and Function of His Altarpiece for Old Saint Peter's." *Mededelingen van het Nederlands Instituut te Rome* (The Hague), vol. 47, n.s., vol. 12 (1987), pp. 83–113.

Kennedy 1934
Ruth Wedgwood Kennedy. Review of Salmi c. 1932. *The Art Bulletin* (New York), vol. 16, no. 4 (December 1934), pp. 396–97.

Kennedy 1938
Ruth Wedgwood Kennedy. *Alesso Baldovinetti: A Critical and Historical Study.* New Haven, 1938.

Kennedy 1964
Ruth Wedgwood Kennedy. "The Contribution of Martin V to the Rebuilding of Rome, 1420–1431." In *The Renaissance Reconsidered: A Symposium* (pp. 27–52). Smith College Studies in History, 44. Northampton, Mass., 1964.

Kent 1977
Francis William Kent. *Household and Lineage in Renaissance Florence: The Family Life of the Capponi, Ginori, and Rucellai.* Princeton, 1977.

Kent et al. 1981
Francis William Kent et al. *Giovanni Rucellai ed il suo Zibaldone.* Vol. 2, *A Florentine Patrician and His Palace.* Introduction by Nicolai Rubinstein. London, 1981.

Kermer 1967
Wolfgang Kermer. "Studien zum Diptychon in der sakralen Malerei von den Anfängen bis zur Mitte des sechzehnten Jahrhundert: Mit einem Katalog." Doctoral diss., Universität Tübingen. Düsseldorf, 1967.

Kern 1905
Joseph Kern. "Die Kritik der perspektivischen Zeichnung und ihre Bedeutung für die Kunstgeschichte." *Sitzungsbericht der Berliner Kunsthistorischen Gesellschaft* (Berlin), October 13, 1905.

Kéry 1972
Bertalan Kéry. *Kaiser Sigismund: Ikonographie*. Vienna, 1972.

Kessler 1925
J.H.H. Kessler. "The Master of S. Miniato." *The Burlington Magazine* (London), vol. 46, no. 266 (May 1925), pp. 230–35.

Khvoshinsky and Salmi 1914
Basile Khvoshinsky and Mario Salmi. *I pittori toscani dal XIII al XVI secolo*. Vol. 2, *I fiorentini del trecento*. Rome, 1914.

Kiev 1985
Kiev, Museum of Western and Oriental Art. *Painting, Sculpture, Minor Arts, Prints, and Drawings*. Compiled and with an introduction by Helena Roslavets. Translated from the Russian by Dmitry Pago. St. Petersburg, 1985.

Kimball 1931
Fiske Kimball. "The Display Collection of the Art of the Middle Ages." *The Pennsylvania Museum Bulletin* (Philadelphia), vol. 26, no. 141 (April 1931), pp. 3–27.

E. King 1936
Edward S. King. "Notes on the Paintings by Giovanni di Paolo in the Walters Collection." *The Art Bulletin* (New York), vol. 18, no. 2 (June 1936), pp. 215–39.

G. G. King 1934
Georgiana Goddard King. "Iconographical Notes on the Passion." *The Art Bulletin* (New York), vol. 16, no. 3 (September 1934), pp. 291–303.

Kirchen
Die Kirchen von Siena. Edited by Peter Anselm Reidl and Max Seidel. Vol. 1–. Munich, 1985–.

Kirsh and Levenson 2000
Andrea Kirsh and Rustin S. Levenson. *Seeing through Paintings: Physical Examination in Art Historical Studies*. Materials and Meaning in the Fine Arts, vol. 1. New Haven, 2000.

Kitao 1962
Timothy K. Kitao. "Prejudice in Perspective: A Study of Vignola's Perspective Treatise." *The Art Bulletin* (New York), vol. 44, no. 3 (September 1962), pp. 173–94.

Klein 1961
Robert Klein. "Pomponius Gauricus on Perspective." *The Art Bulletin* (New York), vol. 43, no. 3 (September 1961), pp. 211–30.

Klesse 1967
Brigitte Klesse. *Seidenstoffe in der italienischen Malerei des 14. Jahrhunderts*. Bern, 1967.

Knust 1890
Hermann Knust. *Geschichte der Legenden der h. Katharina von Alexandrien und der h. Maria Aegyptiaca*. Halle, 1890.

Koudelka 1959
Vladimir Koudelka. "Spigolature dal memoriale di Niccolò Galgani, O.P. (†1424)." *Archivum fratrum praedictatorum* (Rome), vol. 29 (1959), pp. 111–47.

Krautheimer 1949
Richard Krautheimer. "Some Drawings of Early Christian Basilicas in Rome: St. Peter's and S. Maria Maggiore." *The Art Bulletin* (New York), vol. 31, no. 3 (September 1949), pp. 211–15.

Krautheimer 1956
Richard Krautheimer in collaboration with Trude Krautheimer-Hess. *Lorenzo Ghiberti*. Princeton Monographs in Art and Archaeology, 31. Princeton, 1956.

Krautheimer 1982
Richard Krautheimer in collaboration with Trude Krautheimer-Hess. *Lorenzo Ghiberti*. Princeton Monographs in Art and Archaeology, 31. 3rd ed. Princeton, 1982.

Krautheimer, Corbett, and Frankl 1967
Richard Krautheimer, Spencer Corbett, and Wolfgang Frankl. *Corpus basilicarum christianarum Romae: The Early Christian Basilicas of Rome (IV–IX cent.)*. Monumenti di antichità cristiana, Pontificio Istituto di Archeologia Cristiana, 2nd ser., 2. Vol. 3. Rome, 1967.

Krinsky 1970
Carol Herselle Krinsky. "Representations of the Temple of Jerusalem before 1500." *Journal of the Warburg and Courtauld Institutes* (London), vol. 33 (1970), pp. 1–19.

Kustodieva 1979
Tatiana Kustodieva. "Due primitivi all'Ermitage." *Paragone-arte* (Florence), vol. 30, no. 357 (November 1979), pp. 71–74.

Lachi 1995
Chiara Lachi. *Il Maestro della Natività di Castello*. Artisti toscani dal trecento al settecento. Florence, 1995.

Laclotte 1964
Michel Laclotte. "Musée des Tours: La Donation Octave Linet. I: Peintures italiennes." *La Revue du Louvre* (Paris), 14th year, nos. 4–5 (1964), pp. 181–87.

Laclotte and Mognetti 1976
Michel Laclotte and Élisabeth Mognetti. *Avignon—Musée du Petit Palais: Peinture italienne*. Inventaire des collections publiques françaises, 21. Paris, 1976.

Laclotte and Mognetti 1977
Michel Laclotte and Élisabeth Mognetti. *Avignon—Musée du Petit Palais: Peinture italienne*. Inventaire des collections publiques françaises, 21. Paris, 1977.

Laclotte and Mognetti 1987
Michel Laclotte and Élisabeth Mognetti. *Avignon—Musée du Petit Palais: Peinture italienne*. Rev. ed. Inventaire des collections publiques françaises, 21. Paris, 1987.

Ladis 1981
Andrew Ladis. "Fra Angelico: Newly Discovered Documents from the 1420s." *Mitteilungen des Kunsthistorischen Institutes in Florenz* (Florence), vol. 25, no. 3 (1981), pp. 378–79.

Ladis 1982
Andrew Ladis. *Taddeo Gaddi: Critical Reappraisal and Catalogue Raisonné*. Columbia, Mo., 1982.

Ladis 1984
Andrew Ladis. "The Velluti Chapel at Santa Croce, Florence." *Apollo* (London), n.s., vol. 120, no. 272 (October 1984), pp. 238–45.

Ladis 1989
Andrew Ladis. "A High Altarpiece for San Giovanni Fuorcivitas in Pistoia and Hypotheses about Niccolò di Tommaso." *Mitteilungen des Kunsthistorischen Institutes in Florenz* (Florence), vol. 33, no. 1 (1989), pp. 3–16.

Ladis 2003
Andrew Ladis. "The Music of Devotion: Image, Voice, and the Imagination in a *Madonna of Humility* by Domenico di Bartolo." In *Art and Music in the Early Modern Period* (pp. 3–26). Edited by Katherine M. MacIver. Aldershot, England, 2003.

Lafontaine-Dosogne 1964–65
Jacqueline Lafontaine-Dosogne. *Iconographie de l'enfance de la Vierge dans l'empire byzantin et en occident*. Académie Royale de Belgique, Mémoires de la Classe des Beaux-Arts, 2nd ser., vol. 11, no. 3. 2 vols. Brussels, 1964–65.

Lambraki-Plaka 1999
Marina Lambraki-Plaka, ed. *National Gallery, 100 Years: Four Centuries of Greek Painting from the Collections of the National Gallery and the Euripidis Koutlidus Foundation*. Athens, 1999.

Lamo 1560, 1844 ed.
Pietro Lamo. *Graticola di Bologna, ossia descrizione delle pitture, sculture e architetture di detta città fatta l'anno 1560*. Bologna, 1844.

Langasco and Rotondi 1957
Cassiano da Langasco and Pasquale Rotondi. *La "Consortía deli forestèri" a Genova: una Madonna di Barnaba da Modena e uno statuto del trecento*. Genoa, 1957.

Lanzi 1809, Capucci ed.
Luigi Lanzi. *Storia pittorica della Italia: dal risorgimento delle belle arti fin presso al fine del XVIII secolo*. 3rd critical ed., rev. and enlarged by the author. 1809. Edited by Martino Capucci. 3 vols. Florence, 1968–74.

Larousse 1979
Petit Larousse de la peinture. Edited by Michel Laclotte and Jean-Pierre Cuzin. Paris, 1979.

Lasareff 1965
Victor Lasareff. "Saggi sulla pittura veneziana dei sec. XIII–XIV, la maniera greca e il problema della scuola cretese (I°)." *Arte veneta* (Padua), vol. 19 (1965), pp. 17–31.

Lasareff 1971
Victor Lasareff. "Un nuovo maestro del trecento." *Commentari* (Rome), n.s., vol. 22, no. 1 (January–March 1971), pp. 12–23.

Laskin and Pantazzi 1987
Myron Laskin, Jr., and Michael Pantazzi. *Catalogue of the National Gallery of Canada, Ottawa: European and American Painting, Sculpture, and Decorative Arts, 1300–1800*. 2 vols. Ottawa, 1987.

Lastri 1791–95
Marco Lastri. *L'Etruria pittrice, ovvero storia della pittura toscana dedotta dai suoi monumenti che si esibiscono in stampa dal secolo X fino al presente*. 2 vols. Florence, 1791–95.

Lavin 1994
Marilyn Aronberg Lavin. *Piero della Francesca: San Francesco, Arezzo*. The Great Fresco Cycles of the Renaissance. New York, 1994.

Lecchini Giovannoni 1991
Simona Lecchini Giovannoni. *Alessandro Allori*. Archivi di arte antica. Turin, 1991.

Lenotti 1955
Tullio Lenotti. *Chiese e conventi scomparsi*. Vol. 1, *A destra dell'Adige*. Verona, 1955.

Leonardi 1906
Valentino Leonardi. *La tavola della Madonna della Neve nel Museo Nazionale di Napoli*. Siena, 1906.

Leoncini 1991
Giovanni Leoncini. "Due oratori e due affreschi." *Antichità viva* (Florence), vol. 30, no. 6 (November–December 1991), pp. 17–23.

Leone de Castris 1986
Pierluigi Leone de Castris. *Arte di corte nella Napoli angioina.* Florence, 1986.

Lessi 1986
Franco Lessi. *Volterra: la Pinacoteca e il Museo Civico di Palazzo Minucci Solaini.* Milan, 1986.

Levi D'Ancona 1958
Mirella Levi D'Ancona. "Some New Attributions to Lorenzo Monaco." *The Art Bulletin* (New York), vol. 40, no. 3 (September 1958), pp. 175–91.

Levi D'Ancona 1959
Mirella Levi D'Ancona. "Zanobi Strozzi Reconsidered." *La bibliofilia* (Florence), vol. 41, no. 1 (1959), pp. 1–38.

Levi D'Ancona 1960
Mirella Levi D'Ancona. "La pala de 1436 di Zanobi Strozzi." *Rivista d'arte* (Florence), vol. 35, 3rd ser., vol. 10 (1960; published 1961), pp. 103–6.

Levi D'Ancona 1962
Mirella Levi D'Ancona. *Miniatura e miniatori a Firenze dal XIV al XVI secolo: documenti per la storia della miniatura.* Introduction by Mario Salmi. Florence, 1962.

Levi D'Ancona 1970
Mirella Levi D'Ancona. "Battista di Biagio Sanguigni (1392/3–1452)." *La bibliofilia* (Florence), vol. 72, no. 1 (1970), pp. 1–35.

Levi D'Ancona 1977
Mirella Levi D'Ancona. *The Garden of the Renaissance: Botanical Symbolism in Italian Painting.* Arte e archeologia, studi e documenti, 10. Florence, 1977.

Levi D'Ancona 1979
Mirella Levi D'Ancona. "Arte e politica: l'interdetto, gli Albizzi e la miniatura fiorentina del tardo trecento." In *La miniatura italiana in età romanica e gotica* (pp. 461–87). Edited by Grazia Vailati Schoenburg Waldenburg. Atti del I congresso di storia della miniatura italiana, Cortona, May 26–28, 1978. Storia della miniatura: studi e documenti, 5. Florence, 1979.

Liberati 1936
A. Liberati. "Le vicende della canonizzazione di S. Bernardino." *Bullettino di studi bernardiniani* (Siena), vol. 2, no. 2 (1936), pp. 91–124.

Liberati 1940
A. Liberati. "Chiesa e monastero di Santa Marta." *Bullettino senese di storia patria* (Siena), n.s., vol. 11 (1940), pp. 162–65.

Liberati 1999
Germano Liberati, ed. *Il gotico internazionale a Fermo e nel fermano.* Livorno, 1999. Exhibition, Fermo, Palazzo dei Priori, August 28–October 31, 1999.

Lightbown 1980
Ronald W. Lightbown. *Donatello and Michelozzo: An Artistic Partnership and Its Patrons in the Early Renaissance.* 2 vols. London, 1980.

Lignelli 1997
Teresa Lignelli. "Use of a *Rigatino* Inpainting Technique for Compensation of Losses in Panel Paintings—A Case Study." In *1997 AIC Paintings Specialty Group Postprints, Papers Presented at the Twenty-fifth Annual Meeting of The American Institute for Conservation of Historic and Artistic Works* (pp. 96–105). San Diego, California, June 13–14, 1997.

Lindberg 1931
Hendrik Lindberg. *To the Problem of Masolino and Masaccio.* Malmö, Sweden, 1931.

Linnenkamp 1958
Rolf Linnenkamp. "Opera sconosciuta di Paolo Schiavo a Castellaccio." *Rivista d'arte* (Florence), vol. 33, 3rd ser., vol. 8 (1958), pp. 27–33.

Lipman 1936
Jean Lipman. "The Florentine Profile Portrait in the Quattrocento." *The Art Bulletin* (New York), vol. 18, no. 1 (March 1936), pp. 54–102.

Lippi 1994
I Lippi a Prato. Monografie del Museo Civico, Prato, 1. Prato, 1994.

Lippincott 1981
Louise W. Lippincott. "The Unnatural History of Dragons." *Philadelphia Museum of Art Bulletin*, vol. 77, no. 334 (Winter 1981), pp. 1–24. Published on the occasion of an exhibition at the Philadelphia Museum of Art. John G. Johnson Collection, Special Exhibition Gallery, December 12, 1981–June 27, 1982.

Lisini 1928
Alessandro Lisini. "La Pia di Dante." *La Diana* (Siena), vol. 3, no. 4 (1928), pp. 249–75.

Litta 1819–85
Pompeo Litta. *Famiglie celebri italiane.* Issued in parts. Milan, 1819–85.

Liverpool 1963–66
Liverpool, Walker Art Gallery. *Foreign Schools Catalogue.* 2 vols. Catalogue by Michael Compton. Liverpool, 1963–66.

Liverpool 1977
Liverpool, Walker Art Gallery. *Foreign Catalogue: Paintings, Drawings, Watercolours, Tapestry, Sculpture, Silver, Ceramics.* Compiled by Edward Morris and Martin Hopkinson. 2 vols. Liverpool, 1977.

Llompart 1978
Gabriel Llompart. *La pintura medieval mallorquina: su entorno cultural y su iconografía.* Colección Eura, 1. Vol. 3. Palma de Mallorca, 1978.

Lloyd 1977
Christopher Lloyd, comp. *A Catalogue of the Earlier Italian Paintings in the Ashmolean Museum.* Oxford, 1977.

Lloyd 1993
Christopher Lloyd. *Italian Paintings before 1600 in The Art Institute of Chicago: A Catalogue of the Collection.* Contributions by Margherita Andreotti, Larry J. Feinberg, and Martha Wolff. Martha Wolff, general editor. Chicago, 1993.

Logan 1901
Mary Logan. "Compagno di Pesellino et quelques peintures de l'école." *Gazette des beaux-arts* (Paris), 43rd yr., 3rd ser., vol. 26, no. 529 (July 1901), pp. 18–34; vol. 26, no. 532 (October 1901), pp. 333–43.

London 1878
London, Royal Academy of Arts. *Exhibition of Works by the Old Masters, and by Deceased Masters of the British School. . . .* Exhibition, Winter 1878.

London 1887
London, Royal Academy of Arts. *Exhibition of Works by the Old Masters, and by Deceased Masters of the British School. . . .* Exhibition, January 3–March 12, 1887.

London 1893–94
London, The New Gallery. *Exhibition of Early Italian Art. From 1300 to 1550.* Exhibition, 1893–94.

London 1896
London, Royal Academy of Arts. *Exhibition of Works by the Old Masters, and by Deceased Masters of the British School. . . .* Exhibition, January 6–March 14, 1896.

London 1904
London, Royal Academy of Arts. *Exhibition of Works by the Old Masters, and by Deceased Masters of the British School. . . .* Exhibition, Winter 1904.

London 1904a
London, Burlington Fine Arts Club. *Exhibition of Pictures of the School of Siena and Examples of the Minor Arts of That City.* Exhibition, 1904.

London 1930
London, Burlington House, Royal Academy of Arts. *Exhibition of Italian Art, 1200–1900.* Exhibition, January 1–March 20, 1930.

London 1946
London, Royal Academy of Arts. *The King's Pictures: An Illustrated Souvenir of the Exhibition of the King's Pictures at the Royal Academy of Arts, London.* Exhibition, 1946–47.

London 1965
London, Wildenstein. *The Art of Painting in Florence and Siena from 1250–1500.* Exhibition, February 24–April 10, 1965. Catalogue by St. John Gore.

London 1983
London, Matthiesen Fine Art Ltd. *Early Italian Paintings and Works of Art, 1300–1480.* Exhibition, 1983. Catalogue edited by Carlo Volpe. Introduction by Dillian Gordon.

London 1989
See Bomford et al. 1989

London 1998
London, National Gallery. *Zanobi Strozzi: In the Light of Fra Angelico* (pamphlet). Exhibition, December 10, 1998–March 7, 1999.

Longhi 1926
Roberto Longhi [Andrea Ronchi, pseud.]. "Primizie di Lorenzo da Viterbo." *Vita artistica* (Rome), vol. 1, nos. 9–10 (September–October 1926), pp. 109–14.

Longhi 1927
Roberto Longhi. *Piero della Francesca.* Rome, 1927.

Longhi 1928
Roberto Longhi. "Ricerche su Giovanni di Francesco." *Pinacotheca* (Rome), vol. 1, no. 1 (July–August 1928), pp. 3–48.

Longhi 1940
Roberto Longhi. "Fatti di Masolino e di Masaccio." *Critica d'arte* (Florence), vol. 5, no. 34, fascs. 25–26, pt. 2 (July–December 1940), pp. 145–91.

Longhi 1947
Roberto Longhi. "Calepino veneziano. II: il trittico di Lorenzo Veneziano per l'Ufficio della Seta (1371)." *Arte veneta* (Venice), vol. 1, no. 2 (April–June 1947), pp. 80–85.

Longhi 1948
Roberto Longhi. "Giudizio sul duecento [1939]." *Proporzioni* (Florence), vol. 2 (1948), pp. 5–54.

Longhi 1948a
Roberto Longhi. "'Me pinxit.' I: il Maestro della Predella Sherman." *Proporzioni* (Florence), vol. 2 (1948), pp. 161–62.

Longhi 1950
Roberto Longhi. "La mostra del trecento bolognese." *Paragone-arte* (Florence), vol. 1, no. 5 (May 1950), pp. 5–44.

Longhi 1950a
Roberto Longhi. "Un esercizio sul Daddi." *Paragone-arte* (Florence), vol. 1, no. 3 (March 1950), pp. 16–19.

Longhi 1951
Roberto Longhi. "La mostra di Arezzo." *Paragone-arte* (Florence), vol. 2, no. 15 (March 1951), pp. 50–63.

Longhi 1951a
Roberto Longhi. "Un ritrovamento eccezionale." *Paragone-arte* (Florence), vol. 2, no. 21 (September 1951), p. 64.

Longhi 1952
Roberto Longhi. "Presenza di Masaccio nel trittico della Neve." *Paragone-arte* (Florence), vol. 3, no. 25 (January 1952), pp. 8–16.

Longhi 1952a
Roberto Longhi. "Il 'Maestro di Pratovecchio.'" *Paragone-arte* (Florence), vol. 3, no. 35 (November 1952), pp. 10–37.

Longhi 1958
Roberto Longhi. "Due pannelli del seguito di Altichiero." *Paragone-arte* (Florence), vol. 9, no. 107 (November 1958), pp. 64–65.

Longhi 1959
Roberto Longhi. "Qualità e industria in Taddeo Gaddi." *Paragone-arte* (Florence), vol. 10, no. 109 (January 1959), pp. 31–40; vol. 10, no. 111 (March 1959), pp. 3–12.

Longhi 1965
Roberto Longhi. "Una 'riconsiderazione' dei primitivi italiani a Londra." *Paragone-arte* (Florence), n.s., vol. 16, no. 183/2 (May 1965), pp. 8–16.

Longhi 1965a
Roberto Longhi. "Un'aggiunta al 'Maestro del Bambino Vispo' (Miguel Alcañiz?)." *Paragone-arte* (Florence), n.s., vol. 16, no. 185/5 (July 1965), pp. 38–40.

Longhi 1965b
Roberto Longhi. "Un incontro col 'Maestro dei Santi Quirico e Giulitta.'" *Paragone-arte* (Florence), n.s., vol. 16, no. 185/5 (July 1965), pp. 40–43.

Longhi *Opere*
Roberto Longhi. *Edizione delle opere complete di Roberto Longhi.* 14 vols. Florence, 1956–91.

Longpré 1935–37
Ephrem Longpré. "S. Bernardin de Sienne et le nom de Jésus." *Archivum franciscanum historicum* (Florence), vol. 28 (1935), pp. 443–76; vol. 29, nos. 1–2 (January–April 1936), pp. 142–68; vol. 30, nos. 1–3 (January–April 1937), pp. 170–92.

Los Angeles 1994
See Caroselli 1994

Loseries 1987
Wolfgang Loseries. "La pala di San Giorgio nella chiesa di San Cristoforo a Siena: Sano di Pietro o il 'Maestro dell'Osservanza'?" *Prospettiva* (Siena-Florence), no. 49 (April 1987; printed December 1988), pp. 61–74.

Louvre 1960
Paris, Musée du Louvre. *Exposition de 700 tableaux de toutes les écoles antérieurs à 1800, tirés des réserves du département des peintures.* 2nd ed. rev. Paris, 1960.

Loyrette 1978
Henri Loyrette. "Une source pour la reconstruction du polyptyque d'Ugolino da Siena à Santa Croce." *Paragone-arte* (Florence), vol. 29, no. 343 (September 1978), pp. 15–23.

Lübke 1870
W. Lübke. "Masolino und Masaccio." *Jahrbuch für Kunstwissenschaft* (Leipzig), vol. 3 (1870), pp. 280–86.

Lucca 1968
See Martinelli and Arata 1968

Lucca 1998
See Filieri 1998

Lucco 1977
Mauro Lucco. "'Me pinxit': schede per un catalogo del Museo Antoniano." *Il Santo: rivista antoniana di storia, dottrina, arte* (Padua), vol. 12, nos. 1–2 (January–August 1977), pp. 243–81.

Lucco 1989–90
La pittura nel Veneto: il quattrocento. 2 vols. Edited by Mauro Lucco. Milan, 1989–90.

Lucco 1992
Mauro Lucco, ed. *La pittura nel veneto: il trecento.* 2 vols. Milan, 1992.

Ludovico da Pietralunga c. 1570–80, Scarpellini ed. 1982
Ludovico da Pietralunga. *Descrizione della basilica di S. Francesco e di altri santuari di Assisi.* Introduction, notes, and critical commentary by Pietro Scarpellini. Fonti per la storia dell'arte. Treviso, 1982.

Lugano 1991
Lugano-Castagnola, Villa Favorita, Fondazione Thyssen-Bornemisza. *"Manifestatori delle cose miracolose": arte italiana del '300 e '400 da collezioni in Svizzera e nel Liechtenstein.* Exhibition, April 7–June 30, 1991. Catalogue by Gaudenz Freuler. Einsiedeln, Switzerland, 1991.

Lunghi 1981
Elvio Lunghi. "Affreschi del 'Maestro della Santa Chiara' (e la primitiva decorazione del duomo di Giovanni da Gubbio)." *Paragone-arte* (Florence), vol. 32, no. 381 (November 1981), pp. 59–66.

Lurie 1989
Ann T. Lurie. "In Search of a Valencian Madonna by Starnina." *The Bulletin of The Cleveland Museum of Art*, vol. 76, no. 10 (December 1989), pp. 335–73.

Lusini 1908
Vittorio Lusini. *La basilica di Santa Maria dei Servi in Siena.* Siena, 1908.

Lusini 1912
Vittorio Lusini. "Di Duccio di Buoninsegna." *Rassegna d'arte senese* (Siena), vol. 8, no. 1 (January–March 1912), pp. 60–98.

Lusini 1912a
Vittorio Lusini. "Duccio di Buoninsegna e la sua scuola: catalogo dei dipinti." *Rassegna d'arte senese* (Siena), vol. 8, no. 2 (April–June 1912), pp. 105–34.

Lusini 1913
Vittorio Lusini. "Per lo studio della vita e delle opere di Duccio di Buoninsegna." *Rassegna d'arte senese* (Siena), vol. 9, nos. 1–2 (January–June 1913), pp. 19–32.

Lydecker 1987
John Kent Lydecker. "The Domestic Setting of the Arts in Renaissance Florence." Ph.D. diss., The Johns Hopkins University, 1987.

Lynes 1983
Barbara Buhler Lynes. "Bicci di Lorenzo's 'Lost' Compagni Polyptych." *Gazette des beaux-arts* (Paris), 125th yr., 6th ser., vol. 102, no. 1379 (December 1983), pp. 208–14.

Macerata 1971
Macerata, San Paolo. *Pittura nel maceratese dal duecento al tardo gotico.* June 27–August 17, 1971.

Mack 1980
Charles R. Mack. "A Carpenter's *Catasto* with Information on Masaccio, Giovanni Dal Ponte, Antonio di Domenico, and Others." *Mitteilungen des Kunsthistorischen Institutes in Florenz* (Florence), vol. 24, no. 3 (1980), pp. 366–69.

Madrid 1990
Madrid, Museo del Prado. *Colección Cambó.* Exhibition, October 9–December 31, 1990. Also shown at Barcelona, Museu d'Art de Catalunya. Catalogue edited by Alfonso E. Pérez Sánchez and Joan Sureda I Pons. Madrid, 1990.

Madsen 1918
Karl Madsen. "Gamle Billeder i Bergens Billedgalleri." In *Festskrift til Johan Begh* (pp. 135–36). Oslo, 1918.

Maetzke 1998
Anna Maria Maetzke. *Introduzione di capolavori di Piero della Francesca.* Cinisello Balsamo (Milan), 1998.

Magagnato 1962
Licisco Magagnato. *Arte e civiltà del medioevo veronese.* Turin, 1962.

Magagnato 1991
Licisco Magagnato. *Arte e civiltà a Verona.* Edited by Sergio Marinelli and Paola Marini. Introduction by Renzo Zorzi. Saggi e studi di storia dell'arte, n.s., 1. Vicenza, 1991.

Maginnis 1971
Hayden B. J. Maginnis. "Cast Shadow in the Passion Cycle at San Francesco, Assisi: A Note." *Gazette des beaux-arts* (Paris), 113th yr., 6th ser., vol. 77, no. 1224 (January 1971), pp. 63–64.

Maginnis 1974
Hayden B. J. Maginnis. "Lorenzettian Panels in Prague." *The Burlington Magazine* (London), vol. 116, no. 851 (February 1974), pp. 98–101.

Maginnis 1974a
Hayden B. J. Maginnis. "Una Madonna col Bambino di Niccolò di Segna a Cortona." *Arte illustrata* (Milan), vol. 7, no. 58 (July 1974), pp. 214–18.

Maginnis 1975
Hayden B. J. Maginnis. "Pietro Lorenzetti's Carmelite Madonna: A Reconstruction." *Pantheon* (Munich), vol. 33, no. 1 (January–March 1975), pp. 10–16.

Maginnis 1975a
Hayden B. J. Maginnis. "Assisi Revisited: Notes on

Recent Observations." *The Burlington Magazine* (London), vol. 117, no. 869 (August 1975), pp. 511–17.

Maginnis 1975b
Hayden B. J. Maginnis. "Pietro Lorenzetti and the Assisi Passion Cycle." Ph.D. diss., Princeton University, 1975.

Maginnis 1976
Hayden B. J. Maginnis. "Letters: The Frescoes in the Lower Church at Assisi." *The Burlington Magazine* (London), vol. 118, no. 874 (January 1976), p. 32.

Maginnis 1976a
Hayden B. J. Maginnis. "The Passion Cycle in the Lower Church of San Francesco, Assisi: The Technical Evidence." *Zeitschrift für Kunstgeschichte* (Munich), vol. 39, nos. 2–3 (1976), pp. 193–208.

Maginnis 1980
Hayden B. J. Maginnis. "The So-Called Dijon Master." *Zeitschrift für Kunstgeschichte* (Munich), vol. 43, no. 1 (1980), pp. 121–38.

Maginnis 1980a
Hayden B. J. Maginnis. "A Lorenzettian Crucifix in Cortona." *RACAR—Revue d'art canadienne* (Quebec), vol. 7, nos. 1–2 (1980), pp. 59–61.

Maginnis 1983
Hayden B. J. Maginnis. "The Thyssen-Bornemisza Ugolino." *Apollo* (London), vol. 118, no. 257 (July 1983), pp. 16–21.

Maginnis 1984
Hayden B. J. Maginnis. "Pietro Lorenzetti: A Chronology." *The Art Bulletin* (New York), vol. 66, no. 2 (June 1984), pp. 183–211.

Magliabechiano 1536–46, Frey ed. 1892
Il codice magliabechiano cl. XVII. 17 contente notizie sopra l'arte degli antichi e quella de' fiorentini da Cimabue a Michelangelo Buonarroti scritte da anonimo fiorentino. Edited by Carl Frey. Berlin, 1892.

Magnuson 1958
Torgil Magnuson. *Studies in Roman Quattrocento Architecture.* Figura, 9. Stockholm, 1958.

Malesci 1961
Giovanni Malesci. *Catalogazione illustrata della pittura a olio di Giovanni Fattori.* Novara, 1961.

Mallory 1974
Michael Mallory. "An Altarpiece by Lippo Memmi Reconsidered." *Metropolitan Museum Journal* (New York), vol. 9 (1974), pp. 187–202.

Mallory 1975
Michael Mallory. "Thoughts Concerning the 'Master of the Glorification of St. Thomas.'" *The Art Bulletin* (New York), vol. 57, no. 1 (March 1975), pp. 9–20.

Mallory and Freuler 1991
Michael Mallory and Gaudenz Freuler. "Sano di Pietro's Bernardino Altar-Piece for the Compagnia della Vergine in Siena." *The Burlington Magazine* (London), vol. 133, no. 1056 (March 1991), pp. 186–92.

Malquori 2001
Alessandra Malquori. "La 'Tebaide' degli Uffizi: tradizioni letterarie e figurative per l'interpretazione di un tema iconografico." *I Tatti Studies* (Florence), vol. 9 (2001), pp. 119–37.

Malvasia 1678, Zanotti ed. 1841
Carlo Cesare Malvasia. *Felsina pittrice: vite de' pittori bolognesi.* Edited by Giampietrino Zanotti. 2 vols. Bologna, 1841.

Manchester 1857
Manchester, Museum of Ornamental Art. *Catalogue of the Art Treasures of the United Kingdom Collected at Manchester in 1857.* Exhibition, 1857.

Manchester 1976
Manchester, University of Manchester, Whitworth Art Gallery. *Medieval and Early Renaissance Treasures in the North West.* Exhibition, January 15–February 28, 1976. Catalogue edited by Jonathan Alexander and Paul Crossley. Manchester, 1976.

Mancini 1992
Francesco Federico Mancini. *Benedetto Bonfigli.* Perugia, 1992.

Mancini 1897
Girolamo Mancini. *Cortona nel medio evo.* Florence, 1897.

Mancini c. 1617–24, Marucchi ed. 1956–57
Giulio Mancini. *Considerazioni sulla pittura.* Edited by Adriana Marucchi. Commentary by Luigi Salerno. Preface by Lionello Venturi. Accademia Nazionale dei Lincei, Fonti e documenti inediti per la storia dell'arte, 1. 2 vols. Rome, 1956–57.

Manetti 1480s–90s, Milanesi ed. 1887
Antonio di Tuccio Manetti. *Operette istoriche edite ed inedite.* Edited by Gaetano Milanesi. Florence, 1887.

Manetti early 1480s, De Robertis and Tanturli ed. 1976
Antonio di Tuccio Manetti. *Vita di Filippo Brunelleschi preceduta da La Novella del Grasso.* Edited by Domenico De Robertis. Introduction and critical notes by Giuliano Tanturli. Testi e documenti, 2. Milan, 1976.

Mannini 1990
Maria Pia Mannini, ed. *Il Museo Civico di Prato: le collezioni d'arte.* Florence, 1990.

Mannini 1995
Maria Pia Mannini, ed. *La "Natività" di Filippo Lippi: restauro, saggi, e ricerche.* Monografia 2 del Museo Civico. Prato, 1995.

Mantese 1964
Giovanni Mantese. *Memorie storiche della chiesa vicentina.* Vol. 3, pt. 2. Vicenza, 1964.

Marabottini Marabotti 1951–52
Alessandro Marabottini Marabotti. "Allegretto Nuzi." *Rivista d'arte* (Florence), vol. 27, 3rd ser., vol. 2 (1951–52; printed 1953), pp. 23–55.

Marceau 1940
Henri Marceau. "Conservation and Technical Research." *Philadelphia Museum Bulletin,* vol. 35, no. 184 (January 1940), n.p.

Marceau 1944
Henri Marceau. "The McIlhenny Collection: Paintings." *Philadelphia Museum Bulletin,* vol. 39, no. 200 (January 1944), pp. 54–59.

Marceau 1963
Henri Marceau. "The Aesthetic and Historical Aspects of the Presentation of Damaged Pictures: Discussion Session" (pp. 179–80). In *Problems of the 19th and 20th Centuries.* Studies in Western Art, Acts of the Twentieth International Congress of the History of Art, vol. 4. Princeton, 1963.

Marcelli 1998
Fabio Marcelli, ed. *Il Maestro di Campodonico: rapporti artistici fra Umbria e Marche nel trecento.* Fabriano, 1998.

Marchi 1906
Giulio Marchi. *La cappella del capitolo di San Bonaventura in Pisa: memorie storico-artistiche.* Florence, 1906.

Marchini 1942
Giuseppe Marchini. "Spigolature del tesoro pratese." *Archivio storico pratese* (Prato), vol. 20, nos. 3–4 (December 1942), pp. 95–108.

Marchini 1973
Giuseppe Marchini. *Le vetrate dell'Umbria.* Corpus vitrearum medii aevi. Italia. Vol. 1, *L'Umbria.* Rome, 1973.

Marchini 1975
Giuseppe Marchini. *Filippo Lippi.* Milan, 1975.

Marchini 1980
Giuseppe Marchini. "La cupola: medievale o no." In *Filippo Brunelleschi: la sua opera e il suo tempo* (pp. 91–120). 2 vols. Florence, 1980.

Marchini and Micheletti 1987
Giuseppe Marchini and Emma Micheletti. *La chiesa di Santa Trinita a Firenze.* Introduction by Maria Grazia Ciardi Dupré Dal Poggetto. Florence, 1987.

Marcucci 1965
Luisa Marcucci. *Gallerie Nazionali di Firenze: i dipinti toscani del secolo XIV.* Cataloghi dei musei e gallerie d'Italia. Rome, 1965.

Marczell von Nemes 1931
Sammlung Marczell von Nemes. Vol. 1, *Gemälde des XIV. bis XIX. Jahrhunderts.* Munich, 1931. Catalogue of a sale held at Munich, Tonhalle, June 16, 1931, and organized by Mensing & Sohn (Frederik Muller & Co.), Amsterdam; Paul Cassirer, Berlin; and Hugh Helbing, Munich.

Mariacher 1957
Giovanni Mariacher, ed. *Il Museo Correr di Venezia: dipinti dal XIV al XVI secolo.* Fondazione Giorgio Cini. Cataloghi di raccolte d'arte, 1. Venice, 1957.

Mariani Canova 1978
Giordana Mariani Canova, ed. *Miniature dell'Italia settentrionale nella Fondazione Giorgio Cini.* Preface by Rodolfo Pallucchini. Cataloghi di raccolte d'arte, n.s., 11. Venice, 1978.

Mariotti 1968
Andrea Mariotti. "Modulo di progettazione del politico di Arezzo di Pietro Lorenzetti." *Critica d'arte* (Florence), vol. 33, n.s., vol. 15, no. 100 (December 1968), pp. 35–45.

Markova 1992
Viktorija Emmanuilovna Markova. *Ital'janskaja živopis' XIII–XVIII vekov.* Gosudarstvennyj Muzej Izobrazitel'nych Iskusstv imeni A. S. Puškina. Moscow, 1992.

Marques 1987
Luiz C. Marques. *La peinture du duecento en Italie centrale.* Paris, 1987.

Martindale 1988
Andrew Martindale. *Simone Martini: Complete Edition.* Oxford, 1988.

Martinelli and Arata 1968
Giovanni Martinelli and Fidia Arata. *Museo di Villa Guinigi, Lucca: la villa e le collezioni.* Introduction by

Ubaldo Lumini. Texts by Giorgio Monaco, Licia Bertolini Campetti, and Silvia Meloni Trkulja. Lucca, 1968.

Martini 1883
Angelo Martini. *Manuale di metrologia, ossia misure, pesi e monete in uso attualmente e anticamente presso tutti i popoli.* Turin, 1883. Reprint, Rome, 1976.

Masini 1666, Fanti ed. 1986
Antonio Masini. *Bologna perlustrata.* Introduction and edited by Mario Fanti. 3 vols. in 2. Bologna, 1666. Reprint, Bologna, 1986.

Mather 1906
Frank J. Mather, Jr., and Roger E. Fry. "Recent Additions to the Collection of Mr. John G. Johnson, Philadelphia." *The Burlington Magazine* (London), vol. 9, no. 41 (August 1906), pp. 351–63.

Mather 1911
Frank J. Mather, Jr. Abstract of paper on "Italian Paintings in America." *American Journal of Archaeology* (Norwood, Mass.), vol. 15 (1911), pp. 61–62.

Mather 1913
Frank J. Mather, Jr. "A Starnina Attribution." *Art in America* (New York), vol. 1 (July 1913), pp. 178–81.

Mather 1923
Frank Jewett Mather, Jr. *A History of Italian Painting.* New York, 1923.

Mather 1944
Frank Jewett Mather, Jr. "The Problem of the Brancacci Chapel Historically Considered." *The Art Bulletin* (New York), vol. 26, no. 3 (September 1944), pp. 175–87.

Mazzalupi 2002
Matteo Mazzalupi. "Carlo da Camerino, il pittore inesistente." *L'appennino camerte* (Camerino), vol. 20 (May 18, 2002), p. 5.

Mazzei, late fourteenth–early fifteenth century, Guasti ed. 1880
Lapo Mazzei. *Lettere di un notaro a un mercante del secolo XIV con altre lettere e documenti.* Edited by Cesare Guasti. 2 vols. Florence, 1880.

Mazzoni 2001
Gianni Mazzoni. *Quadri antichi del novecento.* Vicenza, 2001.

McCall and Valentiner 1939
George Henry McCall, comp., and William Valentiner, ed. *Catalogue of European Paintings and Sculpture from 1300–1800.* New York, 1939. Exhibition, New York, World's Fair, "Masterpieces of Art," May–October 1939.

Medici 1886
Ulderigo Medici. *Catalogo della galleria dei principi Corsini in Firenze.* Florence, 1886.

Meiss 1931
Millard Meiss. "Ugolino Lorenzetti." *The Art Bulletin* (New York), vol. 13, no. 3 (September 1931), pp. 376–97.

Meiss 1936
Millard Meiss. "The Madonna of Humility." *The Art Bulletin* (New York), vol. 18, no. 4 (December 1936), pp. 435–64.

Meiss 1936a
Millard Meiss. "Bartolommeo Bulgarini altrimenti detto 'Ugolino Lorenzetti'?" *Rivista d'arte* (Florence), vol. 18, 2nd ser., vol. 8 (1936), pp. 113–36.

Meiss 1951
Millard Meiss. *Painting in Florence and Siena after the Black Death.* Princeton, 1951.

Meiss 1952
Millard Meiss. "London's New Masaccio." *Art News* (New York), vol. 51, no. 2 (April 1952), pp. 24, 50–51.

Meiss 1955
Millard Meiss. "Nuovi dipinti e vecchi problemi." *Rivista d'arte* (Florence), vol. 30, 3rd ser., vol. 5 (1955; printed 1956), pp. 107–45.

Meiss 1961
Millard Meiss. "An Early Lombard Altarpiece." *Arte antica e moderna* (Florence), vols. 13–16 (January–December 1961), pp. 125–33.

Meiss 1963
Millard Meiss. "Masaccio and the Early Renaissance: The Circular Plan." In *The Renaissance and Mannerism* (pp. 123–45). Studies in Western Art. Acts of the Twentieth International Congress of the History of Art, vol. 2. Princeton, 1963.

Meiss 1963a
Millard Meiss. "French and Italian Variations on an Early Fifteenth-Century Theme: St. Jerome and His Study." *Gazette des beaux-arts* (Paris), 105th year, 6th ser., vol. 62 (September 1963), pp. 147–70.

Meiss 1964
Millard Meiss. "The Altered Program of the Santa Maria Maggiore Altarpiece." In *Studien zur toskanischen Kunst: Festschrift für Ludwig Heinrich Heydenreich, zum 23. März 1963* (pp. 169–90). Munich, 1964.

Meiss 1964a
Millard Meiss. "The Yates Thompson Dante and Priamo della Quercia." *The Burlington Magazine* (London), vol. 106, no. 738 (September 1964), pp. 403–12.

Meiss 1967
Millard Meiss. *French Painting in the Time of Jean de Berry: The Late Fourteenth Century and the Patronage of the Duke.* 2 vols. National Gallery of Art, Kress Foundation, Studies in the History of European Art, 2. London, 1967.

Meiss 1967a
Millard Meiss. "A Lunette by the Master of the Castello Nativity." *Gazette des beaux-arts* (Paris), 109th yr., 6th ser., vol. 70, no. 1185 (October 1967), pp. 213–18.

Meiss 1971
Millard Meiss. "Alesso di Andrea." In *Giotto e il suo tempo* (pp. 401–18). Atti del congresso internazionale per la celebrazione del VII centenario della nascita di Giotto; Assisi, Padua, and Florence, September 24–October 1, 1967. Rome, 1971.

Meiss 1974
Millard Meiss with Sharon Off Dunlap Smith and Elizabeth Home Beatson. *French Painting in the Time of Jean de Berry: The Limbourgs and Their Contemporaries.* 2 vols. London, 1974.

Mellini 1969
Gian Lorenzo Mellini. "Miniature di Martino da Verona." *Arte illustrata* (Milan), vol. 2, nos. 17–19 (July–September 1969), pp. 63–75.

Mellini 1970
Gian Lorenzo Mellini. "Commento a 'Dalmasio.'" *Arte illustrata* (Milan), vol. 3, nos. 27–29 (March–May 1970), pp. 40–55.

Meoni 1993
Lucia Meoni. *San Felice in Piazza a Firenze.* Florence, 1993.

Mesnil 1927
Jacques Mesnil. *Masaccio et les débuts de la renaissance.* The Hague, 1927.

Messini n.d.
Angelo Messini. *Foligno, Bevagna, Montefalco, Spello, Trevi.* Revised and updated by Giovanni Cecchini. Guide Moneta. Milan, n.d. [1960s].

Micheletti 1959
Emma Micheletti. *Masolino da Panicale.* Milan, 1959.

Middeldorf 1955
Ulrich Middeldorf. "L'Angelico e la scultura." *Rinascimento* (Florence), vol. 6, no. 2 (December 1955), pp. 179–94.

Middeldorf 1962
Ulrich Middeldorf. "Un rame inciso del quattrocento." In *Scritti di storia dell'arte in onore di Mario Salmi,* vol. 2 (pp. 273–89). Edited by Alessandro Marabottini Marabotti. Rome, 1962.

Middeldorf 1978
Ulrich Middeldorf. "Some Florentine Painted Madonna Reliefs." In *Collaboration in Italian Renaissance Art* (pp. 77–90). Edited by Wendy Stedman Sheard and John T. Paoletti. New Haven, 1978.

Milan 1988
Milan, Palazzo Reale. *Arte in Lombardia tra gotico e rinascimento.* 1988.

Milan 1997
Milan, Musei e Gallerie di Milano. *Museo d'Arte Antica del Castello Sforzesco: Pinacoteca.* Vol. 1. Milan, 1997.

Milan 2001
Milan, Museo Poldi Pezzoli. *Omaggio a beato Angelico: un dipinto per il Museo Poldi Pezzoli.* Exhibition, September 20–December 2001. Catalogue edited by Andrea di Lorenzo. Cinisello Balsamo (Milan), 2001.

Milan 2003
Milan, Pinacoteca di Brera. *Brera mai vista: il colore di Benozzo Gozzoli, due predelle della Pinacoteca di Brera.* Exhibition, June–November 2003. Catalogue edited by Matteo Ceriana, Valentina Maderna, and Cristina Quattrini. Milan, 2003.

Milanesi 1854–56
Gaetano Milanesi. *Documenti per la storia dell'arte senese.* 3 vols. Siena, 1854–56.

Milanesi 1860
Gaetano Milanesi. "Le vite di alcuni artefici fiorentini scritte da Giorgio Vasari corrette ed accresciute coll'aiuto de' documenti." *Giornale storico degli archivi toscani* (Florence), vol. 4, no. 3 (July–September 1860), pp. 177–210.

Milanesi 1873
Gaetano Milanesi. *Sulla storia dell'arte toscana: scritti varj.* New ed. Siena, 1873.

Milanesi 1883
Gaetano Milanesi. *Catalogue des tableaux, meubles, et objets d'art forment la galerie de M. le Chevalier Toscanelli.* Florence, 1883.

Millon and Magnago Lampugnani 1994
Henry A. Millon and Vittorio Magnago Lampugnani. *The Renaissance from Brunelleschi to Michelangelo. The*

Representation of Architecture. Milan, 1994. Exhibition, Venice, Palazzo Grassi, March 27–November 6, 1994.

Mills and White 1987
John Mills and Raymond White. *The Organic Chemistry of Museum Objects*. London, 1987.

Miner 1960
Dorothy Miner. "A New Renaissance Manuscript." *The Bulletin of the Walters Art Gallery* (Baltimore), vol. 12, no. 6 (March 1960), pp. 1–4.

Miner 1968–69
Dorothy Miner. "Since De Ricci—Western Illuminated Manuscripts Acquired since 1934. A Report in Two Parts: Part II." *The Journal of the Walters Art Gallery* (Baltimore), vols. 31–32 (1968–69; published 1971), pp. 41–118.

Minneapolis 1935
"Florentine and Umbrian Paintings in the Van Derlip Bequest." *Bulletin of the Minneapolis Institute of Arts*, vol. 24, no. 2 (December 7, 1935), pp. 158–63.

Misciatelli 1928
Piero Misciatelli. "Arte antica senese: tavole e statue inedite." *La Diana* (Siena), vol. 3, no. 3 (1928), pp. 110–15.

Misciattelli 1929
Piero Misciatelli. "Cassoni senesi." *La Diana* (Siena), vol. 4, no. 2 (1929), pp. 117–26.

Moench 1993
Esther Moench. *Les primitifs italiens du Musée des Beaux-Arts de Strasbourg*. Strasbourg, 1993.

Molajoli 1960
Bruno Molajoli. *Notizie su Capodimonte: catalogo del Museo e Gallerie Nazionali*. Naples, 1960.

Molajoli 1964
Bruno Molajoli. *Notizie su Capodimonte: catalogo delle Gallerie e del Museo*. Naples, 1964.

Molajoli 1968
Bruno Molajoli. *Guida artistica di Fabriano*. Genoa, 1968.

Molten 1992
Carol Monfort Molten. "The Sienese Painter Martino di Bartolomeo." Ph.D. diss., Indiana University, Bloomington, 1992.

Mongellaz 1985
Jacqueline Mongellaz. "Reconsidération de la distribution des rôles à l'intérieur du groupe des mâitres de la sacristie de la cathédrale de Sienne." *Paragone-arte* (Florence), vol. 36, no. 427 (September 1985), pp. 73–89.

Montefalco 2002
See Toscano and Capitelli 2002

Monti 1927
Gennaro Maria Monti. *Le confraternite medievali dell'alta e media Italia*. 2 vols. Storici antichi e moderni. Venice, 1927.

Moran 1975
Gordan Moran. "Christ as Savior by Taddeo di Bartolo." *Yale University Art Gallery Bulletin* (New Haven), vol. 35, no. 3 (Fall 1975), pp. 4–7.

Moran 1977
Gordan Moran. "Un affresco di Paolo Schiavo al Monte San Michele." *Il Gallo Nero* (Florence), no. 6 (November–December 1977), pp. 7–9.

Moran 1978
Gordan Moran. "Un'ipotesi circa l'identificazione del Maestro di Panzano." *Il Gallo Nero* (Florence), vol. 1 (January–February 1978), pp. 10–13.

Morçay 1913
Raoul Morçay. "La cronaca del convento fiorentino di San Marco. La parte più antica, dettata da Giuliano Lapaccini." *Archivio storico italiano* (Florence), vol. 71, vol. 1, pt. 1 (1913), pp. 1–29.

Morçay 1914
Raoul Morçay. *Saint Antonin, fondateur du convent de Saint-Marc, archevêque de Florence, 1389–1459*. Tours, 1914.

Morello and Kanter 1999
Giovanni Morello and Laurence B. Kanter, eds. *The Treasury of Saint Francis of Assisi*. Milan, 1999. Exhibition, New York, The Metropolitan Museum of Art, March 16–June 27, 1999.

Moreni
Domenico Moreni. *Notizie istoriche dei contorni di Firenze dalla Porta al Prato fino alla Real Villa di Castello*. 6 vols. Florence, 1791–95.

Moriondo 1952
Margherita Moriondo. "Battista da Pisa." *Bollettino d'arte* (Rome), 4th ser., vol. 37, no. 1 (January–March 1952), p. 57.

Morris 1930
Harrison S. Morris. *Confessions in Art*. New York, 1930.

Moschini Marconi 1955
Sandra Moschini Marconi. *Gallerie dell'Accademia di Venezia: opere d'arte dei secoli XIV e XV*. Rome, 1955.

Moscow 1995
Moscow, State Pushkin Museum of Fine Arts. *Catalogue of Painting* (in English and Russian). Moscow, 1995.

Mount Holyoke 1984
See Harris 1984

Munich 1930
Munich, Neue Pinakothek. *Sammlung Schloss Rohoncz: Gemälde*. Exhibition, 1930. Catalogue by Rudolf Heinemann-Fleischmann.

Munich 1966
Munich, Julius Böhler. *Gemälde Alter Meister, Plastiken, Kunstgewerbe*. Exhibition, June–September 1966.

Müntz 1889
Eugène Müntz. *Histoire de l'art pendant la renaissance*. Vol. 1, *Italie: Les Primitifs*. Paris, 1889.

Münz 1948
Ludwig Münz. *Katalog des wiederöffneten Teilen der Gemäldegalerie*. Vienna, 1948.

Muraro 1970
Michelangelo Muraro. *Paolo da Venezia*. University Park, Pa., 1970.

Murphy 1985
Alexandra R. Murphy. *European Paintings in the Museum of Fine Arts, Boston: An Illustrated Summary Catalogue*. Boston, 1985.

Musatti 1950
Riccardo Musatti. "Catalogo giovanile di Cosimo Rosselli." *Rivista d'arte* (Florence), vol. 26, 3rd ser., vol. 1 (1950), pp. 103–30.

Naples 1950
Naples, Palazzo Reale. *IV mostra di restauri*. Exhibition, 1950. Catalogue by Bruno Molajoli and Raffaello Causa. Naples, 1950.

Naples 1995
Naples, Museo e Gallerie Nazionali di Capodimonte. *La collezione Farnese: i dipinti lombardi, liguri, veneti, toscani, umbri, romani, fiamminghi, altre scuole, fasti farnesiani*. Naples, 1995.

Nash 1968
Ernest Nash with the collaboration of the Deutsches Archaeologisches Institut. *Pictorial Dictionary of Ancient Rome*. Rev. ed. 2 vols. London, 1968.

Neilson 1938
Katharine B. Neilson. *Filippino Lippi: A Critical Study*. Harvard-Radcliffe Fine Arts Series. Cambridge, 1938.

Neri di Bicci 1453–75, Santi ed. 1976
Neri di Bicci. *Le ricordanze (10 Marzo 1453–24 Aprile 1475)*. Edited by Bruno Santi. Pisa, 1976.

Neri Lusanna 1981
Enrica Neri Lusanna. "Un episodio di collaborazione tra scultori e pittori nella Siena del primo quattrocento: La 'Madonna del Magnificent' di Sant'Agostino." *Mitteilungen des Kunsthistorischen Institutes in Florenz* (Florence), vol. 25, no. 3 (1981), pp. 325–40.

Neri Lusanna 1990
Enrica Neri Lusanna. "Ventura di Moro: un riesame della cerchia del Pesello." *Paragone-arte* (Florence), vol. 41, n.s., no. 22/485 (July 1990), pp. 3–20.

New York 1917
See Sirén and Brockwell 1917

New York 1936
See Barr 1936

New York 1939
See McCall and Valentiner 1939

New York 1983
New York, The Metropolitan Museum of Art. *The Vatican Collections: The Papacy and Art*. Exhibition, February 26–June 12, 1983. Also shown at The Art Institute of Chicago, July 21–October 16, 1983, and The Fine Arts Museums of San Francisco, November 19, 1983–February 19, 1984.

New York 1984
New York, Piero Corsini, Inc. *Italian Old Master Paintings: Fourteenth to Eighteenth Century*. Exhibition, November 17–December 8, 1984.

New York 1984a
New York, The Metropolitan Museum of Art. *Notable Acquisitions, 1983–1984*. Selected by Philippe de Montebello, Director. New York, 1984.

New York 1988
See Christiansen, Kanter, and Strehlke 1988

New York 1990
New York, Piero Corsini, Inc. *Important Old Master Paintings: Within the Image*. Fall 1990.

New York 1994
See Kanter et al. 1994

Niccolai 1914
Francesco Niccolai. *Mugello e Val di Sieve: guida topografica, storico-artistica*. Borgo San Lorenzo, 1914. Reprint, Rome, 1974.

Nicolson 1954
Benedict Nicolson. "The Master of 1419." *The Burlington Magazine* (London), vol. 96, no. 615 (June 1954), p. 181.

Nordenfalk 1961
Carl Nordenfalk. "Saint Bridget of Sweden as Represented in Illuminated Manuscripts." In *De Artibus Opuscula XL: Essays in Honor of Erwin Panofsky* (vol. 1, pp. 371–93). Edited by Millard Meiss. New York, 1961.

Nussbaum 1965
Otto Nussbaum. *Die Standort des Liturgen am christlichen Altar vor dem Jahre 1000: Eine archäologische und liturgiegeschichtliche Untersuchung.* Theophaneia, 18. Bonn, 1965.

Occhioni 1984
Il processo per la canonizzazione di S. Nicola da Tolentino. Critical edition edited by Nicola Occhioni. Preface by André Vauchez. Introduction by Domenico Gentili. Collection de l'École Française de Rome, 74. Rome, 1984.

Oertel 1933
Robert Oertel. "Die Frühwerke des Masaccio." *Marburger Jahrbuch für Kunstwissenschaft* (Marburg), vol. 16 (1933), pp. 191–289.

Oertel 1961
Robert Oertel. *Frühe italienische Malerei in Altenburg: Beschreibender Katalog der Gemälde des 13.–16. Jahrhunderts im Staatlichen Lindenau-Museum.* Museumsschriften, 2. Berlin, 1961.

Oertel 1964
Robert Oertel. "Der Laurentius-Altar aus dem Florentiner Dom: Zu einem Werk des Maestro del Bambino Vispo." In *Studien zur Toskanischen Kunst: Festschrift für Ludwig Heinrich Heydenreich, zum 23. März 1963* (pp. 205–20). Munich, 1964.

Offner 1919
Richard Offner. "Italian Pictures at the New York Historical Society and Elsewhere: I and II." *Art in America* (New York), vol. 7, no. 4 (June 1919), pp. 148–61; vol. 7, no. 5 (August 1919), pp. 189–98.

Offner 1921
Richard Offner. "Niccolò di Pietro Gerini." *Art in America* (New York), vol. 9, no. 4 (June 1921), pp. 148–55; vol. 9, no. 6 (October 1921), pp. 233–40.

Offner 1924
Richard Offner. "Niccolò di Tommaso." *Art in America* (New York), vol. 13, no. 1 (December 1924), pp. 21–37.

Offner 1927
Richard Offner. *Studies in Florentine Painting: The Fourteenth Century.* New York, 1927.

Offner 1927a
Richard Offner. *Italian Primitives at Yale University: Comments and Revisions.* Publications of the Associates in Fine Arts at Yale. New Haven, 1927.

Offner 1930
Richard Offner. *A Critical and Historical Corpus of Florentine Painting.* Sec. 3, vol. 3, *The Fourteenth Century.* New York, 1930.

Offner 1931
Richard Offner. *A Critical and Historical Corpus of Florentine Painting.* Sec. 3, vol. 1, *The Fourteenth Century.* New York, 1931.

Offner 1932
Richard Offner. "The Works and Style of Francesco di Vannuccio." *Art in America* (Westport, Conn.), vol. 20, no. 3 (April 1932), pp. 89–114.

Offner 1933
Richard Offner. "The Mostra del Tesoro di Firenze Sacra." *The Burlington Magazine* (London), vol. 63, no. 365 (August 1933), pp. 72–84; vol. 63, no. 367 (October 1933), pp. 166–78.

Offner 1934
Richard Offner. *A Critical and Historical Corpus of Florentine Painting.* Sec. 3, vol. 4, *The Fourteenth Century.* New York, 1934.

Offner 1947
Richard Offner. *A Critical and Historical Corpus of Florentine Painting.* Sec. 3, vol. 5, *The Fourteenth Century.* New York, 1947.

Offner 1947a
Richard Offner. "A Florentine Panel in Providence and a Famous Altarpiece." *Studies: Museum of Art* (Providence), 1947, pp. 41–61.

Offner 1956
Richard Offner. "A Ray of Light on Giovanni del Biondo and Niccolò di Tommaso." *Mitteilungen des Kunsthistorischen Institutes in Florenz* (Florence), vol. 7, nos. 3–4 (July 1956), pp. 173–92.

Offner 1958
Richard Offner. *A Critical and Historical Corpus of Florentine Painting.* Sec. 3, vol. 8, *The Fourteenth Century.* New York, 1958.

Offner 1960
Richard Offner. *A Critical and Historical Corpus of Florentine Painting.* Sec. 4, vol. 2, *The Fourteenth Century: Nardo di Cione.* New York, 1960.

Offner 1962
Richard Offner. *A Critical and Historical Corpus of Florentine Painting.* Sec. 4, vol. 1, *The Fourteenth Century: Andrea di Cione.* New York, 1962.

Offner 1981
Richard Offner. *A Critical and Historical Corpus of Florentine Painting.* Edited by Hayden B. J. Maginnis. *The Fourteenth Century: A Legacy of Attributions.* Suppl. New York, 1981.

Offner / Boskovits 1987
Richard Offner with Klara Steinweg, continued under the direction of Miklós Boskovits and Mina Gregori. *A Critical and Historical Corpus of Florentine Painting.* Sec. 3, vol. 2, *The Fourteenth Century,* by Richard Offner. New edition by Miklós Boskovits. Florence, 1987.

Offner / Boskovits 1989
Richard Offner with Klara Steinweg, continued under the direction of Miklós Boskovits and Mina Gregori. *A Critical and Historical Corpus of Florentine Painting.* Sec. 3, vol. 3, *The Fourteenth Century: The Works of Bernardo Daddi,* by Richard Offner. New edition by Miklós Boskovits with Enrica Neri Lusanna. Florence, 1989.

Offner and Steinweg 1965
Richard Offner and Klara Steinweg. *A Critical and Historical Corpus of Florentine Painting.* Sec. 4, vol. 3, *The Fourteenth Century: Jacopo di Cione.* New York, 1965.

Offner and Steinweg 1967
Richard Offner and Klara Steinweg. *A Critical and Historical Corpus of Florentine Painting.* Sec. 4, vol. 4, pt. 1, *The Fourteenth Century: Giovanni del Biondo.* New York, 1967.

Offner and Steinweg 1969
Richard Offner and Klara Steinweg. *A Critical and Historical Corpus of Florentine Painting.* Sec. 4, vol. 5, pt. 2, *The Fourteenth Century: Giovanni del Biondo.* New York, 1969.

Offner and Steinweg 1979
Richard Offner and Klara Steinweg. *A Critical and Historical Corpus of Florentine Painting.* Sec. 4, vol. 6, *The Fourteenth Century: Andrea Bonaiuti.* New York, 1979.

O'Foghludha 1998
Ria Mairead O'Foghludha. "*Roma nova:* The Santa Maria Maggiore Altarpiece and the Rome of Martin V." Ph.D. diss., Columbia University, 1998.

Olson 1999
Roberta J. M. Olson. "Pietro Lorenzetti's Dazzling Meteor Showers." *Apollo* (London), vol. 149, no. 447 (May 1999), pp. 3–10.

Orlandi 1954
Stefano Orlandi. "Il beato Angelico." *Rivista d'arte* (Florence), vol. 29, 3rd ser., vol. 4 (1954; printed 1955), pp. 161–97.

Orlandi 1964
Stefano Orlandi. *Beato Angelico: monografia storica della vita e delle opere con un'appendice di nuovi documenti inediti.* Florence, 1964.

Osservanza 1984
L'Osservanza di Siena: la basilica e i suoi codici miniati. Text by Cecilia Alessi et al. Siena, 1984.

Paatz
Walter Paatz and Elisabeth Paatz. *Die Kirchen von Florenz: Ein kunstgeschichtliches Handbuch.* 6 vols. Frankfurt am Main, 1940–54.

Pacetti 1935a
Dionisio Pacetti. "Breve vita inedita di S. Bernardino da Siena scritta da Giannozzo Manetti." *Bullettino di studi bernardiniani* (Siena), vol. 1, nos. 3–4 (1935), pp. 183–90.

Pacetti 1940–41
Dionisio Pacetti. "La predicazione di S. Bernardino in Toscana con documenti inediti estratti dagli atti del processo di canonizzazione." *Archivum franciscanum historicum* (Florence), vol. 33, nos. 3–4 (July–October 1940), pp. 268–318; vol. 34, nos. 3–4 (July–October 1941), pp. 261–83.

Pacetti 1943
Dionisio Pacetti. "Cronologia bernardiniana." *Studi francescani* (Florence), vol. 40, 3rd ser., vol. 15, nos. 3–4 (July–December 1943), pp. 160–77.

Padoa [Rizzo] 1969
Anna Padoa [Rizzo]. "Benozzo ante 1450." *Commentari* (Rome), n.s., vol. 20, nos. 1–2 (January–June 1969), pp. 52–62.

Padoa Rizzo 1972
Anna Padoa Rizzo. *Benozzo Gozzoli: pittore fiorentino.* Monografie e studi. Florence, 1972.

Padoa Rizzo 1973
Anna Padoa Rizzo. "Il percorso di Pier Francesco

Fiorentino." *Commentari* (Rome), n.s., vol. 24, no. 3 (July–September 1973), pp. 154–75.

Padoa Rizzo 1975
Anna Padoa Rizzo. "Aggiunte a Paolo Schiavo." *Antichità viva* (Florence), vol. 14, no. 6 (November–December 1975), pp. 3–8.

Padoa Rizzo 1977
Anna Padoa Rizzo. "La cappella Salutati nel duomo di Fiesole e l'attività giovanile di Cosimo Rosselli." *Antichità viva* (Florence), vol. 16, no. 3 (May–June 1977), pp. 3–12.

Padoa Rizzo 1980
Anna Padoa Rizzo. "Note su un 'San Girolamo penitente' di Benozzo." *Antichità viva* (Florence), vol. 19, no. 3 (May–June 1980; printed January 1981), pp. 14–19.

Padoa Rizzo 1981
Anna Padoa Rizzo. "Nota breve su Colantonio, Van der Weyden, e l'Angelico." *Antichità viva* (Florence), vol. 20, no. 5 (September–October 1981; printed June 1982), pp. 15–17.

Padoa Rizzo 1981a
Anna Padoa Rizzo. "Ancora sul 'Maestro dei Santi Quirico e Giulitta.'" *Antichità viva* (Florence), vol. 20, no. 2 (March–April 1981; printed December 1981), pp. 5–7.

Padoa Rizzo 1982
Anna Padoa Rizzo. "Sul polittico della cappella Ardinghelli in Santa Trinita, di Giovanni Toscani." *Antichità viva* (Florence), vol. 21, no. 1 (January–February 1982; printed December 1982), pp. 5–10.

Padoa Rizzo 1983
Anna Padoa Rizzo. "Paolo Schiavo all'Antella." *Antichità viva* (Florence), vol. 22, nos. 5–6 (September–December 1983; printed May 1984), pp. 3–6.

Padoa Rizzo 1986
Anna Padoa Rizzo. "Pittori e miniatori a Firenze nel quattrocento." *Antichità viva* (Florence), vol. 25, nos. 5–6 (September–December 1986; printed March 1987), pp. 5–15.

Padoa Rizzo 1990
Anna Padoa Rizzo. "Stefano d'Antonio di Vanni a Cigoli." *Bollettino dell'Accademia degli Euteleti della città di San Miniato* (San Miniato al Tedesco), no. 57 (December 1990), pp. 75–83.

Padoa Rizzo 1991
Anna Padoa Rizzo. "L'ultima bottega di Cosimo Rosselli." *Bollettino dell'Accademia degli Euteleti della città di San Miniato* (San Miniato al Tedesco), no. 58 (December 1991), pp. 31–39.

Padoa Rizzo 1992
Anna Padoa Rizzo. *Benozzo Gozzoli: catalogo completo dei dipinti*. I gigli dell'arte, 27. Archivi di arte antica e moderna. Florence, 1992.

Padoa Rizzo 1994
Anna Padoa Rizzo. *La cappella dell'Assunta nel duomo di Prato*. Prato, 1994.

Padoa Rizzo 1997
Anna Padoa Rizzo, ed. *La cappella dell'Assunta nel duomo di Prato*. Prato, 1997.

Padoa Rizzo and Casini Wanrooij 1985
Anna Padoa Rizzo and Marzia Casini Wanrooij. "Appunti sulla pittura fiorentina del quattrocento: Benozzo Gozzoli, Domenico di Michelino." *Antichità*

viva (Florence), vol. 24, nos. 5–6 (September–December 1985; printed June 1986), pp. 5–17.

Padoa Rizzo and Frosinini 1984
Anna Padoa Rizzo and Cecilia Frosinini. "Stefano d'Antonio di Vanni (1405–1483): opere e documenti." *Antichità viva* (Florence), vol. 23, nos. 4–5 (July–October 1984; printed April 1985), pp. 5–33.

Padovani 1976
Serena Padovani. "Nuove personalità della pittura emiliana nel primo quattrocento." *Paragone-arte* (Florence), vol. 27, nos. 317–19 (July–September 1976), pp. 40–59.

Padovani 1979
Serena Padovani. "Una tavola di Castiglione d'Orcia restaurata di recente." *Prospettiva* (Siena-Florence), no. 17 (April 1979), pp. 82–88.

Padovani and Santi 1981
Serena Padovani and Bruno Santi. *Buonconvento: Museo d'Arte Sacra della Val d'Arbia*. Guide turistiche e d'arte, 5. Genoa, 1981.

Paliaga and Renzoni 1991
Franco Paliaga and Stefano Renzoni. *Le chiese di Pisa: guida alla conoscenza del patrimonio artistico*. Pisa, 1991.

Pallucchini 1964
Rodolfo Pallucchini. *La pittura veneziana del trecento*. Storia della pittura veneziana. Venice, 1964.

Palm Beach 1949
Palm Beach, Florida, Society of the Four Arts. *Early European Paintings*. Exhibition, January 7–30, 1949.

Palumbo 1963
Giuseppe Palumbo. "Importanti lavori di restauro negli affreschi del Lorenzetti." *San Francesco: patrono d'Italia* (Assisi), vol. 43 (September 1963), pp. 164–71.

Panders 1997
Janneke Panders. *The Underdrawing of Giovanni di Paolo: Characteristics and Development*. Berlin, 1997.

Pandimiglio 1987
Leonida Pandimiglio. *Felice di Michele, vir clarissimus e una consorteria: i Brancacci di Firenze*. Quaderni di restauro, 3. Milan, 1987.

Pani Ermini 1974
Letizia Pani Ermini. "Note sulla decorazione dei cibori a Roma nell'alto medioevo." *Bollettino d'arte* (Rome), 5th ser., vol. 59, nos. 3–4 (July–December 1974), pp. 115–26.

Panofsky 1927
Erwin Panofsky. "'Imago Pietas': Ein Beitrag zur Typengeschichte des 'Schmerzensmanns' und der 'Maria Mediatrix.'" In *Festschrift für Max J. Friedländer zum 60. Geburtstage* (pp. 261–308). Leipzig, 1927.

Panofsky 1953
Erwin Panofsky. *Early Netherlandish Painting: Its Origins and Character*. 2 vols. The Charles Eliot Norton Lectures, 1947–48. Cambridge, Mass., 1953.

Paoli 1985
Marco Paoli. "Documento per Priamo della Quercia." *Critica d'arte* (Florence), 4th ser., vol. 50, no. 6 (July–September 1985), pp. 98–101.

Paolucci 1985
Antonio Paolucci. *Il Museo della collegiata di S. Andrea in Empoli*. Florence, 1985.

Paolucci 1989
Antonio Paolucci, ed. *La Pinacoteca di Volterra*. Florence, 1989.

Paolucci 1992
Antonio Paolucci. *Antoniazzo Romano: catalogo completo dei dipinti*. I gigli dell'arte, Archivi di arte antica e moderna, 26. Florence, 1992.

Paris 1935
Paris, Petit Palais. *Exposition de l'art italien de Cimabue à Tiepolo*. Exhibition, May–July 1935. Catalogue edited by Raymond Escholier.

Paris 1956
Paris, Orangerie des Tuileries. *Le Cabinet de l'amateur organisé par La Société des Amis du Louvre en souvenir de Monsieur A.-S. Henraux, son président, 1932–1953*. Exhibition, February–April 1956.

Paris 1956a
Paris, Orangerie des Tuileries. *De Giotto à Bellini: Les primitifs italiens dans les musées de France*. Exhibition, May–July 1956. Catalogue by Michel Laclotte. 2nd ed., rev. and corrected.

Paris 1957
Paris, Musée de l'Orangerie. *Exposition de la collection Lehman de New York*. Exhibition, 1957. Catalogue (2nd ed., rev. and corrected) edited by Charles Sterling with Olga Raggio and Michel Laclotte, and with the collaboration of Sylvie Béguin.

Paris 1978
See Ressort, Béguin, and Laclotte 1978

Paris 1993
Paris, Grand Palais. *Le Siècle de Titien: L'âge d'or de la peinture à Venise*. Exhibition, March 9–June 14, 1993.

Parronchi 1957
Alessandro Parronchi. "Le fonti di Paolo Uccello: i 'prospettivi passati'—I." *Paragone-arte* (Florence), vol. 8, no. 89 (May 1957), pp. 3–32.

Parronchi 1958
Alessandro Parronchi. "Le due tavole prospettiche del Brunelleschi, I." *Paragone-arte* (Florence), vol. 9, no. 107 (November 1958), pp. 3–32.

Parronchi 1959
Alessandro Parronchi. "Le due tavole prospettiche del Brunelleschi, II." *Paragone-arte* (Florence), vol. 9, no. 109 (January 1959), pp. 3–31.

Parronchi 1963
Alessandro Parronchi. "Il più vero ritratto di Dante." *Bollettino del Museo Civico di Padova* (Padua), vol. 52, nos. 1–2 (1963), pp. 7–13.

Parronchi 1964
Alessandro Parronchi. *Studi su la dolce prospettiva*. Milan, 1964.

Parronchi 1965
Alessandro Parronchi. "Due note para-uccellesche." *Arte antica e moderna* (Bologna), vol. 8, no. 30 (1965), pp. 169–80.

Parronchi 1966
Alessandro Parronchi. *Masaccio*. I diamanti dell'arte. Biblioteca di pittura, scultura e architettura. Florence, 1966.

Parronchi 1974
Alessandro Parronchi, ed. *Paolo Uccello*. Il numero e l'immagine, collezione di studi sull'arte classica, 1. Bologna, 1974.

Parronchi 1981
Alessandro Parronchi. "Paolo Uccello 'segnalato' 'per la prospettiva e animali.'" *Michelangelo* (Florence), vol. 10, no. 34 (January–March 1981), pp. 25–36.

Pasquinucci and Deimling 2000
Simona Pasquinucci and Barbara Deimling. *Tradition and Innovation in Florentine Trecento Painting: Giovanni Bonsi—Tommaso del Mazza.* Edited by Miklós Boskovits. Sec. 4, vol. 8 of *A Critical and Historical Corpus of Florentine Painting,* by Richard Offner with Klara Steinweg, continued under the direction of Miklós Boskovits and Mina Gregori. Florence, 2000.

Passerini 1853
Luigi Passerini. *Storia degli stablimenti di beneficenza e d'istruzione elementare gratuita della città di Firenze.* Florence, 1853.

Passerini 1861
Luigi Passerini. *Genealogia e storia della famiglia Ricasoli.* Florence, 1861.

Patrizi 1928
Irnerio Patrizi. *Le grandi orme dell'arte del quattrocento in Recanati.* Preface by M. L. Patrizi. Recanati, 1928.

Pavone and Pacelli 1981
Mario Alberto Pavone and Vincenzo Pacelli, eds. *Enciclopedia bernardiniana.* Vol. 2, *Iconografia.* L'Aquila, 1981.

Pazzelli and Sensi 1984
Raffaele Pazzelli and Mario Sensi, eds. *La beata Angelina da Montegiove e il movimento del terz'ordine regolare francescano femminile.* Atti del convegno di studi francescani, Foligno, September 22–24, 1983. Analecta Tertii Ordinis Regularis Sancti Francisci. Rome, 1984.

Pecci 1752
Giovanni Anton Pecci. *Relazione delle cose più notabili della città di Siena sì antiche, come moderne.* Siena, 1752.

Pellegrin 1988
Élisabeth Pellegrin. *Bibliothèques retrouvées: Manuscrits, bibliothèques, et bibliophiles du moyen âge et de la renaissance. Recueil d'études publiées de 1938 à 1985.* Paris, 1988.

Pepper 1984
D. Stephen Pepper. *Bob Jones University Collection of Religious Art: Italian Paintings.* Greenville, S.C., 1984.

Perkins 1904
Francis Mason Perkins. "The Sienese Exhibition of Ancient Art." *The Burlington Magazine* (London), vol. 5, no. 18 (September 1904), pp. 581–84.

Perkins 1904a
Francis Mason Perkins. "La pittura alla Mostra d'Arte Antica in Siena." *Rassegna d'arte* (Milan), vol. 4, no. 10 (October 1904), pp. 145–53.

Perkins 1905
Francis Mason Perkins. "Pitture italiane nella raccolta Johnson a Filadelfia (S.U.A.)." *Rassegna d'arte* (Milan), vol. 5, no. 8 (August 1905), pp. 113–21.

Perkins 1908
Francis Mason Perkins. "Ancora dei dipinti sconosciuti della scuola senese—parte II." *Rassegna d'arte senese* (Siena), vol. 4, no. 1 (1908), pp. 3–9.

Perkins 1910
Francis Mason Perkins. "Spigolature di arte senese." *Rassegna d'arte senese* (Siena), vol. 6, no. 4 (1910), pp. 71–73.

Perkins 1913
Francis Mason Perkins. "Alcuni dipinti senesi sconosciuti o inediti." *Rassegna d'arte* (Milan), vol. 13, no. 8 (August 1913), pp. 121–26; vol. 13, no. 12 (December 1913), pp. 195–99.

Perkins 1914
Francis Mason Perkins. "Una tavola smarrita di Giotto." *Rassegna d'arte* (Milan), vol. 14, no. 9 (September 1914), pp. 193–200.

Perkins 1918
Francis Mason Perkins. "Alcune opere d'arte ignorate." *Rassegna d'arte* (Milan), vol. 18, nos. 7–8 (July–August 1918), pp. 105–15.

Perkins 1920
Francis Mason Perkins. "Some Sienese Paintings in American Collections." *Art in America* (New York), vol. 8, no. 5 (August 1920), pp. 195–210; vol. 8, no. 6 (October 1920), pp. 272–92; vol. 9, no. 1 (December 1920), pp. 6–21.

Perkins 1921
Francis Mason Perkins. "Some Recent Acquisitions of the Fogg Museum." *Art in America* (New York), vol. 10, no. 1 (December 1921), pp. 43–45.

Perrig 1986
Alexander Perrig. "Massacios 'Trinità' und der Sinn der Zentral-perspektive." *Marburger Jahrbuch für Kunstwissenschaft* (Marburg), vol. 21 (1986), pp. 11–43.

Péter 1927
András Péter. "Un Lorenzettiano: 'Il Maestro della Madonna d'Ovile.'" *La balzana* (Siena), vol. 20, n.s., vol. 1, no. 2 (March–April 1927), p. 93.

Péter 1931
András Péter. *Pietro es Ambrogio Lorenzetti egy elpusztult freskóciklusa.* Budapest, 1931.

Péter 1931a
András Péter. "'Ugolino Lorenzetti' e il Maestro di Ovile." *Rivista d'arte* (Florence), vol. 13, 2nd ser., vol. 3 (1931), pp. 1–44.

Péter 1933
András Péter. "Contributi alla conoscenza di Pietro Lorenzetti e della sua scuola." *La Diana* (Siena), vol. 8, nos. 3–4 (1933), pp. 164–90.

Petri 1962
Aldo Petri. "Un pittore pratese del trecento: Arrigo di Niccolò." *Prato: storia e arte* (Prato), vol. 3, no. 6 (December 1962), pp. 47–50.

Petrioli Tofani 1992
Annamaria Petrioli Tofani, ed. *Il disegno fiorentino del tempo di Lorenzo il Magnifico.* Cinisello Balsamo (Milan), 1992. Exhibition, Florence, Galleria degli Uffizi, Gabinetto Disegni e Stampe, April 8–July 5, 1992.

Pfeiffenberger 1966
Selma Pfeiffenberger. "The Iconology of Giotto's Virtues and Vices at Padua." Ph.D. diss., Bryn Mawr College, 1966.

Philadelphia 1876
United States Centennial Commission. *International Exhibition, 1876: Official Catalogue. Art Gallery and Annexes. Department IV. Art.* 14th rev. ed. Philadelphia, 1876.

Philadelphia 1876a
Esposizione universale di Filadelfia 1876. Catalogo degli espositori italiani. Florence, 1876.

Philadelphia 1920a
Philadelphia, Pennsylvania Museum, Memorial Hall. *Temporary Exhibition of a Selection of Italian Paintings of the XIV and XVI Centuries from the John G. Johnson Collection.* March 10–June 6, 1920.

Philadelphia 1926
Philadelphia, Pennsylvania Museum. "John D. McIlhenny Memorial Exhibition [March 2–April 10, 1926]." *The Pennsylvania Museum Bulletin* (Philadelphia), vol. 21, no. 100 (February 1926), pp. 85–112.

Philadelphia 1950
Philadelphia Museum of Art. *Diamond Jubilee Exhibition: Masterpieces of Painting.* November 4, 1950–February 11, 1951. Philadelphia, 1950.

Philadelphia 1953
Philadelphia Museum of Art. "Annual Report, 1952–1953." *Philadelphia Museum Bulletin,* vol. 48, no. 238 (Summer 1953), pp. 50–82.

Philadelphia 1965
Philadelphia Museum of Art. *Check List of Paintings in the Philadelphia Museum of Art.* Philadelphia, 1965.

Philadelphia 1981–82
See Lippincott 1981

Philadelphia 1989
See Brownlee 1989

Philadelphia 1993
Philadelphia Museum of Art. *Exploring a Renaissance Masterpiece by Masolino in the John G. Johnson Collection.* Philadelphia, videocassette, 18 min.

Philadelphia 1994
Philadelphia Museum of Art. *Paintings from Europe and the Americas in the Philadelphia Museum of Art: A Concise Catalogue.* Philadelphia, 1994.

Philadelphia 1995
Philadelphia Museum of Art. *Handbook of the Collections.* Philadelphia, 1995.

Philadelphia 1999
Philadelphia Museum of Art. *Annual Report 1999.* Philadelphia, 1999.

Piattoli 1929–30
Renato Piattoli. "Un mercante del trecento e gli artisti del tempo suo." *Rivista d'arte* (Florence), vol. 11, 2nd ser., no. 1 (1929), pp. 221–53, 396–437, 537–79; vol. 12, 2nd ser., no. 2 (1930), pp. 97–150.

Piattoli 1932
Renato Piattoli, ed. *Guida storica e bibliografica degli archivi e delle biblioteche d'Italia.* Vol. 1, *Provincia di Firenze.* Pt. 1, *Prato.* Rome, 1932.

Piccolomini 1458–64, Totaro ed. 1984
Enea Silvio Piccolomini (Pope Pius II). *I commentarii.* Edited and translated by Luigi Totaro. 2 vols. Milan, 1984.

Pierallini 1849
Giovanni Pierallini. "Monastero di San Michele." *Pel calendario pratese del 1850: memorie e studi di cose patrie* (Prato), vol. 5 (1849), pp. 145–56.

Pietrangeli 1988
Carlo Pietrangeli, ed. *Santa Maria Maggiore a Roma.*

Introduction by Giulio Andreotti. Chiese monumentali d'Italia. Florence, 1988.

Pietrangeli 1990
Carlo Pietrangeli, ed. *San Giovanni in Laterano*. Introduction by Ugo Poletti. Florence, 1990.

Pinelli 2001
Antonio Pinelli. *Roma del rinascimento: storia di Roma dall'antichità a oggi*. Bari, 2001.

Pini and Milanesi
Carlo Pini and Gaetano Milanesi. *La scrittura di artisti italiani*. 3 vols. Florence, 1869–76.

Pisani 1996
Linda Pisani. "Appunti su Priamo della Quercia." *Arte cristiana* (Milan), n.s., vol. 84, no. 774 (May–June 1996), pp. 171–86.

Pittaluga 1941
Mary Pittaluga. "Fra Diamante, collaboratore di Filippo Lippi." *Rivista d'arte* (Florence), vol. 23, 2nd ser., vol. 8, nos. 1–2 (January–June 1941), pp. 19–71.

Pittura 1986
La pittura in Italia: il duecento e il trecento. Edited by Enrico Castelnuovo. 2 vols. Rev. and enlarged ed. Milan, 1986.

Pittura 1987
La pittura in Italia: il quattrocento. Rev. and enlarged ed. 2 vols. Milan, 1987.

Platina 1474, Giada ed. 1913
Bartolomeo Platina. *Liber de vita Christi ac omnium pontificum*. Edited by Giacinto Giada. In *Rerum italicarum scriptores: raccolta degli storici italiani dal cinquecento al millecinquecento ordinata da L. A. Muratori*. Newly edited by Giosuè Carducci and Vittorio Fiorini. Vol. 3, no. 1. Città di Castello, 1913.

Poggi 1909
Giovanni Poggi. "L'Annunciazione del beato Angelico a San Francesco di Montecarlo." *Rivista d'arte* (Florence), vol. 6 (1909), pp. 130–32.

Poggi 1909, Haines ed. 1988
Giovanni Poggi, ed. *Il duomo di Firenze: documenti sulla decorazione della chiesa e del campanile tratti dall'Archivio dell'Opera*. 2 vols. Italienische Forschungen, 2. Berlin, 1909. Reprint, with notes by Margaret Haines. Florence, 1988.

Poggi and Bucciardini 1998
Matteo Poggi and Leonardo Bucciardini. "Elementi nuovi per un' attribuzione." Unpublished paper, 1998, n.p. Philadelphia Museum of Art curatorial files.

Polcri 1995
Franco Polcri. "Un nuovo documento su Niccolò di Segna, autore del politico della Resurrezione di Sansepolcro." *Commentari d'arte* (Rome), vol. 1, no. 2 (1995), pp. 35–40.

Pope-Hennessy 1938
John Pope-Hennessy. *Giovanni di Paolo, 1403–1483*. London, 1938.

Pope-Hennessy 1939
John Pope-Hennessy. *Sassetta*. London, 1939.

Pope-Hennessy 1943
John Pope-Hennessy. "A Predella Panel by Masolino." *The Burlington Magazine* (London), vol. 82, no. 479 (February 1943), pp. 30–31.

Pope-Hennessy 1944
John Pope-Hennessy. "The Development of Realistic Painting in Siena." *The Burlington Magazine* (London), vol. 84, no. 494 (May 1944), pp. 110–19; vol. 84, no. 495 (June 1944), pp. 139–44.

Pope-Hennessy 1947
John Pope-Hennessy. *Sienese Quattrocento Painting*. Oxford, 1947.

Pope-Hennessy 1947a
John Pope-Hennessy. *A Sienese Codex of the Divine Comedy*. Oxford, 1947.

Pope-Hennessy 1948
John Pope-Hennessy. "A Diptych by Francesco di Vannuccio." *The Burlington Magazine* (London), vol. 90, no. 542 (May 1948), pp. 137–41.

Pope-Hennessy 1950
John Pope-Hennessy. *The Complete Work of Paolo Uccello*. London, 1950.

Pope-Hennessy 1952
John Pope-Hennessy. *Fra Angelico*. London, 1952.

Pope-Hennessy 1952a
John Pope-Hennessy. "Letters: The Sta Maria Maggiore Altarpiece." *The Burlington Magazine* (London), vol. 94, no. 586 (January 1952), p. 31.

Pope-Hennessy 1956
John Pope-Hennessy. "Rethinking Sassetta." *The Burlington Magazine* (London), vol. 98, no. 643 (October 1956), pp. 364–70.

Pope-Hennessy 1964
John Pope-Hennessy assisted by Ronald Lightbown. *Catalogue of Italian Sculpture in the Victoria and Albert Museum*. 3 vols. London, 1964.

Pope-Hennessy 1969
John Pope-Hennessy. *Paolo Uccello: Complete Edition*. 2nd ed. London, 1969.

Pope-Hennessy 1974
John Pope-Hennessy. *Fra Angelico*. 2nd ed. London, 1974.

Pope-Hennessy 1983
John Pope-Hennessy. "Die Maler von Siena." Translated from the English by Jörg Trobitius. *Du: Die Kunstzeitschrift* (Zurich), vol. 5 (May 1983), pp. 26–65.

Pope-Hennessy 1985
John Pope-Hennessy. *Italian Renaissance Sculpture*. 3rd ed. New York, 1985.

Pope-Hennessy 1986
John Pope-Hennessy. *The Study and Criticism of Italian Sculpture*. New York, 1986.

Pope-Hennessy 1987
John Pope-Hennessy assisted by Laurence B. Kanter. *The Robert Lehman Collection*. Vol. 1, *Italian Paintings*. New York, 1987.

Pope-Hennessy 1988
John Pope-Hennessy. "Giovanni di Paolo." *The Metropolitan Museum of Art Bulletin* (New York), vol. 46, no. 2 (Fall 1988), pp. 6–48.

Pope-Hennessy 1993
John Pope-Hennessy. *Paradiso: The Illuminations to Dante's "Divine Comedy" by Giovanni di Paolo*. London, 1993.

Pope-Hennessy and Christiansen 1980
John Pope-Hennessy and Keith Christiansen. "Secular Painting in 15th-Century Tuscany: Birth Trays, Cassone Panels, and Portraits." *The Metropolitan Museum of Art Bulletin*, vol. 38, no. 1 (Summer 1980), pp. 1–64.

Post
Chandler Rahfton Post. *A History of Spanish Painting*. 14 vols. Vols. 13–14 edited by Harold E. Wethey. Cambridge, 1930–66.

Post 1915
Chandler Rahfton Post. "A Triptych by Allegretto Nuzi at Detroit." *Art in America* (New York), vol. 3, no. 5 (August 1915), pp. 213–22.

Pouncey 1946
Philip Pouncey. "A Painted Frame by Paolo Schiavo." *The Burlington Magazine* (London), vol. 88, no. 522 (September 1946), p. 228.

Pouncey 1954
Philip Pouncey. "Letters: A New Panel by the Master of 1419." *The Burlington Magazine* (London), vol. 96, no. 618 (September 1954), pp. 291–92.

Prager and Scaglia 1970
Frank D. Prager and Gustina Scaglia. *Brunelleschi: Studies of His Technology and Inventions*. Cambridge, Mass., 1970.

Prampolini 1939
Giacomo Prampolini, ed. *L'annunciazione nei pittori primitivi italiani*. Milan, 1939.

Prato 1995
La sacra cintola nel duomo di Prato. Prato, 1995.

Prato 1998
Prato, Museo di pittura murale. *I tesori della città: pittura del tre-quattrocento a Prato*. Exhibition, 1998. Catalogue edited by Claudio Cerretelli.

Preiser 1973
Arno Preiser. *Das Entstehen und die Entwicklung der Predella in der italienischen Malerei*. Studien zur Kunstgeschichte, 2. Hildesheim, 1973.

Previtali 1964
Giovanni Previtali. *La fortuna dei primitivi dal Vasari ai neoclassici*. Turin, 1964.

Previtali 1967
Giovanni Previtali. *Giotto e la sua bottega*. Milan, 1967.

Previtali 1974
Giovanni Previtali. *Giotto e la sua bottega*. Rev. ed. Milan, 1974.

Previtali 1989
Giovanni Previtali. *La fortuna dei primitivi dal Vasari ai neoclassici*. New rev. and enlarged ed. Introduction by Enrico Castelnuovo. Turin, 1989.

Previtali 1993
Giovanni Previtali. *Giotto e la sua bottega*. Edited by Alessandro Conti with notes by Giovanna Ragionieri. With updated illustrations. Milan, 1993.

Prijatelj 1962
Kruno Prijatelj. "Triptih iz splitskog arheoloskog muzeja." *Peristil* (Zagreb), vol. 5 (1962), pp. 29–35.

Procacci 1932
Ugo Procacci. "L'incendio della chiesa del Carmine del 1771." *Rivista d'arte* (Florence), vol. 14, 2nd ser., vol. 4, nos. 1–2 (January–June 1932), pp. 141–232.

Procacci 1932a
Ugo Procacci. "Documenti e ricerche sopra Masaccio e

la sua famiglia." *Rivista d'arte* (Florence), vol. 14, 2nd ser., vol. 4 (1932), pp. 489–503.

Procacci 1933
Ugo Procacci. "Relazione dei lavori eseguiti nella chiesa del Carmine di Firenze per la ricerca di antichi affreschi." *Bollettino d'arte* (Rome), vol. 27 (1933), pp. 327–34.

Procacci 1933–36
Ugo Procacci. "Gherardo Starnina." *Rivista d'arte* (Florence), vol. 15, 2nd ser., vol. 5 (1933), pp. 151–90; vol. 17, 2nd ser., vol. 7 (1935), pp. 333–84; vol. 18, 2nd ser., vol. 8 (1936), pp. 77–109.

Procacci 1935
Ugo Procacci. "Opere sconosciute d'arte toscana, III." *Rivista d'arte* (Florence), vol. 17, 2nd ser., vol. 7 (1935), pp. 405–11.

Procacci 1935a
Ugo Procacci. "Documenti e ricerche sopra Masaccio e la sua famiglia [II]." *Rivista d'arte* (Florence), vol. 17, 2nd ser., vol. 8 (1935), pp. 91–111.

Procacci 1936
Ugo Procacci. *La regia Galleria dell'Accademia di Firenze.* Itinerari dei musei e monumenti d'Italia, 52. Rome, 1936.

Procacci 1951
Ugo Procacci, ed. *Tutta la pittura di Masaccio.* Milan, 1951.

Procacci 1952
Ugo Procacci, ed. *Tutta la pittura di Masaccio.* 2nd ed., rev. Milan, 1952.

Procacci 1953
Ugo Procacci. "Sulla cronologia delle opere di Masaccio e di Masolino tra il 1425 e il 1428." *Rivista d'arte* (Florence), vol. 28, 3rd ser., vol. 3 (1953; printed 1954), pp. 3–55.

Procacci 1960
Ugo Procacci. "Di Jacopo di Antonio e delle compagnie di pittori del corso degli Adimari nel XV secolo." *Rivista d'arte* (Florence), vol. 35, 3rd ser., vol. 10 (1960; printed 1961), pp. 3–70.

Procacci 1961
Ugo Procacci, ed. *Tutta la pittura di Masaccio.* 4th ed. Milan, 1961.

Procacci 1961a
Ugo Procacci. "Il primo ricordo di Giovanni da Milano a Firenze." *Arte antica e moderna* (Florence), vols. 13–14 (January–December 1961), pp. 49–66.

Procacci 1976
Ugo Procacci. "Una lettera del Baldinucci e antiche immagini della beata Umiliana de' Cerchi." *Antichità viva* (Florence), vol. 15, no. 3 (May–June 1976), pp. 3–10.

Procacci 1976a
Ugo Procacci. "Nuove testimonianze su Masaccio." *Commentari* (Rome), n.s., vol. 27, nos. 3–4 (July–December 1976), pp. 223–37.

Procacci 1980
Ugo Procacci. *Masaccio.* Florence, 1980.

Procacci 1984
Ugo Procacci. "Le portate al catasto di Giovanni di ser Giovanni detto lo Scheggia." *Rivista d'arte* (Florence), 37th yr., 4th ser., vol. 1 (1984), pp. 235–57.

Proto Pisani 1982
Rosanna Caterina Proto Pisani. "Tre casi d'intervento nel territorio toscano." *Bollettino d'arte* (Rome), 6th ser., vol. 67, no. 15 (July–September 1982), pp. 99–108.

Proto Pisani 1989
Rosanna Caterina Proto Pisani. *Il Museo di Arte Sacra a San Casciano Val di Pesa.* Biblioteca de "Lo Studiolo." Florence, 1989.

Proto Pisani 1992
Rosanna Caterina Proto Pisani. *Il Museo di Arte Sacra di San Martino a Gangalandi.* Introduction by Antonio Paolucci. Biblioteca de "Lo Studiolo." Florence, 1992.

Providence 1923
Providence. *Rhode Island School of Design Catalogue of Paintings.* Providence, 1923.

Providence 1923–24
Providence. *Rhode Island School of Design. Memorial Exhibition of Works of Art Given by Manton Bradley Metcalf: Catalogue.* December 12, 1923–January 9, 1924. Providence, 1923.

Pudelko 1932–34
Georg Pudelko. "Studien über Domenico Veneziano." *Mitteilungen des Kunsthistorischen Institutes in Florenz* (Florence), vol. 4 (1932–34), pp. 145–200.

Pudelko 1938
Georg Pudelko. "The Maestro del Bambino Vispo." *Art in America* (Westport, Conn.), vol. 26, no. 2 (April 1938), pp. 47–63.

Puerari 1951
Alfredo Puerari. *La Pinacoteca di Cremona.* Cremona, 1951.

Puglioli 1926
Giorgina Puglioli. *San Bernardino da Siena e la sua attività in Firenze negli anni 1424–1425.* Florence, 1926.

Pujmanová 1980
Olga Pujmanová. "Několik poznámek k dílům Tomasa da Modena na Karlštejně" [with an English-language summary by T. Gottheinerová]. *Umění* (Prague), vol. 28, no. 4 (1980), pp. 305–32.

Pujmanová 1984
Olga Pujmanová. *Italienische Tafelbilder des Trecento in der Nationalgalerie Prag.* East Berlin, 1984.

Pujmanová 1987
Olga Pujmanová. "Italian Gothic and Renaissance Art in Czechoslovakia." *The Burlington Magazine* (London), vol. 129, no. 1006 (January 1987), pp. 16–24.

Pupilli and Costanzi 1990
Laura Pupilli and Costanza Costanzi. *Fermo: Antiquarium, Pinacoteca Civica.* Musei d'Italia—Meraviglie d'Italia, 23. Bologna, 1990.

Ragghianti 1938
Carlo Ragghianti. Review of Georg Pudelko, "Intorno a Filippo Lippi" (*The Art Bulletin*, vol. 18 [1936], pp. 104–12). *Critica d'arte* (Florence), vol. 3 (1938), pp. xxii–xxv.

Ragghianti 1949
Carlo L. Ragghianti. "Collezioni americane: la collezione Rabinowitz." *Critica d'arte* (Florence), 3rd ser., vol. 8, no. 1, fasc. 27 (May 1, 1949), pp. 76–80.

Ragghianti 1974
Carlo L. Ragghianti. "Ferrara 1432." *Critica d'arte* (Florence), vol. 39, n.s., vol. 20, no. 138 (November–December 1974), pp. v–vi.

Ragionieri 1989
Giovanna Ragionieri. *Duccio: catalogo completo dei dipinti.* I gigli dell'arte, 4. Florence, 1989.

Ragusa and Green 1961
Meditations on the Life of Christ: An Illustrated Manuscript of the Fourteenth Century. Paris, Bibliothèque Nationale, Ms. Ital. 115. Translated by Isa Ragusa. Completed from the Latin and edited by Isa Ragusa and Rosalie B. Green. Princeton Monographs in Art and Archaeology, 35. Princeton, 1961.

Ramboux 1862
Johann Anton Ramboux. *Katalog der Gemälde alter italienischer Meister (1221–1640) in der Sammlung des Conservator J. A. Ramboux.* Cologne, 1862.

Ramboux 1867
Catalog der nachgelassenen Kunstsammlungen des Herrn Johann Anton Ramboux. Cologne, 1867.

Ramsey 1982
P. A. Ramsey, ed. *Rome in the Renaissance: The City and the Myth.* Papers of the Thirteenth Annual Conference of the Center for Medieval and Early Renaissance Studies, State University of New York at Binghamton. Medieval and Renaissance Texts and Studies, 18. Binghamton, 1982.

Rankin 1909
William Rankin. "The Collection of Mr. John G. Johnson: The Early Italian Pictures." *The International Studio* (New York), vol. 37, no. 147 (May 1909), pp. lxxix–lxxxiii.

Ravenna 1988
Pinacoteca Comunale di Ravenna. *Opere dal XIV al XVIII secolo.* Ravenna, 1988.

Razzi 1627
Silvano Razzi. *Vite de' santi e beati toscani de' quali insino a hoggi comunemente si ha cognizione.* Florence, 1627.

Reinach
Salomon Reinach. *Répertoire de peintures du moyen âge et de la renaissance (1280–1580).* 4 vols. Paris, 1905–23.

Relazione 1819
Relazione in compendio delle cose più notabili nel Palazzo e Galleria Saracini di Siena. Siena, 1819.

Repetti
Emanuele Repetti. *Dizionario geografico fisico storico della Toscana.* 6 vols. Florence, 1833–46.

Ressort, Béguin, and Laclotte 1978
Claudie Ressort, Sylvie Béguin, and Michel Laclotte. *Retables italiens du XIIIᵉ au XVᵉ siècle.* Les dossiers du Département des Peintures, Musée du Louvre, 16. Paris, 1978. Exhibition, Paris, Musée du Louvre, October 14, 1977–January 15, 1978.

Ricci 1834
Amico Ricci. *Memorie storiche delle arti e degli artisti della Marca di Ancona.* 2 vols. Macerata, 1834. Reprint, Bologna, 1970.

Ricci 1904
Corrado Ricci. *Il Palazzo Pubblico di Siena e la mostra d'antica arte senese.* Collezione di monografie illustrate, 5th ser., Raccolte d'arte, 1. Bergamo, 1904.

Ricci 1904a
Corrado Ricci. "Benozzo Gozzoli: la pala della Compagnia della Purificazione." *Rivista d'arte* (Florence), vol. 2, no. 1 (1904), pp. 1–12.

Rice 1983

Eugene Rice, Jr. "St. Jerome's 'Vision of the Trinity': An Iconographical Note." *The Burlington Magazine* (London), vol. 125, no. 960 (March 1983), pp. 151–55.

Rice 1985

Eugene F. Rice, Jr. *Saint Jerome in the Renaissance.* The Johns Hopkins Symposia in Comparative History, 13. Baltimore, 1985.

Richa

Giuseppe Richa. *Notizie istoriche delle chiese fiorentine, divise ne' suoi quartieri.* 10 vols. Florence, 1754–62.

Richter 1936

J. Paul Richter. *The Cannon Collection of Italian Paintings of the Renaissance, Mostly of the Veronese School.* Princeton, 1936.

Richter 1943

George Martin Richter. *Andrea dal Castagno.* Chicago, 1943.

Ridderbos 1984

Bernhard Ridderbos. *Saint and Symbol: Images of Saint Jerome in Early Italian Art.* Groningen, 1984.

Riedl 1986

Peter Anselm Riedl. *Eine wiederentdeckte "Verkündigung Maria" von Giovanni di Paolo.* Sitzungsberichte der Heidelberger Akademie der Wissenschaften, Philosophisch-historische Klasse. Heidelberg, 1986.

Rigatuso 1934

Lucia Rigatuso. "Bartolo di Fredi." *La Diana* (Siena), vol. 9, nos. 3–4 (1934), pp. 214–67.

Rimini 1995

Rimini, Museo della Città. *Il trecento riminese: maestri e bottege tra Romagna e Marche.* Exhibition, August 20, 1995–January 7, 1996. Catalogue edited by Daniele Benati. Milan, 1995.

Rio 1861

Alexis-François Rio. *De l'art chrétien.* New ed. Vol. 2. Paris, 1861.

Rio 1874

A. F. Rio. *De l'art chrétien.* New ed. 4 vols. Paris, 1874.

Roberts 1985

Perri Lee Roberts. "St. Gregory the Great and the Santa Maria Maggiore Altar-piece." *The Burlington Magazine* (London), vol. 127, no. 986 (May 1985), pp. 295–96.

Roberts 1993

Perri Lee Roberts. *Masolino da Panicale.* Clarendon Studies in the History of Art. Oxford, 1993.

Roberts 1998

Perri Lee Roberts. "A Newly Discovered Painting by Masolino da Panicale." *Artibus et historiae* (Vienna), vol. 38 (1998), pp. 171–77.

Roberts 2002

Perri Lee Roberts. *Sacred Treasures: Early Italian Paintings from Southern Collections.* With essays by Bruce Cole and Hayden B. J. Maginnis. Athens, Georgia, 2002. Exhibition, Athens, Georgia Museum of Art, October 12, 2002–January 5, 2003; Birmingham Museum of Art, January 26–April 13, 2003; Sarasota, The John and Mable Ringling Museum of Art, May 31–August 10, 2003.

Robertson 1992

Clare Robertson. *"Il gran cardinale": Alessandro Farnese, Patron of the Arts.* New Haven, 1992.

Romagnoli before 1835

Ettore Romagnoli. *Biografia cronologica de' bell'artisti senesi.* 13 vols. Biblioteca Communale, Siena, MSS L.II.1–13, before 1835. Florence, 1976–78.

Romagnoli 1927

Fernando Romagnoli. *Allegretto Nuzi, pittore fabrianese.* Fabriano, 1927.

Romano 1990

Giovanni Romano. *Da Biduino ad Algardi: pittura e scultura a confronto.* Entries by Alessandro Ballarin et al. Turin, 1990. Turin, Antichi Maestri Pittori di Giancarlo Gallino, Ezio Benappi & C., May 12–June 23, 1990.

Romano 1992

Serena Romano with Domenico Compisano. *Eclissi di Roma: pittura murale a Roma e nel Lazio da Bonifacio VIII a Martino V (1295–1431).* Rome, 1992.

Rome 1980

Rome, Museo di Palazzo Venezia. *Palazzo Venezia, Paolo II e le fabbriche di San Marco.* Exhibition, May–September 1980. Catalogue by Maria Letizia Casanova Uccella.

Rome 1984

Rome, Palazzo Venezia. *Roma, 1300–1875: l'arte degli anni santi.* Exhibition, December 20, 1984–April 5, 1985. Catalogue edited by Marcello Fagiolo and Maria Luisa Madonna. Milan, 1984.

Rome 1992

Alle origini della nuova Roma: Martino V (1417–1431). Edited by Maria Chiabò, Giusi d'Alessandro, Paola Piacentini, and Concetta Ranieri. Atti del convegno, Rome, March 2–5, 1992. Nuovi studi storici.

Ronan 1982

Helen Ann Ronan. "The Tuscan Wall Tomb, 1250–1400." Ph.D. diss., Indiana University, Bloomington, 1982.

Rønning Johannesen 1961

Ole Rønning Johannesen. *Catalog ober det Bergnske Museums Maliersamling.* Norges Eldste Kunstsamling. Introduction by Aslaug Blytt. Bergen, Norway, 1961.

Rosen 1941

David Rosen. "Preservation versus Restoration." *Magazine of Art* (Washington, D.C.), vol. 34, no. 9 (November 1941), pp. 458–71.

Rosini 1839–47

Giovanni Rosini. *Storia della pittura italiana esposta coi monumenti.* 7 text vols. Pisa, 1839–47. 6 plate vols. Pisa, 1840–45.

Rosini 1848–52

Giovanni Rosini. *Storia della pittura italiana esposta coi monumenti.* 2nd ed. 7 vols. Pisa, 1848–52.

Rossi 1966

Filippo Rossi, ed. *Il Museo Horne a Firenze.* Gallerie e musei minori di Firenze. Florence, 1966.

Rossi 1968

Francesco Rossi. "Appunti sulla pittura gotica tra Ancona e Macerata." *Bollettino d'arte* (Rome), 5th ser., vol. 53, no. 4 (October–December 1968), pp. 197–206.

Rossi 1977

Francesco Rossi. "Lo 'stile feltresco': arte tra Gubbio e Urbino nella prima metà del '400." In *Rapporti artistici tra le Marche e l'Umbria.* Convegno interregionale di studio, Fabriano-Gubbio, 8–9 Giugno 1974 (pp. 55–68). Deputazione di storia patria per l'Umbria: Appendici al Bollettino, 13. Perugia, 1977.

Rossi 1994

Francesco Rossi, ed. *Catalogo della Pinacoteca Vaticana.* Vol. 3, *Il trecento: Umbria, Marche, Italia del Nord, con un'appendice sui toscani.* Monumenti, Musei, e Gallerie Pontificie: Reparto per l'Arte Bizantina, Medioevale, e Moderna. Cataloghi. Vatican City, 1994.

Rossi and Lasinio 1820

Giuseppe Rossi and Giovanni Paolo Lasinio. *Pitture antiche di Niccolò Petri nel capitolo di S. Francesco in Pisa.* Pisa, 1820.

Rowlands 1996

Eliot W. Rowlands. *The Collections of The Nelson-Atkins Museum of Art. Italian Paintings, 1300–1800.* Kansas City, Mo., 1996.

Rowlands 2003

Eliot W. Rowlands. *Masaccio: Saint Andrew and the Pisa Altarpiece.* Los Angeles, 2003.

Rubinstein 1958

Nicolai Rubinstein. "Political Ideas in Sienese Art: The Frescoes by Ambrogio Lorenzetti and Taddeo di Bartolo in the Palazzo Pubblico." *Journal of the Warburg and Courtauld Institutes* (London), vol. 21, nos. 3–4 (1958), pp. 179–207.

Rucellai 1457–73, Perosa ed. 1960

Alessandro Perosa, ed. *Giovanni Rucellai ed il suo zibaldone.* Vol. 1, *Il zibaldone quaresimale.* Studies of the Warburg Institute, 24. London, 1960.

Ruda 1993

Jeffery Ruda. *Fra Filippo Lippi: Life and Work with a Complete Catalogue.* London, 1993.

Rumohr

Carl Friedrich von Rumohr. *Italienische Forschungen.* 3 vols. Berlin, 1827–31.

Russell 1983

Francis Russell. "Fabrianese Notes." *The Burlington Magazine* (London), vol. 125, no. 968 (November 1983), pp. 676–79.

Russo 1987

Daniel Russo. *Saint Jérôme en Italie: Étude d'iconographie et de spiritualité (XIIIe–XVIe siècle).* Images à l'appui, 2. Paris, 1987.

Russoli 1962

Franco Russoli. *La raccolta Berenson.* Introduction by Nicky Mariano. Milan, 1962.

Saalman 1959

Howard Saalman. "Giovanni di Gherardo da Prato's Designs Concerning the Cupola of Santa Maria del Fiore in Florence." *Journal of the Society of Architectural Historians* (Amherst, Mass.), vol. 18, no. 1 (March 1959), pp. 11–20.

Saalman 1980

Howard Saalman. *Filippo Brunelleschi: The Cupola of Santa Maria del Fiore.* Studies in Architecture, 20. London, 1980.

Saalman 1993

Howard Saalman. *Filippo Brunelleschi: The Buildings.* Studies in Architecture, 27. University Park, Pa., 1993.

Sacchetti before 1399, Pernicone ed. 1946

Franco Sacchetti. *Il trecento novelle.* Edited by Vincenzo Pernicone. Florence, 1946.

Sainati 1886
Giuseppe Sainati. *Diario sacro pisano.* 2nd ed. Siena, 1886.

Salerno 1955
Salerno, Duomo. *Opere d'arte nel Salernitano del XII al XVIII secolo.* Exhibition, September 1954–September 1955. Catalogue by Ferdinando Bologna. Naples, 1955.

Salmi 1913
Mario Salmi. "Spigolature d'arte toscano." *L'arte* (Rome), vol. 16 (1913), pp. 208–27.

Salmi 1928–29
Mario Salmi. "Gli affreschi della collegiata di Castiglione Olona." *Dedalo* (Milan), vol. 9, no. 1 (1928–29), pp. 3–30.

Salmi 1929
Mario Salmi. Review of Offner 1927. *Rivista d'arte* (Florence), vol. 9, 2nd ser., vol. 1 (1929), pp. 133–45.

Salmi 1929a
Mario Salmi. "Francesco d'Antonio fiorentino." *Rivista d'arte* (Florence), vol. 11, 2nd ser., vol. 1 (1929), pp. 1–42.

Salmi 1931–35
Mario Salmi. "La scuola di Rimini." *Rivista del reale Istituto d'Archeologia e Storia dell'Arte* (Rome), vol. 3, no. 3 (1931–32), pp. 226–67; vol. 4, no. 1 (1932–33), pp. 145–201; vol. 5, nos. 1–2 (1935), pp. 98–127.

Salmi 1932
Mario Salmi. *Masaccio.* Rome, c. 1932.

Salmi 1935
Mario Salmi. "Aggiunte al tre e al quattrocento fiorentino." *Rivista d'arte* (Florence), vol. 17, 2nd ser., vol. 7 (1935), pp. 411–21.

Salmi 1938
Mario Salmi. "La Madonna 'dantesca' del Museo di Livorno e il 'Maestro della Natività di Castello.'" *Liburni civitas* (Livorno), vol. 11, nos. 5–6 (1938), pp. 217–56.

Salmi 1948
Mario Salmi. *Masaccio.* 2nd ed. Collezione "Valori plastici." Milan, 1948.

Salmi 1950
Mario Salmi. "Problemi dell'Angelico." *Commentari* (Florence), vol. 1, no. 2 (April–June 1950), pp. 75–81; no. 3 (July–September 1950), pp. 146–56.

Salmi 1951
Mario Salmi. "Postille alla mostra di Arezzo." *Commentari* (Florence), vol. 2, nos. 3–4 (July–December 1951), pp. 169–95.

Salmi 1952
Mario Salmi. "Gli scomparti della pala di Santa Maria Maggiore acquistati della 'National Gallery.'" *Commentari* (Rome), vol. 3, no. 3 (January–March 1952), pp. 14–21.

Salmi 1958
Mario Salmi. *Il beato Angelico.* Collezione "Valori plastici." Spoleto, 1958.

Salmi 1961
Mario Salmi. *Andrea del Castagno.* Novara, 1961.

Salmi 1966
Mario Salmi. *L'abbazia di Pomposa.* Milan, 1966.

Salvatore 1919
P. Salvatore. *Il monastero dell'Angelo sui monti di Brancoli (cenni di storia dell'arte).* Lucca, 1919.

Salvini 1934
Roberto Salvini. "Opere inedite di Agnolo Gaddi." *Rivista d'arte* (Florence), vol. 16, 2nd ser., vol. 6 (1934), pp. 29–44.

Salvini 1934a
Roberto Salvini. "In margine ad Agnolo Gaddi." *Rivista d'arte* (Florence), vol. 16, 2nd ser., vol. 6 (1934), pp. 205–28.

Salvini 1934b
Roberto Salvini. "Lo sviluppo stilistico di Giovanni Dal Ponte." *Atti e memorie della regia Accademia Petrarca di Lettere, Arti e Scienza* (Arezzo), vols. 16–17 (1934), pp. 1–44.

Salvini 1936
Roberto Salvini. *L'arte di Agnolo Gaddi.* Monografie e studi, 1. Florence, 1936.

Salvini 1938
Roberto Salvini. *Giotto: bibliografia.* Regio Istituto d'Archeologia e Storia dell'Arte. Bibliografie e cataloghi, 4. Rome, 1938.

Salvini and Traverso 1960
Roberto Salvini and Leone Traverso. *The Predella from the XIIIth to the XVIth Centuries.* London, 1960.

Sánchez Cantón 1955
F. J. Sánchez Cantón. *La colección Cambó.* Barcelona, 1955.

Sandberg Vavalà 1926
Evelyn Sandberg Vavalà. *La pittura veronese del trecento e del primo quattrocento.* Verona, 1926.

Sandberg Vavalà 1927
Evelyn Sandberg Vavalà. "A Madonna by Niccolò di Tommaso." *Art in America* (New York), vol. 15, no. 6 (October 1927), pp. 273–87.

Sandberg Vavalà 1929
Evelyn Sandberg Vavalà. *La croce dipinta italiana e l'iconografia della passione.* 2 vols. Verona, 1929.

Sandberg Vavalà 1929a
Evelyn Sandberg Vavalà. "A Chapter in Fourteenth-Century Iconography: Verona." *The Art Bulletin* (New York), vol. 11, no. 4 (December 1929), pp. 376–412.

Sandberg Vavalà 1929–30
Evelyn Sandberg Vavalà. "Vitale delle Madonne e Simone dei Crocifissi." *Rivista d'arte* (Florence), vol. 11, 2nd ser., vol. 1 (1929), pp. 449–80; vol. 12, 2nd ser., vol. 2 (1930), pp. 1–36.

Sandberg Vavalà 1931
Evelyn Sandberg Vavalà. "Some Bolognese Paintings outside Bologna and a Trecento Humourist." *Art in America* (Westport, Conn.), vol. 20, no. 1 (December 1931), pp. 12–37.

Sandberg Vavalà 1940
Evelyn Sandberg Vavalà. "Paintings by Salerno di Coppo." *Art in America* (Westport, Conn.), vol. 28, no. 2 (April 1940), pp. 47–54.

Sandberg Vavalà 1953
Evelyn Sandberg Vavalà. *Sienese Studies: The Development of the School of Painting of Siena.* Pocket Library of "Studies" in Art, 3. Florence, 1953.

San Francisco 1939
San Francisco, The California Palace of the Legion of Honor and The M. H. de Young Memorial Museum. *Seven Centuries of Painting: A Loan Exhibition of Old and Modern Masters.* December 29, 1939–January 28, 1940. Catalogue edited by Walter Heil.

San Francisco 1939a
San Francisco, Golden Gate International Exposition. *Masterworks of Five Centuries.* Exhibition, 1939. Catalogue by Walter Heil.

San Giovanni Valdarno 1999
See Cavazzini 1999

San Marco 1990
La chiesa e il convento di San Marco a Firenze. Vol. 2. Florence, 1990.

San Miniato 1966
Museo Diocesano d'Arte Sacra di San Miniato. Bollettino dell'Accademia degli Euteleti della città di San Miniato, 39th yr., n.s., no. 38 (1966).

San Miniato 1969
San Miniato al Tedesco, Accademia degli Euteleti. *Mostra d'arte sacra della diocesi di San Miniato.* Exhibition, 1969. Catalogue edited by Luciano Bellosi, Dilvo Lotti, and Anna Matteoli. Introductions by Ubaldo Lumini, Licia Bertolini Campetti, and Silvia Meloni Trkulja.

San Miniato 1979
Tesori d'arte antica a San Miniato. Edited by Pietro Torriti. Genoa, 1979.

Sansepolcro 1992
See Berti 1992

Sansepolcro 1998
Sansepolcro, Museo Civico. *Un "San Girolamo" di Matteo di Giovanni dal polittico senese di San Pietro a Ovile.* October 1998. Catalogue by Keith Christiansen.

Sansovino 1604
Francesco Sansovino. *Venetia città nobilissima et singolare.* Enlarged. ed. by Giovanni Stringa. Venice, 1604.

Santangelo 1948
Antonino Santangelo, ed. *Museo di Palazzo Venezia.* Catalogue 1, *Dipinti.* Rome, 1948.

Santarelli 1647
A. M. Santarelli. *Memorie notabili della basilica di Santa Maria Maggiore e di alcuni suoi canonici nelli pontificati di Clemente VIII, Leone XI, Paolo V, e Gregorio XV. ss. mem.* Rome, 1647.

B. Santi 1973
Bruno Santi. "Dalle *Ricordanze* di Neri di Bicci." *Annali della Scuola Normale Superiore di Pisa: classe di lettere e filosofia* (Pisa), 3rd ser., vol. 3, no. 1 (1973), pp. 169–88.

F. Santi 1969
Francesco Santi. *Galleria Nazionale dell'Umbria: dipinti, sculture, e oggetti d'arte di età romanica e gotica.* Cataloghi dei musei e gallerie d'Italia. Rome, 1969.

Santoni 1847
Luigi Santoni, ed. *Raccolta di notizie storiche riguardanti le chiese dell'arci-diogesi di Firenze tratte da diversi autori.* Florence, 1847.

Sassi 1923–24
Romualdo Sassi. "Sonetti di poeti fabrianesi in onore di Gentile da Fabriano." *Rassegna marchigiana* (Pesaro), vol. 2 (1923–24), pp. 273–81.

Sassi 1924
Romualdo Sassi. "Documenti di pittori fabrianesi:

secolo XV." *Rassegna marchigiana* (Pesaro), vol. 3, no. 2 (November 1924), pp. 45–56.

Sassi 1927
Romualdo Sassi. "Arte e storia fra le rovine di un antico tempio francescano." *Rassegna marchigiana* (Pesaro), vol. 5 (1927), pp. 331–51, 419–29.

Satkowski 2000
Jane Immler Satkowski. *Duccio di Buoninsegna: The Documents and Early Sources.* Edited and with an introduction by Hayden B. J. Maginnis. Issues in the History of Art, edited by William U. Eiland. Athens, Ga., 2000.

Saur
Saur allgemeines Künstler-Lexikon: Die bildenden Künstler aller Zeiten und Völker. Vol. 1–. Munich, 1992–.

Savio 1901
Fedele Savio. "Pietro suddiacono napoletano agiografo del secolo X." *Atti della reale Accademia delle Scienze di Torino* (Turin), vol. 36 (1901), pp. 665–79.

Scaglia 1968
Gustina Scaglia. "An Allegorical Portrait of Emperor Sigismund by Mariano Taccola of Siena." *Journal of the Warburg and Courtauld Institutes* (London), vol. 31 (1968), pp. 428–34.

Scapecchi 1983
Piero Scapecchi. "Quattrocentisti senesi nelle Marche: il polittico di Sant'Antonio abate del Maestro dell'Osservanza." *Arte cristiana* (Milan), n.s., vol. 71, no. 698 (September–October 1983), pp. 287–90.

Scarcella 1948
Francesco Scarcella. *Feste, santi, chiese, e gonfaloni delle arti veronesi.* Quaderni di vita veronese, 1. Verona, 1948.

Scarpellini 1976
Pietro Scarpellini. *Giovanni di Corraduccio.* Studi umbri, 1. Foligno, 1976.

Schaff 1975
See Ferguson et al. 1975

Schiaparelli 1983
Attilio Schiaparelli. *La casa fiorentina e i suoi arredi nei secoli XIV e XV.* Edited by Maria Sframeli and Laura Pagnotta. Introduction by Mina Gregori. 2 vols. Florence, 1908. Reprint, Florence, 1983.

Schiller
Gertrud Schiller. *Ikonographie der christlichen Kunst.* 5 vols. Gütersloh, Germany, 1966–91.

Schmarsow
August Schmarsow. *Masaccio Studien.* 5 vols. Kassel, 1895–99.

Schmarsow 1928
August Schmarsow. *Masolino und Masaccio.* Leipzig, 1928.

Schmarsow 1928a
August Schmarsow. "Masaccios Heilung des Mondsüchtigen Knaben in Philadelphia, U.S.A." *Belvedere* (Vienna), vol. 12, no. 65 (May 1928), pp. 103–16.

Schmarsow 1930
August Schmarsow. "Zur Masolino-Masaccio-Forschung." *Zeitschrift für bildende Kunst* (Leipzig), vol. 64 (1930–31), *Kunstchronik und Kunstliteratur,* vol. 1 (April 1930), pp. 1–3.

Schmidt 2002
Victor M. Schmidt, ed. *Italian Panel Painting of the Duecento and Trecento.* Studies in the History of Art, 61. Washington, D.C., 2002.

Schottmüller 1911
Frida Schottmüller, ed. *Fra Angelico da Fiesole: Des Meisters Gemälde.* Klassiker der Kunst in Gesamtausgaben, 18. Stuttgart, 1911.

Schottmüller 1924
Frida Schottmüller, ed. *Fra Angelico da Fiesole: Des Meisters Gemälde.* Klassiker der Kunst in Gesamtausgaben, 18. Stuttgart, 1924.

Schubring 1915
Paul Schubring. *Cassoni: Truhen und Truhenbilder der italienischen Frührenaissance.* 2 vols. Leipzig, 1915.

Schubring 1923
Paul Schubring. *Cassoni: Truhen und Truhenbilder der italienischen Frührenaissance.* 2 vols. 2nd ed., with supplement. Leipzig, 1923.

Schwarz 2002
Michael Viktor Schwarz. "Die Bank, die nichts bedeutet: Pietro Lorenzetti in S. Francesco, Assisi." In *Visuelle Medien im christlichen Kult: Fallstudien aus dem 13. bis 16. Jahrhundert* (pp. 65–99). Vienna, 2002.

Scudieri and Rasario 2003
Magnolia Scudieri and Giovanna Rasario, eds. *Miniatura del '400 a San Marco: dalle suggestioni avignonesi all'ambiente dell'Angelico.* Florence, 2003. Exhibition, Florence, Museo Nazionale di San Marco, April 30–June 30, 2003.

Sebregondi 1991
Ludovica Sebregondi. *Tre confraternite fiorentine: Santa Maria della Pietà, detta "Buca" di San Girolamo, San Filippo Benizi, San Francesco Poverino.* Florence, 1991.

Sebregondi Fiorentini 1985
Ludovica Sebregondi Fiorentini. *La compagnia e l'oratorio di San Niccolò del Ceppo.* Florence, 1985.

Sedelmeyer 1898
Charles Sedelmeyer. *Illustrated Catalogue of 300 Paintings by Old Masters of the Dutch, Flemish, Italian, French, and English Schools: Being Some of the Principal Pictures Which Have at Various Times Formed Part of the Sedelmeyer Gallery.* Paris, 1898.

Segorbe 2001
Segorbe, Spain, Catedral. *La luz de las imágenes Segorbe.* Exhibition, September 2001–March 2002. Valencia, 2001.

Seidel 1981
Max Seidel. "Das Frühwerk von Pietro Lorenzetti." *Städel-Jahrbuch* (Frankfurt), n.s., vol. 8 (1981), pp. 79–158.

Seidel 1996
Katrin Seidel. *Die Kerze: Motivgeschichte und Ikonologie.* Studien zur Kunstgeschichte, 103. Hildesheim, Germany, 1996.

Séroux d'Agincourt 1823
Jean-Baptiste-Louis-Georges Séroux d'Agincourt. *Histoire de l'art par les monuments depuis sa décadence au IVe siècle jusqu'à son renouvellement au XVIe.* 6 vols. Paris, 1823.

Séroux d'Agincourt 1826–29
Jean-Baptiste-Louis-Georges Séroux d'Agincourt. *Sto-ria dell'arte dimostrata coi monumenti dalla sua decadenza nel IV secolo fino al suo risorgimento nel XVI.* 8 vols. Prato, 1826–29.

Serra 1929
Luigi Serra. *L'arte nelle Marche dalle origini cristiane alla fine del gotico.* Pesaro, 1929.

Seymour 1970
Charles Seymour, Jr. *Early Italian Paintings in the Yale University Art Gallery.* New Haven, 1970.

Seymour 1973
Charles Seymour. *Jacopo della Quercia, Sculptor.* Yale Publications in the History of Art, 23. New Haven, 1973.

Sframeli 1983
Maria Sframeli. "Due inediti fiorentini del quattrocento ritrovati nell'Archivio Capitolare fiorentino." *Paragone-arte* (Florence), vol. 34, no. 395 (January 1983), pp. 35–40.

Shapley 1952
Fern Rusk Shapley. "A Predella Panel by Benozzo Gozzoli." *Gazette des beaux-arts* (Paris), 94th yr., 6th ser., vol. 39 (January–June 1952), pp. 77–88; with summary in French, pp. 135–38.

Shapley 1966
Fern Rusk Shapley. *Paintings from the Samuel H. Kress Collection: Italian Schools, XIII–XV Century.* London, 1966.

Shapley 1968
Fern Rusk Shapley. *Paintings from the Samuel H. Kress Collection: Italian Schools, XV–XVI Century.* London, 1968.

Shapley 1979
Fern Rusk Shapley. *Catalogue of the Italian Paintings: National Gallery of Art, Washington.* 2 vols. Washington, D.C., 1979.

Shearman 1975
John Shearman. "The Collections of the Younger Branch of the Medici." *The Burlington Magazine* (London), vol. 117, no. 862 (January 1975), pp. 12–27.

Shearman 1983
John Shearman. *The Early Italian Pictures in the Collection of Her Majesty the Queen.* Cambridge, 1983.

Shell 1965
Curtis Shell. "Francesco d'Antonio and Masaccio." *The Art Bulletin* (New York), vol. 47, no. 4 (December 1965), pp. 465–69.

Shell 1972
Curtis Shell. "Two Triptychs by Giovanni dal Ponte." *The Art Bulletin* (New York), vol. 54, no. 1 (March 1972), pp. 41–46.

Shorr 1954
Dorothy C. Shorr. *The Christ Child in Devotional Images in Italy during the XIV Century.* New York, 1954.

Siena 1904
Siena, Palazzo Pubblico. *Mostra d'arte antica senese: catalogo generale illustrato.* Exhibition, April–August 1904. Catalogue edited by Corrado Ricci.

Siena 1975
Siena, Palazzo Pubblico. *Jacopo della Quercia nell'arte del suo tempo: mostra didattica.* Exhibition, May 24–October 12, 1975. Also shown at Grosseto, Museo Archeologico e d'Arte della Maremma, November 3–27, 1975. Florence, 1975.

Siena 1979

Siena, Soprintendenza per i Beni Artistici e Storici delle Province di Siena e Grosseto. *Mostra di opere d'arte restaurate nelle province di Siena e Grosseto.* Exhibition, 1979. Genoa, 1979.

Siena 1981

Siena, Soprintendenza per i Beni Artistici e Storici delle Province di Siena e Grosseto. *Mostra di opere d'arte restaurate nelle province di Siena e Grosseto, II—1981.* Exhibition, 1981. Genoa, 1981.

Siena 1982

Siena, Palazzo Pubblico. *Il gotico a Siena: miniature, pitture, oreficerie, oggetti d'arte.* Exhibition, July 24–October 30, 1982. Florence, 1982.

Siena 1985

Siena, Pinacoteca Nazionale. *Simone Martini e "chompagni."* Exhibition, March 27–October 31, 1985. Catalogue edited by Alessandro Bagnoli and Luciano Bellosi. Florence, 1985.

Siena 1987

Siena, Palazzo Pubblico, Magazzini del Sale. *Palio e contrade tra ottocento e novecento.* Exhibition, June 27–August 23, 1987. Catalogue edited by Mauro Civai and Enrico Totti. Siena, 1987.

Siena 1987a

Siena, Pinacoteca Nazionale. *Scultura dipinta: maestri di legname e pittori a Siena, 1250–1450.* Exhibition, July 16–December 31, 1987. Catalogue edited by Alessandro Bagnoli and Roberto Bartalini. Florence, 1987.

Siena 1988

Siena, Palazzo Pubblico, Magazzini del Sale. *Siena tra purismo e liberty.* Exhibition, May 20–October 30, 1988. Catalogue edited by Marta Batazzi with Giovanni Marziali and Letizia Sensini. Milan, 1988.

Siena 1994

See Alessi and Martini 1994

Simeoni 1909

Luigi Simeoni. *Verona: guida storico-artistica della città e provincia.* Verona, 1909.

Simeoni 1910

Luigi Simeoni. "Il giurista Barnaba da Morano e gli artisti Martino da Verona and Antonio da Mestre." *Nuovo archivio veneto* (Venice), 10th yr., n.s., vol. 19, pt. 1 (1910), pp. 216–36.

Simpson 1966

W. A. Simpson. "Cardinal Giordano Orsini (†1438) as a Prince of the Church and a Patron of the Arts." *Journal of the Warburg and Courtauld Institutes* (London), vol. 29 (1966), pp. 135–59.

Sinibaldi 1933

Giulia Sinibaldi. *I Lorenzetti.* Preface by Adolfo Venturi. Istituto Comunale d'Arte e di Storia, Collezione di monografie d'arte senese. Siena, 1933.

Siracusa 1999

See Barbera 1999

Sirén 1904

Osvald Sirén. "Di alcuni pittori fiorentini che subirono l'influenza di Lorenzo Monaco: il Maestro del Bambino Vispo." *L'arte* (Rome), vol. 7 (1904), pp. 337–55.

Sirén 1906

Osvald Sirén. "Florentiner Trecentozeichnungen." *Jahrbuch der königlich Preuszischen Kunstsammlungen* (Berlin), vol. 27 (1906), pp. 208–23.

Sirén 1908

Osvald Sirén. *Giottino und seine Stellung in der gleichzeitigen florentinischen Malerei.* Kunstwissenschaftliche Studien, 1. Leipzig, 1908.

Sirén 1908a

Osvald Sirén. "Trecento Pictures in American Collections—II." *The Burlington Magazine* (London), vol. 14, no. 69 (December 1908), pp. 188–94.

Sirén 1909

Osvald Sirén. "Opere sconosciute di Lorenzo Monaco." *Rassegna d'arte* (Milan), vol. 9, no. 2 (February 1909), pp. 33–36.

Sirén 1914

Osvald Sirén. "A Late Gothic Poet of Line." *The Burlington Magazine* (London), vol. 24, no. 132 (March 1914), pp. 323–30; vol. 25, no. 133 (April 1914), pp. 15–24.

Sirén 1914

Osvald Sirén. "Pictures in America by Bernardo Daddi, Taddeo Gaddi, Andrea Orcagna, and His Brothers: I." *Art in America* (New York), vol. 2, no. 4 (June 1914), pp. 263–75.

Sirén 1916

Osvald Sirén. *A Descriptive Catalogue of the Pictures in the Jarves Collection Belonging to Yale University.* New Haven, 1916.

Sirén 1917

Osvald Sirén. *Giotto and Some of His Followers.* Translated from the Swedish by Frederic Schnenck. 2 vols. Cambridge, Mass., 1917.

Sirén 1917a

Osvald Sirén. "Tidiga italienska målningar i Bergen." *Tidskrift för Konstvetenskap* (Lund), 1917, pp. 45–55.

Sirén 1921

Osvald Sirén. "Alcune note aggiuntive a quadri primitivi nella Galleria Vaticana." *L'arte* (Rome), vol. 21, no. 1 (1921), pp. 24–28; vol. 2, no. 2 (1921), pp. 97–102.

Sirén 1922

Osvald Sirén. *Toskanische Maler im XIII. Jahrhundert.* Berlin, 1922.

Sirén 1925

Osvald Sirén. "Two Early Quattrocento Pictures." *The Burlington Magazine* (London), vol. 46, no. 267 (June 1925), pp. 281–87.

Sirén 1926

Osvald Sirén. "Pictures by Parri Spinelli." *The Burlington Magazine* (London), vol. 49, no. 282 (September 1926), pp. 117–24.

Sirén 1927

Osvald Sirén. "A Szépművészeti Múzeum Néhany Korai Olasz Képéről." *Az Országos Magyar Szépművészeti Múzeum Évkönyvei: Közrebocsátja az Igazgatóság* (Budapest), vol. 4, *Kötet, 1924–1926* (1927), pp. 10–29.

Sirén 1927–28

Osvald Sirén. "Il problema Maso-Giottino." *Dedalo* (Milan), vol. 8 (1927–28), pp. 395–424.

Sirén and Brockwell 1917

Osvald Sirén and W. Maurice Brockwell. *Catalogue of a Loan Exhibition of Italian Primitives in Aid of the American War Relief.* New York, 1917. Exhibition, New York, F. Kleinberger Galleries, November 1917.

Skaug 1983

Erling Skaug. "Punch Marks—What Are They Worth? Problems of Tuscan Workshop Interrelationships in the Mid-Fourteenth Century: The Ovile Master and Giovanni da Milano." In *La pittura nel XIV e XV secolo: il contributo dell'analisi tecnica alla storia dell'arte,* vol. 3 (pp. 253–82). Edited by Henk W. van Os and J.R.J. van Asperen de Boer. Atti del XXIV congresso internazionale di storia dell'arte, Bologna, September 10–18, 1979. Bologna, 1983.

Skaug 1994

Erling Skaug. *Punch Marks from Giotto to Fra Angelico: Attribution, Chronology, and Workshop Relationships in Tuscan Panel Painting with Particular Consideration to Florence, c. 1330–1430.* 2 vols. Oslo, 1994.

Skaug 2001

Erling Skaug. "St. Bridget's Vision of the Nativity and Niccolò di Tommaso's Late Period." *Arte cristiana* (Milan), vol. 79, no. 804 (May–June 2001), pp. 195–209.

Skaug 2003

Erling Skaug. "The Altarpiece for St. Bridget's First Chapel at Piazza Farnese in Rome." *Kunst und Kultur* (Oslo), vol. 3 (2003), pp. 190–201.

Skerl Del Conte 1979

Serena Skerl Del Conte. "Una tesi di laura su 'Il Maestro del 1419' e Paolo Uccello." *Arte in Friuli, arte a Trieste* (Udine), vol. 3 (1979), pp. 175–84.

Skerl Del Conte 1993

Serena Skerl Del Conte. *Vitale da Bologna e la sua bottega nella chiesa di Sant'Apollonia a Mezzaratta.* Saggi studi ricerche, 3. Bologna, 1993.

Skipsey 1993

David Skipsey. "A Note on the Conservation of Fra Angelico's *Saint Francis of Assisi.*" *Philadelphia Museum of Art Bulletin,* vol. 88, no. 376 (Spring 1993), pp. 27–28.

Solberg 1991

Gail E. Solberg. "Taddeo di Bartolo: His Life and Work." Ph.D. diss., New York University, 1991.

Solberg 1992

Gail E. Solberg. "A Reconstruction of Taddeo di Bartolo's Altar-Piece for S. Francesco a Prato, Perugia." *The Burlington Magazine* (London), vol. 134, no. 1075 (October 1992), pp. 646–56.

Solberg 1992a

Gail E. Solberg. "Taddeo di Bartolo at Yale." *Yale University Art Gallery Bulletin* (New Haven), 1992, pp. 13–25.

Spallanzani and Gaeta Bertelà 1992

Marco Spallanzani and Giovanna Gaeta Bertelà, eds. *Libro d'inventario dei beni di Lorenzo il Magnifico.* Florence, 1992.

Spike 1995

John T. Spike. *Masaccio.* New York, 1995.

Spike 1997

John T. Spike. *Fra Angelico.* New York, 1997.

Spencer 1991

John R. Spencer. *Andrea del Castagno and His Patrons.* Durham, N.C., 1991.

Spiazzi 1989

Anna Maria Spiazzi, ed. *Giusto de'Menabuoi nel battistero di Padova.* Trieste, 1989.

Spinosa 1994

Nicola Spinosa, with Luisa Ambrosio et al., eds. *Museo Nazionale di Capodimonte.* Naples, 1994.

Sricchia Santoro 1976

Fiorella Sricchia Santoro. "Sul soggiorno spagnolo di Gherardo Starnina e sull'identità del 'Maestro del Bambino Vispo.'" *Prospettiva* (Siena-Florence), no. 6 (July 1976), pp. 11–29.

Sricchia Santoro 1986

Fiorella Sricchia Santoro. *Antonello e l'Europa.* Milan, 1986.

Stechow 1930

Wolfgang Stechow. "Zum Masolino-Masaccio-Problem." *Zeitschrift für bildende Kunst* (Leipzig), vol. 63 (1929–30), *Kunstchronik und Kunstliteratur* (separately paginated supplement), vol. 2 (February 11, 1930), pp. 125–27.

Stechow 1944

Wolfgang Stechow. "Marco del Buono and Apollonio di Giovanni: Cassone Painters." *Bulletin of the Allen Memorial Art Museum* (Oberlin, Ohio), vol. 1, no. 1 (June 1944), pp. 5–21.

Steinbart 1948

Kurt Steinbart. *Masaccio.* Vienna, 1948.

Steinhoff-Morrison 1990

Judith Steinhoff-Morrison. "Bartolomeo Bulgarini and Sienese Painting of the Mid-Fourteenth Century." Ph.D. diss., Princeton University, 1990.

Steinmann 1901

Ernst Steinmann. *Die Sixtinische Kapelle.* 2 vols. Munich, 1901.

Steinweg 1957–59

Klara Steinweg. "Die Kreuzigung Petri des Jacopo di Cione in der Pinacoteca Vaticana." *Atti della pontifica Accademica Romana di Archeologia: rendiconti* (Vatican City), 3rd ser., vols. 30–31 (1957–59), pp. 231–44.

Steinweg 1961

Klara Steinweg. "Rekonstruktion einer orcagnesken Marienkrönung." *Mitteilungen des Kunsthistorischen Institutes in Florenz* (Florence), vol. 10, no. 2 (December 1961), pp. 122–27.

Storia

Storia dell'arte italiana. Pt. 11, 3 vols. Turin, 1979–83.

Strahan 1876

Edward Strahan. *The Masterpieces of the Centennial International Exhibition Illustrated.* Vol. 1, *Fine Art.* Philadelphia, 1876.

Strehlke 1984

Carl Brandon Strehlke. "La *Madonna dell'Umilità* di Domenico di Bartolo e San Bernardino." *Arte cristiana* (Milan), vol. 72, no. 705 (November–December 1984), pp. 381–90.

Strehlke 1985

Carl Brandon Strehlke. "Domenico di Bartolo." Ph.D. diss., Columbia University, 1985.

Strehlke 1985a

Carl Brandon Strehlke. "Sienese Paintings in the Johnson Collection." *Paragone-arte* (Florence), vol. 36, no. 427 (September 1985), pp. 3–15.

Strehlke 1985b

Carl Brandon Strehlke. "Focus on the Collection: Madonna and Child with Donor and Angels." *Philadelphia Museum of Art Members' Magazine* (Fall 1985), p. 10.

Strehlke 1987

Carl Brandon Strehlke. "A Celibate Marriage and Franciscan Poverty Reflected in a Neapolitan Trecento Diptych." *The J. Paul Getty Museum Journal* (Malibu), vol. 15 (1987), pp. 79–96.

Strehlke 1989

Carl Brandon Strehlke. "Three Notes on the Sienese Quattrocento." *Gazette des beaux-arts* (Paris), 131st yr., 6th ser., vol. 114, no. 1451 (December 1989), pp. 271–84.

Strehlke 1990

Carl Brandon Strehlke. "Bernhard and Mary Berenson, Herbert P. Horne, and John G. Johnson." *Prospettiva* (Siena-Florence), nos. 57–60 (April 1989–October 1990), pp. 427–38.

Strehlke 1991

Carl Brandon Strehlke. Review of Van Os et al. 1989. *The Burlington Magazine* (London), vol. 133, no. 1056 (March 1991), pp. 199–200.

Strehlke 1991a

Carl Brandon Strehlke. "Lugano: Early Italian Works from Swiss Collections [exhibition review of Lugano 1991]." *The Burlington Magazine* (London), vol. 133, no. 1060 (July 1991), pp. 464–68.

Strehlke 1992

Carl Brandon Strehlke. "Cenni di Francesco, the Gianfigliazzi and the Church of Santa Trinita in Florence." *The J. Paul Getty Museum Journal* (Malibu), vol. 20 (1992), pp. 11–40.

Strehlke 1993

Carl Brandon Strehlke. "Fra Angelico and Early Florentine Renaissance Painting in the John G. Johnson Collection at the Philadelphia Museum of Art." *Philadelphia Museum of Art Bulletin,* vol. 88, no. 376 (Spring 1993), pp. 5–26.

Strehlke 1994

Carl Brandon Strehlke. Review of Volpe 1989. *The Burlington Magazine* (London), vol. 136, no. 1090 (January 1994), p. 31.

Strehlke 1995

Carl Brandon Strehlke. Review of Pope-Hennessy 1993. *The Burlington Magazine* (London), vol. 137, no. 1109 (August 1995), p. 561.

Strehlke 1995a

Carl Brandon Strehlke. Review of Skaug 1994. *The Burlington Magazine* (London), vol. 137, no. 1112 (November 1995), pp. 753–54.

Strehlke 1997

Carl Brandon Strehlke. Review of Bologna 1996. *The Burlington Magazine* (London), vol. 139, no. 1137 (December 1997), pp. 884–85.

Strehlke 1998

Carl Brandon Strehlke. *Angelico.* Milan, 1998.

Strehlke 1999

Carl Brandon Strehlke. Review of Cavazzini 1999. *The Burlington Magazine.* (London), vol. 141, no. 1154 (May 1999), pp. 314–15.

Strehlke 2001

Carl Brandon Strehlke. "A Signature for Pietro Lorenzetti." In *Opere e giorni: studi su mille anni di arte europea dedicati a Max Seidel* (pp. 131–34). Edited by Klaus Bergdolt and Giorgio Bonsanti. Venice, 2001.

Strehlke 2002

Carl Brandon Strehlke with Cecilia Frosinini, eds. *The Panel Paintings of Masolino and Masaccio: The Role of Technique.* Milan, 2002.

Strehlke and Tucker 1987

Carl Brandon Strehlke and Mark Tucker. "The Santa Maria Maggione Altarpiece: New Observations." *Arte cristiana* (Milan) n.s., vol. 75, no. 719 (March–April 1987), pp. 105–24.

Stubblebine 1969

James H. Stubblebine. "Segna di Buonaventura and the Image of the Man of Sorrows." *Gesta* (New York), vol. 8, no. 2 (1969), pp. 3–13.

Stubblebine 1969a

James H. Stubblebine. "The Angel Pinnacles on Duccio's *Maestà.*" *The Art Quarterly* (Detroit), vol. 32, no. 2 (Summer 1969), pp. 131–52.

Stubblebine 1973

James H. Stubblebine. "Duccio and His Collaborators on the Cathedral *Maestà.*" *The Art Bulletin* (New York), vol. 55, no. 2 (June 1973), pp. 185–204.

Stubblebine 1979

James H. Stubblebine. *Duccio di Buoninsegna and His School.* 2 vols. Princeton, 1979.

Stubblebine 1980

James H. Stubblebine with Mary Gibbons, Frank Cossa, Sharon Sitt, and George Chapman. "Early Masaccio: A Hypothetical, Lost *Madonna* and a Disattribution." *The Art Bulletin* (New York), vol. 42, no. 2 (June 1980), pp. 217–25.

Suida 1911

Wilhelm Suida, ed. *Österreichische Kunstschätze.* Vol. 1, no. 2. Vienna, 1911.

Suida 1923

Wilhelm Suida. "Giottos Tafel des Todes der Maria im Kaiser-Friedrich-Museum." *Jahrbuch der Preuszischen Kunstsammlungen* (Berlin), vol. 44 (1923), pp. 127–35.

Suida 1950

William E. Suida. "Some Bolognese Trecento Paintings in America." *Critica d'arte* (Florence), 3rd ser., vol. 9, no. 1, fasc. 33 (May 1950), pp. 52–58.

Suida 1955

Wilhelm E. Suida. *The Samuel H. Kress Collection.* San Francisco, 1955.

Supino 1924

Igino Benvenuto Supino. *La basilica di San Francesco d'Assisi: illustrazione storico-artistica.* Bologna, 1924.

Sutton 1979

Denys Sutton. "Robert Langton Douglas. Part III, XV: The War Years." *Apollo* (London), n.s., vol. 109, no. 208 (June 1979), pp. 428–38.

Sutton 1979a

Denys Sutton. "Robert Langton Douglas. Part II, XIII: A Lawyer from Philadelphia." *Apollo* (London), n.s., vol. 109, no. 207 (May 1979), pp. 387–93.

Sutton 1985

Denys Sutton. "Herbert Horne and Roger Fry." *Apollo* (London), n.s., vol. 123, no. 282 (August 1985), pp. 130–59.

Sweeny 1966

[Barbara Sweeny]. *John G. Johnson Collection: Catalogue of Italian Paintings.* Foreword by Henri Marceau. Philadelphia, 1966.

Symeonides 1965

Sibilla Symeonides. *Taddeo di Bartolo.* Preface by Enzo Carli. Accademia Senese degli Intronati, Monografie d'arte senese, 7. Siena, 1965.

Syre 1979

Cornelia Syre. *Studien zum "Maestro del Bambino Vispo" und Starnina.* Habelts Dissertationsdrucke, Reihe Kunstgeschichte, 4. Bonn, 1979.

Syre 1990

Cornelia Syre. *Frühe italienische Gemälde aus dem Bestand der Alten Pinakothek.* Essay by Hubertus F. von Sonnenburg. Munich, 1990. Exhibition, Munich, Alte Pinakothek, July 13–September 30, 1990.

Taccone-Gallucci 1911

Domenico Taccone-Gallucci. *Monografia della patriarcale basilica di Santa Maria Maggiore.* Rome-Grottaferrata, 1911.

Tamassia 1995

Marilena Tamassia. *Collezioni d'arte tra ottocento e novecento: Jacquier fotografi a Firenze, 1870–1935.* Ministero per i Beni Culturali e Ambientali: Collezioni e raccolte fotografiche, 3. Naples, 1995.

Tanfani Centofanti 1898

Leopoldo Tanfani Centofanti. *Notizie di artisti tratte dai documenti pisani.* Pisa, 1898.

Tartuferi 1985

Angelo Tartuferi. "Appunti tardogotici fiorentini: Niccolò di Tommaso, il Maestro di Barberino, Lorenzo di Bicci." *Paragone-arte* (Florence), vol. 36, no. 425 (July 1985; printed November 1985), pp. 3–16.

Tartuferi 1990

Angelo Tartuferi. *La pittura a Firenze nel duecento.* Florence, 1990.

Tartuferi 1993

Angelo Tartuferi. "Per la pittura fiorentina di secondo trecento: Niccolò di Tommaso e il Maestro di Barberino." *Arte cristiana* (Milan), vol. 81, no. 758 (September–October 1993), pp. 337–46.

Tartuferi 2000

Angelo Tartuferi. *Bernardo Daddi: l'Incoronazione di Santa Maria Novella.* Il Luogo del David: Restauri, I. Livorno, 2000.

Tartuferi 2001

Angelo Tartuferi. "Il restauro del 'Compianto sul Cristo morto' di Giovanni da Milano." *Gazetta antiquaria* (Florence), n.s., vol. 40, no. 2 (2001), pp. 21–22.

Terni de Gregory 1950

W. Terni de Gregory, "Giovanni da Crema and His 'Seated Goddess.'" *The Burlington Magazine* (London), vol. 92, no. 567 (June 1950), pp. 159–61.

Terraroli 1993

Valerio Terraroli, ed. *La pittura in Lombardia: il quattrocento.* Milan, 1993.

Testi 1909

Laudedeo Testi. *La storia della pittura veneziana.* Vol. 1. Bergamo, 1909.

Thiébaut 1987

Dominique Thiébaut. *Ajaccio, Musée Fesch: Les Primitifs italiens.* Inventaire des collections publiques françaises, 32. Paris, 1987.

Thieme-Becker

Ulrich Thieme and Felix Becker, eds. *Allgemeines Lexikon der bildenden Künstler von der Antike bis zur Gegenwart.* 37 vols. Vols. 5–13 edited by Ulrich Thieme. Vols. 14–15 edited by Ulrich Thieme and Fredrich C. Willis. Vols. 16–37 edited by Hans Vollmer. Leipzig, 1907–50.

Thomas 1993

Anabel Thomas. "Neri di Bicci, Francesco Botticini, and the Augustinians." *Arte cristiana* (Milan), vol. 81, no. 754 (January–February 1993), pp. 23–24.

Thomas 1993a

Anabel Thomas. "Neri di Bicci: The S. Sisto Crucifixion, the Mantellate Nuns of S. Monaca at Florence, and the Compagnia di Miransù." *Antichità viva* (Florence), vol. 32, no. 5 (September–October 1993; printed November 1993), pp. 5–15.

Thomas 1995

Anabel Thomas. *The Painter's Practice in Renaissance Tuscany.* Cambridge, 1995.

Tietze 1935

Hans Tietze, ed. *Meisterwerke europäischer Malerei in Amerika.* Vienna, 1935.

Tietze 1939

Hans Tietze, ed. *Masterpieces of European Painting in America.* New York, c. 1939.

Titi 1751

Pandolfo Titi. *Guida per il passeggiere dilettante di pittura, scultura, ed architettura nella città di Pisa.* Lucca, 1751.

Todini 1977

Filippo Todini. "Schede e note: sul trittico vaticano di Allegretto Nuzi." *Antologia di belle arti* (Rome), vol. 1, no. 3 (September 1977), pp. 291–93.

Todini 1989

Filippo Todini. *La pittura umbra dal duecento al primo cinquecento.* 2 vols. "I marmi," 151. Milan, 1989.

Todini 1991

Filippo Todini. "Lello da Velletri e il vero Bartolomeo da Miranda." *Studi di storia dell'arte* (Todi), vol. 2 (1991), pp. 51–84.

Toesca 1904

Pietro Toesca. "Opere di Giovanni di Paolo nelle collezioni romane." *L'arte* (Rome), vol. 7, nos. 6–8 (1904), pp. 303–8.

Toesca 1904a

Pietro Toesca. "Umili pittori fiorentini del principio del '400." *L'arte* (Rome), vol. 7, nos. 1–2 (1904), pp. 49–58.

Toesca 1917

Pietro Toesca. "Il 'pittore del trittico Carrand': Giovanni di Francesco." *Rassegna d'arte* (Milan), vol. 17, nos. 1–2 (January–February 1917), pp. 1–4.

Toesca 1930

Pietro Toesca. *La collezione di Ulrico Hoepli.* I monumenti e studi per la storia della miniatura italiana. Milan, 1930.

Toesca 1951

Pietro Toesca. *Il trecento.* Storia dell'arte italiana, 2. Turin, 1951.

Tokyo 1987

Tokyo, The National Museum of Western Art. *Space in European Art: Council of Europe Exhibition in Japan.* Exhibition, March 28–June 14, 1987. Tokyo, 1987.

Toledo 1976

The Toledo Museum of Art. *European Paintings.* Toledo, 1976.

Tomaso 1979

Tomaso da Modena e il suo tempo. Atti del convegno internazionale di studi per il 6° centenario della morte, Treviso, August 31–September 3, 1979. Treviso, 1980.

Torriti 1977

Piero Torriti. *La Pinacoteca Nazionale di Siena: i dipinti dal XII al XV secolo.* Genoa, 1977.

Torriti 1978

Piero Torriti. *La Pinacoteca Nazionale di Siena: i dipinti dal XV al XVIII secolo.* Genoa, 1978.

Torriti 1987

Piero Torriti. *Il Pellegrinaio nello Spedale di Santa Maria della Scala a Siena.* Siena, 1987.

Torriti 1988

Piero Torriti. *Tutta Siena contrada per contrada: nuova guida illustrata storico-artistica della città e dintorni.* Florence, 1988.

Torriti 1990

Piero Torriti. *La Pinacoteca Nazionale di Siena: i dipinti.* New ed. in 1 vol. Genoa, 1990.

Torriti 1999

Paolo Torriti. "La chiesa dei Santi Leonardo e Cristoforo." In *Monticchiello: arte, storia, itinerari* (pp. 39–63). Edited by Paolo Torriti. Siena, 1999.

Toscano 1964

Bruno Toscano. "Bartolomeo di Tommaso e Nicola da Siena." *Commentari* (Rome), n.s., vol. 15, nos. 1–2 (January–June 1964), pp. 37–51.

Toscano and Capitelli 2002

Bruno Toscano and Giovanni Capitelli, eds. *Benozzo Gozzoli: allievo a Roma, maestro in Umbria.* Milan, 2002. Exhibition, Montefalco, Chiesa-Museo di San Francesco, June 2–August 31, 2002.

Tours 1998

Tours, *Musée des Beaux-Arts. Guide des collections.* Paris, 1998.

Trame 2000

Umberto Trame, ed. *L'abbazia di Santa Maria di Sesto al Reghena.* Milan, 2000.

Trenti Antonelli 1990

Maria Grazia Trenti Antonelli. *La chiesa di S. Michele a Carmignano.* Prato, 1990.

Trexler 1974

Richard C. Trexler. "Ritual in Florence: Adolescence and Salvation in the Renaissance." In *The Pursuit of Holiness in Late Medieval and Renaissance Religion: Papers from the University of Michigan Conference* (pp. 200–265). Edited by Charles Trinkaus with Heiko A. Oberman. Studies in Medieval and Reformation Thought. Leiden, 1974.

Trexler 1980

Richard C. Trexler. *Public Life in Renaissance Florence.* New York, 1980.

Trnek 1997

Renate Trnek. *Die Gemäldegalerie der Akademie der bildenden Künste in Wien: Die Sammlung im Überblick.* Vienna, 1997.

Trotta 1987

Giampaolo Trotta. *Monticelli: Da borgo suburbano a periferia fiorentina.* Preface by Carlo Natali. Appendix of artists by Marzia Casini Wanrooij. Saggi e documenti, 60. Florence, 1987.

Trotta 1989

Giampaolo Trotta. *Legnaia, Cintoia, e Soffiamo: tre*

aspetti dell'antico "suburbio occidentale" fiorentino. Texts by Giovanna Damiani, Cecilia Frosinini, and G. M. Manetti. Florence, 1989.

Trübner 1925
Jörg Trübner. *Die stilistische Entwickelung der Tafelbilder des Sano di Pietro (1405–1481)*. Études sur l'art de tous les pays et de toutes les époques, 6. Strasbourg, 1925.

Tucker 1997
Mark Tucker. "Rogier van der Weyden's Philadelphia 'Crucifixion.'" *The Burlington Magazine,* vol. 139, no. 1135 (October 1997), pp. 676–83.

Turin 1987
Turin, Giancarlo Gallino. *Antichi maestri pittori: 18 opere dal 1350 al 1520*. Exhibition, April 9–24, 1987. Turin, 1987.

Turin 1988
See Bellosi 1988

Turin 1990
See Romano 1990

Uffizi 1979
Florence, Galleria degli Uffizi. *Gli Uffizi: catalogo generale*. Florence, 1979.

Uffizi 1990
La "Maestà" di Duccio restaurata. Gli Uffizi, Studi e ricerche, 6. Florence, 1990.

Uffizi 1992
La "Madonna d'Ognissanti" di Giotto restaurata. Gli Uffizi, Studi e ricerche, 8. Florence, 1992.

Ughelli 1720
Ferdinando Ughelli. *Italia sacra*. Vol. 5. Venice, 1720.

Ugurgieri Azzolini 1649
Isidoro Ugurgieri Azzolini. *Le pompe sanesi, o'vero relazione delli huomini, e donne illustri di Siena e suo stato*. 2 vols. Pistoia, 1649.

Ulmann 1890
Hermann Ulmann. *Fra Filippo Lippi und Fra Diamante als Lehrer Sandro Botticellis*. Wrocław, Poland, 1890.

Urban 1961–62
Günter Urban. "Die Kirchenbaukunst des Quattrocento in Rom." *Römisches Jahrbuch für Kunstgeschichte* (Vienna), vols. 9–10 (1961–62), pp. 73–287.

Urbino 1968
Urbino, Palazzo Ducale. *Mostra di opere d'arte restaurate*. 11a settimana dei musei. 1968.

Urbino 1969
Urbino, Palazzo Ducale. *Mostra di opere d'arte restaurate*. 12a settimana dei musei. 1969.

Urbino 1970
Urbino, Palazzo Ducale. *Mostra di opere d'arte restaurate*. 13a settimana dei musei. Exhibition, 1970.

Urbino 1973
Urbino, Palazzo Ducale. *Restauri nelle Marche: testimonianze, acquisti, e recuperi*. Exhibition, June 28–September 30, 1973. Ancona, 1973.

Vailati Schoenburg Waldenburg 1983
Grazia Vailati Schoenburg Waldenburg. "L'osservanza leccetana e la genesi della libreria di coro." *Antichità viva* (Florence), vol. 22, no. 2 (March–April 1983; printed October 1983), pp. 5–26.

Valencia 1973
Valencia, Museo de Bellas Artes. *El siglo XV valenciano*. Exhibition, May–June 1973. Catalogue edited by Felipe Vicente Garín Leombart.

Valentiner 1914
Wilhelm R. Valentiner. *Catalogue of a Collection of Paintings and Some Art Objects: German, French, Spanish, and English Paintings and Art Objects*. Philadelphia, 1914.

Valentiner 1926
Wilhelm R. Valentiner. "The Three Archangels by Neri di Bicci." *The Detroit Institute of Arts Bulletin*, vol. 8 (November 1926), pp. 13–16.

Valentiner 1931
Wilhelm R. Valentiner. "Eine Verkündigung Masolinos." *Pantheon* (Munich), vol. 8 (October 1931), pp. 413–16.

Valentiner 1937
Wilhelm R. Valentiner. "Andrea dell'Aquila: Painter and Sculptor." *The Art Bulletin*, vol. 19, no. 4 (December 1937), pp. 503–36.

Valentini and Zucchetti 1959
Roberto Valentini and Giuseppe Zucchetti, eds. *Codice topografico della città di Roma*. Vol. 4, *Scrittori: secoli XIV–XV*. Fonti per la storia d'Italia, 91. Rome, 1959.

Van Buren 1975
Anne H. van Buren. "The Canonical Office in Renaissance Painting: Raphael's *Madonna at Nones*." *The Art Bulletin* (New York), vol. 57, no. 1 (March 1975), pp. 41–52.

Van Marle 1920
Raimond van Marle. *Simone Martini et les peintres de son école*. Études sur l'art de tous les pays et de toutes les époques. Strasbourg, 1920.

Van Marle 1921
Raimond van Marle. "La scuola di Pietro Cavallini a Rimini." *Bollettino d'arte* (Milan-Rome), vol. 1, no. 6 (December 1921), pp. 248–61.

Van Marle 1926
Raimond van Marle. "Dipinti sconosciuti della scuola di Duccio." *Rassegna d'arte senese* (Siena), vol. 19 (1926), pp. 3–6.

Van Marle 1929
Raimond van Marle. "Quadri senesi sconosciuti." *La Diana* (Siena), vol. 4, no. 4 (1929), pp. 307–10.

Van Marle 1931
Raimond van Marle. "Quadri ducceschi ignorati." *La Diana* (Siena), vol. 6, no. 1 (1931), pp. 57–59.

Van Marle
Raimond van Marle. *The Development of the Italian Schools of Painting*. 19 vols. The Hague, 1923–38.

Van Os 1968
Henk W. van Os. "Schnee in Siena." *Nederlands kunsthistorish jaarboek* (Bussum, The Netherlands), vol. 19 (1968), pp. 1–50.

Van Os 1969
Henk W. van Os. *Marias Demut und Verherrlichung in der sienesischen Malerei, 1300–1450*. Kunsthistorische Studiën van het Nederlands Historisch Instituut te Rom, 1. The Hague, 1969.

Van Os 1971
Henk W. van Os. "Giovanni di Paolo's Pizzicaiuolo Altarpiece." *The Art Bulletin* (New York), vol. 53, no. 3 (September 1971), pp. 289–302.

Van Os 1971a
Henk W. van Os. "Andrea di Bartolo's *Assumption of the Virgin*." *Arts in Virginia* (Richmond), vol. 11, no. 2 (Winter 1971), pp. 3–11.

Van Os 1972
Henk W. van Os. "Possible Additions to the Work of Niccolò di Segna." *The Bulletin of The Cleveland Museum of Art*, vol. 59, no. 3 (March 1972), pp. 78–83.

Van Os 1974
Henk W. van Os and Marian Prakken, eds. *The Florentine Paintings in Holland, 1300–1500*. Maarssen, The Netherlands, 1974.

Van Os 1974a
Henk W. van Os. "Andrea di Bartolo's *Madonna of Humility*." *M: A Quarterly Review of The Montreal Museum of Fine Arts*, vol. 6, no. 3 (1974), pp. 19–27 (in English and French).

Van Os 1978
Henk W. van Os. "The Discovery of an Early Man of Sorrows on a Dominican Triptych." *Journal of the Warburg and Courtauld Institutes* (London), vol. 41 (1978), pp. 65–75.

Van Os 1983
Henk W. van Os. "Discoveries and Rediscoveries in Early Italian Painting." *Arte cristiana* (Milan), vol. 71, no. 695 (March–April 1983), pp. 69–80.

Van Os 1984
Henk W. van Os. *Sienese Altarpieces, 1215–1460: Form, Content, Function*. Vol. 1, *1215–1344*. Contribution by Kees van der Ploeg, "On Architectural and Liturgical Aspects of Siena Cathedral in the Middle Ages." Groningen, 1984.

Van Os 1990
Henk W. van Os. *Sienese Altarpieces, 1215–1460: Form, Content, Function*. Vol. 2, *1344–1460*. Groningen, 1990.

Van Os et al. 1989
Henk W. van Os, J.R.J. van Asperen de Boer, C. E. de Jong-Janssen, and C. Wiethoff, eds. *The Early Sienese Paintings in Holland*. Translated from the Dutch by Michael Hoyle. Florence, 1989.

Van Os et al. 1994
Henk W. van Os with Eugène Honée, Hans Nieuwdorp, and Bernhard Ridderbos. *The Art of Devotion in the Middle Ages in Europe, 1300–1500*. Translated by Michael Hoyle. Princeton, 1994. Exhibition, Amsterdam, The Rijksmuseum, November 20, 1994–February 26, 1995.

Varanini 1965
Giorgio Varanini, ed. *Cantari religiosi senesi del trecento: Neri Pagliaresi, fra Felice Tancredi da Massa, Niccolò Cicerchia*. Scrittori d'Italia, 230. Bari, 1965.

Varnhagen 1891
Hermann Varnhagen. *Zur Geschichte der Legende der Katharina von Alexandrien*. Erlangen, Germany, 1891.

Vasari 1550, Bellosi and Rossi ed. 1986
Giorgio Vasari. *Le vite de' più eccellenti architetti, pittori et scultori italiani, da Cimabue insino a' tempi nostri nell'edizione per i tipi di Lorenzo Torrentino, Firenze 1550*. Edited by Luciano Bellosi and Aldo Rossi. Introduction by Giovanni Previtali. I millenni. Turin, 1986.

Vasari 1550–73, Masselli ed.
Giorgio Vasari. *Le opere*. 2 vols. Edited by Giovanni Masselli. Florence, 1832–38.

Vasari 1550 and 1568, Bettarini and Barocchi eds.
Giorgio Vasari. *Le vite de' più eccellenti pittori, scultori e architettori nelle redazioni del 1550 e 1568.* Text edited by Rosanna Bettarini. Commentary edited by Paola Barocchi. Multivolume. Florence, 1966–.

Vasari 1568, Schorn ed.
Giorgio Vasari. *Leben der ausgezeichnetsten Maler, Bildhauer und Baumeister von Cimabue bis zum Jahre 1567.* Edited by Ludwig Schorn. 6 vols. Stuttgart and Tübingen, 1832–49.

Vasari 1568, Le Monnier ed.
Giorgio Vasari. *Le vite de' più eccellenti pittori, scultori e architetti.* Edited by Vincenzo Marchese, Carlo and Gaetano Milanesi. 14 vols. Raccolta artistica. Florence, 1846–70.

Vasari 1568, Milanesi ed.
Giorgio Vasari. *Le vite de' più eccellenti pittori, scultori ed architettori.* Edited by Gaetano Milanesi. 9 vols. Florence, 1878–85.

Vasari 1568, Perkins ed. 1912
Giorgio Vasari. *Vita di Pietro Laurati (Pietro Lorenzetti).* With an introduction, notes, and bibliography by F. Mason Perkins. *Le vite dei più eccellenti pittori, scultori, e architettori scritte da Giorgio Vasari.* Florence, 1912.

Vasari 1568, Club del Libro ed.
Giorgio Vasari. *Le vite de' più eccellenti pittori, scultori e architettori.* 9 vols. Milan, 1962–66.

Vassar 1967
Vassar College Art Gallery. *Selections from the Permanent Collection.* Poughkeepsie, N.Y., 1967.

Vatican City 1913
Vatican City, Musei e Gallerie Pontificie. *Guida della Pinacoteca Vaticana.* Catalogue by Pietro D'Archiardi. Vatican City, 1913.

Vatican City 1933
Vatican City, Musei e Gallerie Pontificie. *Guida della Pinacoteca Vaticana.* Catalogue by Amadore Porcella. Vatican City, 1933.

Vatican City 1955
Vatican City, Palazzo Apostolico Vaticano. *Mostra delle opere di Fra Angelico nel quinto centenario della morte (1455–1955).* Exhibition, April–May 1955. Florence, 1955.

Vayer 1962
Lajos Vayer. *Masolino ès Roma: Mecénás és müvész a reneszánsz Kezdetén.* Budapest, 1962.

Vayer 1965
Lajos Vayer. "Analecta iconographica masoliniana." *Acta historiae artium* (Budapest), vol. 11, nos. 3–4 (November 1965), pp. 217–39.

Venice 1994
See Millon and Magnago Lampugnani 1994

A. Venturi
Adolfo Venturi. *Storia dell'arte italiana.* 11 vols. Milan, 1901–40.

A. Venturi 1905
Adolfo Venturi. "La quadreria Sterbini in Roma." *L'arte* (Rome), vol. 8, no. 6 (November–December 1905), pp. 422–40.

A. Venturi 1906
Adolfo Venturi. *La Galleria Sterbini in Roma.* Rome, 1906.

L. Venturi 1907
Lionello Venturi. *Le origini della pittura veneziana: 1300–1500.* Venice, 1907.

L. Venturi 1930
Lionello Venturi. "Contributi a Masolino, a Lorenzo Salimbeni e a Jacopo Bellini." *L'arte* (Rome), vol. 33, no. 2, pt. 1 (March 1930), pp. 165–86.

L. Venturi 1931
Lionello Venturi. *Pitture italiane in America.* Milan, 1931.

L. Venturi 1933
Lionello Venturi. *Italian Paintings in America.* Vol. 1, *Romanesque and Gothic.* Translated by Countess Van den Heuvel and Charles Marriott. New York, 1933.

Venturini 1994
Lisa Venturini. *Francesco Botticini.* Artisti toscani dal trecento al settecento. Florence, 1994.

Verona 1969
Verona e il suo territorio. Vol. 3, pt. 2. Verona, 1969.

Verona 1970
Verona, Soprintendenza ai Monumenti di Verona. *Pitture murali restaurate.* Exhibition, 1970. Catalogue by Maria Teresa Cuppini. Rome, 1971.

Verona 1988
Verona, Museo di Castelvecchio. *Gli Scaligeri, 1277–1387.* Exhibition, June–November 1988. Catalogue edited by Gian Maria Varanini.

Vertova 1967
Luisa Vertova. "'What Goes with What?'" *The Burlington Magazine* (London), vol. 109, no. 777 (December 1967), pp. 668–72.

Vertova 1968
Luisa Vertova. "La raccolta di Locko Park." *Antichità viva* (Florence), vol. 7, no. 3 (May–June 1968), pp. 23–30.

Vespasiano da Bisticci 1480s, Greco ed. 1970–76
Vespasiano da Bisticci. *Le vite.* Edited with an introduction and commentary by Aulo Greco. 2 vols. Florence, 1970–76.

Vienna 1972
Vienna, Akademie der bildenden Künste. *Katalog der Gemälde Galerie.* Vienna, 1972.

Vienna 1973
Vienna, Kunsthistorisches Museum. *Verzeichnis der Gemälde.* Edited by Klaus Demus. Führer durch das Kunsthistorische Museum, no. 18. Vienna, 1973.

Vignola 1988
Rocca di Vignola. *Il tempo di Nicolò III: gli affreschi del castello di Vignola e la pittura tardogotica nei domini estensi.* Exhibition, May–June 1988. Modena, 1988.

Villers 2000
Caroline Villers, ed. *The Fabric of Images: European Paintings on Textile Supports in the Fourteenth and Fifteenth Centuries.* London, 2000.

Visonà and Bruschi 1986
Maria Visonà and Alberto Bruschi. "Il fratello di Masaccio, Giovanni di ser Giovanni detto Scheggia." *Quadrante padano* (Mantua), vol. 7, no. 2 (June 1986), pp. 21–25.

Vitalini Sacconi 1968
Giuseppe Vitalini Sacconi. *Pittura marchigiana: la scuola camerinese.* Trieste, 1968.

Vitalini Sacconi 1969
Giuseppe Vitalini Sacconi. "Un inedito giottesco in San Francesco a Matelica." *Paragone-arte* (Florence), vol. 20, no. 227 (January 1969), pp. 63–64.

Vitalini Sacconi 1972
Giuseppe Vitalini Sacconi. "Due schede di pittura marchigiana." *Commentari* (Florence), vol. 23, nos. 1–2 (January–June 1972), pp. 164–66.

Vitzthum 1903
Georg Vitzthum. *Bernardo Daddi.* Leipzig, 1903.

Vogel 1960
Cyrille Vogel. "*Versus ad orientum:* L'Orientation dans les *Ordines Romani* du haut moyen âge." *Studi medievali* (Turin), 3rd ser., vol. 1, no. 2 (December 1960), pp. 447–69.

Volbach 1987
Wolfgang Fritz Volbach. *Il trecento: Firenze e Siena.* Catalogo della Pinacoteca Vaticana, 2. Italian translation and iconographic revision by Francesca Pomarici. Vatican City, 1987.

Volpe 1951
Carlo Volpe. "Proposte per il problema di Pietro Lorenzetti." *Paragone-arte* (Florence), vol. 2, no. 23 (November 1951), pp. 13–26.

Volpe 1958
Carlo Volpe. "Deux panneaux de Benedetto di Bindo." *La Revue des arts* (Paris), vol. 8, no. 4 (July–August 1958), pp. 172–76.

Volpe 1960
Carlo Volpe. "Nuove proposte sui Lorenzetti." *Arte antica e moderna* (Bologna), vol. 11 (July–September 1960), pp. 263–77.

Volpe 1965
Carlo Volpe. *La pittura riminese del trecento.* Milan, 1965.

Volpe 1965a
Carlo Volpe. *Pietro Lorenzetti ad Assisi.* Le grandi imprese decorative nell'arte di tutti i tempi. Milan, 1965.

Volpe 1973
Carlo Volpe. "Alcune restituzioni al Maestro dei Santi Quirico e Giulitta." In Giorgio Bonsanti et al., *Quaderni di emblema 2: miscellanea* (pp. 17–22). Bergamo, 1973.

Volpe 1973a
Carlo Volpe. "Per il completamento dell'altare di San Lorenzo del Maestro del Bambino Vispo." *Mitteilungen des Kunsthistorischen Institutes in Florenz* (Florence), vol. 17, nos. 2–3 (1973), pp. 175–88.

Volpe 1974
Carlo Volpe. "Una ricerca su Antonio da Viterbo." *Paragone-arte* (Florence), vol. 22, no. 253 (1974), pp. 44–52.

Volpe 1977
Carlo Volpe. "La donazione Vendeghini Baldi a Ferrara." *Paragone-arte* (Florence), vol. 28, no. 329 (July 1977), pp. 73–78.

Volpe 1989
Carlo Volpe. *Pietro Lorenzetti.* Edited by Mauro Lucco. Milan, 1989.

Von der Osten 1954
Gert von der Osten, ed. *Katalog der Gemälde alter Meister in der Niedersächsischen Landesgalerie Hannover.* Kataloge, 1. Hanover, 1954.

Waadenoijen 1974
Jeanne van Waadenoijen. "A Proposal for Starnina: Exit the Maestro del Bambino Vispo?" *The Burlington Magazine* (London), vol. 116, no. 851 (February 1974), pp. 82–91.

Waadenoijen 1983
Jeanne van Waadenoijen. *Starnina e il gotico internazionale a Firenze.* Translated from the Dutch by Catia Michenzi. Istituto Universitario Olandese di Storia d'Arte, Firenze, 9. Florence, 1983.

Waagen 1837–39
Gustav Friedrich Waagen. *Kunstwerke und Künstler in England und Paris.* 3 vols. Berlin, 1837–39.

Waagen 1838
Gustav Friedrich Waagen. *Works of Art and Artists in England.* English translation by Hannibal Evans Lloyd. Introduction to reprint by R. W. Lightbown. 3 vols. London, 1838. Reprint, London, 1970.

Waagen 1854–57
Gustav Friedrich Waagen. *Treasures of Art in Great Britain: Being an Account of the Chief Collections of Paintings, Drawings, Sculptures, Illuminated Mss., &c.* 4 vols. London, 1854–57.

Waddingham 1962
Malcolm R. Waddingham. "La politica artistica in Inghilterra: i nuovi acquisti della National Gallery." *Antichità viva* (Florence), vol. 1, no. 10 (December 1962), pp. 29–38.

Waetzoldt 1964
Stephan Waetzoldt. *Die Kopien des 17. Jahrhunderts nach Mosaiken und Wandmalereien in Rom.* Römische Forschungen der Bibliotheca Hertziana, 18. Vienna, 1964.

Wagner 1898
Hans Joachim Wagner. *Domenico di Bartolo Ghezzi.* Göttingen, 1898.

K. Walsh 1972
Katherine Walsh. "The Observant Congregations of the Augustinian Friars in Italy, c. 1385–c. 1465." Ph.D. diss., Oxford University, 1972.

Walsh 1979
Barbara Buhler Walsh. "The Fresco Paintings of Bicci di Lorenzo." Ph.D. diss., Indiana University, Bloomington, 1979.

Walsh 1981
Barbara Buhler Walsh. "Two Early Bicci di Lorenzo 'Annunciations.'" *Antichità viva* (Florence), vol. 20, no. 4 (July–August 1981; printed April 1982), pp. 7–13.

Washington 1941
Washington, D.C., National Gallery of Art. *Preliminary Catalogue of Paintings and Sculpture: Descriptive List with Notes.* Washington, D.C., 1941.

Washington 1975
See Ferguson et al. 1975

Wasserman 1935
Gertrud Wasserman. *Masaccio und Masolino: Probleme einer Zeitenwende und ihre schöpferische Gestaltung.* Zur Kunstgeschichte des Auslandes, vol. 134. Strasbourg. 1935.

Watson 1979
Paul F. Watson. *The Garden of Love in Tuscan Art of the Early Renaissance.* Philadelphia, 1979.

Watson 1979–80
Paul F. Watson. "Apollonio di Giovanni and Ancient Athens." *Allen Memorial Art Museum Bulletin* (Oberlin, Ohio), vol. 37, no. 1 (1979–80), pp. 3–25.

Weber 1898
Eduard Friedrich Weber. *Gemälde alter Meister der Sammlung Weber.* Hamburg, 1898.

Wehle 1940
Harry B. Wehle. *The Metropolitan Museum of Art: A Catalogue of Italian, Spanish, and Byzantine Paintings.* New York, 1940.

Weigelt 1911
Curt H. Weigelt. *Duccio di Buoninsegna: Studien zur Geschichte der frühsienesischen Tafelmalerei.* Leipzig, 1911.

Weigelt 1923
Curt H. Weigelt. "Lombardische Miniaturen im Kupferstichkabinett." *Jahrbuch der Preuszischen Kunstsammlungen* (Berlin), vol. 44 (1923), pp. 37–52.

Weigelt 1930
Curt H. Weigelt. *Die sienesische Malerei des vierzehnten Jahrhunderts.* Florence, 1930.

Weinberger 1941
Martin Weinberger. *The George Grey Barnard Collection.* New York, 1941.

Weisbach 1898
Werner Weisbach. "Exposition d'objets d'art du moyen âge et de la Renaissance à Berlin." *Gazette des beaux-arts* (Paris), 40th yr., 3rd ser., vol. 20 (1898), pp. 156–64.

Weisbach 1901
Werner Weisbach. *Francesco Pesellino und die Romantik der Renaissance.* Berlin, 1901.

Weisbach 1901a
Werner Weisbach. "Der Meister der carrandischen Triptycons." *Jahrbuch der königlich Preuszischen Kunstsammlungen* (Berlin), vol. 22 (1901), pp. 35–55.

Weller 1940
Allen Weller. "A Reconstruction of Francesco di Giorgio's 'Chess Game.'" *The Art Quarterly* (Detroit), vol. 3, no. 2 (Spring 1940), pp. 162–72.

Weller 1943
Allen Weller. *Francesco di Giorgio, 1439–1501.* Chicago, 1943.

White 1957
John White. *The Birth and Rebirth of Pictorial Space.* London, 1957.

White 1973
John White. "Measurement, Design, and Carpentry in Duccio's *Maestà.*" *The Art Bulletin* (New York), vol. 55, no. 3 (September 1973), pp. 334–66; vol. 55, no. 4 (December 1973), pp. 547–69.

White 1979
John White. *Duccio: Tuscan Art and the Medieval Workshop.* London, 1979.

Wieck 1988
Roger S. Wieck. *Time Sanctified: The Book of Hours in Medieval Art and Life.* New York, 1988. Exhibition, Walters Art Gallery, Baltimore, April 23–July 17, 1988.

Wilkins 1969
David Wilkins. "Maso di Banco and Cenni di Francesco: A Case of Late Trecento Revival." *The Burlington Magazine* (London), vol. 111, no. 791 (February 1969), pp. 83–84.

Williamstown 1962
Williamstown, Mass., Sterling and Francine Clark Art Institute. *Heptaptych: Ugolino da Siena.* Exhibition, September 1962. Catalogue by John Pope-Hennessy.

Williamstown 1972
Williamstown, Mass., Sterling and Francine Clark Art Institute. *List of Paintings in the Sterling and Francine Clark Art Institute.* Williamstown, 1972.

Wilson 1995
Carolyn C. Wilson. "Fra Angelico: New Light on a Lost Work." *The Burlington Magazine* (London), vol. 137, no. 1112 (November 1995), pp. 737–40.

Wilson 1996
Carolyn C. Wilson. *Italian Paintings, XIV–XVI Centuries, in the Museum of Fine Arts, Houston.* Houston, 1996.

Winkelman 1942
Barnie F. Winkelman. *John G. Johnson: Lawyer and Art Collector, 1841–1917.* Philadelphia, 1942.

Wisch and Ahl 2000
Barbara Wisch and Diane Cole Ahl, eds. *Confraternities and the Visual Arts in Renaissance Italy: Ritual, Spectacle, Image.* Cambridge, 2000.

Woermann 1907
Karl Woermann. *Wissenschaftliches Verzeichnis der älteren Gemälde der Galerie Weber in Hamburg.* Dresden, 1907.

Wohl 1980
Hellmut Wohl. *The Paintings of Domenico Veneziano, ca. 1410–1461: A Study in Florentine Art of the Early Renaissance.* New York, 1980.

Wohl 1984
Hellmut Wohl. "Papal Patronage and the Language of Art: The Pontificates of Martin V, Eugene IV, and Nicholas V." In *Umanesimo a Roma nel quattrocentro* (pp. 235–46). Edited by Paolo Brezzi and Maristella De Panizza Lorch. Atti del convegno su umanesimo a Roma nel quattrocentro, New York, December 1–4, 1981. Rome, 1984.

Wolf 1990
Gerhard Wolf. *Salus populi romani: Die Geschichte römischer Kultbilder im Mittelalter.* Weinheim, 1990.

Wollesen 1977
Jens T. Wollesen. *Die Fresken von San Piero a Grado bei Pisa.* Bad Oeynhausen, Germany, 1977.

Worcester 1951
Worcester (Mass.) Art Museum. *Condition: Excellent. A Catalogue of a Special Exhibition of Paintings Notable for Their State of Preservation.* March 22–April 22, 1951.

Worcester 1974
Worcester (Mass.) Art Museum. *European Paintings in the Collection of the Worcester Art Museum.* 2 vols. Worcester, 1974.

Wright 1980
Christopher Wright, comp. *Paintings in Dutch Museums: An Index of Oil Paintings in Public Collections in The Netherlands by Artists Born before 1870.* London, 1980.

York 1955
City of York Art Gallery. *The Lycett Green Collection: Interim Catalogue.* 1955.

York 1975
City of York Art Gallery. *Catalogue Supplement 1974: Amendments and Additions to Catalogue Volume I and II.* York, 1975.

Zahn 1869
Albert von Zahn. "Masolino und Masaccio." *Jahrbücher für Kunstwissenschaft* (Leipzig), vol. 2 (1869), pp. 155–71.

Zampa 1908
Raffaello Zampa. *Illustrazione storico-artistica del monastero di Montelabate nel comune di Perugia.* Santa Maria degli Angeli, 1908.

Zampetti 1969
Pietro Zampetti. *La pittura marchigiana del '400.* Milan, 1969.

Zampetti 1971
Pietro Zampetti. *Paintings from the Marches: Gentile to Raphael.* Translated by R. G. Carpanini. London, 1971.

Zampetti 1988
Pietro Zampetti. *Pittura nelle Marche.* Vol. 1, *Dalle origini al primo rinascimento.* Preface by Carlo Bo. Florence, 1988.

Zanardi 1996
Bruno Zanardi. *Il cantiere di Giotto: storie di san Francesco ad Assisi.* Introduction by Federico Zeri. Essay by Chiara Frugoni. Milan, 1996.

Zander 1984
Giuseppe Zander. "Considerazioni su un tipo di ciborio in uso a Roma nel rinascimento." *Bollettino d'arte* (Rome), 6th ser., vol. 69, no. 26 (July–August 1984), pp. 99–106.

Zehnder 1993
Frank Günter Zehnder, ed. *Stefan Lochner: Meister zu Köln. Herkunft—Werke—Wirkung.* Cologne, 1993. Exhibition, Cologne, Wallraf-Richartz-Museum, December 3, 1993–February 27, 1994.

Zeri 1948
Federico Zeri. "'Me pinxit,' 3: Giovanni Antonio da Pesaro." *Proporzioni* (Florence), vol. 2 (1948), pp. 164–67.

Zeri 1949
Federico Zeri. "Note su quadri italiani all'estero." *Bollettino d'arte* (Rome), 4th ser., vol. 34, no. 1 (January–March 1949), pp. 21–30.

Zeri 1954
Federico Zeri. "Il Maestro dell'Osservanza: una 'Crocefissione.'" *Paragone-arte* (Florence), vol. 5, no. 49 (January 1954), pp. 43–44.

Zeri 1958
Federico Zeri. "Un riflesso di Antonello da Messina a Firenze." *Paragone-arte* (Florence), vol. 9, no. 99 (March 1958), pp. 16–21.

Zeri 1958a
Federico Zeri. "Una precisazione su Bicci di Lorenzo." *Paragone-arte* (Florence), vol. 9, no. 105 (September 1958), pp. 67–71.

Zeri 1958b
Federico Zeri. "Altri due scomparti veronesi della fine del '300." *Paragone-arte* (Florence), vol. 9, no. 107 (November 1958), pp. 65–66.

Zeri 1959
Federico Zeri. "Il Maestro di Santa Verdiana." In *Studies in the History of Art: Dedicated to William E. Suida on His Eightieth Birthday* (pp. 35–40). London, 1959.

Zeri 1963
Federico Zeri. "Tre argomenti umbri." *Bollettino d'arte* (Rome), 4th ser., vol. 48, nos. 1–2 (January–June 1963), pp. 29–45.

Zeri 1963a
Federico Zeri. "La mostra 'Arte in Valdelsa' a Certaldo." *Bollettino d'arte* (Rome), 4th ser., vol. 48 (July–September 1963), pp. 245–58.

Zeri 1964
Federico Zeri. "Angelo Puccinelli a Siena." *Bollettino d'arte* (Rome), 4th ser., vol. 49, no. 3 (July–September 1964), pp. 229–35.

Zeri 1964–65
Federico Zeri. "Investigations into the Early Period of Lorenzo Monaco." *The Burlington Magazine* (London), vol. 106, no. 741 (December 1964), pp. 554–58; vol. 107, no. 742 (January 1965), pp. 3–11.

Zeri 1966
Federico Zeri. "Aggiunta a una primizia di Lorenzo Monaco." *Bollettino d'arte* (Rome), 5th ser., vol. 51, nos. 3–4 (July–December 1966), pp. 150–51.

Zeri 1968
Federico Zeri. "Sul catalogo dei dipinti toscani del secolo XIV nelle gallerie di Firenze." *Gazette des beaux-arts* (Paris), 110th yr., 6th ser., vol. 71, no. 1189 (February 1968), pp. 65–78.

Zeri 1971
Federico Zeri. *Quaderni di emblema 1: diari di lavoro.* Bergamo, 1971.

Zeri 1973
Federico Zeri. "Una scheda per Battista di Gerio." In Giorgio Bonsanti et al., *Quaderni di emblema 2: miscellanea* (pp. 13–16). Bergamo, 1973.

Zeri 1974
Federico Zeri. "Major and Minor Italian Artists at Dublin." *Apollo* (London), n.s., vol. 99, no. 144 (February 1974), pp. 88–103.

Zeri 1975
Federico Zeri. "Un'ipotesi sui rapporti tra Allegretto Nuzi e Francescuccio Ghissi." *Antichità viva* (Florence), vol. 14, no. 5 (September–October 1975), pp. 3–7.

Zeri 1976
Federico Zeri. *Italian Paintings in the Walters Art Gallery.* Condition notes by Elisabeth C. G. Packard. Edited by Ursula E. McCracken. 2 vols. Baltimore, 1976.

Zeri 1976a
Federico Zeri. *Diari di lavoro 2.* Turin, 1976.

Zeri 1980
Federico Zeri with Elizabeth E. Gardner. *Italian Paintings: A Catalogue of the Collection of The Metropolitan Museum of Art—Sienese and Central Italian Schools.* New York, 1980.

Zeri 1983–84
Federico Zeri. "Un appunto su Tommaso di ser Giovanni, detto Masaccio, e suo fratello Giovanni di ser Giovanni, detto Scheggia." *Prospettiva* (Siena-Florence), nos. 33–36 (April 1983–January 1984; printed May 1985), pp. 56–58.

Zeri 1986
Federico Zeri. "Diari di Lavoro, 3: Giovanni di Paolo e Martino di Bartolomeo—una proposta." *Paragone-arte* (Florence), vol. 37, no. 435 (May 1986), pp. 6–7.

Zeri 1992
Federico Zeri. *Giorno per giorno nella pittura: scritti sull'arte dell'Italia centrale e meridionale dal trecento al primo cinquecento.* Archivi di arte antica. Turin, 1992.

Zeri and De Marchi 1997
Federico Zeri and Andrea G. De Marchi. *Dipinti: La Spezia, Museo Civico Amedeo Lia.* Edited by Marzia Ratti and Angela Acordon. I cataloghi del Museo Civico Amedeo Lia, 3. La Spezia, 1997.

Zeri and Gardner 1971
Federico Zeri with Elizabeth E. Gardner. *Italian Paintings: A Catalogue of the Collection of The Metropolitan Museum of Art—Florentine School.* New York, 1971.

Zeri and Rossi 1986
Federico Zeri and Francesco Rossi. *La raccolta Morelli nell'Accademia Carrara.* Bergamo, 1986.

Ziemke 1969
Hans-Joachim Ziemke. "Ramboux und die sienesische Kunst." *Städel-Jahrbuch* (Frankfurt), n.s., vol. 2 (1969), pp. 255–300.

Zlamalik 1967
Vinko Zlamalik. *Strossmayerova Galerija Starih majstora Jugoslavenske Akademije Znanosti i umjetnosti.* Zagreb, 1967.

Zonghi 1908
Augusto Zonghi. "Allegretto Nuzi morto a Fabriano nel 1373." *Le Marche* (Senigallia), 8th yr., vol. 3, nos. 1–2 (1908), pp. 51–55.

Zuliani 1970
Fulvio Zuliani. "Per la diffusione del giottismo nelle Venezie e in Friuli: gli affreschi dell'Abbazia di Sesto al Reghena." *Arte veneta* (Venice), vol. 24 (1970), pp. 2–25.

Zuraw 1992
Shelly E. Zuraw. "Mino da Fiesole's First Roman Sojourn: The Works in Santa Maria Maggiore." In *Verrocchio and Late Quattrocento Italian Sculpture* (pp. 303–20). Edited by Steven Bule, Alan Phipps Darr, and Fiorella Superbi Gioffredi. Florence, 1992.

INDEX

Wiltshire, England, Corsham Court, Puccio di Simone, *Marriage of Saint Catherine,* 212n.15
Wittelsbach, Elisabeth, of Bavaria, 231n.8
Worcester, Mass., Worcester Art Museum, Andrea di Bartolo, female saints (nos. 1940-31 a, b), 44n.7
Wrocław, Muzeum Narodowe, Schiavo, Paolo, *Apostle Paul* and *Apostle Peter* (nos. VIII-741, 742), 387, 389
Würzburg, Martin von Wagner Museum, Starnina, altarpiece (no. 89, inv. F20), 390
Wyman, Mrs. Rosamond, 102

Wyndham, the Hon. Percy Scawen, 105
Wyndham, Capt. Richard, 105

Y

Yellin, Samuel, 19n.42
Yerkes, Charles Tyson, 1
York, City Art Gallery
 Daddi, Bernardo, *Saint Zenobius(?)* (no. 806), 104, *105,* 105 and n.3
 Martino di Bartolomeo, *Saint Paul* and *Saint Peter* (nos. 779a, b), 176, *176*
Yourtz, Philip N., 9

Z

Zanino di Pietro, altarpiece (Avignon, Musée du Petit Palais, no. 251), 268n.54
Zannoni, Giuseppe, 4
Zanobi di Matteo, 196
Zanobi di Migliore, 352
Zenobius, Saint, 208

Index of Accession Numbers

INDEX OF PROVENANCE

PHOTOGRAPHIC CREDITS

INTRODUCTION
Figs. 3, 9, 12: Courtesy of Philadelphia Museum of Art
Fig. 6: New York, Art Resource
Fig. 17: Lynn Rosenthal
Fig. 18: Courtesy of the Museum of Modern Art, New York
Fig. 21: Graydon Wood
Fig. 22: Joe Mikuliak

CATALOGUE
ALLEGRETTO DI NUZIO
Plates 1A–E (JC cat. 5): Graydon Wood
Figs 1.1, 1.2: Urbino, Soprintendenza per i Beni Artistici e Storici delle Marche, Archivio Fotografico, neg. nos. 4937 – H, 4938 – H
Figs. 1.3, 1.4: Joe Mikuliak
Fig. 1.5: Florence, Soprintendenza per il Patrimonio Storico, Artistico e Demoetnoantropologico, Gabinetto Fotografico
Plate 2 (JC cat. 2): Graydon Wood
Fig. 2.1: Graydon Wood
Fig. 2.2: Attila Mudrák
Plate 3 (JC cat. 119): Graydon Wood
Fig. 3.1: Luciano Francioni
Plate 4 (JC cat. 118): Graydon Wood
Fig. 4.1: Joe Mikuliak
Fig. 4.2: Graydon Wood
Fig. 4.3: © Nicolò Orsi Battaglini
Figs. 4.4, 4.5: Florence, Kunsthistorisches Institut
Figs. 4.6, 4.7: Vatican City, Musei Vaticani, Archivio Fotografico, neg. nos. XXXI.12.95, XXXI.12.101
Fig. 4.8: Urbino, Soprintendenza per i Beni Artistici e Storici delle Marche, Archivio Fotografico, neg. no. 31761 H

ANDREA DI BARTOLO
Plate 5 (JC cat. 99): Graydon Wood
Figs. 5.1–5.3: Joe Mikuliak
Plates 6A–B (JC cat. 96): Graydon Wood

FRA ANGELICO
Plate 7 (JC cat. 15): Joe Mikuliak
Fig. 7.1: Graydon Wood
Fig. 7.2: The Minneapolis Institute of Arts
Fig. 7.4: New York, Feigen Collection
Fig. 7.5: Florence, Soprintendenza per il Patrimonio Storico, Artistico e Demoetnoantropologico, Gabinetto Fotografico, neg. no. 130182
Fig. 7.8: Florence, Kunsthistorisches Institut
Figs. 7.9, 7.10: Lynn Rosenthal
Fig. 7.11: London, Courtauld Institute of Art, neg. no. 980/71 (19)
Plate 8 (JC cat. 14): Graydon Wood
Figs. 8.1, 8.2: Joe Mikuliak
Fig. 8.3: Florence, Opificio delle Pietre Dure
Figs. 8.4, 8.6, 8.7: Florence, Soprintendenza per il Patrimonio Storico, Artistico e Demoetnoantropologico, Gabinetto Fotografico, neg. nos. 378598, 337901, 49880
Fig. 8.5: Alinari / Art Resource, New York

WORKSHOP OF FRA ANGELICO
Plate 9 (JC cat. 1166): Graydon Wood
Fig. 9.4: Courtesy of Michel Laclotte

APOLLONIO DI GIOVANNI AND MARCO DEL BUONO
Plate 10 (JC cat. 26): Graydon Wood
Fig. 10.1: New York, Samuel H. Kress Foundation and the Photographic Archives

ARRIGO DI NICCOLÒ
Plate 11 (PMA 1950-134-528): Graydon Wood
Fig. 11.1: Joe Mikuliak
Fig. 11.2: Philadelphia Museum of Art
Fig. 11.3: Florence, Soprintendenza per il Patrimonio Storico, Artistico e Demoetnoantropologico, Gabinetto Fotografico, neg. no. 306093

BATTISTA DI GERIO
Plate 12 (JC cat. 12): Graydon Wood
Figs. 12.1–12.3: Joe Mikuliak
Fig. 12.6: Courtesy of Maria Teresa Filieri

ATTRIBUTED TO BENEDETTO DI BINDO
Plate 13 (JC cat. 153): Graydon Wood
Fig. 13.1: Graydon Wood
Fig. 13.2: Joe Mikuliak
Fig. 13.5: Pisa, Soprintendenza per i Beni Ambientali, Architettonici, Artistici, e Storici, Archivio Fotografico, neg. no. L4471
Figs. 13.6, 13.7: Siena, Soprintendenza per il Patrimonio Storico, Artistico e Demoetnoantropologico, Archivio Fotografico, neg. nos. 45650, 18337

WORKSHOP OF BICCI DI LORENZO
Plate 14 (JC cat. 7): Graydon Wood
Fig. 14.2: Florence, Soprintendenza per il Patrimonio Storico, Artistico e Demoetnoantropologico, Gabinetto Fotografico, neg. no. 15155

BARTOLOMEO BULGARINI
Plate 15 (JC cat. 92): Graydon Wood
Fig. 15.3: Joe Mikuliak
Fig. 15.4: Graydon Wood
Fig. 15.7: Siena, Soprintendenza per il Patrimonio Storico, Artistico e Demoetnoantropologico, Archivio Fotografico, neg. no. 37002
Fig. 15.9: Pisa, Soprintendenza per i Beni Ambientali, Architettonici, Artistici, e Storici, Archivio Fotografico, neg. no. 73855

CENNI DI FRANCESCO
Plates 16A–C (JC invs. 1290–92): Graydon Wood
Fig. 16.1: London, Christie's, Old Master Picture Department
Fig. 16.2: Marcello Bertoni
Figs. 16.3, 16.4: Cambridge, Fogg Art Museum, Department of Conservation and Technical Research
Fig. 16.5: Florence, Soprintendenza per il Patrimonio Storico, Artistico e Demoetnoantropologico, Gabinetto Fotografico, neg. no. 128068

BERNARDO DADDI
Plate 17 (JC inv. 344): Graydon Wood
Fig. 17.1: Joe Mikuliak
Fig. 17.5: © President and Fellows of Harvard College (Harvard University Art Museums), Cambridge
Figs. 17.6, 17.8: Florence, Soprintendenza per il Patrimonio Storico, Artistico e Demoetnoantropologico, Gabinetto Fotografico, neg. nos. 144157, 10794
Fig. 17.9: Parma, Università di Parma, Centro Studi e Archivio della Communicazione
Plate 18 (JC cat. 117): Graydon Wood
Fig. 18.4: Pisa, Università degli Studi, Dipartimento di Storia delle Arti
Fig. 18.6: Alinari / Art Resource, New York

DALMASIO
Plate 19 (JC cat. 3): Joe Mikuliak
Fig. 19.1: Graydon Wood
Fig. 19.2: Joe Mikuliak
Fig. 19.3: © Réunion des Musées Nationaux, Paris
Fig. 19.5: Florence, Soprintendenza per il Patrimonio Storico, Artistico e Demoetnoantropologico, Gabinetto Fotografico, neg. no. 181218
Fig. 19.6: Prague, Národni Galerie

DIAMANTE DI FEO
Plate 20 (JC cat. 55): Graydon Wood
Fig. 20.1: Joe Mikuliak
Fig. 20.2: © Szépmüvészeti Múzeum, Budapest
Fig. 20.3: © Nicolò Orsi Battaglini
Fig. 20.4: Vatican City, Musei Vaticani, Archivio Fotografico, neg. no. XXXIV.5.4

DOMENICO DI BARTOLO
Plate 21 (JC cat. 102): Graydon Wood
Figs. 21.1–21.4: Joe Mikuliak
Fig. 21.7: © 1996 The Trustees of Princeton University

DOMENICO DI ZANOBI
Plate 22 (JC cat. 61): Graydon Wood
Fig. 22.2: London, Christie's
Fig. 22.3: Antonia Reeve Photography
Fig. 22.4: New York, Samuel H. Kress Foundation and the Photographic Archives

DUCCIO
Plate 23 (JC cat. 88): Graydon Wood
Fig. 23.1: Graydon Wood
Fig. 23.6: Jörg P. Anders
Figs. 23.7, 23.10: Siena, Soprintendenza per il Patrimonio Storico, Artistico e Demoetnoantropologico, Archivio Fotografico, neg. nos. 1020, 9338

FRANCESCO D'ANTONIO
Plate 24 (JC cat. 17): Graydon Wood
Figs. 24.1–24.7: Joe Mikuliak
Fig. 24.9: Alinari / Art Resource, New York
Fig. 24.10: © Nicolò Orsi Battaglini
Fig. 24.11: Courtesy of the Cleveland Museum of Art
Fig. 24.12: © Réunion des Musées Nationaux, Paris

FRANCESCO DI VANNUCCIO
Plate 25 (JC cat. 94): Graydon Wood
Fig. 25.1: Graydon Wood
Fig. 25.5: Siena, Soprintendenza per il Patrimonio Storico, Artistico e Demoetnoantropologico, Archivio Fotografico, neg. nos. 24505–24506

AGNOLO GADDI
Plate 26 (JC cat. 9): Joe Mikuliak
Fig. 26.1: Joe Mikuliak
Fig. 26.2: Florence, Soprintendenza per il Patrimonio Storico, Artistico e Demoetnoantropologico, Gabinetto Fotografico, neg. no. 25573
Fig. 26.3: Nystad Antiquairis Lochem B.V. © W. Nienhuis, Amsterdam

NICCOLÒ DI PIETRO GERINI
Plate 27 (JC cat. 8): Graydon Wood
Figs. 27.1–27.3: Joe Mikuliak
Plate 28 (JC inv. 1163): Graydon Wood
Fig. 28.1: Joe Mikuliak
Fig. 28.3: Scott Bowron
Fig. 28.5: Graydon Wood
Figs. 28.8, 28.9: © Nicolò Orsi Battaglini

GIOVANNI DAL PONTE
Plate 29 (JC inv. 1739): Graydon Wood
Fig. 29.4: Mark Tucker

GIOVANNI DI FRANCESCO
Plate 30 (JC cat. 59): Graydon Wood

GIOVANNI DI PAOLO
Plate 31 (JC cat. 105): Joe Mikuliak
Fig. 31.1: Joe Mikuliak
Fig. 31.2: Alinari / Art Resource, New York
Fig. 31.4: Vatican City, Musei Vaticani, Archivio Fotografico, neg. no. XXXIV.26.17
Fig. 31.7: © Réunion des Musées Nationaux, Paris
Plates 32A–B (PMA 1945-25-121–2): Graydon Wood
Fig. 32.3: Siena, Soprintendenza per il Patrimonio Storico, Artistico e Demoetnoantropologico, Archivio Fotografico
Plate 33 (JC inv. 723): Joe Mikuliak
Figs. 33.2, 33.5: Joe Mikuliak
Fig. 33.3: Siena, Soprintendenza per il Patrimonio Storico, Artistico e Demoetnoantropologico, Archivio Fotografico
Fig. 33.4: Vienna, Gemäldegalerie der Akademie der bildenden Kunst

GIOVANNI DI PIETRO
Plates 34A–B (JC cats. 107–8): Graydon Wood
Fig. 34.1: Vatican City, Musei Vaticani, Archivio Fotografico, neg. no. XXVI.23.78
Fig. 34.3: © Réunion des Musées Nationaux, Paris
Fig. 34.5: Siena, Soprintendenza per il Patrimonio Storico, Artistico e Demoetnoantropologico, Archivio Fotografico

BENOZZO GOZZOLI
Plate 35 (JC inv. 1305): Graydon Wood
Figs. 35.2, 35.3: Joe Mikuliak
Plate 36 (JC cat. 38): Joe Mikuliak
Figs. 36.1, 36.2: Joe Mikuliak
Fig. 36.6: Jörg P. Anders
Fig. 36.8: © Her Majesty Queen Elizabeth II

JACOPO DI CIONE
Plate 37 (JC cat. 4): Joe Mikuliak

Fig. 37.1, 37.4: Joe Mikuliak
Fig. 37.3: Courtesy of the National Gallery, London
Figs. 37.6, 37.7, 37.9: Vatican City, Musei Vaticani, Archivio Fotografico, neg. nos. VII-35-4, V-2-19, XXXIV.28.90/2
Figs. 37.8, 37.10: Philadelphia Museum of Art, John G. Johnson Collection, Curatorial Files
Plate 38 (JC cat. 6): Graydon Wood

PIETRO LORENZETTI
Plates 39A–C (JC cat. 91, PMA EW1985-21-1–2): Joe Mikuliak
Figs. 39.1, 39.2, 39.12: Joe Mikuliak
Fig. 39.5: Arezzo, Soprintendenza per i Beni Architettonici e per il Paesaggio, per il Patrimonio Storico, Artistico e Demoetnoantropologico, Archivio Fotografico, neg. no. 40814
Figs. 39.6–39.8, 39.10, 39.11: Siena, Soprintendenza per il Patrimonio Storico, Artistico e Demoetnoantropologico, Archivio Fotografico, neg. nos. 6277, 29445, 1729, 6324, 29246
Fig. 39.9: Florence, Soprintendenza per il Patrimonio Storico, Artistico e Demoetnoantropologico, Gabinetto Fotografico, neg. no. 118924

LORENZO MONACO
Plate 40 (JC cat. 10): Graydon Wood
Figs. 40.1–40.3: Joe Mikuliak
Fig. 40.5: Molly Faries

LORENZO VENEZIANO
Plate 41 (JC cat. 128): Graydon Wood
Fig. 41.2: Vanves, Giraudon Photographie, neg. no. LAC 945 96
Fig. 41.3: Messina, Soprintendenza per i Beni Culturali ed Ambientali
Figs. 41.4, 41.7, 41.9: Bologna, Soprintendenza per il Patrimonio Storico, Artistico e Demoetnoantropologico, Gabinetto Fotografico, neg. nos. A1192, A1193, 4069
Figs. 41.5, 41.6: Courtesy of Andrea De Marchi

ATTRIBUTED TO MARTINO DA VERONA
Plate 42 (JC inv. 3024): Graydon Wood
Fig. 42.1: Oxford, Ashmolean Museum
Fig. 42.3: Philadelphia Museum of Art, John G. Johnson Collection, Curatorial Files
Fig. 42.4: Alinari / Art Resource, New York
Fig. 42.5: Venice, Soprintendenza per il Patrimonio Storico, Artistico e Demoetnoantropologico, Gabinetto Fotografico, neg. no. 6792

MARTINO DI BARTOLOMEO
Plates 43A–D (PMA 1945-25-120a–d): Graydon Wood
Fig. 43.1: Bullaty-Lomeo Photographers
Fig. 43.3: Siena, Soprintendenza per il Patrimonio Storico, Artistico e Demoetnoantropologico, Gabinetto Fotografico, neg. no. 17919

MASACCIO AND MASOLINO
Plate 44A (JC inv. 408): Joe Mikuliak
Figs. 44A.1–44A.3, 44A.5, 44A.6: Joe Mikuliak
Fig. 44A.4: Florence, Opificio delle Pietre Dure
Plate 44B (JC inv. 407): Joe Mikuliak
Figs. 44B.1, 44B.3, 44B.4: Joe Mikuliak
Fig. 44B.2: Florence, Opificio delle Pietre Dure
Figs. 44B.5, 44B.6: Alinari / Art Resource, New York
Fig. 44B.10: Alinari / Art Resource, New York
Fig. 44B.11: Graydon Wood

Fig. 44B.12: Vienna, Kunsthistorisches Museum, Archivphoto, neg. no. I 22.115
Figs. 44B.13, 44B.14: Siena, Soprintendenza per il Patrimonio Storico, Artistico e Demoetnoantropologico, Archivio Fotografico, neg. nos. 55391, 19206
Fig. 44B.17: Florence, Soprintendenza per il Patrimonio Storico, Artistico e Demoetnoantropologico, Gabinetto Fotografico, neg. no. 125812

MASTER OF CARMIGNANO
Plate 45 (PMA 1950-134-527): Graydon Wood
Figs. 45.1, 45.2: Florence, Soprintendenza per il Patrimonio Storico, Artistico e Demoetnoantropologico, Gabinetto Fotografico, neg. nos. 1243, 98188

MASTER OF THE CASTELLO NATIVITY
Plate 46 (JC cat. 23): Graydon Wood
Fig. 46.2: Munich, Bayerische Staatsgemäldesammlungen
Fig. 46.3: Florence, Soprintendenza per il Patrimonio Storico, Artistico e Demoetnoantropologico, Gabinetto Fotografico, neg. no. 94693
Fig. 46.5: Pisa, Soprintendenza per il Patrimonio Storico, Artistico e Demoetnoantropologico, Archivio Fotografico, neg. no. 157372
Fig. 46.6: Cambridge, England, Stearn & Sons
Fig. 46.7: Lucerne, Galerie Fischer Auktionen AG
Plates 47A–B (JC cats. 24–25): Graydon Wood
Fig. 47.4: Florence, Soprintendenza per il Patrimonio Storico, Artistico e Demoetnoantropologico, Gabinetto Fotografico

MASTER OF 1419
Plate 48 (JC cat. 48): Graydon Wood
Fig. 48.1: Joe Mikuliak

MASTER OF THE JOHNSON TABERNACLE
Plate 49 (JC inv. 2034a): Graydon Wood
Fig. 49.1: Joe Mikuliak
Fig. 49.2: Graydon Wood
Fig. 49.3: Oxford, Christ Church Picture Gallery

MASTER OF MONTELABATE
Plate 50 (PMA W1952-1-1): Will Brown
Fig. 50.1: Graydon Wood
Fig. 50.4: Perugia, Soprintendenza per il Patrimonio Storico, Artistico e Demoetnoantropologico, Gabinetto Fotografico, neg. no. 4321
Plate 51 (JC inv. 325): Graydon Wood
Fig. 51.1: Courtesy of Bruno Lorenzelli, Jr.

MASTER OF THE OSSERVANZA
Plate 52 (JC inv. 1295): Graydon Wood
Figs. 52.1–52.3: Joe Mikuliak
Fig. 52.5: Vatican City, Musei Vaticani, Archivio Fotografico, neg. no. XXXIV.28.90/6
Fig. 52.7: Cambridge, Harvard University Art Museums, Photographic Services © President and Fellows of Harvard University
Fig. 52.8: © 1987 The Detroit Institute of Arts
Fig. 52.10: Courtesy of Sotheby's, New York

MASTER OF THE PESARO CRUCIFIX
Plate 53 (PMA 1943-40-51): Graydon Wood
Figs. 53.1a, b: Joe Mikuliak
Fig. 53.2: Filippo Todini
Fig. 53.4: Strasbourg, Musées de la Ville de Strasbourg
Fig. 53.5: Bologna, Soprintendenza per il Patrimonio

Storico, Artistico e Demoetnoantropologico, Gabinetto Fotografico, neg. no. A 17360

Fig. 53.7: Venice, Soprintendenza per il Patrimonio Storico, Artistico e Demoetnoantropologico, Gabinetto Fotografico, neg. no. 6710

Fig. 53.8: © Réunion des Musées Nationaux, Paris

MASTER OF THE POMEGRANATE
Plate 54 (JC cat. 36): Graydon Wood
Fig. 54.1: Courtesy of Everett Fahy
Figs. 54.2: Joe Mikuliak
Fig. 54.4: Florence, Soprintendenza per il Patrimonio Storico, Artistico e Demoetnoantropologico, Gabinetto Fotografico, neg. no. 2208

MASTER OF STAFFOLO
Plate 55 (JC cat. 121): Graydon Wood
Figs. 55.1, 55.3: Joe Mikuliak
Fig. 55.2: Vienna, Österreichische Nationalbibliothek, Archiv

MASTER OF THE TERNI DORMITION
Plate 56 (JC cat. 123): Graydon Wood

NERI DI BICCI
Plate 57 (PMA 1899-1108): Graydon Wood
Fig. 57.1: Rome, Gabinetto Fotografico Nazionale
Plate 58 (JC inv. 2073): Graydon Wood
Fig. 58.1: Courtesy of Alessandro Parronchi
Figs. 58.2, 58.3: The Hague, Rijksbureau voor Kunsthistorische Documentatie
Plate 59 (JC cat. 27): Graydon Wood
Figs. 59.1, 59.2: Florence, Soprintendenza per il Patrimonio Storico, Artistico e Demoetnoantropologico, Gabinetto Fotografico, neg. nos. 2124, 96936
Plates 60A–F (JC cats. 28–33): Graydon Wood
Fig. 60.1: Joe Mikuliak

NICCOLÒ DI SEGNA
Plate 61 (JC cat. 90): Graydon Wood
Fig. 61.3: Sotheby's, London, neg. no. A6866

NICCOLÒ DI TOMMASO
Plate 62 (JC cat. 120): Graydon Wood
Fig. 62.2: Vatican City, Musei Vaticani, Archivio Fotografico, neg. no. XXXIII-47-47

NICOLA D'ULISSE DA SIENA
Plates 63A–B (JC cats. 103–4): Graydon Wood

ANTONIO ORSINI
Plates 64A–B (JC cats. 98a–b): Graydon Wood
Fig. 64.1: Paris, Union des Arts Décoratifs

PESELLINO
Plate 65 (JC cat. 35): Graydon Wood
Figs. 65.2, 65.3, 65.7: Joe Mikuliak
Fig. 65.5: Florence, Soprintendenza per il Patrimonio Storico, Artistico e Demoetnoantropologico, Gabinetto Fotografico, neg. no. 83127
Fig. 65.6: Graydon Wood

PIETRO DI DOMENICO DA MONTEPULCIANO
Plate 66 (JC cat. 1170): Graydon Wood
Fig. 66.2: Florence, Kunsthistorisches Institut
Fig. 66.3: © 1974 Sotheby's, Inc., London
Fig. 66.4: Courtesy of Andrea De Marchi

PIETRO DI MINIATO
Plate 67 (PMA 1950-134-532): Graydon Wood
Fig. 67.2: Florence, Soprintendenza per il Patrimonio Storico, Artistico e Demoetnoantropologico, Gabinetto Fotografico, neg. no. 120588

PRIAMO DELLA QUERCIA
Plate 68 (JC cat. 20): Graydon Wood
Fig. 68.1: New York, Samuel H. Kress Foundation and the Photographic Archives
Fig. 68.2: Courtesy of Carl Brandon Strehlke

PSEUDO-PIER FRANCESCO FIORENTINO
Plate 69 (JC cat. 41): Graydon Wood
Fig. 69.1: Courtesy of Philadelphia Museum of Art
Plate 70 (JC cat. 40): Graydon Wood
Fig. 70.1: Joe Mikuliak
Plate 71 (JC cat. 39): Graydon Wood
Fig. 71.1: Florence, Soprintendenza per il Patrimonio Storico, Artistico e Demoetnoantropologico, Gabinetto Fotografico, neg. no. 7090
Fig. 71.2: Perugia, Soprintendenza per il Patrimonio Storico, Artistico e Demoetnoantropologico, Gabinetto Fotografico
Fig. 71.3: Joe Mikuliak

FOLLOWER OF PSEUDO-PIER FRANCESCO FIORENTINO
Plate 72 (JC cat. 42): Graydon Wood
Fig. 72.2: London, Courtauld Institute of Art, Witt Library, Photographic Survey

SANO DI PIETRO
Plate 73 (JC cat. 106): Graydon Wood

SCHEGGIA
Plate 74 (JC cat. 34): Graydon Wood
Fig. 74.1: Joe Mikuliak

PAOLO SCHIAVO
Plates 75A–D (JC cats. 124–27): Eric Mitchell, plates 75A, C; Graydon Wood, plates 75B, D
Fig. 75.2: Jörg P. Anders

STARNINA
Plate 76 (JC cat. 13): Graydon Wood
Plate 76.1: Joe Mikuliak
Figs. 76.3, 76.4: Pisa, Soprintendenza per il Patrimonio Storico, Artistico e Demoetnoantropologico, Archivio Fotografico
Fig. 76.9: Philadelphia Museum of Art, John G. Johnson Collection, Curatorial Files

ZANOBI STROZZI
Plate 77 (JC cat. 22): Joe Mikuliak
Fig. 77.1: Alinari / Art Resource, New York

TADDEO DI BARTOLO
Plate 78 (JC cat. 95): Graydon Wood
Fig. 78.1: Joe Mikuliak
Fig. 78.2: A. C. Cooper. Courtesy of Christie's, London
Plate 79 (JC cat. 101): Graydon Wood
Fig. 79.1: Joe Mikuliak
Fig. 79.3: Courtesy of Gail Solberg
Fig. 79.4: Stephen Petegorsky, neg. no. 2723b
Fig. 79.5: Siena, Soprintendenza per il Patrimonio Storico, Artistico e Demoetnoantropologico, Archivio Fotografico, neg. no. 8537

TOMMASO DEL MAZZA
Plate 80 (PMA 1945-125-99): Graydon Wood
Fig. 80.1: Graydon Wood
Fig. 80.3: Florence, Soprintendenza per il Patrimonio Storico, Artistico e Demoetnoantropologico, Gabinetto Fotografico, neg. no. 376087

GIOVANNI TOSCANI
Plate 81 (PMA 1943-40-45): Graydon Wood
Plate 82 (JC cat. 11): Graydon Wood
Figs. 82.1, 82.4–82.6, 82.8, 82.9: Florence, Soprintendenza per il Patrimonio Storico, Artistico e Demoetnoantropologico, Gabinetto Fotografico, neg. nos. 5514, 121170, 121169, 76505, 106619, 160314
Fig. 82.2: London, Former Archive of the Heim Gallery
Plates 83A–B (JC cats. 18–19): Graydon Wood
Fig. 83.1: Joe Mikuliak
Fig. 83.4: Florence, Kunsthistorisches Institut, neg. no. 179652

UGOLINO DI NERIO
Plate 84 (JC cat. 89): Joe Mikuliak
Figs. 84.1, 84.2: Joe Mikuliak
Fig. 84.5: Vatican City, Biblioteca Apostolica Vaticana, Archivio Fotografico
Fig. 84.7: Jörg P. Anders
Fig. 84.9: Siena, Soprintendenza per il Patrimonio Storico, Artistico e Demoetnoantropologico, Archivio Fotografico, neg. no. 17059

VITALE DA BOLOGNA
Plate 85 (JC cat. 1164): Joe Mikuliak
Fig. 85.3: © Réunion des Musées Nationaux, Paris
Fig. 85.4: Bologna, Soprintendenza per il Patrimonio Storico, Artistico e Demoetnoantropologico, Gabinetto Fotografico
Fig. 85.5: © Elke Walford
Fig. 85.6: Vatican City, Biblioteca Apostolica Vaticana, Archivio Fotografico

VENETIAN ADRIATIC SCHOOL
Plate 86 (JC cat. 116): Graydon Wood
Fig. 86.1: Graydon Wood
Fig. 86.2: Joe Mikuliak
Fig. 86.3: Venice, Soprintendenza per il Patrimonio Storico, Artistico e Demoetnoantropologico, Gabinetto Fotografico, neg. no. 3764/G
Fig. 86.5: Barcelona, Institut Amatller d'Art Hispànica, neg. no. 49454
Fig. 86.6: Courtesy of Christie's Images

PADUAN SCHOOL
Plate 87 (JC cat. 1): Graydon Wood
Fig. 87.1: Graydon Wood
Fig. 87.2: Joe Mikuliak
Figs. 87.3, 87.4: Florence, Kunsthistorisches Institut, neg. nos. De Giovanni 190/8, De Giovanni 316/8
Fig. 87.5: Padua, Musei Civici, neg. no. 3739
Fig. 87.8: Osvaldo Böhm, neg. no. 10464
Figs. 87.9, 87.10: Elio e Stefano Ciol, s.n.c.

ADRIATIC SCHOOL
Plate 88 (PMA 1950-134-195): Graydon Wood
Fig. 88.1: Zagreb, Croatia, State Agency for the Protection of Cultural and Natural Heritage
Fig. 88.2: London, Agnew's
Fig. 88.4: Venice, Fotoflash di Zennaro Elisabetta

SIENESE SCHOOL
Plate 89 (JC cat. 93): Graydon Wood
Fig. 89.1: Graydon Wood
Fig. 89.2: Joe Mikuliak

FLORENTINE SCHOOL
Plate 90 (PMA F1938-1-51): Graydon Wood

SIENESE SCHOOL
Plate 91 (JC cat. 100): Graydon Wood

Fig. 91.1: Joe Mikuliak
Fig. 91.2: Siena, Soprintendenza per il Patrimonio Storico,
 Artistico e Demoetnoantropologico, Archivio
 Fotografico
Fig. 91.3: Siena, Soprintendenza per il Patrimonio Storico,
 Artistico e Demoetnoantropologico, Archivio
 Fotografico, neg. no. 9452

UMBRIAN SCHOOL
Plate 92 (1945-25-118): Graydon Wood

MARCHIGIAN SCHOOL
Plate 93 (JC cat. 16): Graydon Wood
Fig. 93.1: Joe Mikuliak
Fig. 93.2: Vatican City, Musei Vaticani, Archivio
 Fotografico, neg. no. XXXIV.28.93/8
Figs. 93.3, 93.4: Florence, Kunsthistorisches Institut, neg.
 nos. 10.373, 16017

SIENESE SCHOOL
Plate 94 (PMA 1919-447): Graydon Wood